The
Encyclopedia
of the Central West

by Allan Carpenter

Editorial Assistant
Carl Provorse

Contributor
Randy Lyon

Facts On File
New York • Oxford • Sydney

The Encyclopedia of the Central West

Facts On File, Inc.
460 Park Avenue South
New York, NY 10016
USA

Facts On File Limited
Collins Street
Oxford OX4 1XJ
United Kingdom

Facts On File Pty Ltd
Talavera & Khartoum Rds
North Ryde NSW 2113
Australia

Library of Congress Cataloging-in-Publication Data

Carpenter, Allan. 1917-
 The encyclopedia of the Central West / Allan Carpenter.
 p. cm.
 ISBN 0-8160-1661-5
 1. Middle West—Dictionaries and encyclopedias. I. Title.
 F351.C325 1990 89-25849
 977—dc20 CIP

A British CIP catalogue record for this book is available from the British Library.

Australian CIP data available on request from Facts On File.

Facts On File books are available at special discounts when purchased in bulk quan-
tities for businesses, associations, institutions or sales promotions. Please call our
Special Sales Department in New York at 212/683-2244 (dial 800/322-8755 except
in NY, AK or HI) or in Oxford at 865/728399.

Jacket design by Duane Stapp
Manufactured by the Maple Vail Book Manufacturing Group
Printed in the United States of America

10 9 8 7 6 5 4 3 2 1

This book is printed on acid-free paper.

CONTENTS

ACKNOWLEDGMENTS

Air Force Academy, 13
American Air Lines, 68
Atchison, Topeka and Santa Fe RR, 222, 280, 309,
Austin, Texas Chamber of Commerce, 462
Beaumont, Texas, Commerce and Business Bureau, 272
Cherokee Nation Historical Society 328
Colorado Tourism Board, 28, 47, 60, 88, 94, 95, 96, 129, 176, 192, 225, 282, 302, 396, 402, 420
Denver Metropolitan Conv. Bur., 53, 75, 115, 125, 126, 442, 500
Dwight D. Eisenhower Library, Abilene Kansas, 8, 140, 140, 144, 206, 258, 488
J.C. Penney Stores, 136, 365
Kansas Department of Economic Development, 105, 131, 139, 162, 217, 242, 266, 284, 394, 441, 459, 483
Library of Congress, 424
Lubbock, Texas, Chamber of Commerce, 385
Montana Travel Promotion, 116, 181, 183, 221, 287, 289, 300, 479
NASA, 102
Nebraska Department of Economic Development, 64, 82, 204, 265, 311, 316, 317, 439
New Mexico State Dept. of Development, Tourist Div., 70, 81, 152, 219, 413, 443
North Dakota Tourism, 225, 336, 399
Oklahoma Tourism and Recreation Department, 19, 24, 78, 195, 197, 252, 278, 305, 307, 347, 349, 371, 397, 398, 466
Pikes Peak County Attractions Association., 110
Santa Fe Opera Association, 325
Sioux Falls, S.D., Chamber of Commerce, 147
South Dakota Dept. of Tourism and Economic Devel., 209, 362, 369, 428, 433
Texas Highway Department, 212
Texas Senate, 232
Texas Tourist Development Agency, 14, 15, 37, 107, 113, 119, 121, 144, 160, 166, 186, 194, 205, 214, 327, 359, 407, 409, 437, 452, 453, 455, 498
Thermopolis, WY, Chamber of Commerce, 456
United Air Lines, 471
U.S. Department of Agriculture, 21, 389, 419
U.S. Department of Interior, Alibates Nat. Mon., 156
U.S. Dept. of Interior, Chaco Canyone Nat. Mon., 381
U.S. Department of Interior, Dinosaur Nat. Mon. 169
U.S. Dept. of Interior, Yellowstone Nat. Park, 497
U.S. Postal Service, Stamp Division, 140
University of Texas, Austin, 32
Winterthur Museum, 356
Woolaroc Museum, Frank Phillips Foundation, Bartlesville, Oklahoma, 267, 463
Wyoming Travel Commission, 58, 80, 128, 138, 189, 201, 352, 446, 484, 495, 496

INTRODUCTION

Approach to Content

The essence of this work is its concentration on the region involved. The user will not find any long descriptive entries dealing with the type of general information found in encyclopedias of wider scope. Instead each entry attempts to confine itself to the aspects of the subject related in some way to the Central West region.

Thus, the work will provide a useful supplement and enhancement of atlases, gazetteers, almanacs and biographies—reference works which because of space limitations cannot devote broad attention to a particular subject within a specialized field such as the Central West.

This approach assures a greater number of entries on the region and permits the inclusion of the more localized subject matter not provided elsewhere.

For example, the references to President Theodore Roosevelt deal only with the formative years he spent in North Dakota and with other aspects of his impact on the region. The entry is not intended as a full-fledged biography such as is expected of more general reference works, but it provides the kind of information not usually found in such works.

Such coverage emphasizes the importance of the biographees and other types of entries in the region itself. However, treatment of natives of the region is designed to provide somewhat fuller coverage, as is other information of special interest in the Central West.

Although users of encyclopedias, and even some scholars, have a tendency to equate the volume of information with the value of such information, the length of an entry in this work is not intended to indicate that one entry is necessarily either more or less important than a similar entry. Again, the emphasis and length of the content depend on both the relationship of the material to the region and the addition of any unique quality or qualities a given entry is thought to possess, particularly if the information given is not readily available in other references.

Methodology

The *Encylopedia of the Central West* follows the usual alphabetical arrangement, presenting information of the widest variety, focused on the ten states selected by the author as comprising that region. The states are Colorado, Kansas, Montana, Nebraska, New Mexico, North Dakota, Oklahoma, South Dakota, Texas and Wyoming.

Various factors of geography, such as the demarcation of rivers have influenced the selection of these states to be included in the Central West region. It is, of course, well known that the various configurations of U.S. regions have resulted in an almost complete lack of uniformity in the selection of the particular states which belong in each region, and this selection of states may contribute to that lack of uniformity.

The encyclopedic format of the work has been extended to reflect the author's experience, developed in writing 107 volumes about the states of the U.S. over a period of fifty-five years. Retaining its encylcopedic form in every sense, the work is intended also to provide interesting and pleasant reading and to enhance the variety of types of information found in encyclopedias. The addition of incidents, anecdotes and other items of human interest hopefully gives added dimension to the encyclopedia, and is, again, a response to the author's experience in the field.

The intent has been not only to present the widest possible body of reference material on the Central West but also to offer a readable work, one to be dipped into for enjoyment as well as information.

Illustrations

Iconography alone has not formed the basis for selection of illustrations for this volume. The selection of most of the 162 illustrations has been designed to emphasize the theme or importance of an existing entry. However, some illustrations do stand alone, with reference only to their alphabetical location. These have been provided not only for visual variety and interest but also to add subject matter. Any illustration which is not related otherwise to the text will be treated as a separate entry in the caption describing it.

Of special importance is the inclusion of

6

archival illustrations, paintings and portraits by well known artists. The emphasis on the region permits the use of such illustrations, which cannot, of course, be found in more general works.

Coverage

Content is designed to cover the entire range of germane subject matter on the region, including aspects of:
Geology
Geography
History
Anthropology
Natural History
Economy
Biography
Academic Institutions
Cultural Institutions
Political, Social and Religious Concerns
Government
Education
Tourism

A brief summary of facts and statistics precedes each state entry as well as those of the larger cities of the ten states covered in the work.

Organization

Entries are in boldface type and are alphabetized after the comma, viz, OKLAHOMA, UNIVERSITY OF. Personalities are alphabetized by inverted name—LINCOLN, Abraham. Titled personalities are listed in the manner of most frequent usage, as LA SALLE, Sieur de (Robert Cavelier), not Cavelier, Robert (Sieur de La Salle).

Subjects alluded to in one entry are often covered in more depth or in a different manner in other entries. To assist readers in finding related entries, these are indicated within the text by the use of small capital letters, as, AGRICULTURE. As additional aids, a brief bibliography and very thorough index are included. The bibliography is designed to provide reference to frequently recommended books covering aspects of the region in more depth.

Sunshine and Wilson Peaks, Colorado. The region is enhanced by its beautiful high country.

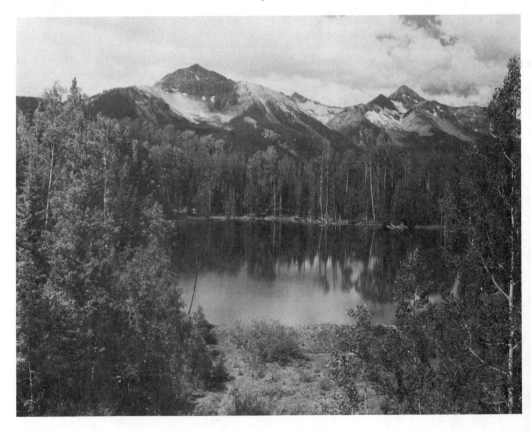

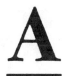

ABBOTT, Grace. (Grand Island, NE, Nov. 17, 1878—Chicago, IL, June 19, 1939). Social reformer. After growing up in her home town and graduating from Grand Island College in 1898, she did graduate work at the University of Nebraska in Lincoln, while teaching high school in Grand Island. In 1908 she joined Jane Addams at Hull House in Chicago and in that year was made director of the Immigrants' Protective League. She received a Ph.M degree in political science at the University of Chicago in 1909 and joined the faculty of the Chicago School of Civics and Philanthropy the following year. In 1917 she became director of the child-labor division of the Children's Bureau in Washington and administered the first federal child-labor law. Her subsequent moves took her to the War Labor Policies Board advisory, 1918; executive secretary of the Illinois Immigrant's Commission, 1920; chief of the U.S. Children's Bureau, 1921-1934; and professor of public welfare, University of Chicago, until her death. In the period 1909-1910 her series of articles for the Chicago *Evening Post* exposed the exploitation of immigrants, and she continued this expose in several periodicals and in her book *The Immigrant and the Community* (1917). At the University of Chicago she also edited the *Social Service Review* (1934-1939). Her best known work is considered to be *The Child and the State*, two volumes (1938).

"ABERDEEN PLAN." Educational program known generally as Cooperative Education where part of the student's course is actual on-the-job training, supervised by the school. The origin of such school and college courses offering on-the-job-training alternating with class work is claimed by NORTHERN STATE TEACHERS COLLEGE at ABERDEEN, South Dakota. In 1920 the college president, Harold W. Foght, and Dr. M.M. Guhin began a program in which students preparing to teach were taken each day by Model T Ford or small bus to rural schools for a three month period of work in a situation resembling that in which they would later teach. The regular classroom teachers in the schools worked closely with the college. Work-study plans eventually proliferated in many academic and practical studies.

ABERDEEN, South Dakota. City (pop. 29,-956), Seat of Brown County, northeast South Dakota, northwest of WATERTOWN and southwest of SISSETON. The name comes from the county and city of Aberdeen in Scotland. Aberdeen has long been and continues to be one of the nation's principal cattle shipping cities, thanks in large part to the three railroads there. Along with the railroads, the presence of NORTHERN STATE TEACHERS COLLEGE, of the the Baltimore Orioles' farm club and varied business opportunities provide Aberdeen with a more metropolitan aspect than might be expected for a city of its size. A famous Aberdeen resident was L. Frank BAUM (1856-1919), the author of *The Wizard of Oz*, the books, the phenomenally popular musical play in New York and later an extremely successful motion picture. Other Aberdeen natives include nationally recognized portrait artists Frances Crammer Greenmen and Frank Ashford. The snow Queen Festival is an annual event in January.

ABILENE, Kansas. City (pop. 6,572), seat of Dickinson County, north-central Kansas, northeast of SALINA and southwest of MANHATTAN. The name was derived from the Biblical reference to a region in Syria. In 1867 Abilene was the first of the major cow towns, as the terminus of the CHISHOLM TRAIL at the Union Pacific Railroad. The community mushroomed with the shipment of more than a million cattle. Today Abilene considers itself the "Heart of the Kansas Wheat Belt." Abilene was one of the roughest towns in the West and the best known of the Kansas cow towns. Often 500 cowboys might be paid at one time, resulting in boistrous sprees and frequent wild conflict.

Famous lawmen of Abilene included Tom

Abilene

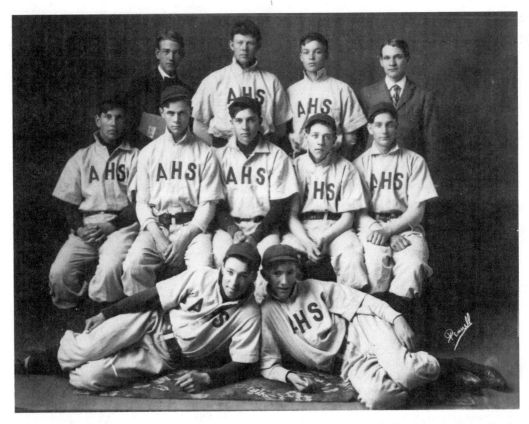

Future U.S. president Dwight D. Eisenhower grew up in Abilene, Kansas, and played on the high school baseball team, top row, second from the right.

Smith and "Wild Bill" HICKOK (1837-1876). Some biographers say that Wild Bill added 57 notches to his gun while in Abilene, increasing the total number of his killings from 43 to 100. Dwight D. EISENHOWER (1890-1969) grew up in the city and became internationally famed as General of the Army and Allied commander during WORLD WAR II and as President of the United States.

It is thought that the lunch wagon had its origin in Abilene. When local restaurants were unable to handle the many cowboys in town at the completion of a cattle drive, the chuck wagon was pulled into town to feed the hungry men. The custom of pulling a wagon loaded with food for sale into a popular spot continued and flourished and was adopted widespread.

One of the largest of all the federal establishments dedicated to United States presidents, the EISENHOWER CENTER contains an unusually large collection of historial memorabilia. The

Museum of Independent Telephony offers a unique display of antique phones and telephone equipment. Old Abilene Town is a replica of the community during the cattle boom, including several original buildings. The National Coursing Meet is considered the "world series" of greyhound racing. The Greyhound Hall of Fame displays the history of greyhound racing from ancient times to the present.

ABILENE, Texas. City (pop. 98,315) seat of Taylor County in northwest central Texas. It was settled in 1881 as a railhead for the Texas and Pacific Railway to accommodate overland cattle drives. Abilene's economy is now based on agriculture, livestock, and industry, with some manufacturing related to agriculture, including light machinery. It is the home of Abilene Christian University, HARDIN-SIMMONS UNIVERSITY, McMurry College, and the West

Texas Medical Center. The annual West Texas Fair and various rodeos and stock shows are held in Abilene. Dyess Air Force Base is located six miles to the Southwest. Other attractions include Buffalo Gap Historic Village and the Hardin Simmons Cowboy Band.

ABSAROKA MOUNTAIN RANGE. Range of the ROCKY MOUNTAINS running approximately 175 miles from southern Montana across the northeast corner of YELLOWSTONE NATIONAL PARK into northwest Wyoming. The highest point, Franks Peak, reaches 13,140 feet. Other peaks include Dead Indian Peak at 12,216 feet and Mt. Crosby at 12,345 feet.

ACEE BLUE EAGLE. (Wichita Indian Reservation north of Anadarka, Oklahoma, Aug. 17, 1910—1959). Artist. Born Che Bon Ah Bu La, Laughing Boy, also known as Alex C. McIntosh, he preferred the name Acee Blue Eagle, by which he is known in art encyclopedias. That picturesque name was chosen based on his father's dream, of a blue eagle soaring in the sky. When the mother heard of the dream she is said to have exclaimed, "That's it!" or "accee" in their language. So the son became That's It Blue Eagle. Mostly self-taught, he became a watercolorist of world-wide reputation. Understandably, he specialized in paintings of Indian life and times. In 1934 he completed several murals in Oklahoma public buildings as a W.P.A. artist. He is known for his rather flat work, conceived in broad planes of bright color. The largest collection of his work is found in the National Gallery of Art in Washington, D.C. Acee Blue Eagle is represented in the PHILBROOK ART CENTER, TULSA , Oklahoma, in the DENVER, Colorado Art Museum and the MUSEUM OF NEW MEXICO, SANTA FE . He lectured extensively in Europe during the 1930s and founded the art department at Bacone College, MUSKOGEE, Oklahoma, which he headed from 1935 to 1938. Beginning in 1946 he became a radio and television critic and gained recognition as an early television personality. In 1937 he was named the "Foremost Indian Artist," and in 1959 he was given the title the "Outstanding Indian in the U.S."

ACOMA INDIANS. Pueblo tribe living in west-central New Mexico. The ACOMA PUEBLO, established in about 1200 A.D., is one of the oldest continuously inhabited villages in the United States. Migrating from the north, the Acoma had, by 1100 A.D., settled along the Rio

de los Frijoles (Bean River) in northern New Mexico.

They chose as the site for their community the top of a sandstone mesa with steep walls, making access difficult for any possible invader. With the gradual change from a life of hunting and grazing, the Acoma developed a relatively complex agricultural system. Descending from the mesa to the farming lands below, the farmers of each household would grow their beans, corn and squash on assigned plots.

The women were at work with the corn and other crops. Last year's harvest had been set out in the sun to dry, following the usual practice of keeping at least one year's crop in reserve. The women owned the seeds and so, also, owned the crop. Corn was ground three times to the desired fineness and turned into piki, the paper-thin bread, the staple crop.

Crafts developed as well, and more and more skill was exhibited in the pottery that today is carried on in much the same tradition as in earlier times.

The arrival of the Spanish interrupted this settled and generally peaceful life. The early attempts at Spanish settlement were made by Don Juan de Onate, who established a settlement on July 11, 1598, near the Tewa pueblo of Yugeuingge. This was the second European settlement in what is now the U.S. Recognizing the superior force, the Pueblo people, including the Acoma, had submitted to Onate's authority. When Onate visited Acoma, the leaders tried to lure him into a trap, but he avoided it.

Realizing that submission to the foreigners meant loss of their freedom, the pueblo people almost immediately began to resist. Onate's nephew Juan de Zaldivar and eighteen of his men were killed. His brother organized a force to avenge his brother's death. In early 1599 he attacked the Pueblo fortress of Acoma in what has been described as an epic battle. The Acoma people held out for a month, but at last were conquered.

Half of the Acoma population was destroyed. Because the other pueblos had considered Acoma to be invincible, their resistance was discouraged, as the Spanish crushed resistance to their rule. At Acoma Pueblo the few men left under the age of twenty-five were punished for the general resistance by the loss of a foot and "personal service" for twenty years. Women and children above the age of twelve were given "only" the twenty years of slavery, while children under the age of twelve were placed in the care of priests.

In 1680 the Acoma participated in the PUEBLO REVOLT, which forced the Spanish temporarily to flee the region, but by 1699 the Spanish recaptured all they had lost. At that time the Acoma population had stood at approximately 1,500, but within a hundred years was reduced to nearly 800 by smallpox and other diseases. During the long Spanish rule of nearly 130 years, most of the Indians were converted to Christianity, but the pueblo people continued in most of their old ways.

End of the Spanish rule, and the opening of the Santa Fe Trail to the east brought to a close much of the isolation of the area. Completion of the Santa Fe Railroad in 1879 brought the Acoma society into greater contact with the outside world.

That society continues today, following many of the old traditions. History had been kept alive by constant oral repetition over the generations, and much of the life and times of the pueblo is known now.

The Acoma, a part of the Keresan language family, were divided into about twenty matrilineal clans. Marriage was forbidden with the mother's clan, and approved grudgingly within the father's clan. Leadership traditionally came from the cacique, the leader in peace, and a warchief, both chosen for life by clan-associated priesthoods.

The Acoma religion revolved around many traditions about their origin. The greatest dieties were the Sky Father and Earth Mother. Ceremonial dances were held in semi-subterranean chambers called kivas. Annual festivals included the Corn Dance and the Rain Dance. After the introduction of Christianity by the Spanish, the fiesta of San Estevan, patron saint of the Franciscan mission at Acoma, became very important.

Before being taught about Christianity, the Acoma believed that in death the soul hovered around its earthly home for four days before traveling to Shipapu, the place of origin of all Keresan people. Bodies, wrapped within twenty-four hours of death, were interred with the head toward the east, in a graveyard next to the San Estevan church.

The Acoma village was composed of three rows of terraced, three-story adobe houses, each one a thousand feet long. The first adobe houses were divided into separate, single family units. The first, or lower level, for storage, with ladders used to reach the upper two levels for housing. Each housing unit contained an open hearth for cooking and three corn grinding troughs at one end. Baking ovens were located outside. Two natural cisterns at the northern edge of the village collected rain water, only available source for the villagers.

The Acoma used land on the plains below their 350-foot high mesa-top home to grow corn, wheat, peaches, melons, beans and squash. The Acoma raised goats, sheep, horses and donkeys and, before the Spanish conquest, turkeys. The men hunted for deer and rabbits and the women gathered pine nuts, prickly pear cactus fruit and gooseberries.

Today the Acoma, relatively unaffected by the white culture, continue to practice many of their traditional ways. They have shifted from sheep raising to cattle. A community herd was begun in 1940. Tourism brings in additional money from the sale of pottery, silverwork and leatherwork. The tribal government has been in the hands of a governor, one or two lieutenant governors, and a tribal council.

ACOMA PUEBLO. Reservation, (pop. est. 2,887) Rising high on a mesa at 7,000 feet elevation, Acoma has been called the Skyhigh City. It is said by some archeologists to be the oldest continuously occupied community in the U.S. Lying today in Valencia County, west central New Mexico, the Pueblo is thought to have been started at about 1150 A.D. According to legend, it was inhabited even earlier, at the time of Christ. The steep sided mesa rises 357 feet, and below it are the fields which have apparently been cultivated since its first habitation.

The Church of San Isabel Rey was begun in 1629. Enormous beams of 40 foot length were laboriously hauled up the cliffs to build the church, after being cut in mountains 30 miles away. The dirt for the graveyard had to be carried up by the people. As it was in the past, the water supply is captured in stone basins on the top.

Residents still speak a Keresan language and occupy the historic community with its dizzying location. Their city has been a marvel from the most recent visitor back to the first known Europeans to view it, Fray Marcos DE NIZA in 1539, and Francisco CORONADO in 1540. Juan de ONATE and his men were permitted to visit in 1598.

Today the pueblo is admired for its traditionally fine pottery, which is exhibited in the Indian Museum, along with other historic objects. A craft shop, information and tours are available. Visitors are taken to the top of the pueblo by shuttle bus. Several of the annual religious rites are private, but visitors enjoy a

number of other annual events, including the Governor's Feast, Santiago Day, Christmas Eve LUMINARIAS and the dances of the Christmas celebration.

ADA, Oklahoma. City (pop. 15,902). Seat of Pontotoc County, southeastern Oklahoma, south of SHAWNEE and and northeast of Sulphur. The name honors Ada Reed, daughter of the first postmaster. Ada is a manufacturing center whose principal industries are glass, rubber, denim clothing, automotive parts, plastic cups and cement. The city is a center for cattle and oil production. The fine silica sand and limestone quarries are the source of the glass and cement. Ada, founded 1890, had a reputation for lawlessness as late as 1908 when there were 38 unsolved murders. Murder defendants often employed one lawyer, Norman Pruiett. In his career, Pruiett defended 342 accused murderers, of whom 304 received no punishment. Not one of the 38 found guilty was executed. On February 27, 1909, Gus Bobbitt, a prominent citizen was gunned down on his way to town. Outraged citizens, afraid the killers would seek out Pruiett, broke into the jail and lynched those accused of the crime. This vigilante action plus, stricter courts, gradually brought an end to Ada's crime wave. East Central University is located there.

ADAMS STATE COLLEGE. Publicly supported, located in ALAMOSA, Colorado. Teacher education continues to be the principal emphasis of the college, although the program has been broadened to include vocational, preprofessional and liberal arts. During the 1985-1986 academic year Adams State enrolled 2,002 students and had a staff of 99.

ADOBE ARCHITECTURE. Style of architecture using brick made of clay, straw, and water formed in a mold and hardened in the sun. The term "adobe," referring to both the material and a building constructed of the material, originated in Mexico. Pre-European buildings of adobe were found as far north as Montana and Wyoming. In western slang the word adobe is often shortened to "'dobe." Adobe construction has been widely used throughout the world, adapted by the Japanese until recent years, and popular in Britain, especially rural wales. Europeans in the Southwest quickly adopted the local material for their buildings. The most famous of these is the Palace of the Governors, built at Santa Fe in 1610. It is the oldest public building in continuous use in the country. Cristo Rey Church

(1939) in Santa Fe is the largest adobe structure in the U.S., with walls two to seven feet thick. Most of the rancho buildings of the Spanish and Mexican periods were adobe. Today many modern homes in the Southwest favor adobe because of its tradition and its insulating qualities from heat and cold. It also is popular for the way it appears to blend in with its surrounding.

AGASSIZ, LAKE. Prehistoric lake existing an estimated ten thousand years ago and lasting for probably one thousand years. Named in honor of Louis Agassiz (1807-1873), the first advocate of the theory that drift was formed by land ice, the lake covered an area larger than the present Great Lakes. Today its remnants are lakes Manitoba, Winnipeg, Winnipegosis and Lake of the Woods. Lake Agassiz was estimated to be 650 feet deep, seven hundred miles long, two hundred miles wide, and of an area at least 110,000 square miles. The western shore of the lake was near present-day BUFFALO, North Dakota. It is believed that the site of modern FARGO, North Dakota, may have been two hundred feet below the lake's surface. The lake was formed at the last stage of North American GLACIERS, about eleven thousand years ago when the ice retreated northward from Iowa across the divide, which sends water either to Hudson Bay on the north or to the Mississippi River on the south. As ice melted, the water became trapped between the divide and the remaining ice over an area across North Dakota, northern Minnesota, and large portions of Canada. When the water eventually flowed away it left behind rich sedimentary deposits in such locations as the RED RIVER Valley.

AGATE. Official gem of three of the central western states, Montana, Nebraska and South Dakota. The agate is a variation of quartz which is banded in two or more colors. The colors are built up by the slow deposit of silica in softer rocks. Blue agate is the Nebraska choice and fairburn agate the selection of South Dakota. Montana, not content with one state gem has chosen both the agate and the sapphire.

AGATE FOSSIL BEDS NATIONAL MONUMENT. One of Nebraska's four national preserves, these renowned quarries were selected for national preserve status by the national park service because they contain numerous well preserved Miocene mammal

fossils and represent an important chapter in the evolution of mammals. The monument was authorized June 5, 1965, headquartered GERING, Nebraska.

AGATE SPRINGS FOSSIL QUARRIES.
Rich fossil site near Harrison, Nebraska The first fossil-hunting expedition was conducted by the Carnegie Museum in 1904 at the area where the buttes and hills have been cut by erosion. Fossils lie in a layer of rock averaging twelve inches in thickness. Chief quarries on Bear Dog Hill, University Hill and Carnegie Hill have yielded fossil remains of a small two-horned rhinoceros, the dinohyus, a giant hog, the claw-footed moropus, which resembled a rhinoceros, and the ancestral horse.

AGRICULTURAL AND MECHANICAL UNIVERSITY OF TEXAS.
Referred to as Texas A and M, the college, renowned for its military discipline, has operated since 1876 in COLLEGE STATION, Texas. During the 1985-1986 academic year the school enrolled 35,675 students and employed 2,240 faculty members.

AGRICULTURE IN THE REGION BY STATE.
Texas leads all the Central West states in value of its total agricultural product, $9,683,000,000 per year, and it ranks second among all the states in that regard. Nebraska is second in the region in agriculture with annual income of more than seven billion, and ranking fourth among the states. Kansas is third in the region with about six billion, in 7th U.S. rank. It is followed by New Mexico, South Dakota, Oklahoma, North Dakota, Montana, Colorado and a very low last in the region for Wyoming, as well as the latter with a ranking of 39th in the nation.

Nebraska leads the entire region in income from CORN, with more than two billion, and with Texas second with only 440 million.

In WHEAT, of course, Kansas leads the nation far and away with North Dakota in second place in the nation and Oklahoma a national third place.

Texas is the only Central West state ranking in COTTON income. More importantly, Texas leads the nation in that important crop, bringing in about a billion dollars annually.

Texas, again, leads the nation in the total value of CATTLE produced, followed by Nebraska and Kansas as second and third in U.S. cattle income.

Nebraska and South Dakota are the only substantial growers of chickens in the region.

The Central West states and their principal products are:
Colorado—Cattle, wheat, corn, diary products
Kansas—Cattle, wheat, hogs, sorghum grain
Montana—Cattle wheat, barley, dairy products
Nebraska—Cattle, corn hogs, soy beans
New Mexico—Cattle, dairy products, hay, wheat
North Dakota—wheat cattle, sunflowers, barley
Oklahoma—Cattle, wheat, turkeys, dairy products
South Dakota—Cattle, wheat, hogs, corn
Texas, Cattle—cotton, dairy products, sorghum grain
Wyoming, Cattle—wheat, sheep, sugar beets

AGRICULTURE, PUEBLO.
The PUEBLO culture extended from southern Utah and southern Colorado into Arizona, New Mexico and adjacent areas of Mexico. Pueblo dwellers did some hunting, but the people were basically agriculturists. They tilled and cultivated the fields, in which they grew crops of tobacco, squash, beans and principally corn. Each morning the farmers would make their difficult way down from the high mesa or other remote places on which the pueblos were built. Sometimes this meant a descent down almost vertical slopes of 600 feet or more, with only small footholds in crevices or breaks in the surface. Crops were grown on the level desert flatlands. Rain dances and other rituals were an essential part of pueblo life, as the people prayed for enough moisture to grow their crops. There was some irrigation. In fact, in some areas, patterns of irrigation ditches stretched for miles from the cultivated fields to the nearest water supply. But for the most part irrigation water was scattered and undependable, and the pueblo farmers were experienced in dry farming, depending on the sparse rainfall of the region. The same scraggly corn of centuries past is still grown today. It is descended from a hardy variety that grows quickly and resists the extreme heat of the region. Key to the success of corn planting is the depth of the seed in the ground. Holes are drilled as much as twelve inches deep, with five-foot spaces between each hill, and as many as 20 seeds may be planted in one hole. This deep planting, done in April, takes advantage of whatever ground water may be available at the bottom of the hole. The small ears, harvested in September, would not take a prize at the Iowa State Fair, but they have helped the PUEBLO PEOPLE to survive for centuries.

One of the twenty-four squadrons that comprise the cadet wing passes before the seventeen spired, glass and aluminum inter-faith chapel at the U.S. AIR FORCE ACAEDEMY near Colorado Springs.

AGUARDIENTE. A powerful inferior brandy known as "Taos Lightning. Under the influence of aguardiente the TAOS INDIANS rebelled against the Americans and killed Governor Charles BENT in the revolt of 1680.

AIR FORCE ACADEMY. Agency of the Department of the Air Force, located in the foothills of the ROCKY MOUNTAINS on an eighteen thousand acre site near COLORADO SPRINGS, Colorado. The establishment of the academy was authorized by Congress on April 1, 1954, after recommendations in the 1920s by Brigadier General Billy Mitchell and a service academy board established in 1949. A committee appointed by the Secretary of the Air Force chose the site, and the academy was dedicated in 1955. Lt. General Hubert Harmon, the first superintendent, oversaw the training of the first cadets at the academy's temporary site at Lowry Air Force Base, near DENVER, Colorado. The academy moved to its permanent location in 1958. Women were admitted for the first time in 1976. Students, referred to as cadets, take four years of academic work to earn the Bachelor of Science degree. They are also instructed in military training to earn commissions in the United States Air Force. Cadets agree to serve four years as a cadet and five years as an Air Force officer. The United States government provides food, medical attention and housing plus a monthly salary to each cadet to pay for uniforms, personal expenses and textbooks. Cadet enrollment is 4,400, Academy officers 1,900

AIRCRAFT INDUSTRY. WICHITA, boasts a larger number of aircraft manufacturers than any other city in the world. It grew with such air pioneers as Clyde CESSNA (1879-1954), Glenn MARTIN (1886-1955) and pioneering Jake Moellendick. By the mid-1920s Wichita had become known as the Air Capital of the World, having fifteen different companies producing aircraft there, even at that early period. The giant companies, Boeing, Cessna, Beech, Learjet and Gates, continue to lead the way, and some have done pioneering work in the aerospace industry.

AK-SAR-BEN, Knights of. Members of a non-profit enterprise with a board of governors, serving without compensation, they conduct various civic activities. The Knights began in 1894 when a group of OMAHA, Nebraska, businessmen, returning from Mardi-Gras in New Orleans, were convinced that a festival of similar importance would help unite the city

with people living near Omaha. A name for the festival was suggested by spelling the word "Nebraska" backwards. An Arabic scholar interpreted the syllables as: Ak, Syrian, meaning head of the household; Sar, Arabic, for household; Ben, Hebrew, meaning brother in the household. "Ak-Sar-Ben" was then to mean the king, his domain, and his retainers. The Knights adopted a coat of arms which incorporated corn, wheat, sugar beets, and alfalfa. Rituals and costumes have been retained with little change. Thousands of Omahans have held membership.

ALABAMA AND COUSHATA RESERVATION. The only federal Indian reservation remaining in Texas. Total population of the reservation is now 525. In addition to the Alabama and Coushatta, people of the Tiwa and Kickapoo tribes also are settled on the reservation, which is near Livingston, Texas.

ALABASTER CAVERNS. The world's largest gypsum cave, located in Alabaster Caverns State Park near Freedom, Oklahoma. The cave extends for slightly more than half a mile, with

Colorful tribal dances are one of the biggest attractions at the Alabama-Coushatta Indian Reservation in East Texas.

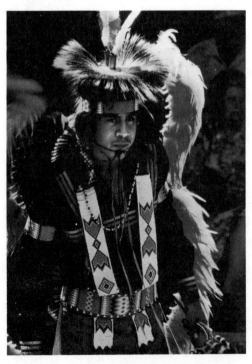

a walking tour covering three fourths of a mile. Caves in this area reputedly shelter an unbelievable total of ten million bats.

ALAMO. Spanish mission in SAN ANTONIO, Texas, most famous as the site of the massacre of Texas defenders during a battle in the War for Texas Independence. Named for a Spanish word meaning "cottonwood," it was built as a mission in 1744 and converted into a fort by the Spanish colonizers of Mexico in 1793. The Alamo was captured by rebels for the cause of Texas independence from Mexico in December of 1835. Subsequently, the defenders, including commander William Barret TRAVIS (1809-1836), James BOWIE (1796-1836), Albert Martin and the rest of the 157 defenders were captured and killed during the Battle of the ALAMO.

ALAMO, BATTLE OF. After the declaration of independence by American settlers of Texas, the Mexican forces under dictator-president, General SANTA ANA (1794-1836), marched on Texas to put down the insurrection. In December, 1835, the American insurgents had captured San Antonio. On February 23, 1836, Santa Ana arrived at the city with a force of 6,000 men. The American commander, William Barret TRAVIS (1809-1836) had only 157 men to withstand the Mexican army. Of course, choice of a last stand defense was crucial. Travis chose the abandoned ALAMO mission. The mission was more than a century ago old, but its adobe walls were thick and sturdy.

The commander of Texas forces, General Sam HOUSTON (1793-1863), had called on Travis to blow up the Alamo and retreat while he could, but Travis and his men had decided to fight to the last man.

They managed to send out a messenger asking for help, Travis wrote: "The enemy has demanded a surrender at discretion, otherwise, the garrison are to be put to the sword if the fort is taken—I have answered the demand with a cannon shot, and our flag still waves proudly from the walls—I shall never surrender or retreat. I call on you in the name of liberty and patriotism to come to our aid....If this call is neglected, I am determined to sustain myself as long as possible and die like a soldier who never forgets what is due to his own honor and that of his country—victory or death. William Barret Travis."

Houston set out on an almost hopeless rescue mission. Meanwhile, Captain Albert Martin managed to slip into the Alamo with his 32 men (The THIRTY-TWO IMMORTALS), giving the

Alamogordo

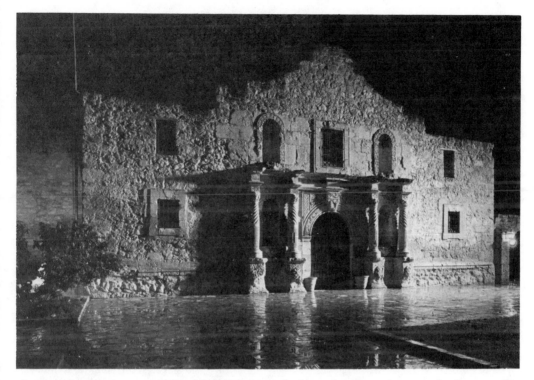

The Alamo (Mission San Antonio de Valero) was a historic building when the 13-day siege of its fortress walls brought capture and death to its brave defenders on March 6, 1836.

defenders a tiny force totalling less than 200.

Nearing San Antonio, Houston tried an old Indian trick. He put his ear to the ground but could hear no rumbling of cannons or firing of rifles. He was convinced that the Alamo had fallen. A woman fleeing from the town with her baby brought confirmation of this, relating that all the defenders had been killed and their bodies had been piled outside the Alamo and burned.

Texas was inflamed with this massacre. "Remember the Alamo," became one of the most noted of all battle cries. Recruits continued to come in to Sam Houston as he set about a strategic retreat to the swamps of SAN JACINTO, where he finally defeated the merciless Santa Ana.

ALAMOGORDO, New Mexico. City (pop. 24,024). Seat of Otero County, south-central New Mexico, west of ARTESIA and southeast of ALBUQUERQUE, name in Spanish meaning "Spring of the big cottonwood." TRINITY SITE, a remote section of the White Sands Missile Range near Alamogordo, witnessed the dawn of

the atomic age on July 16, 1945. On this date the first manmade atomic explosion sent a huge cloud 40,000 feet into the sky. The Air Force Missile Development Center of nearby Holoman Air Force Base conducts a great deal of this nation's rocket research. Blessed for its ample water supply, the town was founded in 1898 as a railroad division point. It grew as a lumbering, farming and ranching center. Based on the community's location near the desert and the cool, timbered mountains, the tourist industry increased dramatically. Important prehistoric carvings are found at Three Rivers Petroglyph Site, and WHITE SANDS NATIONAL MONUMENT is nearby. The International Space Hall of Fame is another notable visitor attraction. This institution came into being through the efforts of former Alamagordo mayor Dwight Ohlinger. His concept of a museum honoring the city as "cradle of the space age" was accepted on July 25, 1973, and the museum was created with the support of the local community and the state. Trinity Site, where the first atomic bomb was tested, is opened to visitors only twice a year.

ALAMOSA, Colorado. City (pop. 6,830), seat of Alamosa County, south-central Colorado, on the RIO GRANDE RIVER, southeast of Monte Vista and southwest of CANON CITY. Its name in Spanish means cottonwood trees. Alamosa is a shipping center for the San Luis Valley, a region known for its production of vegetables, potatoes, barley and hay. The city was established in 1878 when Garland City, the former terminus of the DENVER AND RIO GRANDE WESTERN RAILWAY, was moved to this site. Houses, stores, and churches were transported on flatcars.

ALBUQUERQUE, NEW MEXICO

Name: From the Duke of Alburquerque, Viceroy of New Spain when it was founded in 1706.

Nickname: The Duke City; Hot Air Balloon Capital of the World.

Area: 127.2 square miles

Elevation: 5,311 feet

Population:
1986: 366,750
Rank: 40th
Percent change (1980-1986): +10.2%
Density (city):2,883 per sq. mi.
Metropolitan Population: 449,389 (1984)
Percent change (1980-1984): +6.9%

Race and Ethnic (1980):
White: 81%
Black: 2.52%
Hispanic origin: 112,030 persons (33.78%)
Indian: 7,163 persons (2.21%)
Asian: 3,755 persons (0.95%)
Other: 37,400 persons

Age:
18 and under: 27.8%
65 and over: 8.4%

TV Stations: 5

Radio Stations: 21

Hospitals: 17

Sports Teams:
Albuquerque Dukes (baseball)

Further Information: Albuquerque Chamber of Commerce, 401 2nd NW, Albuquerque, NM 87102.

ALBUQUERQUE, New Mexico. City (pop. 332,336). seat of Bernalillo County, largest city in New Mexico, situated on the RIO GRANDE RIVER, slightly north and west of the center of the state, lying in the river valley between the SANGRE DE CRISTO MOUNTAINS on the east and the JEMEZ RANGE on the west. The community is generally considered to have been named in honor of the Spanish Duke of Alburquerque by New Mexico governor Don Francisco Cuervo y Valdes, who later renamed it San Phelipe de Alburquerque, to add the name of Spain's King Philip. The first "R" has been removed, probably by Americans who mistook the name for Portuguese admiral Alphonso d'Albuquerque.

Don Valdes founded the community in 1706, moving settlers from BERNALILLO, fifteen miles farther north, because he thought the pasturage was better at the new site. Modern Albuquerque, the new town, was platted in 1880 as part of the development of the railroad. Its rapid growth quickly surrounded the old town. The small communities of Alameda and Pajarito are suburbs.

Sandia Laboratories, a national organization, is the largest single employer with a work force of 7,000 engaged in solar and nuclear endeavors of a wide variety. Kirtland Air Force base adds to the bustle of commercial activity. More than sixty companies undertake research development and production in the electronic field. The city is the center of a substantial livestock business, reaching nearly $200,000,-000 annually.

With more than 76% of daylight hours free of clouds and with its dry and healthful air, the city has long been known as a health center, including numerous sanitariums, hospitals and a U.S. veterans center.

In the decade between 1970 and 1980, Albuquerque's population grew 36%. The broad base of its commercial activity kept the city from feeling much effect of the general drop in the economy during the period. Its attraction to tourists is particularly important to its economy.

A substantial center of education, Albuquerque is home to The University of NEW MEXICO, University of ALBUQUERQUE and the U.S. Polytechnical School for Indians.

Old Town retains its charming Spanish flavor, sporting fine shops, galleries and eating places. The Old Town Fiesta is held each June. Albuquerque Museum is solar heated, the only one of its kind. One of the features of the New Mexico Museum of Natural History is a simulated walk through a volcano. The National

Atomic Museum is one of the most complete of its type. There is an Indian Pueblo Cultural Center, sponsored by 19 of the Pueblos, providing the history of the Pueblos, exhibits of arts and crafts and a restaurant with typical Pueblo meals.

Attractive in its modified Pueblo architecture, the University of New Mexico has a wide range of visitor attractions. Museums of anthropology and geology, Fine Arts Center, with galleries, concert hall for the New Mexico Symphony, and theater, featuring Broadway productions, are all notable attractions of the award winning campus.

Few metropolitan areas can equal the number of points of interest to be found within a few miles of Albuquerque. Attracting the most visitors is the Sandia Peak Aerial Tramway, longest unsupported cable transport in the world, carrying crowds to the crest of Sandia Peak, where a wide variety of winter and summer recreation can be found. The peak also can be reached by car, and the views are among the best in the Southwest.

The numerous Pueblos include JEMEZ, ZIA and SANTA ANA. SAN ILDEFONSO PUEBLO is world renowned for the black glazed pottery that originated there. ISLETA PUEBLO is one of the most prosperous and interesting in the area, with its church having a particularly fine altar; the Indian market center features arts and crafts.

Indian Petroglyph State Park preserves one of the finest collections of prehistoric carvings, dating as far back as 1100 A.D.

Many of the annual events revolve around Indian culture and tradition. Isleta Pueblo has its Corn and Turtle dances and Spring Corn dances, as do some of the other pueblos. Santa Ana Pueblo features St. Ann's Day, and Jemez Pueblo celebrates Pecos Feast. Tourist towns nearby include the mining community of Cerillos, known for its unusual shops. Madrid has been reborn as a community of artists, writers, film makers and craft experts. Its shops have fine offerings in many fields. Its opera house is renowned for its melodramas.

ALCOVA LAKE. Impounded water behind Pathfinder Dam on the NORTH PLATTE RIVER in south central Natrona County, central Wyoming. Pathfinder Dam has a height of 265 feet and was completed in 1938. The lake is important for irrigation.

ALDER GULCH. Site in 1863 of an important gold discovery in Montana. Now a part of VIRGINIA CITY, the camp, which was established after the strike, became the center of the gold rush in Montana. The Territorial capital was located in Virginia City from 1865 to 1875. The discoverer of the gold, Bill Fairweather, often scattered gold dust in the road for children to pick up.

ALDRICH, Bess Streeter. (Cedar Falls, IA, Feb. 17, 1881—Elmood, NE, Aug. 3, 1954). Author. One of a once very prominent group of prairie writers, she drew most of her inspiration from the prairie life she knew first hand and from the pioneers with whom she was acquainted. Her best known work, *A Lantern in Her Hand* (1928), is a striking example of her work in the prairie genre.

ALFALFA. Valuable crop grown for livestock feed. Its proteins, vitamins and minerals promote rapid growth and good health, especially in cattle. Alfalfa is also grown as a pasture crop both for feed to add nutrients to the soil and to protect the soil from erosion. Known first as lucerne, for the city in Switzerland where it was developed, alfalfa is produced in greatest quantity in the United States, where Nebraska, North Dakota, Kansas and South Dakota rank as major production sites. Nearly one-half of the total United States supply of dehydrated alfalfa comes from Nebraska. Of Nebraska's 82 dehydrating plants, sixty-three are found in Dawson County, the self-professed "nation's number one hay processor." Alfalfa hay is processed into green pellets called "green gold" for use in protein feed for cattle. Hardy alfalfa, including varieties first developed in Turkey and Russia, thrives in the Northern United States. These plants grow primarily in the spring and early summer. "Nonhardy" alfalfa grows on irrigated land in the southwestern parts of the United States including New Mexico. This fall variety cannot survive cold winters.

ALIBATES FLINT QUARRIES NATIONAL MONUMENT. For more than 10,-000 years pre-Columbian peoples dug agatized dolomite from quarries here to make projectile points, knives, scrapers and other tools. First authorized for national monument status August 21, 1965, headquartered Fritch, Texas.

ALLIANCE, Nebraska. City (pop. 9,869). Seat of Box Butte County, west-central Nebraska, northeast of SCOTTSBLUFF and southeast of CHADRON. It was named for Alliance, Ohio, or

possibly because the name begins with "A", since points on certain railroads were given names in alphabetical order as the line progressed westward. It is a trade center for the large region surrounding it. Alliance was the home of Mari SANDOZ (1896-1966), who memorialized her father in her book *Old Jules* (1935).

ALPINE MEADOWS. A large number of hardy plants and flowers grow at the high altitudes in almost every area above the tree line. They cover the vast areas above the treeline throughout the mountainous areas of the Central West. They reach their greatest profusion in such national preserves as ROCKY MOUNTAIN NATIONAL PARK. The name comes from a similar profusion of such meadows in the Alps. Mostly perennials, these have a short but profuse blooming season. Many are dwarfed forms of larger flowers and plants found at lower regions, such as primroses, iris and violets. An entire Alpine violet may grow no higher than an inch, with flowers in proportion. Some Alpine flowers bloom at the very edge of snow patches, drawing moisture from the melting snow. There are no named or renowned meadows, but travelers on the high roads encounter them frequently.

ALTAMONT MORAINE. A line of rough hills lying between the Missouri Escarpment and the MISSOURI RIVER in North Dakota.

ALTUS, Oklahoma. City (pop. 23,101. Seat of Jackson County, southwestern Oklahoma, northwest of Frederick and southwest of ANADARKO. The name is derived from the Latin *altus*, meaning high. Founded in 1891, the original town was located on low ground and was destroyed in a flood, so, beginning that same year, the town was rebuilt on higher land and renamed. Situated on the border between the HIGH PLAINS and the Southland, the city lies between the winter wheat on the north and cotton on the south. Altus is the center of one of the major cotton growing areas in the world. The city also lies at the heart of the 70,000-acre Lugert-Altus Irrigation District. A major employer for the area is the Altus Air Force Base which serves as the primary training facility for flight engineers and pilots on jumbo jet transports. Many first-edition publications may be found in the reference library of Altus' Museum of the Western Prairie.

ALVA, Oklahoma. City (pop. 6,416), Woods County, north Central Oklahoma, northwest of

ENID and northeast of Woodward, named for Santa Fe Railroad lawyer Alva Adams who later became the governor of Colorado. It was incorporated as a city in 1907. Among the unusual products manufactured there are unicycles. The Cherokee Strip Museum houses a large collection of Cherokee Strip artifacts including pioneer medical and dental equipment, guns, and military items. Nearby are Alabaster Caverns and Great Salt Plains.

AMARILLO, Texas. City (pop. 149,230), seat of Potter County, but partially located in Randall County in southwest Texas. Its name, from the Spanish meaning yellow, was given because of the color of the creek bank nearby. The major city of the Texas PANHANDLE, Amarillo originated in 1887 as a railroad construction camp, and grew after 1900 due to the importance of local wheat cultivation and cattle ranching. Its population expanded again in the 1920s with the discovery of gas and oil. After the depression of 1929, extensive irrigation improvements increased agricultural production. In more recent years Amarillo has developed zinc smelters and helicopter factories, and it is now the site of a major government helium plant and an atomic research project. Once thought of as worthless and uninhabitable, the area was neverthless settled slowly as ranchers drifted in to graze their cattle. Others collected buffalo hides, then worth $3.75 each, and recovered buffalo bones, used for fertilizer. The railroad brought greater stability. One of the world's largest cattle auctions is open free to the public. The Discovery Center features exhibits of science and technology. Cal Farley's Boys Ranch holds its annual rodeo during the week after Labor Day. Will Rogers Range Riders' Rodeo is held on the weekend of July 4, and there is a National Old Time Rodeo in November. From May through December visitors are treated to the Cowboy Morning Breakfast.

AMERICAN BISON SOCIETY. Organization responsible in 1909 for establishing the National Bison Range which provided open range for the remnants of the once huge bison herds in Montana. The society deserves much of the credit for preserving the great animal.

AMERICAN ELM. The official state tree of North Dakota, the American elm is a member of a large family which includes hackberries and sandalwood. Probably the most popular shade tree in America, the elm was almost

wiped out in many parts of the country by the Dutch elm disease.

AMERICAN FUR COMPANY. Major force in the early fur industry in the United States. The American Fur Company was established by John Jacob Astor in 1808 to control the fur trade with the Indians and trappers in the Great Lakes region. In 1810 he established the Pacific Fur Company to further his plans in the Far West. In actual fact, it was nearly impossible to tell the two companies apart as Astor controlled both and used their funds, supplies and men interchangeably. The American Fur Company sent agents into the Missouri Valley in 1822 and established headquarters in St. Louis for the Western Department of the company. Peter Sarpy established a post at BELLEVUE, Nebraska, in 1823. During the late 1820s and until 1834 Kenneth McKenzie, the company's regional manager, oversaw the construction of the area's largest chain of fur posts including Forts Chardon, LEWIS, Cass, Piegan and McKenzie in Montana. FORT UNION, constructed in North Dakota and the most important post in the whole region for forty years, was built in 1828. The company launched a fleet of shallow draft STEAMBOATS, including the *Yellowstone, Omega*, and *Assinboin* to travel the Missouri in 1830. In South Dakota the company established trading posts near the sites of present-day VERMILLION in 1835 and ABERDEEN in

1836. In speaking of the American Fur Company and its treatment of the Indians, who were the main source of the furs, Zachary Taylor declared the company to be "the greatest scoundrels the world ever knew." Scholars have taken a different view, seeing the company's sale of liquor to the Indians as a last attempt to remain competitive with the other fur companies doing business in the West. Astor retired from the company in 1834 when the fur business was at its height, but the company remained strong for another decade. The impact of the company, along with the other fur trading companies, was immediately felt in the areas where it was established. Almost everywhere a company outpost was founded, a settlements would begin to grow around it. Traders, trappers and Indians sparked a local economy dealing in supplies and other necessities for the newcomers. Soon farming or mining or other industries followed, adding to the population. For the local Indians, the coming of a trading post brought new ways of life, generally not for the better. The furs they trapped could be traded for the white man's goods, cloth and clothing, utensils, and other things they desired. But with the traders also came alcohol and diseases, such as smallpox, for which the Indians had not acquired immunity.

AMERICAN INDIAN EXPOSITION. Annual gathering of as many as three thousand

Darkness and torches add an eerie quality to the dances of the American Indian Exposition.

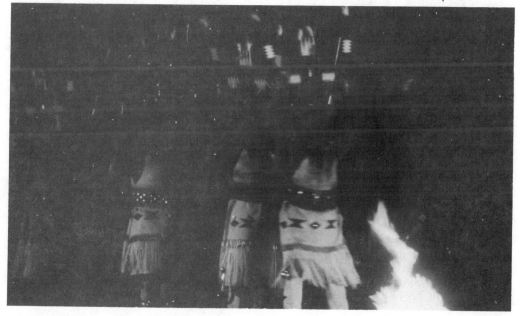

Indians from Florida to Alaska, who arrive at ANADARKO, Oklahoma, for the "Pow-wow" every August. The notable gathering is sometimes called the "All Indian Exposition." Traditional dances, arts and crafts are featured along with parades and horse races.

AMISTAD NATIONAL RECREATION AREA. The federal preserve features boating and watersports in the U.S. section of Amistad Reservoir on the RIO GRANDE. It is administered under cooperative agreement with United States Section, International Boundary and Water Commissions, United States and Mexico, Nov. 11, 1965, headquartered DEL RIO , Texas.

AMMONITES. Coiled or straight-shelled aquatic creatures dating from the Cretaceous period. Huge fossilized ammonites weighing more than one hundred pounds have been found in breaks of the Missouri and Cheyenne rivers in South Dakota.

ANACONDA, Montana. City (pop. 12,518). Seat of Deer Lodge County, southwest Montana, northwest of BUTTE and southwest of Deer Lodge. The site for the city was chosen by Marcus DALY (1841-1900), founder of Montana's copper industry, because of its ample water supply. Daly's city was first called Copperopolis when it was platted in 1883. Its name was changed when it was discovered that the name Copperopolis had already been used in the state. Postmaster Clinton Moore suggested the name Anaconda in 1894 after reading that during the Civil War Grant had encircled Lee like an anaconda. Daly promoted the city he founded at every turn. In 1889, he established the Anaconda *Standard* to advance Anaconda's prospects for becoming the state capital. The campaign proved unsuccessful, but the newspaper made publishing history by outbidding the New York *Herald* for artists to prepare one of the first colored comic sections published in the United States. A western Montana landmark is the 585 foot high smoke stack of the Washoe Smelter, one of the largest copper smelters in the world. The smelter has concentrated and smelted nearly all the copper and zinc ores mined in the state. Popular tourist sites are the nearby ghost towns and sapphire mines, and Anaconda residents celebrate Sno-Fest in February with snowmobile and ski races, snow sculpturing and a parade.

ANADARKO, Oklahoma. City (pop. 6,378). Seat of Caddo County, southwestern Oklahoma, southwest of OKLAHOMA CITY and north of LAWTON. The community was named for a tribe of the Hasinai Confederacy, of Caddoan linguistic stock. The meaning of the name is uncertain. Anadarko, settled in 1901 by whites on land once part of the COMANCHE, KIOWA and WICHITA reservations, depended on farming and cattle raising as primary industries until 1920 when oil was discovered. Today agriculture and the oil industry are the principal employers. Primarily an Indian town, Anadarko provides an example of the Indian community of today. It is the home of the Bureau of Indian Affairs area office and annually hosts the AMERICAN INDIAN EXPOSITION, a week-long series of arts and craft shows, parades, and dances, while Indian City U.S.A. re-creates villages common to Plains Indian tribes including the PAWNEE, Kiowa, NAVAJO, PUEBLO, Wichita, and APACHE. Among the displays are examples of tepees, earth lodges, mud huts, and grass houses. The National Hall of Fame for Famous American Indians displays statues honoring more than twenty famous Indians. The Indian Arts and Crafts Board of the United States Department of the Interior operates the Southern Plains Indian Museum and Crafts Center. The Center emphasizes the cultural history of the Southern Plains tribes including their metalwork, beadwork, carvings and hide paintings. Pioneer relics and Indian photographs are located in the Anadarko Philomatic Museum,

ANCESTRAL ROCKIES. Vast prehistoric mountain range, which reached through the Central West Region from the north into what is now southern New Mexico. Tremendous forces beneath the surface lifted these rugged ranges to far greater heights than those of the Rockies today. The range is thought to have begun its rise in the Proterozoic era, perhaps as long ago as two billion years. The ancient lofty peaks were gradually eroded away, and seas covered the area.

ANGEL OF GOLIAD. During the War for Texas Independence, James W. FANNIN (1804-1836) tried to escape the town of GOLIAD with his 330 troops, as the Mexican forces attacked the town. They were overtaken and overwhelmed, and they surrendered on supposedly honorable terms. Without mercy, more than 300 were massacred, but with the help of Senora Alvarez, 27 Texans were able to escape. Ever since that

time, Senora Alvarez, wife of a Mexican officer, has been honored as the Angel of Goliad.

ANIMALS—OFFICIAL BIRDS, FISH, IN- SECTS OF THE STATES. In the Central West region, South Dakota has the most official state creatures, with the COYOTE as state animal, the Chinese ringneck PHEASANT (a well established immigrant) as state bird, the WAL- LEYE as state fish and the HONEYBEE as state insect. Colorado is alone in choosing the BIGH- ORN SHEEP as state animal and LARK BUNTING as state bird. The most popular state bird of all is the WESTERN MEADOWLARK, chosen by Kansas, Nebraska, Montana, North Dakota, and Wyo- ming. Other birds include the comic and de- lightful ROAD RUNNER of New Mexico, the MOCK- INGBIRD of Texas and the SCISSOR-TAILED FLY- CATCHER of Oklahoma. Other official state creatures include the BUFFALO of Kansas and the same animal called bison by Oklahoma, the BLACK BEAR of New Mexico, the GRIZZLY BEAR of Montana. Only three states have chosen a state insect, and all selected the HONEYBEE, including Montana and Nebraska, in addition to South Dakota. In the Central West region, only Oklahoma has been daring enough to select an official state reptile, the MOUNTAIN BOOMER LIZ- ARD.

ANTELOPE. Animals with hoofs and hollow horns, belonging to the same family as oxen and goats, also known as pronghorn, prongbuck, or American antelope, they are native to the American West. The animals known as ante- lopes in North America are not the true antelope as found in most of Africa. Unlike many of the larger native animals, antelopes are not on the list of endangered species. They are found in every state of the region, and the states of the Central West maintain strict quotas wherever hunting is permitted.

APACHE INDIANS. Greatly feared Indian group which ranged over southern Colorado, Kansas, western Texas, eastern Arizona, New Mexico and northern Mexico beginning as early as the late 1500s. In later years they were famed for their leaders such as COCHISE (1812?-1874) and GERONIMO (1829?-1909). Apache tribes spoke versions of the Apachean language, a southern dialect of the Athapascan language family.

The word "Apache" may have come from the Zuni word "apachu," meaning "enemy." Apaches and NAVAJO both referred to themselves as Dine, meaning "the people." For purposes of identification, they have been identified as Eastern, Western, Southern and Northern. However, these terms seldom applied to the actual regions they occupied, due to their extensive wanderings. Eastern Apaches in- cluded the LIPAN, MESCALERO, KIOWA, JICARILLA and CHIRICAHUA. Western Apaches were the South-

The antelope, or pronghorn, of the Central West.

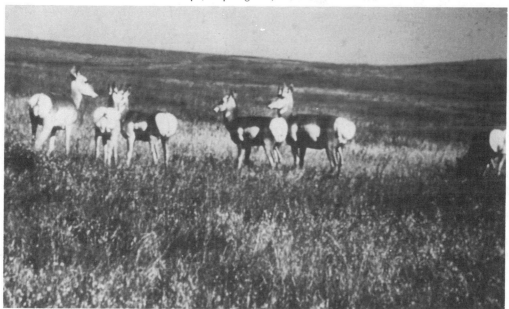

ern and Northern Tonto, Cibecue, White Kiowa and the Coyotero.

The various tribes were loosely organized individually with no formal alliances with other groups or overall leadership. Leaders, chosen for their proven ability and skill in raiding and hunting, were purely advisory.

Residence was generally matrilocal, the newly-married couple became a part of the girl's family. Polygamy was practiced by men marrying sisters or a brother's widow. While the social unit was the extended family, the Western Apache tribes were also organized into matrilineal clans similar to those of the Navajo with whom they associated.

Apache culture, rich in mythology, possessed a complex set of spirits and deities including the Sky, Sun, Moon, Earth, Sun Boy and Water People. Some spirits, called Gans, were impersonated by masked dancers at important ceremonies. Shaman performed ceremonies related to hunting, curing, rainmaking and cultivation. Apache dead were buried or placed in caves, and their possessions burned.

Western Apache lived in dome-shaped wickiups thatched with grass. Eastern Apache lived in buffalo skin tipis or the wickiup. Clothing was made from finely-tanned hides. Decorations on the surface included beadwork and fringes. Eastern Apache were hunters and gatherers who practiced a limited amount of agriculture. Western Apaches raised beans, squash and corn to augment hunting and gathering.

Apaches began migrating from their homes in northwestern Canada along the eastern slope of the Rocky Mountains around 1000 A.D. By the 1500s they lived in New Mexico, Kansas and Colorado. Eastern Apaches became skilled riders and buffalo hunters after acquiring horses in the mid-17th century, but were driven from the plains by the CADDOAN and COMANCHE tribes, armed with guns from the French. Apaches, in turn, raided the Spanish, Mexicans and Americans.

As early as the Civil War, the government forced them into reservations in an attempt to end their raids on travelers and settlers. As this process continued during the 1870s, the Apaches' hatred, fear and dissatisfaction with reservation life led to almost constant breakouts and nearly continuous raids on settlers and travelers. So numerous and fierce were these encounters that they became known as the APACHE WAR (1868-1886).

Principal figures in these raids were Cochise and Gerronimo. After Geronimo led his Chiri-

cauhua Apache band on numerous raids, he was arrested in 1877. In the typical harsh treatment of the Indians of the period, he and his men were confined to the San Carlos reservation—called by some of the whites of the area "Hell's Forty Acres." For four years they tried unsuccessfully to farm the poor land. In 1881 Geronimo escaped and resumed raiding on both sides of the border. He was recaptured by General George Crook, but he soon escaped with his men. He finally was captured in 1886, and the raiders were imprisoned in one Florida camp and their relatives and other peaceful reservation Apaches in another, despite previous promises to keep them together. Next, Geronimo and his group were sent to a damp unfamiliar climate in Alabama, where 25 percent of them died. By 1894 all surviving Apaches were sent to Fort Sill, Oklahoma. The Apache wars ended with the surrender of Geronimo's Chiricahua band in 1886.

Today nearly twenty thousand Apaches live on four reservations in the United States. Western Apaches occupied reservations at Fort Apache and San Carlos in eastern Arizona; the Mescalero, Lipan, and Chiricahua shared the Mescalero Reservation in southern New Mexico; and the Jicarilla lived on the Jicarilla Reservation in northern New Mexico. A small group of Chiricahua live in Oklahoma. Important contributors to the Apache economy are tourism, stockraising, and lumbering. The crafts of leatherwork and basketry are being revived.

APACHE WAR.. Term used to describe an almost continuous state of conflict between whites and APACHE INDIANS of the American Southwest between 1868 and 1886. With the passing of Spanish rule in Latin America, relations between the Apache and the white settlers gradually worsened. Animosity was heightened after the region came into American hands. Apache lands stood squarely in the path of American westward movement, increasing the friction as travelers and settlers gained in numbers. Leaders of the various bands, GERONIMO, COCHISE, MANGAS COLORADAS and Victorio, gained notoriety as leaders of the various Apache bands, which almost constantly raided the frontier settlements and travelers on the road to the west. Despite the frequent captures of the leaders and their followers and their isolation in reservations, many of them managed to escape (Geronimo on at least three occasions) and resume their raids. Generally they managed to elude government forces, and

there were few pitched battles. Finally General O.O. Howard was sent to make peace. By 1886, the leading Apache forces were subdued and confined, but isolated instances of attacks occurred into the early 1900s.

AQUAMARINE. State gem of Colorado. The name means seawater in Latin, and this blue or bluish-green byrl is similar to the emerald, differing only in color.

ARANSAS PASS, Texas. City (pop. 7,173), located in Aransas, San Patricio, and Nueces counties. This deepwater port on the Corpus Christi Channel and the GULF INTRACOASTAL WATERWAY is in an important oil producing and refining area. Commercial and sport fishing bring in additional revenue. The city was settled in 1890 and incorporated in 1910.

ARANSAS WILD LIFE REFUGE. Near CORPUS CHRISTIE, Texas, this habitat provides shelter for many wading and migratory birds. However, it is renowned as the winter home of the most famous of all the migrants, the majestic whooping crane, once almost extinct. The drama of their fight for survival has drawn many visitors to the refuge to see the flock, which at one time had been reduced to fewer than twenty birds. With strict controls and the use of breeding in zoos and other controlled situations and with some additions to the flock in the wild, it appears that the breed may be saved. The Aransas flock annually make the long trip to their breeding grounds in Canada and return in the fall, hopefully with all the mature birds and with a few new recruits born during the summer. As spring of 1989 approached, approximately 131 birds were wintering in the wild life refuge.

ARAPAHO INDIANS. Algonquin tribe living between the ARKANSAS and PLATTE rivers in eastern Colorado and southeastern Wyoming in the mid-19th century. "Arapaho" came from a Pawnee word meaning "he who trades," referring to the role of the Arapaho as middlemen in trades between the northern and southern plains Indians. The Arapaho, who referred to themselves as Hinanaeina, "our people," are thought to have lived originally between the headwaters of the Mississippi River and Lake Superior in five subtribes, or bands.

The Arapaho moved to the upper MISSOURI RIVER from the Lake Superior region and then drifted southeastward onto the plains, becoming nomadic hunters as they gave up agricul-

ture and left their permanent homes. One band split off and became the GROS VENTRE of the Northwest. The four remaining subtribes lived separately during the winter, keeping track of each other through messengers. When the buffalo herds gathered in the spring, the four bands joined together to hunt communally and to celebrate their sacred ceremonies including the Sun Dance and festivals related to their sacred pipe.

The keepers of this pipe always pitched their tipi in the center of the Arapaho camping circle. When the tribe moved, the sacred pipe headed the line of march. When an Arapaho died, he was dressed in his finest clothing and laid in state for all to see. After burial the grave was covered with brush and the best horse of the deceased was killed and placed over the grave. Mourners cut their hair, wore old clothes and lightly cut their legs and arms.

Each of the subtribes had a chief, but there was no principal chief of the entire clan. Decisions of the four subchiefs were enforced by a soldier-police group which also served as a peacemaker during the long buffalo hunt. A series of age-graded societies existed for the men. The women had one group, the Buffalo Lodge society. Societies recruited across the band lines and there was a great deal of intermarriage among the bands. Polygamy was practiced, with men marrying sisters or their brother's widow. A mother-in-law taboo prevented a man from talking to his mother-in-law and vice versa.

A less rigid taboo existed between the woman and her father-in-law. Each household averaged ten horses, and these formed an important part of Arapaho life. Some were used only for war, and others were used as pack animals. Dog travois were often used for transporting goods. Pottery and basketry were given up by the Arapaho when they moved to the plains. Decorations on clothing were produced by quillwork, cups from buffalo horns and bowls from tree knots. In another rather remarkable craft, an assembly-line procedure was used by specially skilled old men in the manufacture of arrows.

About 1835, the Arapaho divided, with the larger group moving south to the Arkansas River in eastern Colorado. These became the southern Arapaho who, by 1840, made peace with the other tribes in the area, and sometimes joined such tribes as the KIOWA and COMANCHE on their raids into Mexico and Texas. In 1861, the southern Arapaho ceded their lands for a reservation in INDIAN TERRITORY on land so poor that they were given new lands along the NORTH

CANADIAN and upper WASHITA rivers. In 1890, the Arapaho, principal supporters of the Ghost Dance movement, sold their Oklahoma reservation and received individual allotments of 160 acres of land. This opened up three and one-half million acres for white settlement. Subsequently they were moved about frequently. In the 1970s, stock-raising was the main source of tribal income.

The tribal language was most commonly spoken by members of the northern group where the sacred pipe was guarded by a family who served as its caretakers. An annual Sun Dance is held in July in Wyoming for the combined members of the northern and southern tribes.

ARBOR DAY. National day of tree-planting. Suggested in 1872 by Julius Sterling MORTON (1832-1902) in Nebraska and first celebrated at his home at NEBRASKA CITY on April 10th that year, the day is now usually recognized in most states on the last Friday in April.

ARBOR LODGE STATE HISTORICAL PARK. Site of Arbor Lodge, the estate of Julius Sterling MORTON, secretary of Nebraska Territory, Secretary of Agriculture for President Cleveland and founder of ARBOR DAY. Fifty-two room Arbor Lodge, the Morton home in NEBRASKA CITY, is part of the property given to the state of Nebraska by the Morton sons in 1923. At the lodge each year the founder of Arbor Day is honored on his birthday, April 22, with the symbolic planting of another tree.

ARBUCKLE MOUNTAINS. Scenic Oklahoma range which marks the northernmost edge of the COASTAL PLAINS. Within the mountains is Arbuckle Wilderness, a 400-acre wildlife park containing more than two thousand exotic animals allowed to roam freely. Visitors may feed the animals from their cars along an eight-mile scenic drive.

ARCHAIC CULTURE. Prehistoric people, widely distributed over the GREAT PLAINS around

Turner Falls are an attraction of the Arbuckle Mountains, a welcome highland recreation area at the northern edge of the Coastal Plains.

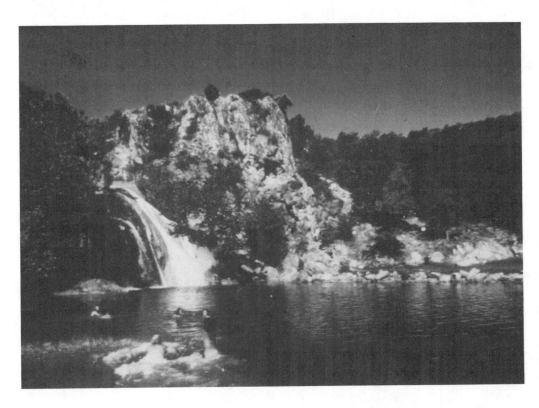

4,000 B.C. Known as the Pre-Pottery People, they left mounds of trash now called KITCHEN MIDDENS, which provide most of the known clues about their way of life. Their lives were extremely simple. They roamed about hunting the diminishing number of larger animals and subsisting increasingly on the smaller animals. They foraged for vegetables and grain and developed a wide assortment of simple tools from various materials, such as obsidian, where it was available. By about 1000 B.C. dramatic changes ensued, as the native peoples developed such skills as pottery. In some areas many ancient ways went almost unchanged. In others new methods of survival and culture emerged leading to new cultural periods.

ARCHIVES WAR. In 1842 the people of AUSTIN, Texas, refused to allow the messenger of Sam HOUSTON to take the republic's supplies and records from Austin to HOUSTON, where the capital had been temporarily moved by Houston, supposedly because of the Mexican threat. The mane and tail of the messenger's horse were shaved, and the messenger returned to Houston without the papers. A second attempt to smuggle the records to Houston was discovered and the documents were retrieved. In 1844, under the new president, Anson JONES, the capital was officially returned to Austin, and the "war" ended.

ARIKARA INDIANS. An agricultural Caddoan tribe who moved into the Dakotas along the MISSOURI RIVER Valley in the late 17th century. Originating in the Southwest, they were found by French traders south of the CHEYENNE RIVER. Before smallpox epidemics in the 1780s and 1803 took their toll, the Arikara numbered as many as four thousand people. The Arikara were closely related to the Skidi PAWNEE from whom they separated around the late 1600s. Their tribal name meant "horn" from the practice of wearing their hair with two pieces of bone standing up on either side like horns.

Calling themselves Tanish, "the original people," the Arikara were a loosely organized confederacy of subtribes. Each subtribe had a village, a name and a village chief. The hereditary village chiefs formed a council which advised the head chief of the tribe, who was chosen by them, generally from their own number. Built overlooking the Missouri River, the villages were fortified by timber stockades reinforced with earth and surrounded by ditches.

Their lives and habits were similar to many other Indian groups. Houses, semi-subterranean earth lodges about forty feet in diameter, sheltered two or three families. On hunting trips the Arikara used portable skin tipis. They grew eight or nine varieties of corn, along with beans, squash, sunflowers and pumpkins. Surplus corn was traded by the women to neighboring tribes, such as the CHEYENNE, for buffalo robes and meat.

Religious leadership was vested in the chiefs, and religious festivals were associated with corn planting, cultivating and harvesting. The Arikara believed in a supreme diety who shared his powers with four assistants. Fasting, sacred ceremonies, visions and sacred bundles were all part of Arikara religious life.

Membership in the priesthood was hereditary in certain families. Other families enjoyed the prestige of caring for the tribe's medicine bundle which contained such items as perfect ears of corn, sacred pipes, tobacco and skins of various animals. Arikara dead were usually wrapped in skins and buried in a sitting position with their faces painted red. A horse was sometimes killed and placed over the mound grave. A year of mourning followed.

By the early 1820s the Arikara joined Pawnee relatives on the LOUP RIVER in Nebraska in war with the United States Army. Smallpox in 1837 severely reduced the number of all Indians in the region, and by 1862 the Arikara had joined the MANDAN and HIDATSA at a bend in the Missouri River. In 1870 this area was established as the Fort Berthold Reservation. Twenty-five percent of the land, including the best farmland and the housing areas, was flooded in the 1950s by the impounded water of Garrison Dam. In the 1970s tourism facilities were built by the tribes on Lake SAKAKAWEA, the reservoir formed by the dam. In the 1970s, 45,000 acres of tribally owned land and 350,000 acres of land owned by individual members of the tribe remained.

ARIKAREE RIVER. Joining with the North Fork REPUBLICAN RIVER at Haigler, Nebraska, the Arikaree forms the main Republican River. The Arikaree rises in northern Lincoln County, Colorado and flows for 129 miles. At Beecher Island in Colorado Colonel George A. Forsythe and fifty soldiers successfully fought off the attacks of nearly one thousand ARAPAHOE and SIOUX in a conflict remembered as The Battle of BEECHER ISLAND on September 16, 1868.

ARKANSAS CITY, Kansas. City (pop. 13,-201), Cowley County, southeastern Kansas, at the confluence of the Arkansas and Walnut rivers, south of WINFIELD and southeast of WELLINGTON. Founded in 1870, the community was named for a band of the Quapaw SIOUX. Early Europeans had translated the Quapaw name roughly as Arkansa. Arkansas City served as one of the primary jumping-off points for the land rush into the CHEROKEE OUTLET in 1893. In late summer of that year as many as 50,000 people swarmed into the community which until then had boasted a population of only 5,000. Of course, most of the newcomers went on to settle Oklahoma. Wealth came to the town, beginning in 1914, when oil-rich Indians rushed to the community to make their homes and to splurge. The Oklahoma rush is commemorated by the Cherokee Strip Museum there. The economy is based on the local products of oil and wheat, with substantial flour milling.

ARKANSAS RIVER. Source in Lake County in central Colorado. It is one of the two principal southern tributaries of the Mississippi River. The 1,450 mile river flows east through southern Kansas and southeast across the northeast corner of Oklahoma, bisects Arkansas where it empties into the Mississippi River in Desha County. The MC CLELLAN-KERR ARKANSAS RIVER NAVIGATION SYSTEM has made the Arkansas navigable for 650 miles. Its largest tributaries are the CIMARRON and CANADIAN rivers. In the Central West region, principal Arkansas River cities are GARDEN CITY, Kansas, PONCA CITY, and TULSA, Oklahoma.

ARLINGTON, Texas. City (pop. 160,123), Tarrant County, northern Texas, halfway between DALLAS and FORT WORTH. Originally settled in 1843 on Indian land as Bird's Fort, it was renamed after General Robert E. Lee's ancestral home. The city was incorporated in 1896. Rapid development of aerospace and automobile industries in the 1950s doubled the population and made the city an industrial and commercial center. Arlington features the University of TEXAS at Arlington, Bible Baptist Seminary, SIX FLAGS OVER TEXAS (a large amusement park), and Turnpike Stadium, The home of the Dallas-Fort Worth ball teams.

ARMADILLO. Any of several small American mammals with bony plates on their upper body skin. Only the nine-banded variety is found in the United States, throughout the southern part of the region. An eater of insects, spiders and land snails, the armadillo has strong claws with which to dig burrows. Insects are licked up with the long, narrow sticky tongues. Having only small teeth in the back of their mouths, armadillos do not bite in self-defense, relying on flight to their burrows or on the protection of their shell, as they curl into a ball.

ARROWWOOD LAKE. Natural lake stretching north and south between North Dakota's Foster and Stutsman counties, southeast of Carrington. The Lake is an important feeding ground for pelicans, and the Arrowwood Migratory Refuge is located there.

ARROWMAKER (SHEEPEATER) INDIANS. Little-known and peaceful tribe who lived in the area of YELLOWSTONE PARK and were noted for their beautifully made arrowheads chipped from obsidian (volcanic glass). Early explorers called them "pitiful, timorous creatures," perhaps because they made the crudest shelters and seldom had more than a few shreds of clothing. However, other white visitors described them as "intelligent and self-reliant people."

ARSENIC. A grayish-white poisonous byproduct of several mineral processes in the Central West, particularly in Montana, recovered by passing furnace gasses through electric dust precipitators and settling chambers. The product is important to areas in which it is found because of its wide varieties of use in addition to that of an insecticide. It is used in tanning and taxidermy as a preservative, in printing materials, metal alloys, pigments, glassmaking, calico and other cloth making and in production of pyrotechnic materials. It also is important in poison gasses for chemical warfare.

ARTESIA, New Mexico. City (pop. 10,385), Edy County, southeastern New Mexico, northwest of CARLSBAD and southeast of ROSWELL. The city is named for the tremendous underground water which once spurted out when artesian wells were drilled but is now pumped to the surface, due to the diminished water pressure. The discovery of oil in 1922 has made the city one of New Mexico's most productive oil centers. Potash mining is also profitable.

ARTESIAN SPRINGS. Underground water trapped in an aquifer layer between layers of impermeable rock, rises to the surface without

the aid of pumps due to the pressure applied to the trapped water by inflowing water. A well-known artesian basin occurs in South Dakota. One of the world's largest artesian springs is COMANCHE, near FORT STOCKTON, Texas. The city is famous for being a green oasis in the desert, made possible by its artesian springs. Experts continue to puzzle over the source of the San Felipe springs near Del Rio, Texas, which daily pour out fifty million gallons of water.

ARTHUR, Nebraska. Town (pop. 513), Arthur County, west-central Nebraska, southeast of ALLIANCE and northeast of OGALLALA, founded 1870. Pilgrim Holiness Church, in Arthur, was built in 1928 out of baled hay, making it one of the region's most unusual places of worship.

ARTISTS. Some of the world's best-known artists have fallen in love with the Central West Region, have either made their homes there or traveled extensively, absorbing the feeling of the West and the frontier and portraying their various impressions of the region. However, others have been born there.

Among artists native to the region, one of the most noted was John Steuart CURRY, born at Dunavant, Kansas, noted particularly for his murals in Washington, D.C., and the Kansas capitol. Of modern artists native to the region, Jackson POLLACK of CODY, Wyoming, is one of the best known. Another Wyoming artist is E. W. Gollings, known for his modern cowboy paintings, based on his extensive study and observation of cowboy life. Other native artists of the region include Kansan sculptor Robert M. Gage; Edgar S. Paxson of Montana, who spent 21 years researching his famed painting of Custer's last stand; New Mexico Indian artist, Paul Flying Goodbear; Oklahoma's contemporary Indian artist, Acee BLUE EAGLE, who studied at Oxford, and David Miller, also of Oklahoma.

Perhaps one of the most outstanding native artists created some of her finest works in a field only now gaining artistic recognition. The extraordinary pottery of Maria MARTINEZ has provided for her an unequalled reputation as a true artist in a field not generally recognized.

Of modern artists who revelled in the sunshine and color of the region, Georgia O'Keefe was perhaps the best-known, particularly for her devotion to SANTA FE, New Mexico.

Famed for their paintings of the pioneer life of the Central West were two youthful migrants, Charles RUSSELL and Frederick REMINGTON. Both depicted cowboy and high prairie life in painting and sculpture in a manner une-

qualled before or since. Others enchanted by their own interests in the life of the region were naturalist-artist John James Audubon; Albert BIERSTADT, noted for his huge oils of western scenery; Thomas MORAN also renowned for his large canvases of western scenery; students and experts on early Indian life George CATLIN and Carl BODMER, and the creators of the most colossal sculptures of modern times, Gutzon BORGLUM and Korczak ZIOLKOWSKI.

Among women artists, Texas claims Eugenie LAVENDER, who came from the settled life of Europe and gathered her paints from local materials, and Elizbet Ney, whose portraits of Samuel HOUSTON (1793-1863) and Stephen AUSTIN (1793-1836) are in Statuary Hall of the national capitol.

ARVADA, Colorado. City (pop. 84,576, a nearby northwest suburb of DENVER, situated in Jefferson and Adams counties, Arvada is mainly a residential community. However, it does produce beer, chemicals, wood and metal products and processed foods. Incorporated in 1904, it is named for Hiram Arvada Haskins, a relative by marriage of Benjamin F. Wadsworth one of the founders.

ASHLEY, William Henry. (Powhatan County, VA, 1778— Boonesville, MO, Mar. 26, 1838). Fur trader. Ashley served as the lieutenant governor of Missouri in 1820, as a general in the Missouri Territorial Militia, and as a member of the United States House of Representatives from 1831 to 1837, but it is his fur business, begun in 1822, for which he is best remembered. As one of the principals of the Rocky Mountain Fur Company, Ashley sent fur trading parties throughout the West. The first wagon across Nebraska accompanied the Ashley expedition of 1824 which explored the Green River, Wyoming, area. The Great Salt Lake region was explored by Ashley in 1826. He revolutionized the fur business by instituting an annual meeting of trappers, traders, Indians and representatives of his company. The first of these colorful, rowdy gatherings, known as RENDEZVOUS, was held in 1824 on the GREEN RIVER. They continued to be held annually through the 1840s.

ASPEN INSTITUTE FOR HUMANISTIC STUDIES. Described as having a "famed program of culture and conditioning for top executives," the Institute, in ASPEN, Colorado, was founded in 1949. Industrialist Walter PAEPCKE organized the program to bring world

In any season Aspen's mountains, such as the Marroon Bells, provide much of the attraction of the great resort.

leaders to Aspen to offer their knowledge and skills to large enthusiastic audiences through seminars, classes and lectures.

ASPEN MUSIC FESTIVAL. ASPEN, Colorado's, annual dazzling summer attraction. Held in July and August, the festival presents recitals and concerts by many of the world's greatest musical artists.

ASPEN, Colorado. Town (pop. 3,678), seat of Pitkin County, west-central Colorado, southwest of Eagle and north of GUNNISON. Aspen is the home of the prestigious ASPEN INSTITUTE FOR HUMANISTIC STUDIES and the enchanting ASPEN MUSIC FESTIVAL, held annually in July and August. Aspen providess $30,000 to the winner of its Award for Service to Humanities and hosts a music school for three hundred top students.

Aspen's wealth first came with the silver boom of the 1880s. Silver ore was so plentiful that miners asked permission to stockpile the excess in the streets of the then tiny community. A silver nugget, 93% pure and weighing 1,840 pounds, was taken from the Smuggler Mine near Aspen and displayed at the Chicago World's Columbian Exposition in 1893. Careful civic planning avoided the excesses which plagued other mining towns. The silver bust and Panic of 1893 reduced the population from more than 12,000 to less than 1,000. The second stage of prosperity began in the 1930s when the first simple ski area was constructed. Today, thousands are attracted annually to the Aspen ski slopes. "Winterskol," Aspen's winter carnival, is held in January, and the World Cup Giant Slalom is held in February.

ASPENS. One of the most admired trees in the Rocky Mountain west, the aspen leaves seem to quiver constantly. Indian legends claim that when the Great Spirit came to Earth all the creatures, except the aspen, trembled. Angered by the haughty display of the aspen, the Great Spirit decreed that the aspen would tremble whenever anyone looked at it. In the fall the aspens are notable for their brilliant yellow coloring.

ASSINIBOIN INDIANS. Tribe which hunted a vast area of the northern plains and frequently went to war with the CROW, GROS VENTRE,

and DACOTAH. A Siouan tribe which lived between the Lake of the Woods and Lake Winnipeg, they may have separated from the YANKTO-NAI in Minnesota as late as the 1700s. By the mid-17th century the Assiniboin reached the region around Lake Nipigon and Lake of the Woods before moving west and joining the CREE in the Lake Winnipeg area.

Assiniboin is an OJIBWAY word meaning "he who cooks with stones." In modern times the Indians live in Montana and the Canadian provinces of Alberta and Saskatchewan. Assiniboin villages once contained as many as two hundred skin lodges or tipis. The tribe was organized into as many as thirty bands each having its own chief chosen for his ability, family connections and popularity. Each band also had its own akitcita, a police unit comprised of the most responsible warriors, and a council.

Religious leadership came from priests, sorcerers and physicians. Both men and women were thought to have power to invoke the spirits. The principal deity was Wakaonda, the creator of all things, but the sun, thunder and other spirits were also worshipped. Dead warriors, in war-dress, their faces painted red, with many weapons beside them, were placed on tree scaffolds. A horse was killed for the use of the warrior in the after-life. Women were buried with skin-dressing tools and other implements they might need. Mourners cut their hair and slashed their arms and legs in their grief.

Buffalo were the principal source of food and clothing. Before the coming of the horse, Assiniboin traveled using dogs to carry packs or drag travois. While they were involved in the fur trade with the HUDSONS BAY COMPANY, a smallpox epidemic in 1780, reduced the population of the Assiniboin to only 300 lodges. In 1836 another smallpox epidemic killed four thousand Assiniboin. Treaties signed with the United States in 1851 and 1855 assigned them to reservations in western Montana.

By the late 1800s the Assiniboin occupied Fort Belknap Reservation with the Gros Ventre and the FORT PECK RESERVATION with the DACOTAH. During the winter of 1883-1884 several hundred Assiniboin starved to death at Fort Peck when food was not delivered. In the early 1920s lands were given to tribal members and parts of the reservations were opened to homesteaders.

ASTAIRE, Fred. (Omaha, NE, May 10, 1899—Los Angeles, CA, June 22, 1987). Hollywood's "elegant hoofer." Astaire's graceful approach to movement, his style and his elegance made him the movies' most celebrated dancer. He danced with his sister, Adele, from 1916 to 1932. He made his screen test in 1928 and went on to make 35 motion pictures. Adele left the act in 1932, and Astaire went on to dance with a succession of partners, then continued to act long after becoming unable to execute the eloquent slides and staccato taps which were his trademark. He is best remembered for the films he made with Ginger Rogers. *The Barkleys of Broadway* (1939), made for RKO, saved the troubled studio by earning a reported $30 million. He was loaned by RKO to Metro-Goldwyn-Mayer to do the 1933 film *Dancing Lady* with Joan Crawford. RKO then teamed Astaire with Rogers to dance in the film *Flying Down to Rio* (1933). In 1950 Astaire won a special Academy Award for his contributions to film. A 1959 television special by Astaire won nine Emmy awards. *Astaire Time* in 1960 won another.

ATCHISON, Kansas. City (pop. 11,407). Seat of Atchison County, northeast Kansas, on the MISSOURI RIVER, northwest of LEAVENWORTH and TOPEKA. The city was named in honor of David R. Atchison, United States Senator from Missouri and once said to have been President of the United States for a day when he was president pro temp of the U.S. Senate. Zachary Taylor refused to take the oath of office on a Sunday, and Atchison is considered by some authorities to have been the president during that interval. Atchison attended the celebration surrounding the opening of the town and announced his belief that "some Northerners are fairly worthy men."

The Atchison area early became a popular gathering spot for, French explorers, who were followed by LEWIS AND CLARK in 1804 and Stephen Longstreet in 1819. The community was founded in 1854 and grew up around its fine port on the river. In the 1850s Atchison was temporarily a terminus of the famous BUTTERFIELD OVERLAND DISPATCH Express. Prior to the CIVIL WAR, slavery advocates used Atchison as a principal center for promoting Kansas as a slave state. Missouri slave-holders filed land claims in Atchison to obtain the right to vote in the elections.

A city bond issue made possible the arrival of the ATCHISON, TOPEKA AND SANTA FE RAILROAD in 1872. Today the city remains a railroad hub, processing and shipping manufactures including feeds, flour, steel castings and alcohol. St. Benedict's College was founded in 1859, and was merged with Mt. St. Scholastic College to

form BENEDICTINE COLLEGE. Visitors are attracted to the notable chapel.

Atchison is remembered as the hometown of internationally known Amelia EARHART Putnam, the first woman to fly across the Atlantic alone. The International Forest of Friendship, honoring Putnam contains trees from every state and several foreign countries. This memorial was contributed by the International Organization of Women Pilots, The Ninety Nines, Inc.

Breathtaking views of the surrounding region are enjoyed from Benedictine College on the bluffs above the Missouri River. St. Benedict's Abbey is copied after Benedictine monasteries of the Middle Ages.

ATCHISON, TOPEKA AND SANTA FE RAILROAD. The railroad once described as "starting nowhere and going nowhere" was chartered in 1859. Under the direction of Cyrus K. HOLLIDAY, the railroad was planned to run from TOPEKA, Kansas, to SANTA FE, New Mexico. Construction started on October 30, 1868, with a generous land grant voted by Congress in 1863, but the going was slow. The first official train, a "Picnic Special," ran a trip over seven miles of completed track on April 2, 1869. EMPORIA, Kansas, was reached in 1870; LAS ANIMAS, Colorado, in 1875; and PUEBLO, Colorado in 1876. Searching for a pass through the mountains of Colorado and New Mexico brought the Santa Fe into conflict with the DENVER AND RIO GRANDE Western Railroad, particularly at RATON PASS in New Mexico and in the deep and narrow ROYAL GORGE of the ARKANSAS RIVER in Colorado. This was one of the few contests the Santa Fe lost. The Santa Fe became a transcontinental railroad by a number of acquisitions, reaching Los Angeles, California, in 1885 and San Francisco in 1900. Under tight secrecy to keep land prices low, the Santa Fe surveyed and bought a right-of-way from KANSAS CITY to Chicago. In 1887 the first Santa Fe train entered Chicago. Until 1909 it was the only railroad running on its own rails all the distance from the Pacific Coast to Chicago.

ATHABASKAN INDIANS. American Indian language family including the NAVAJO and APACHE.

ATLANTIC CREEK. Wyoming stream formed near the crest of Two Ocean Pass, south of YELLOWSTONE PARK. Water flowing into this creek flows eventually to the Atlantic Ocean, while water less than one quarter of a mile away flows into Pacific Creek, named for the destination of its waters.

ATLATL. A spear-throwing tool consisting of a hollow wooden shaft nearly two feet long filled with weight, fitted with a hook of antler at one end and a handle at the other. By using an atlatl, hunters were able to throw their spears farther and with greater force.

ATOMIC BOMB. The testing of the atomic bomb used in WORLD WAR II occurred at TRINITY SITE near LOS ALAMOS, New Mexico. The tremendous blast on July 16, 1945, caused such searing heat that the white gypsum sands were turned to glass. Work on the bomb actually began in 1942 when government scientists took over the Los Alamos School for Boys as their laboratory.

ATSINA INDIANS. More commonly known as the GROS VENTRE of the Prairie, the Atsina were Algonquin-speaking Indians with a language very similar to that of the ARAPAHO with whom they were united before 1700. By the time they came into contact with white traders of the HUDSON'S BAY COMPANY on the northern plains in the 1770s, the Atsina were traders in wolf and buffalo pelts instead of the more valuable beaver. Because of this, the Atsina were given second-class trade treatment by the Hudson's Bay Company and the Northwest Company. The Atsina were gradually pushed south and east by the ASSINIBOIN and CREE who enjoyed better trade treatment and were therefore better armed. SMALLPOX struck the Atsina in 1780. For more than 50 years they wandered, sometimes joining with other friendly tribes. Smallpox struck another devastating blow at the tribe in 1829, but their fortunes improved in the middle thirties when buffalo hides, which they traded, grew in value. Greater trade profits brought the tribe additional guns. The smallpox epidemic of 1837-1838, which decimated the Assinboin and BLACKFOOT, did little damage to the Atsina who were left with only one enemy, the Crow. Their improved position among the tribes of the northern prairie coincided with peaceful relations with the whites. In 1855 the Treaty of Judith River established common hunting grounds for the Blackfoot and Atsina. The Fort Belknap Reservation for the Blackfoot and Atsina was established in 1873.

AUGUSTANA COLLEGE. Privately supported Lutheran liberal arts college in SIOUX

FALLS, South Dakota. Established in 1860, the college now has a one hundred acre campus containing eighteen buildings. During the 1985-1986 academic year Augustana enrolled 1,866 students and employed 188 faculty members.

AURORA, COLORADO

Name: From the Rome goddess of dawn.

Nickname: Gateway to the Rockies; Best of Many Worlds.

Area: 66.2 square miles

Population:
1986: 217,990
Rank: 71th
Percent change (1980-1986): +37.5%
Density (city): 3,293 per sq. mi.
Metropolitan Population: 1,791,416 (1984)
Percent change (1980-1984): +2.4%

Race and Ethnic (1980):
White: 88.20%
Black: 6.87%
Hispanic origin: 7,950 persons (5.03%)
Indian: 0.50%
Asian: 2.10%

Age:
18 and under: 29.5%
65 and over: 4.3%

Hospitals: 3

Further Information: Aurora Chamber of Commerce; 14001 East Lliff Ave., Suite 303; Aurora, CO 80014.

AURORA, Colorado. City (pop. 158,588), a suburb to the east of DENVER situated in Adams and Arapahoe counties, and named for Aurora, the goddess of the dawn. One of the area's fastest growing communities, Aurora is a trade center for livestock and crops. Manufacturing includes oilfield equipment, aircraft parts and electrical products. The city was incorporated in 1903. Fitzsimmons Army General Hospital and Lowry Air Force Base are nearby.

AUSTIN, Moses. (Durham, CT, Oct. 4, 1761—June 10, 1821). Businessman. Austin established the town of Potosi, Missouri, surveyed lead mines in southeastern Missouri and assisted in the organization of the Bank of St. Louis in 1816. The bank failed in 1819, and he moved to SAN ANTONIO, Texas, where he successfully applied to the Spanish government for permission to bring three hundred families into Texas, but ill health prevented him from carrying out his plans, and he died soon after. Before dying, Austin received the promise of his son, Stephen, to carry out his plans for the American settlement in Texas. On the basis of on his father's land grants in Texas, Stephen AUSTIN was able to build successful American colonies in Texas, leading eventually to its separation from Spanish and Mexican rule.

AUSTIN, Stephen Fuller. (Austinville, VA, November 3, 1793—Columbia, TX, December 27, 1836). American founder of Texas. The son of prominent American businessman Moses AUSTIN, Stephen Austin was raised in Missouri and in 1821 inherited a Texas land grant on the death of his father. In 1822, with the consent of the Spanish governor of Mexico, he then settled 300 original families at SAN FELIPE DE AUSTIN on the Gulf Coast. By 1834 his successful commercial and social planning had attracted another 750 American families to the settlement, and tensions between Mexicans and Americans threatened to erupt into outright war. Austin served in the Coahuila and Texas legislature 1831-1832, when he traveled to Mexico City to petition for the establishment of Texas as a separate Mexican state. He was imprisoned for three years, charged with attempting to revolutionize the colony. When released in 1835, Austin returned to Texas and, having given up hope for continuing relations with Mexico, joined in the military actions for independence. He became the commander of the Texas Revolutionary Army. Austin was in favor of an independent Texas, but this did not please most Texans, and in 1836 they elected Sam Houston president of the republic. Austin, the loser, died within the year while serving as secretary of state. He had also advocated continuation of the slave trade. The capital of Texas is named in his honor.

AUSTIN, TEXAS

Name: From Stephen Fuller Austin (1793-1836) Texas colonizer.

Nickname: Fun-tier Capital of Texas; The Big Heart of Texas; City of the Violet Crown.

Area: 232 square miles

Elevation: 505 feet

Austin, Texas

The 48,000 students on the main grounds of the University of Texas at Austin enjoy one of the finest campuses and the extraordinary facilities of the most adequately funded of all U.S. universities.

Population:
1986: 466,550
Rank: 27th
Percent change (1980-1986): +34.9%
Density (city): 2,011 per sq. mi.
Metropolitan Population: 645,442 (1984)
Percent change (1980-1984): +20.3%

Race and Ethnic (1980):
White: 75.59%
Black: 12.19%
Hispanic origin: 64,945 persons (18.75%)
Indian: 1,516 persons (0.29%)
Asian: 4,127 persons (1.05%)
Other persons: 34,175

Age:
18 and under: 24.5%
65 and over: 7.5%

TV Stations: 5

Radio Stations: 16

Hospitals: 13

Further Information: Austin Chamber of Commerce, 901 West Riverside Drive, Austin, TX 78701.

AUSTIN, Texas. City (pop. 345,496), state capital and seat of Travis County, in central Texas on the eastern COLORADO RIVER. An important educational, industrial, agricultural, and research center, Austin also has a great deal of manufacturing, producing such products as boats, defense items, candy, furniture, structural steel, brick and tile, and electronics equipment. The region's growing eminence in computer electronics has mounted a rapidly advancing challenge to California's "Silicon Valley." Austin is also a convention city.

Austin was named for Stephen F. AUSTIN, The "Father of Texas." The city originally consisted of three Spanish missions, built near the present site of the city in 1730. Actual settlement of the site, called Waterloo, began in 1838. The town was incorporated in 1839, renamed

Austin and was selected to be the capital of the newly formed Republic of Texas.

Industry and commerce came to Austin after the CIVIL WAR, thanks to the arrival of the railroad and the city's proximity to the famous CHISHOLM TRAIL. A dam built across the Colorado River in 1893 made the city one of the first in the state to have its own electric plant. Historical attractions include the granite state capitol and Austin's famous mercury vapor lamps, installed on 27 high towers in 1896. Museums include the O. Henry Museum, Texas Memorial Museum, and Elisabet Ney Museum, dedicated to the early Texas artist, as is the French Legation building museum (1841). Bergstrom Air Force Base is seven miles to the South. Nearby recreation areas include Lake Austin, Town Lake, and Barton Springs. Austin boasts its own orchestra and ballet society.

A major educational center, Austin is home to the principal campus of the University of TEXAS, the Texas state schools for the blind and deaf, the Episcopal Theological Seminary of the Southwest, Concordia Lutheran College, and Houston-Tillotson College.

AWANYU. A principal deity of the Pajaritan PUEBLO INDIANS of New Mexico. The legendary Awanyu was shown as a great serpent wearing a plume. The fierce reptile guarded the crucial springs of the Pajaritan and eventually threw himself across the heavens as a starry path now called the Milky Way. Water jars and bowls of the Puye region of New Mexico show this ribbon of stars as a wide band of color.

AXOLOTL SALAMANDER. Rare water reptile which can adapt to living on land if its pools dry up. The salamander is found in Montana's Madison County.

AYRES NATURAL BRIDGE STATE PARK. Natural rock formation between Douglas and Casper, Wyoming. For thousands of years, La Prele Creek has eroded the thick stone, leaving an arch 30 feet high and fifty feet across. It would not be unusual farther west but is notable in a region otherwise lacking in such natural phenomena. Several hundred tons of sandstone are supported above the tiny stream.

AZTEC RUINS NATIONAL MONUMENT. Ruins of this large PUEBLO community of the 12th century include masonry and timber buildings which have been largely excavated and stabilized. The ruins, misnamed by settlers, are unrelated to the Aztecs of Mexico. Headquartered Aztec, New Mexico, it was established January 24, 1923.

B

BACA, Elfego. (Socorro, NM, 1865—1945). Lawman. Baca, a Mexican-American folk hero, is best remembered for a 36 hour gunfight in Upper Frisco, New Mexico, in 1884 in which he held off 80 Texas cowboys who unsuccessfully attempted to free a prisoner. Accused of killing one of the cowboys, deputy sheriff Baca surrendered only after being promised a fair trial. He was found innocent of the killing and eventually became the sheriff of Socorro County.

BACKABOAR. One of the most popular of the many imaginary creatures of Wyoming. Supposedly, the backaboar was adapted to life in the mountains by having short legs on one side of its body. This was one of the many creations of writer Grant Jones (1871-1903), who made a substantial reputation by bringing such vivid images into American folklore. According to his accounts, the backaboar could be captured by turning him so that his shorter legs were on the downhill side. Another striking image was that of the Cogly Woo. When chased, this creature would bore a hole in the ground with its tail, jump into the hole and pull the hole after him.

BACONE COLLEGE. Private junior college founded in 1880 at MUSKOGEE, OKLAHOMA, as a Baptist Missions University. Founder Almon C. Bacone's goals for the school were to preserve the ancient arts of the Indians as part of the curriculum, and that is still the aim of the college, which now enrolls students of all races. Bacone College is the oldest institution of

higher education in Oklahoma. Recent enrollments totalled approximately four hundred students, instructed by a faculty of thirty-five.

BAD RIVER. South Dakota, source lies in east Pennington County in the south central part of the state. The stream flows approximately 110 miles eastward into the MISSOURI RIVER opposite PIERRE, South Dakota.

BADLANDS These areas of severe erosion, typical of semi-arid climates, are made up of gullies and steep ridges, often piled into fantastics shapes, sometimes featuring the varying colors of the uncovered layers of soil. The most extensive of such regions in the world is the Badlands of South Dakota, covering about 2,000 square miles, where the term was first applied by Indians who found them difficult to cross. Gullies drop as deep as 500 feet, and there are grotesque sculptures carved by wind and water. Much of this area is now included in BADLANDS NATIONAL PARK. The Badlands area of North Dakota is different, consisting of clay hills cut by the wind and rain, rather than the deep eroded valleys and carved formations to the south. The North Dakota Badlands also supports a good deal of vegetation. Much of this region is included in THEODORE ROOSEVELT NATIONAL PARK. The Badlands of Nebraska are an extension of those of South Dakota, but they are somewhat modified, a combination of the types found in the two Dakotas. The valleys are wider and not so deep, but there are few rounded tops and almost no vegetation.

BADLANDS NATIONAL PARK. Carved by erosion, this scenic landscape contains animal fossils of 40 million years ago. Prairie grasslands extending across 243,302 acres support bison, bighorn sheep, deer and antelope. Authorized March 4, 1929, headquartered Interior, South Dakota.

BAKER UNIVERSITY. Founded in 1858 at Baldwin, Kansas, in the Old Castle Building which continues to stand on campus and is the oldest college building in the state. The university proudly boasts that one of its earliest donations came from Abraham Lincoln in 1864. The Bishop Quayle Collection of Bibles, housed at the university, is one of the finest assemblages of rare Bibles, including among its most prized possessions two copies of the original King James version and Bibles handprinted by monks. During the 1985-1986 academic year the university enrolled 825 students and employed fifty-six faculty members.

BALCONES ESCARPMENT. Natural boundary between the coastal plains region of Texas and the Central Plains, named by the Spanish for its resemblance to a balcony.

BALDWIN CITY, Kansas. Town (pop. 2,-829), Douglas County, east-central Kansas, southeast of LAWRENCE and southwest of OLATHE, founded 1857, site of BAKER UNIVERSITY. Today's quiet college town is a contrast to the bloody period of the clash between proslavery and antislavery forces in 1856. Proslavery Missourians raided Baldwin City and captured many Abolitionists. These unfortunates were held hostage until rescued by Federal troops. Before the angry Missourians returned home they raided OSAWATOMIE, the headquarters of John BROWN. Today, on the third weekend in October, the residents celebrate the Maple Leaf Festival with a parade and craft displays.

BALLOON, RECORD FLIGHT. Record setting flight into the stratosphere in 1935 of the huge balloon *Explorer II* and its crew, Albert W. Stevens and Orvil A. Anderson. Launched from the STRATOSPHERE BOWL in the BLACK HILLS, the balloon rose 13.71 miles on a flight that lasted eight hours. The flight brought international attention to South Dakota and the Black Hills and was said to have been one of the most important scientific events of the period.

BANCROFT, Nebraska. Town (pop. 552), Burt County, northeastern Nebraska, northwest of Fremont and east of Norfolk. Bancroft, platted in 1881. Named for famed historian George Bancroft, the community is located near the Omaha Indian Reservation. The Bancroft cemetery contains the grave of Susette TIBBLES (1854-1903), a lecturer, writer, and illustrator, who toured the United States (1897-1893) with her husband speaking out against mistreatment of Indians and successfully influenced others to introduce and pass laws protecting Indian rights. She first started on the tours as the interpreter for Standing Bear, Chief of the Ponca tribe, and continued almost until her death. Bancroft is also known for the John G. NEIHARDT (1881-1973) Center, named for Nebraska's poet laureate and author of many books of poetry. The Neihardt Study has been restored and furnished. A Sioux prayer garden illustrates Neihardt's interest in Indian lore and customs.

BANDELIER NATIONAL MONUMENT.
On the canyon-slashed slopes of the Pajarito Plateau are the ruins of many cliff houses of 15th century PUEBLO peoples. Proclaimed February 11, 1916, headquartered Los Alamos, New Mexico.

BANDELIER, Adolph Francis Alphonse.
(Berne, Switzerland, Aug. 6, 1840—New York, NY, Mar. 19, 1914). Archaeologist. Bandelier, the first scientist to investigate the New Mexico area thoroughly, became so knowledgeable about the prehistoric people of the region that he wrote a successful novel, *The Delight Makers*, based on the lives of the PUEBLO Indians. Bandelier traveled among the Indians of the Southwest between 1880 and 1885 under the auspices of the Archaeological Institute of America. He later went to South America and became a leading authority on the pre-Columbian civilizations there.

BANNACK, Montana. Village. Located in southwestern Montana in Beaverhead County, Bannack was the first territorial capital of Montana. The town, southwest of present-day Dillon, was founded after a gold strike on Grasshopper Creek in 1862. Lack of water and richer discoveries in other locations caused most of the population to drift away until five ditches, dug between 1866 and 1870, brought the water that made placer mining possible. An electric dredge was first used in 1895. Mineral production continued at a steady, but not spectacular pace. Bannack was the center of the Plummer gang's criminal activities. Plummer was captured in 1864 and hung at Hangmans' Gulch near Bannack. A few mines continue to operate, but the town ceased to exist in 1938 and the post office was closed. Bannack is now a state park.

BANNOCK INDIANS. Small Shoshonean tribe living in southeastern Idaho and western Wyoming in the early 19th century. Speaking a language of the Shoshonean division of the Uto-Aztecan linguistic family, the Bannock were loosely organized into semi-nomadic bands which roamed along the Snake River. Band chiefs inherited their office through the male line, subject to community approval. The Bannock acquired horses and became skillful riders in the early 18th century. Shaman, men or women, obtaining their powers by dreams or through inheritance, cured the ill, "controlled" the weather and conducted ceremonies such as the Grass Dance, the Scalp Dance and the Bear

Dance. The dead were buried among the rocks and dressed in their best clothes, with their heads pointed east. It was believed that they moved west along the Milky Way on their way to the land of the dead. In mourning, the friends of the deceased often killed his favorite horse and cut their own hair and legs as they began a year of mourning. Winter houses were made of buffalo skins, and dome-shaped grass houses with a willow framework were used in the summer. The Bannock fished for salmon in the spring on the Snake River, gathered seeds and roots on Camas Prairie in the summer, and hunted buffalo in the fall in Montana. Enemies of the Bannock included the BLACKFOOT, CROW and Nez Perce. Bannock weapons included bows of wood and horn of mountain sheep, buffalo hide shields, a pogamoggan, or war club, and stone tipped arrows and spears. War horses, obtained in trade with the Nez Perce, were painted white with clay and decorated with feathers. As the Oregon Trail began to be well defined, a flood of settlers moved in. Allied with the Shoshone the Bannock fought the white settlers but failed, and in 1868 the Bannock signed the Fort Bridger Treaty in which they agreed to move to the Fort Hall Reservation. Difficulties in adjusting to reservation life, the disappearance of the buffalo, loss of their lands and insufficient food caused the Bannock to revolt in 1878. By 1880, the uprising had been put down and the remaining Indians returned to Fort Hall. By the 1970s about 3,200 Bannock and Shoshoni lived together on or near the 500,000 acre Fort Hall Reservation.

BARBED WIRE. Simple fence wire with barbs on it. Invented in 1874, the most common designs had the barbs twisted several times in various ways. Only five tons were produced the first year, but between 1868 and 1873 eleven patents for barbed wire were issued. The number of patents climbed to ninety-four in the years from 1881 to 1885. In seventeen years, a total of 306 patents were issued. The first manufacturers of barbed wire were located in Illinois and Iowa. Barbed wire had tremendous effect on the West. Most ranchers were advocates of the open-range until the powerful XIT Ranch in the Texas Panhandle fenced an almost unbelievable area of 3,050,000 acres in 1874. Ranchers found that barbed wire could be used to keep others from precious water; some used it to block trails. They found that it was most useful in keeping cattle from drifting, but found that the wire also prevented the cattle

from escaping the effects of cold and snow and caused thousands of animals to perish in great "die-ups." To the American cowboy the advent of barbed wire meant that the spade, hammer, and pliers were now as important as the horse in his work.

BARTLESVILLE, Oklahoma. City (pop. 34,-568), Seat of Washington County, northeast Oklahoma, north of TULSA and east of PONCA CITY, on the Caney River. Founded in 1785 by Jacob Bartles, a U.S. Army officer, merchant and rancher, the community was named in his honor. In 1876 the power of the river was used to produce the state's first hydrolectric current.

The community also became the pioneer in Oklahoma's greatest industry when oil was first produced there in 1897. An exact reproduction of the NELLIE JOHNSTONE WELL NUMBER ONE, the "discovery well" of the Oklahoma oil industry, is preserved in Bartlesville's Johnstone Park. Oil is still the leading commercial enteprise in Bartlesville, home of the Phillips Petroleum Company. The United States Bureau of Mines Petroleum Experiment Station there is known for its research into all aspects of the petroleum industry.

The most sensational highway robbery in Oklahoma history occurred three miles west and slightly south of Bartlesville. On June 14, 1903, between seventy-five and one hundred people were stopped one by one and held hostage by robbers evidently intent only on finding three good horses. As soon as the horses were obtained the robbers made off with probably less than $500 in cash, three saddles, a gold watch and the horses.

Bartlesville was the home in the early 1890s of Bill Dalton who used his real estate business to hide his role as operations manager for his outlaw brothers who hid in the hills nearby between robberies. Bill finally turned to robbery and was killed in 1894 near Ardmore, Oklahoma.

Bartlesville Wesleyan College was founded there in 1877.

Bartlesville residents rank among the best educated in the United States, with a larger percentage of residents having earned the Doctor of Philosophy degree than in any other city in the nation.

The six-level home of Frank PHILLIPS, founder of the Phillips Petroleum Company, is open to the public as a museum. It is known for its hand-carved oak woodwork. Another community landmark is Price Tower, designed with many unusual engineering features by the

internationally famous Frank Lloyd Wright. WOOLAROC is a complex of wildlife preserve and museum, with the museum one of the most notable in its field, particularly in Western art. Ranch and museum Indian artifacts and Western art illustrate the development of civilization in the Southwest.

BASIN, Wyoming. Town (pop. 1,349), seat of Big Horn County, north-central Wyoming, southwest of Sheridan and southeast of CODY first settled in the 1880s. The local economy is based on the oil wells. Basin also has been known for its plantings of trees, begun in 1910, and for its beautiful rows of lilacs planted throughout the town in 1936. The reputation of the region as a major bean producer is promoted and enhanced by many of the women of the area who have made plaques and pictures with beans.

BASINS. In general, any valley or depression in the landscape, but in the Central West and West more particularly a depression having no outlet to the sea. Streams flowing into such basins end either in desert sinks, fresh water lakes with no visible outlets, or salt lakes. Most notable of such depressions in the Central West is Wyoming's GREAT DIVIDE BASIN, formed by a unique separation of the Continental Divide. Waters falling in this basin also have no outlet to the sea, but waters falling on the outer slopes of this basin flow to opposite ends of the continent, those on the east to the Atlantic and those on the west to the Pacific. Other basins, such as Wyoming's Big Horn, have mighty outlets to the ocean. Smaller "basins" in Kansas and elsewhere are created by the collapse of underground caves caused by the erosion of limestone beneath the ground. Big Basin, in Clark County, Kansas, was formed this way and measures one mile long and one hundred feet deep. Some such basins are ancient while others have occurred recently.

BASKETMAKERS. Name given to the third major period of prehistoric people in present-day southwestern United States. One system of dating places their arrival in the region at about 1500 B.C. The Basketmakers were originally nomadic hunters and gatherers. They gradually developed agriculture and built crude homes, partially sunk below ground level. Over the years they developed their skill in creating baskets until they truly deserved that name. It is unknown whether another group of people brought the Basketmakers new skills or

whether they simply developed a higher level of civilization on their own, but by A.D. 500 the civilization had reached the stage known as Anasazi, the name the Indians used to describe "the ancient ones."

BASS, Sam. (Mitchell, IN, July 21, 1851—Round Rock, TX, July 21, 1878). Bandit and folklore figure. He moved to Texas about 1870 and pursued various jobs, including deputy sheriff, until 1875, when he became a "Robin Hood" type stage and train robber who often provided largess in the local bars. Bass began his outlaw career in 1876 when he robbed stage coaches near DEADWOOD, South Dakota. Near Big Springs, Nebraska, on September 19, 1877, Bass and his gang robbed a Union Pacific train and allegedly made away with $65,000 in the robbery. On July 19, 1878, Bass and three companions attempted to rob the bank in Round Rock, Texas. Texas Rangers were warned of the planned robbery by a spy, Jim Murphy, in the outlaw gang. Bass and his men were soon in a pitched battle, and Bass was fatally shot.

Only thirty-five miles from the bustle of Austin, Texas, wilderness recreation may be found in the 3,350 acres of quiet rolling Bastrop State Park, with its stately pines, rustic cabins and camp and trailer sites.

BASTROP, Texas. Town (pop. 3,789). Seat of Bastrop County, south-central Texas, east of AUSTIN and northeast of SAN ANTONIO. It was named for Felipe Enrique Neri, Baron de Bastrop, founder of this and several other Texas towns. The community was first settled in 1829 to protect the trade on the Old San Antonio Road. Indian raids caused it to be virtually abandoned in the early 1830s, but it was resettled in 1836. Light industry and service are the basis for the economy. The Lost Pines of Bastrop is an unusual woodland area where a group of pine trees stands completely isolated by 100 miles from the pine forests of east Texas. The annual Homecoming features a thirty-mile canoe race.

BATES, Katharine Lee. (Falmouth, MA, Aug. 12, 1859—Dedham MA, Sept. 28, 1898), Author, educator, best known for her poem "America the Beautiful," (1859) composed on a visit to Colorado. The view from the top of Pikes Peak was so compelling that the Wellesley College professor wrote: "It was then and there, as I was looking out over the sea-like expanse of fertile country spreading away so far under those ample skies, that the opening lines of the hymn floated into my mind." As soon as she left the mountain, Katharine Bates wrote the first stanza of the song about which C.A. Browne says, "The alabaster cities and the purple mountain majesties were already in her dreams when that wider vision of 'America the Beautiful' swept over her in words so noble that they lift the thought of the nation as no other of our songs has the power to do." Set to music in 1911, the work became the unofficial national hymn.

BATHOLITH. A dome of rock. Created underground by volcanic forces, the molton rock may be pushed slowly to the surface where it does not cause a volcanic eruption and is exposed to the effects of weathering. BEAR BUTTE in western South Dakota is one of the best examples of this formation in the Central West, but there are other examples in the region.

BATTLE LAKE. Region in Wyoming which was the scene of a study of an eclipse by the Henry Draper Astronomical Expedition in 1878. Accompanying the scientists was famous inventor Thomas Edison who, according to legend, envisioned the idea of using bamboo as the filament for his first successful electric light while there fishing with a bamboo pole.

BAYLOR UNIVERSITY. Independent Baptist coed institution located on a 300-acre campus in the central Texas city of WACO. Founded in 1845, named after Texas jurist Robert E. B. BAYLOR (1791-1873), it is the oldest Texas university in continuous operation, and is regarded as one of the nation's most important church-related institutions. This strongly Baptist, somewhat conservative, university was originally located in Independence, Texas, but moved to Waco in 1886. The Waco campus is the site of the Colleges of Arts and Sciences, The Graduate School, and the school of Nursing, Law, Music, Business, and Education. The Medical and Dental Schools are based in DALLAS and HOUSTON. There is also a school of Nursing in Dallas. Academic emphasis is on liberal arts and sciences, religion, education, law, nursing, business, computer and engineering science, pre-dentistry and pre-medicine. There are over 100 major areas of study and 35 degree programs. The student body of 11,481 is instructed by a faculty of 636.

BAYLOR, Robert Emmet Bledsoe. (Lincoln or Bourbon County KY, May 10, 1791—Washington County, TX, December 30, 1873). Judge and Baptist leader. Baylor was a member of the Kentucky and Alabama legislatures from 1812 until early 1820. He went to Texas in 1839 and served as a Supreme Court judge in Texas until the Civil War. As a jurist, he helped draft the Texas state constitution. He was co-founder of the first Baptist college in Texas, later named BAYLOR UNIVERSITY.

BAYTOWN, Texas. City (pop. 56,923), Harris County, Southeastern Texas on GALVESTON BAY, from which it takes its descriptive name. It is an industrial center with oil refineries, petroleum, and synthetic rubber plants, and steel plate mills. The community evolved from the consolidation of a number of smaller settlements, beginning in 1822, when the first settlement was called Baytown. Adjoining Pelly and Baytown merged in 1845, and Goose Creek followed to form the present city of Baytown, which was incorporated in 1948. Oil was discovered here in 1916 and is still shipped from Baytown over the HOUSTON SHIP CHANNEL. Lee College was founded there in 1934. Anahuac National Wildlife Refuge is nearby.

BEACH, North Dakota. Town (pop. 1,381), Golden Valley County, southwestern North Dakota, southwest of WILLISTON and west of DICKINSON, just two miles from the Montana border. Settled about 1880, it was named for an officer who helped survey the area. The community is a center for a two-state agricultural area and shipping point. Beach is the location of Father Cassedy's Home on the Range for Boys. Founded in 1948, the home provides homeless and needy boys with a place to live on a 1,900 acre working ranch.

BEAN, Roy. (Mason County, KY, 1825—Langtry, TX, Mar. 16, 1903). Frontier lawman. In 1882 Bean moved to a lonely spot on the lower PECOS RIVER, known as Vinegaroon. There he opened a saloon and became a semi-official justice of the peace. Having set up a court in his saloon on the basis of one lawbook and a sixshooter, he displayed a sign calling himself "the law west of the Pecos." That phrase worked itself into a western legend. He dispensed his own brand of justice and became noted throughout the Southwest. He renamed Vinegaroon Langtry in honor of the actress Lillie Langtry. In 1896 he staged the Fitzsimmons-Maher heavyweight boxing championship fight on a sandbar in the RIO GRANDE RIVER after Texas refused to permit the licensing of the contest.

BEAR BUTTE. Located in Meade County, South Dakota, near Sturgis it rises abruptly from level ground to a height of 4,422 feet. This BATHOLITH of granite in the past was the scene of annual pilgrimages of Indians who considered the place a sacred shrine.

BEAR PAW MOUNTAIN, Battle of. Final large-scale Indian fighting in Montana. Fought in August, 1877, the battle pitted Colonel Nelson A. MILES against the Nez Perce Indians under Chief Joseph. The Indians, attempting to escape into Canada, were forced to surrender after a six day struggle. Joseph and his tribe were sent to Oklahoma, but in 1885 they were returned to their native lands in Washington state and settled on the Colville Reservation, where Joseph died in 1904.

BEAR PAW BATTLEFIELD STATE MONUMENT. Montana site in Blaine County, sixteen miles south of Chinook. The monument preserves 160 acres of rolling grassland where fighting known as the Battle of BEAR PAW MOUNTAIN took place in September, 1877, between Nez Perce Indians led by famed Chief Joseph the Younger and troops under the command of Colonel Nelson A. MILES.

BEAR RIVER. Stream flowing through south-eastern Idaho and northern Utah which begins in the UINTA MOUNTAINS in northern Utah. With a length of 500 miles, it is the longest river in the Western Hemisphere not flowing to any ocean. It flows north crossing the Wyoming border twice and turning northwest into southeastern Idaho, it then curves south to empty into Great Salt Lake in northern Utah.

BEAR RIVER DIVIDE. The only portion of the Great Basin in the Central West region is the tiny semi-circle cut into Wyoming's western border, marked by the small Wyoming portion of the BEAR RIVER. A short distance to the east of the river the Bear River Divide separates the waters, those to the east flowing into the river systems emptying into the Gulf of California and those to the west flowing into the Bear River, emptying into the Great Basin, where the waters never reach any ocean.

BEARS, grizzly. Large omnivorous North American animal named for the texture of his coat which is somewhat grizzled, the bear is referred to by zoologists as *Ursus horribilis.* Color variations in the fur range from dark brown to a straw-colored blond. In pre-Columbian times the bear ranged from the Pacific Ocean to the Mississippi River and from Mexico to the Arctic Circle.

To many Indian tribes of North America the grizzly was a sacred animal, but it was also hunted for its claws whose possession gave the hunter high status. Eating the meat of the bear raw was thought to give the hunter the strength, cunning and courage of the animal.

At the time of white exploration, grizzlies lived in the foothills and river valleys of the ROCKY MOUNTAINS where food supplies were abundant. In 1540 CORONADO was the first to see and record the grizzly, in west-central New Mexico. The bear was first described scientifically and named by George Ord in 1815 after he observed a specimen collected by the LEWIS AND CLARK EXPEDITION in 1805 along the Missouri River.

As many as eighty-six species were designated in 1918 by C. Hart Merriam, a number reduced in 1928 to eleven species by Harold E. Anthony.

Grizzlies have disappeared from such present states as Nebraska, Oklahoma, Kansas, New Mexico, the Dakotas and probably Colorado. There are presently thought to be less than a thousand grizzlies in the United States, with some in Wyoming in YELLOWSTONE

NATIONAL PARK. In 1966 the Committee on Rare and Endangered Wildlife Species of the Bureau of Sport Fisheries and Wildlife officially listed the animal as one of the endangered species whose survival prospects were in immediate jeopardy.

Generally a shy animal, the grizzly has been known to attack man and larger animals including buffalo when cornered, startled, or injured. There appears to be a critical attack distance within which the bear charges almost automatically. This critical attack distance, generally less than one hundred yards, varies with the age and sex of the bear and the particular situation. Having poor eyesight, grizzlies appear unable to identify man beyond one hundred or two hundred yards. Victims are generally knocked over with powerful blows of the paws and then bitten repeatedly on the head. Attempts to escape or fight off the attack will prolong the ordeal. Grizzly attacks on humans are rare. Between 1900 and 1970 there have been only two fatalities in Yellowstone from grizzly attacks. Given the visiting rate in the park the chances of being attacked and injured has been established as one in 600,000.

BEARTOOTH HIGHWAY. Considered one of the nation's most scenic highways, it stretches from RED LODGE, Montana, across Beartooth Pass to the northeastern entrance of YELLOWSTONE NATIONAL PARK, via the colorful old gold camp of Cooke City, Wyoming. The sixty-four mile drive begins at an elevation of 5,650 feet and rises to Beartooth Plateau's crest of 11,000 feet. While sudden snows may occur in almost any month, the highway is usually open from early June to mid-October. The highway was the dream of Red Lodge physician J.C.F. Siegfriedt who hoped to create a tourist attraction that would restore prosperity to Red Lodge after the closing of the town's coal mines. The highway was opened on June 14, 1936, at a cost of $2.5 million. Unsuspecting travelers are treated annually on an undisclosed date when the Red Lodge Chamber of Commerce hosts a "snow bar" with soft drinks at the Beartooth Highway Summit.

BEARTOOTH MOUNTAINS. Range of the ROCKY MOUNTAINS lying between RED LODGE, Montana, and COOKE CITY, Wyoming. The mountains were created as long ago as seventy million years, from the uplifting of rock over four billion years old. As the rock was shoved upward the crust broke and great quantities of lava spewed to the surface. Volcanos erupted

and buried the countryside in several thousand feet of ash. As time passed ice age GLACIERS ground across the land carving canyons and forming many lakes. One glacier scoured the walls and floor of an ancient volcano and created Rock Creek Canyon south of Red Lodge and the valley in which Cooke City is located. The ice also scraped away hundreds of feet of rock to expose deposits of silver, gold and copper.

BEATRICE, Nebraska. City (pop. 12,891). Seat of Gage County, southeastern Nebraska, south of Lincoln and southeast of OMAHA. Founded in 1857, the community was named for the daughter of Judge John Kinney, one of the founders. Beatrice has developed from a stagecoach stop into a thriving light industrial and farming center. Nebraska's boast to having the first land claim under the HOMESTEAD ACT of 1862 is based on the application of Daniel Freeman, near Beatrice, on a few minutes past midnight on January 1, 1863. Although the office was not open, his application was processed to permit him to go into Civil War service that day. The unique HOMESTEAD NA- TIONAL MONUMENT OF AMERICA stands on land homesteaded by Freeman. Beatrice boasts the distinction of nurturing not one but two famed movie stars, Harold LLOYD and Robert TAYLOR . Homestead Week is celebrated annually in June. Beatrice is today the home of John J. Pershing College, one of Nebraska's new private colleges.

BEAUMONT, Texas. City (pop. 118,102), seat of Jefferson County, 28 miles from the Gulf of Mexico at the head of navigation of the NECHES RIVER, 16 miles from PORT ARTHUR, and 70 miles from GALVESTON. Founded in 1835, it was named for the Beaumont family, early settlers in the area. A shipping depot for timber and African slaves before the CIVIL WAR, Beaumont experienced little growth until the turn of the century. The railroad expansion of the 1890s, which brought five lines to the area, and the discovery of the Spindletop oil well nearby in 1901, brought prosperity to the city, and population went from less than 10,000 in 1900 to more than 50,000 in 1925. Today Beaumont is the second-largest port in Texas and a prime location of the oil industry. Beaumont's industries include petrochemicals, shipping, ship and barge construction, manufacture of drill and pipeline equipment, and the milling of rice products. Beaumont houses its own art museum, the Spindletop Museum at Lamar State University (1923). An unusual memorial is dedicated to athlete Babe Didrikson Zaharias.

BEAVER. Aquatic mammal once widespread over the northern hemisphere, so valued for its fur that it had been almost exterminated in many areas. In the U.S. the beaver appeared doomed for a while but over the years has gradually made a comeback, returning in some cases to regions where it has not been seen for 150 or more years.

The search for beaver fur led the earliest white explorers farther and farther into the West, founding posts for trading with the Indians for their beaver pelts and paving the way for other trade, settlement and development to follow.

The beaver was well known in all the Central West region, but particularly so in the northern areas, where most of the region's trapping and trading took place. Trappers carried traps weighing five pounds each which, they set at sites displaying evidence of the animal, such as houses or slides on stream banks. The trap was anchored in deep water so that when the animal hit the trap with its front feet it would throw itself into the water and drown. Beaver musk, which was thought to have medicinal value, was spread on a stick stuck into the stream bottom above the trap to cover any human scent left in the area. Skinning was done on the spot. Then the hide was stretched and tied to a circular frame and stored in a cool place.

Fortunately the rage for beaver fur died out before the wonderful animal was completely exterminated. Beavers are known as the "engineers of the animal kingdom." Their carefully engineered dams are placed so perfectly that the water level reaches exactly the height needed for their partially underwater lodges of sticks and mud. One story is told that as human builders were constructing a small dam, they noticed that the beavers watched them constantly. Before the dam was finished, the beavers went upstream a given distance and began to build their lodges. When the water backed up behind the dam, the beaver houses were surrounded by water of exactly the right depth, demonstrating their extraordinary instinct in engineering.

BEAVER RIVER. Oklahoma river beginning in the northwestern Panhandle, flowing approximately two hundred eighty miles east. It enters Texas for fifteen miles then flows back into Oklahoma where it joins with Wolf Creek forming the North Canadian River.

BECKNELL, William. (Amherst County, VA, 1796—Texas, Apr. 30, 1865). Explorer and trader. In 1822 Becknell successfully blazed the first overland wagon route to SANTA FE, New Mexico, pioneering the SANTA FE TRAIL. This led from what is now Kansas City, Missouri, cutting across Kansas diagonally to the CIMAR-RON RIVER, near present Cimarron, Kansas. From that point earlier pack trails had taken a long roundabout route by way of Bent's Fort, Colorado. However, Becknell took a desperate gamble on a shorter route. No one thought a wagon train could be taken across the Cimarron and into semi-desert country, where water sources were unknown. Nevertheless, the Becknell party proceeded across the northwest corner of the present Oklahoma panhandle to FORT UNION in New Mexico and then on to their destination. Although they had almost died of thirst, finding underground water at the last moment, Becknell and his bedraggled company of men and animals pulled into Santa Fe on November 6, 1822, hauling the first wagons ever brought from the East to that city. They received a rousing welcome. Becknell and his associates made a huge profit selling calico cloth, beads and other goods manufactured in the states. The calico which was eagerly snapped up at $3.00 a yard in Santa Fe cost as little as five cents a yard in Franklin, Missouri. For his trading expeditions and trail blazing, Becknell became known as the "Father of the Santa Fe Trail." He moved to Texas in 1834 and served with the revolutionary forces there and later joined the Texas Rangers.

BECKWOURTH, James P. (Fredricksburg, VA, Apr. 26, 1798—Denver, CO, 1867). Fur trader and explorer. Beckwourth was a member of the W.H. ASHLEY trading expeditions into the ROCKY MOUNTAINS in 1824-1825. He lived with the CROW INDIANS from 1825 to 1833, taking advantage of his mulatto background and skin color to convince the Indians that he was actually part Indian. Beckwourth moved to Colorado in 1858 and participated in the Cheyenne War of 1864. Hiram Martin Chittenden in his monumental work, *The American Fur Trade of the Far West*, relates that Beckwourth often invented the truth. However, this does not diminish his importance in the history of the region. The fact that Beckwourth was employed at $800 per year by the AMERICAN FUR COMPANY, a high wage for the time, signifies the high regard in which he was held by the fur industry. The book, *James P. Beckwourth, Mountaineer, Scout, and Pioneer and Chief of the Crow*

Nation (1856) by T.D. Bonner is considered largely autobiographical.

BEECHER ISLAND, BATTLE OF. Nine days of combat in 1868 between United States troops and Indians in Yuma County, Colorado, which greatly reduced the power of the Plains Indians. A force of fifty frontiersmen under Major George A. Forsyth fought as many as 1,000 Sioux and Cheyenne. Reinforcements from Fort Wallace 125 miles away rescued the defenders, who suffered fifty percent of their number wounded, including Major Forsyth four times. There was one army death, Lieutenant Frederick W. Beecher for whom the island and site of the battle is named. The Indian chief, ROMAN NOSE, was killed. Shifting currents in the ARIKAREE RIVER have obliterated the island.

BEET SUGAR. Source of more than half of the sugar produced in the United States, taken from the roots of the beet by washing them, cutting the roots into thin strips and soaking the strips in hot water which brings out the sugar. The solution is purified, filtered and boiled to form sugar crystals. Major sources in the United States include the Central West states of Nebraska, Colorado, and North Dakota.

BELL, New Mexico. Village in northeastern New Mexico. Located on Johnson Mesa between Folsom and RATON, Bell was founded in 1887 by miners from Bossburg, New Mexico. Under the mesa's north rim are the famous ICE CAVES discovered by Eli and Fred Gutierrez in 1934. Rooms in the caves have solid ice floors and walls. In 1936 Dr. S.B. Talmadge discovered Talmadge Glacier, one of the few underground glaciers of its type. This stretches from two to twenty-five feet wide and nearly two hundred feet long.

BELLE FOURCHE, South Dakota. Town (pop. 4,692). Seat of Butte County, west-central South Dakota, northwest of RAPID CITY and southwest of Buffalo, on the BELLE FOURCHE RIVER, founded 1890. Belle Fourche, meaning "beautiful forks," is the site of one of the world's largest deposits of BENTONITE, a swelling clay used in oil drilling, ceramics, insulation and detergents. The community has also been a center of South Dakota's wool industry with many sheep and wool warehouses. In September, 1895, the community was almost totally destroyed when rival gangs of outlaws set it on fire. One of its many historic events was the

raid on the Butte County Bank on June 28, 1897, by members of the infamous Wild Bunch gang under the leadership of the Sundance Kid and Kid Curry. Today, the residents hold the annual Black Hills Roundup, one of the leading rodeos in the United States.

BELLE FOURCHE RIVER. Western South Dakota and northeast Wyoming, beginning in Wyoming and flowing northeast and east for three hundred fifty miles into the CHEYENNE RIVER in eastern Meade County, South Dakota. The river flows past DEVIL'S TOWER in Wyoming, BELLE FOURCHE, South Dakota, and west of the Black Hills National Forest in Wyoming.

BELLEVUE, Nebraska. City (pop. 21,813), Sarpy County, southeastern Nebraska, southeast of OMAHA and northeast of LINCOLN. Bellevue (beautiful view), on the MISSOURI RIVER near the confluence with the PLATTE RIVER to the south, has been an important city of commerce since the mid-1820s and was the first permanent European settlement in present-day Nebraska. It was incorporated in 1855 as Ne-

braska's first city. In the 1830s the city became the headquarters for an Indian agency. The arrival of the first piano to the home of Peter Sarpy brought Indians from miles around to stand and listen in amazement. Nebraska's first newspaper, the *Nebraska Palladium and Platte Valley Advocate* was published there in 1854. In the same year Yosette LA FLESCHE Tibbles, a part-Indian artist was born in Bellevue. Tibbles was eventually to illustrate a book in 1898 entitled *Oo-Mah-Ha Ta-Wa-Tha* which is considered to be the first work by an Indian artist ever published. In the 1890s Bellevue was chosen as the site for Fort Crook which developed years later into Offutt Air Force Base and the headquarters of the Strategic Air Command. The Sarpy County Historical Museum recalls the establishment of Nebraska's first permanent white settlement on the Missouri River. The Strategic Air Command Museum displays aircraft and missiles from World War I to the present. Indoor exhibits trace the development of the American Air Force from the flights of the Wright brothers to the establishment of the Strategic Air

Nebraska's first European style community, Bellevue, was pictured by famed artist George Catlin during one of his Missouri River voyages in the 1840s.

Command. A film dramatizing SAC's response to a red alert is shown several times daily.

BELLOWS, George. (Columbus, OH, Aug. 12, 1882—New York, N.Y., Jan. 8, 1925). Painter, lithographer. He left Ohio State University before graduation because he was anxious to take up art. Going to New York City in 1904, he studied with Robert Henri, quickly developed a distinctive style and associated with a group of young New York artists called "The Eight." He specialized in outdoor action scenes and athletics and was himself a talented athlete. Settling for about a year in New Mexico beginning in 1917, he became one of the most ardent boosters of the region. Bellows promoted lithography in the U.S. and became one of the finest experts in that field. He taught art intermittently at the Art Institute of Chicago and at the Art Students League in New York between 1910 and 1920. His best known work is "Stag at Sharkeys" (1907).

BELLY RIVER. Montana river rising in GLACIER NATIONAL PARK and flowing north and northeast for one hundred eighty miles into southwestern Alberta, Canada.

BELMONT, North Dakota. Ghost town in east central North Dakota near Buxton and Cummins in Trail County, founded 1862. Belmont was once a thriving river port on the RED RIVER between North Dakota and Minnesota. In 1871 the HUDSON'S BAY COMPANY constructed a trading post named Belmont on the site which becamee the head of navigation in 1872 when the level of the river fell. The importance of the bustling center in the wilderness caused its fame to be spread all the way to Europe where it was believed Belmont had broad avenues and buildings with tall spires. A second fall in the river's level led to the quick loss of the city's wealth. Many residents promptly left for other towns, and fires destroyed many buildings which were never rebuilt. A brief return to prosperity came when the river level rose and Belmont enjoyed a short revival as a grain-shipping center until the flood of 1897 ruined the elevators and their contents.

BENEDICTINE COLLEGE. Founded in AT-CHISON, Kansas, in 1859; known for its "million dollar monastery," copied after the Benedictine monasteries of the Middle Ages. During the 1985-1986 academic year the school enrolled 865 students and employed 92 faculty members.

BENT AND SAINT VRAIN. The firm was the largest trader in furs in the Southwest. BENT'S FORT, one of the great frontier outposts, was begun in 1828 by Bent and St. Vrain on the ARKANSAS RIVER near present-day LA JUNTA, Colorado. Near the modern community of GILCREST, Colorado, in 1838 the firm built Fort St. Vrain, eventually one of the most important forts on the frontier. The firm was founded by the BENT brothers (WILLIAM, 1809-1869) and CHARLES (1799-1847). Charles was manager until he became governor of New Mexico in 1847, when William took over. In 1849 he decided to sell Bent's Fort, but upon the refusal of the government to buy the property, William had the fort blown up and built a new fort a short distance down the Arkansas. He operated this with success until the decline of the furbearers. In 1859 William leased the fort to the U.S. government and retired. The government then operated the outpost as Fort Lyon.

BENT'S FORT (Fort Bent or Fort William). Adobe fortress and trading post begun in 1828 near present-day LA JUNTA, Colorado. Bent's Fort, as it was generally known, was one of the leading frontier outposts in the West and was the largest in Colorado. It was one of several built by the firm of BENT AND SAINT VRAIN. Its construction of adobe was dictated by Charles BENT who imported workers and material from New Mexico. The walls were 180 by 135 feet, two to four feet thick, and fifteen feet high. Two corners were guarded by thirty-foot towers and the outer walls were topped with cactus to keep Indians from crawling over at night. Indians who wished to trade were allowed to camp outside the walls and enter the fort at sunrise. Armed guards constantly watched the milling crowds to see that no surprise attacks were possible. Maintaining the post required one hundred workers. One of the many noteworthy events at the fort was the grand council of the CHEYENNE, KIOWA, ARAPAHO and COMANCHE in 1840, when past differences were forgotten and a permanent alliance was established. With the decline of the Indian trade by 1852 William BENT attempted to sell the fort to the United States government as a military post. When his idea was rejected Bent loaded his remaining goods on mules and blew the fort up rather than have it used without payment.

BENT, Charles. (Charles Town, VA, Nov. 11, 1799—Taos, NM, Jan. 19, 1847). Fur trader and government official. Bent began trapping as an agent of the AMERICAN FUR COMPANY in 1823 and

worked throughout New Mexico and Colorado between 1824 and 1828. With his brother, William, Bent founded BENT AND ST. VRAIN, a fur trading company, in 1828 and built BENT'S FORT, near present-day LA JUNTA, Colorado, between 1828 and 1832. He insisted the fort be made of adobe, and he imported workers and materials from New Mexico. The fort became the trading and social center for the entire mountain and plains region in which it was located. Bent led trading expeditions from the United States to SANTA FE, New Mexico, in 1829, 1832 and 1833. After the American conquest of the region, Bent was appointed the civil governor. While American troops were away in 1847, some of the New Mexican people staged a brief revolt in which Bent was scalped alive. Bent's family escaped by digging through the adobe wall to the next house.

BENT, William. (St. Louis, MO, May 23, 1809—Boggsville, CO, May 19, 1869). Fur trader. A younger brother of noted trader Charles BENT. With his brother, he is considered to have been the founder of the first European style settlement in Colorado, BENT'S FORT, sometimes called Fort William in his honor. It was located near present-day LA JUNTA, Colorado Charles Bent directed the activities of Bent's fort, and William took over in 1847 after his brother's death. Competition from SAN LUIS, founded in 1851, reduced trade at the fort so much that William attempted to sell the post to the government. When the government refused, Bent loaded his goods on wagons, packed powder around the fort's foundations and blew it up. He constructed a fort on the COLORADO RIVER and, in 1859, sold it to the government. This became Fort Lyon. Bent remained an Indian agent in Colorado and built a stockade on the PURGATOIRE RIVER which later became Boggsville and is now LAS ANIMAS, Colorado.

BENT'S OLD FORT NATIONAL HISTORIC SITE. As principal outpost of civilization on the Southern Plains in the early 1800s and a rendezvous for Indians, the post became the center of a vast fur-trading empire in the West. It was established in 1960 and headquartered at LA JUNTA, Colorado.

BENTON, Wyoming. Deserted, former supply town for the construction of the Union Pacific Railroad. Established in 1868, Benton was the first town to mushroom west of LARAMIE, Wyoming. Within weeks it had a population of three thousand, but as the railroad moved westward

the residents vanished. Within two months Benton had become a ghost town.

BENTONITE CLAY. A clay used in oil drilling, ceramics, insulation and detergents found in abundance in South Dakota. Bentonite acts as a bonding agent for insulation against sound and against heat and cold, as an adhesive agent in horticultural sprays and insecticides, and as a mineral filter. One of the world's largest deposits is found near BELLE FOURCHE, which has four bentonite plants. The clay is also mined in North Dakota.

BERNALILLO, New Mexico. Town (pop. 2,763), Sandoval County, northwestern New Mexico, northwest of ALBUQUERQUE and southeast of GALLUP. In a cave near BERNALILLO, in the SANDIA MOUNTAINS, remains have been found which date the presence of man in the region to 25,000 years ago. These have been called, (although probably not accurately) "the earliest humans" on the continent. Bernalillo continues to be primarily an Indian and Spanish community. The first Spanish arrived in the area in 1698. The pueblos of SANTA ANA and ZIA lie to the northwest. One of the oldest missions in the United States (c1700) is located in Santa Ana.

BERRY, Raymond. (Corpus Christi, TX, February, 27, 1933—). Football player. He graduated from Southern Methodist University and played with the Baltimore Colts (1955-1967) where he was the favorite target of Johnny Unitas's passes. He was inducted into the Pro Football Hall of Fame in 1973. His lifetime record as a receiver was 9,275 yards.

BERTHOUD PASS. Northern Colorado mountain pass in the FRONT RANGE of the ROCKY MOUNTAINS. Berthoud Pass, 11,315 feet high, lies in Clear Creek and Grand counties and marks the beginning of several runs for intrepid skiers.

BESSEY, Charles Edwin. (Milton, OH, May 21, 1845—Lincoln, NE, Feb. 25, 1915). Botanist. Bessey was the advocate who convinced President Theodore ROOSEVELT to establish the NEBRASKA NATIONAL FOREST, a living demonstration that forest land could be created on the GREAT PLAINS and a test site on which different types of trees have been planted to determine the best varieties for such cultivation. Bessey served as as a professor of botany from 1870 to 1884 and acting president in 1882 of the Iowa

Agricultural College before moving to the University of NEBRASKA where he served as a professor of botany, then acting chancellor and head dean between 1888 and 1909. Bessey was the author of many books including *Geography of Iowa.*

BETHANY COLLEGE. Liberal arts college founded in 1881 in LINDSBORG, Kansas. Bethany is widely recognized for its MESSIAH FESTIVAL of Music and Art held In Presser Auditorium during Easter Week. The tradition began in 1881 when Dr. Carl Swensson and his wife rehearsed untrained, but enthusiastic villagers in Handel's "Messiah. The chorus evolved into the Bethany Oratorio Society, one of the oldest continuously active oratorio societies in the country. A liberal arts college, with emphasis on the fine arts, Bethany has a student body of 728 and a faculty of 82

BETHANY, Oklahoma. City (pop. 22,130), Oklahoma County, central Oklahoma, suburb of OKLAHOMA CITY It was settled in 1906 by members of the the Nazarene church, incorporated in 1910 and named for Bethany in the New Testament. Bethany's economy centers on airplane manufacture and tires. It is the home of BETHANY-NAZARENE COLLEGE (1899) and the Southwestern College of Christian Ministers (1946).

BETHANY-NAZARENE COLLEGE. Private four-year college, founded 1899, located in BETHANY, Oklahoma. The school is the recognized college for the South Central Educational Zone for the Church of the Nazarene, including the state of Texas, Louisiana, Arkansas and Oklahoma. Students majoring in medical technology may take part in a cooperative program with the University of OKLAHOMA Medical Center. A liberal arts college, its emphasis is on religion. During the 1985-1986 academic year the college enrolled 1,175 students and employed 106 faculty members.

BETHEL COLLEGE. Oldest of all Mennonite colleges in the United States. Bethel, founded in 1887, is located in Newton, Kansas. Documents at the college are said to prove the Mennonites were the first to bring Red Turkey hard winter wheat to Kansas. The thirteen buildings of the college are located on a forty-seven acre campus of the liberal arts college. During the 1985-1986 academic year the college enrolled 639 students and employed 69 faculty members.

BIDAI INDIANS. "Brushwood" Tribe of Atakapan linguistic stock inhabiting the BIG THICKET region of Texas. They are reported to have been intermediaries between the Spanish and Apache Indians in the sale of firearms.

BIERSTADT, Albert. (Solingen, Germany, 1830—New York, NY., 1902). Landscape painter. Bierstadt, one of the first to present a scenic image of the West to the American public, joined a military expedition in 1858, which surveyed a wagon road from FORT LARAMIE to the Pacific. He spent the summer of 1859 sketching in the WIND RIVER and LARAMIE, Wyoming regions, and in 1860 exhibited the first of his Rocky Mountain landscapes at the National Academy of Design in New York City, winning almost immediate acclaim. A romanticist who loved large dramatic views, Bierstadt was inspired by many Colorado subjects and produced such works as *Rocky Mountains-Landers Peak* and *Morning in the Rocky Mountains.* One of the finest collections of his works is housed in the THOMAS GILCREASE INSTITUTE OF AMERICAN HISTORY AND ART in TULSA, Oklahoma.

BIG BASIN. Huge depression, one mile long and hundred hundred feet deep, in Clark County, Kansas, caused by the collapse of underground caves when water eroded the limestone beneath the ground.

BIG BEND. Distinguishing feature of the MISSOURI RIVER in South Dakota, southeast of PIERRE in Hughes County where Registre Loisel constructed the first permanent fur trading post in South Dakota, in 1796. A second fort, constructed on the site by Manuel LISA, helped hold the West for America during and after the War of 1812.

BIG BEND NATIONAL PARK. A 1,080-square mile preserve in western Texas on the Mexican border. Considered the last great wilderness region in the state, it is named for the Big Bend of the RIO GRANDE RIVER, which forms its southern border. The park has dramatic contrasts of scenery and geological features. Also found there are fossil trees, millions of years old. The Chisos Mountains, which are surrounded by desert, as well as the Boquillas, Mariscal, and Santa Elena canyons, are located within the park. The state donated the land to the federal government in 1935 and the park was established in 1944, headquartered, Big Bend National Park, TX.

BIG BLUE RIVER. Stream rising in Hamilton County in southeastern Nebraska, which flows three hundred miles in a southeasterly direction into the KANSAS RIVER at MANHATTAN , Kansas. The river passes Seward and BEATRICE, Nebraska, and forms Tuttle Creek Lake in Marshall and Pottawatomie counties, Kansas.

BIG ELK. (—) Far-seeing chief of the OMAHA INDIAN nation who did his best to prepare his people for white rule which he saw was unavoidable. Big Elk adopted a son of French and Ponca heritage, Joseph LA FLESCHE, who succeeded him. Big Elk convinced his tribe to take in members of the Winnebago tribe when they were driven out of their traditional homes.

BIG HOLE NATIONAL BATTLEFIELD. Nez Perce Indians and U.S. Army troops fought here in on August 9, 1877, in the Battle of Big Hole. This was one of the many dramatic episodes in the long journey of the Nez Perce Indians under Joseph the Younger to reach Canada to escape confinement by the U.S. government. The long journey culminated in the Battle of BEAR'S PAW MOUNTAIN. The preserve was founded in 1910 and is headquartered at Wisdom, Montana.

BIG SIOUX RIVER. Stream beginning in western Grant County in northeast South Dakota. Flowing south-southeast to form the Iowa-South Dakota border, it empties into the MISSOURI RIVER at the extreme southeast corner of South Dakota on the western boundary of Sioux City, Iowa.

BIG SPRING, Texas. Town (pop. 24,804), seat of Howard County, western Texas. Big Spring's economy is based primarily on the petroleum industry, farming (mostly cotton), and cattle. Before European settlement began, the area was renowned for its buffalo herds, which were fought over by Comanche and white hunters. Big Spring is the site of Howard County Junior College. Big Spring State Park is a leading tourist attraction, along with the annual Rattlesnake Roundup, National Texas Style Domino Tournament and Crossroads Stampede.

BIG STONE LAKE. A narrow lake, about thirty miles long, located between the northeast corner of South Dakota and western Minnesota. It is the source of the Minnesota River, one of the principal tributaries of the Mississippi river system.

BIG THICKET NATIONAL PRESERVE. A great number of plant and animal species coexist in this "biological crossroads of North America." Study and research opportunities are excellent. Naturalists consider the area to be unique for several reasons in addition to the mingling of species from biological areas both east and west and north and south. Experts point out that the thickness of growth of the trees and underbrush is found nowhere else except in rainy, swampy areas, quite unlike the Thicket. It is difficult to explain the concentration of exotic plants, including fifteen varieties of unusual orchids and rare ferns growing up to six feet tall. The Thicket is said to be one of the few areas of the country that remain almost completely unaltered by human interference. Headquartered Beaumont, Texas, authorized as a national preserve in 1974.

BIGHORN BASIN. Wyoming basin which is drained by the mighty BIGHORN RIVER. The basin is the site of two creations of prehistoric man, a fifty-eight-arrow made of rocks with an arrowhead five feet across and the famous Wyoming MEDICINE WHEEL, a huge stone formation of mysterious origin 245 feet in circumference.

BIGHORN CANYON NATIONAL RECREATION AREA. Bighorn Lake, formed by Yellowtail Dam on the BIGHORN RIVER, extends 71 miles, including 47 miles through spectacular Bighorn Canyon. The Crow Indian Reservation borders a large part of the area. Established October 15, 1966, headquartered Fort Smith, Montana.

BIGHORN MOUNTAINS. Range in northern Wyoming stretching north and south from the Montana border to Natrona County. The highest point in the range is Cloud Peak at 13,175 feet.

BIGHORN RIVER. Stream formed by the meeting of the Wind and Popo Agie rivers in Fremont County in north central Wyoming. Three hundred thirty-six miles long, the Bighorn River flows north into the YELLOWSTONE RIVER in southwestern Treasure County in south central Montana, flowing past THERMOPOLIS and Worland, Wyoming.

BIGHORN SHEEP. Bighorn, or Rocky Mountain sheep, official animal of Colorado. Extremely hardy, active and sure-footed animals, the male is distinguished by its massive horns curved backward, downward and side-

Majestic bighorn sheep, state animal of Colorado.

ways; the female develops modest spikes. Rams may weigh as much as three hundred pounds and reach six feet in length. There are two distinct species, the true big horn and the Dall's sheep. The animals were hunted by mountain men, immigrants headed for California and sportsmen to the point that the number of animals has been severely reduced.

BIGHORN SPRING. World's largest medicinal spring, located in Hot Springs State Park near THERMOPOLIS, Wyoming. Twenty-five feet across, the spring pours out nearly nineteen million gallons of water daily. The blue-green water gained its early reputation from those who felt that it was useful in treating infantile paralysis and rheumatism. Since only a small amount of the water is taken away for fountains and irrigation, the pool constantly overflows causing terraces, colored brilliantly by various algae.

BILLINGS, MONTANA

Name: For Frederick K. Billings (1823-1890) Northern Pacific railroad president, 1879-1881.

Nickname: Star of the Big Sky Country; Capital of the Midland Empire

Area: 29.9 square miles

Population:

1986: 80,310

Rank: 249

Percent change (1980-1986): +20.2%

Density (city): 2,686 per sq. mi.

Metropolitan Population: 118,741 (1984)

Percent change (1980-1984): +9.9%

Race and Ethnic (1980):

White: 95.15%

Black: 0.38%

Hispanic origin: 3.09%

Indian: 2.34%

Asian: 0.42%

Age:

18 and under: 26.2%

65 and over: 10.8%

Hospitals: 2

Sports Teams:

Billings Mustangs (baseball)

Further Information: Billings Area
Chamber of Commerce, 10 North 27th St., Billings, MT 59101

BILLINGS, Montana. City (pop. 66,789). Seat of Yellowstone County, in south central Montana, on the west bank of the YELLOWSTONE RIVER. Built by the Northern Pacific Railroad, it took the name of the road's president, Frederick K. Billings. The city is picturesquely located in a valley surrounded by seven mountain ranges. Founded in 1882 and incorporated in 1885, Billings thrived with the coming of the railroad.

Today it is the trading and communications center for a vast area of southern Montana and northern Wyoming. Particularly important are the enormous coal strip mining operations. Meat packing, oil and sugar refining and flour milling are the major industries. The livestock, wheat and sugar beets of the area are traded or processed. The city hosts many regional conventions.

Rocky Mountain College, founded 1878, is situated there, and some of its picturesque sandstone buildings are among the city's oldest.

Local attractions include the Western Heritage Center, with exhibits of prehistory and history of the Yellowstone Valley, and Yellowstone Art Center. Oscar's Dreamland is the realization of Oscar C. Cooke, who wanted to assemble the world's largest private collection of agricultural artifacts and equipment. He is considered to have accomplished his goal with the collection shown on the 300 acre museum.

At nearby Indian Caves, visitors view pictographs of a 4,500 year old culture. POMPEY'S PILLAR is a rock formation where William CLARK of the LEWIS AND CLARK EXPEDITION carved his name. He named the formation for little Pompey, son of their guide SAKAKAWEA.

The International Livestock Exposition and the Midland Empire Horse Show enhance the city's reputation in the field of livestock. Other annual events include the Spotted Ass Race in June and Yellowstone River float trips in July.

BIRD, Isabella Lucy (Bishop). (England, 1831—1904), travel writer. Before she reached America, this famed observer of the world scene, traveling alone, was the first European woman permitted, in Korea, had journeyed up the Yangtze in China, visited Australia and New Zealand and spent a fascinating time among the royalty of Hawaii. She arrived in California in 1873, only four years after the first U.S. transcontinental railroad had been completed. She took the train over the high Sierras, across the plains and stopped at CHEYENNE, Wyoming. Her description of a very proper Englishwoman alone in the riotous Wyoming capital at the height of its rip-roaring period is one of the most interesting to be found. Buying a gentle mare, she started off alone across the high prairies toward DENVER, Colorado. The visit is described in her book *A Lady's life in the Rocky Mountains*, published in 1879. In it she describes her stay in ESTES PARK, with the valley's first owner, Joel ESTES and his family, and she picturesquely describes her feat of being the first woman to scale Mount Evans. She provides a description of Rocky Mountain Jim and tells of her visits to Denver and the high country around it, providing one of the finest travel accounts in American literature, an indispensable record of much of the Central West in the period.

BISMARCK, NORTH DAKOTA

Name: For Otto von Bismarck (1815-1898) chancellor of Germany (1871-1890).

Nickname: Skyscraper City of the Prairies; City beside the Broad Missouri.

Area: 23.1 square miles

Elevation: 1,674 feet

Population:

1986: 48,040

Rank: 479

Percent change (1980-1984): +8%

Density (city): 2,080 per sq. mi.

Metropolitan Population: 86,071 (1984)

Percent change (1980-1984): +7.6%

Race and Ethnic (1980):

White: 97.70%

Black: 0.08%

Hispanic origin: 0.38%

Indian: 1.46%

Asian: 0.42%

Age:

17 and under: 29%

65 and over: 8.9%

Hospitals: 2

Further Information: Bismarck-Mandan Convention and Vistors' Bureau, 523 North Fourth St., Bixmarck, ND 58501

BISMARCK, North Dakota. City (pop. 44,-485), capital of North Dakota and seat of Burleigh County, lies perched on the MISSOURI RIVER hills, on the east bank, in south central North Dakota. The town of MANDAN lies opposite on the west bank. The capital was named for German Chancellor Bismarck, with the hope that German capital might finance the railroad.

In early days there was a MANDAN INDIAN village, which LEWIS AND CLARK visited in 1804. A logical spot for river crossing and steamboat landing, the small settlement became a port in the 1830s, known as the Crossing on the Missouri. As the railroads moved forward, Camp Greeley (Hancock) was planted there in 1872 to protect the railroad workers. The railroad terminus brought new settlers and commerce. The rush to the gold of the BLACK HILLS in 1874 increased Bismarck's role as a supply center. In 1876 General George CUSTER and his SEVENTH CAVALRY galloped out of newly constructed FORT ABRAHAM LINCOLN on their way to the massacre at Little Big Horn, and a river steamboat brought the first word of the disaster to wives and friends at the fort.

The city became territorial capital in 1883 and state capital in 1889.

The thoroughly modern city today is the hub of an agricultural area with mechanized farms and ranches averaging a thousand acres each. A large plant manufactures farm machinery, and the vast supplies of spring wheat are distributed or processed at Bismarck. With the state's first oil well in production nearby in 1951, the city became a center of the area's oil industry. The business of state, county and city administration further adds to the economy.

Dominating the city, the splendid skyscraper capitol looms above the nearby wheat fields. The interior is decorated with paneling of rare woods, stone and metals. Administrative offices are housed in the tower, the legislature in a circular wing and the Supreme Court in the judicial wing.

Another attraction for visitors is the North Dakota State Museum with exhibits featuring Indian and white life on the plains. A part of the old fort has been preserved at Camp Hancock State Historic Site. Nearby is Double Ditch Indian Village, a state historic site preserving the ruins of one of the major Indian villages of the west, the historic Mandan community so prominent in Lewis and Clark annals.

River boat excursions are available for rides on the scenic and historic Missouri River.

The National Miss Indian America Pageant in early September and the United Tribes International Pow-Wow, one of the nation's largest of its kind, are also held each September.

BISON, South Dakota. Town (pop. 457), Perkins County, northeastern South Dakota, northeast of BELLE FOURCHE and west of M O B - RIDGE. In one of the many large South Dakota deposits of petrified wood, a petrified tree found near Bison was claimed to be the largest of its kind in the world.

BITTERROOT RANGE. Range of the ROCKY MOUNTAINS extending along the Montana-Idaho border. The Bitterroot Range, approximately three hundred miles long, is pierced by the Bitterroot Tunnel, a railroad tunnel nearly two miles long. The highest point in the range is Scott Peak at 11,393 feet.

BITTERROOT (LEWISIA REDIVIVA). The official state flower of Montana, bitterroot was found by LEWIS AND CLARK on their western expedition, and the genus was named in honor of Meriwether LEWIS (1774-1809). It is a member of the purslane family of herbs and small shrubs. The Flathead Indians used it as food, dried and eaten like a parsnip, or pounded into powder, or mixed with wild berries. Its name is given to a mountain range, river and valley of the region where it grows most commonly.

BITTERROOT RIVER. Stream beginning in southern Ravalli County in western Montana. It flows north and joins CLARK FORK near M I S - SOULA in central Missoula County.

BLACK BEAN LOTTERY. Inhumane sentence meted out to Texans commanded by Colonel W.S. Fisher, who were captured in a raid on Mier, Mexico, in 1842. The prisoners, who had escaped to Salado and were recaptured by the Mexican authorities there, were forced to draw from a jar filled with the same number of beans as the prisoners. Every tenth bean was black, and drawing a black bean led to execution.

BLACK BEAR. The state animal of New Mexico is not really a separate species. It is one of the many colorations of the so-called brown bear of North America, which can range in color from yellow to nearly black, as in the New Mexico symbol.

BLACK FOOTED FERRET Also called the North American ferret, the animal inhabited parts of the great plains and probably was never very numerous. Its principal food was the prairie dog. When prairie dogs became scarce, the food supply was cut back, and the black footed ferret disappeared and was considered to be extinct. However, in the mid 1980s sightings were made of the animal in South Dakota, and apparently a small number still survive. Efforts continue to study and protect them.

BLACK HILLS PASSION PLAY. One of Europe's oldest productions, the Passion Play became a permanent part of South Dakota when the Luenen Passion Play Company from Germany settled in the BLACK HILLS in 1939. In an amphitheater constructed near SPEARFISH, South Dakota, the last seven dramatic days in the life of Christ are portrayed every summer, complete with such pageantry as camel caravans and Arabian horses.

BLACK HILLS SPRUCE. The official state tree of South Dakota is a member of the pine family related to the Engelmann spruce. The Indians used spruce gum for calking their canoes. They sometimes separated the inner bark for food and wove strips of spruce into mats and blankets.

BLACKBIRD (chief). (—) Cruel leader of the Omaha Indians in eastern Nebraska, who poisoned many of his tribe who opposed him.

Artist George Catlin noted the lofty grave of Chief Blackbird on the heights far above the Missouri River.

He started the pirate custom, later copied by the SIOUX, of stopping travelers on the MISSOURI RIVER and demanding a fee before letting them proceed. He died when a smallpox epidemic swept the region.

BLACKFEET GLACIER. Largest glacier in GLACIER NATIONAL PARK, Montana. It covers approximately ten square miles.

BLACKFOOT INDIANS. Confederacy of three Algonquin tribes living primarily in Montana and the Canadian province of Alberta. The Blackfoot confederacy, also called the Siksika, included the Blackfoot proper, the Piegan and the Blood groups. The Blackfoot proper occupied territory from the northern branch of the Saskatchewan River south to the Battle River. The Piegan, or Pikuni, meaning "small robes" lived along the foothills of the ROCKY MOUNTAINS, south of the MARIAS RIVER. The Blood, who called themselves Kainah, or "many chiefs," were located between the Battle and Bow Rivers.

Each of the three tribes organized themselves into autonomous bands. The Piegan had twenty-three such bands, the Blood seven and the Blackfoot at least six. Bands, living separately except in spring for communal hunts of buffalo or to celebrate the Sun Dance, were each led by a headman who gained his position by hosting social events, showing bravery in battle and helping the poor. The headmen formed the tribal council and selected the tribal chief.

The Blackfoot social organization was complex. Men were divided by age into military societies called Ikuhnuhkahtsi, or "all comrades." Dance and religious associations, open to both men and women, had their own ceremonies. The Northern Blackfoot and Blood tribes had a women's society called the Malaki. Individuals, bands and societies had their own medicine bundles consisting of collections of sacred objects.

The dead were usually placed on a tree scaffold, and a favorite horse was killed to aid the deceased on his journey to the land of the dead. If a Blackfoot died in his tipi it was often used as a burial tipi.

The Blackfoot, nomadic hunters of buffalo, added to their diet by gathering onions, cherries, turnips, plums and berries. Bow and arrow hunting was the preferred style even after the introduction of firearms.

The introduction of the horse probably occurred between 1725 and 1750. Horses enabled the Blackfoot to travel from the northern branch of the Saskatchewan River south to the headwaters of the MISSOURI RIVER. While friendly with the Sarsi and GROS VENTRE Indians, the Blackfoot fought other tribes including the NEZ PERCE, CROW and CREE.

Smallpox epidemics in 1782, 1839, 1869 and 1870 and measles in 1864 severely reduced the numbers of Blackfoot. They ceded their lands in treaties with the United States and Canada between 1851 and 1878. A Blackfoot reservation was set aside in western Montana with three other reserves in Alberta, Canada.

In 1883, the last buffalo herd was destroyed causing six hundred Montana Blackfoot to starve the next year. Drought in the 1880s foiled attempts at raising crops. Stock raising in the 1890s was more successful. In the 1970s 120,-000 of the 950,000 acres included in the northwestern Montana reservation were tribally owned with the rest allotted to individuals.

BLACKFOOT RIVER. Idaho, with its source in the Blackfoot River Reservoir in Caribou County. Approximately one hundred miles long, the Blackfoot flows northwest and west into the SNAKE RIVER in central Bingham County.

BLAIR, Nebraska. City (pop. 6,418). Seat of Washington County, east-central Nebraska, northeast of Fremont and northwest of Omaha. It was named for railroad man John I. Blair. Blair is the home of Dana College, a Lutheran four-year institution. The Danish origin of the college is evident from the 250-acre campus which is landscaped with gas lamps imported from Copenhagen and a rose garden honoring Queen Margarethe II. The college is host on the first Sunday of December to a Danish Christmas festival including folk dancing, drama, and a Danish smorgasbord. Blair is also the headquarters for the Papio Soil Conservation District, the first cooperative soil-building agency in Nebraska. Nearby is the De Soto National Wildlife Refuge where the 1865 wreck of the steamboat *Bertrand* was discovered.

BLIZZARDS. Winter storm officially described as weather in which snowy conditions occur when winds are 35 miles per hour or higher and the temperature is 20 degrees or lower. South Dakota is often called the Blizzard State, but blizzards are common in all the north plains states and may occur as far south as Texas. HILAND, Wyoming, is described as "notorious for its blizzards," often reaching winds of 80 miles per hour, bringing zero visibility and

endangering the lives of all living things out-doors. Beginning in October, 1880, and extending through spring of 1881, the winter was the worst in history, with one of the blizzards in South Dakota the worst on record anywhere. All of the northern plains states were hard hit that year, with great loss of life and livestock. The blizzards of another terrible winter, 1886, struck most of the region, causing loss of half the cattle in several areas. The winters of 1905 and 1935 also brought some of the worst blizzards. Blizzards have created many heroes and heroines, including sixteen-year-old Hazel Miner of Center, North Dakota. She and her brother and sister were caught on the plains in a blizzard. They were found with the younger children huddling safe under her frozen body, still holding the blanket over them. The community of Center remembers the act of courage with a monument.

BLUE HOLES. Extinct geysers near DUBOIS, Wyoming.

BLUE SPRUCE. Official state tree of Colorado, is considered to be one of the most beautiful of the conifers. There was consternation when it was attacked by the avaricious spruce beetle between 1939 and 1952, when the epidemic was finally brought under control, and the state tree was saved.

BLUEBONNET. The official Texas state flower is a member of the lupine family. It blankets the Texas plains in springtime and is sometimes known as buffalo clover.

BLUEBUNCH WHEATGRASS. Montana has chosen this member of the vast grass family as its official state grass.

BLUESTEM GRASS. Sometimes referred to as gumbo grass, bluestem was a type of grass of blue-green color found on the Great Plains.

BLUMENSCHEIN, Ernest L. (Pittsburgh, PA, 1874—Unknown). Artist. Blumenschein was one of four artists who, in 1912, formed the Taos Society of Artists, the beginning of the artist colony in TAOS, New Mexico, which has left a distinctive impression on art in the United States. The Ernest L. Blumenschein home in Taos is now a center for the exhibition of paintings by other Taos artists.

BODMER, Karl. (Riesbach, Switzerland, Feb. 6, 1809—Barbizon, France, Oct. 30, 1893). Artist. Bodmer, a noted western specialist, accompanied Bavrian Archduke Maximilian on a tour of the United States (1832-1834) and made numerous sketches of towns, landscapes, equipment and Indians. In completed form the works provide a splendid record of the people and natural history of the area.

BOETTCHER CONCERT HALL. A unique part of the Denver Center for the Performing Arts. The hall-in-the-round is the home of the DENVER SYMPHONY ORCHESTRA. It is the only concert home of a metropolitan symphony in which the orchestra is completely surrounded by the audience. All of its 2,650 seats are within 85 feet of the stage. Movable disks suspended from the ceiling allow adjustments to be made to provide proper acoustics for each presentation. It opened on March 4, 1978.

"BOGUS LEGISLATURE." Illegal body claimed to have been elected on March 30, 1855, in Kansas by pro-slavery forces who brought in several thousand Missouri voters to win the election. The legislature adopted laws for Kansas that were based on similar laws in Missouri, including one which added the death penalty for anyone inciting slaves to rebel and a penitentiary sentence for anyone talking or writing against slavery. Anti-slavery forces stepped up their efforts to encourage anti-slavery settlers to move into Kansas and shipped arms and cannon to protect these newcomers. They refused to recognize the elected legislature and set up a government of their own, preparing the stage for the period of "Bloody Kansas."

BONNER SPRINGS, Kansas. City (pop. 6,266). In northeast Kansas, a suburb of KANSAS CITY, it was named for Robert Bonner, local editor and horseman. Its Wyandot County Museum has a notable collection of WYANDOTTE INDIAN relics and pioneer furniture, costumes and other items.

BOOT HILL. Cemetery outside of DODGE CITY, Kansas, named for the fate of a gunman killed on the site and buried so quickly his boots were left on. The Boot Hill Museum in Dodge City duplicates the historic cemetery. Horse-drawn stage tours of the grounds are available during the summer. The name has been applied to similar burying places in much of the region.

BOIS de SIOUX RIVER. Northeastern South Dakota river flowing north out of Lake Traverse to form the northern border of South Dakota

Boettcher Concert Hall in Denver was the nation's first symphony hall to be designed in-the-round. It is a major feature of the performing arts center.

with Minnesota as well as the southern part of the Minnesota-North Dakota border. It joins with the OTTER TAIL RIVER to form the RED RIVER OF THE NORTH.

BONANZA FARMS. Developed in eastern North Dakota, western Minnesota and the Red River Valley in the late 1870s, bonanza farms were large, very profitable wheat farms. Bonanza farm owners were primarily land speculators who considered farming a temporary operation, although some of the large holdings lasted for many years.

The Panic of 1873 forced the Northern Pacific Railroad into bankruptcy and parts of its fifty million-acre land grant could be purchased for between 37 cents and $1.65 an acre. George W. Cass, president of the Northern Pacific and Benjamin Cheney, one of the railroad's directors, purchased 13,440 acres near Casselton, North Dakota, paying between 40 and 60 cents an acre. Other large holdings included 75,000 acres purchased by the Grandin brothers, bankers from Pennsylvania, and the acquisition of 36,877 acres by Charlemagne Tower of Potsville, Pennsylvania.

Bonanza farms were encouraged in their development by three principal factors: cheap land, a new milling process which created a demand for hard spring wheat, and flat, treeless prairies which could easily be farmed with the new machines coming on the market.

Managers divided the large holdings into 5,000 acre plots under the supervision of superintendents, and these plots were further divided into subdivisions of 1,200-acres under foremen. Labor was supplied by transients who were hired for wages between $16 and $25 a month.

One bonanza farmer had one thousand men in the harvest fields operating two hundred self-binding reapers pulled by eight hundred horses.

Rising land taxes, and for others rising land values, encouraged the break-up of bonanza farms. This was done generally with substantial financial advantage to the owners. The Amenia and Sharon Land Company, incorporated in 1885 with $92,600 in capital, purchased 58,350 acres of land and liquidated its holdings in 1922 for nearly three million dollars.

BONNEVILLE, Benjamin Louis Eulalie de. (Paris, France, April 14, 1796—Fort Smith, AR, June 12, 1878). Army officer and explorer. The

subject of Washington Irving's *Adventures of Captain Bonneville* (1837), the famous explorer passed through Wyoming in 1832. He used his leave of absence from the army to explore the northwestern country until 1835. He traveled as far west as Idaho, following the PLATTE RIVER route. It has been said he received undue publicity, as the ground had been explored for twenty years, and he had neither the training or knowledge to make accurate scientific observations.

BONNEY, William (Billy the Kid). (New York, NY, Nov. 23, 1859—Ft. Sumner, NM, July 15, 1881). Outlaw. Bonney may have lived in COFFEYVILLE, Kansas, as a youngster. His family moved to New Mexico in 1868, and authorities agree he lived in Alma, New Mexico, in 1873, where his stepfather, William Antrim, was a part-owner of a blacksmith shop on the edge of town. At the age of sixteen, Bonney killed three peaceful Indians near Ft. Bowie, Arizona, for their furs. He participated in the famous "Lincoln County War" during the 1870s. This was a struggle for political power and control of the beef industry in New Mexico. Bonney was accused of killing Sheriff William Brady on April 1, 1878, but escaped arrest. On November 30, 1880, Bonney was trapped near Corona, New Mexico but succeeded in escaping after killing the deputized blacksmith who led the posse which cornered Bonney and his gang in a trading post. He was finally arrested in Mesilla, New Mexico, and charged with the murder of Brady. Tried and found guilty, Bonney was returned to Lincoln to await execution. Housed in a store which had been hastily converted into a courthouse, jail and sheriff's office, Bonney starved himself for several days until he could wriggle out of his handcuffs. On April 28, 1881, using a gun smuggled to him in jail, Bonney shot and killed two deputies in a daring escape. He was tracked to Fort Sumner, New Mexico, by Sheriff Pat Garrett. Garrett killed Bonney in an ambush and had the outlaw's body buried quickly in a cemetery which served the fort.

"BOOMERS" Term used to refer to a person who settled in present Oklahoma before the land was opened for white settlement. Also called "Sooners," these people entered Oklahoma's Cherokee Strip in 1889 before the legal run for land. Most were probably never caught. STILLWATER, Oklahoma, was founded by Boomers, and Oklahoma now pays ironic tribute to the illegal settlers by its nickname of the Sooner State.

BOQUILLAS CANYON. Extremely narrow pass created by a great opening in a mountain of rock carved by the RIO GRANDE RIVER. Average depth of the canyon wall is 1,600 feet. Its name is Spanish for "little mouths."

BORDEN, Gail, Jr.. (Norwich, NY, Nov. 9, 1801—Borden, TX, Jan. 11, 1874). Inventor, surveyor, newspaper publisher, and western pioneer. Borden is best known as the inventor of condensed food products. He came to Texas around 1829 and was active in promoting the independence of Texas from Mexico. Borden helped write the first state constitution just prior to Texas statehood in 1845, made the first topographical map of the territory and laid out the city of GALVESTON. He established *The Telegraph and Texas Register* in SAN FELIPE, Texas, in 1835, to further his advocacy of the Republic of Texas. Upon statehood the *Telegraph* became the first permanent state newspaper and was the first newspaper in HOUSTON. In the 1850s he returned to New York where he was the inventor and patenter of evaporated milk. He also adapted similar processes to coffee, tea, cocoa, and beef extract products. In addition, Borden patented a process for concentrating juices and fruits in 1862, and he founded the dairy company now bearing his name. Returning to Texas in 1861, he became a leading proponent of sanitary dairying processes. The town of Gail and the county and town of Borden in Texas are named in his honor.

BORDER, longest state. The longest boundary between any two states of the United States lies between Oklahoma and Texas. On the north it delineates the panhandles of both states, then sweeps in a straight line south to the RED RIVER and turns southeast to follow the river until it passes the Oklahoma border.

BORGLUM, John Gutzon de la Mothe. (St. Charles, ID, March 25, 1867—Chicago, IL, March 6, 1941). Sculptor. In the Central West region Borglum is best remembered as the creator of the gigantic Mount RUSHMORE sculpture of Presidents George Washington, Thomas Jefferson, Theodore Roosevelt, and Abraham Lincoln. Borglum was an inventor, engineer, and artist of international acclaim when he visited Custer State Park in September of 1924 to find a suitable site for a massive sculpture.

He chose Mount Rushmore in the Black Hills of South Dakota. The task was monumental. To remove unnecessary rock, Borglum used dynamite with such a delicate touch that he blasted within two inches of the finished surface. Five-foot models of each figure guided Borglum who multiplied each measurement from the model by twelve to guide his workers in removing stone. He designed a "bosun chair" to lower workmen over the edge of the mountain to work and labored tirelessly himself to raise money for the project. Borglum skillfully used the completion of portions of the figures for maximum public promotion. Borglum timed the finish of Washington's face for July 4, 1930. On the day of unveiling, a flag was pulled from in front of the face as an airplane roared overhead and guns were fired in salute. The unveiling of the Jefferson face was scheduled to coincide with a visit of President F.D. Roosevelt, and the dedication of the Lincoln face was scheduled on September 17, 1937, by Borglum to coincide with the 150th anniversary of the adoption of the United States Constitution. To raise the necessary funds Borglum even held a one-man strike, refusing to continue his part of the work until 1938, when an additional $300,-000 in federal aid was authorized. Borglum was hospitalized in Colorado for failing health due to overwork, but continued to plan for his Mount Rushmore Hall of Records which he envisioned as the most elaborate national archive in the world. He was in Chicago for a minor operation when he died of a heart attack.

BORGLUM, Lincoln. (1912—Beeville, TX, Jan., 1986). First National Park Service Superintendent of the MOUNT RUSHMORE NATIONAL MEMORIAL. Lincoln Borglum was the son of Gutzon BORGLUM and his second wife, Mary Montgomery. Lincoln began work on Mount Rushmore as a pointer and became a foreman and later superintendent of the construction. When his father died, Lincoln supervised the final steps in completing the four faces. He retired from the Park Service in 1944 and managed the family ranch in Hermosa, South Dakota, before starting up a ranch in Beeville, Texas, where he was active in civic affairs.

BOTTINEAU, North Dakota. Town (pop. 2,829). Seat of Bottineau County, north-central North Dakota, northeast of MINOT and northwest of Devils Lake. Founded in 1883, it was named for Pierre Bottineau, a frontier scout and guide for the Isaac Stevens northern railroad survey in 1853. A portion of North Dakota's few native forests grew on the Turtle Mountains near Bottineau. Today Bottineau is the home of a two-year State School of Forestry. Salyer National Wildlife Refuge is nearby, and Bottineau is the gateway to the INTERNATIONAL PEACE GARDEN, thirteen miles to the north. The International Music Camp is held there each summer.

BOULDER RINGS. Mysterious pattern of rocks laid in a circular form by people living in North Dakota nearly four hundred years ago. Once thought to be simply the stones used to hold the bottom edge of a tepi covering in place (tepi rings), the rings of stones were also found on steep slopes where tepees would not have been pitched. Boulder rings are found in many places in North Dakota.

BOULDER, Colorado. City (pop. 76,685), seat of Boulder County, situated northwest of DENVER, closer to the looming FRONT RANGE of the Rockies, it takes its name from Boulder Creek, named, in turn, for the great boulders of the area.

Unique in the world for city ownership of its own glacier from which it draws a part of its water supply, the city is also set apart by its unusual Greenbelt concept. This provides an extensive park system for recreation and helps to preserve the natural setting of the city.

The city was incorporated in 1871. Close to the many scenic centers of the Rockies the city soon became a major resort and health spa center, concentrated on its mineral springs. Boulder is now known as the scientific, technical and educational center of the state. It is home of the main campus of the University of COLORADO, the National Center for Atmospheric Research, the laboratory of the Bureau of Standards and headquarters of many private scientific and technical firms.

As with many university and scientific communities, it enjoys cultural advantages disproportionate to its size, such as its symphony orchestra, dance festivals and seasonal performances of Shakespeare.

The University campus offers many attractions for visitors, including Fiske Planetarium and Science Center, Henderson Museum, and Sommers-Bausch observatory.

Boulder Center for the Visual Arts features changing exhibits of sculpture, painting and other media. Visitors may take self-guided tours of both the Bureau of Standards and Atmospheric Research facilities.

Performances of puppets, mimes, acrobats

and strolling musicians enliven the Downtown Mall, noted for its fine dining and shops, with periodic sales of art and crafts. The annual Shakespeare Festival in mid July to late August, Colorado Music Festival, June-July, Kinetic Conveyance Challenge, first week in May, and Bolder Boulder, a citizens' footrace on Memorial Day, all contribute to visitor interest and attendance.

BOWIE KNIFE. Name given to a heavy type of knife which was probably developed by Rezin Bowie beginning about 1810, but which was made famous by his brother Jim BOWIE, who died at the ALAMO. The knife had a long single-edged blade that broadened along the spine toward the tip before tapering suddenly to a double-edged point. The blade's shape allowed the knife to be thrown accurately.

BOWIE, James. (Burke County, GA, 1796—San Antonio, TX, March 6, 1836). Adventurer and pioneer. In his youth a reputed slave trader who dealt with pirate Jean Laffite, he moved to Louisiana and bought a sugar plantation where he introduced steam power for grinding cane. A member of the state legislature, he allegedly killed a man in a duel. Having gone to Texas about 1828, he befriended Mexican Vice-Governor Juan Martin de Veramendi, whose daughter he married, and in 1830 he assumed Mexican citizenship. Bowie became interested in the Texas revolutionary movement and in 1835 was made a colonel in the Texas Army. Early in 1836 he joined Colonel William B. TRAVIS to defend the ALAMO, an abandoned mission in SAN ANTONIO, where the American defenders had gathered for the protection of the mission's thick walls. There in the one-sided battle of February 23, 1836, he was killed by the forces of SANTA ANNA. He popularized the Bowie knife, a large single-edged steel hunting knife thought to have been designed by his brother Rezin.

BOWMAN, North Dakota. Town (pop. 2,-071). Seat of Bowman County, southwestern North Dakota, southwest of DICKINSON and south of WILLISTON. Settlement began in the early 1880s, and it was named for a North Dakota assemblyman. Nearly half of the United States' supply of VAN DYKE BROWN, a coloring material which uses lignite, is processed in Bowman.

BOY SCOUTS. The first Boy Scout troop in America was organized in PAWHUSKA, Okla-

homa, in May, 1909, by the Reverend John Mitchell.

BOY'S TOWN, Nebraska. Also known as Father Flanagan's Home for homeless boys, Boy's Town was established by the Right Reverend Monsignor Edward J. FLANAGAN in 1917. The home, which began in an old house in Omaha, Nebraska, soon outgrew its facility and was moved to the German Civic Center in Omaha. Fund-raising by Father Flanagan led to the purchase of the present land, where wooden shelters were built on the site then known as Overlook Farm. The home was incorporated as a village in August, 1936. The name of the institution spread with the popular 1938 motion picture *Boys Town* starring Mickey Rooney and Spencer Tracy. Today most of the buildings on the 320-acre facility near Omaha are made are of sturdy red brick construction. Over 10,000 boys may be counted as "alumni." Both boys and girls are now welcomed.

BOYD, David Ross. (Coshocton, OH, July 31, 1853—Glendale, CA, November 17, 1936). Educator. Boyd, president of the University of OKLAHOMA from 1892 to 1908, was a tree enthusiast responsible for planting thousands of saplings of all varieties around NORMAN, Oklahoma. Boyd headed educational work for the Presbyterian Board of Missions among Alaskans, Indians, Southern mountaineers and Puerto Ricans from 1908 to 1912 when he became the president of the University of NEW MEXICO, a position he held from 1912 to 1918.

BOZEMAN PASS. Mountain pass at an elevation of 6,000 feet near BOZEMAN, Montana. Tunnels for the last section of the first transcontinental railroad had to be bored under it.

BOZEMAN TRAIL. Pioneer route which stretched from Julesburg, Colorado, on the SOUTH PLATTE RIVER to the southwestern Montana mining town of VIRGINIA CITY. Previous approaches to the mining centers of Montana were long and circuitous. John M. BOZEMAN determined to find a better route. The trail he blazed, starting in late in 1862, went eastward from BANNACK, Montana, crossed the CONTINENTAL DIVIDE at what is now known as BOZEMAN PASS then turned south through the eastern foothills of the BIGHORN MOUNTAINS until it reached the NORTH PLATTE RIVER and LARAMIE, Wyoming, and then went on into Colorado. The route crossed sacred lands consisting of some of the best hunting grounds of the Indians, solemnly

promised to them by treaty. Opening of the trail created such hostility among the tribes toward those using the route that the trail was abandoned after 1868, with the closing of FORT BENTON. In 1877 the trail was reopened as an important route for cattle drives.

BOZEMAN, John M. (GA, 1835—Yellowstone River, MT, Apr. 20, 1867). Pioneer. Bozeman traveled to the CRIPPLE CREEK, Colorado, gold fields in 1861 and then moved on to VIRGINIA CITY, Montana, in 1862. He opened a trail across the ROCKY MOUNTAINS from Virginia City in the period between late 1862 and 1865. Bozeman also founded the town named in his honor in southwestern Montana. Alarmed at the loss of their treaty rights, Indians attacked travelers on the BOZEMAN TRAIL. Bozeman refused to accept this situation and set out from Virginia City on his trail. He reached the YELLOWSTONE RIVER, where he was killed by the BLACKFOOT Indians. The Bozeman Trail was closed in 1868 and was not reopened until 1877.

BOZEMAN, Montana. City (pop. 21,645), seat of Gallatin County, southwestern Montana, southeast of Butte and northeast of Dillon, settled in 1864 and founded by John M. BOZEMAN who led a train of immigrants there. The city is located in Gallatin Valley, once considered sacred to the Indians. Today the land has become the state's most agriculturally productive. Bozeman's location in the 1800s made it a natural supply point for emigrants headed west. Today Bozeman stands at the gateway to YELLOWSTONE NATIONAL PARK and the hiking, camping, and sports opportunities in the neighboring mountains. Bozeman is the home of MONTANA STATE UNIVERSITY, especially noted for its outdoor museum featuring pools stocked with many varieties of rainbow trout. Celebrations in Bozeman include the College National Finals Rodeo held annually in June and sponsored by the university. There is a Montana Winter Fair and a four-day celebration of the arts on the first full weekend in August.

BRADFORD BRINTON MEMORIAL RANCH. Re-creation of a western ranch and its ranching activities, southwest of Sheridan, Wyoming. The ranch features a spectacular collection of sculpture, etchings and paintings by such renowned artists as Frederic REMINGTON and Charles M. RUSSELL and a large display of Indian crafts, documents and rare books pertaining to the history of the ranch.

BRAHMA CATTLE. Descendants of the Asian-Indian stock introduced into South Carolina in 1849. Shortly thereafter, some brahma were brought to Texas to be raised "in breed." There it was found that they were better able to survive Texas fever than some breeds. However, the brahma did not have the hardiness of the LONGHORN CATTLE, ao experiments were begun at the great KING RANCH in 1874. Texas longhorns were not as meaty as the brahma, but they had the other characteristics that were highly valued. Crossing of the two breeds at the ranch resulted in the successful Brahma cattle of today.

BRAHMALO. Experimental animal created in South Dakota by crossing buffalo with brahma cattle. Other experiments have crossed cattle with buffalo creating what is known as cattalo.

BRANDING. Method of identification used on individual ranges with a single brand or on round-ups or before a trail drive where several brands were involved. There were two branding methods. In one, the animals were run through a branding chute. Each "critter" was stopped by bars pushed through the narrow wooden passage of the chute so that each could be branded without being roped. Branding calves was faster by roping, the second method. Before branding was done, representatives of the different ranches would settle any disputes as to which ranch the calf belonged. In most cases this could be determined by placing the same brand on the calf as that of its mother. Branding roping crews consisted of a roper, a bulldogger, a brander, a flanker, and a tallyman. The roper caught the animal. The bulldogger threw the animal on its side and either held it or tied its legs. The bulldogger was often assisted in holding the animal by a flanker. At this time the animal's ears were marked with a knife. If flesh was removed the skin was kept in the marker's pocket or given to the tallyman. Male calves were castrated. One man was usually given the task of actually choosing the correct brand from the fire and branding the animal. In later years another man was assigned the task of disinfecting the castrated calves.

BRANDO, Marlon. (Omaha, NE, Apr. 3, 1924—). Actor. Brando gained star-status as an actor for his role in *A Street Car Named Desire* (1947). He received the Academy Award for Best Actor in 1954 for his role in *On the*

Branding cattle is still a chore on the vast ranges of the Central West.

Waterfront and again in 1972 for playing the Mafia chief in *The Godfather*.

BRANDON MOUNDS. Prehistoric mounds located near SIOUX FALLS, South Dakota.

BRANDS, CATTLE. One method of marking an animal for identification. Brands were often burned on the animal's left hip, but might also be placed on the leg, ribs, jaw or neck. Horse brands, possibly for cosmetic reasons, were much smaller. The position of the brand on the animal was entered in the county brand book. The position of the brand was often as important as the brand itself, especially if two different ranchers had a similar brand. Branding was not a completely effective deterrent from rustling. A brand blotter, a man adept at blotting out brands with further burning, could render the identification of an animal almost impossible. Brand artists could alter brands with nothing more than the cook's hot pothook. Brands included several universally recognized symbols such as circle, box and diamond. There were also partial symbols—halves and quarters of circles or diamonds. Reading a brand followed a pattern of moving from top to bottom, outside to inside, or left to right. The letter "J" inside a circle was read "Circle J." Brands did more than identify animals. The name of a brand was often used to indicate the range on which particular cattle grazed. Brand names were also given to the drovers who guarded the cattle and occasionally even to entire towns.

BRAZITO, BATTLE OF. The only battle of the MEXICAN WAR to be fought on the soil of New Mexico. In the battle, Christmas Day, 1846, Colonel Alexander DONIPHAN (1808-1887) defeated Mexican troops and then hurried south to help Americans at Chihuahua, Mexico. While Doniphan was gone, some residents of New Mexico staged a rebellion in which the governor, Charles BENT, was killed.

BRAZOS RIVER. Originating in LLANO ESTA-CADO in eastern New Mexico and northwest Texas. It flows more than 870 miles generally southeast to enter the Gulf of Mexico at FREEPORT, Texas. One of the state's major waterways, it is important because of its many

irrigation, flood control and hydroelectric projects. The main river is formed by the Double Mountain Ford, where it meets the Salt Ford. Rich soil surrounding the river was crucial for the development of the large plantations during Texas settlement time. The Brazos is accessible to ships from the Gulf for about 40 miles upstream. Possum Kingdom Lake is formed by the damming of the river.

BRECKENRIDGE, Colorado. Town (pop. 818), Summit County, central Colorado, southwest of DENVER and northeast of LEADVILLE, settled 1859. Breckenridge was once the center of a group of gold mining camps which together sported a population of 8,000. Alex Sutherland, a local hotel operator, was noted for having sounded the charge for the ill-fated Light Brigade at Balaklava in the Crimean War in Russia. Today Breckenridge is one of the many small communities where the local population is multiplied many times in the tourist season. This popular Rocky Mountain ski resort community offers a noted music institute in July and August. Its winter activities include a very popular seven-day Winter Carnival, honoring the Norwegian god of the snow. The ice sculptures at the Carnival are particularly notable. The annual No Man's Land Day Celebration recalls the period in 1936 when a local woman's club asked the state to allow Breckenridge to act as a free and independent kingdom for three days annually as, they contended, the Breckenridge area had not officially been made a part of Colorado. Several nearby ghost towns are particular tourist attractions.

BRIDGER, James. (Richmond, VA, Mar. 17, 1804—Washington, MO, June 17, 1881). Fur trader and guide. In the first half of the 19th century, Bridger was considered to have had the greatest knowledge of any white man concerning the central west region. Bridger joined a fur company in 1822 and became a mountain man. In 1824 he was the first white man known to have visited the Great Salt Lake, which was then assumed to be an arm of the Pacific Ocean. With his partner in 1843 he constructed FORT BRIDGER, one of the West's most famous posts, on the Oregon Trail, in the beautiful valley of Black's Fork of the GREEN RIVER, Wyoming. He rediscovered SOUTH PASS and was one of the first to visit the site of the future YELLOWSTONE NATIONAL PARK. He served as a guide for the United States government from 1857 to 1868, for Albert Sidney Johnston's troops in the Utah

Campaign in 1857-1858, and for the POWDER RIVER expeditions in 1865-1866. Bridger became the first person to estimate the mileage of the BOZEMAN TRAIL from VIRGINIA CITY, Montana, to FORT LARAMIE, Wyoming. He settled down as a farmer near Kansas City, Missouri, in 1868.

BRIDGER, Montana. Town (pop. 724), Carbon County, south-central Montana, southwest of BILLINGS and southeast of BOZEMAN. Named for famous frontiersman Jim BRIDGER, the area is noted for its cattle and sheep. Its economic dependence on coal mining slowed its growth until the discovery of oil and gas at nearby Elk Basin and Dry Creek.

BRINKLEY, John R. (Jackson County, NC, July 8, 1885—May 26, 1942). Milford, Kansas, doctor. Brinkley advertised that he had perfected a method of restoring youth in humans with transplanted goat glands. Before his license to practice medicine was revoked, Brinkley had founded a modern hospital attracting people from around the world and providing him with an annual income, in 1917, of half a million dollars. Decried as a fraud, with his medical practice ruined, in 1930 Brinkley decided to run for governor of Kansas. As a write-in candidate, Brinkley used his radio station, one of the earliest in Kansas, to great advantage. The election return, in which it is said not all the write-in ballots were counted, left Brinkley 33,893 behind the winner. He ran again in 1932 and 1934, losing both times. Brinkley moved to DEL RIO, Texas, and established a radio station in Mexico, but never regained his former prominence.

BRIQUETTES, lignite. Popular fuel material produced from LIGNITE, found abundantly in North Dakota. Because lignite tends to crumble due to its high water content, it could not be widely distributed as a fuel. The process for converting lignite to briquettes, which are tightly compressed and are easy to handle and burn like charcoal, was perfected at the School of Mines of the University of NORTH DAKOTA. This provides an attractive and inexpensive fuel which can be made widely available.

BROADMOOR HOTEL. Luxurious resort hotel and sports center of international renown. Located in the unincorporated COLORADO SPRINGS suburb of Broadmoor, the original hotel was constructed in 1918 by wealthy developer, Spencer PENROSE. New buildings and dining facilities have been added, and recreational

When Spencer Penrose founded the Broadmoor Hotel, it was one of the first such luxury resorts anywhere. The facilities have continued to be expanded to keep it in the forefront of the accommodations and attractions that enhance the vast resources of the Colorado Springs area.

activities including skiing and golf have been promoted by hosting many tournaments. A fascinating collection of Chinese art gathered by the Penroses is exhibited in the Lake Terrace Lounge of the Main Building. The Broadmoor Golf Club was Colorado's first 36-hole club. Colorful flamingos provide the hotel's trademark.

BROKEN BOW, Nebraska. Town (pop. 3,-979). Seat of Custer County, central Nebraska northwest of KEARNEY and northeast of NORTH PLATTE, founded 1882. Broken Bow claims to have the only two-story sod house still standing in the United States. The town's name came from Wilson Hewitt who found a broken Indian bow there. The mineral waters of Victoria Springs State Recreation Area, nearby, are popular.

BROOKINGS, South Dakota. City (pop. 14,-951). Seat of Brookings County, east-central South Dakota, south of WATERTOWN and north of SIOUX FALLS. Founded in 1879, it was named for prominent pioneer Judge Wilmot W. Brookings, who stayed to live in the area despite losing both of his legs to frostbite during his first winter in South Dakota. SOUTH DAKOTA STATE UNIVERSITY was started at Brookings in 1883 and has pioneered in many fields of agriculture, including the renowned efforts of Professor James WILSON who developed a much desired breed of tailless sheep. The research of the university has been instrumental in the city's reputation as hub of the state's agriculture. Manufactures developed at the university include devices for seed cleaning, planting and counting. The city of Brookings owns and operates hospitals, as well as telephone, power

and water facilities. South Dakota Memorial Art Center is noted for its fine collection of paintings by famous South Dakota artist Harvey DUNN, who specialized in war scenes. One of South Dakota's outstanding structures is the 165-foot high Coughlin Campanile and chimes, a gift to the college by Charles L. Coughlin. The Agricultural Heritage Museum at the university depicts the development of the state's farm production. The Little International Livestock Show, Jackrabbit Stampede Rodeo and Hobo Day are annual events.

BROOMCORN. One variety of sorghum grown for the branches of the seed cluster. These branches are the source of straw for making brooms. The crop is planted and grown like corn in many locations on the Great Plains where the largest market in the world has existed at Wichita, Kansas.

BROWN PALACE HOTEL. DENVER, Colorado, landmark, pioneer of the modern atrium hotel with its nine-story tall lobby. This "queen of hotels" was opened on August 1, 1892, by the principal builder, Henry Brown, who spent $1,600,000 on its construction with an additional $400,000 for furnishings. Red sandstone was used in the building with onyx from Mexico in the panelling. Financial difficulties resulted in the hotel's sale in 1931 to Charles Boettcher and his son Claude. A new era for the grand hotel began in 1959 when Brown Palace Tower, a twenty-two story structure was built across the street and connected to the original building. The Brown Palace acquires publicity each year, as a supporter of National Western Stock Show, by purchasing prize steers which are often exhibited in the lobby.

BROWN v BOARD OF EDUCATION OF TOPEKA. Originating in the TOPEKA, Kansas, schools, this case was heard by the U.S. Supreme Court in 1954. The court decided that deliberate racial segregation in public schools was unconstitutional. This decision overturned the 1896 ruling of Plessy v Ferguson which upheld the constitutionality of separate but equal facilities for whites and blacks. The Court held that de jure (by law) segregation violated the Fourteenth Amendment to the Constitution which gives all citizens the right to equal protection under the law. This far-reaching decision resulted in the almost complete restructuring of some school systems and in sweeping changes for most others, changes which in many cases are still continuing.

BROWN, John. (Torrington, CT, May 9, 1800—Charles Town, VA, Dec. 2, 1859). Abolitionist. Perhaps the most notorious of all the Abolitionists, Brown moved to OSAWATOMIE, Kansas, in 1855 and became a principal figure in the anti-slavery activities in the region. As a conductor on the Underground Railroad, he brought many former slaves from Kansas through Nebraska on to freedom. John Brown's cave, his station on the escape route for blacks, is located in NEBRASKA CITY, Nebraska. Brown approved of violence and participated in armed attacks on pro-slavery citizens or on those even suspected of such feelings. Frederick Brown, Brown's son, was killed by pro-slavery raiders in August, 1856. Brown's activities were so associated with Osawatomie that he became known as "Old Brown of Osawatomie." Leaving the region to promote his anti-slavery cause in the east, he was captured during his siege of Harpers Ferry, West Virginia, and executed for treason. John Brown Memorial Park in Osawatomie contains a cabin he used and a statue in memory of the man who claimed he was an instrument of God.

BROWN, Mrs. James J. (Molly) (Hannibal, MO, July 18, 1867—New York, NY, 1937). Socialite. Mrs. James J. Brown, whose husband made his fortune in LEADVILLE, Colorado, became prominent in Eastern society and was rescued when the elegant oceanliner *Titanic* sank. Molly Brown was one of the "fabled" women of the region. Her story was made into the Broadway hit *The Unsinkable Molly Brown*, and later into a motion picture. She has been widely memorialized in her home town of Denver, where the Molly Brown House Museum, built in 1889 and restored to its Victorian splendor, is open to visitors.

BROWNSVILLE, Texas. City (pop. 84,997) seat of Cameron County, in south Texas, on the RIO GRANDE RIVER opposite Matamoros, Mexico. The semi-tropical nature of the area is indicated by palm, citrus and papaya trees, yet the breezes from the Gulf of Mexico provide the southernmost city in Texas with delightful climate for vacationers. General Zachary Taylor placed a United States flag on the site, then part of Matamoros, and constructed a fort in 1846. His arrival was considered one of the key elements in the commencement of the MEXICAN WAR, which started May 13, 1846. Incorporated in 1850, Brownsville served as the outlet for Confederate cotton during the CIVIL WAR. The standard-gauge railroad was introduced here in

1904. The "Brownsville Affair" in 1906 led to the discharge of 167 black United States Army soldiers charged with being implicated in the fatal shooting of a white resident. That conviction was reversed in 1972. A 17-mile deepwater international seaport was opened in 1936, making the city the southwest terminus of the Gulf Intercoastal Waterway. Industries include food processing, petroleum products, aircraft repair, and agriculture (citrus fruit, grain, cotton, and livestock). The area produces Texas' famed red grapefruit, oranges and other citrus, sorghum and winter vegetables. Shrimp fishing is an important industry, and tourists are attracted to the deep-sea fishing. Across the border, the Mexican town of Matamoros offers a colorful contrast to the American side. Brownsville celebrates its Mexican connections with the annual Charro Days.

BROWNWOOD, Texas. Town (pop. 19,203), seat of Brown County located on Pecan Bayou River, central Texas, incorporated in 1876, named for Henry S. Brown, Brownwood was once the largest cotton-buying center west of FORT WORTH. Its present diverse manufactures include industrial and transportation equipment. It lies at the heart of some of the nation's richest and most varied farming country, with grain crops, cattle, goats, sheep, poultry and pecans among its products. Howard Payne College and a branch of Southern Methodist University are located there. Douglas MacArthur Academy of Freedom is located at Payne College. The annual Rattlesnake Roundup attracts widespread attention.

BRULE INDANS. Second largest subdivision of the Teton Dacotah (SIOUX). In the mid-19th century, there were an estimated 3,000 Brule living near the headwaters of the NIOBRARA and WHITE rivers in South Dakota and Nebraska. Subdivisions of the Upper Brule and Lower Brule were again divided into about thirteen bands. In the 1970s 8,000 Brule descendants lived primarily on or near the Rosebud and Lower Brule reservations in South Dakota.

BRYAN, Texas. City (pop. 44,337), seat of Brazos County, east-central Texas, northeast of AUSTIN. The city was founded in 1865 by William Joseph Bryan, who inherited the land for the townsite from his uncle, Stephen F. AUSTIN. It was incorporated in 1872. Cotton dairy, and poultry are the chief agricultural produce. The growing United States space research, data processing and nuclear science

centers also strengthen the local economy, which has expanded in general industry. Allen Military Academy is located there, and the Texas Agriculture and Mechanical University is at nearby COLLEGE STATION. The Texas International Speedway schedules a number of widely popular events for a variety of motor vehicles. Brazos de Dios (Arms of God) celebration is an annual western fiesta.

BRYAN, William Jennings. (Salem, IL, Mar. 18, 1860—Miami, FL, July 26, 1925). Politician, statesman. While not native to Nebraska Bryan was generally associated with the state after moving to LINCOLN in 1887 and beginning a law practice there. He was elected as Nebraska's first Democratic congressman in 1890. Defeated when he ran for the United States Senate, Bryan became the editor of the distinguished Omaha, Nebraska, *World-Herald* in 1894. He was a delegate to the Democratic National Convention in 1896 and authored the "silver plank" in its platform, which promoted the free coinage of silver. He was chosen as the party's presidential nominee against William McKinley, but he was unsuccessful. Later he raised the Third Regiment of Nebraska Voluntary Infantry for the SPANISH-AMERICAN WAR and served as its colonel. Defeated by Theodore ROOSEVELT in 1900 in another bid for the presidency, Bryan founded the weekly paper *The Commoner* in which he carried on his fight against the wealthy and powerful, who he felt controlled American politics. Although defeated by William Howard Taft in 1908, Bryan was still powerful enough in Democratic political circles in 1912 to help secure the nomination of Woodrow Wilson. Bryan served as President Wilson's secretary of state until 1915. Bryan's last major public appearance was as the principal attorney for the prosecution at the trial of John T. Scopes, the teacher arrested for teaching evolution. Bryan won the case against famed defense attorney Clarence Darrow. He died a few days later. The Lincoln, Nebraska home of Bryan is now open to the public and is registered as a National Historic Landmark.

BUCHANAN, Lake. Artificial body located between Llano and Brunet Counties, on the COLORADO RIVER. Its dam is one of the longest in the world, stretching for about two miles, and it covers 62 square miles.

BUCKSKIN JOE, Colorado. Recreated 1850s mining town located eight miles west of CANON

CITY, Colorado. The popular movie *Cat Ballou* was filmed here. This 1859 mining camp was named for Joseph Higginbottom, "Buckskin Joe," who first discovered gold in Park County. For a time Buckskin Joe was the county seat. Early prosperity came from the Phillips Lode which was said to have been discovered when a hunter shot at a deer and found that his bullet had uncovered gold-bearing quartz. So much gold was found that it was stored in pots and pans in the miners' shacks. H.A.W. TABOR built a store here in the early 1860s and bought up a number of claims, all of which proved worthless.

BUFFALO. Dominant animal of the early American West and principal source of food, clothing and shelter of the Plains Indians. The buffalo had two sub-species, the plains buffalo and the woods buffalo. Also known as the mountain buffalo, the woods buffalo wintered in the Rocky Mountains and were bigger and darker than the plains variety. Bulls weighed as much as 2,500 pounds and cows up to 1,600.

Buffalo were first reported about 1530 by Nunez Cabeza DE VACA. At that time the animals probably ranged between Canada, the eastern Rocky Mountains and the Rio Grande eastward into western Maryland and as far south as Louisiana. The appearance of the buffalo as a large, clumsy animal hides the fact that bulls race along at 35 to 40 miles per hour over a quarter of a mile and can outrun their enemies over long distances.

The buffalo provided the Plains Indians with hides for tents and clothing, meat, horns for spoons and utensils, and hair for ropes and belts. Rituals and charms were devised to ensure the appearance of buffalo each hunting season.

Before they had horses, the Indians drove buffalo herds into corrals or stampeded them over cliffs to be killed. The carcass was skinned, and the meat was cut up. Horses gave the Plains Indians far greater mastery of buffalo hunting. Riding at full gallop, they could maneuver the ungainly beasts almost on command. Such mastery made the practice of stampeding the animals over a cliff much more effective. They also could pursue the buffalo across the plains and kill them with arrows or guns while riding at a full gallop. Strict discipline during these hunts was enforced by special Indian police. Official hunts were conducted during June, July and August.

When white hunters appeared in the West there were three main buffalo herds: the south-

ern, the Republican (or central) and the northern. Originally, hunting was done from horseback. Later hide-hunters worked in teams to dig deep holes to hide the hunter until daybreak when the lead animal was killed. Deprived of leadership, the other buffalo generally remained quietly in the area unless they sensed the presence of the hunter. Hundreds of animals could be killed at a time. Neither the sound of the gun nor the bodies of the other buffalo frightened these dull creatures. By the 1880s hide-hunters had nearly eliminated the vast herds. Bone hunters collected the bones for phosphorous fertilizer. Between 1872 and 1874 nearly four and one-half million buffalo were killed, often with only the hide being taken and the meat left to rot. An estimated thirty-two and one-half million pounds of bones was shipped east during the same period.

Slaughter of the buffalo, the Indians' principal source of food, was promoted by some soldiers and settlers as the only way to end the reign of the Indian on the prairie.

True buffalo are African animals of the same family. The American bison has larger mane and beard than the European cousin. Full-grown males may reach 2,500 pounds in weight. Their thick winter hair is shed for the summer. Feeding on the rich prairie grasses, the buffalo generally moved south for the winter. However, before the coming of Europeans, they roamed over almost all of present United States, although principally on the central prairies. In the year 1800, according to estimates, there were 60,000,000 buffalo in the present U.S. limits. By 1900 there were only two wild herds left. Careful conservation and cultivation have brought back substantial numbers. Today, an estimated 30,000 buffalo are raised in the United States in protected areas such as Yellowstone Park. Private herds are widely kept for slaughter.

BUFFALO (state animal). Kansas calls its state animal BUFFALO, while Oklahoma more precisely calls it bison. However, they refer to the same majestic animal, which once roamed the American plains in such enormous numbers.

BUFFALO BILL'S WILD WEST SHOWS. William F. "Buffalo Bill" CODY first took to the stage in 1872. From that time, with a brief exception in 1876 when he returned to the frontier to fight Indians, Cody devoted his life to show business. He developed his first show soon after completing his performance in the

Buffalo Bill Cody was one of the first entertainers to gain an international reputation, and the fame of his Wild West Show was spread by clever advertising such as this dynamic poster.

Scouts of the Plains at the St. Louis Opera House and taking as his manager John M. Burke. Cody's first show, in partnership with Dr. William Frank Carver, opened in OMAHA, Nebraska, in 1883. The program, an outdoor spectacle, included an old Deadwood stagecoach, a small herd of buffalo, bucking bronchos, horse races, and fancy shooting. Cody and Carver separated after the first year, and Cody's Wild West show played the Cotton Exposition in New Orleans during the winter of 1884-1885 where it acquired the talents of Annie Oakley, known as "Little Sure Shot." SITTING BULL joined the show in 1885 when the show toured Canada. In 1887 Cody took the show to Europe for Queen Victoria's Golden Jubilee. A huge success, Cody once drove a stage carrying four kings and the Prince of Wales. Business fell by 1903 and Cody, deeply in debt, had to be financially rescued by Pawnee Bill, a character Cody had once employed. A new show, the Buffalo Bill Wild West and Pawnee Bill Far East Show, kept Cody from bankruptcy until 1913 when the show had to be sold to pay off debts.

BUFFALO, Wyoming. Town (pop. 3,799), seat of Johnson County, north-central Wyoming, southeast of SHERIDAN and west of GIL-LETTE. Buffalo was founded in 1879 by a wave of miners, NESTERS, ranchers and freighters who craved the recently opened SIOUX lands. The town soon became known as the "Rustlers' Capital." Tensions between sheepherders and cattlemen led in 1892 to the JOHNSON COUNTY CATTLE WAR, which pitted the unlikely combination of nesters and rustlers against the cattlemen. Troops of the U.S. Army were required to restore order. The town is situated near sites of several major battles of the Indian wars including the FETTERMAN MASSACRE on December 21, 1866, and the Wagon Box Fight on August 2, 1867. A major attraction in town is the Jim Gatchell Memorial Museum. Gatchell spent years among the Sioux and BLACKFOOT Indians and collected a wide variety of Indian relics and pioneer items.

BULL LAKE. Wyoming, near Crowheart, known to the Indians as The Lake That Roars. According the Indian legend, a rare white

buffalo was driven into the lake by Indian hunters who wanted his unique fur. He drowned there, and has been moaning ever since. Modern observations have traced the source of the roar to wind that raises the ice on the lake and then lets it drop, causing a moaning sound.

BULLBOATS. Round boats made from buffalo hide stretched over a frame of light wood. They were difficult to handle because of their shape. They were used primarily by the HIDASTA and MANDAN Indians. Bullboats were also useful during rainy weather when they were placed over the smoke holes in the tribes' earthen lodges.

BURKBURNETT, Texas. Town (pop. 10,-668) Wichita County, in north central Texas. Settled in 1907, it was named for Captain Burk Burnett, a cowhand, who won his boss's ranch in a card game. Burkburnett became a boom-town in 1918 when a 3,000-barrel oil gusher came in, on Burnett's property, causing the so-called "Burk Boom." Burnett became one of the richest men in the area. Today the community's industrial plants produce chemicals, plastics, and rodeo equipment.

BURNET, David Gouverneur. (Newark, NJ, Apr. 4, 1788— Galveston, TX, Dec. 5, 1870). Politician. The grandson of William Burnet, governor of New York, and New Jersey (1720-1728), he went to Texas about 1817, where his legal training established him as a spokesman for American settlers during the problems with the Mexican government. He promoted independence from Mexico, drew up a declaration of independence, and was made interim president of the Republic and served eight months in 1836.

BURNET, Texas. Town (pop. 3,410), seat of Burnet County, 45 miles northwest of AUSTIN, founded in 1849 and named for Texas states-man David G. BURNET. Burnet is often called "Versatile County," because of its wealth of natural resources and potential productivity. Burnet's economy is today dependent on stone quarrying, graphite products, farming, ranching, and tourism. It features the annual Blue-bonnet Festival.

BURROS. Referred to ironically as the Rocky Mountain canary because of their hoarse bray, burros were irreplacable helpers of early miners in the West. Wild burros, remnants of those released by desert prospectors, have increased to herds totalling an estimated eight thousand animals in the Southwest. Highly controversial, wild burros are blamed for consuming the food supplies of other wildlife and for being vicious killers of young livestock. Scientific studies of the validity of these claims are still going on. Attempts to kill burros have resulted in protective legislation being passed in conjuction with efforts to protect wild horses. Public Law 92-195, passed in December, 1971, now protects wild burros.

BURROWING OWL. Unique bird widely found through most of the Central West region. It is distinguished by its habit of making homes in the deserted burrows of badgers, gophers, foxes and other underground animals.

BUTTE, Montana. City (pop. 37,205). Seat of Jefferson County, southwestern Montana on the SILVER BOW CREEK, southeast of ANACONDA and northwest of BOZEMAN, named for Big Butte, a volcanic cone to the northwest. The Butte area has been called "The Richest Hill on Earth." In 1864 the first settlers in Butte found a shallow prospect hole dug with a sharpened elk horn. It was assumed this was the work of Indians, and the site became the original mine. Butte's fortunes began in 1864 when William Allison and G.O. Humphrey found placer gold at Silver Bow Creek. In 1875 a rich silver strike at William Farlin's Travonia Mine made Butte the "silver city." Silver remained the mainstay of the Butte economy into the 1880s when mines began running into a reddish metal—copper.

The electrical industry kindled an explosion in the demand for copper, met in Butte around 1884 by 300 operating mines working twenty-four hours a day, seven days a week. In three years the population of Butte rose from 4,000 in 1884 to 22,000, including the entrepreneurs known as the "copper kings."

One of these barons was Marcus DALY who came to Butte in 1876 to purchase the Alice silver mine and later bought the Anaconda claim and others and became the father of the copper industry in the Butte area. Another wealthy character was F. Augustus HEINZE who used litigation and occasionally violence to achieve his goals of bettering the other industry leaders in the area.

The rivalry of the leaders as they fought to control the industry during the late 1870s and 1880s resulted in what has come to be called the "war of the copper kings". Eventually no

individual could claim to be a "king." By 1900 virtual control was won by the Amalgamated Copper Company owned by Standard Oil interests. During this period of strife the workers were union members. In 1914, in a rare moment of dissatisfaction with a large increase in union dues the workers in Butte blew up the union hall.

Despite the enormous quanties of minerals already extracted, the supply still seems inexhaustible. By the mid-twentieth century over 250 underground mines were operating at Butte. Open-pit excavations began at the Berkeley mine in 1955. Open-pit mines were started to meet foreign competition, copper substitutes, high labor costs, and lower prices for the ore. The famous Berkeley pit of the Anaconda Company is the largest truck-operated pit mine in the United States. Twenty-five miles of roads lie within the excavation which has remained closed since the deteriorating metals market of 1982. The decline has caused a worsening of the local economy, with a drop in Butte's population approaching 25 percent.

The deepest mine is the Mountain Con, originally called the Mountain Consolidated, with a mine shaft 5,291 feet deep. A century of mining in Butte, has yielded an estimated $22 billion in valuable ores.

Butte is the home of MONTANA COLLEGE OF MINERAL SCIENCE AND TECHNOLOGY, with its Mineral Museum, where exhibits display a geological map of the area, fossils, and a wide-variety of minerals. Our Lady of the Rockies atop the Continental Divide near Butte is a ninety-foot monument to motherhood which was airlifted into place one piece at a time. The 32-room Victorian home of "Copper King" W.A. Clark has been restored is open to the public. Visitors can relive Butte's rough-and-tumble past in the World Museum of Mining and Hell-Roarin' Gulch at the site of the Orphan Girl mine, featuring a collection of buildings reconstructed as an early mining town.

BUTTERFIELD OVERLAND STAGE COMPANY. One of many stage lines organized by ex-stage driver John Butterfield. The coaches, financed by American Express, Adams and Company, and Wells Fargo, began to run in 1858 after the company was awarded the government mail contract which paid $600,000 annually for a semiweekly service taking not over twenty-five days for a single trip. Along the twenty-six-hundred-mile route between Tipton, Missouri, and San Francisco, California, stages used 139 way stations. "Swing stations" provided minimum care for the stock. "Home stations" served as headquarters for company agents and served travelers' meals, which cost as much as $1.50. A cavalry detail sometimes escorted coaches through Apache territories in New Mexico and Arizona. The usual time for a one-way trip was twenty-four days. The best time posted for the trip was twenty days, eighteen hours, and sixteen minutes. Equipment costing an estimated one million dollars was used including specially built Concord stages with wide wheels for travel through sand, leather straps for springs and leather curtains. Three seats, designed for nine passengers, often held more travelers who were crowded on-board after paying the 1859 fare of $200 for the trip West. The trip east was only $150, the difference due to the light eastward traffic. The Company maintained its mail service until the outbreak of the CIVIL WAR disrupted its southern route and the company was reduced to delivering mail between Utah and California.

BUTTERFIELD TRAIL. Route used by the Butterfield Overland Mail Company, once the longest stage run in the world. The twenty-six-hundred-mile route from Tipton, Missouri, to San Francisco, California, followed the long, sweeping old Jackass Mail, or Ox-bow Route, to the south to avoid the harsh climatic conditions making the central route inoperable part of the year. The trail ran through Fort Smith, Arkansas, in a wide sweep south and then west to EL PASO, Texas, Tucson and Fort Yuma, Arizona, and then Los Angeles and San Francisco, California. The outbreak of the CIVIL WAR forced the company to abandon the route, leaving nothing more than a mail route between Salt Lake City, Utah, and Placerville, California.

BYERS, William Newton. (Madison County, OH, Feb. 22, 1831—Denver, CO, 1903). Newspaper publisher. Byers, once governor of Iowa, brought the first newspaper to Colorado when he founded the *Rocky Mountain News* on April 23, 1859. Byers edited the paper for nineteen years. Byers also served in Nebraska's first legislature and Colorado's constitutional convention.

C

CABEZA DE VACA, Alvar Nunez. (Jerez de la Frontera, Spain, c.1490—Seville, Spain, 1557). Spanish explorer. Cabeza was one of four survivors of an ill-fated expedition to the New World led by Panfilo de Narvaez (1527). Shipwrecked off the Texas coast, the four endured much suffering as Indian prisoners before their escape. Together they traveled through Texas, New Mexico, Arizona and into Mexico, where their tales of riches encouraged new expeditions north. Cabeza later served as governor of Paraguay (1540), but a revolt forced him to return to Spain, where he was sentenced to exile in North Africa on a trumped up charge of "high-handed practices," but later pardoned by the king.

CACHE LA POUDRE RIVER. Colorado, source near Milner Pass in the northern part of the state. The stream flows north and east for approximately one-hundred-twenty-five miles to the SOUTH PLATTE RIVER, near GREELEY, Colorado.

CACHE, Oklahoma. Town (pop. 1,661), Comanche County, southwestern Oklahoma, southwest of Anadarko and northwest of Lawton. Founded in 1889, Cache (in French meaning a "hiding place) was named for nearby Cache Creek." Cache was the home of Quanah PARKER, the famous Comanche chief. Parker built an eight-room house in 1890 and settled in Cache with his five wives. Parker and his mother are buried there.

CADDO INDIANS. Confederacy of up to 25 small tribes, including the Kadohadacho Confederacy in Texas, all living in eastern Texas and along the Red River in Louisiana and Arkansas. Caddo tribes were headed by a caddi, meaning "chief," who was assisted by canaha and lesser grades of officials. All offices and titles were hereditary through the male line. The Caddo, worshippers of numerous deities, held ceremonies throughout the year to coin-cide with planting, the ripening of the corn, and harvest.

A dead warrior was buried with all the scalps he had taken so that his enemies would serve him in the afterlife. Food and water were placed in the grave along with the deceased's tools and weapons. Women were buried with their household utensils. A fire was kept burning beside the grave for six days. Warriors killed in battle were cremated.

The Caddo hunted and practiced agriculture. Two corn crops were grown each year, and the best ears were kept for seed. The Caddo gathered acorns, mulberries and blackberries. Turkey, deer, bear, and buffalo were hunted. Deer were stalked by men wearing stuffed deer heads. Bows were made from osage orange, a favorite wood which was traded.

Recognized as excellent craftsmen, the Caddo made pottery, fine baskets, and cloth of mulberry bark. Caddo pottery was second only to that made by the PUEBLO PEOPLE.

The Caddo may have originated in the southwest, but by the time they were visited by Desoto in 1540-1541 they had migrated to the Red River Valley in Arkansas and Louisiana and lived along the BRAZOS, COLORADO, NECHES , and SABINE rivers in eastern Texas. Land inhabited by the Caddo became a battlefield in the struggle between the Spanish and French.

Diseases brought by the whites to the Indians who had no immunity to them proved more deadly than battle, and many tribes were reduced to extinction. The Louisiana Caddo ceded their lands in 1835 to the United States and moved to Texas to join the Caddo tribes in that region. They were forced to move again in 1859 to Indian Territory. A reservation was established north of the WASHITA RIVER for the Caddo, Delaware and Wichita tribes. In 1901 the lands were allotted to individuals. In the final allotment, the three tribes had 61,000 acres of allotted lands and 2,370 acres of tribal land. In the 1970s there were 800 Caddo descendants living in Oklahoma.

CALAMUS RIVER. Nebraska river beginning in Brown County in the north central part of the state and flowing through a lightly populated area for seventy miles in a southeasterly direction into the North Loup River in Garfield County in central Nebraska.

CALDWELL, Kansas. Town (pop. 1,401), Sumner County, south-central Kansas, southwest of WICHITA and west of ARKANSAS CITY. Settlement in the area began in the early 1870s. Caldwell was the last Kansas town on the CHISHOLM TRAIL. Like other frontier towns, Caldwell had lawmen who often worked both sides. Caldwell's marshall, Henry Brown, was riddled with bullets while attempting to escape a bank robbery he was participating in at MEDICINE LODGE, Kansas (1878). Just before the Cherokee Outlet in Oklahoma was opened for settlement (September 16, 1893), Caldwell saw its population take a temporary leap of 15,000, as people lined up to make a mad-dash across the border to claim land.

CALIFORNIA GULCH. Principal site of mineral bearing ores near present-day LEAD-

Camels once roamed the region during an ill-fated experiment, but The New Mexico landmark of Camel Rock has remained stationary through the ages.

VILLE, Colorado. Gold was discovered in the Gulch in 1860. Soon more than five thousand miners were living in lean-tos and old wagon-boxes. Easily recovered gold was soon exhausted, and by 1870 only a few people, such as H.A.W. TABOR, remained. By 1878, rich deposits of carbonate ores, appearing as black-sand-bearing lead and silver, were discovered by Abe Lee. Most of the silver interests were bought up by Tabor, and the Gulch was again booming. With the repeal of the Sherman Silver Act of 1893, the silver boom collapsed.

CALIFORNIA TRAIL. Pioneer route beginning west of Fort Hall, Wyoming, along the OREGON TRAIL where it ran near the SNAKE RIVER.

CAMELS. Experimental use of camels was carried on in much of the dry Southwest because the region seemed similar to African and Asian deserts. It was hoped that camels could handle the dry sandy terrain better than horses or mules. Edward F. Beale, Superintendent of Indian Affairs for California and Nevada convinced the secretary of war, Jefferson Davis, to test camels in arid regions of the American West. In 1855 Congress appropriated $30,000 toward the experiment and seventy camels were purchased by the War Department. As early as 1857 a camel caravan headed by Beale crossed the deserts of the Southwest on its way to California. The principal center for experiments was Camp Verde, Texas. The outbreak of the CIVIL WAR, the terror caused other animals which came into contact with the camels, and the stigma associated with any project linked with then Confederate President Jefferson Davis, gradually led to the sale or auction of the camels. Some were turned loose to wander in the desert, where their ghostly appearance created legends for years among the Indians and whites.

CAMERON CREEK RUINS. Pueblo ruins in Grant County in southwestern New Mexico. Archaeological work of the universities of Minnesota and New Mexico yielded shell beads, necklaces, skeletal material and one hundred-thirty-five pit rooms. Pit rooms, an indication of early pueblo architecture, were built with the first two or three feet of the structure beneath ground level. Unusual burial grounds in oval pits beneath the ground floor of the rooms were found. Jars discovered with the deceased had holes drilled in the bottom to allow the spirit of the jar to escape with the soul of the dead.

CANADIAN RIVER. Southwestern United States, flowing 906 miles from its source in Las Animas County in the SANGRE DE CRISTO MOUN- TAINS of southern Colorado south and east across northeast New Mexico where it forms the Conchas Reservoir. It proceeds into north- western Texas, crossing the Panhandle, then on into Oklahoma where at MC ALESTER it meets the North Canadian River in eastern Oklahoma's Muskogee County. The Canadian is one of the principal tributaries of the ARKANSAS RIVER . Along its course the Canadian River flows past RATON, New Mexico, and into Lake Meredith created by Sanford Dam in the panhandle of Texas. The Canadian River flows south of OKLAHOMA CITY and into EUFAULA RESERVOIR be- fore reaching Sequoyah National Wildlife Ref- uge on the banks of the Arkansas River.

CANARY, Martha (Calamity Jane). (Prince- ton, MO, 1852— Deadwood, SD, Aug. 1903). Frontierswoman. Canary and her parents moved to VIRGINIA CITY, Montana, in 1864. There she learned to be an expert with pistol and rifle and became skilled as a horsewoman. She dressed habitually as a man. Legends sur- rounding her nickname suggest she warned anyone that to annoy her was to invite calamity. She may have served as a scout for George Armstrong CUSTER and certainly spent some time at such frontier posts as FORT BRIDGER and Fort Russell in Wyoming. In 1875, Canary moved to DEADWOOD, South Dakota, during the gold rush and became a heroine by treating smallpox victims during an epidemic in 1878. She married a man named Clinton Burke and moved to EL PASO, Texas, where Burke soon deserted her. She returned to Deadwood in 1903, where the citizens supported her and collected money to send her daughter to school in the East. She is buried next to "Wild Bill" HICKOK in Mt. Moriah Cemetery, Deadwood, South Dakota, lending support to the stories that they were married.

CANES, LINCOLN. Symbol of office given to the governors of the seven New Mexican Pueb- los when they visited Washington, D.C. in 1856 and met President Abraham Lincoln. Lincoln gave each of the governors a cane, engraved "A. Lincoln, Prst. U.S.A.," with a silver head along with the name of the Pueblo and the date. The canes, still treasured in the Pueblos, are passed to each new governor as a badge of office.

CANNONBALL RIVER. North Dakota river rising in the southwestern part of the state in Slope County flowing one hundred forty miles eastward into the MISSOURI RIVER on the north- west boundary of Sioux County.

CANON CITY, Colorado. City (pop. 13,037), seat of Fremont County, south-central Colo- rado, on the ARKANSAS RIVER southwest of COLO- RADO SPRINGS and northwest of PUEBLO. Settle- ment began in 1807 and its name, meaning canyon in Spanish, comes from the nearby ROYAL GORGE of the Arkansas River. Canon City in 1868 was given the choice of being the home of the state university or the state penitentiary. The residents chose the prison because they felt it was more likely to be better attended. Today the community is best known as the gateway to the Royal Gorge and its famed suspension bridge, the highest in the world. The scenic canyon attracted Hollywood film- makers in the early 20th century and Canon City briefly became a movie capital when Tom Mix began his career here in 1910. Stockraising, agriculture and tourism maintain the local economy. The vast cherry and apple orchards of the region annually inspire a Blossom and Music Festival in early May. The Royal Gorge Rodeo is held in July.

CANTON, South Dakota. Town (pop. 2,886), Lincoln County, southeastern South Dakota, southeast of Sioux Falls and northeast of Vermillion. The name was chosen because the settlers thought they were situated directly opposite Canton, China, across the world. The lives of the six Berdahl brothers, pioneers in the Canton region, were immortalized in Ole Ed- vart Rolvaag's (1876-1931) book *Giants in the Earth* (1927).

CANYON, Texas. City.(pop. 10,724), seat of Randall County, located in the PANHANDLE of Texas. Settled in 1892 and named for Palo Duro Canyon, the town's present economy is largely dependent upon West Texas State University. Ranching and farming are also important. The Panhandle-Plains Historical Museum is lo- cated in Canyon.

CAP ROCK ESCARPMENT. Natural forma- tion creating the boundary between the CENTRAL PLAINS and HIGH PLAINS of Texas.

CAPPER, Arthur. (Granett, KS, July 14, 1865—Topeka, KS, Dec. 19, 1931). Republican Governor of Kansas and United States Senator. Capper, the first native Kansan elected gover- nor of Kansas, served for two undistinguished

terms in the office, from 1915 to 1919, when he was elected to the United States Senate. He served there for 24 years but did not choose to run again in 1948, when he returned to his publishing business. Capper's career in Congress was concerned mainly with issues for or affecting Kansas. He was best known for his *Capper's Weekly, Capper's Farmer* and *Household Magazine.*

CAPULIN MOUNTAIN NATIONAL MONUMENT. The main feature of the monument is the symmetrical cinder cone of the mountain, interesting example of a geologically recent, extinct volcano. This is a huge cinder cone described as the most nearly perfect symmetrical volcanic body in North America. Located in northeastern New Mexico, Mount Capulin is nearly one mile in diameter at the base. A trail leads from the rim into the 700 foot deep crater. It was proclaimed a national preserve in 1916 and is headquartered at Capulin, New Mexico.

CARISSA LODE. Gold discovery site in 1867 at SOUTH PASS in Wyoming. An estimated ten thousand miners raced to the area in the next three years.

CARLSBAD CAVERNS NATIONAL PARK. This series of connected caverns, with one of the world's largest underground chambers, has countless magnificent and curious formations. It also is noted for the millions of bats living there. Headquartered Carlsbad, New Mexico.

CARLSBAD, New Mexico. City (pop. 25,-496), Eddy County, southeastern New Mexico, on the PECOS RIVER, southeast of ARTESIA and southwest of CLOVIS. Carlsbad, originally called Eddy, was founded in 1889. It was named for resemblance to the springs of Bohemia's Karlsbad. The potash industry, responsible for some of the recent rapid growth of New Mexico, is centered in Carlsbad, the "Potash Capital of America." The Carlsbad region also has vast supplies of ground water used by one of the oldest units of the United States Bureau of Reclamation in irrigating 25,000 acres of alfalfa, vegetables and cotton of the Pecos Valley and surrounding area. Irrigation has been carried on in the region since the coming of the Spaniards in the early 1600s. The first industry of Carlsbad was cattle, which were brought to the region in the 1860s on the Goodnight-

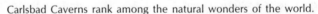

Carlsbad Caverns rank among the natural wonders of the world.

Loving Trail. Recreational opportunities are provided by Lake Carlsbad, formed by damming the Pecos River. President's Park, a local amusement center with a Gay 90s street features a small sternwheeler for use on the river, a miniature train and a 1903 carousel. The Annual Bat Flight Breakfast at the Flying X Restaurant recognizes the noctural animals of CARLSBAD CAVERNS NATIONAL PARK, one of the nation's most spectacular caves, which is about 50 miles away. Living Desert State Park is a unique indoor/outdoor museum of animals and plants of the state. To the northwest is spectacular Sitting Bull Falls.

CARNOTITE. A yellowish ore mined in Colorado and one of the sources of uranium and radium. Carnotite shipped to the Curies in 1898 was analyzed for its radioactive elements and proved helpful in their discovery of radium.

CARROLL COLLEGE. Four-year, independent college in HELENA, Montana. Founded in 1909, it was dedicated by President William Howard Taft. It is operated under the immediate supervision of the Roman Catholic Bishop of Helena. The site f the campus was previously considered for the location of the state capitol, and was accordingly named Capitol Hill. During the 1985-1986 academic year the college enrolled 1,501 students and employed 113 faculty members.

CARROLLTON, Texas. City (pop. 40,591), a northwestern suburb of DALLAS, located in Dallas and Denton County. Origin of the name is uncertain, possibly for George Carroll, a pioneer from Carrollton, Maryland. Carrollton was established in 1872 as a railroad station for the Missouri, Kansas and Texas, and the Saint Louis and Southwestern railroads. Now a residential area, it is one of the fastest-growing communities in Texas.

CARSON, Christopher (Kit Carson). (Madison County, KY, Dec. 24, 1809—Fort Lyon, CO, May 23, 1868). Frontiersman, Indian agent, army officer. Carson gained his earliest experiences in the West as a fur trapper from 1829 to 1841. In 1842 he served as a guide for the John C. FREMONT expedition along the OREGON TRAIL to SOUTH PASS in the Rockies. In 1843-1844 Carson guided Fremont's second expedition which surveyed the Great Salt Lake and part of the Oregon Trail. In 1845 Carson again guided Fremont's travels from Colorado to California and north into the Oregon country. It was the praise Fremont gave his scout that made Carson famous. Carson and two others saved General Stephen Kearny's troops during the MEXICAN WAR of 1846, by walking and crawling thirty miles for reinforcements when the Americans were surrounded at San Pasqual, California. Carson served as an Indian agent from 1853 to 1861. In 1861 Carson organized the First New Mexican Volunteer Infantry and served as its colonel. He led this force on campaigns against Indian tribes in the southwest during the CIVIL WAR and fought the Confederates in a battle at Valverde, New Mexico, in 1862. As a Civil War colonel, Carson led groups against the NAVAJOS in the Southwest in which the winning strategy of destroying the Indian's food supplies forced 8,000 Indians to accept life on a reservation. He brought hundreds of APACHES to a reservation near FORT SUMNER, New Mexico, and fought the COMANCHE and KIOWA at Adobe Walls, an abandoned trading post in Texas. He was made a brigadier general in 1865, but he resigned in 1867, due to poor health, and returned to his home in TAOS, New Mexico, where he died and was buried in the Kit Carson Cemetery. Taos is the headquarters of the Kit Carson National Forest and the site of Kit Carson Memorial Park, as well as the location of his home which was made into a museum.

CARTER MUSEUM OF WESTERN ART. Part of the Will Rogers Memorial Center in FORT WORTH, Texas, the museum claims the world's most important collection of art of the American West including paintings, photography and sculpture.

CARVER, George Washington. (Diamond Grove, MO, 1859—Tuskeegee, AL, Jan. 5, 1943). Agricultural researcher. Carver, later famous for experiments with peanut cultivation and use, lived fifteen miles west of Ness City, Kansas, from 1888 until 1891. Before he sold his 160-acre farm and left the state, Carver engaged in geological research and predicted that oil would be found in Ness County. His greatest fame was gained outside the Central West Region.

CASPER, Wyoming. City (pop 51,016), seat of Natrona County, situated in east central Wyoming, on the wide and wandering NORTH PLATTE RIVER, the city takes its name from Lieutenant Casper W. Collins, killed by the Indians.

Now the largest community in the state,

Casper has been an oil town since oil was discovered in 1890 in the Salt Creek Field. It boasts some of the largest oil refineries. Other minerals (coal uranium, and bentonite), tourism, and the cattle-rich region around the city are additional important economic factors. Wool and livestock markets and meat packing add to the commercial activity.

Indians and immigrants at this important ford on the OREGON TRAIL passed the site. The Mormons operated a ferry at the site until the Platte bridge was completed in the 1850s. Some small numbers settled before the railroad arrived in 1888. Then many new settlers and new sources of trade and commerce arrived with the railroad. Casper was incorporated in 1889, just before the oil boom. That boom found traders in the local hotel lobbies dealing for half a million in stocks almost every day. The Salt Creek Oil field is the site of the rock formation known as the Teapot Rock. As late as 1948, a new discovery, the Lost Soldier Field, brought a new oil boom.

The city's four museums, Fort Casper Museum, Natrona County Pioneer Museum, Nicolaysen Art Museum and Werner Wildlife Museum, provide a wide variety of subjects for display and explanation. Werner, part of Casper College, has a particularly fine collection of indigenous animals and birds.

Questions in connection with Salt Creek Oil Field leases led to the Congressional inquiry and shakeup fimiliarly known as the TEAPOT DOME scandal. The Teapot Rock and Independence Rock, with more than 50,000 pioneer names carved on its face, are nearby attractions for tourists. Essentially, however, tourists are most taken with the almost numberless opportunities for winter and summer outdoor recreation, including skiing, horseback riding, and many others.

The Central Wyoming Fair races and rodeo are notable annual events, as is the State Championship Canoe Racing on the North Platte.

CASTLE GARDENS. State historical monument twenty-five miles east of Riverton, Wyoming. Petroglyphs of hunters, warriors and animals are found on many of the stone spires and pinnacles which rise abruptly up to one hundred feet.

CASTORVILLE, Texas. Town (pop. 1,821), Medina County, south-central Texas, west of SAN ANTONIO and southwest of AUSTIN. The community is best known for its French-settler heritage in its quaint Alsatian architecture.

CATHEDRAL OF THE PLAINS. St. Fidelis Catholic Church, in VICTORIA, Kansas, with its twin towers soaring 140 feet into the sky, was begun in the 1870s and constructed by the religious German-Russian immigrants who were each assessed $45.00 and six loads of stone to provide funds for the construction. Stained glass windows were imported from Munich, Germany. The structure looms as a notable prairie landmark.

CATHER, Willa. (Winchester, VA, Dec. 7, 1873—New York, NY, Apr. 24, 1947). Author. Best known for her work praising the heroic spirit of the pioneers and their conquest of hardships, her first work on the theme was *O Pioneers!* (1913), based on her own frontier childhood in RED CLOUD, Nebraska. *My Antonio* (1918) continued the theme. The 1922 novel *One of Ours*, mourned the passing of the frontier life and won the Pulitzer Prize. Cather later turned to an earlier era to produce an extraordinary memorial to the life of Archibishop Jean Baptiste LAMY, the remarkable rejuvenator of the Catholic church in the Southwest, in her novel *Death Comes for the Archbishop* (1927).

CATLIN, George. (Wilkes Barre, PA., July 26, 1796—Jersey City, NJ., Dec. 23, 1872). Painter. Catlin, who devoted his life to portraying what he considered to be a vanishing race of men, the American Indian, began his studies among eastern tribes living on reservations. Catlin had first taken an interest in the history of the Indians who had lived in the area of his birthplace. In 1824 he visited a gathering of Indians from the West in Philadelphia. Encouraged by his wife who recognized the importance of Indian studies in his life, he decided to take a trip to western states to see and visit with various tribes. In 1832 Catlin sailed up the MISSOURI RIVER on the maiden voyage of the steamer *Yellowstone*. Wherever he went, he took great pains to gain the confidence of the Indians before attempting to paint them. He journeyed across the prairie to join soldiers operating out of FORT GIBSON, Indian Territory (now Oklahoma), as they rode into Pawnee and Comanche country, and went almost everywhere among the Indians of the region. He published many works, the most famous of which is *Letters and Notes on the Manners, Customs, and Conditions of the North American Indians* (two volumes, 1841). This reproduced many of his finest sketches of Indian people and Indian life and had a substantial narration

of his experiences among the Indians. His paintings and writings provide one of the most important resources regarding the life of the peoples of the Central West during the period. Important collections of Catlin's works are found in the Smithsonian Institution, Washington, D.C., the THOMAS GILCREASE INSTITUTE OF AMERICAN HISTORY AND ART, TULSA, Oklahoma, and the Joslyn Art Museum, OMAHA, Nebraska.

CATTLE PRODUCTION IN THE CENTRAL WEST. Major agricultural resource of the Central West. With a cattle population of 48,165,000 in 1984, the region accounts for almost half of the entire U.S. production. Texas led all states in cattle population with 14.35 million head; other states in the area are Nebraska (6.9 million head), Kansas (6 million head), Oklahoma (5.5 million head), South Dakota (4.22 million head), Montana 3.15 million head), Colorado (3.12 million head), North Dakota (2.14 million head), and New Mexico and Wyoming (1.393 million head, each).

CATTLE DRIVES. Months-long movements of cattle from Texas plains to shipment centers to the North, also known as trail drives. The paths chosen by the cowboys went in the earliest days as far north as Sedalia, Missouri, and Quincy, Illinois. The first recorded drive was made in 1846 by Edward Piper from Texas to Ohio.

The main trail-driving period occurred after the CIVIL WAR, from 1866 to 1885. At the close of the war, millions of cattle bred unattended on the Texas plains during the war, could be driven north to rail shipping points, and transshipped to eastern markets.

The trails themselves became famous, including the CHISHOLM TRAIL, the Shawnee Trail, and the WESTERN TRAIL. Herds were moved as far north as Wyoming and Montana and were pushed over the often lethal stretches of the Southern Trail and up the Goodnight-Loving Trail into Colorado. The destinations changed with each new and closer terminus of the railroad. DODGE CITY, Kansas, was perhaps the most notorious of all the receiving stations. Cattle drives usually began in the early spring so that the animals could feed on the way and yet reach the new grazing grounds in the north before the hard winters began. Late-starting cattle drives had the additional problem of flooded streams.

There were few agreed-upon ways to handle a drive. Each drive faced new problems with different crews, cattle and weather conditions. Certainly one of the greatest concerns was the stampede which could result in the loss of entire herds and lives of the drovers.

Herds were moved at a rate of approximately fifteen miles per day. The cowboys did not attempt to move the cattle any faster so that the animals could gain weight before they reached their destination. Dinner was served to the drovers around 11:00 a.m. so that the cattle could graze through noon.

A herd of three thousand head of cattle needed between ten and fifteen drovers, one of whom would be the foreman or trail boss. Foreman were appointed by the cattle owners and usually had experience in the job. The cook was probably the second most important member of the crew. The status of the other men could be seen from the position they held. The highest rank was held by the "pointers" who rode at the head of the herd. The "swing" position was followed by the "flankers." The back position was taken by the "drag.."

Some trail crews exchanged positions, but the "pointers" usually kept their jobs for the entire drive. Drovers made better wages than ordinary cowboys and the cook received more money than the drovers. Each drover had eight to ten horses, one of which was used to swim rivers and an extra in case of the need during a long, hard run. A third favorite horse was a "night horse" which proved especially sure-footed and confident in the dark.

Using another man's horse was a serious matter. Horses were left in the hands of the wrangler who was usually young and inexperienced.

The numbers of cattle moving north grew from an estimated 260,000 in 1866 to a peak of 600,000 in 1871. The total figure of cattle driven in this way exceeds six million.

CATTLE RANCHING. Cattle in the West were of four distinct types: the multicolored Texas Longhorn, the small-boned Spanish cow, the wild brown cow, and the curly haired chino breed. Cattle ranching in the Southwest, using all of these breeds, started in Texas. During the MEXICAN WAR, Texas cattlemen sold cattle to the military and drove some to New Orleans for shipment by water eastward. The Union blockade during the CIVIL WAR prevented cattle drives from Texas, and by the end of the war an estimated five million head ran wild on the Texas prairies.

Millions of these Texas cattle were sent north over the various cattles trails, some for

slaughter others for fattening on the broad plains of Montana, North and South Dakota Wyoming and Nebraska. By 1871 the ranges of the Central and Northern Plains were well stocked, with as many as three hundred thousand head arriving in that year alone. Ranches in those areas grew larger and more prosperous as rangy cattle became prize beef. Ranch kings included Granville Stuart, Conrad Kohrs, John W. Iliff, and Alexander H. Swan. In the 1880s, the latter founded the great Swan Land and Cattle Company of Wyoming.

But, of course, all others were eclipsed by the great KING RANCH, founded in 1854. King and the other major Texas ranchers based their fortunes on the longhorns, but crossbreeding produced many new and more profitable strains. The growing demand for beef was met by feeding cattle on Middle West corn crops and introducing such breeds as the Shorthorn, Angus and Hereford, as well as by the crossbreeding, producing such mixtures as the BRAHMA.

A boom period in cattle ranching occurred around 1880 when the prospect of quick wealth brought a huge influx of foreign and domestic capital to the industry. The largest cattle companies operating in the United States during this period were owned by British or Scottish financiers. Entrepreneurs in the eastern United States, including as many as twenty corporations, also participated. Swindles occurred during this time as men of wealth invested in herds which never existed or which did exist over areas so large that accurate counts could never be made. When ranchers sold their herds during this period of use of the open range, estimates of the size of the herd often were the only available numbers.

Barbed wire, at first a threat to the cattlemen, eventually was used to protect the herds. Fence wars erupted when many ranchers fenced lands in the public domain and used barbed wire to control the supplies of water. The fencing of the land led to overgrazing which left cattlemen ill-prepared for blizzards which killed thousands of poorly fed cattle. The terrible winter of 1886 killed entire herds and made it clear that future plans for cattle ranchers had to include better procedures for caring for the stock. This meant working with the settlers and sheep herders who also claimed the land and water.

By the late 1870s, states required branding of cattle and records of the BRANDS in local brand books. Quarantines and branding were only two of the strictures cattlemen resented. Cattlemen opposed much of the land legislation, for they saw it limiting their use of public domain including its free grass and water. In 1890 the National Cattlemen's Association lobbied for a federal leasing bill to allow them to control the rangelands.

The cattlemen bitterly opposed the Newlands Reclamation Act (June 17, 1902) which, when passed, encouraged the use of arid lands. A commission formed by President Theodore ROOSEVELT in 1905, exposed many of the evils of unregulated range. The major break with an unregulated past came in the administration of F.D. Roosevelt, with the passage of the Taylor Grazing Act (1907) which placed all public lands outside of Alaska under the control of the Bureau of Land Management. Since that time most of the major problems of land use have been settled. The cattle industry continues to be the leading agricultural producer of the region.

CAVANAL HILL. Site in Oklahoma which residents humorously claim is the "world's highest hill." Cavanal Hill, 1,999 feet high, is technically one foot short of being classified as a mountain, officially described as any site with an elevation of 2,000 feet or more.

CAVE DWELLERS. Prehistoric peoples of the Central West such as SANDIA MAN are thought by some to be "the earliest humans yet discovered on the continent." The earliest yet discovered lived in caves near BERNALILLO, New Mexico, as long ago as 25,000 years, with some experts saying 40,000 years. FOLSOM MAN, also cave dwellers, roamed throughout the West, hunting now extinct animals such as the giant sloth, mastodon, and mammoth of the Pleisticine period. They were named for the town of FOLSOM, New Mexico, near where artifacts were found. Remains of cave dwellers in Texas are often associated with the SHUMLA CAVE SHELTERS near Shumla, Texas. These people, living from 2,000 to 8,000 years ago demonstrated a rather high degree of culture by weaving baskets and cloth and braiding twine and rope. They used a throwing weapon now called an atlatl and another weapon, a rabbit stick, similar to that of the modern-day Australian boomerang. Cave Dweller infant burials have been discovered with the tiny bodies buried in well-made cradles.

CAVE OF THE WINDS. Colorado attraction near MANITOU SPRINGS. The drive to the cave offers magnificent views along a spectacular

approach through Williams Canyon. The cave's high location and vivid rock formations make it one of the principal attractions of the area.

CAVETT, Dick. (Gibbon, NE, 1936—). Entertainer. Cavett is best known as a talk show host and star of his own program, the Dick Cavett Show, on the Public Broadcasting Network from 1977 to 1982. Cavett was renowned for his quick wit and dry style. After leaving Public Broadcasting, he attempted the move to hosting a late night program on ABC-TV, but failed to secure the viewing public necessary for the program's renewal. Viewers of Cavett have remained loyal and he continues to be a popular host of television and radio specials. He received an Emmy award in 1972.

CEDAR RIVER. North Dakota river, lying in the southwestern part of the state, flowing east for two hundred miles to its mouth on the CANNONBALL RIVER.

CENTER MONUMENT. Marker on Snake Butte in South Dakota, locating the GEOGRAPHIC CENTER of North America.

CENTRAL CITY, Colorado. Village (pop. 329), Gilpin County, central Colorado, northwest of DENVER and southwest of BOULDER. First settled in 1859, Central City developed as the main community of the GREGORY GULCH area of gold and silver mining. The mineral riches of the area were emphasized when in 1873 President U.S. Grant walked across a sidewalk of 30 solid silver bricks from his stagecoach to the door of Central City's famous Teller House Hotel, which was built in 1872 for $107,000. A granite monument at the boundary between Central City and Blackhawk marks the site of the first gold lode dicovery in Colorado. Made by John H. Gregory on May 6, 1859, the claim was sold by its discoverer for $21,000 after he had mined $900 in gold. The site proved to be one of the richest in Colorado. Tourists may visit the restored Opera House with its crystal chandeliers and fine murals. Today's performances are said to rival those when such performers as Edwin Booth and Sarah Bernhardt acted on the stage. The Teller House is still open and recalls to visitors its fame as the home of "The Face on the Barroom Floor." The Central City Gold Mine and Museum offers a

The restoration of dozens of Central City's historic Victorian buildings has resulted in an opportunity for visitors to experience such old-time attractions as the local opera, shops, restaurants and "Old West" saloons.

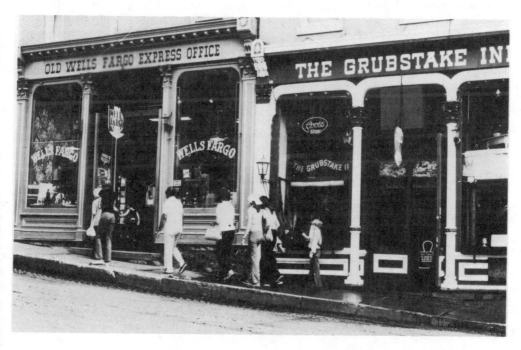

tour of the Bugher mine by way of the Diamond Lil Tunnel, carved 250 feet into Central Hill.

CENTRAL PLAINS REGION. Area of Texas lying between the BALCONES ESCARPMENT, which separates the COASTAL PLAINS from the CENTRAL PLAINS, and the CAP ROCK ESCARPMENT, which lies between the Central Plains and the HIGH PLAINS. The boundary of the region can be described very roughly as lying above a line east and west from SAN ANTONIO. San Antonio is also marks the eastern boundary, and the region stretches north nearly touching AUSTIN and FORT WORTH along its eastern boundary. The western boundary runs roughly north and south through AMARILLO.

CESSNA, Clyde Vernon. (Hawthorne, IA, Dec. 5, 1879—Nov. 20, 1954), pioneer WICHITA, Kansas aircraft manufacturer. He built the first cantilever airplane and in 1927 founded the Cessna Airplane Company at Wichita, Kansas, which continues as one of the leaders in its field. The company continued his aviation pioneering by supplying some of the first commercial passenger planes to an early airline, the Curtiss Flying Service.

CHACO CULTURE NATIONAL HISTORICAL PARK. The canyon, with hundreds of smaller ruins, contains thirteen major ruins unsurpassed in the United States, representing the highest point of Pueblo pre-Columbian civilization. Proclaimed on March 11, 1907, headquartered Bloomfield, New Mexico.

CHADRON STATE COLLEGE. One of ten schools in the nation recognized for excellence in teacher education in 1968, 1969 and 1971 by the American Association of Colleges for Teacher Education. The school was founded in 1911 at Chadron, Nebraska. The college enrolled 2,083 students during the 1985-1986 academic year and employed 104 faculty members.

CHADRON, Nebraska. City (pop. 5,933). Seat of Dawes County, northwestern Nebraska, northwest of ALLIANCE and northeast of SCOTTS BLUFF, founded in 1885. It was named for Pierre Chadron, French-Indian fur trapper of the region. The city received nationwide attention as the starting point of the 1,000 Mile Horse Race from Chadron to Chicago, Illinois, in 1893. The winner among the nine entries was John Berry, who posted a time of 13 days and 16 hours to reach the entrance of BUFFALO BILL'S

WILD WEST SHOW at the Chicago World's Columbian Exposition. The frontier days of Chadron are annually celebrated in the Buckskin Rendezvous and Fur Trade Days which include demonstrations of hide-tanning and axe throwing. Chadron's Museum of the Fur Trade places an emphasis on 19th-century operations on the MISSOURI RIVER. The 1840s trading post of James Bordeaux has been reconstructed and outfitted as it was originally. The museum features one of the finest collections of Northwest Indian trade guns found anywhere in the United States.

CHALK PYRAMIDS. Unusual surface feature between Oakley and Scott City, Kansas. Also known as the "Kansas Pyramids," the rocks are said to resemble the pyramids of ancient Egypt. One of the chalk rocks is called the Sphinx because of its resemblance to the famous Egyptian relic.

CHAMBERLAIN, South Dakota. city (pop. 2,258), seat of Brule County, in south central South Dakota, on the MISSOURI RIVER, named for railroad official Selah Chamberlain, founded 1880. It lies between the corn country to the east and the cattle country to the west and helps to serve the needs of both industries. Chamberlain is the supply center for the Big Bend Dam-Lake Sharpe area, with a museum and visitor center at the dam site. Swimming, fishing, boating and camping are popular. The Old West Museum near Chamberlain features pioneer and Indian displays.

CHAMBERS, Jean Wilson. (Traer, Iowa, 1896—Clear Lake, South Dakota, 1958). Artist, poet. After her art studies at Chicago and the study of chiropractic with her husband, Ralph Chambers at Davenport, Iowa, in 1927 she and her husband settled in Clear Lake to practice. She continued her career as an artist and commercial artist, illustrating covers for most of the major magazines and creating her line drawings for books. These were noted for their sparcity of line. Turning to poetry she won recognition in the region, and her work appeared in many anthologies, such as the annual *Pasque Petals.*

CHAMIZAL NATIONAL MEMORIAL. The peaceful settlement of a 99-year boundary dispute between the United States and Mexico is memorialized at the site, between EL PASO, Texas and Juarez, Mexico. The Chamizal Treaty, ending the dispute, was signed in 1963,

with each country making concessions of land. The disputed claims came about when the RIO GRANDE RIVER changed its course, leaving the location of the border unclear. The memorial amphitheater and 500-seat auditorium are used by theatrical groups from both nations.

CHANUTE, Kansas. City (pop. 10,506). Seat of Neosho County, southeastern Kansas, northeast of INDEPENDENCE and southeast of EMPORIA. The city was founded in 1873 and named for Octave Chanute, a civil engineer for the Santa Fe Railroad in the 1870s and aviation pioneer, known as the "Father of Aviation." Chanute's designs for heavier-than-air machines were helpful to the Wright brothers in the design of their first airplane. The city was the hometown of Osa Leighty Johnson who, with her husband Martin, was among the earliest wildlife photographers and authors. The Martin and Osa Johnson Safari Museum displays many of the photographs they took and some of the finest artifacts these fascinating Americans collected from more than forty African tribes.

CHAPPEL, Nebraska. Town (pop. 1,095). Seat of Deuel County, southwestern Nebraska, west of OGALLALA and southeast of SCOTTS BLUFF. Settlement began in the region in the late 1860s, and the community was named for John Chappell, founder and president of the Union Pacific Railroad. Chappel is noted for the Memorial Art Gallery with a remarkable collection for a town of its size, containing, among others, etchings by such artists as Rembrandt and Whistler.

CHARBONNEAU, Pompey. (1805—Unknown). Also known as Jean Baptiste, Charbonneau was the son of Toussaint Charbonneau and SAKAKAWEA, guide and translator for the LEWIS AND CLARK EXPEDITION (1804-1806). He became the pet of the expedition and was known as "Little Pomp." William CLARK of the expedition paid for the boy's schooling in St. Louis where the child learned many languages. In his early adult years the boy followed the career of his father and by the late 1860s had settled on the Wind River Reservation with three concubines.

CHARBONNEAU, Toussaint. (—). French Canadian trapper, hired as an interpreter by the LEWIS AND CLARK EXPEDITION (1804-1806, who traveled with his wife, SAKAKAWEA, and young son, POMPEY. Charbonneau was hired as the guide, but he was lazy and ineffectual and Sakakawea took over most of his duties.

CHARISSE, Cyd. (Amarillo, TX, Mar. 8, 1921—). Dancing heroine of MGM musical dramas of the 1950s. Charisse starred in such motion pictures as *The Unfinished Dance*, (1947), *Brigadoon*, (1954), and *It's Always Fair Weather*, (1955). In 1978 she published her autobiography, *The Two of Us*, with her husband Tony Martin.

CHATEAU DE MORES STATE MONUMENT. Historic MEDORA, North Dakota, home of the Marquis de Mores, a wealthy French nobleman who dreamed of revolutionizing the meatpacking industry by slaughtering beef on the range rather than shipping it to eastern slaughterhouses. The concept failed, and de Mores left his 26-room chateau and many of his personal possessions when he returned to Europe. The chateau, the remains of a packing plant, an interpretative center and a park are now a tourist site in Medora.

CHEROKEE INDIANS. One of the FIVE CIVILIZED TRIBES and the largest southeastern tribe at the time of European contact. Before they were forcibly moved to the Central West region, they had developed a remarkable degree of civilization, including a written language. There were wealthy Cherokee landowners who kept slaves, and the people in general lived in much the same way as their white neighbors.

Their success in some ways led to their undoing. Their greedy white neighbors wanted their land and properties. By the Treaty of New Echota in 1835 a few Cherokee leaders who represented a minority of the Cherokee ceded the lands of the Eastern Cherokee and agreed to join the Western Cherokee in Indian Territory.

An estimated 15,000 Cherokee were forced to begin the dreadful journey known as the TRAIL OF TEARS in the winter of 1838-1839, with one-fourth to perish on the way, before they arrived in what is now Oklahoma.

There the Cherokee established a formal government and were recognized as an independent nation under U.S. protection. In the following years they again prospered, becoming the most successful of the FIVE CIVILIZED NATIONS of what is now Oklahoma. Their capital at TAHLEQUAH was sturdily built, and the public buildings are still being used. Under the Allotment Act of 1902 the reservation lands were divided among the tribal members, and the independent Indian nations ceased to exist

The Cherokee savant Sequoyah ranks among the world great for his accomplishments.

with the coming of Oklahoma statehood in 1807.

CHEROKEE OUTLET. Also known as the Cherokee Strip, the Outlet was a section of Indian Territory promised by the treaty of 1866 to the FIVE CIVILIZED TRIBES as communal property. The Outlet survived until 1891 when the government forced the tribes to sell the tract for approximately $8,596,000. The area was then opened for white settlement on September 16, 1893. The change in government of the Outlet eliminated a hideout for criminals, who used the land outside white jurisdiction without fear of punishment.

CHEROKEE WAR. Name given to an effort made in 1839 by Texans to remove Cherokee Indians from possession of any land in Texas. It was led by Republic of Texas President Mirabeau LAMAR, successor of Sam HOUSTON . Lamar was the former private secretary of Governor Troup of Georgia who had expelled the CREEKS and CHEROKEES from the South. In 1839, regiments of Texas troops attacked and

destroyed a village of Cherokees, on the Angelina River. The Indian leader named Bowl, a close friend of Houston, and many of his tribe were slain. Survivors were driven into Mexico.

CHEYENNE RIVER. Beginning in eastern Wyoming, the Cheyenne enters South Dakota in Fall River County, flows near HOT SPRINGS and then generally northeastly for a total of five hundred twenty-seven miles, to join the MISSOURI RIVER at OAHE LAKE in South Dakota.

CHERRY CREEK. Site of a hoax in 1858-1859 that started off a stampede of gold seekers to Colorado. News of a small gold find by the Russell brothers was magnified until the Cherry Creek area was thought to be a major gold field. Two new settlements, Auraria and DENVER, were quickly established. When the truth was discovered, many miners started moving back East. Then a major strike at Chicago Creek was made in 1859, and the exodus from Denver and Auraria left the communities almost deserted for the time being.

CHEYENNE INDIANS. Algonquin language tribe which left their Minnesota homelands in the 17th century, due to pressure of hostile SIOUX and OJIBWAY tribes. Beginning about 1500, they gradually moved southwest following the CHEYENNE RIVER and established an agricultural life.

After the establishment of the horse-oriented life in the 1700s, they became nomadic hunters of buffalo. Their life and customs were similar in most ways to the other plains tribes. Women were not considered to be chattels. Although the groom was expected to give a horse to the bride's family, this was said to be a gift and not a "purchase." The simple marriage ceremony consisted of carrying the bride on a blanket to the lodge of the groom's father, where the couple lived until they made their own tepee.

Because of the large number of men lost in war and hunting accidents, there were always more women than men, and some men had as many as three wives. Girls married young, and the arrival of babies was greeted with celebration. Children were cherished and given great freedom to learn from experience. Education was carried on by the elders, who taught the necessary skills to boys and girls. At puberty both girls and boys spent several days in isolation, and during that time the boys were expected to have a vision of their future life.

Religion embraced every aspect of life and was expressed in a large number of traditional

ceremonials. The sacred pipe was the central element of religion. It was held aloft in prayer to express the link between man and nature and the supreme deity. As in other tribes, certain men and women were accepted as having received the gifts of healing and prophecy, and most of these were skillful in the use of medicinal plants and minerals.

In the 1830s the tribe split, with the smaller group living along the PLATTE RIVER in present Nebraska (the Northern Cheyenne) and with a larger group going to the area of the upper ARKANSAS RIVER and becoming known as the Southern Cheyenne. There they engaged in fierce warfare with the KIOWA, APACHE and COMANCHE, until the treaty of 1840 brought them all together as allies.

The gold rush in Colorado brought trouble between the Indians and the whites who were overruning their traditional land. Attacks by the Indians on settlements and travelers were met by responses of the army in almost every instance.

The Indians were often subdued and sent to reservations and frequently returned to resume their fight. A treaty of 1861 resulted in the removal of most of the Southern Cheyenne to western Colorado, where they came close to starvation because of the federal neglect of the treaty provisions. Cheyenne raids, government counter-raids and cruel massacres of noncombatant Cheyenne ended finally when Colonel George CUSTER destroyed the village of Cheyenne leader Black Kettle on the WASHITA RIVER (1868). The northern Cheyenne joined in the fight against Custer at the Battle of LITTLE BIGHORN, June 25, 1876.

Both groups finally surrendered and in 1877 were joined in an Oklahoma reservation, where they suffered disease and starvation. They failed in an attempt to escape but in 1881 were given a separate reservation in Montana.

CHEYENNE MOUNTAIN. COLORADO SPRINGS, Colorado, site of numerous attractions, including the Will ROGERS Shrine of the Sun Memorial, built by the mountain's owner, Spencer PENROSE, to honor his friend. The memorial, originally planned by wealthy developer Penrose as his own tomb, was dedicated in memory of the noted actor, humorist, and journalist after his untimely death in an airplane crash (August 15, 1935). Cheyenne Mountain Zoo is a collection of animals started by Penrose on the lower slopes of the mountain. The original animals housed in the zoo were once privately owned by Penrose who found they were too much to care for properly. Today the collection has grown to approximately six hundred animals including lions, tigers, birds of prey and several giraffe. The Broadmoor-Cheyenne Mountain Highway provides one of the most scenic trips of the area. Buried deep within the mountain lies the fantastic operations center for the NORTH AMERICAN AIR DEFENSE COMMAND (NORAD). The $65 million combat operations center directs the entire aerospace defense of the continent.

CHEYENNE OUTBREAK. Battle on the frontier between the CHEYENNE INDIANS and the United States Army, with whom they had served earlier. The Cheyenne, sent to Indian Territory in 1877, escaped and made their way as far north as Nebraska before being recaptured and brought to FORT ROBINSON. When told his people must return to Oklahoma, Chief Dull Knife said, "We are home. You may kill us, but you can never make us leave our land again." On January 9, 1877, after three months of imprisonment, the Cheyenne again managed an escape with a resulting battle continuing for two weeks along Warbonnet, Smiley and Hat Creeks and Sowbelly canyons. After the battles, the Cheyenne returned to Fort Robinson and the Red Cloud Indian agency.

CHEYENNE, WYOMING

Name: From the Cheyenne Indians.

Nickname: Home of Frontier Days; Magic city of the Plains; Capital City.

Area: 16.4 square miles

Elevation: 6,098 feet

Population:
1986: 53,960
Rank: 420th
Percent change (1980-1984): +14.1%
Density (city): 3,290 per sq. mi.

Race and Ethnic (1980):
White: 91.61%
Black: 2.97%
Hispanic origin: 11.38%
Indian: 0.52%
Asian: 0.80%

Age:
17 and under: 28.4%
65 and over: 10.2%

Cheyenne, Wyoming

The chuck wagon races have top favor during Frontier Days at Cheyenne, Wyoming, the top-ranked festival of its kind.

Hospitals: 4

Further Information: Greater Cheyenne Chamber of Commerce, 201 W. 16th st., Cheyenne, WY 82003

CHEYENNE, Wyoming. City (pop. 47,283), capital of Wyoming and seat of Laramie County, situated on the Crow River in southeast Wyoming, very near the Colorado border and not far from the border with Nebraska. The city takes its name from the CHEYENNE INDIANS, and the word means "red talkers."

In addition to the economy generated by local, county and state governments, the city is the marketing center for nearby ranches, and has substantial transportation facilities, with two railroads and the junction of two principal Interstates.

Transportation, in fact, has been a prime factor in Cheyenne's growth, and the approach of the transcontinental railroad sparked the founding of the community. Even prior to the railroad's arrival on November 13, 1867, 4,000 people had formed a crude town. One of the brawlingest towns of the west, Cheyenne early became known as "Hell on Wheels," with professionl gunmen, promoters, trainmen, soldiers, gamblers and confidence men consuming the cheap liquor, enjoying the dancing girls and living up to the rowdy reputation now so much a part of frontier movies and television.

As early as 1869 it was territorial capital and became state capital with statehood July 10, 1890, and the city celebrated with a performance of the Anvil Chorus employing real anvils, a forty gun salute and a balloon ascension that didn't quite make it.

Always a center of tourist activity, today Cheyenne continues the annual tradition started in 1897 known as FRONTIER DAYS. This is one of the largest and most notable of the country's annual festivals. Its rodeo is considered the best anywhere; there is a unique parade, and dances and carnivals with western themes continue throughout the nearly week-long event.

The capitol, in Corinthian style, is a notable structure, particularly for a city of Cheyenne's size. The historic Governors' Mansion was home to governors from 1905 to 1976. It is remembered especially as the home of Nellie Tayloe ROSS, one of the nation's first two women governors, serving in that capacity for the term 1925-1927.

The State Museum and Art Gallery and the National First Day Cover Museum have interesting displays, with the latter devoted to an extensive collection of stamps, dating almost to the earliest period of their use. Cheyenne Frontier Days Old West Museum has an unusual collection featuring early costumes, weapons, carriages and the overland stage.

From Mid June through August, visitors may

thrill to the Melodrama, performed by the Cheyenne Little Theater Players in historic Atlas Theater.

CHICKASAW INDIANS. One of the FIVE CIVILIZED TRIBES which were removed to Indian Territory (Oklahoma) in the 1830s after white settlers forced the Chickasaw to sign away most of their lands east of the Mississippi River between 1801 and 1832. Five thousand Chickasaw and one thousand of their slaves were settled in Oklahoma on land bought from the CHOCTAW NATION. There they formed the independent Chickasaw Nation. By concentrating on agriculture, the Chickasaw were producing a surplus by 1843. By the 1850s they had constructed schools, sawmills and blacksmith shops and were publishing newspapers. The Chickasaw fought on the side of the Confederacy during the CIVIL WAR. After the war more whites flooded into Indian Territory, and by 1906 the independent nation states of the Five Civilized Tribes had been dissolved to make way for the new state of Oklahoma in 1907. By the 1970s the Chickasaw were well assimilated into non-Indian society.

CHICKASAW NATIONAL RECREATION AREA. The manmade Lake of the Arbuckles provides water and recreation for an extensive area, and numerous cold mineral- and freshwater springs, including bromide waters, surface here. Headquartered Sulphur, Oklahoma.

CHICKASHA, Oklahoma. City (pop. 15,828). Seat of Grady County, on the WASHITA RIVER in southwestern Oklahoma, southwest of OKLAHOMA CITY and east of ANADARKO. Founded on 1892 on land originally given to the CHOCTAW INDIANS in 1820, the area became part of the Chickasaw Nation in 1834. The city is known as the "nation's horse trailer capital." Other manufacturing, agriculture, with livestock and dairy production, and energy related industries further bolster the economy. Chickasha was a favorite resting place for travelers on the old CHISHOLM TRAIL. Today memorabilia of the pioneer days is housed in the Pioneer Museum located in the old territorial jail in town. Washita Valley Invitational Golf Tournament is Oklahoma's oldest golfing event.

CHILI. Official dish of Texas, the only state to have chosen an official state dish. Perhaps chili, with its almost innumerable combinations of local chili peppers, beans and local meats, represents the Southwest in a way that no other symbol could accomplish, signifying the melding of the various cultures of the state.

CHILI PEPPERS. These thin and elongated peppers provide one of the most colorful crops grown in New Mexico. This is especially true after the fields are harvested and the bright scarlet pods of the peppers have been placed on drying racks. When grown in small home gardens, chili peppers are often hung on the porch to dry, the long strings providing colorful red splashes on a majority of houses in many areas. In the economy, the pepper crop plays a minor role, but its use as a "red hot" seasoning makes it a universal favorite in the southwest.

CHIMAYO REBELLION. The so called rebellion of 1837 was an attempt by a group of Indians centered at CHIMAYO, New Mexico, to overcome the Mexican rulers and their injustice to the Indian peoples. SANTA FE was captured, and Governor Albino Perez was killed. His head was carried back to the PALACE OF THE GOVERNORS and displayed on the plaza in Santa Fe. The next year Manuel Armijo, the new governor, overcame the briefly victorious rebels and became governor of the Spanish Southwest.

CHIMAYO, New Mexico. Town (pop. 1,300), Rio Arriba County, north-central New Mexico,

Santuario de Chimayo.

Chimney Rock was one of the most important landmarks for travelers on the Oregon Trail.

northeast of SANTA FE and Northwest of LAS VEGAS, New Mexico. Dating to the prehistoric times of the Chimayo people, the community has been noted for its many generations of talented weavers. The Ortega family, weavers of soft-colored Chimayo blankets and rugs, have pursued their craft here for eight generations. The town is also noted for "probably the best known chapel in New Mexico," El Santuario de Nuestro Senor de Esquipulas, constructed by a farmer who claimed he was directed by a vision to dig beneath his plow for earth with curative powers. The farmer found a cross and piece of cloth belonging to two martyred priests. The cross was placed in a crude abobe chapel. Today pilgrims travel hundreds of miles for the "benefits" of the supposedly curative earth found in a pit inside the chapel. The town square stands as one of the oldest of Spanish colonial origin surviving in the Southwest.

CHIMNEY BUTTE RANCH. North Dakota land owned by two ranchers where Theodore ROOSEVELT, in 1883, at the age of twenty-five grazed four hundred head of cattle while on his first trip to the Dakota BADLANDS, on the LITTLE MISSOURI RIVER. The ranch was known as the Maltese Cross Ranch because of its distinctive brand. The Maltese Cross cabin, restored and furnished as it was in Roosevelt's day, is exhibited at the THEODORE ROOSEVELT NATIONAL MEMORIAL PARK near MEDORA, North Dakota.

CHIMNEY ROCK NATIONAL HISTORIC SITE. Famous landmark on the trail of pioneers to the west, rising abruptly for 500 feet above the PLATTE RIVER along the OREGON TRAIL . Headquartered at nearby Bayard, Nebraska, the site is managed under a cooperative agreement between the National Park Service and the Nebraska State Historical Society. It became a national site on August 2, 1956.

CHINESE IN THE CENTRAL WEST. The Chinese population in the United States was increased by nearly 30,000 who came to California from Canton during the gold rush, beginning in 1850. Few found their fortunes in the mines, and most were desperate to make a living. It was thought that they were too thin and frail for heavy work. However, Charlie Crocker, superintendent of the Central Pacific Railroad, declared, "Did they not build the Chinese Wall? Starting in the mid 1860s, he hired thousands, and they became known as outstanding workers. Other railroads followed his example, and the Chinese workers made a notable contribution to American progress, working in most cases for a little more than half of wages paid white workers. The Chinese offered docile behavior, a willingness to work at low wages, and were quite happy to survive on the little food offered. With the completion of the railroads, these people became unemployed and soon found themselves in competition for

jobs with whites. Prevented by color prejudice from becoming independent miners, they took menial jobs in the towns and cities of the West. Those who attempted to mine were killed and their claims were "jumped." The depression of 1873 found the Chinese laborers willing to work for less than the whites, who were enraged. Forced to live in confined areas of such towns as ROCK SPRINGS, Wyoming, the Chinese found they were still not safe from attack. One of the sad examples of this occurred when Chinatown in Rock Springs in 1875 was stormed by a mob who were determined to destroy it. Thirty people were killed. Conditions eventually improved, but the Chinese people of the Central West have generally kept to themselves and retained much of their past culture. Today these groups are found in all the larger metropolitan centers of the region.

CHINOOK WINDS. Warm dry gales that descend the eastern slopes of the Rocky Mountains, spreading over the plains to bring warming temperatures, sometimes as much change as 40 degrees in a few hours. Extremely important to western agriculturists, chinook winds can bring relief from bitter cold. Melting snows allow cattle to reach needed grass. These winds occasionally turn financial disaster into commercial success by saving starving herds. Over the years the chinooks have been known to save many human lives as well, turning death-dealing cold into shirtsleeve weather.

CHINOOK, Montana. Town (pop. 1,660), seat of Blaine County, north-central Montana, northeast of HAVRE and northwest of BILLINGS . The name comes from the warm CHINOOK WINDS common to the area. Settlement came to the area in the early 1870s. Between September 30 and October 3, 1877, Chief Joseph and his Nez Perce Indians fought General Miles near Chinook on their epic flight to Canada. The defeat of the Indians, the end of the major Indian wars in the United States, is marked by the BEAR'S PAW BATTLEFIELD STATE MONUMENT. Today the principal economic factors are gas wells and the farming and grazing of the surrounding area.

CHIRICAHUA INDIANS. An Apache tribe which originally lived in southwestern New Mexico and southeastern Arizona in the 19th century and which is now found in Oklahoma and on the Mescalero Reservation in New Mexico. The Chiricahua were divided into three bands: the Southern, with its great chief GERON-

IMO; the Eastern, with its famous leaders Victorio and Mangas Colorado; and the Central with its chief COCHISE. Bands were composed of extended families, each with a band leader, respected for wisdom and recognized for ability in warfare.

While friendship, visiting and some intermarriage existed among the bands, each traveled too frequently for any unified tribal organization. Chiricahua women built dome-shaped wickiups of poles covered with thatch, to which hides were added in rainy weather. The economy was based on hunting and gathering. Families often traveled several days to enjoy certain plants as they came into season. The base of the agave plant was baked to become a nutritious food called mescal.

The Chiricahua believed in many supernatural spirits, and children were told of the Mountain Spirits and the trickster, the Coyote. Rites-of- passage for adolescent boys included accompanying the adults on four raids against enemy tribes. When a member of the band died, his face was painted red, the body was wrapped in skins and buried in a cave or under a pile of rocks the same day. Personal possessions of the deceased were destroyed or buried; his favorite horse was killed; the wickiup in which he lived was burned and occasionally the entire band moved.

Relations between the Chiricahua and whites were friendly until 1861, when Cochise was falsely accused of kidnapping. Beginning that year, warfare continued until 1873 when Cochise was persuaded to settle on a reservation. After his death in 1874, the rest of the Apache were moved against their will to the San Carlos Reservation in New Mexico.

The Chiricahua escaped in 1881, touching off another ten years of warfare, with the Indians being led by Juh and Victorio. In 1883 General George CROOK (1829-1890) managed to move many Apache back to the reservation, but again some escaped under the leadership of Geronimo. These Indians surrendered in 1886 and began twenty-seven year terms as prisoners of war at Fort Marion, Florida, Mount Vernon Barracks, Alabama, and finally FORT SILL, Oklahoma, where eventually almost all of the tribal members were confined.

In 1913 the prisoners were given the choice of living in Oklahoma or moving to the southern New Mexico Mescalero Reservation near Ruidoso. Most of them chose the latter course. Over the years they have developed their reservation land, with particular attention to the tourist attractions. Using local talent for both architec-

ture and construction, they created an outstanding tourist inn and provided skiing and other facilities.

In the late 1970s several hundred Chiricahua also lived around the town of Apache, Oklahoma, as stock-raisers and small farmers.

CHISHOLM TRAIL. Cattle trail that ran from SAN ANTONIO, Texas, to ABILENE, Kansas. The trail was named for Indian trader Jesse CHISHOLM, who drove a wagon loaded with buffalo hides down it in 1866. It played a major role in the development of the cattle industry in the Southwest. In 1869 a cattle shipping depot serving the Kansas Pacific Railroad was opened in Abilene. Between that time and 1871, a reported 1.5 million head of cattle were driven along the trail for shipment to the East Coast. The trail began in San Antonio, and ran northeast to the RED RIVER near Ringgold, Texas, where it entered Oklahoma and crossed northward to CALDWELL, Kansas, then northeast past WICHITA to Abilene. The route declined in importance after 1871 with the rise of DODGE CITY, Kansas, as a shipping point farther west and the development of railroad lines into Texas, which made the long cattle drives uneconomical. However, there was a brief hiatus during the 1880s when the Santa Fe Railroad moved into Kansas, and the Chisholm Trail again saw some use.

CHISHOLM, Jesse. (Tennessee, 1805—Left Hand Spring, near present Geary, OK, 1868). Trader. Best known for blazing the CHISHOLM TRAIL, Chisholm began trading with the OSAGE, KIOWA, COMANCHE, and WICHITA tribes of Indian territory from several trading posts including one in COUNCIL GROVE on the North Canadian River near present-day OKLAHOMA CITY, Oklahoma, soon after he moved west in 1820. Reputedly able to communicate in fourteen Indian languages, Chisholm was a valuable aid to government authorities in FORT GIBSON and FORT SMITH. He served as an interpreter, participated in negotiations which led to treaties and the release of prisoners held by the Indians, and guided such important expeditions as that of Dodge- Leavenworth in 1834. Chisholm operated a trading post near Wichita during the CIVIL WAR and later opened a wagon trail south to the RED RIVER. His trader's route across Indian Territory became the famous Chisholm, one of the West's most-used cattle trails, which linked the railroad in Kansas with ranches in Texas.

CHISUM, John Simpson. (Hardeman County, TN, Aug. 15, 1824—Eureka Springs, AR, Dec. 23, 1884). Rancher. Chisum, who was to become the largest cattle owner in the United States by the 1870s, was one of the earliest Texas ranchers to establish operations in New Mexico, in 1866. Chisum drove herds of cattle into New Mexico before they were sold in Wyoming and Colorado. He was active in establishing law and order in the region in 1880.

CHOCTAW INDIANS. Muskogean language tribe which originally lived in central and southern Mississippi and southwestern Alabama but were forced to move to Oklahoma with the other tribes of the FIVE CIVILIZED NATIONS. The Choctaw lacked a complex religious or political system. Highly successful in agriculture, the Choctaw were able to export their surplus to their neighbors. Known among Indian tribes as a peace-loving people, the Choctaw preferred to settle disputes through discussion, concensus or even a stickball game. Although it never fought against the United States, the Choctaw tribe was forced to cede its lands in a series of treaties starting in 1801 and ending with the Treaty of Dancing Rabbit Creek in 1830. The principal removal of the Choctaw occurred between 1831 and 1833. Cholera and blizzards took a terrible toll in life in the painful journey over the TRAIL OF TEARS . Adapting to the harsh conditions in Oklahoma, the Choctaw achieved remarkable progress as an independent nation under the protection of the U.S. and by 1860 had adapted their agriculture to the new conditions, established a constitutional form of government, and set up schools with the help of missionaries. To make way for the new state of Oklahoma, Congress dissolved the five independent Indian nations in 1906, and they were absorbed into the new state in 1907. By the 1970s 17,000 Choctaw living in Oklahoma held nearly 10,100 acres of tribally owned land and another 134,300 acres of allotted land.

CHRYSLER, Walter P. (Wamego, KS, Apr. 2, 1875—Great Neck, Long Island, NY, Aug. 18, 1940). Auto manufacturer, founder of the Chrysler Company. After graduating from high school in Ellis, Kansas, Chrysler became a railroad machinist's apprentice and was eventually named superintendent of motive power and machinery for the C.G.W. Railway at age 33. In 1912, he became works manager of the Buick Motor Company, and was appointed president and general manager in 1916. In 1919,

Chrysler was put in charge of operations for General Motors. Chrysler became a vice president and retired as a millionaire at age 45. He returned to the business world in 1920 as executive vice president of Willys-Overland Company, and became president of the Maxwell Motor Corporation. In 1925, Chrysler launched his own company, the Chrysler Corporation, and served as the first chairman of the board of directors. In 1928 he took control of the Dodge Company after the death of the Dodge brothers and merged it into Chrysler. The Chrysler Corporation introduced the high-compression engine and torsion bar suspension to automobile manufacturing. During Chrysler's lifetime, the company's four original manufacturing plants grew into a corporation ranked as the third of the Big Three automobile manufacturers.

CHURCH BUTTES. Landmark used by pioneers in Wyoming to guide them to the safety and hospitality of FORT BRIDGER. At one time the buttes were the site of Mormon religious services under the stars, as the Mormon groups jouneyed westward, thence the name.

CHUSKA PEAK. Sacred place in New Mexico for Navajo rainmakers. It lies on the New Mexico portion of the Navajo Reservation, almost on the border with Arizona.

CIBOLA MOUNTAINS. Vaguely defined historical area in northern New Mexico, thought by the Spanish explorers to have been the location of the seven golden cities of Cibola, with their legendary wealth.

CIBOLA, SEVEN CITIES OF. Mythical golden cities of the American Southwest. They attracted the attention of gold-hungry Spanish rulers of Mexico, who in 1540 sent Francisco Vasquez de CORONADO into the present Central West region to find them. Cibola was the most common spelling of a group of Pueblos along the ZUNI River in northwestern New Mexico. The Coronado party discovered that these unimportant communities were in reality quite unlike the fabulous cities of wealth described by Fray Marcos DE NIZA in 1539. Coronado, explored much of the region expecting to find the wealthy cities somewhere to the north of Mexico. He conquered the Pueblos, and reached as far as Kansas, perhaps even Missouri, before turning back. He returned to Mexico in disgrace after finding no gold.

CIMARRON COUNTY. Westernmost Oklahoma county, the only county in the United States bordering on four different states—New Mexico, Colorado, Texas and a sliver of Kansas.

CIMARRON RIVER. Rising in Colfax County of New Mexico, east of New Raton, the "Dry" Cimarron flows through arid semi-desert and passes south of Black Mesa, highest point in Oklahoma. After it cuts across a small portion of the Oklahoma Panhandle, it bites off a tiny triangle of Colorado before flowing northeastward into Kansas. Its "dry" reputation comes from the fact that its flow often is buried a few feet underground as an intermittent stream. Many a thirsty party has missed the water which could sometimes be found only a few feet beneath the surface. It remains an intermittent stream until it picks up the North Fork of The Cimarron near Satanta. Next the Cimarron turns south to take a tiny slice out of the Panhandle, returns briefly to Kansas where it meets the Bluff River, then dips into the main body of Oklahoma. There it passes through one of the principal wheat producing regions, flows past oil derricks and refineries and joins the ARKANSAS RIVER in the Keystone Reservoir, only seventeen miles west of TULSA.

CIMARRON, New Mexico. Town (pop. 888), Colfax County, northeastern New Mexico, northeast of SANTA FE and west of CLAYTON, incorporated 1899. Early Cimarron deserved its reputation as, "wild" or "untamed." Among the town's part-time residents were such notorious outlaws as Billy the Kid, Clay Allison, and Bob Ford. During the frequent battles between settlers and cattlemen in the late 1800s, sixteen men were killed and New Mexico's first printing press was dumped into the river there. The town developed near the center of the land claim of Lucien Maxwell, trapper and scout with Colonel John C. FREMONT. Cimarron, once the county seat, lost the office to Spencer in 1890. It has remained a quiet community playing host to the tourist trade. The St. James Hotel, where William F. "Buffalo Bill" CODY initiated his Wild West Shows, stands as a reminder of the past. Residents thrill every July 4th to the Cimarron Rodeo. Labor Day is enlivened by Cimarron Days, featuring carriage rides and joyous celebration. Philmont Scout Camp, five miles south of town, annually hosts more than 15,000 boys. The 137,493-acre national camping center is operated by the National Council of the Boy Scouts of America.

CITRUS. After Florida and California, Texas is the third largest producer of U.S. citrus crops, with about 50,000,000 boxes annually. These are grown mainly in the lower RIO GRAND RIVER Valley. Best-known of the area's crop are the delicious ruby red grapefruit. The other popular citrus products, oranges, lemons and limes, are known for their size and quality.

CIVIL WAR EVENTS IN THE CENTRAL WEST. The Central West Region is not celebrated as the site of many Civil War Battles, but the region has a strange renown as the site of the last battle of that war, fought more than a month after the war was over in the East. This was the Battle of PALMITO HILL, near BROWNSVILLE, Texas. Although labeled as a "battle," this was little more than a skirmish as Texas forces continued to fight for a month after the surrender of Appomatox, until they heard of the war's end.

One of the few major battles in the region was the Battle of MINE CREEK, Kansas, October 25, 1864, when troops totalling 25,000 fought, and the Union won, saving Kansas from further threat of Confederate takeover. Kansas had another Civil War record. It could boast that it sent into wartime service the highest percentage of its population of any of the states.

Few other real battles occurred in the region. Much of the suffering of the region during the war was due to the often heartless and militarily useless attacks of guerrilla forces on the border between Confederate and Union states. These attacks are too numerous to be enumerated, but some deserve to be mentioned such as the one on September 12, 1861, at HUMBOLDT, Kansas. The town was ruthlessly sacked by Confederate guerrilla forces. The worst of these raids was carried out by the force led by William Clarke QUANTRILL on LAWRENCE, Kansas, August 21, 1863, when 150 innocent civilians were slaughtered and two hundred buildings devastated.

Oklahoma experienced twenty-eight military encounters during the war. The first of these has been known as the Battle of ROUND MOUNTAIN (November 19, 1861), near Keystone. In Texas, on December 24, 1862, GALVESTON was captured and held for a few months by the Union but retaken by the Confederates. For most of the war Union ships blockaded Texas ports and captured CORPUS CHRISTI briefly in 1862. However, after the Battle of MANSFIELD, Louisiana, in 1864 most of Texas remained in Confederate hands for the rest of the war.

New Mexico was proclaimed a part of the Confederacy in August, 1861. After the Battle of Valverde on Febrary 21, 1862, the Confederates captured ALBUQUERQUE. Union troops then retreated from SANTA FE, and the Confederates occupied the capital. However, Union forces were successful in the Battle of APACHE PASS near GLORIETA, as well as at Pigeon's Ranch. The Confederates abandoned Santa Fe on April 8, 1862, and after a skirmish at PERALTA, the war was over in New Mexico.

In the less settled areas of the Central West region, the Indians often took advantage of the absence of troops and the occupation of the government with the war in other areas, and there were many instances of Indian disturbances, particularly a general uprising in Kansas, which was not put down until 1867.

CLAREMORE, Oklahoma. City (pop. 12,-085). Seat of Rogers County, northeastern Oklahoma, northeast of TULSA and northwest of MUSKOGEE. The city was founded in 1889 and named for Clermont, a chief of the Osage. Rogers County was named for the father of Will ROGERS, Clem Rogers. Famous humorist, actor and journalist, Will Rogers liked to claim he was born "halfway between Claremore and Oolagah before there was a town at either place." Rogers' first appearance in show business occurred on July 4, 1899, in Claremore at a roping contest. On May 22, 1944, Oklahoma dedicated the Will Rogers Memorial at Claremore on a site where Rogers had planned to build a home. Both Rogers and his wife Betty are buried there. Claremore's J.M. Davis Gun Museum with 20,000 guns is one of the largest in the world. Twelve miles northwest, Will Roger's birthplace is preserved as a memorial. Several artesian mineral wells, considered beneficial to those suffering from arthritis, skin problems, or rheumatism, continue to maintain Claremore's reputation as a health resort.

CLARK FORK, COLUMBIA RIVER. Tributary of the Columbia River, rises near BUTTE, Montana and flows 449 miles to MISSOULA, Montana where it is joined by the BITTERROOT and BLACKFOOT rivers.

CLARK'S FORK, YELLOWSTONE RIVER. Rising in the Absaroka Range in southern Montana, it flows approximately 120 miles east through northwestern Wyoming and then north into the YELLOWSTONE RIVER in south central Montana.

CLARK, Tom Campbell. (Dallas, TX, Sept. 3, 1899—New York, NY, June 3, 1977). Supreme Court associate justice. After serving as attorney general (1945-1949), Clark was appointed to the Supreme Court by President Harry S Truman. Primarily a conservative, he was a moderate supporter of civil rights, but favored the government's position where national security or subversion were the principal issues. He often delivered minority opinions in cases where the liberal members prevailed. However, he joined in the unamimous vote to end school segregation in *Brown v Board of Education,* 1954. Clark retired from the bench in 1967, when his son Ramsey Clark (1927—) became United State attorney general.

CLARK, William. (Caroline County, VA, Aug. 1, 1770—St. Louis, MO, Sept. 1, 1838). Explorer and territorial governor. Clark, brother of Revolutionary War hero George Rogers Clark, was asked by Meriwether LEWIS to accompany him as joint leader of an expedition President Jefferson was sending to explore the area of the LOUISIANA PURCHASE. The LEWIS AND CLARK EXPEDITION left ST. LOUIS, Missouri, in 1804, reached the Pacific Ocean, and returned to St. Louis on September 23, 1806. Clark served as governor of the Missouri Territory from 1813 to 1821 after protecting the frontiers from Indian attacks during the War of 1812. Clark served as the U.S. superintendent of Indian affairs in St. Louis, from 1813 to 1838, and attempted to establish with Lewis Cass a permanent peace with the Indians in the Treaty of Prairie du Chien in 1825.

CLARK, William Andrew. (Fayette County, PA, 1839—New York, NY, Mar. 2, 1925). Industrialist and senator. Clark, once a storekeeper in Ophir City, Montana, became a leading merchant, banker and millionaire by the time he was thirty-three. Described as "detached, arrogant and uncompromising," Clark spent a fortune backing his choice of HELENA for the state's capital. In 1888, when he first openly expressed his desire to win a seat in the U.S. Senate, Clark was opposed by his perennial rival, Marcus DALY. This feud centered on the control of the Montana Democratic Party from 1888 to 1890, in the period when U.S. Senators were still selected by state legislatures. Charges that he spent $431,000 to bribe state legislators to choose him for the seat kept Clark from taking office in 1890. He tried for a Senate seat four more times before he was finally able to serve a full term as Senator from

1901 to 1907. The Corcoran Gallery in Washington, D.C. houses his collection of art.

CLAYTON, New Mexico. Town (pop. 2,968). Seat of Union County, northeast New Mexico, northeast of LAS VEGAS and Tucumcari, founded 1887 and named for Clayton Dorsey, son of Senator Stephen Dorsey of Arkansas. The town was so important on the cattle trails of the mid-1880s that the Denver and Fort Worth Railroad made it a division point. An unfortunate effect of the town's prosperity was the repeated appearance of criminals such as Black Jack Ketchum. Ketchum was hanged in Clayton on April 25, 1901, from a gallows surrounded by a stockade to prevent another escape. Ketchum urged the hangman to hurry up as, "I'm due in hell for dinner." He also requested to be buried face down. Clayton was also bothered in the late 1800s by a huge wolf which provided the basis for Ernest Thompson Seton's book *Lobo, King of the Currumpaw.* Clayton continues to be an important cattle town, but it is also the world's largest producer of carbon dioxide. Of special interest are the nearly 500 dinosaur tracks clearly visible on the spillway of Clayton Lake State Park.

CLEAR LAKE, South Dakota. Town (pop. 1,310), seat of Deuel County, northeastern South Dakota, southeast of Watertown and northeast of Brookings, settled 1880. To win the battle for the county seat both Clear Lake and Gary, South Dakota, built splendid courthouses. When Clear Lake won the contest, the building at Gary eventually became the State School for the Blind. Clear Lake was the home of South Dakota poet and artist Jean Wilson CHAMBERS.

CLIBURN, Van (Harvey Lavan, Jr.) (Shreveport, LA, July 12, 1934—). Concert pianist. He was taught the piano by his mother before attending the Julliard School in New York City, graduating in 1954. Van Cliburn became internationally famous four years later when he was the first American to win the International Tchaikovsky Piano Competition in Moscow. After recording and concert successes, he returned to Texas, living in semi-retirement and sponsoring the Van Cliburn contest, which attracts some of the world's finest young pianists. In 1989 he began a new series of concert appearances, including another tour of Russia.

CLIFF PALACE. The most noted and best preserved of all prehistoric ruins in the United

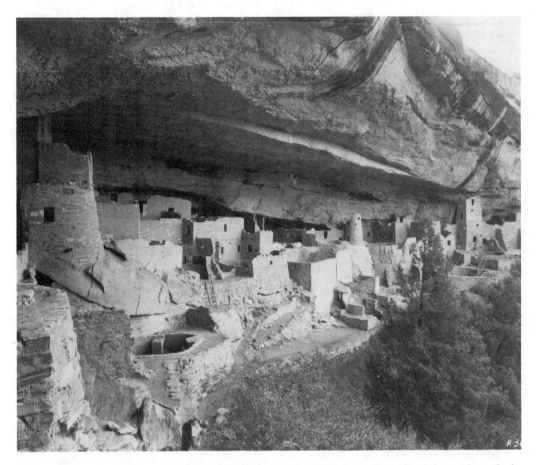

Mesa Verde National Park is noted for its pueblo remains. The Cliff Palace in its rocky cleft must be ranked among the principal prehistoric remains anywhere.

States. Cliff Palace, a 400 room apartment-like building, is part of southwestern Colorado's MESA VERDE NATIONAL PARK. It perches in a grotto 300 feet long and 100 feet high just beneath the mesa's rim. The outwardly sloping cave floor caused the builders to use terraces, creating six distinct floor levels. Despite their great age, dating from the 1200s, designs in bright red, made by mixing water and hematite, or red ochre on a white background, have remained to the present. The use of a round stone tower south of the palace center is still unknown.

CLIMAX MOLYBDENUM MINE. The world's largest underground mine. The mine, a gigantic operation that produces three-fifths of the free world's supply of molybdenum, a mineral used in the hardening of steel, is located in Lake County, Colorado.

CLINKER (scoria). A material found in the millions of tons in North Dakota and used in roads, sidewalks, and highway base material.

CLOUD PEAK. Highest point in the BIGHORN MOUNTAINS in northern Wyoming. Cloud Peak has an elevation of 13,175 feet.

CLOUDCROFT, New Mexico. Town (pop. 521), Otero County, south-central New Mexico, northeast of ALAMOGORDO and northwest of ARTESIA in a region first settled in the 1880s. Constructed beginning in 1947, Sunspot, the world's largest solar observatory, is located on SACRAMENTO PEAK, near Cloudcroft. Solar research conducted there is of great importance to the White Sands Missile Range and Holloman Air Force Base. The community also claims to have the nation's highest golf course—9,000

feet. Cloudcroft Ski Area and Lincoln National Forest attract thousands of visitors annually, contributing to the important tourist industry there.

CLUBB HOTEL. Astonishing establishment in tiny Kaw City, Oklahoma, owned by wealthy Laura Clubb and her husband who made their fortune from oil discoveries. Mrs. Clubb assembled one of the world's most unusual and valuable private collections of art, including works by Titian, Winslow Homer and Gainsborough, which she displayed lining the walls of the hotel.

COAHUILTECAN INDIANS. Group of Indian tribes located in Mexico and most of Texas west of the SAN ANTONIO RIVER and Cibolo Creek, of Coahuiltecan linguistic stock. In the early 1700s great numbers of them were gathered into missions but they rapidly declined and the tribes were all but lost by the late 1800s.

COAL. Among the Central West states, Wyoming is the only one in the top five in coal production, with 140,000,000 short tons. It ranks third among all the states. All the states of the region have reserves of coal, but the remoteness of these reserves has been a principal factor in keeping production down in the region, which remains too far from the eastern markets. In view of the continuing increased demand for coal, that situation is expected to change, with new delivery methods and updating of railroad delivery techniques.

COASTAL PLAIN. Geologic area of Texas in the Central West, stretching from the Gulf of Mexico to the BALCONES ESCARPMENT, where the CENTRAL PLAINS begin.

COASTLINE. Texas is the only Central West state with a coastline. Stretching for 367 miles, it is almost entirely protected from the Gulf of Mexico by a series of very narrow islands, such as PADRE ISLAND, and thin peninsulas. This provides sheltered passage for ships in the Intracoastal Waterway, which ends at BROWNSVILLE.

COCHITI PUEBLO. Indian community west of the RIO GRANDE RIVER near Domingo, New Mexico. The pueblo is noted for its Corn Dance held annually in early May. Visitors are welcome from sunrise to sundown. Photography is not permitted.

CODY, William Frederick (Buffalo Bill). (Scott County, IA, Feb. 26, 1846—Cody, WY, Jan. 10, 1917). Frontier scout and showman. Cody was a PONY EXPRESS rider (1860-1861), and he made the longest ride in history because his replacement had been killed. He then served as a government scout, guide and member of the 7th Kansas Cavalry from 1861 to 1865.

Cody began to earn his nickname when he was contracted to provide the Kansas Pacific Railway workers with all the buffalo meat required. In one eighteen month period, Cody killed 4,280 buffalo. When another buffalo hunter, Billy Comstock, claimed to have killed more bufalo, a contest was set up. The one who killed the most buffalo in a given time period would receive $500 and the title of Buffalo Bill. Cody killed sixty-nine, to forty-six for Comstock, earning Cody the nickname for which he is remembered.

Between 1868 and 1872 Cody acted as a government scout and guide in operations against the Cheyenne and Sioux. Cody served as a member of the Nebraska Legislature in 1872 before joining the 5th Cavalry as a scout.

Late in 1872 he made his first appearances as a showman. He had a leading role in the play *Scouts of the Prairies*, but always returned to the plains to scout. In 1876 at the battle of Indian Creek he killed and scalped the Cheyenne Chief Yellow Hand in a famous duel.

In 1883 Cody formed the Buffalo Bill's Wild West Circus Show, which toured the United States and Europe, staging mock battles with Indians and giving Cody ample opportunity to demonstrate his skill with guns. They performed before crowned heads, including Queen Victoria, who loved the "bucking ponies." In the 1890s Cody retired to a life of ranching in northwestern Wyoming. He is buried on LOOKOUT MOUNTAIN, near GOLDEN, Colorado.

CODY, Wyoming . City (pop. 6,790), seat of Park County in northwest Wyoming, northeast of JACKSON and southwest of Powell. Famous frontiersman and showman William F. CODY founded the city bearing his name in 1897. He built the Irma Hotel, named for his daughter, and used the community for the start of many hunting expeditions into the area. Cody was one of the first western towns to capitalize on the lifestyle of the West. The Eaton brothers opened a DUDE RANCH, and the community became a vacation center, taking advantage of its location near the east entrance to YELLOWSTONE NATIONAL PARK, and Shoshone National Forest.

Colorado

Counties and County Seats

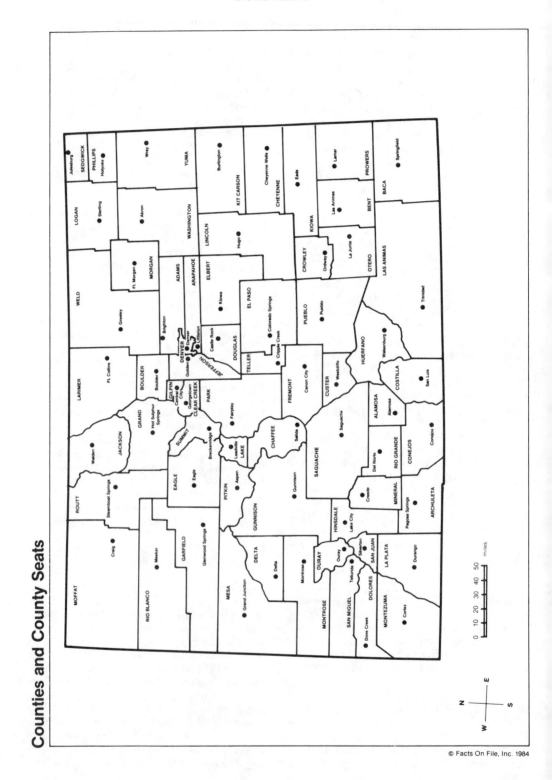

Colorado

STATE OF COLORADO

Name: Colorado from the Colorado River which is Spanish for the river's reddish-brown color.

Nickname: Centennial State

Capital: Denver, founded 1858

Motto: "Nil Sine Numine" (Nothing Without Providence)

Symbols and Emblems:

Bird: Lark Bunting
 Flower: Rocky Mountain Columbine
 Tree: Colorado Blue Spruce
 Stone: Aquamarine
 Animal: Rocky Mountain Bighorn Sheep
 Colors: Blue and white
 Song: "Where the Columbines Grow"

Population:

1985: 3,231,000
 Rank: 26th
 Gain or Loss (1970-80): +680,000
 Projection (1980-2000): +1,768,000
 Density: 31 per sq. mi.
 Percent Urban: 80.6% (1980)

Racial Makeup (1980):

White: 88.9%
 Black: 3.5%
 Hispanic: 339,717 persons
 Indian: 18,100 persons
 Others: 216,517 persons

Largest City:
 Denver (505,000-1986)

Other Cities:
 Colorado Springs (272,000-1986)
 Aurora (217,990-1986)
 Lakewood (122,140-1986)
 Pueblo (101,240-1986)

Area: 104,091 sq. mi.
 Rank: 8th

Highest Point: 14,433 ft. (Mt. Elbert)

Lowest Point: 3,350 ft. (Arkansas River)

H.S. Completed: 78.6%

Four Yrs. College Completed: 23%

STATE GOVERNMENT

Elected Officials (4 year terms, expiring Jan. 1991):
 Governor: $70,000 (1986)
 Lt. Gov.: $48,599 (1986)
 Sec. Of State: $48,500 (1986)

General Assembly:
 Meetings: Annually in Denver
 Salary: $17,500 (1986)
 Senate: 35 members
 House: 65 members
 Congressional Representatives
 U.S. Senate: 2, Terms expire 1991, 1993
 U House of Representatives: Six members

Colorado Lakes

Major Rivers and Drainage System

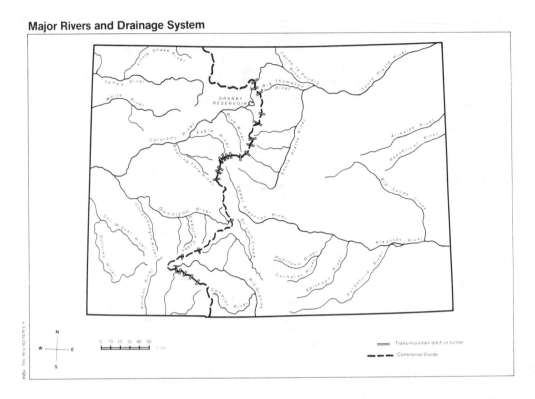

COLORADO. State, located in south central United States. Colorado is one of the two states which have completely artificial boundaries with no twists or jogs and have perfectly straight border lines. Kansas, to the east, Nebraska to the Northeast, Wyoming to the north, Utah to the west and New Mexico to the south are the neighboring states. There are, of course, no border rivers.

Outstanding natural feature is the vast bulk of the ROCKY MOUNTAINS, which reach their highest and broadest mass in the state. Switzerland could be engulfed six times over in the Colorado Rockies, rooftop of the nation. The average elevation of 6,800 feet is the highest in the U.S. Of the nation's mountains higher than 14,000 feet, over half are found in Colorado. The central portion of the state is occupied by one great range after another.

The HIGH PLAINS REGION of the east, covering about a third of the state, rises gradually to the west until it encounters the barricade of the great FRONT RANGE. Most of the state's population lives to the east of this massive wall, concentrated in a line from north to south. The mountains rise on either side of the great divide, covering about the middle third of the

state, and the last third is the land of high mesas.

Among the unusual natural features, GRAND MESA is unique. It is thought to be the largest flat-top mountain in the world. This level table land, averaging 10,500 feet in height, covers 625 square miles.

Three major divides send the waters of the state into three of the major rivers of the nation. Two of these, the COLORADO and the RIO GRANDE, originate in Colorado. The Colorado begins in tiny GRAND LAKE and flows westward across the state toward Pacific waters, ending eventually in the Gulf of California. The Rio Grande originates in southwestern Colorado and leaves almost at the center of the state, ending its flow in the Gulf of Mexico. Two major branches of the Mississippi River system originate not far from each other near LEADVILLE. The SOUTH PLATTE flows northeastward across much of the state, following its shallow winding course ending in the MISSOURI and then to the Mississippi, while the ARKANSAS crosses most of southeast Colorado, on its distant course also to end in the Mississippi.

The natural lakes are modest. Lake Granby on the Colorado, John Martin Reservoir on the

Arkansas and Blue Mesa Reservoir on the Gunnison are the major artificial lakes.

With an area of 104,091 square miles, Colorado is fourth in size in the region.

Despite the cold winters, the climate of Colorado has long beckoned to health seekers, drawn by the quality of the air. That quality has been compromised in cities such as Denver, where smog and air pollution are a major problem. However, as a whole, the state averages almost 3,000 sunny hours per year. The cities lying at the foot of the Front Range are greatly affected by the strong winds which often sweep down from the mountainsides, sometimes bringing summerlike weather in winter, along with other dramatic changes. The state's temperature range of 179 degrees is one of the most extreme of all the states. The lowest temperature ever recorded in Colorado was 61 degrees below zero, the highest 118 degrees.

Geologically, the early Cambrian period found northern Colorado mostly covered by plains, with some central mountains. In the Ordovician period, most of the present state lay under shallow seas. Silurian times brought a vast mountain range running diagonally from southwest to northeast. During most of the Mesozoic era, much of the state was again covered by shallow seas. The Cenozoic era found the state beginning to take its present shape, particularly as the Rocky Mountain uplift gained momentum.

The sedimentary rocks of eastern Colorado are the inheritance of the Cenozoic and Mesozoic eras. Western Colorado has much the same geologic makeup. Most of the central mountain area has been built from the igneous metamorphic and volcanic rocks from pre-Cambrian to Cenozoic periods.

Remains of early animals are preserved in some of the finest fossil beds anywhere. DINOSAUR NATIONAL MONUMENT has disclosed the bones of almost every type of dinosaur known.

Due to the sweeping changes over the eons, Colorado has inherited a wealth of minerals, which have been the source of much of the state's commerce. The world receives sixty percent of its molybdenum from Colorado, along with a large percentage of the vanadium. The state has the country's largest reserves of coal. The vast shale beds contain enough oil to fuel the world for decades, but commercial development is not yet practical. The mineral wealth has spurred Denver on to become the world's largest producer of mining equipment and machinery. Milling and smelting continue to be important.

Livestock brings the greatest agricultural income, and GREELEY has the world's largest livestock feed lots. However, in the Central West region the state only ranks third in value of agricultural product, behind Texas and Nebraska. Principal products are cattle, wheat, corn and diary products.

Manufacturing brings in almost as much income as all the other Colorado commercial activities combined. In the Central West, Colorado ranks second in manufacturing, but a far second, to Texas. Principal products are machinery, instruments and food.

Service ranks second to manufacturing in Colorado's income, again ranking second only to Texas in the region.

Surprisingly, minerals are last among Colorado's income producers, ranking fifth in a region of vast mineral wealth. Petroleum, natural gas and coal are the leading mineral products. Not surprisingly, tourism is the third largest income source in Colorado, making it second to Texas in the region.

In population Colorado ranks third among the states of the Central West, with a 1984 total of 3,178,000. By the year 2000 the population is expected to reach 4,657,000, an increase of 24 percent. The population is predominately white. The small Hispanic population is concentrated in the southern area. Only 2,427 Indians are listed in the 1980 cencus.

PREHISTORIC PEOPLES may have been in present Colorado as early as 30,000 years ago. Their weapons points, found among the remains of very early animals, indicate that the two earliest groups existed at the same time. Later the BASKETMAKERS dominated the region.

The best known of all the prehistoric dwellings in the United States was discovered in 1888 by Charlie Mason and Richard Wetherill. This was the CLIFF PALACE in what is now MESA VERDE NATIONAL PARK. This community was the work of the PUEBLO PEOPLE who came to the area in about 800 AD. They built durable structures of adobe, many of them placed high in openings in the cliffs, to ward off attack. Growth of their crops was assisted by ingeneously engineered irrigation systems, and their ruins evidence many other skills. They began to die out starting, apparently, with the drouth of 1276.

By the time the first Europeans became acquainted with the region the UTE INDIANS were the dominant group. Later came such successive groups as ARAPAHOE, CHEYENNE, KIOWA and COMANCHE. These PLAINS INDIANS were wanderers, very seldom building permanent homes.

In 1694, Diego DE VARGAS searched for runa-

Colorado Civil War

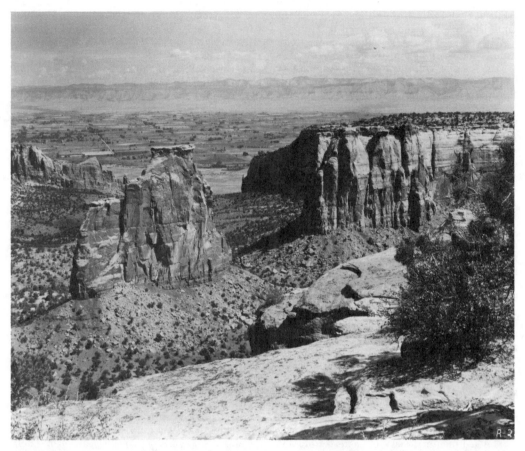

Although not the best-known, Colorado National Monument near Grand Junction, Colorado, with its Independence Rock, above, can hold its own with the many other scenic attractions of the state.

way slaves in the area. Before long, missionaries, trappers and explorers from Mexico visited the region, which Spain claimed. When the U.S. purchased LOUISIANA TERRITORY, Zebulon PIKE explored the area in 1806, proclaiming that the peak named for him would never be climbed.

When the Pike party of explorers entered SAN LUIS VALLEY, they were arrested by Spanish authorities for trespassing becauses that region was still claimed by Spain. They were later released. When Mexico became independent, the new rulers encouraged trade with the U.S. and thousands of traders passed over the SANTA FE TRAIL, which cut across southeastern Colorado. They were followed later by more thousands of gold seekers and settlers. The Mexican claims to a part of Colorado were given up in the Treaty of GUADALUPE HIDALGO, which ended the WAR WITH MEXICO.

FORT BENT, first permanent U.S. outpost in Colorado, was established near present LA JUNTA

in 1828 by the firm of BENT AND ST. VRAIN. First northern outpost was Fort Lupton, in 1837. Fort St. Vrain was established by 1838 and soon was the center of trading activity.

Jim BECKWOURTH founded PUEBLO in 1842. By 1850 the state had gained its present boundaries, and Denver was founded in 1858, the same year that rumors of gold brought thousands to CHERRY CREEK, chanting the slogan "Pikes Peak or Bust." There was little gold there, but a year later John GREGORY found the "Richest Mile on Earth," where the boom town of CENTRAL CITY was founded.

The CIVIL WAR did not come directly to Colorado, but it brought disturbances among Union and Confederate sympathizers and numerous Indian attacks. When government forces massacred 500 Indians, fierce reprisals followed, until the Indians were finally subdued and moved to Oklahoma. President Johnson vetoed two statehood bills, but statehood

finally came in 1876, arriving just in time to make Colorado the "Centennial State." Just as gold was dying out, the silver of LEADVILLE brought another boom; then gold once more lured the fortune hunters to CRIPPLE CREEK. Uprisings by the Ute Indians were finally put down in 1887.

Women were given the vote in 1895, and the Democratic National Convention met at Denver in 1908. WORLD WAR I, floods at Pueblo, robberies at the Denver mint, duststorms and the great depression followed.

In 1965 CHEYENNE MOUNTAIN became headquarters of the NORTH AMERICAN AIR DEFENSE COMMAND, with its continent-wide responsibilities.

The growth and expansion of Denver, with vast new building projects, and the establishment of many new corporate headquarters highlighted recent developments in Colorado.

The mining tycoons who made their fortunes in Colorado have provided some of the nation's most colorful personalities. H.A.W. TABOR (1830-1899) made his killing, became a politician and state leader, divorced his first wife and married Elizabeth "Baby Doe" McCourt who helped run through his fortune. After Tabor died, Baby Doe continued to live on in a shack on their remaining claim, hoping it would make a comeback, but she died almost penniless in the shack in 1935.

The life of Spencer PENROSE (1865-1939) was far different. His Cripple Creek fortune was wisely invested. He built the BROADMOOR HOTEL at COLORADO SPRINGS, still one of the nation's finest resorts, financed the PIKES PEAK road, constructed the SHRINE TO THE SUN in memory of Will ROGERS, and founded the CHEYENNE MOUNTAIN ZOO.

Thomas F. WALSH lost one fortune and made another at Leadville and passed his fortune on to his daughter, the famous society leader Evelyn Walsh MC LEAN. Perhaps most successful of all was the "Midas of the Rockies," Samuel NEWHOUSE (1853-1930).

Famed newspaperman Horace GREELEY (1811-1872) took his own advice to go West and founded the community of GREELEY, Colorado. David MAY of department store fame, George ENGELMAN (1809-1884) of Engelman spruce fame, novelist Helen Hunt JACKSON, (1830-1885) Poet Eugene FIELD 1850-1895), artist Albert BIERSTADT (1830-1902), all were associated with Colorado.

Kit CARSON (1809-1868), noted frontier scout, William "Buffalo Bill" CODY (1846-1917), Jazz King, Paul WHITEMAN (1890-1967), heavyweight

The Capitol at Denver

champion Jack DEMPSEY (1895-1983), newsman Lowell Thomas (1892-1981) and astronaut Scott Carpenter (1925-) have had Colorado connections.

The visitor to Colorado today is apt to start from Denver, a city which has sprouted so many mighty skyscrapers, great shopping malls, convention centers and other recent developments that residents of only a few years back would find it difficult to recognize. Most visitors to the state capitol pause at the thirteenth stair on the capitol steps, exactly a mile high. Larimor Square, the home of the Unsinkable Molly Brown, mile-long Sixteenth Street Mall, the 80-million dollar performing arts center, with its DENVER SYMPHONY, the Denver Mint, Museum of Western Art and RED ROCKS PARK AND AMPHITHEATRE near Denver all have their attractions for the hordes of visitors.

From Denver the visitor might go to storied CENTRAL CITY, a National Historic District which looks much as it did a hundred years ago. The historic old opera house is still used for performances. The road to the top of MT. EVANS is the highest paved road in the U.S. and second highest in the world. The victorian buildings of GEORGETOWN are a great tourist drawing card as is the Georgetown Loop Railroad.

The Great Circle Route from Denver into ROCKY MOUNTAIN NATIONAL PARK, up over TRAIL RIDGE ROAD, the world's highest major highway,

charming ESTES PARK Village, beautiful GRAND LAKE are all within a day's drive, circling back to Denver.

Another excursion of a day or two will take the visitor to the attractions of the Colorado Springs area: the town itself, Pikes Peak, GARDEN OF THE GODS, CAVE OF THE WINDS, WILL ROGERS SHRINE, the historic mining town of CRIPPLE CREEK and the AIR FORCE ACADEMY are all nearby magnets.

Pueblo, and its state fair, CANON CITY with nearby gorge of the Arkansas River, with the bottom reached by the world's steepest incline railroad, are other attractions.

Central Colorado offers the mineral waters of GLENWOOD SPRINGS, with the largest natural hot springs swimming pool, the resplendent ski resort of ASPEN with its educational activities and cultural festivals and "lives of the rich and famous," Leadville with its Tabor Opera House and memories of Baby Doe Tabor, the community of Climax which produces three-fifths of the world's MOLYBDENUM and the resort community of VAIL.

Southwest Colorado provides the spectacle of the Pueblos of Mesa Verde and the pit dwellings of the Basketmakers. Other Colorado attractions include the narrow-gauge railroad to SILVERTON, GREAT SAND DUNES NATIONAL MONUMENT, BLACK CANYON OF THE GUNNISON NATIONAL MONUMENT and DINOSAUR NATIONAL MONUMENT , with its enormous collection of prehistoric animal relics.

The size and beauty of the Colorado columbine, make it, perhaps, the most outstanding of all the state flowers.

COLORADO BLUE SPRUCE. Official state tree of Colorado. This beautiful member of the pine family with its silvery blue-tipped needles, rises spectacularly among the greener evergreens. It is particularly numerous in Colorado.

COLORADO CITY, Colorado. Now is a part of COLORADO SPRINGS, but was founded as El Dorado City in 1859 by gold hunters from Kansas. The site, planned the year before or a town to be called El Paso, was soon renamed Colorado City. By 1861 more than three hundred cabins had been built along Fountain Creek, but by 1912 the mines had run their course, and the mills were closed or torn down, the population dwindled, and in 1917 the community, described as a forlorn little industrial town, was absorbed by thriving Colorado Springs to the east and renamed West Colorado Springs.

COLORADO COLLEGE. Publicly supported four-year institution of higher learning located in COLORADO SPRINGS. Colorado College grants a Bachelor's degree and a Master of Arts in Teaching degree. A cooperative program with the Whitney Museum of American Art provides eligible students the opportunity for independent study in New York. Cooperative programs also exist with Columbia University, Rensselaer Polytechnic Institute and the University of Southern California. Colorado College is part of a thirteen liberal arts college consortium known as the Associated Colleges of the Midwest. Through the consortium, students of Colorado College may participate in a variety of programs in the United States. During the 1985-1986 academic year Colorado College enrolled 1,906 students and employed 175 faculty members.

COLORADO COLUMBINE. State flower, selected by schoolchildren of Colorado in 1891, the columbine displays showy blue blossoms sometimes two or three inches in diameter. Known as Aquilegia coerulea, the flower was not discovered until 1820. It lives in shady woods of pine and spruce in the mountains and may reach a height of three feet.

COLORADO NATIONAL MONUMENT. Sheer-walled canyon, towering monoliths, weird formations, dinosaur fossils and remains of prehistoric Indian cultures reflect the environment and history of this colorful sandstone country, proclaimed as a national preserve May 24, 1911 and headquartered at Fruita, Colorado.

COLORADO PLATEAU PROVINCE. Region in northwestern New Mexico, marked by wide valleys and plains, deep canyons, rugged, lonely, flat-topped mesas, and sharp cliffs. Unique SHIPROCK, a 1,678 foot outcropping, resembling a ship in full sail, has been a San Juan County landmark for hundreds of years. South of San Juan basin lies the malpais, a forty-mile strip of badland with extinct volcanoes and lava plains. Split by the CONTINENTAL DIVIDE, streams on the plateau flow toward both the Pacific Ocean and the Gulf of Mexico.

COLORADO RIVER (Texas). River providing the primary drainage system for the entire central section of Texas, a region as large as Tennessee. Rising in the LLANO ESTACADO, or Staked Plains, the waterway proceeds southeast about 840 miles to empty into the Gulf of Mexico at MATAGORDA BAY. AUSTIN lies on its banks, and six artificial lakes, including Buchanan and Travis, are impounded by it, providing irrigation and hydroelectric power.

COLORADO RIVER. (Colorado) Majestic river of the southwestern United States. The Colorado passes through the Grand Canyon and Black Canyon as it travels a course from its source in GRAND LAKE in northern Colorado's Grand County for 1,450 miles to its mouth in the Gulf of California. Among its tributary rivers in the region are the GUNNISON, GREEN, SAN JUAN, and LITTLE COLORADO. The Colorado passes through parts of Colorado, Utah, Arizona and Mexico. It marks part of the boundary between Arizona and Nevada and the entire Arizona-California boundary.

COLORADO SCHOOL OF MINES. Oldest institution in the United States devoted exclusively to educating mining engineers. The school was founded in 1874 and is located in GOLDEN. Its ore collection is said to be one of the three finest in the world, with 11,277 items. The school's library houses one of the largest and most complete specialized collections in the West. An academic novelty reflecting its mining interests—graduation diplomas have been made of silver on which the certificate has been engraved. During the 1985-1986 academic year the school enrolled 2,758 students and maintained a faculty of 210.

COLORADO SPRINGS, COLORADO

Name: From the State of Colorado and from all the mineral springs in the area.

Nickname: Newport of the West; Little Lunnon (London); City of Sunshine.

Area: 135.7 square miles

Elevation: 6,008 feet

Population:
1986: 272,000
Rank: 57th
Percent change (1980-1984): +15.2%
Density (city): 1,826 per sq. mi.
Metropolitan Population: 349,000 (1984)
Percent change (1980-1984): +2.8%

Race and Ethnic (1980):
White: 87.90%
Black: 5.56%
Hispanic origin: 18,268 persons (8.49%)
Indian: 1,100 persons (0.51%)
Asian: 3,144 persons (1.46%)

Age:
18 and under: 28.3%
65 and over: 8.3%

TV Stations: 13

Radio Stations: 15

Hospitals: 6

Sports Teams:
Colorado Springs Sky Sox;(baseball)

Further Information: Colorado Springs Chamber of Commerce, P.O. Drawer B, Colorado Springs, CO 80901.

COLORADO SPRINGS, Colorado. City, nestled at the foot of mammoth PIKES PEAK on Fountain and Monument creeks, named for the many mineral springs of the region. Nearby communities are Fountain, MANITOU SPRINGS and the neighbor to the north, the AIR FORCE ACADEMY.

Described as "a beautifully maintained garden spot," the city has been known for its stimulating air and the wide variety of mountain attractions within a few miles of city center, making it one of the nation's major tourist meccas. However, the community is diverse in its interests, with a wide variety of industrial products to add to the tourist income. Just south of the city, the NORTH AMERICAN AIR DEFENSE COMMAND (NORAD) brings American and Canadian servicemen and women to the area and heightens the military flavor.

The city began in 1859 as a mining community on Fountain Creek, first known as El Dorado and then Colorado City. Nearby, in 1870, General William PALMER brought the DENVER AND RIO GRANDE RAILROAD to establish the modern city, then known as Fountain Colony, as a tourist resort. The name was soon changed to Colorado Springs, to emphasize the supposedly curative waters of the area. As the resort and health spa grew, Colorado City was absorbed in 1917.

The huge mass of Pikes Peak calls so forcefully that most tourists feel compelled to make the ascent to the top, defying the prediction of the discoverer, Zebulon PIKE, that it could never be climbed. The easy way to reach the summit is by car or, more vertically, up the famed COG RAILROAD. Hiking and horseback are other means of ascent. Most visitors agree that grand view of the enormous expanse of Colorado on all sides is worth the ascent, by whatever method. This was the view which inspired Katherine Lee BATES (1859-1929)to write "America the Beautiful" (1895).

Another "must" attraction is the GARDEN OF THE GODS, a city park and a Registered National Landmark, a region of fantastically formed rocks, carved by nature from the red sandstone of the area. Another nearby natural attraction is Seven Falls, with its seven sections of falling water.

The Broadmoor-CHEYENNE MOUNTAIN area offers many attractions, including the zigzagging highway up the mountain, where the zoo and SHRINE TO THE SUN, a memorial to will ROGERS, are major attractions. The BROADMOOR HOTEL resort is considered one of the outstanding of its kind in the world.

Pikes Peak Ghost Town is a most authentic revival of the Old West. Other city attractions include the Pro Rodeo Hall of Champions and Museum of the American Cowboy, White House Ranch Historic Site, a working ranch of 1895, and the Wildlife World Museum.

Easter Sunrise at Gateway Rocks and Pikes Peak Auto Hill Climb are noted annual events. Few visitors miss the opportunity to see the Air Force Academy a few miles to the north. Most are anxious to visit the Academy's renowned ultra modern chapel. Cadet parades provide a colorful spectacle for visitors and may be viewed, as scheduled. There are guided mini-tours.

COLORADO STATE UNIVERSITY. Chartered at FORT COLLINS in 1870, Colorado State College was opened to students in 1879, spe-

cializing in agriculture. It gained its present title in 1957. Among the several other specialties, the Hydraulic Laboratory is one of the best known. Research at the laboratory focuses on river projects, such as new dams. Also located at the university are the Rocky Mountain Forest and Range Experiment Station and Colorado State Forest Service Headquarters. The student body of 18,084 is instructed by 1,101 faculty.

COLORADO, UNIVERSITY OF. Publicly supported university founded in 1876 and located in BOULDER. Branches of the university are operated at COLORADO SPRINGS and DENVER . The Colorado Springs branch, with a campus of eighty acres, was a gift of the Cragmor Foundation. Classes in Colorado Springs began in 1965. The Denver branch was founded in 1912 as an extension division, but was given status as a separate campus in 1972. During the 1985-1986 academic year, the campuses enrolled 61,502 instructed by 4,675 faculty.

COLORADO YULE MARBLE. Type of stone found near MARBLE, Colorado. Colorado Yule Marble was used in the construction of the Lincoln Memorial in Washington, D.C., and other notable structures.

COLTER, John. (Staunton, VA, 1775—Dundee, MO, Nov., 1813). Trapper and explorer. After leaving the LEWIS AND CLARK EXPEDITION, in 1807 Colter was the first explorer to cross the passes at the head of WIND RIVER; the first to see the headwaters of the COLORADO RIVER, the TETON MOUNTAINS, JACKSONS HOLE, and the sources of the SNAKE RIVER; the first to explore the valley of the BIGHORN RIVER; and the first to pass through a region then known as "Colter's Hell" and now known as YELLOWSTONE NATIONAL PARK. It is perhaps for his remarkable escape from the BLACKFOOT INDIANS in 1808 that he is best remembered. Colter eluded hundreds of Indians who had stripped him of his clothes and weapons and made him run for his life. After outrunning all his foes, he traveled in rugged territory for seven days to elude his captors, eating only roots. In 1810 he returned to St. Louis where his stories of the Yellowstone region were met with ridicule. When Colter died of jaundice he was buried in a graveyard on what is today called Tunnel Hill, near Dundee, Missouri. The Missouri Pacific Railroad, unaware of the forgotten graves, dug up the hill to lay their tracks. Thus there is no graveside monument to this pathfinder of the West.

COLUMBUS, Nebraska. City (pop. 17,328). Seat of Platte County, east-central Nebraska, northwest of LINCOLN and west of FREMONT, at the confluence of the Loup and Platte rivers. The city was incorporated in 1857 and named for Columbus, Ohio. It is a center of electrical power distribution through the Loup River Power Project. There is varied manufacturing and processing and distribution of crops and livestock of the surrounding area. On August 14, 1720, near the present site of Columbus, a Spanish force under the command of Pedro de Villasur was attacked by PAWNEE INDIANS, aligned with the French. Villasur and a large number of his men were killed, ending Spanish attempts to drive the French out of what is now Nebraska.

COLUMBUS, New Mexico. Village. Luna County, southwestern New Mexico, south of DEMING and southeast of Lordsburg. On March 9, 1916, Mexican revolutionary Pancho VILLA and an estimated one thousand guerrillas raced across the boundary between the United States and Mexico and attacked Columbus. Eighteen Americans were killed and homes were destroyed. Mementos of the raid are displayed in the Columbus Historical Society's Museum in the restored depot of the Southern Pacific. A few of the buildings used by General John PERSHING to prepare to hunt Villa are preserved in Pancho Villa State Park.

COMANCHE (horse). Sole survivor of the American forces at the Battle of LITTLE BIGHORN. After General George Custer's defeat there (June 24, 1876), Comanche was brought to FORT MEADE, South Dakota, where he lived for many years.

COMANCHE INDIANS. Shoshonean tribe which migrated from Wyoming to the southern plains by the late 18th century. By 1700 the Comanche ranged from the Platte to the headwaters of the ARKANSAS RIVER. The name Comanche was derived either from a UTE term meaning "enemy" or the Spanish term camino ancho meaning "broad tail." The Comanche called themselves Numinu, meaning "the people."

They were loosely organized into thirteen autonomous bands which cooperated with each other, but over which there was no overall chief or council. Polygamy was practiced, especially of the men marrying sisters or a brother's widow.

Artist George Catlin captured the fierce warfare of the Comanche.

Although their lifestyle was generally similar to those of the other plains Indians, some aspects of their lives should be mentioned. The Comanche ate neither coyote nor dog, believing that both shared a special relationship with the tribe, nor did they perform the Sun Dance, which was popular with other plains tribes. However, they did participate in an Eagle dance and Beaver ceremony.

The Comanche believed in an afterlife for everyone except those who were scalped, strangled, died in the dark or were drowned. Mourners dressed the deceased in his best clothing, painted his face vermilion and sealed the eyes with red clay. The body was placed in a flexed position in a shallow grave, cave, or crevice after which the mourners gave away their possessions, burned the tipi of the deceased and never spoke the person's name again.

They became skilled horsemen, and eventually built up large herds. By 1790 the Comanche and the KIOWA had become raiding partners. Pressure on the Comanche and the Kiowa and the promise of fresh targets in Texas and Mexico caused the Comanche to move farther south during the early 1800s.

The Comanche maintained a good relationship with the SHOSHONE even after moving south to the NORTH PLATTE RIVER in the late 1600s, but the Comanche and APACHE were often at war. Despite the war losses, the size of the tribe remained fairly constant due to the practice of adopting captive women and children, both Indian and white. The most punishing wars against the Comanche were organized by Texans who were determined to rid their lands of all Indians. During the CIVIL WAR, when both sides needed the support of the Indians, these white raids on the Indians ended. An attempt in 1864 to raid the land of the Comanche was a total failure.

In 1865 the Comanche and Kiowa signed a treaty on the Arkansas River with the United States government, in which they reserved a large section of western Oklahoma for themselves. However, the whites failed to live up to their promises. Government promises again were broken after the 1867 Medicine Lodge Treaty, in which the government had promised to keep squatters off Indian land. The disillusioned Indians continued hostilities until 1875 when Quanah PARKER and his band surrendered.

Reservation lands of 160 acres were allotted to each tribal member in 1892. In the 1970s the Comanche were part of the Kiowa-Comanche-Apache Intertribal Business Committee. Many Comanche live in the Oklahoma cities of ANADARKO, Apache, Hogart, CACHE, and Mountain View.

COMANCHE SPRINGS. One of the world's largest artesian springs, located near FORT STOCKTON, Texas.

COMMAND AND GENERAL STAFF COLLEGE, United States Army. Considered the world's finest senior tactical school for advanced military education. The college was established at FORT LEAVENWORTH, Kansas, by the order of General William T. SHERMAN (1820-1891) in 1881. Officer- students number 993, instructed by a staff of 711.

COMO BLUFF. Site of the first discovery of a complete dinosaur fossil in the Rocky Mountain area, near MEDICINE BOW, Wyoming. The presence of the rich fossil site was known as early as 1877. Since 1880, fourteen other similar skeletons have been removed from the fossil beds there.

COMPROMISE OF 1850. Last of three great compromises authored by Henry Clay. In the Central West region the act provided for the division of the Mexican Cession into the territories of New Mexico and Utah, based on the principle of popular sovereignty and reduction in the size of the state of Texas. Texas received a payment of ten million dollars as compensation for its war debt, accrued prior to 1845. The act further provided for the admission of California as a free state, the abolition of the slave trade in the District of Columbia, and a stricter fugitive slave law.

COMSTOCK, Henry Tompkins Paige. (Trenton, Ontario, Canada, 1820—Bozeman, MT, Sept. 27, 1870). Prospector. Active in Nevada between 1856 and 1862, Comstock was the discoverer of the Comstock Lode, at Virginia City, Nevada, one of the richest mineral deposits in the world in 1858, and the founder of the Ophir Mine which produced hundreds of thousands of dollars in silver. After he had spent the $10,000 he received for the Comstock Mine, he fled to Montana and took his own life at BOZEMAN.

CONCORDIA TEACHERS COLLEGE. One of thirteen colleges owned and operated by the Lutheran Church—Missouri Synod. The college, located in Seward, Nebraska, was founded in 1894 as a preparatory school and became a

four-year teachers' college in 1939. During the 1985-1986 academic year the college enrolled 858 students and employed 87 faculty members.

CONFEDERATED TRIBES OF FLATHEAD. Group of Indian tribes which included the KALISPEL, Kootenai and SALISH.

CONLEY, Lydia. (Kansas City, KS, 1874—Kansas City, KS, May 28, 1946). Wyandotte Indian advocate. Lydia Conley became a nationally known advocate of Indian rights through her efforts and those of her two sisters to retain the ancient Wyandotte burial place in KANSAS CITY, Kansas. Because the Indian cemetery lay in the heart of the fast growing city, business interests there wanted to remove it and build city structures.

Lydia Conley led her two sisters to the cemetery where they padlocked the cemetery gates and built a crude six by eight foot shack near their parents' burial site and called it "Fort Conley." There they held out from 1907 until 1911. Meanwhile, Lydia studied law and found that at that time any citizen was permitted to appear before the U.S. Supreme Court and argue a case in which a direct interest was involved.

Lydia reviewed the legal ramifications and on January 15, 1910, she became the first woman to argue a case before the U.S. Supreme Court, a notable case reported at length in the Kansas City *Star* of that date. The court responded by prohibiting Congress from taking any action to seize the Wyandotte property.

Mainly becase of Lydia Conley's efforts the Wyandotte cemetery has been preserved as a part of Huron Park and has become one of the city's most popular tourist attractions.

CONNALLY, John Bowden. (Floresville, TX, Feb. 27, 1917—). Politician. Connally was twice elected governor of Texas (1963-1969), and was Secretary of the Navy under President John Kennedy (1961-1962). He was seriously wounded in Dallas during the shooting that claimed President John F. Kennedy's life on November 22, 1963. Under President Richard Nixon, he was secretary of the treasury (1970-1971). Originally a conservative Democrat, Connally joined the Republican party in 1975. Ambitious for the Republican presidential nomination in 1976, he failed to reach that goal, and he retired to private life. His investments in real estate toppled during the decline of

Texas oil fortunes in the 1980s, and he entered bankruptcy in 1988.

CONQUEROR'S STONES. Two large slabs of rock now displayed in Mobridge, South Dakota. According to legend, Indian chiefs defeated in battle were made to kneel on the stones with their hands in the hand-shaped grooves to indicate their complete submission to their captors.

CONTINENTAL DIVIDE. The crest of land which separates waters flowing west from those flowing east or north. This watershed, also known as the Great Divide, runs south and southeast from northwestern Canada across the western United States, then through Mexico, Central America and South America. In the United States the line may be considered to coincide for much of its length with various ranges in the ROCKY MOUNTAINS. In North America, the central point of the Continental Divide lies in Colorado, where it cuts the crests of many mountains higher than 13,000 feet. Entering from Canada at the Montana border, the Continental Divide takes a tortuous journey across western Montana finally reaching the crest of the BITTERROOT RANGE, which it follows to the border of Wyoming at the west edge of YELLOWSTONE NATIONAL PARK. It cuts across the park and much of western Wyoming following the WIND RIVER RANGE for much of the way until it makes a unique split, forming the GREAT DIVIDE BASIN into which waters are trapped and do not flow to any ocean.

Crossing into Colorado, the Continental Divide continues along the crests of the many ranges, following a snaking course into New Mexico, where it angles to the west and meanders across the western part of the state to enter Mexico at the very southwest corner of New Mexico.

Two Ocean Pass in Wyoming has been called "the most remarkable example...in the world" of two streams which form less than a quarter of a mile apart, yet send their waters to two different oceans.

COOLIDGE, CALVIN, IN THE CENTRAL WEST. (Plymouth Notch, VT, July 4, 1872—Northhampton, MA, Jan. 5, 1933). President of the United States. In 1927 the Coolidge family made a trip to the BLACK HILLS of South Dakota for a summer vacation. On August 2, one day before the fourth anniversary of his presidency, Coolidge called reporters to an office he maintained in the RAPID CITY high

school and handed each a slip of paper on which was written the political bombshell, "I do not choose to run for President in 1928."

COOKE CITY, Montana. Village (pop. 100), Clark County, southern Montana, east of GARDI-NER and southeast of BOZEMAN. Cooke City, located less than four miles from the northeast gate of YELLOWSTONE NATIONAL PARK, was settled by gold miners in 1873. The community, first called Shoofly, was renamed almost immediately for the son of Jay Cooke, the financial backer of the Northern Pacific Railroad. Nez Perce burned the town on their flight toward Canada. Cooke City was rebuilt during the 1880s into a community of 135 log cabins, two general stores and thirteen saloons. Mining efforts proved the richness of the surrounding hills, but transportation costs destroyed the profits. Efforts to bring a railroad into the area failed for forty years. Then in the summer of 1971, out of desperation, a little red caboose was hauled in symbolically by truck. Today Cooke City stands among some of Montana's most breath-taking scenery. The community depends on service to visitors to Yellowstone and other attractions of the area. Winters provide opportunities for skiing and snowmo-

biling, and trout streams beckon in the spring and summer. GRASSHOPPER GLACIER is a nearby attraction.

COOKE, Philip Saint George. (Leesburg, VA, June 13, 1809— Detroit, MI, March 20, 1895). Military officer, West Point graduate (1827). Cooke commanded the MORMON BATTAL-ION in 1846 during the MEXICAN WAR, when it was instructed to meet General Stephen KEARNY (1814-1862) in California. On the journey from Council Bluffs, Iowa, through Colorado, New Mexico and California, they were to break a wagon trail to the West Coast as they marched, and despite the almost incredible hardships of the trail, this was perhaps their most important accomplishment in their 2,000 mile trek. Cooke became a Union brigadier general in the CIVIL WAR and retired from the army in 1873. Among his writings, Cooke produced *The Conquest of New Mexico and California* in 1878.

COOPERSTOWN, North Dakota. Town (pop. 1,308). Seat of Griggs County, east-central North Dakota, southwest of GRAND FORKS and northwest of FARGO. The community was named for William Cooper, father of novelist James Fenimore Cooper. Cooperstown was the hometown of well-known United States Senator from North Dakota, Gerald P. NYE.

COPPER AND COPPER MINING IN THE CENTRAL WEST. By the 1880s the Central West region was beginning to outpace the earlier major copper producing states, such as Michigan and Wisconsin. The discovery of high-grade copper deposits at BUTTE, Montana, overshadowed any of the earlier finds in this country. Butte produced five thousand tons of copper in 1882 through the efforts of Butte's Copper Barons. Montana, which replaced Michigan as the nation's leading copper producer in 1887, reached its peak production of 176,000 tons in 1916.

As the high grade copper resources began to experience rapid depletion, a revolutionary era began with the working of low-grade porphyry, copper sulphides, scattered through large mas-

COOPER, Leroy Gordon. When Cooper was launched into orbit on May 15, 1963, he began a voyage that made him the hero of the first space landing ever to be accomplished without automatic controls, providing proof that this could be done.

ses of rock. In 1903 Daniel C. Jackling constructed a two thousand-ton-per-day concentrating plant and used steam shovels to strip off the overburden and scoop the ore into railroad cars.

The success of the concentrating process encouraged engineers to discover more low-grade deposits in such locations as Santa Rita, New Mexico.

High prices during the world wars made many deposits, once considered worthless, highly profitable. Technological advances were also vital in the low-grade mass-production revolution. The flotation process of concentration, which improved recovery as much as fifty percent, was introduced between 1912 and 1925. Oxide ores were worked by leaching until the mid-1950s, when companies adopted the "dual process" of combining leaching and flotation or Anaconda's "LPF method," of leaching, precipitation, and flotation. By the end of the 1960s an estimated eighty percent of the copper mined in the United States was recovered by the open-cut method. Open-pit operations were improved with the use of diesel trucks and sophisticated earth-moving equipment, which replaced or assisted the railroads. Despite the concern of environmentalists that open-pit mining damages the affected areas and promotes ground pollution, it has become the accepted method of production in the copper industry.

Because vast amounts of capital are needed to maintain an open-pit operation, many smaller copper companies were forced out. Today twenty-five of the estimated 360 mines in the nation are in position to account for ninety-six percent of the total output. Kennecott, Phelps Dodge, and Anaconda mine about seventy-five percent of the total. In combination with American Smelting and Refining Company the "Big Three" refine more than eight-five percent of the copper produced in the United States. Today New Mexico and Montana rank third and fourth in U.S. copper production.

CORMORANT ISLAND. Nesting place of the long-necked black waterfowl on Waubay Lake in South Dakota. So many birds flock to the location that there is often no room for people to walk on the shore.

CORN. Generic name used throughout the world for grain crops, and used in the United States for the grain more precisely called maize, or Indian corn. This crop was cultivated by North American Indians long before European exploration of the continent, and it is now so domesticated that it never reverts to the wild state. United States sweetcorn is a popular seasonal food and canned vegetable, but the bulk of the United harvest is the heavier type used for animal feed. The great "corn belt" of the United States lies across the Midwest. The Central West, although not the heart of the "corn belt," contributed about 1,280 million bushels of corn to the 1984 harvest with a farm value of about 3,475 million dollars. Nebraska led the Central west with 799 million bushels valued at 2,158 million dollars followed by South Dakota with 186 million bushels, Texas 144 million bushels, Kansas 109 million bushels, and North Dakota with 42 Million bushels.

CORN PALACE. Striking tourist attraction of MITCHELL, South Dakota, which features huge exterior murals made of various colors of corn and grasses. The first Corn Palace was constructed on Mitchell's Main Street in 1892. A new permanent building was completed at a cost of $200,000 in time for the 1921 festival. In 1929, 7,230 bundles of grain and 4,100 pounds of corn were needed in preparing the Corn Palace for Mitchell's fiftieth anniversary in 1964, when a $300,000 overhaul of the building provided new lighting and increased seating to 5,000. Corn Palace attractions have included North Dakota-born Lawrence WELK and his orchestra, the John Philip Sousa Band, Tommy Dorsey and Bob Hope. The last full week in September is annually designated as Corn Palace Week.

CORONADO HEIGHTS. Site in Kansas on which the Spanish explorer CORONADO (1510-1554) is said to have camped. Fragments of Spanish chain mail have been found in the area. The Heights, one of the Smoky Hill (or Spanish Buttes, is located between the cities of SALINA and LINDSBORG.

CORONADO STATE MONUMENT. Site of two pre-Columbian Tiguex Pueblo ruins where the Spanish explorer CORONADO (1510-1554) had headquarters in 1540-1542, as he searched for the supposed riches of Cibola. Located near BERNALILLO, New Mexico, the archaeological finds included a series of murals in a subterranean kiva. Three of the four walls were covered with twenty-nine coats of plaster. As many as twelve layers contained murals which were removed intact layer-by-layer and taken to New Mexico State University, and copies made.

CORONADO, Francisco Vasquez de. (Salamanca, Spain, Feb. 25, 1510—Mexico, c. Nov. 12, 1554). Spanish explorer. He was particularly noted for his discoveries on expeditions from Mexico into what is now the American Southwest. Coronado was the first to record such sights as the Grand Canyon. While he was unsuccessful in his search for treasure, he did bring back invaluable information about this region, and opened up the Southwest to Spanish claims. In the Central West, his travels took him from headquarters near BERNALILLO, New Mexico, into much of the central part of that state, across into west Texas, north across western Oklahoma into Kansas, where he reached the Newburg area. Returning he passed near DODGE CITY and back into New Mexico.

CORONAGRAPH. An instrument invented in France in 1931, capable of creating artificial eclipses of the sun. The first solar coronagraph in the Western hemisphere is located at Climax, Colorado. The instrument makes it possible to study the sun in way never before possible except during a total eclipse.

CORPUS CHRISTI BAY. An inlet of the Gulf of Mexico in northeast Nueces County in southern Texas. Corpus Christi Bay is sheltered by Mustang Island from the often tempestuous weather of the gulf.

CORPUS CHRISTI, LAKE. Artificial lake in Live Oak, Jim Wells, and San Patricio Counties in southern Texas on the NUECES RIVER. Completed in the early 1930s, it was one of the first of its kind and supplies water to the city of CORPUS CHRISTI. Its 1,200-acre state park was opened to the public in 1936.

CORPUS CHRISTI, Texas. City (pop. 231,-999). Seat of Nueces County on the southeastern coast of Texas on the Gulf Intracoastal Waterway. The area was first explored by the Spanish on Corpus Christi Day in 1519. The city was named for the Latin meaning body of Christ. Corpus Christi is a major American seaport and resort area. Settled around 1839, the area was a center for the wool market between 1870 and 1880. After 1880, cattle packing houses and stockyards flourished. In 1923 Corpus Christi developed its first natural gas well, and in 1926, opened its port, two events that caused its population to mushroom. Today Corpus Christi serves the large petrochemical and agricultural area surrounding it. Chemicals, petroleum, coal products and processed foods are its main manufactures. The Corpus Christi Naval Air Station (1941) is a leading employer in the city. The Art Museum of South Texas, the Corpus Christi Museum, Museum of Oriental Cultures and the Museum of Science and History are located here. The community celebrates with an annual Bayfest in the last weekend of September.

CORSICANA, Texas. City (pop. 21,712). Seat of Navarro County, in northeast Texas, southeast of Dallas. Settled in 1848, it was named by Jose Antonio Navarro for the French island of Corsica where his father was born. In 1894 a water well was drilled, and the unhappy owners complained that it was contaminated by a greasy substance. It was soon made clear that this substance was petroleum, and the city gained fame for the first such discovery made west of the Mississippi. The state's first oil refinery was constructed there two years later. The rotary drill for oil wells was developed at Corsicana and patented in 1909. Besides oil production and refining, the local economy includes oil field machinery, textiles, clothing and food products from the surrounding agricultural area, producing cotton, grain, and cattle. Navarro Junior College is located there. Derrick Days is an annual late march celebration.

COTEAU du MISSOURI. Area of land lying between the ALTAMONT MORAINE and the MISSOURI RIVER in North Dakota.

COTTON. The pliable white seed hairs produced by the pod, or boll, of plants of the genus *Gossypium*, cultivated around the world as a source of textile fibers. The name is of uncertain Arabic origin, transferred into old French *coton* and Middle English *cotoun*.

In the United States cultivation is based on *G barbadense*, known as Egyptian cotton, and *G. hirsutum*, called American upland cotton and the source of most of the world's cotton fiber. These varieties grow as shrubby plants anywhere from three to six feet in height. They are thickest at the bottom and combine leaf foliage with boll growth. The boll itself forms at the base of a blossom. It remains closed for a period of about six weeks, during which the fiber growth of the seeds fills the cavity of the boll. When ready for harvest, the boll opens and exposes its white raw cotton.

Three states in the Central West regularly produce cotton, but Texas, leads not only the region but also is the leading producer of cotton

in the nation. Texas produced 2,421 million bales of cotton in 1983 with a farm value of 695 million dollars. The other states in the Central West with a measureable cotton harvest are New Mexico, with 86,000 bales with a farm value of 34 million dollars, and Oklahoma, with 145,000 bales with a farm value of 40 million.

COTTONWOOD. State tree of Kansas, Wyoming and Nebraska. The cottonwood or poplar is a member of the willow family, which includes the aspens. Its popularity, demonstrated by its choice as state tree by three states, is due to the fact that cottonwoods grow along the streams of the plains states and often were the only trees to be seen for miles. They were greatly cherished by the pioneers and often grow to very large size in a relatively short time. The term cotton comes from the clusters of seeds which are covered with a fibrous coat and clump together in feathery balls, much like cotton.

COTTONWOOD FALLS, Kansas. Town (pop. 954). Seat of Chase County, east-central Kansas, southwest of EMPORIA and northeast of

WICHITA, named for the falls of the Cottonwood River. Knute Rockne, famed football coach of Notre Dame, was killed nearby in an airplane accident in 1931, and the site is visited constantly by football buffs and curiosity seekers.

COUNCIL GROVE, Kansas. Town (pop. 2,381). Seat of Morris County, east-central Kansas, southwest of TOPEKA and northwest of EMPORIA, founded 1858. In the "council grove" there, government officials, in a meeting with Osage leaders in 1825, negotiated the right-of-way for the SANTA FE TRAIL. Council Grove, was established in the year of the great council and became the last outfitting point on the trail. It was named for the shaded treaty-signing site. The remains of Council Oak, under which the treaty was signed are preserved on the site. A second tree of importance, the Custer Elm, is said to have sheltered the famous general, George A. CUSTER (1839-1876), in his 1867 campaign against the Indians of western Kansas. The Kaw Methodist Mission, erected in 1851 as a school for Indian children, became in 1854 one of the first schools in Kansas for the children of settlers. With the completion of the

The Last Chance store at Council Grove, Kansas, really was the last chance for travelers on the Santa Fe Trail to get their provisions for the long journey.

Kansas Pacific Railroad in 1866, about fifty miles to the south nearly all the commerce on the Santa Fe Trail ended and Council Grove settled into the quiet life of a county seat and trading center for the area. The Post Office Oak may still be seen. It served as an unofficial post office on the Santa Fe Trail. The pioneer jail also survived, along with the Kaw Indian Mission, with its memories now preserved in a museum.

COUGAR. Large American carnivore of the cat family. Also called the puma and mountain lion, of a tawny or brownish-yellow color. Much more widely distributed in earlier times, its largest numbers are now thought to be surviving in the Southwest. However, the cougar has proved able to survive in a variety of habitats despite being constantly hunted as a predator of sheep, cattle, horses, and deer. The cougar has survived by being an elusive animal which often escapes danger by climbing trees. Dogs have been used extensively in hunting the cougar, and it has been eliminated from many of its former haunts. Now on the list of endangered animals, the cougar appears to be making a comeback in the Central West, particularly in the southern and western sections.

COUNTRY AND WESTERN MUSIC. Popular American musical form that originated in the South among rural whites. A variation on the country theme appeared in the 1930s with the rise of western music, popularized by "the singing cowboy," Gene Autry (1907-), a native of Tioga, Texas, who extended its influence through films, as did Tex Ritter (1905-1973), Murvaul, Texas, native, and Roy Rogers (1911-), "the king of the cowboys," who emerged from the successful Western group Sons of the Pioneers. Western was one of the most important of a variety of allied forms ranging from the folk tradition of Woodie Guthrie (1912-1967) to the big-band western swing of Bob Wills (1905-1975), to the banjo instrumentals of bluegrass music, as exemplified by Bill Morroe (1911-), Lester Flatt (1914-) and Earl Scruggs (1924-).

COWAN, George F. (—) Not listed in any important reference works but whose story is a real saga, in the history of the region. The story of George Cowan deserves a small part in regional annals.

In 1877 Cowan and his wife were among one of the early parties to visit YELLOWSTONE NATIONAL PARK. Unfortunately, they arrived at the time Chief Joseph and his Nez Perce followers were there in their attempt to escape to Canada. After capturing the party, the chief let them go, but without his knowledge a group of younger braves recaptured some and drove off others of the party. Cowan had been badly injured by rocks, and they left him for dead.

Nevertheless, he struggled to his feet, only to be shot by another Indian and again left for dead. Still able to crawl on his knees, carrying three bullet wounds and terrible bruises, he began a journey that "...probably has no parallel in history."

Crawling from dusk until dawn he passed several days, finally reaching the party's abandoned wagons. Sadly, there was no food or water. However, one of the abandoned dogs greeted him wildly. Still crawling, followed by the dog, Cowan reached one of the old camps. There he found enough coffee to brew some in an old fruit can. Next day to his joy he was found by army men who had been sent to bury his body. They gave him food, built a fire to warm him and told him the army would come by soon and rescue him.

As if he had not been plagued enough already, he awoke after a nap to find himself surrounded by flames consuming the dry material around him. He dragged himself away, suffering severe burns. Finally the army reached him, took him to camp and treated his wounds, then placed him in a wagon. Suddenly they deserted him. Just as he thought he would never be rescued the troops came back from meeting what they thought was to be an Indian attack, but they found the Indians friendly.

They left Cowan at a nearby ranch, and Mrs. Cowan, who had escaped, brought a wagon for him. To add another bit of bad luck, the horses ran away, overturning the wagon and dumping Cowan onto the road. Finally he reached the supposed safety of a hospital at BOZEMAN, Montana. Anxious to encourage him and hear his story, many of his friends crowded around and sat on his bed. As a last bit of trouble, the bed collapsed under the weight, throwing Cowan to the floor. In spite of it all, he recovered completely, and twenty-four years after his series of mishaps he returned to visit the scenes that were so vivid in his memory.

COWBOYS. Term most frequently applied to any man tending cattle. The origin of the term is clouded in mystery. It is claimed that the word was seldom used within the early ranching business except for the young, inexperienced drovers who herded or hunted cattle. By

A Charro (Mexican cowboy) competes in the charreada (rodeo) during Charro Days in Brownsville, Texas.

the 1870s the use of the term became generally applied to anyone tending cattle. The use of the term by pulp-fiction writers has disguised the fact that it was often used by the general population in western towns to refer to those who were uncouth and rowdy. Some criminal gangs were known as "Cowboys," particularly the Clanton group notorious for their troubles with the Earps in the 1880s.

Cowboys were employed prior to the CIVIL WAR, and they had a long tradition for work as herders and tenders of cattle, but the great cattle drives of the postwar period provided enormous impetus for young adventurers and impetuous and even reckless men of any age to became cattle herdsmen, and the term cowboy emerged in its present form. Next to the cattle themselves, "the most important element in making a ranch successful was the quality and dedication of the hired hands—the cowboys."

Traditional cowboy duties have included roundups and herding of cattle, branding, protecting the herds from rustlers and driving them to shipping points. Western writer Emerson Hough's *Story of the Cowboy,* (1897) is a classic description of cowboy life.

The life of the cowboy required great skill and daring and often proved dangerous. The dull routine of keeping the animals together and in good condition was interrupted by the excitement of roundup time, when young unbranded cattle were roped and branded. The expert ropers had mastered the cowboy's hardest learned skill. They became perfect judges of distance and speed of the pursued animal and had mastered complete control of their horses.

With the exception of the roundups, cowboy daily life usually meant fifteen hours rounding up cattle and branding calves and stray steers, after which the bone weary men ate their evening meal, supplied by the cherished cook from the cookwagon, and crawled into their bedrolls.

After days or weeks on the trail or holed up at a ranch, the cowboy sought recreation in the frontier towns, such as DODGE CITY. Much of the "wickedness" of such towns has been exaggerated in novels, motion pictures and television. The off-duty life of the cowboy actually was generally colorful and sometimes reckless of human life but far from the rowdy, brawling, shooting-up wildness so often pictured.

Contrary to prevailing accounts, in most Kansas cattle towns the efficient marshalls required guns to be checked at the town office. What the cowboy wanted after months on the trail or range was "booze, bawds, music and merriment." Most towns were willing to oblige within reason.

From 1870 to 1885 the documented homicide rate for the five chief Kansas cattle towns—Wichita, Dodge, Caldwell, Abilene and Ellsworth—amounted to a rather unimpressive total of 45, few of them resulting from the traditional gun fights so dear to moviemakers' hearts.

During the early cowboy period from 1865 through the late-1800s, the contribution of the cowboy to the national economy was said to be "staggering, although difficult to tabulate."

Recent attempts to provide a more realistic picture of early cowboy life have zeroed in upon the various misconceptions. The most dramatic of these is the position of the black cowboy. While no precise estimates are available, it is sometimes said that the number of active and respected black cowboys during the post-Civil War period was as high as a fourth of all the cowhands employed at a given time. Responding to this new insight, some modern media have attempted to portray the racial mix of the cowhand in light of this perspective. The cowboy still has an important role on the ranches of the region. While walkie talkies, pickup trucks and other modern advantages have modified the life, much of the work of the cowboy remains the same as it has been from the early days onward.

COYOTE. State animal of South Dakota. The wily coyote or the little wolf of the prairies or the barking wolf is sometimes also called the prairie wolf. Actually it is a small member of the wolf family. The coyote was known to kill sheep and lambs, but generally lived on carrion or other small animals. Cattlemen customarily disregarded the coyote, which posed little threat to their animals. However, the intelligent creature gradually came to be considered as a pest. It was thought that they were a menace to chickens and livestock, and they have been hunted mercilessly. Nevertheless, being much more adaptable to human presence than the wolf, the coyote has thrived on situations which have driven many other animals nearly to extinction. Despite widespread attempts to eliminate the coyote in modern times, this intelligent animal has actually increased its numbers in many areas of the Central West and West. The numbers of coyotes have made them an increasing nuisance in many locations. They often surprisingly are found in or near urban areas, where their forays for food are disturbing to the residents.

CRABS. Shellfish of commercial importance, along the Gulf of Mexico. In the Central West, the Texas crab catch averages about 45 million pounds per year, which far exceeds the Texas shrimp catch of less than 20 million pounds.

CRADLEBOARDS. Method used by Indian women of several tribes to carry their infants. The child was strapped to the board which could then be hung on a limb, tied to a horse, or carried on the back, while the baby had an almost unobstructed view of his or her surroundings.

CRAWFORD, Nebraska. Town (pop. 1,315), Dawes County, northwestern Nebraska, southwest of CHADRON, northwest of ALLIANCE and south of the Nebraska badland. This area is less known than those in South Dakota, but it still is recognized as an area of eerie beauty. Founded in 1885 and named for Lieutenant Emmet Crawford of Fort Robinson, Crawford benefitted from its location along the WHITE RIVER, which provided irrigation for farms. Historic FORT ROBINSON, erected in 1874 during Indian troubles, is the focal point of FORT ROBINSON STATE PARK, site of a museum of Indian and pioneer displays. Nearby Oglala National Grassland provides a unique opportunity to visit prairie grass country, for backpacking, hiking and hunting in season. The grassland includes TOADSTOOL GEOLOGIC PARK, a collection of strange forms sculptured by the wind.

CRAZY HORSE (Chief Tashunca-Uitco)). (near Rapid City SD 1849?—Fort Robinson, NE, Sept. 5, 1877). Indian chief of the OGALLALA SIOUX. Crazy Horse was a leader in the Sioux War of 1876 and considered one of the great Indian general strategists. As a youth, he allied with Chief RED CLOUD (1822-1909), using masterly decoy tactics against the defenders of the hated Powder River army road (BOZEMAN TRAIL). He became a major leader in the FETTERMAN MASSACRE on December 21, 1866 and also took part in the Wagon-Box fight of August 2, 1867. He defeated General George CROOK (1829-1890) on June 17, 1876, in the Battle of the Rosebud in Montana and wiped out General George Armstrong CUSTER (1839-1876) and his command at the Battle of the LITTLE BIGHORN eight

days later. Crazy Horse and an estimated eight hundred warriors were defeated near Birney, Montana, on January 7, 1877, by General Nelson Miles (1829-1935). In 1877, Crazy Horse voluntarily surrendered to American troops and was treacherously killed with a bayonet when it was said he resisted his captors while being forced into a jail cell.

CRAZY HORSE MEMORIAL. Planned non-profit educational and cultural memorial as a tribute to all North American Indians, located southwest of RAPID CITY, South Dakota. The focal point of the memorial is to be a sculpture of Chief CRAZY HORSE (1849?-1877). This work in progress was the dream of and founded by Korczak Ziolkowski. He designed a gigantic sculpture of the chief on his horse, to be blasted from a granite mountain in much the same way as the Mt. Rushmore sculptures. When completed, in the round, this sculpture will be the largest in the world at a height of 563 feet and a length of 641 feet. All four presidential heads at MT. RUSHMORE would fit into the head of Crazy Horse who is to be seen sitting upon his horse. Four thousand people would be able to stand on Crazy Horse's outstretched arm. The horse's head will be 22 stories tall and his nostrils would be large enough to hold a five-room house. No tax money has been used for the project which is to include an Indian Museum of North America and a planned University and Medical Training Center for the North American Indian. Only approximately four months per year are used for work on the mountain. Due to weather and limited finances no completion date for any of the work has been projected, but models and other displays are shown.

CREE INDIANS. Important Algonquian tribe which occupied a large territory south of Hudson Bay in the early 17th century and expanded into northern Montana and North Dakota. Gradually migrating westward to the prairies and plains, they became dependent on buffalo. When the large herds dispersed in the winter to forage for food the Cree split up into small groups to follow them. In summer, camps were formed for communal buffalo hunts. Each of the eight to twelve bands of Plains Cree was led by a head man. The position was often heredi-tary, particularly if the heir was an acknowledged expert in war or hunting. The Plains Cree practiced wife exchange, common to the Plains tribes, between close male friends. They observed the mother-in-law taboo, which prohibited a husband to speak to his wife's mother. By

the mid-18th century, the Cree had acquired horses, allowing them to roam between the Rocky Mountains southward into the Missouri Valley in Montana. By the mid-19th century the Cree controlled a vast portion of this land. The decline in Cree power coincided with epidemics of smallpox and warfare with the BLACKFOOT in the 1850s. In 1916, Rocky Boy's Reservation, named for a Cree-Objibway chief, was established for Cree and OJIBWAY in Montana. In the late 1970s nearly 1,800 Cree-Objibway were living on or near the 107,600-acre reservation in Hill and Chouteay counties.

CREEDE, Colorado. Town (pop. 610), seat of Mineral County, southwestern Colorado, northwest of ALAMOSA, and northeast of DURANGO. Creede was founded by Nicholas C. Creede, a discouraged miner who stumbled upon a silver bonanza in 1890 which he named the Holy Moses and later the Amethyst. With the discovery of another strike called the King Solomon, the rush to the area was on. The tiny camp, first called Jim Town, soon required 200 carpenters to build its houses. Life in Creede was celebrated by Cy Warman's poem "And There is No Night in Creede." A saloon in town was operated by Bob Ford, the reputed killer of Jesse JAMES (1847-1882). Ford was killed in Creede on June 10, 1892, by a miner who claimed Ford had harassed his parents years before. An area of eroded volcanic cones, near Creede, is known locally as "Wheeler National Monument" but does not have that status officially.

CREEK INDIANS. Originally inhabitants of Georgia and Alabama, one of the FIVE CIVILIZED TRIBES, the Creeks were forced by the federal government in the 1830s to move to Indian Territory. As one of the CIVILIZED TRIBES, their life in the east differed very little from the lives of their white neighbors. Few received compensation for confiscation of their rich eastern land holdings and most had to leave their belongings behind. Poor and reduced to starvation, the Creeks struggled to develop crops and farming methods suitable for the new land in present-day Oklahoma. As with the other five tribes, they established an independent Indian nation and prospered. When Oklahoma became a state, the Indian lands were divided, but many of the Creeks refused to select their share, so they were given "worthless" land in the black-jack hills area. Though rich oil finds were discovered on much of this area, many of the Creek people were cheated out of their wealth.

A trip on the Cripple Creek-Victor narrow gauge railroad takes visitors on a scenic route past a number of formerly productive mines.

Today the Creeks have established a Creek Indian Memorial Association museum in their former capitol building at Okmulgee, their capital from 1868 to 1897.

CREIGHTON, Edward. (Licking County, OH, Aug. 31, 1820—Omaha, NE, Nov. 5, 1874). Banker, philanthropist, and telegraph builder. Creighton and his brother John Andrew, with Hiram Sibley, built a fortune extending telegraph lines to the Pacific Coast from 1860 to 1861, finally establishing the Western Union Telegraph company. Through Edward's will, Mary Lucretia Creighton, his wife, left $100,000 to build a school in her husband's memory. The school, CREIGHTON UNIVERSITY in OMAHA, Nebraska, received more than two million dollars more from John A. Creighton.

CREIGHTON UNIVERSITY. Private independent university established in OMAHA, Nebraska, and conducted by the Jesuits who receive no funds from the Catholic Church. The school was founded in 1876 by Mary Lucretia

Creighton in memory of her husband, Edward. The initial donation of $100,000 in 1876 was supplemented over the years by more than $2,000,000 by Edward's brother, John A. Creighton. During the 1985-1986 academic year the university enrolled 5,927 students and employed 1,021 faculty members.

CRIPPLE CREEK, Colorado. Town (pop. 655), Teller County, central Colorado, southwest of COLORADO SPRINGS and northeast of CANON CITY. Cripple Creek was overlooked as a potential gold site until 1891 when a young cowboy, Robert Womack, found a rich vein. Womack sold his claim, called the El Paso mine, for $500 and went on a wild binge in Colorado City, now Colorado Springs. He lived to see his mine produce almost $12,000,000 in gold. Cripple Creek's gold production helped Colorado weather the drop in the silver price when Congress repealed the Sherman Silver Purchasing Act in 1893. Cripple Creek's population skyrocketed in two years from a tent town to a bustling center of 18,000 residents with five opera houses kept busy providing entertainment for the miners. When the town was rebuilt in 1896 after a disasterous fire most of the buildings were constructed of brick. These are the structures visible today. Over the years an estimated $400 million in gold has been recovered from this site. One of the people to benefit from Cripple Creek gold was mining tycoon and developer Spencer PENROSE (1865-1939) whose fortune began and grew there. Boxers Jack JOHNSON (1876-1946) and Jack DEMPSEY (1895-1983) once worked in the town. The career of stage personality Texas Guinan (1884-1933) began there. Recent increases in the price of gold have brought some new life in the mining town. It has been declared a National Historic Mining District, with much of the old town being restored. Visitors witness the process of gold mining in the Mollie Kathleen Gold Mine during forty-minute tours one thousand feet underground. A region of abandoned mines may be toured on a four-mile trip behind a coal-burning steam locomotive on the Cripple Creek and Victor Railroad.

CROCKETT, David. (Limestone, TN, Aug. 17, 1786—San Antonio, TX, Mar, 6, 1836). Legendary frontiersman, soldier, humorist, and politician. Crockett first made a name for himself as a scout for General Andrew Jackson during the Creek War (1813-1815). He later joined the Tennessee militia and attained the rank of colonel. In 1821 he won election to the

Tennessee legislature, chiefly on the strength of his humor and storytelling abilities. His subsequent election to the U.S. Congress in 1827 (he failed to win in his first attempt in 1825) was marked by independent voting and stringent opposition to the policies of Jackson. In 1835 Crockett moved to Texas, apparently hoping to find a new place to settle and build political support for another term in Congress, if Texas became part of the United States. He joined the revolutionary movement there. He gave his life for the cause of Texas freedom and died at the ALAMO when the Mexican army, under the command of General Antonio Lopez de SANTA ANNA (1794-1876), overran the fort, killing all 184 defenders. Some historians believe Crockett and several others may have survived the battle, only to be executed by firing squad. Crockett's expert marksmanship, witty stories and anecdotes and his valiant death at the Alamo contributed greatly to making him a legend. He was represented as the author of several books (possibly dictated), including *A Narrative of the Life of David Crockett* (1834).

CROCKETT, Texas. City (pop. 7,405). Seat of Houston County, eastern Texas, south of TYLER and northwest of BEAUMONT. Incorporated December 29, 1837, Crockett is one of Texas' oldest cities. A.E. Gossett, veteran of the Battle of SAN JACINTO (April 21, 1836), gave the site and named the town for Davy CROCKETT (1786-1836) and the county for Sam HOUSTON (1793-1863). More than 10,000 pecan trees have been planted near this city where Crocket is said to have rested there under a large oak on his way to join the Texas defenders. Occasional signs warning *Watch Out For Hogs* have referred to the mean-tempered razorbacks, descendents of those introduced to the area more than two centuries ago by the Spanish. The World's Champion Fiddlers' Festival is held there each June.

CROOK, George. (Dayton, OH, Sept. 23, 1829—Chicago, IL, Mar. 21, 1890). Army officer. Crook, a master tactician and innovative military officer, commanded the Department of the Platte in 1875 and again from 1886 to 1888. He participated in the Sioux War of 1876 where he fought Indians at the indecisive Battle of Powder River, Montana, in March and the bitterly fought Battle of the Rosebud which caused Crook to retreat to SHERIDAN, Wyoming to regroup. Crook fought against the APACHE INDIANS from 1882 to 1886, but was reassigned before their final surrender and so did not

receive credit for a victory which might otherwise have been his.

CROW BUTTE. Landmark near Whitney, Nebraska, where according to tradition SIOUX INDIANS besieged a band of Crow. The Sioux cut off all paths of retreat and waited for the Crow to surrender. The young Crow warriors cunningly escaped by tying blankets together to make a rope with which they scaled down the perpendicular north face of the butte, 100 feet high. To cover the daring escape, older Crow warriors sang and danced all night, holding the attention of the Sioux. It is not known how long the Sioux waited before realizing they were besieging only a few old men, but the remaining Crow were not killed. The Sioux interpreted a form of white clouds floating above the butte as a spiritual message, and the Sioux and Crow later made a lasting peace agreement.

CROW CREEK RESERVATION. One of the major SIOUX INDIAN reservations, including Pine Ridge, Rosebud, Cheyenne River, and Lower Brule, located in South Dakota, which together contain 8,400 square miles of land. CHAMBERLAIN has been the headquarters for the Crow Creek and Lower Brule.

CROW INDIANS. Siouan tribe living in southwestern Montana and northern Wyoming in the late 18th century. The Crow, originally lived in the Lake Winnipeg region, but moved westward to southwestern Montana and northern Wyoming, where they lived along the WIND, POWDER, BIGHORN and YELLOWSTONE rivers. Two divisions, the Mountain Crow and the River Crow, developed, based on preference of location.

The Crow called themselves Absoroka, for a bird no longer found in the area. They were subdivided into thirteen clans each headed by a man distinguished in war. The tribe was governed by a council of chiefs. Chiefs gained their title by doing four things: counting coup (touching an enemy), leading a successful war party, taking an enemy's weapon from him, and cutting loose a horse tied in the enemy's camp.

Military societies for the men took turns as the tribal police force, charged with keeping order in camp, preventing war parties from starting out at bad times, and enforcing discipline during buffalo hunts.

The Crow believed a vital force was found in all nature. When a Crow died, his body was taken out under the side of his tipi rather than by the door in the belief that if done otherwise

someone else in the tipi would also die. The body was dressed in its best clothes, painted and placed on a scaffold. After decomposition, the remains were buried under rocks or in a cave. Mourners gave away their property, cut their hair and sometimes cut off fingers. Crow material culture was similar to that of the other Plains tribes.

While living on the plains the Crow grew only tobacco. Buffalo meat, the main item in the diet, was roasted or boiled with heat from hot rocks in a skin-lined pit. Women dug roots and gathered edible plants. There were male specialists in making bows and arrows. The Crow served as middlemen in the horse trades.

In 1833 smallpox hit the Crow, with large loss of life. In 1851 they agreed to settle on 38.5 million acres as a Montana reservation, greatly reduced by 1868. In the 1860s and 1870s the Crow served as scouts for the United States Army in its campaigns against the SIOUX.

In the 1970s nearly 5,000 Crow lived on or near the 1.5 million acre Crow Reservation in southeastern Montana. Tourism, agriculture, ranching and manufacturing are important to their economy. The CUSTER BATTLEFIELD NATIONAL MONUMENT is found on the Crow Reservation.

CRUMBINE, Samuel J. (Emlenton, PA, 1862—Jackson Heights, NY, 1954). Physician. While a Dodge City, Kansas, doctor, Crumbine gained a national reputation for his campaign for better public sanitation. He became internationally recognized for his methods of fighting typhoid and tuberculosis and in 1908 organized the Kansas Society for the Study and Prevention of Tuberculosis. Crumbine served as the president of the organization from 1908 to 1910.

CULTURAL INSTITUTIONS IN THE CENTRAL WEST. A famous cartoon in the *New Yorker* Magazine depicts a U.S. map with almost nothing showing beyond the Hudson River. That might well typify the opinion of those from other areas who are not acquainted with the real Central West region.

Fortunately, most cultivated Americans are well aware of the unique wealth of museums, musical organizations, theaters, associations and other institutions that enrich the area. The array of institutions is particularly noteworthy in an area of art which is rapidly growing in worldwide appeal and popularity—American western art.

The several museums of the region which

feature every top western artist and every aspect of the field, collectively represent the best assemblage of such works to be found anywhere.

Nor has theater been neglected in the region. What is probably the very first play ever "staged" in the present U.S. was performed in Texas in 1598. The very night that the huge and wonderfully outfitted procession of Don Juan de ONATE first crossed the RIO GRANDE RIVER near present EL PASO, Texas, Senora Onate and the lovely ladies-in-waiting with her staged a play in the wilderness. With sixteen high-born Spanish senoritas, 150 gentlemen at arms in full battle dress, with their magnificent horses, hundreds of sheep and cattle, great supplies of silks and every known luxury transportable luxury of the time, this noble family provided an early example of Texas culture which was to follow over a period of many years.

Today even the smaller Texas cities have centers providing almost every cultural amenity. The larger cities possess some of the finest general and specialized musuems anywhere, along with musical organizations of high rank.

At Dallas, State Fair Park, alone, provides the Age of Steam Railroad Museum, the Hall of State, Dallas Museum of Natural History, Dallas Aquarium, The Science Place and Music Hall, where the renowned Dallas Symphony performs. The new DALLAS MUSEUM OF ART already holds a special and important place in the art world. The Biblical Arts Center, Owen Arts Center of SOUTHERN METHODIST UNIVERSITY and two galleries of the University of DALLAS round out a remarkable assemblage of fine art institutions. The DALLAS THEATER CENTER occupies two buildings, including one designed by Frank Lloyd Wright.

Fort Worth's Will Rogers Memorial Center is perhaps the most ambitious of all, encompassing the Kimbell Art Museum, Fort Worth Art Museum, Amon Carter Museum, Fort Worth Museum of Science and History, William Scott Theater, Omni theater and Noble Planetarium, all in one complex.

Houston's Civic Center makes splendid provision for music performances, theater and art exhibitions. There are also the outstanding Museum of Fine Arts and the Contemporary Arts Museum. Decorative arts are displayed in the Bayou Bend Collection. The universities of RICE, HOUSTON and TEXAS SOUTHERN all offer a wide variety of community cultural institutions. The impressive modern Alley Theatre provides two ultra-modern theaters. Houston Symphony Orchestra performs in Jesse H.

Cultural Institutions

One of the many outstanding cultural institutions of the region is the Kimbell Art Museum, where visitors can view works of art from prehistoric to Picasso in an innovative building with unexcelled lighting and display areas, courtesy of philanthropist Kay Kimbell.

Jones Hall for the Performing Arts, as do the Houston Ballet and Houston Grand opera.

Fort Bliss Museum at EL PASO is one of the most complete military display centers. El Paso also has a fine Museum of Art and a Museum of History.

The Texas State Library at AUSTIN is one of the finest of its type. Also on the capitol grounds are the Texas Confederate Museum and Daughters of the Republic of Texas Museum. The main campus of the University of TEXAS at Austin features the Texas memorial Museum, two Huntington Art galleries, the LYNDON BAINES JOHNSON LIBRARY AND MUSEUM and the Harry Ransom Center. Austin offers three unique specialized museums, Leguna Gloria Art Museum, Elsabet Ney Museum and O. Henry Museum. The French Legation Museum is housed in the only foreign legation building constructed outside Washington, D.C. ST. EDWARDS UNIVERSITY presents a year-long program of drama featuring major guest stars.

At historic San Antonio the Institute of Texan Cultures in HemisFair Plaza is remarkable for its coverage of the state's historical, racial and ethnic mixtures, presenting what amounts to a revolutionary concept of museum treatment. Also on the Plaza are the Museum of Transportation, Texas Science Center and Theater for the Performing Arts. Arneson River Theater is noted not only for its performances but also for the fact that the stage is on one side of the SAN ANTONIO RIVER, and the audience safely on the other. The extraordinary River Walk (Paseo del Rio) might well be considered a cultural institution in itself. Marion Koogler McNay art Museum, San Antonio Museum of Art and Southwest Craft Center harbor other worthwhile collections. Majestic Performing Arts Center houses Broadway plays, ballet and symphonic presentations.

New Mexico's cultural institutions might be said to reach back to prehistoric times, when arts and crafts flourished among the Pueblos. Today SANTA FE has an international reputation as a home of music and art. Santa Fe Opera

attracts audiences from around the world to hear singers of international renown in opera classics both established and experimental. The setting, an auditorium partially open to the sky, is another attraction. Nowhere else is there such a concentration of institutions devoted to native American art and other native and folk culture. INSTITUTE OF AMERICAN INDIAN ARTS Museum is especially complete. The Wheelwright Museum is entirely dedicated to Indian arts and culture, including many top contemporary artists. The laboratory of Anthropology Museum of Indian Arts has another very complete collection on its subject. Santa Fe also features the Museum of International Folk Art and the International Institute of Iberian Colonial Art at the College of Santa Fe.

Other New Mexican cultural institutions include the TAOS art Association, the ALBUQUERQUE Museum, the Indian Pueblo Cultural Center at Albuquerque and the Albuquerque Fine Arts Center, with the University of New Mexico's Art Museum, Southwest Music Archives, Rodey Experimental Theater, Keller Hall of music and Popejoy Hall, home of the New Mexico Symphony Orchestra and Broadway Theater productions.

The small Oklahoma community of BARTLESVILLE, Oklahoma offers one of the nation's outstanding museums, featuring western art, including much by the finest specialists in the field. This is the WOOLAROC MUSEUM. The larger city of TULSA has two such outstanding offerings, THOMAS GILCREASE INSTITUTE OF AMERICAN HISTORY AND ART and PHILBROOK ART CENTER. Theater Tulsa is the oldest in the state. At OKLAHOMA CITY are Oklahoma Art Center, Oklahoma Museum of Art, Arts Place, International Photography Hall of Fame and Museum, NATIONAL COWBOY HALL OF FAME AND WESTERN HERITAGE CENTER and Civic Center Music Hall

The Kansas Historical Society and Museum at TOPEKA houses, among other treasures, the largest files of newspapers outside the Library of Congress. Kansas' largest city, WICHITA, provides the Wichita Art Museum, Wichita Art Association Museum, Ulrich Museum of art at WICHITA STATE UNIVERSITY and Mid-America all Indian Center and Indian museum.

One of the country's notable small town museums is found at GRAND ISLAND, Nebraska, where the STUHR MUSEUM OF THE PRAIRIE PIONEER provides a unique complex of architecture and exhibits. The University of NEBRASKA at LINCOLN offers the Sheldon Memorial Art Gallery and Sculpture Garden and the Christlieb Collection of Western Art. Omaha's Joslyn Art Museum's

art deco building houses one of the most diverse collections, ranging through most of the art categories and many other types of exhibits, as well. Great Plains Black Museum is devoted to the contributions of black Americans in this country.

Charles M. Russell Museum and Original Studio at GREAT FALLS, Montana, is one of the notable examples of a museum devoted to a single artist. MUSEUM OF THE PLAINS INDIAN and Crafts Center at BROWNING, Montana, features the art of the northern plains Indians. BILLINGS, Montana, is represented by the Yellowstone Art Center, while MONTANA STATE UNIVERSITY at BOZEMAN presents the Museum of the Rockies.

Great Plains Museum at MANDAN, North Dakota, has a unique approach to the native heritage of the region, presenting life-size wax figures of the MANDAN and SIOUX leaders, along with similar representations of officers of FORT LINCOLN. There are, as well, many pioneer artifacts. Buffalo Trails Museum of WILLISTON, North Dakota, presents a unique view of Indian and pioneer cultures.

At BROOKINGS, South Dakota, the Memorial Art Center of the state presents a wide variety of local arts plus a unique collection of the art of linen. Oscar Howe Art Center at MITCHELL, South Dakota, features work of the noted Sioux artist of that name, along with exhibits of native art and culture. Dahl Fine Arts Center at RAPID CITY features an unusual painting, a 200 foot cyclorama illustrating 200 years of American history, along with works of regional artists. Another unique institution is the Shrine to Music Museum of the University of SOUTH DAKOTA at VERMILLION, displaying a collection of 3,500 antique instruments. Many of the South Dakota communities have lovingly gathered displays of local lore, history and art in such institutions as Dakota Territorial Museum at YANKTON.

Both experts and lay visitors alike speak of the Buffalo Bill Historical Center at CODY, Wyoming, as a very special place, with its four separate museum centers, each approaching local culture, art and artifacts in an extraordinarily effective and modern manner. They include the Whitney Gallery of Western Art, with many of the best works of foremost western artists, the Buffalo Bill Museum, the Winchester Arms Museum and the Plains Indian Museum, featuring one of the most complete displays of its type. At LARAMIE, the University of WYOMING displays paintings, graphics and sculpture in its Fine Arts Museum. The Bradford Brinton Memorial Ranch

Denver's unique Art Museum is housed in a building featuring unusual geometric windows and more than a million hand-set tiles gracing the battlement-like walls.

Museum in its founder's 20 room mansion at SHERIDAN features more than 600 oils, watercolors and sketches by Frederick REMINGTON and many others, along with bronzes, prints and rare books. Again many Wyoming communities have interesting and often unique collections of mountain and prairie memorabilia in a wide variety of fields.

CURECANTI NATIONAL RECREATION AREA. Three lakes—Blue Mesa, Morrow Point and Crystal—extend for 40 miles along the GUNNISON RIVER. When full, Blue Mesa Lake, with a surface area of 14 square miles, is the largest lake in Colorado. The preserve was established on February 11, 1965 and is headquartered at GUNNISON, Colorado.

CURRY, John Steuart. (Dunavant, KS, Nov. 14, 1897—Madison, WI, Aug. 29, 1946). Artist. Curry is considered one of the premiere artists of Kansas. Among his renowned murals are those on the second floor of the Capitol in TOPEKA. This collection includes the controversial "Tragic Prelude," depicting the life of Abolitionist John Brown. Works by Curry are also displayed in the Department of Justice and Department of Interior in Washington, D.C., the Whitney Museum of American Art, and the Metropolitan Museum.

CURTIS, Charles. (North Topeka, KS, Jan. 25, 1860—Topeka, KS, Feb. 8, 1936). Vice President of the United States. Curtis, the son of a Kansas pioneer and an Indian princess and the great-great-grandson of Kansa chief White Plume, was raised among the KAW Indians in Oklahoma. Elected as a Republican to Congress in 1893, he served until January 28, 1907, when he resigned to become a U.S. Senator. In Congress he was noted for his advocacy of Indian rights and for farm and veteran benefits. He served in the Senate until 1929, when he took the oath of office as vice president in the administration of Herbert Hoover, the highest office attained by a person of Indian descent.

The bleak setting of Custer's Last battlefield enhances the visitor's appreciation of the tragedy which happened there.

CUSTER BATTLEFIELD NATIONAL MONUMENT. The famous Battle of LITTLE BIG HORN between twelve companies of the SEVENTH U.S. CAVALRY and the SIOUX and Northern Cheyenne Indians was fought near the LITTLE BIGHORN RIVER in South Central Montana on June 25-26, 1876. Lieutenant Colonel George CUSTER (1839-1876) and about 268 of his force were killed. Custer Battlefield National Cemetery with 4,487 interments, 277 unidentified, is included within the park. Ordered established as a national cemetery by secretary of war, January 29, 1879; proclaimed National Cemetery of Custer's Battlefield Reservation, December 7, 1886; transferred from the war department July 1, 1940; changed to Custer Battlefield National Monument March 22, 1946, Headquartered Crow Agency, Montana.

CUSTER PEAK. Mountain in western South Dakota's Lawrence County. Custer Peak stands 6,804 feet high.

CUSTER STATE PARK. Rugged area of 73,000 acres in the BLACK HILLS near CUSTER, South Dakota, one of the largest state parks in the nation. The park contains one of the world's largest bison herds. Geological, historical, forestry and wildlife exhibits are located in the Peter Norbeck visitor's center. On a side road east of Legion Lake is the Badger Clark Memorial, the home of South Dakota's first poet laureate. A replica of the stockade built by the first prospectors in the gold rush of 1874 is located near a monument to Annie Tallent, the first white woman to enter the Black Hills.

CUSTER, George Armstrong. (new Rumley, OH, Dec. 5, 1839—Little Bighorn, MT, June 25, 1876). Military leader and Indian fighter. Custer was a flamboyant and controversial man who always wanted to be a soldier. His gallant service during the entire length of the CIVIL WAR led to his promotion to the temporary rank of general at the age of 23, the youngest in the

Union army. After the war, he was reduced in rank to captain. In 1866, he enlisted in the SEVENTH U.S. CAVALRY REGIMENT, subsequently becoming a lieutenant colonel in command and fought Indians in the Southwest, Montana, and the Dakota territories. Custer's troops were involved in the controversial Battle of WASHITA in Oklahoma in 1868, which led to a lamentable loss of Indian life. In 1874 Custer led one of the largest military operations in the history of the West into the BLACK HILLS to discover what minerals were present and to study the geology. His party's discovery of gold led to wholesale disregard of treaties which promised the area to the Indians who considered it sacred ground. Custer and his troops were annihilated at the Battle of LITTLE BIGHORN in 1876, while attempting to move Cheyenne and Sioux Indians to reservations. Custer's mistakes in leadership before this battle and some of his excesses in the previous encounters with the Indians have led to general criticism of his life in most biographies. However, recent studies have indicated that his ego and his talents and his mistakes have been magnified to provide a distorted view of a many-sided and in many ways admirable figure, while not denying the negative aspects of his complex personality.

CUSTER, South Dakota. Town (pop. 1,830). Seat of Custer County, southwestern South Dakota, northwest of HOT SPRINGS and southwest of RAPID CITY, named for George Armstrong

CUSTER (1839-1876). In early August of 1874 Horatio N. Ross discovered gold about three miles east of present-day Custer. Ross, a member of the Custer expedition into the BLACK HILLS, touched off a stampede of gold seekers to the Black Hills. The discovery of gold has been called the "most important single event in South Dakota history." Custer became the first town settled after gold was discovered. Within its first month the town, then called Custer City, grew from a population of six to over 1,000. It became a ghost town almost as quickly when more gold was discovered at Dead Tree Gulch, soon to be known as DEADWOOD. A second gold boom near Custer brought miners back in 1879. Custer's annual Gold Discovery Days pageant has been called the "most fascinating thing of its type in the Hills." Popular visitor sites in the Custer area continue to be the colossal CRAZY HORSE MEMORIAL, MOUNT RUSHMORE, and CUSTER STATE PARK.

CUTTHROAT TROUT. New Mexico has designated the cutthroat trout as its official state fish. It is said to be more properly called a char. There are many variations, including the state fish of Montana, the blackspotted cutthroat trout. The trout is a member of the large salmon family. Cutthroat trout are not as plentiful as they were at one time. This is not thought due to the popularity among fishermen, but rather to the aggressive nature of the rainbow trout which has made inroads on a number of varieties.

D

DACOTAH INDIANS. Dacotah is another name for the large number of language-related groups, more commonly called the SIOUX INDIANS, and the words have been used interchangeably although not completely accurately. The major tribes of the Dacotah were very similar in customs and lifestyle, as well as language. This large linguistic family stretched westward across most of the northern portions of the Central West region.

DAKOTA WESLEYAN UNIVERSITY. Privately supported four-year college located in MITCHELL, South Dakota. Dakota Wesleyan grants the degrees of Bachelor of Arts and Bachelor of Music Education with Associate degrees in Business Areas Technology, Nursing and Radiologic Technology. During the 1985-1986 academic year Dakota Wesleyan enrolled 692 students and employed 59 faculty members.

DALLAS MUSEUM OF ART. The Dallas Museum of Art has formed a collection which has been designed to compare favorably with others worldwide. Much of the collection has resulted from the generosity of those who amassed the oil and real estate wealth of the great Texas city. The collection is particularly strong in American modern works. The streamlined structure, opened January 29, 1984, is particularly noted for the space available to permit dramatic display of the collection. Typical is the great hall where the 40 foot high "rope" *Stake Hitch* of Claes Oldenburg rises to an arched ceiling. This hall permits other massive sculpture and expansive paintings to be viewed in perspective. With its striking presentation of "active art" for children and its many related activities, its fine gardens and fountains, the new/old museum has gathered much of the cultural life of the city to itself.

DALLAS MUSEUM OF FINE ARTS. Built in 1936 in FAIR PARK with fourteen galleries, the museum's space was doubled by the merger with the Dallas Museum of Contemporary Art in 1963 and construction of a new wing in 1965. The museum enjoys an influential place in education and art appreciation with its special exhibitions four times annually, its large permanent collection of media and periodicals, and its impressive collection of Southwestern paintings and sculpture. Supported by the Dallas Art Association, the museum annually holds four competitions.

DALLAS THEATER CENTER. Repertory organization, founded in 1959 by the Dallas Theater Association, which has provided an extensive program of classical and modern plays, producing as many as nine plays annually. With a permanent faculty of fourteen, the Center operates six groups: Drama in the Evening, an educational program; the Technical Laboratory, research center into the use of light, film and sound; the Repertory Artists; the Academy which provides two years of training; the Graduate School affiliated with Trinity University of SAN ANTONIO which grants master's degrees; and the Teenchildren's Theater. The current structure (1959) designed by Frank Lloyd Wright is particularly striking and provides two theaters with flexible seating and interior arrangements.

DALLAS, TEXAS

Name: From George Mifflin Dallas (1792-1864) political figure and Vice President of the United States from 1845-1849.

Nickname: Big "D"; The Electronics aerospace Center; The Southwest Metroplex; The All American town.

Area: 331.4 square miles

Elevation: 468 feet

Population:
1986: 1,003,520
Rank: 8th
Percent change (1980-1984): +7.7%
Density (city): 3,028 per sq. mi.
Metropolitan Population: 2,203,664 (DFW 3,348,030) (1984)
Percent change (1980-1984): +12.6% (DFW 14.2%)

Race and Ethnic (1980):
White: 61.42%
Black: 29.38%
Hispanic origin: 110,511 persons (12.29%)
Indian: 3,878 persons (0.41%)
Asian: 9,163 persons (0.85%)

Age:
18 and under: 27%
65 and over: 9.5%

TV Stations: 9

Radio Stations: 38

Hospitals: 30

Sports Teams:
Dallas Sidekicks (soccer)
Cowboys (football)
Mavericks (basketball)
Rangers (baseball, Arlington, TX)

Further Information: Dallas Chamber of Commerce, 1507 Pacific Avenue, Dallas, TX 75201.

DALLAS, Texas. City (pop. 904,599), seat of Dallas County, in central Texas. Dallas is a major industrial, financial, educational, and cultural center of the American Southwest. The second-largest city in Texas, it is the hub of an enormous urban area comprising several coun-

Dallas, Texas

The striking and varied towers of downtown Dallas provide the core for the what is now the largest metropolitan area in Texas,

ties and many communities. As a city of millionaires, the name Dallas has become a cliche for wealth and power, however, substantially dimmed by the oil crises in the petroleum producing areas of the country.

Economically, Dallas is highly diversified. Oil has been the leading industry since the early part of the 20th century, and today many major oil companies are headquartered in Dallas and have producing wells in the immediate vicinity. Natural gas production is also of great importance. Big business has spawned a major financial community of banks, insurance companies, and real estate concerns. But the financial community of Dallas depends upon more than the oil business for its existence. Dallas has always been a major center of trade: primarily cotton, livestock, and other agricultural products. Two area aircraft firms supply a very substantial number of jobs to area residents. Other major employers are geophysical companies whose operations extend throughout the world. On the retail level, almost 17% of the city's work force is employed in retail-related industry. Manufacturing is a big business with products including machinery, nondurable goods, cotton ginning equipment, and electronic equipment.

The settlement of Dallas began in 1841 when John Neely Bryan built his cabin on the shore of the TRINITY RIVER. The Community was named for the Vice President of the United States, George Mifflin Dallas. When the nearby Fourierist utopian colony at La Reunion failed, many of its French and Swiss inhabitants came to Bryan's fledgling settlement. Dallas continued to expand, experiencing its first significant growth in the 1870s as a cotton center, when the railroad came to town. When it was incorporated as a city in 1871, cattle also figured prominently in the city's economy at that time. By 1920 almost 40% of the nation's cotton came from the Dallas area. The discovery of the vast East Texas oil field in 1930 spurred the city's already active oil and gas industry. Since then the city has grown phenomenally, with business and employment opportunities attracting thousands of workers and scores of major corporations.

As in Houston, employment opportunities have attracted a wide variety of people to Dallas. There are many Mexicans, blacks, and Indians, and white groups are represented by a cross section of ethnic backgrounds. A city of both slums and sprawling middle-class neighborhoods and suburbs, Dallas is most famous

for the extravagant mansions of its very rich. A communications center, Dallas has two newspapers, seven television stations, and 35 radio stations, which are shared with the nearby FORT WORTH area. The city is also served by a variety of transportation facilities: major truck and bus lines, railroads, and two sizable airports, Love Field and the Dallas-Fort Worth Airport, the largest in the Southwest.

There is a great deal to see and do in Dallas and the immediate area, which overlaps into Fort Worth. In 1987 that area gained the first rank in metropolitan population in Texas, outdistancing the Houston metropolitan area.

The downtown section of Dallas contains many interesting buildings, such as the world-famous Neiman-Marcus Company store, as well as many modern high rise structures of dramatic appearance. The State FAIR PARK hosts the state's largest annual exposition. The city's MUSEUM OF NATURAL HISTORY and The DALLAS MUSEUM OF FINE ARTS are of special interest. The city has many municipal parks. A center of many cultural activities, Dallas also has its own ballet and opera companies as well as a nationally famous symphony orchestra and the DALLAS THEATER CENTER. John F. Kennedy Memorial Plaza honors the martyred president with a Philip Johnson monument. The metropolitan area has professional baseball, football, hockey, and soccer teams.

The Dallas Market Center Complex is said to be the world's largest wholesale merchandise mart. The annual Cotton Bowl Festival attracts national attention. State Fair of Texas is said to be the country's largest. In 1987 Dallas was the site of Texas Sesquicentennial Exposition, celebrating the 150th anniversary of the Texas republic.

Many colleges and universities are located in Dallas. They include SOUTHERN METHODIST UNIVERSITY, the University of Texas at ARLINGTON, Texas Woman's University in DENTON, Bishop College, Dallas Baptist College, The University of DALLAS, and BAYLOR UNIVERSITY College of Dentistry. A leading medical and scientific center, Dallas institutions provide research and development programs and studies in such fields as molecular sciences, geophysics, and solar physics. Two nationally known private secondary schools, The Saint Mark's School for Boys and Hockaday school for Girls are located there.

DALLAS, University of. Roman Catholic coed institution located in DALLAS, Texas. The University was founded in 1955 when the Roman Catholic Dioceses of Dallas/Fort Worth bought 1,000 acres northwest of the city for the purpose of creating a university that would be open to students of all faiths. Undergraduates take courses in the Constantin College of Liberal Arts. Graduate programs abound and include a five-year M.B.A., the Graduate School of Management (largest in the Southwest), plus programs in art, theology, literature, philosophy, psychology, and politics. University of Dallas has a faculty of 181 with an enrollment of 2,766 graduate and undergraduates.

DALTON GANG. Outlaws who began operations in 1889. The Dalton gang was built around the Dalton brothers, Robert, Grattan and Emmett, who had all been deputy United States marshals before turning to crime. The first activities of the gang were centered in Oklahoma where they looted and burned barns. After an unsuccessful journey to California and an attempted train robbery on February 6, 1891, the Daltons returned to Oklahoma and near Kingfisher began recruiting extra men for a gang which often totalled ten. On May 9, 1891, the gang successfully looted the Santa Fe Limited at Wharton in the Cherokee Outlet. On June 2, 1892, the gang struck again at the Santa Fe express train near Red Rock and then on July 15, 1892, on the Missouri, Kansas, and Texas Railroad at Adair in the Outlet. On October 4, the gang set out for COFFEYVILLE, Kansas, and the attempted robbery of two banks in the same town. In that raid Robert and Grattan were killed. Emmett, severely wounded, was nursed back to health, jailed, and later served on the police force of TULSA, Oklahoma, as a special officer.

DALY, Marcus. (Ireland, 1842—Anaconda, MT, 1900). City builder and copper king. Daly is often called the "father of the copper industry in the Butte, Montana, area." He came to Butte in 1876, representing the Walker brothers of Salt Lake City who were interested in buying the Alice silver mine. Daly bought the Anaconda claim and others, constructed the smelter at Anaconda and within twenty years was the head of one of the world's most powerful monopolies. Daly fought to etablish ANACONDA, the city he founded, as the state's capital. His Anaconda *Standard* newspaper attracted a nationwide reputation pioneering in such fields as full-color comic sections, in which it was one of the first. Daly also unsuccessfully opposed William Andrews CLARK for

the United States Senate, a position Daly sought before the state legislature in 1899.

DANA COLLEGE. One of eleven colleges founded by the American Lutheran Church. Established in 1884 in BLAIR, Nebraska, Dana is located on a 250-acre campus. It grants the bachelor's degree. The college usually enrolls approximately six hundred students and maintains a faculty of forty-three.

DANIEL, Wyoming. Village. Sublette County, west-central Wyoming, southeast of JACKSON and west of LANDER in an area first settled in the mid 1800s. The first church service in Wyoming, conducted by Father Pierre DE SMET (1801-1873), was held on the prairie near Daniel. A monument at Rendezvous Park honors the wives of missionaries Henry H. Spalding and Marcus WHITMAN (1802-1847), the first two women to travel through Wyoming.

DAVIS MOUNTAINS. Texas range found in the region of the upper Limpia Canyon of Western Texas, primarily in Jefferson Davis County in western Texas. A popular summer recreation area, the Davis' highest peak is Mount Livermore, also known as Old Baldy, 8,382 feet.

DAVIS, Edmund J. (St. Augustine, FL, Oct. 2, 1827—Austin, TX, Feb. 7, 1883). Governor of Texas. Davis was active in Texas politics before the Civil War and was a delegate to the Texas Constitutional Convention in 1866. He served as president of the Texas Reconstruction Convention from 1868 to 1869 before becoming the Republican governor in 1869 and serving until 1874. He refused to accept his defeat in the election of that year and remained in his office with armed guards. This was one of the most prominent of several such confrontations in U.S. history. However, President U.S. Grant would not support the Davis claims, and Richard Coke, the newly elected official, finally was able to take over.

DAWES, Charles Gates. (Marietta, OH, Aug. 27, 1865—Evanston, IL, Apr. 23, 1951). Vice

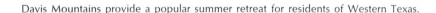

Davis Mountains provide a popular summer retreat for residents of Western Texas.

president of the United States. Dawes career began with the practice of law in Nebraska, where he had offices in LINCOLN in the same building as William Jennings BRYAN, from 1887 to 1894. He quickly acquired extensive interests in utilities, which drew him to the Chicago, Illinois, area. In 1898 he became the U.S. comptroller of the currency and in 1902 he organized a large banking company. He joined the U.S. Army in 1917 and served as a brigadier general in charge of military procurement for U.S. forces in France. He stayed on after the war to dispose of U.S. military surplus in Europe. He was the author of the 1924 Dawes Plan which set reparations payments for Germany after WORLD WAR I. For this work he won the 1925 Nobel Peace prize. Elected U.S. vice president with Calvin Coolidge, he attempted to enlarge the importance of the position, but with little success. After he left the vice presidency, he served in a number of government posts before returning to private life in Evanston, Illinois.

"DAYS OF '76". Annual celebration the first weekend of August, when DEADWOOD, South Dakota, re-creates its rough and tumble past with a rodeo and festivities, often recognized as one of the leading annual celebrations in the country.

DAYTON, Wyoming. Village (pop. 701), Sheridan County, north-central Wyoming, northwest of SHERIDAN and northeast of CODY. The first DUDE RANCH in the West was begun in 1904 near Dayton, on Wolf Creek, by the Eaton brothers, Alden, Willis, and Howard. Their ranch comprised seven thousand acres along the foothills of the BIG HORN MOUNTAINS. The ranch had its own store, telephone system, individual houses, a hotel and a post office. Beautiful two thousand foot deep TONGUE RIVER Canyon lies just west of town.

DE GOLYER, Everette. (Greensburg, KS, Oct. 9, 1886—Dallas, TX, Dec. 14, 1956). Geologist, oil producer. De Golyer devoted his lifetime to collecting books and materials on the history of science and technology. In addition to his work in the profession, De Golyer devoted himself to the assembling of an extraordinary collection of scientific materials, which he he bequeathed to the University of OKLAHOMA. This collection and the center housing it was described by *Fortune* magazine as providing "a magnificent new western center for the study of science history."

De NIZA, Marcos. (Nice, France, 1531—Mexico, March 25, 1558). Explorer and missionary. Father De Niza was sent by the governor of New Spain into present-day Arizona and New Mexico to find seven fabulously rich cities reported by Indians and early Spanish travelers, and described by them as the SEVEN CITIES OF CIBOLA. In looking down on Hawikuh, one of the cities of the Zuni Indians, De Niza believed he saw walls of gold. His reports led to the dispatch of Francisco CORONADO (1510-1554) in 1540 to explore and conquer the region. De Niza served as a guide for Coronado. Coronado reported bitterly that De Niza had "told the truth about nothing he had seen."

DE SMET, LAKE. Body of water seven miles north of BUFFALO, Wyoming. In pioneer days the waters were thought to possess healing powers. Originally the lake was two separate bodies of salty water. The smaller lake was primarily marsh, while the larger was 1,500 acres in size. Today the two lakes have been joined as a single reservoir, fed by Clear and Piney creeks, a popular recreational spot which features an annual fishing derby in addition to water skiing and wind surfing.

DE VACA, Alvar Nunez Cabeza. (1490?—1557?). Explorer. A member of an expedition attempting to colonize Florida, De Vaca was shipwrecked in 1858. With other survivors, he built crude boats in which an unsuccessful attempt was made to sail back to Mexico. Captured by the cannibal Karankawa Indians of Texas, de Vaca saved himself by impressing the Indians with his power as a medicine man. Held captive for seven years, de Vaca and three others of his party escaped on foot and began an incredible journey across Texas, passing what is today EL PASO in 1536. In returning to their countrymen in Lower California, the Spaniards told stories they had heard of SEVEN CITIES OF CIBOLA, supposedly wealthy lands with cultured people, jewels and gold. These fables led to further exploration of the Central West by the Spanish.

DE VARGAS, DON DIEGO. (Madrid, Spain, 1650—Sandia Mountains, NM, April 4, 1704). Spanish governor of New Mexico. De Vargas, appointed as the colonial governor and captain general of New Mexico in 1688, controlled great areas of land in Spain and Mexico through his wife. In 1692, he reconquered the upper RIO GRANDE RIVER from the PUEBLO INDIANS after their insurrection, without losing any of his men and

with only one small battle with the APACHES. De Vargas vowed that annually the people would pay homage to *La Conquistadora*-Our Lady of the Conquest, a small statue of the Virgin which he brought with him. That vow is kept each year during the fiesta in SANTA FE with the re-enactment of the colorful procession in which De Vargas entered the city leading his cavalry. De Vargas participated in suppressing Indian uprisings between 1693 and 1697, and he was reappointed as governor of New Mexico by the viceroy of New Spain in 1696. De Vargas was imprisoned by another governor appointed by the Spanish king, on charges made against him by the town council of Santa Fe, but he was later reappointed governor and served from 1701 to 1703. He died while on a campaign against the Faraon Apaches.

DEAD TREE GULCH. Site in the northern BLACK HILLS of South Dakota where gold was discovered in the early spring of 1876. The area, known from its many dead trees, eventually was renamed DEADWOOD, South Dakota.

DEADWOOD DICK. Fictional character, popularized in cheap novels of the late 1800s, which may have been based on the life of Richard Clark, supposedly the first man to drive a stage into DEADWOOD, South Dakota.

DEADWOOD, South Dakota. Town (pop. 2,035), Lawrence County, western South Dakota, northwest of RAPID CITY and southeast of BELLE FOURCHE. Originally known as Dead Tree Gulch, Deadwood was the site of gold fever in the early spring of 1876. The rough-and-tumble life of the early mining camp continued for years. Nearly every famous outlaw and lawman came to Deadwood at one time or another. Among the infamous and famous who walked Deadwood streets were Wild Bill HICKOCK (1837-1878), Wyatt EARP (1848-1929), Sam Bass, and Calamity Jane (Martha CANARY 1852?-1903). The most famous shooting in Deadwood history was the assassination of Wild Bill Hickock by Jack McCall. The motive for the shooting has never been determined. Hickock was buried at Mount Moriah Cemetery near Calamity Jane, to whom it was said he had been married. Souvenir hunters have torn each of five gravestones or markers apart. Today *The Trial of Jack McCall for the Murder of Wild Bill Hickock* is staged six days a week during the summer in the Old Towne Hall. Museums of wild west memorabilia include the Adams Memorial and the Western Heritage at the Old Towne Hall. Gold mining processes and equipment used between 1878 and 1904 may be seen in the Broken Boot Gold Mine. The Chinese Museum Tunnel Tour takes visitors through a 100-year old tunnel built by Chinese workers, a simulated opium den and a small museum containing artifacts of the Chinese contributions to life in rough-and-tumble Deadwood.

DEATH CAMASS. This highly poisonous plant, member of the lily family, is fairly common in the Central West, particularly in Montana.

DEER CREEK, Wyoming. Way station constructed in the 1850s by the Mormons as a resting place for their emigrant trains. The Mormons abandoned their station in 1857 when U.S. troops attacked them in Utah. The buildings were almost immediately occupied by Thomas Twiss, Indian agent at FORT LARAMIE, who moved in with his Indian wife and pet bear. Twiss remained in his Upper Platte River Agency until President Lincoln removed him in 1861. The buildings were then used as the Deer Creek Station, a military post on the OREGON TRAIL. The site saw many battles as the Indians attempted to wreck the telegraph line. The site of the station is located near Glenrock, Wyoming.

DEER PARK, Texas. Town (pop. 22,648), Harris County, in southeast Texas. An industrial suburb of HOUSTON, Deer Park's manufactures include plastics, paper products, carbon, petroleum products, and chemicals. San Jacinto Junior College (1961) is nearby.

DEL RIO, Texas. City (pop. 30,034), seat of Val Verde County, in extreme south central Texas near the border with Mexico. Founded in 1868 and incorporated in 1911, Del Rio's economy revolves around sheep and goat ranching, and Laughlin Air Force Base. Tourist attractions include the Val Verde Winery and the Whitehead Memorial Museum, the site of which was once the largest trading center between SAN ANTONIO and EL PASO.

DELAWARE CREEK. Intermittent Texas stream rising in Culberson County, in the Delaware Mountains of western Texas. It flows northeast past GUADELUPE MOUNTAIN NATIONAL PARK and crosses the border of New Mexico to empty into the PECOS RIVER.

DELTA, Colorado. Town (pop. 3,931), Delta County, west- central Colorado, southeast of GRAND JUNCTION and northwest of DURANGO . Founded in 1882 by the Uncompahgre Town Company and named Uncompahgre, the town was renamed Delta because the shape of the townsite was similar to the Greek letter delta. The economy of the area has remained stable due to its fruit industry, with secondary industries being mining, lumbering and livestock. Recreational opportunities abound, and the community supplies sportsmen headed to GRAND MESA, BLACK CANYON OF THE GUNNISON NATIONAL MONUMENT or the Gunnison and Uncompahgre National Forests. The region is rich in the fossilized remains of prehistoric creatures. Two recent fossil discoveries indicate that the dinosaurs known as supersaurus and ultrasaurus, may each have weighed eighty tons and stood an amazing five stories tall.

DEMING, New Mexico. City (pop. 9,964), seat of Luna County, southwestern New Mexico, southwest of LAS CRUCES and southeast of Lordsburg. Vast fields of yucca plants yield yucca stems which supply quality fiber for twine, seat pads, and bagging material. Fields of feed grain and cotton thrive in an apparently waterless valley. Water for agriculture comes from the subsurface Mimbres River which disappears into the earth north of the city only to reappear in a lake hundreds of miles south in Mexico. Rock hounds swarm over the Little Florida Mountains southeast of town where deposits of AGATE, jasper and fire OPAL are abundant. Residents of Deming enjoy the festivities of the Rockhound Roundup in early March and the Southwestern New Mexico State Fair in October. The unique Great American Duck Race is held at Duck Downs in late August.

DEMPSEY, William Harrison (Jack). (Manassa, CO, June 24, 1895—New York, NY, May 31, 1984). World heavyweight boxing champion from 1919 to 1926. Known as the *Manassa Mauler*, Dempsey worked as a mucker in Colorado mining camps, where he first fought professionally in 1912. He fought a much publicized heavyweight title fight with Tommy Gibbons in SHELBY, Montana, which turned out to be a flop. Dempsey knocked out Jess Willard in 1919 to win the title he eventually lost in 1926 to Gene Tunney in a highly controversial match featuring the "long count." Dempsey provided an account of his life in his autobiography, *Round by Round* (1940).

DENISON, Texas. Town (pop. 23,884), Grayson county, located in northeastern Texas on Lake TEXOMA on the Oklahoma border. Named for railroad man George Denison, the community was founded in 1858 as a stop on the BUTTERFIELD OVERLAND MAIL Route. The birthplace of Dwight David EISENHOWER (1890-1969), the Eisenhower home is now open as a state historical site. Denison is currently a manufacturing, transportation, and tourism center.

DENTON, Texas. Town (pop. 48,063), seat of Denton, County, in central Texas, named for John B. Denton, army officer killed by Indians. Founded in 1855, Denton is best known as a university town today, especially prominent for scientific research. North Texas State University and Texas Woman's University are located here. At the latter, visitors marvel at Little Chapel in the Woods. Its stained glass windows, carved ornamental work and mosaics were all handmade by students. It was designated one of the twenty best buildings in Texas by the Texas Society of Architects in 1984. Denton's present manufactures include food products, clothing, trucks, and brick. The Women's University also sponsors the annual Texas Wild Flower Day.

DENVER AND RIO GRANDE RAILROAD. Chartered by DENVER, Colorado. It was founded in 1870 in response to the construction of the ATCHISON, TOPEKA AND SANTA FE, which threatened to draw all the business of southern Colorado away from Denver. The Denver and Rio Grande, a narrow-gauge line built south to collect the rich minerals from the mountain area, reached PUEBLO in 1873, where it was planned to extend southward toward SANTA FE, New Mexico. The Santa Fe road reached the critical RATON PASS first and thus forced the Rio Grande to confine its business to Colorado. The two lines also found themselves in conflict over the Grand Canyon of the Arkansas River, known as the ROYAL GORGE, which was too narrow for more than a single set of tracks. Workmen from the Santa Fe arrived first and were aided by angry local residents who protested what they felt were unnecessary delays by the Rio Grande. The Rio Grande, threatened by the Santa Fe with a parallel set of track all the way to Denver, leased its entire line to the Santa Fe while continuing its fight in the courts. In 1879 the Rio Grande won a tremendous legal victory when the courts gave the prior rights to the Royal Gorge to the Rio Grande and prevented a Kansas railroad from

operating in Colorado. The lease with the Santa Fe was repudiated and the Rio Grande agreed to pay for the construction of tracks along the ARKANSAS and not to build competitively toward the south. The Santa Fe was allowed to build a line into Denver, but not to build any parallel track beside a competitor. As a result of the court decision, the Rio Grande expanded within Colorado and toward the west, completing track to Salt Lake City, Utah, in 1883 when it was then able to compete with the Union Pacific. Replacing narrow-gauge track with standard gauge by 1890 improved the Rio Grande's competitive edge as did its eastern connection with the Burlington and the Kansas Pacific. The railroad was one of the few to continue passenger operations after AMTRAK—on its Denver-Salt Lake city line. However, this operation was taken over by AMTRAK in 1986. The road continues freight service on all its branches.

DENVER BOTANIC GARDENS. Site of the domed Boettcher Memorial Conservatory in which over eight hundred types of tropical and sub-tropical plants are displayed. The Gardens, covering twenty-two acres, feature highly detailed examples of Japanese gardens, as well as herb, water, and rock gardens.

DENVER, COLORADO

Name: Originally Denver City after James William Denver governor of Kansas Territory when the city was named. Later it was shortened to Denver.

Nickname: Mile High City; Queen City of the Rockies.

Area: 106.8 square miles

Elevation: 5,280 feet

Population:
1986: 505,000
Rank: 23rd
Percent change (1980-1986): +2.5%
Density (city): 4,728 per sq. mi.
Metropolitan Population: 1,791,416 (1984)
Percent change (1980-1984): +10.7%

Race and Ethnic (1980):
White: 74.76%
Black: 12.03%
Hispanic origin: 92,257 persons (18.76%)
Indian: 4,318 persons (0.78%)

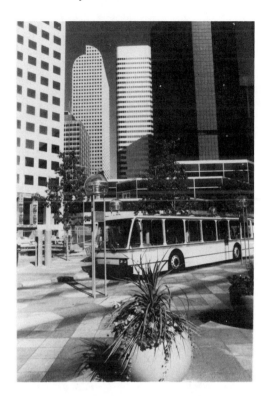

The towers of downtown Denver loom over the 16th Street Mall, where free buses provide transportation for busy shoppers.

Asian: 8,936 persons (1.43%)
Other: 44,390 persons

Age:
18 and under: 22.5%
65 and over: 12.6%

TV Stations: 7

Radio Stations: 35

Hospitals: 22

Sports Teams:
Denver Broncos (football)
Denver Nuggets (basketball)
Denver Zephyrs (baseball)

Further Information: Denver Chamber of Commerce, 1301 Welton Street, Denver, CO 80204.

DENVER, Colorado. City, capital of Colorado, coextensive with Denver County, named for James William DENVER, a governor of Kan-

Denver

sas Territory, which then included eastern Colorado, situated in north east-central Colorado on the slope of the FRONT RANGE. That range, looming to the west, provides the principal physical attribute of the region of the "mile high city," and one of the steps of the state capitol marks the exact height of 5,280 feet above sea level.

Denver is surrounded by a number of satellite communities, some of substantial size, such as AURORA with 158,588 population, LAKEWOOD, 112,848, and ARVADA with 84,576. Others are ENGLEWOOD, Evergreen, Littleton and Westminster.

Denver is a commercial center of great importance, serving a vast area as metropolitan hub. The center of state government, it also is said to have the greatest concentration of federal offices outside of Washington, D.C. It is a major hub of transportation and the leading center of banking between Chicago and the west coast. Its 1,300 energy companies make it a nucleus of energy research and production. Its main manufactures are rubber goods and luggage, but meat packing, stockyards, food canneries and flour and feed mills add to industrial income. Denver is one of the nation's leading tourist magnets.

In earlier days as silver and gold miners began to reach the area, many of them eventually settled in Denver, which was made the territorial capital in 1867. By the 1870s the gold and silver from the nearby mountain towns brought great prosperity, and by 1890 the city's population had exceeded 100,000. It is said to be the youngest of the country's major metropolises.

At one time invalids and semi invalids flocked to the area for its noted clear crisp air. Unfortunately, the city now has substantial problems in air quality control. In other city ratings, however, Denver ranks high in housing growth, library budgets and is one of the best among U.S. metropolitan centers in the cost of

The lofty downtown Denver skyscrapers provide an appropriate setting for the even more lofty peaks of the great Front Range in the near distance.

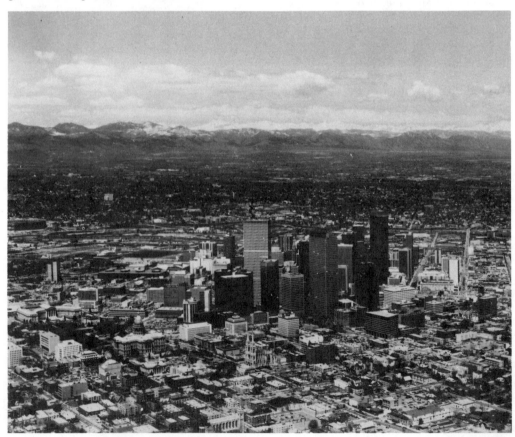

living and enjoys generally high overall ranking for the quality of life.

One of the best-known of the city's attractions is the old mint, established in 1862, where money-making is demonstrated in thirty-minute tours. Also a magnet for tourists is the capitol, with its dome of Colorado gold leaf and walls of Colorado granite.

The city has been accused of lacking a cultural base, but much progress has made in the Denver Center for the Performing Arts, described as "one of the most innovative and comprehensive performing arts centers in the country." It provides three theaters in the Bonfils Complex, the Auditorium Theater, Boettcher Concert Hall, the only "in-the-round" hall for symphonic concerts, and a Recording and Research Center.

Other notable cultural institutions include the Museum of Western Art, DENVER MUSEUM OF NATURAL HISTORY and DENVER BOTANIC GARDENS.

The city's park system is like no other. Denver operates 201 parks inside the city, but it also owns and operates 49 mountain parks within a distance of 72 miles from the city, all of wide variety and located in the mountain foothills. Most noted of these is RED ROCKS PARK AND AMPHITHEATER, with its 10,000 seat amphitheater in a natural setting of huge red rocks, where the much publicized Easter sunrise services are held, as well as concerts of all kinds and drama.

Historically interesting are the Molly Brown House, home of the Victorian socialite and heroine of the *Titanic* disaster, Grant Humphreys Mansion, Pearce-McAllister Cottage and Forney Transportation Museum. Larimer Square is a restoration of an old section of the city, lit by gaslights, dotted with Victorian buildings, quaint shops and restaurants.

One of the best known events of its kind is the annual National Western Livestock Show, Horse Show and Rodeo. The annual Cherry Blossoms Festival also attracts many visitors.

DENVER MUSEUM OF NATURAL HISTORY. One of the largest natural history museums in the United States with representative birds and mammals from five continents, displayed in natural background dioramas, in addition to exhibits on geology and prehistoric peoples of the Old and New worlds. One of the largest gold nuggets ever found in Colorado is displayed in the Coors Mineral Hall. Star shows and laser light concerts are presented in Gates Planetarium.

DENVER, James W. (Winchester, VA, Oct. 23, 1817— Washington, DC, Aug. 9, 1892). Army officer. The capital of Colorado, DENVER, is named in his honor of this man. He served as the secretary of the Kansas Territory from 1857 to 1858 when he became the governor, at which time he proposed separating Colorado from Kansas. During the Civil War Denver served as a brigadier general of volunteers with the Army of the Tennessee. He was active in the promotion of the transcontinental railroad and served as the United States Commissioner of Indian Affairs from 1858 to 1859.

DENVER, UNIVERSITY OF. Oldest institution of learning in Colorado, the university was chartered at DENVER by the Territorial Legislature as the Colorado Seminary of the Methodist Episcopal Church on March 5, 1864. The Seminary, opened through the efforts of John Evans, the governor, closed from 1867 to 1879 and reopened in 1880 as the University of Denver. It granted degrees in dentistry, medicine, law and pharmacy, the first in Colorado. It continues to be well known in those fields, although it has broadened its educational field to full university scope. During the 1985-1986 academic year the university enrolled 7,875 students and employed 387 faculty members.

DES LACS. Remnants of glacial action, near Kenmare, South Dakota, now divided into three parts which are drained by the Des Lacs River. A large migratory waterfowl project has been maintained by the United States Fish and Wildlife Service on the lower lake.

DEVIL'S GATE. Dramatic section of the SNAKE RIVER near Lamont, Wyoming, has been called "one of the most notable features of its kind in the world." The canyon is 330 feet deep and only 30 feet wide at the bottom where the river rushes through with such force the noise can be heard for miles. In the 1850s one hundred Mormon pioneers died nearby in nine days when they were caught in a fierce early Wyoming blizzard.

DEVIL'S GULCH. A jagged gash in the prairie near GARRETSON, South Dakota. Also known as "Spirit Canyon," the abyss features sheer walls of quartzite which appear red in the sunlight and purple in the shadows. Bushes and ferns cling wherever a bit of earth has blown into a crack in the rock, and beautiful cedar trees seem to grow on bare stone at the very rim of the cliffs. Wind racing through the

crevass often causes a moaning sound which explains the belief of many Indians that the area was haunted.

DEVILS LAKE, North Dakota. City (pop. 7,442). Seat of Ramsey County, northeastern North Dakota, northwest of JAMESTOWN and southeast of BOTTINEAU, near the lake of the same name. DEVILS LAKE is an important recreational center. Fishing is popular all year and the position of the community on a major waterfowl migration flyway makes the city a hunters' headquarters. A major participant in the Chautauqua Movement in the 19th century, Creel's Bay at Devils Lake was the third largest such meeting center in the United States. The huge educational and recreational meetings are remembered annually during the North Dakota Chautauqua in early July. Both the city and lake take the name from an Indian legend that recalled a war party being drowned by the Great Spirit while returning over the lake from a forbidden night attack. From that time on the Indians avoided the lake, the largest natural body of water in North Dakota. North Dakota's School for the Deaf is located in Devils Lake. The Skyline Drive along the shore of Devils Lake is exceptionally picturesque.

The nation's first national monument, Devil's Tower, is a unique and awesome landmark rising abruptly 1,280 feet above the valley of the Belle Fourche River.

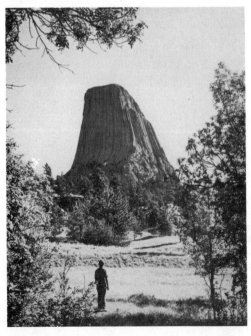

DEVILS'S LAKE. Large saline lake, lying in central northeast North Dakota between Ramsey and Benson counties, the largest natural body of water in the state. Its salty waters result from the lack of an adequate natural outlet. The main body of the lake is about twelve miles in circumference. The lake follows another channel to a small arm about seven miles long. It is popular for hunting and sports events. The nearby city of DEVIL'S LAKE meets the needs of sportsmen and visitors.

DEVIL'S RIVER. Southwest Texas It flows one hundred miles from the northeast corner of Crockett County southerly past Juno, where it meets the Johnson Draw, then to its mouth in the Amistad Reservoir of the RIO GRANDE RIVER north of DEL RIO, Texas in southeastern Val Verde County.

DEVILS TOWER NATIONAL MONUMENT. This 865-foot natural "skyscraper" of columnar rock, the remains of a volcanic extrusion, is the nation's first national monument, proclaimed September 24, 1906, headquartered Devils Tower, Wyoming. The tower provides a notable challenge for climbers. It was first climbed in 1893. Indian legend says that two Indian girls were attacked by bears. When they prayed to the Great Sprit to save them, the Spirit raised the ground, carrying them high into the air, forming the tower. The striations on the sides of the tower were made by the bear's claws, according to the story.

DIABLO MOUNTAINS. Southwestern Texas range running north and south in Hudspeth County west of PECOS, long a preserve for the last herd of bighorn sheep in Texas.

DIAMONDS. Precious gemstone found on a scattered basis at Greenhorn Gulch in Madison County, Montana, one of the two places in the U.S. where such finds have been made. However, the scarcity of the gems makes the site of little commercial importance.

DICKINSON, North Dakota. City (pop. 15,-924. Seat of Stark County, southwestern North Dakota, west of BISMARCK. Settled in 1880, it was named for railroad agent Wells S. Dickinson, its founder, and is an important marketing center for the three states in its area. It boasts two of the northwest's largest livestock marketing rings as well as steel prefabrication, furniture manufacturing and other industries. The city claims to have the nation's only lignite

briquetting plant. Dickinson celebrates Rough-rider Days, a western-style festival featuring a rodeo, horse pull, barn dance, and tractor pull, annually from late June to early July. The festival revives the interest this community has held in Theodore ROOSEVELT, in his day a popular neighbor. He was chairman of the local Stockmen's Association, which he helped organize long before he entered national public life.

DICKINSON, Texas. Town (pop. 7,505), Galveston County, in southeastern Texas. Dickinson is named for one of Stephen F. Austin's "Old Three Hundred Colonists," John Dickinson, probably the first white man in the area. Settlement began in the early 1830s, as Austin continued to promote Texas for U.S. settlers. Once called the "Strawberry Capital of the World," Dickinson has changed from farming to become a residential suburb of GALVESTON.

DIDRICKSON, Mildred "Babe". (Port Arthur, TX, June 26, 1913—Galveston, TX, Sept. 27, 1956). Athlete. Didrickson became a pro athlete after the 1932 Olympic Games in Los Angeles, at which she set two world records, in the 80-meter hurdles and the javelin throw. She excelled in a variety of sports, including basketball, baseball, billiards, and swimming. In 1947 she began her career as a pro golfer, winning every possible women's title at least once during the next decade and was named outstanding woman athlete of the first half of the 20th century by an Associated Press poll. Didrickson was married to George Zaharias, a pro wrestler. Her autobiography *This Life I've Led* was published in 1955, a year before her death from cancer.

DILLON, Montana. Town (pop. 3,976), seat of Beaverhead County, southwest Montana, southwest of BUTTE and southeast of ANACONDA. Dillon is the home of WESTERN MONTANA COLLEGE. The town began where a rancher temporarily blocked the construction of the Utah and Northern Railroad by refusing to sell his ranch or grant the train any right-of-way. A group of businessmen bought the ranch, granted the right-of-way, and sold off lots at public auction. In its history Dillon has been an important wool market, the largest wool-shipping point in Montana. Bannack State Park, seventeen miles from Dillon, contains the ruins of Bannack, the state's first capital. The MEDICINE WHEEL south of Dillon consists of a group of stones in a circular pattern and is thought to have been

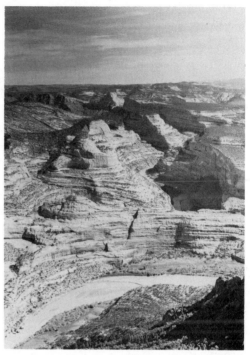

One of the greatest storehouses of fossils, Dinosaur National Monument, lies among the spectacular reaches of the Yampa river.

used by prehistoric peoples in religious ceremonies.

DINOSAUR NATIONAL MONUMENT. Spectacular canyons were cut by the GREEN and YAMPA rivers through upfolded mountains. A quarry contains fossil remains of dinosaurs and other ancient animals. The national preserve was organized 1915 and is headquartered at Dinosaur, Colorado.

DINOSAURS. The Central West region is one of the richest anywhere in dinosaur remains. Some of the finest have been found at DINOSAUR NATIONAL MONUMENT, shared between Colorado and Utah, and in the unusually extensive dinosaur beds of DINOSAUR NATIONAL MONUMENT. An exceptional brontosaurus skeleton was found at Colorado's Devil's Playground, near De Beque. It measured 140 feet in length. Thought to be unique was the prized fossil of the six-horned vintacolotherium found in northwestern Colorado in 1924. One of the most complete skeletons of TYRANOSAURUS REX ever known was found near JORDON, Montana, at Hell Creek. Another very complete specimen was that of the triceratops found near GLENDIVE,

Montana. Remains of other dinosaurs have been found in the RED LODGE, Montana, area. Dinosaur skeletons picked up from many parts of South Dakota are displayed at the museum of the State School of Mines at RAPID CITY. At the dinosaur quarry near ENID, Oklahoma, more than 4,000 dinosaur bones have been found, and many others have been unearthed from the dinosaur pits of the BLACK MESA OKLAHOMA STATE PARK and at Oklahoma's BOISE CITY region.

DISASTERS. The Central West region has been the scene of some of the country's most tragic disasters, including the single natural disaster which took the most lives of record in this country. One of the cruelest hurricanes known struck the Gulf coast of Texas at GALVESTON with winds of 110 miles per hour. The low-lying city was overwhelmed with gigantic waves, which flooded large areas. The toll of life has never been exactly determined, but it was known to be over 6,000, with 8,000 people made homeless and property damage of, for the time, the enormous sum of thirty million dollars. The force of the storm can be illustrated with the example of the 4,000 ton ship which was swept twenty-two miles inland.

Since that time many hurricanes and floods have swept the gulf coast, with much higher property damage but fewer lives lost. The most recent major loss of life was brought on by Hurricane Audrey, June 25-30, 1957, sweeping the coast from Texas to Alabama and killing 390.

Those other wind storms, tornadoes, have taken their toll. The worst in the Central West region on April 9, 1947, killing 169 as it swept across Texas, Oklahoma and Kansas. Those same states suffered 115 deaths in the tornado of May 25, 1955.

The worst mine disaster in the region occurred at Hanna, Wyoming, on June 30, 1903, when 169 miners were killed.

Texas has suffered two of the worst explosion tragedies in the country. As many as 561 were killed when a ship exploded at TEXAS CITY on April 16, 1947. A total of 413, many of them children, were killed at the explosion of a school at NEW LONDON, Texas, on March 18, 1937.

The greatest toll of life in the region due to a railroad wreck occurred at Eden, Colorado, on August 7, 1904, when 96 lost their lives. At Dawson, Texas, 85 were killed in a railroad accident on March 116, 1969.

DISSECTED TILL PLAINS. Land surfaces which are substantially eroded. Approximately

half of Nebraska's land surface has this classification; while the rest, designated as "constructional plains," is not much affected by erosion. The northeastern corner of Kansas north of the KANSAS RIVER and east of the BIG BLUE RIVER, an area referred to as the Bluestem Region, is dissected, while in South Dakota dissected till plains are found in the southeastern corner of the state.

DIVIDES. These imaginary demarcations are sometimes also called watersheds because they indicate the division of waters falling on a region, sending the rain that falls on one side of a slope to a different destination from that falling on the other side. Small streams nearest the crest of the divide become the *headwaters* of river systems. Divides may be little more than a small rise in the land, such as the divide which runs east and west across the Central Plains and directs water south toward either the Gulf of Mexico or north to Hudson Bay.

The Central West region harbors the major divide of the continent, one of the world's most extensive and important, the CONTINENTAL DIVIDE. Entering from Canada at the Montana border, the Continental Divide takes a tortuous journey across the entire region. Another major divide in the region cuts diagonally through North Dakota from the northwest corner. Waters falling to the north flow eventually into Hudson Bay, those to the south through the Missouri/Mississippi system to the Gulf of Mexico. However, both of these river systems reach inlets of the Atlantic Ocean and do not flow into two different oceans, as is the case on the Continental Divide.

Within the states the watersheds become gradually smaller until they merely divide the waters between small streams. One of the most interesting internal divides is found in Nebraska, where the great PLATTE RIVER and its branch the NORTH PLATTE flow across the entire state without having a single tributary flowing in from the south. The divide between the Platte and rivers to the south follows along those rivers only a few miles to the south. Sending rainfall south of the divide into other tributaries of the Missouri River. This freak of geography was of great importance to early travelers. If they traveled along the Platte north of the divide, they had no rivers of any consequence to cross.

DODGE CITY, Kansas. City (pop. 18,001). Seat of Ford County, southwestern Kansas, on the ARKANSAS RIVER, southeast of GARDEN CITY. It

Dodge City, Kansas, now offers a two block reconstruction of historic Front Street, the main street of the 1870s, with its Long Branch Saloon, saddle shop, gunsmith and other old time buildings.

was named for Richard I. Dodge, who commanded Fort Dodge when the city was established in 1872. In 1541 the present site of Dodge City was visited by Francisco CORONADO (1510-1554). The first Santa Fe Railroad train arrived in September and before long Dodge was either the "Queen of the Cowtowns" or "the beautiful, bibulous Babylon of the frontier." Dodge City's Front Street once boasted one saloon for every fifty citizens. The 400,000 longhorns shipped from Texas to the railhead at Dodge by 1882 had made it the "Cowboy Capital of America" until the railroad built farther west. A rough town, Dodge City drew many of the most famous lawmen of the day including Wyatt EARP (1848-1929) and Bat Masterson (1853-1921). Among the unique forms of money once used in Dodge were buffalo bones, sought by bone dealers, who sold them to be used as fertilizer. In 1879 Chalkley Beeson, the owner of the Long Branch Saloon, organized the Dodge City Cowboy Band whose western outfits and musicianship gained national attention. Today Dodge City is a center of one of the world's great wheat production regions, and it continues to be an important cattle-shipping site and trading center. A Dodge City doctor, Samuel J. CRUMBINE, is remembered as one of the nation's leading proponents of public sanitation. Citi-

zens of Dodge City revive the colorful past annually in July with Dodge City Days which include rodeo events and a parade as well as with the annual Longhorn Steer Drive. Front Street has been reconstructed and stages daily "shootouts."

DODGE, Grenville Mellen. (Danvers, MA, 1831—Council Bluffs, IA, 1916). Railroad builder. Dodge became the chief engineer for the Union Pacific Railroad, which linked the railroads of the East with those of the West, as part of the nation's first transcontinental railroad, completed in 1869. During the construction, the track-laying record of 568 miles in one year was set. Dodge discovered a pass over the CONTINENTAL DIVIDE in Wyoming, through the LARAMIE MOUNTAINS, in a place now called Sherman Hill. Referred to as a "railroad pathfinder," Dodge was the chief engineer for the Texas and Pacific until its failure in the depression of 1873. He directed the construction of nine thousand miles of track for the Denver, Texas and Fort Worth and the Denver, Texas and Gulf railroads between, 1873 and 1883. It is estimated that during his career he surveyed approximately sixty thousand miles of railroad line in the West, Midwest and Cuba. In later life Dodge was a popular speaker on the

CIVIL WAR and western personalities and events.

DONIPHAN, Alexander William. (Maysville, KY, July 9, 1808—Richmond, MO, Aug. 8, 1887). Military officer. Doniphan commanded troops against the Mormons and refused to carry out the subsequently revoked order to execute Mormon leader Joseph Smith. Doniphan was the commanding officer in New Mexico during the MEXICAN WAR in 1846. He defeated Mexican troops on Christmas Day, 1846, in the only battle of the war fought on the soil of New Mexico. Doniphan then led the First Missouri Volunteers from Valverde, New Mexico, to Chihuahua, Mexico, to reinforce American forces in Mexico. The march is considered one of the longest and most brillant ever made, but in his absence residents of New Mexico revolted and killed Charles BENT, the governor. Doniphan opposed secession of the South and favored Missouri neutrality during the CIVIL WAR.

DONOHYUS. Prehistoric tusked pig which was six feet high. Fine specimens have been found in Nebraska fossil beds.

DORION, Pierre. (1760?—) Frontiersman, guide. About 1780, Dorion came to live with the YANKTON SIOUX and became the first known European resident of present South Dakota. He married a woman from the tribe, and Marie Dorion became his trail companion in travels over much of the north and west. Pierre Dorion was a guide and translator for the LEWIS AND CLARK EXPEDITION in 1804 and was able to help Clark in the conciliation of the Sioux of the region. Marie Dorion (Iowa Nation, c 1791—Salem, OR, c.1791) served as an interpreter for the Astoria land expedition of 1811-1812.

DOTSERO, Colorado. Junction of the Royal Gorge and Moffat Tunnel routes of the Denver and Rio Grande Western Railroad. Completed in 1935, the Dotsero Cutoff links the DENVER AND RIO GRANDE WESTERN and the Denver and Salt Lake Railway at Orestod, Dotsero spelled in reverse. The Dotsero Cutoff gives DENVER, Colorado, a direct link with the Pacific Coast.

DOUGLAS, Wyoming. City (pop. 6,030), seat of Converse County, east-central Wyoming, southeast of CASPER and north of LARAMIE. Since 1905 Douglas has been the home of the Wyoming State Fair which is held annually in September. Douglas also claims credit as home of the "jackalope," an imaginary beast, half antelope and half jackrabbit, created by some of Wyoming's taxidermists. Douglas was known as Tent Town when it was founded in 1886 as a supply point for the railroad crews and local ranchers who appreciated the good water supply and fine grass. One of the earliest ranchers in the state was John Hunton who used the S O brand on his cattle kept near Douglas. Cattle brought rustlers, including the notorious George Pike, who was actually hired by different ranchers so that at least his current employer could benefit from his activities. The range soon became overcrowded and thousands of animals died in the fierce snow storm in March, 1887, which drove many ranchers out of business. Settlement of the area proceeded slowly until the Federal Land Office was moved in 1890 to Douglas from LARAMIE, two hundred miles away. Among the first citizens of Douglas were DeForest Richards, fourth governor of Wyoming and Dr. A.W. Barber, governor during the Johnson County War. Between Casper and Douglas is AYRES NATURAL BRIDGE STATE PARK. Southeast of Douglas is a typical badlands region. Fort Fetterman State Historic Site preserves the post which was once an important supply point for the Army.

DOVE CREEK, Colorado. Town (pop. 826), Dolores County, northwestern Colorado, northwest of Durango and southwest of Grand Junction. Settlement began in the area in the early 1880s. Zane GREY (1875-1939), the famous writer of western fiction, lived for some time in his youth in Dove Creek where, it is said, his *Riders of the Purple Sage* (1912) was written.

DRIFT PRAIRIE. Region in North Dakota lying between the PEMBINA (or Manitoba) Escarpment on the east and the MISSOURI ESCARPMENT on the west.

DRISCOLL, Clara. (Saint Mary's TX, Apr. 2, 1881—Corpus Christi, TX, July 17, 1945). Philanthropist, politician. The heiress of the vast Driscoll oil fortune, she returned to Texas from France in 1899 and immediately enlisted in the campaign to save the ruins of the ALAMO Mission in SAN ANTONIO. She contributed most of the funds needed to restore it and in 1925 became president of the Daughters of the Republic of Texas, which administered the memorial. In 1939 Texas set aside a public holiday to honor this "Saviour of the Alamo." In the 1920s and 1930s Driscoll was actively engaged in Democratic national politics.

DRY FARMING. System of tilling the land so that crops can be grown with sparse natural rainfall. Moisture in the soil is conserved by careful cultivation. The field is worked continuously, but only planted in alternate years. Keeping a dust mulch over the ground's surface at all times retains a two-year supply of moisture in the ground, unless a windstorm blows away the topsoil. Dry farming requires large tracts of land and the efficient use of farm machinery. The system was introduced into Wyoming in 1878, about forty miles northeast of CHEYENNE, by a group of Swedes. By the end of the 1890s, dry farming had become popular in a section of the eastern part of the state twenty to one hundred miles wide, running north to south. Lack of rain, windstorms which blow away the topsoil, and invasions of insects have all conspired to ruin many dry farmers.

DUBOIS, Wyoming. Town (pop. 1,067), Park County, west-central Wyoming, east of JACKSON and northwest of LANDER. A three-way watershed, the only one of its type in the United States, exists at Union Pass near Dubois. From this point some waters flow toward the Atlantic through the Missouri/Mississippi river system, other waters flow to the Pacific Ocean through the Columbia River system, while other waters enter the Gulf of California by way of the GREEN and COLORADO rivers. Dubois began in the 1830s as a rendezvous for Indian, American and French trappers. Between 1914 and 1946 stacked decks of railroad ties were floated down the WIND RIVER, from the tie camps near Dubois to the railhead at RIVERTON. The area around Dubois is now mostly devoted to dude ranches and cattle operations.

DUDE RANCHES. Uniquely western-style enterprise begun by Howard Eaton. At his Custer Trail Ranch in South Dakota, Eaton was impressed that friends from the East who visited him wanted to pay their way. Eaton and his brothers, Alden and Willis, sold the Dakota ranch and moved to DAYTON, Wyoming, where they purchased seven thousand acres in the foothills of the BIGHORN MOUNTAINS and began their dude ranch there in 1904. Trails were created on the ranch, which also sported a post office, hotel, individual houses, and its own telephone system. Hundreds of imitators in other parts of the country soon followed the example of this first dude ranch.

DUNN, Harvey. (Manchester, SD, Mar. 8, 1884—Tenafly, NJ, Oct. 29, 1952). Artist. He grew up on the family homestead in Dakota Territory. After becoming interested in art in high school, Dunn worked on farms during the summer to pay his way through the Art Institute of Chicago (1902-1904). He became a highly paid illustrator of books and magazines, including the *Saturday Evening Post.* In 1908, with his friend N.C. Wyeth as best man, Dunn married Tulla Krebs, daughter of a wealthy chemical manufacturer. In 1915 he moved to Leonia, New Jersey and established the Harvey Dunn School of Illustration. His work continued to appear in almost every issue of the *Post*, along with other leading magazines, and he kept up his illustration of books and advertising copy, becoming one of the best known illustrators of the time. In 1918 he was asked to serve as an official artist for the American Expeditionary Forces in Europe in WORLD WAR I, with the rank of captain. His "Machine Gunner" was said to have been the most widely reproduced of all the war paintings. His paintings of the war began to appear on covers of the *American Legion Monthly*, and the exposure made Dunn the best known of the artists of that war. He made frequent excursions to his old home area in South Dakota and began to paint pictures of life of the area, working on them throughout the 1940s. After a show of his work at De Smet, South Dakota, in 1950, eighty of his paintings were given to SOUTH DAKOTA STATE UNIVERSITY, at BROOKINGS, where they now are displayed. Forty of these works provide a unique interpretation of life in the northern region of the Central West.

DUNRAVEN, EARL OF. (Ireland, 1841-1926). British hunter, explorer, yachtsman, author and war correspondent for the London *Daily Telegraph* in Abyssinia in 1867. The Earl of Dunraven, in the 1870s, bought most of ESTES PARK for a private hunting preserve, a purchase since called "one of the most gigantic land steals in the history of Colorado." The Earl, who had hunted with Buffalo Bill and 100 warriors near Fort McPherson in 1874, built the park's first hunting lodge and entertained European gentry and American frontiersmen in a setting described by German landscape painter Albert BIERSTADT (1830-1903) as, "nature's finest composition for the painter." The Earl left the park to fight in the Boer War and sold his American property in 1904.

DURANGO, Colorado. City (pop. 11,426), seat of La Plata County, southwestern Colorado, southeast of GRAND JUNCTION and south-

west of ALAMOSA, founded 1880 and named for the Durango in Mexico. FORT LEWIS AGRICULTURE AND MECHANIC ARTS COLLEGE operates at Durango. The Silverton, the last remaining narrow-gauge, coal-burning passenger railroad in the country, operates over a spectacular route from SILVERTON to Durango through the majestic San Juan National Forest. The business center of the San Juan basin, Durango also attracts tourists on their way to nearby MESA VERDE NATIONAL PARK or FOUR CORNERS, where Colorado, Utah, Arizona, and New Mexico meet at a point. White-water rafting thrills riders on daily trips along the Animas River. Durango also claims to have one of the state's best period theaters, the Diamond Circle, located in the Strater Hotel.

DUST BOWL. The worst U.S. drouths in recorded history wreaked their greatest devastation in the states of the Central West, reaching an overall extent of 25,000 square miles at their peak in the late 1930s. As the rains practically ceased, the soil dried to dust, and unusually high winds created vast dust storms, turning much of the area into a "Dust Bowl."

The plight of the people of Oklahoma gained special attention in such works as John Steinbeck's *The Grapes Of Wrath (1939)*. In this book the tragedy of the drouth was vividly portrayed and called widespread attention to the problem of the disposessed. However, Oklahomans were not alone in their suffering. The dust bowl's devastation stretched north to south from border to border, affecting most of the nation's center.

Great areas of the Central West region had been plowed to grow grain for the WORLD WAR I food effort. Much of this land should have been left in its original condition. Without roots or cover the land was unprotected, and the dust storms carried off untold tons of topsoil, which might otherwise have been held down by the original prairie grasses. This situation provided one of the principal object lessons of the need for land conservation. One Kansan kept his sense of humor and remarked that the prairie dogs were digging their holes in the air.

The drouth added to the hardships of the Great Depression, with banks foreclosing on thousands of farm mortgages and with the farmers striking back, sometimes with violence.

In South Dakota for four years, from 1933 through 1936, high winds carried choking clouds of dust, darkening the sun and burying the fences until they disappeared. As in some of the other areas, Dakotans turned to Indian rainmakers who had difficulty remembering the ancient rituals. They had little success in ending the drouth. In North Dakota one-third of the state's lakes dried up and never refilled.

Gradually, of course, the rains returned to the region. Meanwhile, many conservation lessons had been learned. The administration of F.D. Roosevelt planted a belt of trees from north to south across much of the area. This "shelter belt" was designed to restrain the "dust-busting" winds. Vast reservoirs were created in the Dakotas, Oklahoma and elsewhere, to provide more moisture generally, and soil conservation measure were greatly encouraged. Subsequent periods of low rainfall, although not as severe as the great drouth, have caused substantially less damage, because of the precautions taken.

The drought of the summer of 1988 was one of the most severe of the several droughts which have hit the region since the great drouth. Most of the northern parts of the region suffered the worst losses, and local, state and federal governments were forced to step in to help farmers who faced foreclosure because of the total failure of their crops.

DUST STORMS. Clouds of dust propelled by a powerful, turbulent wind blowing at least twenty-five miles per hour, capable of carrying as much as four thousand short tons of fine particles of silt, clay and light material suspended per cubic mile of air for long distances. Severe dust storms were recorded as early as the 19th century in the Central West, but extensive farming of the Central West, deforestation, over-grazing, and soil erosion led to ever more disaster. Dust clouds, reaching five miles high, buried the land and destroyed its fertility during the 1930s in parts of every state in the Central West, then called the DUST BOWL. Farmers in the region had planted wheat during WORLD WAR I to meet the great demand, but the crop did not adequately protect the ground against wind. Great clouds of dust from the Central West were carried across the continent to the Atlantic Coast and far into the Gulf of Mexico in 1934. Farmhouses were often nearly hidden by the mounds of dust, and residents wore masks to protect their throat and lungs. Hardships faced by area residents who attempted to leave the region were the basis of John Steinbeck's novel, *The Grapes Of Wrath* (1939). Rehabilitation efforts included the great shelter belt. This was a wide band of trees planted across the region from north to south,

designed to reduce the effect of the wind in picking up the dry soil and carrying it across country. In the late 1930s and early 1940s increased rain fell in the region and farmers were able to harvest good crops. A decrease in rainfall has caused less severe dust storms at least once every decade since the 1940s.

EAGLE PASS, Texas. City (pop. 21,407), seat of Maverick County, in south-central Texas, on the RIO GRANDE RIVER at the border with Mexico. Named for the frequency of Mexican eagles that once flew over the land, Eagle Pass was settled in 1850. It is a gateway to Mexico through the town of Piedras Negrasand on the Constitution Highway to Mexico City. A tourism center, its other industries include oil production and agribusiness.

EAKER, Ira Clarence. (Field Creek, TX, Apr. 13, 1896—). Pioneer aviator and military commander. During WORLD WAR II, Eaker served as head of the 8th Army Air force (1943) and the Allied air forces in the Mediterranean (1944). He was deputy commanding general, United States Air Force, from 1945 to 1947.

EARHART, Amelia. (Atchison, KS, July 24, 1898—Lost in the Pacific, July, 1937). Pioneer aviator. Earhart was the first woman passenger to fly across the Atlantic Ocean, from Trepassey Bay, Newfoundland, to Burryport, Wales, in 1927. She wrote about that epic journey in her book entitled *20 hrs., 40 min.* (1928). In 1931 she married publisher, George Putnam. In 1932, she flew alone across the Atlantic from Newfoundland to Ireland. In 1935, Earhart was the first woman to fly to the mainland of the United States from Honolulu, Hawaii, and was the first woman to fly successfully across the United States alone in both directions. On a planned round the world trip, Earhart vanished near Howland Island in the Pacific. After her last contact on March 17, 1937, no confirmed report of her fate has ever been made.

EARP, Wyatt Berry Stapp. (Monmouth, IL, 1879—Los Angeles, CA, 1929). Peace officer. Earp is possibly best remembered as one of the participants in the famous gunfight at the O.K. Corral in Tombstone, Arizona, in 1881. He served as a peace officer in such other tough frontier towns as WICHITA, Kansas in 1875, DODGE CITY, Kansas in 1876 and also in 1877 after a short stay in Dakota Territory and in Tombstone, Arizona, 1879. His life has been the much glamorized subject of books, television and movies.

EAST CENTRAL OKLAHOMA STATE UNIVERSITY. One of three regional state normal schools founded in 1909 in the eastern half of the state. In 1919 it was authorized to increase its programs to four-years. In 1939 arts and science programs were added. Located in ADA, Oklahoma, the home of former Senator Robert S. KERR. During the 1985-1986 academic year the university enrolled 4,277 students and employed 210 faculty members.

EASTERN MONTANA COLLEGE. One of the six units in Montana's university system, located in BILLINGS. From 1927 to 1945 the primary responsibility of the school was to train teachers for elementary schools. The program has since been expanded. The college enrolled 4,173 students during the 1985-1986 academic year and employed 236 faculty members.

EASTERN NEW MEXICO UNIVERSITY. State university in PORTALES, operated as a two-year college until 1940 when the third and fourth years were added to the program. Branches are operated at ARTESIA, Hobbs, TUCUMCARI and ROSWELL. A special summer program is offered incoming freshman who desire personalized assistance in preparing for college. A university operated preschool is used by the child development and psychology classes for observation purposes. Eastern New Mexico University enrolled 3,732 students during the 1985-1986 academic year and employed 200 faculty members.

EBERHART, Mignon Good. (Lincoln, NE, July 6, 1899—). Author. Eberhart is credited with more than 50 Gothic/mystery novels. Among the best-known of these are *While the Patient Slept* (1930, *The Case of Susan Dare* (1934) and *The Bayou Road* (1979).

ECHO PARK. Vast and lonely valley in the center of DINOSAUR NATIONAL MONUMENT near the Western Colorado border where the GREEN and YAMPA rivers meet. An echo is said to carry back and forth four different times.

ECONOMY, REGIONAL STATUS. The economy of Texas accounts for annual income to the state equal to more than twice that of all the other states of the Central West region combined. Texas gross income exceeds 280 billion dollars, and the total for the other nine states of the region reaches only 212 billion. A distant second is Texas neighbor, Oklahoma (46.5 billion), followed by the next neighbor north, Kansas (39.6 billion) and the neighbor to the north, again, Nebraska (36 billion). Colorado follows with 34 billion, Wyoming, 17.7 billion, New Mexico, 15.3 billion, Montana, 8.9 billion, North Dakota, 7.7 billion and last, South Dakota, with 5.9 billion. Total gross annual income for the region is 493.3 billion dollars.

EDINBURG, Texas. City (pop. 18,706), seat of Hidalgo County, located near the southernmost tip of Texas 50 miles from BROWNSVILLE. It was founded in 1907. Originally the site of Hidalgo Village, the name was changed in honor of the birthplace of an early settler. Oil, natural gas, and citrus fruits are produced, and

Merchandising practices that have contributed much to the economy were introduced in the Central West by James Cash Penney, who built one of the largest merchandising chains from his beginning at a small store in Kemmerer, Wyoming.

there are creameries, ironworks, planing mills, and cotton gin industries in the area. Edinburg hosts Moore Air Force Base, Pan American College, and the most dispersed school system in the United States, spread over 945 square miles.

EDUCATION IN THE CENTRAL WEST.

By the time the first formal education reached the Central West region, the educational system of the east was more than two centuries old in some places. However, the region's educational institutions caught up rapidly, and in many cases for very unusual reasons:

Colorado: The first university to be established in the state was the University of DENVER, 1864. The University of COLORADO was authorized in 1861 but did not come into existence until 1867. One of the nation's newest and most "glamorous" institutions of higher education is the AIR FORCE ACADEMY, arriving near COLORADO SPRINGS in 1958. Several educational novelties have evolved in Colorado. The EMILY GRIFFITH OPPORTUNITY SCHOOL, founded at Denver in 1916, was one of the first to provide basic education combined with vocational training. The OUT-WARD BOUND SCHOOL at MARBLE provides unique training and first-hand experience in wilderness survival, designed to toughen America's "soft" generation. The entire concept of domestic science education might be said to have originated in Colorado with Louis du Puy of the Hotel de Paris in GEORGETOWN. Dr. James E. Russell of Teachers College of Columbia University, observed the Du Puy methods and techniques of cooking and originated the first courses in homemaking, based on the westerner's concepts.

Kansas: The first free schools in the state were opened at present KANSAS CITY by the WYANDOTTTE INDIANS in 1844. Kansas first college, Baker University, at Baldwin, was opened in 1859. The University of KANSAS at LAWRENCE was begun in 1866. The first community college west of the Mississippi was WICHITA STATE UNIVERSITY, founded in 1895 as Fairmont College.

Nebraska: The first school in present Nebraska was, established at FORT ATKINSON in 1820. The University of NEBRASKA at LINCOLN was opened in 1869, and CREIGHTON UNIVERSITY was initiated by the Creighton family at OMAHA in 1876.

Montana: Formal schooling in the state began at BANNOCK in 1863 under the governor's niece, teacher Lucia Darling. She left an interesting account of pioneer education in the region: The community was "...tumultuous and rough, the headquarters of...highwaymen, and lawlessness and misrule seemed the prevailing spirit...But...many worthy people...were anxious to have their children in school. I was requested to take charge." Miss Darling held class in her own home. The children had no textbooks but brought whatever reading they might have at home. The cold forced the school to close in the winter, but it reopened in the spring. The log schoolhouse built that summer may still be seen. In 1864 the Jesuits opened the first Indian boarding school in the northwest at ST. IGNATIUS. The University of MONTANA was founded at MISSOULA in 1895.

New Mexico: The University of NEW MEXICO was founded at ALBUQUERQUE in 1889. One of the most highly regarded private educational institutions in the state is the NEW MEXICO MILITARY INSTITUTE at ROSWELL. Both public and private schools for Indian youth are found in numbers in the state, some of the best having been founded and carried on by the tribal organizations themselves.

North Dakota: JAMESTOWN COLLEGE, the first college in North Dakota, was founded by the Presbyterian church in 1883. A year later the University of NORTH DAKOTA, GRAND FORKS, was founded on September 8th, one of two state supported schools in U.S. history to have been founded when the territory had not yet become a state. The other was the University of Wyoming at Laramie. The state's first school was founded at PEMBINA in 1823. The two earliest methods of teaching industrial arts originated in North Dakota. They are the North Dakota Plan and the Babcock Plan. The first free course in manual training originated in the state. One of the more unusual educational advantages is the Summer School of Fine Arts at the INTERNATIONAL PEACE GARDENS. North Dakota is particularly renowned for its careful and effective use of the large acreages of public lands given by and to the state for the support of education.

Oklahoma: The Indian nations in the state had formal education as early as 1820. By 1836 the CHOCTAW nation had eleven schools in operation, and by 1853 the Choctaw had a completely organized school system, as did the CHEROKEE. The Cherokee were among the first nations of the world to claim that the whole population could be considered "literate." During the entire period of the Indian nations, experts generally agreed that the Indian schools were better than their neighbors. BACONE COLLEGE, first in the state, opened at the Indian

Edwards Mountain

The first school building in Wyoming may still be seen at the Fort Bridger Historic Site.

town of MUSKOGEE in 1880. Ten years later the University of OKLAHOMA at NORMAN was organized. Its Kellogg Center for Continuing Education has been called the "nation's finest" in the field of adult learning. Another unusual Oklahoma educational institution is the ACADEMY OF CIVIL AVIATION at OKLAHOMA CITY, the only one in the U.S. to train airport personnel.

South Dakota: YANKTON COLLEGE, founded in 1881, is the oldest in the state. The University of SOUTH DAKOTA at VERMILLION had an unusual beginning. In 1882 the people of Vermillion funded the first year of operation of the institution because the state did not provide financing until the next year. One of the several devoted to its field in the Central West region, the SOUTH DAKOTA SCHOOL OF MINES AND TECHNOLOGY at RAPID CITY, founded in 1885, is considered one of the best of its type. ABERDEEN inaugurated the first program in what is now called cooperative education, also known as the ABERDEEN PLAN. South Dakota's first school opened in 1860 in Bon Homme County.

Texas: In 1838 Texas set aside vast acreages for elementary and high school education along with 50 leagues of territory for universities. Used wisely in many cases, this land provided financing which helped to make the Texas school and college system one of the most studied in the world. The University of TEXAS (founded 1883) benefitted particularly from this land largess when in 1923 oil was found on its land. The main plant at AUSTIN was completed without use of tax funds, and the university's endowment-style income is one of the highest in the world. RUTERSVILLE UNIVERSITY, founded in 1840, was Texas' first institution of higher education. The free public school system was inaugurated in 1854.

Wyoming: The nation's "highest" state university opened at the lofty city of LARAMIE in 1887, one of the two to commence before statehood in 1890. The other was the University of North Dakota at Grand Forks. FORT LARAMIE witnessed the founding of Wyoming's first school in 1852.

EDWARDS MOUNTAIN. Montana. This peak clearly illustrates the fact that the present state was formed under shallow seas. As the

waters rose and fell they left thick layers of sediment, which hardened into layers of sedimentary rock, raised by the mountain uplift and now seen clearly as the sides of the mountain.

EDWARDS PLATEAU. Texas landmass rising from the COASTAL PLAIN on the south and taking up much of the south central portion of Texas, forming the southern end of the GREAT PLAINS. Its subhumid climate produces mesquite shrubs and grasses, fed upon by cattle, goats, and sheep. Many rivers flow through the plateau including the MEDINA, FRIO, Concho, and San Saba.

EIELSON, Carl Ben. (Hatton, ND—Siberia). Pioneer aviator. Eielson was given an airplane by his friends in Hatton after serving in WORLD WAR I and began barnstorming North Dakota. He journeyed to Alaska, became one of the early aviation leaders there in the early 1920s, when he flew the first airmail in the territory. With famous explorer Sir Hubert Wilkins, Eielson made a flight over the Arctic in 1928 from Point Barrow to Spitzbergen. The two men also flew numerous flights in Antarctica. Eielson was killed on a rescue flight in Siberia.

EISENHOWER CENTER. ABILENE, Kansas, site which includes the Eisenhower family home, a museum, a place of meditation and the Eisenhower Presidential Library. The Center covers twenty-two acres of carefully landscaped grounds, which were once part of the land plowed and planted by the six Eisenhower brothers. The place of meditation is the final resting place of President and Mrs. Eisenhower and their son, Doud Dwight Eisenhower. The Eisenhower home, the boyhood home of the president, is maintained as it was in 1946. Items relating to Eisenhower's boyhood in Abilene, his military career, and his life after serving as President of the United States are contained in the Eisenhower Memorial Museum. The Presidential Library houses the papers Eisenhower accumulated during his life in Washington, D.C.

EISENHOWER BIRTHPLACE STATE HISTORIC SITE. At DENISON, Texas. Home of future president, Dwight D. EISENHOWER. He lived there for only his first year of life and then was moved by his parents to Kansas. The home, now a museum, contains old furnishings and some of Eisenhower's personal effects.

EISENHOWER, Dwight David "Ike. (Denison, TX., October 14, 1890—Washington DC., March 28, 1969). Military leader and 34th President of the United States. A year after Eisenhower's birth, his family moved from Texas to ABILENE, Kansas, where the future president was raised. He began his career in the military with study at the United States Military Academy at West Point, graduating in 1915.

His early military service was extremely varied. After the Academy, his first assignment was at Fort Sam Houston, San Antonio, Texas, in 1915, where he met his future wife, Mamie Geneva Doud. One year later he married Mamie, who would very much later prove to be one of the most admired first ladies.

In 1918 he was sent to Camp Meade to prepare troops for service in WORLD WAR I. The young officer had looked forward to active duty at the front in Europe, but his superior officer was so impressed by his "organizational ability" that he was directed to organize a training camp at Gettysburg, Pennsylvania. The new center was named Camp Colt.

Eisenhower's rapid development of Camp Colt as an efficient training operation became

The Place of Meditation chapel is one of the features of the Eisenhower Center at Abilene, Kansas.

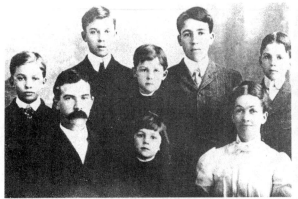

EISENHOWER · USA

David and Ida Eisenhower raised six sons, Dwight D., Edgar, Earl, Arthur, Roy and middle front Milton; Dwight D. Eisenhower as a West Point cadet, left; a U.S. postage stamp is another tribute to the late president.

legendary as a classical example of efficiency in such efforts, and he advanced from captain to lieutenant colonel. He was especially commended for his handling of the crisis in the flu epidemic of 1918. He also was primarily responsible for the rapid deployment of the hundreds of thousands of army personnel at the end of the war, and at Camp Holt he had already begun the work which would make him one of the few early experts in tank warfare.

Reassigned to Camp Meade in 1819, in July he undertook to lead the first large scale army truck convoy ever to cross the country from coast to coast. The leader and his convoy had a sendoff from Secretary of War Newton Baker in Washington D.C., in July and received a hero's welcome by the California governor when they arrived at San Francisco in early September. During the three month trip, Eisenhower became intimately acquainted with an important cross-section of the country.

After returning to Camp Meade he resumed his friendly acquaintance with Colonel George S. Patton. Their organization of tank forces despite opposition in higher quarters proved invaluable in their later operations in WORLD WAR II. However, they could not persuade the top brass to establish a separate tank corps.

Eisenhower's next assignment was to "understudy" General Fox Conner, commandant of U.S. forces in the Panama Canal. General Conner, was a brilliant student of the history of military strategy worldwide, and he and Eisenhower spent many hours discussing and dissecting battles from ancient Greece to modern Germany. A year after returning to the states in 1924, Ike was assigned to the extremely important Command and General Staff School at Fort Leavenworth and arrived there in August, 1925, where he was the most successful of all the officers in his year-long studies.

Eisenhower was assigned to Camp Benning, Georgia, in 1926. From there he came under the jurisdiction of America's leading army personality, General John J. Pershing. As General Pershing's executive officer, he was assigned to head the Battle Monuments Commission. This

office took him to Europe for the first time, where, beginning in 1928, he had an opportunity to become intimately acquainted with European geography and to meet with important foreign leaders in discussing the many U.S. battle memorials to be erected in Europe. In a revealing sidelight he wrote, "...I would save my lunch, look for a little *auberge* or inn, and eat there to mingle with the people of the countryside. They were unlike some of the city people, warm and jolly and courteous." Many of his associates have noted that it was this interest and his unique ability in meeting people at all levels of society which made Eisenhower so adept at reading public opinion.

In 1929 Eisenhower, became senior deputy to the secretary of war. He was assigned to study the industrial system of the U.S. and advise how it could most rapidly and efficiently be transformed during a wartime emergency. The plans developed through this study proved to be invaluable prior to and during World War II.

January, 1933, found Eisenhower assigned to then chief of staff general Douglas MacArthur, as his principal assistant. During that time, he developed a complete military plan for defense of the Philippines, where he went with MacArthur to help in organizing that defense. There Eisenhower became well acquainted with President Emanuel Quezon of the Philippines.

In 1939, when war broke out in Europe, Eisenhower requested assignment back to the U.S., where he hoped to prepare the U.S. for possible involvement in the war. His leadership of the Third Army in maneuvers in 1941 was so effective that he was made brigadier general and brought to the War Plans division of the army in Washington in 1942. There his administrative ability and extraordinary military training quickly gained attention.

His unique formal education included not only graduation from West Point, but also rank as first in his class at the Command and General Staff College at Fort Leavenworth, as well as first rank in his class at the Army War College at Fort McNair, one of the highest educational honors for an army man. He even graduated from Cooks and Bakers School. His memory was extraordinary. He is said to have remembered every memo that he had written and every conversation of his long life. Coupled with his personal ability and popularity, this extraordinary education and the diversity of his military experience seemed to assure almost automatic entree to any position for which he was considered.

Superbly equipped as he was, however, his meteoric rise to high command was surprising even to the general himself. His major advances began with his appointment as commander of the Allied Forces landing in North Africa in 1942 and continued with the landings in Sicily and Italy proper. He was given the rank of full general in 1943. In 1944, as Supreme Commander of the Allied Expeditionary Forces in Europe, he directed the D-Day invasion of Occupied France at Normandy Beach. He became one of the few to hold the five-star rank of General of the Army. After accepting the surrender of the German Army at Rheims on May 7, 1945, Eisenhower remained in Europe to oversee the United States Occupation Forces in Germany.

He then returned to the United States as Army Chief of Staff (1945-1948). He described the course of the war in *Crusade in Europe,* which was published in 1948 and became a best-seller.

Eisenhower's first non-military position was as president of Columbia University of New York City, a post he occupied from 1948 to 1953 with a leave of absence in 1950 taken to command the forces of the new North Atlantic Treaty Organization Alliance (NATO). Having resigned from the Army in 1952, he was considered for a presidential nomination by both the Republican and the Democratic parties. He accepted the Republican nomination, and in the 1952 presidential election he defeated Adlai E. Stevenson, the Democratic candidate, whom he would defeat again in 1956.

As President, Eisenhower espoused moderately conservative policies. He hastened the end of the Korean War, but defended other American involvements in southeast Asia. He sent troops to enforce school desegregation in Little Rock, Arkansas, but refused to oppose the anti-Communist agitation of Senator Joseph McCarthy. Known as a grandfatherly figure with a great love of golf, Eisenhower retired in 1960 to a farm near Gettysburg, Pennsylvania.

His apparently mild manner and the smoothness of his administration gave rise to the criticism that he was a "do-nothing" president both during and after his presidency. However, Eisenhower's record is undergoing substantial reevaluation, indicating that he will be recognized as a brilliant administrator. Richard Rhodes wrote that he was "...The most skillful delegator of authority the nation has known. Things seemed to run smoothly while he appeared to sit back and do nothing. This is supposed to be the mark of a leader."

Mamie Eisenhower, wife of President Dwight D. Eisenhower, shown here with Prince Phillip of England, above, became one of the most admired first ladies.

Many authorities now say that he was much more responsible for presidential decisions than had been supposed, despite his reputation for delegation.

Much of this new recognition will come from closer scrutiny of his record in office. As a military man he knew the danger of too much military power and worked to reduce military influence. He keenly perceived the dangers of atomic buildup and warned against atomic war. Having had long first-hand experience in dealing with the Soviet leaders, he created a network of bases against what he perceived as possible designs for power, called for freedom for the satellite nations and averted a broader conflict in Vietnam. The nation was prosperous and at peace during his presidency.

Among the accomplishments of his presidency, the St. Lawrence Seaway was opened and ten million recipients were added to Social Security. He prohibited racial discrimination in government employment as well as intervening in the school crisis in Little Rock. He produced the greatest network of superhighways the world has known. He did all this while both houses of Congress were controlled by the opposition party.

With a surprisingly extensive formal education, which included much more background in philosophy, education and social science than is usually credited to him, Eisenhower had developed a strong philosophy against warfare and for a government which was dedicated to serving the people. He called war the most stupid, tragic, worst of all human activities, which unbelieveably damaged the world through the loss of its youth and most creative people.

Ike was middle of the road throughout his life, declaring that people who stick to the center must have more courage because they are constantly attacked from both sides. On his death the *Reader's Digest* declared, "For most of his life, what he thought he really wanted to do was to be a cowboy in Argentina. Instead he organized an army and ran a war and guided the strongest nation in the world for eight hard years....He didn't give a damn about discipline, but he learned not only to live by its rules himself but also to confer its lifesaving strength on whole armies. He didn't give a damn about offices and position and rank, but he took them all on because he believed he could handle them better than anyone else available."

It was said that for a battlefield commander, Ike was a surprisingly great general, "perhaps the best of his century," according to one source. General Douglas MacArthur once said, and Churchill repeated, that he possessed the gift of being able to see the whole problem. Not a wartime president, he was particularly proud that for eight years he kept the peace. He viewed his balancing of the national budget as his most important domestic contribution. Called a "do-nothing president," by the end of the 1960s a good many of those same critics "would like to have seen Ike back in office," as one periodical commented.

The burial place of president and Mamie Eisenhower at the Eisenhower Center in Abilene, Kansas, attracts millions to pay tribute to a great leader in both war and peace. He had truly provided for America a period of peace and prosperity never equalled before or since.

EISENHOWER, Milton. (Abilene, KS, Sept. 15, 1899—). College president. Brother of the late Dwight D. EISENHOWER, Dr. Eisenhower served as Director of Information for the United States Department of Agriculture from 1928 to 1941, the president of KANSAS STATE UNIVERSITY from 1943 to 1950, the president of Pennsylvania State University from 1950 to 1956, the president of Johns Hopkins University from 1956 to 1967 and the Special Ambassador and Personal Representative of the President of the

United States on Latin American Affairs in 1953, 1957, 1959, and 1960. He served as the chairman of the President's Commission to Examine Violence, in June of 1968. The commission made a lengthy report on violence in the U.S. and formed extensive proposals of a general nature.

EL CAMINO DEL RIO (Road of the River). One of the most beautiful highways in the United States, running along the RIO GRANDE RIVER in the BIG BEND area.

EL CAMINO REAL. Spanish for the "the King's Highway," the term was used throughout areas colonized by the Spanish. New Mexico's El Camino Real, the oldest highway in the United States and the only route from the Southwest to the outside world during the entire Spanish period, had its first travelers in 1581. Later, great mule trains carried supplies northward to missions and returned with cargoes of turquoise, copper, salt and products made by the Indians.

EL CHAMIZAL. A large wedge of land between Mexico and the United States at EL PASO, Texas, caused by a shift in the course of the RIO GRANDE RIVER in 1851. Although the land was awarded to Mexico by arbitration in 1911, the United States refused to give up control over the area. In 1963 a board of review gave Mexico 436.6 acres and the United States 193.2. Mexico had to be compensated for land occupied by Americans, and more than 3,500 Americans had to be relocated and reimbursed for their property. Formal settlement of the dispute came on October 28, 1967, in the signing of an agreement between President Lyndon B. JOHNSON and President Gustavo Diaz Ordaz of Mexico. The area is now administered jointly as a park.

EL CRISTO REY CHURCH. One of the largest adobe churches in the United States, the church's construction in 1939 in SANTA FE, New Mexico, required two hundred thousand man-made adobe bricks. The churchs' famous carved stone altar screens were removed from the old military chapel, La Castrense, which stood until 1850.

EL MORRO NATIONAL MONUMENT. Principal feature is "Inscription Rock," a soft sandstone monolith on which are carved hundreds of names and phrases, including those of 17th-century Spanish explorers and 19th-century American emigrants and settlers. There are, as well, pre-Columbian petroglyphs. Headquarters, Ramah, New Mexico.

EL PASO (mine). Initial gold strike on CRIPPLE CREEK, Colorado, in 1891. The rich vein of gold was discovered in an extinct volcano west of PIKE'S PEAK by a cowboy named Robert Womack. Womack sold his claim for $500 and proceeded to drink up most of his new-found wealth the first night. The mine, which he had named El Paso, later produced $12,000,000 in gold, but Womack died penniless.

EL PASO, TEXAS

Name: From the Spanish "the ford" of a river.

Nickname: Gateway to Mexico; International Hub of the Southwest.

Area: 239.7 square miles

Elevation: 3,695 feet

Population:
1986: 491,800
Rank: 24th
Percent change (1980-1984): +15.6%
Density (city): 2,052 per sq. mi.
Metropolitan Population: 526,000 (1984)
Percent change (1980-1984): +2.2%

Race and Ethnic (1980):
White: 58.6%
Black: 3.17%
Hispanic origin: 265,997 persons (62.5%)
Indian: 1,563 persons (0.29%)
Asian: 3,995 persons (0.83%)
Other: 99,500 persons

Age:
18 and under: 35%
65 and over: 6.9%

TV Stations: 6

Radio Stations: 23

Hospitals: 13

Sports Teams:
El Paso Diablos (baseball)

Further Information: El Paso Convention and Visitors Bureau, 5 Civic Center Plaza, El Paso, TX 79901.

At nightfall the lights of El Paso take on a special glow at Christmas time.

EL PASO, Texas. City (pop. 425,259), seat of El Paso County, located at the extreme western point of Texas on the RIO GRANDE. An industrial and agricultural center, the city is also a port of entry, situated directly across from the Mexican city of Juarez. Its name comes from the fact that it provided a "pass" from Mexico to the U.S. Together, both cities are known as the "International City."

Mineral processing (mining, smelting, refining) is an important industry, with copper, gold, silver, lead, petroleum, and zinc all found nearby. Other industries include the manufacture of apparel, cement and building material, and tourism. An important agricultural and livestock center, El Paso annually handles beef, peppers, long staple cotton, pears, onions, alfalfa, pecans, sugar beets and tomatoes.

Although the present-day site of El Paso did not experience settlement until 1827, the area was first visited by the Spaniard Cabeza DE VACA in 1536 and officially claimed for Spain in 1598. The first permanent European settlement was founded nearby in 1659. El Paso became a part of Texas in 1846, was named Franklin for a short while, and was incorporated in 1873. With the coming of the railroad in 1881 the city experienced rapid growth.

Points of interest include the El Paso Museum of Art and the El Paso Centennial Museum. The city has its own symphony orchestra and is the home of the annual Sun Bowl football game. Area attractions include nearby FORT BLISS (1849), the nation's largest guided missile center. Biggs Field Air Force Base and William Beaumont Hospital are part of the fort. The city's major educational institution is the University of TEXAS at El Paso.

EL QUARTELEJO. Settlement of PICURIE INDIANS in Kansas in which the first hard walls ever constructed in Kansas were built. The Picuries had escaped Spanish persecution in New Mexico by moving to Kansas. While living in present-day Scott County the Indians constructed a village of adobe. The Indians abandoned this settlement and disappeared. The mystery of this disappearance has never been solved.

ELBERT, MOUNT. At 14,431 feet the highest point in Colorado, the state with the highest mean altitude.

ELECTRIC PEAK. At 11,155 feet, highest point in the Gallatin Range in southern Mon-

tana, near the Wyoming border in YELLOWSTONE NATIONAL PARK.

ELEPHANT BUTTE LAKE. One of the largest lakes in the West, with a 240-mile shoreline, impounded behind Elephant Butte Dam across the RIO GRANDE RIVER in southern New Mexico, north of TRUTH OR CONSEQUENCES.

ELIOT MISSION. Religious school provided for the CHOCTAW in present-day Oklahoma around 1820. Typical of many western mission schools, now long gone, children lived at the school, studied before they had prayer and breakfast and after a play time assembled for school which began with singing, prayer and Bible reading. A test on the Bible reading from the day before was given and then other studies followed. When school was dismissed the boys did farm work while the girls performed tasks associated with housework. After supper there was additional Bible reading, prayer and singing. Despite spartan conditions at the school, observers felt that Indian children had better educational opportunities before Oklahoma statehood than did their white peers.

ELK. A member of the deer family living in North America. The name was given to the animal despite the fact that it had previously been used to describe a European moose. The elk has also been called the wapiti. Elk once lived throughout most of the United States. They are now primarily confined to Jackson Hole National Elk Refuge, where the world's largest herd numbers about 10,000 head. Elk remain in the reserve during the winter. When they shed their antlers in the spring, they move into the cooler mountains. Other substantial numbers are found in Washington's Olympic Mountains. Elk eat grasses, twigs, and the needles of juniper and fir. Many die of disease and starvation. Cougars and wolves are among the elk's natural enemies. At the Jackson reserve, antlers are collected by Boy Scouts for sale in town. Elk antlers are made into "aphrodisiacs" in the far East and are sometimes fashioned into furniture or jewelry in the United States.

ELK POINT, South Dakota. Town (pop. 1,661), Union County, southeastern South Dakota, northwest of Sioux City, Iowa, and southeast of VERMILLION. The LEWIS AND CLARK EXPEDITION made its first camp in present-day South Dakota near the future site of Elk Point on August 22, 1804. On that night they conducted

an election, for sergeant, the first popular vote ever held in the Northwest. South Dakota contends that Mahlon Gore of Elk Point was the first in the nation to file a claim under the Homestead Act of 1863, but this claim is contested.

ELKHART, Kansas. Town (pop. 2,243). Seat of Morton County, extreme southwestern Kansas, southwest of HUGOTON and west of LIBERAL. The name probably comes from a translation of the Indian term for elk's heart. Elkhart annually hosts one of the largest general cattle roundups in the United States.

ELKHORN, Montana. Ghost town located in Jefferson County ten miles northeast of Boulder, Montana. Prospectors explored the area around Elkhorn prior to 1870, but the community was not formed until the early 1880s. The Elkhorn Mining Company purchased the site and erected a mill which in one ten-month period produced $183,000 in silver and $23,000 in gold. The town flourished through the 1880s and 1890s. In 1889 the Northern Pacific linked it with the main route with a rail connection. During its active years, Elkhorn shipped out $14 million in lead, gold and silver. When mining proved unprofitable, the town was abandoned. When the prices of gold and silver rise, the area is again occasionally the scene of some small-scale mining.

ELKHORN RANCH. One of the two ranches owned by Theodore ROOSEVELT (1858-1919) near MEDORA, North Dakota. While living at the ranch most of the time for two years (1884-1886) and during the summer for the next four years, Roosevelt helped organize the Missouri River Stockmen's Association and served as its chairman, wrote a number of articles, and completed part of a book. Land once part of the ranch is now preserved in the THEODORE ROOSEVELT NATIONAL PARK, popular among many other attractions for such animals as coyote, bobcat, beaver, buffalo and bighorn sheep, in some of the rougher terrain.

ELKHORN RIVER. Northeastern Nebraska, flows southeastward from its source in Rock County, then southward for a total of 333 miles to its mouth in the PLATTE RIVER. The Elkhorn flows past O'Neill and NORFOLK, Nebraska.

ELLENDALE, North Dakota. Town (pop. 1,967), Dickey County, southeastern North Dakota, southeast of JAMESTOWN and southwest

of Valley City. On September 3, 1863, General Alfred H. Sully fought the SIOUX INDIANS at the Battle of WHITESTONE HILL, near Ellendale. The State Normal and Industrial School at Ellendale offered the first free course in manual training in the United States.

EMILY GRIFFITH OPPORTUNITY SCHOOL. Pioneer institution in the field of adult education, established in DENVER, Colorado, in 1916 to train those in need of a fundamental education or who desired training in skills or trades.

EMMESSOURRITA INDIANS. Tribe of SIOUX INDIANS whose name, meaning "dwellers on the Big Muddy," may have been the source of the name for the MISSOURI RIVER.

EMPORIA *GAZETTE*. Emporia, Kansas, newspaper purchased in 1895 by William Allen WHITE (1868-1944), whose editorials helped make the Gazette the best-known small-town newspaper in its day and White "The Sage of Emporia." The newspaper gained national recognition when its owner took a critical look at his home state in the editorial, "What's the Matter With Kansas?" (1896). White strongly sided with the people, and his editorials generally took a decided Populist tone. Though generally loyally Republican, his editorials promoted Theodore ROOSEVELT's Bull Moose philosophy, and the paper joined the Muckraker movement with numerous instances of investigative journalism.

EMPORIA, Kansas. City (pop. 25,287), seat of Lyon County, east-central Kansas, southwest of LAWRENCE and northeast of WICHITA. Emporia was the home of William Allen WHITE (1868-1944), Pulitzer Prize winning publisher and editor of the EMPORIA *GAZETTE*. White built such a national following with his incisive editorials that he became known as "The Sage of Emporia." Memorials to White include William Allen White Memorial Drive and William Allen White Library at Emporia State University. The site of the town was purchased for $1,800 from an Indian named A. Hicks. It was founded in 1857 and named by George W. Brown, president of the town company which purchased the land, for an ancient Carthaginian city known for fabulous wealth and importance. Emporia is one of the nation's premiere cattle-shipping cities. Water sources were for years the major need of the residents. Attempts to divert water from the Cottonwood or Neosho

rivers proved unsuccessful. In August 1920 Dan Dryer, commissioner of public utilities, was ridiculed across the nation by demanding that no more than four inches of water be used in Emporia bathtubs. Aided by the Federal Government in 1926, Emporia successfully solved this vexing problem by damming the Kahola River. Emporia is the site of Emporia State University. Tourists use Emporia as the gateway to the FLINT HILLS NATIONAL WILDLIFE REFUGE. White's residence, Red Rocks and the *Gazette* building are open to the public.

ENGELMANN, George. (Frankfurt, Germany, Feb. 2, 1809—St. Louis, MO, Feb. 4, 1884). Botanist, whose name was given to a variety of spruce tree widely found in the West. Engelmann was an early user of quinine in the treatment of malaria and discovered the roll of the Pronuba moth in the pollination of yuccas. Engelmann discovered an immunity of the American grape to phylloxera and organized the St. Louis Academy of Science in 1856.

ENGLEWOOD, Colorado. City (pop. 30,021) a nearby western suburb of DENVER, in Arapahoe County on the SOUTH PLATTE RIVER, taking its name fron Englewood, Illinois. Incorporated in 1903, the city now is both a residential and industrial center, producing precision instruments, and nursery stock, along with iron work and dairy processors.

ENID, Oklahoma. City (pop. 50,363), seat of Garfield County, north-central Oklahoma, northwest of OKLAHOMA CITY and southwest of BARTLESVILLE. Named for a character in Tennyson's "Idylls of the King," Enid is located in the center of the state's wheat producing region. The Cherokee Strip was opened for general settlement September 16, 1893, but the site of future Enid had been occupied previously for a year by surveyors and U.S. troops. Those residents chose their site for the future city without the knowledge that the Cherokee Indians had prior claim to their chosen location. This discovery caused the whites to move their townsite three miles to the north, creating a North and South Enid and beginning a longstanding feud between the white and Indian communities. The feud between the towns ended when the two communities were united, and they buried a ceremonial six-foot hatchet, a symbol of the strife. Free wheat seed, distributed by the Rock Island Railroad in 1894, was not enough to save crops destroyed by drouth in the years 1894-1896. In 1897 the Ringling

Brothers' Circus "big tent" had its largest crowd ever to that date when twenty thousand people stormed in to see the animals and celebrate the rains which finally came. As the Oklahoma wheat-growing hub, Enid was made the site of the Pillsbury Mill, the largest in the state. Oil became a major industry for the city as a result of the discovery of the famous Tonkawa district in 1921 and the Crescent pool in 1926, both of which lay beneath the exploited Garber pool. The discovery of dinosaur bones in a quarry near Enid yielded one of the largest collections in the United States, nearly 4,000 bones. An annual Cherokee Strip Opening Celebration is held in September.

ENTERTAINERS. Possibly the best known entertainer today, talk show host Johnny CARSON (1925-), was born in Iowa but grew up in Nebraska, and he frequently comments on those beginnings. Perhaps as widely known in his day not only as a frontiersman but as an entertainer was William "Buffalo Bill" CODY (1846-1917), whose Wild West Show circulated widely both in the U.S. and in world capitals.

More than an entertainer, Will ROGERS (1879-1935) of Oklahoma was a world figure of vast influence, but he was, indeed, an entertainer in many media. His motion pictures include some of the funniest and most poignant ever made. He starred in vaudeville and on radio, and the humor and human understanding of his syndicated newspaper column provided the appeal that made his serious thoughts so popular.

Nebraska seems to have had almost a monopoly of movie stars, including Harold LLOYD (1894-1971), Fred ASTAIRE (1899-1988), Henry FONDA (1905-1982), Marlon BRANDO (1924-)and Robert TAYLOR 1911-1969). Tim MC COY of Wyoming started as a star in opera, but when his voice failed he became one of the best known western movie stars of his day. Television personality Dick CAVETT (1936-) also came from Nebraska.

Denver musician Paul WHITEMAN (1891-1967) gained fame in both popular and classical fields. He traveled the world with his large orchestra, playing in concert halls as well as night clubs. He was one of the foremost promoters of George Gershwin and his music and gave some of the first performances of Gershwin's new style of classical works.

The facilities of the EROS Center at Sioux Falls are among the many installations which have brought substantial prosperity to that city.

One of the most popular musicians of his time was Lawrence WELK (1903-) of North Dakota. His television shows have never been surpassed in audience ratings in their class and are still being widely syndicated on TV.

Two widely different music hall entertainers started their careers in CRIPPLE CREEK, Colorado. Texas Guinan became one of the best known performers in her field. In another instance, when a young miner saw a girl perform in a Cripple Creek dance hall, he admired her so much he made her a pair of heels of silver for her shoes, and she became known as Silver Heels, renowned as one of the beauties of Colorado. Her career might have blossomed further, but when a smallpox epidemic hit Cripple Creek she not only refused to leave but nursed the sick miners, until she took the disease. Then she disappeared. Years later a heavily veiled woman made repeated visits to the graves at Cripple Creek, and, of course, legend has it that this was Silver Heels, her beauty ruined by the marks of smallpox.

EROS (Earth Resources Observations Systems). Center operated at SIOUX FALLS, South Dakota, by the United States Department of the Interior for the processing and disseminating of information on the earth's surface and resources. The basic material is collected from photographs and electronic data acquired by aircraft and satellites. The high altitude airplane photos and satellite photos are processed to define a large number of objectives, such as the color enhancement of forest, agricultural, topographical and other features. Military analysis is also an important factor in the processing of these photos. Maps of a wide variety are derived from them. All of these are made available to the public, except for classified material.

ESTES PARK, Colorado. Town (pop. 2,703), Larimer County, north-central Colorado, southwest of FT. COLLINS and northwest of DENVER. Estes Park is one of the leading resort centers in the United States. The first settler in the region was Joel Estes who arrived in the park (valley) about 1860. The valley and the community both are named for him. The arrival of a few new families caused him to flee the area because it was too crowded. One of the area's most colorful characters was the British Earl of DUNRAVEN (1841-1926), who built the park's first hunting lodge in the 1870s after buying as many as 10,000 acres for a private hunting preserve, where he entertained European and American

friends. Most of the surrounding land is now part of ROCKY MOUNTAIN NATIONAL PARK. Estes Park, located on the eastern edge of the national park also benefits from the TRAIL RIDGE ROAD and Bear Lake Road, two scenic alpine highways nearby. Big Thompson Canyon stretches just east of town, and the auto road up Mount EVANS is the highest in the country. The European heritage of the region is celebrated annually on the first weekend after Labor Day with a Scottish Highland Festival.

ESTEVAN. (dates unknown). Black slave, member of the shipwrecked party of Alvar Nunez DE VACA. The party made its way across much of Texas (1535-1536) in a journey of dreadful hardship until they reached safety in Mexico. Because of Estavan's supposed knowledge of the area, about a year later, he was sent with Father Marcos DE NIZA to find the fabled seven wealthy cities of Cibola. Father de Niza sent Estavan ahead. To impress the Indians, he wore a costume covered with bright feathers and tinkling bells. Awed by his appearance, the superstitious Pima Indians let him pass. However, when he reached the Pueblo city of Hawikuh near present GALLUP, New Mexico, he was killed by the ZUNI INDIANS.

EUFAULA RESERVOIR. Oklahoma recreational site formed by the damming of the CANADIAN RIVER in east central Haskell County. The resulting lake stretches northwest into McIntosh County and southeast for many miles into Pittsburg County. Fountainhead and Arrowhead State Parks are located along its shores.

EUREKA, South Dakota. Town (pop. 1,360), McPherson County, north-central South Dakota, northwest of ABERDEEN and northeast of Mobridge. The community was named for the Greek word meaning "I have found it," a pleasant place to settle. During the 1890s Eureka was one of the world's principal wheat markets, with 36 grain elevators doing a brisk business. However, the center of the grain trade moved to the east, and left a sleepy community. The Russian-German heritage of the area is shown through exhibits in the Eureka Pioneer Museum.

EVANS PLUNGE. Largest natural warm water indoor swimming pool in the world located in HOT SPRINGS, South Dakota. The pool's multiple springs feed it 5,000 gallons of water per minute.

EVANS, Dale. (Uvalde, TX, Oct. 31, 1912—). Leading lady of the 1940s. A former band singer, Evans frequently appeared in motion pictures with Roy Rogers and married him in 1947.

EVANSTON, Wyoming. City (pop. 6,421), seat of Uinta County, far southwestern Wyoming, on Interstate 80 west of ROCK SPRINGS Utah. It was settled in 1869 and named for railroad surveyor James A. Evans. A dairying and farming area, Evanston is better known today as the center of development of the coal-rich Overthrust Belt. Recreation opportunities nearby include trips into the UINTA MOUNTAINS, skiing at Eagle Rock Ski area, and water sports at Woodruff Narrows Reservoir. Seasonal festivities include the Winter Carnival the last weekend in February, the Chili Cook-off on the third Saturday in June and Cowboy Days on Labor Day weekend. Historic Fort Bridger has been restored with museums featuring fascinating collections of military equipment from the Indian Wars.

EVENTS, ANNUAL. Several celebrations in the Central West have long held a place among the top annual events in the country. Among the most noted and certainly the most typical of the general perception of the West is FRONTIER DAYS at CHEYENNE, Wyoming, originated in 1897. Carnivals, parades, entertainment, free pancake breakfasts and a rodeo, said by many to be the world's best, are among the features which bring crowds much larger than Cheyenne's 47,283 population. Almost as notable in the same field is DEADWOOD, South Dakota's, DAYS OF '76, with its rodeo, exceptional parade and reenactment of early days.

The nation's oldest annual festival is FIESTA SANTA FE, founded in 1712 and featuring all the many elements that make SANTA FE unique. Its ancient tribal dancing ceremonies, Indian markets and other Indian features, ethnic dancing in the streets, parades and many other highlights, all make it one of principal annual events.

Omaha, Nebraska, set out to sponsor one of the top-rated festivals and came up with a winner in its AK-SAR-BEN BALL and associated activities, founded in 1894.

Although performances worldwide of Handel's *Messiah* at Christmas time now must number in the thousands, the oldest performance of that work in the Central West has gained world publicity and continues to attract a far-flung audience and top performers. That performance has now expanded to become the annual MESSIAH FESTIVAL at LINDSBORG, Kansas, featuring the Bethania Choirs of BETHANY COLLEGE (said to be the second oldest community chorus in the country), with world famed singers and symphony. This festival now occupies an entire week of musical and other events.

SPEARFISH, South Dakota, has a unique distinction. It inherited the famed Luenen (Germany) PASSION PLAY, when Joseph Meier, the play's Christus, fled from Adolf Hitler before WORLD WAR II and settled at Spearfish. Each year from June through August the tradition continues there, attracting thousands from the U.S. and abroad.

Throughout the Central West region, many even of the smaller communities present other annual attractions in a variety of fields, generally one-of-a-kind and all of interest to tourists. Many are listed separately or in the entry on the community in this encyclopedia.

EYEISH INDIANS. Tribe of Caddoan linguistic stock. They lived in northeastern Texas on Ayish Creek, between the SABINE and NECHES Rivers.

FAIR PARK. Site of the State Fair of Texas, located in East Dallas, covers 187 acres of landscaped grounds. On the grounds are many of the most notable museums of DALLAS: the Dallas Aquarium, the Dallas Health and Science Museum, the Dallas Museum of Fine Arts, the DALLAS MUSEUM OF NATURAL HISTORY, and the TEXAS HALL OF STATE, a shrine to Texas history. The Dallas Garden Center displays seven acres of southwestern flowers and the

unusual Scent Garden features markers in braille. The State Fair Music Hall is used every summer for twelve weeks by the Dallas Summer Musicals, a nonprofit civic organization that presents Broadway and Hollywood stars, with a resident ballet and chorus.

FAIRBURY, Nebraska. City (pop. 5,265), seat of Jefferson County, southeastern Nebraska, southwest of BEATRICE and southeast of GRAND ISLAND. Settlement of the region began in the 1850s. The name is another form of "Fair City." Fairbury is the site of Rock Creek Station, a stage stop for the PONY EXPRESS, where James Butler "Wild Bill" HICKOK made his debut as a gunfighter by killing the station owner and two hired men. Supporters of Hickok claimed that he singlehandedly fought and killed ten men, and his evil reputation spread as a popular character in dime novels. The truth of the Rock Creek incident continues to remain unclear, and the Rock Creek State Historic Park remains the focal point of one of the West's most controversial stories. Fairbury annually recreates the Rock Creek event and in August celebrates its Echoes of the Oregon Trail pageant.

FAIRPLAY, Colorado. Town (pop. 421), Park County, central Colorado, southeast of LEADVILLE and northeast of GUNNISON. South Park City in Fairplay is an authentic re-creation of an early western mining town with more than thirty original buildings. A unique memorial in the town marks the grave of Prunes, a 63-year-old burro, said to have worked on every mine in the Fairplay-Alma district. Fairplay was given its name by miners who settled it in 1859 after they had been driven out of nearby Tarryall by miners who had staked more claims than they could work. The new community was named for their hope of better treatment. They referred to Tarryall as "Grab-all."

FALL, Albert Bacon. (Frankfort, KY, Nov. 26, 1861—Three Rivers, NM, Nov. 30, 1944). Secretary of the Interior in the administration of President Warren Harding, in 1931 Fall was given a sentence of a year in prison and a fine of $100,000 for his role in the fraud by which leases to valuable oil properties were assigned to favored oil companies. Before becoming a cabinet officer, Fall had served in the U.S. Senate from New Mexico from 1912 to 1921.

FANNIN, James Walker. (GA., c. January 1, 1804—Goliad, TX., March 27, 1836). Texas Revolutionary. Admitted to West Point Military Academy in 1819, Fannin left school after a fight with another student. In 1834, he moved to Texas and became active in the revolutionary movement. In 1836 he led a group of 300 men toward Mexico, despite the opposition of General Sam HOUSTON (1793-1863), who knew the expedition was foolhardy. On March 19, 1836, they were caught in retreat from the Texas town of Goliad. Despite a supposed promise of safety, they were executed under the direct orders of Mexican General SANTA ANNA. This "Massacre of Goliad" became one of the rallying cries of Texas independence, "Rememember Goliad!"

FAR WEST. A steamboat, chartered by the government as a supply vessel during the Indian campaign of 1876-1877, the *Far West* was commanded by Captain Grant Marsh when it arrived at FORT ABRAHAM LINCOLN, on the MISSOURI RIVER near BISMARCK, North Dakota, in July, 1876, with news of the CUSTER defeat at the LITTLE BIG HORN (June 25, 1876). On that voyage, the *Far West* carried the wounded survivors of another battle, under Major Marcus Reno's command, to Bismarck in a record-breaking 54-hour voyage under forced steam. Notes of the Little Bighorn battle were found in the buckskin pouch belonging to slain reporter Mark Kellogg, assigned from the Bismarck *Tribune* to the Seventh Cavalry. These notes allowed Colonel C.A. Lounsberry, founder and editor of the *Tribune,* to scoop the journalism world on what was one of the major stories of the time.

FARGO, North Dakota. City (pop. 61,308), seat of Cass County, largest city in North Dakota, situated in the southeast part of the state on the RED RIVER OF THE NORTH at the boundary with Minnesota. It takes its name from William G. FARGO, founder of the famed Wells-Fargo company. As an outfitting point, beginning about 1871, Fargo grew with railroad prosperity and was incorported in 1875.

Fargo is the center of a metropolitan area which includes its twin city, Moorhead, across the river in Minnesota, and its neighbor West Fargo.

The eastern gateway to the state, a center of river and railroad traffic and heart of an enormously rich agricultural area, Fargo enjoys an economy which would be the envy of cities many times its size. It is the wholesale and retail hub of the entire Red River Valley, receiving, distributing and processing the wheat and livestock of that prosperous region.

With blackjack now legal in the state, the tourist business flourishes at the 31 casinos in the city. Charitable and not-for-profit organizations run the casinos and receive all revenues above expenses.

The influx of gamblers, especially from the three state area including Minnesota and South Dakota, reminds some old-timers of another period when quicky divorces were legal in North Dakota, and many prominent and not so prominent people flocked to Fargo to wait out the 90-day residency requirement.

In 1890 NORTH DAKOTA STATE UNIVERSITY was founded there. An unusual offering of the university is provided by the North Dakota Institute for Regional Studies. Visitors are attracted to the university's herbarium and wildlife museum. Concordia Conservatory of Music and a school for crippled children are other educational institutions of the city.

Outside to the west is Bonanzaville, USA, a reconstruction featuring agricultural life of the 1800s. It includes a Plains Indian Museum and a wide variety of other displays.

The Red River Valley Fair, with its pioneer village, is held at Fargo each second week in July.

FARGO, William G. (Pompey, NY., May 20, 1818—Buffalo, NY, Aug. 3, 1881). Businessman. Beginning with operations in the East, Fargo was a partner in a number of transportation companies and banks. The best known of his operations was WELLS, FARGO AND COMPANY, founded in 1852, a gold rush express firm which provided the best and cheapest transportation over the major routes from Missouri to the West Coast in the mid-1800s. By 1866 he had achieved a virtual monopoly of public transportation in the West until the coming of the railroads, beginning in 1869. Fargo also was one of the founders of the American Express Company. FARGO, North Dakota, was named in his honor. Fargo served as a messenger with Wells and Company, the first express company to move west of Buffalo, New York, and later became a part owner. Fargo served as mayor of Buffalo, New York, from 1862 to 1866.

FARMERS BRANCH, Texas. Town (pop. 24,863), Dallas County, in central northern Texas, a northern suburb of DALLAS. Farmers Branch once served as the site for meetings between Sam HOUSTON (1793-1863) and Indian tribal representatives. Today it is a residential area with varied manufacturing concerns.

FARMINGTON, New Mexico. City (pop. 30,729), San Juan County, far northwestern New Mexico, on the SAN JUAN RIVER east of SHIPROCK and southwest of Aztec. Farmington is the major industrial and retail center for the FOUR CORNERS region. The name is descriptive of good farm land, which, once barren, is now irrigated to nurture lush orchards and field vegetables. The Navajo Indian Irrigation Project, the largest still under development, will provide water from Navajo Reservoir to 110,600 acres of Indian land near Farmington. The growth of the community began in the 1950s with the discovery of rich deposits of coal, gas and oil. The Navajo Mine is one of the largest coal-mining operations in the United States. The community has also benefitted from its closeness to the AZTEC RUINS NATIONAL MONUMENT, MESA VERDE and CHACO CANYON. Farmington hosts the annual Hot Air Balloon Rally on Memorial Day.

FEBOLDSON, Febold. Nebraska's own great legendary folk hero, credited with the ability to perform such incredible feats as cross breeding eagles with bees to produce "beeagles." These he hitched to a plow and made a perfect "beeline" across the state. This became the southern boundary of Nebraska, as the story goes.

FERGUSON, James Edward. (Bell County, TX, Aug. 31, 1871—Temple, TX, Sept. 21, 1944). Governor of Texas. Ferguson was an organizer of the Temple State Bank in 1907, and he became a champion of the small farmer and of business in general. A candidate for governor in 1914 on a businessman's platform, he was elected and started his a term in 1915. Accused of corruption, misuse of state funds and improper treatment of the university, Ferguson was impeached and removed from office in 1917 during his second term. Because of his record, he could not run again in 1924, but capitalizing on the family name, his wife Miriam A. Wallace FERGUSON (1875-1961) won the post. James quickly resurfaced as "the man behind the governor" and continued his influence in state affairs.

FERGUSON, Miriam A. (Ma) (Bell County, TX., June 13, 1875—Austin, TX., June 25, 1961). Texas governor. Mrs Ferguson was the wife of state governor James Edward FERGUSON (1871-1944). When he was not allowed to run for governor, because of being removed from office in 1917 for corruption and misuse of state

funds, his wife ran "in his place," winning the 1924 vote. Although she held the office, it was generally known that James was the one who ran the state for a single term. After a lapse of two terms, "Ma" Ferguson was elected again in 1932, with a policy of government retrenchment.

FERRIS, Warren Angus. (Glen Falls, NY., December 26, 1810—Rinehardt, TX., February 8, 1873). Fur trader and surveyor. Beginning as a fur trader in the Rockies, Ferris went to Texas in 1836, where he surveyed a large part of northern Texas. His *Life in the Rocky Mountains*, published serially in 1842-1843 in the *Western Literary Messenger* and in 1940 in book form, is considered an important document of early Western history.

FETTERMAN MASSACRE. The worst defeat inflicted on American troops by Plains Indians up to that time. Events leading to the massacre began on December 21, 1866, when a small Indian war party, in a feint, made a typical attack on a wood train returning to FORT PHIL KEARNEY, Wyoming. Colonel Henry B. Car-

rington ordered Colonel William Fetterman (1833-1866), two other officers, 48 infantrymen, 28 cavalrymen and two civilians to relieve the train. Fetterman was warned not to cross Lodge Trail Ridge where he would be out of sight of the fort. Despite the warning, Fetterman allowed a small band of warriors to decoy him into an ambush led by RED CLOUD (1822-1909). Within thirty minutes hundreds of SIOUX, ARAPAHO and CHEYENNE had annihilated every one of the relief column. Following the Fetterman defeat, Carrington asked John "Portugee" PHILLIPS to carry a message calling on FORT LARAMIE for reinforcements. Phillips requested the commander's favorite thoroughbred horse, and slipped through the water gap in the stockade walls at midnight. Phillips fought numbing cold, deep snow drifts, and exhaustion for four days to arrive at Fort Laramie on Christmas night. His desperate 236 mile ride has been described as "one of the truly heroic episodes of American history," and reinforcements arrived to rout the Indians from Kearny.

FIELD, Eugene. (St. Louis, MO, Sept. 2 or 3, 1850—Chicago, IL, Nov. 4, 1895). Journalist.

Fiesta San Antonio, organized in 1891, pays tribute to Texas heroes and adventurers with a reenactment of the coming of Don Diego De Vargas, among other activities.

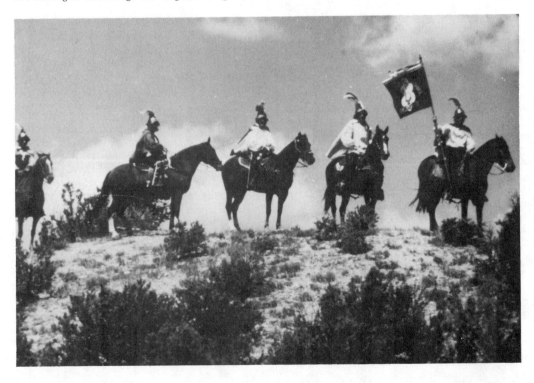

The famed creator of the poems *Little Boy Blue* and the lullaby *Wynken, Blyken and Nod*, undertook a career as newspaper columnist, writing for several papers. It was in his column "Odds and Ends" for the DENVER *Tribune* that he gained a reputation as a pioneer in recounting personal human interest items. He strongly influenced American journalism through his aid of young journalists and his innovative ideas. He left the Central West in 1883 and went on to greater literary fame elsewhere.

FIESTA SAN ANTONIO. Since 1891 the city has held a celebration in mid to late April honoring Texas heroes. More than 150 different events are presented, making this one of the more important of U.S. annual festivals. A parade of craft of all kinds on the famed river provides a particularly novel and attractive spectacle. There are three other major parades, a festival of foods of the southwest, special sporting events and many other attractions.

FISHER, Dorothy Canfield. (Lawrence, KS, Feb. 17, 1879—Arlington, VT, Nov. 9, 1958). Author and humanitarian. Generally using the name of Dorothy Canfield, she appeared in many anthologies and contributed many stories to magazines. In 1899 she graduated from Ohio State University, where her father was president, then went on to further studies at the Sorbonne in Paris and took a Ph.D. in 1904 from Columbia University. After marrying John R. Fisher, she made her home for the rest of her life on the farm near Arlington, Vermont, which had been in her family for generations. During WORLD WAR I, she and her husband undertook relief work in France, resulting in her collected stories *Home Fires in France* (1918). In 1926 she was chosen as the only woman to serve on the board of the Book-of-the-Month Club, continuing for twenty-four years. During WORLD WAR II, she founded and led the Children's Crusade to help war victims in other countries. She introduced and popularized the Montessori method of early childhood education in her *A Montessori Manual* (1913) and *Mothers and Children* (1914). Her fictionalized treatment of Monetssori appeared in *the Bent Twig* (1915) and *Understood Betsy* (1916), the latter considered a children's classic. Her fiction was "commonsensical" and marked by great concern for her characters, such as in her *American Portraits* (1946). Her non fiction included such works as *Day of Glory* (1919). When her father, J.H. Canfield, was a professor at the University of KANSAS, he was the author of

a plan which was adopted by Kansas to provide a state-wide system of city high schools.

FITZPATRICK, Thomas. (County Cavan, Ireland, c. 1799—Washington, DC, February 7, 1854). Mountain man and guide. Except for a period when he was part owner of the Rocky Mountain Fur Company, Fitzpatrick spent most of his career as a guide in the Central West and West. He led such expeditions as those of William H. ASHLEY and party up the MISSOURI RIVER (1824-1826) and John C. FREMONT's May, 1843, expedition to California.

FIVE CIVILIZED TRIBES The term used since about the mid 1800s to include the CHEROKEE, CHOCTAW, SEMINOLE, CREEK and CHICKASAW tribes. All of these, originally from the Southeast, had become as "civilized" as their white neighbors. Their ranks included owners of great plantations with hundreds of slaves, professional people of many ranks, people of business and finance and others. The greed of white neighbors and the indifference and cruelty of officialdom led to the government decree forcing them to "sell" their holdings, generally for a pittance, and move to "worthless" government lands in present Oklahoma. Over a period of years they were herded like cattle to their new homes along the "Trail of Tears with a loss of thousands of lives. In Oklahomaa each of the tribes was given its own tract of land and permitted to develop forms of semi-independent government. Amazingly, at least to some, the five groups brought a high degree of civilization to the frontier, in many cases much sooner than elsewhere. They set up constitutions, some portions of which are still in the Oklahoma constitution, organized courts, founded exceptional school systems and policed themselves efficiently. Because they supported the Confederacy in the CIVIL WAR, many of their rights were taken from them, but because of the skill of their leaders in negotiation, they managed to regain from Congress a good deal of their lost independence. When the Indian and white portions of Oklahoma seemed ready for statehood, which came in 1907, the Indian nations petitioned to have a separate state of Sequoyah, named for the great Cherokee savant, but Congress combined the two groups into a single Oklahoma. Tribal rights were divided among the individual members. Today, many of the buildings and institutions of the five tribes remain in Oklahoma as reminders of a unique and often tragic episode of American history.

Trails of Tears, 1816-1850

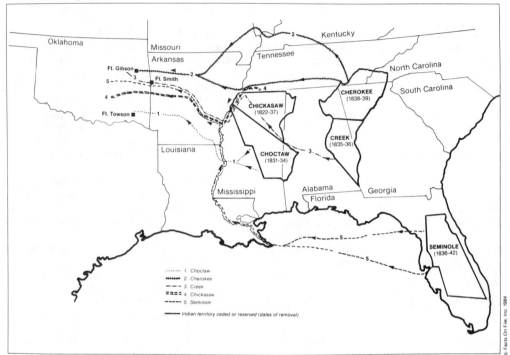

The forced marches of the Five Civilized Tribes from their various homes in the East to new situations in Oklahoma were so filled with tragedy and death that the routes they took, as shown above, came to be known as the Trails of Tears.

FLAMING GORGE AND RESERVOIR. The gorge, mapped and named by one-armed Army major and explorer John Wesley POWELL (1834-1902), was carved through the UINTA MOUNTAINS by the GREEN RIVER. Flaming Gorge Reservoir, famous for its fishing opportunities, is bordered to the north by abrupt cliffs and rolling hills and to the south by Horseshoe and Red Canyons. A spectacular view from 1,360 feet above the Red Canyon and Flaming Gorge Reservoir is available from the Red Canyon Visitor Center. A 160-mile loop drive around the entire area provides views of Flaming Gorge, the Sheep Creek Geological Loop and the Flaming Gorge Dam.

FLANAGAN, (Father) Edward Joseph. (Ballymoe, Ireland, 1886—Berlin, Germany, May 15, 1948). Founder of BOYS TOWN. A parish priest in O'Neill, Nebraska, Father Flanagan's first social service was with a Workingmen's Hostel in Omaha. He became interested in the treatment of homeless or lawbreaking boys and founded Boys Town, near OMAHA, in 1917. The work began in a rented house where he sheltered five young boys, including three delinquents. Operating on a financial shoestring, he took in more boys and the next year bought a small tract near Omaha, where he and the boys began to build the institution. Boys Town was incorporated as a municipality in 1922, and the boys elected their own town government. Father Flanagan's creed was expressed in his famous declaration, "there is no such thing as a bad boy," and his belief was confirmed by his spectacular success in training and rehabilitating thousands of young men, many who went on to successful careers and some also to fame. The work of Father Flanagan was featured in the popular 1938 movie, *Boys Town*. Spencer Tracy, the star, presented his Academy Award for the part to Father Flanagan. Following WORLD WAR II, Father Flanagan became a special consultant on youth to the U.S. government and traveled to the Orient and Europe to inspect youth work and facilities. He died in Berlin on one of these trips.

FLATHEAD INDIANS. Salish tribe originally located in western Montana and Idaho, north of the GALLATIN RIVER, between the Little Belt Range to the east and the ROCKY MOUNTAINS on the west. The Flathead called themselves Se'lic, meaning "people." The name Flathead does not come from the fact that they flattened their heads like some other nearby tribes. On the contrary, the Flathead did not practice head deformation. They left the top of the head in its natural shape and were said by their neighbors to be "flat headed" since their heads did not slope back from the forehead to the crown.

The Flathead probably migrated from British Columbia and may have once lived farther eastward in the plains before being pushed west by the Blackfoot into western Montana in about 1600. They centered their life around FLATHEAD LAKE.

The Flathead acquired horses around 1700 and became a part of the buffalo hunting culture of the PLAINS INDIANS. Smallpox epidemics in 1760-1770 and 1781 and wars with the Blackfoot severely decreased their population. The Flathead were always a loose organization of bands, made up of related families who camped together. Each band was led by a chief and assistant chief selected on the basis of wisdom, bravery and influence. A tribal chief and the band chiefs made up the tribal council.

Religious life centered around guardian spirits obtained through dreams and visions. The dead were wrapped in robes and placed on scaffolds until time for burial. The pole used to transport the corpse to the grave served as a marker and offerings were tied to it.

Flatheads lived in one to three family conical dwellings. Temporary brush dwellings were used in the mountains on hunting trips. After the acquisition of horses and the development of buffalo hunts the Flathead lived in skin tipis. LEWIS AND CLARK visited the Flathead in 1805. Missions were founded in Flathead country after 1841.

In 1855 the Flathead ceded their lands in Montana and Idaho for a reservation around Flathead Lake. One group under the leadership of the the great chief Charlot, refused to relocate and held out in the Bitterroot Valley until 1890. By 1909 some of the reservation land had been opened to white settlement.

In the 1970s the Flathead lived with the KALISPELL and Kootenai on the 1,244,000-acre Flathead Reservation in western Montana. Important sources of income continue to be forestry, tourism, and timber sawmilled on the reservation.

FLATHEAD LAKE. Largest lake in western Montana. Approximately thirty miles long and twelve to fourteen miles wide, the lake receives the FLATHEAD RIVER. Near the large northwestern Montana city of KALISPELL, the lake is the home of the University of Montana Biological Station. Recreational sites in the area include Walstad Memorial, Finley Point, Woods Bay and Yellow Bay.

FLATHEAD RIVER. Rising in southeast British Columbia, the river flows south across the Canadian-United States border into Montana and for 245 miles to FLATHEAD LAKE and then south out of the lake and west to its mouth in the CLARK FORK RIVER. The Flathead flows near Columbia Falls, Whitefish and KALISPELL, Montana.

FLATHEAD RIVER WILD AND SCENIC RIVER SYSTEM. Coursing the western boundary of GLACIER NATIONAL PARK, this is a noted spawning stream. Headquartered KALISPELL, Montana.

FLAX. Plant raised for seed as the source of an animal feed and linseed oil used in paints, and for its fiber, which is spun and woven into linen products ranging from coarse rope to laces and fine cloth. American settlers often planted flax as one of their first crops as they moved west. The invention of the cotton gin by Eli Whitney made cotton yarn more economical, which led to low United States production of fiber flax. With the availability of polyester and other manufactured fibers, United States consumers began using even less linen in the mid-1900s. United States manufacturers of toweling, fish lines and nets import most of their fiber flax from Europe as fiber flax is not grown commercially in this country. The United States, a major producer of flax for seed, must import more to meet its needs. North and South Dakota and Minnesota are the principal growing areas in this country. The threat of a deadly wilt to the United States crop was solved with the development of a wilt resistant flax by NORTH DAKOTA STATE UNIVERSITY scientist, Dr. Henry L. Bolley.

FLINT HILLS REGION. Low range occupying the eastern third of Kansas, also known as the Bluestem Belt because of its bluestem grass.

FLINT. Alibates Flint Quarries National Monument near Fritch, Texas, was for more than 10,000 years the source of the unique flint used by the prehistoric peoples to make their projectile points, knives and other tools.

FLORAL VALLEY. Campsite in Wyoming named when troops serving with General George Armstrong CUSTER, according to a witness, "...festooned their hats and their horses' bridles with flowers while the expedition's band, seated on an elevated rock ledge played...*The Mocking Bird*, the *Blue Danube*, and snatches from *Il Trovatore* and other popular tunes of the day...The music of the band was weird and fascinating." In this way the valley gained its name.

FLORENCE, Colorado. Town (pop. 2,981), Fremont County, central Colorado, southeast of CANON CITY and northwest of PUEBLO. A.M. Cassedy's well near Florence produced Colorado's first oil in 1862. The first coal mines here were opened by Jesse Frazier who also planted the first apple orchard, with trees he brought from Missouri. Residents of the community celebrate an annual Pioneer Day.

FLORISSANT FOSSIL BEDS NATIONAL MONUMENT. A wealth of fossil insects, seeds and leaves of the Oligocene Period are preserved here in remarkable detail. Here, too, is an unusual display of standing petrified sequoia stumps. The preserve was authorized August 20, 1969, headquartered at Florissant, Colorado.

FLUORSPAR. Industrial name given to the mineral fluorite, a soft mineral with a glassy luster used to absorb impurities and lower the melting point in production of aluminum and steel. Fluorite is also used to make hydrofluoric acid, a powerful industrial chemical and in the manufacture of prisms in spectrographs. Found throughout the United States, the supplies of fluorspar in New Mexico have been termed "practically inexhaustible."

FOLEY, James William. (St. Louis, MO, Feb. 4, 1874—Pasadena, CA, May 17, 1939). Newspaperman. Poet laureate of North Dakota. Foley, who started newspaper work on the *Tribune* in BISMARCK, North Dakota, in 1892, began publishing poetry in 1905. He is best remembered for his *Prairie Breezes*, which was published in that year, and for *Voices of Song* (1916). By order of the State Department of Public Instruction Foley's fiftieth birthday was celebrated by all public schools in the state, a practice which has been continued annually.

FOLSOM MAN. Term used to describe those peoples who settled in the Southwest between twelve thousand and fifteen thousand years ago. Remains of these people were first excavated in 1926 near FOLSOM, New Mexico, where the name originated.

FOLSOM MAN STATE MONUMENT. Site near Raton, New Mexico, where remains of the prehistoric human known as FOLSOM MAN continue to be discovered.

FONDA, Henry. (Grand Island, NB, May 16, 1905—Los Angeles, CA, Aug. 12, 1982). Actor. Playing a strong, silent type in movies, Fonda appeared in more than seventy films including *Grapes of Wrath (1940) and The Ox-Bow Incident* (1943). After he returned from three years of service in the navy, he starred in *Mister Roberts* on the stage in 1948 and in the movie in 1955. This has been acclaimed as his greatest role. He won an Oscar in 1982 for his performance in the film *On Golden Pond*, which attracted great acclaim. An earlier work of

substantial fame was *Young Mr. Lincoln* (1939). The next year also saw the release of an entirely different historical film, *The Grapes of Wrath*. Perhaps his best known film was *Mr. Roberts* (1955).

FONTENELLE FOREST. Largest tract of virgin timber in Nebraska, home of the Fontenelle Forest Nature Center near BELLEVUE. The Center, a 1,300-acre preserve with seventeen miles of wilderness trails, offers ecology exhibits at its interpretive center.

FORD, Gerald Rudolph. (Omaha, NB, July 14, 1913—). President of the United States. Two years after his birth, Ford's parents divorced and his mother took him from his birthplace in OMAHA, Nebraska, to Grand Rapids, Michigan, where she had friends. In 1916 she married Gerald Rudolph Ford who adopted the boy and gave him his name. Ford grew up in Grand Rapids and entered the University of Michigan where he played center on the undefeated Michigan football teams of 1932 and 1933. Although offered professional football contracts with the Detroit Lions and the Green Bay Packers, Ford accepted a job coaching football at Yale from 1935 to 1938 until he was accepted to law school at Yale, where he received his law degree in 1941.

Successful in his run for Congress in 1948, Ford was re-elected by the citizens of Michigan's Fifth Congressional District in twelve consecutive elections and became the House minority leader in 1965. Ford attracted national attention when he appeared with Senate Minority Leader Everett M. Dirksen in a series of televised Republican press conferences dubbed by reporters the "Ev and Jerry Show."

Reversing his support of the Johnson Administration, Ford became a vocal opponent of the administration's policies in Vietnam and managed to unite Republican and Southern Democrats in opposition to President Johnson's social programs. In 1970 Ford's effort to impeach Justice William O. Douglas ended with the House deciding there was insufficient evidence to support the proceedings.

Vice-President Spiro Agnew resigned in 1972 amid proof that he had accepted bribes as a public official, and President Nixon nominated Ford to become Vice President. The Senate approved the nomination by a vote of 92 to 3 on November 27. The House approved by a vote of 387 to 35 on December 6th.

Ford was sworn in as the 40th Vice-President, the first to be appointed in the history of the United States. Ford went on a forty state speaking tour in support of President Nixon as the facts continued to mount that the president had withheld evidence on the Watergate scandal. In July, 1974, the House Judiciary Committee recommended that Nixon be impeached. Nixon resigned on the morning of August 9th, and Ford took the oath of office as the 38th President of the United States, becoming the only American to become president without being elected vice-president or president.

Ford's ability to handle domestic problems was severely hurt by his pardon of Richard Nixon on September 8, 1974, for any crimes he might have committed while president. Ford claimed to take the action to end divisions within the country. Ford attempted to deal with draft violence by granting amnesty to draft dodgers and deserters of the Vietnam War period, if the offenders would work in a public service job for up to two years. Twenty-two thousand of the estimated 106,000 eligible men applied for the amnesty, while the others objected to the work requirement.

On the economic front, Ford declared inflation to be the nation's major problem and launched the "WIN," Whip Inflation Now, campaign. Ford survived two assassination attempts. In the 1976 election Ford and California governor Ronald Reagan fought a bitter contest for the nomination eventually won by Ford.

The Democratic nominee, Jimmy Carter, charged that Ford had mismanaged the economy. Carter defeated Ford by less than two million votes out of nearly eighty-two million cast. Ford carried twenty-seven states while Carter carried 23 states and the District of Columbia, but Carter received 297 electoral votes compared to Ford's 240.

Ford left office to enter the political scene as a retired president, author and frequently requested speaker.

FORREST, Steve. (Huntsville, TX, Sept. 29,1924—). Leading man in motion pictures, brother of Dana Andrews. Forrest starred in such pictures as *Phantom of the Rue Morgue*, (1954), *The Living Idol* (1957), and *The Wild Country* (1971). He starred in a television series entitled *The Baron* in 1965 and appeared in supporting television roles including recurrent appearances in the series *Dallas* during 1986-1987.

FORT ABERCROMBIE STATE PARK. Site near Abercrombie, North Dakota, preserv-

ing twenty acres of the original seven square mile military reservation of the fort, the first military post in North Dakota. The fort, built in 1858, was named for Lieutenant Colonel John J. Abercrombie, the officer in charge of construction. Soon known as the "Gateway to the Dakotas," the post was vulnerable to Indian attacks, and during the Sioux Uprising of 1862 was besieged for five weeks by an estimated four hundred warriors. In November of 1862 ten acres of the fort were enclosed by a stockade, and this reinforced garrison was maintained until the fort was abandoned in 1877. In later years an old cabin in the park was converted into a museum of early white and Indian artifacts.

FORT ABRAHAM LINCOLN STATE PARK. Near MANDAN, North Dakota, preserving three sites of historical and archaeological interest, a MANDAN INDIAN village and two old military posts. Developed by the State Historical Society of North Dakota, the National Park Service, and the Civilian Conservation Corps, the park features a Mandan settlement containing sixty-eight lodges. Five have been restored, including four houses and the eighty-four foot diameter ceremonial lodge. The troops of Fort McKeen, built in 1872 on the site of the Indian village, were to protect the surveyors, engineers and workmen of the Northern Pacific Railroad. The post's name was changed to Fort Abraham Lincoln, in 1872, in honor of the former president. Life at the post included fighting the Sioux, maintaining law and order, and building smudge fires to protect the railroad workers from swarms of mosquitoes. It was from Fort Abraham Lincoln that the men of the SEVENTH U.S. CAVALRY marched toward their death at the Battle of LITTLE BIG HORN. The battle, strangely, marked the beginning of the end of Indian hostilities in the area, and troops were withdrawn from the fort in 1891. Buildings from the post were carried off by settlers in the area before a new infantry post, called Fort Lincoln, was established across the river.

FORT ASSINIBOIN. Montana military post thirty-eight miles south of the Canadian border assigned to prevent SITTING BULL (1831?-1890) and his followers, who had fled to Canada in 1876, from re-entering the United States. The fort also protected settlers from the BLACKFOOT Indians. Built of brick, it was one of the most elaborate forts in Montana. The post was closed in 1911 and acquired by the Department of Agriculture in 1913 when many of the

buildings were torn down. The remaining structures are used by a United States Agricultural Experiment Station.

FORT ATKINSON. First permanent settlement by Europeans in the present state of Nebraska, the first post west of the MISSOURI RIVER, and at the time of its construction the largest frontier post. Planned after the War of 1812 by Secretary of War John C. Calhoun, Fort Atkinson was one of several forts built to awe the Indians with American military power and to counter British influence in the region. The post, the most remote outpost of the United States, served as an administrative center for the Indians on the upper Missouri River and was a favorite base for explorers and fur traders. In 1820 Nebraska's first school was opened at the fort. The government closed the post in 1827 when it opened FORT LEAVENWORTH, Kansas, which was located closer to the the routes of travel west. The site of the fort is now part of the Fort Atkinson State Historical Park, where archaeological excavations continue to yield numerous artifacts which are displayed in the Fort Calhoun Museum.

FORT ATKINSON, TREATY OF. Treaty signed on July 27, 1853, between representatives of the United States government and the COMANCHE, KIOWA, and KIOWA-APACHE tribes. The treaty pledged the southern Indians to stop warring with each other and not to molest travelers on the SANTA FE TRAIL or to obstruct the construction of military roads and posts.

FORT BEND, Texas. Frontier outpost on the site of present-day Richmond, Texas, first settled in 1822. In 1838, when Richmond became the county seat of the newly formed Fort Bend County, the Fort Bend settlement was absorbed into it.

FORT BENT. A name that can refer to any of three forts built by Charles, George, Robert and William BENT in southeastern Colorado between 1826 and 1853. The forts, erected as trading centers, were sufficiently strong to withstand a siege. The first fort, built near the ROCKY MOUNTAINS, was closed on the advice of Indian friends. The Bents moved eastward and in 1828 built what became known as the Old Fort, at the mouth of the PURGATOIRE RIVER. Built of adobe, the post was the stopping place for travelers and a headquarters for traders and trappers. Thirty-foot guard towers and walls, topped with cactus, protected those inside the

fort. The operation required one hundred workers at all times. Only William Bent survived to see the last structure, the one that he built near Big Timbers on the ARKANSAS RIVER in 1853. More elaborate than the others, this fort covered about an acre and was built of stone, with cannon mounted on the walls.

FORT BENTON. This Montana military post was named for Missouri Senator Thomas Hart Benton. From the post the MULLAN ROAD stretched to Walla Walla, Washington. Fort Benton, established in 1847 by Alexander Culbertson of the AMERICAN FUR COMPANY, quickly became a trade and transportation center as the last stop for steamboat transportation on the MISSOURI RIVER. In 1881 the troops were transferred to Fort Shaw.

FORT BLISS. Located near EL PASO, Texas, Fort Bliss was founded in 1848. During the CIVIL WAR it was headquarters for the Confederate Army in the Southwest, and during the 1800s it became a "service station" for troops seeking GERONIMO (1829?-1909), the plundering Apache chief. In 1944 the United State Army set up an Air Defense Center for guided missiles at Fort Bliss. The fort today continues as a major defense installation and houses a principal tourist attraction—a replica of the original post, given by the citizens of El Paso to Fort Bliss on its 100th anniversary.

FORT BRIDGER. Second settlement in Wyoming begun in 1842 near present EVANSTON and named for its builder, frontiersman Jim BRIDGER (1804-1881). The fort was originally built as a trading post by Bridger and his partner, Louis Vasquez. Constructed near Black's Fork of the GREEN RIVER, the post offered supplies and the services of a blacksmith to travelers on the OREGON TRAIL. Fort Bridger was second only to FORT LARAMIE as an important outfitting point for immigrants as they moved across the plains to the Pacific. In 1853, the fort was occupied by parties of Mormons. Their occupation lasted only two years. Fort Bridger was burned by U.S. troops during the Mormon Wars. The site was occupied by government troops from 1858 to 1890, and they rebuilt much of the compound. During the 1860s the fort was a station on the PONY EXPRESS and the overland stage routes. With the start of the CIVIL WAR the post's troops were ordered east, and the fort remained empty until a volunteer militia of local citizens was organized. Volunteer regiments from California and Nevada used the

fort from 1862 to 1866 when a company of "galvanized Yankees," former Confederate prisoners of war allowed to serve in the Union Army, was garrisoned at the fort. Soldiers stationed at Fort Bridger during the 1870s often escorted work crews from the Union Pacific Railroad. The fort was also headquarters of the Shoshone Indian Agency. The post was closed from 1878 to June 28, 1880, when it was reopened due to an uprising of the UTE INDIANS. With peace on the frontier the usefulness of the post waned and it was finally closed in 1890. Until it was acquired by the State of Wyoming in the late 1920s, Fort Bridger remained a community center and home of Judge W.A. Carter. Today it is a state museum.

FORT BUFORD STATE HISTORICAL PARK. North Dakota historical site seventeen miles from WILLISTON. The 1881 surrender of SITTING BULL at the fort ended the Indian disturbances in the region. Nearly thirty-six acres are maintained as a state historic site. The officers' quarters, today a museum, and the stone powder magazine are the only two buildings which have survived in their original location.

FORT C. F. SMITH. Military post activated in 1866 at the upper Bighorn Crossing of the BOZEMAN TRAIL as the northernmost of three forts to protect travelers to Montana goldfields from CHEYENNE and SIOUX attacks. The post was kept in a state of perpetual siege for two years by warriors under the Sioux chief RED CLOUD (1822-1909). On August 1, 1867, a force of approximately one thousand Indians attacked a detail of soldiers and civilians working in a hayfield two and one-half miles from the fort. This battle, known as the Hayfield Fight, led to many Indian casualties, but only three white deaths and four wounded. In 1868, in accordance with the Fort Laramie Treaty, the post was abandoned and was immediately burned to the ground by the Indians. Bighorn Canyon National Recreation Area, established in 1966 near HARDIN, Montana, contains mounds of earth outlining the foundations of the adobe and log buildings. A marker, placed by a local historical society marks the site of the fort, while a second marker locates the scene of the Hayfield Fight.

FORT CASPER. Frontier military post near present-day CASPER, Wyoming, named for Lieutenant Caspar W. Collins of the 11th Ohio Volunteer Cavalry who died in the battle of

The forts of the region were enormously important to development of the Central West. Many are still standing in various stages of disrepair. Among the best preserved of Texas frontier military forts, with 18 original buildings still standing and in use, is Fort Concho at San Angelo. There the troops protected stagecoaches and wagon trains, escorted U.S. mail, explored and mapped new territory and occasionally clashed with Indians.

Platte Bridge on July 26, 1865. Collins had arrived at the bridge with twenty-five men on their way to protect a wagon train seventeen miles away. An estimated six hundred CHEY-ENNE attacked to the front and left of the soldiers while 1,800 Sioux charged from the right. Collin's force was so close to the enemy they had to use hand-to-hand fighting to avoid hitting each other with gunfire. Collins was killed while attempting to save another soldier. On November 11, 1865, Platte Bridge Station was renamed Fort Caspar. The name of Wyoming's second largest city was misspelled by a railroad clerk and the error was allowed to remain.

FORT COLLINS, Colorado. City (pop. 82,-150), seat of Larimer County, north-central Colorado, northwest of GREELEY and north of LOVELAND. With the end of Indian troubles in the 1860s the army garrison stationed on the CACHE LA POUDRE RIVER moved away, leaving the buildings of the post and the name to the nearby settlement. Commerce along the OVER-LAND TRAIL and an increasing number of farms and ranches helped the community grow. Fort Collins became and continues to be a center for the winter feeding of sheep. The cultivation of sugar beets and vast livestock feedlots have been replaced by electronics and regional retailing as the principal industries. COLORADO STATE UNIVERSITY was established there in 1879. In and around Fort Collins are forty-eight historic sites. Five listed on the National Register for historic places. Fort Collins Lincoln Center, opened in 1978, provides a home for the Fort Collins Symphony Orchestra, the Foothills Civic Theater, the Larimer Chorale, Childrens' Theater and the Canyon Concert Ballet.

FORT CONNAH. In 1847 this post, near St. Ignatius Mission in Montana, was the last of the HUDSON'S BAY COMPANY's forts to be constructed in the United States.

FORT CUSTER. Military post constructed near HARDIN, Montana, by Colonel George P. Buell in 1877, the year after the Battle of LITTLE BIG HORN (June 25, 1876). Named for the battle leader, General George A. CUSTER (1839-1876), the fort was built just after hostilities had ended in the area. Soldiers were often treated to entertainment there. Once while John Maguire, a frontier impressario, was presenting *Captain John Smith* to an audience, using CROW Indians as actors, SIOUX Indians slipped into the post and stole the Crows' horses. Both Crow and cavalry joined in pursuit of the thieves.

FORT DAVIS NATIONAL HISTORICAL SITE. A key post in the West Texas defensive system, the fort guarded emigrants on the San Antonio-El Paso road from 1854 to 1891. Headquartered FORT DAVIS, Texas. The fort was one of the key posts in the defensive system of western Texas during the Indian Wars, especially during the campaign against Apache chief Victorio from 1879 to 1880.

FORT DILTS STATE PARK. Site near Rhame, North Dakota, where an immigrant train headed for the Montana gold-fields was attacked on September 1, 1864, by Hunkpapa Sioux. A rescue column arrived too late and the party's scout, Jefferson Dilts, who had been reconnoitering in the Badlands was killed as he returned and rode directly into the escaping Indians. Before leaving after the attack, the immigrants left a poisoned box of hardtack which killed an estimated twenty-five Indians, more than had been killed by the immigrants' guns. The wagons were moved only ten miles before being circled behind a defensive wall of sod the immigrants called Fort Dilts. The Indians moved on, and a rescue party arrived from Fort Rice to escort the wagons. The state park, dedicated to Dilts in 1932, contains nine acres and the remains of the sod fortification with nine grave markers placed in memory of those who died in the event.

FORT GIBSON. Near present MUSKOGEE, Oklahoma, the first fort established in Indian Territory and a hub of frontier commerce and military activity associated with the relocation of the FIVE CIVILIZED TRIBES from the Southeast. Established in 1824, the fort garrison kept peace between the OSAGE and the CHEROKEE, and helped receive, settle and enforce peace for the SEMINOLES, CHICKASAWS, CREEKS and CHOCTAWS, protecting them from the Plains tribes. Troops escorted surveyors marking the boundaries of Indian lands, helped establish other forts, and tried to control the illegal liquor traffic. Located beyond the point where river navigation was possible, Fort Gibson was a supply depot and a federal stronghold in 1863. A reconstruction of the original log stockade and several outlying buildings was financed by the State of Oklahoma in 1936 with a Works Progress Administration grant.

FORT GIBSON RESERVOIR. Large man-made body of water impounded by Fort Gibson Dam, in eastern Oklahoma's Wagoner and Cherokee counties, west of TAHLEQUAH.

FORT HOOD. U.S. Army post located between Killeen and Gatesville, in south central Texas, founded in 1942. More concentrated armored power is centered at Fort Hood today than anywhere else in the United States. It is said to support the largest population (102,171, combined military and civilian) of any military post in the Western World.

FORT KEARNEY HISTORICAL PARK. Recreational area near KEARNEY, Nebraska, including forty acres of the second Fort Kearney site, featuring replicas of the palisade and blacksmith-carpenter shop, which were once part of the fort located on the south bank of the PLATTE RIVER halfway between FORT LEAVENWORTH, Kansas, and FORT LARAMIE, Wyoming. Audio-visual programs and museum displays are presented at an interpretive center.

FORT LARAMIE NATIONAL HISTORIC SITE. A fur-trading post once stood here, but the surviving buildings are those of a major military post that guarded covered wagon trails to the West, 1849-90. Proclaimed July 16, 1938, headquartered Fort Laramie, Wyoming.

FORT LARNED NATIONAL HISTORIC SITE. From 1859 to 1878 this fort protected traffic along the SANTA FE TRAIL, was the key military base in the Indian war of 1868-69 and served as an Indian agency. Authorized August 31, 1964, headquartered LARNED, Kansas.

FORT LEAVENWORTH. Oldest military post in continuous operation west of the MISSOURI RIVER. Located near LEAVENWORTH, Kansas, Fort Leavenworth has been called one of the most beautiful military posts in the United States. Established in 1827 to protect trade and travel on the SANTA FE TRAIL, Fort Leavenworth is the home of the Army's Command and

"Fort Leavenworth Under Construction" is represented in a mural at the fort.

General Staff College, considered the finest senior tactical school in the world for advanced military education. The post is also the site of the United States Disciplinary Barracks, a military prison.

FORT MANDAN HISTORIC SITE. Near Wilton, North Dakota, on the site of Fort Mandan on the north bank of the MISSOURI RIVER. LEWIS AND CLARK wintered there in 1804-1805 with the friendly Mandan Indians and it was there that SAKAKAWEA joined the expedition as a guide and interpreter. Warring SIOUX INDIANS destroyed the buildings of the fort in 1805, and the ever-changing river channel has altered the physical features.

FORT MEADE. Frontier post founded in 1878 about fourteen miles northeast of DEADWOOD, South Dakota. The fort controlled the SIOUX INDIANS and protected miners in the BLACK HILLS. Fort Meade, replacing a temporary installation called Camp Sturgis, was the army headquarters in 1890-1891 during the Sioux uprising which ended in the Battle of WOUNDED KNEE. Since 1944, when Fort Meade became a Veterans' Administration Hospital, most of the original buildings have been replaced with the exception of the officers' quarters dating from the 1880s. COMANCHE, the horse that survived the Battle of LITTLE BIG HORN (June 25, 1876), was quartered in the fort's stables (1879-1887).

FORT PECK DAM. Located at the town of Fort Peck (pop. 600), Valley County, northeastern Montana, southeast of Glasgow and west of Wolf Point. Fort Peck was a planned community to house the administrators and workers on the Fort Peck Dam, world's largest earth-fill dam. Built during the period of 1933-1940 by the U.S. Bureau of Reclamation as a flood-control and navigation-improvement project, the dam became a part of the Missouri River Basin Project in 1944. In addition to its earlier uses the dam now provides electric power, and Fort Peck Reservoir has become an important recreation area of the region.

FORT PHIL KEARNY. One of three forts constructed to protect travelers on the BOZEMAN TRAIL. Located seventeen miles north of Buffalo, Wyoming, the fort was constructed in 1866 by Colonel Henry B. Carrington. Built along Little Piney Creek, the post was a 600 foot by 800 foot stockade with walls of eleven foot logs, sharpened and placed on end. The timber had to be cut high in the mountains because it was not available where the fort was planned. The almost constant Indian harrassment of the troops led to the FETTERMAN MASSACRE (December 21, 1866) in Wyoming, a significant blow to the morale of the Army. With the death of the eighty-one men of Fetterman's command, the fort was forced to send for reinforcements from FORT LARAMIE, 236 miles away. The successful

and daring four-day ride of John "Portugee" PHILLIPS is well remembered. He was able to slip out unseen and ride the 236 miles to bring help. On August 2, 1867, Captain James Powell and a small detachment were attacked only five miles from the fort. New breechloading rifles and relative safety within a ring of old wagon boxes allowed the Army to successfully defend their position with estimates of Indian deaths running from 12 to over 1,000. The hostility of the Indians led to the decision to close the fort. Within an hour of the post's abandonment in 1868, RED CLOUD (1822-1909) and his warriors burned the stockade to the ground. Today a new visitor's center and museum contain many displays and artifacts.

FORT PIERRE. Oldest continuously inhabited settlement in present-day South Dakota. Fort Pierre, established by the Columbia Fur Company in 1822, was replaced in 1831 by Fort Pierre Chouteau, later shortened to Fort Pierre. Purchased by the government from its private owners in 1855, the fort was used between 1876 and 1881 as the head of the wagon road to the BLACK HILLS gold fields, and then as the railhead for several years after that.

FORT RANDALL DAM. Once one of the world's twelve largest dams, located north of where the MISSOURI RIVER forms the South Dakota-Nebraska border. The dam, created from 50,200,000 yards of earth and concrete sections, formed Lake Francis Case.

FORT RILEY. One of the largest inland military installations in the United States. Established in 1853 at the junction of the Smoky Hill and Republican forks of the KANSAS RIVER, Fort Riley was one of several posts built to protect the Smoky Hill Trail to DENVER, Colorado, the SANTA FE, OREGON and California Trails. The post drilled troops for frontier duty and, during the 1850s and 1860s, was the base of several military operations against the Indians. In 1866 Lt. Colonel George A. CUSTER (1839-1876) organized the newly authorized SEVENTH U.S. CALVARY Regiment at the post. In 1891 the fort became headquarters of the School of Application for Cavalry and Light Artillery which became the Mounted Service School in 1908 and in 1919 the Cavalry School. Today Fort Riley houses the Army General School.

FORT ROBINSON. Historic military post in Nebraska. Fort Robinson, erected in 1874 just

prior to the last major Indian uprising in the West, protected the Red Cloud Agency, the distribution point for food and annuities to the SIOUX and CHEYENNE Indians, where as many as 13,000 Indians camped nearby waiting for supplies. The violations of the Fort Laramie Treaty and attempts in September of 1875 to buy the sacred BLACK HILLS increased Indian hostility. Fort Robinson was a supply post in 1876 for troops engaged in campaigns in Wyoming and Montana against the Sioux and Cheyenne who had defeated General George Armstrong CUSTER (1839-1876). Victories in this campaign and a major defeat of the SIOUX INDIANS at the Battle of Slim Buttes, South Dakota, caused nearly 4,500 Indians including Sioux chief CRAZY HORSE (1849-1877) to surrender at Fort Robinson. In September, 1877, due to a misunderstood order, the fort's commander attempted to arrest Crazy Horse who, in resisting arrest, was bayoneted to death. Soldiers from Fort Robinson pursued and captured Dull Knife and many Cheyenne warriors in September, 1878. The Indians escaped in January, 1879, but were again pursued and killed or captured. During the Ghost Dance in 1890 members of the black 9th Cavalry and the white 8th Infantry from Fort Robinson were used at the Pine Ridge Agency in South Dakota. Through the 1870s Fort Robinson acted in peace-keeping between the ranchers and the homesteaders in the region and grew in importance with the closing of Fort Laramie in 1890. Fort Robinson remained in operation through World War II serving as a cavalry base, remount depot where fine horses and mules were raised, a war-dog training post, and a prisoner-of-war camp. In 1947 the Army left, but the buildings were reoccupied by 1949 by the Fort Robinson Beef Cattle Research Station, a joint project of the University of NEBRASKA and the United States Department of Agriculture. The officers' quarters, a blacksmith shop and the original barracks have been reconstructed. Tours are conducted by guides in period costumes. Fort Robinson Museum, located in the fort's headquarters building, displays pioneer and Indian artifacts, maintained by the Nebraska State Historical Society as part of the Fort Robinson State Park.

FORT SCOTT NATIONAL HISTORIC SITE. Established in 1842 as a base for the U.S. Army's peacekeeping efforts along the "permanent Indian frontier," the fort was manned by U.S. Dragoons who served valiantly in the MEXICAN WAR (1846). The post was

abandoned in 1853 and reactivated during the CIVIL WAR (1861-1865) as a supply and training center. The restored and reconstructed buildings of the fort today recreate the American frontier of the 1840s and 1850s. Headquartered Fort Scott, Kansas.

FORT SCOTT, Kansas. City (pop. 8,893), Bourbon County, eastern Kansas, northeast of Chanute and south of Olathe, named for General Winfield Scott. The Fort Scott National Cemetery established in 1862 is said to be the first to be established in the United States. The history of the military post and town of Fort Scott had three distinct phases. Between 1842 and 1853 the fort was part of a chain of the forts on the "Permanent Indian Frontier." The second phase occurred 1862-1865, when the fort was an important Union outpost. The town of Fort Scott was a focal point for the violence that preceded the CIVIL WAR. The "Free-State Hotel" in Fort Scott was a stopping point for John BROWN (1800-1859). During the war the community was a link between men and supplies in the north with campaigns in Missouri, Arkansas and Indian Territory. From 1865 to 1873 Fort Scott served a unique role of protecting the men building the Missouri River, Fort Scott, and Gulf Railroad, from settlers who attacked the construction crews because they said the railroad's land claims were fraudulent. The Fort Scott Historic Area is located in the northeastern part of the Fort Scott business district. While the city currently encroaches on the fort site, long-range plans call for the removal of nonhistorical structures and restoration of the area to its condition in 1842-1853.

FORT SHAW. Montana military post founded in 1867. Located in Cascade County, the fort protected settlers, kept the road between FORT BENTON and HELENA open, and guarded miners in northwestern Montana. Troops from the fort helped defeat nontreaty Nez Perce at the Battle of BIG HOLE (August 9, 1877) as they retreated from Idaho to Montana. Once the social center for a large area of Montana, the fort's personnel saw the first performance of professional theater in Montana. Closed in 1891, the fort was used by the Department of Interior as an Indian school.

FORT SILL NATIONAL HISTORIC LANDMARK. Oklahoma military post in Comanche County, named for General Joshua W. Sill. Fort Sill contains an artillery museum considered among the finest in the world.

Among the other displays is the saber of General George Armstrong CUSTER (1839-1876). Following the surrender of the Apache leader GERONIMO (1829?-1909) and his band, many of the Indians, including their leader were imprisoned at the fort. Geronimo, who died after his release from prison, is buried at the fort as is Chief Satanta of the Kiowa who was killed while attempting to escape the arrest order issued by General W.T. Sherman.

FORT SISSETON. South Dakota military post established in 1864. The two million dollars cost of constructing Fort Sisseton made it one of the most expensive military installations of its time. Supplies for building the fort had to be carried from St. Paul, Minnesota, and stone used in the construction was dragged across the prairies from WAHPETON, North Dakota. The post was built to assure settlers of their safety after the campaigns of Hiram Sibley and Alfred Sully in 1863-1864 had pacified most of the SIOUX INDIANS in the area. The fort also protected emigrants traveling to Idaho and Montana goldfields, aided railroad surveyors, and was a policing agency before the establishment of courts. The post became the social and cultural center for half of the state. One of the fort's most memorable residents was Samuel J. Brown who rode 135 miles through a blizzard to remedy a warning he had given in error. Brown was paralyzed for the rest of his life as a result of harsh conditions he endured during the journey.

FORT SMITH NATIONAL HISTORIC SITE. Shared by Oklahoma and Arkansas, headquartered at Fort Smith, Arkansas, the preserve features one of the first U.S. military posts in the Louisiana Territory. It contains the remains of two frontier military forts and a federal court. There Judge Isaac C. PARKER (1838-1806), known as the "Hanging Judge," served for 21 years. Until Judge Parker arrived at Fort Smith and began his historic "conquest" of the region, there was no law and order in the vast Indian Territory (now Oklahoma) to the west. The lawlessness in the territory is said to have been without parallel in this country until the judge sent out his deputies to haul in the lawbreakers, then constructed the historic gallows now on view at the site and put it to almost constant use.

FORT STOCKTON, Texas. Town (pop. 8,-688), seat of Pecos County, located on the Old San Antonio Road, founded 1859, once a mail

route connected to San Diego. Today, its livelihood comes mainly from the petroleum industry, farming, and tourism. The site of Old Fort Stockton (opened in 1869 and abandoned in 1886) is a main attraction.

FORT SUMNER. New Mexico military installation was constructed in 1862 at Bosque Redondo along the PECOS RIVER to guard four hundred MESCALERO APACHE and 8,000 NAVAJO conquered by Kit CARSON (1809-1868) in 1862-1864. The Mescalero fled in 1865, and in 1868 the federal government negotiated a treaty with the Navajo allowing them to return to their ancestral homeland. From 1866 to the early 1870s the fort was a way station on the Goodnight-Loving Cattle Trail. Herds wintering near the post were occasionally purchased by the government for the reservation Indians. In 1869, the year the Navajo left, the fort was demilitarized and sold to Lucien Maxwell, a New Mexico cattle baron who remodeled some of the buildings for residential and ranching purposes. In 1881 Sheriff Pat Garrett killed "Billy the Kid" in the remodeled ranch house. All remains of the adobe ruins were washed away in a flood in 1941. The land is now privately owned.

FORT UNION NATIONAL MONUMENT. Three U.S. Army forts were bult on this site—a key defensive point on the SANTA FE TRAIL—and were occupied from 1851 to 1891. Ruins of the last fort, which was the largest military post in the Southwest, have been stabilized. Headquarters, Watrous, New Mexico.

FORT UNION TRADING POST NATIONAL HISTORIC SITE. The trading post that stood here was the principal fur-trading depot in the upper MISSOURI RIVER region from 1829 to 1867. Fort Union served the Dakotas, Montana and the Prairie Provinces. Founded June 20, 1966, headquartered, WILLISTON, North Dakota.

FORT WASHAKIE. Frontier fort named for Wyoming's great Shoshone chief, WASHAKIE (1804?-1900) who guided his people in peace for sixty years and who was the first Indian to be buried with military honors. Fort Washakie, renamed from Fort Brown in 1878, is the headquarters for the SHOSHONE and ARAPAHO reservation, the only one in Wyoming.

FORT WORTH, TEXAS

Name: For General William Jenkins Worth of Mexican War fame.

Nickname: Fort Town; Gateway to West Texas; Southwest Metroplex; The City Worth Looking Into.

Area: 258.5 square miles

Elevation: 670 feet

Population:
1986: 429,550
Rank: 30th
Percent change (1980-1984): +11.5%
Density (city):1,662 per sq. mi.
Metropolitan Population: 1,144,366 (DFW 3,348,030) (1984)
Percent change (1980-1984): +17.6% (DFW 14.2%)

Race and Ethnic (1980):
White: 68.92%
Black: 22.78%
Hispanic origin: 48,568 persons (12.64%)
Indian: 1,841 persons (0.32%)
Asian: 2,954 persons (0.61%)
Other: 26,098 persons

Age:
18 and under: 27.1%
65 and over: 11.8%

TV Stations: 9

Radio Stations: 37

Hospitals: 17

Further Information: Fort Worth Chamber of Commerce, 700 Throckmorton, Fort Worth, TX 76102.

FORT WORTH, Texas. City (pop. 385,141), seat of Tarrant County, located in the rolling range country of north central Texas. Surrounded by ranches and farms, Fort Worth is an industrial center of more than 20 suburbs. Fort Worth was a jumping-off point for settlers heading westward during the 1840s and 1850s, and in 1847 a cavalry outpost was established on the city's present site to protect settlers on their way west. In 1853 the outpost was named Fort Worth in memory of General William J. Worth, a former commander of the army's

The spectacular Water Gardens of Fort Worth are among the many attractions of the city.

Texas Department. Fort Worth developed into a cattle town in the 1870s because of the nearby CHISHOLM TRAIL, along which cowboys drove vast herds of longhorn cattle to Kansas, and the city became known as "Cowtown." With the coming of the railroad, Fort Worth was transformed into an important cattle shipping center. Grain milling became a worthwhile industry a few years later. In the early 1900s the economy again boomed with the discovery of oil in the region. While oil, grain, and beef are still important to the city's economy, the present-day major employers are Bell Helicopter Company and the Fort Worth General Dynamics division and other extensive manufacturing.

Fort Worth's many points of interest include the Fort Worth Zoo, SIX FLAGS OVER TEXAS amusement park, several fine art museums, Trinity Park, and Fort Worth Botanical Gardens. An educational center, Fort Worth is home to TEXAS CHRISTIAN UNIVERSITY, Fort Worth Christian College, Southwestern Baptist Theological Seminary, Texas Wesleyan College, and Tarrant County Junior College.

FORT YATES, North Dakota. Town (pop. 771), Sioux County, south-central North Da-

kota, southeast of MANDAN and south of BISMARCK. Fort Yates is the agency headquarters for the Standing Rock Indian Reservation of 876,796 acres which extends into South Dakota. The reservation is the site of the grave of one of America's best-known Indian leaders, SITTING BULL (1830?-1890).

FORTS AND INSTALLATIONS. fortifications of the widest variety played an especially important part in the history of the Central West. They were thrown up by the Indians, by the Spanish, the Texans and the Americans and by many private parties as well.

Colorado: In 1819 the Spanish built a fort near present Walsenburg to ward off possible American invasion. In 1828 The private firm of BENT AND ST. VRAIN built FORT BENT near present LA JUNTA, Colorado, constructed of adobe by New Mexican workers, a stopping place on the way to Mexican lands. Private forts Lupton and Vasquez were built in 1837, with Fort St. Vrain near Gilcrest in the same year. Fort Garland became the government stronghold in the San Luis Valley in 1854. Fort Lupton and Fort Massachusetts were other strong points.

Kansas: The year 1827 brought Colonel

Henry H. LEAVENWORTH (1783-1834) to the SANTA FE TRAIL, when he built a small fortification on the MISSOURI RIVER and called it FORT LEAVEN-WORTH. Today Fort Leavenworth is the oldest military installation still in operation west of the MISSOURI RIVER. Old FORT LARNED near LARNED is now a national historic site, and the block house of Fort Hays at HAYS is a museum. FORT RILEY, west of MANHATTAN, was one of the largest of the military reservations. At FORT SCOTT , established in 1842, is the national cemetery, said to be the nation's first (1862).

Nebraska: Privately owned Fort Lisa was established in 1812, north of present OMAHA. In 1827 FORT ATKINSON was the most remote federal military establishment in the U.S. FORT ROBIN-SON was the site of the tragic murder of Chief CRAZY HORSE (1849:-1877).

Montana: In 1807 Manuel LISA (1772-1820) built a trading fort at the mouth of the BIG HORN RIVER. John Jacob Astor's AMERICAN FUR COMPANY manned seven trading forts in Montana, including famed FORT UNION. The HUDSON'S BAY COMPANY built FORT CONNAH near St. Ignatius in 1847. FORT BENTON was the last steamboat landing point on the Missouri River, and remains of the historic fort may still be seen. FORT SHAW, near GREAT FALLS, became an early social center.

New Mexico: Many of the Pueblos of New Mexico were essentially forts, built in the sides of cliffs or on high ground for protection from enemies. The first U.S. fort built in the state was Fort Marcy, in 1846, a strong place of the war with Mexico. During the CIVIL WAR the main concentration of federal forces was at FORT UNION, now a national monument. Old FORT SUMNER at one time was considered "the hand-sommest in the Union."

North Dakota: FORT MANDAN was an Indian strongpoint when LEWIS AND CLARK wintered there in 1804. It was burned by the SIOUX INDIANS in 1805. Private Fort Berthold was established in 1845 by Bartholomew Berthold as a trading post, near preent GARRISON. Constructed in 1857 on the banks of the RED RIVER, FORT ABERCROMBIE was the first built there by the U.S. FORT BUFORD was bought by the government from private owners in 1866, the first of a string of forts extending westward to protect the immigrants. From FORT ABRAHAM LINCOLN, near present BIS-MARCK, George Armstrong CUSTER (1839-1976) and his men took off on their fatal expedition. Fort Dilts, near Rhame, was the site where eighty wagons were formed in a circle for defense and held off Indian attack for 14 days. It took its name from Jefferson Dilts, killed

during the fight. Fort Totten, near Devils Lake, now a state monument, at one time provided the last stop for travelers for 300 lonely and dangerous miles. It has nineteen original build-ings still standing and is the only one of its kind.

Oklahoma: FORT SILL was built by General Philip SHERIDAN (1831-1888) in 1869, near present LAWTON, and maintained law and order in much of southwestern Oklahoma, as well as serving as a prison for many Indians. At one time old FORT GIBSON, near MUSKOGEE, was one of the principal links between East and West. Portions of it have now been restored. Fort Nichols near Mesa was established by Kit CARSON (1809-1868) to guard the Santa Fe Trail. Fort Reno was another Oklahoma historical outpost.

South Dakota: During the War of 1812, Manuel LISA (1772-1820) built Fort Manuel and after that was destroyed built another at BIG BEND. This did much to keep the region in U.S. hands during that war. A trading fort was established by Joseph la Framboise in 1817, at the mouth of the BAD RIVER. Fort Tecumseh was built in 1822 by the Columbia Fur company. This was taken over in 1821 by Pierre Choteau, taking his name as FORT PIERRE, the oldest European type settlement in the state. The fort was purchased by the government in 1855. Historic FORT MEADE has been converted to a veterans' hospital.

Texas: Short-lived Fort St. Louis was built on the banks of Lavaca Bay by LA SALLE (1643-1687) and his men in 1687. FORT WORTH was an army post in 1847, and the city grew around it. FORT BLISS, named for Colonel William Bliss, was built in 1849 and guarded the Mexican border, protecting westbound travelers and settlers. Due to flooding the fort was moved to a mesa near EL PASO. From it in 1916 General John J. PERSHING (1860-1948) set out to capture Mexican bandit Pancho Villa. Fort Bliss is still a major army center. Fort Sam Houston was begun at SAN ANTONIO in 1879, and is now Fourth Army headquarters. Fort Davis, near Alpine, stood out against the worst Apache raids and is now a National Historic Site.

Wyoming: Fort William had been estab-lished in 1834 by Sublette and Campbell and then sold to the AMERICAN FUR COMPANY. Later called St. John on the Laramie, it soon became simply FORT LARAMIE, one of the most famous outposts of the West. It became a U.S. strong-hold in 1849 and is now a national historic site. Jim BRIDGER (1804-1881) established FORT BRIDGER in 1843. The Mormons held this fort

from 1853 until 1857 but were forced out by federal troops. Some of the original buildings are still standing in a state park. FORT CASPER was named to honor Lieutenant Caspar Collins who died in the 1865 Indian fighting known as the "bloody year on the plains,." It has been restored as a pioneer museum. FORT PHIL KEARNY was one of the three forts built in rich Indian hunting grounds to protect the gold hunters on their way to Montana. Fort Kearny was the scene of one of the greatest Indian sieges, and center of nearby battles, involving as many as 2,500 Indian troops. The Indian defeat there brought an end to much of the power of Chief Red Cloud.

FOSSIL BUTTE NATIONAL MONU-MENT. An abundance of rare fish fossils, 40-65 million years old is evidence of former aquatic habitation of this now semiarid region, established October 23, 1972, headquartered KEMERER, Wyoming.

FOSSIL REMAINS. Not until about 1800 were the fossils of plants and animals recognized as being the remains of living things, and the science of paleontology was instituted to discover and study such remains. Some of the most valuable of these invaluable relics of the past have been discovered in the Central West region.

Colorado: Some of the most numerous and valuable of all U.S. fossil grounds are found in Colorado. DINOSAUR NATIONAL MONUMENT, shared with Utah, has yielded particularly fine remains of that extinct group, ranging from monsters to tiny lizard-like creatures. Many other dinosaurs have been found in COLORADO NATIONAL MONUMENT. One of the truly great prizes in the field was the vintacolotherium, a beast with six horns, found in northwestern Colorado in 1924. At PAWNEE BUTTES, prehistoric horses, huge rhinoceroses and gigantic prehistoric turtles have been found. Some of the finest fossilized plants are uncovered in Colorado's petrified forest, west of COLORADO SPRINGS, including remains of vast fern forests and fossil palms, along with trunks of other trees as large as 74 feet in circumference.

Kansas: Fine sources of fossil remains have been located in Kansas, including the largest sources of fossil crabs and other crustaceans. Another Kansas treasure was the fossil of the earliest ancestor of the horse, only about a foot high. Huge turtles, other reptiles and birds with teeth are among the many others found in various parts of the state.

Montana: One of the most complete fossil skeletons of the fierce tyranosaurus rex was found near JORDAN on Hell Creek. Nearly as complete was the triceratops found near GLENDIVE. Portions of dinosaur eggs were found near RED LODGE. The BILLINGS area produced a rare hoplitosaurus, a fifteen-foot relative of the horned toad. A fossil of the earliest known primate, relative of apes and humans, was also found in the state. Giant sequoia and other petrified trees came from the fossil beds near Baker. Fossil sources in the state include those of Hysham, Little Dry Creek, FORT PECK, EKALAKA and Harlowtown.

Nebraska: This state has chosen its official fossil—the mighty mammoth. Chief RED CLOUD (1822-1909) called fossils "stone bones," and as early as the 1850s a book had been written about the state's fossils. Today the Agate Springs Fossil Quarries continue to pour out their treasures, many housed in the Cook Museum of Natural History nearby. Devil's gulch and Hay Springs are other major sources. So many varieties of fossils have been found in Nebraska that several, such as the huge shovel-tusked mastodon, appear to have had no connection with present living creatures. Among Nebraska's other fossils are the titanotheres, like a rhinocerous, the pig-like oredonts, primitive tusked pig, donohyus, and a relative of the horse, called moropus. Giant beavers, camels, crocodile and turtle fossils are are found in the state.

New Mexico: The fossils of marine creatures found at the top of the SANDIA MOUNTAINS indicate the periods when the present land lay beneath the seas. The huge coal deposits exhibit ancient plant life. Most of the common kinds of fossils have been found in the state, especially in the northwest corner and the fossil regions near Pojoaque.

North Dakota: The BADLANDS there are rich in remains of petrified forests, including prehistoric sequoia and cypress. Many fine remains of titanothere have been taken from the White River fossil beds. Fish, reptiles and mammal fossils have been found in many other parts of the state.

Oklahoma: Some of the most numerous dinosaur fossils ever found in this country, representing at least 4,000 of the extinct animals, have been found at the quarry near ENID. Dinosaurs and other fossils have been recovered at BLACK MESA STATE PARK and in the Boise City region.

South Dakota: Some paleontologists contend that the South Dakota BADLANDS have yielded

Visitors to the headquarters of Dinosaur National Monument have a unique opportunity to view the various fossils exactly where they were found in a specially constructed pavalion erected over one of the excavation sites.

the world's most valuable fossil remains, including a tiny camel, thought to be the ancestor of all those to follow. The Badland fossils are particularly important for their remains of the Oligocene period, from 40,000,000 to 25,000,000 years past. Also important were the bones of the tiny three-toed horse, about two feet high, along with little deer and giant hogs. The Badlands digs have also yielded the rare saber toothed tiger. In the breaks of the MISSOURI and CHEYENNE rivers, enormous numbers of marine fossils have been found, including great ammonites and strange baculites, relatives of devil fish. At Fossil Cycade National Monument the largest known deposits of those fernlike plants of the mesozoic period have been discovered. Most of the known dinosaurs have been found in especially good condition in various parts of the state. Other fine fossil sources are the beds of Hell Creek and the slopes of Slim Buttes. Large quantities of petrified wood are also found in the state, the largest near LEMMON, including one claimed as the largest petrified tree ever found, dating from perhaps a hundred millions years in the past.

Texas: The strange Rockwall formation of Texas has provided many unusual fossils. As the earth went through its many periods of rising and falling levels, Texas experienced a large number of such cycles, which buried and pressed together the remains of bodies of sea creatures, shellfish, animals and plants. Over the eons these formed the petroluem, natural gas, coal and sandstone so important to the state's mineral industry. The impressions and remains of many of these prehistoric plants and animals have been left in the state, providing rich study for paleontologists.

Wyoming: One of Wyoming's most famed fossil finds was that of the "horned dinosaur" discovered at Lance Creek. The COMO BLUFFS have yielded dinosaur fossils since about 1877. Wyoming boasts some of the finest discoveries of fossil fish. RAWLINS is noted for its mammoth remains as well as the tiny four-toed horse. Near Powell are found the remains of doglike animals. MEDICINE BOW is known for its petrified forest, many of the trees of semi-tropical types. The nearby fossil cliffs have given the town of Fossil its name.

FOSSIL, Wyoming. Village. Lincoln County, southwestern Wyoming, west of Kemmerer. Fossil is named for the nearby Fossil Cliffs which have been the scene of exploration since 1890. Specimens found in the rock include six-foot long gar fish, other fish and small plants, and a thirteen-foot long alligator. Anna RICHEY, the only woman ever convicted of cattle rustling, had a ranch near Fossil. She died, believed poisoned, before serving her sentence.

FOULOIS, Benjamin Delahauf. CT, Dec. 9, 1879—Ventnor City, NJ, Apr. 25. 1967). Army officer. In 1910 at SAN ANTONIO, Texas, Foulois and one machine formed the entire United States Air Force. A Congressional appropriation of $150 was used to purchase a second-hand Wright Brothers plane on which Foulois spent $300 of his own money for repairs. While stationed in San Antonio, Foulois invented the use of wheels on planes which had previously used skids, and he developed the first seat belts. During his stay in San Antonio, Foulois' contributions earned him a lasting place as an air force pioneer, perhaps even as the "Father of the Air Force."

FOUR CORNERS REGION. Unique in the country is the point at which the corners of four states—New Mexico, Colorado, Utah and Arizona—come together. Many tales are told of the droll happenings at the Four Corners. A person standing with a right foot in New Mexico and a left foot across the border in Arizona might then lean over and place a right hand on Colorado and a left hand on Utah. That person would be simultaneously touching four states, as well as both the Central West and Far West regions. Some people lie down across the corners and claim they have slept in four states at once, while others race around the corners and insist they have traveled through four states in a matter of seconds.

FRAY CRISTOBAL MOUNTAINS. In 1683, SIERRA DE ORO (Mountain of Gold) in New Mexico's Cristobal Range was discovered and worked by the Spaniards, the first such activity in the present U.S. west of the Mississippi River. However, little gold is found in the region today.

FRAZIER, Lynn J. (Steele County, MN, Dec. 21, 1874—Hoople, ND, Jan. 11, 1947). Governor and Senator. Elected in 1917, Frazier was the first governor in the history of the United States to be removed from his office by the voting process of "recall." This occurred in 1921 amid charges of mismanagement and excessive spending during a unique experiment in which North Dakota's state government entered the fields of business and finance. However, Frazier's reputation was restored quickly as he was elected to the U.S. Senate in 1922 with the expectation that his experience in government, business and finance would be helpful to his state. His success in promoting state interests brought about his re-election in 1928 and 1934.

FREDERICKSBURG, Texas.. City (pop. 6,-412), Gillespie County, south-central Texas, northwest of SAN ANTONIO and west of AUSTIN. German settlers to the area in 1846 were brought by the Adelsverein, Society for the Protection of German Immigrants in Texas. Funds for the project failed and the immigrants were given land in an almost inaccessible region claimed by the Comanches. An epidemic killed 156 of the 600 settlers in 1847, the year the community was named after Frederick the Great of Prussia and a peace treaty was negotiated with the Indians. The rich land was soon producing abundant crops and providing grazing for sheep, goats and cattle. During the Civil War many of the residents refused to enlist in the Confederate army, and some of the men fled conscription by hiding in the hills. The isolation of the community continued until 1912 when the citizens built their own railroad connection with the San Antonio road at ARANSAS PASS. The first hard-surface road did not reach the community until 1936. The area is now a large producer of wool, cattle and mohair. Fredericksburg residents have included World War II Admiral Chester W. NIMITZ (1885-1966), whose grandfather built a house in the form of a ship, and Texas composer-conductor Frank VAN DER STUCKEN.

FREE SOIL PARTY. Political party founded in 1848 upon the principle that the slave system should not be extended into the territories recently acquired from Mexico. Organized after the MEXICAN WAR (1846) when Texas was about to become a state, the Free-Soil Party was founded by dissident members of the Democratic and Whig parties, later joined by members of the Liberty party, who held their first convention in Buffalo, New York, August 9, 1848. Represented were all the non-slave states, along with delegates from Delaware, Maryland, Virginia, and the District of Columbia. Their platform called for "Free Soil, Free

Speech, Free Labor, and Free Man," and the confinement of slavery to the slave states. Their ticket, which ran Martin Van Buren for President of the United States and Charles Francis Adams for Vice President, received a popular vote of 291,000 but no electoral votes. In 1852 candidate John P. Hale for president received a popular vote of 157,000. Although the party virtually disappeared in 1856, it formed the nucleus of the historical Republican Party.

FREE STATE PARTY. Anti-slavery faction in Kansas organized in response to the election on March 30, 1855, of pro-slavery candidates to what was then called the "BOGUS LEGISLATURE." The Free State Party refused to recognize the elected government of Kansas and set up a government of its own.

FREEPORT, Texas. Town (pop. 13,444), Brazoria County, in southeast Texas on the Gulf of Mexico. Freeport was founded in 1912 by New York businessmen hoping to cultivate the town's rich sulfur deposits. Today, Freeport's industries include petrochemical plants, marine repairs, and shrimp processing. The annual sand castle and Sand Sculpture Contest is a popular event, and the Great Mosquito Festival attracts crowds.

FREMONT'S PRIMROSE. Wildflower with blossoms almost two inches in diameter, native to Nebraska.

FREMONT, John Charles (The Pathfinder). (Savannah, GA, Jan. 21, 1813—New York City, NY, July 13, 1890). Surveyor, military and political leader. Noted for opening and exploring California, Fremont began his career as a lieutenant of topography for the army corps of engineers (1838-1841) under Jean Nicollet. He never lived in the Central West, but his expeditions and explorations across many states in the region helped to bring the area to public attention. He helped Joseph Nicollet map the MISSOURI RIVER region (1838-1839), where he practiced his cartography, traced water levels and achieved other scientific firsts as the party crossed South and North Dakota and Montana. In 1839 in North Dakota he named Lake Jessie in honor of Jessie Benton, his fiance, daughter of Senator Thomas Hart Benton, whom he married in 1842. That year he began mapping for the war department on expeditions which carried him from the Mississippi River to the Pacific. In Colorado in 1842 he led the first of his explorations into the

mountain region. He also declared the Royal Gorge impassable. In Nebraska he made a more cogent observation, "The names given by the Indians are always remarkably appropriate, and cerainly none was ever more so than that which they have given to this stream the Platte—the Nebraska, or Shallow River!" He also discovered the Nebraska flower named FREMONT'S PRIMROSE in his honor. In Wyoming in 1843, his party was attacked by 70 Arapaho and Cheyenne, who were beaten off and later appologized for mistaking them for another Indian party. Much of the original glamor attached to Fremont's name has worn off, and the importance of his discoveries has been questioned. Authorities now consider his principal accomplishment was in focusing wide public interest on the entire western region, over which he had traveled so widely. His later life and career were only marginally related to the Central West. Briefly, however, he accumulated a large fortune in California, became one of that state's first U.S. Senators, was nominated for president by the Republicans in 1856, held two commands during the CIVIL WAR, lost most of his fortune in railroad ventures, became territorial governor of Arizona in 1883 and retired to California where he lived on the pension of a retired major general. His *Memories of My Life* appeared in 1887.

FREMONT, Nebraska. City (pop. 23,979). Seat of Dodge County, east-central Nebraska, on the Platte River, northwest of OMAHA and east of COLUMBUS. Named for General John C. FREMONT (1830-1890), Fremont was established in 1856 by Pinney, Barnard and Company, which offered free timber for shelters, free land, and one year's supply of firewood. Crop failures for three consecutive years reduced the price of lots in town to seventy-five cents until the westward movement of settlers brought a stagecoach depot and later a stop for the Union Pacific Railroad, which led to greater prosperity. Today it is the center of a grain-growing, grazing and dairying area. A collegiate atmosphere is provided by MIDLAND LUTHERAN COLLEGE.

FRIENDS UNIVERSITY. Private, liberal arts college in WICHITA, Kansas. The institution was founded as a Christian college by the Kansas Yearly Meeting of Friends. Bible courses are required. During the 1985-1986 academic year the university enrolled 813 students and employed 57 faculty members.

FRIO RIVER. Texas waterway rising in the Edwards Plateau, running 160 miles southeast to form Choke Canyon Reservoir before it meets the NUECES RIVER. Its name is Spanish for "cold."

FRONT RANGE. Rocky Mountain range running across Colorado from north to south in "front," that is to the east, of the rest of the Rockies. The range rises abruptly from the plains in front of DENVER, forming a magnificent backdrop for Denver and the other cities just to the east. The highest point is Grays Peak at 14,270 feet.

FRONTIER DAYS. Full week of celebration held annually during the last week of July in CHEYENNE, Wyoming. Considered the world's oldest and largest professional rodeo, it now features many related events. Frontier Days attracts approximately 300,000 visitors who consume an estimated 100,000 pancakes made with the help of a cement mixer which is used to stir the batter. In addition to the rodeo, scheduled events include, chuckwagon races and a parade, which showcases a one-of-a-kind collection of horse-drawn vehicles, including conestoga wagons and stagecoaches. Big-name performers provide entertainment at night.

FRYING PAN-ARKANSAS RECLAMATION PROJECT. One of several gigantic projects in Colorado, designed to make the most efficient use of scarce water of the area.

FUNSTON, Frederick. (New Carlisle, OH, Nov. 9, 1865—Iola, KS, Feb. 19, 1917). Army officer. Raised on a farm in Kansas and educated at the University of KANSAS, Funston received the Medal of Honor for his leadership of United States troops in the Philippines in 1899 where he later led forces which captured Aguinaldo, the insurgent leader. Returning to the United States, Funston commanded the Departments of the Colorado, the Columbia, the Lake, and California. His handling of the disaster of the 1906 San Francisco earthquake and fire further enhanced his national reputation. He commanded an expedition to Vera Cruz in 1914 and was the military governor of the city until November, 1914. He served as the commander of United States forces along the Mexican border in 1916 and was active in the pursuit of Pancho VILLA (1878-1923). Had his death not intervened, it is thought he might have been selected to lead United States forces in World War I.

FUR TRADING. French traders known as *voyageurs* traveled the lonely waters of the Central West probably for generations before there were any records of their wanderings. They carried blankets utensils and other goods to trade for the valuable furs. For at least a century after the fur trade was well organized farther east and north, especially by the HUDSON'S BAY COMPANY (actual trading posts had not been established in the region). Then in 1794 Jean Baptiste Trudeau gave up school teaching to establish a trading company, Pawnee House, in present Charles Mix County, South Dakota. Registre Loisel established a trading post on an island above the Big Bend of the MISSOURI RIVER in 1796. The first fur trading post in present North Dakota was set up near modern PEMBINA by Charles Chaboillez in 1797.

The LEWIS AND CLARK party were visited by several French traders from the north while they wintered at MANDAN, North Dakota in 1804. The success of their expedition prompted a rush of traders from St. Louis as well as from the north and east, and the establishment of a rash of trading companies. Trader Manuel LISA (1772-1820) was active in South Dakota during the War of 1812.

Soon competition for furs became fierce. The great Hudson's Bay Company was reaching down from its northern headquarters. The NORTH WEST COMPANY was its biggest competitor. The easterner John Jacob Astor sent agents of his AMERICAN FUR COMPANY; there were the Missouri Fur Company and Northwestern Fur Company as well as other smaller groups. In 1828 Astor established FORT UNION at the Missouri River in present North Dakota, just east of the present boundary of Montana. This became the most important outpost in the whole central northwest and remained so for about 40 years.

The first trading post in Montana had been built even earlier by Manuel Lisa at the mouth of the BIG HORN RIVER on the YELLOWSTONE RIVER. As the regions to the east became over-trapped and furs diminished, the tentacles of the trading companies spread farther into the west.

The trappers knew every inch of the dangerous ground—the rivers, the mountains, the landmarks—but they kept no records, so all of their discoveries had to be rediscovered at later times. Their life was lonely, hard, precarious. Some estimates indicated that three out of every five trappers lost their lives at an early age, mostly by Indian attack, others by weather or accident.

General William H. ASHLEY (1778?-1838) de-

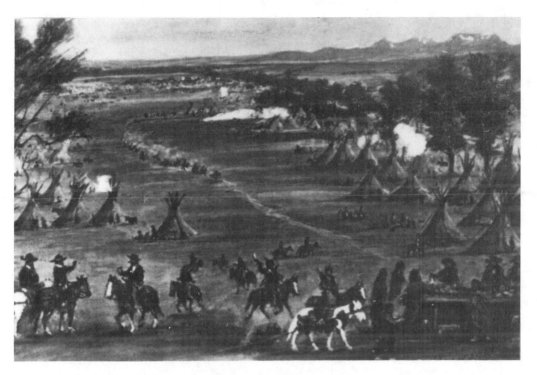

The annual fur traders' rendezvous were enormously important to the development of the region. An artist on the scene recreated some of the spectacle of the rendezvous of 1824.

cided to make a departure from the practice of setting up fur trading posts like those of the other trading companies. Instead, he hit on the idea of great annual meetings, welcoming all trappers, traders, Indians and any others who had business with him. The first small meeting was held in 1824 on the GREEN RIVER in Wyoming, conducted by Thomas Fitzpatric, Ashley's assistant. The meetings came to be called Fur RENDEZVOUS and were held each year until 1840. Probably no more interesting business conventions were ever held—with the makeshift shelters of the whites close to the tepees of the Indians, housing men, women and children, along with their dogs, and countless horses tied outside. Various trading companies came to compete for the services of the best traders and trappers. As many as 1,500 total would attend, and there were contests, games, fights and almost constant brawling.

The first white women to visit a Rendezvous arrived at the one in 1836, the wives of the missionaries Marcus Whitman and Henry H. Spalding. Naturally, they were uproariously welcomed by the white attendees, and the Indians thought it remarkable that such pale

creatures could have survived such arduous travels. They provided a great feast, serving the fattest dogs.

The first authentic trading post in Wyoming was established near the forks of the POWDER RIVER by Antonio Mateo in 1828. Here, as in many of the other posts, the beaver skins were compressed into bales in a baler.

In 1832 the firm of BENT AND ST. VRAIN set up a trading post on the ARKANSAS RIVER near present LA JUNTA, Colorado. Sturdy BENT'S FORT was for years the most important outpost for the whole south central trading area. Indians brought their valuable furs, and mountain men and trappers used it as their supply center.

While furs were important in the southern part of the Central West region, the beaver was not plentiful, nor were most of the other fur bearers. By the mid 1830s, while trapping and trading were about at their peak, it had already become apparent that the supply of animals could not last very much longer, at least in the region. As settlers came in and "civilization" followed, the haunts of the animals were disturbed and over-trapping had brought some to near extinction.

More people and more travelers brought new kinds of business to many of what had been remote outposts, and as the fur business faltered the trading posts became the nucleus of many sometimes prosperous communities. With the fall of the fur hat from favor in Europe and the American East, the demand for beaver fur fell off at a fortunate time when there still were enough beavers left to permit the skilled and wily animals to make a comeback, and many can be seen in their old haunts today, where they once were trapped without mercy.

G

GADSDEN PURCHASE. Acquisition by the United States from Mexico of 45,535 square miles of land, south of the GILA RIVER in southern New Mexico and Arizona. In addition to the value of the large "real estate" acquisition, the purchase gave the United States the best route for a railroad across the southern ROCKY MOUNTAINS to the Pacific Coast. It also finally established the border between the U.S. and Mexico in the area. The boundary had never been exactly defined at the end of the MEXICAN WAR of 1846. In 1853 railroad magnate James Gadsden was sent to Mexico and instructed to negotiate for the large area in question. He came back with a proposal to pay Mexico $15,000,000, but the U.S. Senate would not accept that figure. When a purchase was ratified by the Senate in June, 1854, the price had dropped to $10,000,000, and the territory obtained was reduced by about 30,000 miles. The payment of $10,000,000 to Mexico has been called "conscience money" for the provinces the United States obtained through the Treaty of GUADALUPE-HIDALGO after that war.

GAIL, Texas. Village. Borden County, north-central Texas, southeast of Lubbock and north of Big Spring. Gail was named for Gail BORDEN (1801-1874), founder of the Borden company and inventor of condensed milk. The walls of the Gail courthouse have for years shown the bullet holes of years gone by, when jubilant cowboys celebrated legal victories. Cattlemen once kept settlers from filing claims to land by having cowboys forcibly remove farmers from the lines of people waiting at the courthouse.

GAINESVILLE, Texas. Town (pop. 14,081), seat of Cooke County, in northeastern Texas, settled in the 1850s. The community grew on the BUTTERFIELD STAGE route and as a way station on the CHISHOLM TRAIL and was named for Seminole War commander, Edmund P. Gaines. Gainesville continued to expand as a prosperous cattle and cotton farming area. Oilfield supplies, paint, foodstuffs, clothing, and artificial lures are among its current manufactures. It is, perhaps, best known for its annual snake hunt in the second week of April.

GALENA, Kansas. Town (pop. 3,587), Cherokee County, southeastern Kansas, west of JOPLIN, Missouri. Galena is the center of lead and zinc mining in Kansas and has one of the world's largest smelters. The community was named for Galena, Illinois, and in turn for the mineral galena, a kind of lead.

GALLATIN RIVER. One of the three rivers which join to form the MISSOURI RIVER. The Gallatin, named by Meriweather LEWIS (1774-1809) of the LEWIS AND CLARK EXPEDITION, rises in the northwest corner of Wyoming and flows north into Montana to meet with the MADISON and JEFFERSON rivers. A canyon formed by the Gallatin provides one of the entrances to YELLOWSTONE NATIONAL PARK.

GALLUP, New Mexico. City (pop. 18,167). Seat of McKinley County, near the western border with Arizona, in north-central New Mexico. It was named for railroad workers' paymaster, David L. Gallup, and the name developed from the workers' habit of saying "going to Gallup's to collect wages." Until the ATCHISON, TOPEKA AND SANTA FE RAILROAD pushed into the region in 1881 to develop the coal deposits, Gallup was only a stagecoach stop called Blue Goose. The railroad and mining opportunities attracted people from all over the

world, who gave the city a cosmopolitan flavor. Today that heritage is enhanced by the presence of the Navajo in their principal trading center. Navajo rug auctions are held in Crownpoint, near Gallup, every six weeks. Nearby attractions include the impressive Red Rock State Park and Museum with its Hopi, Navajo and Zuni artifacts. Gallup is the site of the annual four day Inter-Tribal Indian Ceremonial, the largest Indian celebration in the United States, usually attracting more than 50 tribes.

GALVESTON BAY. An inlet of the Gulf of Mexico in southeastern Texas. Galveston Bay serves as the key water connection from Galveston to Houston, continued by the Houston Ship Channel. The Spanish were known to have explored the bay by the early 16th century, but major exploration of the area as a port of entry did not come until the 18th century. Pirates, including those under Jean LAFFITE (1780?-1825?), are known to have frequented the region. In 1896 the port was expanded to accept larger vessels by construction of a $3 million jetty system. Today it is a major shrimping and fishing area.

GALVESTON ISLAND. Thirty mile long strip of land used by the pirate Jean LAFFITE (1780?-1825?) as a rendezvous between 1817 and 1821. The island became an American naval base during the Texas revolt from Mexico in 1835 and was later a temporary capital of the republic. GALVESTON, Texas, is located on the eastern end of the island which is connected to the mainland by a bridge and causeway.

GALVESTON, Texas. City (pop. 61,902), seat of Galveston County, located at the northeast end of GALVESTON ISLAND, which extends 32 miles along the Gulf of Mexico in Southeast Texas. The island is known to have been visited by Cabeza DE VACA in 1528. Don Luis Aury arrived in 1816 with fifteen ships to claim the island for Mexico. He built a fort and set up an administration. Pirate Jean LAFITTE (1780?-1825?) presided regally over Galveston from 1817 until 1821, ruling from his fortress-house Maison Rouge. The city was settled in the 1830s and named for Don Bernardo de Galvez, viceroy of Mexico.

The city's commercial power was challenged in the late 1800s by competition from other ports and severely damaged by the HURRICANE of 1900, which killed over 5,000. However, the city recovered quickly. As protection a 17-foot, 8-mile long retaining seawall was built. As a result, when the worst hurricane in Texas history hit there in 1961, that barrier did much to prevent damage and kept the death toll under 50.

Known today as a resort and shipping center, Texas' leading cotton port, Galveston's industries include oil, insurance, banking and education. It is the home of the University of Texas School of Medicine. TEXAS A AND M UNIVERSITY operates a marine-oriented branch at Galveston. The Strand National Historical Landmark District preserves the handsome homes of the mid-1800s. The Railroad Museum is housed in the restored Santa Fe Railroad Union Station. At the port, the sailing ship *Elisa* is a famed representative of her type. The Battle of Galveston is recreated every January, and Galveston Island Shrimp Festival is held in mid-April. Christmas is celebrated with Dickens on the Strand, a recreation of a street in Dickens' London, with characters representing the period.

GANNETT PEAK. Highest point in Wyoming. Gannett Peak, 13,804 feet high, is located in Fremont County in central Wyoming in the WIND RIVER RANGE.

GARDEN CITY, Kansas. City (pop. 18,256). Seat of Finney County, southwestern Kansas, northwest of DODGE CITY and northeast of LIBERAL. The area surrounding Garden City is one of the state's most extensively irrigated regions. A major site of cattle raising and shipping, the region also produces annual bumper crops of alfalfa and corn. The world's largest factory for the production of carbon black is located at Garden City and has been a principal Garden City employer. The historic Windsor Hotel, known as the "Waldorf of the Prairies," has hosted many celebrities. Beef Empire Days in early June with a western art show, cattle shows and contests is an annual event.

GARDEN OF THE GODS. Spectacular 940-acre natural park containing massive formations of red sandstone, near COLORADO SPRINGS, Colorado. Especially photogenic at sunrise and sunset when the color of the stone is accentuated, the park features an Easter sunrise service held east of the Gateway Rocks. The area now is a National Landmark, including such features as the Kissing Camels and Balanced Rock.

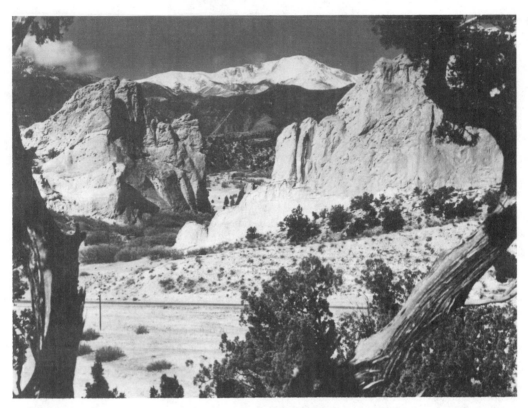

Two of the country's best known natural wonders are provided in this dramatic glimpse of the entrance to the Garden of the Gods, with Pikes Peak looming in the background.

GARDINER, Montana. Town (pop. 600), Park County, southwestern Montana, southeast of BOZEMAN. It was founded in 1883 as the original entrance to YELLOWSTONE NATIONAL PARK. It provided the only railroad gateway to the park, and its economy has been based on tourism ever since. Roosevelt arch, at the southern edge of Gardiner, today stands as a stark reminder of a glorious past. In 1903 President Theodore ROOSEVELT (1858-1919) came to Gardiner to lay the cornerstone of the Roosevelt arch, a fifty foot high and thirty foot wide span at the park entrance. Famous Seattle, Washington, architect Robert C. Reamer designed the nearby Northern Pacific Railroad station, a striking combination of beamed ceilings, rustic logs, and massive stone fireplaces. At the height of the railroad age fleets of park buses and automobiles replaced rows of stagecoaches, which once met the trains and then carried visitors to the splendors of the park. Today, the decline of the railroad has left Gardiner with a splendid arch through which a narrow highway quickly speeds tourists to larger towns. The annual Winter Camera Safari provides a free tour of Yellowstone Park.

GARLAND, Hamlin. (West Salem, WI, Sept. 14, 1860—Hollywood, CA, Mar. 4, 1940). Pulitzer-Prize-winning novelist, for *Daughter of the Middle Border* (1921). Garland, author of *Main Traveled Roads* (1891) and *A Son of the Middle Border* (1917), spent much of his youth in Ordway, South Dakota and began his writing career there. His novels reflect the experiences he gained among the people of the ABERDEEN region. *Prairie Folks* (1893) portrayed Garland's view of the despair and ugliness of western life.

GARLAND, Texas. City (pop. 138,857), Dallas County, in northeast central Texas, named for Augustus H. Garland. Garland is an industrial center with manufactures including scientific instruments, electrical equipment, and chemicals. The strong agricultural base in the nearby blacklands flourished with irrigation beginning in the 1950s. The city was founded

(1887) when Embree and Duck Creek, two rival railroad station communities, were amalgamated by an act of Congress.

GARNER STATE PARK. Named in honor of John Nance GARNER, Vice President of the United States from 1933 to 1941, the 478-acre park near Sabinal, Texas, is located on the west bank of the FRIO RIVER. The park features a 75 foot deep natural cave.

GARNER, James. (Norman, OK, Apr. 7, 1928—). Leading man in television and movies. Garner is best remembered for his starring role in the long-running television series *Maverick*, from 1957 to 1961. He had a short-lived series in 1971 called *Nichols* and then returned for the very popular *Rockford Files*. Garner's movie roles include *The Americanization of Emily*, (1964), *Support Your Local Sheriff*, (1969), and *The Skin Game* (1971).

GARNER, John Nance "Cactus Jack." (Red River County, TX, Nov. 22, 1869—Uvalde, TX, Nov. 7, 1967). Vice President (1933-1941) under F.D. Roosevelt. Admitted to the Texas bar in 1890, Garner served two terms in the state legislature (1898-1902) before being elected to the U.S. House of Representatives, where he remained for 30 years (1903-1933). He supported the graduated income tax and the Federal Reserve system. In 1917, he was called one of the most influential politicians in Congress. He was named Speaker of the House in 1931, after serving as Democratic whip and floor leader. Garner was a candidate for the presidency at the 1932 Democratic National Convention but released his delegates to ensure Roosevelt's nomination, and became Vice President. He retired to his Texas ranch after finishing his second term as Roosevelt's Vice President. The UVALDE home of Garner is now a memorial museum.

GARNETT, Kansas. Town (pop. 3,310). Seat of Anderson County, east-central Kansas, northwest of FORT SCOTT and southeat of EMPORIA, named for founder William Garnett. Senator Arthur CAPPER, born in Garnett, was the first native Kansan to be elected governor.

GARRISON, North Dakota. Town (pop. 1,-830), McLean County, central North Dakota, northwest of BISMARCK and southwest of MINOT. Bartholomew Berthold established his trading post known as Fort Berthold in 1845 near present-day Garrison. Garrison is a major

recreational area due to its location near man-made Lake SAKAKAWEA. "Wally Walleye," a huge replica of a walleyed pike, is a favorite symbol of the area. The Governor's Walleye Cup Derby is annually held on the third weekend of July at Fort Stevenson State Park.

GARZA-LITTLE ELM RESERVOIR. Man made lake situated northwest of DALLAS, in Denton County, in central Texas. Created by the construction of a dam to impound the TRINITY RIVER, it provides Dallas with much of its water supply and serves as a recreation area.

GATES, John Warne (Bet-a-Million). (Turner Junction (now West Chicago), IL, 1855—1911). Businessman. Gates took his experience from a small hardware store in Illinois to Texas on his way to becoming a salesman of barbed wire. To demonstrate the strength of his product, Gates set up a wire fence in the city plaza of SAN ANTONIO to prove the wire would hold the toughest cattle. Gates amassed a large business and established several wire companies which bought out their competition. His last venture eventually became part of the U.S. Steel Corporation. Gates accumulated large holdings in railroad and industrial stock. He was associated in Texas with Arthur Edward Stillwell in building PORT ARTHUR.

GEMS. The Central West region produces a large percentage of the country's semi-precious stones. Wyoming and Montana are among the leaders in this field. Most communities have their rockhound clubs, and rockhounds from around the world converge on the leading gem tracts. Among others, Wyoming is noted for its alabaster, onyx, agate, petrified wood, quartz, chalcedony, jade (the official state stone), rhodonite, garnet, sapphire, malachite, gastrolith, azurite, ruby and bloodstone.

Although perhaps not so numerous as to type of stones, Montana makes up for variety by value. More gem sapphires (the state gem) are discovered in Montana than in any other state. The very rare finds include the occasional diamond, in such locations as Grasshopper Creek in Beaverhead County, Greenhorn Gulch in Madison County and (rarely) in Deer Lodge County. The unusual cornflower blue sapphires of Yogo Gulch are also greatly prized. Quality sapphires in red, aquamarine and green may be found with careful searching. Other Montana gems include amazonstones, garnets, white topaz, jasper and amethyst. Corundum of gem

quality is found near Norris, and rubies are mined commercially in the state.

The turquoise of New Mexico is world-renowned, providing the Indian masters with prime stones for their jewelry craft. Rockhounds delight in such other unusual New Mexican gems as Apache tears, actinolite, peacock copper, tourmaline, staurolite, olivine crystals, fossil resin and alabaster.

North Dakota provides many of the gems already mentioned, along with scoria, the handsome milky blue opal, agates and moss agates of wide variety. Toredo petrified wood is the state rock of North Dakota, prized rose quartz the state gem of South Dakota and topaz the state gem of Texas, and many others are found there, as well.

Oklahoma chose barite rose (rose rock) for its state gem symbol. Nebraska's official gem is the blue agate.

GEODETIC CENTER OF THE U.S. Point eighteen miles southeast of Osborne, Kansas, from which all measurements of latitude and longitude in the conterminous 48 states are determined. This point has been accepted by the other countries of North America, making this the geodetic center of the continent.

GEOGRAPHIC CENTER, North America. North Dakota is almost equally distant from the Pacific and Atlantic coasts from east to west and from the Arctic Ocean and the Gulf of Mexico, north to south. Logically, the geographic center of the continent is found in North Dakota, about half a mile from Rugby. Located by the U.S. Geological Survey, the site is marked by the Center Monument on a long twisting ridge of hills.

GEOGRAPHY OF THE CENTRAL WEST. A diagonal drawn on a map of the Central West region from its far northeast corner of North Dakota to the far southwest tip of New Mexico roughly bisects the region, leaving about half of its vast area to the southeast and half to the northwest. The six states on the east, from North Dakota through the southern tip of Texas total 639,432 square miles, those to the west 471,222. Total area of the region is 1,110,-654 square miles.

The region embraces the second, fourth and fifth largest states of the nation—Texas, Montana and New Mexico.

Along the eastern boundary, the altitude ranges from sea level at the Gulf of Mexico to only about 600 feet above sea level in the region's northeast. To the west, very close to the western border of the region, the nation reaches its highest average elevations along the crest of the ROCKY MOUNTAINS, where the CONTINENTAL DIVIDE mostly follows the crests to send the waters flowing both east to the Atlantic and West to the Pacific.

Those waters flow into five of the nation's major river systems, beginning with the waters of the SNAKE RIVER-Columbia River system to the northwest, the waters of the COLORADO to the Gulf of California, the waters of the RED RIVER OF THE NORTH to Hudson Bay, the waters of the RIO GRANDE to the Gulf of Mexico and the waters of the MISSOURI to the same gulf, by way of the Mississippi delta, not too many miles away.

The latter two and their tributaries encompass most of the territory of the region, from north to south and from east to west. In Montana the exception is the region to the west of the Continental Divide, flowing to the Snake-Columbia. Other exceptions include the corner of southwest Wyoming, the northwest and small part of the west of Colorado and the small western portion of New Mexico, all of which empty into the Colorado River.

The only sizable tributary of the Red River of the North in the region is the SHEYENNE. Major tributaries of the Missouri in the northern part of the region include the JAMES, CHEYENNE, LITTLE MISSOURI and YELLOWSTONE, the vast PLATTE system and the KANSAS RIVER toward the south. Flowing directly to the Mississippi but originating in the Central West are the mighty ARKANSAS and RED rivers. The GREEN RIVER, originating in Wyoming, is the major tributary of the Colorado. The PECOS is the longest tributary of the Rio Grande.

Texas is the only state of the region to send its rivers directly to the Gulf of Mexico. These include another COLORADO, the BRAZOS, TRINITY, NECHES and SABINE.

The latter forms part of the Texas border with Louisiana. Regarding other borders, the Missouri separates Iowa from Nebraska and the state of Missouri from parts of Nebraska and Kansas. The BIG SIOUX forms the border of Iowa with South Dakota. The MINNESOTA RIVER makes up a tiny part of the border between Minnesota and North Dakota, and the Red river of the North provides the border between Minnesota, the northeast corner of South Dakota and all of North Dakota's eastern boundary with Minnesota.

The only river boundary of the Central West region on the west is so tiny on U.S. maps as to go almost unnoticed. This is the small part of

Topographic Areas

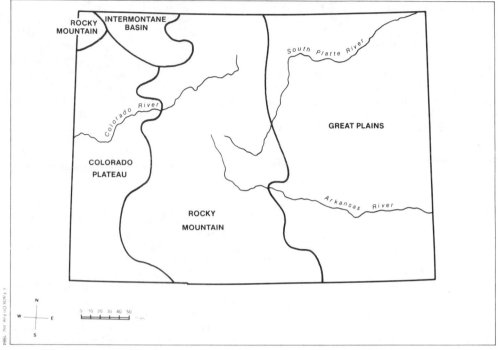

Among the many useful tools in the geography of the region are such maps as this showing the topographic regions of Colorado.

the Rio Grand which separates Texas from New Mexico.

The western boundary states separated by manmade borders are Arizona, Utah and parts of Idaho. The rest of the Idaho-Montana border follows the crest of the Great Divide and the ranges of the Rockies.

Beginning with the Texas gulf coast, the land of the Central West rises gradually from the COASTAL PLAINS through the rich DISSECTED TILL PLAINS, the GREAT PLAINS, the HIGH PLAINS and then abruptly into the Mountain region.

The climate of the far north and central north is subject to low winter temperatures, high winds, blizzards and high summer readings, with quick variations from high to low and low to high. These rapid variations depend most often on warm winds called CHINOOK. Some of these extremes reach as far south as northern Texas. Then the influence of the Gulf of Mexico begins to provide moderation until in the far south much of Texas southern border has warm to mild winters, with the BROWNSVILLE area and PADRE ISLAND being favorite wintering spots.

GEOLOGY. Geologists know little about the region prior to the early Cambrian period,

during which time much of it fell within the lower reaches of the great Canadian shield, with a small mountain range in northeast South Dakota, a small range in southeast Colorado and three parallel diagonal ranges across New Mexico. Ordovician times found most of the region under shallow seas, except for the enlargement of the New Mexican ranges, then extending into the Texas Panhandle. Much of Texas lay in the Ouachita Trough, with the massive Llanoria Range paralleling the present Texas Gulf Coast.

The Llanoria Range continued to dominate its area during the Silurian period. At that time parallel ranges extended from east to west across much of the region. Remnants of the former New Mexico-Texas Panhandle ranges remained, but central Texas was cut by the comparatively deep Marathan Trough.

The Devonian period found much of eastern portion of the region in the Mid-Continent High, while the western section was cut across by extensions of the Cordilleran Trough. During the Carboniferous Period, that trough increased greatly, and, along with the Ouachita Trough, covered a large portion of the region. During the Permian period, most of the

region was overwhelmed by the Guadaloupe Sea, from which only small ranges were raised. The most massive ranges of the period were the Marathon Mountains, along the Texas Gulf coast.

The Mesozoic Era witnessed the extension of the shallow sea until most of the region was covered during the Cretaceous period. By the Tertiary period of the Cenozoic Era, much of the present outline of land had been established in the region, to be followed by the enormous uplift of the Rockies and other less major changes.

The Quaternary or Ice Age found the southernmost reaches of the great glaciers extending through much of present North and South Dakota into northeast Nebraska, with a fringe from Canada invading the Montana border.

The entire south and east portion of Texas is today composed of sedimentary rocks of the Cenozoic period and this area is now known as the East Texas Plains. North central Texas, most of Oklahoma, the eastern half of Kansas and a small southeast corner of Nebraska are late Paleozoic. The eastern halves of Nebraska and North Dakota are Mesozoic in nature, along with most of South Dakota, where the ancient Black Hills intrude their mostly cenozoic formations. New Mexico, Colorado and Utah are extremely mixed in the periods of their geologic formations, with much of the higher elevations precambrian or volcanic, and the latter generally cenozoic. From east to west, Montana extends about equally through stages of Cenozoic, Mesozoic and Precambrian formations.

GEORGETOWN, Colorado. Town (pop. 830), seat of Clear Creek County, central Colorado, west of DENVER and northeast of Eagle, named for George Griffith, a local official. Georgetown enjoyed a celebrity status between 1880 and 1890 as the home of the Hotel de Paris, the most celebrated hotel of the period west of the Mississippi River. Dr. James E. Russell of Teachers College of Columbia University developed the idea for domestic science courses after observing the hotel operator, Louis du Puy, in his cooking and housekeeping methods. Between 1864 and 1878 Georgetown was at the center of Colorado's silver mining district. Georgetown was nicknamed the "Silver Queen" and became the third largest city in the state. Unlike many other mining towns which perished in fires, Georgetown continues to maintain approximately two hundred of its original buildings.

GERING, Nebraska. City (pop. 7,760). Seat of Scotts Bluff County, western Nebraska, southeast of SCOTTSBLUFF and southwest of ALLIANCE, named for local businessman Martin Gering. Chimney Rock, standing 350 feet high near Gering, was a landmark for early pioneers migrating to Oregon and gold seekers journeying to California as they moved down the Gering Valley by way of Roubidoux Pass. Gering annually celebrates the stop made on July 17, 1830, by the Sublette Expedition, the first group of wagons across the prairie to the Rocky Mountains. Massive SCOTTS BLUFF NATIONAL MONUMENT is another significant marker on the trail.

GERONIMO. (Arizona, June, 1829—Fort Sill, OK, Feb. 17, 1909). Apache leader. Geronimo was the last American Indian to surrender formally to the United States. Known as Goyakla, or "One Who Yawns," by the Apache, Geronimo grew to adulthood at a time of continuously increasing hostility between whites and Indians, but he continued to keep the peace. However, his first wife, their children and his mother were killed in a raid from Mexico, and despite a later marriage Geronimo never forgot or forgave. Leading many raids on communities and travelers, he became one of the most vigorous leaders of the Apache groups which opposed white encroachment on both sides of the border. In April, 1877, federal forces finally caught up with Geronimo, and he was arrested at OJO CALIENTE, New Mexico, and taken to San Carlos, Arizona, where he remained until 1881 when he broke out of the reservation with other Apaches and began terrorizing the Southwest. He surrendered to General George CROOK (1829-1890) in 1883, but did not give himself up until 1884. He again escaped the reservation in May, 1885, and again surrendered to Crook in 1886. He escaped once again, but surrendered on September 3, 1886, to General Nelson MILES. Geronimo was sent to exile and prison in Florida where he earned money by selling autographed pictures and bows and arrows. Returned to Fort Sill, he took up farming and finally adopted Christianity. He enjoyed his status as a major attraction at such events as the 1898 TRANS-MISSISSIPPI AND INTERNATIONAL EXPOSITION at OMAHA, Nebraska, the Louisiana Purchase Exposition at St. Louis in 1804 and in Theodore ROOSEVELT's inaugural procession in 1905. At the time of his death he was listed on the federal payroll as an army scout.

Part of the "romance" of the region may be found in the many ghost towns, spooky reminders of once thriving mining communities, such as Elk Horn, with the remains of its no longer "Grand Hotel."

GEYSERS. One of a variety of thermal features present in Wyoming and Montana and other areas. Of the ten thousand thermal features found just in YELLOWSTONE NATIONAL PARK, only three percent are geysers. Most geysers are small and simply sputter and splash rarely reaching a height of ten feet. In Yellowstone there are only six geysers which erupt one hundred feet or higher on a predictable basis. In areas of geysers, the earth's crust is often less than forty miles thick in comparison to its normal depth of ninety miles under most land areas. The zone between molten rock and the crust heats water that seeps down from the surface. The water temperature rises to above surface boiling point, but it does not boil because of the tremendous pressure of the earth around it. As the super-heated water works its way upwards, the pressure on it is lessened. The water is trapped before it reaches the surface and cools. Near the surface the pressure is suddenly released and boiling explosions occur forming steam. Geysers vary in volume of eruption, length and frequency. Geyserite cones form around the necks of some geysers, while others lie below a pool of water. A geyser must have a nearly vertical underground tube connecting with porous rock or side chambers where water can be collected. If the underground network is twisted, the water can cool and will flow out as a hot spring. In fumaroles only the steam reaches the surface causing a hissing sound.

GHOST TOWNS. Abandoned or nearly abandoned towns. Throughout the American West these generally traced their origin to the boom periods of mining. Many, situated in dry areas, have been well enough preserved to be used as movie sets. Miners, desiring to make the most money with the least effort, often abandoned towns when word came of a placer strike in another location that offered easier methods of mining than digging shafts or using sluice boxes, procedures which required more advanced training than most of the men possessed. Generally, however, towns were abandoned when the original reason for their prosperity dwindled—with the diminished supplies of minerals or after being bypassed by a railroad. Western ghost towns have a strong attraction for visitors, and many of them have been restored as examples of early commnities. Ranking among the most interesting and popular of the ghost towns of the Central West are ELKHORN, VIRGINIA CITY and GRANITE, Montana, St. Elmo, Colorado, Tyrone, New Mexico, and Burning Bush, Texas.

GIANT SPRINGS. Said locally to be the world's largest spring. Located near GREAT FALLS, Montana, Giant Springs' daily flow of 388,800,000 gallons of water is actually less than half that of Big Springs in Missouri. The crystal clear waters of Giant Springs enter the MISSOURI RIVER and dramatically clear the legendary muddy waters of that river for a long distance.

GIBBON'S PASS. On the border between Montana and Idaho, now crossed by US Highway 93 over the CONTINENTAL DIVIDE. It lies fifty miles north of present-day Salmon, Idaho. After the party of LEWIS AND CLARK divided for a time on their homeward journey, Gibbon's Pass was discovered by Meriwether LEWIS and used for his eastward crossing of the Continental Divide.

GILA CLIFF DWELLINGS NATIONAL MONUMENT. These well-preserved cliff dwellings in natural cavities on the face of an

overhanging cliff were inhabited from about AD 1290 to early 1300s. Proclaimed November 16, 1907, headquartered Silver City, New Mexico.

GILA MONSTERS. A poisonous lizard found in the American Southwest. With an average length of 19 inches the sluggish and slow-moving animal is covered with irregularly shaped orange markings on its black body. When it bites it holds on as tenaciously as a dog. Its poison, transmitted to victims through grooves in its teeth, is not very dangerous to humans.

GILA RIVER. Rising in the Elk Mountains of western New Mexico, the Gila courses for 630 miles to become one of the most important rivers in the Southwest. Flowing southwest from its source through a canyon where four preserved cliff dwellings are now a part of the GILA CLIFF DWELLING NATIONAL MONUMENT, Catron County, New Mexico. At the New Mexican town of Virden, the river crosses the Arizona border, leaving the Central West, eventually to enter the Colorado River south of the Laguna Dam. The Gila is one of the most important irrigation sources in its vast area. The Gila River region is the principal habitat of the large and poisonous lizard, the GILA MONSTER.

GILCREASE, Thomas. (Robeline, LA, Feb. 8, 1890—Tulsa, OK, May 6, 1962). Businessman. Gilcrease made fortunes in ranching, banking and oil. He founded the Gilcrease Oil Company in 1922 and the Thomas Gilcrease Foundation in 1942. Gilcrease established the THOMAS GILCREASE INSTITUTE OF AMERICAN HISTORY AND ART in TULSA. The Institute houses an extraordinary collection of frontier art, sculpture and painting including outstanding works of Frederic REMINGTON (1861-1909).

GILCREST, Colorado. Town (pop. 1,025), Weld County, north-central Colorado, northeast of Denver and southwest of Greeley. FORT ST. VRAIN, the third most important in the Rocky Mountains, was built near present-day Gilcrest in 1838. As a flourishing outpost, Fort St. Vrain was surpassed only by BENT'S FORT in Colorado and FORT LARAMIE in Wyoming. It was constructed by William BENT (1809-1869) and Ceran St. Vrain of the AMERICAN FUR COMPANY to compete with Fort Vasquez and Fort Lupton of the Rocky Mountain Fur Company.

GIRARD, Kansas. Town (pop. 2,888). Seat of Crawford County, southwestern Kansas, south-

east of CHANUTE and southwest of FORT SCOTT , settled in the mid-1870s. It was named for Girard, Pennsylvania, which was named for philanthropist Stephen Girard. The *Appeal to Reason*, a Socialist paper printed in Girard, had a circulation of over 200,000 and was one of Kansas' most unusual and controversial newspapers.

GISH, Lillian Diana. (Springfield, Ohio, Oct. 14, 1896—). Actress. Much of the actress' fame, extending over a period of screen and stage successes for more than eighty years, was won outside the Central West. However, she made a notable contribution for which she is still remembered in the area. The once glorious but sadly faded CENTRAL CITY, Colorado, Opera House was permanently revived when Lillian Gish reopened the house with a performance of *Camille* in 1932, under the sponsorship of the University of DENVER.

GLACIER NATIONAL PARK. With precipitous peaks ranging above 10,000 feet, this ruggedly beautiful land includes nearly 50 glaciers, many lakes and streams, a wide variety of wildflowers and wildlife. It was established on May 11, 1910, authorized as part of Waterton-Glacier International Peace Park May 2, 1932, designated a Biosphere Reserve in 1976, headquartered West Glacier, Montana.

GLASGOW, Montana. Town (pop. 4,455), seat of Valley County, northeast Montana, northwest of Wolf Point and northeast of Jordan. Glasgow claims a record for the number of "boom" periods in a western town. The "booms" have included the opening of Indian land and the subsequent opening of an additional eighteen million acres, the construction of the Fort Peck Dam, and lastly the growth of Glasgow Air Force Base. The town is the oldest community in northeastern Montana and for years has been a sheep, cattle and grain-shipping center.

GLASS MOUNTAINS. Range in the northern part of Brewster County in western Texas. The highest peak is 6,487 feet.

GLASS, Hugh. (Unknown-1833). Mountain man. Little is known of Glass before he joined William H. ASHLEY's (1778-1838) fur-trading expedition of 1823 as a trapper. He was wounded in the leg during a battle with ARIKARA INDIANS, but recovered sufficiently to join Major Andrew Henry's party as it moved overland

St. Mary Lake is one of the many attractions of Glacier National Park.

toward the YELLOWSTONE RIVER. Near G R A N D RIVER, South Dakota, Glass was attacked and severely mauled by a grizzly bear. Left for dead by his two companions, Jim BRIDGER (1804-1881) and John Fitzpatrick, who took his rifle and reported him dead, Glass survived and crawled miles, living on berries and the remains of animals brought down by wolves, before joining another party headed up the Missouri. He eventually forgave Bridger, later one of the most famous mountain men of his day, and journeyed over the SANTA FE TRAIL. Glass represented independent fur trappers who faced inflated prices from St. Louis fur-trading rendezvous. After being wounded in an Indian attack at Bear Lake in 1828 Glass lived around FORT UNION. He was killed by ARIKARA INDIANS near the Yellowstone River.

GLENDIVE, Montana. City (pop. 5,978), seat of Dawson County, northeastern Montana, northeast of MILES CITY and southeast of Wolf Point. Natural gas was first discovered in

Montana at Glendive. Glendive was once a major city of the cattle empire, but has become a more diversified shipping and trading center for the region, which raises sugar beets, forage crops and grain.

GLORIETA PASS. One of few major routes through the mountains of the area near SANTA FE New Mexico. The pass was the scene of a CIVIL WAR battle, in nearby Apache Canyon, in which Union forces leaped on horseback sixteen feet across an arroyo after Confederate troops had destroyed a bridge on March 28, 1862. Just as the Confederates were about to win, they found that the Union forces had destroyed their supplies. The Confederates withdrew, ending their campaign in the Southwest which had threatened FORT UNION and Colorado's rich mineral supplies.

GOING-TO-THE-SUN-HIGHWAY. Acclaimed as one of the most scenic roads in the United States, the fifty mile highway provides

vistas of mountains, glaciers, and lakes. Connecting the east and west sections of GLACIER NATIONAL PARK over the CONTINENTAL DIVIDE at Logan's Pass, 6,664 feet, the route is usually closed to traffic by snow from mid-October to mid-June.

GOLD. On March 17, 1968, the London gold pool established a two tiered gold price system. The official price remained at $35 an ounce, but the commercial private market price was allowed to fluctuate. The low price had kept gold production down and demand high. Most large scale U.S. domestic production in the U.S. was discontinued. The removal of the ceiling on gold prices and its increased value during the periods of heavy inflation brought about a dramatic rise in gold prices during the economic uncertainty of much of the 1970s and early 1980s This created a revival of interest in gold in the Central West.

Some small operations were resumed at many of the former mining sites, but the major return of activity came at the great HOMESTAKE MINE at LEAD, South Dakota. There, where mining operations must be carried out in deep underground tunnels, higher gold prices made such mining techniques economically practical once again, after they had been moribund for several years. The Homestake continues to pour out a steady flow of gold, making it, over more than 100 years of operation, the world's leading producer of gold.

Gold production has a long history in the Central West. The Homestake operation was the sole successor of the dozens of grubstake operators and small mining companies that sprang up after the discovery of gold in the BLACK HILLS in 1876.

Colorado's gold rush came much earlier, with the first frantic group arriving only to find that the story of huge gold resources was only a hoax. Then the real thing was found at Chicago Creek, now IDAHO SPRINGS. In May, 1859, John Gregory struck a rich find in what came to be called GREGORY GULCH, and during the balance of that year as many as 10,000 men, many with families, rushed there to discover golden treasure. By the 1870s gold had almost completely disappeared in Colorado, but then silver took over.

In 1862 the first substantial Montana gold strike was made by John Stanley in July. There a camp called BANNACK boasted a population of 500 within a few days, hurriedly attracting miners from many other areas farther west. Within a year 10,000 people were living within a ten-mile radius of the discovery point, and the town became VIRGINIA CITY the "cradle of Montana." In 1864 some disgruntled miners left Virginia City to make their final try in a spot they called Last Chance Gulch. When they succeeded, Last Chance Gulch became the main street of HELENA. In 1864, also, BUTTE was begun as a gold camp. One observer remarked of the area, "Out there every prairie dog hole is a gold mine..."

North Dakota did not have a gold rush of its own, but the little town of BISMARCK experienced its first boom when the rush to the Black Hills brought thousands of people through the town on their way to hoped-for riches, many of whom stayed or returned to stay.

Wyoming's relatively minor gold find occurred at SOUTH PASS as early as 1842, but the state profited more from the California gold rush, beginning in 1849. In 1850 alone, more than 50,000 people had crossed Wyoming, bringing a rush of new business and settlements to supply the needs of such a crowd in what had been undeveloped country. In 1868 seven Swedish miners made a gold strike near BUFFALO, Wyoming, but the mine was lost and became one of the many lost mines for which people are still searching, generally in vain.

Texas, the nation's greatest mineral producer, even boasts of small finds of gold over the years. In New Mexico the gold of the SIERRA DE ORO (Mountain of Gold) in 1683 was the first gold strike made west of the Mississippi River in what is now the U.S. It was mined for some time, but little gold is produced today in the state.

GOLD RUSH. Dramatic episodes in the history of the American West, gold rushes had far reaching effects on American culture. Gold rushes have been defined as a brief period, from a few months to a few years, in which a varied group of people pour into an area where alleged deposits of a mineral have been found. Placer deposits ensured the success of many gold rushes in the Central West. Placer gold, already broken out of its surrounding rock and left in nugget or flake size, was easy for the first wave of inexperienced miners to find. These inexperienced miners lacked the equipment, patience and capital to handle the vein (or "rock" or "quartz") mining that followed in a few circumstances with varying amounts of success. The end of a "rush" has been defined as the time when the type of mining places greater demands on the participants, including greater experience, higher capital investment, and

more equipment. While placer deposits were the ideal basis for a rush, vein deposits, in some regions such as Colorado, were important from the very beginning. In such instances the average miner with little capital participated in the strike by speculating in "claims" or shares of claims while making little if any effort to extract the mineral. Participants in the California gold rush of 1848 played important roles in succeeding rushes in Montana and South Dakota. Former Californians played a lesser role in the Colorado gold rush, which drew most of its participants from the east by way of the Missouri River. Mislabeled the "Pike's Peak" rush of 1859, the Colorado rush has been thought second only to that of California with estimates of those involved reaching fifty thousand or more. The collapse of that rush by the mid-1860s coincided with rushes to Montana where rich placers were found in 1862-1864. Montana's inaccessibility and harsh climate played an important role in limiting the number of miners who participated and therefore the size of the rush, although the richness and number of the deposits gave prospectors their best opportunity since California. Inaccessibility also played a role in the gold rushes to the BLACK HILLS which had been closed to whites through solemn treaties with the Indians. The first prospectors slipped into sites which later became DEADWOOD and LEAD in 1874, and the real boom only developed in 1875-1876. Scenes similar to California, Colorado and Montana were repeated in the camps of South Dakota where a high percent of the population engaged in every activity except mining. The average rush was composed primarily of men, thus prostitution developed almost as quickly as the towns. The daily income of a miner in 1848 was estimated as high as twenty dollars, sixteen dollars in 1849, and five dollars in 1853. Similar drops in their income occurred throughout mining towns in the Central West, prompting miners to move on quickly when the minerals seemed exhausted, and away from the high prices for food, lodging and supplies.

GOLD CREEK, Montana. Village near the confluence of Gold Creek and Clark Fork and the site where gold was first discovered in Montana. The symbolic last spike on the Northern Pacific Railroad was driven into the tie at Gold Creek, near GARRISON, in 1883.

GOLDEN, Colorado. City (pop. 12,237). Seat of Jefferson County, north-central Colorado, northwest of DENVER and south of BOULDER. The

capital of Colorado Territory from 1862 to 1867, Golden rivaled Denver in importance after the discovery of gold along Cherry Creek in 1859. Named for miner Tom Golden, the city has been the home since 1874 of the COLORADO SCHOOL OF MINES, one of the three finest in the world, and the site of the National Earthquake Information Center. The Adolph Coors Company, offers free, thirty-minute tours of their facility. The Astor Hotel Museum is located in what is said to be the oldest stone hotel in the state. Golden also claims to have the largest cobblestone building in the United States, a structure completed with three thousand wagon loads of rock from Clear Creek. Records and artifacts of early railroads in Colorado are found in the Colorado Railroad Museum. LOOK-OUT MOUNTAIN Park, near Golden, holds the much-visited Buffalo Bill Memorial Museum and Grave. The old West is celebrated annually during Buffalo Bill Days in mid-July.

GOLDENROD. This North American weedy herb is the official state flower of Nebraska. For a long period the plant was wrongly considered to be a principal cause of hay fever because it bloomed at about the same time as the notorious ragweed. Thomas Edison found that some species contained latex, and he considered them as a source of rubber, but they have never been commercially developed in that way. Some species also have been used to produce a dye. Goldenrod leaves have been used as a tea and for medicinal preparations. The goldenrod has even been suggested as the national flower.

GOLIAD, Massacre of. Slaughter of Texans fighting for independence from Mexico. During the War of Texas Independence, GOLIAD on the SAN ANTONIO RIVER in southeast Texas was taken by Texas rebels on October 12, 1835. It was then evacuated after the fall of the ALAMO on March 6, 1836. Later in the same month a force of Texans under James W. FANNIN was captured near Goliad while attempting to evacuate the town. More than 300 of them, including Fannin, were shot by Mexican troops on orders from Mexican General Jose Urrea on March 27, 1836.

GOLIAD, Texas. Town (pop. 1,990). Seat of Goliad County, southeastern Texas, southwest of Victoria and northeast of Beeville. The name is thought to have originated with the Biblical Goliath. Goliad developed around a mission and presidio built by the Spanish in 1749. An important link in the Spanish colonization system, Goliad's fortunes faded when soldiers

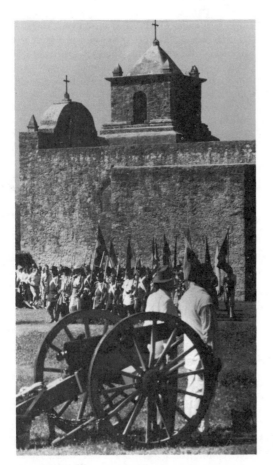

The Presidio La Bahia at Goliad is the scene of the reenactment of the occupation of the town by Colonel James Fannin in 1836 during the war for Texas independence. Most of the troops were later massacred by Mexican forces.

were removed following Mexico's revolt against Spain. In July, 1812, Augustus MAGEE and his outlaw band, called the Republican Army of the North, captured Goliad for a short time. The bloody history continued in March, 1836, when Colonel James W. FANNIN and 330 other Texas soldiers were massacred on Palm Sunday under orders to General Jose Urrea by the treacherous Mexican general, SANTA ANNA. Twenty-seven prisoners were able to escape through the help of Senora Alvarez, "The ANGEL OF GOLIAD," the wife of one of Santa Anna's officers. "Remember Goliad" became one of the Texas battle cries. The partially burned bodies of the Goliad defenders were gathered and buried at a place now marked by the Goliad Memorial Shaft. In

1857 a labor conflict between non-Hispanic and Mexican freighters resulted in the Cart War in which several Mexicans were killed before fighting was stopped by the Texas Rangers. Goliad's Aranama College became defunct almost overnight when its entire student body deserted their classes in 1861 to enlist in the Confederate army. The Presidio La Bahia (1749) remains as a showplace. It is said to have been the "Most fought over fort in Texas history."

GONZALES, Texas. City (pop. 7,152), Gonzales County, east of SAN ANTONIO and northwest of Yoakum. The community was settled in 1825. Ten years later the first shots of the Texans' revolution against Mexico were fired in Gonzales on October 2, 1835. The Mexican army was turned back by Texans as they attempted to recapture a cannon originally given the settlers to fight Indians. Following the battle, the first Texan revolutionary army was organized. Gonzales was also the only community to reply to William Barret Travis' appeal from the Alamo for reinforcements. The "Thirty-Two Immortals" who left to join the doomed garrison are remembered by a monument erected in 1936. The annual Come and Take It Celebration brings a variety of festivities to recall the first shot of the revolution.

GOODHUE, Bertram Grosvenor. (Pomfret, CT, Apr. 28, 1869—New York, NY, April 23, 1924). Architect. Goodhue's design for the capitol at LINCOLN, Nebraska, was described by *The International Journal of the Architect* as, "an expression of the Nebraska pioneer faith and frontier hope. Its tower rises as an exclamation point over a broad, firm base in daring defiance of the tradition that capitols should have pillars and domes. It stands as a crow's nest surveying the rippling prairie, its golden tip symbolizing the inherent purpose of its citizens." Most of Goodhue's reputation was gained in the design of churches and cathedrals. He acquired his early reputation from winning an 1889 competition to design a cathedral in DALLAS (never built).

GOODNIGHT, Charles. (Macoupin County, Illinois, Mar. 5, 1839—Tucson, Arizona, Dec. 12, 1929). Texas cattlemen and Indian scout. After a distinguished career as a Texas Ranger and trailblazer, with Oliver Loving in 1866 he pioneered a trail later called the Goodnight-Loving Trail, over which they drove hundreds of cattle. Goodnight became one of the first

cattle ranchers in New Mexico and Colorado. In 1877 he and John Adair set up a million-acre ranch in Palo Duro Canyon in the Texas PANHANDLE, with 100,000 head of cattle, and three years later he organized the Panhandle Stockmen's Association to curb rustling and promote purebred cattle. He was also involved in breeding experiments, crossing LONGHORNS with Herefords and crossbreeding beef cattle and buffalo. Among his other accomplishments, he developed a safer sidesaddle for women and created the first chuckwagon.

GOOSE RIVER. Eastern North Dakota, formed by a meeting of smaller streams in Steele County. It flows approximately eighty-five miles in an easterly direction into the RED RIVER OF THE NORTH in eastern Trail County.

GOVERNMENT. With one exception, the form and operation of the governments of the ten Central West states are in general conformity with each other and with the other states, as well. That exception, however, makes Nebraska unique among all the states. It is the only state government operating with a unicameral legislature, having only one branch instead of two. The 49 members of the legislature occupy the single legislative chamber in the magnificent Nebraska capitol at LINCOLN, the only state capitol without provision for two houses.

GRAFTON, North Dakota. City (pop. 5,293). Seat of Walsh County, northeastern North Dakota, northeast of DEVILS LAKE and northwest of GRAND FORKS. Settled in the late 1870s, it was named for Henry Fitzroy, Duke of Grafton, taken from Grafton, New Hampshire where many of the settlers originated. Today the community is a hub for transportation and agriculture. It has become the headquarters for tourists who want to visit North Dakota's first community, PEMBINA, where Pembina State Monument and Museum houses relics of the pioneers.

GRAND CANYON OF THE YELLOW-STONE RIVER. Valley of the YELLOWSTONE RIVER in YELLOWSTONE NATIONAL PARK. The valley in the park is 2,000 feet deep and 1,200 feet wide. Thomas MORAN's (1837-1926) famous 1872 oil painting of the canyon and sketches of the artist were used by the Northern Pacific Railroad to help persuade Congress to pass the necessary legislation to create Yellowstone National Park.

GRAND FORKS, North Dakota. City (pop. 43,765), seat of Grand Forks County, situated in east north-central North Dakota on the RED RIVER OF THE NORTH where it is joined by the Red Lake River, creating the river forks which give the city its name.

The metropolitan area includes East Grand Forks, across the rivers in Minnesota.

Center of a livestock and spring wheat area, the city has grain elevators, flour mills owned by the state, and potato processing plants. It processes a variety of other products including sugar beets, meat and dairy products.

Early French fur traders traveled the two rivers and established the communities there. They called the settlements *La Grandes Fourches*, French for Grand Forks. River traffic brought further growth. With the coming of the railroads, settlers flocked in and established a firm agricultural base. The city was incorporated in 1881.

The University of NORTH DAKOTA with its 12,000 students and substantial faculty is located at Grand Forks. Visitors are attracted to the "Eternal Flame of Knowledge" at the university, housed in a huge sphere of steel girders, commemorating both the past presidents and the Old Main building. A historic home, J. Lloyd Stone Mansion, houses the Alumni Center.

Campbell House, an older historic home, features the original log house and postoffice, along with Myra Museum, a collection of early Grand Forks artifacts.

Skiing, snowmobiling and snow hill slides are features of Turtle River State Park, which also offers many summer activities.

The university hosts the annual state hockey tournament in February. North Dakota Indian Association sponsors the Native American Annual Time Out and Wacipi in April. Potato Bowl week in early September features a Potato Queen pageant, parade and football game.

GRAND ISLAND, Nebraska. City (pop. 33,-180), Hall County, south-central Nebraska, southwest of COLUMBUS and southeast of BROKEN BOW. Named for a major island in the PLATTE RIVER. The new town of Grand Island was built five miles north to the Union Pacific, when the railroad reached the area in 1866.

The community was developed by a group of businessmen from Davenport, Iowa, and because of its central location in the nation, it was promoted, although unsuccessfully, as a prime candidate for the capital of the United States. The community became a business center as a

trading post for mule raisers and buyers and as a railroad distribution point. Always benefitting from its rich agricultural region, the city now also has diversified industry with food and meat processing and production of agricultural and irrigation equipment and mobile homes.

German settler William Stolley made the first claim in Hall County in 1857 and became a community leader. Stolley planted groves of more than fifty varieties of trees and guided the construction of Fort Independence when Indian attacks threatened in the 1860s.

Among renowned residents of Grand Island were actor Henry FONDA, Grace ABBOTT, who pioneered women's involvement in public office, and Jake Easton, who in managing to chew three hundred sticks of gum earned the title of "Champion Gum Chewer of the World."

STUHR MUSEUM OF THE PRAIRIE PIONEER is renowned as one of the finest and most extensive museums of its type. An annual event in December is the Christmas Island Lighting Night.

GRAND JUNCTION, Colorado. City (pop. 28,144), seat of Mesa County, taking its name from the junction of the COLORADO (formerly the Grand) and GUNNISON rivers in western Colorado, northwest of DELTA and southwest of Eagle. It was settled in 1881. Three years later Grand Junction became the site of the first sugar beet refinery in Colorado. The community is also the center of the Western Slope's famous fruit belt. Lush orchards of pears and peaches flourish in the Grand Valley. The Atomic Energy Commission operates its administrative agency at Grand Junction. Today Grand Junction is the principal distribution and trade center for territory lying between DENVER and Salt Lake City, Utah. Museum of Western Colorado is a principal attraction of the community. Nearby are Grand Mesa National Forest and Colorado National Monument. Annual events include the Coors International Bicycle Classic and Land's End Hill Climb for cars, on Labor Day.

GRAND LAKE OF THE CHEROKEES. Impounded behind the Pensacola Dam across the Grand (Neosho) River in northeastern Oklahoma's Delaware County. Completed in 1940, the dam forms a lake with an area of 64 square miles. The lake is also known as Pensacola Reservoir. The lake lies west of VINITA, Oklahoma, and south of Miami. Recreational areas include Honey Creek, Spavinaw, Snowdale, and Cherokee.

GRAND LAKE, Colorado. Town (pop. 382), Grand County, north-central Colorado, northwest of BOULDER and southwest of FORT COLLINS. It forms an enclave in ROCKY MOUNTAIN NATIONAL PARK, at the terminus of TRAIL RIDGE ROAD. The community is located on GRAND LAKE, the largest natural body of water in the state, boasting the world's highest yacht club. The lake is the source of the COLORADO RIVER. In the past, Utes avoided the area believing the mists rising from the lake were the spirits of women and children who drowned when their raft capsized. Annual events today include turtle races and Buffalo Barbecue. In late summer there are sailing regattas on weekends from July through early August.

GRAND MESA. Located in western Colorado, southwest of ASPEN and north of Telluride. Said to be the world's largest flat-topped mountain, Grand Mesa stretches over 625 square miles, a 10,500 foot high tableland containing national forests, deep canyons, waterfalls and more than 200 small lakes. Like a colossal island in the sky, Grand Mesa was known to the Indians as the "land of the departed spirits."

GRAND PRAIRIE, Texas. City (pop. 71,-462), Dallas, Ellis, and Tarrant Counties, located in northeast Texas. Part of the Dallas-Fort Worth metropolitan area, Grand Prairie was founded at the end of the CIVIL WAR. Manufactures today include industrial supplies, tanks, pipes, bottling, trailers, and aerospace equipment. It is home of the Texas Sports Hall of Fame.

GRAND RIVER. Name given to the lower course of the NEOSHO RIVER in northeastern Oklahoma below the Pensacola Dam.

GRAND RIVER. Northwestern South Dakota river formed in northern Pekin County by the meeting of its north and south forks. The river flows approximately two hundred miles eastwardly into the MISSOURI RIVER near MOBRIDGE.

GRAND TETON NATIONAL PARK. Covering the most impressive part of the TETON MOUNTAINS, this series of blue-gray peaks rises above the sagebrush flats. The area was once a noted landmark for Indians and "mountain men." The park includes part of JACKSON HOLE, winter feeding ground of the largest American elk herd. Grand Teton mountain is the highest peak (13,766 feet). Proclaimed March 15, 1943, headquartered Moose, Wyoming.

The Snake River runs tumultuously through the Jackson Hole Country, with the spectacular Grand Teton National Park soaring to majestic heights in the background, with the Grand Teton reaching the highest elevation.

GRANT-KOHRS RANCH NATIONAL HISTORIC SITE. This was the home ranch area of one of the largest and best known 19th-century range ranches in the country. It was authorized on August 25, 1972, headquartered Deer Lodge, Montana.

GRAPES OF WRATH, THE. Poignant novel (1939) written by John Steinbeck telling of the plight of farm families of the Central West who were ruined by the Great Depression and the DUST STORMS of the 1930s, and of their migration to California. The opening of the book was set in Sallisaw, Oklahoma.

GRAPHITE. Texas is the only place in the United States which produces natural graphite. One of nature's softest minerals, occurring as a smooth, black solid-feeling material, greasy to the touch. Hardened with clay, graphite is made into the material known as "lead" in pencils. A conductor of electricity and not combustible, graphite electrodes are used in situations where metal electrodes would be destroyed. Capable of conducting heat without combining with other metals, graphite is used in crucibles for melting metals. Because it is not easily dissolved, graphite is used in tanks holding strong acids. Graphite finds use as a lubricant and as the raw material for synthetic diamonds.

GRANITE, Montana. Ghost town. Near Philipsburg in Granite county, southwest of Deer Lodge and northwest of ANACONDA. Sometimes labeled "the richest silver mine on earth," its real wealth was discovered by accident. The owners of the mine ordered work halted after lack of success, but the message did not arrive in time before the last blast uncovered a vein worth $40,000,000.

GRASSHOPPER GLACIER. Fascinating phenomenon located ten miles north of COOKE CITY, Montana, in the rugged BEARTOOTH MOUNTAINS. Over the last two thousand years, thousands of grasshoppers have died there and been buried in snow. Repeated from season to season, the effect from a distance is that of black strips in the glacial ice. Closer inspection reveals the countless bodies of the insects.

GRASSHOPPER INVASION, 1874. The worst destruction by grasshoppers in the Central West occurred in 1874 when most of the area from the Dakotas to Texas was a scene of devastated crops. The Indians ground the insects into mash and made a type of porridge. The Osceola *Homesteader* wrote of 1874, "Our foreign readers must forgive us for giving so much grasshopper news. We cannot help it. The air is filled with them, the ground is overed with them, and people think and talk of nothing else...We cannot walk the streets without being struck in the face and eyes by grasshoppers, and we cannot sleep for dreaming grasshoppers..."

GREASEWOOD (sarcobatus vermiculatus). A quick burning source of fuel found primarily on dry alkali plains such as those of the central west. Other varieties are found in Russian alkali plains in similar areas.

GREAT DIVIDE BASIN. An unusual feature of the CONTINENTAL DIVIDE occurs as the watershed wanders through Wyoming. Just south of SOUTH PASS the Divide splits in two and separates, with arms spreading northeast and southwest. Formed between the arms in a rough circle more than sixty miles wide at its widest point is Great Divide Basin. Waters falling to the east drain toward the Atlantic, and those to the west toward the Pacific Ocean, but within this circle, or basin, all the water which falls on its inner slopes remains trapped in the basin. Then, just south of Lander the divide comes together again, into a single imaginary line, to continue across Wyoming, Colorado and New Mexico. The Great Basin is thought to be the only one of its kind anywhere.

GREAT FALLS OF THE MISSOURI. First seen by Captain Meriwether LEWIS (1774-1809) in 1805, the falls on the MISSOURI RIVER were noted for their striking majesty and for abundant wildlife of the area including mountain lions, buffalo and rattlesnakes. The LEWIS AND CLARK EXPEDITION (1804-1806) again passed through the area on their return from the Pacific Ocean in 1806, but no further written record of the area was made until Jim BRIDGER (1804-1881) traveled through the region in 1822. Strong Indian resistance to white settlement prevented development of the area until 1855 when peace treaties were signed with the BLACKFOOT. With the platting of a townsite, the falls became a source of power. They were later harnessed and obliterated by the construction of dams for hydroelectric power.

GREAT FALLS, COLLEGE OF. Independent Catholic college operated by the Sisters of Providence in GREAT FALLS, Montana. Founded in 1932, the college campus has grown from 64 to 104 acres. The college enrolled 1,078 students during the 1985-1986 academic year and employed 87 faculty members.

GREAT FALLS, Montana. City (pop. 56,725), seat of Cascade county, straddling the MISSOURI RIVER at its confluence with the Sun River in north-central western Montana. It takes its name from the principal falls of the river. Except in very high water these have now disappeared under the water behind the dams there.

The hydroelectric power generated from the dramatic drop of the great river has given the community its name as the Electric City. Electricity powers oil and copper refineries along with a zinc reduction plant and flower mills. As a center for a large area of irrigated crops, Great Falls also is the focal point of the Sun River Project.

The falls has been prominent in the entire history of the community. Minnesota businessman Paris Gibson was so impressed on a visit that he returned to the area in 1883, platted the town and gave it its name. By 1888 Great Falls had grown large enough to be incorporated, and it has continued to grow with few interruptions. However, the 1984 population was lower than that of 1970.

Charles M. Russell Museum and Original Studio is devoted to one of the country's notable artists. The western specialist, Charles M. RUSSELL (1865-1926), is represented in one of the finest collections of his paintings, wax models and bronzes. His original log studio, a part of the museum, preserves his collection of Indian costumes and paraphernalia.

One of the world's largest freshwater springs is the site of Giant Springs and State Trout Hatchery and State Park, where trout are reared.

The College of Great Falls is notable for its chapel sculpture and stained glass windows, products of the college.

Malmstrom AFB, center of the free world's largest intercontinental ballistic missile complex, stands in contrast to Lewis and Clark national Forest, which encompasses a natural formation known as the Chinese Wall, stretching across the forest for fifteen miles.

GREAT LAKES OF SOUTH DAKOTA.

Term used to describe the huge man-made lakes created in South Dakota by the construction of enormous dams along the MISSOURI RIVER. OAHE DAM, among the largest in the world, has blocked the waters of the Missouri to create Oahe Reservoir, a lake covering 23,600,000 acre feet. Gavins Point dam created LEWIS AND CLARK LAKE, while Big Bend Dam formed Lake Sharpe.

GREAT NORTHERN RAILROAD. Built

without subsidies, the Great Northern, completed in 1893 under the leadership of James J. Hill, ran from Duluth, Minnesota, through South Dakota, North Dakota, northern Montana, Idaho, and Washington where it ended in Seattle. The chief competitor of the Great Northern was the Northern Pacific. Among Central West cities which developed with the Great Northern were MINOT, North Dakota, which "sprang up overnight with the arrival of the Great Northern in 1887," and HAVER, Montana, in which the railroad maintained large diesel shops.

GREAT PLAINS. A vast region stretching

from the north central plains of Texas into New Mexico with the LLANO ESTACADO forming the border between Texas and New Mexico and the EDWARDS PLATEAU bordering it on the south. This semi-arid, treeless expanse is largely a high plateau, with elevations ranging from 2,000 to 6,000 feet. The Texas PANHANDLE, which occupies a large section of the Great Plains is mostly used as a grazing area. Several rivers including the CANADIAN run through this area.

GREAT SALT PLAINS. Located in north-

western Oklahoma's Alfalfa County, northwest of ENID, the salt plains once shimmered and looked so much like water that waterfowl mistook the surface for water and landed. That illusion became reality when much of the area was submerged by the waters of Great Salt Plains Lake, formed by the damming of the SALT FORK RIVER.

GREAT SAND DUNES NATIONAL MON-

UMENT. Among the largest and highest in the United States, these dunes were deposited over thousands of years by southwesterly winds blowing through the passes of the lofty SANGRE DE CRISTO MOUNTAINS. Proclaimed March 17, 1932, headquartered at Mosca, Colorado.

GREELEY, Colorado. City (pop. 53,006), seat

of Weld County, northeastern Colorado, northeast of DENVER and southwest of STERLING, on the banks of the CACHE LA POUDRE RIVER. Founded in 1870 by the Union Colony, a group of New England teetotalers, Greeley, noted for having no dance halls or saloons, quickly prospered and built one of the first large irrigation systems in Colorado Territory by 1875. The first settlers were guided to the area by Nathan Meeker, the agricultural editor of the New York *Tribune* who was sent to the region by Horace GREELEY (18121-1872) to establish a model cooperative colony. Colony members paid dues of $5.00 to $150 for not more than 160 acres of land which included a town lot. Crops, especially barley and hay, and cattle became the principal products of the community. Greeley has had the world's largest feed lots. It is the home of the University of NORTHERN COLORADO. The Greeley Independence Stampede is one of the largest outdoor rodeos in the United States. In several restored buildings, Centennial Village demonstrates the growth of Greeley and Weld County from 1860 to 1920.

GREELEY, Horace. Amherst, NY, Feb. 3,

1811—Pleasantville, NY, Nov. 29, 1872). Editor, developer. Greeley, a prosperous and prominent New York newspaper publisher, supported the idea of free land for settlers and was credited with coining the phrase, "Go West, young man, go West!" In his paper, the *Tribune*. He opposed the KANSAS-NEBRASKA ACT and the Fugitive Slave Law and supplied arms for the Free-Soilers in Kansas. Greeley spent considerable time in early Colorado mining camps. In 1870 he directed one of his editors, Nathan Meeker, to establish a model cooperative community, called Union Colony, on the banks of the CACHE LA POUDRE RIVER. Meeker was later killed in an Indian attack, but the little town grew and took the name of its sponsor, GREELEY. The combination of his loss to Grant in the Presidential Election of 1872 and the death of his wife the same year is thought to have driven Greeley insane.

GREEN FLAG. Symbol of the army of outlaws led out of the Neutral Strip between Texas and Mexico by former U.S. Army officer, Augustus MAGEE. The outlaws boasted of their intention of capturing Texas and possibly Mexico. They referred to themselves as the REPUBLICAN ARMY OF THE NORTH. In July, 1812, Magee's forces captured NACOGDOCHES. They captured GOLIAD and SAN ANTONIO before being defeated and most of their rag-tag army killed.

GREEN ISLANDS. South Dakota community entirely destroyed when an ice dam on the MISSOURI RIVER, near YANKTON, broke in 1881, sending a wall of water crashing down the narrow river channel. It has been told that the town's church was swept away intact with church bell peeling an eerie sound.

GREEN RIVER. Major river, seven-hundred-thirty miles long, beginning in the WIND RIVER RANGE in northeastern Sublette County in western Wyoming. The river, flowing south past ROCK SPRINGS, Wyoming, and forming FLAMING GORGE RESERVOIR, continues on into Utah where it bends east, making a loop into the northwest corner of Colorado near DINOSAUR NATIONAL MONUMENT. The Green River snakes southwest and south into Utah to join the COLORADO RIVER.

GREENVILLE, Texas. Town (pop. 22,161), seat of Hunt county, in northeastern Texas. Located in a cotton-producing area, Greenville was once the location of one of the world's largest inland compresses for making cotton bales. Food processing and the manufacture of electronic parts are important to Greenville's present economy. Cotton Pickin' Art Jubilee is held each October.

GREGORY GULCH. Once known as the "richest square mile on Earth," site of a gold

The mighty Green River winds a majestic course through Lodore Canyon on its way to meet the Colorado River.

strike made in May, 1859, by John Gregory. Within the area of the many camps grew the modern town of CENTRAL CITY, Colorado.

GREY, Zane. (Zanesville, OH, Jan 31, 1875—Altadena, CA, Oct. 23, 1939). Author. Grey is considered the most famous of all writers about the West. Almost every year between 1904 and 1937 he wrote one and often several action novels of the rough and tumble life on western plains and in sudden-death cattle towns. His *Riders of the Purple Sage* (1917) was a huge success. It is believed that this book was written at Dove Creek, Colorado. In Wyoming, Grey gathered material for his book *U.P. Trail* (1918). His view of the West of the lone wolf gunfighter and other aspects of the region had a profound influence on all the subsequent books, motion pictures and television series on the West.

GRINNELL GLACIER. Named for George GRINNELL (1849-1938), a conservationist who did much to publicize GLACIER NATIONAL PARK. In the park Grinnell Glacier is famed for its ice caves.

GRINNELL, George Bird. (Brooklyn, NY, Sept. 20, 1849—New York, NY, April 11, 1938). Explorer, author and editor. A prominent conservationist and naturalist, Grinnell was the leader in bringing news of the wonders of GLACIER NATIONAL PARK to the American public. Grinnell, for whom GRINNELL GLACIER is named, was a naturalist with George Armstrong CUSTER's (1839-1876) expedition to the BLACK HILLS in 1874. Grinnell joined Ludlow's exploration to YELLOWSTONE NATIONAL PARK in 1875 before becoming the editor of *Forest and Stream* in 1876. An accomplished author, Grinnell wrote fiction and books based on stories learned from first-hand study of many of the Indian tribes in the West. He was chosen a commissioner to deal with the BLACKFOOT and Fort Belknap Indians in 1895.

GRIZZLY BEAR. The official state animal of Montana. This variant of the more common brown bear of North America is thought by some authorities to be related to the brown bear of Europe. The grizzly has been the most feared animal of the West. The LEWIS AND CLARK EXPEDITION (1904-1806) had encounters with them and paid a great deal of respect to their fierce nature and extraordinary strength. In later years, conservationists have feared the grizzly would become extinct, due to the loss of much of their habitat. At present they seem to be holding their own in protected areas.

GROS VENTRE INDIANS. Algonquin tribe living along the MILK RIVER of northern Montana. The name, meaning "big belly," probably resulted from an incorrect French interpretation of sign language. They were also known as the Gros Ventre of the Prairie to distinguish them from the HIDATSA, known as the Gros Ventre of the Missouri. The Gros Ventre called themselves Haaninin, meaning "lime men" or "chalk men." The Gros Ventre were subdivided into twelve autonomous bands each headed by a chief. Like many other plains tribes they split into small groups during the winter and then regrouped in the spring for communal hunts. A person's band was inherited through the father. Youth married outside the bands of both their father and mother. The Gros Ventre lived in skin tipis which were made by the women. Snow packed around the tipi in the winter made it snug. Camps might be moved as many as eight times during the summer to follow the herds of buffalo. The Gros Ventre joined the BLACKFOOT to fight the CROW, but in 1867 joined the Crow in a disastrous war against their former ally. In the 1880s, the Gros Ventre and the ASSINIBOIN were placed on the Fort Belknap Reservation in northern Montana. In the late 1970s, there were about two thousand Gros Ventre living on or near the 600,000-acre reservation.

GRUEN, Victor. (Vienna, Austria, July 18, 1903—Vienna, Austria, Feb. 16, 1980). Austrian-American architect. Best known for his innovative design of suburban shopping centers and for his solutions to problems in city planning, Gruen's projects for FORT WORTH , Texas were particularly noteworthy. He retired in 1968.

GUADALUPE MOUNTAINS NATIONAL PARK. Rising from the desert, this mountain mass contains portions of the world's most extensive and significant Permian limestone fossil reef. Also featured are a tremendous earth fault, lofty peaks, unusual flora and fauna and a colorful record of the past. Headquartered CARLSBAD, New Mexico.

GUADALUPE PEAK. (8,751 feet) Texas mountain peak in the Guadalupe Mountain Range, Culberson County, in western Texas. The highest peak in the state, it is located within a national park on the New Mexico

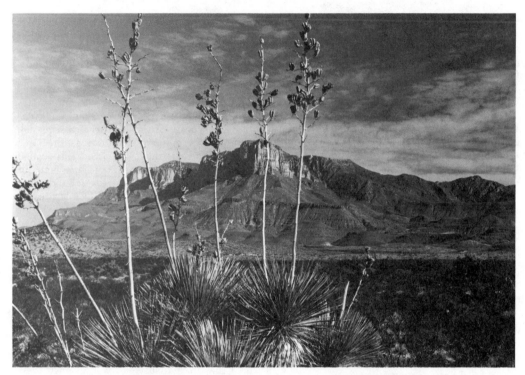

Four of Texas' highest peaks lie in Guadalupe Mountains National Park in West Texas.

border, with salt lakes and salt flats to the west. Its crest is rounded and topped with pine trees.

GUADALUPE RIVER. Texas River formed in the southeast part of the state, flowing 300 miles southeast to meet the SAN ANTONIO RIVER. It is the largest of the spring-fed rivers of the area and because of its steady, heavy flow is an important hydroelectric energy source.

GUADALUPE-HILDAGO, TREATY OF. Conclusion of negotiations between the United States and Mexico ending the MEXICAN WAR in 1848. In the treaty's provisions Mexico ceded the territories of New Mexico and Utah, and the United States paid Mexico $15 million. California was annexed by the United States and Mexico agreed to recognize the prior annexation of Texas by the United States and the course of the RIO GRANDE RIVER as the boundary line between the two nations.

GUERNSEY LAKE. Reservoir created by the construction of the Guernsey Dam on the NORTH PLATTE RIVER in Wyoming, it regulates the river, produces hydroelectric power for the North Platte Valley and assures water for irrigation. Recreational activities, dating from 1933, have included an annual re-enactment of the battle between the *Merrimac* and the *Monitor*.

GUERNSEY, Wyoming. Town (pop. 1,512), Platte County; southeastern Wyoming; southeast of Casper and northeast of Laramie; named for Charles A. Guernsey, author of *Wyoming Cowboy Days.* Register Cliff State Historic Site near Guernsey records the carved names of thousands of pioneers who journeyed past the 100-foot chalk cliff between 1840 and 1860. Some of the settlers who died are buried near the base of the cliff. The meadow nearby was the first stopping point of emigrants west of FORT LARAMIE. Oregon Trail State Historic Site preserves examples of pioneer trails. Ruts five and six feet deep lie next to the footpaths used by pioneers.

GULF AND COASTAL PLAINS REGION. Area of the United States from Florida to southern Texas, marked in the Central West with numerous rivers including portions of the Rio Grande Valley, belts of hilly forests, many sandy beaches, offshore islands, and bays. Covering an area from the ARMISTAD RESERVOIR north and northeast through Texas to the region of Lake TEXOMA, the plains area contin-

ues north and northeast through the southeastern corner of Oklahoma in the Central West. Natural resources of the region include vast deposits of petroleum, rich grazing land, and fertile farmland.

GULF INTRACOASTAL WATERWAY. A sea-level, 1,100-mile waterway traveling a sheltered route that extends from Apalachee Bay Florida, to BROWNSVILLE, Texas, on the Mexican border. It was authorized by Congress in 1919. Natural portions sheltered by islands have been linked by a series of canals and channels to provide an extremely important commercial route for ocean-going vessels. The waterway connects with the Mississippi River system so that barge travel can continue to such points as Chicago and Pittsburgh. Petroleum and petroleum products are among the principal items shipped over the route.

GUNNISON RIVER. West central Colorado, beginning in southwestern Gunnison County and flowing west and northwest into the COLORADO RIVER in central Mesa County near GRAND JUNCTION. The BLACK CANYON OF THE GUNNISON, southeast of DELTA, Colorado, is a national monument.

GUNNISON, Colorado. City (pop. 5,785), seat of Gunnison County, west-central Colorado, southeast of DELTA and north of CREEDE. The first Reclamation Bureau project was dedicated near Gunnison in 1908 by President Theodore ROOSEVELT (1858-1919). Gunnison is home of Western State College of Colorado, which opened in 1911. The community serves as headquarters for a vast recreational area including the Gunnison National Forest and the CURECANTI NATIONAL RECREATION AREA. Tourists use Gunnison as a hub for excursions to mysterious ghost towns. West of Gunnison is the fantastic BLACK CANYON OF THE GUNNISON NATIONAL MONUMENT, remembered for its sheer walls, some 2,425 feet high. Colorado State Windsurfing Championships are held on nearby Blue Mesa Reservoir.

GUNNYSACKERS. Term applied to cattlemen who wore gunnysacks over their heads to hide their identity when they attacked the camps of sheepmen during the wars between cattlemen and sheepmen in the northwest.

GUTHRIE, Oklahoma. City (pop. 10,312). Seat of Logan County, central Oklahoma, north of OKLAHOMA CITY and southwest of STILLWATER.

It was named for Kansas jurist John Guthrie. Guthrie was founded when as many as 20,000 settlers arrived only a few hours after that portion of Oklahoma was opened to settlers in 1889. It was the capital of Oklahoma Territory, which was established in May, 1890. Guthrie became the burial site for many of Oklahoma's most notorious outlaws. Summit View Cemetery contained the graves of such criminals as Charles Pierce and Bill Doolin, leaders of a gang of Oklahoma outlaws. The state's first flag, sewn by ninety-two seamstresses, flew in front of the first capitol—a convention hall. Guthrie claims the first Carnegie Library in the state. Among the famous people who have lived for a time in Guthrie are Carry NATION (1846-1911), cowboy actor Tom MIX (1880-1940), master of horror Lon Chaney, and Will ROGERS (1879-1935). The city is listed on the National Historical Register and is being restored to its early appearance. The Oklahoma Territorial Museum is located there. Annually for three days in late April residents honor the birth of their city in the Eighty-Niner Celebration.

GUYMON, Oklahoma. City (pop. 8,492). Seat of Texas County, central Panhandle. It is a

Guymon's annual Pioneer Celebration includes a lively rodeo.

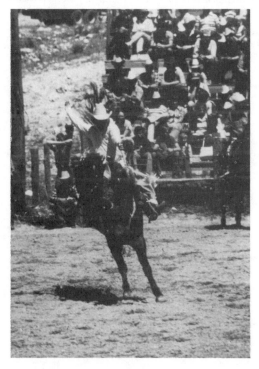

center of natural gas and oil, of a large irrigated region and boasts several manufacturers and feed lots. It is home of Panhandle State University. Guymon annually sponsors the unusual wild-cow milking contest.

GYPSUM HILLS. Unusual geologic formation near MEDICINE LODGE, Kansas, where red stone mesas are capped with white gypsum, giving the appearance of "strawberry shortcake topped with whipped cream."

HAGMAN, Larry. (Ft. Worth, TX, Sept. 21, 1931—). Actor, known as "The Man America Loves to Hate." Hagman made the character of J.R. Ewing almost an institution, as a star of the long-running television series *Dallas*, in which he plays an evil oilman. His starring role from 1965 to 1968 in the television comedy series *I Dream of Jeannie* was a distinct contrast. Hagman is the son of actress Mary Martin.

HALTOM CITY, Texas. City (pop. 29,014), Tarrant County, located in east central Texas northeast of FORT WORTH. Primarily a residential suburb, Haltom City's population rose dramatically after WORLD WAR II, from 200 in 1940, when it was formed as a village, to 23,133 in 1960 to 28,127 in 1970, but barely holding its own in the 1980s, due to the general slump in the Texas economy.

HAMILTON, Andrew Jackson. (Huntsville, AL., Jan. 28, 1815—Austin, TX, Apr. 11, 1875). Politician. After removing to Texas in in 1847, he was a member of the Texas volunteers. Hamilton served as a Democratic member of Congress from Texas, 1859-1861. He was military governor of Texas by appointment of President Abraham Lincoln (1862), and provisional governor under President Andrew Johnson (1865-1866). He became a justice of the state supreme court in 1866 and was opposed to black suffrage.

HAMILTON, Montana. Town (pop. 2,661). Seat of Ravalli County, southwestern Montana, south of MISSOULA and northwest of ANACONDA . The town was named for land agent James Hamilton, who platted the community. Hamilton is the home of the ROCKY MOUNTAIN LABORA-

TORY of the United States Public Health Service, the center which developed a vaccine for Rocky Mountain spotted fever. It is a trading point for a large area of the county and a tourist center for a wide variety of attractions: Fort Owen State Monument, first European style settlement in Montana; St. Mary's Mission; Bitterroot National Forest; Big Hole National Battlefield; Gem Mountain Sapphire Mines and Painted Rocks State Recreation Area. The annual celebration of McIntosh Apple Days occurs in September.

HANDCART COMPANIES. Experiment tried by the Mormons in 1856 to reduce the cost of moving settlers across the plains. Carts had a body of from three to four feet in length. Five people were assigned to each cart, and each person was allowed only seventeen pounds of baggage. General supplies for the company were carried in other wagons. The carts, which averaged ten to twenty miles per day, were pulled by the Mormon men. Tragedy occurred when groups began the trip too late in the year and were caught in winter storms. One hundred Mormons died near DEVIL'S GATE in Wyoming when caught in a blizzard. The experiment was abandoned in 1860 after ten companies had made the incredible journey. An estimated 2,962 people pulled 653 handcarts.

HANSON, Howard Harold. (Wahoo, NB, Oct. 28, 1896—Rochester, NY, Feb. 26, 1981). Composer, conductor, educator, winner of the 1944 Pulitzer Music Prize for his Fourth Symphony. He studied music at Luther College in Wahoo, Nebraska and the University of NEBRASKA, at what is now the Juilliard School, and then graduated from Northwestern University 1916. In that year he joined the faculty of the

Although "Hanging Judge" Isaac C. Parker's courtroom stood at the eastern border of Arkansas, the jurist was renowned for bringing law to the notorious lawless area in what is now the eastern portion of the Central West.

College of the Pacific and three years later became dean of the conservatory there. His 1920 compositions earned him the Prix de Rome, for a three year advanced study period in that city. His works there included his Symphony Number One, the *Romantic*. In 1924 Hanson became director of the newly formed Eastman School of Music at Rochester, New York, serving from 1924 to 1964. He made the school one of the most famous in the world for music study and performance. He founded the American Composers Concerts in Rochester, to encourage composers by performing their orchestral works. Hanson wrote six symphonies, an opera *Merry Mount* (1934) based on a Nathanial Hawthorne tale, and many other symphonic and choral works. Although he was one of the most influential teachers and composers of his time, his compositions grew "repetitive" and "tiresome" in the eyes of some critics. However, modern conductors are using his works increasingly in concert, and many critics are revising their earlier opinions.

HARDIN, John Wesley. (Bonham, TX, May 26, 1853—El Paso, TX, Aug. 19, 1895). Outlaw. Subject of a folk song by Bob Dylan, Hardin was a gambler and gunman who is thought to have killed 44 men. He managed to avoid jail until 1877 when he was sentenced to 25 years in the prison at HUNTSVILLE, Texas, for shooting a sheriff. He studied law in prison, and when pardoned on February 17, 1894, set up a practice in EL PASO, Texas. A year later, however he was shot in the back by local constable on suspicion of another crime.

HARDIN, Montana. Town (pop. 3,300). County Seat of Big Horn County, south-central Montana, east of BILLINGS and southwest of MILES CITY. A local trade center, it is particularly popular with the residents of the adjacent CROW INDIAN Reservation. The community was named for Samuel Hardin, a Wyoming rancher who leased land on the reservation. Near Hardin on June 25, 1876, the forces of Lieutenant Colonel George Armstrong CUSTER (1839-1876) were annihilated by SIOUX and CHEYENNE Indians in the Battle of LITTLE BIG HORN (June 25, 1876). After the end of most hostilities in the region, FORT CUSTER was constructed in 1877. The area was opened to white settlement in 1906. The 90,000-acre Thomas Wheat farm is one of the world's largest wheat farming operations. FORT C.F. SMITH, the first army post in Montana, was built near Hardin to safeguard travelers on the

BOZEMAN TRAIL, and the ruins may be seen there. CUSTER BATTLEFIELD NATIONAL MONUMENT is thirteen miles distant.

HARDIN-SIMMONS UNIVERSITY. Leading religious school in ABILENE, Kansas. Founded in 1891, the university is privately supported. Since 1941, control has rested with the Baptist General Convention which elects the school's trustees. During the 1985-1986 academic year the university enrolled 1,817 students and employed 124 faculty members.

HARLINGEN, Texas. City (pop. 34,543), Cameron County, in southern Texas, 28 miles northwest of BROWNSVILLE. The city was founded in 1904, incorporated in 1910, and named after Van Harlingen, Netherlands, a city with a similar location on a barge canal. Harlingen began to develop when it became a station on the Saint Louis, Brownsville, and Mexico (now Missouri Pacific) Railroad. The city is an agricultural center and a major distribution point for vegetables and citrus fruits from the lower Rio Grande Valley. The Harlingen Channel provides the city with a link to the Gulf Intracoastal Waterway, making it a leading port. Port Harlingen has oil terminals, chemical plants, grain operations, and other industries. Confederate Air Force Flying Museum does not preserve the few balloons of the CIVIL WAR period, but, rather, concentrates on preserving WORLD WAR II flying craft of all kinds.

HARNEY PEAK. Highest point in the Dakotas—at 7,242 feet, dominates the BLACK HILLS area.

HARPER, Kansas. City (pop. 7,778). Seat of Harper County, south-central Kansas, west of Wellington and southeast of Pratt, named for CIVIL WAR cavalryman Marion Harper. Harper stands near the site of Runnymeade, a town founded in 1887 by Ned Turnly and settled by wealthy English people who brought their butlers, coaches and high society clothes to the Kansas frontier. The short-lived experiment in elegant country living is now remembered by one tombstone at the site of the town.

HARRIS, Roy Ellsworth. (Lincoln County, OK, Feb. 12, 1898—Pacific Palisades, CA, Oct. 1, 1979). Classical composer. Harris began to study music while working as a truck driver, after attending the University of California (1919-1929). His *Andante* (1926) brought him a Guggenheim Fellowship in Paris, where he studied with famed classical teacher Nadia Boulanger. *When Johnny Comes Marching Home* (1935), a Civil War overture, gained wide attention. The completion of his *Third Symphony* in 1939 marked Harris as a leading American classicist. He returned to the Central West in 1948, where he was on the faculty of COLORADO COLLEGE until 1967. His output included six symphonies; music for school bands, choruses, and orchestras; string and piano quintets; choral compositions; and piano solos. A recipient of numerous awards, Harris also won the prestigious Coolidge Medal for eminent contributions to chamber music, from the Library of Congress in 1942.

HART, William S. (Newburgh, NY, Dec. 6, 1872—Newhall, CA, June 23, 1946). Actor. Hart, the star of a host of silent screen movies set in the frontier West, contributed the statue *Range Rider of the Yellowstone* to BILLINGS, Montana. The life-sized statue of a cowboy and his horse, modeled from Hart and his pony, Paint, stands just south of the airport.

HARTFORD BEACH MOUNDS. On BIG STONE LAKE, these relics of prehistoric peoples are among several groups in South Dakota that are well-known to archeologists. However, not much has been determined about the peoples who constructed them. It is thought that they probably were related to the eastern groups who produced similar mounds. Excavations in the mounds have indicated that the builders had passed the stone age. Many of the mounds were used for burials.

HASINAI CONFEDERACY ("our own folk"). Cluster of Indian tribes, all of Caddoan linguistic stock, who lived between the headwaters of the NECHES and TRINITY rivers in northeast Texas. They were placed on a reservation with the Louisiana CADDO Indians in the early 19th century, but continued threats from nearby settlers forced them to move and seek safety in Oklahoma. They were noted as makers of fine pottery ware.

HASKELL INDIAN JUNIOR COLLEGE. One of the oldest and the largest government boarding schools for Indians in the United States. Located in LAWRENCE, Kansas, the college is operated by the Bureau of Indian Affairs, Department of the Interior. Normal enrollment of the school includes students from 90 tribes and 30 states. Courses are balanced between shop, classroom instruction and on-the-job

training. Students must be of at least one-fourth Indian blood and must receive Agency approval for eligibility.

HASTINGS, Nebraska. city (pop. 23,045), seat of Adams County, located in south-central Nebraska about 25 miles south of GRAND ISLAND. It was named in honor of Francis Rawdon-Hastings, Earl of Moira and aide-de-camp to General Clinton during the American Revolution. Founded in 1872, the town sprang up almost overnight when two railroads arrived simultaneously. Farm implements are presently the leading manufacture. However, during WORLD WAR II and the Korean conflict Hastings was a center of munitions manufacture. There are flour and feed mills and creameries, along with building materials. Hastings College (1882) is located there. Unusual for a city of its size is the Crosier Asmat Museum, housing a fine collection of the craft of the Asmat people of Indonesia. Hastings Museum is notable for its varied collections of natural science, pioneer history, Indian lore and pioneer vehicles. Also unusual is Jacob Fisher Rainbow Fountain in Highland Park. About thirty miles south is Willa CATHER (1873-1947) Historical Center, where a branch of the state historical museum displays mementoes of the author and preserves several local buildings of interest.

HAVRE, Montana. City (pop. 10,891), seat of Hill County, north-central Montana, northwest of LEWISTON and northeast of GREAT FALLS. Havre was named after the French city of Le Havre. The town came into existence in 1887 when railroad builder James J. Hill found a fine supply of fresh water and decided to build a southern branch to Great Falls from there rather than to a dry area to the west, and the community became a stock-shipping center. It is now a principal distribution point on the Burlington Northern Railway and center for the large wheat harvests. Northern Montana College, founded in 1929, is located there. Some original buildings of FORT ASSINIBOIN are still to be found as part of the agricultural experiment station there. Nearby is the Rocky Boy Indian Reservation where an annual Bear Paw Ski Bowl is held between December 15 and April 1.

HAY. Wild and cultivated grasses and other plants mown and dried for use as animal fodder. In the Central West where hay is an important support of the cattle industry, most hay consists of timothy, alfalfa, or clover crops, but field grazing is still important. In 1985 the Central West produced about 44.88 million tons of hay, over 30% of the total United States production. Texas leads the area with 8.18 million tons followed by Kansas (7 million tons), Nebraska (6.76 million tons), South Dakota (4.83 million tons), Oklahoma (4,79 million tons), North Dakota (3.77 million tons), Colorado (3.64 million tons), Montana (2.76 million tons), Wyoming (1.7 million tons), and New Mexico (1.44 million tons).

HAYDEN, Ferdinand Vandiveer. (Westfield, MA, Sept. 7, 1829—Philadelphia, PA, Dec. 22, 1887). Geologist. Hayden served as geologist on the staff of Lieutenant G.K. Warren in the surveying expedition of the YELLOWSTONE and MISSOURI rivers and the BADLANDS of South Dakota in 1856-1857. Hayden joined F.B. Meek in exploring the Kansas Territory in 1858 and returned to the Yellowstone and Missouri rivers with Captain W.F. Raynolds from 1859 to 1862. Hayden's survey of the Nebraska Territory in 1867 has served as a model for the United States Geological Survey to the present day. His work and photographs of the Yellowstone area proved to be one of the most effective influences in the setting aside of land for YELLOWSTONE NATIONAL PARK through the Yellowstone Park Act, signed swiftly into law by President Ulysses S. Grant only three months after the bill was introduced.

HAYS, Kansas. City (pop. 16,301). Seat of Ellis County, west-central Kansas, northeast of DODGE CITY and west of Russell, on Big Creek and Interstate 70. It was named for Fort Hays, in turn for CIVIL WAR General Alexander Hays. Hays developed from Fort Hays which, when built in 1865 and named Fort Fletcher, was one of three new military posts established in Kansas. Fort Hays became one of the most famous military camps of its time. William F. CODY (1846-1917), nicknamed "Buffalo Bill," killed four thousand two hundred and eighty buffalo in eighteen months near Hays, to provide food for railroad workers and the fort. Hays developed as an outgrowth of the fort, and by the time the fort was abandoned in 1889 the town was a thriving ranching and railroad center. Now, in addition, it is supported by nearby oil wells. Education and medical facilities also are important. The old military post was deeded to the state and became Fort Hays State University with a four thousand acre dryland agricultural experiment station, one of the world's largest. Sternberg memorial Museum of the university has surprisingly large

collections of natural history materials. Nearby St. Fidelis Church is widely known as the Cathedral of the Plains.

HEAVENER RUNESTONE. Unlike its better-known counterpart, the Kensington (Minnesota) Runestone, the Heavener Runstone remains intact in the exact location in which it was discovered. It also appears to enjoy more scholarly support for its purported origin than that in the northern state. In 1830, hunters from nearby Heavener, Oklahoma, entered a wooded ravine and came upon a large stone with unknown carvings. The local people dismissed it as the more recent work of American Indians. However, one of the local women, Gloria Farley, began to investigate and came to the conclusion that the inscription was the product of Scandinavian explorers and that the date of the carving was November 11, 1012. This conclusion appears to have been corraborated by at least one prominent Scandinavian scholar, and local boosters claim that there has been general expert acceptance of the runestone's authenticity. This theory gains further credence from the discovery of similar smaller stones found in the general area and now on view in the Kerr Museum at Toteau, Oklahoma. The site of the original stone has been set aside as Heavener Runestone State Park. The stone rests precisely where it was discovered, and it is now protected by the park headquarters building.

HEINZE, F. Augustus. (Brooklyn, NY, Dec. 5, 1869—Butte, MT, Nov. 4, 1914). Mining engineer. Heinze used whatever means were available to forward his ambitions. After gaining a fortune in mining, he founded the United Copper Company (1892-1906), and he hired as many as thirty-two lawyers to handle countless court actions to beat his competition during the period when he operated his company. In 1906 Heinze sold his Butte properties to the Amalgamated Copper Company for $10,500,000 and agreed to the settlement of the 110 suits he had filed in the courts. He later became practically bankrupt and died at age 45.

HELENA DUEL. Named for Helena, Texas, a type of frontier fight where two men had their wrists tied together and fought it out with short-bladed knives.

HELENA, MONTANA

Name: From Helena Minnesota.

Nickname: The Last chance Gulf; Queen City of the Mountains; The Capital City.

Area: 13.3 (1980)

Elevation: 4,155 feet

Population:
1986: 24,670

Percent change (1980-1986): 3.1%

Density (city): per sq. mi. 1,800 (1980)

TV Stations: 2

Radio Stations: 10

Sports Teams:
Helena Brewers (baseball)

Further Information: Chamber of Commerce, 201 E. Lyndale, Helena, MT 59601

HELENA, Montana. City, state capital and seat of Lewis and Clark County, the state's fourth largest city, situated in the central west portion of the state on the eastern slopes of the Rockies, taking its name from a Helena in Minnesota.

In 1864 a group of discouraged prospectors wandered into a valley they felt was their last chance to find gold. They were lucky, and almost instantly "Last Chance" Gulch was filled with prospectors grubbing for gold. Millions of dollars flowed out of the valley. Today Last Chance Gulch is the main street of the capital. More than $20,000,000 in gold has come from the area, and minerals are still important, along with smelting and refining. Other major activities include, of course, the business of state, county and city government, as well as production of machine parts, paints and concrete. Farmland to the south provides another source of prosperity.

As the town grew rapidly in the 1860s and 1870s, a state election in 1874 chose Helena to replace VIRGINIA CITY as capital. In the 1890s ANACONDA tried but could not wrest the state's capital away from Helena. Silver and lead strikes in the area have continued to supply the mineral industries of the capital city.

CARROLL COLLEGE is the city's representative in higher education.

Today The Last Chancer, a simulated train and cars, carries tourists along Last Chance gulch. Legend has it that the many twists and turns in the main street were deliberately designed so that gunfighters could not get a long, straight shot at a proposed victim.

A unique display is the gold collection of

Helena, Montana's tour trolley now runs along Alder Gulch, site of the gold discovery.

Northwest Bank. Also of interest are the Original Governors Mansion, the Cathedral of St. Helena, with its 68 imported stained glass windows, and Reeder's Alley, an artists' center. The Neoclassic capitol is faced with Montana granite, the dome, of course, of Montana copper. Capitol murals are by Charles M. RUSSELL (1865-1926), premiere western artist.

Fifteen miles from Helena on the top of the CONTINENTAL DIVIDE is Frontier Town, a model pioneer village carved from the solid rock and finished with logs.

A cruise on the nearby MISSOURI RIVER offers a spectacular view of the Gates of the Mountains, the gorge LEWIS AND CLARK considered to be the river entry to the ROCKY MOUNTAINS.

HELIUM. Lightweight gas occurring in natural gas deposits, first found in 1903 in Kansas. The United States Bureau of Mines began producing helium at AMARILLO, Texas, in 1929.

Plants for producing helium are now found in New Mexico, Oklahoma and Kansas. Helium is mixed with oxygen by deep-sea divers to prevent nitrogen narcosi, and by the government to maintain proper pressure in rocket fuel tanks. Industrial uses of helium include heliarc welding where helium keeps oxygen from reaching the metal which might either burn or corrode. Helium is also used to prevent chemicals from reacting during storage or transportation. Safer than hydrogen, because it will not burn, helium provides the lift for scientific balloons and blimps, as well as for the small balloons so popular at birthdays and festivals. The Central West states hold a near-monopoly of helium's world production, of 1,299 million cubic feet (1984).

HELL'S HALF ACRE. Area near Waltman, Wyoming, known for its unusual rock formations and eroded canyons. It has been called a

"cave without a roof." The 320-acre chasm, surrounded by flat wilderness, contains spires, pits, crevices, deep canyons and oddly shaped stones. Because it was so different, the Indians believed it to be sacred, while trappers avoided it entirely on so-called bad luck days.

HELLGATE RIVER. One of the several names given to the CLARK FORK RIVER in Montana. The stream, beginning as the Silver Bow Creek, becomes, as it flows along, the Deer Lodge River, the Hellgate River, the MISSOULA and finally the CLARK FORK.

HENDERSON, James Pinckney. (Lincoln County, NC, Mar. 31, 1808—Washington, D.C. June 4, 1858). Texas statesman. On February 19, 1846, Henderson was inaugurated as the first governor of the state of Texas. Henderson had served the Texas Republic as attorney general in 1836, secretary of state from 1836 to 1837, diplomatic agent to England and France, with the power to effect treaties, from 1837 to 1840, and special envoy to the United States to assist with Texas annexation in 1844. He commanded United States volunteers during the MEXICAN WAR (1846) and served Texas in the United States Senate from 1857 until his death.

HENRY STANDING BEAR (chief). (Pine Ridge, SD, Reservation, date unknown, circa 1865—Pine Ridge Reservation, 1955) Sioux Indian leader. He told his fellow Sioux, "I have dreamed of a mountain top memorial like the vast carving on the peak that they now call RUSHMORE—a picture on a grand scale of our historic leaders, so that the white people may know that the red race had brave men and great men also..." This vision is supposed to have led to the plan for South Dakota's CRAZY HORSE MEMORIAL. When finished it is expected to be the world's largest work of art.

HENRYETTA, Oklahoma. City (pop.6,432). Seat of Okmulgee County, east-central Oklahoma, southwest of MUSKOGEE and east of OKLAHOMA CITY. Henryetta was the home of legendary rodeo star Jim Shoulders, winner of sixteen national rodeo championships.

HERTZLER, Arthur E. (West Point, IA, July 26, 1870—Halstead, KS, Sept. 12, 1946). Physician and medical pioneer. His autobiography entitled *Horse and Buggy Doctor* brought him a nationwide reputation. Hertzler made important discoveries in the use of local anesthesia and in diseases of the thyroid gland. Beginning

in 1894, he conducted research into diseases of the peritoneum. In 1902 Hertzler founded the Agnes Hertzler Memorial Hospital.

HIAWATHA, Kansas. Town (pop. 3,702). Seat of Brown County, in far northeast Kansas, named for the Iroquois Indian leader made famous by Longfellow. Hiawatha is the home of the unique Davis Memorial, an unusual tribute commissioned by John Davis in memory of his wife, Sarah, at a cost of $500,000. This work consists of eleven life-sized Italian marble statues of Davis and his wife, depicted at different periods of their lives. The figures are protected under a marble canopy. The town offers visitors the unusual brilliant fall spectacle of more than one hundred varieties of maple trees planted by the residents to enhance the beauty and appeal of their streets. The Halloween Frolic and Parade, lasting a week, has been held since 1914.

HICKOK, James Butler (Wild Bill). (Troy Grove, IL, May 27, 1837—Deadwood, SD, Aug. 2, 1876). Army officer, scout, United States Marshall. Hickok, has been considered by some historians to be the best known gunfighter of the Old West. This reputation came about largely because of the narrative of his exploits published in *Harper's New Monthly Magazine* in February, 1867, as Hickok related them to author Colonel George Ward Nichols.

Hickok moved to Kansas in 1855 and took part in the border wars of the region. He served as constable in Monticello Township, Kansas, in 1856 and participated in the highly controversial gunfight at Rock Creek Station, Nebraska, in which he killed the stationmaster and two other men, an act for which he gained immediate notoriety. Hickok served as a stage driver on the SANTA FE TRAIL and a scout for the United States Army during the CIVIL WAR, before his appointment as deputy United States Marshal at FORT RILEY, Kansas, in 1866.

He was the marshal of HAYS CITY, Kansas, in 1869 before succeeding Tom Smith as the marshal of ABILENE, Kansas, in 1871 where he began a shotgun patrol of the streets. Hickok dressed picturesquely in a Prince Albert coat, checked trousers and occasionally a silk-lined cape. He carried silver-mounted pearl-handled revolvers when dressed up, but preferred heavy double-action army pistols for everyday use.

While marshall of Abilene, Hickok increased his number of confirmed killings from 43 to 100. From 1872 to 1873 Hickok toured the East with Buffalo Bill, displaying such sure-shooting

feats as keeping a tomato can dancing in the dust by shooting a revolver from each hand, or perforating a hat brim while it was spinning in the air. Hickok returned west in 1874 and spent some uneventful time in CHEYENNE, Wyoming, where it appears he tried hard to avoid trouble. There is speculation he was losing his eyesight from glaucoma or venereal disease.

Hickok was warned against taking the marshall's job in DEADWOOD, South Dakota, but he went there in 1874 and was shot from behind by Jack McCall while playing cards. McCall may have been acting as a hired killer or as a grieving friend of a man Hickok killed in SIDNEY, Nebraska, in 1874. Hickok was buried in Mt. Moriah Cemetery in Deadwood where his grave became such an attraction that the original marker had to be replaced five times as each marker was torn apart by souvenir hunters. It was said that he never killed a man except in self defense.

HIDATSA INDIANS. Siouan tribe (also People of the Willows and Minnetaree), living in North Dakota near the meeting place of the MISSOURI and KNIFE rivers. The Hidatsa were composed of loosely associated bands which were subdivided into seven clans. Clan membership was inherited through the mother. Men belonged to age-graded military societies. Important to the Hidatsa religion was the preserving of medicine bundles and the seeking of visions through fasting. Villages were ruled by a village council, chief and warchief. Hidatsa villages were made of earthen lodges and located along the river. Each lodge housed two or three families. The Hidatsa economy was based on hunting and agriculture. The preferred foods were corn and buffalo. The Hidatsa and CROW may have been one tribe until the late 17th century when the Crow moved farther west. The Hidatsa population, severely reduced by smallpox in 1837, and warfare with the SIOUX INDIANS, was practically confined to several villages on the Knife River when visited by LEWIS AND CLARK in 1804. In 1862 an area along the Missouri River inhabited by the Hidatsa, MANDAN, and ARIKARA tribes was established as the Fort Berthold Reservation. The size of the reservation was reduced in 1887 when the land was assigned in severalty and again in the 1950s when the Garrison Dam flooded nearly one-quarter of the reservation, including its best farming lands. In the 1970s tourist facilities were established by the three tribes on Lake SAKAKAWEA, the reservoir formed by Garrison Dam.

HIGHLAND LAKES. Eighty mile chain of lakes near SAN ANTONIO, Texas, including Lake Austin, Lake Lyndon B. Johnson, Lake Marble Falls, Inks Lake, and Lake Buchanan.

HIGH PLAINS REGION. Usually designated as a division of the larger GREAT PLAINS REGION, the High Plains extend southward from the westward third of Kansas, through western Oklahoma and the Oklahoma PANHANDLE, through the Texas PANHANDLE and portions of west-central Texas, reaching as far west as eastern New Mexico and Colorado.

HIGHWOOD MOUNTAINS. Range of Montana mountains northeast of Great Falls.

HILLSBORO, Kansas. Town (pop. 2,717), Marion County, central Kansas, northeast of HUTCHISON and southeast of SALINA, named for early settler John G. Hill. Hillsboro was settled by Russian Mennonite immigrants in the late 1870s. Today the community is the home of the Mennonite Brethren Headquarters of North America as well as Tabor College.

HISTORY The first record of European explorers in the Central West region occurred along the Texas' gulf coast in 1519, when Alonzo Alvarez DE PINEDA mapped most of the coast. He made such discoveries as Corpus Christi Bay and the RIO GRANDE RIVER and a few years later established a short lived colony at what is believed to have been the mouth of the Rio Grande. The shipwrecked party of Alvar Nunez CABEZA DE VACA (1490-1560) was held captive in present Texas by the Indians and escaped being eaten by demonstrating "supernatural" powers. They crossed Texas on foot in about 1536 and returned to Mexico.

To the north, the mammoth expedition of Fransico CORONADO (1510-1554) crossed parts of New Mexico and Texas, Oklahoma, Kansas and possibly Colorado (1540-1542). Their historian wrote, as translated, "Who would believe that a thousand horses and five hundred of our cows, and more than five thousands rams and ewes, and more than fifteen hundred friendly Indians and servants in traveling over these plains, would leave no more trace where they had passed than if nothing had been there."

Another great expedition, financed and headed by Don Juan de ONATE (1550?-1630), entered Texas in 1598 and passed through much of New Mexico, bringing 7,000 head of stock, a supply train of 83 wagons and carts along with seventeen aristocratic Spanish gen-

Among the many historic places of the region, one of the lesser-known is the site at Fort Robinson, now marked by a monument, where the great Chief Crazy Horse was killed while supposedly trying to escape capture by the U.S. Army.

tlewomen riding in ox carts and dressed in satins and velvets, and 400 soldiers and settlers. On July 11, 1598, they established a settlement in New Mexico, the second in the present U.S., at the Tewa Pueblo called Yugeuingge.

The first permanent European settlement in Texas was called YSLETA. It was begun in 1682 near present EL PASO on the Mexican side but came to the U.S. side with a shift in the Rio Grande. Spanish settlement and control grew stronger throughout the southwest and even as far north as Colorado.

Meanwhile, to the north, some stories say Norse explorers had reached the RED RIVER OF THE NORTH as early as 1100 A.D. However, France claimed a large part of the area much later, in 1682. French traders and trappers came into the northern portions of the region, but the first official representative of France was Pierre Gaultier de Varennes, called Sieur de la VERENDRYE (1685-1749), in 1738. He and his sons explored the Dakotas in 1742.

The first fur trading post in the Dakotas was set up by Charles Chaboillez in 1797 at what is now PEMBINA, North Dakota. Other trading companies followed. Then America's most important exploration, the party of LEWIS AND CLARK advanced up and across and back across the Central West region in 1804-1806. The contacts they made with the Indians, the geographical, floral, fauna and minerals discoveries they made opened the way for much of the exploration, trade and settlement which were to follow.

To a lesser extent the same was true of the explorations of Zebulon PIKE (1779-1813) in the Southwest in 1806.

In the northern portions of the area, more and more fur traders and major trading companies set up operations. From 1824 through the 1840s, the annual fur trappers RENDEZVOUS brought hundreds of whites and Indians together to trade. Although furs were valuable in the southwest, trade there was more varied because settlements had been established for some time. In 1824 the opening of the trail to SANTA FE from established settlements in Missouri brought fantastic profits. This led to the establishment of private trading forts along the way, such as FORT BENT, in 1828, and prepared the way for substantial U.S. incursions in the area.

The struggle for Texas independence was the principal historical event of the mid 1830s when the ALAMO fell and its defenders were

massacred, and Sam HOUSTON (1793-1863) won Texas independence from Mexico with the Battle of SAN JACINTO (April 21, 1836) and was made first president of the Republic of Texas in 1836.

This was one of the principal events bringing on the WAR WITH MEXICO in 1846. Santa Fe was captured by U.S. forces without a shot, and at Brazito, New Mexico, Mexican forces were defeated on Christmas day, 1846. At the end of the war, U.S. control of Texas and New Mexico was guaranteed, along with territory that carried U.S. borders to the Pacific for the first time.

Meanwhile, other states had gained permanent settlements. SALINA had been established in Oklahoma in 1817, BELLEVUE at Nebraska in 1823, FORT LEAVENWORTH in Kansas, 1827, FORT UNION, 1828, serving as the main river port of the time for both Montana and North Dakota, also in 1828 FORT BENT in Colorado, PIERRE in South Dakota, 1831 and LARAMIE in Wyoming, 1834.

Most of these became important jumping off places in the great movements to the West, along the Santa Fe and Oregon trails and other routes. The hordes of gold seekers to California and the settlers on the routes to various destinations of the West all found comforts and supplies in the growing settlements.

One of the most amazing episodes in American history occurred with the forced movement of the FIVE CIVILIZED TRIBES to Oklahoma and the remarkable civilization which they built, beginning as early as 1820 and continuing after 1834 when INDIAN TERRITORY was established in the wilderness there and during the entire period when they were semi-independent nations.

The settlement of Kansas was both hastened and complicated by the rush to establish both pro- and anti-slavery settlers, in the effort to decide whether Kansas would be free or slave. These forces clashed with such fury that Kansas was described as "Bloody Kansas." This was one of the important elements in bringing on the CIVIL WAR (1861-1865). Battles of that war were fought in Kansas, and guerrila warfare brought even worse hardships to the state during the war. Other states of the region experienced battles of that war including both Texas and New Mexico.

Although the northern portion of the region escaped "formal" Civil War battles, with the government forces occupied elsewhere, Indian warfare plagued much of the area during the war. After the Civil War, wars with the Indians increased in intensity, climaxing with the notorious defeat of Colonel George Armstrong CUS-

The lofty monument at San Jacinto near Houston, Texas, commemorates Samuel Houston's phenomenal victory at the Battle of San Jacinto, now said to have been one of the ten most crucial battles of world history.

TER (1839-1876) in the Battle of LITTLE BIG HORN in Montana June 25, 1876. By the 1890s the Indian conflicts had ceased.

The settlement and general economy of both the region and the nation were vastly enhanced with the completion of the first transcontinental railroad in 1869, headquartered at OMAHA, Nebraska and crossing the heart of the Central West region. The ATCHISON, TOPEKA AND SANTA FE RAILROAD performed the same function in the Southwest.

One of the historic documents of all times, Allied commander Dwight D. Eisenhower's proclamation of the end of World War II, is preserved in the general's own handwriting at the Eisenhower Center, Abilene, Kansas.

After the Civil War, the great herds of cattle of the Texas plains had been driven across the prairies on the CHISHOLM and other noted trails, over which hundreds of thousands were shipped to the newly established railheads for shipment to eastern markets. Others were driven farther north and fattened on the rich grasslands of Montana.

The gold, silver, copper and other minerals of South Dakota, Colorado and Montana brought wealth and a rush of settlers to those states, along with the rip-roaring mining towns such as CENTRAL CITY, Colorado, BUTTE Montana, and DEADWOOD, South Dakota.

The opening of Oklahoma to outside settlement in the 1890s and the creation of Oklahoma's capital, OKLAHOMA CITY, and other cities literally "overnight" was one of the unique episodes in U.S. history.

Montana, North Dakota and South Dakota all attained statehood in 1889, and Oklahoma and New Mexico became states in 1907 and and 1912, respectively.

A principal economic development was the discovery of oil in most states of the region, particularly in Texas and Oklahoma. The oil and gas industries of those states have brought great wealth not only to the region but also to the country as a whole. The Twentieth Century brought important events too numerous to mention, including in 1900 the worst natural disaster ever to strike the country, when as many as 7,000 persons lost their lives in the hurricane and flood at GALVESTON, Texas. That state also suffered two others of the country's worst DISASTERS in the NEW LONDON School disaster of 1934 and the TEXAS CITY explosion of 1947.

Disasters of another kind, the two WORLD WARS, took hundreds of thousands of men and

women of the region to war service and battle-fields, and brought death for too many. New Mexico was the site of a world shaking event during World War II when the first atomic bomb ever was exploded at the TRINITY SITE in 1945.

Other disasters, one natural, the other man-made, occupied the region throughout the 1930s—the twin plagues of DROUTH and DUST STORMS and the Great Depression. Since much of the region was hardest hit of all by the drouth and the terrible clouds of dust that continued to roll across most of the region, the Central West suffered more, perhaps, than any other. The suffering is well documented in the ac-counts of such problems as those suffered by the "Okies" of Oklahoma.

Happier times came with the creation of SHELTER BELTS, widespread use of conservation measures in agriculture, the building of the great dams and creation of artificial lakes which transformed many once dry prairie states into lands of great lakes.

The transformation of Nebraska's govern-ment into a UNICAMERAL system in 1934; the completion of the sculptures of MOUNT RUSHMORE in 1941; the earthquake of 1959 in Montana and Wyoming, which created a new lake and altered many of the thermal features of YELLOWSTONE NATIONAL PARK; the elections which brought Texas natives Dwight D. EISENHOWER (1890-1969) and Lyndon B. JOHNSON (1908-1973) and Nebraska native Gerald FORD (1913-) to the presidency of the country—all were events of note throughout the region.

Another president was involved in one of the saddest events of the century when John F. KENNEDY (1917-1963) was assassinated in DAL-LAS, Texas, in 1962. Also in the 1960s, the almost unbelieveable NORTH AMERICAN AIR DE-FENSE COMMAND (NORAD) headquarters opened in 1965 in the heart of CHEYENNE MOUNTAIN, near COLORADO SPRINGS.

The first year of the 1970s witnessed the opening of the CLELLAND-KERR NAVIGATION SYSTEM, making ocean traffic accessible up the ARKANSAS RIVER into Oklahoma, and bringing new opportunities for prosperity to the states served by the system. RAPID CITY, South Dakota, experienced a disastrous flood in 1973, and in 1974 Indians gathered once again at WOUNDED KNEE to protest their treatment by the U.S. government. In 1978 the first discovery in the hemisphere of a dinosaur nest with eggs was made at Chouteau, Montana.

In 1980 the U.S. Supreme Court ordered federal authorities to pay the SIOUX INDIANS 122

million dollars for lands seized in 1877. The frightening television image of a Russian take-over was filmed at LAWRENCE Kansas in 1984. Senator Gary Hart of Colorado, a Kansas native, lost bids for the Democratic presiden-tial nomination in both 1984 and 1988, and the city of AURORA, Colorado, became the fastest growing of all American cities in the top 100 of population.

HOBBY, Oveta Culp. (Killeen, TX, Jan. 19, 1905—). Newspaper publisher and politician. The first woman parliamentarian for the Texas House of Representatives (1925-1931, 1939-1941), she went to work for the Houston *Post* after marrying its publisher William Pettus Hobby. In 1938 she became the paper's execu-tive vice president and editor. Mrs Hobby served as a colonel and director of the Women's Army Corp (WAC's) in WORLD WAR II, and became the first secretary of health, education and welfare in 1953 under President Dwight EISENHOWER (1890-1969). After her resignation (1955) she returned to the *Post*, and became chairman of the board in 1965.

HOGANS. Dwelling associated with the NA-VAJO who built the structure in a conical or rectangular shape with brush and grass plas-tered with mud. Doorways faced east, and an opening in the roof allowed smoke to escape. Certain superstitions led to hogans being de-stroyed or the position of the doorway being changed.

HOGS. The Central West states account for only about 16% of the total U.S. hog population, with an annual total of 8,277 million hogs/pigs. Nebraska is far and away the Central west leader with 3,700 million, followed in the region by Kansas and South Dakota with 1,600 each. The other states of the region annually produce fewer than a million hogs and pigs, with Wyoming producing only 250,000.

HOLLADAY, Ben. (Carlisle County, KY, 1819—Portland, OR, 1887). Transportation businessman. Holladay, a man of minimal education, was a shrewd businessman who, in 1858, became associated with Russell, Majors and Wadell when he bought large quantities of livestock for them. In 1860 he loaned money to assist the Central Overland California and Pike's Peak Express Company, owned by Rus-sell, Majors and Waddell, in establishing the PONY EXPRESS. He took over the holdings of that

partnership at a foreclosure sale in March, 1862, for $100,000. Holladay organized the Overland Stage Line which operated the eastern section of the trans-Mississippi stage mail until 1864. He also operated branch lines into Colorado and Nebraska on which he carried government mail. In 1864 Holladay was awarded a four-year government contract to carry the mail eastward of Salt Lake City and on new branches he established in Montana, Washington, Idaho, and Oregon. Financial setbacks from Indian attacks forced him to sell out to WELLS, FARGO AND COMPANY in 1865. Other business setbacks later forced him into retirement in 1876. Holladay was an unscrupulous businessman who bought influence, juggled his books, engaged in price wars which drove competitors out of business and allowed him to increase his prices drastically. He may have even staged "Indian" attacks on rival lines. He traveled by private coach outfitted with a food locker and silver decanters. By contrast, Holladay also grubstaked many prospectors and contributed generously to charities.

HOLLIDAY, Cyrus K. (Carlisle, PA, April 3, 1826—Topeka, KS, Mar. 29, 1900). Railroad executive. Holliday, as president of the Topeka Town Company from 1854 to 1859, along with several other pioneers chose the site of TOPEKA, Kansas, as a railroad center. The men succeeded in founding the city and convincing the Kansas Constitutional Convention of 1859 to name the city the state capital. Holliday drafted the bill which chartered the ATCHISON, TOPEKA AND SANTA FE RAILROAD, which he served as a director from 1859 to 1900.

HOLLY. Evergreen tree with green, glossy leaves and red berries whose branches are used for Christmas wreaths. The name holly comes from the past use of the tree in houses and churches at Christmas when it was called the *holy tree.* Growing in many of the states from Massachusetts to Texas, the native holly tree may reach one hundred feet in height. Texas has claimed having the country's largest American holly tree, while the largest field of holly was observed in McCurtain County, Oklahoma.

HOLY CROSS, MOUNT OF THE. A peak in the SAWATCH RANGE of the ROCKY MOUNTAINS. Located in Eagle County in northwest central Colorado, the peak is 14,005 feet high. When transecting valleys on the mountain are filled with snow, they appear to form an almost perfect white cross.

"HOME ON THE RANGE." State song of Kansas and favorite song of former president F.D. Roosevelt and millions of Americans, first written as a poem by Dr. Brewster Higley about his dugout home on the banks of Beaver Creek in Smith County, Kansas. The poem, had its first printing in the Smith County *Pioneer* in 1873, was put to music by Daniel Kelley.

HOMESTAKE GOLD MINE. One of the largest producing gold mines in the Western Hemisphere, in operation near LEAD, South Dakota, since 1876 except for a period during WORLD WAR II. Among those to prosper from the mine was George Hearst, father of William Randolph Hearst, who increased his fortune from his initial investment. Rapid increases in the price of gold in the 1970s and 1980s brought substantially increased operations in the mine during that period. Tours of the surface operations are available.

HOMESTEAD ACT. Legislation passed by Congress in 1862 which provided that the head of a family could acquire a quarter section of government land, if the family settled and cultivated it for five years. At the end of the five years the settler acquired title to the land. The head of a family had to be either a citizen or to have declared his intention of becoming a citizen. The act stimulated post-Civil War westward movement, and altogether about 400,000 families moved into the region and claimed homesteads. By 1890 all then available federal land had been settled.

HOMESTEAD NATIONAL MONUMENT OF AMERICA. One of the first claims under the Homestead Act of 1862 was filed for this land; includes Freeman School, authorized March 19, 1936, headquartered BEATRICE, Nebraska.

HOMESTEAD PIONEER. Title claimed by the residents of Nebraska for Daniel Freeman. Freeman, scheduled to leave for military service, was allowed to make his homestead claim at the land office in BEATRICE just minutes after midnight on January 2, 1863. The land claimed by Freeman was set aside in 1936 through the efforts of Senator George NORRIS (1861-1944) as "a proper memorial emblematical of the hardships and the pioneer life through which the early settlers passed in the settlement." It is now the HOMESTEAD NATIONAL MONUMENT OF AMERICA.

The Homestake Goldmine is now said to hold the world record for value of gold produced.

HONEY, Uvalde. UVALDE, Texas, is the self-proclaimed "Honey Capital of the World." The honey produced in the area comes from nectar gathered from special desert blossons which create the uniquely flavored Uvalde Honey.

HONEYBEE. Only three states of the Central West have chosen an official state insect. The three states are Kansas, Nebraska and South Dakota. The insect they all have chosen is one of the most beneficial to mankind, the honey-bee. Scientists have named 20,000 different species of bees. The honeybee is one of a group of about 400 species of so-called social bees. Honeybees are kept throughout the world. In North America, the honeybee commonly kept for production of honey, or apiculture, is a native of Europe.

HOPE DIAMOND. Blue diamond of 45.5 carats, principally associated with Evelyn Walsh McLean, Colorado heiress. It became the property of the Smithsonian Institution in 1958, a gift she considered appropriate in returning to the nation an outstanding mineral treasure from one who had become a leading social figure despite her humble beginnings as a miner's daughter. She further emphasized her background with her book entitled *Father Struck It Rich*, the story of her father Thomas F. WALSH who made and lost a fortune in LEADVILLE and then made a larger fortune in the Camp Bird Mine of OURAY, Colorado.

HOPI INDIANS. Shoshonean tribe originally living in pueblos in northeastern Arizona and descendants of the ANASAZI, or "ancient ones," who lived in cliff dwellings throughout the southwest before drought conditions brought them to the region of BLACK MESA. The tribal name is derived from the name they gave themselves, Hopitu, meaning "peaceful ones." They were also called the Moqui.

The tribe was divided into twelve phratries each of which contained numerous clans. Clan membership was inherited through the mother. Marriage was forbidden into the clan or phratry of either the mother or the father. The clan could own land and give it to its members for use.

Each clan also had a ceremonial house in which rituals were held and religious objects were kept. Hopi religion included many spirits, such as the Katchina, who were often imper-

sonated in rain dances and other rituals. Specialized societies existed such as those for weather control.

With the exception of Oraibi, dating from the 12th century, the present-day pueblos of the Hopi are relatively recent. Before Spanish times, Hopi villages were located at the base of Black Mesa. During the Pueblo Revolt in 1680 they were moved to the top of the mesa for better defense. These mesas contained one and two-story houses of sandstone plastered with adobe and subterranean rectangular kivas which were religious centers.

The traditional Hopi grew corn, cotton, beans and squash. Agriculture was carried out anywhere water was present or could be collected. The women gathered pine nuts, yucca, currants, seeds and prickly pear. The men hunted large and small game.

Presently, nearly 7,200 Hopi live in northeast Arizona on a 2,470,000-acre reservation completely surrounded by the NAVAJO Reservation. Hopi pottery, textiles, katchina dolls, silverwork and basketry remain popular tourist attractions.

HOPLITOSAURUS. Rare prehistoric horned toad which was fifteen feet tall. Its remains have been found near BILLINGS, Montana.

HORNSBY, Rogers. (Winters, TX, Apr. 27, 1896—Jan. 6, 1963). Baseball player. Hornsby is a legend among baseball players and fans. He was the batting champion in the National League from 1920 to 1925, and again in 1928. Considered the greatest right-hand pitcher of all time, his 1924 record of .424 still stands as a modern day league record. He was player-manager for the St. Louis Cardinals from 1925 to 1926, leading the team to a winning World Series in 1926. He maintained a lifetime batting average of .358 from 1915 to 1933, won the most valuable player awards in 1925 and 1928, and was elected to the National Baseball Hall of Fame in 1942.

HORSE, three-toed. Prehistoric animal, twenty-four inches high, whose remains have been found in many parts of the region, particularly in the BADLANDS of South Dakota. An interesting display of prehistoric horse remains is mounted at the School of Mines Museum, RAPID CITY, South Dakota.

HORSES, WILD. The term wild horse was used to differentiate undomesticated horses from the "mustang," Spanish-blooded horses.

Today the terms "wild horse" and "mustang" are used interchangeably. Wild horses, a product of many stocks including the Spanish breed, are indigenous to North America. Fossil remains suggest that the wild horse lived in large numbers over much of the continent until fifteen thousand years ago when, for unknown reasons, the wild herds disappeared over a period of seven thousand years. Domesticated horses, brought to the New World by the Spanish, were pastured in large herds on the open range until a spring roundup, when the animals were gathered together for branding and the unbroken horses were trained. Some of these horses escaped their owners, while others were taken from the Spanish by Indian servants when they ran off to live with the wild tribes on the GREAT PLAINS. The escaped horses lived on in many parts of the region and became plentiful. Wild horses developed into two types. One variety, with light bones and a trim shape, was often captured and used for riding. The second variety, with large bones and a stocky build, was the draft horse. The millions of wild horses which lived in the West of the nineteenth century have been reduced in number to about seventeen thousand. Because of the use of the animal for pet food and the inhumane methods of capture, well-organized campaigns have led to legislation placing these animals under federal protection. They are increasingly seen in many parts of the region as symbols of stamina, ruggedness, and unbridled freedom, traits needed by the pioneers themselves to tame the frontier. Leader of efforts to protect the wild horse, Mrs. Velma Johnston, of Reno, Nevada, was nicknamed "Wild Horse Annie." Public Law 86-234, known as the "Wild Horse Anne Act," prohibits the use of mechanized and airborne vehicles in rounding up horses. Two areas have been reserved by the federal government for wild horses. One, a refuge in Nevada, is in the Nellis Air Force Base bombing range, while the other is the Pryor Mountain Wild Horse Range on the Montana-Wyoming border. Scientific study continues on the role of the wild horse in the ecology of the West.

HOT SPRINGS (Wyoming). Hot Springs State Park, across the BIG HORN RIVER from THERMOPOLIS, Wyoming, boasts the world's largest hot medicinal springs, Bighorn Spring, along with many others. The millions of gallons of water emitted by Bighorn Spring, at 135 degree temperature, pour into the Big Horn River, which never freezes in the area. The colorful limestone terrace built up by the

springs is one of the largest and finest any-
where. The medicinal properties of the waters
were highly prized by the Indians, and the great
Chief WASHAKIE (1804?-1900) built a bathhouse
at one of the springs. He finally made a gift of
the springs to the state of Wyoming. In honor of
the gift the colorful pageant "Gift of the
Waters" is held each year at the park, and
Washakie Fountain at Thermopolis commemo-
rates the peaceful leader.

HOT SPRINGS, South Dakota. Town (pop.
4,742). Seat of Fall River County, southwestern
South Dakota, northwest of Pine Ridge and
southwest of RAPID CITY. Quarries of pink and
buff sandstone are found near Hot Springs. In
the past the mineral springs were considered
much more important. The SIOUX and CHEYENNE
once fought on Battle Mountain for possession
of the springs, which they felt offered a cure for
all ills. The community, first settled in 1879,
once provided quick divorces, which were possi-
ble in South Dakota in the early 1900s. Today,
with quick divorce laws repealed in the state,
the mineral springs continue to be a popular
tourist attraction. EVANS PLUNGE is fed by
springs which create the largest natural indoor
warm water pool in the world, flowing at the
rate of 5,000 gallons per minute. Less than two
miles south of Hot Springs scientists have
discovered the largest concentration of mam-
moth bones ever found in the Western Hemi-
sphere. An annual CRAZY HORSE pageant recalls
the life of the famous Sioux warrior (1842?-
1877).

HOUGH, Emerson. (Newton, IA, June 28,
1857—Evanston, IL, Apr. 30, 1923). Author.
Hough's trip on skis through YELLOWSTONE
NATIONAL PARK in the winter of 1895 and his
resulting stories of its wonders was largely
responsible for passage of the act protecting the
park buffalo. Hough's best remembered novel
The Covered Wagon (1922) is considered one of
the most popular stories about the West and
the glory of the OREGON TRAIL. It was made into a
classic and enormously successful motion pic-
ture in 1923. Hough picked up many experi-
ences and insights into the West as he worked
on the White Oaks, New Mexico, newspaper.

HOUSE, Edward Mandell. (Houston, TX,
July, 26, 1858—New York, NY, Mar. 28, 1938).
Diplomat. He was a political adviser to several
Democratic Texas governors between 1892 and
1904. Governor James Hogg (Texas) gave
House the honorary title of "colonel." He

assumed a major role in Woodrow Wilson's
1912 presidential campaign, and refused a
cabinet post, choosing instead to help Wilson
in a variety of political and administrative
functions. He became recognized as Wilson's
chief agent in foreign affairs and helped explore
mediation alternatives with European coun-
tries in WORLD WAR I. He headed a U.S. mission
to the Inter-Allied Conferences in London and
Paris that led to the coordination of the Allied
effort, and was one of the signers of the Treaty
of Versailles in June 1917. After he advised
Wilson to consider compromise for the ratifica-
tion of the treaty and the entry of the United
States into the League of Nations, the two men
separated, never seeing each other again.
House, along with Charles Seymour, edited a
collection of essays by American delegates to
the peace conference called *What Really Hap-
pened at Paris* (1921).

HOUSTON, D. H. (Glasgow, Scotland, June
14, 1841—Hunter, ND, May 6, 1906) Inventor,
rancher. After being brought to Wisconsin as a
boy, Houston served in the CIVIL WAR and in
1879 bought ranch land near Hunter, North
Dakota. This was the beginning of what became
one of the largest and most prosperous farming
ventures in the area. For his ranching improve-
ments and his inventions, Houston became
known as the "Genius of the Prairie." This
North Dakota experimenter invented, and on
June 21, 1881, patented the roll film camera, an
advance which is generally credited to George
Eastman of the Eastman Kodak Company. The
name Kodak is said to have been applied by
Houston to his camera in honor of his state, as
a version of Dakota spelled backward. George
Eastman, founder of the Kodak Company,
contested that claim. However, Houston is
quoted as stating flatly, "I devised the name
myself," but Eastman trademarked the name.
Houston patented a total of 20 inventions
related to photography, all sold to various
photographic manufacturers. He is said to have
patented an improved model of the disc plow
and developed a strain of wheat capable of
producing a larger yield. The "prairie mansion"
Houston built on his ranch was moved to Fargo,
where it remains on display.

HOUSTON, Samuel. (Rockbridge County,
VA, Mar. 2, 1793—Huntsville, TX, July 26,
1863). Politician, statesman. As a child, Hous-
ton was brought to Tennessee where he spent
several years with the CHEROKEE INDIANS, who
named him "The Raven." In 1814, although

The famed portrait of an aging Sam Houston by Freeman Thorp.

badly wounded, he distinguished himself at the Battle of Horseshoe Bend against the CREEK tribes, leading to a close friendship with his commander, Andrew Jackson.

After a brief study of the law, he entered Tennessee politics as a Jacksonian Democrat, serving in Congress from 1823 to 1827 and being elected governor of Tennessee in 1827. He resigned his governorship two years later, in the wake of a highly publicized separation from his wife of three months, and went to live again with the Cherokees in what is now Oklahoma, taking a wealthy and highly placed Indian wife there and becoming a Cherokee ambassador in Washington.

In 1833 Houston first went to Texas, where he gained immediate fame as a hard-line proponent of the region's independence from Mexico. Named commander-in-chief of the Texas revolutionary troops in 1836, he responded to the massacre at the ALAMO in that year by leading a masterful retreat across Texas to present SAN JACINTO. His brilliant strategy brought hated Mexican General Santa Ana into a trap and led to his capture with his army of 1,500 in the Battle of SAN JACINTO (April 21, 1836), with almost no casualties to Houston's

own army of only 800. Although a small conflict as battles go, the Battle of San Jacinto has been called one of the ten most crucial battles in history because of the consequences which followed.

Houston's success was the motivation for his overwhelming victory in the election for president of the newly independent Texas Republic, serving from 1836 to 1838 and again from 1841 to 1844. Texas was admitted to the Union as a state in 1845, and as a Democrat Houston served as both United State senator (1846-1859) and governor of Texas (1859-1861). An eloquent orator on the need to preserve the Union, he was forced to resign as governor in March of 1861 because the secessionist movement prevailed in the state, and Houston refused to take the oath of allegiance to the Confederate States. In his speeches he had predicted the terrible tragedy that would befall his beloved state if it entered the Confederate ranks. No other person has served as a governor of two states, as a congressman from one state and a senator from another and as the president of a recognized independent nation.

HOUSTON SHIP CHANNEL. Vital to the shipping industry of HOUSTON, Texas, the channel, originally 300 feet wide, 36 feet deep and fifty miles long, was widened to 400 feet during the 1960s. Interest in port improvement and channel deepening began as early as 1869 when the Buffalo Bayou Ship Channel Company was organized. In 1873 Commodore Charles Morgan, often called the "father of the ship channel," began private dredging and deepened the channel off Morgan's Point. Civic leaders went to Congress in 1900 and won approval for deepening the waterway to 18.5 feet, but the work carried on between 1902 and 1905 soon proved inadequate. When cargo vessels found the new channel hazardous, Houston again petitioned Congress for help and offered to pay half of the cost. The work on the deepening the channel to 36 feet deep was completed in 1914.

HOUSTON, TEXAS

Name: From Samuel Houston.(1793-1863), first President of the Republic of Texas.

Nickname: The Space Center; Home of the Astronauts; Energy Capital of the World.

Area: 572.7 square miles

Elevation: 55 feet

Houston, Texas

Population:

1986: 1,728,910

Rank: 4th

Percent change (1980-1984): +8.4%

Density (city): 3,019 per sq. mi.

Metropolitan Population: 3,565,656 (1984)

Percent change (1980-1984): +15%

Race and Ethnic (1980):

White: 61.33%

Black: 27.61%

Hispanic origin: 280,691 persons (17.64%)

Indian: 3,945 persons (0.20%)

Asian: 35,448 persons (2.07%)

Other: 134,607 persons

Age:

18 and under: 28.4%

65 and over: 6.9%

TV Stations: 8

Radio Stations: 40

Hospitals: 45

Sports Teams:

Houston Astros (baseball)

Houston Oilers (football)

Houston Rockets (basketball)

Further Information: Houston Chamber of Commerce, 1100 Milam, Houston, TX 77002.

HOUSTON, Texas. City, seat of Harris County, in southeastern Texas. Houston is the fourth-largest city in the United States and the third-largest port, owing to its direct linkage to the Gulf of Mexico, 50 miles away, via the HOUSTON SHIP CHANNEL and the GULF INTRACOASTAL WATERWAY. Houston has had a steady population and commercial growth until the problems of oil in the 1970s. Major growth had begun with the discovery of oil in the area in the early 1900s.

The Houston metropolitan area covers 6,931 square miles, containing several counties and a multitude of communities, many of them annexed to the city in recent years.

The city is a major petrochemical and petroleum refining center. Besides oil and gas and shipping concerns, other significant industries in Houston include the manufacture of chemical and electrical equipment, government, medical, professional services, aerospace research,

and agricultural activities. Thousands of people are employed in the city's enormous retail industry.

Houston was settled soon after the Mexicans were defeated by the troops of Sam HOUSTON (1793-1863) nearby in the Battle of SAN JACINTO (April 21, 1836) and named in Houston's honor. From 1837 to 1839 and from 1842 to 1845 Houston was the capital of Texas. In spite of its humid, somewhat swampy location Houston grew steadily, becoming a major cotton shipping port by the middle of the 19th century, the result of successful afforts to link Houston with the Gulf of Mexico. As the waterway to the Gulf was improved, and with the coming of the railroad, Houston began to mushroom in population and land area. Cotton was king until 1901, when oil was discovered and since then, Houston's economy and history have been dominated by oil. Until the problems with oil in the 1980s, skilled and unskilled labor had been pouring into the the the city for years. This great growth brought a diverse group of people to the semitropical climate of Houston. There are large minority populations of blacks, Mexicans, and others. In order to absorb the steady increases in population, the city has been forced to expand repeatedly.

Because its low-density population is a deterrent to mass transportation, most residents rely on cars, which means that Houston, like many other major cities, has major traffic problems.

Houston has a wide variety of sports, cultural, and recreational offerings. Three professional sports teams are based there: the Houston Oilers football team, the Houston Rockets basketball team, and the Houston Astros baseball team. The Oilers and the Astros both play their home games in the famous Houston Astrodome, the world's first fully enclosed football and baseball stadium.

Houston has its own ballet and opera companies, as well as the Houston Symphony Orchestra. There are professional theater groups, and the Museum of Natural Science and the Museum of Fine Arts. Houston's points of interest include the award-winning architecture of much of the ultra-modern downtown area. Outside the city are the San Jacinto Monument, the LYNDON B. JOHNSON SPACE CENTER and the Battleship *Texas.*

Transportation and communications have grown along with the city. The William P. Hobby Airport handles a great deal of private air traffic, and the Houston Intercontinental Airport is one of the world's largest. Many

The smoothly sculpted glass and metal skyline of downtown Houston marks a space-age giant which still manages to maintain many of its Old West attributes.

interstate trucking companies are based in the city as are bus and railroad lines. There are several television stations, over 30 radio station, two large circulation newspapers, and many smaller publications.

A major educational center, Houston is home to 23 colleges and universities. Among them are RICE UNIVERSITY, TEXAS SOUTHERN UNIVERSITY, the University of HOUSTON, BAYLOR UNIVERSITY College of Medicine, many law schools, and the Texas Woman's University College of Nursing. The city is also the home of the American Society of Oceanography. A noted cultural activity is the Houston Festival, which lasts for two weeks in March.

HOVENWEEP NATIONAL MONUMENT. Pre-columbian peoples built these six groups of towers, pueblos and cliff dwellings. Proclaimed March 2, 1923, headquartered at MESA VERDE NATIONAL PARK, Colorado.

HOWE, Edgar Watson. (Treaty, IN, May 3, 1853—Atchison, KS, Oct. 3, 1937). Editor and author. Howe, known as the "Sage of Potato Hill," wrote the widely popular *Story of a*

Country Town (1883), which William Allen WHITE (1866-1944) described as "one of the ten best novels written in America." It prepared the way for the realism of later American writers. Howe published *The Golden Globe* (1872) at the age of nineteen and was the editor and proprietor of *The Atchison Daily Globe* from 1877 to 1911.

HUDSON'S BAY COMPANY. Largest of the major fur trading firms, almost law unto itself, the company operated throughout much of the Central West. In 1801 Hudson's Bay had established trading posts in present-day North Dakota including one in the PEMBINA area. In 1847, Fort Connah, near St. Ignatius, Montana, was the last of the Company's forts to be established in what is now the United States. Trappers working for the Company also traveled to Wyoming where a large shipment of furs was once stored through a winter near Kaycee.

HUECO INDIANS. Band of Texas Indians of the Caddoan language family which gave WACO, Texas, its distinctive name.

HUECO TANKS. Area near Dell City, Texas, where holes called "tanks," have been excavated in the rocks over the centuries by rain and wind erosion in the soft granite. These hold rainwater, making the site a popular stop for explorers and passengers on stage lines. Rich in archaeological and historical interest, the giant rocks in the location are scattered over an area one mile long and half a mile wide. They provided a natural shelter for various tribes of Indians. Mortar holes, worn by the Indians while grinding corn, and pictographs on the sheltered rock walls are found among the boulders.

HUGHES, Howard Robard. (Houston, TX, Dec. 24, 1905—en route to Texas over Mexico, April 6, 1976) Industrialist, aviator, motion picture producer. His father had developed oil drilling equipment and acquired the family fortune through his Hughes Tool Company. The son studied at Rice Institute of Technology and California Institute of Technology until his father died in 1925.

At the age of twenty, he inherited a fortune, took control of the family business and went to Hollywood to produce motion pictures. His *Two Arabian Nights* won the Academy Award in 1928. Two years later he introduced Jean Harlow in *Hell's Angels,* winner of the Academy Award in 1930. Other prominent actors he brought to fame were Paul Muni and Jane Russell.

Meanwhile, not content with his other interests, in 1933 he founded Hughes Aircraft Company which developed airplane designs. In one of his personally designed planes he set a world speed record in 1935, flying at 352 miles per hour. In July, 1938, he completed a record flight around the world (3 days, 19 hours, 8 minutes). Later, he designed the world's largest airplane, a plywood flying boat, which made only one short flight, with Hughes at the controls (November 2, 1947).

Among his many other interests were his acquisition of the controlling interest in Trans World Airlines, completed in 1959, and purchase of the major stock interest in Northeast Airlines (1962-1964). In the late 1960s he began to buy enormous tracts of land in and around Las Vegas, Nevada, and was one of the principal figures in development of that resort community.

Becoming a recluse in later life, haunted by phobias and concern for his health, he moved to Nicaragua and London (reputedly to other localities, as well) and was widely followed by the media as one of the world's wealthiest and most mysterious figures.

His health had been deteriorating for years, and in early April, 1976, while in Mexico he became delirious, supposedly from dehydration and starvation. On April 5th Hughes took off in a chartered plane on a flight to Houston, where it was hoped he could find find medical treatment. He died before reaching the Texas city. The immediate cause of death was said to be liver failure.

HUGO, Oklahoma. City (pop. 7,172). Seat of Choctaw County, southeastern Oklahoma, northeast of Paris, Texas, and southeast of Durant, Oklahoma, it was named for French novelist Victor-Marie Hugo. Hugo is called "Circus Town U.S.A." because of the three circuses which have chosen to winter there.

HUGOTON, Kansas. Town (pop. 3,165). Seat of Stevens County, southwestern Kansas, southwest of GARDEN CITY and northwest of LIBERAL. Deep beneath Hugoton lies one of the largest reserves of natural gas in the world. Gas from the fields is pumped to such distant points as Minneapolis, Minnesota, and Detroit, Michigan.

HUNKPAPA INDIANS. Subdivision of the Teton DACOTAH. The Hunkpapa lived in an area bordered by the Big Cheyenne River, the YELLOWSTONE RIVER, and the BLACK HILLS. The name means "at the end of the circle," referring to their position in the camping circle of the Teton. SITTING BULL (1830?-1890) was a famous Hunkpapa medicine man. In the 1970s descendants were located on the Standing Rock Reservation in North and South Dakota.

HUNT, Wilson Price. (Asbury, NJ, 1783—St. Louis, MO, 1842). Fur trader. Hunt was one of the first traders to lead a party of trappers from St. Louis to the mouth of the Columbia River. Starting on October 21, 1810 in St. Louis, Hunt left his boats at the ARIKARA villages in South Dakota and traveled westward across the mountains to the SNAKE RIVER with Indian horses. Cast as the hero of Washington Irving's *Astoria,* Hunt was no mountain man but a merchant who was chosen by John Jacob Astor to lead the overland expedition to the Pacific coast, while another party traveled to the same destination by sea. Hunt has been criticized for attempting to navigate the turbulent Snake River. The party was split by difficulties on the river, and the various groups suffered severe

hardships before reaching Astoria on the Pacific coast. Nevertheless, Hunt is credited with tracing the route between the Snake and Columbia rivers that would later be an important part of the OREGON TRAIL. Hunt returned to St. Louis to the life of a prosperous landowner.

HUNTLEY, Chester Robert (Chet). (Cardwell, MT, Dec. 10, 1911—Bozeman, MT, March 20, 1974). News commentator. Huntley worked as a newsman for CBS and ABC, but it was for his stint with NBC from 1955 to 1970 that he is best remembered, as co-anchor of the very popular Huntley-Brinkley Report on the evening news. Huntley became the anchor for syndicated news commentaries for Horizon Communications from 1970 to 1974 and was the chairman of Big Sky Montana, Inc.

HUNTSVILLE, Texas. Town (pop. 23,936), seat of Walker County, in southeast Texas north of HOUSTON. Settled in 1836, Huntsville was the home of many famous early Texans, including Sam HOUSTON (1793-1863). Today it is the site of the Texas State Penitentiary, created in 1847. From 1960 to 1970, Huntsville's population rose 47%, in part due to labor opportunities provided by extensive improvements to the penitentiary. Sam Houston State University is there.

HURLEY, Patrick J. (Choctaw Indian Territory near present-day Lehigh, OK, Jan. 8, 1883—Santa Fe, NM, July 30, 1963). Lawyer and diplomat. Hurley served as secretary of war under President Herbert Hoover from 1929 to 1933. In a distinguished career as a diplomat, Hurley was the personal representative of the United States to the Soviet Union in November-December, 1942 and to Egypt, Syria, Lebanon, Iraq, Iran, Palestine, Saudi Arabia, India, China, and Trans-Jordan in 1943. He was the American ambassador to China in 1944. Among his many civic contributions Hurley assisted in organizing the United States Chamber of Commerce in 1912. He negotiated an agreement between Mexico and five expropriated oil companies in 1940 and was the Republican nominee for U.S. Senator from New Mexico in 1946 and 1948.

HURON, South Dakota. City (pop 13,000). Seat of Beadle County, in east-central South Dakota, on the JAMES RIVER, named for the Huron Indians, more commonly known as the WYANDOTTE. Meat packing is a principal industry, based on the surrounding livestock production. Lumbering is also important. The city is noted as the site of "the world's largest pheasant," a forty-foot high, twenty-ton reminder of the city's role as a center of hunting. On Dakota Street is the Hubert H. Humphrey Drug Store, owned by the vice-president until his death. A memorial to prominent writer Laura Ingalls Wilder is found thirty-three miles east in De Smet. At Huron there is an annual Laura Ingalls Wilder Pageant in early July. The Huron Air Show is held in late June. South Dakota State Fair runs for seven days, ending on Labor Day. From May through mid-August, the State Fair Speedway presents South Dakota's largest auto racing program.

HURRICANES. Whirling, powerful wind storms, named from lists of names approved by the World Meteorological Organization. In the Central West region, many hurricanes have struck the Gulf Coast and spread damage far inland. In the region, most hurricanes affect areas along the Gulf of Mexico between the months of June and November.

These storms may measure hundreds of miles in diameter and have winds blowing at 130 to 150 miles per hour or more.

Their winds travel in a counterclockwise direction in the Northern Hemisphere, flowing around a central *eye* which measures about twenty miles in diameter and is relatively calm. Hurricanes generally form in warm ocean waters and travel westward as they gain strength and become larger. They turn eastward after reaching temperate latitudes.

Produced in a low air pressure area, the hurricane's wind generates huge waves, which are particularly destructive if they reach land during high tide.

When a hurricane moves over land, several hours of high wind and rain may occur. Sometime after leaving the sea, however, hurricanes lose strength because of their need for moisture and the friction which occurs between the wind and the land. Scientists have attempted cloud seeding during hurricanes to slow the winds by producing rain. Scientists of the National Weather Service carefully track the path of hurricanes and issue reports to those in the hurricane's track.

Hurricanes have caused thousands of deaths and millions of dollars in property damage. In 1900, six thousand people were killed by a hurricane which hit GALVESTON, Texas. In 1957, Hurricane Audrey hit Louisiana, Mississippi and Texas killing 550. Hurricane Carla struck the Texas coast in 1961, killing 46 and causing

The stark outline of the Far-Mar-Co elevators marks Hutchinson Kansas's world record as a grain storage center.

millions of dollars in damage with high tides, floods and prolonged winds. Damage approaching $467 million and eleven deaths were caused by hurricane Celia which hit the Texas Gulf Coast near CORPUS CHRISTI in 1970.

HUTCHINSON, Kansas. City (pop. 40,284). Seat of Reno County, central Kansas, northwest of WITCHA and southwest of SALINA. C.C. Hutchinson, founder of the city in 1872, knowing the route of the ATCHISON, TOPEKA AND SANTA FE RAILROAD, planned his city to be nearby and outlawed the sale of liquor by writing an injunction into the original deeds for the lots he sold. Following the practice of many communities, Hutchinson offered a free lot to the builder of the first house in town.

A.F. Horner won the lot with what must be the first mobile home. Constructed by Horner so that it could be moved, the house won free lots in Florence, Newton and two other Kansas towns before "settling down" in Hutchinson. The dwelling later became Hutchinson's first post office and even later its first hotel.

In its early days Hutchinson was surrounded by a plowed furrow to guard the community against prairie fires, and streets were marked off with buffalo bones.

A major industry of the community since 1888 has been salt mining and processing. A salt bed estimated to be 350 feet thick and six hundred feet below the surface was discovered in 1887 while drillers were attempting to find natural gas. Hutchison has one of the world's largest rock salt mines which, together with three evaporation plants, annually produce over eight hundred thousand tons of salt. The exhausted mines are used as fireproof vaults for the storage of valuable records.

Wheat is a more obvious source of regional wealth. Hutchinson has been the largest primary hard wheat market in the United States. Regional wheat storage tanks and elevators have the capacity of storing fifty million bushels of grain. The Far-Mar-Co Elevator, one of the largest in the United States, is nearly one-half mile long.

Visitors to Hutchnison thrill to the simulated space flight made possible by Cosmosphere, a planetariumlike building which uses an elaborate sound and light production. Discovery Center displays a lunar module, rocket engines, satellites and several space suits.

I

ICE CAVES. Occurring in many places throughout the Central West. Ice caves are dependent on certain conditions in the caves which allow the maximum quantity of ice to form during the spring when the snow melts on the surface. The position of the caves must permit free circulation of air in the winter, freezing the ice and holding the cold air in the cave. Summer conditions allow little circulation, so the cold air remains, permitting what little warm air enters the cave to be chilled to freezing. Major attractions in Montana's GLACIER NATIONAL PARK are the ice caves of GRINNELL GLACIER. Other ice caves in Montana may be found not far from Grinnell. In Oklahoma the Sierra Negra Ice Caves have supplied ice for Folsom residents since they were discovered in 1921. Near Grants, New Mexico, the Perpetual Ice Caves occur in a volcanic sinkhole. There the aquamarine ice is banded with dark horizontal stripes, lying in a bed approximately fifty feet wide and fourteen feet high. Its underground depth is unknown. Ice caves were also discovered in 1934 under the north rim of the Johnson Mesa by Eli and Fred Gutierrez of Raton, New Mexico. Rooms in the cave have solid ice floors and walls. Dust, alternating with layers of ice, has made dating the formation of the ice possible.

ICEBERG LAKE. Fed by melting snowbanks above a glacial cirque at an elevation of 11,500 feet, the lake lies near Timberline, Colorado. Great cakes of ice float on its surface for most of the summer.

IDAHO SPRINGS, Colorado. Town (pop. 2,077). Seat of Gilpin County, north-central Colorado, southwest of BOULDER and west of ENGLEWOOD. The first major gold strike in Colorado was made near here in early 1859 by a miner named George Jackson. The location, at the junction of Clear and Chicago creeks, is marked with a monument. Two hundred mines in the area still produce uranium, gold, lead, silver, tungsten, zinc and molybdenum. The community has remained a popular health spa since the 1880s. It is known particularly for the

radium hot springs. The Colorado School of Mines operates the Edgar Mine as an experimental underground classroom for undergraduate work in mine surveying, geology, drifting, drilling and blasting. Argo Town, USA, is a reproduction of a western style mining town with Argo Gold Mill and tours of an authentic gold mine.

ILLINOIS RIVER. Beginning in Benton County, Arkansas, and flowing west and northwest, it eventually joins the ARKANSAS RIVER in OKLAHOMA. The Illinois River flows past TAHLEQUAH, Oklahoma, home of NORTHEASTERN OKLAHOMA STATE UNIVERSITY, to enter the TENKILLER RESERVOIR. It is a popular recreational stream, noted for its float trips.

INDEPENDENCE ROCK. Favorite resting spot for travelers headed for California, Oregon and the valley of the Great Salt Lake. Located near Alcova, Wyoming, Independence Rock is 193 feet high with a base covering approximately 27 acres. Called the "Great Register of the Desert," the rock is covered with more than five thousand names carved into its surface by trappers, explorers, soldiers, and emigrants. It was given its name on July 4, 1830, after a celebration by a party of fur trappers commanded by William SUBLETTE.

INDEPENDENCE, Kansas. City (pop. 10,-598). Seat of Montgomery County, southeastern Kansas, northwest of COFFEYVILLE and southwest of CHANUTE. It was named for Independence, Iowa. Independence was formerly the Osage Indian Reservation. When the Osage agreed to move into Indian Territory, white settlement began in 1870. Natural gas was discovered in the area in 1881, and oil was found in 1903. The supplies of both have been exhausted, and today the community relies on agriculture and manufacturing of cement, gas heaters, wood products, electric and electronic parts, as well as the substantial dairying and agriculture of the region. Champion quarter horses are raised at the Rutland Quarter Horse Ranch. The popular annual Neewollah celebra-

Much of the Indian craftwork of today reflects the fine traditions of generations.

tion, one of Kansas' largest, brings entertainers from around the world during Halloween week.

INDIAN ART AND CRAFTS the work of Indian artists today is most often carried on in the tradition of their peoples, and the art of Indians of the Central West region varies widely from place to place. Historically, in the plains the women were the artists, and much the same work was done all across the plains. The best craftswomen and artists were highly honored. The intricate beadwork and decoration with porcupine quills required substantial skill. One girl wrote, "Grandmother's teeth were all worn down from flattening quills between her teeth. But she gained much honor from the work."

Throughout the plains the Indians were said to have decorated almost everything that could be painted, including horses, human bodies, utensils, buffalo robes, tepis and other surfaces—all were painted. Often the work represented a kind of signature or biography by which the artist could be recognized. History was often represented in pictorial form. As with most artists, the animals of the area, the scenery, neighbors, highly placed tribesmen, all were subject of plains Indian art.

As with many artists today, many plains artists preferred stylized or geometric forms to realism. The various colors used often had symbollic meaning within a given tribe or group. Black signified victory to the CROW, but it meant night to the SIOUX. Their pigments came from natural materials, such as duck manure for blue, yellow from bullberries or buffalo gallstones. Burnt wood provided black; certain clays produced white. Brushes were derived from chewed ends of sticks or antelope hair tied to twigs.

The murals of chiefs or other highly placed persons adorned their lodges. These murals often represented the dreams or visions of the owners and were produced by trained artists who translated the vision as instructed. The finished product was thought to have supernatural powers.

Indians of the Southwest were even more advanced in art and crafts. HOPI men of all ages were the weavers, creating everything from the gathering and carding of the cotton to the spinning. However, the women dyed the threads in brilliant colors. On warm days men would sit outdoors at their looms, working on the family clothing or on ornate and skillful designs of braids and sashes.

Hopi women made the baskets, and some brought this work to high forms of art. Sumac twigs and other natural materials, such as the shrub known as rabbit brush, provided variety in the materials. Some baskets depended entirely on natural colors, while others were highly dyed. Hopi potters were renowned for the artistry of their work, such as that of master potter Nampeyo, who around the turn of the century designed work of such perfection of shape color and design that it can scarcely be equalled today.

However, master pottery skills among the various groups have been handed down from generation to generation. Today's master potters of the Southwest are renowned around the world, and their creations command very high prices.

Also known and copied around the world are the NAVAJO RUGS, wall hangings and blankets, long produced by this ingenious and artistic people, with some of the best earlier rugs now selling for prices which place them in competition with other art of all types. The Navajo historically also have excelled in jewelry of exquisite design and complex and intricate workmanship, sometimes created with only the most primitive tools. Their work often combines stone cutting of the highest order with equally fine silversmithing. Their enormously varied creations of silver and turquoise have reached fad status in many nations. Every type of metalwork is practiced with skill.

Kachina dolls today also have become "fashionable." These are derived from the traditions of those supposedly supernatural beings, who were represented first by men wearing kachina masks and also by kachina dolls. Men dressed as kachinas often were the equivalent of the modern Santa Claus, bringing dolls and other good things to the children. These dolls were among the most precious possessions and were carved, painted and provided with costumes, all work being done by the men. Today, some of the finest figures in a wide variety of sizes vie in artistic quality with similar doll work by artists all over the world.

Dry, or sand, paintings were done by medicine men to cure the sick. Sand, dried vegetable matter and other loose materials were laid in intricate and often beautiful patterns on a bed of smooth sand. The multitude of designs were created to cure various diseases and a single sand painting might take as many as fifteen men all day to finish. The sick person sits on or is placed on the design to absorb the healing, and the pattern is immediately destroyed. Now, however, these patterns are being reproduced in permanent form by artists, some of whom have achieved a very high order of art.

Many modern Indian artists of the Central West region have achieved international reputations. One of these of world fame is Oklahoma watercolorist ACEE BLUE EAGLE. Indian wood sculptor John Clark and another Montana sculptor, Gary Sohidt, both from the BLACKFOOT group, have achieved substantial reputation. Indian illustrater Yosette LA FLESCHE Tibbles of BELLVUE, Nebraska, created what is thought to be the first work of an Indian artist ever published.

The late Maria MARTINEZ of SAN ILDEFONSO, New Mexico, gained international fame as one of the finest artists in pottery who ever lived. Her work is being carried on by her son Popovi Da.

INDIAN CITY, USA. Unique exhibit in ANADARKO, Oklahoma, re-creating villages common to the Plains Indians including grass houses, mud huts, earth lodges and tepees of the NAVAJO, PAWNEE, KIOWA, COMANCHE, and APACHE Indians. Tribal dances are held during the summer and on weekends during the winter. A museum shelters exhibits of items used by the Southern Plains Indians.

INDIAN DANCES. Some of the most spectacular dances anywhere have developed from the ageless traditions of the PUEBLO PEOPLE and other southwest tribes. Each group had its own variation, as well as dances quite distinctive to the individual group. Many of these dances are performed today, some for an appreciative public and others as private religious rituals.

One of the most striking of all the Southwest dances is the snake dance of the HOPI. The ceremonies last for nine days, with the live snakes playing a constantly important part. The ceremony is climaxed as the Snake men dance and the Antelope men chant. The dancers snatch the snakes from the receptacle, place them in their mouths and dance around the village plaza. Finally the serpents are taken back and released to the desert, where it is hoped they will tell of the Hopi good works and persuade the spirits to send rain.

At the ZUNI Pueblos, the Shalako ceremony is especially notable. The Shalako are giant messengers of the gods, represented by dancers in Shalako masks and costumes. Each year the Shalako are said to send their messengers to bless all of the houses and buildings built during the preceding year, and this is demonstrated by means of the dance.

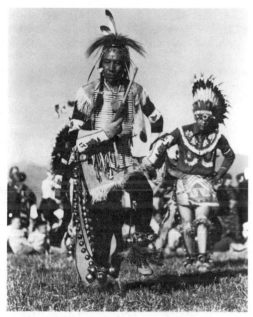

Indian dances are featured at the many annual powwows in the region.

Another spectacular dance ceremony is part of the APACHE puberty ritual, lasting four days. Each evening the Gans dancers perform to entertain the guests. The Gans represent the mountain spirits, who heal the sick and defy evil powers. Their dances and elaborate costumes are choreographed by the shaman. The dancers appear in fantastic body paint with elaborate slat headpiecees and wearing decorated kilts and black masks. Early missionaries thought these costumes represented the devil and called the Indians devil worshippers, the opposite of the truth.

To the north the HIDATSAS had a scalp dance to celebrate a triumph over enemies. The dancers carried poles from which dangled the scalps of their enemies. If a local warrior was killed and no comparable foe had lost his life, the scalp dance was cancelled, and the war leader went into mourning. If this happened twice in a sequence, the war leader lost his position. The Hidatsas, and many others, also performed the green corn dance. This took place whenever there was a successful buffalo hunt or a good harvest. The warriors stomped around a cooking fire to the chant of the shamans.

When starvation appeared to threaten, MANDAN warriors, wearing their masks of buffalo heads, went into their Buffalo Calling Dance. This often went on for days or weeks until

buffalo appeared. Whenever a dancer would fall exhausted, onlookers would drag him off and pretend to skin and cut him up, as they would a buffalo.

Throughout the plains one of the most important relgious ceremonies was the Sun Dance. This went on for twelve days as a symbol of individual courage and endurance. The climax of the dance was the test of endurance for which some of the dancers had volunteered. Some had bits of skin cut from them, others inserted skewers in their chest skin and dragged attached buffalo skulls about in a shuffling dance. The most courageous of all were hung from poles by thongs placed in cuts in their chests. As a means of keeping continuity with the traditions of the past certain portions at least of the sun dance are still performed widely by the various groups.

All of these and many others were copied among the various tribes, each of which might have its own variation or might have come up with something completely new, which then might become traditional.

"INDIAN HIGHWAY." Fifty-mile stretch of highway between Mena, Arkansas, and Talihina, Oklahoma, which follows the peaks of the Winding Stair Mountains and Rich Mountains to offer travelers panoramic views of the area.

INDIAN PAINTBRUSH. The state flower of Wyoming is a member of the large figwort family, which includes foxglove (source of digitalis), veronica, wild snapdragon and the muleins. Indian paintbrush is often partially parasitic, growing sometimes to a yard high. The red color is not a part of the flower but is a bracht around it, as also in the case of the poinsettia.

INDIAN POWWOW CAVERN. Enormous opening in a high red cliff near TENSLEEP, Wyoming. SIOUX and CROW Indians met in the fifty foot high cavern in times of bad weather or to powwow. The ceiling and walls of the cave are covered with pictographs. A word spoken at the mouth can be heard three hundred feet back in the rear of the cave.

INDIAN TERRITORY. Area in the eastern part of Oklahoma, which was called by this name although it was never regularly organized. As a result of treaties made between 1820 and 1845, most Southeast Indian tribes were removed to this region by the United States government. Each tribe maintained its own

government while in the territory, but when Oklahoma entered the union (1907), any Indians still living there became citizens of that state.

INDIAN TRIBES. The Indian tribes found in the Great Plains by the early European explorers were relative newcomers. Older settlers had generally moved out, perhaps due to drouth. Then beginning in about 1300 A.D. various groups began to move into the plains, coming into the grassland regions from all directions. There were several reasons for these moves, drouth in their original home areas, increased Indian population and, later, the pressures of other stronger tribes pushing their weaker neighbors westward as they too were forced from their homes by white settlement.

First to come into the plains were the PAWNEE, moving up from east Texas into Nebraska, followed by the ARIKARA. The MANDAN and HIDATSA came into North Dakota from the east and northeast. The ASSINIBOIN from Canada into northern North Dakota the GROS VENTRE and BLACKFOOT from Canada to north central Mon-

tana, the ARAPAHO from the far north into Colorado, the CHEYENNE from the east and the north into eastern Wyoming, the COMANCHE from the west into the Texas PANHANDLE, the KIOWA-APACHE and the KIOWA from northern Montana and Idaho into the Oklahoma Panhandle and western Oklahoma.

Much of the Texas RIO GRANDE border and the PECOS RIVER valley was in the hands of the LIPAN APACHE, with the MESCALERO APACHE to the north and into south eastern New Mexico. The CHIRICAHUA APACHE occupied southwest New Mexico, and the wonderful civilization of the RIO GRANDE Pueblos hugged the river region. The Western Pueblos lived on either side of the present central border between New Mexico and Arizona, with the NAVAJO to the north. Northeastern New Mexico and the northern Texas PANHANDLE were home to the JICARILLA APACHE.

As time went by, many of these groups made various moves, and it becomes almost impossible to give general indications as to where each was at any given time after European exploration and settlement. Their location was further

The spirit of the extraordinary civilization of the pueblo Indians has been captured in this striking painting of "Evening at Taos Pueblo," by prominent Southwest artist Ernest L. Blumenschein.

Indian Warfare

complicated by attempts by the government to move them and by the retreats of some back to their old homelands. These various locales are given in more detail in the articles on the various tribes and individual states.

INDIAN WARFARE. Before the coming of the white man, intertribal warfare in the Central West appeared to be almost constant. As new tribal groups were pushed into the region, friction increased. Most tribes had their war chiefs as well as their civil chiefs. For many tribes, warfare was a way of life. In the more warlike tribes the social standing of a warrior depended on the number of "coup" he could accumulate. Bringing home a scalp, touching an enemy in battle and other accomplishments added to the coup record. If the opposing side killed more braves or accomplished something more in battle than the local warriors, the local chief was in disgrace. If this happened more than once, he was dismissed.

With the early incursions of the Spanish in the southwest, the Indians acquired the horse, which added greatly to their ability and mobility in warfare. The plains Indians came to rank among the great horsemen warriors of the world.

In the Central West, warfare involved the white settlers of present New Mexico almost immediately. Inflamed by the cruelties and injustices of their Spanish captors, the PUEBLO INDIANS turned on their tormenters under the leadership of Tu-pa-tu, governor of the Picruis Pueblo. The revolt began on August 10, 1680, when the Pueblo confederates, with promise of Apache assistance, swept toward SANTA FE, killing four hundred Spaniards as they went. The defenders gathered in Santa Fe, and the Indians offered them safe passage out of the country, but this was refused. When the Spanish attacked, they could not overcome the Indian resistance, and more than 1,000 fled to EL PASO. For twelve years the Indians ruled from the PALACE OF THE GOVERNORS in Santa Fe, defeating numerous attempts by the Spanish to oust them. However, by 1692 the Spanish had reconquered Santa Fe, and controlled most of the Southwest for 130 years.

Until 1861 the plains Indians had few en-

The long, seemingly endless conflict with the Indians on the frontier reached its peak in the period depicted in the map. Best known of all the Indian battles and skirmishes on U.S. territory was that at Little Big Horn River in south central Montana. Perhaps the most tragic for the Indians was the surrender of Chief Joseph in north central Montana.

Indian Battles and Skirmishes, 1876-1877

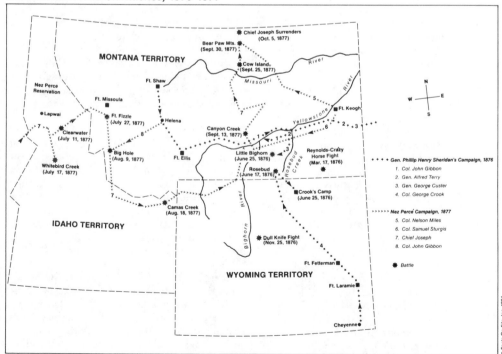

counters with the white man. But as more and more of the invaders kept coming in, slaughtering the invaluable buffalo and taking more and more land, Indian distress led to rapidly increasing violence on both sides. Four tribes were the principal combatants, APACHE, COMANCHE, CHEYENNE and SIOUX. Others in the Central West region were the BLACKFOOT, BANNOCK and SHOSHONE. In addition to the general fear of encroachment, the Indians had much more justification for outrage. Corruption of Indian agents and others, prospectors violating territory guaranteed to the Indians and disruption of the hunting lands by the railroads, ranked high among other causes.

Most of the fighting took place between 1869 and 1878. Generals Nelson MILES (1839-1925) and George CROOK (1829-1890) were the army's principal Indian fighters, opposing such Indian masters of warfare as CRAZY HORSE (1842?-1877), RED CLOUD, (1822-1909) Mangas Coloradas, GERONIMO (1829-1909) and COCHISE (1812?-1874).

At the least there were 200 pitched battles of the wars with the Indians. Some of the most notable engagements included the FETTERMAN MASSACRE on February 21, 1866, a part of the siege of FORT KEARNY, the Sand Creek massacre, the famed Battle of LITTLE BIG HORN (June 25, 1876) with its destruction of George Armstrong CUSTER (1839-1876) and his men and the tragic Battle of WOUNDED KNEE in 1890, often considered the last battle of the Indian wars.

The passage of the Dawes Act and the ability of the government to enforce the reservations policies put an end to the Indians' further effective resistance.

INGALLS, John James. (Middleton, MA, Dec. 29, 1833—East Las Vega, NM, Aug. 16, 1900). United States Senator. Ingalls served as president pro tempore of the U.S. Senate from 1887 to 1891. He was first elected to the Senate, as a Republican, in 1873. An extremely gifted orator, Ingalls attracted such popularity that he is one of Kansas' two representatives in the national Hall of Fame in the Capitol in Washington, D.C. Upon leaving public life Ingalls became a journalist and lecturer. His main claim to fame came from his "denunciatory oratory," according to one biographer.

INGE, William. (Independence, KS, May 3, 1913—Hollywood Hills, CA, June 10, 1973). Playwright. Author of *Come Back, Little Sheba* (1950), *Bus Stop, Picnic*, winner of the 1953 Pulitzer Prize in drama and and *The Dark at the Top of the Stairs* (1957). Inge won the 1961

Academy Award for best original film script, and adaptation of his *Splendor in the Grass*.

INSCRIPTION ROCK. Principal feature of EL MORRO NATIONAL MONUMENT near GRANTS, New Mexico, has served for hundreds of years as a record of travels throughout the area from prehistoric times onward. With whatever tools were available, explorers have carved their names and messages into the stone. The earliest legible entry, from 1605, belongs to Governor Juan de ONATE (1550?-1630), the first colonizer of New Mexico. Among the more than five hundred inscriptions are those of many other Spanish governors, scouts, travelers, and immigrants.

INSTITUTE FOR HUMANISTIC STUDIES. Cultural exchange program organized in 1949 by industrialist Walter PAEPCKE. The Institute brings world leaders together for a summer-long celebration of thought in ASPEN, Colorado. Scholars attend and offer lectures, seminars and classes.

INSTITUTE OF AMERICAN INDIAN ARTS. Extraordinary institution in SANTA FE, New Mexico, which enrolls Indian students of artistic talent from throughout the United States. It also features a museum which displays contemporary painting and sculpture along with traditional crafts of beadwork, basketry, and weaving, highlighted by changing exhibits of the work of local artists.

INSTITUTE OF ATMOSPHERIC SCIENCES. Division of the SOUTH DAKOTA SCHOOL OF MINES AND TECHNOLOGY in RAPID CITY, conducts research into the climate of the future.

INTER-TRIBAL COUNCIL. Assembly of representatives of all the Indian tribes of Oklahoma Territory. The first council met at OKMULGEE in 1859 to draw up intertribal laws, including the treatment of criminals escaping from one Indian nation or group to another, provisions concerning citizenship and other laws and regulations governing their relations with one another. From that point on the council met regularly until statehood (1907).

INTER-TRIBAL INDIAN CEREMONIAL. Annual four-day event held in GALLUP, New Mexico, featuring arts and crafts, rodeo events, and tribal games, including tribes from throughout the United States. Taking place the second week of August, this largest Indian

celebration in the nation, is held at Red Rock State Park.

INTER-UNIVERSITY HIGH ALTITUDE LABORATORY.

Highest permanent laboratory in the Northern Hemisphere, located on the peak of Mount EVANS at an altitude of 14,150 feet. Originally known as the Cosmic Ray Laboratory of the University of DENVER, the facility was constructed in 1936 for scientific study of cosmic rays, meteorological observation and experiments in biochemistry. Built in a conical shape to help the building withstand winds in excess of 150 miles per hour, the facility was produced in Denver, cut into sections, and reassembled on the site. The center has been used by Nobel Prize winning scientists Carl Anderson, A.H. Compton and R.A. Millikan and is now funded jointly by Colorado colleges.

INTERNATIONAL PANCAKE RACE.

Race held simultaneously between contestants in LIBERAL, Kansas, and Olney, England, on a one-quarter mile course, over which each participant races with a pancake in a skillet, tossing it twice on the way. The Liberal race was started in 1950 by a member of a local civic group who learned of the Olney event which traces its origin to 1445 when a housewife was in such a hurry to get to church she forgot to leave her cooking at home.

INTERNATIONAL PEACE GARDEN.

Peaceful relations between Canada and the United States are commemorated here. North Dakota holds the 888-acre U.S. portion. International Peace Garden, Inc. administers the area for North Dakota and Manitoba. The National Park Service has assisted in the master plan. Originated by North Dakota in 1931; federal aid authorized in acts of October 25, 1949, June 28, 1954, August 28, 1958, October 226, 1974. Headquartered Dunseith, North Dakota.

INTERNATIONAL PEACE PARK.

Also known as the Waterton-Glacier International Peace Park composed of GLACIER NATIONAL PARK in the United States and the adjoining Waterton Lakes National Park in Canada. Glacier Park was rededicated in 1932 in cooperation with Canada as the American portion of this symbol of peaceful relations between the two nations.

INTERNATIONAL PETROLEUM EXPOSITION.

World's largest show devoted to a single industry, held in TULSA, Oklahoma, every other year.

IONIA "VOLCANO."

A high bluff near Ponca, Nebraska, which contains chemicals that react with water to form a smoke or steam often mistaken for volcanic activity.

IOWAY INDIANS.

The tribe originally lived in eastern Iowa and southwestern Minnesota in the 17th century. In the late 18th and early 19th centuries the Ioway lived near the confluence of the PLATTE and MISSOURI rivers. Competition for this hunting ground with the Sauk, Fox and DACOTAH tribes coupled with a smallpox epidemic in 1803 severely reduced their population. In treaties with the United States in 1824, 1825, 1830, 1836 and 1837 the Ioway ceded all their lands in Missouri, Iowa and Minnesota. They were assigned to a reservation along the Great Nemaha River in southeastern Nebraska and northeastern Kansas in 1836. The size of the reservation was reduced in 1854 and again in 1861. Part of the Ioway moved to Indian Territory in 1883 where they were assigned a reservation. In the late 1970s nearly 700 Ioway Indians lived on or near the Ioway Reservation in Richardson County, Nebraska and Brown County, Kansas. Nearly 150 Ioway Indians

The International Peace Gardens celebrate generations of peace between Canada and the U.S.

lived on allotted lands in Oklahoma's Lincoln, Payne and Logan counties. Some had moved back to Iowa, on land which they purchased near the city of Tama.

IRRIGATION. Irrigation, a process of bringing water to parched areas, in the U.S. most generally linked to land reclamation in the West. It was successfully practiced by the PUEBLO INDIANS long before historic times. Early settlers followed the Indians' lead, and individual and group efforts to capture water for irrigation purposes had made significant progress by 1880 when an estimated one million farm areas were irrigated.

Prior to 1888, the federal government limited itself to publishing studies of irrigation experiences in other countries and to attempts at encouraging irrigation through the Desert Land Act of 1877. There was little practical effect of any of these attempts, but progress began with direct federal assistance for irrigation started in 1888 with the congressionally authorized Geological Survey of John Wesley Powell. The survey marked all possible reservoir sites and called for the withdrawal of public land entry in these areas. The idea of arbitrary reservation of public land and Powell's plan for an ordered economic development of the western basins threatened private enterprise, and the resulting pressure on Congress led to the Geologic Survey's funds being drastically cut in 1890.

The proponents of irrigation began efforts to cede federal public lands to the western states. Elwood Mead, the state engineer of Wyoming, proposed the subject to the Senate's Irrigation Committee in 1889. The concept was given great emphasis during 1887-1893, the irrigation boom period when private enterprise promoted irrigation as an aspect of economic development. The Irrigation Congress, begun in Salt Lake City, Utah, adopted land cession as its primary goal for national legislation.

Promotion of the idea was given to William E. Smythe, founder of *Irrigation Age* and secretary of the Irrigation Congress. The Panic of 1893 removed local support for cession, and subsequent Congresses adopted the idea of federal construction of reclamation dams at sites first proposed by the Geologic Survey. Only in Wyoming was an effort made at a state-level alternative to a federal program.

Wyoming, under Mead, took full advantage of the Carey Act which authorized the donation of one million acres of public lands to each of the arid states and territories. Mead's efforts on a federal bill preserving state control over water

rights and encouraging homestead settlement were defeated with the passage of the *Newlands Reclamation Act of 1902* which came about through an alliance of water and forest conservation proponents. The "stream flow" theory of the era stated that forests slowed down the run-off from storms and snow melt while preventing destructive floods and allowing a greater amount of the run-off to be captured within reservoirs. This had the additional benefit of adding to supplies of water needed for summer irrigation.

Wyoming's Mead was chosen to head the Reclamation Bureau in 1924, and he cultivated the support of Presidents Hoover and Roosevelt and western economic interests to the point that Congress supported new projects even during the Depression. In 1970 land with a total crop value of two billion dollars representing 140,505 farms was irrigated by Bureau of Reclamation reservoirs. Among the states gaining the most benefit from these irrigated acres was Colorado. The chief crops grown on irrigated land were alfalfa, potatoes, sugar beets, cotton and oranges. A problem not yet solved involves "excess acres," land owned by agricultural producers above 160 acres or 320 acres for a man and his wife. Current law states that acres held above this amount must be sold at "pre-water" prices to the government or put on sale in the general market if water is received from the Bureau of Reclamation. The directors have never successfully enforced this provision which favored the original homesteader over the speculator. In its quest for new dam sites the Bureau of Reclamation has been successfully thwarted by conservationists and in 1987 announced that it would sponsor no further construction of dams.

IRVING, Texas. Town (pop. 109,943), Dallas County, in northeast central Texas. A residential and industrial suburb of DALLAS, Irving has experienced rapid growth in recent years. Present manufactures include aircraft parts, machinery and metal and paving products. It is the site of the University of DALLAS, and the official home of the Dallas Cowboys football team.

ISLETA PUEBLO. Village (Pop. 2,974). perched at an altitude of 4,885 feet in Bernalillo County, Central New Mexico, on the RIO GRANDE, this prosperous pueblo features the church originally built by Father Juan de Salas, burned during the rebellion of 1680 and later rebuilt. There is a fine Indian market center.

J

JACKRABBITS. Common name given to large North American hares, with long hind legs and long ears. They live in the open grasslands, deserts and brushlands of the Central West. Of the four species of jackrabbit, the most common is known as the black-tailed jackrabbit which is found throughout the Great Basin, short-grass prairie and low desert areas of Nebraska, Texas and west to California. The white-tailed jackrabbit, the next most common species, is found in the open-plateau areas of Montana and Wyoming. The antelope jackrabbit lives in the deserts of the Southwest, and the Gaillard jackrabbit inhabits the desert grasslands of southwestern New Mexico. When frightened a jackrabbit can travel at forty miles an hour or more and can leap twenty feet. The large ears, comprising one third of the body length, keep the animal alert and act as a heat-regulating device in hot weather by allowing the blood to cool by circulating through them. Jackrabbits feed on whatever vegetation they find, drawing moisture from the plants, and can go for long periods without water. Important elements of the western foodchain, the animals provide food for predators like the bobcat. In large numbers they are a major nuisance to farmers who lose valuable crops such as alfalfa and grain to the animals who also catch such rabbit diseases as tularemia. To control large numbers of jackrabbits, area residents often conduct massive drives where they are herded into wire pens and slaughtered.

JACKSON HOLE NATIONAL ELK REFUGE. Winter home of an estimated seven thousand elk, a 23,500 acre refuge located near JACKSON, Wyoming. When the elk shed their antlers in the spring the local Boy Scouts collect them for sale in town. During the summer the herds migrate to the high mountain meadows in the YELLOWSTONE and GRAND TETON national parks. Visitors may watch a film and slide show at the visitors' center. Winter sleigh rides are available.

JACKSON LAKE. Impounded reservoir behind Jackson Lake Dam on the SNAKE RIVER in northwestern Wyoming's Teton County. Jackson Lake lies north of JACKSON, Wyoming, and south of YELLOWSTONE NATIONAL PARK.

JACKSON, William Henry. (Keeseville, NY, 1843—New York, NY, June 30, 1942). Photographer, explorer and artist. Jackson, one of America's most notable photographers, was the first to take photographs in the YELLOWSTONE PARK region. He was also acclaimed for his early photography of the TETONS, MESA VERDE and of the Indian leaders and people. He was the official photographer for the U.S. Geologic Survey from 1870 to 1878. A prolific writer on western themes, Jackson was awarded the gold medal for distinguished service to Colorado and the West by the University of COLORADO in 1937.

JACKSON, Wyoming. City (pop. 4,511), seat of Teton County, western Wyoming, southwest of CODY and northwest of LANDER. Founded 1901, it was named for early trapper David E. Jackson. Jackson is a picturesque center of activity for area ranchers and tourists visiting the breath-taking JACKSON HOLE and TETON country. Recreation opportunities in the surrounding mountains abound including whitewater rafting, hiking, fishing, and skiing. It is one of the country's most popular spots for the latter sport, renowned not only for its slopes but for the termendous views of the mountains and Jackson Hole. The two-and-a-half mile Aerial Tramway provides one of the nation's most spectacular vistas, from the top of Rendezvous Mountain. Excursions and float trips are available on the SNAKE RIVER. Wagon treks and covered wagon tours add to the area's interest. Old West Days is a Memorial Day celebration of Jackson's heritage. Nightly between Memorial Day and Labor Day visitors are captivated by the Jackson Hole Shootout a recreated robbery and capture, supposedly typical of the Old West. Jackson maintains its reputation as

a center of western arts with the Jackson Hole Fall Arts Festival in September.

JACKSONVILLE, Texas. City (pop. 12,264), Cherokee County, in east central Texas. It was named for both its first physician, William Jackson and for Jackson Smith who donated the town land. The city was founded in 1847 and incorporated in 1916. Jacksonville's current manufactures include wood and plastic products, and baskets. Lon Morris College (1854) and Jacksonville College (1899) are located there.

JADE. The official state gem of Wyoming is more properly known as nephrite, the less valuable of the two types of jade. Nephrite is found fairly widely around the state. Jadeite, the more valuable, is not found in the United States. Jade has been cherished through history, especially in Japan and China, where it has been carved into magnificent designs by great artists.

JAGUARUNDI. Diurnal animal which roams from Arizona and Texas to South America, the jaguarundi is a strange-looking cat with short ears, stubby legs, a long tail and neck, and a weasel-shaped head. Feeding on rodents, farm animals, and birds, it may weigh up to thirty pounds. the color is black or dark grayish-brown.

JAMES RIVER. Also known as the Dakota River, the James rises in Wells County in central North Dakota and flows south across east central South Dakota to empty into the MISSOURI RIVER at YANKTON in Yankton County in southeastern South Dakota. The James passes ABERDEEN, HURON and MITCHELL, South Dakota. With a length of 710 miles, the James is considered the longest non-navigable river in the world.

JAMESTOWN COLLEGE. Oldest privately-supported liberal arts college in North Dakota. Located in JAMESTOWN, the college is accredited by the North Central Association of Colleges and Schools and the National League of Nursing. Located equidistant between BISMARCK and FARGO, the college occupies a 107-acre campus. It grants the bachelor of arts degree. There are 695 students and a faculty of 50.

JAMESTOWN, North Dakota. City (pop. 16,280). Seat of Stutsman County, southeastern North Dakota, on the JAMES RIVER about

midway between BISMARCK and FARGO. It was founded in 1872 as a transportation center and soon developed the prosperous diversified agriculture for which it is still known. JAMESTOWN COLLEGE, the state's first institution of higher education, was founded in 1883 by the Presbyterian denomination. Among Jamestown's famous residents, Lyman Casey, was one of the first two North Dakota Senators. Author Maxwell ANDERSON (1888-1959), lived and went to school in the community. Today the city is known as a recreation center with nearby Jamestown Reservoir, a 1,500-acre lake, and 892-acre Pipestem Lake. The Arrowhead National Wildlife Refuge is a feeding and nesting grounds for migratory waterfowl and many game birds. Hunting of deer and upland game birds is permitted in season. Self-guided auto tours introduce the ecology of the area. Frontier Village exhibits the World's Largest Buffalo, a three-story statue. Within the village are a print shop, drug store, pioneer schoolhouse, and jail. Visitors may enjoy a week of touring in the annual Fort Seward Wagon Train, which stops at scenic and historical sites. Participants dress and camp as the pioneers before them.

JEFFERSON RIVER. Formed at the meeting of branches in northwestern Madison County in southwestern Montana, the Jefferson flows north and east for 217 miles to meet with the MADISON and GALLATIN rivers to form the MISSOURI RIVER near THREE FORKS, Montana.

JEMEZ INDIANS. Tribe and pueblo located on the Jemez River northwest of ALBUQUERQUE, New Mexico. The Jemez and the extinct Pecos Indians were the only speakers of the Towa language of the Tanoan language family. The Jemez called themselves Walatowa meaning, "people of the canyon." They were divided into matrilineal clans. There were twenty ceremonial societies and two men's societies, Eagle and Arrow. Individuals generally belonged to the kiva of his or her father, but after marriage a woman often joined the kiva of her husband. The Jemez grew corn, squash and beans, taking up later crops such as wheat, melons and alfalfa after their introduction by the Spanish. Communal rabbit hunts were held in addition to occasional trips to the plains to hunt buffalo. When the Spanish under Francisco CORONADO (1510-1554) visited the area in 1541 the Jemez occupied eleven pueblos in the Jemez Valley. The Spanish constructed missions among the Indians and convinced the Jemez to consoli-

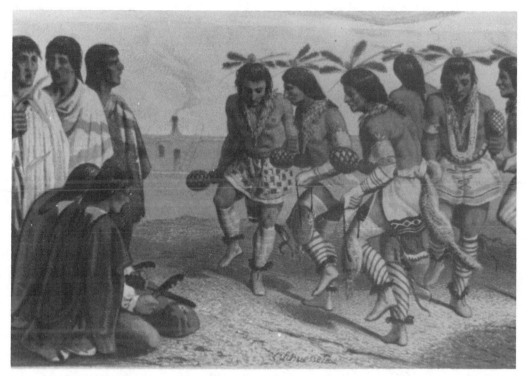

A dance at the Jemez Pueblo was depicted in the journal of James H. Simpson by artist R.H. Kern who accompanied the Simpson expedition.

date their pueblos into two. In the mid-17th century the Jemez joined the NAVAJO in an unsuccessful rebellion against the Spanish. In 1680 the Jemez took leading roles in the Pueblo Revolt, but were forced to leave the mesa. They raided the pueblos of Santa Ana and Zia in 1693, which forced these Indians to become allies of the Spanish. In 1693 the residents of Santa Ana and Zia joined the Spanish in successfully attacking the pueblo of the Jemez. An estimated 360 captive Jemez Indians were taken to SANTA FE. The Jemez, allied with the Acoma and Navajo in 1697, again fought the Spanish, but were unsuccessful and fled to the Navajo country where they remained until the mid-18th century. The Jemez gradually returned to the mesa and constructed the present pueblo near the site of the original pueblo which had been destroyed by the Spanish. There they rebuilt and continued to live keeping much of the traditional way of life. In 1838 the remnants of the Pecos tribe joined the Jemez. While aspects of modern life have crept in over the years, much of the old life still remains. In the late 1970s the Jemez pueblo had a population of nearly 2,000.

JEMEZ RANGE. Mountains in New Mexico, remnants of the crumbled rim of one of the world's largest volcanic craters.

JENNY LAKE. Jewel-like glacial lake, situated at an entrance to GRAND TETON NATIONAL PARK, which mirrors the cathedral-like crags of Owen, Teewinot, and GRAND TETON. The lake was named in honor of the wife of a member of Dr. V.F. Hayden's party which surveyed the region in 1871 to 1872 and 1877 to 1878.

JEWEL CAVE NATIONAL MONUMENT. Limestone caverns consisting of a series of chambers connected by narrow passages, with many side galleries and fine calcite encrustations. Founded February 7, 1908, headquartered CUSTER, South Dakota.

JICARILLA APACHE INDIANS. They lived in southeastern Colorado and northern New Mexico and ranged into Oklahoma, Texas and Kansas. They probably migrated to the southwest from the eastern side of the ROCKY MOUNTAINS in northwestern Canada. The Jicarilla, traditional enemies of the NAVAJO, COMAN-

CHE, CHEYENNE and ARAPAHO, were usually on peaceful terms with the UTE and PUEBLO tribes.

The Jicarilla spoke a version of the Athapascan language and were linguistically closest to the LIPAN APACHE. They were culturally more influenced by the Pueblo and Plains tribes than were most of the other Apache groups. Their name, meaning "little basket," probably referred to their basketry water vessels. The Jicarilla's principal social unit was the extended family. Residence was matrilocal, although the Jicarilla practiced the mother-in-law taboo of the daughter's husband neither looking at nor speaking to his wife's mother.

Dome-shaped wickiups of a pole-frame construction covered with bark, thatch and, in cold weather, skins, provided the home. During buffalo hunts the families lived in tipis. From their neighbors in the pueblos of TAOS and PICURIS the Jicarilla learned how to cultivate corn, beans, pumpkins, peas and squash. They created good quality pottery as well as clay ceremonial pipes. The Jicarilla were recognized for their fine basketry including water vessels sealed with pitch.

During the 1830s and 1840s the Jicarilla raided along the SANTA FE TRAIL and were pursued by American soldiers who finally defeated them in 1854. For thirty years the Jicarilla were forced from one reservation to another. They finally were settled on the Jicarilla Reservation in northern New Mexico in an area known as Terra Amarilla. It was there that the tribe suffered a tuberculosis outbreak in 1890.

In the 1970s there were nearly two thousand Jicarilla living on the 740,000-acre reservation. Among the tribal enterprises are Jicarilla Buckskin and Leathercraft, Jicarilla Arts and Crafts and many tourism facilities.

JOHN D. ROCKEFELLER, JR., MEMORIAL PARKWAY. Linking West Thumb in YELLOWSTONE NATIONAL PARK with the South Entrance of GRAND TETON NATIONAL PARK, this scenic 82-mile corridor commemorates Rockefeller's role in aiding establishment of many parks, including Grand Teton. Headquartered Moose, Wyoming.

JOHNSON COUNTY CATTLE WAR. Conflict in 1892 between cattle ranchers on one side and the unlikely team of rustlers and nesters on the other. The events began when the small ranchers and nesters, people who settled on land without permission, decided to have an early roundup. This created a problem for the large ranchers who feared rustlers would be able to round up the unbranded cattle. The Regulators was a group organized by the big ranchers who controlled the Wyoming Stock Growers Association. Hired gunmen were brought in from other states, organized under the leadership of a former army officer, and led against the K.C. Ranch where two men were killed. Robert Foote, the leading merchant of BUFFALO, Wyoming, rode through the countryside warning others about the Regulators and then opened his store and gave out free guns and ammunition to the defenders. One hundred deputies were sworn into duty and several hundred other people were organized to defend the town. The defenders cornered the Regulators at the T.A. Ranch south of Buffalo and were about to attack when the cavalry arrived to restore order. The army remained in Buffalo until tempers had cooled.

JOHNSON, Alex C. (Crawford County, PA, May 20, 1861—Rapid City, SD, Mar. 18, 1938). Railroad official. Johnson was a principal promoter of the BLACK HILLS and RAPID CITY where he was president of the Alex Johnson Hotel. He served as vice president of the Chicago and North Western Railroad from 1920 to 1929 and was a leader in the movement to make PIERRE the state capital.

JOHNSON, Claudia Alta "Lady Bird" (Mrs. Lyndon B). (Karnack, TX, Dec. 22, 1912—). Wife of President Lyndon B. JOHNSON (1908-1973). Mrs. Johnson, the daughter of a wealthy family, from the age of two had been called "Lady Bird" because a nurse had said the little girl was "as pretty as a lady bird." The Johnsons married on November 17, 1934, and had two daughters, Lynda Bird and Luci Baines. During much of Lyndon Johnson's public life, Mrs. Johnson managed the family business and financial affairs. During her husband's presidency, Lady Bird gave up directing the family investments. As first lady, she was prominently identified with promotion of highway and civic beautification projects around the country. After her husband's presidency she continued to be active in these interests, particularly roadside beautification.

JOHNSON, John Arthur "Jack" or "Li'l Arthur". (Galveston, TX, Mar. 31, 1878—Raleigh, NC, June 11, 1946). Boxer. The first black to hold the heavyweight boxing championship of the world, he gained the title by knocking out champion Tommy Burns in Sydney, Australia,

on December 12, 1908. He was considered a controversial figure because of his two marriages to white women and his victory over popular white champion James J. Jefferies in 1910. In 1912 he was convicted under the Mann Act for transporting his future wife over a state line before their marriage. Sentenced to a year in prison, he escaped to Canada, then Europe. He lost the title to Jess Willard in Havana, Cuba, on April 5, 1915 and surrendered himself to United States marshals in 1920.

JOHNSON, Lyndon Baines. (Stonewall, TX, Aug. 27, 1908—Johnson City, TX, Jan. 22, 1973). U.S. congressman, senator, and 36th President of the United States. All of Johnson's youth was spent in Texas, and he graduated with a BS from Southwest Texas State Teacher's College in 1930. While teaching public speaking in HOUSTON, he served an apprenticeship in politics as an assistant to Representative Richard M. Kleberg, from 1931 to 1935. During this period he married Claudia Alta Taylor, known as "Lady Bird" JOHNSON, and attended Georgetown University law school in Washington, D.C.

Johnson's first political office was as U.S. representative from Texas in 1937 to fill an office vacated by the death of Representative James Paul Buchanan (Democrat). He was returned to Congress for a full term in 1938. As a member of the House he was a strong supporter of the New Deal but was said to have remained relatively obscure, meanwhile acquiring substantial legislative skill as a protege of fellow Texan Sam RAYBURN. After more than ten years in the House, he was elected as senator from Texas in 1948. That term was interrupted by a period of service in the navy (1941-1942) until President F.D. Roosevelt recalled all members of Congress. He became Democratic minority leader of the Senate Democrats in 1953, and was chosen majority leader when the Democrats took a one vote lead in the 84th Congress in 1955. Because of the small Senate majority, Johnson's parliamentary skills were particularly important in keeping party members in line, in promoting Democratic causes and in working with then Republican President Dwight D. EISENHOWER.

Johnson was the principal figure in the passage of the Civil Rights acts of 1957 and 1960. Having established himself as the primary strategist of the Democrats, he campaigned for the presidency in 1960 but agreed at the Democratic National Convention to run as vice president on a ticket with the more charismatic John F. KENNEDY. Johnson became president when Kennedy was assassinated on November 22, 1963.

As president, Johnson launched a "Great Society" program of domestic reforms in the areas of civil rights, welfare, education, and taxation. The first of these was the December, 1963, act setting up a $1.2 billion construction program for college classrooms, laboratories and libraries. He promoted the ratification of the 24th Amendment to the Consitution, banning poll taxes in federal elections, effective in 1964. In March of that year he sent his anti-poverty program to Congress, and in July he signed the Civil Rights Act. This was followed by the signing of the billion dollar anti-poverty bill in August.

Nominated by the Democratic convention for election in 1964, he soundly defeated Republican candidate Barry Goldwater. His domestic policies continued along the lines of his Great Society program with his April, 1965, signing of $1.3 billion elementary and secondary school aid bill. In August of that year he signed a voting rights bill and a $7.5 billion housing bill with rent subsidy provision, and the cabinet post of Housing and Urban Affairs was created. In October he more than doubled the anti-poverty appropriation to a $1.785 billion figure. The next month he signed the Higher Education Act, authorizing federal aid and a National Teachers Corps.

In March, 1966, he submitted his consumer defense program and in June he held a White House Conference on Civil Rights attended by 2,400 participants.

In foreign affairs, both terms were clouded by the conflict in Vietnam. During Johnson's first term, he encountered growing opposition to operations in Vietnam, especially after August 7, 1964, when Congress gave advance approval to the president to take any actions in Southeast Asia, following U.S. raids on North Vietnamese bases in retaliation for attacks on U.S. destroyers in the Gulf of Tonkin.

After his reelection to a full term in 1964, his commitment to the war in Vietnam became increasingly unpopular, following the Feburary, 1965, bombing of north Vietnamese bases provoked by a Vietcong attack on U.S. forces. Opposition became especially intense after the first U.S. combat troops landed in South Vietnam on March 8-9, 1965.

The war there rapidly escalated. In an attempt to improve the situation, in October, 1966, the president toured six Asian and Pacific nations, attended summit conferences in Ma-

This portrait of Lyndon Baines Johnson by artist David Philip Wilson was commissioned by the Texas Senate and hangs in the Senate chamber.

at the Democratic national convention in Chicago in August, 1968, as protesters fought with Chicago police and attempted to storm the convention hall. On October 31 of that year President Johnson announced a complete halt to bombing in North Vietnam.

On January 20, 1969, he departed the presidency for his first day in 34 years as a private citizen, leaving the problem of Vietnam to his Successor, Richard Nixon. Johnson's calm retirement was interrupted by the heart attack at Charlottesville, Virginia, in April, 1972, and his death early the next year.

JOHNSON, Martin. (Rockford, IL, 1884—Fairhope, AL, Jan. 13, 1937). Educated in INDEPENDENCE, Kansas, he joined author Jack London on the cruise of the *Snark*. He made a well-known expeditions to the Solomon and New Hebrides islands (1914) and Borneo in 1917-1919 and 1935. Johnson and his wife, Osa traveled around the world six times, wrote, lectured and gained a reputation as jungle experts, especially on Africa. They were famed for their motion pictures of their explorations, such as *Jungle Calling* (1937). *I Married Adventure* (1940) was particularly well-known. Among the books written by the Johnsons are *Cannibal Land* (1922), and *Camera Trails in Africa* (1924). Both are buried at CHANUTE, Kansas, where Osa Leighty Johnson was born and where the Safari Museum of trophies collected in their travels is located.

JOHNSON, Walter. (Humboldt,KS, 1887—1946). Baseball player. Elected to the Baseball Hall of Fame in 1936, Johnson ranks as one of the greatest fast-ball pitchers in history. While pitching for the Washington Senators from 1907 to 1927, Johnson won 416 games. He set a career strike-out record of 3,508, and in 1913 pitched 56 consecutive innings without allowing a run. In his career, he pitched seven opening-game shutouts. COFFEYVILLE, Kansas, where Johnson once lived, established his memorial in Walter Johnson Park.

JONES, Anson. Great Barrington, MA, Jan. 20, 1798—Houston, TX, Jan. 9, 1858). Last president of the Republic of Texas. A doctor, he was an early supporter of Texas independence and was Secretary of State for Texas from 1841 to 1844, when he was elected president of Texas. In 1846, when Texas became the 28th state of the Union, Jones resigned his position to the new governor of the state, James Pickney Henderson.

nila and visited troops in Vietnam, but the anti-war sentiment continued to grow, with peace marches and widespread protests.

The single issue of American forces in Vietnam so severely eroded his national support that on March 31, 1968, he made a widely observed television address in which he declared he would not accept the Democratic nomination for the presidency, although he was eligible to run for a second full term in office. Senator Eugene McCarthy was the principal opponent of the war. His strong race in the New Hampshire Democratic primary for president is thought to have been one of the major reasons for Johnson's decision not to run again.

Anti-war feeling continued, reaching its peak

JONES, Jesse Holman. (Robertson County, Tennessee, Apr. 5, 1874—Houston, TX, June 1, 1956). Financier and politician. Based in HOUSTON, Jones became a millionaire lumber magnate and land developer. President Herbert Hoover appointed him to the Reconstruction Finance Corporation in 1929, and the following year he became its chairman. When President F.D. Roosevelt merged the RFC with other agencies in 1939 he became head of the Federal Loan Administration. The following year he was appointed secretary of commerce, serving in that post until 1945. His close ties to business made him a vital member of the wartime cabinet. He was one of the major figures in the rapid development of U.S. wartime industrial growth and in the planning for postwar adjustments.

JORDAN, Montana. Town (pop. 485), seat of Garfield County, northeastern Montana, northwest of MILES CITY and southwest of Wolf Point. Jordan was called "the lonesomest town in the world" by a New York radio station in 1930. Long hair and beards were worn by the men because there was no barber. The road and telephone line from Miles City did not reach Jordan until 1935. It has been one of Montana's true cow towns. One of the most complete skeletons of a tyrannosaurus rex was found near Jordan on Hell Creek.

JUDITH BASIN. Region in Montana named by Lieutenant William CLARK (1770-1838), of the LEWIS AND CLARK EXPEDITION, in 1805 in honor of Judith Hancock of Faircastle, Virginia, who later became his wife. Mountains encircling the basin ensure that the land receives slightly more rain than other areas of central and eastern Montana. The rich soil has yielded excellent crops. Among the animals of the basin are a small number of unusual white wolves.

JUDITH RIVER. Lying in central Montana, flows northeast and then north through JUDITH BASIN and Fergus counties. The Judith flows west of LEWISTOWN, Montana, and joins the MISSOURI RIVER at the Judith Landing State Recreational Area.

JUNCTION CITY, Kansas. City (pop. 19,305). Seat of Geary County, northeastern Kansas, southwest of MANHATTAN and northeast of ABILENE named for its site at the junction of the REPUBLICAN and SMOKY HILL rivers. In 1541 the Spanish explorer Francisco Vasquez de CORONADO (1510-1554) entered Kansas and reached the area of present-day Junction City. The community, established at the strategic river location, was founded in 1858. It is a major trading center for the region, especially for soldiers from FORT RILEY. Each year's July 4th Sundown Salute (firing of 50 cannon) ranks as one of the largest Independence Day events in Kansas.

KADOHADACHO CONFEDERACY ("real chiefs"). Group of Indian tribes of Caddoan linguistic stock who lived in northeast Texas. One of the most dominant tribes of this Confederacy was the CADDO, who gave their name to the linguistic group of which they were a part.

KALISPEL INDIANS. One of the three Confederated Tribes of FLATHEAD including the Salish and the Kootenai tribes.

KALISPELL, Montana. City (pop. 10,648). Seat of Flathead County, northwestern Montana, north of MISSOULA and northwest of GREAT FALLS, for the Indian tribe of that name. Center of a principal vacation area, it lies midway between GLACIER NATIONAL PARK and FLATHEAD LAKE in a region noted for its production of sweet cherries. The area is prominent for annually shipping more than one and one-half million Christmas trees to market, as well as for growing and processing seed potatoes. The

settlements of Ashley and Demersville were moved here to create the community of Kalispell when the Great Northern laid track to the point in the late 1800s. Credit for founding the town in 1891 goes to Charles E. Conrad who freighted and traded on the MISSOURI RIVER. His twenty-three room mansion, containing many original furnishings, is open to the public. Scenic cruises are available on Flathead Lake.

KANSA INDIANS. Siouan tribe which lived near the MISSOURI and KANSAS rivers. Together with the OSAGE, PONCA, OMAHA and QUAPAW tribes the Kansa formed the Dhegiha branch of the Siouan linguistic family. The Kansa were organized into two moieties, the Ictunga and the Nata. These were subdivided into phratries each having sixteen clans. Clans were divided into families, some patrilineal and others matrilineal. Marriage within a family was prohibited. Pressure from whites forced the Kansa to adopt a hereditary chieftain system. Prior to this pressure each village was ruled by a chief elected by a council. A head chief ruled over all the villages. The Kansa lived in round or oval wood-framed earth-covered lodges floored with mats woven of reed, grass or bark. Skin tipis

A portrait of White Plume, Chief of the Kansa Indians.

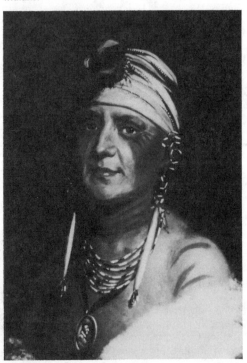

were used on hunting trips. The Kansa culture was based on hunting, plus a very limited amount of agriculture. Women did the menial work of the village as the men were concerned with warfare and hunting. The 18th and 19th centuries were filled with conflict with the Sauk, Fox, Osage, Omaha, IOWAY, PAWNEE and CHEYENNE. In 1825 the Kansa received a two million acre reservation in Kansas. This land was ceded by treaty in 1846 and the Kansa were removed to a 265,000-acre reservation on the NEOSHO RIVER farther west. These lands came under pressure from white settlers, and the Indians were again forced to move in 1873 to a reservation in Oklahoma near the Osage. All the land was allotted in severalty in 1902 and the tribe was dissolved as a legal entity.

KANSAS. State. Kansas lies in the center of the United States from east to west and somewhat south of the center from north to south. In the Central West, Kansas guards the eastern border, again somewhat south of the center north to south.

Kansas has a geographic distinction unique on the continent. A point on Meades Ranch in Osborne County is the GEODETIC DATUM POINT of North America, the point from which all latitude and longitude are measured for the North American continent. There are only four border states, Missouri to the east, Oklahoma, south, Colorado, west and Nebraska, north. All the borders are straight and man-made except for the northeast corner, delineated by the curves of the MISSOURI RIVER.

Six Kansas rivers are designated on the U.S. Geological Survey of the nation's principal rivers. These are the REPUBLICAN, KANSAS, SMOKY HILL, ARKANSAS, CIMARRON and NEOSHO. Among the other rivers of the state are the MARAIS DES CYGNES, Verdigris, Blue, Saline and SOLOMON.

There are few natural lakes, but man-made bodies of water have helped to transform much of dry Kansas. Milford and Tuttle Creek reservoirs are the largest. Others include Kanapolis, Perry, Redmond, Toronto, Fall River, Cheney and Cedar Bluff.

Kansas has no mountains, but there are other natural features of interest. These include the CHALK PYRAMIDS, Rock City, Monument Rocks and GYPSUM HILLS. Many of these were critical landmarks on the routes to the West. Among the more unusual features are the BASINS. These occur when the support underneath a limestone surface gives way, and the top level drops down. BIG BASIN in Clark County is a hundred feet deep and about a mile long.

Kansas Climate

Major Rivers and Waterways

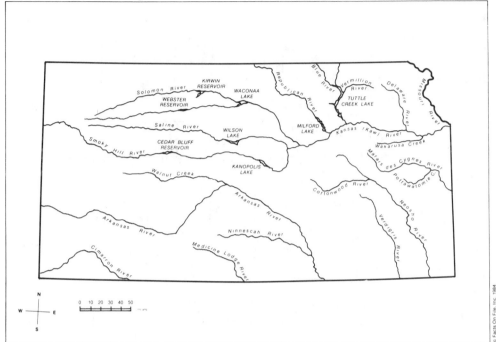

Basins are being formed almost constantly, and farmers may wake in the morning to find a piece of their landscape altered in this way.

Among the Central West states, Kansas ranks 8th in area, with 82,264 square miles of territory.

In early Cambrian times most of Kansas consisted of low lying plains, which lowered into shallow seas during the Ordovician period. The Silurian period brought up a low lying range in the south, which was joined by two parallel ranges to the north. In Carboniferous times, these had mostly subsided, leaving shallow seas once more in the northwest. These covered all but the eastern section of the present state during Permian times. During the Triassic age, most of Kansas had risen to a ridge of peaks parallel to the present eastern border. The Jurassic era saw much of the western section under seas, a process expanded in the Cretaceous age, except for the eastern Mid-Continent High.

In the Cenozoic Era, beginning about 65 million years ago, as the ROCKY MOUNTAINS lifted skyward to the west, the climate was warm, and tropical conditions prevailed. Sediment washed down from the Rocky Mountains spread over the GREAT PLAINS, and fertile grasslands sprang up. Only one of the great glaciers reached present Kansas, bringing sand and gravel and rich soil to portions of Nemaha and Brown counties, but the glacial age dramatically altered the climate, forcing the tropical belt to the south and creating a cold semi desert.

Today, most of eastern Kansas lies in the late Paleozoic period, with a slash of Mesozoic surface cutting from central northeast to central southwest, partially interrupted by the sedimentary rocks of the Cenozoic period which occupy most of the western third of the state.

Kansas has many exceptional fossil beds, including the nation's largest beds of crabs and other crustaceans, the earliest ancestor of the horse, toothed birds and reptiles, including huge turtles.

Temperature extremes in Kansas range from a high of 121 degrees near Alton to a low of minus 40 degrees at LEBANON. Rainfall averages 28.6 inches per year. The record rainfall for a twenty-four hour period occurred in 1941—12.59 inches, at Burlington. In agriculture, Kansas is known as "The Breadbasket of the Nation," far ahead of all the other states in production of wheat. Kansas produces almost twice as much wheat as the next state, North Dakota, and the value of Kansas wheat is

Kansas

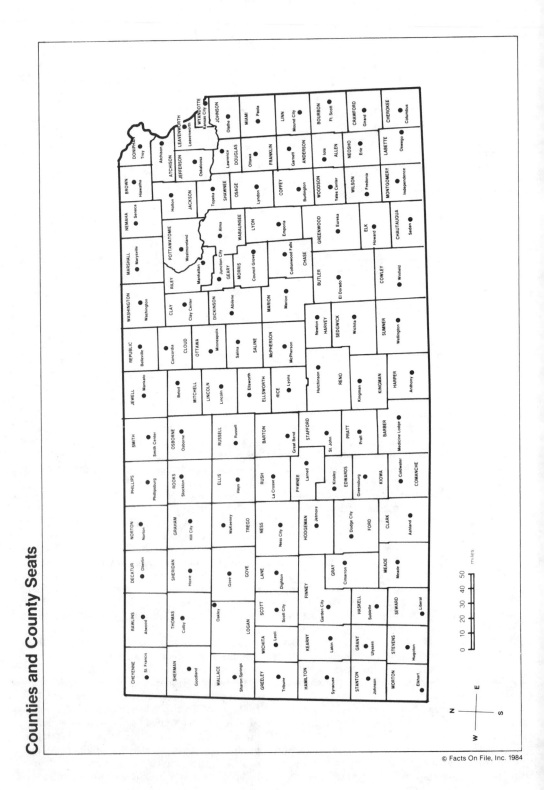

Counties and County Seats

Kansas

STATE OF KANSAS

Capital: Topeka, founded 1854

Name: Kansa, from the old Siouan language for "people of the South wind."

Nicknames: Sunflower State; Jayhawk State

Motto: "Ad Astra per Aspera" (To the Stars Through Difficulties)

Symbols and Emblems:
Bird: Western Meadowlark
Flower: Native Sunflower
Tree: Cottonwood
Song: "Home on the Range"
March: "'The Kansas March"
Animal: American Buffalo

Population:
1985: 2,450,000
Rank: 32nd
Gain or Loss (1970-80): +115,000
Projection (1980-2000): +131,000
Density: 30 per sq. mi.
Percent urban: 66.7% (1980)

Racial Makeup (1980):
White: 91.7%
Black: 5.3%
Hispanic: 63,333 persons
Indian: 15,400 persons
Others: 53,929 persons

Largest City:
Wichita (288,000-1986)

Other Cities:
Kansas City (162,070-1986)
Topeka (118,580-1986)
Overland Park (81,784-1980)
Lawrence (52,738-1980)

Area: 82,277 sq. mi.
Rank: 14th

Highest Point: 4,039 ft. (Mount Sunflower)

Lowest Point: 680 ft. (Verdigris River)

H.S. Completed: 73.3%

Four Yrs. College Completed: 17%

STATE GOVERNMENT

Elected Officials (4 year terms, expiring Jan. 1991):
Governor: $65,000 (1986)
Lt. Gov.: $18,207 (1986)
Sec. of State: $50,000 (1986)

General Assembly:
Meetings: Annually at Topeka
Salary: $49.00 a day plus $50.00 a day expenses while in session and $600.00 per month when not in session(1986)
Senate: 40 members
House: 125 members

Congressional Representatives
U.S. Senate: Terms expire 1991, 1993
U.S. House of Representatives: Five members

Kansas, Economy

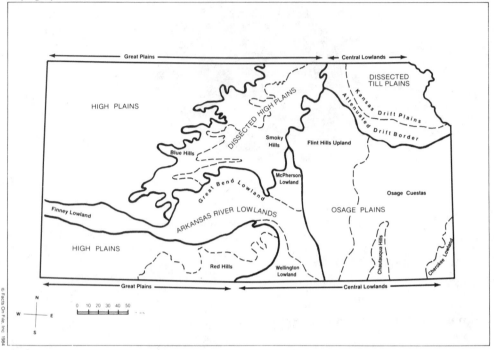

nearly double that of North Dakota. In 1984 the Kansas crop brought $1,445,000,000. In bulk and food value, Kansas wheat is second in the world only to the Iowa corn crop.

HUTCHINSON thrives as the largest primary hard wheat market in the country, and that city and KANSAS CITY are proud of the largest grain elevators anywhere.

Sorghum and corn are the next in order of value of Kansas crops.

Livestock, cattle, sheep and hogs, bring more income to Kansas farmers than do the crops, not excluding wheat. Total value of Kansas agriculture in 1984 was $5,957,000.

However, the value of manufactured products in Kansas is almost five times greater than that from agriculture—$26,753,000,000 in 1984. Principal products are transportation equipment, food and printing and publishing. Most spectacular is the aircraft industry. With giants such as Boeing, Beech, Cessna, Learjet and Gates at WICHITA, which has world leadership among cities in the production of aircraft and builds more private planes than the rest of the U.S. combined.

Kansas City, Kansas, is a world leader in meat packing and manufacture of animal serums. The vast quantities of Kansas wheat make the state one of the great milling centers of the world.

In less spectacular industries, Kansas leads the world in production of carbon black and machinery to manufacture pre-cooked dog food.

Kansas had the first producing oil well west of the Mississippi—Old Norman at NEODESHA, which came through in 1892. The state now ranks eighth in petroleum production and fifth in natural gas. Cement ranks third in value among Kansas mineral products. Total mineral income for Kansas in 1984 was $3,019,000. In 1819 modern transportation reached Kansas in the form of the WESTERN ENGINEER, first steamboat on the Missouri River. Other Kansas rivers were not adequate for mass transportation. The first railroad reached Kansas at Elwood in 1860, and ATCHISON supported the ATCHISON, TOPEKA AND SANTA FE RAILROAD with a bond issue. That road's first service came to Kansas in 1869.

In the decade 1975-1984 all the Central West states increased in population. During that period Kansas population increased by 157,000 to a total of 2,438,000, ranking 32nd in the nation and fourth in the Central West. Population in the year 2000 is projected to be 2,494,000, an increase of 4%. Of the total population,

126,127 were listed as black in the 1980 census, with 63,339 as Hispanic. The Indian population was, 2,254.

Surprisingly little is known about the prehistoric inhabitants of present Kansas. A few pictographs and petroglyphs, flint tools, some pottery and small mounds are about all the prehistoric materials found so far. The exception is the Salina discovery in 1937 of forty bodies, carefully laid in patterned rows, many of the men substantially over six feet tall. However, the meaning of this discovery is not very clear.

The first European explorer known to have been in present Kansas was Spanish general Francisco Vasquez de CORONADO (1510-1554). Seeking the riches of the fabled SEVEN CITIES OF CIBOLA, he entered Kansas, going as far as present DODGE CITY, then turned north and east before turning back, exactly where is not known.

Perhaps the seven cities actually were the rather humble villages of the WICHITA tribe. Of the other Indian tribes, early Europeans described the OSAGE, PAWNEE and KANSA, from which the state takes its name, meaning people of the south wind. The Osage were an extraordinary group, said to be the "tallest Indians in North America." The Indians of Kansas lived in villages of earth lodges but left those villages to go on great buffalo hunts, a province of the men. The women did the rest of the work, including some raising of crops. Much of the life of Indian men centered on warfare. The high honor of a test tattoo could only be gained upon proof of having killed seven warriors in battle. The Valley of the Walnut River has been called "the scene of more tribal conflicts than any other spot in America." The death struggles there between the Cheyenne and the Pawnee were devastating. MEDICINE LODGE, under the protection of the Great Spirit, was the only neutral ground.

The early Spanish explorers left a great legacy to the Indians. Some of their horses were lost or abandoned and others were stolen by the Indians. Soon the plains people had bred large numbers of horses, and every aspect of Indian life on the plains was changed as the plains Indians became noted as some of the world's greatest horsemen.

Coronado's otherwise fruitless journey gave Spain claim to the lands which he had covered. Franciscan priest Father Juan de Padilla had been with Coronado and returned to present Kansas, only to become the first martyr in the southwest. Few other Europeans cared, or

dared, to enter the region which included Kansas. All the colonizing nations considered the area unfit for anything.

The Spanish continued to claim the area, but by 1803 when the U.S. purchased the Louisiana Territory, new interests in the southwest were developing. The northeast corner of present Kansas was touched by the LEWIS AND CLARK EXPEDITION in 1804. They passed along the Missouri River shores, and skirted the mouth of the Kansas River on June 26th. They celebrated Fourth of July in present Atchison County by firing one of their heavy guns. The summer heat at the NODAWAY RIVER caused some of the party to suffer sunstroke, and then the group went on up stream.

In 1806 Zebulon PIKE (1779-1813) traveled entirely across the state, making this note on his way: "My feet were blistered and very sore. I stood on a hill and in one view below me saw buffalo, elk, deer, cabrie antelope and panthers...I prevented the men shooting at the game, not merely because of the scarcity of ammunition, but, as I conceived, the laws of morality forbade it also."

Pike went on to hold a grand council of the Indians at Council Grove, when the American flag was exchanged for the Spanish for the first time in present Kansas. The event probably occurred in Republic County.

In 1824 the Rev. Benton Pixley set up a mission among the Osage Indians in present Neosho County, and within a period of ten years a number of missions of several denominations had been founded. The first wagon party to cross on the overland route from Missouri to SANTA FE passed through Kansas in 1822 under the leadership of Captain W. H. BECKNELL (1796-1865).

When they came to the CIMARRON RIVER, its bed was dry. They almost died from thirst before they discovered that the water was flowing close beneath the surface. The largest section of the SANTA FE TRAIL coursed through Kansas, and within a few years, hundreds of wagons were crossing the prairies for the trade with New Mexico. With four to eight wagons abreast, the trail became so hard that it could not be plowed for years. Fortunes might be made in a single trip.

Later, the trail was used by settlers and the gold seekers en route to California after 1849.

Another trail brought travelers—the even more widely used Oregon Trail, splitting from the Santa Fe near OLATHE.

The first true "settlers" of Kansas were Danial Morgan BOONE, son of famed frontiers-

man Daniel Boone, and his wife. When their son was born, he was the first non-Indian native of Kansas. In 1827 they arrived at the area where Colonel Henry H. LEAVENWORTH (1783-1834) had built a small fort on the Missouri River, sent by the federal government to teach the Indians how to farm. FORT LEAVENWORTH was the first permanent European settlement in present Kansas.

After the KANSAS-NEBRASKA ACT opened the two territories to settlement, the population grew both rapidly and unhappily. Because the territories were to choose whether they would permit slavery, the slave interests in Missouri recruited settlers to make Kansas a slave state. Abolitionists, opposed to slavery, recruited northern settlers to face them. The conflict brought about "Bloody Kansas," with the area suffering a "little civil war" as a prelude to the CIVIL WAR, as pro-slavery forces pillaged and burned and were in turn attacked by such forces as those trained in Iowa by enraged Abolitionist John BROWN (1800-1859). Five governors, five acting governors and three state constitutions failed to stem the hostilities. The fourth constitution was approved in 1859,

calling for Kansas to become a free state. Congress stalled approval until after several states already had joined the Confederacy. Kansas became the thirty-fourth state on January 29, 1861, following the signing of the legislation by President James Buchanan. The state had grown in population from almost nothing in 1854 to 107,206 in 1860.

Almost immediately Kansas became involved in the Civil War. Kansas Frontier Guard was sent to camp on the velvet carpet of the White House East Room to protect the new president, Lincoln, from kidnapping. Then Confederate guerilla forces attacked Humboldt, Kansas, on September 12, 1861. Some of the war's worst guerilla fighting raged through Kansas during the war. One of the worst such attacks was the raid of William Clarke QUANTRILL (1837-1865) on LAWRENCE, August 21, 1863, when 1,250 civilians were killed and 200 buildings burned.

Most notable of the "formal" engagements fought in Kansas was the Battle of MINE CREEK, October 25, 1864, involving 25,000 men and resulting in the Union victory which assured federal control of the state. In proportion to

The mural in the Kansas capitol at Topeka depicts "John Brown at Ossowatomie," symbolizing the tragic period before the Civil War when the conflict over legalizing slavery created "Bloody Kansas."

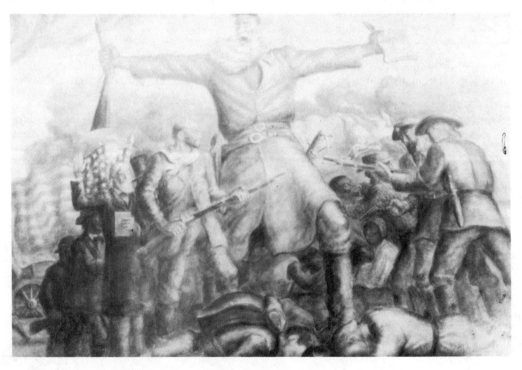

population, Kansas sent the largest number of soldiers to the war of any of the states.

After the war, Kansas became the model for a hundred movie and TV westerns. As the various towns were reached by the railroads, each successive town became the terminal for the great cattle drive northward from Texas—Abilene, NEWTON, Ellsworth, Wichita, Dodge City and CALDWELL all had their turn. After delivering their cattle up the CHISHOLM and other trails, the cowboys were ready to celebrate, and the saloons of each terminal town in turn were packed with brawling crowds.

Perhaps rip-roaringest of all was Dodge City, established in 1872. In September of that year the first Santa Fe train reached Dodge and almost overnight it became Queen of the Cow Towns. Millions of television screens have captured the names of its lawmen and outlaws—Bill Tilghman, Bat Masterson, Wyatt EARP (1848-1929), Mysterious Dave Mather, Prairie Dog Dave Morrow and others.

As the cattle drives gave way, beginning about 1870, the rush of settlers began. German refugees arrived in numbers, and Swedish immigrants settled LINDSBORG. Among all the many frontier hardships, one of the most severe was the absence of trees for wood. Fence posts often had to be hewn from rocks, and buffalo chips were gathered for fires. Some settlers simply dug their houses into the sides of hills. Others cut the solid chunks of prairie to make the famed SOD HOUSES. Indians, drouth, prairie fires and insect infestations added to the hardships.

After years of Indian troubles, 15,000 Indians and their leaders gathered in the largest meeting of its kind ever to take place in the U.S. A number of troublesome matters were settled at this council of Medicine Lodge. But the Indian troubles continued until 1878 when a group of Cheyenne raided the state in the last Indian conflict in Kansas.

The 1880s saw the first of the annual performances of Handel's MESSIAH at the Swedish town of Lindsborg, the first state wide prohibition amendment and the election of the first woman mayor in the U.S.—Susanna SALTER of ARGONIA—whom some claim as the first woman to achieve such a position in world history.

The 1890s saw Republicans contesting a governor's election and being held under siege in the capital by the Democrats until the U.S. Supreme Court decided in favor of the Republicans. In 1893 Kansas hosted thousands of people camping on the Kansas side of the Oklahoma border, waiting for the run for land

in the CHEROKEE OUTLET. In 1898 Kansas' own Frederick FUNSTON (1865-1917) became one of the major heroes of the SPANISH AMERICAN WAR, by capturing Philippino guerilla leader Aguinaldo.

The turn of the century saw a devastating flood in 1903 and the franchise of Kansas women in 1912. During WORLD WAR I, so much of Kansas was plowed to grow wartime grain that the DROUTH of the 1930s dried up the fields; great clouds of choking dust carried off the precious Kansas soil, setting the scene for vigorous conservation measures later.

In 1931 famed Notre Dame football coach Knute Rockne was killed when his plane crashed near Bazaar. In 1936 Kansas governor Alf LANDON (1887-1987) lost the presidential election to F.D. Roosevelt by the largest margins in U.S. history.

During WORLD WAR II, the Kansas aircraft industry delivered great numbers of planes, and Kansas walnut was converted into hundreds of thousands of gunstocks. Of the 215,000 Kansans who saw service in that war, the Supreme Commander of Allied Forces was Kansan Dwight D. EISENHOWER (1890-1969), who returned in triumph after the war to his hometown of ABILENE.

The famed Rural Health Plan and the floods of 1951 were important happenings in post-war Kansas, along with the overwhelming vote for Eisenhower for president in 1952. World attention focused on Kansas when the TOPEKA school system was forced to desegregate by the famous Supreme Court decision in 1954. In 1961 Kansas celebrated its statehood centennial. Kansas native Gary Hart lost his bid in 1984 for the Democratic nomination, and dropped out for personal reasons from his bid for the 1988 nomination.

No Kansas native has reached the presidency, but Dwight Eisenhower was only a year old when the family moved to Abilene, and he grew to manhood and developed his philosophy and skills of leadership there. His career as commander of the greatest fighting force in world history, as president of a great university, as head of NATO and as U.S. president has not been equalled before or since.

Not so successful as a presidential candidate, Alf Landon of Kansas celebrated his 100th birthday in 1987, surrounded by President and Mrs. Reagan and his daughter Nancy Katzenbaum of the U.S. Senate. On that occasion he was hailed as the grand old man of U.S. politics, and his death occurred only a few weeks later.

Highest political position reached by an

American Indian was achieved by Topeka native Charles CURTIS (1860-1936), vice president under Herbert Hoover.

Kansas has nurtured many notable journalists, perhaps most notable of all, William Allen WHITE (1868-1944) of EMPORIA, whose impact through his modest *Gazette* became international. Through his editorials and with the help of his influential friends throughout the nation and the world, he is said to have "colored the course of American history in a way few others have mastered." Among other distinctions, his writing captured two Pulitzer Prizes.

Author the Rev. Charles M. SHELDON and playwright William INGE (1860-1954) both gained national fame for their writings. Muralist John Steuart CURRY (1897-1946) was a notable Kansas artist. His *Tragic Prelude,* a Kansas capitol mural, was highly controversial. Fame in another field has come to the MENNINGER FAMILY, through the work of Dr. Karl Menninger and the other family members who started and developed the famed MENNINGER CLINIC at Topeka, said by some to be the "mental health center of the world." In still another field, the hero of The Spanish Ameri-

can War in the Philippines, General Frederick Funston, who organized San Francisco after the famous earthquake and fire, might have been chosen to lead American forces in World War I if he had not died suddenly at the age of 51.

The first woman ever to plead before the U.S. Supreme Court was a Kansan of Indian descent, Lydia B. CONLEY. One of the most notable women of her times was Atchison native Amelia EARHART (1897-1937) Putnam, premiere aviator, who died mysteriously in a flight over the Pacific. Jungle experts Osa and Martin JOHNSON grew up in southeast Kansas.

Baseball's greatest pitcher of all time, Walter JOHNSON (1887-1946), native of Humboldt, Kansas, holds more records in the books than any other pitcher. World heavyweight boxing champion Jess WILLARD was known as The Pottawatomie Giant.

In the early 1860s the Indians built a village of grass lodges in central Kansas. Today the modern metropolis of Wichita stands in great contrast at the same location. Beginning in 1872, Wichita developed as a notorious cow town. Then "Where cattle had built dance halls and gambling houses, wheat built churches and

The capitol at Topeka.

schools," along with many of the airplanes which have given America wings. Today the state's largest city has preserved a segment of the past in Cowtown Wichita, with the first log house and reproductions of early businesses.

Kansas' second largest city was founded by the WYANDOTTE INDIANS, who built a church, store, council house and school at the junction of the Missouri and Kansas rivers. This came to be known as Kansas City. In the rivalry between the Kansas and Missouri twin cities, the Kansas side reminds the Missouri side that most of the valuable manufacturing is carried on across the border in Kansas.

The Indians gave the place its name meaning "a good place to grow edible roots," and Kansas found Topeka just such a good place to build its capital. The striking capitol building stands on grounds contributed by the Atchison, Topeka and Santa Fe Railroad, which was founded at the two Kansas towns. The design of the building is based on the capitol at Washington. Murals in the capitol are especially renowned. The famed Menninger Foundation is a highlight of the city. One of the country's outstanding historical societies, the State Historical Society and Museum, keeps a file of newspapers second only to that of the Library of Congress.

Kansas' first capitol has been restored at Fort Riley. First incorporated city in Kansas was Leavenworth, for many years the largest city in the state. So many army officers stationed at Fort Leavenworth married local women that the city gained its nickname, Mother-in-Law of the Army. The fort is the oldest operating military post west of the Mississippi. The army Command and General Staff College operates at the fort, and there is a national military cemetery, resting place of the fort's founder, Henry Leavenworth.

Emporia is noted for the many memories it preserves of noted journalist William Allen White. A completely opposite personality gained notoriety for Osawatomie, remembered as the home of violent Abolitionist John Brown, where the John Brown Memorial Park preserves his cabin.

COFFEYVILLE is known as the site of the "most famous street fight of the Old West." This was the attempt of the outlaw DALTON gang to rob two Coffeyville banks at the same time, but the local hardware store armed the citizens, who fought back bravely, killing four of the outlaws. The community has erected a museum to honor the defenders of the town.

History of an entirely different kind was made at RUNNYMEDE, near Harper. Its British name recalls the English community which settled there, bringing its Tally-ho coaches, butlers and other symbols of high living in their home country. VICTORIA was another British community where riding to the hounds was as familiar as riding the range.

Kansas' noted Swedish community, Lindsborg, has special fame as the home of an annual performance of Handel's *Messiah*, founded in 1892 and carried on continuously since, attracting famed artists and concertgoers alike.

At Smith Center is the log cabin home of Dr. Brewster Higley, who wrote "Home on the Range." Center of another kind is Lebanon. No community occupies the exact center of the 48 conterminous states, but Lebanon is the closest to it.

GARDEN CITY is the metropolis of western Kansas, where the three story atrium of the Windsor Hotel was renowned across the country. Dodge City, to the east, has rebuilt its notorious Front Street; there visitors are treated to gunfights and other excitement of the Wild West, personified by the name Dodge City.

A quite different claim to fame is held by LIBERAL, where housewives compete long distance with competitors in Olney, England, running the noted pancake race over a tenth of a mile course, carrying pancakes in a skillet and flipping them as they run.

At the Missouri River town of Atchison, a plaque memorializes the founding of the Atchison, Topeka and Santa Fe Railroad, founded with a $500,000 Atchison city bond issue.

During the period of "bleeding Kansas," Lawrence suffered most, being burned and sacked twice by pro-slavery forces before it had reached ten years. At Oak Hill Cemetery a monument honors the memory of the victims of a raid by William Clarke Quantrill.

Today Kansas "raids" are confined to tourists who spend close to two billion dollars each year visiting such unique sites as the EISENHOWER CENTER, with its Memorial Museum, library and boyhood home. The complex is one of the most complete of all those honoring U.S. presidents. President and Mrs. Eisenhower are buried on the grounds at Abilene.

KANSAS CITY, KANSAS

Name: Originally Town of Kansas From the Kansas river. Later it was the City of Kansas then Kansas City, "kansa" "people of the south wind" from the Siouan language.

Nickname: KC

Area: 107.4 square miles

Elevation: 744 feet

Population:
1986: 162,070
Rank: 99th
Percent change (1980-1984): +0.6%
Density (city): 1,509 per sq. mi.
Metropolitan Population: 1,476,715 (1984)
Percent change (1980-1984): +3%

Race and Ethnic (1980):
White: 70.96%
Black: 25.34%
Hispanic origin: 4.85%
Indian: 0.46%
Asian: 0.44%

Age:
18 and under: 29.6%
65 and over: 11.7%

TV Stations: 6 (KC, MO)

Radio Stations: 32 (KC, MO)

Hospitals: 4

Sports Teams:
Kansas Ctiy Royals (baseball)
Kansas City Chiefs (football)
Kansas City Comets (soccer)

Further Information: Kansas City Kansas Area Convention Bureau, 636 Minnesota, P.O. Box 1576, Kansas City, Kansas 66117

KANSAS CITY, Kansas. City (pop. 161,082). Seat of Wyandotte County, situated in far eastern Kansas at the bend of the MISSOURI RIVER where it meets the KANSAS or Kaw river and adjoining its twin city Kansas City, Missouri. The city takes its name from the Kansa Indians, "people of the south wind."

The city is a major transportation center, gathers the region's grain into eight elevators, one the world's largest, and manufactures automobiles, fabricates steel and produces soap and other products in various industrial districts.

The city was gradually formed by the consolidation of eight communities which grew up in the area. The first of these, Wyandot, was founded in 1843 by the successful WYANDOTTE INDIANS. They created the first schools in what

is now the state and added churches and businesses, practiced advanced agriculture and good government. When white settlers began to encroach, the Wyandotte sold their properties for a good price and departed.

The successors slightly changed the name to Wyandotte and profited from the ever-increasing number of westward bound crowds and the river traffic. After other towns came into being as meat packing and processors of other produce, the towns were finally merged into the present entity.

Although dependent on the larger neighbor city for many metropolitan amenities, the Kansas side offers such attractions as the unique Agricultural Hall of Fame and National Center, with a wide variety of restorations, displays and demonstrations bringing agricultural history to life. Of particular historical interest, also, is the Grinter House of about 1857, home of the first permanent white settler in Wyandotte County. Another aspect of history is demonstrated in Old Shawnee Town, where a Midwestern pioneer town of the 1800s has been restored or recreated. The Indian influence on the community is preserved at the Huron Indian Cemetery, where visitors wander among the graves of 400 Indians.

A notable tour is provided by the General Motors Assembly Plant.

The six week Renaissance Festival begins in August and lasts through Labor Day weekend. Applefest takes place on the fourth weekend of September.

"KANSAS PYRAMIDS" Rock formations located between Oakley and Scott City which are said to resemble the pyramids of Egypt.

KANSAS RIVER. Formed by the joining of the SMOKY HILL and REPUBLICAN rivers at JUNCTION CITY, Kansas, the Kansas River, generally called the Kaw, flows eastward for 170 miles through the state past TOPEKA and LAWRENCE to meet the MISSOURI RIVER at KANSAS CITY.

KANSAS STATE UNIVERSITY. State-supported university located in MANHATTAN, Kansas. The school was first operated on the grounds of Bluemont Central College, a Methodist institution chartered in 1858, but the university was moved to its present site in 1875. The university maintains a campus of 315-acres, which contains most of the buildings, and 4,036-acres of land used for experimental work in agriculture. The school gained national prominence when Milton EISENHOWER (1899-

1985), brother of the United States president, was its president. During the 1985-1986 academic year the university enrolled 17,570 students and employed 1,544 faculty members.

KANSAS, University of. Publicly supported state university located in LAWRENCE, Kansas. Founded in 1864, the university's 1985-1986 student population was 24,774, instructed by a faculty of 1900. A valued part of the campus is the Snow Entomological Museum, one of the most complete in the United States, in which more than two million insect specimens are exhibited. The lofty campanile has been dedicated to those killed in WORLD WAR II. The university's Medical Center is located in KANSAS CITY with the Schools of Medicine, Nursing and Allied Health.

KANSAS-NEBRASKA ACT. Statute enacted in 1854 which provided that Nebraska and Kansas would be organized as territories on the basis of popular sovereignty, the doctrine that the people of a territory had the right to decide whether they wished the territory to be admitted to the Union as a free state or a slave state. The result of the law was to open Kansas to organized migrations of anti-slave and pro-slave groups which, within the next five years, proceeded to attack each other in bloody warfare. Each group sought to prepare a territorial constitution based on its philosophy. The territory became known as "Bleeding Kansas" during this period.

KARAKUL SHEEP. Animal, popular for its fur, was introduced into the United States from Russia by Theodore Roosevelt's Secretary of Agriculture, "Tama Jim" Wilson. The Karakul Sheep Ranch located near Holliday, Texas, is the largest of its type.

KARANKAWA INDIANS. Extinct tribe of independent linguistic stock, which once lived on the Texas Gulf Coast, and may have numbered about 2,800. The Karankawa were nomadic and lived a day-to-day subsistence existence in portable huts, which they packed to move when food became scarce. Their diet was based on shellfish, nuts, eggs, wild fowl, and roots. The Karankawa lived in small groups and reportedly buried their dead, except for their doctors who were burned. They practiced cannibalism, as did some of the other tribes in the area, and resented all incursions including those of the Spanish, Texans and the pirate Jean LAFITTE (1780-1826). Cabeza DE VACA lived

among them after being shipwrecked in 1528. For Saint Louis was built in their country by LA SALLE (1643-1687) in 1685, when he thought he was near the mouth of the Mississippi River. Because of their constant raiding, they were finally destroyed by the settlers by the mid-1800s.

KAW CITY, Oklahoma. Town (pop. 283), Kay County, northeastern Oklahoma, northwest of TULSA and northeast of PONCA CITY. Tiny village site of the CLUBB HOTEL in which the walls were lined with priceless works of art created by such masters as Gainsborough, Titian, Gilbert Stuart and Winslow Homer. Laura A. Clubb, wife of a wealthy oilman, assembled the collection despite her husband's observation that, with the $12,500 she paid for her first painting, she "...could have bought a trainload of cattle." When Kaw Lake was created, the old Kaw City was covered by the waters of the reservoir. The Clubb Hotel was torn down, and when the town was relocated on a hill overlooking the lake, the decision was made not to rebuild the hotel there. The art collection, estimated to be worth $1,500,000, was donated to the PHILBROOK ART CENTER at TULSA.

KAW INDIANS. Common name for the KANSA INDIANS.

KAYCEE, Wyoming. Town (pop. 241), Johnson County, northeastern Wyoming, south of BUFFALO and southwest of GILLETTE. Founded in 1900, Kaycee was named for the nearby K C Ranch. Across the Red Fork of the POWDER RIVER lies Hole-in-the-Wall, a gap carved through Red Wall, a jutting fault thirty-five miles long. The region to the west takes its name from the Hole-in-the-Wall, which served as an outlaw hideout for half a century. An outlaw named Sanford "Sang" Thompson first used the area in the mid-1880s, when he discovered that by moving a few boulders about on the trail leading up to the gap at the wall's rim, it could be made to appear there was no trail on the other side. The eastern entrance could easily be defended by a few armed men, while the western side offered trails leading into Utah, Montana, Idaho and Colorado through rugged terrain with plenty of hiding spaces, and with only a few settlers who knew better than to ask too many questions of neighbors. Members of the JAMES gang were said to use the region as did the Wild Bunch headed by Butch CASSIDY. By 1900, Hole-in-the-Wall was part of an elaborate outlaw trail leading from Mexico to Canada and

the Pacific to the Great Lakes. Gang members kept in communication with notes hidden in hollow trees or under rocks. Following the last hold-up of the Wild Bunch, at Exeter, Montana, in July 1901, the gang broke up, and with so few outlaws around, the area was gradually inhabited by settlers. Today a group of Colorado ranchers and businessmen recreate the days of the Wild Bunch by riding far back into the region for a week-long session of "strong drink and windy stories."

KEARNEY, Nebraska. City (pop. 21,158). Seat of Buffalo County, south-central Nebraska, southwest of GRAND ISLAND and west of HASTINGS. It was named for General Stephen Watts KEARNY (1794-1848) (and misspelled). Given its central location in the United States, residents of Kearney once harbored hopes that their city would become the capital of the nation. Today the city is a center of agriculture and diversified industry. Kearney is home to Kearney State College, founded in 1905. The $150,000 Kearney Opera House had the only stage between the MISSOURI RIVER and DENVER large enough to feature major productions. FORT KEARNY, now part of the Fort Kearny Historical Park, was moved to Kearney in 1848 to protect settlers on the OREGON TRAIL, gold rush prospectors and, later, the crews constructing the Union Pacific Railroad. The Fort Kearny Museum, Trails and Rails Museum and George W. Frank Home are points of interest. Snow skiers in mid-winter enjoy the Prairie Hills Golf and Ski Club with its man-made a one-fourth mile, 120-foot vertical-drop hill, covered with artificial snow.

KEARNY, Stephen Watts. (Newark, NJ, Aug. 30, 1794—St. Louis, MO, Oct. 31, 1848). Army officer. Kearny, a member of General Henry ATKINSON's (1782-1842) expedition to the mouth of the YELLOWSTONE RIVER in 1825, led an expedition to SOUTH PASS, Wyoming, in 1845. In 1846 he began building the first FORT KEARNY near present-day NEBRASKA CITY, Nebraska. That same year he commanded the Army of the West and with 1,700 troops conquered New Mexico during the MEXICAN WAR. After spending a month organizing the territory, he took 100 troops to California and on September 25 he joined forces with Commodore Robert F. Stockton to capture San Diego, in December and Los Angeles in January, 1847. Kearny served as military governor of California until August, 1847, during which time he pacified the people of California. In 1848 he served as governor-

general at Veracruz, Mexico, and Mexico City. Having contracted a tropical disease at Vera Cruz, he died in St. Louis that year, while seeking treatment.

KEMMERER, Wyoming. Town (pop. 3,273), seat of Lincoln County, southwestern Wyoming, northwest of ROCK SPRINGS and northeast of EVANSTON. Kemmerer retains a page in merchandising history as the site where J.C. PENNEY (1875-1971), the future department store tycoon, opened his first store. Penney's establishment, called The Golden Rule, opened for business in 1902 on an investment of $500. At nearby FOSSIL BUTTE NATIONAL MONUMENT, some of the world's finest examples of fossilized fish, clams, and turtles have been found. A popular annual event in early August is Turn of the Century Days which features a parade, old-style western shootout and dance.

KENDRICK, John B. (Cherokee County, TX, Sept. 6, 1857—Sheridan, WY, Nov. 3, 1933). Senator. Kendrick, a powerful cattleman in northern Wyoming and southern Montana in 1885, was the owner of one of the largest range ranches in the West. A Democrat, he served in the Wyoming Senate from 1910 to 1914 before serving as governor from 1915 to 1919. He received the Democtratic nomination for the U.S. Senate in the primaries of 1916, although his name did not appear on the ballot and had to be written in. Kendrick was the first person from Wyoming to be elected to the U.S Senate directly by the voters, and he served in the Senate from 1916 to 1933. He was noted as a strong proponent of interests of the region, especially of ranchers and stockmen. Called the "Cowboy Senator," Kendrick claimed to be the only Senator who rode the cattle trails from Texas to Wyoming (1879). He is credited with establishment of Grand Teton National Park, worked to curb the powers of the meat packing industry, was responsible for the inquiry that led to the uncovering of the TEAPOT DOME scandal (1922), and after great effort successfully promoted the Alcova Dam at Casper, Wyoming (1933). He died soon after, the oldest man in the Senate at that time

KENNEDY, John F. (Brookline, MA, May 29, 1917—Dallas, TX, Nov. 22, 1963). 35th President of the United States. Kennedy was shot while traveling in a motorcade in DALLAS, Texas. Also injured in the tragic event was the governor of Texas, John B. Connally, Jr. Kennedy was rushed to Parkland Hospital, but never

recovered consciousness. Arrested soon afterwards for the killing was Lee Harvey Oswald who was himself assassinated in front of millions of television viewers by Jack Ruby, a local tavern operator who somehow gained access to the Dallas police station. John F. Kennedy Memorial Plaza at Dallas commemorates the fallen chief executive with a Philip Johnson monument, located only 200 yards from the place where the martyred president was assassinated.

KERR, Robert Samuel. (Ada, OK, Sept. 11, 1896—Washington, DC, Jan. 1, 1963). Governor of Oklahoma and U.S. Senator. Kerr was the first native-born governor of Oklahoma. A lawyer in the firm of Kerr, Lambert and Conn, Kerr gained great wealth in ranching and oil, being chairman of the board of Kerr-McGee Oil Industries, Inc., beginning in 1944, and as a partner in Kerr-McGee and Company. A Democrat, he was elected governor in 1943 and served until 1947. Kerr was elected to the Senate from Oklahoma in 1949 and served until his death. His principal accomplishment in the Senate was his leadership in the creation of the MC CLELLAN-KERR ARKANSAS RIVER NAVIGATION SYSTEM. One of the major public improvements of the period, this system deepened and enlarged the channel of the ARKANSAS RIVER and provided an outlet to the sea for ports as far inland as TULSA, Oklahoma

KERRVILLE, Texas. Town (pop. 15,276), seat of Kerr County, on the banks of the GUADALUPE RIVER in central southern Texas. Kerrville was founded in the late 1840s and soon became a center for cattle, sheep, and goat raising, called the "Mohair Center of the World." Its present economy is also based on tourism. Cowboy Artists of America Museum offers a unique display of cowboy art. The nearby Y.O. Ranch, of 100 square mile area, is one of the largest working ranches in Texas. It offers tourists photo safaris through herds of wildlife, and visits to other facilities.

KETCHUM, Tom "Black Jack". (San Angelo, TX., 1862—Clayton, NM, April 26, 1901). Outlaw. During a ten-year career of crime, Ketchum looted and killed across a span of seven western states. He turned to crime beginning with the murder of Levi Herzstein, a postmaster of TUCUMCARI, New Mexico. Ketchum and his brother, Sam, moved into Wyoming where they joined the Wild Bunch in the Hole in the Wall country. For the next eight years Ketchum led gangs on robberies of trains, banks, and stores, resulting in twelve murders and the theft of bullion and currency valued at $250,000. Ketchum, with a reward of $10,000 on his head, returned to New Mexico where he was captured on July 11, 1899. He was found guilty at his trial in SANTA Fe. The eventual hanging is best remembered for the fact that misjudging the length of rope caused the noose to severe the torso from his head which rolled across the ground bringing the career of crime to a bizarre end.

KEYES, Oklahoma. Town (pop. 557), Cimarron County, PANHANDLE area, northwest of GUYMON and northeast of BOISE CITY. A helium plant in Keyes processes one-third of the world's production of this valuable gas.

KEYSTONE, South Dakota. Town (pop. 295), Pennington County, southwest South Dakota, southeast of RAPID CITY and northeast of CUSTER. The Keystone area has been found to have 87 types of minerals, more than are found in any similar sized area in the world. Visitors may take a steam train ride, one of the few of its kind still available, between Hill City and Keystone. Keystone was founded as a mining community in 1874. The Holy Terror Mine, named by the owner for his wife, who complained that the family mines were not named for her, yielded $70,000 in gold each week at its peak production. The Rushmore-Borglum Story is explained in a unique museum offering the visitor glimpses of the life of the gifted sculptor Gutzon BORGLUM (1867-1941), carver of mountains and creator of Mount RUSHMORE memorial. The Rushmore section of the museum includes a full-sized reproduction of the Lincoln statue's eye and examples of the equipment used in the renowned project.

KICHAI INDIANS ("water turtle"). Tribe of Caddoan linguistics stock that lived along the upper course of the TRINITY RIVER in Texas. They were assigned to a reservation on the BRAZOS RIVER in 1855, but continued threats by settlers drove them to seek safety in Oklahoma with the WICHITA INDIANS.

KICKAPOO CANYON. A New Mexican region in which circumstances combine to create "sub-climates." Such climates support plants and wildlife different from the rest of the region. In Kickapoo Canyon, many plants are related to those normally seen in New England.

KICKAPOO INDIANS. Midwestern tribe which, by 1832, had been moved to a reservation in Kansas. They called themselves Kiwegapaw meaning, "he who moves about, standing now here, now there." The Kickapoo culture was organized into patrilineal clans with marriage always outside the clan. The dead were buried in graveyards in or near the villages. The feet of the dead were pointed toward the west, the direction of the land of the dead. Burial was done in slab or hollow log vaults with food and water provided for the journey to the afterlife. In 1838 a small group migrated to Mexico. Treaties signed in 1854 and 1862 opened some of the Kickapoo land in Kansas to white settlement. The 1862 treaty also allotted some of the reservation land in severalty with the remainder being sold to a railroad company. By 1873 the Indians who had migrated to Mexico had been convinced to return to Oklahoma and Kansas. In 1883 those who returned were granted a 100,000-acre reservation in Oklahoma. Under protest, the Kickapoo accepted the lands in severalty in 1893. By the 1970s only 6,000 acres of the allotted lands remained. Today several hundred Kickapoo live on reservations in Mexico, nearly 800 have a reservation in Kansas and some 600 lived in Pottawatomi County, Oklahoma.

KILGORE, Texas. Town (pop. 10,968), Gregg and Rusk Counties, in northeast Texas. Founded in 1872 and named for Judge Constantine Kilgore, the community was at one time known as the "Oil City of the World" because it had over 1,000 producing oil wells within its city limits. Still an oil center, Kilgore has other manufactures which include clothing, bath fixtures, and metal products. Kilgore was the childhood home of concert pianist Van CLIBURN (1934-). Kilgore College is there, with its East Texas Oil Museum.

KILLDEER MOUNTAIN, BATTLE OF. Fought on July 28, 1864, between an estimated 1,600 Santee and Teton SIOUX and military forces commanded by Brigadier General Alfred Sully who was sent to campaign against the Sioux responsible for the uprising in Minnesota in 1862. The battlefield, located in Dunn County, about eleven miles northwest of Killdeer, North Dakota, is partially owned by the state which erected a large marker and gravestones for two soldiers killed in the battle, an Indian defeat.

KILLDEER MOUNTAINS. One of three groups of rolling hills found in North Dakota, which are known as mountains. The Killdeer Mountains, near Killdeer in Dunn County, consist of two six hundred foot hills, known to the SIOUX as *Tahkahokuty* or "the place where the deer is killed," the bases stretch for about ten miles.

KILLEEN, Texas. Town (pop., 46,296), Bell County, in central east Texas. Settled in 1882 and called Palo Alto, the town was renamed Killeen in honor of a railroad official. Located in one of the fastest-growing areas of the nation, Killeen is near FORT HOOD, and the military payrolls account for much of the town's economy.

KIMBELL ART MUSEUM. Rich collection of modern Dutch, Flemish, Spanish and Italian art, located in FORT WORTH, Texas. The construction of the museum, a part of Amon Carter square, was authorized by the Kimbell Foundation, administrator of the estate of Kay Kimbell whose fortune was based on insurance, oil and grain.

KING RANCH, Texas. Headquartered in Kingsville, Kleberg County, in southeastern Texas. A ranching complex of nearly one million acres, the King ranch has additional units in Texas, Kentucky, Pennsylvania, Australia, Argentina, and Brazil. There are several divisions of the main ranch, with the best known being Santa Gertrudis, which serves as the central base. Various breeds of beef cattle and thoroughbred racehorses are developed there. Many of their horses have become national and international champions, including Kentucky Derby winners in 1936, 1946, and 1950. Former steamboat captain Richard King founded the original ranch in 1853 and developed it into one of the largest cattle spreads in the world. Farming also became important after the advent of the artesian well in 1900. The complex stayed within the family until 1935, when the enterprise was divided, leaving today's giant. Since that time, oil production has been added to the operation.

KINGSVILLE, Texas. City (pop. 28,808), seat of Kleberg County, at the head of Baffin Bay on the Gulf coast of southern Texas near CORPUS CHRISTI. Founded on a 41,820-acre tract purchased by the KING RANCH enterprises (1903) and is headquarters of the KING RANCH. Kingsville is a center for cattle and horse breeding, as well as oil and natural gas. It is the home of

TEXAS A AND I UNIVERSITY. The annual King Ranch Santa Gertrudis Bull and Quarter Horse Sale brings buyers from around the world. The Texas Wagon Train Celebration is held in February. A self-guided tour of the King Ranch is available.

KINKAID LAW. Nebraska law taking effect in 1904 which permitted homesteading of as much as 640 acres in western Nebraska.

KIOWA APACHE. Southern plains tribe of the Athapascan linguistic family. The branch originated in the mountains of western Montana, near the headwaters of the YELLOWSTONE and MISSOURI rivers. The Kiowa Apache migrated along with the Kiowa to the region of the RED and ARKANSAS rivers by the early 19th century. The Kiowa Apache, one of seven bands of the Kiowa, had its own chief and war chief. There was limited marriage between the Kiowa and Kiowa Apache. Couples generally lived with the woman's family. There were numerous secret societies for men and women. Like the Kiowa, the Kiowa Apache acquired horses in the early 18th century and became great buffalo hunters and warriors. The men killed buffalo in highly organized hunts, while the women butchered the animals and dried and stored the meat. Corn was obtained in trade with the PUEBLO and WICHITA peoples. From their Montana homeland the Kiowa Apache moved into the BLACK HILLS region before being forced south by the CHEYENNE and DACOTAH. The Kiowa Apache finally settled in an area of western Kansas, eastern Colorado, western Oklahoma and the adjoining areas of New Mexico and Texas. In the late 1970s some 600 Kiowa Apache were living in southwestern Oklahoma near the towns of Fort Cobb and Apache.

KIOWA INDIANS. Southern plains tribe which originated in the mountains of western Montana near the headwaters of the YELLOWSTONE and MISSOURI rivers. They migrated to the southeast arriving at the RED and ARKANSAS rivers in the early 19th century. The Kiowa had seven divisions or bands which remained fairly autonomous, each with its own peace and war chief. Bands lived apart in the winter and came together in the summer to celebrate the Sun Dance.

Social classes were based on rank attained through military exploits, religious power, and wealth. Warriors achieved status by "counting coup," which included touching an enemy or rescuing a comrade. Some credit was given for

stealing horses or killing an enemy. Societies abounded in the Kiowa culture. Boys under twelve belonged to the Rabbits Society, while those over twelve joined the Herders in preparation for their life as warriors. Among the plains Indians the Kiowa were recognized as musicians. Religious status was achieved by prominence in a given skill or by becoming a guardian of sacred items.

Kiowa villages were located near streams. Skin tipis were constructed and owned by the women. Men hunted buffalo, deer, antelope and small game, but not bear, which was considered taboo to kill or eat. Kiowa, like other plains tribes, preferred not to eat fish. In annual trading sessions, Kiowa traded salt, hides and buffalo meat to the Pueblos for dried fruit and cornmeal.

Years of intra-tribal warfare were ended by peace treaties in 1834 and 1840. Until the end of the CIVIL WAR the Kiowa and their allies were able to offer stiff resistance to white emigration on southern overland trails. In 1865 the Kiowa and COMANCHE agreed to settle a reservation south of the Arkansas River.

By 1868 they had been forced to relocate to a reservation around FORT SILL, Oklahoma. In 1877, 1895 and 1902 measles epidemics killed many Kiowa. In 1901 the reservation of the Kiowa, Kiowa Apache and Comanche was allotted in severalty, 160 acres to each person, and the remaining land sold to the highest bidder. By the 1970s most of the 3,500 Kiowa lived in Oklahoma near Fort Cobb, Mountain View, Carnegie and ANADARKO. The Kiowa include among their famous people N. Scott Momaday, a winner of the Pulitzer Prize.

KITCHEN MIDDENS. Trash heaps created by ancient peoples, where the refuse of everyday living was dumped. They provide insight to archaeologists regarding the everyday lives of ancient peoples. Such refuse is found almost universally along with other evidences of prehistoric peoples such as pottery and stone tools. In the Central West most archeolgogical sites have yielded interesting "trash." The remainders of meals, such as bones, and such non-biodegradable items as broken cutlery are among debris in such middens. Included among the Central West sites are the Burned Rock Kitchen Middens in Texas; the Church Butte and Spanish Diggings at Manville, Wyoming; the cast-off items of the Folsom culture of Oklahoma, Texas and New Mexico; the Sandia culture of New Mexico; the Pueblo of New Mexico and Colorado; the Ancient Hunter

relics found near Billings, Montana; the Sterns Creek Culture of Nebraska and the ancient sites near Salina, Kansas.

KIVAS. PUEBLO Indians' ceremonial chamber. Circular and subterranean, the kiva was probably a religious center. Some kivas reached sixty feet in diameter, and some villages had several. Contrary to the general rule of no chimneys, kivas had highly developed ventilating flues connected to the fireplaces. Kivas found today do not vary greatly from those of prehistoric times when the chamber stood only far enough above ground to insure drainage. Kivas built above ground are still circular within, although they are often enclosed today in rectangular walls and joined to other buildings. While of great interest architecturally, kivas have had little effect on subsequent architecture in the Southwest. Excellent examples of the old circular kivas only partially above ground may be found at COCHITI PUEBLO and the south plaza of SAN ILDEFONSO PUEBLO. The rectangular type attached to other buildings may be seen in SAN JUAN, TESUQUE and SANTA CLARA. Underground kivas are found in BANDELIER NATIONAL MONUMENT, Chetro Ketl in the CHACO CANYON NATIONAL MONUMENT and at AZTEC NATIONAL MONUMENT.

KNIFE RIVER. Tributary of the MISSOURI RIVER which rises in northern Billings County, North Dakota, and flows one hundred sixty-five miles in an easterly direction into the Missouri at Stanton, North Dakota, in central Mercer County.

KNIFE RIVER INDIAN VILLAGES NATIONAL HISTORIC SITE. Remnants of historic and prehistoric Indian villages, last occupied in 1845 by the HIDATSA, contain an array of artifacts of PLAINS INDIAN culture. Authorized October 26, 1974, headquartered Stanton, North Dakota.

KOOTENAI FALLS. Named for a tribe of Indians, the falls plunge more than two hundred feet in a series of cascades near Troy, Montana.

KOOTENAI INDIANS. One of the tribes comprising the Confederated Tribes of the FLATHEAD. Of particularly interest were the ceremonial sweat baths maintained by the Kootenai where Pipe Creek flows into the KOOTENAI RIVER in Montana. Steam was generated by throwing heated stones into the shallow water-filled covered pits six to eight feet square. The bather steamed himself while covered by hides.

KOOTENAI RIVER. International river between Canada and the United States. The river, known as the Kootenay or Kutenai in Canada, arises in Kootenay National Park in southeastern British Columbia. It flows across the border into Montana and Lake Koocanusa in Kootenai National Forest before it turns west and north into Idaho. It sweeps again across the border into Canada and enters Kootenay Lake from which it eventually flows past Nelson to the Columbia River. The river was explored in 1807 by David THOMPSON (1770-1857).

KOSATI INDIANS. Tribe of Muskogean linguistic stock which lived in Alabama near the junction of the Coosa and Tallapoosa rivers. Member of the Upper Creek Confederacy, the tribe appears to have split in the late 1700s, some going to Texas, some to Florida. The ones remaining in Alabama eventually joined the Creek Confederacy's move to Indian Territory in Oklahoma.

LA FARGE, Oliver. (New York, NY, Dec. 19, 1901—Santa Fe, NM, Aug. 2, 1963). Author. LaFarge won the Pulitzer Prize in 1929 for his novel *Laughing Boy; a Navajo Romance*, which dramatized the painful effort of present day Indians to adjust their age-old ways with the modern age. La Farge went on to serve as the director for the Eastern Association on Indian Affairs from 1930 to 1932, as president of the National Association on Indian Affairs from 1933 to 1937 and the American Association on Indian Affairs from 1937 to 1942.

LA FLESCHE FAMILY. Prominent Nebraska family. Susette (Bright Eyes), the daughter of Iron Eyes (Joseph La Flesche), was born on the OMAHA (Nebraska) Reservation in 1854 and became a writer and reformer in the cause of justice for Indians. With her father, she wrote stories of PONCA Indians being forcibly removed from their reservation by the federal government and their suffering on the new reservation. Susette made a speaking tour through the East with her brother Francis and Standing Bear, chief of the Poncas, and later toured Scotland with her husband in the spirit of encouraging reform in the way Indians were treated in the United States. She wrote *Ploughed Under, the Story of An Indian Chief* (1881). In 1898, Susette's daughter, Yosette, illustrated the book *Oo-Mah-Ha Ta-Wa-Tha*, believed to be the first example of work by an Indian artist ever published in that form. Susette LaFlesche died near Bancroft, Nebraska, 1903.

LA JUNTA, Colorado. City (pop. 8,338), seat of Otero County, southeastern Colorado, southwest of LAS ANIMAS and southeast of PUEBLO, at the junction of the old Santa Fe and Navajo trails, its name means "junction" in Spanish. It is the center of an irrigated farming area producing vegetables and sugar beets. Cattle auctions are a frequent occurance. One of the west's greatest forts and trading posts, BENT'S FORT, was constructed near present-day La Junta in 1828. Although destroyed by William BENT (1809-1869), the fort has been reconstructed as BENT'S OLD FORT NATIONAL HISTORIC SITE. La Junta is home of the Koshare Kiva, headquarters of the nationally-recognized Koshare Boy Scout Indian dancers. Discovered nearby in December, 1935, along the banks of the PURGATOIRE RIVER were the tracks of a Tyrannosaurus Rex, fiercest of the ancient dinosaurs. A short distance away the tracks of a triceratops were found. Koshare Indian Kiva Museum reproduces a ceremonial kiva of the Southwest and features Indian artifacts and western paintings. Koshare Winter Night Ceremonial features Christmas week performances in the kiva. There is an annual Kids' Rodeo for those 6 to 16 in age.

LA SALLE, Sieur de (Rene Robert Cavelier). (Rouen, France, Nov. 21, 1643—unknown, probably present Texas or Louisiana, Mar. 19, 1687). Explorer-colonizer. The famed explorer had a short and tragic experience in the Central West Region. After returning to France from the New World in 1683, he received a new commission and in 1684 set out from France with four ships, hoping to reach the mouth of the Mississippi and take over command of a vast area. However, the ships went astray and found their way into Lavaca Bay in present Texas, thus bringing the great explorer into the Central West region for the first time. Some historians have thought that La Salle went off course deliberately in order to take over some of the Spanish claims in the present Southwest. La Salle and his party made three attempts to reach the Mississippi by an overland route. On the third attempt the men mutinied and killed their leader.

LAFFITE, Jean. (France, c. 1780—unknown, 1826?). Adventurer and pirate/privateer. Little is known of his early life, but he was a partner in a blacksmith business in New Orleans, Louisiana, in 1809. By 1810 Laffite had become the acknowledged leader of a band of pirates operating out of Barataria Bay, Louisiana, plundering Spanish ships. Because the War of 1812 was keeping the federal government occupied, Laffite and his group were able to prey openly upon commerce in the Gulf region. The English, in fact, offered Laffite large rewards if he would aid in their attack on New Orleans. In a patriotic gesture, Laffite informed Louisiana officials of the offer; the government's response, however, was to imprison Laffite and his band. After promising to serve in the battle of New Orleans, they were released and pardoned, only to return to pirating. Texas, then under Spanish rule, became Laffite's new headquarters. He operated out of GALVESTON until several attacks on American vessels prompted the United States government in 1821 to send troops to curtail his activities. There were reports of Laffite operations in the Spanish Main, but by 1825 he was no longer heard of. It was variously reported that he died at sea during a battle, or died of a fever in a Central American village.

LAGUNA PUEBLO. Village (pop. 7,000). One of the largest and most progressive of the nineteen New Mexican pueblos, the village is located about 30 miles east of Grants, New Mexico and is the largest of the pueblos east of the CONTINENTAL DIVIDE. It is known as the "Mother Pueblo" of six nearby villages. The Mission of San Jose, built there in 1699 is still in use. There are festivals throughout the year, but the principal annual event is Laguna Village Traditional Feast, on March 19.

LAKE JACKSON, Texas. City (pop. 19,102), Brazoria County, in southeastern Texas near the Gulf of Mexico. It was named for the Jackson Brothers, plantation owners of the region. The largest community in Brazosport's nine-city complex, Lake Jackson was founded and developed by the Dow Chemical Company during 1941-1942 to house its employees.

LAKE MEREDITH RECREATION AREA. Manmade Lake Meredith on the Canadian River is a popular water-activity center in the Southwest. Headquartered Fritch, Texas.

LAKES. The transformation of much of the dry prairie and desert land of the Central West region into a land of many great lakes and many other smaller lakes has been one of the country's most successful attempts to modify the landscape.

This dramatic change has been most noticeable in the east and north of the region. Beginning in north central Wyoming and south central Montana with Bighorn Lake on the

BIGHORN RIVER and following along the MISSOURI. The most westerly of the great engineering miracles on that river was the mighty Fort Peck Dam, impounding Fort Peck Lake. Just across the western border of North Dakota are the farthest reaches of even larger Lake SAKAKAWEA, impounded by giant Garrison Dam.

In South Dakota, just north of PIERRE, OAHE DAM on the Missouri creates OAHE RESERVOIR, extending almost to the other Dakota capital at BISMARCK. Just below Pierre, lakes Sharpe and Francis Case are enlargements of the Missouri extending to the border with Nebraska. Neither Nebraska nor Kansas has any very large lakes, artificial or otherwise, but eastern Oklahoma has been transformed by artificial bodies of water.

Kaw Lake on the northern Oklahoma border almost surrounds KAW CITY. Nine artificial lakes dot the Tulsa-Bartlesville area, including giant Keystone Reservoir, Skiatook Lake, Birch and Candy reservoirs, Hula Lake and Copan Reservoir. Southeast of BARTLESVILLE is giant Oolagah Lake, still farther to the east GRAND LAKE OF THE

The artificial lakes created in the region have transformed many sections of the Central West from parched areas to water wonderlands. Oklahoma, alone, has more manmade lakes than any other state.

CHEROKEE. Fort Gibson Reservoir lies west of TAHLEQUAH. Giant Robert S. Kerr Reservoir floods the ARKANSAS RIVER near the Arkansas border, and not far to the west on the Canadian River spread the tentacles of EUFALA RESERVOIR.

Shared by Oklahoma and Texas is giant Lake TEXOMA, taking its name from both states. Lakes Lewisville, Gravine and Lavon give DALLAS a "waterfront" of sorts. Other eastern Texas bodies of water are Tawakawni, Patman, and Lake O'the Pines. Largest of the Texas lakes are Toledo Bend Reservoir on the SABINE RIVER and Sam Rayburn Lake on the Angelina River. Several lakes north and west of AUSTIN and a few smaller lakes near SAN ANTONIO help to round out the eastern Texas lake picture, except for Falcon Lake on the RIO GRANDE RIVER, shared by both Texas and Mexico. Largest lake in the PANHANDLE is Lake Meredith on the CANADIAN RIVER north of AMARILLO.

In west Texas there is a small cluster of natural lakes west of GUADALUPE MOUNTAINS NATIONAL PARK.

Dry New Mexico supports ELEPHANT BUTTE RESERVOIR on the RIO GRANDE and two small reservoirs on the Canadian River.

FLAMING GORGE RESERVOIR on the GREEN RIVER, extends its length into southern Wyoming.

Among the larger natural lakes of the region are FLATHEAD LAKE in northwest Montana and YELLOWSTONE LAKE in YELLOWSTONE NATIONAL PARK, the latter at the highest elevation of any large lake on the continent. Even higher is beautiful GRAND LAKE in north central Colorado. This source of the mighty COLORADO RIVER boasts the highest yacht club in the country.

LAKEWOOD, Colorado. City (pop. 112,848), suburb of DENVER, situated west of the city center, somewhat closer to the looming foothills of the Rockies. The city was incorporated in 1969 and is one of the fastest growing in the area. It is mainly a "bedroom" community of Denver.

LAMAR, Mirabeau Buonaparte. (Louisville County, GA, Aug. 16, 1798—Richmond, TX, Dec. 19, 1859). Second president of the Republic of Texas, diplomat, and poet. While president of the new republic (1834-1841), Lamar opposed annexation to the United States. He founded a new capital at AUSTIN in 1840. Lamar served in the MEXICAN WAR (1846) and as United States minister to Nicaragua and Costa Rica (1857-1859). He published romantic poetry in *Verse Memorials* (1857).

LAMY, John Baptiste. (Lempdes, France, October 11, 1814— Santa Fe, NM, Feb. 13, 1888). Clergyman. Lamy was named vicar apostolic of New Mexico in 1850 and became the bishop of SANTA FE in a diocese which included New Mexico, Arizona and parts of Colorado, Nevada and Utah. Lamy convinced the Sisters of Loretto to found a settlement in Santa Fe and ordered the construction of many churches and schools, including eighty-five new churches in sixteen years. The greatest of the churches built under his leadership was the Cathedral of Saint Francis at Santa Fe which was constructed around the old church so that services were not interrupted. Lamy became an archbishop in 1875 when Pope Pius IX raised the Diocese of Santa Fe to the rank of metropolitan see. The life of Lamy was the basis of the novel *Death Comes for the Archbishop* written in 1927 by Willa CATHER (1873-1947).

LANDER, Wyoming. City (pop. 9,126), seat of Fremont County, central Wyoming, southwest of RIVERTON and northeast of ROCK SPRINGS. The first oil well in Wyoming was drilled near Lander in 1888. Lander was named for Colonel W.F. Lander who convinced the Shoshone to allow a road to be constructed through the POPO AGIE Valley. A branch of the Popo Agie, one of the nation's most unusual rivers, disappears into a sink on a mountain near Lander and then bursts out several hundreds yards below as a waterfall. Among weathermen, Lander is remembered as the city in the United States with the lowest wind velocity. Residents of Lander in the 1800s remarked that George Parker always seemed to have more horses to sell than he raised. Parker, who regularly sold his horses in Lander, is now better known as the notorious outlaw Butch Cassidy. Today Lander is the home of the popular Wyoming State Winter Fair held the last weekend of January. Annual events in Lander also include the One-Shot Antelope Hunt in mid-September, Old Timer's Rodeo in late May, and Apple Festival in mid-August. Wind River Indian Reservation about fifteen miles northwest is the home of the ARAPAHO and SHOSHONE tribes. Sun Dances are held near FORT WASHAKIE for three days at the end of July near the time of powwows held in the same area.

LANDON, Alfred Mossman (Alf). (West Middlesex, PA, Sept. 9, 1887—Topeka, KS, Oct. 12, 1987). Politician, governor. Before running for public office, Landon was a banker and oilman. He served as governor of Kansas

from 1933 to 1937. He was widely praised for the efficiency of his administration, particularly for economy in government operations during the Great Depression. Running for his second term, he became the sole Republican governor to be reelected in the non-presidential year of 1934. He gained national renown for the economic record of his administration and for his support of Kansas farmers in the depth of the depression. His record as governor brought him the Republican nomination for president in 1936. Running against the enormously popular F.D. Roosevelt, Landon carried only two states, Vermont and Maine, in the worst defeat ever suffered by a candidate up to that time. He had stood up for the farmers of his state. "I took the farmers through the drought and the dust storms," he once said. During one foreclosure sale he told a banker he would send the sheriff to stop it. "If he can't handle it, I'll send in the troops. I asked him, 'Is that worth it to you?'"

Despite his record for the state, he had not even carried his own Kansas. However, as the years went by, Landon came to be regarded as the grand old man of Kansas (and Republican) politics. On his 100th birthday, president and Mrs. Ronald Reagan went to his home at TOPEKA to wish him well. Also on hand for the birthday celebration was his daughter, U.S. Senator Nancy Katzenbaum, who had followed her father into politics. The centenarian died little more than a month after the birthday event.

LANGTRY, Texas. Val Verde County, southwest Texas, northwest of DEL RIO near the R I O GRANDE RIVER. Frontier Texas town, named for famous actress Lily Langtry, in which "Judge" Roy BEAN (1825?-1903) administered justice. A fine for a person found guilty might only be a round of drinks for the house, served by Bean who slipped behind the bar to serve everyone.

Lark bunting, official state bird of Colorado.

LARAMIE MOUNTAINS. Range in northern Colorado and southeastern Wyoming. The highest point is 10,272 foot Laramie Peak.

LARAMIE RIVER. Southeastern Wyoming stream rising in the LARAMIE MOUNTAINS west of CHEYENNE and flowing east-northeast to its mouth in the NORTH PLATTE RIVER below the GUERNSEY LAKE in Platte County.

LARAMIE, Wyoming. City (pop. 24,410), seat of Albany County, in southeast Wyoming, on the LARAMIE RIVER. The community was named for the river and in turn for Jacques LaRamie, Canadian trapper, who was killed by the Indians near the river. Laramie was settled in 1868 and incorporated in 1873. It came into being as the transcontinental railroad pushed through on its way to the West Coast. Frontier Laramie was said to have been a "lawless community inhabited by saloonkeepers, hunters and brawlers." Today it is a commercial center catering to tourists, lumbering and livestock. The University of WYOMING, centered there, features geological, anthropological and fine arts museums. There is also the Laramie Plains Museum, with frontier collections. The gigantic bronze head of Lincoln on Interstate 80, weighing three and a half tons, is said to be the largest of its type. The nearby SNOWY RANGE offers skiing, hiking and other sports opportunities.

LAREDO, Texas. City (pop. 91,449), seat of Webb County on the RIO GRANDE RIVER in southwest Texas. A border city with major railroad and highway connections with Mexico, it was settled by Spanish families in the 1750s. Under Mexican jurisdiction after the Texas Revolution, it was ceded to the United States in 1848 after the MEXICAN WAR. An international commercial and tourist center because of its position on the border, its early economy was based on cattle raising and agriculture. Today its industries have expanded to include meat packing and manufactures such as bricks, shoes, clothing and electronics. Fort McIntosh, established as Camp Crawford (1849) during the MEXICAN WAR, is now the site of Laredo Junior College. Laredo State University (1969), a part of the University of South Texas, is also in the city. Across the Rio Grande in Mexico is Nuevo Laredo, a typical Mexican market town with curio shops and sidewalk stands.

LARK BUNTING. Official bird of Colorado, the bunting, is a small plump bird of the finch family. This white-winged prairie bird attained its official standing over the meadowlark and the bluebird through the efforts of Roy Langdon, a FORT COLLINS teacher, who led the fight for its selection.

LARNED, Kansas. Town (pop. 4,811), seat of Pawnee County, central Kansas, northeast of DODGE CITY and southeast of HAYS. FORT LARNED NATIONAL HISTORIC SITE preserves Old Fort Larned, the only completely preserved fort of its type in the West. Besieged many times by Indians, the defenders were always able to obtain water by access through a secret tunnel that ran from one of the buildings for seventy-five feet to a nearby creek. The fort was built in 1859 to protect mail coaches and wagons on the SANTA FE TRAIL. The community of Larned developed as the construction of the ATCHISON, TOPEKA AND SANTA FE RAILROAD neared the fort. Fertile agricultural land led to prosperous trade. The Santa Fe Trail Center displays items of early transportation.

LAS ANIMAS, Colorado. Town (pop. 2,818), seat of Bent County, southeastern Colorado, southeast of COLORADO SPRINGS and northeast of LA JUNTA. From a location near La Junta, Lieutenant Zebulon PIKE (1779-1813) discovered the peak that would bear his name. Las Animas was also the last home of famous frontiersman Kit CARSON (1809-1868) who died there in 1867. Today the community serves as a trading center for the local ranches.

LAS CRUCES, New Mexico. City (pop. 45,-086). Seat of Dona Ana County, in south central New Mexico, on the RIO GRANDE. Named "The Crosses" because of the crosses found there. Although their origin is uncertain, the accepted account ascribes the crucifixes to a party from TAOS who were massacred by the APACHE and buried at the present city site. The modern city was founded in 1848 and incorporated in 1907. The economy is based on irrigated agriculture and ranching of the area as well as on the WHITE SANDS MISSILE RANGE, once the atomic bomb testing site. Early Las Cruces was said to harbor more thieves, murderers and other tough gunmen than any other town in the southwest until vigilantes took over the cleanup. Nearby, the historic village of Mesilla has memories of its service as Confederate territorial capital and of Billy the Kid. Fort Selden State Monument, Gadsden Museum and White Sands Missile Range are points of interest.

LAS VEGAS, New Mexico. City (pop. 14,-322). Seat of San Miguel County, northwestern New Mexico, northeast of ALBUQUERQUE and southwest of Clayton, founded 1835. The name is a shortend form of the Spanish "Our Lady of Sorrows of the Meadows." It was a stopover on the SANTA FE TRAIL and today is a farming and ranching center. Las Vegas is home of the New Mexico Highlands University and of the Armand Hammer United World College of the West. It was one of the roughest frontier towns. So many outlaws were hung from the windmill in the plaza that the windmill's owner had the structure taken down. The arrival of the railroad in 1879 led to a flurry of construction that provided the city with a wealth of architectural styles to contrast with the native adobe buildings. FORT UNION NATIONAL MONUMENT lies twenty miles to the northeast. Theodore ROOSEVELT'S ROUGH RIDERS' Memorial and City Museum hold mementos and relics, and the Teddy Roosevelt Rough Riders' and Cowboys' Reunion, begun in 1898 and held annually, boasts, reputedly, the oldest continuing rodeo in the Southwest.

LAWRENCE, D(AVID) H(ERBERT). (Nottinghamshire, Eng., Sept. 11, 1883— Vence, France, Mar. 2, 1930). Author. The controversial writer enjoyed a nomadic existence in various parts of the world, but he wrote of TAOS, New Mexico, "I think the skyline of Taos the most beautiful of all I have ever seen in my travels around the world." He arrived in New Mexico in 1923 and spent about two years there at his ranch overlooking his beloved Taos. Those years must have been particularly notable for him, because his ashes were returned for burial on the ranch. Today the D.H. Lawrence Ranch and Shrine, three miles east of Taos, is maintained by the University of NEW MEXICO as a conference and recreational facility.

LAWRENCE, Kansas. City (pop. 52,738). Seat of Douglas County, northeastern Kansas, on the Kansas River, southwest of KANSAS CITY and southeast of TOPEKA. Founded in 1854 by the New England Emigrant Aid Company, it was named for Amos A. Lawrence of the society. The community was at the very center of the slavery versus free-state controversy that swept Kansas prior to the CIVIL WAR. The city was first looted and burned in May, 1856, by a band of "BORDER RUFFIANS" from Missouri. Although the free-state forces eventually won the state, the murderous raid in 1863 by Confederate guerrilla William QUANTRILL (1837-1865) and 450 raiders, including Jesse James and Cole

Younger, left a shattered community with 150 citizens killed and over a million dollars in damage. BAKER UNIVERSITY, the oldest in the state, was built in 1858. The University of KANSAS, planned for Lawrence in 1856, was finally built in 1866. HASKELL INDIAN JUNIOR COLLEGE, one of the oldest federally supported schools, opened in 1884 and now enrolls students from 37 states and 120 tribes. In addition to education, the economy of the community is based on light industry and transportation. The University of Kansas features two interesting museums, and the original building at Baker University is now Old Castle Museum and Complex. The Kansas Relays at Memorial Stadium are a major U.S. track and field event.

LAWTON, Oklahoma. City (pop. 80,054), seat of Comanche County in southwest Oklahoma on the CACHE RIVER, it takes its name from Medal of Honor winner Henry Ware Lawton, distinguished in CIVIL WAR annals, who was killed leading American forces in the Philippines during the SPANISH AMERICAN WAR (1898).

A large farm territory provides an economic base for the city, but the principal local employer is FORT SILL, just to the north. The city distributes or processes the region's wheat, cotton and cattle and produces mattresses, horse trailers, mobile homes, clothing and processed foods.

Lawton was the last of Oklahoma's several "instant towns," communities formed overnight in the various land rushes which opened parts of the state to settlement. It was the last rush on August 6, 1901, that brought a flood of settlers, creating a tent city before the next dawn.

The lots had been platted beforehand and were auctioned for $25 in cash. For those bidders who did not have enough cash, getting to the portable bank and standing in line sometimes took so long that both the down payment and the right to buy were forfeited. Local lore has many stories of the confusion and drama of that day, including the tale of the man named Wood, who laid out his tract so as to cut off his lady neighbor, Miss Mattie Beal. He was given the name of "Hog" Wood, and she gained 500 offers of marriage from the publicity.

Cameron College represents higher education in the city.

Of particular interest is nearby Fort Sill, started in 1869. The Old Post National Historic Landmark there includes 43 of the native stone buildings, many still being used for their original purpose. At the porch of the old

Sherman House, General William T. SHERMAN (1820-1891) was almost killed by KIOWA Indians. The U.S. Army Field Artillery and Fort Sill Museum houses exhibits of field artillery, missiles, cavalry, and local Indians.

The MUSEUM OF THE GREAT PLAINS features many aspects of the region, exploration, fur trade, cattle and other industries, period rooms and reproduction of a main street of a frontier town. Outdoors are exhibits of farm equipment, locomotives and a reproduction of a typical trading post.

A popular annual event is the Lawton Birthday and Rodeo Celebration in early August.

LEAD. Where silver deposits were found in lead-bearing ores both minerals were brought into production in the American West. The LEADVILLE, Colorado, smelters were the most sophisticated of their day in extracting silver from lead carbonate, and by 1879 lead production in the region totaled nearly two million dollars. The tri-state region of southwest Missouri, southeastern Kansas, and northeastern Oklahoma contributed greatly to lead production after 1900. Lead in this area, in scattered shallow deposits of galena (a form of lead), were generally free of silver or other mineral "impurities." While some lead mining was done in the region prior to the CIVIL WAR, large scale production began in the 1870s. The district remained a poor area, however, because the shallow and scattered deposits eliminated the possibility of introducing the newest industrial techniques. The most productive period came between 1900 and 1930. As much as fifteen thousand tons of lead were produced in 1926. No new fields were discovered after 1930 and the remaining fields became increasingly marginal. Among the few Central West states still producing lead, Colorado is responsible for four percent of the nation's total annual supply.

LEAD (pronounced Leed), South Dakota. Town (pop. 4,330), Lawrence County, western South Dakota, northwest of RAPID CITY and southeast of BELLE FOURCHE. Lead, is the site of the HOMESTAKE GOLD MINE, claimed to have produced more gold by value than any other single mine in the world. Homestake purchased the many smaller mines for $77,000 in 1877. Among the many investors who made fortunes from this shrewd purchase was George Hearst, the father of publisher William Randolph Hearst. The community was named from the mining term meaning vein or lode. A spectacular view of the countryside as far away as parts

of Wyoming, Montana, North Dakota and Nebraska is possible for the brave visitor who rides the 4,000 foot long chair lift at Terry Peak ski area. Tours of the Homestake are available.

LEADERS OF THE CENTRAL WEST. The Central West region has produced three dramatically different presidents of the United States and was given distinguished service by the only U.S. citizen ever to serve as president of a sovereign nation, along with others distinguished in various fields.

First of these was Dwight D. EISENHOWER (1890-1959), born in DENISON, Texas, and raised to maturity in ABILENE, Kansas. He received, perhaps, more high international honors than any other person in U.S. history, as supreme commander of Allied force during WORLD WAR II, as army chief of staff, as president of Columbia University, head of NATO and president. Called a "do-nothing" president during his two terms, his achievements are rapidly being reappraised, and his leadership strongly acknlowledged.

Second of the Central West presidents was Lyndon Baines JOHNSON (1908-1973), native of Gillespie County, Texas. He succeeded to the presidency after the assassination of President John F. KENNEDY. A masterful politician, he led in the passage of legislation for civil rights, tax reduction and vast social services. His escalation of the Vietnam War brought such condemnation that he refused to run for a second full term in office.

Third of the Central West presidents was Gerald Rudolph FORD (1913-), native of OMAHA, Nebraska. His presidency was unique, being the only one in which an appointed vice president succeeded to the presidency. After long and popular service as a Michigan congressman, Ford was appointed vice president by Richard Nixon and succeeded Nixon when he resigned as president. Due probably for the most part to his pardon of Nixon, Ford did not win reelection, but his presidency is being increasingly upgraded by historians.

The Central West man who was president of an independent nation was Samuel HOUSTON (1793-1863), who became a Texas pioneer and won Texas independence. Houston was elected to more high political offices than any other American—governor of two different states, congressman, U.S. senator, Ambassador of the Cherokee and President of the Republic of Texas.

Another U.S. president, Theodore ROOSEVELT, has written that the time he spent as a young

Perhaps the mark of a leader is to be able to relax—Dwight Eisenhower in a moment of relaxation.

man in pioneer North Dakota proved to be one of the most influential periods of his life.

Of course, the region has produced many other political leaders, such as William Jennings BRYAN (1860-1925) and George NORRIS (1861-1944), both of Nebraska.

Among the many great Indian leaders of the region, some of the best known were WASHAKIE (1804?-1900), peaceful chief of the SHOSHONE, war leaders SITTING BULL (1830?-1890), CRAZY HORSE (1842?-1877), RED CLOUD (1822-1909), GERONIMO (1829-1909) and COCHISE (1822?-1874), and such savants as SEQUOYAH (1770?-1848).

Also, of course, vast numbers of leaders in all other fields of endeavor, art, literature, business, finance and military came from the Central West region including—Admiral Chester W. NIMITZ(1885-1966) of Texas, department store tycoon J.C. PENNEY (1875-1971), entertainer-columnist-philosopher Will ROGERS (1879-1953) of Oklahoma, South Dakota's Fiorello Henry LaGuardia, perhaps the best known and most popular mayor in New York City history, and the two political figures of the region who almost simultaneously became the first women governors, Mariam A. FERGUSON (1875-1961) of Texas and Nellie Tayloe ROSS (1876-1977) of Wyoming. Perhaps even more prominent was the first woman ever to be elected to the U.S. House of Representatives, Jeannette RANKIN (1880-1973) of Montana, noted for her stand on women's rights and her influence on world peace.

LEADVILLE, Colorado. City (pop. 3,879). Seat of Lake County, perched just below the treeline at 10,200 feet, near the ARKANSAS RIVER headwaters in the Rockies, the community

sprang up almost overnight in 1860, when Abe Lee found one of the state's richest gold diggings, and the discovery canyon became the site of Leadville. As gold was becoming scarce there, rich silver deposits were found in California Gulch near Leadville. At the height of the silver rush as many as 30,000 people had braved the altitude and were headquartered in Leadville, giving Leadville a leading place in the history of mining.

Almost every spadeful of earth "turned to silver." On the death of one miner, the sexton digging a grave made a rich silver strike, and the cemetery was soon full of mining claims. At the richest of all the mines, a single day's work resulted in silver valued at $118,500. Great fortunes were made and lost. The usual outlaws, gamblers and followers made for such perilous times that one saloon implored, "Please don't shoot the pianist." But vigilantes, lynchings and the coming of full-fledged law officers put an end to outlawry.

The leadville region is still highly mineralized, and continues to produce wealth, with some mining and smelting, particularly of molybdenum at nearby CLIMAX. Farming ranching and the tourist trade contribute to the economy.

H.A.W. TABOR was one of the most successful mine owners. Among his contributions to Leadville was the ornate opera house. Jack Morrisey made a Leadville fortune but died in the poorhouse at DENVER. Auguste Rische did not squander his money, but was generous with his charity in Leadville. Perhaps the most widely known Leadville mining king was James J. Brown, who died on the *Titanic*. His wife, who was saved, became internationally known as "The Unsinkable Molly BROWN." One of Leadville's notorious marshalls was Mart Duggan.

Today, after declining into near-ghost status, Leadville revived itself, restored much of its early flavor and became one of the nation's leading tourist meccas. The Tabor mansion, the Tabor House and the ornate Leadville Opera House are all current attractions. The cabin at the mine where Baby Doe TABOR froze to death is open to the public. The past is celebrated in the annual Boom Days and Burro Race in the last weekend of August, and there is a winter carnival in March.

LEASE, Mary Elizabeth. (Ridgway, PA, Sept. 11, 1853—New York, NY, Oct. 29, 1933). Writer and lecturer. Lease was appointed president of the State Board of Charities in Kansas, the first woman in the United States to hold

such a position. A political activist, Lease toured Kansas tirelessly in the POPULIST cause encouraging farmers to "raise less corn and more hell." Her work led to the retirement of Senator John J. Ingalls. She represented Kansas at the National Convention of Charities and Corrections and was the national vice president at Chicago's World's Peace Congress in 1893.

LEAVENWORTH, Henry. (New Haven, CT, Dec. 10, 1783—Camp Smith, KS, July 21, 1834). Army officer. In 1823 Leavenworth led 220 regular troops, 120 mountain men, and several hundred SIOUX allies northward along the MISSOURI RIVER to meet ARIKARA villagers responsible for attacking a fur brigade of William ASHLEY (1778-1838). This first large-scale battle between United States troops and Plains Indians recovered some of Ashley's goods, but Leavenworth's mismanaged attack led the Arikaras to feel contempt for the ability of the military. In 1827 Leavenworth directed the construction of FORT LEAVENWORTH, the first permanent white settlement in Kansas and from 1827 to 1839 the headquarters for the Upper Missouri Indian Agency.

LEAVENWORTH, Kansas. City (pop. 33,-656). Seat of Leavenworth County, northeastern Kansas, northeast of LAWRENCE and southeast of ATCHISON. It was named for the fort, in turn for Indian fighter Henry LEAVENWORTH (1783-1834). The energetic modern city of Leavenworth began illegally in 1854 when a group of proslavery Missourians set up a settlement on land belonging to the Delaware Indians. In July, 1855, Leavenworth became the first incorporated town in Kansas Territory. The community grew quickly. In 1857 the vast overland transportation system of Russell, Majors and Waddell made the community its headquarters. The company is best remembered for its PONY EXPRESS which carried mail from St. Joseph, Missouri, to Sacramento, California, in as few as nine days. The first regular weekly newspaper was the *Kansas Weekly Herald* of Leavenworth which set type under a tree for its first issue of September 15, 1854. Leavenworth has been called the "Mother-in-Law of the Army" because so many army officers from the fort married girls from the city. FORT LEAVEN-WORTH, one of the oldest and most beautiful military posts in the United States, was established in 1827. The post is the site of the United States Disciplinary Barracks, a military prison and the prestigious Command and General Staff College. The United States Federal Penitentiary lies between the fort and the city, and south of the city, are the Women's State Prison and the Kansas State Penitentiary.

LEBANON, Kansas. Town (pop. 440), Smith County, north-central Kansas, northwest of Concordia and northeast of Russell. Lebanon is the nearest town to the geographical center of the forty-eight conterminous states.

LEE, Peggy. (Jamestown, ND, May 26, 1922—). Singer, born Norma Jean Engstrom. Lee sang on a FARGO, North Dakota, radio station at the age of sixteen and later with Will Osborne and Benny Goodman. She recorded *Elmer's Tune* with the Benny Goodman orchestra and later wrote the popular songs, *Manana* and *It's a Good Day.*

LEGIA GREISCHA COLONY. Swiss colony established in 1875 near present-day ARLINGTON, South Dakota. Originally all the land was owned in common. As soon as the residents were financially able, the cooperative principle was discontinued, assets divided, and many of the younger men began private businesses.

"LEGISLATIVE WAR." Political battle in Kansas between the POPULISTS/Democrats and the Republicans, each side claimed to have won control of the legislature in the election of 1892. A fusion of Democrats and Populists was able to elect the governor in that election. In addition, they claimed control of the legislature and took possession of the chambers. The Republicans, who also claimed the legislature, managed to eject the Populists. The Populist governor then called out the state militia to hold the Republicans in a state of siege. The issue was settled later by the U.S. Supreme Court, which ruled in favor of the Republicans.

LEHMI PASS. Locale southwest of Dillon, Montana, where Meriweather LEWIS (1884-1809), of the LEWIS AND CLARK EXPEDITION, became the first American of record to stand on the CONTINENTAL DIVIDE. At Lehmi Pass, elevation 7,373 feet, the divide separates present Montana and Idaho,

LEIGH LAKE. Irregular glacial lake covering 1,229 acres in GRAND TETON NATIONAL PARK, named for a member of Dr. V.F. Hayden's party, which surveyed the area in 1871 to 1872 and 1877 to 1878.

American Explorers, 1804–1839

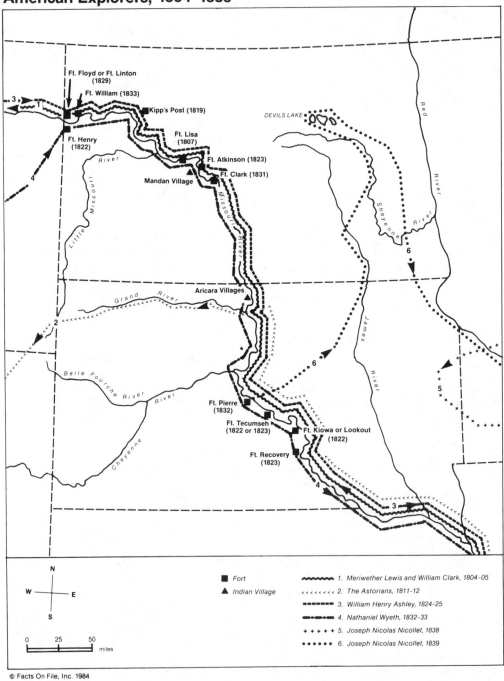

Ft. Floyd or Ft. Linton (1829)
Ft. William (1833)
Kipp's Post (1819)
DEVILS LAKE
Red River
Ft. Henry (1822)
Ft. Lisa (1807)
Ft. Atkinson (1823)
Ft. Clark (1831)
Mandan Village
Little Missouri River
Missouri River
Cheyenne River
Sheyenne River
Grand River
Aricara Villages
James River
Belle Fourche River
Cheyenne River
Ft. Pierre (1832)
Ft. Tecumseh (1822 or 1823)
Ft. Kiowa or Lookout (1822)
Ft. Recovery (1823)

N
W — E
S

0 25 50
miles

■ Fort
▲ Indian Village

〜〜〜 1. Meriwether Lewis and William Clark, 1804–05
<<<<<< 2. The Astorians, 1811–12
■■■■■■ 3. William Henry Ashley, 1824–25
●—●—● 4. Nathaniel Wyeth, 1832–33
+ + + + + 5. Joseph Nicolas Nicollet, 1838
● ● ● ● ● 6. Joseph Nicolas Nicollet, 1839

© Facts On File, Inc. 1984

Much of the route of Lewis and Clark, both outgoing and homecoming, lay through the northeastern section of the region.

LEMMON, South Dakota. Town (pp. 1,871), Perkins County, northwestern South Dakota, northwest of MOBRIDGE and almost on the border with Canada. Lemmon is the site of the largest deposit of petrified wood in South Dakota. Petrified wood is used as a building material at Petrified Wood Park and Museum. In its early days Lemmon boasted a unique combination of sheepmen, cattlemen and farmers living together peacefully.

LENAPAH, Oklahoma. Town (pop. 350), Nowata County, northeastern Oklahoma, northeast of BARTLESVILLE and north of CLAREMORE. The nickname "Cradle of Rodeo World Champions" has been given to this tiny Oklahoma town which has produced more such champs than any other, including such greats as Everett Shaw, Buck Rutherford, Shoat Webster, Fred Lowery and "Nowata Slim" Richardson.

LEPIDOLITE. Mineral used in the manufacture of shatter-proof glass. A principal source is the Glen-Woody Bridge area of New Mexico.

LEWIS AND CLARK CAVERN. A limestone cave, also known as Morrison Cave, in the southeastern corner of Jefferson County in central Montana. The cavern forms the basis of Lewis and Clark Caverns State Park.

LEWIS AND CLARK EXPEDITION. One of the most important and successful explorations of world history. Under the leadership of Meriwether LEWIS (1774-1809) and William CLARK (1770-1838), the group reached the West Central region not long after leaving St. Louis. They had been sent by President Thomas Jefferson to explore and strengthen the U.S. hold on the region. Clark wrote in his diary: "Arrived at the mouth of the great PLATTE RIVER at 10 o'clock July 21, 1804. This great river, being much more rapid than the MISSOURI, forces its current against the opposite shore....Captain Lewis and myself...went up this great river Platte about two miles...passing through different channels, none of them more than five or six feet deep....The Indians pass this river in Skin Boats which is flat and will not turn over. The Otteaus (Oto) a small nation reside on the South Side...the Panies (Pawnee) on the same side higher up."

On August 22, 1804, the party made their last camp in Nebraska and went into South Dakota. That night they elected a sergeant, in the first election of record ever held in what is now the West Central region. They shot their first buffalo, explored for minerals, met with many Indian groups and impressed them with the power of the new government. Their diaries contain some of the most accurate and thoroughly detailed accounts ever made of this and the other regions they visited, providing invaluable records for all those who would follow.

At present FORT PIERRE, South Dakota, they had a showdown with the SIOUX who tried to keep them from going farther upstream. "Capt Lewis...ordered every man to his arms. The large swivel cannon was loaded immediately, the other 2 swivels loaded well with buck shot and each of them manned. Capt Clark used moderation with them, told them that we must and would go on and would go, that we were not squaws but warriers sic.. The chief sayed he had warriers too and if we were to go on they would follow us and kill and take the whole of us...Then Capt Clark told them that we were sent by their great father the President of the U.S. and that if they misused us that he or Capt Lewis could be writing to him to have tham all destroyed as it were in a moment." Then the Teton Sioux chief "...took up the pipe of peace...lit it and presented the stem to us to smoke." After the party went on, the Sioux were never again feared quite so much.

Much of the valuable information they gathered on Indian organization and customs and the flora and fauna of the region came to them when they wintered (1804-1805) near the main villages of the MANDAN and ARIKARA about twelve miles up the Missouri from present Washburn, North Dakota.

One of the party described the camp: "This place which we call FORT MANDAN...two rows of huts or sheds, forming an angle, of 114 feet square and 78 feet high, with plank ceiling, and the roof slanting so as to form a loft above the rooms, the highest part of which is 18 feet from the ground." The log cabins were chinked with mud to keep out the cold.

They were visited by several French trappers, introduced the Indians to the celebration of Christmas and New Years and entertained them with singing and dancing. They met with the great chief of the Mandan and many other leaders, gave them medals and gifts and did what they could to turn their trade toward the U.S.

When they left Fort Mandan, Lewis wrote, "the party are in excellent health and sperits, zealously attached to the enterprise and anxious to proceed; not a whisper or murmor of discontent to be heard among them, but all act

Explorers, 1742–1853

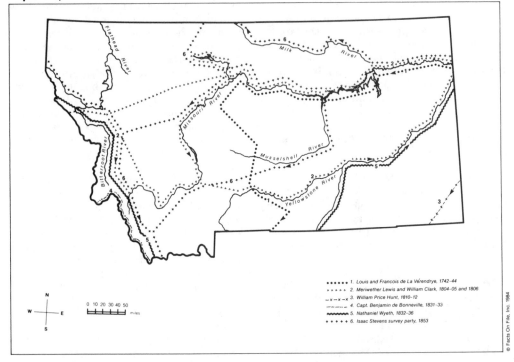

The longest portions of the routes of Lewis and Clark in any state lay through Montana.

in unison, and with the most perfect harmony."

A high point of the voyage was the first sight of the mouth of the great YELLOWSTONE RIVER on the Missouri River, and they took careful measurements of the width and depth of the channel. Leaving North Dakota, they went on to present Montana. At the GREAT FALLS of the Missouri they spent a month portaging their boats and equipment around the falls. Then they found the three forks which they eventually decided marked the beginning of the great Missouri River, one of the major geographical highlights of all time.

They came to the crest of the ROCKY MOUNTAINS, found that tiny stream known as the ultimate source of the Missouri and passed on to the other side of the CONTINENTAL DIVIDE. There they could no longer use the boats and had to purchase horses to continue. On their return journey in 1806, they again went through Montana, dividing their forces to make additional discoveries. Altogether, they had traveled 1,940 miles in what is now Montana.

As they continued back to St. Louis, they visited with the Indian friends they had met along the way, left gifts with them and invited several to accompany them back to "civilization."

LEWIS AND CLARK LAKE. Popular lake west of YANKTON, South Dakota between Nebraska and South Dakota formed on the MISSOURI RIVER by Gavins Point Dam, the "Mighty Mite."

LEWIS AND CLARK NATIONAL HISTORIC TRAIL. The trail commemorates the route of the 1804-1806 LEWIS AND CLARK EXPEDITION from the Mississippi River to the Pacific Ocean at the mouth of the Columbia River, and return. Approximately 4,500 miles of water routes, planned trails, and marked highways follow the outbound and return routes. Almost 500 public and private recreation and historic sites along the trail provide for public use and interpretation of the expedition, including eight National Park Service areas. About half of the route covered by this extraordinary expedition took the travelers through the Central West, and the trail is headquartered in OMAHA, Nebraska.

LEWIS OVERTHRUST. Awesome mountain-moving prehistoric force which lifted up the area of GLACIER NATIONAL PARK and transported it about twenty-five miles over the plains to its present location.

LEWIS, Meriwether. (Albemarle County, VA, Aug. 18, 1774—near Nashville, TN, Oct. 11, 1809). Explorer. Lewis, private secretary to President Jefferson beginning in 1801, was sent by Jefferson in 1803 to Philadelphia and Lancaster, Pennsylvania, to study map-making and astronomy prior to beginning the famous overland journey in 1804 known as the LEWIS AND CLARK EXPEDITION. It was carried out with the provision of $2,500 by Congress. The expedition's exploration of what is now the northern central west and western U.S. was one of history's most notable and most successful, and certainly least expensive. Lewis' vision as a leader was invaluable in guiding the party on the long and often perilous journey from St. Louis to the Pacific Ocean and back with the loss of only one man. The identification of new plants, animals and minerals, mapping of the vast region and the growing familiarity of the leaders with much of the territory through which they passed helped in the rapid advancement of westward settlement. The party found the long-sought headwaters of the MISSOURI RIVER, the three streams of which they named JEFFERSON, GALLATIN and MADISON. The firm but friendly treatment of the Indians, proved of enormous value in keeping the peace in some areas for many decades after the party's visit. In 1807 Lewis was made governor of Louisiana Territory, including parts of the western region he had explored. According to accounts, his death was the result of suicide or murder at a lonely inn on the Natchez Trace while he was traveling to Washington, D.C.

LEWISVILLE, Texas. Town (pop. 24,273), Denton County, in northeast Texas. Founded in 1844, Lewisville was first called Holford Prairie Settlement. It was named for early settler B.W. Lewis. It is located near the Dallas-Fort Worth Airport and Lewisville Lake, which is a resort area for residents of the Dallas-Fort Worth metropolitan area. There is diversified farming, and present manufactures include boats, clothing and aluminum products.

LIBBY DAM. Mammoth structure on the KOOTENAI RIVER near LIBBY, Montana, forming ninety-mile-long Lake Koocanusa, a popular fishing, swimming and fishing area.

LIBBY, Montana. Town (pop. 2,748). Seat of Lincoln County, far northwestern Montana, northwest of KALISPELL. Named for Libby Davis, daughter of one of the men who discovered gold in a nearby creek, Libby developed a lumber industry with the arrival of the Great Northern Railroad in 1892. Today, in addition to the lumber business, the Libby economy is based on copper mining, silver mining and vermiculite extraction. Because of its new industry of raising and harvesting evergreen trees, Libby calls itself the Christmas tree capital of the United States. Near Libby is one of the nation's finest stands of virgin cedars, the Giant Cedars Nature Trail of the Kootenai National Forest. Another popular nearby recreation area is Lake Koocanusa. Libby Logger Days and River Races occurs annually.

LIBERAL, Kansas. City (pop. 14,911). Seat of Seward County, southwestern Kansas, southwest of DODGE CITY and south of GARDEN CITY. The name came from the liberality of postmaster L.E. Keefer, who allowed anyone to use water from his well at no cost, in an area where water was scarce. Liberal has been the world's largest producer of helium gas. Other industry includes beef processing and aircraft production. Irrigation has brought substantial agriculture to the region. Known as the "key-city" of the Texas-Oklahoma-Hugoton PANHANDLE area, Liberal's most peculiar claim to fame is the annual INTERNATIONAL PANCAKE RACE, begun in 1950. Honed by weeks of practice, many contestants, waiters and waitresses of both Liberal and Olney, England, run for a quarter of a mile with a pancake in a skillet, tossing it twice on the way. The Rock Island Railroad Bridge, called "Mighty Sampson," across the CIMARRON RIVER is one of the largest of its kind. The Coronado Museum displays its own version of Dorothy's house from the *Wizard of OZ*.

LIEURANCE, Thurlow. (Oskaloosa, IA, Mar. 21, 1878—Wichita, KS, Oct. 9, 1963). Composer. While a professor at the University of WICHITA, Kansas, Lieurance spent twenty years of research among the American Indians recording their songs. His best remembered work among many concerning Indians was "By the Waters of Minnetonka."

LIGNITE. A black or brownish substance at a stage between peat and bituminous coal, lying at or near the earth's surface. Lignite has a conspicuously woody appearance, showing the material from which it has developed. It under-

lies the entire western part of North Dakota which according to estimates of the United States Geological Survey constitutes sixty-four percent of the lignite resources in the nation. Lignite was originally almost entirely used locally because it contained as much as twenty to sixty percent moisture. When the moisture was evaporated, the material crumbled, making it difficult to transport and use. Shipment of lignite was carried out successfully in closed boxcars. However, briquetting proved the most successful means of providing a usable form. Lignite has proven a valuable resource since it was discovered that activated carbon, used in water purification, sugar refining and tire manufacturing, could be produced from it. Low atmospheric temperatures oxidize lignite outcroppings and produce leonardite. North Dakota leonardite has been used as the base for an estimated seventy-five percent of the Vandyke brown pigment produced in the United States. The lignite mine of the Knife River Coal Mining Company near Hazen has been one of the largest in North Dakota. A fleet of four hundred fifty mine cars, six electric locomotives and thirty miles of track have been provided to carry the lignite from the mine to the processing plant.

LILLIE, Gordon William (Pawnee Bill). (Bloomington, IL, Feb. 14, 1860—Pawnee, OK, Feb. 3, 1942). Entertainer. Lillie was a pioneer in developing Wild West shows. In 1893 he developed Pawnee Bill's Wild West Circus and in 1929 established Old Town in Oklahoma, one of the first commercial reproductions of a pioneer settlement. Lillie gained experience as the interpreter and manager of PAWNEE INDIANS in the first Buffalo Bill CODY's (1846-1917) Wild West Show from 1883 to 1886. He was a partner with Cody from 1908 to 1913. Lillie was active for much of his life in programs designed to keep the buffalo from extinction. At Pawnee, Oklahoma, today the 1910 home of Pawnee Bill, wild west mementos and buffalo in the nearby pasture are featured at Pawnee Bill Museum and Park.

LINCOLN COUNTY WAR. A deadly power struggle for political influence and control of the beef industry during the 1870s in Lincoln County, New Mexico. Trouble flared into bloodshed with the killing of wealthy English rancher and businessman John Henry Tunstall in February 1878. On April 1st, Sheriff William Brady, reportedly controlled by the faction which killed Tunstall, was murdered by a group calling itself the "Regulators" in Lincoln, New Mexico. The army was finally called in to restore order when the Regulators, including Billy the Kid, barricaded themselves in a building and fired pot shots at local lawmen. The sight of the troopers' Gatling gun led many of the gang to surrender, and the rest were driven out when the building was set on fire. The appointment of CIVIL WAR general, Lew Wallace, as territorial governor calmed the feelings in Lincoln, and Billy the Kid was eventually tried and convicted for the killing of Sheriff Brady.

LINCOLN MONUMENT. Forty-two foot tall monument marking the CONTINENTAL DIVIDE at the summit of Sherman Hill, the highest point on the first transcontinental railroad, outside of LARAMIE, Wyoming. The monument, including the world's largest bronze head, is the work of Wyoming sculptor Robert Russin.

LINCOLN, NEBRASKA

Name: From Abraham Lincoln sixteenth President of the United States.

Nickname: Cornhusker Capital; Hartford of the West; Lilac City; The Holy City.

Area: 60.9 square miles

Elevation: 1,176 feet

Population:
1986: 183,050
Rank: 85th
Percent change (1980-1984): +4.9%
Density (city): 2,962 per sq. mi.
Metropolitan Population: 203,021 (1984)
Percent change (1980-1984): +5.3%

Race and Ethnic (1980):
White: 95.48%
Black: 2%
Hispanic origin: 2,745 persons (1.60%)
Indian: 922 persons (0.54%)
Asian: 1,681 persons (0.98%)

Age:
18 and under: 23.5%
65 and over: 10.3%

TV Stations: 5

Radio Stations: 13

Hospitals: 7

A dominant feature of Lincoln, Nebraska, is the great stadium of the University of Nebraska, where the Huskers are renowned for perennial leadership in college football.

Further Information: Lincoln Chamber of Commerce, 1221 North Street, Lincoln, NE 68508.

LINCOLN, Nebraska. City, (pop. 171,932). Capital of Nebraska and seat of Lancaster County, situated in southeast Nebraska 56 miles south and west of OMAHA, one of the many cities named for the martyred president.

In addition to the substantial business of state, county and municipal government, Lincoln is a center for a large farm and livestock region, is important in railroad shipments and trade, meat slaughtering and packing and other food processing. Among the many products are railroad cars, rubber goods, vehicles and circuit breakers. The city is also a center of insurance companies, known as the Hartford of the West.

Called Lancaster when it was founded in 1864, the community could boast only 50 residents in 1867 when it was renamed and selected as capital over the violent protests of Omaha. The state records had to be smuggled out of Omaha in the night to keep them from armed Omaha boosters. By 1870 the population had reached 2,500.

Famed Lincolnians include William Jenning BRYAN (1860-1925), who went to Congress from that city and native son John J. PERSHING (1860-

1948), who taught military science at the University of NEBRASKA before going on to become one of America's greatest generals.

Although of high academic standing and one of the cultural centers of the city, the university is perhaps even better known for its football teams, which perennially rank number one or two among the nation's universities. Nebraska Wesleyan University and UNION COLLEGE add to the city's academic resources.

One of the most notable of all the nation's capitols, the skyscraper structure at Lincoln is remarkable in several ways. It is the only U.S. state headquarters designed and built to house only one branch of the legislature. At the urging of Senator George W. NORRIS (1861-1944), Nebraska amended its state constitution to provide a unicameral legislature, the only one in the country.

The Nebraska capitol has been acclaimed by professional and amateurs alike. In a world poll of 500 leading architects the capital was named the fourth among the world's 25 finest public buildings. The building is particularly notable for its murals, some of intricate mosaics, by notable artists. The chandelier in the rotunda is the largest of its kind anywhere. The statue of Lincoln by Daniel Chester French is one of the nation's finest of the Great Emancipator. The gold glazed tower is topped by the agricultural

Lindsborg, Kansas, celebrates its Old World heritage with a Swedish festival.

LINDSBORG, Kansas. Town (pop. 3,155), McPherson County, central Kansas, southwest of SALINA and northeast of HUTCHISON. Lindsborg was founded by Swedish settlers in 1868, and its name came from the first syllable "Lind" of three settlers, plus "Borg," Swedish for town or castle. The community is widely recognized for its MESSIAH FESTIVAL of Music and Art held annually during Easter Week on the BETHANY COLLEGE campus since 1889. Other annual events with Swedish origin include Mid-Summer's Day Festival on the third Saturday of June and the Swedish Christmas on December 13th or the closest Saturday. The Svensk Hyllningsfest, honors Swedish pioneers in October of odd-numbered years.

LING FISH. A popular target of ice fisherman in Wyoming. The ling fish is a variety of whitefish which grows to a length of four feet and is said to taste like trout.

LIPAN INDIANS. Tribe of Athapascan linguistic stock, they roamed the territory of West Texas southeast to the Gulf of Mexico. They made war on the Spanish frontier and desolated mission stations. Having learned the Spanish language, they became allies of the Mexican partisans in the revolution of that country. At the close of the MEXICAN WAR (1848), they began raiding frontier settlements in Texas. They eventually retired to Mexico.

LISA, Manuel. (New Orleans, LA, Sept. 8, 1772—St. Louis, MO, Aug. 12, 1820). Fur trader. Lisa, a St. Louis fur trader in 1790, received a patent from the Spanish government granting him a monopoly of trade with the OSAGE Indians. He established Fort Manuel, originally called Fort Raymond, at the mouth of the BIG HORN RIVER in 1807. Fort Manuel, the first trading post in Montana, was also the first on the upper MISSOURI RIVER. Lisa, a founder of the Missouri Fur Company in 1808, established FORT LISA at the mouth of the Big Knife River in 1809. He served as the United States sub-agent for Indian tribes on the Missouri River around the mouth of the KANSAS RIVER, between 1814 and 1820.

LITTLE ARKANSAS RIVER. Beginning near Geneseo, Kansas, in the central part of the state, the Little Arkansas, generally parallels the main ARKANSAS RIVER as it flows southeast across the state's center. The Little Arkansas passes Medora and Halstead before meeting the Arkansas within the WICHITA city limits.

symbol of "The Sower." The University of Nebraska State Museum exhibits the world's largest mammoth skeleton among other notable displays. At the University also is Sheldon Memorial Art Gallery and Sculpture Garden, Christlieb Collection of Western Art and Ralph Mueller Planetarium.

The State Museum of History provides exhibits from prehistoric times to the present. Its other properties include the William Jennings Bryan Home, the Kennard House Memorial and the Ferguson mansion, an example of Renaissance revival style.

A unique institution is the National Museum of Roller Skating, with skates, costumes, photographs and mementoes of the sport and industry from 1700 to the present, considered the only one in the world exclusively devoted to that sport.

There are exceptional city parks and a children's zoo with exotic animals, areas for contact with the animals and a train ride.

At the nearby Acreage there are turn-of-the-century shops and an antiques market, as well as craftspeople creating and selling their wares.

LITTLE BIGHORN RIVER. Famed as the site of the defeat and devastation of the Seventh Cavalry under the command of General George A. CUSTER (1839-1876) in their destruction by the SIOUX and their allies at the Battle of LITTLE BIG HORN on June 25, 1876. The Little Bighorn, approximately ninety miles long, rises in northern Wyoming and flows north through Big Horn County into southern Montana where it joins with the BIGHORN RIVER.

LITTLE BIG HORN, Battle of. On June 25, 1876, the SEVENTH REGIMENT of the United States cavalry was at its full strength of 666 well-equipped officers and men, plus Indian guides and observers. By nightfall one-third of the men were dead and the remainder were pinned down by overwhelming numbers of SIOUX and CHEYENNE. The Seventh Regiment was part of an all-out attempt to crush the Northern Plains Indians. In June of that year, as many as six thousand Indians gathered in the valley of the LITTLE BIG HORN RIVER to stand against the whites. The political leader of the Indians, SITTING BULL, was assisted by such warchiefs as CRAZY HORSE (1842?-1877), Gall, Hump, Rain-in-the-Face and Black Moon. Hearing that a large encampment of Indians could be found in the valley, Lieutenant Colonel George Armstrong CUSTER (1839-1876) split his command into three battalions led by Major Marcus Reno, Captain Benteen and himself. Reno and Benteen were to ride parallel to Custer as he attacked the enemy camp. The triple-headed attack fell apart when Custer's force was met by as many as three thousand well-armed Indians, and Reno and Benteen were pinned down. The course of the battle is unclear to historians. It appears that within minutes Custer's men were forced to dismount and attempt the climb to higher ground on foot. In thirty minutes Custer's men were completely wiped out. Custer's body was later found unmutilated except for a bullet wound in the temple. The condition of the corpse suggests that Custer followed the unwritten rule of Indian battle to "save the last bullet for yourself." This might also account for the Indians not scalping the body as they did not interfere with the body of a suicide. However, Sitting Bull said they did not scalp Custer because of their admiration for his bravery. Reno and Benteen survived when the Indians stopped their battle after this partial but important victory and moved away on June 26th. The casualties included: Custer's Battalion, 200 killed; Reno's Battalion, 36 killed and

Artist William R. Leigh depicted "Custer's Last Fight."

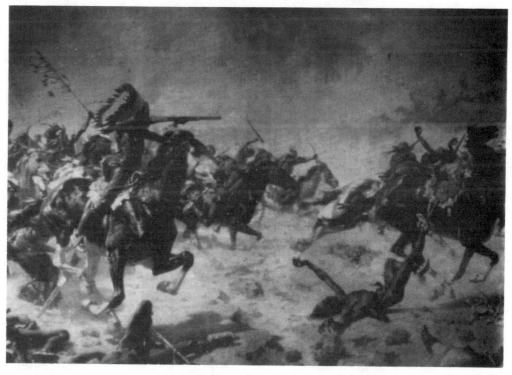

26 wounded; Benteen's Battalion, 11 killed and 29 wounded; Sioux, 21 killed and an unknown number wounded, and the CHEYENNE, 12 killed and an unknown number wounded. A CROW scout named Curley brought word of the battle to the steamer *Far West,* which carried the news of the massacre back to BISMARCK, North Dakota, along with the Reno and Benteen wounded. The only survivor of the federal forces at the Custer battle was a horse named Comanche.

"LITTLE BLUE BOOKS." Produced after 1912 on an extremely wide variety of topics by GIRARD, Kansas, publisher, E. Haldeman-Julius, who also was publisher of the Socialist paper *Appeal to Reason.* The books, on subjects ranging from agnostics to zoology, sold by the millions of copies, leading to the description of the enterprise as "one of the greatest outputs in American publishing history."

LITTLE BLUE RIVER. Tributary of the BIG BLUE RIVER, rising in southern Nebraska and flowing southeasterly across the Kansas border into the major stream in Marshall County below MARYSVILLE.

LITTLE BLUESTEM. This member of the vast grass family is the official grass of Nebraska.

LITTLE EAGLE, South Dakota. Town (pop. 300), Corson County, north-central South Dakota, northwest of MOBRIDGE and southeast of LEMMON. SITTING BULL (1830?-1890), the famous SIOUX leader, was shot and killed by federal Indian police while being arrested at his camp near Little Eagle in 1890. Sitting Bull's homesite is now known as Sitting Bull Park. A monument to all Indian soldiers who died during WORLD WAR I is located nearby, and it was here that the Sioux revived their rain dance during the terrible drouth of 1936.

LITTLE MISSOURI RIVER. Northwestern United States, begins its 560 mile course in northeast Wyoming. It flows northeast across the southeast corner of Montana and northwest corner of South Dakota before entering North Dakota where it continues northward into McKenzie County. It turns east before entering the MISSOURI RIVER in Dunn County. The Little Missouri flows near MEDORA, North Dakota, and through the Little Missouri National Grassland.

LITTLE ROCKIES. Range in Montana con-

fused by Meriwether LEWIS (1774-1809), of the LEWIS AND CLARK EXPEDITION (1804-1806), with the mightier range farther west.

LITTLE TVA. Name given to a series of dams, lakes and hydroelectric sources for power and conservation constructed in the PLATTE RIVER Valley of Nebraska, patterned by its proponent, Senator George William NORRIS (1861-1944), after the Tennessee Valley Authority which he also championed.

LITTLEFIELD, George Washington. (Panola County, MS, June 21, 1842—Nov. 10, 1920). Cattle baron and philanthropist. After serving in the CIVIL WAR, Littlefield began a cattle-driving business between Texas and the Midwest. His cattle range near Tascosa, Texas, was established in 1877. His LFD brand on 40,000 head of cattle became one of the most famous in the region. After founding the American National Bank at Austin in 1883, he became known as one of the principal advocates and largest benefactors of the University of TEXAS. He also used his wealth to advance various institutions.

LIVERMORE, Mount. Jeff Davis County, in western Texas. The highest peak in the DAVIS MOUNTAINS (8,382 feet), it is also known as Baldy Peak or Old Baldy. Today one of the world's largest observatories is situated on the mountain.

LIVINGSTON, Montana. City (pop. 6,994). Seat of Park County, south-central Montana, southeast of BOZEMAN and southwest of BILLINGS. It was named for railroad official Crawford Livingston. Livingston lies near where the LEWIS AND CLARK EXPEDITION discovered the YELLOWSTONE RIVER. At the head of Paradise Valley, it is a transportation center with agriculture, lumber and ranching as the chief industries, along with tourism. Many tourists to YELLOWSTONE NATIONAL PARK stop over, and the community is a supply point for outdoor enthusiasts. The Yellowstone River float trip is popular, and Dan Bailey Yellowstone Days brings a variety of sporting events. The city is home of the Park County Museum, a collection of exhibits which record the history of the Northern Pacific Railroad. Buried in the Sunset Hills Cemetery are Henry T.P. COMSTOCK, discoverer of the famed Comstock Lode, who committed suicide after he spent the $10,000 he received for selling the Nevada lode, and John M. BOZEMAN (1835-1867), trailblazer.

LLANO ESTACADO. An extensive plateau, translated as the Staked Plain, in southeastern New Mexico, northwest Oklahoma, and western Texas. With an area of approximately 35,000 square miles, the plateau has rich resources of oil and natural gas and is used to graze animals and grow wheat. Many legends surround the area's name. One popular account claims the fictional character Pecos Bill roped a tornado which leveled the country so flat for so far that people had to drive stakes in the ground at regular intervals to find their way across.

LLANO RIVER. River originating on the Edwards Plateau in southwest Texas, and flowing generally northeast for 150 miles to empty into the COLORADO RIVER.

LLOYD, Harold. (Burchard, NE, Apr. 20, 1894—Beverly Hills, CA, Mar. 8, 1971). Motion picture actor. Lloyd began his movie career at the age of nineteen by working as an extra before joining Hal E. Roach in 1914 for a starring role in one-reel comedies entitled *Lonesome Lukes.* Lloyd went on to form his own corporation where he produced feature-length films. These portrayed him as a bumbling young man (He always wore rimmed glasses with no lenses.) who was constantly getting into the most foolhardy situations. He acted in these foolhardy parts without tricks or stand-ins. Probably no motion picture scene has been reproduced in print so frequently as the one in which Lloyd hung high above the street, clinging to the hands of a giant clock. He was the highest paid actor of the 1920s. Lloyd usually is ranked as one of the three great clowns of the century. He is renowned as one of the most innovative performers and directors in motion picture history. He acted in some 500 films. Some of the most popular included *For Heaven's Sake* (1926), *The Kid Brother* (1927) and *Speedy* (1928).

LOGAN, Joshua. (Texarkana, TX, Oct. 5, 1908—). Playwright, director, and producer. Winner of a Pulitzer Prize in 1950 for coauthoring *South Pacific* with Oscar Hammerstein, Logan is best known as the director of such plays as *Charley's Aunt* (1940), *Annie Get Your Gun* (1946), *Mr. Roberts* (1948), *South Pacific* (1949), *Picnic* (1953), and *Fanny* (1954). As a film director, his credits include *South Pacific* (1958), *Fanny* (1961), and *Camelot* (1967).

LOLO HOT SPRINGS. Site near MISSOULA, Montana, of the first luge run built in the United States. On such a one- or two-man bobsled course, the sled, steered entirely by the body, can reach speeds of ninety miles an hour. The waters of the hot springs, a popular tourist attraction, are not mineralized.

LONG, James. (North ? Carolina, c.1793—Mexico, 1822) Military adventurer. James Long was the leader of a faction which opposed the Adams-Onis Treaty of 1819. In exchange for U.S ownership of Florida, the federal government relinquished certain claims in the West, particularly in Texas. The opposition faction contended that the treaty was illegal and that Texas should rightfully be a part of the U.S. Americans living on the frontier with Texas formed the largest segment of this opposition. The frontiersmen were certain that more vigorous negotiation would have placed Texas in U.S. hands, as well as Florida. Long decided to organize this opposition and gathered a volunteer "army" of 300 men. Without a shot they captured the Texas border town of NACOGDOCHES in June 1819. He called it the capital of the "Republic of Texas," and declared himself the president and commander-in-chief on June 23. However, when Long went to GALVESTON ISLAND to get assistance from the strong pirate Jean LAFITTE (1780-1826) the pirate refused. Without their leader, Long's disorganized army was defeated by a Spanish force. Two years later Long joined the forces of Agustin de Iturbide in the overthrow of the Spanish government. However, Iturbide was not about to give up Texas, so Long tried to leave Mexico City in 1822, but a Mexican sentry shot him in a dispute over his passport, and he died without ever seeing Texas again.

LONG, Stephen Harriman. (Hopkinton, NH, Dec. 30, 1784—Alton, IL, Sept. 4, 1864). Army officer, explorer, engineer. In 1819 Long wrote that the lands west of the Missouri were an "abode of perpetual desolation." He became the first official American explorer in northern Colorado in 1820, and discovered and named Long's Peak for himself. He continued south to the area of COLORADO SPRINGS, then returned to the East by way of the ARKANSAS RIVER and its tributaries. He became a consulting engineer for various railroad enterprises. Long received a patent for a system of bracing and counterbracing wooden bridges in 1836.

LONGHORN CATTLE. Hardy breed of cattle with a nondescript color, with a horn spread of three to five feet, with coarse and stringy meat

and wild nature, a direct descendant of Spanish animals. Early American settlers in Texas believed the longhorns to be native, such as the buffalo, and referred to them as "wild cattle, Spanish cattle, or mustang cattle." Animals brought into the region by settlers from the Eastern United States interbred with the longhorns, and the result was an animal with longer horns, unlimited color variations, and a heavier and rangier body. By the beginning of the CIVIL WAR the term "Texas cattle" and "Longhorn" were synonymous. Longhorns seemed to thrive on extended cattle drives. Cowboys credited the animal's endurance to tougher hooves and an ability to go longer without water than the newer breeds of cattle. The ability of Longhorns to walk as far as sixty miles between waterings and their capacity to withstand heat and hunger helped compensate for their limited quality and quantity of beef.

LONGHORN CAVERN. Limestone cave complex in Burnet County in central Texas at the northern edge of the Edwards Plateau. It is noted for its unusual limestone and crystal formations. In past centuries, it served as a hiding place for Indians and outlaws, most notably the feared Sam BASS gang for which its main entrance is named. It was also a gunpowder manufacturing station during the CIVIL WAR. Only a part of the cavern has been explored.

LONG'S PEAK. Highest peak in ROCKY MOUNTAIN NATIONAL PARK, Colorado, rising to a height of 14,256 feet high. It is located in Boulder County in north central Colorado and named in honor of Stephen H. LONG, an American military officer, who discovered it in 1820.

LONGVIEW, Texas. City (62,762), seat of Gregg County, in northeastern Texas, on the north bank of the SABINE RIVER. The city was settled in 1865, incorporated in 1872 and given a descriptive and promotional name. Located in a rapidly growing urban region, Longview lies in the heart of the east Texas oil fields with over 20,000 producing wells. Its manufactures include oil- and oil-field machinery, steel, natural gas, chemicals, plastics, paper, building materials and agricultural equipment. It is the site of LeTourneau College. Longview Museum and Arts Center and Caddo Indian Museum are found there. Annual events include the Great Texas Balloon Race, ViewFest and Fall Fest.

LOOKOUT MOUNTAIN. Southwestern Colorado, rising 13,660 feet high in San Juan and San Miguel counties, south of Golden, Colorado, is the site of William F. (Buffalo Bill) CODY's (1846-1917) grave. From the grave a panoramic view of Denver is obtained.

LORENZO DE ZAVALA ARCHIVES AND LIBRARY BUILDING. Formerly the State Library and Archives Building, AUSTIN, Texas. It houses one of the largest collections of historical documents of state, including the Texas Declaration of Independence. A quick review of Texas history is provided by a forty-five foot mural.

LORETTO ACADEMY. One of the oldest educational institutions in the United States, located in SANTA FE, New Mexico. The Lady of Light Chapel features the "miraculous stairs," a staircase making two 360-degree turns, built with wooden pegs instead of nails and having no apparent means of support. The staircase was constructed by a stranger who disappeared before the grateful nuns could thank him.

LORETTO HEIGHTS COLLEGE. Private, independent, liberal arts college in DENVER, Colorado, accredited with the North Central Association of Colleges and Schools. The college employs one of the original University Without Walls programs to provide alternative education for adult students. Loretto Heights enrolled 772 students and employed 85 faculty members during the 1985-1986 academic year.

LOS ALAMOS, New Mexico. City (pop. 11,039). Seat of Los Alamos County, northwestern New Mexico, a few miles north and west of SANTA FE. The name comes from the Spanish poplars or cottonwoods. The Los Alamos Ranch School for Boys was chosen in 1942 as the site for top-secret research on atomic bombs. As more scientists and the support facilities arrived, it became a planned community. The Los Alamos Scientific Laboratory, a classified operation of the University of California, continues to conduct extensive research into both war and peaceful use of nuclear energy. Today the city is a quiet residential suburb of Santa Fe. Bradbury Science Museum of the Los Alamos National Laboratory provides unique displays and artifacts relating to the history of the laboratory and the atomic bomb. Near Los Alamos the immense energy of the earth is displayed in Valle Grande, one of the largest calderas in the world. Valle Grande

was formed nearly one million years ago when a volcanic vent blew hundreds of cubic miles of ash and stone into the air and then collapsed. The rim stands 500 feet above the 175-acre floor. Also nearby are BANDELIER NATIONAL MONUMENT and the Jemez State Monument.

LOST PINES. Unusual stand of trees near BASTROP, Texas, completely isolated, about 100 miles away, from the other pine forests of east Texas. Timber from the forest was used in the construction of the Texas capitol at AUSTIN.

LOUISIANA PURCHASE. The largest and most important annexation to the original 13 states, purchased from France in 1803. The boundaries were vaguely defined and were not settled until various treaties and agreements were made. However, as the area was eventually carved out into states, about two-thirds of the lands of the Louisiana Purchase fell in what is now the Central West: all of Oklahoma, except the PANHANDLE, all of Kansas except the far southwest corner, the northeastern half of Colorado, all of Nebraska, all of South Dakota, all but the southwest corner of Wyoming, and all but the northwest corner of Montana. The northern border of Louisiana Territory was disputed by Britain, and the treaty of 1818 settled that question by establishing the 49th parallel as the northern boundary. This placed all of North Dakota in the territory. By 1870 Kansas and Nebraska had become states; Dakota Territory included both the Dakotas, and the other states of the region had been organized as territories, with their present boundaries. Statehood for the other portions of the purchase in the region came to Colorado, 1876, both of the Dakotas in 1889, Wyoming, 1890 and Oklahoma, 1907,

LOUP RIVER. Nebraska river which originates as three branches, North Loup, Middle Loup, and South Loup rivers. It flows eastward toward COLUMBUS, Nebraska, where it enters the PLATTE RIVER.

LOVELACE CLINIC AND FOUNDATION. ALBUQUERQUE, New Mexico, medical facility responsible for providing American astronauts with physical checkups before their flights.

LOY, Myrna. (Helena, MT, Aug. 2, 1905—1987). Actress. Born Myrna Williams, she began her film career playing mysterious and dangerous characters, graduating to some of the most prominent films of all time, includ-

ing *The Best Years of Our Lives* (1946) and *Cheaper by the Dozen* (1950). She was particularly recognized for the picture series *The Thin man* of the 1930s and 1940s. Her other films include *The Rains Came* (1939), and *Mr. Blandings Builds His Dream House.* (1948).

LUBBOCK, Texas. City (pop. 173,979). Seat of Lubbock County, in northwest Texas. Lubbock was set up by two rival town builders who consolidated their townsites of Monterey and Old Lubbock in 1891. The community was named for Texas pioneer Thomas S. Lubbock. Originally it was a headquarters for buffalo hunters, early ranchers and trail drivers. Today it is the center of the wealthiest agricultural region of Texas and has one of the largest inland cotton markets in the U.S. Its grain elevators have a capacity of nearly fifteen million bushels, and more than 260 industries produce a wide variety of products, including processing of more cottonseed oil than any other city in the world. Reese AFB is a training center for jet pilots. TEXAS TECH UNIVERSITY and Lubbock Christian College are other educational centers. The university is known for its Health Sciences Center, the Ranching Heritage Center and the Lubbock Lake Landmark, a large archaeological dig.

LUCAS, Anthony Francis. (Trieste, Austria, Sept. 9, 1855— Washington, DC, Sept. 2, 1921). Mining engineer. Lucas drilled the "discovery" well of the Texas oil industry. Developer of the dome theory of oil concentration about salt domes, Lucas discovered rocksalt in domes at a depth of three thousand feet and more. While he and his men were drilling on Spindletop near Beaumont, Texas, on January 10, 1901, suddenly oil spouted two hundred feet in the air and established for the well an initial capacity of 100,000 barrels of oil per day. Lucas also discovered the presence of profitable deposits of sulphur in the coastal plains of Texas.

LUCAS GUSHER MONUMENT. Tall granite spike at Spindletop, scene of the most spectacular oil strike in history when the Lucas Gusher came in on January 10, 1901. Surrounded by a small park on the southeastern limits of Beaumont, Texas, the monument bears an inscription reading, "Petroleum has revolutionised industry and transportation; it has created untold wealth, built cities, furnished employment for hundreds of thousands, and contributed billions of dollars in taxes to support institutions of government. In a brief

The Lucas well is represented in the shadow of the San Jacinto monument.

span of years it has altered man's way of life throughout the world."

LUFKIN, Texas. City (pop. 28,562). Seat of Angelina County, in eastern Texas, 117 miles north of HOUSTON. Founded in 1882 and incorporated as a city in 1890, Lufkin is in the heart of lumbering country on the south bank of the Sam Rayburn Reservoir. The city's manufactures include newsprint, woodworking products, trailers, and oil field equipment. It is the site of Angelina Junior College and a state-run school for the mentally retarded.

LUMBER. The Central West states account for about 10.5% of the total United States sawtimber supply each year. The region includes more than 56.23 million acres of commercial timberland, or about 11.7% of the United States total. The leading states within the region are Montana with over 14.35 million acres, producing just over 97 billion board feet of sawtimber; Colorado 11.3 million acres, 54.9 billion board feet of sawtimber; Texas, (12.5 million acres, 50 billion board feet sawtimber; Wyoming 4.3 million acres, 27 billion board feet of sawtimber and New Mexico 5.5 million acres, 25.9 billion board feet of sawtimber. The other states in the region produce a total of 16 billion board feet of sawtimber on 35.2 million acres.

LUMINARIAS. Traditional Christmas lighted decorations, consisting simply of a lighted candle placed in wet sand in a paper bag. Thousands of these provide spectacular Christmas decoration. Started in the Southwest, the custom is now widespread and particularly effective in the cities of New Mexico.

LUSK, Wyoming. Town (pop. 1,650), Niobrara County, eastern Wyoming, east of Douglas and southwest of Newcastle. Named for an early settler, Lusk was on the route of the Cheyenne and Black Hills Stage Line, a route marked by two rows of white posts. Red-colored cliffs to the west furnished the Indians with material for paint. The community, once a bustling oil boom town of 10,000 is now a trading center for area ranches and dry-farmers. An original Concord stagecoach is displayed along with western relics in the Stagecoach Museum. Reminders of early days are relived annually in the *Legend of Rawhide*, the story of Rawhide Buttes.

LYNDON B JOHNSON HOME. Part of the LYNDON B. JOHNSON NATIONAL HISTORICAL PARK in JOHNSON CITY, Texas. Johnson's residence from 1913 to 1934 is a Victorian-style frame house furnished with period furniture including some family heirlooms.

LYNDON B. JOHNSON LIBRARY AND MUSEUM. Located on the campus of the University of TEXAS at AUSTIN, the exhibits include an archives collection of thirty-five million documents, memorabilia of political campaigns, and gifts from world leaders.

LYNDON B. JOHNSON NATIONAL HISTORICAL PARK. The park consists of the birthplace, boyhood home and ranch of the 36th president, 1963-69, and his grandparents' old ranch. Headquartered JOHNSON CITY, Texas, authorized December 2, 1969.

LYNDON B. JOHNSON SPACE CENTER. Formerly called the Manned Spacecraft Center, in HOUSTON, Texas. The complex was begun in 1962 and became the headquarters of all manned space flight in January, 1964. It was renamed in 1973 after the death of former President and native Texan, Lyndon Baines JOHNSON (1908-1973). It covers 1,600 acres and is the headquarters for training U.S. astronauts. It houses the National Aeronautics and

Space Administration's Mission Control Center, which monitors the system functions of spacecraft after liftoff from Cape Canaveral, Florida. While the actual parts of the spacecraft are manufactured at various factories around the country, scientists and engineers there are responsible for the design and development of all parts and equipment. Soil and rock samples taken during the first manned moon landing in 1969 were analyzed in laboratories at the center.

MACKENZIE STATE PARK. Preserve near LUBBOCK, Texas, devoted for the most part to saving the prairie dogs in the area. Nearly one million visitors annually view the park's Prairie Dog Town, center of this unique effort.

MADISON RIVER. One of the three rivers, named by the LEWIS AND CLARK EXPEDITION (1804-1806), which combine at the THREE FORKS OF THE MISSOURI RIVER to form that great stream. The Madison, approximately 180 miles long, begins in southern Gallatin County, Montana, and flows west and north through Madison County to join with the Gallatin and Jefferson rivers at the community also named THREE FORKS.

MADRID, TREATY OF. Agreement in 1801 in which Spain returned all of Louisiana to France, resulting eventually in most of the present Central West Region coming under U.S. control. The return of the vast area to France caused great concern among Americans who used the Mississippi River. Controlled by Spain, Louisiana posed no threat to American farmers who transported their harvests to New Orleans for shipment. This freedom to trade, the "right of deposit," was not assured under French rule. President Thomas Jefferson was surprised when he learned that France might be willing to sell Louisiana to the U.S. Neither the people of the U.S. or their leaders had expressed any great desire to own the western lands, much of which was considered desert. However, the need to control the Mississippi and avoid any difficulty with France placed the possible ownership of Louisiana in a new light, and the president began negotiations for its acquisi-

tion, which, of course, resulted in the LOUISIANA PURCHASE of 1803, one of the United States' outstanding real estate transactions.

MAGEE, AUGUSTUS. (—). Leader of a band of outlaws, calling itself the Republican Army of the North, which sought to capture Texas for the U.S. They captured NACOGDOCHES in July, 1812, took GOLIAD, Texas, and, not long after, the capital SAN ANTONIO. By then Magee was dead from causes still not known, and the invasion failed.

MAGNESIUM. Light, silver-white metallic element, the eighth most abundant mineral in nature, used in lightweight alloys. When complicated processes were developed to extract magnesium from seawater, that industry became concentrated in plants in Texas.

MAGRUDER, John Bankhead. (Winchester, VA, Aug. 15, 1810—Houston, TX, Feb. 18, 1871). Military officer. A graduate of West Point (1830), he served in the war against Mexico and joined the Confederates in 1861. He commanded the defense of Richmond in 1862 and that same year commanded Confederate forces in Texas, New Mexico, and Arizona, and headed the expedition against the Nationals at GALVESTON, Texas. He was modestly successful in several small operations. When the war ended he would not seek parole and went to Mexico where he became a major-general under Maximilian. After the Mexican emperor's fall, Magruder returned to Texas.

MAIDEN'S ISLAND. Focus of a legend tell-

ing of the formation of an island in Lake Kampeska in eastern South Dakota's Codington County, west of WATERTOWN. An Indian maiden, in love with a warrior away on a long journey, was forced by other braves to marry one of them, and she agreed to marry the man who could throw the largest stone into the lake. Despite the fact that so many stones were thrown into the lake that an island was formed, the girl could not make up her mind. The braves marooned the girl on the island in hopes that starvation would make her decide, but white pelicans brought her food until her real lover returned to rescue her.

MAMMOTH. Official fossil of Nebraska. The fossil fields of Nebraska have yielded perhaps the greatest variety of prehistoric fossils found anywhere. Colorado is the only other state of the Central West to have chosen an official fossil. Morrill Hall Museum at the University of NEBRASKA displays the world's largest mammoth skeleton. Found on the great plains, the imperial mammoth was the giant of this prehistoric breed of elephants, some reaching almost fourteen feet in height.

MAMMOTH HOT SPRINGS. Called "a mountain turning inside out," Mammoth Hot Springs is one of the main attractions of YELLOWSTONE NATIONAL PARK. More than 700,000 gallons of water and two tons of limestone pours daily from deep beneath the earth's crust to create tier upon tier of cascading stone terraces, each lightly tinted in pastel colors. Because the building material is limestone and not a harder stone, terraces build up quickly, often within months.

MANDAN INDIANS. Tribe of the Siouan linguistic family who lived on the MISSOURI RIVER in present-day North Dakota in the early 18th century. The tribal name was given to them by the DACOTAH, but they referred to themselves as Numakiki, or "people." The Mandan consisted of five bands, each of which spoke a slightly different dialect. Mandan religious life included the Okipa, a summer ritual to ensure the prosperity of the people and to bring buffalo. A torture ritual subjected young men volunteers to suspension on rawhide ropes attached to skewers through their chest muscles. Many festivals were associated with hunting and agriculture. Mandan villages were located on high bluffs above the river, with stockades and barrier ditches on the other sides. Both hunting and agriculture were important to the economy.

Women grew corn, squash, and beans. They used digging sticks, hoes made from the shoulder blade of buffalo and antler rakes. Surplus corn was traded to the ASSINIBOIN for buffalo hides and meat. In the late 18th century the population of the Mandan was severely reduced by smallpox epidemics and warfare with the Dacotah. A second smallpox epidemic in 1837 nearly destroyed the tribe, killing all but 150 out of an estimated 1,800. The surviving Mandan joined the HIDATSA in 1845 and moved farther north to a bend in the Missouri they called Like-a-Fishhook. The ARIKARA joined them in 1862 and around the 1870s the area in which they lived was established as Fort Berthold Reservation. In 1887 most of the land was allotted in severalty. In the 1950s Garrison Dam flooded one-quarter of the reservation including the best farming areas. In the 1970s tourist facilities were established by the tribes on Lake SAKAKAWEA, the reservoir formed by the dam.

MANDAN, North Dakota. City (pop. 15,513). Seat of Morton County, south-central North Dakota, west of BISMARCK and south of MINOT. Mandan, founded in 1881 on the site of an Indian village, was first visited by Pierre de la VERENDRYE (1685-1749) in 1738. LEWIS AND CLARK found the settlement badly hurt by smallpox in 1804, and in June, 1876, George Armstrong CUSTER (1839-1876) rode out of nearby FORT ABRAHAM LINCOLN on his way to subdue the SIOUX. In July the steamboat *Far West* returned to Mandan with the news of Custer's defeat. Originally named Lincoln, Mandan was renamed with a form of the word, mantani, meaning "people on the bank" which described the first Indian settlements along the MISSOURI RIVER. Mandan is today the home of the Amoco Oil Refinery, one of the state's largest industrial operations, and Cloverdale Farms, an agricultural product processing firm. The University of Mary, North Dakota's only private university, was established in 1955 in Mandan by the Benedictine Sisters of Annunciation. Annual events in Mandan include the Jaycee Rodeo Days, held on the Fourth of July weekend. Fort Abraham Lincoln State Park includes reconstructed blockhouses of an Army infantry post and Mandan Indian earthen lodges. The Great Plains Museum depicts the history of the North Dakota frontier with life-sized wax likenesses of famous figures, collections of Indian artifacts, and photographs.

MANGANESE. Hard, brittle, grayish-white

metallic element used primarily in alloys of steel and found in abundance in Montana, which has long ranked first in the United States by producing forty-three percent of the nation's total.

MANHATTAN, Kansas. City (pop. 32,644). Seat of Riley County, northeastern Kansas, northwest of TOPEKA and northeast of WICHITA , named for Manhattan in New York City. Tuttle Creek Dam near Manhattan is one of the largest earthen dams in the United States. Manhattan also boasts that the first regular weather reports ever given over the radio originated from the State College at Manhattan in 1912, now KANSAS STATE UNIVERSITY, the country's first land grant college. The institution gained further fame from its president Milton EISENHOWER (1899-1985), the brother of President Dwight EISENHOWER (1890-1969). Manhattan began as a series of small villages which consolidated around 1855. Most of the settlers had come from the north, so the community maintained a free-state, anti-slavery stance prior to and through the CIVIL WAR. Near Manhattan, in the village of Wabaunsee, money raised by Henry Ward Beecher's Brooklyn congregation was used to purchase rifles for the anti-slavery forces. The guns were packed in crates marked "Bibles" to avoid detection. Because of this action, the church was called the Beecher Bible and Rifle Church. Manhattan prospered after the war as an educational center and with the arrival of the railroad in the 1870s, which made the city an important shipping center. Manhattan enjoys the annual Kansas Folklife Festival at the beginning of May. The Goodnow Memorial House is a museum in the former home of Isaac Goodnow, founder of the Kansas public school system.

MANITOBA ESCARPMENT. Proper name for the Pembina Escarpment, a three hundred to four hundred foot rise along the western edge of the RED RIVER Valley in North Dakota.

MANITOU SPRINGS, Colorado. City (pop.4,475). At the foot of PIKES PEAK, three miles northwest of COLORADO SPRINGS, the community is the gateway to some of Colorado's principal tourist attractions, the GARDEN OF THE GODS and CAVE OF THE WINDS, in addition to the great mountain which dominates the entire area. The area was long known to the Indians for the curative powers of the springs, which they considered miraculous, giving the site the Indian name Manitou, meaning Great Spirit.

The tribes had set the springs aside as a healing sanctuary. The Mount Manitou Incline takes a constant stream of visitors to the top of the peak by cable car. The Manitou Cliff Dwellings Museum demonstrates the culture of the cliff-dwellers of A.D. 1100 to 1300, and the Colorado Car Museum includes cars used by Queen Elizabeth, and presidents Truman, Kennedy and Eisenhower, among other notable vehicles. Annually the Pikes Peak Marathon in August brings out some of the top marathon runners for the 28 mile climb and descent of the mountain, which begins and ends at the mountain's cog railroad depot.

MANKATO, Kansas. Town (pop. 1,205). Seat of Jewell County, north-central Kansas, northwest of CONCORDIA and east of LEBANON, named from the Sioux meaning "blue earth." Mankato, a pioneer in providing quality health care, was the first community in Kansas to put a rural clinic into operation under Kansas' Rural Health Plan, an attempt to encourage doctors to practice in small towns and rural areas. To attract a doctor to their community, the residents of Mankato raised money, built and completely equipped a building to be a state-of-the-art facility for medical care.

MANSFIELD, BATTLE OF. Occurring March 10, 1864, this was the last major Union attempt to capture Texas, which remained in Confederate hands until the end of the CIVIL WAR.

MANSFIELD, Mike. (New York, NY., 1903—). Senator, ambassador to Japan. Mansfield, a Montana Democrat, served a record sixteen years as the majority leader of the U.S. Senate, from 1961 to 1977. His service in the Senate began with the election of 1952. During his record breaking career in the Senate he was particularly known for his influence in foreign affairs, for which he was well qualified by long experience. He was said to maintain a clear vision of the requirements of national security and balance-of-power relationships. Prior to his election to the Senate, Mansfield had served ten years in the House of Representatives. He carried out foreign diplomatic assignments for Presidents Dwight D. EISENHOWER (1890-1969), John F. Kennedy (1917-1963) and Lyndon JOHNSON (1908-1973) and was appointed ambassador to Japan by President Jimmy Carter and retained the position under President Reagan. In November, 1988, he announced his resignation from the post. Upon

his retirement from the Senate, Senator Edward Kennedy said, "No one in this body personifies more nearly than Mike Mansfield the ideal of the Senate. Wisdom, integrity, compassion, fairness, humanity—these virtues are his daily life. He inspired all of us, Democrat and Republican, by his unequalled example. He could stretch this institution beyond its ordinary ability, as easily as he could shame it for failing to meet its responsibility."

MANTLE, Mickey Charles. (Spavinaw, OK, Oct 20, 1931—) Baseball luminary. As a boy he was groomed for baseball by his father, who named him in honor of Micky Cochrane, a great catcher. Signed in high school by the New York Yankees, Mantle played in the minor leagues after graduation. In 1951, he was brought to New York as a center-fielder. Beginning in 1952, he hit over 300 in 10 of his 14 seasons, and his career average was 298. He was the American League's most valuable player in 1962. He hit 54 home runs in 1961 and played in 12 World Series, including the record of 18 home runs in one series. He retired in 1969.

MANUFACTURING IN THE CENTRAL WEST. Texas is far and away the leader of the West Central region in manufacturing and is second among the states in the country, producing value of shipments larger than the total of the other nine states of the Central West combined (1984):

Texas	$281,208,000,000
Oklahoma	46,462,000,000
Kansas	39,547,000,000
Nebraska	36,211,000,000
Colorado	34,143,000,000
Wyoming	17,793,000,000
New Mexico	15,394,000,000
Montana	8,954,000,000
North Dakota	7,787,000,000
South Dakota	5,886,000,000

MANZANO MOUNTAINS. Range in central New Mexico. Manzano Peak, 10,086 feet high, in western Torranco County is the highest point.

MARAIS DES CYGNES RIVER. Eastern Kansas and Missouri. Begins in southern Wabaunsee County, Kansas, and flows east and southeast to the OSAGE RIVER on the boundary between Vernon and Bates counties in Missouri. In Kansas, the river flows past OTTAWA and through the Marais des Cygnes Waterfowl Refuge.

MARBLE, Colorado. Village. Gunnison County, northwestern Colorado, southwest of Aspen and northwest of Gunnison. Marble is the home of the Outward Bound School. With the goal of instilling maturity and independence, the school annually trains and sends three hundred volunteers, most of them young people, into the wilderness to depend on their wits for survival and to undergo many stressful situations. Known for Colorado Yule marble, both pure white and veined in pale brown, the town gains its name from the marble quarried there. Marble from Marble, Colorado, has been used in the Lincoln Memorial, the Tomb of the Unknown Soldier, and municipal buildings in San Francisco and New York.

MARIAS RIVER. Montana river starting in Glacier County in northwestern Montana and flowing east and southeast into the MISSOURI RIVER which it meets in Chouteau County in central Montana.

MARISCAL CANYON. Brewster County, Texas, at the point where the RIO GRANDE RIVER winds around the Big Bend in BIG BEND NATIONAL PARK. Its walls tower 1,950 feet over the river bed. It is noted as one of the largest canyons and as the most hazardous river section in the area.

MARSHALL, Texas. Town (pop. 24,921), seat of Harrison County, in northeast Texas, named for Chief Justice John Marshall. During the CIVIL WAR the community served as the Confederate "capital" of the state of Missouri when the Missouri governor fled there in exile. Settled in 1838, Marshall was the site of the first Western Union Telegraph office in Texas (1854). Its primary industries today include petroleum, forestry products, chemicals, steel and tile. It is the home of East Baptist College (1917), and Wiley College (1873). Sixteen-hundred antique dolls are displayed at Franks Antique Doll Museum. T.C. Lindsey and Company, in operation since 1847, was the site of two Walt Disney movies.

MARTIN, Glen. (Macksburg, IA, Jan. 17, 1886—Baltimore, MD, Dec. 1955). Airplane manufacturer. Educated at Kansas Wesleyan University, Martin began to build gliders in 1907 and by 1908 was experimenting with pusher type airplanes. He taught himself to fly and built one of the first airplane factories in the United States in 1909 which, by the 1920s, helped promote WICHITA, Kansas, as the "air

capital of the world." Martin later produced the first American designed airplane for Liberty engines and constructed Martin bombers.

MARTINEZ, Maria Antonita. (San Ildefonso Pueblo, NM, Apr. 5, 1887—Santa Fe, NM, July 20, 1980). Potter. Known as the "Potter of SAN ILDEFONSO," Martinez was named Outstanding Indian Woman at the Indian Council Fire in Chicago in 1934, in addition to many other national and international awards which gained for her the reputation as the finest artist in her field. Her beautiful ware, mostly of her own "signature" black color, is known and cherished around the world.

MARYSVILLE, Kansas. Town (pop. 3,670). Seat of Marshall County, northeastern Kansas, northeast of CONCORDIA and north of MANHATTAN, named for Mary Marshall. Marysville has been the site of the largest covered railroad stockyards in the world. Marysville is also known as the "Black Squirrel City" as it is one of the few places in the nation in which the black squirrel is found in such numbers. The squirrels came to town in 1912 as part of a carnival and were allowed to escape their cages. The first post office in Kansas was originally used as a PONY EXPRESS station. The building now exhibits memorabilia from the Pony Express days.

MARYSVILLE, Montana. Montana's leading gold producing town in the 1880s and 1890s. The fortune of the community was based on the Drumlummon Mine, a rich strike of gold and silver that brought its finder, Thomas Cruse, $1,500,000 in cash and $1,000,000 in stock of the corporation a group of English capitalists established to develop the mine. Estimates of the amount of gold and silver taken from the mine between 1885 and 1895 range up to $20,000,000. The cyanide process of recovering gold and silver was used on the mine's tailings and yielded another $8,000,000.

MASON, Texas. City (pop. 2,153), seat of Mason County, in west central Texas. Named for the pre-Civil War army post Fort Mason, out of which settlement the town grew. Mason's economy today prospers from ranching and tourism.

MASSACRE CANYON, BATTLE OF. Nebraska battle in 1873 in which the SIOUX INDIANS almost managed to destroy the PAWNEE nation. On the 50th anniversary of the battle, in 1923, members of both tribes were finally willing to smoke the peace pipe as a sign of forgiveness of past events. Both tribes have made this an annual tradition and an occasion for pow-wow and smoking peace pipes.

MASTERS, Edgar Lee. (Garnett, KA, Aug. 23, 1869—Philadelphia, PA, Mar. 5, 1950. Poet and biographer. A graduate of Knox College, he was admitted to the bar in 1891, when he moved to Chicago. His rather slow law practice gave him time to produce poetry. Interestingly, he spent a brief time in practice with Clarence Darrow. His early poetic works gained little attention, but his *Spoon River Anthology* (1915) created a sensation in the American literary scene. As early as 1940, it had passed through 70 editions, with several foreign translations. But this fame had brought his legal career to an end, and he moved to New York City. His subsequent writing was never again as successful as the Spoon River work, although he and many critics felt that *Domesday Book* (1920) was his best later work. His debunking biography of Abraham Lincoln was very controversial. His autobiography, *Across Spoon River*, appeared in 1936.

MATAGORDA BAY. Inlet of the Gulf of Mexico, on the southern Texas coast. This bay, along with its sister, Lavaca Bay, was explored as early as 1685. The bay is protected by the Matagorda Peninsula. Matagorda was once a major access point until the hurricanes of 1874 and 1886 severely crippled its ports. Then its trade was shifted to CORPUS CHRISTI BAY.

MATAGORDA ISLAND, Texas. Island in Calhoun County, in the Gulf of Mexico. Actually just a long sandbar located south of MATAGORDA BAY, at the entrance of San Antonio Bay, it is important for fish and oyster production. A bombing and gunnery range is located here.

MATAGORDA, Texas. City (pop. 37,828), Matagorda County, southeast coast of Texas on the Gulf of Mexico and southwest of HOUSTON, named for Matagorda Bay, in turn for Spanish "thicket," or "rough place." Officially designated as a port of entry by the Mexican government, Matagordo, settled in 1825, was one of the old harbors of the Austin colony. Nearby, at Decro's Point, lived Samuel A. Maverick whose name, from the action of an employee failing to brand a herd of stock, has lived on as a synonym for unbranded cattle. A tourist center, with fishing and hunting areas,

its main industries today include petrochemical, plastics, fertilizer, and nuclear power plants.

MATCHLESS MINE. Source of the silver bonanza upon which H.A.W. TABOR built much of his fortune. Located near LEADVILLE, Colorado, the mine yielded up to $100,000 a month at its peak. In the Panic of 1893, Tabor lost his millions as the price of silver sank. On his deathbed, Tabor instructed his second wife, "Baby Doe" Tabor, to "hold on to the Matchless." She did for thirty-six years in the hope it would once again bring her fame and fortune. Her frozen body was found in a shack on the mine property in 1935.

MAXIMILLIAN JAY. One of the previously unknown creatures of the Central West region discovered in 1805 by LEWIS AND CLARK. This large bird was first noted at their La Hood, Montana, campsite. It is a larger bird than the common bluejay, "of more somber color," as described by Clark.

MAXWELL, Nebraska. Town (pop. 410), Lincoln County, west-central Nebraska, southeast of NORTH PLATTE and northwest of Lexington. Fort McPherson Military Cemetery, near Maxwell, contains the bodies of soldiers who had fought in the Indian wars, brought there from more than twenty military posts of the West.

MC ALESTER, Oklahoma. City (pop. 17,-255). Seat of Pittsburg County, southeastern Oklahoma, southwest of MUSKOGEE and southeast of Henryetta. Oklahoma's major coal fields are found in the region around McAlester. Coal has been mined there since 1870 when James J. McAlester, a trader, married an Indian girl. The marriage gave him full rights in the Choctaw nation. Indian courts rejected the claims of the Choctaw nation to McAlester's mining revenues. The city of McAlester began as a tent store, owned by McAlester, at the meeting of the Texas Road and the old California Trail, and was named for him. Today, the city of McAlester is the site of the state prison, well known for the annual prison rodeo.

MC ALLEN, Texas. City (pop. 67,042) Hi-

The Mc Clellan-Kerr Arkansas River Navigation System has made Tulsa an important inland port and placed many other regional cities on the waterway to the Gulf.

dalgo County, in southern Texas. Incorporated in 1911, McAllen is a port of entry and winter resort. Industries include packing and shipping of citrus fruits and vegetables, clothing, food processing, and petroleum products. McAllen is located seven miles from the International Bridge over the RIO GRANDE RIVER to Reynosa, Mexico. It was named for John McAllen whose ranch provided the site for the town, and it is the oil center for the lower RIO GRANDE Valley.

MC CAMEY, Texas. Town (pop. 2,436), Upton County, southwestern Texas, southeast of Monahans and northeast of Fort Stockton. McCamey is the annual host of the Rattlesnake Derby, an event begun in 1936. This widely publicized feature provides a prize for the fastest rattler in a race. Each year large crowds watch the competitors, such as Drain pipe, Slicker, Esmerelda and Wonder Boy, compete.

MC CLELLAN-KERR ARKANSAS RIVER NAVIGATION SYSTEM. Waterway stretching from Catoosa, a suburb of TULSA, Oklahoma, to the junction of the Mississippi and ARKANSAS rivers in Arkansas. The waterway, dedicated in 1971, is 440 miles long and contains seventeen locks. The completed system allows barges from the Mississippi River to reach such Oklahoma ports as Tulsa and MUSKOGEE. The system allowed Tulsa to become the busiest port in the state and broadened Oklahoma's industrial activity.

MC CONAUGHY, LAKE. Recreational area formed by the damming of the NORTH PLATTE RIVER as it flows through southwest Nebraska's Keith County. Lake Ogallala and Lake McConaughy State Recreation Areas are located on it.

MC COOK, Nebraska. City (pop. 8,404). Seat of Red Willow County, southwestern Nebraska, directly south of NORTH PLATTE, near the border with Kansas. Founded in 1882, it was originally called Fairview but renamed in honor of Civil War Union General Alexander McCook. The railroad boom of 1882 saw tremendous growth in the size of the community, and increased rail use resulted in doubling of the population in the 1920s. McCook was the home of Senator George William NORRIS (1861-1944), promoter of the Tennessee Valley Authority, co-author of the Norris-La Guardia Anti-Injunction Act and the Lame Duck amendment to the Federal Constitution in 1933. The Norris Home, the restored residence of the senator, is a popular tourist attraction. McCook annually celebrates Heritage Days in early May.

MC COY, Tim. Saginaw, MI, April 10, 1891—Nogales, AZ, Jan. 29, 1978). Actor. An opera singer until his voice failed, Mc Coy became the adjutant general of Wyoming in 1919 and an expert on Indian sign language, acquired during his life on the SHOSHONE reservation. He opened a dude ranch and later gained great success as star of western motion pictures including *Arizona Bound* (1941) and *War Paint* (1953).

MC LEAN-WALSH FAMILY. Thomas F. Walsh was a wealthy Colorado mine owner. His biography, *Father Struck It Rich*, written by his daughter Evelyn Walsh McLean, tells the story of early mining days and the wealth and power that followed. Mrs. Mc Lean was a leading society figure of her era and owner of the famed Hope Diamond which she willed to a museum on her death.

MC PHERSON, Kansas. City (pop. 11,753). Seat of McPherson County, central Kansas, northeast of HUTCHINSON and south of SALINA, named for Union Civil War hero, James Birdseye McPherson. McPherson is the home of McPherson College, independent liberal arts institution affiliated with the Church of the Brethren. The college was chartered in 1887. Student enrollment averages around five hundred students annually. The museum of the college displays the world's first man-made diamond.

MEADE, Kansas. Town (pop. 1,777). Seat of Meade County, southwestern Kansas, southwest of DODGE CITY and northeast of LIBERAL, named for Union CIVIL WAR General George Meade. Meade is the site of the world's largest volcanic ash mine. The ample supplies of water which account for the lush farms and profitable ranches of the region come from deep artesian wells. Tourists visit the DALTON GANG Hideout and Museum, displaying antique guns, furnishings of the 1887 period, and a tunnel which led to the barn and escape horses for the outlaws.

MEAGHER, Thomas Francis. (Waterford, Ireland, Aug. 3, 1823—Ft. Benton, MT, July 1, 1867). Soldier, Montana governor. A Civil War hero, he fought in the battles of Bull Run, Peninsular Campaign, Fredericksburg, and Chencellorsville, with the rank of brigadier general. He was appointed the territorial secretary of Montana in 1865 and served as the territorial governor from 1865 to 1866. On July

1, 1867, Meagher arrived at FORT BENTON to take a river steamer and was never seen again after entering his stateroom. His fate is unknown and remains one of the major mysteries surrounding the country's political leaders.

MEAL PAINTINGS. Sacred paintings made from grain of various colors which gave rise to the development among the NAVAJO of similar paintings for which colored sand was substituted. Originally the paintings were made along highly stylized lines and intended to bring about certain results, such as cures for illness. In more recent times they have in many cases become a form of art, although they still may be used for healing and other mystical purposes.

MEDICINE BOW MOUNTAINS. Range of the Rockies, south central Wyoming. The Medicine Bow Mountains extend north and south through Colorado and Wyoming. Highest peaks are Medicine Bow Peak, at 12,013 feet and Elk Mountain, 11,156 feet.

MEDICINE BOW, Wyoming. Village. (pop. 953), Carbon County, southeastern Wyoming, northwest of LARAMIE and northeast of RAWLINS. Near Medicine Bow is a petrified forest which covers 2,560 acres. The forest is believed to be fifty million years old and developed through the simplest type of petrifying process in which silica has replaced the trees' tissues.

MEDICINE LODGE, Kansas. Town (pop. 2,384). Seat of Barber County, far south-central Kansas, southwest of HUTCHINSON and west of WELLINGTON. Medicine Lodge draws its name from a small lodge, built by local Indians on the MEDICINE LODGE RIVER, a sanctuary where all could fast, rest and heal in absolute safety. The wooded valley of the river was thought to be protected by the Great Spirit. At this spot representatives of the APACHE, COMANCHE, KIOWA, ARAPAHO, and CHEYENNE nations chose to meet with representatives of the United States Government in October, 1867. Treaties were signed that ended three years of constant warfare, determined the southern boundary of Kansas, stated that lands south of the Kansas line were Indian Territory and opened western Kansas to settlement and railroad expansion. A pageant held every three years reenacts the signing of the agreements. Medicine Lodge is today a wheat and cattle shipping center. Nearby Gypsum Hills provide gypsum for industrial uses. The museum at the Carry NATION (1846-1911) home contains memorabilia of the "John

Brown of Prohibition" who made her first demonstration for temperance in Medicine Lodge in 1899. The road between Medicine Lodge and Coldwater is remembered for its "Cedar Lane," a forty-two mile stretch lined with beautiful cedar trees.

MEDICINE LODGE RIVER. Begins in Kiowa County, Kansas, southwest of GREENS-BURG, flows east past Belvidere and Sun City, turning gradually to the south, beginning at Sun City. It then flows past MEDICINE LODGE, turns directly south and passes out of Kansas near KIOWA. In Oklahoma it meets the Salt Fork of the ARKANSAS RIVER north and east of Ingersoll.

MEDICINE MEN. Every Indian tribe had at least one person believed to have gifts of healing and prophecy. They were thought to have magical powers to ascertain the locations of game, find missing people or missing objects and other ability beyond the scope of others. The rituals and objects associated with the various tribes varied widely.

The Sioux Yuwipis wrapped themselves in blankets like mummies to perform their healing. Others used rocks or other objects to divine the future and answer other questions. Divination and magic were particularly important in predicting the best days and hours for battle and for determining a successful outcome.

Not all healing was left to magic. Some medicine men had become expert in setting broken bones. The medicine men and women also often had a really remarkable knowledge of the healing properties of many plants and minerals. Some were applied to the body as poultices, and others given internally. Some stopped the loss of blood or even had the ability to bring about abortion, but only in the direst necessity, since children were highly valued. Modern medicine has begun to pay attention to many of these powerful natural cures, and several have been found to be effective. Others have been known and used by white physicians also.

Most attempts at healing were accompanied by dancing of the medicine man and sometimes others. Often fantastic costumes were used to drive away the evil spirits that had caused the illness. Artist George CATLIN (1796-1872) described a BLACKFOOT medicine man in his healing ritual as wearing "tails and tips of almost everything that swims, flies, or runs."

Women could also be healers, and almost every tribe had one or more midwives.

In the Southwest the medicine men directed many of the activities, such as the puberty rites. One of the most often used approaches to healing in the Southwest was the meal or sand painting. These intricate designs sometimes took several people an entire day to make. The design was chosen for its usefulness in a particular illness. When the design was finished, the invalid was brought to sit on the pattern, while its healing power was thought to be flowing into the body, after which the work was destroyed.

MEDICINE MOUNTAIN. In the BIG HORN MOUNTAINS, west of SHERIDAN, Wyoming. The mountain has special significance as the site of the mysterious MEDICINE WHEEL, a prehistoric relic likened by some to Stonehenge in England.

MEDICINE ROCKS. A grouping of sandstone buttes near Baker, Montana. The buttes, carved into caves, arches, spirals, and pyramids cover more than one square mile and tower as sharp peaks or ridges above low, sandy hills. The name for the rocks comes from the times when Indian medicine men circled among the spires in ritual dances. Several of the buttes once carried Indian inscriptions. Among the more recent names added was that of Theodore ROOSEVELT (1858-1919) who had a stock ranch a short distance away.

MEDICINE WHEEL. Mysterious formation of huge rocks laid in a circle having a circumference of 245 feet. Twenty-eight lines of stones radiate out from a center stone. Around the rim of the wheel stand six rock shelters now called medicine tepees. Scientists believe prehistoric medicine men may have huddled by these shelters during ancient rites. The appearance of the circle reminds scientists of another wheel found in the Gobi Desert. To some it even seems reminiscent of the circular shape of Stonehenge in England. The wheel was known to the Indians of the area who visited the site. Near Meeteetse a huge 58 foot long arrow made of stones with an arrowhead five feet across has been found. The arrow points to the Medicine Wheel across the BIG HORN BASIN.

MEDINA RIVER. Originating in the Edwards Plateau in south central Texas. It flows east-southeast approximately 170 miles to join the GUADELUPE RIVER at GONZALES. Lake Medina is created on its course. The river valley was the site of the Battle of Medina in 1813, when the Mexican army sought and captured a band of revolutionaries trying to seize power. Of the 1,700 revolutionary soldiers captured only about 90 escaped. The government soldiers ordered those remaining to dig their own mass grave before they were lined up and shot. The corpses were left in the makeshift shallow graves for more than nine years before the Mexican government dug up the remains and buried them properly with military honors.

MEDORA, North Dakota. Village (pop. 94), Billings County, southwestern North Dakota, west of DICKINSON and south of WILLISTON. In 1883 Medora was founded by the Marquis de MORES, a wealthy French noblemen. Mores envisioned revolutionizing the meatpacking industry by slaughtering beef near the range rather than shipping it east to slaughter houses. De Mores' venture failed, but his 26-room chateau, many of his personal effects and the remains of his packing plant still stand in the De Mores Historic Site. Many historic houses in Medora have been restored for modern use. The ranch established by Theodore ROOSEVELT (1858-1919) in 1883 is preserved in THEODORE ROOSEVELT NATIONAL PARK. Roosevelt may have been thinking of Medora's Rough Rider Hotel when he named his cavalry unit the "Rough Riders." Another famous resident of Medora was movie cowboy star Tom MIX (1880-1940).

MEIER, Josef. (Luenen, Germany—). Director and Producer. Meier played the role of Christ in the Passion Play of his hometown in Germany before fleeing from Hitler at the beginning of WORLD WAR II. Meier took the production to many American cities before coming to SPEARFISH, South Dakota, in 1939, where he was asked by Guy Bell to make the South Dakota city the permanent home of the play, giving Spearfish a notable tourist attraction. Meier has directed the cast of 250 players in Spearfish during the summer months and since 1952 in the Lake Wales, Florida, amphitheater during the winter.

MELLETTE, Arthur Calvin. (Henry County, IN, June 23, 1842—Pittsburg, KS, May 25, 1896). Former governor of South Dakota. Mellette, the last governor of the territory, was the first governor of the State of South Dakota. Mellette, an unselfish public official, turned over his complete fortune to repay losses caused by alleged dishonest acts of the state treasurer.

MELON DAY. Annual celebration in ROCKY FORD, Colorado, "Melon Capital of the World." As many as sixty tons of delicious watermelons and a wide variety of cantaloupes are served during the feast.

MENNINGER FOUNDATION CLINIC. Medical facility established in TOPEKA, Kansas, as part of the Menninger Foundation, a non-profit organization and one of the world's leading psychiatric centers. Established by Dr. Charles F. MENNINGER and two of his sons, Drs. William and Karl, in 1925. The clinic includes two psychiatric hospitals, a department of neurology, internal medicine and neuro-surgery and outpatient and aftercare programs.

MENNINGER FAMILY. Leading American psychiatrists. Dr. Charles Frederick Menninger and sons Drs. Karl and William Menninger founded the MENNINGER FOUNDATION AND CLINIC in TOPEKA, Kansas. Charles Frederick (1862-1953) led his sons in pioneering the treatment of physical disorders in a community clinic setting. Karl (Topeka, KS, 1893—) maintained an active medical practice, but devoted most of his time to the administration of the Menninger Clinic and its teaching and research programs.

Mesa Verde National Park preserves some of the finest prehistoric relics, including Square Tower House

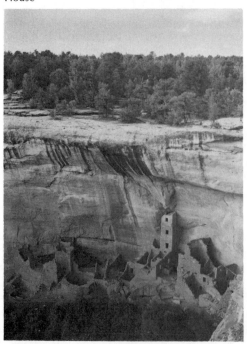

The Clinic changed its total emphasis to psychiatry in 1941. William (Topeka, KS, 1899—1966) was the foundation's general secretary and also served as chief consultant on psychiatry to the Surgeon General of the United States Army during WORLD WAR II. Among the writings of William are *Psychiatry in a Troubled World*, and *Psychiatry: Its Evolution and Present Status*.

MENNONITE BRETHREN OF NORTH AMERICA. Protestant religious organization with headquarters at HILLSBORO, Kansas. This branch of the multi-faceted Mennonite faith in the U.S. follows many of the general traditions of the sect, emphasizing plain ways of dressing, worshipping and living. Their creed is the Sermon on the Mount. Mennonites believe their religion forbids their holding offices that require the use of force, going to war, or swearing oaths. They view BETHEL COLLEGE at NEWTON, Kansas, as "the ultimate cultural achievement of their group."

MERCURY. A silver-colored metal which, unlike any other metal, is a liquid at room temperature. Central West Texas is a principal source. Mercury flows about so rapidly it is sometimes called *quicksilver*. Concern about its effect on man and the environment has lessened its use in agriculture and industry. Mercury was once used to prevent fungi growth in paint, paper and lumber. Shipbuilders used mercury in paint to keep plants and animals from growing on the hulls of ships. Since 1972 the federal government has halted the use of mercury compounds in most cases, bringing about wide changes as various substitute measures were developed.

MESA COUNTRY. *Mesa*, a Spanish term meaning "table" describes many flat-topped land forms in the Central West which were once part of larger plateaus that were gradually worn away partially by erosion. "Mesa Country" refers to a broad area of Colorado west of the mountains. Roan Plateau is one of the largest and loneliest areas of this region. Uncompahgre Plateau is nearly as isolated. Canyons carved into the region include Vermillion and the eerie BLACK CANYON OF THE GUNNISON. Well-known mesas include MESA VERDE in Colorado and Mesa Encantada, or the Enchanted Mesa, in New Mexico.

MESA VERDE NATIONAL PARK. This extraordinary prehistoric remains was desig-

nated a World Heritage Site on September 6, 1978. Experts consider these pre-Columbian cliff dwellings and other works of early man to be the most notable and best preserved in the United States. The park was established in 1906. Spruce Tree House with its 110 rooms is considered to be the best preserved of all the ruins. It also includes eight ceremonial rooms known as kivas. Another well preserved ruin is Square Tower House. The largest structure of the park is CLIFF PALACE with 400 rooms, where brightly painted pictographs can be seen. There are many other attractions. Perhaps most spectacular of all is the location of these structures, clinging to the sides of the cliff.

MESCALERO APACHE INDIANS. Apache tribe located in southern New Mexico, western Texas, and northern Mexico in the early 19th century. Their name came from the Spanish who noticed the Indians' custom of making a nutritious food called mescal from the base of the agave plant. The Mescalero lived in buffalo hide tipis, but sometimes constructed wickiups of poles and thatch or brush. The coming of horses made buffalo hunting easier, and communal hunts were held in late fall and into the winter. The smallest political unit was the gata, or extended family. Mescalero couples usually lived with the family of the bride, although it was taboo for a man to speak to his mother-in-law. It is believed the Mescalero and other APACHE groups came from the north into the southwest in about 1200 AD. By the 17th century the Mescalero were raiding Spanish settlements in New Mexico. Around 1727, under pressure from the neighboring tribes of the COMANCHE and UTE who had firearms, the Mescalero were forced to abandon their buffalo hunting north of the ARKANSAS RIVER. The Mescalero made peace with the Spanish and served as scouts for their military. In 1825 the Indians moved north and began raiding New Mexico settlements, but they made peace with the United States in 1852. In 1873 the Mescalero Reservation in southern New Mexico was established. In the late 1870s many Mescalero joined the CHIRICAHUA APACHE in their wars against the United States and many became prisoners of war until their release in 1913. In the late 1970s about 2,500 Mescalero, Chiricahua and Lipan Apache lived on the 460,000-acre reservation. The economy of the reservation benefits from lumbering, cattle-raising and tourism.

MESILLA, New Mexico. Town (pop. 2,029), Donaana County, southwestern New Mexico. Just south of LAS CRUCES, founded by the Spanish in 1598. Excellent farmland attracted many settlers. Today the largest pecan orchard in the world is located in the area. By 1858, when the Butterfield Trail Overland mail route arrived, Mesilla was the largest town in southern New Mexico Territory which then included the state of Arizona. During the CIVIL WAR, Colonel John Baylor declared Mesilla the capital of a Confederate territory which stretched from Texas to California. The hope of a coast-to-coast Confederacy died in August, 1862, with the arrival of the Union's "California Column." Mesilla began a decline in 1881 when its residents failed to attract the Southern Pacific Railroad. Widespread attention focused on Mesilla during the April, 1881, murder trial of Billy the Kid who was accused of killing William Brady, the Lincoln County sheriff. Billy was found guilty and was sentenced to be hanged.

MESQUITE, Texas. Town (pop. 67,053), Dallas County, in northeast Texas, named for a creek, which was named for the plant. Mesquite was established in 1872 as a stop on the Texas and Pacific Railroad. From 1950 to 1970, the town grew rapidly. A residential suburb of DALLAS with some light manufacturing, it is the home of Eastfield College.

MESSIAH FESTIVAL, Lindsborg, Kansas. Annual event held during Easter Week in Presser Auditorium on the BETHANY COLLEGE campus. Dr. Carl Swensson and his wife began the tradition in 1881 when they started to train local residents to sing Handel's "Messiah." In 1882 the first performance took place, with an orchestra provided by the Swedish colony in Rock Island, Illinois. The chorus has developed into the Bethany Oratorio Society, one of the oldest continuously active such societies in the United States. In addition to the central performance, the event has expanded to cover eight days of cultural events and has a widespread following.

MESSIAH WAR. Militant action of some eastern and most of the western tribes by a movement begun about 1880 by followers of WOVOKA (1858-1932), "Jack Wilson," an Indian mystic of Nevada, whose teachings of submission, love and brotherhood were twisted into aggression by the general Indian feelings of bitterness and impotence. Whipped into delusions of immortality by medicine men such as

The annual Messiah Festival has made tiny Lindsborg, Kansas, world renowned.

Yellow Bird, Indians donned ghost shirts which were supposed to make them invulnerable to bullets. The Messiah War was brought to a decisive and brutal end by the massacre at WOUNDED KNEE, South Dakota, December 29, 1890.

METEOR CRATER. Vast depression in the earth, with a surface area of ten acres, near ODESSA, Texas. One of the largest of its type, where a nickel and iron meteor weighing an estimated 625 tons crashed to earth about 20,000 years ago.

MEXICAN WAR. The U.S. acceptance of Texas as a state on December 29, 1845, was one of Mexico's principal complaints with the U.S., but U.S. ambition to take over California precipitated the war. With the failure in early 1846 of negotiations to buy California and portions of New Mexico claimed by Texas, the U.S. decided on war. In the southwest portion of the action, U.S. troops advanced to the SABINE RIVER, then on to the RIO GRANDE, which the U.S. had claimed as a boundary. When Mexican forces crossed the Rio Grande on April 25, 1846, the two armies clashed, and actual hostilities had begun. Calling these actions aggression on American soil, President James K. Polk requested a declaration of war on May 13, 1846. The Mexicans retreated across the Rio Grande. American General Zachary Taylor followed them, and the war action shifted elsewhere. In New Mexico General Stephen W. KEARNY (1794-1848), with the help of volunteers of Alexander DONIPHAN (1808-1887), captured SANTA FE in August. Taylor left Doniphan in charge. After receiving reinforcements, Doniphan moved operations to capture EL PASO in December and moved on into Mexico. No other engagements of the war were fought in the Central West region.

MIDLAND, Texas. City (pop. 69,844), seat of Midland County, located midway between DALLAS and EL PASO in the western part of the state. Midland is a center of Permian Basin oil administration, agriculture (livestock, cotton), and industry (aircraft, steel, dairy processing, plastics, chemicals, and clothing). The city

developed in 1881 as a cattle-shipping center, and its greatest growth began with the discovery of oil in 1923. Now known as "Tall City" for the office buildings which tower over the surrounding flatlands, Midland is the administrative center for one-fourth of U.S. crude oil, liquid gas, and natural gas production.

MIDWEST CITY, Oklahoma. City (pop. 49,-559). A suburban residential community, directly east of OKLAHOMA CITY. With the establishment of Tinker Air Force Base, on the city's southern border in 1942, Midwest City began a period of substantial growth. Much of the progress of the city has been based on the proximity of that government logistics center.

MIDWEST, Wyoming. Town (pop. 638), Natrona County, northeastern Wyoming, north of CASPER and southeast of BUFFALO, founded by the Midwest Oil Company and once the center of the billion-dollar Salt Creek Oil Field. Midwest is the nearest town to Teapot Rock, a famous sandstone formation resembling, perhaps, a disfigured human hand rather than a teapot, and providing the common designation of a federal problem known as the TEAPOT DOME SCANDAL.

MILBANK, South Dakota. Town (pop. 4,-120). Seat of Grant County, northeastern South Dakota, northeast of WATERTOWN and southeast of ABERDEEN. In the heart of the productive Whetstone Valley, it is a center of grain and cattle production. It was named for railway official Jeremiah Milbank. It is the site of the world's largest mahogany granite quarry, and quarrying is the principal industry. The old English gristmill is a local attraction.

MILES CITY, Montana. City (pop. 9,602). Seat of Custer County, southeastern Montana, southwest of GLENDIVE, on the YELLOWSTONE RIVER near its junction with the TONGUE RIVER. In 1881 the first transcontinental railroad tracks crossed into Montana and reached Miles City before the coming of winter. The city was named for General Nelson A. MILES (1839-1925), who arrived in August of 1876 to force the SIOUX and CHEYENNE to return to the reservation. Under the direction of Miles, Fort Keogh was constructed there in 1877 and used as a base for troops engaged in the Indian wars. Frontier days in Miles City were rough and tumble. Evidence suggests that Butch Cassidy and the Sundance Kid may have met here to start their outlaw practices. Modern Miles City's Live-

stock Auction Saleyards processes about a fourth of all Montana livestock. The city claims the largest railroad shops between the Twin Cities and the Pacific Coast. The unique Bucking Horse Sale stemmed from the Miles City Roundup and is held annually.

MILES, Nelson A. (Westminister, MA, Aug. 8, 1839—Washington, DC, May 15, 1925). Military officer. Miles, led American troops in the Battle of BEAR'S PAW, August 8, 1877, the last large-scale Indian fighting in Montana. In the battle, Miles defeated the Nez Perce under the brilliant leadership of Chief Joseph, by cutting off their historic retreat only forty miles from their goal, the Canadian border. Miles was also in command of troops who defeated SITTING BULL (1830?-1890) at the Tongue River's mouth and at Cedar Creek. Miles defeated CRAZY HORSE (1842?-1877) near Birney, Montana. In 1890 Miles commanded the largest concentration of troops to be assembled anywhere in the United States between the CIVIL WAR and the SPANISH-AMERICAN WAR when the Army confronted the Ghost Dance participants at South Dakota's Pine Ridge and Rosebud Reservations. His decision to incarcerate the most conspicious agitators among the Indians led to the death of Sitting Bull on December 15 and precipitated events which led two weeks later to the tragic Battle of WOUNDED KNEE in South Dakota.

MILITARY LEADERS. Of the varied military leaders associated with the Central West region, only two were natives of the region. Both were born in Texas. Admiral Chester NIMITZ (1885-1966) of WORLD WAR II fame of FREDRICKS-BURG and Dwight D. EISENHOWER (1890-1969) of DENISON. As the leader of all Allied forces in Europe, Eisenhower became probably one of the most famed and successful military leaders of all time. He received more of the world's highest military honors than any other. The man most associated with Texas, spent most of his life as a politician, but when Samuel HOUSTON (1793-1863) became a general he was a victor in one of the major battles of world history in the defeat of Mexican dictator Santa Ana. Then he went on to become the president of Texas. Another quite different leader who also was not primarily a military man, Theodore ROOSEVELT (1858-1919), credited his years in North Dakota with much of his later success. He gained his early fame by leading the renowned charge up San Juan Hill in the SPANISH AMERICAN WAR. By contrast, George Armstrong CUSTER (1839-1876) was a military man

throughout his life. His spectacular operations in the CIVIL WAR won him promotion as the nation's youngest general. His successes in fighting the Indians of the West seemed to be carrying on that tradition for him until his dramatic defeat at the Battle of LITTLE BIGHORN (June 25, 1776) and subsequent reevaluation of his career. A still further contrast is afforded by General Lew WALLACE (1827-1905) who had a mixed career as a Civil War leader but enjoyed an assignment to SANTA FE, New Mexico, where he finished the famous novel *Ben Hur*. Some of the most brilliant military leaders of their day, heroes of their own people for tremendous fights against even greater, odds were the war leaders of the various Indian tribes, including such brilliant strategists as CRAZY HORSE (1842?-1877) and RED CLOUD (1822-1909), as well as the medicine man SITTING BULL (1830?-1890).

MILK RIVER. Northern Montana, starting in Glacier County in northwestern Montana and flowing northeast across the Canadian border and east across southern Alberta. The river turns southeast and flows back across the Montana border and then eastward across northern Montana into the MISSOURI RIVER in Valley County, Montana.

"MILLION DOLLAR HIGHWAY." Name often applied to all of US 550 south from OURAY to SILVERTON, Colorado. In reality the name should only apply to the six-mile section that follows the roadbed of Otto Mear's toll road. The mine tailings used to build the road were later found to be gold-bearing, thus giving the road its name. Those who have driven the highway claim the name should be given the road for the spectacular views it affords the travelers.

MINDEN, Nebraska. Town (pop. 2,939). Seat of Kearney County, south-central Nebraska, southeast of KEARNEY and west of HASTINGS, founded in 1878 and named for Minden, Germany. At Minden is one of the most extensive historical centers of its type, Pioneer Village. The center is built around the theme "How America Grew." Its twenty-four buildings display more than fifty thousand items from Nebraska's pioneer past since 1830, including antique autos, farm tractors, and horse-drawn vehicles. Among the buildings are an original Pony Express station, a railway depot which served between 1872 and 1882 as the western terminus for the Burlington Railroad, and a 19th century general store.

MINE CREEK, BATTLE OF. Fought on October 25, 1864, the engagement, involving twenty-five thousand men, resulted in a Union victory which ended threats of a Confederate invasion of Kansas during the CIVIL WAR.

MINERAL WELLS, Texas. Town (pop. 14,-468). Seat of Palo Pinto County, in north central Texas, west of FORT WORTH. In 1885 the Crazy Well was discovered here, and its waters were claimed to have medicinal powers. By 1920 Mineral Wells was a flourishing health resort. It is a substantial center of manufacture, including clay pipes, plastic products, and aircraft equipment. Lakes and streams surround the area, providing substantial outdoor recreation. The Crazy Water Festival is held the third weekend in May.

MINING AND MINERALS. Despite the fact that the Central West as a whole is one of the great mineral producing areas of the world, Texas still far and away leads all the rest in value of mineral products and is the U.S. mineral leader as well. With nearly 55 billion dollars of annual mineral revenue, Texas produces over one and a half times more mineral revenue than all the other Central West states together. Although gold historically has been the most exciting of the minerals, the famed gold states of Montana, Colorado and South Dakota rank far down the list in total value of mineral products. In order of rank the Central West states are (1984):

Texas	$54,453,000,000
Oklahoma	13,274,000,000
New Mexico	7,127,000,000
Wyoming	6,859,000,000
Kansas	3,196,000,000
Colorado	3,098,000,000
North Dakota	1,999,000,000
Montana	1,695,000,000
Nebraska	246,000,000
South Dakota	116,000,000
Total	$92,063,000,000

MINOT, North Dakota. City (pop. 32,843). Seat of Ward County, north central North Dakota, on the SOURIS RIVER, it was named for railroad executive Henry D. Minot. The rapid growth of Minot from its founding in 1886 to a dynamic community and hub of a region extending into Canada, has given Minot the nickname of "Magic City." Today it benefits from the great harvests surrounding it, from the lignite reserves, from oil pools discovered in 1951, from the railroad yards and from nearby

Mineral wealth can still be sought by individual miners, but mining today is only practical with heavy equipment supplied by ample capital.

Minot Airforce Base. Early settlers found the waters of the river rich in fish. In the winter the fish rose to any holes cut in the ice, in such numbers they were easily speared with pitchforks. Fish were stacked, like cordwood, next to many of these ice-fishing spots. The earliest economic boom came from the huge piles of buffalo bones which were collected on the prairie and brought to Minot for shipment east where they were used in fertilizer. The city is the home of Minot State College. Minot celebrates with the North Dakota State Fair, which is held here for nine days in July. Thousands come to Norsk Hostfest, a festival of Scandinavian culture, in mid-October. Pastaville, USA is a mid-November celebration honoring the combination of noodle and North Dakota farmers.

MINT, UNITED STATES. The DENVER, Colorado, mint was originally a private business operated by Clark, Gruber and Company which coined $5, $10, and $20 gold pieces beginning in 1860. Purchased by the Federal Government in 1863, the Denver Mint began federal operations in 1869 and originally limited itself to melting, refining, assaying and stamping bullion. Coin-

age was begun in 1906. The last gold coins made at the mint were produced in 1931. A bold and well-planned robbery of the mint was carried out on December 18, 1922, when a sedan pulled alongside a Federal Reserve truck being loaded with $200,000 in five dollar bank notes. Three bandits opened fire, seized the currency and sped away. One of the bandits was later found dead in the bullet-riddled getaway car, but the money was not found.

MISSION, Texas. Town (pop. 22,589), Hidalgo County, in the far southern tip of Texas, near MC ALLEN. Founded in 1908, it was named for La Lomita Mission, three miles south of the town. Mission was the winter home of William Jennings BRYAN (1860-1925) for two years. By 1930 the town had become the center for the Texas citrus industry. Today, agribusiness and tourism are the two main industries. La Lomita Mission has been carefully restored. Tourists are interested in Los Ebanos International Ferry on the RIO GRANDE RIVER, to the south. It is the only hand-drawn ferry crossing the border. Texas Citrus Fiesta and American Poinsettia Society Flower Show are annual attractions.

MISSOULA, Montana. City (pop. 33,-388).Seat of Missoula County, west central Montana, south of KALISPELL and northwest of ANACONDA. Located at the mouth of Hell Gate Canyon, Missoula's name is derived from a Salish Indian word meaning "near the chilling waters" which probably refers to the meeting of Clark's Fork River with Rattlesnake Creek within the city. Missoula developed as a stopover for the 1860s gold miners who traveled the Mullan Road. However, it had been a trading center from the days of the LEWIS AND CLARK EXPEDITION (1804-1806). Mills and stores, built to supply the hundreds of miners needed lumber, and one of the first lumber mills in the area developed there. Still a major industry, the region's timber has caused the United States Forest Service to establish its Region No. 1 headquarters and Smokejumpers' training center in Missoula. Papermaking is an important industry. The city also is the home of the University of MONTANA with its 22,000-acre experimental forest and its wildlife and conservation research stations. Famous residents of Missoula have included Jeannette RANKIN (1880-1973), the first woman elected to the United States House of Representatives. Missoula was the site of the 1967 Winter Olympic trials, and saw the construction of the first luge run built in the United States near Lolo Hot Springs. The Aerial Fire Depot offers displays about the Smokejumpers and other firefighting activities of the region. Nearby Fort Missoula features a museum. Events celebrated annually include the Montana State Expo Winter Star Festival in February and the five-day Western Montana Fair in August.

MISSOURI ESCARPMENT. Region in western North Dakota rising three hundred to five hundred feet above the Drift Plains which lie to the east of the PEMBINA or Manitoba Escarpment, west of the RED RIVER Valley.

MISSOURI INDIANS. Siouan tribe who lived near the junction of the GRAND and MISSOURI rivers. The Missouri called themselves Niutachi, or "people of the river mouth." In early times the Missouri lived with the OTO, IOWAY, and Winnebago tribes near the Great Lakes. The tribes migrated, with the Oto and Missouri staying together until they reached the Grand and Missouri rivers where legend says the tribes split after the son of the Oto chief ran off with the daughter of the Missouri chief. By 1693 the Missouri began trading with the French. For the next century this trade continued despite great suffering caused by attacks from neighboring tribes. In 1730 after nearly three hundred of their tribe were killed in an attack by the Sauk, the Missouri moved across the Grand River to live near the OSAGE. In 1798 the Missouri were nearly wiped out when the Fox ambushed their canoes on the Missouri River. The survivors fled to live with the Oto, although they kept their own chief. The two tribes battled epidemics of cholera and attacks of neighboring Indians. By treaties of 1830, 1833, 1836 and 1854 the Oto-Missouri ceded all their lands and moved to a reservation on the BIG BLUE RIVER between Kansas and Nebraska. Intra-tribal conflict around 1880 split the tribes. The Coyote, or traditional faction, moved to Oklahoma. The other faction, the Quakers, ceded their lands for a reservation near Red Rock in north central Oklahoma. In 1907 the lands were allotted to individual tribal members. In 1955 the United States Supreme Court upheld an award of one million dollars to the Oto-Missouri in repayment of illegal land agreements. This money was divided among the two thousand members on the tribal rolls.

MISSOURI NATIONAL RECREATIONAL RIVER. One of the last free-flowing stretches of the Missouri, this reach from Gavins Point Dam, near YANKTON, South Dakota, to Ponca, Nebraska, still exhibits the river's dynamic character in its islands, bars, chutes and snags. In all respects, the "Big Muddy" lives up to its name. The U.S. Army Corps of Engineers, Omaha District, manages the river through a cooperative agreement with the National Park Service. Headquartered OMAHA, Nebraska.

MISSOURI PLATEAU. Region in North Dakota beginning at the MISSOURI ESCARPMENT and crossing the state from northwest to southeast, with hilly land mainly useful for grazing cattle but harboring mineral deposits. Beneath the irregular and rolling surface of the plateau are vast deposits of bentonite and lignite. The plateau also holds one of the most unusual features in the state—the Badlands of the Little Missouri. Buttes and mesas, characterizing the landscape, increase in number and size toward the southwest corner of the state. Black Butte, lying in this area, at 3,468 feet, is the highest point in North Dakota. The area is marked with many small lakes, which attract thousand of migrating ducks annually.

MISSOURI RIVER. With a length of 2,533 miles, the Missouri is the longest river on the

The Missouri River, longest on the continent, has brought water transport to the far reaches of the Central West. A replica of the *Sgt. Floyd* plies the waters as a reminder of the days when steamboats reigned.

North American continent. It rises in southwest Montana and flows southeast to Saint Louis Missouri. Because its drainage area is nearly three times that of the Mississippi River and because the Mississippi appears to flow into the Missouri, opinions have been expressed that the Mississippi should be considered the tributary and the entire course from Montana to the Gulf of Mexico should be called the Missouri.

However, officially the Missouri is a tributary of the Mississippi. Perhaps the principal reason for this ranking is that it is only eighth among U.S. rivers in the volume of water it carries. The extent of its watershed (529,400 square miles) is only slightly less than the total watershed of the Mississippi and the rest of its tributaries. An important source of transportation to the Indians, the Missouri was opened to settlement beginning with the LEWIS AND CLARK EXPEDITION in 1804. It then soon became and has remained one of the principal commercial water routes of the continent.

The long sought source of the Missouri was determined by Lewis and Clark to be at the junction of the JEFFERSON, MADISON and GALLATIN rivers, near present THREE FORKS, Montana. Beginning its flow at 8,000 foot elevation, it flows north past Lombard, Toston and Townsend to enter Ferry Lake, Hauser Lake and Lake Helena. After HELENA, Montana, it turns northeast at Craig, winds its way across northern Montana, forming the Fort Peck Reservoir, then Lake SAKAKAWEA, turning south past BISMARCK, North Dakota, then into Lake OAHE, past PIERRE, South Dakota, through several more artificial lakes.

Then the Missouri forms the borders between South Dakota and Nebraska and Nebraska and Iowa, passing Sioux City, Iowa, OMAHA, NEBRASKA CITY, and LEAVENWORTH, Kansas. Turning east at KANSAS CITY, it crosses Missouri and enters the Mississippi above St. Louis.

The flow of the river is at a low in the winter and high in April through June. Average flow at the mouth is 64,000 cubic feet per second. Its greatest recorded flow was 900,000 feet per second and the least was 4,200 cubic feet.

The lower portion of the river was discovered

by Marquette and Jolliet in 1764, but it was not completely traversed until Lewis and Clark in 1804-05. The first steamboat passed up part way in 1819, and steamboats multiplied, reaching the farthest port of FORT BENTON. Steamboats were replaced by tugs and barges, which carry on substantial trade up the river.

MISSOURI RIVER BASIN PROJECT. A hydroelectric plan developed in 1944 in response to the federal Flood Control Act. This plan, set fourth by the United States Army Corps of Engineers and the Bureau of Reclamation, provided for the coordinated development and flood control of the Missouri River and its surrounding region. Besides the state of Missouri, the plan also incorporated lands in the states of Colorado, Iowa, Kansas, Minnesota, Montana, Nebraska, North Dakota, South Dakota, and Wyoming, for a total project irrigation area of nearly four million acres. The project is under control of seven federal agencies as well as the governors of the ten states involved. The purpose is to control flooding, improve navigation, and develop hydroelectric power sources along the river.

MISSOURI RIVER WILD AND SCENIC RIVER SYSTEM. A spectacular Montana valley with striking rock formations and diverse flora and fauna, this river corridor also includes numerous historical and archeological sites. Headquartered BILLINGS, Montana.

MISTLETOE. The state flower of Oklahoma bears the common name of the parasitic herb of the Loranthacea family. Oklahoma lawmakers were the first in the country to select an official flower, even before Oklahoma became a state. Mistletoe attaches itself to the host tree by means of haustoria, a kind of modified root. The mistletoe has long been associated with healing powers.

MITCHELL, South Dakota. City (pop. 13,-916). Seat of Davison County, southeastern South Dakota, in the JAMES RIVER valley between SIOUX FALLS and CHAMBERLAIN. Founded in 1879, it was named for railroad executive Alexander Mitchell. In 1903 the community attempted to be named the state capital, in opposition to PIERRE. The Milwaukee Railroad helped Mitchell in its bid by carrying almost 100,000 people on free passes to visit the city, but in the election of 1904 Mitchell lost to Pierre. Mitchell is the home of DAKOTA WESLEYAN UNIVERSITY , one of the state's outstanding private colleges.

Mitchell's internationally known CORN PALACE continues to be the principal visitors' attraction. Each year thousands of bushels of various shapes and shades of grain and grasses are used to redecorate the building's exterior. Decorative interior panels have been designed by Oscar Howe. The Enchanted World Doll Museum of Mitchell is internationally recognized as one of the world's finest collections of its type. Nearly 400 scenes, a unique feature of this museum, are used to display the museum's more than 5,000 dolls. The museum is itself housed in a 9,000 square foot castle complete with turrets, stone walls, drawbridge and stained glass windows. Friends of the Middle Border Museum is a seven-building complex featuring the early life of the region.

MIX, Tom. (Driftwood, PA, 1880—Florence, AZ, Oct. 12, 1940). Famous American motion-picture cowboy. After service in the Spanish American War in 1898, he stayed in the army until 1904, then was reported to have worked in China. He became a cowboy in Oklahoma in 1906. His cowboy skills almost immediately involved him in wild west shows, and he attracted the attention of movie makers. Mix entered movies in 1910 with an easygoing manner and expert horsemanship which made him a Hollywood star. He lived for a time at MEDORA, North Dakota, where he married Olive M. Stokes. During the 1920s he was the leading box office draw of the decade. He appeared in more than 100 films, leaving pictures in 1928 with the advent of sound. For another ten years he toured with his own wild west show, then retired. He lived lavishly after his retirement, and died as a result of an automobile accident in Arizona. The Tom Mix Museum, containing his elaborate costumes, hats, guns and saddles, is located in Dewey, Oklahoma.

MOBRIDGE, South Dakota. Town (pop. 4,174), Corson County, north-central South Dakota, near the North Dakota border. Its name is a combination form of Missouri and bridge, for the Milwaukee Railroad bridge over the MISSOURI RIVER there. The original banks of the Missouri and the GRAND RIVER have been covered by vast OAHE RESERVOIR, which lies both south and east of the town. Mobridge was founded in 1906 on the site of Sioux and Arikara Indian villages. The area still has a substantial Indian population. Today it is a farm, ranch and recreational center. The historic CONQUEROR'S STONES were found nearby and are now displayed in the community. On a high

rise above the Missouri River is the grave and monument of SITTING BULL (1830?-1890), the famous SIOUX INDIAN leader. Sitting Bull was killed by Indian police and his body was buried at Fort Yates, North Dakota, before being moved there in 1953.

MOCKING BIRD. Official bird of Texas, famous for its vocal powers. Its family, Mimidae, is exclusive to North America, and it is more properly called a mimic thrush. Perched high and exposed, the mockingbird will sing not only its own happy song but also can mimic the calls of most birds, ringing out a phrase as many as thirty times in a row.

MOFFAT TUNNEL. On the Denver and Rio Grande Western Railway, completed on July 7, 1927, at a cost of eighteen million dollars. It shortened the rail distance between DENVER and Salt Lake City by 176 miles. The success of the tunnel was due to Denver banker David Moffat who found that a railroad he purchased which ran over the mountains was hindered during the winter by heavy snows in the high passes. In his determination to build a tunnel and eliminate this obstacle to transportation Moffat went bankrupt, but his ideas were carried out by others.

MOLYBDENUM. Vital mineral used in the hardening of steel. Colorado has two-thirds of the known world's reserve. Said to be the largest underground mine, the Climax Molybdenum Mine, is located in Lake County. This one mining operation produces three-fifths of the free world's supply of the mineral.

MONTANA. State, fourth largest in the union, a northern border state, situated about 400 miles from the Pacific Ocean. The Montana border with Canada to the north is the longest of any U.S. state with that northern neighbor. Bordering on the east are North and South Dakota, on the south, Wyoming; while the entire western and southwestern border is occupied by Idaho.

There are no river boundaries. All the boundaries are manmade except for the northwest-southwest border, which begins to follow the crest of the BITTERROOT MOUNTAINS west of the town of Noxon. To the south at Chief Joseph Pass, the border is taken over by the CONTINENTAL DIVIDE, which winds and twists along the crest of the mountains until it reaches the border with Wyoming near that state's northwest corner.

Montana is the only state where three divides form watersheds which send the rivers south to the Atlantic by way of the Gulf of Mexico, also to the Atlantic even more circuitously by way of Hudson Bay, and to the Pacific through the enormous Columbia River system. The flow north to the bay originates on the divide in a small portion of GLACIER NATIONAL PARK at Waterton Lake. The main continental divide enters Montana at the center of the northern border of Glacier National Park and follows a tortuous course southward past HELENA on the west, then almost touching BUTTE, until it turns northwest for a short distance, then southwest until it forms the Montana-Idaho border. Along the eastern slope of the Continental Divide, all waters of the continent flow to the Atlantic and all on the west to the Pacific. Perhaps unique is the fact that a freak loop of the divide near the Yellowstone boundary sends the eastbound waters first toward the west and the westbound first toward the east, before they finally reverse their directions.

Just to the east of the great divide the nation's most majestic river system, the MISSOURI-Mississippi, rises in the mountains of southwest Montana, with the waters eventually reaching the Mississippi and the Gulf of Mexico. The BIG HOLE RIVER begins its flow on the eastern slopes of the Bitterroot Range, joins the Beaverhead at Twin Bridges, then unites with the JEFFERSON RIVER, which joins the MADISON and GALLATIN rivers at THREE FORKS to form the mighty Missouri River, which flows north and then east, gathering strength from the Smith and Marais tributaries. From the south, the Judith and Mussellshell rivers increase the Missouri flow as it swells into Fort Peck Reservoir, created by giant Fort Peck Dam, once the largest earthfill dam in the world. The great river continues its eastward course past the eastern Montana border near Sidney, joined by the YELLOWSTONE RIVER just east of the border with North Dakota.

The Yellowstone crosses the Montana-YELLOWSTONE NATIONAL PARK border at GARDINER , flows northeast to Big Timber, from which, as it flows east, the only tributary streams join from the south. These include the CLARK FORK, BIG HORN, TONGUE and POWDER rivers.

West of the divide the rivers all join eventually to flow into the Columbia River system to the Pacific. The western CLARK FORK is the major stream flowing in that direction. It picks up the FLATHEAD RIVER before crossing the Montana border to flow into Pend Oreille Lake in Idaho. The KOOTENAI flows south from British Colum-

Montana

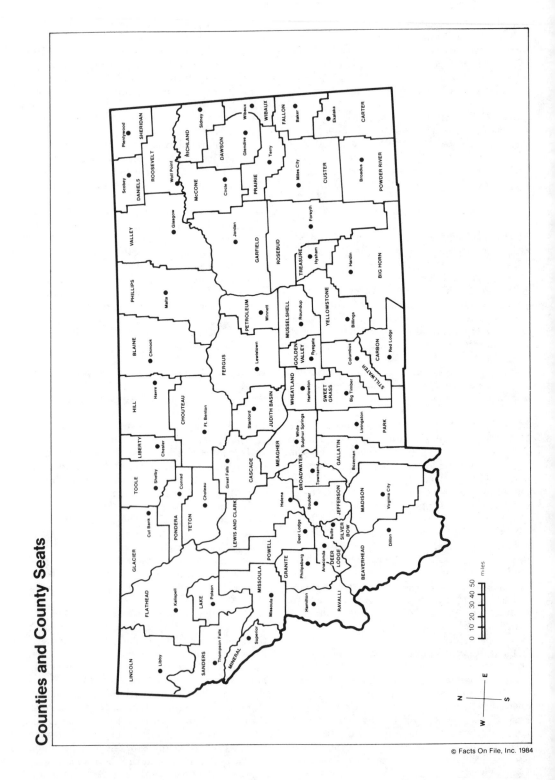

Counties and County Seats

© Facts On File, Inc. 1984

STATE OF MONTANA

Capital: Helena, settled 1864

Name: From the latin Mantana meaning "mountainous regions."

Nickname: Treasure State

Motto: Oro y Plata (Gold and Silver)

Symbols and Emblems:
Bird: Western Meadowlark
Flower: Bitterroot
Tree: Ponderosa Pine
Stones: Sapphire & Agate
Song: "Montana"

Population:
1985: 826,000
Rank: 44th
Gain or Loss (1970-80): +93,000
Projection (1980-2000): +176,000
Density: 6 per sq. mi.
Percent urban: 52.9% (1980)

Racial Makeup (1980):
White: 94%
Black: 1,786 persons
Hispanic: 9,974 persons
Indian: 37,300 persons
Others: 7,600 persons

Largest City:
Billings (66,842-1980)

Other Cities:
Great Falls (56,725-1980)
Butte (37,205-1980)
Missoula (33,388-1980)
Helena (23,938-1980)

Area: 147,046 sq. mi.
Rank: 4th

Highest Point: 12,799 ft. (Granite Peak)

Lowest Point: 1,800 ft. (Kootenal River)

H.S. Completed: 74.4%

Four Yrs. College Completed: 17.5%

STATE GOVERNMENT

Elected Officials (4 year terms, expiring Jan. 1989):
Governor: $50,452 (1886)
Lt. Gov.: $36,141 (1986)
Sec. of State: $33,342 (1986)

General Assembly:
Meetings: Odd years in Helena
Salary: $59.12 for each legislative day plus $50.00 per day expenses while in session (1986)
Senate: 50 members
House: 100 members

Congressional Representatives
U.S.Senate: Terms expire 1989, 1991
U.S. House of Representatives: Two members

Major Rivers and Waterways

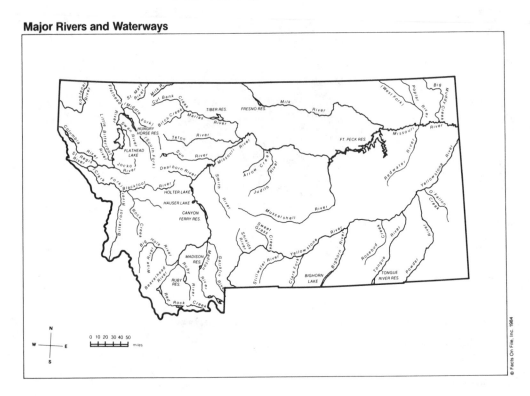

bia to enter Montana near Eureka, then cuts away the northwest corner of Montana with a great U-turn to flow northwest, eventually to meet the Columbia, on its return to Canada.

The largest natural lake in Montana is FLATHEAD, one of the longest lakes west of the Rockies. The eastern third of Montana consists of the rolling hill plains, rising to the GREAT PLAINS in the center with, the western third dominated by the ROCKY MOUNTAINS. Early visitors dubbed the region the "Land of Shining Mountains." In addition to the Bitterroot, some of the multitude of 49 other ranges are the Crazy Mountains, Bear's Paw and Beartooth Mountains, Swan, Sapphire, Tobacco Root, Highwood, Pryor, Mission and Bridger ranges. Granite Peak, in the RED LODGE region, is the highest point in Montana at 12,799 feet.

In the Central West, Montana is second in area only to Texas. During the early Paleozoic Era, Montana rose as plains and mountains, then fell into shallow sea troughs, only to rise again, until the Carboniferous period found the entire state under shallow seas once again. The gradual uplift of the early Mesozoic Era was followed by subsidence of the eastern portion of the state in what is known as the Western Troughs. The Cenozoic Era found the state

above water for good, gradually rising until the mighty uplift of the Rockies brought the present mountain heights.

The great continental ice sheets covered northern Montana east of the Rockies, finally retreating to create most of the state's natural lakes behind natural dams known as moraines. The existing glaciers, about sixty in number, are not remnants of the great glaciers, and they too are melting and expected some day to disappear.

Montana weather is renowned for its dramatic changes, sometimes the thermometer will rise as much as 70 degrees in a few hours, due mostly to the warm winds known as CHINOOKS. The story is told of the rancher who came to town in his sled and had to drive his poor horses home over dry ground, due to the almost instant melting of the snow in a Chinook. The state's extreme temperature range is 177 degrees, only slightly second to Alaska in range.

Although Montana has been known for its precious metals, today's mineral income derives mainly from petroleum, coal and natural gas, with total mineral income of over two billion annually. Wheat is king of Montana agriculture, featuring the spring wheat, mostly

Montana, Prehistoric Peoples

Topographic Areas

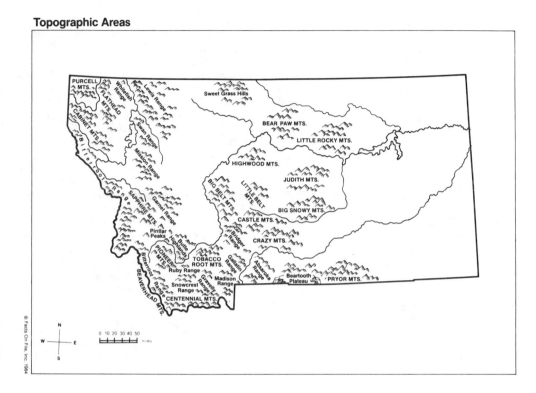

© Facts On File, Inc. 1984

a product of the dry farming process. Agriculture provides total annual income of more than a billion and a half.

However, manufacturing exceeds the total of both minerals and agriculture, reaching close to four and a half billion. Milling of lumber and flower and refining of sugar beets, furniture manufacture, production of mining machinery and small industries such as the manufacture of fancy saddles and the processing of sapphires found in the state's natural tubes of sticky clay, all contribute to the manufacturing wealth.

Few would think of Montana as a Gulf port, but at one time much of the transportation of the northwest flowed into FORT BENTON, the end of the line for steamboats which made their precarious way up the tortuous length of the Missouri and often deposited their cargoes at the distant port of New Orleans.

Montana made railroad connections with both east and south in 1881, and the vast job of tunnelling through mountains and bridging gorges finally was completed to bring the railroads entirely across the state in 1883.

In 1985 the population of the state stood at 826,000, showing a slight gain over the 1980 census. Ninety-four percent of the people are white, with the black population of 2% among the smallest in the nation. The roughly 29,000 Indian population have shown a substantial gain over the years, with most of the native Americans still living on the seven Montana reservations. Only about 10,000 Hispanic Americans make their homes in Montana.

Some of the world's finest fossil remains have been found in Montana, including some of the most complete fossils of the various dinosaurs discovered there. Among the most interesting fossil discoveries are the remains of a hoplitosaurus, a fifteen-foot tall relative of today's tiny horned toad. The oldest known primate once roamed the area and lefts its remains, and giant sequoias have deposited their fossilized remains in the state.

The lives of hunters of the Ancient Period, probably about 12,000 years ago, are represented by objects such as spears and atlatls (throwing weapons), discovered in Montana caves. Items of daily use, such as grinding stones, are reminders of the hunters and gatherers of the Middle Period.

As the buffalo returned to the plains, the Late Period brought use of the bow and arrow and skillful buffalo hunts in an era lasting until about a thousand years ago.

The Indians found by the first Europeans were to benefit greatly from the explorers' visits. The horses, both lost and stolen, multiplied greatly under the care of their new masters and brought a different way of life to the Indians of the region. They joined the ranks of some of the world's best horse breeders and riders. In many Indian tribes, stealing a horse from a rival tribe was a sign of great daring and bravery.

The horse brought new life to the buffalo hunt, the single most important event of life on the plains. The most successful hunts were those in which large numbers of the animals were driven over a cliff to die in the fall below. Every part of the buffalo was used, providing clothing, cups, sinews for binding and sewing and most particularly meat. The meat which could not be eaten was pressed and dried to form PEMMICAN, one of the most nutritious foods known, even today. Because of the great quantity of pemmican pressed on its banks, the MUSSELLSHELL RIVER became known as the Dried Meat River.

The CROW and BLACKFOOT tribes were the largest in the area. The CHEYENNE and ARAPAHO,

SHOSHONE and MOUNTAIN SIOUX, called Assiniboin, were other tribes of the area. Salish, KALISPEL and Kootenai tribes made up the Confederated Tribes of the FLATHEAD nation. A little known, peaceful group were the Sheepeater or ARROWMAKER peoples of the YELLOWSTONE NATIONAL PARK area, who occupied that "haunted" place where other Indians feared to live. The latter were known for the exceptional arrowheads they fashioned from obsidian, the local volcanic glass.

On New Year's Day, 1743, Louis and Francis VERENDREY (1685-1749) were so taken by the beauty of the sun on the mountains that they called the place the shining mountains, giving the present state the nickname it still cherishes. The two brothers were the first Europeans known to have come into Montana.

The LOUISIANA PURCHASE brought to the United States all of present Montana east of the continental divide, but few Americans had visited there, and little was known about the vast area. Then in 1804 President Thomas Jefferson sent LEWIS AND CLARK and their hardy crew on the greatest exploration in American history. In their journey westward and then in

Indian Tribes before European Settlement

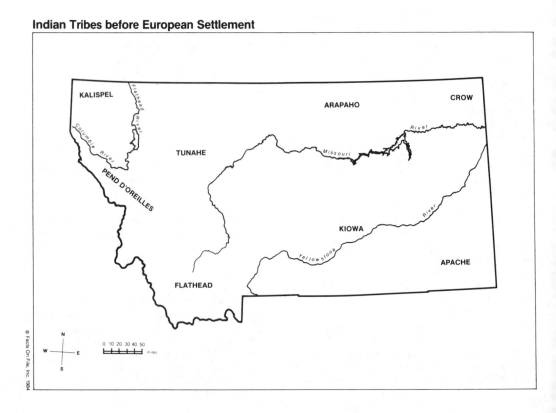

returning to the east, the expedition crossed more miles in Montana than in any other of the present states—totalling 1,940 miles.

The knowledge and respect of the Indians which the explorers achieved, and their keen observation of the wildlife, plant life and mineral resources brought the entire region of the west into focus for the country to the east. Among their discoveries was the long-sought source of the Missouri River and the three tributaries which join to form it. They ascended the Jefferson to its source which they correctly labeled as the farthest reach of the mighty Mississippi River system.

Lewis was the first American to cross the continental divide and stand on the country's western slope. On the return trip the party discovered the Yellowstone River.

The party's reports of the riches of furs in the region led Manuel LISA (1772-1820) to build Montana's first trading station in 1807, a fort on the Yellowstone River at the mouth of the Big Horn River. Other posts were soon built, and the courageous, often foolhardy mountain men visited and traded throughout the region in a fur trapping and trading period which lasted roughly through 1843.

As the number of travelers to the West increased south of Montana, many of them lost or abandoned cattle and oxen. These were picked up by the mountain men, brought to Montana and restored by the wonderful tall grasslands, providing the nucleus of the cattle industry in the state.

The white men brought their diseases to the Indians, who had no immunity to them. Thousands of Indians died from smallpox brought deliberately in some cases in infected blankets. But other visitors were trying to help them, and the work of missionaries began in earnest. Father Pierre Jean DE SMET (1801-1873) founded St. Mary's Mission in 1841, and nearby the first permanent European settlement in Montana was called Stevenson.

Although Father De Smet knew of Montana's gold, he feared the coming of gold seekers and never revealed his secret, but others found out and by 1862 the gold fever had begun. Various discoveries were made, and so many gold seekers had arrived that Congress created Montana Territory on May 26, 1864. Two months later gold was found at LAST CHANCE GULCH, now the main street of Helena. Butte also sprang up in 1864 as a gold camp. Soon, it seemed, "every prairie dog hole had become a gold mine."

Montana passed through most of the experi-

ences of the nation's other mining and frontier periods, outlaws, bandits, stagecoach robberies, shootouts and vigilantes, among others. However, the Indians proved to be an even greater danger. Indian hostilities, sparked by pressure on them to give up their land, went on until the last groups were forced into reservations.

Montana was the scene of one of the world's best known battles, when the Seventh Army under George Armstrong CUSTER (1839-1976) was defeated on June 25, 1876, at the Battle of LITTLE BIG HORN. The entire U.S. force was wiped out by Indians under the general command of Medicine Man SITTING BULL (1830?-1890), who was not at the battle in person. This defeat has been a mystery ever since. Then Sitting Bull and CRAZY HORSE (1842?-1877), the Indian military strategist, were defeated.

Great Chief Joseph of Nez Perce had led his people on a long march from their Washington state homeland. Headed for safety in Canada, they had skillfully escaped all efforts to capture them, but finally were defeated in August, 1877, at the Battle of BEAR'S PAW MOUNTAIN, in the shadow of that peak. The large scale Indian wars were over in Montana.

As early as 1866, the first cattle had been driven over the long trail from Texas, and the cattle industry continued to grow into the 1890s. The arrival of sheep ranchers brought conflict between the two groups, and as farmers began to arrive and fence off the land from grazing, new conflicts came about but were gradually resolved as each group finally found its place. The first farm lands were irrigated in 1882. By November 8, 1889 Montana had become a state.

Political history was made in 1917 when Montana sent the first woman ever elected to the U.S. Congress, Jeannette RANKIN (1880-1973). Almost immediately Congress was required to vote on entering WORLD WAR I, and Congresswoman Rankin voted no despite widespread criticism. She was still willing to stand against war when she also cast her vote against entering WORLD WAR II.

The 1920s first brought prosperity, then the catastrophe of depression, followed by a series of earthquakes in 1936 and by the even worse disaster of drouth and the worst duststorms in history. Finally the rains came, and trees were planted to keep the winds from blowing the soil away.

A severe earthquake rocked the state on August 17, 1959, during which a mountain collapsed into the Madison River, damming it to form what soon was called QUAKE LAKE.

The year 1963 brought the important installation of the intercontinental ballistics missile complex at GREAT FALLS. The state affirmed a new constitution in 1973, and the power from Libby Dam on the Kootenai River began to flow in 1975. Three years later a dramatic discovery of a dinosaur nest and eggs was the first in the Western Hemisphere. This appeared to indicate that dinosaurs care for their young.

The "richest hill on earth" sadly fell quiet in 1983 when Butte discontinued mining operations, throwing thousands out of work. Two years later celebrations marked the 75th anniversary of Glacier National Park.

With Montana's reputation as the most western of the West, it is not surprising that the state has produced some of the most distinctive artists of the western scene. Charles M. "Charley" RUSSELL (1865-1926) trapped, hunted, wrangled cows and herded sheep to become acquainted with every aspect of Montana's western scene. His artistic skill brought him world fame and earned his place as the only artist in the National Hall of Fame in the capitol at Washington. Today a ranch in Montana might cost less than one of his paintings or sculpture.

Frederic REMINGTON (1861-1909), who arrived in Montana at the age of 13, gained almost equal fame with Russell with his paintings and bronzes. He added a stint as Spanish American war correspondent, wrote and illustrated for several magazines. His life is honored at the Remington Museum, Oldenburg, New York.

One of Montana's best known women was the Indian guide who with her husband, Tuissant CHARBONEAU, and small son, POMPEY, accompanied the Lewis and Clark Expedition and whose knowledge of the country and acquaintance with the local groups was invaluable to the expedition's success. This was SAKAKAWEA (1787?-1812?) who grew up in the Three Forks area. Little Pompey literally grew up with the expedition and was its great pet.

Among Montana politician-statespersons none is now more respected than Jeanette Rankin, America's first woman representative in Congress, who long outlived the controversy over her vote against World War I and was noted for her lifelong crusade for world peace.

Two of the most successful mining tycoons spent almost a lifetime in contesting with one another, over the location of the Montana capital and for a U.S. senate seat. They were Marcus DALY and William Andrews CLARK. Clark eventually won the senate seat after the death of his rival.

Another tycoon, Augustus HEINZE, was so ambitious to monopolize the mining interests that he kept 32 lawyers at work on court cases which once numbered 40 at the same time.

Among the many notable Montana Indian leaders were Robert Yellowtail, first Indian to head a federal reservation, and Chief Plenty Coups, famed Crow leader, who represented all the Indian nations at the dedication of the unknown soldier's tomb at Arlington Cemetery.

Not content with one famed national park, Montana can claim to be the gateway to two of the best known, Yellowstone and Glacier. Two of the entrances to Yellowstone Park, GARDINER and RED LODGE, are noted for the scenery in the approach to Yellowstone. GOING TO THE SUN HIGHWAY, slicing through some of the most spectacular areas of Glacier, provides one of the world's notable journeys. Among the many Glacier attractions are the 200 grizzly bears and other animal life, as well as some of the finest wilderness trails and park resorts.

At Great Falls in north central Montana "Charley Russell Country" provides a visit to the artist's home and studio, as well as a museum containing some of his best work.

In stark contrast is the dreary rise of earth which attracts so many thousands of visitors to the scene where Custer's forces were annihilated on the banks of the Little Big Horn River, now a National Battlefield Monument.

The Gold country of southwest Montana offers restored gold mining camps and, particularly, VIRGINIA CITY with its famed Boothill Cemetery, resting place of so many notorious outlaws. Butte brings other memories of the state's mineral wealth, historic mines, museums and architecture of the golden era. The city's reputation as being located on the "richest hill on earth" has somewhat dimmed, but extensive mineral wealth still awaits exploitation there.

Across to the northeast, the Missouri River dominates with Fort Peck Dam and lake, and provides visitors opportunity to follow markers tracing the famed route of those remarkable explorers Lewis and Clark.

Helena's main street grew up around Last Chance Gulch, said to have been laid out with so many curves that gunfighters could not get a straight shot. Sheathed appropriately in copper, the dome of the capitol gleams over a notable building containing Charles Russell's mural of the Lewis and Clark meeting with the Indians at Ross Hole, along with other art, making the building a repository of one of the finest collections of its kind.

At a poignant moment in Montana history, Chief Joseph of the Nez Perce Indians walked slowly toward the assembled cavalry officers and, raising his hand, accepted the terms of surrender offered to him On October 5, 1877. His speech of surrender was one of the notable utterances of all time.

The cathedral of Cologne, Germany, was the model for the grand Helena Cathedral.

Near Helena lies a unique opportunity for visitors, who are permitted to dig for sapphires at the El Dorado Sapphire Mine. Whether lucky at sapphire digging or not few Montana tourists will want to miss the nearby bluffs of the Missouri River, immense masses of solid rock, which Meriwether Lewis labeled "the Gates of the Rocky Mountains."

MONTANA COLLEGE OF MINERAL SCIENCE AND TECHNOLOGY. One of the six units of the MONTANA UNIVERSITY system. The college with its 133-acre campus, is located in BUTTE. The programs prepare students for professional service in a variety of mineral science careers. Founded in 1893, the college enrolled 1,932 students during 1985-1986 and employed 154 faculty members.

MONTANA STATE UNIVERSITY. Founded in 1893, the university is one of the six units of the Montana university system. Originally established as an agricultural college, the university is located in BOZEMAN. During the 1985-1986 academic year Montana State University enrolled 10,710 students and employed 655 faculty members.

MONTANA, UNIVERSITY OF. State university chartered in 1893 and located in MISSOULA. Classes in the university in 1895 were housed in temporary buildings. The first permanent structures were not available until 1899. Accredited with the Northwest Association of Schools and Colleges, the university grants Bachelor's, Master's, Doctor of Education and the Doctor of Philosophy degrees. The University of Montana enrolled 8,989 students during the 1985-1986 academic year and employed 550 faculty members.

MORAINES. Piles of dirt and rock pushed ahead of glaciers and left wherever the glaciers melted. Moraines, blocked rivers with natural dams, creating many of the natural lakes of the present-day in areas once covered by the glaciers. The Wessington Hills, a fifty-mile long stretch of highlands in South Dakota, is one

The University of Montana at Missoula.

gigantic glacial moraine. Terminal moraines, marking the farthest edge of glaciers, may be found throughout the glaciated areas of the Central West.

MORAN, MOUNT. In the Tetons, named for Thomas MORAN (1837-1926) whose painting, *The Grand Canyon of the Yellowstone*, was bought by the government and now hangs in the National Museum of American Art, Smithsonian Institution, Washington, D.C. Moran gathered material for the painting while accompanying the Ferdinand Hayden expedition to Yellowstone at the request of Northern Pacific Railroad which used the art to encourage Congress to create Yellowstone National Park.

MORAN, Thomas. (1837—1926). American painter who in 1871 accompanied the Hayden survey party to the region of present-day YELLOWSTONE NATIONAL PARK. His splendid panoramic painting,*The Grand Canyon of the Yellowstone*, bought by the government for $10,000 for the Capitol galleries, is now housed in the National Museum of American Art, Smithsonian Institution, Washington, D.C. The painting was used to promote legislation in Congress

leading to the creation of Yellowstone National Park in Wyoming, on March 1, 1872. Mt. Moran in the Tetons is named in Moran's honor. Another of Moran's favorite subjects for his many paintings and sketches was Mount of the HOLY CROSS near VAIL, Colorado.

MORES, Marquis de. Flamboyant French aristocrat who proposed to build packing plants near where cattle were raised, to eliminate many of the problems in moving live cattle to the East. De Mores opened his packing plant in 1883 and named the town which grew up around it MEDORA in honor of his wife, the former Medora Von Hoffman of New York. Inexperienced in business, the Marquis failed in his project, but not before building a 28-room chateau overlooking the LITTLE MISSOURI RIVER. Staffed with many servants, the home became a social center on the frontier, visited on several occasions by Theodore ROOSEVELT (1848-1919). With the failure of his packing plant, the Marquis and his wife suddenly departed North Dakota, leaving behind their chateau which was finally taken over by the North Dakota State Historical Society in 1936. The Marquis was later killed by his native guides while on a hunting trip in Africa, and the Marquise died of injuries while serving as a nurse in WORLD WAR I.

MOREAU RIVER. Tributary of the MISSOURI RIVER, the Moreau begins at two forks in northwestern South Dakota's Perkins County and flows 250 miles in an easterly direction toward Dewey County and its mouth.

MORMON BATTALION. Mormon volunteers assigned to meet General Stephen KEARNY (1794-1848) in California and to break a wagon trail to the West as they marched. The formation of the battalion came through an agreement between President Polk and Mormon leaders to demonstrate Mormons' loyalty to the United States in return for protection of Mormons in the West. The all-volunteer group had left their fellows at winter camp near present Council Bluffs, Iowa. After undergoing many hardships they managed to blaze a wagon trail from SANTA FE, New Mexico, to the west coast.

MORMON PIONEER NATIONAL HISTORIC TRAIL. This 1,300-mile trail follows the route over which Brigham Young led the Mormon adherents from Nauvoo, Illinois to the site of modern Salt Lake City, Utah, in 1847. Headquartered DENVER, Colorado.

MORRIS, Esther Hobart, (Spencer, NY, Aug. 8, 1814—Cheyenne, WY, Apr. 2, 1902) Suffragist, jurist. She was known as the Mother of Woman Suffrage. Orphaned at an early age, she made her own way and finally opened a millinery business in the village of Oswego, New York. By the time of her marriage to Artemus Slack in 1841 at the age of 28 she had gained considerable wealth. After Slack's death she moved to Illinois where her husband had large tracts of land. It was said that during the settlement of the Slack estate she encountered legal problems and "... she first conceived the idea that the rights of women under the law should be no less than those of men," according to her biographer Cora Beach. During her stay in Illinois, she became an ardent and outspoken Abolitionist. In 1845 she married John Morris, and in 1869 they moved to SOUTH PASS City, Wyoming. Continuing her work for woman suffrage, in September, 1869, Esther Morris called a meeting in her home to which she invited the candidates for the first territorial legislature of Wyoming. One of these candidates was H.G. Nickerson, whose affidavit in the official files of Wyoming reads: "To Mrs. Esther Morris is due the credit and honor of advocating and originating woman suffrage in the United States." At the meeting Mrs. Morris asked the candidates for a public pledge, "...that whichever one is elected will introduce and work for the passage of an act conferring upon the women of our new territory the right of suffrage." When Wyoming territory was organized later that year, women were given the vote for the first time in the U.S. Esther Morris gained even further distinction when on February 14, 1870, she was appointed Justice of the Peace at South Pass City. Her biographer notes that, "This was the first time in the history of the world that any woman had held judicial office....During her administration she tried 70 cases. Of these several were taken to a higher court, but none was reversed." On statehood day, July 10, 1890, Esther Morris made the principal speech and presented the official state flag, made by the women of the state. She continued to work for women's rights, and was highly acclaimed by the national press when in her eighties she was a delegate to the Republican National Convention at Cleveland in 1894.

MORTON, Julius Sterling. (Adams, NY, Apr. 22, 1832—Nebraska City, NE, 1902). United States secretary of agriculture and early conservationist. In January, 1872, Morton submitted a resolution to the Nebraska legislature calling for a day to recognize the importance of trees. From this came the idea of an annual ARBOR DAY, an event which has become known as "America's loveliest custom." The first Arbor Day was celebrated on April 10, 1872. Morton was also the first person from Nebraska to serve in the Cabinet. Morton served as acting governor of the Territory of Nebraska (1858-1861) and was a member of the territorial legislature. He was an original member, and later president, of the Nebraska Territorial Board of Agriculture, the Territorial Horticultural Society, and the American Forestry Association. He served a very undistinguished term as Secretary of Agriculture from 1893 to 1897. Morton's fifty-two room mansion, Arbor Lodge, was given to the state and is part of ARBOR LODGE STATE HISTORICAL PARK in NEBRASKA CITY. Morton's birthday is celebrated each year with a tree-planting ceremony.

MOSQUITO RANGE. Colorado mountains containing the impressively jagged peaks of Mount Sherman, Mount Democrat, Mount Bross, Mount Lincoln, and Quandary Peak, north of LEADVILLE, Colorado.

MOUNT PLEASANT, Texas. City (pop. 11,003). Seat of Titus county in northeast Texas. Industry is mainly dependent on asphalt and diversified agriculture. Mount Pleasant is known for sponsoring the modern version of medieval jousting, known as Riding the Ring. Fox hunting is also a favorite pastime of the area. The Texas Bass Festival is held there in mid-May, and the Mount Pleasant IRA Championship Rodeo is featured in early June.

MOUNT RUSHMORE NATIONAL MEMORIAL. Colossal heads of presidents George Washington, Thomas Jefferson, Abraham Lincoln and Theodore ROOSEVELT (1848-1919) were sculpted by Gutzon BORGLUM (1867-1941) to form the largest portrait sculpture ever created, looming high on the face of a granite mountain. Headquartered KEYSTONE, South Dakota. The work came about through the untiring persistence of the sculptor, who pursued the idea for fourteen years despite the many detractors, who felt that it could never be completed.

MOUNTAIN, North Dakota. Village (pop. 156), Pembina County, northeastern North Dakota, southeast of Langdon and northwest of Park River. Mountain is known for its Icelandic population. A log church, built in 1886, was

reputedly the oldest Icelandic church in North America. The Icelanders settled near the headwaters of the Little Tongue River and began farming. Distinguished citizens have included Sveinbjorn Johnson, former professor of law at the University of Illinois and later a State supreme court justice, Vilhjalmur Stefansson, scientist and explorer, and Stephen Stephenson, a poet honored by the Icelandic government. Large deposits of fuller's earth, used for reclaiming motor oil and purifying animal and vegetable oils, have been discovered in the region.

MOUNTAINS. The highest point between the Appalachians on the east and the Rockies on the west is found at HARNEY PEAK in the BLACK HILLS of South Dakota, at 7,242 feet. The Hills (actually classified as mountains) are very ancient and have been substantially worn down by wind and weather.

The states on the western edge of the Central West region have the nation's highest average elevations, with Colorado the highest of all, where the ROCKY MOUNTAINS meet their crest and dominate the state with seventeen major ranges and mountain groups, including the Front Range, which forms a giant wall, with the high plains and many major cities lying just to the east.

The Sawatch Range is the loftiest in Colorado; others of importance are the San Juan Mountains, Park and Sangre de Cristo Mountains. Other lesser clusters include the Mummy, Never Summer, Mosquito, Rabbit Ear, Rampart and Ruby ranges. Mt. Elbert (14,431 ft.) is not only Colorado's highest but also is the highest in the Central West region.

Most spectacular of Wyoming's many ranges is the TETON RANGE, said by some to be the most beautiful mountains in the world. Highest of the Wyoming ranges is the Wind River Range,

The storied Rocky Mountains reach their loftiest average in Colorado. Beautiful Echo Lake lies at the foot of one of the state's favorite peaks, Mt. Evans.

with Gannett Peak at 13,785 feet the state's highest. Other groups are the Bighorn Mountains, topped by Cloud Peak at 13,175 feet, Absaroka, Laramie, Medicine Bow, Wind River and Snowy ranges.

In Montana (which means mountain in Spanish), major ranges stretch across a 200-mile-wide section from north to south, covered by range after range. The most substantial is the BITTERROOT. Granite Peak in the RED LODGE area is the state's highest at 13,799 feet. Other Montana ranges include Bear's Paw, Beartooth, Sapphire, Crazy, Tobacco, Root, Bridger, Mission, Pryor and part of the BIG HORN.

Southern New Mexico marks the south edge of the U.S. Rockies. The state is cut from north to south by a swath of the main Rockies about 100 miles in width. The state shares its two mightiest ranges, SAN JUAN and SANGRE DE CRISTO, with Colorado. Other ranges include Guadalupe, Manzano, San Andres, Polvadera, Taos, Florida, Bear, La Plate, Pinos Altos, Truchas, Sandia and Magdalena. Highest point is 13,160 foot Wheeler Peak.

Texas' highest point is GUADALUPE PEAK in the GUADALUPE MOUNTAINS, at 8,751 feet. Other ranges are Davis, Van Horn and Granite Mountain.

Oklahoma's modest ranges include an extension of the OZARKS, along with the OUACHITA and WICHITA elevations. Highest Oklahoma point is 4,978 foot Black Mesa.

Kansas and Nebraska have no real mountains, and North Dakota has some modest ranges, including TURTLE MOUNTAINS near ROLLA, PEMBINA MOUNTAINS and the two hills of Killdeer Mountains. White Butte at 3,506 feet is the highest point in the state.

MOUNTAIN GOATS. Animal, also known as the Rocky Mountain goat or the antelope goat, which inhabits the high mountain areas above treeline. Awkward only in appearance, the mountain goat stands four feet at the shoulder and lower toward the back. They weigh up to three hundred pounds, and both male and female have small upright, backward-curving horns and long shaggy white coats all year around.

MOUNTAIN LION. A large cat, also referred to as cougar and puma, the mountain lion once had the widest distribution of any mammal in the western hemisphere. Males range in weight from 140 to 200 pounds, while females average 100 pounds. Average body length, excluding tail, is five feet. Authentic records of lion

sightings have taken place in forty-seven of the forty-eight conterminous states, excepting Indiana, as well as the District of Columbia. Despite this widespread distribution, the lion has always been extremely shy and shuns contact with humans. Attacks on people are almost unheard of, and the animals have often been held in high regard by the Indians. With white settlement, mountain lions were subjected to indiscriminate killing because they sometimes killed livestock. Even an avid conservationist such as Theodore ROOSEVELT referred to the lion as "a big horse-killing cat...the lord of stealthy murder." The animal has survived in inaccessible mountain regions and broad deserts. Deer is the mainstay of the lion's diet along with bobcat, mountain goat, rabbits, rodents of all kinds, and elk. Each mountain lion establishes a territory for itself, of a size determined by the availability of food and cover, and this acts to limit the size of the population. According to the New York Zoological Society, studies show that lions keep herds of deer and elk within the limits of their food resources. Despite this usefulness and regardless of the majesty and beauty of the animal, the indiscriminate killing of lions has left the population greatly diminished.

MOUNTAIN MEN. Term applied to the hardy souls who ranged over the plains and mountains of the West during the period of approximately 1820 to 1840. A list of names of these men would include Jim BRIDGER (1804-1881), Jedediah SMITH (1799-1831), Jim BECKWOURTH, Hugh GLASS, John COLTER, and Kit CARSON (1809-1868). As a group they were often pictured as rough, uncouth, hard-drinking social outcasts who could hardly wait to strike out into the wilderness alone to hunt and trap. In reality the eagerness with which so many attended the annual rendezvous to exchange furs for supplies indicates they were very similar to any other occupational group, having examples of nearly every racial group and moral persuasion. The mountain men became the best of the frontier scouts and guides, some serving with honor on many wagon trains, survey parties and army posts. The skill with which they guided settlers into the wilderness helped close the frontier and thus hastened the end of the way of life they knew.

MULE DEER. A black-tailed deer, with a number of sub-species, found from Mexico to Canada in large numbers, named because of its long ears like those of a mule.

MULLAN PASS. Mountainous site in western Montana which blocked construction of the first transcontinental railroad tracks across the state until a long tunnel under the pass was constructed.

MULLAN ROAD. Pioneer trail running from FORT BENTON, Montana, at the head of the MISSOURI RIVER across the BITTERROOT RANGE to Walla Walla, Washington. The trail was constructed for wagon trains between 1859 and 1862 under direction of Lt. John Mullan and opened rich mining regions in the northwest.

MUMMY RANGE. Ridge of Colorado mountains with peaks arranged like a vast corpse.

MURPHY, Audie. (Kingston, TX, June 20, 1924—near Roanoke, VA, May 28?, 1971). War hero and movie actor. Attacked with his unit near Colmar, France, on January 26, 1945, Murphy used the machine gun on a burning tank destroyer to hold off six tanks and 250 enemy troops, killing about fifty. Awarded more decorations during WORLD WAR II than any other individual, including the Medal of Honor, Murphy later turned to acting and appeared in such films as *To Hell and Back* (1955). He made about 40 films, but by 1960 his popularity faded. Turning to business he was unsuccessful and declared bankruptcy. He was killed in a light plane on a flight to Atlanta. The wreckage was discovered on June 1, 1971.

MURRAY, William H.(ALFALFA BILL). (Grayson County, NE, Nov. 21, 1869—Oct.15, 1956). Colorful Oklahoma politician. Murray played a major role in Oklahoma statehood and was Democratic speaker of the house in the first Oklahoma legislature, beginning in 1907. Returning from five years of touring in Bolivia he ran successfully for Governor in 1930, traveling around the state in a beat-up Model-T Ford, dressing poorly and eating cheese and crackers. Once elected, Murray denounced the growing power of the federal government and courts, but saw the Oklahoma Tax Commission and a workable system of oil proration established during his administration. His son, Johnston Murray, was later also elected governor.

MUSEUM OF NAVAJO CEREMONIAL ART. Also known as the Wheelwright Museum of the American Indian, at SANTA FE, New Mexico. Built to resemble as much as possible a NAVAJO hogan, the museum houses a unique collection of Navajo sand paintings, pottery, carvings and basketry.

MUSEUM OF NEW MEXICO. Three separate museums and five monuments located in SANTA FE, dealing with periods of southwestern and international culture. The Hall of Ethnology depicts present-day Indian life in the area and compares it to Indian life in other regions. The PALACE OF THE GOVERNORS, the oldest capitol and oldest public building in the United States, is another part of the museum. The New Mexico Museum of Art specializes in regional artists. The Museum of International Folk Art displays the local art of fifty countries including the Girard Foundation's collection of 106,000 objects, featuring its miniature buildings and marketplaces reproduced from one hundred countries.

MUSEUM OF THE FUR TRADE. Unique collection of memorabilia, in CHADRON, Nebraska, focusing on the 19th century fur trade along the MISSOURI RIVER. The Bordeaux Trading Post, from 1840, is reconstructed on its original site and completely outfitted. Displays include a garden of nearly extinct Indian crops, frontier weapons and leather-tanning equipment.

MUSEUM OF THE GREAT PLAINS. Cultural center located in LAWTON, Oklahoma, including replicas of a train depot, a fur-trading post, and a turn-of-the-century frontier settlement, emphasizing man's relationship with the prairie environment. Exhibits feature the life of a frontier soldier, the cattle and fur industries, and the technological revolution in farming.

MUSEUM OF THE PLAINS INDIANS. BROWNING, Montana, cultural center featuring exhibits of historic and contemporary Indian art, dioramas, and murals. Located near the BLACKFOOT reservation, the museum highlights changing exhibitions and a multi-image audiovisual presentation.

MUSIC AND MUSICIANS. Music has played its part in the life of the Central West, even as early as the 1600s, when a Spanish Franciscan Father wrote, "These Indians...are today well instrumented and civilized...Many play the harp, the violin, and the guitar well..." Among the most notable and oldest continuous performances of music in the region is that of the MESSIAH FESTIVAL at LINDSBORG, Kansas, beginning in 1878 with the amazing accomplishment of Dr. Carl Swensson in training a choir and bringing to pioneer Kansas renowned soloists for the work. The tradition has since been carried on and expanded. Another inter-

nationally renowned performance series, made especially notable because of the small size of the community, is the the annual opera season of the SANTA FE OPERA, devoted to the entire opera repertoire, including world premieres, with the finest singers and soloists and attracting an international audience. Several other cities of the region have brilliant opera seasons, and most of the cities of even modest size have symphony orchestras. The musical team of Higley and Kelley is not well known but the composition they created has become one of the country's best loved. Dr. Higley's poem about his dugout home on the banks of Beaver Creek in Smith County, Kansas, was set to music by Daniel Kelley. This work, the favorite song of President F.D. Roosevelt, *Home on the Range*, has become a universal favorite and one of the most enduring of our national melodies. Classical compositions were the forte of composer-conductor Nebraska native Howard HANSON (1896-1981), one of the aknowledged modern American masters in his field. Another stridently acknowledged master of music was Texas pianist Van CLIBURN (1934-) who gained instant and lasting fame and was catapaulted into celebrity status as the first American winner of the prestigious Tschaikowsy Piano Competition in Moscow in 1958.

MUSKOGEE, Oklahoma. City (pop. 40,011), Muskogee County, northeastern Oklahoma, southeast of TULSA and northeast of HENRYETTA. Muskogee, once the most important town in the Indian nations, was one of the Oklahoma cities turned into seaports by the completion of the MCCLELLAN-KERR ARKANSAS RIVER NAVIGATION SYSTEM during the 1970s. Muskogee is the home of BACONE COLLEGE, the oldest college still operating in the state, opened in 1880 as the Baptist Missions University. Its location made it an ideal site for the Indian Agency of the FIVE CIVILIZED TRIBES. Indians pitched their tents in Honor Heights Park, waiting for their government payment and rations. Today the site is a memorial to the veterans of WORLD WAR I. Famous residents of Muskogee included Grant and Carolyn Foreman who wrote numerous books on the Five Civilized Tribes. Artifacts from the five tribes may be seen in the Five Civilized Tribes Museum, the old Union Indian Agency building.

Azaleas brighten Honour Heights Park at Muskogee, Oklahoma.

MUSSELSHELL RIVER. River in central Montana which rises in Meagher County and begins a three hundred mile course east and then north into the MISSOURI RIVER in Garfield County.

MUSTANGS, WILD. Wild horses descended from the original Spanish stock. Either as escaped horses or animals stolen by Indians, the mustang often evolved into animals of small build and poor characteristics which ran in bands of mares with a lead mare and a stallion. By the time of the first white explorations in many areas of the Central West, the herds of mustangs were huge. Hardy and durable, the mustang made an excellent mount for cowboys and Indians. Mustangs were later crossed with Eastern stock such as the quarter horse to create cutting horses. By the mid 1900s, wild horses had multiplied to such an extent that they were considered as a nuisance in some areas. Since that time, the proper disposition of surplus numbers has been greatly disputed. Some were sold at very low cost to persons who would give them a home. Some were relocated to less populous areas. Others were slaughtered for animal food, while others died "mysteriously," probably killed by neighbors as pests. However, they continue to flourish, and the problem of their numbers remains unsolved.

NACOGDOCHES, Texas. Town (pop. 27,-149), seat of Nacogdoches County, in east north-central Texas. Settled in 1716, and named for the Indians who originally inhabited the area, Nacogdoches boasted the first Texas newspaper, the *Gaceta de Tejas*, started in May 1813. Manufactures today include valves, feed, fertilizers, and aluminum furniture. Stephen F. Austin State University is located there. At the university is Old Stone Fort Museum, featuring Texas heritage, including the first newspaper and other east Texas items. Old Nacogdoches University also features a museum. Millard's Crossing is a quaint restored historic village four miles northeast.

NADOCO INDIANS. A band of Texas Indians of the Hasinai group which raised crops, lived in permanent shelters and enjoyed a fairly high standard of living.

NAMBE PUEBLO. One of the Tanoan Pueblos along with ISLETA, SANDIA, TAOS, San Juan, Picuris, SANTA CLARA, TESUQUE, SAN ILDEFONSO, and JEMEZ.

NATION, Carry. (Garrard County, KY, Nov. 25, 1846—Leavenworth, KS, June 9, 1911). Temperance activist. Beginning October 15. 1890, Nation gained national fame protesting the sale of liquor by smashing saloons with a hatchet, beginning in her home county in Kansas. Nation began her crusade as a result of personal experience with the effects of alcohol on her husband and the lack of help she received in the community. Her mind later became somewhat unbalanced and she died in relative obscurity. A monument erected in her memory in WICHITA, Kansas, was later knocked over by a beer truck and never replaced.

NATIONAL BISON RANGE. Area set aside in 1909 through the help of the American Bison Society. The preserve of nearly 19,000 acres near MISSOULA, Montana, shelters a herd of from three to five hundred bison. The range is notable for the two extremely rare albino buffalo born there.

NATIONAL CEMETERY (first). National cemeteries provide burial places for men and women who have served in the United States armed forces, unless they received a dishonorable discharge, and for their spouses and children. Reputedly the first established in the United States lies near FORT SCOTT, Kansas, in

Bourdon County, established July 17, 1862.

NATIONAL CENTER FOR ATMOS-PHERIC RESEARCH. Constructed on Table Mountain near BOULDER, Colorado. In addition to carrying out its research functions, the Center offers exhibits of solar astronomy, atmospheric phenomena and weather.

NATIONAL COURSING MEET. Annual event, called the "world series of greyhound racing," held the last week of April and the first week of October in ABILENE, Kansas.

NATIONAL COWBOY HALL OF FAME AND WESTERN HERITAGE CENTER.
Seventeen western states combined resources to honor the men and women who built the Old West. The complex at OKLAHOMA CITY displays guns and saddles, busts and western movie memorabilia. James Earle Fraser's "The End of the Trail" and a thirty-three foot statue of Buffalo Bill CODY (1846-1917) are featured. A western art collection valued at $50 million contains works of western artists, including Frederick REMINGTON (1861-1909) and Charles M. RUSSELL (1865-1926). A section of the center is named The Great Western Performers Hall of Fame. Portraits of such stars as Roy Rogers, John Wayne, and Tom Mix are featured. John Wayne's vast collection of guns, knives and katchina dolls daily draws tourists. The center also houses a Rodeo Hall of Fame and film and research libraries.

NATIONAL FLYING FARMERS. Organization with headquarters in WICHITA, Kansas, open to bone fide agriculturists who fly their own planes. It is said to be the only aviation organization for farmers.

NATIONAL HALL OF FAME FOR FAMOUS AMERICAN INDIANS. The institution came about as a result of a call by Oklahoma Governor Johnston Murray on January 25, 1952, bringing together a group of public officials, jurists and other civic leaders interested in Indian affairs. The idea for such an organization had first been proposed By Logan Billingsley when he was employed in ANADARKO, Oklahoma, by the U.S. Indian service, before Oklahoma statehood (1907). The organization was founded February 1, 1952. It occupies a ten-acre site at the edge of Anadarko and honors more than twenty famous Indians in statuary. Dedication of the various sculptures has taken place in the states in which the

The western heritage of the Indian peoples is featured at the National Cowboy Hall of Fame and Western Heritage Center.

honorees were most closely identified. Among those honored are Massasoit of the Wampanoag; Oceola and Alice Brown Davis of the Seminole; SEQUOYAH, Will ROGERS and John ROSS of the Cherokee; Charles CURTIS of the Kaw; SAKAKAWEA of the Shoshoni; Quanah PARKER of the Comanche, Pontiac of the Ottawa, Tecumseh of the Shawnee; Pocahontas of the Powhatan and Allen WRIGHT of the Choctaw. Only those persons who are recognized by the federal government as American Indian by blood, or their descendants, and who have been deceased for 15 years prior to their nomination to the Hall of Fame are qualified for honors there. They are selected by the Executive Board and the Board of Directors of the Hall.

NATIONAL PRESERVES. The Central West region possesses two of the nation's most striking national preserves, one natural, the other manmade. YELLOWSTONE NATIONAL PARK contains the world's largest and most varied grouping of thermal features, including the 10,000 geysers, mud springs, hot pools of magnificent color variations, hot springs and

many others, along with fascinating animals, splendid lakes and breathtaking canyons. The Park, the nation's first, was dedicated in 1872. South Dakota's MOUNT RUSHMORE NATIONAL MEMORIAL is the region's great manmade marvel, the colossal heads of four major presidents, largest portrait sculptures in the world.

South Dakota's other preserves are BADLANDS NATIONAL PARK, JEWEL CAVE NATIONAL MONUMENT and WIND CAVE NATIONAL PARK. Wyoming adds to its national luster with GRAND TETON NATIONAL PARK, featuring the grandeur of one of the world's most beautiful mountain ranges. Quite different is DEVILS TOWER NATIONAL MONUMENT, a monolith rising dramatically from the prairies. Wyoming also hosts FORT LARAMIE NATIONAL HISTORIC SITE and JOHN D. ROCKEFELLER, JR., MEMORIAL PARKWAY.

Colorado's national preserves are marked by striking contrast, the archeological treasures of MESA VERDE NATIONAL PARK and HOVENWEEP NATIONAL MONUMENT, the fossils of DINOSAUR and FLORISSANT FOSSIL BEDS national monuments and the natural beauty of ROCKY MOUNTAIN NATIONAL PARK. Also of interest are BLACK CANYON OF THE GUNNISON NATIONAL MONUMENT and COLORADO NATIONAL MONUMENT. Another contrast is provided in the stark beauty of GREAT SAND DUNES NATIONAL MONUMENT.

The two national preserves of Kansas are concerned with historic treasures, FORT LARNED NATIONAL HISTORIC SITE and FORT SCOTT NATIONAL HISTORIC SITE. Montana yields two important historical battle sites, BIG HOLE NATIONAL BATTLEFIELD and CUSTER BATTLEFIELD NATIONAL MONUMENT. FORT UNION TRADING POST NATIONAL HISTORIC SITE also stresses the state's heroic past. Montana's GLACIER NATIONAL PARK is also authorized as the U.S. portion of Waterton-Glacier International Peace Park and is particularly noted for its 50 glaciers.

HOMESTEAD NATIONAL MONUMENT in Nebraska is the country's tribute to the homesteaders who helped to populate the region. AGATE FOSSIL BED NATIONAL MONUMENT preserves important Miocene mammal fossils, representing an especially revealing chapter in the evolution of mammals. The 800 foot height of the massive promontory of SCOTTS BLUFF NATIONAL MONUMENT was one of the most important landmarks on the Oregon Trail.

New Mexico boasts one of the region's largest assemblages of national preserves. Particularly important are the ruins of the PUEBLO culture cared for at AZTEC RUINS NATIONAL MONUMENT, BANDELIER NATIONAL MONUMENT, CHACO CULTURE NATIONAL HISTORICAL PARK, PECOS NATIONAL MONU-

MENT and SALINAS NATIONAL MONUMENT. History of a later time is preserved at FORT UNION NATIONAL MONUMENT.

Outstanding natural features have been set aside at three New Mexican preserves. One of the world's most spectacular underground marvels, CARLSBAD CAVERNS NATIONAL PARK, offers one of the largest underground chambers anywhere. EL MORRO NATIONAL MONUMENT preserves INSCRIPTION ROCK, with its hundreds of names and sentiments carved in its soft sandstone by people from early times through the other epochs of the region's history. WHITE SANDS NATIONAL MONUMENT perserves the world's largest gypsum dunefield.

Nature has provided the scenic badlands of THEODORE ROOSEVELT NATIONAL PARK in North Dakota, and history has added the appeal of the dynamic president whose stay in North Dakota has been memorialized there. The cultures of prehistoric peoples and the Indian residents are recalled at KNIFE RIVER INDIAN VILLAGES NATIONAL HISTORIC SITE. More recent history is preserved at FORT UNION TRADING POST NATIONAL HISTORIC SITE, principal fur trading depot of the Upper MISSOURI RIVER region.

Oklahoma has no national parks or memorials but shares FORT SMITH NATIONAL HISTORIC SITE with Arkansas. Also there is at Sulphur the Chickasaw National Recreation Area.

Texas' two national parks are GUADELUPE MOUNTAIN and BIG BEND. Prehistory and recorded history in Texas are preserved in ALIBATES FLINT QUARRIES NATIONAL MONUMENT, FORT DAVIS NATIONAL HISTORIC SITE, PALO ALTO BATTLEFIELD NATIONAL HISTORIC SITE, SAN ANTONIO MISSIONS NATIONAL HISTORICAL PARK and LYNDON B. JOHNSON NATIONAL HISTORICAL PARK. A unique episode of U.S.-Mexican relations is preserved in CHAMIZAL NATIONAL MEMORIAL.

Having the only seashore of the Central West region, Texas enjoys PADRE ISLAND NATIONAL SEASHORE. A unique natural region is cherished in BIG THICKET NATIONAL PRESERVE. A scenic portion of the RIO GRANDE is maintained in its natural state at RIO GRANDE WILD AND SCENIC RIVER.

NATURAL GAS. Fuel resource found in large quantities in much of the Central West. A naturally inflammable mixture of gases, chiefly methane, it differs in composition from artificially produced fuel gases.

The Central West states of Texas, Oklahoma and New Mexico produce 50% of the United States supply of Natural gas. In 1983 Texas produced 5,939 billion cubic feet, followed by Oklahoma with 1,730 billion cubic feet and

New Mexico with 895 billion cubic feet.

The other producers of natural gas in the Central West, ranked by yield, are: Wyoming (444 billion cubic feet), Kansas (435 billion cubic feet), Colorado (164 billion cubic feet), North Dakota (69 billion cubic feet), Montana (52 billion cubic feet) and Nebraska (2 billion cubic feet). South Dakota is the only state in the Central West that did not have any marketed production of natural gas during the period.

NAVAJO INDIANS. Largest Indian tribe in the United States in recent years. Most are located on or near the Navajo Reservation in New Mexico and Arizona. The Navajo speak a language similar to that of the APACHE. Both tribes had migrated to the southwest from northwestern Canada by 1200 AD. The name Navajo means "large cultivated fields." The Navajo refer to themselves as Dine, or "the people."

Until modern times the Navajo were composed of a number of bands. Each band was led by a natari, appointed for life, who was assisted by one or more war leaders. In the more than sixty clans, membership was inherited through the mother.

Newly married couples built hogans near the bride's mother, although the mother-in-law taboo forbade the man speaking to his mother-in-law. Property was inherited through the female line. An important social and economic unit was the extended family, which cooperated in tasks such as house building, stock raising and crop cultivation. In later times a larger unit, known as the "outfit" was composed of two or more extended families working together.

Many of the Navajo religious customs were borrowed from the PUEBLO PEOPLE. Solemn chants and the performance of sacred dramas by masked impersonators were important parts of the Navajo religion. Having a deep fear of the dead and ghosts, the Navajo removed a deceased relative from a hogan through a hole cut in the north side of the dwelling, and the corpse was immediately buried. Most of the belongings of the deceased were destroyed or buried with the body. The hogan was abandoned.

Navajo raids on white settlements in the

The handsome work of the "Navajo Silversmith" is celebrated in this painting by E. Martin Hennings.

United States in the early 1800s finally led to a concentrated military action (1862-1865) taken against them under Kit CARSON (1809-1868). Navajo crops, orchards and herds were destroyed. The starving survivors of the campaign were rounded up. In 1864 nearly 8,000 Navajo were force-marched 350 miles from Fort Defiance in Arizona to FORT SUMNER, New Mexico, where they were interned for four years. Nearly two thousand died on the march or later during internment.

In 1868 the Navajo Reservation was established. The Indians returned to their homes and re-established their fields, herds and orchards. In the 1880s some of the best land was taken for railroad rights-of-way. Disease, discrimination and alcoholism soon developed as serious threats.

The discovery of oil on the reservation stimulated economic development in the early 1920s. Stockraising was so successful that by the 1930s a stock reduction program was necessary to save the land from overgrazing.

By the late 1970s the resources of the Navajo Reservation proved insufficient to support the growing population. Communities such as Ramah, Puertocito and Canyoncito were established off the reservation to ease the pressure.

Tourism has been developed to take advantage of the world-wide recognition of Navajo pottery, weaving and silver work.

NAVAJO RUGS. The world-famed Navajo rug weaving art originally was borrowed from the PUEBLO PEOPLE, who also taught the Navajo how to make the loom. The work was elevated to its present high standard by the Navajo artists. Before sheep were introduced by the Spaniards, primitive weavers used any suitable fibrous material—animal hair, human hair, cotton and other natural fibers. After sheep became available, the weavers were able to use wool, from which the rugs are now made traditionally. In earlier times the Navajo women always spun the wool into yarn by hand, using only the traditional spindle. Later, many weavers turned to machine-made yarn and also embraced silk and other yarns. European bayeta, a flannel, reached them only as finished cloth, and this had to be unraveled tediously before it could be woven into rugs and blankets. The finest typical rugs are still woven from hand-spindled yarn. The better, older rugs and blankets are highly prized and extraordinarily high-priced. At one time used commonly, the best of the rugs and blankets are now cherished and displayed as true works of art. The evolu-

tion of the design proceeded from simple parallel lines to the very intricate groupings of colors. Many patterns, of course, were based on tribal customs and traditions. As interest increased among white customers, the weavers were encouraged to introduce cows and other non-traditional patterns, and some continue to produce art of their own design, but traditional designs are the most sought-after today. The loom is suspended from a pole that has been hung between two trees, and the work progresses from the bottom upward. When the work comes from the loom, it is curled and somewhat twisted. The weaver simply covers the material with wet sand, and within a few days, the rug or blanket straightens itself perfectly.

NAVASOTA RIVER. Rising north of Grossbeck in central Texas. It flows approximately 90 miles to drain into the BRAZOS RIVER at Navasota.

NAVY, TEXAS. Fleet of ships used by Texas revolutionaries from 1834 to 1836 during the war for Texas independence. Its principal function was to keep Mexico from blockading the coast and, after the war, to capture several Mexican ports in retaliation for Mexico's threat to attempt another blockade. It was disbanded after statehood.

NEBRASKA. State, lying in the heart of the U.S. on the eastern border of the Central Western states. All of the Nebraska borders are straight and manmade with the exception of the MISSOURI RIVER on the east and northeast. A small part of Missouri and much of the western border with Iowa follow the twists of the great river on Nebraska's east. To the north the river delineates the eastern segment of the border with South Dakota, followed by the straight section forming the rest of the Dakota border and Wyoming on the west. Colorado appears to have swallowed the southwest section of Nebraska, and Kansas is the only southern neighbor.

Major internal river of Nebraska is the PLATTE, formed at NORTH PLATTE, where the NORTH and SOUTH branches of the river meet, after the South enters from Colorado and the North from Wyoming. The Indians called the Platte the Nibathaska or Nibrathka (flat or shallow water), giving the state its name. Actually the Platte is so shallow that humorist Artemus Ward said it would make a good river if set on edge. In high water it swells and rages.

To the north the Platte has a network of tributaries, but to the south in Nebraska, the Platte does not have a single tributary. The divide separating the south-flowing waters is very close to the Platte. Pioneer travelers found this long stretch of their route a godsend, as there were no rivers to cross in almost the entire length of the state, if they followed the divide along the south of the Platte.

The LOUP is the major tributary of the Platte, flowing across much of the center of the state before joining the Platte at COLUMBUS. The Platte enters the Missouri at PLATTSMOUTH. The REPUBLICAN RIVER is the major stream of southern Nebraska, and the NIOBRARA to the north.

From its lowest point in Richardson county at 825 feet above sea level, Nebraska rises gradually to the north and west until it reaches an elevtion of a mile above sea level. The eastern fifth of the state is made up of the DISSECTED TILL PLAINS, covered with rich soil deposited by the glaciers. the balance of the state marks the beginning of the GREAT PLAINS, which extend across the western borders.

Unique in the world is the grassland area of the state. These grasses grow in the SANDHILLS area, once the bed of a vast shallow sea. Until the grasses came to hold them down, the sands blew, constantly changing into ridges and roll-ing hills. In the west are the Wildcat Hills. At many points on the Plains are abrupt bluffs and buttes, landmarks for the early travelers. Nebraska has its own badlands, an extension of the better known BADLANDS of South Dakota across the border.

Among the Central West states Nebraska is smaller than all in area except for the two Dakotas.

During the Cambrian period Nebraska was a low, flat land, followed by shallow seas in the Ordovician period. In Silurian times the west rose, while the east still lay below the sea except for a diagonal ridge of low mountains. There was further uplift in the Devonian period, followed by another onrush of the sea, except for some northeast highlands. The Permian age found Nebraska once again mostly covered by shallow seas, raised again in the Triassic perod, only to fall below sea level in the Jurassic and Cretaceous periods. The end of the Tertiary era brought the surface levels about to their present state. Northeastern Nebraska was visited by the great glaciers.

Today the surface outcroppings in the southeast are late Paleozoic; in the northeast the Mesozoic extends almost to the center, and western outcroppings are Cenozoic.

Sunny days and low humidity help to make

Topographic Areas

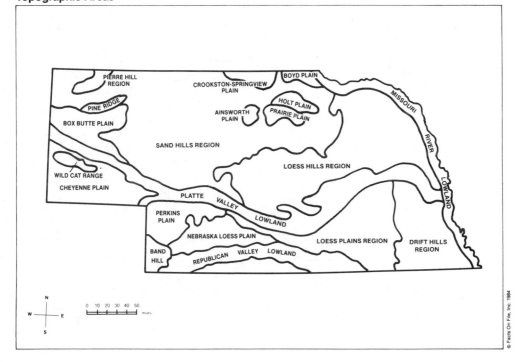

Nebraska

Counties and County Seats

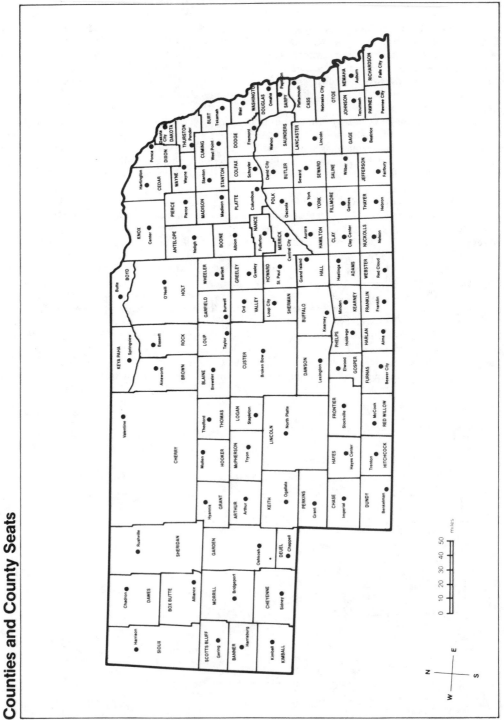

Nebraska

STATE OF NEBRASKA

Capital: Lincoln, settled 1856

Name: From the Platte which the Omaha Indians called the Niubthatak and the Oto Indians called Nebrathka both meaning "flat or spreading water."

Nicknames: Cornhusker State; Tree Planters State;

Motto: Equality Before the Law

Symbols and Emblems:

Bird: Western Meadowlark
Flower: Goldenrod
Tree: Cottonwood
Insect: Honey Bee
Rock: Prairie agate
Gemstone: Blue Agate
Song: "Beautiful Nebraska"
Fossil: Mammoth
Grass: Little Blue Stem

Population:

1985: 1,606,000
Rank: 36th
Gain or Loss (1970-80): +85,000
Projection (1980-2000): +92,000
Density: 21 per sq. mi.
Percent urban: 62.9% (1980)

Racial Makeup (1980):

White: 94.9%
Black: 3%
Hispanic: 28,020 persons
Indian: 9,200 persons
Others: 21,800 persons

Largest City:

Omaha (349,270-1986)

Other Cities:

Lincoln (183,050-1986)
Grand Island (33,180-1980)

Area: 77,355 sq. mi.
Rank: 15th

Highest Point: 5,426 ft. (Johnson Twp., Kimball Co.)

Lowest Point: 825 ft. (Southeast corner of State)

H.S. Completed: 73.4%

Four Yrs. College Completed: 15.5%

STATE GOVERNMENT

Elected Officials (4 year terms, expiring Jan. 1991):

Governor: $40,000 (1986)
Lt. Gov.: $32,000 (1986)
Sec. of State: $32,000 (1986)

General Assembly:

Meetings: Annually in Lincoln
Salary: $4,800 anually plus one round trip travel expenses to and from the session (1986)
Senate, (unicameral legislature): 49 members

Congressional Representatives

U.S. Senate: Terms expire 1989, 1991
U.S. House of Representatives: Three members

Nebraska's continental climate more comfortable. Due to its greater elevation western Nebraska is generally cooler than the east. However, winter can be turned to summer in a few hours when the warm CHINOOK WINDS sweep in. Average rainfall is 22 inches, with more in the East and less in the West. The extreme range of temperature is 165 degrees.

Manufacturing is by far the greatest source of income in Nebraska, bringing in almost thirty billion dollars annually. Much of this is dependent on agriculture, with food products the leader in manufacture, followed by non electrical machinery and chemicals. Agriculture contributes nearly seven billion, giving Nebraska sixth rank in agriculture among the states, including more than half of the country's alfalfa. The state ranks third in livestock and poultry.

An interesting aspect of Nebraska agriculture is visible from the air. From plane windows travelers see huge circles of green crops, surrounded by brown plains. The green areas mark the extent of circular sprinklers as they spread irrigation water from under ground around the verdant circles, which extend for many miles. OMAHA is one of the world's top food processors, ranking first in the country in meatpacking, and among the leaders in frozen foods.

On the route of the nation's first transcontinental railroad, and with Omaha the eastern terminal, Nebraska developed quickly, and Omaha today ranks fourth among the country's rail centers. The city is also an important inland port. As early as 1859 more than 250 steamboats arrived at Omaha that year. Today traffic by barge on the Missouri makes Omaha an even more important port.

In 1985 Nebraska's population stood at 1,606,000, with 95% of these white, and black population at 3.1%. Hispanic people numbered only 28,000. In the period following the 1980 census, the total population noted a very slight decline of 16,000 persons. The state ranks 36th in population among all the states, and fifth in the Central West region.

The FOLSOM people are the earliest prehistoric group known to have been in Nebraska, but almost certainly earlier groups existed. Folsom remains have been found along with mammoth and musk ox fossils, and this helps to date these peoples. Among the early remains are boxes formed by stone slabs, found near O'Neill.

Of the eight major groups found by the early explorers, the PAWNEE were the largest. Others were SIOUX, CHEYENNE, PONCA, OTO, MISSOURI, ARAPA-

HOE and OMAHA. The Pawnee lived in large circular permanent lodges, some sixty feet in diameter. In summer they occupied tepees while hunting. They grew substantial crops of beans, corn, melons and added tobacco later. Each village had its own chiefs and council, and the Pawnee were loosely governed by a Grand Council of the four groups of united Pawnee.

Most important to Indians of the area were the buffalo hunts, and the meat was carefully distributed among the people, providing adequate food for all.

The fierce nomadic plains tribes terrorized both the peaceful agricultural tribes and the early European settlers. The Sioux and Pawnee were almost constantly at war. More peaceful were the Omaha and Oto. Chief BLACKBIRD of the Omaha had considerable success in preparing his people for the inevitable white takeover.

Although both Spain and France claimed the present Nebraska area, few people of either nation ventured into it. France eventually claimed the territory and then almost immediately sold the vast LOUISIANA PURCHASE to the U.S. in 1803. A year later the famed exploring party of LEWIS AND CLARK pushed up the Missouri River, arrived at the Platte River mouth on July 21 and held a council with the Oto Indians. They left Nebraska shores on September 7 and returned in triumph two years later.

When Zebulon PIKE crossed Nebraska in 1806, he too held a great council of the Indians, this time at the Republican River. To demonstrate the new U.S. control, Pike formally lowered the Spanish flag and raised the U.S. symbol.

After a long procession of traders and trappers had cris-crossed the area, the first permanent non-Indian settlement in the state was the AMERICAN FUR COMPANY outpost founded by Peter Sarpy, at BELLEVUE south of present Omaha in 1823.

The next major development was Jim BRIDGER's founding of FORT BRIDGER as a supply station for travelers on the OREGON TRAIL. Travel was greatly enhanced by the passage of thousands of Mormons across the state on their way to found Utah. Permanent settlers were few, but by 1854 enough had come in to form a territory, as part of the Kansas-Nebraska Act.

Nebraska was expected to be a free state, and Kansas was to be a slave state, but the resulting rage over control of Kansas involved Nebraska in the conflict over slavery, particularly in the UNDERGROUND RAILROAD, aiding hundreds of slaves to escape across the territory and north into Canada. Notorious Abolitionist John

BROWN was active in that movement. Despite its light population, Nebraska sent 3,307 into CIVIL WAR service.

With the HOMESTEAD ACT of 1862, landseekers swarmed into Nebraska, where each person could claim up to 160 acres by living and working on the claim for a period of time. The land office at BEATRICE was so crowded, women had to beg for space to keep from fainting. By March 1, 1867, Nebraska was ready for statehood, as the 37th state.

After bitter arguments, Nebraskans chose a bare prairie site as their capital and named it for the martyred President Lincoln.

Indian troubles plagued the state as the original settlers struggled to keep their land, but the tide of white settlers was overwhelming, increasing dramatically with the completion of the transcontinental railroad in 1869.

However, by 1890 a reverse migration began, with thousands moving back east after suffering killing winters, drouth and the collapse of farm prices. However, the state maintained itself and held the Trans-Missisippi International Exposition at Omaha in 1898, with President William McKinley as a distinguished visitor.

WORLD WAR I demand for crops brought a boom, followed by another period of drouth and drop in farm prices, with recovery not complete until coming of WORLD WAR II, in which 120,000 from Nebraska saw service.

Modern Nebraska is the only state to have only one body in its legislature. The UNICAMERAL system was adopted in 1934. The state has been equally inventive in its efforts at conservation of natural resources.

Traditionally Republican, Nebraska went Democratic in 1970 with the election of James Exon as governor, reelected in 1974. Republicans captured the governorship in 1978, but Democrats came back with Robert Kerrey. Then Republicans recouped in 1987 with governor Kay Orr, for a term expiring in 1991.

Nebraskans can boast of one native President of the United States—Gerald FORD (1913—), born at Omaha. However, he left the state at the age of two when his parents were divorced and his mother took him to Michigan where he grew up.

One of the most "sterling" of Nebraska notables was J. Sterling MORTON (1832-1902), a principal figure in the conservation movement and the founder of the national ARBOR DAY. Almost every day after he arrived in Nebraska in 1855, he would plant some trees. He proved that treeless Nebraska could support forests.

Morton was Nebraska's first cabinet officer, as secretary of agriculture under Cleveland.

Morton's son, Joy, continued his father's conservation interests by founding the famed Morton Arboretum at Chicago, Illinois, and was also the founder of the Morton Salt Company. Julius Morton, another son, was secretary of the Navy under Theodore Roosevelt.

However, the most spectacular of Nebraska's political careers was that of William Jennings BRYAN (1860-1925), first Democratic congressman from Nebraska, who gained fame as the country's greatest orator. He was the Democratic candidate for president in 1896, 1900 and 1908. He is still remembered as the winner of the notorious Scopes "monkey" trial in 1925, followed only a few days later by his death.

Another prominent Nebraskan in politics was George W. NORRIS (1861-1944), a Republican although a protege of Bryan. After election to the Senate, Norris served Nebraska in Congress for 47 years. He was responsible for the great Tennessee Valley Authority, with its Norris Dam named in his honor. He was a principal proponent of the Nebraska unicameral legislation and the LITTLE TVA in the Platte Valley. At age 81 he failed to be reelected.

One of the best known Nebraska writers was Willa CATHER (1873-1947) of RED CLOUD, who won the Pulitzer Prize in 1923 and is best known for her *Death Comes for the Archbishop (1927).* Other Nebraska writers were Bess Streeter ALDRICH, (1991-1954) Marie SANDOZ and Mignon G. EBERHART. Famed composer-conductor Howard HANSON (1896-1991) was a Nebraska native.

Showman of a different kind was noted plainsman William "Buffalo Bill" CODY (1846-1917), who organized his great Wild West Show at NORTH PLATTE. Other famed Nebraska entertainers include Johnny CARSON,(1925-) Fred ASTAIRE (1899-1987), Dick CAVETT (1936-), Marlon BRANDO (1924-), Robert TAYLOR (1911-1969) and Harold LLOYD (1894-1971).

Among Nebraska's most famous names is that of Monsignor Edward J. FLANAGAN (1886-1948), who borrowed 90 dollars to begin his home for homeless boys (BOY'S TOWN), which became one of the best known institutions of its kind under his long-term guidance.

One of the nation's major annual attractions began at Omaha in 1894 as a hoped-for civic boost similar to Mardi Gras at New Orleans. A group started the AK-SAR-BEN (Nebraska spelled backwards) organization which ever since has sponsored the Ak-Sar-Ben Ball and coronation, as well as the Ak-Sar-Ben baby

beef show.

Joslyn Art Museum, Great Plains Black Museum and Omaha Children's Museum are outstanding institutions of their kind. Union Pacific Historical Museum presents outstanding railroad displays, and the restored Union Station is now the Western Heritage Museum. Gerald Ford birthsite is another Omaha point of interest, as are CREIGHTON UNIVERSITY and the great University of Nebraska Medical Center.

Not far from Omaha are famed Boy's Town and the STRATEGIC AIR COMMAND headquarters, the nation's defense center, with its museum of SAC memorabilia, at Offutt Air Force Base.

HOMESTEAD NATIONAL MONUMENT at Beatrice brings the homestead period to life, and exhibits of a still earlier time are found at Aurora's Plainsman Museum. STUHR MUSEUM of the Prairie Pioneer at GRAND ISLAND, designed by Edward Durell Stone, is unique, with 60 original buildings, operating steam train, and unusual Pioneer Trail. At Nebraska City the imposing Arbor Lodge, contributed to the state by the

The Nebraska capitol at Lincoln has been hailed as one of the world's finest public buildings.

Morton Family owners, is now a state park, with its noted Tree Trail, commemorating the first Arbor Day.

By contrast visitors to Sand Hills cattle country can see the unique region of the hemisphere's largest stabilized sand dunes. Another natural region of many charms is Niobrara River National Wildlife Refuge.

Visitors may follow the historic trails across Nebraska, including views of such dramatic natural landmarks as CHIMNEY ROCK NATIONAL HISTORIC SITE and SCOTTS BLUFF NATIONAL MONUMENT. Another national monument, FOSSIL BEDS, combines the attractions of the fossils with a prime hunting ground for gems. Nebraska's National Forest near CHADRON is the only one able to boast that it was created entirely by plantings made by man.

Nebraska's capital holds many attractions, including one of the most interesting of all capitol buildings—"a monument to the past and a promise of the future," as the New York *Times* wrote. The capitol is renowned for its external and internal art, including Daniel Chester French's famed "Lincoln." The single legislative chamber underscores Nebraska's unique unicameral status. Topping the skyscraper building is the gold glazed tower with its sculpture of "The Sower."

In the shadow of the capitol is the striking governor's mansion.

Among the attractions of the University of NEBRASKA at Lincoln is the Nebraska State Museum, housing the world's largest mammoth skeleton. Also on campus is the small gem called the Sheldon Memorial Art Museum.

The William Jennings Bryan Home, Fairview, is another Lincoln landmark.

NEBRASKA CITY, Nebraska. City (pop. 7,127), Otoe County, southeastern Nebraska, on the MISSOURI RIVER, southeast of LINCOLN . Formed by the consolidation of three small communities, Nebraska City began as a trading post which grew into a freighting center and later a major shipping center for agricultural products. One of the city's most famous citizens, J. Sterling MORTON (1832-1902), founded ARBOR DAY and served as the secretary of agriculture under President Cleveland. The ARBOR LODGE STATE HISTORICAL PARK includes sixty-five acres and the Morton homestead. Near Nebraska City is John BROWN's (1800-1859) Cave, a major station on the UNDERGROUND RAILROAD. The annual Arbor Day Celebration commemorates the nation's first Arbor Day, held at Arbor Lodge.

NEBRASKA CULTURE. One of the groups of prehistoric people living in the area of present-day Nebraska who have left behind bone hoes and other agricultural implements indicating that they were probably good farmers. They produced brownish-red pottery of many sizes and uses and very little else is known about them.

NEBRASKA WESLEYAN UNIVERSITY. Private institution located in LINCOLN, Nebraska, which was created in 1887 by merging three small Methodist colleges. During the 1985-1986 academic year 1,337 students were enrolled in the university which employed 115 faculty members.

NEBRASKA, UNIVERSITY of. Institution of higher learning established in 1869 under terms of the Morrill Act. The first faculty included four instructors plus a chancellor. There were twenty students. Today the university maintains branches in many parts of the state, although most of the colleges are located on the 180-acre main campus in LINCOLN. The Nebraska Center for Continuing Education has been housed in a building noted for its striking architecture which accommodates educational conferences and seminars. The university is recognized for one of the country's finest small art galleries, given to the university as a gift of the Sheldon family in memory of Mary Frances Sheldon and her brother, A. Bromley Sheldon. The university also houses the outstanding Nebraska State Historical Society and the Nebraska State Museum which contains the world's largest mammoth remains. During the 1985-1986 academic year the university enrolled 23,214 students and employed 1,025 faculty members.

NECHES RIVER. East Texas, rises in Van Zandt County in northeast Texas and flows south and southeast into Sabine Lake. The Neches is part of the Sabine-Neches Waterway system, centered at PORT ARTHUR, Texas.

NEEDLES FORMATION. Remains of the oldest and deepest rocks pushed up to form the BLACK HILLS of South Dakota, southwest of RAPID CITY. The granite spires, standing one mile above sea level, are the result of millions of years of erosion.

NEEDLES HIGHWAY. Otherwise known as South Dakota State Highway 87 southwest of the MOUNT RUSHMORE NATIONAL MEMORIAL. The

The University of Nebraska at Lincoln

paved road winds past HARNEY PEAK and SYLVAN LAKE to the northwest border of CUSTER STATE PARK near Legion Lake. The location of the highway through such picturesque countryside was the result of the efforts of Senator Peter Norbeck.

NEIHARDT, John Gneisenau. (Sharpsburg, IL, Jan 8, 1881-Columbia, MO, Nov. 3 1973). Poet laureate of Nebraska, chosen in 1921 by an act of the state legislature. He attended schools in Wayne, Nebraska, and received a B.S. degree at Nebraska Normal College at the age of 16. After teaching in country schools, he moved to Bancroft, Nebraska, in 1900 where he worked with an Indian trader and became an authority on Indian life and customs. His major work, *A Cycle of the West,* was begun in 1912, and occupied much of his time for 29 years before completion in 1941. It was published in 1949. He was literary editor of the St. Louis Post-Dispatch from 1926 to 1938 and poet in residence and lecturer in English at the University of Missouri, Columbia, from 1949 to 1966. The John G. Neihardt Center in BANCROFT, Nebraska, exhibits professional and personal memorabilia, with a Sioux prayer garden on the grounds symbolizing the writer's interest in Indian customs and traditions.

NELLIE JOHNSTONE WELL NUMBER ONE. Oklahoma's pioneer commercial oil discovery which came in in 1897. An exact reproduction has been created in Johnstone Park at BARTLESVILLE, Oklahoma, near where the discovery well was drilled.

NEODESHA, Kansas. Town (pop, 3,414), Wilson County, southeastern Kansas, north of Independence and south of Chanute, at the junction of the Fall and Verdigris rivers. Its name may have come from the Indian word meaning the junction of rivers. "Old Norman #1," drilled in 1892, was the first commercially producing oil well west of the Mississippi. In pioneer days the town was saved by a quick-thinking doctor. Upon finding the grave of their chief robbed, OSAGE INDIANS prepared to destroy the community. A local doctor pacified the warriors by giving them a skeleton from his office, claiming that it was the body of Little Bear, one of the great Osage chiefs.

NEOSHO RIVER. River in southeast Kansas and northeast Oklahoma where it is called the GRAND. The Neosho begins in Morris County in east central Kansas and flows 460 miles southeast and south into the ARKANSAS RIVER in Muskogee County, Oklahoma.

"NESTERS" A term applied to persons who settled on land without permission. It also was used by cowmen when referring to farmers.

NEUTRAL STRIP. Area of land stretching for an undetermined width on both sides of the SABINE RIVER. forming the border of south-central Texas with southern Louisiana. After the Louisiana Purchase in 1803, Spain and the United States both claimed control. Until the matter could be settled, the two nations agreed to make the strip neutral territory. This temporarily satisfied the concern Spain had for her hold on Texas, which some Americans claimed belonged to the United States as a part of its purchase of the Louisiana Territory from France. Until the Sabine and RED rivers were set as the northern and eastern boundaries of Texas in 1819, this neutral and unpoliced strip calmed the international tension and offered wanted outlaws the ultimate haven from arrest.

NEW BRAUNFELS, Texas. Town (pop. 22,-402), seat of Comal County, located on the COMAL and GUADALUPE rivers in southeast Texas. It was settled in 1845 by Prince Carl of Solms-Braunfels from Germany. He built a castle headquarters on the Texas prairie, and staffed it with velvet uniformed servants. With no transportation provided for them, 5,000 German immigrants started for New Braunfels. As many as 2,000 are thought to have died on the long walk from the Gulf Coast, and the route is lined with German graves. Today the town's industries include textiles, furniture, metal products, and tourism. There is also diversified farming and cattle-raising. Children's May Festival and Masquerade annual continues many of the early German customs.

NEW LONDON, Texas. Town (pop. 942), Rusk County, northeastern Texas, southeast of DALLAS and east of TYLER. On March 18, 1937, 413 people were killed in an explosion in a local school, one of the worst such disasters in history. The victims are remembered by a memorial sundial set with a semi-precious stone for each person killed.

NEW MEXICO. State, located at the southwest corner of the Central West region, with all its borders manmade except for the short border where the RIO GRANDE RIVER separates New Mexico from Texas. The rest of the border with Texas to the south and to the east combines to form one of the longest borders between two states. To the north is Colorado and to the west Arizona. The short international boundary separates New Mexico from Mexico to the south.

A feature unique to the four states involved is the single point in the U.S. where the four come together. New Mexico becomes the southeast portion of this foursome, where its corner meets with those of Arizona, Utah and Colorado. Of particular interest is the fact that Utah and New Mexico come together only at the at the Four Corners.

Principal river of New Mexico is the Rio Grande, one of the country's five major rivers, entering from Colorado in the north, practically bisecting the state, flowing through ALBUQUERQUE, SOCORRO and LAS CRUCES and flowing out of New Mexico as it reaches EL PASO, Texas on its long way to the Gulf of Mexico.

Rivers of New Mexico also flow to the Gulf of Mexico by way of the remote Mississippi River system and others flow to the Gulf of California by way of the COLORADO RIVER. The PECOS RIVER begins in the SANGRE DE CRISTO MOUNTAINS, flows south, then southeast and exits New Mexico to join the Rio Grande in Texas. The CANADIAN RIVER starts its flow at the northern border, flows south then east into Texas, eventually

Topographic Areas and Landforms

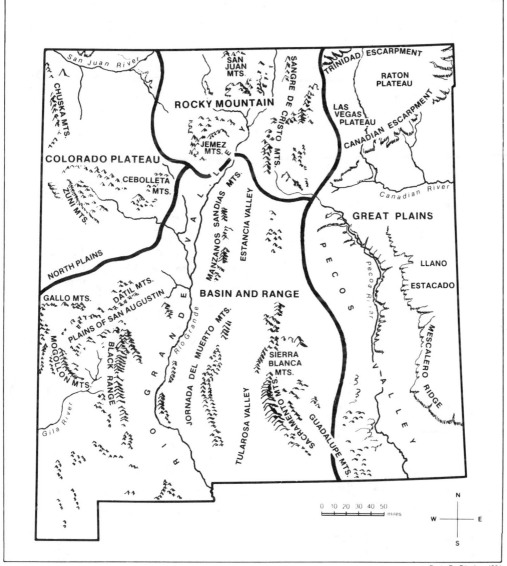

finding its way to the Mississippi system. The SAN JUAN RIVER cuts around the northwest corner of New Mexico and eventually joins the COLORADO RIVER system, flowing to the Gulf of California.

The ROCKY MOUNTAINS march through New Mexico from north to south, gradually lowering in height as they proceed south. Among the most striking ranges are the Sangre de Cristo, named "Blood of Christ" by devout Catholics who saw them reflecting a blood red sunset.

There are at least seventeen other major ranges in the state.

The desolate region known as the STAKED PLAINS occupies much of the northeast of the state. To the south are the arid desert homes of coyotes, lizards, rattlesnakes, green irrigated fields and air conditioned cities and towns. Westward is the high plateau country.

New Mexico is the fifth largest of all the states and third in size in the Central West region.

New Mexico

Counties and County Seats

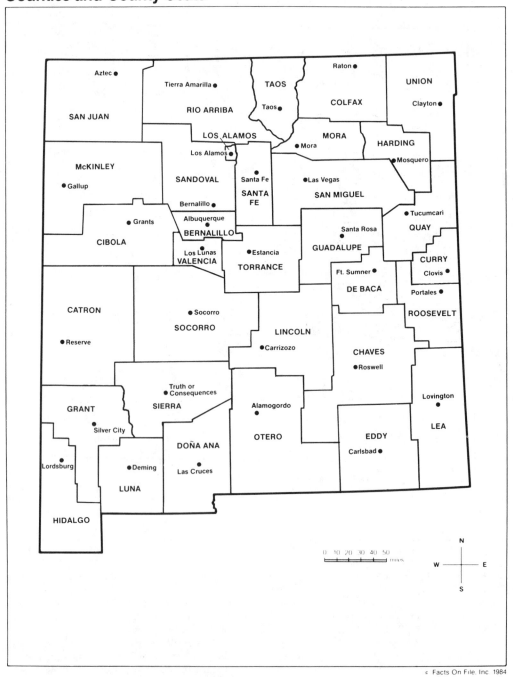

© Facts On File, Inc. 1984

STATE OF NEW MEXICO

Capital: Santa Fe, settled 1609

Name: Mexico from the Aztex Mexitel "place of the war god."

Nickname: Land of Enchantment

Motto: "Crescit Eundo" (It Grows as it Goes)

Symbols and Emblems:
 Bird: Roadrunner
 Animal: Black Bear
 Fish: Cutthroat Trout
Flower: Yucca
 Tree: Pinon
 Gem: Turquoise
 Vegetables: Chile and Frijol
 Colors: Red and Yellow of old Spain
 Songs: "Asi es Nuevo Mejico" & "O, Fair New Mexico"

Population:
 1985: 1,450,000
 Rank: 37th
 Gain or Loss (1970-80): +286,000
 Projection (1980-2000): +427,000
 Density: 12 per sq. mi.
 Percent urban: 72.1% (1980)

Racial Makeup (1980):
 White: 75%
 Black: 24,042 persons
 Hispanic: 32.8%
 Indian: 106,100 persons
 Others: 195,100 persons

Largest City:
 Albuquerque (366,750-1986)

Other Cities:
 Santa Fe (48,899-1980)
 Las Cruces (45,086-1980)
 Roswell (39,676-1980)

Area: 121,593 sq. mi.
 Rank: 5th

Highest Point: 13,161 ft. (Wheeler Peak)

Lowest Point: 2,817 ft. (Red Bluff Reservoir)

H.S. Completed: 68.9%

Four Yrs. College Completed: 17.6%

STATE GOVERNMENT

Elected Officials (4 year terms, expiring Jan. 1991):
 Governor: $60,000 (1968)
 Lt. Gov.: $38,500 and $150 per day as acting governor (1986)
 Sec. of State: $40,425 (1986)

General Assembly:
 Meetings: Annually in Santa Fe
 Salary: $75 per day while in session (1986)
 Senate: 42 members
 House: 70 members

Congressional Representatives
U.S. Senate: Terms expire 1989, 1991
U.S. House of Representatives: Three members

Through much of the Paleozoic Era, present New Mexico remained an elevated region until shallow seas covered most of the area in the Permian period. Portions rose in the Jurasic period, but most of the Mesozoic Era found the seas prevailing. By the end of the Cenozoic area the surface lay much as it does today.

Surface outcroppings of rocks are so varied as to represent almost every geologic period.

The Sunshine State is proud of its climate, with the sun beaming down as much as 80% of the time in many areas. Daytime temperatures are generally comfortable even in the winter, while summer nights are cool. As the elevation rises toward the west, the average temperature drops. The snow that falls generally melts almost immediately except in the mountains. Rainfall ranges from 12 to 16 inches annually, averaging 13 inches. The extreme range of temperature is 166 degrees.

Unlike most of the states, New Mexico does not depend on manufacturing for the largest part of its income. Minerals and mining bring close to six billion dollars in annual income, while manufacturing is second with about three billion. New Mexico ranks first in the nation in potash production, second in uranium, and produces most of the carbon dioxide. Most of the nation's PERLITE (sometimes called mineral popcorn) comes from New Mexico. The state ranks high in natural gas and helium production. Oil production began in 1909 and today includes some of the finest grade petroleum. Copper mining started as early as 1800, rose to great heights, then declined but continues to be important, utilizing the lower grade ores.

Livestock accounts for much of the agricultural income, which in total nearly equals that from manufacturing. Cotton is the most important crop, followed by hay, sorghum, commercial vegetables, wheat, peanuts, broomcorn, barley and pecans. Adding a bright note to agriculture are the fields of chili peppers, which hang out to dry in colorful clusters almost everywhere in the state.

Six million acres of commercial timber make lumber and wood products a profitable part of New Mexican manufacturing.

"Formal" transportation began in New Mexico with the King's Highway (EL CAMINO REAL) in 1581, making it the oldest European period highway in the country. More important was the SANTA FE TRAIL, creating great volumes of trade between eastern U.S. states and the Southwest, then supplanted by the Santa Fe railroad.

Seventy-five percent of the present population is white, 12.5% black. Hispanic persons total 476,089 and Indians number about 120,000. The 1985 population of 1,450,000 shows a dramatic increase of 284,000, or almost 20% in five years since the 1980 census.

Before mankind arrived, New Mexico had a large population of animals now extinct, including dinosaurs, turtle, fish and amphibians, all represented in the numerous fossil quarries.

Human occupation as early as 25,000 years ago is indicated by the remains of people found in the SANDIA MOUNTAINS, consequently known as SANDIA PEOPLE. Later came the FOLSOM PEOPLE , whose remains are found among animals contemporary to them, such as the giant sloths and mastodons. Later, the BASKETMAKER peoples roamed about collecting seeds and nuts.

By the 12th century A.D., the people of New Mexico had developed an amazing degree of civilization, with well-kept roads, construction using timbers brought from as far as thirty miles distance, farmers tending well-kept fields and children herding flocks of turkeys outside cities with buildings five stories tall. One such city was PUEBLO BONITO, sheltering great apartment buildings with 800 apartments each, constructed of masonry of the highest quality found north of Mexico—all created in many parts of the state by the advanced PUEBLO PEOPLE, who reached their peak from 900 to 1200 in the third of their five periods of advancement.

The civilization declined from its peak, and no one knows for sure why the civilization was abandoned; drouth and attack from outside were undoubtedly factors. However, eighteen of the ancient pueblos are inhabited by descendants, even today. The culture is documented by the astonishing art and crafts remaining for study by modern scholars and for the admiration of visiitors.

The peaceful Pueblo people were no match for the fierce ATHABASCAN tribes that had moved south in two main groups—NAVAJO and APACHE. The Navajo became somewhat settled, building houses of rocks and logs and adobe, called hogans. The Apache also became more settled, at a later date. COMANCHE and UTE tribesmen soon appeared in the area also.

Shipwrecked in Florida, three members of the crew of Cabeza DE VACA followed their leader in a desperate journey overland which took them across present New Mexico in 1536. The tales they told on reaching Mexico City excited the Spanish rulers, who sent Francisco Vasquez de CORONADO (1510-1554) in 1539 to search for what were thought to be the golden SEVEN

CITIES OF CIBOLA. Coronado's expedition, one of history's greatest, made many exciting discoveries but failed to find gold and so returned in disgrace.

In 1598 youthful Don Juan de ONATE (1550?-1630) brought a great expedition into the region and established a settlement, conquering the strong fortress of ACOMA PUEBLO, but he returned to Mexico when his fortune gave out.

In 1609 the oldest capital city in the U.S. was called la Villa Real de la Santa Fe de San Francisco by its founder, Don Pedro de Peralta. Of course, it is now simply known as SANTA FE.

Franciscan fathers made substantial headway in converting the Indians, but Spanish cruelties brought about numerous revolts. In 1680 governor To-pa-tu of the PICURIS PUEBLO united the Indians and drove the Spanish from Santa Fe, killing 400 of them, in perhaps the greatest wartime success of the Indians in America.

However, the Spanish returned in 1692 and founded another village in 1706, this one named for the Duke of Alburquerque, now ALBUQUERQUE, with a slight change of spelling. Spanish control continued, with constant harrassment by the Indians and further worry over U.S. purchase of the LOUSIANA TERRITORY with its undetermined boundaries.

In 1821 Spain gave way to a new government in Mexico, which lifted restrictions on U.S. trade. The people of Santa Fe went wild over the wonderful goods transported from the far off U.S. over the newly traced Santa Fe Trail.

A revolt against Mexico in 1837 was put down, but U.S. forces under Stephen Watts KEARNY (1794-1848) captured Santa Fe during the WAR WITH MEXICO in 1846, and all of New Mexico soon fell to the Americans. In the CIVIL WAR, Confederate forces captured Albuquerque in 1862, but the North soon retook the area. Much more disturbing were the continued Indian attacks under famed Indian leaders such as GERONIMO (1829-1909), COCHISE (1812-1874) and Victorio. Bandits and outlaws, generally, added to the concerns of settlers and officials. But law and order gradually developed.

Mining, farming, manufacturing, banking and communication all prospered, and by 1906 New Mexico proposed a plan to create a new state combining both New Mexico and Arizona. This failed, but New Mexico became a state on January 6, 1912. In 1916 Mexican revolutionary Francisco "Pancho" VILLA invaded New Mexico at COLUMBUS, but no further conflict followed in the state. The great conflict of WORLD WAR I drew 15,000 New Mexicans into military service.

The greatest drama of WORLD WAR II began to unfold in New Mexico when the world's first atomic bomb was exploded at LOS ALAMOS. Men and women in service from New Mexico during that war totalled 73,000.

Modern New Mexico values its unparalleled mixture of three of America's great cultures, Indian, Spanish/Mexican and other European. The great appeal of the state as a place to live, work and retire has resulted in one of the most dramatic population growths in the nation, approaching 350%. In 1985 *Places Rated Almanac* named Albuquerque as one of the nation's 25 best cities in quality of life.

Two remarkable clerics have a firm place in early New Mexican history. Padre Antonio Jose Martinez loved the country and was devoted to the people. For forty years he labored to improve conditions, setting up the first coeducational school in the southwest. He founded a newspaper and served in the territorial legislature. Then he fell under the jurisdiction of the American branch of the church, with Monsignor Jean Baptiste LAMY (1814-1888) at the head.

They disagreed so intensely that Father Martinez was defrocked and excommunicated. In his different way Bishop Lamy made many improvements, rebuilt abandoned churches and added 85 new ones. His death in 1888 provided author Willa CATHER (1873-1947) with the title of her novel *Death Comes for the Archbishop*.

New Mexico figured prominently in the life of two authors. While General Lew WALLACE (1827-1905) was in government service in New Mexico, as governor of the territory, he wrote his famed novel *Ben Hur* (1880), one of the most popular novels ever published in the U.S. Noted author D. H. LAWRENCE (1885-1930) made his headquarters at TAOS for two years and is buried there.

The Pulitzer Prize was awarded to author Oliver LA FARGE (1901-1963) for his Navajo romance, *Laughing Boy*.

New Mexico has attracted artists since the days of the prehistoric cave paintings, and modern Santa Fe and Taos for several generations have sheltered noted artists. Most notable of all was Georgia O'Keefe, one of the major talents of her day. She came to New Mexico after gaining fame elsewhere, but she fell in love with the state and her ranch. Her death came in Santa Fe in 1986 at the age of 98.

Another legendary artist was Pueblo potter Maria MARTINEZ, who elevated the traditional

pottery techniques to a form of high art and was world renowned when she died in 1980.

Legend of another kind was Christopher "Kit" CARSON (1809-1868), called "the truest hero of the frontier." Having gained fame as a guide of famous explorer John C. FREMONT (1830-1890), Carson led Union troops to victory in New Mexico during the Civil War. He loved his Taos home and his grave there is a landmark, celebrating his modesty, courage, ability and integrity.

"Bad guys" of the area also became legend, including William H. "Billy the Kid" BONNEY (1859-1881), who perpetrated his first murder at age twelve, and was finally killed himself near Fort Sumner.

Famed lawman Elfego BACA was fearless under fire, and a siege in which he escaped 3,000 shots and was rescued after 30 hours was made into a movie called *The Nine Lives of Elfego Baca.*

The best known newsman of his day, Ernie PYLE (1900-1945) of Albuquerque, was killed while reporting World War II in the Pacific.

Among sports figures, Santa Fe celebrity Jess WILLARD (1881-1968) gained the world heavyweight boxing title in 1915.

For tourists, New Mexico provides attractions which are unique around the world. The magnificent scenery, the varied peoples, the splendid ruins, the customs, fiestas and international cultural attractions have made it irresistable to millions.

Santa Fe, alone, can satisfy almost every whim of a visitor. FIESTA SANTA FE is the oldest annual celebration in the nation and one of the most stirring. The art galleries of the city are internationally renowned, as is the grand opera

of the SANTA FE OPERA Company in its outdoor setting. The unique capitol building reflects the architecture of the area, the only one in the U.S. in the style of territorial days. Most interesting of all is the ancient PALACE OF THE GOVERNORS, oldest public building in the U.S., now surrounded by stalls of the local artists and merchants. San Miguel of Santa Fe is the nation's oldest church.

The Taos area provides not only the finest in modern art but represents the many Indian traditions. TAOS PUEBLO, open to visitors, has a charm not found elsewhere, in this oldest "cooperative apartment complex" in the country. Of the eighteen other occupied Pueblos, each has its own individual attraction, including feast days, dances, processions, art and local customs.

For the amateur archeologist, New Mexico is a never ending delight. GRAN QUIVIRA NATIONAL MONUMENT, Kuaua Kiva in CORONADO STATE MONUMENT, TSWANKAWI CLIFF DWELLINGS AND RUINS, the enormous ancient houses of PECOS and more than 25,000 other ruined sites provide endless opportunities for observation and study of ancient peoples who developed an amazing civilization.

Albuquerque, New Mexico's largest city, has grown around the central plaza, where the old town has been preserved and restored in charming fashion, and its colorful crowds include sombreroed cowboys, Indians in blankets mingling with atomic scientists and tourists.

The federal government is represented by more than 100 agencies in the Albuquerque area.

The nearby SANDIA MOUNTAINS can be reached by the world's longest unsupported cable ride,

The Santa Fe Opera has won a world reputation for the quality of its productions and for the imaginative programming which has brought many premieres to the unique community.

The capitol at Santa Fe is said to be the only one in the nation designed in the style of local architecture.

and the mountain region provides both summer and winter activities.

Among the state's many other attractions are hot air ballooning, the Navajo reservation in the shelter of looming SHIPROCK, CLOUDCROFT with Sunspot, world's largest center for study of the sun and the world's highest golf course, and such exceptional resorts as Ruidoso with its great skiing and the country's richest horse race.

NEW MEXICO HIGHLANDS UNIVERSITY. State university founded in 1893 and located in LAS VEGAS, New Mexico, once a Mormon community on the SANTA FE TRAIL. Undergraduate and graduate course work is offered in liberal arts and teacher education. The University of NEW MEXICO and New Mexico Highlands University offer cooperative plans for students studying industrial education, political science, business, physical therapy, history, and medical technology. Enrollments for the 1985-1986 academic year totalled 2,071 students, while the university employed 165 faculty members.

NEW MEXICO INSTITUTE OF MINING AND TECHNOLOGY. State school in SOCORRO, New Mexico. The four divisions are: the State Bureau of Mines and Mineral Resources, the Research and Development Division, the College, and the Petroleum Recovery Research Center. Langmuir Laboratory in the Magdalena Mountains includes facilities for research on atmospheric phenomena including thunderstorms. During the 1985-1986 academic year the school enrolled 1,280 students and employed 100 faculty members.

NEW MEXICO MILITARY INSTITUTE. Educational facility founded in 1891 in ROSWELL which offers a college preparatory high school and two year junior college. Academics are grouped into the divisions of humanities, social science, and natural science with mathematics. The department of military science, staffed by instructors assigned by the Department of the Army, offers a two year commissioning program. The Institute, considered one of the nation's leading military schools, is rated outstanding by the U.S. defense department. The

school regularly enrolls approximately 700 students.

NEW MEXICO STATE UNIVERSITY. Las Cruces with branches in ALAMOGORDO, CARLSBAD, and GRANTS. Those branches provide freshmen and sophomore class instruction near their homes. Upon completion of sixty-six hours the students may receive the Associate Degree or may transfer to the LAS CRUCES campus to complete the final two years. The main campus at Las Cruces was founded in 1888 as Las Cruces College, a land-grant college. Students may choose undergraduate studies in any of ninety-five areas in five undergraduate colleges. The Graduate School provides forty-one fields of study at the master's level and twenty-three at the doctoral. During 1985-1986 the university enrolled 12,818 students and employed 723 faculty members.

NEW MEXICO, UNIVERSITY OF. Chartered in 1889, opened in 1892, the university's main campus is at ALBUQUERQUE, where modified pueblo style buildings dot a uniquely beautiful campus, where a popular gathering place is the duck pond in the center of the campus. As a key cultural institution of a vast area of the Southwest, the university has given increasing attention to the culture and history of the region and to Latin American affairs. The anthropology and geology museums undertake research and display the various aspects of the region in their fields. Other research centers are located at LOS ALAMOS and Holloman Air Force Base Missile Center. The 24,515 students are instructed by a faculty of 1,239.

NEWCASTLE, Wyoming. Town (pop. 3,596). Seat of Weston County, northeastern Wyoming, southeast of GILLETTE near the South Dakota border. Springs near Newcastle were valuable sources of salt in the pioneer days. The city was founded in 1889 with the discovery of coal and was named after Newcastle-Upon-Tyne in England. The local economy is based on lumbering, mining, ranching and petroleum exploration. Tours of the Accidental Oil Company offer visitors the opportunity of seeing the only known hand-dug oil well in the United States, in addition to antiques of the oil industry. Seasonal events include Whoop 'n Holler Days during the third weekend in June and the Weston County Fair the second week of August.

NEWHOUSE, Samuel. (New York, NY, Oct.

14, 1853—Salt Lake City, UT). Mining capitalist. Newhouse operated a freighting business in LEADVILLE, Colorado, from 1879 to 1886 when he turned to mining. Two years later he moved to DENVER and eventually became president of the Denver, Lakewood and Golden Railroad, the Boston Consolidated Mining Company, the Newhouse Mines and Smelters, and the Nipissing Silver Mines Company. He planned the Newhouse Tunnel between IDAHO SPRINGS and CENTRAL CITY.

NEWSPAPERS. "Kansas is the child of newspapers," according to D. W. Wilder, and another writer declared that "Kansas is perhaps the only place where a newspaper was started before there was any news to print." In one sense, Kansas was the birthlpace of journalism in the Central West. Kansas' first newspaper was printed entirely in the Shawnee language, the *Siwinowe Kesibwilf,* started in 1835. The first weekly was *Kansas Weekly Herald* of LEAVENWORTH, with its type first set under a tree in 1854. From that point on the journalists of Kansas produced some of the finest work in the country, culminating in the internationally famed Pulitzer Prize winner William Allen WHITE (1868-1944) and his Emporia *Gazette.*

Another prominent Kansas paper was the socialist journal *Appeal to Reason.* Its special issues sometimes exceeded 2,500,000 copies, flowing out from the Kansas prairies.

Technically the first newspaper published in the region was the Spanish language *Gaceta de Texas,* begun in 1813. The San Felipe *Telegraph and Texas Register,* begun in 1835 was the first lasting newspaper in the state.

First newspaper published in New Mexico was the Spanish language journal of 1834, *El Crepusculo de la Libertad.* First newspaper published in Oklahoma was the *Cherokee Advocate,* begun in 1844, partly in English and partly in Cherokee. Nebraska's first newspaper was the BELLEVUE *Platte Valley Advocate,* established in 1854. Today the OMAHA *World-Herald* has international fame. The *Rocky Mountain News* and *Cherry Creek Pioneer,* published their first issues at DENVER in 1859 only twenty minutes apart.

In South Dakota newspapers began at SIOUX FALLS in 1859 with the Dakota *Democrat,* succeeded by the *Weekly Dakotan* at YANKTON in 1861. North Dakota's first newspaper was the *Frontier Scout* of FORT UNION and Fort Rice beginning in July 1864, but the state's oldest continuing newspaper is the BISMARCK *Tribune.*

Wyoming was the last state in the region to have a newspaper, FORT BRIDGER's *Daily Telegraph*, begun in 1863.

NEWTON, Kansas. City (pop. 16,332). Seat of Harvey County, south-central Kansas, directly north of WICHITA, named for Newton, Massachusetts. After the railroad terminal moved from ABILENE to Newton, that community became the new railhead, remaining the turbulent end of the CHISHOLM TRAIL for almost two years (July, 1871-January, 1873). Then the railroad reached Wichita. During the cattle-run period so many killings occurred in Newton that it was said there was "no Sunday west of Newton." Later, Newton attracted Mennonite settlers from Russia in 1874 after receiving favorable reports from Bernhard Warkentin who visited the area in 1872. BETHEL COLLEGE, oldest and largest Mennonite college in America, guards the documents said to prove that the Mennonites first brought the hard winter wheat called Red Turkey, named for its color and origin, to Kansas. Warkentin, a miller, promoted the use of the wheat. This new strain of wheat revolutionized Kansas agriculture. Mennonites also introduced a grass burner, a stove able to burn prairie grass for fuel. The first world-wide meeting of the Mennonite church was held in Newton in 1948. Bethel College operates the Kauffman Museum, centered on the peoples and environment of the plains. The Victorian Warkentin House mansion displays the original furnishings. The Kansas Health Museum is devoted to the human body and medicine. Bethel College holds the annual Fall Festival during October.

NEY MUSEUM. At AUSTIN, Texas, honors Elizabet Ney, famed as a sculptress in Europe, who came to Texas with her husband. Among her sculptures were those of Sam HOUSTON (1793-1863) and Stephen AUSTIN (1793-1836) for the Hall of Fame in the Capitol in Washington, D.C. When she heard a complaint that her statue of Austin was shorter than that of Houston she is said to have replied, "God Almighty made the men; I only made the statues." She established the first formal source of art instruction in Texas.

NICKNAMES, STATE. The nicknames of the states of the Central West region have come about for a variety of reasons. Some have been chosen formally and officially, and others have simply evolved because of their appropriate qualities.

Four of the states of the region have nicknames bearing on some aspect of history or the past. Colorado's may seem the most appropriate from the historical standpoint, since the Centennial State takes its nickname from the fact that it gained statehood just one hundred years after the Declaration of Independence was signed.

Texas' nickname has a particularly appropriate background in history. The Lone Star flag of both the republic and the state has inspired the nickname of the Lone Star State. A quite different aspect of history is the reason Wyoming proudly calls itself the Equality State, being the first state to take important steps toward more equal rights for women. Oklahoma is unique in bearing an historical nickname which in some respects glamorizes breaking the law. The Sooner State takes its nickname from those eager beavers who arrived to settle parts of the state ahead of the legal time. North Dakota has three nicknames, with history

Most states have many nicknames, including Texas, which has more than 15, such as Bluebonnet State for the great fields of the state flower.

proudly representing it as the Sioux State.

The various aspects of nature have been responsible for the nicknames of three of the states—Kansas, the Sunflower State and South Dakota, which is called both the Coyote State and the Sunshine State and North Dakota with its second nickname as the Flickertail State. However, North Dakota is also known as the Peace Garden State, which seems now to be the most favored of its three designations. Agriculture is the basis for the Cornhusker State, Nebraska.

Two states emphasize their scenery, New Mexico, Land of Enchantment, and Montana the Big Sky Country or Land of Shining Mountains. However, Montana is also known as the Treasure State, for its mineral wealth.

NICOLLET, Joseph Nicolas. (Cluses, France, July 24, 1786—Washington, D.C., Sept. 11, 1843). Explorer. Nicollet came to the United States in 1832 and made an ascent of the Mississippi River to find its source in 1836. He headed official expeditions to survey the upper MISSOURI RIVER in 1838 and a second in 1839 with John C. FREMONT (1830-1890). Nicollet's vivid description of the waterfalls in the BIG SIOUX RIVER led to the organization of two land companies to encourage settlement in the area.

NIMITZ, Chester William. (Fredericksburg, TX, Feb. 24, 1885—San Francisco, CA, Feb. 20, 1966). Naval commander. A 1905 graduate of the United States Naval Academy at Annapolis, Maryland, he served as chief of staff to the commander of the United States Atlantic submarine force during WORLD WAR I. After the Japanese attack on Pearl Harbor December 7, 1941, he was promoted to the rank of commander-in-chief of the Pacific Fleet. He planned the battles of Midway and the Coral Sea, with enemy casualties numbering ten times that of the American loss at Pearl Harbor. The Japanese surrender was signed on his flagship, the *USS Missouri*, in Tokyo Bay on September 2, 1945, after his promotion to fleet admiral. From 1945 to 1947 he was chief of naval operations then special assistant to the secretary of the Navy. After leaving government service he was a consultant on defense matters and edited with E.B. Potter *Sea Power, a Naval History* (1960.

NIOBRARA RIVER. The Niobrara starts in Niobrara County in eastern Wyoming and flows east across northern Nebraska and into the MISSOURI RIVER in Knox County.

NOLAN, Philip. (1771—TX, Mar. 21, 1801). Trader. A tobacco agent for General James Wilkinson in New Orleans in 1790, Nolan a year later entered the business of trading horses and furs in the Spanish territories, where such an operation was illegal for an American, and carried this on until 1801 with the help of 20 assistants. Long suspicious of American intentions in the Texas area, the Spanish considered Nolan to be an American spy. Nolan and his men were killed and Nolan's ears were cut off and sent to the Spanish governor as proof of his death.

NONPARTISAN LEAGUE. Farmers' movement from 1915 to 1924 originating in resentment felt by spring wheat farmers against the abuses of the grain trade in Minnesota and North Dakota. Charges were made that the Minneapolis Chamber of Commerce exercised monopoly control over the wheat trade. Led by Socialist Party organizer A.C. Townley, other Socialist leaders and the Equity Cooperative Exchange, farmers created the League. Its programs called for taxation reform, hail insurance, state rural credits, and state-owned elevators, packing houses and mills. Politically the League captured North Dakota elections in 1919, and its programs spread to other locations with changes being made to meet various conditions. The movement was broadened to include labor groups, but the League's influence faded after 1920 with the depression following the WORLD WAR I. By 1924 the organization ceased to exist, but some elements survived within North Dakota's Farmer-Labor Party.

NORBECK, Peter. (Vermillion, SD, Aug. 27, 1870—Redfield, SD, Dec. 20, 1936). Senator. Norbeck, one of the leading U.S. conservationists, was one of the BLACK HILLS greatest promoters. He made the natural beauty of the region readily accessible by guiding the construction of the NEEDLES HIGHWAY. Norbeck served in the South Dakota Senate, and as the lieutenant governor and governer. He was elected to the U.S. Senate and served from 1921 to 1939. There he continued his campaign for western improvements.

NORFOLK, Nebraska. City (pop. 19,449), Madison County, northeastern Nebraska, north of Columbus and southwest of Wayne, named as a contraction of the north fork of the Elkhorn River. German farmers from Wisconsin were the first to plant the acreage around

the town, which was founded in 1866. Chief marketplace of northeastern Nebraska, Norfolk is also a center of growing industries. Norfolk includes among its residents Fred Patzel, 1926 winner of the national hog-calling contest who, in demonstrating his skill on the radio, bellowed the local Norfolk station off the air. Nearby Neligh Mills Historical Site displays a restored, but inoperative, water-turbine-powered flour mill, one of the few in the nation. La Vitsef Celebration is an annual festival in September

NORMAN, Oklahoma. City (pop. 68,020). Seat of Cleveland County, central Oklahoma, a southern suburb of OKLAHOMA CITY, named for railroader Abner Norman. The community was almost instantly founded during the great Land Run of 1889. Within nine months of its founding, Norman had four churches, 29 businesses, and two newspapers. The University of OKLAHOMA at Norman was created and located there by the territorial legislature a year after the city's founding, one of the few instances when a state university was founded while the area was still a territory. The community is noted for its convention and symposium facilities and for its balanced economy, including industry, oil, tourism, research and development and high technology, much of the latter in connection with the university. Today the university ranks as one of the nation's perennial football powerhouses. Stoval Museum, on the university campus, has an outstanding collection of nearly four million specimens including, Oklahoma birds and early Indian artifacts. An annual 89'er Days in late April celebrates the town's founding.

NORRIS, George William. (Sandusky County, OH, July 11, 1861—McCook, NE, Sept. 2, 1944). Political leader. Norris is considered the "father of the Twentieth Amendment" to the Constitution in 1933 and of the unicameral legislature in the state of Nebraska. In 1912 he began a 30 year career as Republican U.S. Senator from Nebraska. However, he prided himself on his independence from party domination. He sided with Theodore ROOSEVELT's Bull Moose party in 1912 and with Progressive Robert M. La Follete in 1924 and later supported F.D. Roosevelt in his four campaigns. Norris worked tirelessly for the establishment of the Tennessee Valley Authority, opposed U.S. entry into WORLD WAR I and supported its effort in WORLD WAR II. Norris secured appropriations for a series of dams for

conservation and power in the PLATTE valley of Nebraska, creating what became known as the "LITTLE TVA." He led the fight in the House of Representatives which ended that chamber's legislative system known as "Cannonism" and secured passage of the Anti-Injunction Act (1932).

NORSE EXPLORERS. The as yet unproven story continues to persist that Norse sailors managed to come overland as far as the RED RIVER VALLEY in North Dakota, where they founded a lost race of fair-haired, blue-eyed people whose descendents now live in North Dakota. Evidence to link such a race of people to the MANDAN INDIANS, who have a slight Caucasian look, has never been conclusively found.

NORTH AMERICAN AIR DEFENSE COMMAND (NORAD). Coordinator of air defenses of the United States and Canada. NORAD, headquartered deep within CHEYENNE MOUNTAIN near COLORADO SPRINGS, Colorado, controls all American and Canadian air defense forces through a sixty-five million dollar combat operations center completed in 1965.

NORTH COUNTRY NATIONAL SCENIC TRAIL. The route of the North Country Trail extends 3,200 miles from Crown Point, New York, to the MISSOURI RIVER and Lake SAKAKAWEA in North Dakota, where it intersects the LEWIS AND CLARK National Historic Trail at Garrison Dam. Approximately 800 miles of existing trails that follow the route of the trail are open to public use. Additional miles are being developed. Headquartered OMAHA, Nebraska.

NORTH DAKOTA. State, northernmost of the eastern tier of Central West states. Being almost equidistant between the Arctic Ocean and Central America and from the Atlantic and Pacific Oceans, North Dakota lies at the exact center of the North American continent.

The Canadian provinces of Manitoba and Saskatchewan stretch to the north, Montana on the west and South Dakota to the south, all with straight manmade borders. The eastern border with Minnesota is formed by the twists and turns of the RED RIVER OF THE NORTH.

The mighty MISSOURI RIVER cuts the southwest corner of the state from the rest of North Dakota. Once a land with no vast lakes, now North Dakota has become a land of great lakes, with enormous Lake SAKAKAWEA formed behind

North Dakota

Counties and County Seats

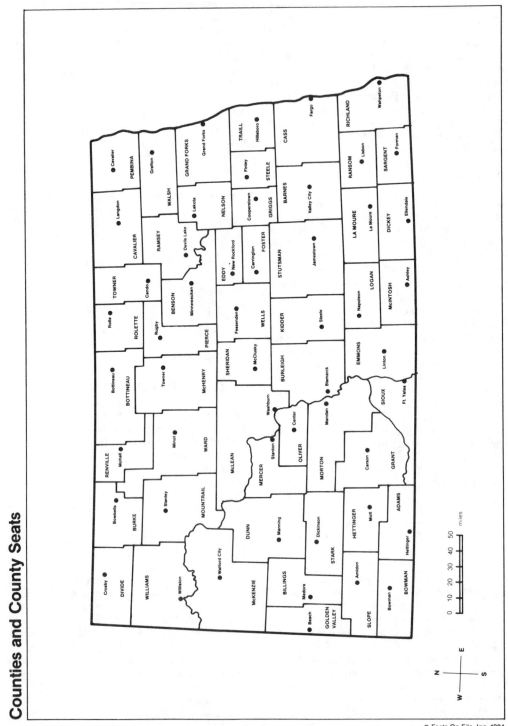

STATE OF NORTH DAKOTA

Capital: Bismarck, settled 1873

Name: Dakota for the Dacotah Indians, Dacotah meaning "friend or ally in the Sioux language."

Nickname: Sioux State

Motto: Liberty and Union, Now and Forever, One and Inseparable

Symbols and Emblems:
Fish: Northern Pike
Bird: Western Meadowlark
Flower: Wild Prairie Rose
Tree: American Elm
Stone: Teredo Petrified Wood
Song: "North Dakota Hymn"

Population:
1985: 685,000
Rank: 46th
Gain or Loss (1970-80): +35,000
Projection (1980-2000): +163,000
Density: 10 per sq. mi.
Percent urban: 48.8% (1980)

Racial Makeup (1980):
White: 95.9%
Black: 2,568 persons
Hispanic: 3,903 persons
Indian: 20,200 persons
Others: 4,300 persons

Largest City:
Fargo (61,308-1980)

Other Cities:
Bismarck (44,485-1980)
Grand Forks (43,765-1980)
Minot (32,843-1980)

Area: 70,702 sq. mi.
Rank: 17th

Highest Point: 3,506 ft. (White Butte, Slope Co.)

Lowest Point: 750 ft. (Red River)

H.S. Completed: 66.4%

Four Yrs. College Completed: 14.8%

STATE GOVERNMENT

Elected Officials (4 year terms, expiring Jan. 1989):
Governor: $65,000 (1986)
Lt. Gov.: $50,000 (1986)
Sec. of State: $46,000 (1986)

General Assembly:
Meetings: Odd years in Bismarck
Salary: $90 for expenses per day when in session and $180 per month when not in session (1986)
Senate: 53 members
House: 106 members
Congressional Representatives
U.S. Senate: Terms expire 1989, 1993
U.S. House of Representatives: One member (at large)

North Dakota, Geography

Major Rivers and Waterways

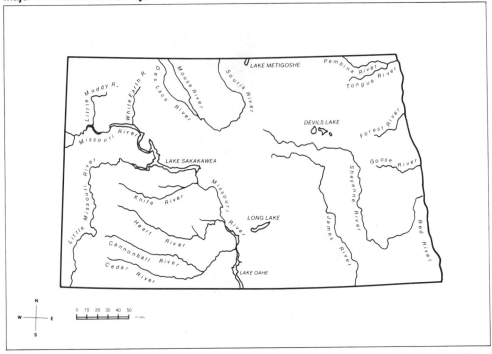

Garrison Dam at the Big Bend of the river, where it turns westward, carrying the artificial lake clear to the Montana border, and huge OAHE LAKE stretching northward up the river from South Dakota. Other smaller artificial lakes dot the state, along with such natural bodies as DEVILS LAKE.

The Red River of the North carries the flow from its watershed northward, past FARGO and GRAND FORKS across the Canadian border where after 545 miles it empties into Lake Winnipeg. The watershed which divides the northward and southward flowing rivers approximately bisects the state from northwest to southeast. One of the most unusual of these northbound rivers is the SHEYENNE, beginning in central North Dakota, flowing east then south, then east, then north, emptying finally into the Red River after a course of 325 miles.

The JAMES RIVER begins near the Sheyenne but flows southward for 710 miles before entering the Missouri. It is considered the longest non-navigable river in the world. The SOURIS RIVER commences in Canada, flows southeast into north Dakota, past MINOT, then turns north into Manitoba to join the Assiniboine River. The LITTLE MISSOURI RIVER starts in Wyoming, cuts a corner of Montana, another of South Dakota before entering North Dakota at the far southwest corner, then flowing north and east to form Little Missouri Bay on Lake Sakakawea. The CANNONBALL starts not far from one of the bends of the Little Missouri but flows almost directly east to meet the Missouri near Lake Oahe.

The Red River Valley is the most easterly of the state's three main physiographic divisions. It actually is not a valley but the bed of gigantic prehistoric Lake AGASSIZ. The western edge of the valley is marked by the PEMBINA ESCARPMENT. Here the DRIFT PRAIRIE begins and extends west to the MISSOURI ESCARPMENT. Residents call the area south and west of the Missouri the Slope, but its proper name is the MISSOURI PLATEAU, with its V-shaped valleys, hills and buttes formed by erosion. There are some scattered low buttes and mountains in the state, with White Butte in the far southwest corner the highest point in the state at 3,506 feet.

Several highland groups are labeled as mountains, including KILLDEER, PEMBINA and TURTLE.

Perhaps the most notable natural feature of North Dakota is the region called "hell with the fires out" by an American general. This is the area of fantastic shapes sculptured by wind and

water now known as the BADLANDS. These are different from the other badlands, being low clay hills carved by the elements.

North Dakota is the smallest but one of the Central West states, ranking in area just above Oklahoma. It is seventeenth in area among all the states.

Present North Dakota began the Paleozoic Era as a low plain, then rose and fell alternately with every period of the era, then spending most the Mesozoic Era under its shallow seas. By the end of the Cenozoic Era, the surface had taken much of its present form. Surface rock outcroppings are Mesozoic to the east and Cenozoic in the west.

The North Dakota climate varies little throughout the state. Its Continental Climate brings a very wide temperature range of 184 degrees, more variation than that of Alaska and only slightly less than that of Montana. Fortunately, the extremes do not generally last long. Summer temperature averages 65 degrees, and the winter is somewhat modified by the low humidity.

From the standpoint of the economy, few other states are so dependent on agriculture, which has a slight lead in the state over manufacturing ($2,691 million to $2,362 mil-

lion). North Dakota holds second place among the states in total wheat production, first in durham wheat, first also in flaxseed, sunflowers, barley and pinto beans. The Red River valley is known as the Breadbasket of the World. The state has been a pioneer in developing the technique of starch gluten processing, expected to yield hundreds of new products in cosmetics, sweeteners and glue, among others.

Principal manufactured products include non-electrical machinery, livestock and vegetable food products, dehydrated alfalfa, processed petroleum and coal. The latter and other mineral products make mining and minerals the third highest income producer of the state. The vast reserves of low grade coal called LIGNITE, largest in the world, will someday produce substantially greater income as more methods for its use will be introduced. The state has pioneered in methods of gassification of lignite and also of conversion of the substance to leonardite, necessary for wood stains, soil conditioners and oil drilling muds.

The vast majority of the state's population is white. Of a total population in 1985 of 685,000 the Indian population is about 22,000 persons, and other races and ethnic groups total less than 10,000 persons. In the Central West,

Topographic Areas

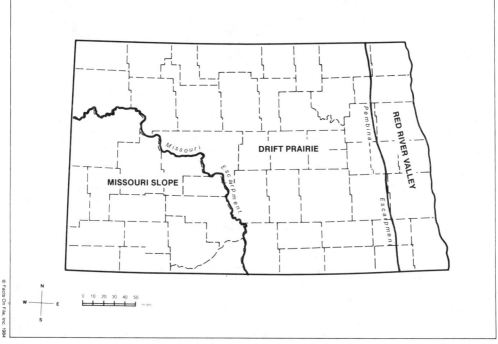

North Dakota ranks ninth in population just ahead of Wyoming and 46th among all the states.

Prehistoric remains in North Dakota indicate human occupation for at least 20,000 years. There are mounds, pictographs, petroglyphs, and stone implements and tools, mostly of unknown era. Among the most interesting remnants are the turtle effigies, rows of rocks laid out to form crude representations of the reptiles.

By the time European settlements were beginning to the east, there apparently were few permanent native residents in present North Dakota. The Indian groups found later were mainly those who had been pushed farther and farther west by European population advances and by the stronger eastern tribes.

The MANDAN were probably the first to arrive, straggling up the Missouri River; they were followed by the HIDATSA (also known as Gros Ventres or Minnetaree or Absaroke) who lived north of the Mandan, and the CHEYENNE. Eventually, the ARIKARA also arrived. These four groups are known as the agricultural tribes, living in permanent homes and villages and growing crops.

The nomadic tribes pushed in from the East included the SIOUX, ASSINIBOIN and Chippewa. Largest group was the Sioux, with seven major tribes—YANKTONAI, YANKTON, Wahpekute, Mdweakanton, Wahpeton, TETON and Sisseton.

In the agricultural tribes the women cultivated the gardens, built the lodges and did most of the other work. The men helped only when the logs were too heavy to lift. Their main duties were hunting and protecting the tribe. Buffalo provided much of the food for both agricultural and nomadic groups.

Eagles were another great hunting prize, cherished for their feathers, which were symbols of valor. Even in those early days eagles were not plentiful, and feathers might be traded for possessions as valuable as a pony.

Nomadic tribes lived in tepees as tall as twenty-five feet, with as many as fifteen buffalo hides wrapped around the tent poles. The men wore leather trousers and wrapped in buffalo robes in cold weather. Women wore loose-fitting leather dresses. Moccasins were the general footwear.

For sixty years after France claimed the region in 1682, no European visited the area. Then in 1738 Pierre Gaultier de Varennes, called Sieur de La VERENDRYE (1685-1749), was the first known to enter present North Dakota, accompanied by his sons Francois and Louis-

Joseph. They were searching for the route to the Orient and for the best fur-bearing areas.

Spain took nominal control of most of present North Dakota in 1762, but few explorers ventured in. The expedition of British scientist David THOMPSON (1770-1857) passed through in 1797. The fur trading post of Charles Chaboillez, set up in 1797 near present PEMBINA, was the first in North Dakota.

One of the most exciting events in Dakota history was the arrival of the great expedition of LEWIS AND CLARK, who entered present North Dakota on October 13, 1804. Winter forced them to make camp (called FORT MANDAN), about twelve miles north of present Washburn, near where the Mandan and Arikara had principal villages. French and Canadian trappers visited them and provided information, and the party introduced the Indians to a Christmas celebration. They also had a lively party on New Years day. Later they met with several Indian chiefs, advised them that their tribes now were under the U.S. government and urged them to channel the fur trade to Americans.

The expedition gained an incredible amount of information about the wildlife and peoples and the geography of the entire surrounding area and beyond. Just before leaving present North Dakota, they sighted the YELLOWSTONE RIVER, a highlight of the trip. On the way back they visited their Indian friends and left them a cannon for protection.

Trapping and trading continued; FORT UNION was established on the Missouri River in 1828 and became the pivotal site for forty years. Smallpox ravaged the Indian villages in the epidemic of 1837, and eight years later Bartholomew Berthold founded Fort Berthold near present GARRISON. In 1857 FORT ABERCROMBIE became the first federal post in the present state. Dakota Territory was established in 1861, including not only the two Dakotas but also large segments of Montana and Wyoming. The capital was at YANKTON in South Dakota.

In 1862 the Sioux massacred settlers and laid siege to Fort Abercrombie on the Red River. In 1863 General H. H. SIBLEY brought an army of 4,000 men and pursued the retreating Sioux until he defeated them at the Battle of Big Mound, near present Tappen. General A. H. Sully met the Sioux at the Battles of KILLDEER MOUNTAIN and WHITESTONE HILL. A peace conference led to the Treaty of Laramie, Wyoming, in 1869, in which the government pledged to keep the region in Indian hands.

The gold rush to the BLACK HILLS killed the treaty, and the government sent Colonel George

Armstrong CUSTER (1839-1876) to FORT ABRAHAM LINCOLN (Bismarck). He and his men of the Seventh Cavalry left the fort to meet their terrible fate of the Battle of LITTLE BIGHORN (June 25, 1876), and the first news of the battle was brought back to the families at the fort, from which the word was telegraphed to the world.

Peace brought expansion of railroads and settlement along with great ranch spreads called bonanza farms, then smaller homesteaders and farmers. The terrible winters of the 1880s, floods, drouth, insects and prairie fires all plagued the settlers. Statehood came to both Dakotas on November 2, 1889. President Banjamin Harrison never disclosed which statehood bill was signed first, so neither state knows its exact order of statehood.

Development continued in both farm and city. WORLD WAR I found 31,269 North Dakotans in uniform.

Just after the war, in 1919, North Dakota began a program never before or since undertaken by a state. The government set up state owned businesses and banks, making the state the only one to operate in several commercial fields.

The terrible drouth and duststorms and the great depression of the 1930s brought severe hardship, but prosperity returned after WORLD WAR II. A discovery of high grade oil in 1951 helped the economy, which was further boosted by the state Economic Development Commission of 1957. Recent years found the Democrats in control of state government, but as the state voted for Ronald Reagan in 1984, the Republicans took control of both houses of the legislature. However, in 1986 Democrat George A. Sinner was elected governor.

Although not a native, the future president, Theodore ROOSEVELT (1858-1919), "grew up" in North Dakota, where the wealthy young aristocrat moved for his health. There he discovered the vigorous life which he promoted for the rest of his own life. As a rancher he did much of his own work, hunted grizzly bears and competed in all the dangerous duties of the range. When a bully once called him four-eyes because of his heavy glasses, Roosevelt floored him and gained the respect of the community. He lived in the state for two years and returned four more summers. When he went to lead his troops in the SPANISH AMERICAN WAR he called them ROUGH RIDERS, the name of the hotel in MEDORA, near his ranch.

Years later, surrounded with the cares of the presidency, Roosevelt wrote, "We worked on the cattle ranch under the scorching sun, when the wide plains shimmered and wavered in the heat...In the soft springtime the stars were glorious in our eyes each night before we fell asleep, and in the winter we rode through blinding blizzards...Ours was the glory of work and the joy of living."

Another young aristocrat built a lovely residence on the Little Missouri River at Medora and lived in fine style with a staff of servants. This was the Marquis de MORES, who established a packing plant to process local cattle and gained the thanks of his neighbors who previously had resented his private railroad car and other extravagances. His wife was envied and admired even in New York society. When the packing business did not do well, the titled couple left the state. He died while hunting in Africa, and she was killed of injuries suffered as a nurse in World War I.

Though not of European nobility, a later North Dakota native was crowned as the polka king of television music. For nearly a generation, Lawrence WELK (1903-) ruled the airwaves of light popular music, with many of his programs continuing to be televised in reruns. Other entertainment celebrities from the state include actress Angie Dickinson, singer Peggy LEE (1920-) and cowboy film star Tom MIX (1880-1940).

The Indians, wildlife and scenery of North Dakota attracted many famed artists, including Indian specialist George CATLIN, naturalist painter James Audubon, and Swiss artist of the contemporary scene Carl BODMER.

The likeness of Running Antelope, a North Dakota Indian, became known worldwide through the use of his profile on the old five dollar bill.

Theodore Roosevelt described it as having "...a desolate grim beauty, that has a curious fascination for me." That place is now THEODORE ROOSEVELT NATIONAL MEMORIAL PARK, which preserves a large portion of the Badlands area as the young Roosevelt knew it. His North Dakota home town, Medora, preserves many Roosevelt memories, including the old Rough Rider Hotel.

Also at Medora is the home of the Marquis de Mores at CHATEAU DE MORES STATE MONUMENT, now a museum preserved just as it was when the noble couple left it.

Quite different is the INTERNATIONAL PEACE GARDENS reaching across the Canadian border and dedicated to the generations of peace between the two great powers. Still another national preserve is the FORT UNION TRADING POST

The North Dakota capitol rises high above the flat prairies surrounding Bismarck.

NATIONAL HISTORIC SITE at WILLISTON. Remnants of historic and prehistoric Indian villages are preserved at KNIFE RIVER INDIAN VILLAGES NATIONAL HISTORIC SITE.

At the geographic center of the North American Continent near RUGBY, a monument marks the exact location of that world geographic symbol.

FARGO, largest city of the state, has outlived its early reputation as the national retreat for quicky divorces. As the center of one of the world's major agricultural regions, its economic heart beats with vigor. NORTH DAKOTA STATE UNIVERSITY at Fargo has many points of interest, as does Bonanzaville, USA, with more than 45 buildings reconstructed to show the 19th-century farm era, along with a number of museums and a sod house. The Red River Valley Fair is held at West Fargo each second week of July.

GRAND FORKS was founded when a Red River flatboat crew was stuck in the ice and was forced to spend the winter. The University of North Dakota at Grand Forks is known for its pioneering courses in radio and the world's first college course in weather-modification pilot training.

From far away on the prairies near Jamestown, travelers can see the world's tallest statue of a buffalo, the multi-story landmark of the community, one of the attractions of the Frontier Village. Jamestown welcomes the annual Fort Seward Wagon Train, with participants dressed in pioneer fashion, traveling for a week to historical landmarks.

Each first week in February MINOT hosts the annual Miss Minot Winterfest Pageant with a fascinating array of competitions. It also is the home of the annual North Dakota State Fair.

Valley City hosts the annual North Dakota Winter Show, the largest agricultural exposition in the Northwest. The Fort Buford 6th Infantry State Historical Encampment features a reenactment of frontier Indian wars army exercises.

The looming bulk of the capitol at Bismarck, a skyscraper building, is visible for miles across a seemingly endless wheat field. The North Dakota Heritage Center at Bismarck includes many exhibits of state and national interest. Double Ditch Indian Village preserves the ruins of a sizeable Mandan earthlodge village of the period 1675-1780. Selection of Miss Indian America is a notable annual Bismarck event along with the annual United Tribes International Pow Wow, both in early September.

NORTH DAKOTA HERITAGE CENTER. Located on the capitol mall in BISMARCK, the Center, home of the State Historical Society, houses the State Archives, a research library, and the State Historical Museum.

NORTH DAKOTA RURAL REHABILITATION CORPORATION. Governmental organization designed in 1936 to help residents of North Dakota recover from the Great Depression. One of the projects undertaken by the Corporation was the Subsistence Homestead Project which included a model village at Burlington to assist miners displaced at lignite mines.

NORTH DAKOTA STATE UNIVERSITY. Publicly supported state university in FARGO. Established in 1890, it was the state's land grant institution. Much of the emphasis continues on agricultural research, through the experiment station. It supports the North Dakota Institute for Regional Studies. The university is known for its Herbarium and wildlife museum. During 1985-1986 the university enrolled 9,413 students and employed 498 faculty members.

NORTH DAKOTA, UNIVERSITY OF. Publicly supported liberal arts institution located in GRAND FORKS. Founded in 1884, the university began operations before the territory had become a state. The school was the second institution in the United States to provide courses in radio, and the School of Mines developed a process of converting LIGNITE, a soft form of coal, into briquettes which burn like charcoal. The "Eternal Flame of Knowledge" burns in an enormous sphere of steel girders, commemorating past presidents and the Old Main building. Stone Alumni Center is housed in a turn-of-the-century mansion on the 480-acre campus which has 118 other buildings. The university grants Bachelor, Specialist, Master, Professional and Doctoral degrees. During the 1985-1986 academic year it enrolled 11,106 and employed 650 faculty members.

NORTH PARK. The most northern of four major valleys or basins, level areas known as "parks," in Colorado. Explorer John C. FREMONT (1830-1890) described it in 1844 as a "beautiful circular valley, thirty miles in diameter, rich in grass and water—a paradise to all grazing animals." North Park is located west of FORT COLLINS and north of Hot Sulphur Springs.

NORTH PLATTE RIVER. Rises in Jackson County in northern Colorado and flows north across the Wyoming border into the central part of the state where it turns east and southeast across the Nebraska border through west central Nebraska to join with the SOUTH PLATTE RIVER in Lincoln County, Nebraska, where the merged rivers form the PLATTE RIVER. The North Platte flows past SCOTTSBLUFF, Nebraska, to form Lake MC CONAUGHY in Keith County.

NORTH PLATTE, Nebraska. City (pop. 24,-479). Seat of Lincoln County, southwestern Nebraska, east of OGALLALA and north of MC COOK, lying at the junction of the north and south branches, which form the PLATTE RIVER. In 1872 the region was visited by Grand Duke Alexis of Russia who came to America to hunt buffalo with General Philip SHERIDAN (1831-1888) and Buffalo Bill CODY (1946-1917). The city was founded in 1866. An enormous prairie fire in April of 1893 threatened the entire town of 3,000, but was turned back after destroying only thirty-five houses. One of the unique early newspapers in Nebraska was the *Pioneer on Wheels* which was printed in a boxcar there. North Platte has become the hub of retail trade,

agriculture and railroading in the area. North Platte boasts the Union Pacific's Baily Yard, one of the largest railroad classification centers in the United States. After 1870 the community was home to Buffalo Bill. A professional rodeo is held nightly between late June and late August across from the Buffalo Bill Ranch State Historical Park. This is the site of Buffalo Bill's Scouts' Rest Ranch with its gigantic barn, where his wild west acts trained, and the rafter supports were carved into the shape of gun stocks. Annually on the third week in June residents enjoy Nebraskaland Days.

NORTH RICHLAND HILLS, Texas. City (pop. 30,592), Tarrant County, a suburban community just northeast of FORT WORTH. In 1960 North Richland Hill's population was 8,662. By 1970, it had nearly doubled to 16,514. In the next decade the population almost doubled again. Although its growth rate has slowed down, the city continues to grow.

NORTHEASTERN OKLAHOMA STATE UNIVERSITY. Publicly supported university located in TAHLEQUAH. The university traces its start to 1846 when the Cherokee National Council provided for a National Male Seminary and a National Female Seminary. In 1909 the Oklahoma Legislature provided for the purchase of the Female Seminary to be used as a state normal school. The institution became a state teachers' college and a member of the Oklahoma State System of Higher Education in 1941. Historic Seminary Hall of the Cherokee now houses the Vaughan Library. It is said to be the oldest building west of the Mississippi used for education. The university grants the Bachelor's and Master's degrees. During the 1985-1986 academic year, it enrolled 7,043 students and employed 350 faculty members.

NORTHERN MONTANA COLLEGE. Four-year state college located in HAVRE. One of the six units of the Montana University System, Northern Montana serves a large segment of the state because of its great distance from the other five units. During the 1985-1986 academic year Northern Montana enrolled 1,729 students and employed 120 faculty members.

NORTHERN PACIFIC RAILROAD. Most northern of the transcontinental transportation projects, it attracted special interest for its prospects of trade with the Orient. Its eastern terminus was located on Lake Superior, so that it drew all the lake commerce, and its western

Northeastern State University at Talequah, Oklahoma, enjoys the use of the oldest educational building still occupied west of the Mississippi.

terminal gave a shorter route to the Far East than any of the other railroads. Financial backing for the railroad came from the famous Philadelphia firm of Jay Cooke and Company. Cooke spoke so highly of the lands in the Central West through which the tracks passed that the region was given the name "Jay Cooke's Banana Belt." This misconception sprang from the impression Cooke fostered that the Dakotas were almost tropical in their abundant vegetation. Construction of the railroad began in 1870, and by 1873 the rails had reached BISMARCK, North Dakota. Construction costs exhausted all available funds, and the firm of Jay Cooke fell into bankruptcy. Under the leadership of Frederick Billings the development of the line became linked with the development of the Oregon Steam Navigation Company which operated on the Columbia River. In 1883 ownership of the railroad eventually went to Henry Villard who saw the last spike driven in central Montana in September of that year. The completion of tracks to Seattle came in 1887.

NORTHERN PIKE. State fish of North Da-

kota, a member of the family which includes muskellunge and pickerel. The northern pike, called jackfish in Canada, is thought to be of the same species as European pike. These voracious eaters consume as much as a fifth of their own weight each day.

NORTHERN STATE COLLEGE. Publicly supported college in ABERDEEN, South Dakota. Established as the Northern Normal and Industrial School in 1901, the college now grants the Bachelor and Master degrees. Northern State College enrolled 2,818 students during the 1985-1986 academic year and employed 118 faculty members.

NORTHWEST COMPANY. Founded in 1790 by Benjamin and Joseph Frobisher and Simon McTavish the company was intended to operate in the MANDAN country and extending westward to the Pacific and from the Hudson's Bay Company territory south to Louisiana. At the height of its power the company employed two thousand men, establishing trading posts and organizing trading expeditions to the important Indian villages. Uncertain boundaries

between the North West Company and Hudson's Bay Company territories led to conflict almost from the start. Competition brought about such devious trading practices as plying the Indians with liquor and encouraging them to attack rival companies. A settlement was reached in 1811 which created a buffer between the two companies. In 1821 the North West Company was absorbed by the Hudson's Bay Company.

NUECES RIVER. In south central Texas, it flows approximately 315 miles south and southeast to the Gulf of Mexico, near CORPUS CHRISTI.

NUGENT, James. (unknown—unknown). Nicknamed Rocky Mountain Jim, one of the most colorful and best-known frontier figures of Colorado. Living at one point in his life in a cabin at the entrance to ESTES PARK, Nugent, with only one eye left after an encounter with a grizzly bear, was described as a "broad, thick-set man, about middle height, with an old cap on his head, and wearing a grey hunting-suit much the worse for wear, a digger's scarf knotted around his waist, a knife in his belt, and a revolver sticking out of the breast-pocket of his coat; his feet were bare except for some dilapidated moccasins made of horse hide." He supported himself by hunting and fishing and sometimes as a guide, he was said to be "a typical representatitve of the mountain men, although rather eccentric."

NUNEZ CABEZA DE VACA, Alvar. (Jerez de la Frontera, Spain, c. 1490 — Spain, c. 1557). Spanish explorer. He was treasurer of the abortive expedition to Florida led by Panfilo de Narvaez (1527-1528), and of 300 Spaniards who began the journey he was one of four who survived. With the three others, he wandered for eight years around the Gulf Coast region and through northern Mexico, Texas, New Mexico and Arizona before returning to Spain. Reports of his explorations are said to have provoked the De Soto (1538) and CORONADO (1540) expeditions.

NUTTALL, Thomas. (Settle, England, Jan. 5, 1786—Liverpool, England—Sept. 10, 1859). Naturalist. Nuttall journeyed along the ARKANSAS and RED rivers in the Indian territories from 1818 to 1820 and joined the Wyeth Expedition to the mouth of the Columbia River from 1834 to 1835. Nuttall made the first attempt in the United States to correlate many widely separated geological formations according to the types of fossils found in the locations.

NYE, Edgar Watson (Bill). (Shirley, ME, 1850—Arden, NC, 1896). American humorist. Nye, who lectured widely alone and with poet James Whitcomb Riley, first achieved fame writing about Wyoming where he was a lawyer, postmaster and editor of the LARAMIE *Boomerang* for three years. Nye and Riley wrote *Nye and Riley's Railway Guide* in 1888. Nye also wrote *Bill Nye and Boomerang* (1881) and *Forty Liars and Other Lies* (1882).

NYE, Gerald. (Hortonville, WI, Dec. 19, 1892—). Senator. After graduation from high school in Wittenberg, Wisconsin, he edited several local newspapers, then went to Fryburg, North Dakota, in May, 1916, to edit the newspaper there. In 1918 he became involved in Populist politics. In 1925 he was appointed to the U.S. Senate from North Dakota, as a Republican, and elected to the post the next year in his own right. He served in the Senate until 1944. He opposed the corruption he perceived in politics, which he said was encouraged by great wealth. He opposed monopolies, price-fixing and bankers and continued to work for farming interests. After the election of F.D. Roosevelt, Nye generally defended the New Deal. However, as the political situation in Europe worsened, he became the chief spokesman for the Peace Lobby in Congress. His investigative efforts revealed the profiteering of munitions makers during WORLD WAR I, and he was most instrumental in the passage of the neutrality Act of 1935 and in opposing Lend Lease. After Pearl Harbor, he voted for a declaration of war and wholeheartedly supported the war effort. Despite this change, he was defeated for reelection in 1944.

O

O'NEILL, Nebraska. Town (pop. 4,049). Seat of Holt County, northeast central Nebraska, named for General John O'Neill, leader of the Irish group who settled the community in 1874. O'Neill has been called the Irish capital of Nebraska. It is known for its annual St. Patrick's Day Celebration. Stone cists, prehistoric mounds used as burial boxes formed from limestone slabs, have been found nearby, containing stone hatchets, spearheads, and jewelry of bone and shell.

OAHE DAM. Requiring ninety-two million yards of material in its construction, the dam, located just north of PIERRE, South Dakota, is the second largest in the world.

OAHE RESERVOIR. Fifteenth largest man-made reservoir in the world, contained behind OAHE DAM in South Dakota. Created by damming the MISSOURI RIVER, the lake covers 23,600,-000 acre feet.

ODESSA METEOR CRATER. Dramatic evidence of the impact of a meteor near Odessa, Texas. That great extraterrestrial body of iron and nickel, weighing approximately 625 tons, struck the earth during the period from 20,000 to 50,000 years ago. It gouged a vast chasm, a mile in diameter and 600 feet deep. An enormous rim was thrown up around the crater, part of the 6,000,000 tons of earth displaced by the impact. Speculation continues as to the exact makeup of the meteor itself.

ODESSA, Texas. City (pop. 90,027). Seat of Ector County, in west central Texas. It was named in 1886 by Russian railroad workers in the area, probably because they thought the region was similar to their homeland near Odessa in Russia. Founded in 1881, it developed as a livestock, shipping, and oil equipment manufacturing center. Other products include synthetic rubber, liquefied petroleum, petrochemicals and cement. Odessa became a hangout for many famous and infamous early Texans. With the discovery of oil in Ector County (1928), Odessa began its rapid growth to its present industrial status. It is the home of Odessa College and a branch of the University of TEXAS. The unique Presidential Museum is devoted to all the presidents, including campaign mementoes, replicas of First Lady costumes, political cartoons, signatures and other items. Boomtown Days Festival is held each May, recreating the period of the 1930s. Huge METEOR CRATER lies eight miles to the west.

OGALLALA SIOUX INDIANS. Largest subdivision of the TETON Dacotah. In the mid-19th century the Ogallala were located in southern South Dakota and northern Nebraska. The name of the tribe means "to scatter one's own." Two of the most famous chiefs of the tribe were RED CLOUD (1822-1909) and CRAZY HORSE (1842-1877). In the late 1970s nearly 12,000 Ogallala descendants lived at the Pine Ridge Reservation in South Dakota.

OGALLALA, Nebraska. Town (pop. 5,638). Seat of Keith County, southwestern Nebraska, on the SOUTH PLATTE RIVER, near the corner formed by the Colorado border. Known in early day as the "Gomorrah of the Plains," Ogallala was named for the OGALALLA tribe of Dacotah SIOUX. It became a railroad town and cattle-shipping point when the Union Pacific reached the site in 1867. At once Ogallala was the end of the trail for the tired cowboys who drove the cattle northward for transfer to rail. Ogallala followed the procession of other pioneer rail terminals which served the same purpose. During the trail period, the town was full of cowboys roistering and spending their newly paid wages. There is the usual Boot Hill, where many of them are buried. There also is the expected Front Street, with its modern reconstruction. Fantasyland features 200 animated storybook characters. A popular recreation center, with nearby Lake Ogallala and Lake McConaughy. The town hosts such annual festivities as the Ogallala Governor's Cup Sailboat Regatta on Labor Day. Fantasyland holds a Christmas display in December.

OJIBWAY INDIANS. Algonquian tribe located north of Lake Huron and northeast of Lake Superior in the early 17th century. By the

late 1970s the Ojibway was the second most numerous tribe north of Mexico with descendants in the Central West living in North Dakota, Montana and Oklahoma. The acquisition of horses brought the Ojibway out of the woodlands onto the plains. By 1830 the Plains Ojibway, also known as Bungi, had moved into northern Dakota and northeastern Montana. The buffalo became the primary source of food, clothing, shelter and tools. The Ojibway adopted many Plains Indian customs including the soldier societies, scaffold burials, buffalo tipis, communal buffalo hunts and hard-sole Plains-style moccasins. In the 1860s Ojibway groups were assigned reservations. The United States Plains Ojibway settled on Turtle Mountain Reservation in North Dakota in about 1892, and others settled with some Plains Cree on Rocky Boy's Reservation in Montana in 1916.

OJO CALIENTE (Warm Springs). Village observed by Captain Zebulon PIKE (1779-1813) when he was a prisoner of the Spanish before being taken to SANTA FE. Pike wrote, "The difference of climate was astonishing, after we left the hills and deep snows, we found ourselves on plains where there was no snow, and where vegetation was sprouting. The village of the Warm Springs or Ojo Caliente is situated on the eastern branch of a creek of that name and at a distance presents to the eye a square enclosure of mud walls, the houses forming the wall. Inside of the enclosure were the different streets of houses of the same fashion, all of one story; the doors were narrow, the windows small and in one or two houses there were talc lights mica windowpanes. This village had a mill near it, situated on the little creek, which made very good flour."

"OKLAHOMA." State song of Oklahoma from the musical by Rodgers and Hammerstein, based on the play *Green Grow the Lilacs* by CLAREMORE, Oklahoma, resident Lynn Riggs. First mounted in 1943, the musical had enjoyed a record run of 2,212 performances on Broadway by 1986 and had been awarded a special Pulitzer Prize. It is frequently revived.

OKLAHOMA. State, situated on the eastern edge of the Central West region. Because of its location, Oklahoma has been called the land "where North touches South and East mingles with West."

All of the Oklahoma borders are manmade except for the long winding stretch following the RED RIVER between Texas and Oklahoma. The border with Texas continues north, then west along the PANHANDLES of both states to become the longest border between any two states. Arkansas and a small portion of Missouri are the border states on the east. There is a long straight border with Kansas on the north plus its short extension along southern Colorado. A very short border with New Mexico, delineates the end of the Panhandle on the west.

All of the state is drained by the great Red River on the south and the ARKANSAS cutting across the northeast corner. Major tributary of the Arkansas is the CANADIAN RIVER, which bisects the state from north to south before entering the Arkansas. Major Arkansas tributary from the north is the GRAND in eastern Oklahoma.

Originally a land without major lakes, Oklahoma, instead, has become a land of great lakes, thanks to dams and reservoirs. The major reservoir on the Arkansas is named in honor of Senator Robert Kerr; nearby on the Canadian is the EUFALA RESERVOIR and not far to the north the TENKILLER on the ILLINOIS RIVER. In the northeast the Grand provides the GRAND LAKE O' THE CHEROKEES, while Oolagah Lake lies to the west on the VERDIGRIS RIVER. In the north the Arkansas provides Kaw Lake near PONCA CITY. Far to the south, shared with Texas, is Lake TEXOMA flooding the Red River valley. Western Oklahoma has a few smaller artificial lakes.

Oklahoma mountains include the OZARK on the northeast the OUICHITAS in the southeast, ARBUCKLES of the south-central and the WICHITA to the southwest. The latter are the granite tops of buried ancient mountains. They and the Arbuckles are much older than the Rockies, probably about the same age as the Appalachians, among the oldest in the world.

The region south of the Ouachitas and the Arbuckles is classified as the upper limits of the COASTAL PLAINS, making Oklahoma in one sense a gulf state. Portions of eastern Oklahoma are known as the Sandstone Hills region. The major portion of the state is part of the GREAT PLAINS region, with west Oklahoma and the Panhandle part of the HIGH PLAINS region. Enormous lava flows contributed the BLACK MESA region of the Panhandle.

Oklahoma is the smallest in area of the Central West region and ranks 19th in area among all the states.

During much of the Paleozoic Era, most of present Oklahoma lay under shallow seas until the Permian period brought the Ouachita

Oklahoma

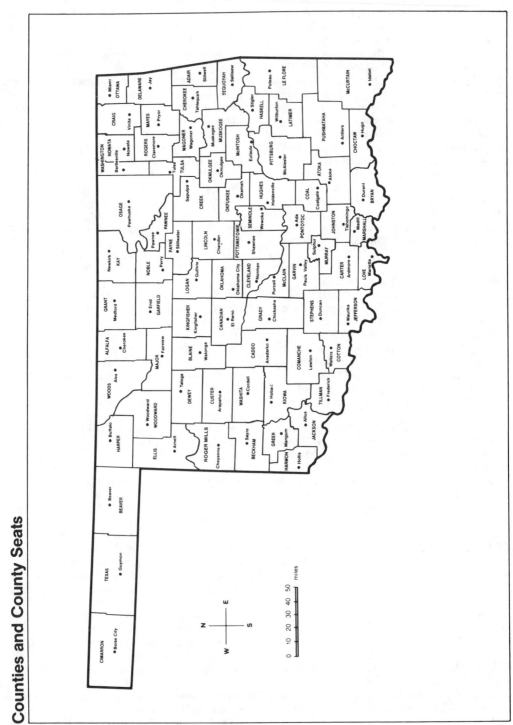

Counties and County Seats

Oklahoma

STATE OF OKLAHOMA

Capital: Oklahoma City, founded 1889

Name: From the Muskogean (Choctaw) language "okla" meaning people and "humma or homma" meaning red, suggested by Allen WRIGHT a Choctaw chief.

Nickname: Sooner State

Motto: "Omnia Vincit" Labor Conquers All Things

Symbols and Emblems
Animal: Bison
Bird: Scissor-tailed Flycatcher
Reptile: Mountain Boomer Lizard
Flower: Mistletoe
Tree: Redbud
Stone: Barite Rose (Rose Rock)
Colors: Green and White
Song: "Oklahoma" by Rodgers and Hammerstein

Population:
1985: 3,301,000
Rank: 25th
Gain or Loss (1970-80): +466,000
Projection (1980-2000): +919,000
Density: 48 per sq. mi.
Percent urban: 67.3% (1980)

Racial Makeup (1980):
White: 85.9%
Black: 6.8%
Hispanic: 57,413 persons
Indian: 5.13%
Others: 53,500 persons

Largest City:
Oklahoma City (466,120-1986)

Other Cities:
Tulsa (373,750-1986)
Lawton (80,054-1980)
Norman (68,020-1980)
Enid (50,363-1980)

Area: 69,956 sq. mi.
Rank: 18th

Highest Point: 4,973 ft. (Black Mesa)

Lowest Point: 287 ft. (Little River)

H.S. Completed: 66%

Four Yrs. College Completed: 15.1%

STATE GOVERNMENT

Elected Officials (4 year terms, expiring Jan. 1991):
Governor: $70,000 (1986)
Lt. Gov.: $40,000 (1986)
Sec. of State: $37,000 (1986)

General Assembly:
Meetings: Annually in Oklahoma City
Salary: $20,000 (1986)
Senate: 33 members
House: 99 members

Congressional Representatives
U.S. Senate: Terms expire 1991, 1993
U.S. House of Representatives: Six members

Oklahoma, Demography

Major Rivers and Waterways

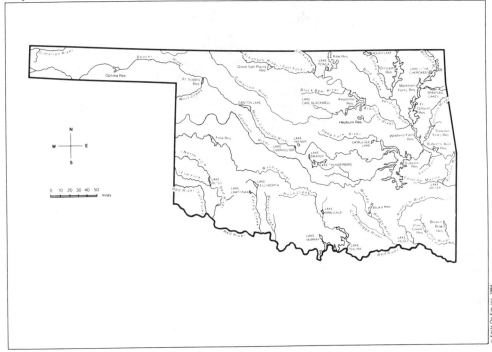

uplift. The early Mesozoic Era found the land continuing to rise followed by the lowering of the Cretaceous period. By the end of the Cenozoic Era the land had become much as it is today.

Surface rock outcroppings in the far southeast are Mesozoic, while most of the state is late Paleozoic, except for the Panhandle which is Cenozoic, with the far western tip Mesozoic.

Climate is that of the temperate southern humid belt, merging with the colder northern continental; eastern portions are humid and western dry. The extreme range of temperature is 147 degrees.

The Oklahoma economy is dominated by manufacturing, bringing annual income of about 26 billion, more than double the income from minerals and mining at around 11 billion. However, much of the manufacturing of the state centers around the wealth of petroleum and its products, particularly oil field machinery and equipment. However, Oklahoma offers other products of a wide range, including unicycles, helicopters, horse trailers, school bus bodies, machinery for producing eyeglasses and jet planes.

Oklahoma's oil field discovery well was the Johnstone Wildcat in 1897. The "worthless" lands given to the OSAGE INDIANS eventually made the tribe wealthy, after great oil discoveries were made there. Although Oklahoma oil production has dropped, the state still ranks fourth among the states in that vital area, and third in natural gas. TULSA calls itself the Oil Capital of the World, sheltering the headquarters of nearly a thousand petroleum related industries, including some of the largest.

Coal is now a growing industry in Oklahoma, and zinc, building stone, sand and gravel are important.

Livestock brings more than half the agricultural income of the state, with another half a billion coming from such crops as wheat and cotton. The problems of the great 30s drouth and dust storms have mostly been controlled, but drouth has continued as a problem from time to time.

In 1985 Oklahoma population stood at 3,-301,000, a slight drop from 1983. By the year 2000 the population is expected to be 3,944,000. White residents make up 85.5% of the people, black 6.76%. Oklahoma's Indian population of more than 184,000 is second only to Arizona among the states. Due to the number of Indian

languages as well as European and Oriental, more languages are spoken in Oklahoma than in all of Europe.

Before human occupation began, Oklahoma was home to vast numbers of prehistoric creatures, and the fossil fields have yielded the greatest variety of dinosaur relics yet found in the nation.

Archeologists believe human occupation of present Oklahoma began about 25,000 years ago. Remains of the various peoples in the region include FOLSOM, BASKETMAKERS and OZARK BLUFF DWELLERS. The Slab-House Culture took its name from the nature of the structures they built.

In 1541 Spanish explorer Francisco de CORONADO (1510-1554) pushed up from Mexico into the present U.S. Southwest, cutting across western Oklahoma and part of the Panhandle, while at the same time the expedition of Hernando De Soto may have reached eastern Oklahoma, although that is considered unlikely. These early visits gave Spain claim to the region. Other expeditions came and went until in 1682 Rene Robert Cavalier, Sieur de LA SALLE (1643-1687), claimed the Mississippi

drainage system for France, and some other French explorer/traders ventured in.

The early Europeans found six major nomadic Indian language groups in what is now Oklahoma, roaming the plains without permanent homes. These were the APACHE, KIOWA, KIOWA-APACHE, CHEYENNE, ARAPAHO and COMANCHE. After some of the European explorers' horses had strayed or were stolen, horses multiplied rapidly among the tribes and changed the lives of the plains Indians. Now they could dash about swiftly on their hunting or warfare expeditions. The Comanche were said to be the most daring and fearless of all riders. The Indians loved to race and bet on the horses.

More settled tribes of the area lived in tepee villages: Osage, QUAPAH, PAWNEE and PONCA. The CADDO and WICHITA had even more permanent settlements and cultivated the land, the latter even growing corn for trade with other tribes.

After nominally changing hands a number of times, the Louisiana Territory, including Oklahoma, became a U.S. possession in 1803, then went through a variety of territorial changes. Finally came the most dramatic change of all, a period unique in U.S. history.

Topographic Areas

N
W — E
S

0 10 20 30 40 50
miles

High Plains
Gypsum Hills
Wichita Mts
Red Bed Plains
Arbuckle Mts
Sandstone Hills
Prairie Plains
Ozark Plateau
Ouachita Mts
Red River Plains

The Indians of the southeast had adopted many European ways over a period of 150 years. Many of them lived much as did their European neighbors; large numbers were wealthy land and slave holders. Eventually, however, their white neighbors grew so jealous of their lands and holdings that the government forced the "Five Civilized Tribes" of the southeast to move. After a tortured trek across the country where thousands died, the five tribes were settled in Indian Territory, now Oklahoma.

Each of the tribes developed its own separate nation under U.S. protection, with formal governments, capitals of sturdy brick buildings, schools, colleges, systems of laws and courts and ambassadors to their neighbor governments and to the U.S., as well.

By 1856 the 25,000 CHOCTAW were the most numerous of the five. Choctaw cotton plantations flourished, including such wealth as that of plantation owner Robert M. Jones, who owned several Red River plantations, worked by more than five hundred slaves.

Steamboats brought trade up the Red and Arkansas rivers. Some of the provisions of the Choctaw constitution, enforced from the capital at TUSKAHOMA, are now part of the present Oklahoma constitution. Schools were run by a board of trustees with a superintendent.

The history of the other four was similar. Gradually the CHEROKEE nation became the largest and most enlightened of the five. Through the unique work of their savant SEQUOYAH, the Cherokee had become literate in a single generation. Their laws and constitution were written entirely in their own language. The sturdy brick buildigns of their capital, TALE-QUAH, have various public uses even today. They boasted the first telephone exchange in Oklahoma.

Others of the five tribes were CHICKASAW, capital TISHOMINGO; CREEK, OKMULGEE, and SEMINOLE, Wewoka. The five nations had an intertribal council to settle problems among the various nations.

When the CIVIL WAR came, many of the Indian people sided with the North, but officially the nations took the side of the Confederacy. During the war there were 28 battles and skirmishes in Oklahoma, beginning with the Battle of ROUND MOUNTAIN. With the collapse of the Confederacy, the five nations were ruined. However, the federal government agreed to negotiate. The Indian leaders were so skillful that they regained most of their losses, with the exception of giving up some of their lands to the west.

Those lands and others in the West were given to other tribes. There were conflicts with their neighbors among most of the tribes of the present state, including the civilized tribes.

The next chapter of Oklahoma history is also unique in U.S. annals. Various sections of unassigned lands were bought from the Indians to be opened for settlement. The first person to legally stake a claim for up to 160 acres of land would gain title to it. But claims could not be made before a deadline. Those who jumped the gun would lose their claim. However, many did go in ahead of time, to become known as "Sooners" and giving the state its nickname.

The first opening was scheduled for high noon, April 22, 1889. More than 100,000 people gathered on the Kansas side of the border. When the signal came, nothing like the "stampede" had ever been seen before. On horseback or muleback, in special railroad trains, by carriage, on foot, running, limping, screaming the crowds rushed in. By noon next day a tent city of 10,000 population had grown on the present site of OKLAHOMA CITY. "Rivals shot it out over claim disputes," wrote one witness. Other present-day towns also sprang up overnight.

Other rushes occurred through 1906. Oklahoma Territory had been created in 1890, with GUTHRIE as capital, and the Panhandle was added to the territory and opened for settlement. Members of the five nations were made U.S. citizens, with the tribal properties divided among the members. The five nations lobbied to have their area made a separate state, but their region and the territorial region were combined when Oklahoma became a state on November 6, 1907.

The progress that followed has been claimed as greater than "has occurred in a single generation in any other area of comparable size in the United States."

When large acreages of land were cultivated to aid in WORLD WAR I, the overused land was subject to the drouth and windstorms which swept in during the 1930s, with devastating results, bringing on the departure of the discouraged "Okies" to California and other areas. Windbreaks, dams and lakes, irrigation and other conservation measures gradually brought much of the land back.

WORLD WAR II sent 200,000 Oklahomans into service but brought the state unparalleled prosperity.

When 1963 carried earth-orbiting Oklahoman L. Gordon COOPER (1927-) into the news, many who were still alive to marvel then could

recall the state's entire history back to the land rushes and even earlier, all in a single generation.

During the 1970s, the opening of the MC CLELLAN-KERR ARKANSAS RIVER NAVIGATIONAL SYSTEM made Muskogee and Tulsa busy inland ports, with outlets to the sea.

Ronald Reagan won the presidential votes of the state in 1980 and 1984, but Democrat George Nigh held the governor's chair. However, Republican Henry Bellmon took the governor's office in 1987 for a term ending in 1991.

Oklahoma's most renowned personality was not a powerful politician, but his influence far exceeded that of most political figures. Will ROGERS (1879-1935), born between CLAREMORE and OOLAGAH, son of a wealthy and influential pioneer family, became a world figure through his multi-faceted activities. He began as a rodeo roping expert, took his act to vaudeville, where his comments and dry humor soon took over from the rope. Eventually his newspaper column was the most widely read in the world. His gently humorous but often brilliant and cutting comments on U.S. and world affairs

were known to bring about reforms and make or break political figures. His comedy work in the movies made him one of film's brightest stars. That star was brought down at the peak of his career when he crashed (August 15, 1935) in Alaska on a round-the-world flight with his aviator friend Wiley POST (1899-1935). As one obituary noted, "The world lost both its courage and its humour."

Also a genius of world fame was the Indian master SEQUOYAH (1770?-1843), only person in world history known to have alone created both a written language and a mathematical system. As a young man, he could not read or write, but he understood that the white people communicated with marks on paper. For twelve years Sequoyah worked to make his own system for writing in the Cherokee language. After he succeeded, his method was so direct that within a generation most of his people could read in the Cherokee language and understand mathematics, as well. Sequoyah moved to Oklahoma with the Cherokee, settling at SALLISAW, where he earned a living with a salt manufacturing business. When he heard of a long lost Cherokee tribe in Mexico, he and his son set out to

The Rodgers and Hammerstein musical "Oklahoma!" is presented on summer evenings at the Discoveryland outdoor amphitheater in Tulsa, a tribute to the state song.

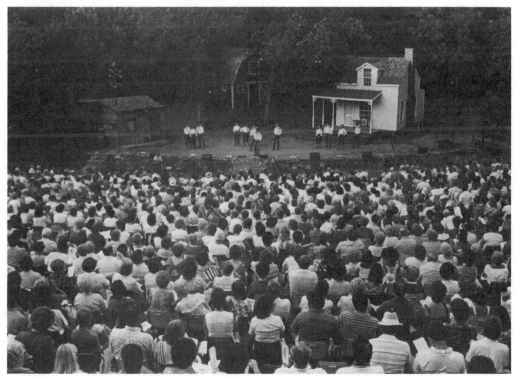

Oklahoma, Attractions

Philbrook Art Center at Tulsa enjoys one of the finest landscape settings and is noted for its collections of Western art.

find it, but he died in Mexico without succeeding in that quest.

Leroy Gordon Cooper (1927-), native of Shawnee, gained world fame when he took off in the space capsule *Faith 7* on May 15, 1963, made 22 orbits and hand maneuvered his landing craft to an ocean landing, without instrumental help, because of a malfunction. President John F. KENNEDY (1917-1963) called his feat "one of the victories of the human spirit."

Among noteworthy Oklahoma politicians were Governor William H. "Alfalfa Bill" Murray, wealthy oilman, U.S. Senator Robert S. KERR, one of the most powerful figures of his day, and another oilman, E. W. Marland, who became the state's first Republican governor, in 1963.

Another Oklahoma oil man, J. Paul Getty, became known as one of the world's richest men.

In the field of art the Oklahoma's Indian artist ACEE BLUE EAGLE has made a substantial reputation.

Oklahoman Milly Francis became the first woman ever to receive a Medal of Honor, her recognition for saving the life of a soldier.

Northeastern Oklahoma provides visitors with three "capitals"—the state capital, the oil capital and the Indian capital.

The International Petroleum Exposition, largest meeting anywhere devoted to one industry, emphasizes Tulsa's role as oil capital. But the city is also a center of fine art, with the THOMAS GILCREASE INSTITUTE OF AMERICAN HISTORY AND ART, and the PHILBROOK ART CENTER, containing the Kress Collection of Italian Renaissance paintings. One of the nation's principal rose gardens is found at the Tulsa Garden Center.

Nearby BARTLESVILLE boasts the WOOLAROC MUSEUM, one of the finest anywhere in its collection of western art by most of the renowned figures in that genre.

The Cherokee capital of Tahlequah now uses the sturdy capitol building as the county courthouse. The community supports the annual Cherokee National Holiday and there is a recreated Indian Village called Tsa-La-gi with displays of Cherokee life.

The historic Creek Council House has been restored at Okmulgee, while Pawhuska is still the headquarters of the Osage Agency, with the

Osage Tribal Museum in the home of Chief Bacon Rind. Pawhuska hosts the largest amateur show of its type, the International Roundup Cavalcade.

Memories of Will Rogers are everywhere at Clarmore, where the Will Rogers Memorial is the burial site for the humorist and his wife, graced by the famed Rogers statue by sculptor Jo Davidson. The original surrey with the fringe on top is housed at Clarmore's Lynn Riggs Memorial Museum, honoring the author of the play on which the musical "Oklahoma" was based.

The "Land that Nobody Wanted," western Oklahoma now supplies much of the world's helium and natural gas. Great Salt Plains, the world's largest gypsum cave—Alabaster Caverns, and GLASS MOUNTAINS near Orienta are attractions of the northwest.

Of all the world's capitals, only one can boast that it literally sprang into being in one night. Where bare prairie existed at daybreak, a tent city of 10,000 was sprawled at the next sunrise. Although the capitol was planned to have a dome, it is one of the few structures of its type

without one, eliminated for the sake of economy. However, the capitol is the only one anywhere which supports itself with its own oil well, pumping in the front lawn.

The city's Metro Concourse connects twenty of the city blocks with underground tunnels.

Unique of its type is the WESTERN HERITAGE CENTER at Oklahoma City, known as the Cowboy Hall of Fame, created by a consortium of 17 western states to pay tribute to their cowboy sons and daughters. Particularly well known is the statue "The End of the Trail."

A football powerhouse, often the nation's number one, the University of Oklahoma at Norman is also distinguished for its academic excellence. It is known, as well, for its fine Museum of Art at Fred Jones, Jr., Memorial Art Center. Each third week in April Norman hosts the 89er Celebration, recalling the first great rush for Oklahoma land.

OKLAHOMA CITY UNIVERSITY. Private university established as Epworth University by the Methodist Episcopal Church; the Methodist Episcopal Church, South; and the Cham-

The oil derrick outside the capitol at Oklahoma City provides evidence that it is the only such building supporting itself from the wealth of its own grounds.

ber of Commerce of Oklahoma City. Classes began in the fall of 1904. The university's campus occupies 64-acres in the northwest section of OKLAHOMA CITY. Accredited by the North Central Association of Colleges and Schools, the university enrolled 2,674 students and employed 235 faculty members during the 1985-1986 academic year.

OKLAHOMA CITY, OKLAHOMA

Name: From the Muskogean (Choctaw) language "okla" meaning people and "humma or homma" meaning red suggested by Allen Wright a Choctaw chief.

Nickname: City of 1,000 Lakes; Capital of Soonerland; The Town where Oil Derricks Loom in Almost any Yard.

Area: 650 square miles

Elevation: 1,207 feet

Population:
1986: 466,120
Rank: 28th
Percent change (1980-1984): +10.4%
Density (city): 739 per sq. mi.
Metropolitan Population: 962,552 (1984)
Percent change (1980-1984): +11.8%

Race and Ethnic (1980):
White: 79.95%
Black: 14.56%
Hispanic origin: 11,767 persons (2.80%)
Indian: 11,199 persons (2.58%)
Asian: 4,610 persons (1.03%)

Age:
18 and under: 27%
65 and over: 11.3%

TV Stations: 8

Radio Stations: 24

Hospitals: 12

Sports Teams:
Oklahoma City 89ers (baseball)

Further Information: Oklahoma City Chamber of Commerce, One Santa Fe Plaza, Oklahoma City, OK 73102.

OKLAHOMA CITY, Oklahoma. City, capital of Oklahoma, seat of Oklahoma County and largest city in the state, situated in central Oklahoma, nearly bisected by the North Canadian River. The city takes its name from the state. The city is a hub for communities such as NORMAN, MIDWEST CITY and Edmund. It is the second largest city in the U.S. in land area, covering parts of three counties and spreading over 650 square miles.

The leading wholesale center of the state, with the major stockyards and meat packing plants, Oklahoma City also is a cotton processing and grain milling center. It assembles autos and aircraft and produces electronic equipment, tires, iron and steel and furniture.

However, the city is overwhelmingly dominated by, and sometimes driven into recession, by oil. The first field began to produce in 1928, and wells pumping high gravity oil spread throughout most of the city to a total number of about 1,800. The capitol itself derives income from its seventeen wells on the capitol grounds, including one in its front yard, which pumps oil from beneath the building itself.

Tinker Air Force Base, one of the world's largest air depots, adds to the city's prosperity.

Oklahoma is unique among world capitals, having been born practically full-fledged overnight. Land hungry settlers poured in with the great land rush when the signal sounded at noon on April 22, 1889. So many had arrived and pitched their tents on the site of the present capital that by morning it was a community of 10,000 souls, and a new city had been established in less than twenty-four hours.

The state capital was selected there in 1910, overcoming complaints by GUTHRIE that Oklahoma City had illegally taken the capital to itself.

OKLAHOMA CITY UNIVERSITY, The Medical School of the University of OKLAHOMA, Oklahoma Christian College and several junior colleges provide an educational base.

The capitol was planned to have a dome, which was never built for reasons of economy. In Graeco-Roman style, the building was completed in 1917. On the capitol grounds, the *Statue of a Cowboy* has been commended as one of the most authentic, by old-timers who should know. The capitol complex includes the Historical Museum, Sequoyah Memorial Building, Jim Thorpe Memorial Building, Oklahoma National Guard Armory and Will Rogers Memorial Building.

One of the largest collections of Indian relics anywhere is found at the State Historical Society Museum.

The Civic Center development encompasses the County and City buildings, the six thousand seat Municipal Auditorium, and the police headquarters.

Said to be unique is the NATIONAL COWBOY HALL OF FAME, organized by a consortium of seventeen western states to pay tribute to their cowboy past, the men who began to build the West. Included are the John Wayne Collection, Rodeo Hall of Fame, famed statuary and other art. Also displayed are life-sized recreations of pioneer times and a portrait gallery of western film stars.

Other museums include the Oklahoma Museum of Art, National Softball Hall of Fame and Museum, 45th Infantry Division Museum, Oklahoma Heritage Center, Oklahoma Firefighters Museum and the Oklahoma Art Center on the fairgrounds.

Kirkpatrick Center includes International Photography Hall of Fame and Museum, Kirkpatrick Planetarium and Omniplex.

The exhibits of unique Enterprise Square feature state-of-the-art, hands-on computer games, electronic displays, giant talking currency and other items designed to promote free enterprise.

The annual Festival of the Arts is held from mid to late April. Festifall in mid September features crafts and their creators, and the State Fair of Oklahoma is one of the largest and most varied in the country, in late September. Lyric Theater, Oklahoma Symphony Orchestra and Ballet Oklahoma have their regular seasons.

OKLAHOMA FLAG (Original). In 1908 ninety-two seamstresses from across Oklahoma had been commissioned by Governor C.N. Haskell for the task of making the first Oklahoma flags. A very special bunting cloth had been prepared from wool shorn from Oklahoma sheep and woven for the purpose. The ninety-two women assembled at the Carnegie Library in GUTHRIE, the first library established in the state, and worked to prepare two flags After two days of steady work, on June 15th and 16th the flags were finished. One flew over the temporary capitol—a convention hall built by the city of Guthrie, and then it was taken down, carefully folded, and shipped to Philadelphia, Pennsylvania where, by tradition, it was flown over Independence Hall on July 4th, a symbol of the new state. The other flag was presented it to the Battleship *Oklahoma* when it was commissioned at Philadelphia on March 23, 1914, by Lorena Cruce. The flag was placed in a glass case and became one of the ship's proudest

possessions. When the proud battleship was sunk in the Japanese attack at Pearl Harbor on December 7, 1941, the flag went down with the ship, which also, sadly, carried many members of the crew to their deaths.

OKLAHOMA PANHANDLE. Prominent western feature of Oklahoma geography. Lying mainly in the HIGH PLAINS region of the U.S., it includes Cimarron, Texas, and Beaver counties. The Panhandle region, a disputed area between Spain and the United States, which claimed it as part of the Louisiana Territory, was given to Spain in 1819 to settle several boundary problems but was later given up by Spain. It was not part of the area allotted to displaced Indian tribes. In 1890 Congress established the Territory of Oklahoma and added the panhandle region to it.

OKLAHOMA STATE UNIVERSITY. Publicly supported, founded in 1890. Located in STILLWATER, the university maintains nineteen experiment stations over the state and a farm of 2,245 acres adjoining the campus. During the 1985-1986 academic year the university enrolled 21,379 students and employed 1,089 faculty members.

OKLAHOMA, **Battleship.** One of eighteen vessels sunk in a surprise attack at Pearl Harbor, Hawaii, by 360 Japanese war planes on December 7, 1941. Sinking of the *Oklahoma* took many of the lives lost in the cowardly Japanese attack. Less important but an interesting sidelight, the Oklahoma was carrying the original flag showing forty-six stars, which had been made to commemorate Oklahoma's statehood in 1908.

OKLAHOMA, UNIVERSITY OF. Publicly supported, approved by the first legislature in the Territory of Oklahoma in 1890. The university is one of the few state educational institutions in the United States to be authorized during the territorial period before statehood. Located at NORMAN and OKLAHOMA CITY, the university comprises 3,063 acres and 338 buildings. It benefitted from the generosity of Frank PHILLIPS, founder of Phillips Petroleum Company, who donated the Phillips Historical Collection to the school. The Stovall Museum contains nearly three million specimens. The opening of the Kellogg Center for Continuing Education has enhanced the university's image as an international leader in adult education. The University of Oklahoma Press is recog-

nized for its work in the area of regional and scholarly publications. The university is also recognized as a national power in football. During the 1985-1986 academic year the university enrolled 23,385 students and employed 1,606 faculty members.

OKMULGEE INDIANS. The name ("Where water boils up") probably refers to the springs in Butts County, Georgia, called Indian Springs. The tribe is of Muskhogean linguistic stock. They lived in the area of Macon, Georgia near the bend of the Chattahoochie River. A generally peaceful tribe, they eventually joined the CREEK INDIANS in the move to Indian Territory.

OKMULGEE, Oklahoma. City (pop. 16,263). Seat of Okmulgee County, northeastern Oklahoma, southwest of MUSKOGEE and south of TULSA, named for the OKMULGEE INDIANS and

established in 1868. It was the capital of the CREEK nation from 1868 to 1897. In 1871 the leaders of the FIVE CIVILIZED TRIBES in Oklahoma met at Okmulgee to establish a confederation of the Indian nations, but the federal government prohibited its formation. Today, Okmulgee is the meeting place of the Inter-Tribal Council, in which tribal representatives discuss mutual problems. The area produces large quantities of wild pecans. Oklahoma State Tech, branch of OKLAHOMA STATE UNIVERSITY, is one of the largest vocational training schools in the nation. The old Creek Council House is now a Museum. Annual events include the Pecan Festival and Creek Nation Rodeo and Festival.

OLATHE, Kansas. City (pop. 37,258). Seat of Johnson County, northeastern Kansas, south of KANSAS CITY and east of LAWRENCE. It was founded in 1858, and the name comes from the Shawnee, which probably means "beautiful."

Old Faithful does not spout quite as regularly as in the past, but it still can be counted on for fairly regular spectacles to thrill the crowds.

Olathe has been called the "Cowboy Boot Capital" because of its nationally known boot manufacturers. However, other manufactures include batteries, aircraft communication and guidance systems, plastic components and machinery.

OLD FAITHFUL GEYSER. Most famous and picturesque of all geysers found in the United States, in YELLOWSTONE NATIONAL PARK. It is not the largest or the oldest, but is the most regular of the geyers shooting up to 150 feet in the air at one time with great dependability about every sixty-five minutes. Recently the delicate balance between water and steam has been disrupted in much of Yellowstone, due to human carelessness and earthquakes, and posted eruption schedules are approximate at best. A naturally-occurring cone of a hard mineral called geyserite has been formed around its vent.

OLD SLANT VILLAGE. One of the attractions in FORT ABRAHAM LINCOLN STATE PARK near BISMARCK, North Dakota. Old Slant Village was constructed by the MANDAN Indians on land offering the protection of the Heart River to the east and a deep coulee on the south. A palisade and moat were constructed to protect the exposed sides. The settlement contained sixty-eight lodges. Five structures, restored by the park department, include four homes and the large ceremonial lodge, which was eighty-four feet across.

OMAHA INDIANS. Tribe of the Dhegiha division of the Siouan language family. The Omaha were located in northeastern Nebraska in the late 18th century. In the late 1970s there were about 1,500 Omaha descendants with most living in Nebraska. The Omaha had two divisions, each containing five patrilineal groups. There were numerous social and secret societies, including warrior societies. Secret societies, which required members to have had a dream or vision, often practiced healing by rituals or medicinal herbs. Omaha religion emphasized Wakonda, an invisible force believed to be in all living things. Omaha villages were located along streams with nearby hills used as lookout posts. The Omaha lived in skin tipis and earth lodges which they adopted from the ARIKARA. The summer buffalo hunt provided food, clothing and shelter as well as materials to make round BULLBOATS and shields. The Omaha excelled in woodcarving, quillwork and beadwork. The Omaha population was ravaged by smallpox in 1802. In 1854 they ceded all their lands to the United States and moved the next year to a reservation in Dakota County, Nebraska. In 1865 the northern portion of this reservation was sold to the Winnebago. Lands were allotted individually to the Indians in 1882.

OMAHA, NEBRASKA

Name: From the Omaha or maha Indians of the area.

Nickname: Boy's Town; The Steak Capital of the World; The Crossroads of the Nation.

Area: 99.3 square miles

Elevation: 1,040 feet

Population:
1986: 349,270
Rank: 45th
Percent change (1980-1984): +6.4%
Density (city): 3,517 per sq. mi.
Metropolitan Population: 607,385 (1984)
Percent change (1980-1984): +3.8%

Race and Ethnic (1980):
White: 85.47%
Black: 12.05%
Hispanic origin: 7,354 persons (2.33%)
Indian: 1.839 persons (0.57%)
Asian: 2,381 persons (0.56%)

Age:
18 and under: 27.5%
65 and over: 12.2%

TV Stations: 6

Radio Stations: 16

Hospitals: 14

Sports Teams:
Omaha Royals (baseball)

Further Information: Omaha Chamber of Commerce, 1301 Harney Street, Omaha, NE 68102.

OMAHA, Nebraska. City. Seat of Douglas County, largest city in Nebraska, situated on the MISSOURI RIVER in east central Nebraska opposite Council Bluffs, Iowa, the city was named for the OMAHA INDIANS who lived on the

Onate

site until they signed a treaty giving up their lands, in June 1854. Omaha is the heart of a sizable metropolitan area. However, the city itself lost about ten percent of its population to the suburbs in the decade 1970-1980. Among the suburbs are PAPILLION, Elkhorn and Washington.

Omaha is a major center of river and railroad transportation and a substantial air hub, one of the world's major livestock, meat packing and grain marketing centers. In the heart of a great farming region, its industry is devoted in large part to food processing. Computer components, farm machinery, fertilizers, furniture, clothing, telephone equipment, airplane and auto parts, cans, soap, paints and chemicals are among the other products. The city is one of the nation's leading insurance centers. The Strategic Air Command headquarters also adds to the economy.

The city is a leading educational center, with CREIGHTON UNIVERSITY, the University of NE-BRASKA at Omaha, the University of Nebraska Medical Center and the College of St. Mary.

Scarcely a month after the Omaha Indians had deeded away their land, a group of emigrants rushed over from Council Bluffs, where they had been waiting, and celebrated Fourth of July on their new territory. The city was quickly laid out with streets a hundred feet wide. A new ferry landing and the first log building were erected before the month was over.

Soon steamboats, at the rate of one a day, were bringing emigrants to Nebraska and the West, along with substantial cargoes; the eastern terminous of the first trans-continental railroad in 1865 saw the beginning of the rails snaking westward, and Omaha was on its way to becoming a major commercial and transportation metropolis. Growth was especially brisk when the railroad was completed for coast to coast travel in 1869.

Civic leaders such as the Cudahys, CREIGHTONS and Paxtons helped the commercial and cultural stimulus, as did the founding of the Knights of the AK-SAR-BEN (Nebraska spelled backwards). The Knights' founders hoped to create annual events which would rival those of New Orleans Mardi Gras and the festivals of other major cities.

A notable event for such a youthful city was the Trans-Mississippi and International Exhibition of 1898.

Unique to Omaha is the Great Plains Black Museum, paying tribute and preserving memorabilia and history of black Americans who helped to create the West. Also notable is the Joslyn Art Museum housed in its Art Deco building with a collection of art ranging from ancient to modern. There is a Children's Museum, and the Union Pacific Historical Museum presents a fascinating display of railroads past, housed in the railroad's headquarters.

Another railroad feature is the transformation of the lofty Union Station into the Western Heritage Museum. Historic homes include the General Crook House and the Gerald FORD (1913-) Birth Site. Memorials of another type are found in the Mormon Pioneer Cemetery, burial site of those religious pioneers who died in the area in the winter of 1846-1847.

Ten miles to the west is one of the world's most famous youth centers, BOYS TOWN, the creation of Father Edward J. FLANAGAN (1886-1948) to serve neglected, handicapped, abandoned and abused youth, a modern facility caring for 400 young people, now girls as well as boys.

Nine mile southeast is historic BELLEVUE with restored buildings of the early period, including some of the first of European style in the territory, and the Sarpy County Historical Museum. The old riverboat, *Belle of Brownville*, is available for river cruising.

One of the country's best known annual festivals is the Ak-Sar-Ben Ball and Coronation. The Knights also sponsor thoroughbred racing, stock shows and the World Championship Rodeo, all in their Field and Coliseum. Another notable annual Omaha event is the NCAA College Baseball World Series in late may and early June.

ONATE, Don Juan de. (Mexico, 1549—1624). Explorer. In 1598 Onate was granted permission by authorities in Mexico to settle the region north of EL PASO, Texas. He served as regional governor and, on July 11, 1598, established the first settlement in New Mexico and the second in what is now the United States, at the Tewa Pueblo called Yugeuingge. In December, 1598, the Pueblo Indians staged a bloody rebellion which Onate savagely quelled. Onate pursued his search for gold, possibly visiting the area of present-day Nebraska in 1598, while others in his party constructed a Spanish irrigation system in New Mexico and the first church in the area. Onate is credited with beginning the livestock industry in New Mexico. A member of the expedition, Don Gaspar Perez de Villagra, wrote *Historia de la Nueva Mexico*, the first poem known to have been written in what is now New Mexico. Onate

journeyed to the Gulf of California in 1605 and claimed more land for Spain, but succeeded in returning to New Mexico only by joining his men in eating their horses, when supplies were exhausted. As Onate returned, he passed what is now known as INSCRIPTION ROCK, near modern-day EL MORRO NATIONAL MONUMENT, and carved the first modern inscription on this New Mexico landmark. His wealth gone, Onate was recalled to Mexico and sentenced to perpetual banishment from New Mexico for misrepresenting the value of the land he claimed, for disobedience to royal orders, and for mistreatment of Indians and his soldiers.

OO-LOO-TE-KA (John Jolly). (—). Indian chief. The White man called him John Jolly, but he was one of the leaders of the Cherokee Nation. However, he is perhaps best known for his considerate treatment of one of America's great statesmen in the times when Samuel HOUSTON (1793-1863) needed wise help and counsel. At the age of fourteen, Houston ran away and sought shelter with the Indians where a group of the Cherokee under Chief Oo-loo-te-ka were living on an island in the Tennessee River. There Sam was adopted by the kindly chief and wrote of his life among the Indians, "...I was initiated into the profound mysteries of the red man's character."

Throughout his unique life Houston continued to comment upon and demonstrate through his actions the effect of his adoptive father and his people on their adopted son's character.

When In despair concerning his personal life Houston went back to his foster people, now forced to live in Oklahoma. He was again welcomed by Oo-loo-te-ka, who said, "My wigwam is yours...my people are yours—rest with us....Eleven years have passed since we met...and I heard you were a great chief among your people...I have heard that a dark cloud had fallen on the white pathway you were walking, and when it fell in your way you turned your thoughts to my wigwam. I am glad of it....We are in trouble, and the Great Spirit has sent you to us to give us council, and take trouble away from us." This quotation is representative of the wisdom with which Oo-loo-te-ka led his people, and in a broader sense, of the wisdom exhibited by many of the other Indian leaders of the region.

OOLOGAH, Oklahoma. Town (pop. 789), Rogers County, northeastern Oklahoma, southeast of BARTLESVILLE and northwest of TULSA .

This quiet agricultural center owes most of its fame as the boyhood home of Will ROGERS (1879-1935), who once remarked that he "was born halfway between CLAREMORE and Oolagah before there was a town at either place." His mother moved into the older part of their house so that her son would be able to say that he had been born in a log cabin, despite the fact that the logs were by then covered with siding and the home was that of a very prosperous family. The original birthplace near Oologah is open to the public.

OREGON TRAIL. Pioneer route to the Oregon Country established between 1804 and 1860. The trail started at Independence, Missouri, and reached across Nebraska following the PLATTE and then the NORTH PLATTE rivers. It crossed Wyoming using SOUTH PASS in the WIND RIVER RANGE and the path of the Snake River across Idaho to the Columbia River. The end of the trail was Fort Vancouver. Particularly heavy wagon train traffic passed along the path between 1842 and 1860. All of that traffic crossed the Central West, but many stopped and settled in one of the states of the region while, others split off the Oregon trail as it branched to other areas of the Central West and West.

OREODONTS. A prehistoric pig-like animal found in fossil beds in Nebraska.

OSAGE INDIANS. Most important of the Dhegiha division of the Siouan linguistic family. The Osage were located along the Osage River in western Missouri in the late 17th century. In early days they were noted for their "noble size," their ability to ignore the white man's firewater and their general contempt for white men and their ways. The Osage believed in Wakonda, a natural force thought to reside in all living things. Shaman provided religious leadership. Women and men could belong to a secret religious society.

Important ceremonies included the Rite of Chiefs in which the oral history of the tribe was recalled. The Osage were divided into two divisions, the Tzisho or Sky People, and the Hunkah, or Land People. Each division was subdivided into twenty-one clans. Membership in a clan was determined through the father. Division chiefs were hereditary in some clans.

From the early 19th century there were three political divisions: the Little Osage, the Arkansas Osage and the Great Osage. The Osage cultivated crops of corn, squash and beans to

descendants lived in northern Oklahoma. Because of their oil wealth many Osage are able to live outside the United States and have chosen to do so.

OSAWATOMIE, Kansas. Town (pop. 4,459), Miami County, east-central Kansas, southwest of OLATHE and southeast of Ottawa. The name was derived from a combination of the OSAGE and POTAWATOMI INDIAN tribes. Osawatomie was founded in 1855 and has been chiefly associated with the headquarters of John BROWN (1800-1859), the "firebrand" opponent of slavery. In May, 1856, Brown and a small group of followers killed several men as a warning to pro-slavery settlers. Retaliation came three months later when pro-slavery supporters killed five of Brown's men, including his son, in a raid known as the Battle of Osawatomie. John Brown Memorial Park contains a statue of Brown and a cabin used by Brown's brother-in-law as a station on the UNDERGROUND RAILROAD. The Old Stone Church is a restoration of one of the first pioneer churches in Kansas. The first pastor of the church was Reverend Samuel L. Adair, brother-in-law of John Brown. There is an annual John Brown Jubilee.

OSWALD, Lee Harvey. (New Orleans, LA, October 18, 1939—Dallas, TX, Nov. 24, 1963). Presumed assassin of President John F. KENNEDY (November 22, 1963). While in police custody in Dallas, Texas, Oswald was murdered by nightclub proprietor Jack Ruby Rubinstein. President Lyndon JOHNSON (1908-1973) ordered a full report from the FBI and an investigation by a special commission headed by Chief Justice Earl Warren on the circumstances surrounding Kennedy's death, because, due to Oswald's death, the evidence against Oswald could not be presented in court. The commission reported that it found Oswald to have been acting alone in the assassination, but many later reports have cast doubt on this verdict, and theories of Cuban, gangland and other plots continue to surface.

OTO INDIANS. Siouan tribe which lived along the PLATTE RIVER in eastern Nebraska in the late 18th century. Oto villages were organized into ten clans. A person inherited clan membership through the father. All household property was owned by the women. Each clan had certain responsibilities. The offices of the clan chief, war chief and priests were hereditary.

The Oto villages contained as many as

"Osage Warrior" by Saint-Memin, 1804

supplement the deer, turkey, wild cat and beaver hunted by the men. Organized buffalo hunts in the early days called for stampeding the animals over a cliff. They either died in the fall or could be killed easily. Bows for the hunt were made of Osage orange wood.

In 1808 the Osage ceded the northern half of Arkansas and most of Missouri to the United States, and the Great and Little bands moved to the NEOSHO RIVER in Kansas. As lands filled up with displaced Indian tribes, fighting increased. By treaties of 1818 and 1825 the Osage ceded all their lands except for a reservation in Kansas, where all the bands were settled by 1836. The Osage fought on both sides during the CIVIL WAR, and this caused internal discontent in the tribe. By 1870 the Osage had sold their Kansas lands and bought lands in Oklahoma. In 1906 the Osage voted in favor of the individual allotment of lands, allowing 658 acres for each of the 2,229 tribal members, with the tribe retaining all mineral rights, an exceptionally wise plan, since vast reserves of oil were found on Indian land. By the 1920s the Osage, famous for their wealth and some initial wild spending, settled down to wise use of their finances. In the late 1970s about 10,000 Osage

seventy semi-subterranean earth lodges. The Oto depended on hunting and agriculture. Men gave some help in the fields, but hunting was their primary responsibility. Buffalo hunts were conducted twice a year. Between 1717 and 1854 the Oto lived in many locations along the PLATTE RIVER and the MISSOURI RIVER where it meets the Platte.

Trade was conducted with the French and the Americans. Warfare with the Sauk, Fox, and PAWNEE and serious epidemics of smallpox reduced the Oto population. By 1829 the Oto had absorbed the surviving one hundred or so Missouri Indians. By treaties of 1830, 1833, 1836 and 1854 the Oto-Missouri ceded all their lands and moved to a reservation on the BIG BLUE RIVER between Nebraska and Kansas.

In 1880 bickering between the two tribes caused a split that resulted in one faction, the Coyote, moving away for a time while another faction, the Quakers, ceded their lands for a reservation near Red Rock in north central Oklahoma. By 1890 the Coyote faction had returned, and in 1907 the reservation lands were allotted to individual tribal members.

In 1955 a United States Supreme Court ruling resulted in the division of one million dollars among the two thousand Oto-Missouri on the tribal rolls. The money came in repayment for past illegal land management. In the late 1970s nearly 2,000 descendants of the combined Missouri and Oto tribes lived mostly in Oklahoma.

OTTAWA INDIANS. Algonquian tribe located in modern times throughout the United States. In the Central West most reside in Oklahoma. The Ottawa, remembered because of their famous chief Pontiac, were forced out of Ohio and lower Michigan in the early 19th century by treaty. Some migrated to Kansas, but in 1867 the Kansas Ottawa moved to the Quapaw Agency in Indian Territory (Oklahoma).

OUACHITA MOUNTAINS. A continuation of the OZARK Plateau, in west central Arkansas and eastern Oklahoma. The highest peak is 2,660 feet.

OURAY, Colorado. Town (pop. 684), Ouray County, southwestern Colorado, located between DURANGO and Montrose, on the GUNNISON RIVER. Deep in a valley, it is surrounded by the awesome SAN JUAN MOUNTAINS. Ouray, named for the leader of the UTE Indians, was the site of the Camp Bird Mine in which Thomas F. WALSH

made a second fortune, after losing another fortune in LEADVILLE. Today the entire community is a historic district. Before 1900 both silver and gold had poured fourth from the area. Because of the many mine tours available, it is said to have more of interest below ground than above. Ouray is reached by the MILLION DOLLAR HIGHWAY, blasted for most of the way out of the solid rock. Nearby is 227-foot Bear Creek Falls, and there is a Hot Springs Pool in Ouray City park. Imogene Pass Mountain Marathon takes competitors along the 18-mile course from Ouray, crossing Imogene Pass at 13,114 feet and ending at TELLURIDE, following an old mining trail.

OUTLAWS. Boothill cemeteries are tourist attractions in many cemeteries of the region. Often it was literally true that men died violent deaths and were buried with their boots on. In early days of the Central West, when population was sparse, few laws existed, and those were almost impossible to enforce because of the scarcity of officials, or the mendacity of sheriffs and other officials. Outlaw gangs were found all along the advancing frontier in every developing region.

Mining areas, where great wealth was being unearthed, especially attracted all kinds of undesirable characters. "There was a saloon every forty feet and a bad man on every corner," as one eyewitness described the scene on the Montana mining frontier.

Sometimes, the law abiding citizens discovered to their horror that their lawmen were part of the criminal element. In BANNOCK, Montana, popular Sheriff Henry Plummer turned out to be the leader of the outlaws, the organizer of a highly efficient criminal mob. But in Bannock, as happened so often around the region, the good citizens finally became fed up, organized a group of vigilantes and rounded up the outlaws. After quick "trials," the Bannock gang was hanged and buried on Boothill, along with "Sheriff" Plummer.

In other communities, such as DEADWOOD, South Dakota, local lawmen became so efficient that they individually stamped out much of the lawbreaking in their communities. Two of the best known lawmen were James Butler (Wild Bill) HICKOK (1837-1876) and Wyatt EARP (1848-1929).

The better known outlaw gangs operated through much of the region, including the DALTONS, Tulsa Jack, Jesse JAMES (1847-1882), the Youngers and the famous woman outlaw Belle STARR (1848-1889). Starr was involved

with the Youngers and the James gang. She was married to Sam Starr, and her home in Oklahoma's Indian territory was a haven for outlaws. She became known as a "fixer," dealing for favors with crooked officials. However, her biographies have made her appear to be much more "glamorous" and influential than she was in real life.

This was the case with many of the notorious figures of the Central West. They were dangerous, sometimes psychotic, often of low mentality and generally deserving of the term punk. However, the fiction works of the day and of later motion pictures and television glamorized the outlaws, giving them a kind of appeal which they in no way deserved.

OVERLAND PARK, Kansas. City (pop. 81,-784), a suburb of KANSAS CITY, Kansas, south of the city in Johnson County. The city was incorporated in 1960 and mainly residential.

OVERLAND TRAIL. Short pioneer route from the PLATTE RIVER fork to FORT BRIDGER. The trail was named in 1862 for Ben HOLLADAY's (1819-1887) Overland Stage Line which was moved to the trail from a road along the NORTH PLATTE RIVER. The Overland Trail was shorter, and benefitted from fewer Indian attacks. In years to come the Lincoln Highway and the Union Pacific Railroad followed the same general route of the Overland Trail through western Wyoming.

OWEN, Robert Latham. (Lynchburg, VA, Feb. 3, 1856—Washington, D.C., July 19, 1947). Cherokee statesman, senator. Owen served as the U.S. Indian agent for the FIVE CIVILIZED TRIBES from 1885 to 1889. He organized the First

National Bank of MUSKOGEE in 1890 and served as its president until 1900. Owen was a member of the Democratic National Committee from 1892 to 1896. In 1907 he became one of Oklahoma's first two U.S. senators. He served in the Senate as a Democrat from 1907 to 1925 and drafted the Federal Reserve Act in 1913 and the Farm Loan Act of 1916.

OYSTERS. In the Central West region, oysters are found along the Gulf Coast of Texas where those living in shallow waters are brought up with huge tongs which work like scissors. Those located in deeper water are harvested with dredges. Most oysters are sold unshelled. Value of the oyster fisheries of that area approach $100,000,000 annually.

OZARK BLUFF DWELLERS. Group of people who lived in the area of modern-day Oklahoma at the same time as the BASKETMAKERS, probably as early as 1500 BC.

OZARK MOUNTAINS. Area of rugged highlands also referred to as the Ozark Plateau, stretching from Saint Louis, Missouri, to the ARKANSAS RIVER. Covering nearly 50,000 square miles, they are mainly in Missouri and Arkansas but portions extend into Illinois, and in the Central West into Oklahoma, and Kansas. Primarily limestone, in the southern regions near the White and Arkansas rivers, elevations occasionally reach 2,000 feet in the Boston Mountains area. They are noted commercially for lead and zinc mines. Though sparsely populated and with numerous areas of extreme poverty in rural regions, the mountains have a large summer tourist trade.

P

PADRE ISLAND. Sandbar approximately 180 miles long, paralleling the southeastern Texas coast, separating the Laguna Madre from the Gulf of Mexico. Noted as the longest barrier beach off United States shores, its causeways give access to CORPUS CHRISTI and BROWNSVILLE. The terrain consists of tall, wind-

swept sand dunes, with some quicksand, and no vegetation. The PADRE ISLAND NATIONAL SEASHORE is located along the island. Tales of buried treasure have long been associated with the island, including a story that pirate Jean LAFFITE (1780-1826) buried his wealth here in about 1820. The island was named for Padre

Padre Island National Seashore is reached from both Corpus Christi and Brownsville, Texas.

Nicolas Balli, a Catholic priest, who settled there in 1800. Today it serves as a recreation center, and the United States Air Force and Navy have bases here.

PADRE ISLAND NATIONAL SEASHORE. Noted for its wide sand beaches, excellent fishing and abundant bird and marine life, this barrier island stretches along the Gulf Coast for 80.5 miles. Headquartered at CORPUS CHRISTI, Texas.

PAINT ROCK. Area near ABILENE, Texas, where hundreds of rock pictographs cover sheltered areas of a bluff along the Concho River. Most of the art work is painted in red, but other drawings are black and white or orange and white. The pictographs date from the prehistoric to those of Indians of historic times.

PALACE OF THE GOVERNORS. Constructed in 1610 in SANTA FE, New Mexico, the palace is a long, low abode building which has served as governmental offices under the Spanish, Indian, Mexican and United States Territorial rule, the latter until 1900. It is the oldest capitol in the United States still being occu-

pied. The sturdy building now shelters a museum of southwest history.

PALEO-AMERICANS. Most ancient of the peoples known to have lived in the south of the present Central West region, probably about 25,000 years ago. Remains of these people found in much of the southern portion of the region include some distinctive spear points with which they hunted prehistoric camels and tiny, prehistoric horses.

PALISADES STATE RECREATION AREA. South Dakota site northeast of SIOUX FALLS featuring a beautiful pink and purple gorge of jasper rock.

PALMER, William J. (Kent County, DE, Sept. 18, 1836—Colorado Springs, CO, 1909). Railroad official. Palmer, a Medal of Honor recipient for CIVIL WAR heroism, served as the president of the DENVER AND RIO GRANDE RAILROAD from 1870 to 1883 and the Rio Grande Western Railroad from 1883 to 1901. Palmer led the Denver and Rio Grande in its successful legal fight for the right to construct tracks through the ROYAL GORGE. In 1871 he founded COLORADO

SPRINGS, Colorado, which rapidly became a popular resort city for society people who relished the mineral baths and pleasant climate.

PALMETTO STATE PARK. Named for the abundant supply of palmetto palms, the park near Waelder, Texas, has been described as a small subtropical jungle. Sulphur springs, mud geysers, and rare and beautiful flowers are some of the attractions of the 500-acre area.

PALMITO HILL, BATTLE OF. Last battle of the CIVIL WAR, fought in May, 1865, near BROWNSVILLE, Texas, more than one month after Lee surrendered at Appomattox. Confederate troops had not heard that the Civil War was over, and they clashed with Union troops.

PALO ALTO BATTLEFIELD NATIONAL HISTORIC SITE. The park preserves the locale of the first of two important Mexican War battles fought on American soil. General Zachary Taylor's victory there on May 8, 1846, made the invasion of Mexico possible. Head-quartered BROWNSVILLE, Texas.

PALO ALTO, BATTLE OF. First battle of the WAR WITH MEXICO, Cameron County, Texas, 12 miles northeast of Brownsville, near the RIO GRANDE RIVER in the southern corner of the state. In the engagement Brigadier General Zachary Taylor led 2,300 men from the newly constructed Fort Texas on an exploratory incursion across the Rio Grande. On his return, Taylor was met at Palo Alto (May 8, 1846) by General Mariano Arista and 6,000 Mexican troops. Better armed, the Americans defeated the larger Mexican force.

PALO DURO CANYON. Rocky pass in northwest Texas, believed discovered as early as 1541. The first ranch on the Texas PANHANDLE was started there in 1865 at the close of the CIVIL WAR. It is part of the Llano Estacado escarpment, and a state park is located there.

PALO DURO CREEK. Stream originating in southwestern Oklahoma. It flows generally southeast for approximately 100 miles to terminate north of the Sanford National Recreation Area in northwestern Texas.

PAMPA, Texas. Town (pop. 21,396), seat of Gray County, in the east center of the PANHANDLE. Founded in 1888, the town's name comes from the Spanish *pampas*, meaning plains. The area is said by some to resemble the Argentine Pampas. Located in an oil producing region, developed after 1826, Pampa's economy is based on supplying to an oil field center, as well as a marketing center for wheat and cattle. The thriving industrial city now produces carbon black and petrochemicals. The grain elevators handle the agricultural bounty of the area. During the year, there are four "Top O' Texas" events in Pampa.

PAN-AMERICAN HIGHWAY. Highway system extending from the United States-Mexican border to southern Chile. The principal entry point into Mexico on the Pan-American Highway is through LAREDO, Texas. Other major terminals in the Central West are Eagle Pass and EL PASO, Texas. The idea of linking North and South America began in the 1800s, but was not seriously considered until the Fifth International Conference of American States in 1923. The first Pan American Highway Congress was held at Buenos Aires two years later. The highway receives financing within each country through which it passes. United States financial support began in 1930 to speed progress of the highway from Panama to Texas. This section, known as the Inter-American Highway, was completed through the 1960s. United States aid, which has paid two-thirds of the cost of the system, has been used by every nation involved except Mexico.

PANHANDLE. Other states have "panhandles," strips of land projecting from the main body of an area, but the panhandle states which first come to mind are both in the Central West Region—Oklahoma and Texas. These also are the only two states with adjoining panhandles. Oklahoma's extends across the northern end of the larger Texas panhandle. The shape of Oklahoma bears the closest resemblance of all to the classic example of a frying pan with a long handle. Texas appears on the map as very large and peculiarly shaped pan with a stubby handle. Together the two panhandles cover something over 36,000 square miles. The only large city in the entire region, the capital of the panhandles, is AMARILLO, Texas. In both states the panhandles are part of the dry High Plains region.

PAPILLION, Nebraska. City (pop.6,399), Sarpy County, eastern Nebraska, southwest of OMAHA and northeast of LINCOLN. Papillion was named by French traders for the many butterflies found in the area. A mill was established

by Peter Sarpy, after whom the county is named. An Omaha Indian village known as "Hill Rising in the Center of a Plain" was built in 1847 and remained the home of the Indians until they sold their land to the Federal government and moved to the Blackbird Hills reservation. Today the Papillion area is one of the fastest growing suburban areas of Omaha.

PARIKI. Scalp lock, shaped as a narrow ridge of hair over the top of the head, worn by PAWNEE warriors. The rest of the head was shaved.

PARIS, Texas. City (pop. 25,498). Seat of Lamar County, located near the northern Texas border and the RED RIVER, 90 miles northeast of DALLAS. It was named for Paris, France. Originally settled as Pinhook, it was renamed in 1844, incorporated in 1854, and charted in 1905. The community was almost completely rebuilt after a great fire in 1916. The rebuilding provided opportunity to create 1,400 acres of parks, with exceptional flower beds, as well as attractive, spacious residential areas. The Maxey house of 1867 escaped the fire and is now a State Historical Structure. Today Paris is a transportation center with four state and federal highways, five rail lines, and trucking. It is also an agricultural center producing lumber, livestock, poultry, cotton, and grains, and an industrial center for cotton products, meatpacking, furniture, processed foods, and containers.

PARK OF THE RED ROCKS. Most famous of the DENVER, Colorado, mountain park system. Consisting of more than six hundred acres, the park contains the Theater of the Red Rocks, a natural amphitheater with exceptional acoustics in which is held the beautiful sunrise Easter service, as well as many others.

PARK RANGE. Range of mountains in northern Colorado. Part of the ROCKY MOUNTAINS, the highest peak in the Park Range is Mount Lincoln at 14,286 feet.

PARKER, Fess. (Fort Worth, TX, Aug. 16, 1925—). Actor. Parker created the movie role of Davy Crockett in 1955. He also starred in such films as *The Great Locomotive Chase*, (1956), *Old Yeller*, (1957), and *Hell is For Heroes*, (1962). Parker starred in two television series: *Mr. Smith Goes to Washington*, (1962) and *Daniel Boone*, (1964-1968).

PARKER, Quanah. (near North Texas, TX.,

1845—near Fort Sill, OK., February 23, 1911). Indian leader. The son of a COMANCHE Indian chief and Cynthia Parker, a white survivor of a massacre, Parker became Chief of the Comanches in 1867. From then until his surrender in 1875, he led raids on frontier settlements. Parker later became a wealthy, successful farmer.

PARKS (valleys). Name given in Colorado to wide level valleys. The largest, the SAN LUIS VALLEY, is the farthest south and is surrounded by the SANGRE DE CRISTO, SAWATCH, and SAN JUAN mountains. South Park, located southwest of FAIRPLAY, Colorado and north of PIKES PEAK , extends for about forty miles and is crisscrossed by many streams. Middle Park, the next walled valley to the north, is found between South and North parks. It was described by explorer John C. FREMONT (1830-1890) in 1844 as "...a beautiful circular valley of thirty miles in diameter, walled in all around with snowy mountains, rich with water, and with grass, fringed with pine on the mountain sides below the snow and a paradise to all grazing animals."

PASADENA, Texas. City (pop. 112,560), Harris County, located south of the Houston Ship Channel, very rapidly growing suburb east of HOUSTON, in the southeastern part of the state. Pasadena is near the site of the capture of General Lopez de Santa Anna (1836), president general of Mexico, after the battle of SAN JACINTO (April 21, 1836). Today it is a center for shipping (agricultural products, cattle), and industry (oil refining, synthetic rubber, chemicals, and paper). Two tunnels in Pasadena run under the shipping channel, providing vehicular access.

PASQUE FLOWER. Official flower of South Dakota. Sometimes called prairie smoke because large fields of blossoms appear as a smoky haze, it received its name in Europe where it blossomed in the Easter season. The flower is known as a herald of spring as well as a symbol of old age, due to its feathery silvery seed heads. The Indians crushed the leaves as a poltice for rheumatism.

PASSION PLAY. The inspiring portrayal of the last seven days in the life of Christ. The Luenen Passion Play was one of Europe's oldest productions. It became a permanent institution in the United States in 1939 when Josef Meier and company settled at SPEARFISH,

The famed Luenen Passion Play is performed annually at Spearfish, South Dakota.

South Dakota in the BLACK HILLS. The performance is now given in an amphitheater constructed for the company, and is now held June through August, Sunday, Tuesday and Thursday evenings.

PAWHUSKA (Paw-Hiu-Skah, chief). (Oklahoma, 1770?—Oklahoma, 1808) Osage Indian, who as a young man, fought with the Indian alliance against General Arthur St. Clair in Ohio Territory in 1790. In one of the battles, he started to scalp a fallen white man. To the Indian's dismay, the man leaped up and ran off leaving a powdered white wig behind. The chief changed his name to Pawhuska, which actually means "white hair." He believed the wig must be magical and carried it with him from that day on. The first to bear that name, his line carried through three other Oklahoma Indian leaders named Pawhuska, and the traditional Osage tribal capital was named PA-WHUSKA.

PAWHUSKA, Oklahoma. Town (pop. 4,771). Seat of Osage County, northeastern Oklahoma, on the Bird River southwest of BARTLESVILLE. It was founded in 1893. Pawhuska means "white hair," the name of Osage chief PAWHUSKA. It is the traditional Osage capital, where the Osage Agency continues to conduct all tribal business. The city also is the center of a large beef-producing area. Auctions of oil rights at Pawhuska in 1934 supervised by the federal govern-

ment, brought the tribe such wealth that they have become known as America's richest Indians. Reverend John Mitchell of Pawhuska founded the first Boy Scout troop in the United States in May of 1909. Pawhuska is the site of the Osage Tribal Museum and annually in July the scene of the International Roundup Cavalcade.

PAWNEE BUTTES. Limestone cliffs, near STERLING, Colorado, which from a distance resemble a sailing ship. Interest in the area centers on the wealth of fossilized animal remains discovered as early as 1875 by scientists, who have since come from throughout the world to work and study at the digs.

PAWNEE INDIANS. Plains confederacy located in the PLATTE RIVER VALLEY by the 18th century. The four tribes of the Pawnee were the Chaui, Kitkehahki, Skidi and the Pitahauerat. Tribes were organized matrilineally, with chiefs inheriting their office through the female line. Governing councils existed at the village, tribal and confederacy levels. Village chiefs protected the sacred bundles, while the priests were in charge of their use. The Pawnee religion was elaborate and depended upon a large and powerful class of shaman and priests. The Pawnee believed in a creator called Tirawa. They also paid close attention to the morning and evening stars.

The Pawnee lived in permanent villages of earthen lodges. Temporary shelter on hunts consisted of skin-covered huts, skin tipis or grass lodges. The Pawnee raised pumpkins, corn, squash and beans. They wove baskets and were recognized for their fine, incised pottery.

According to legend the Pawnee migrated northward from the southwest. By the mid-16th century they reached north central Kansas. The Pawnee and the APACHE were in a state of almost continual warfare from the mid-17th to the 18th century. So many Pawnee women and children were sold into slavery to the Spanish or French that the word pani became the term for slave, of whatever tribe.

The Pawnee became great horse raiders. After avoiding contact with Europeans for longer than most tribes, when they did begin trading with Europeans, especially the French, the diseases which had claimed so many other Indians attacked them. By 1849 cholera and continued warfare with the Dacotah reduced the Pawnee population from as many as 10,000 to about 4,500.

The Pawnee ceded all their lands in treaties

signed in 1833, 1848, and 1857. They only retained a reservation along the Loup fork of the PLATTE RIVER in Nebraska. During this time many Pawnee served as Army scouts. By 1876 their Nebraska reservation was ceded to the United States and the Pawnee were moved to Oklahoma.

Part of their Oklahoma reservation was allotted to individual tribal members in 1892, while the rest was opened to homesteaders the following year. By 1906 the Pawnee population had declined to about 650. By the late 1970s nearly 1,200 Pawnee descendants lived in Oklahoma's Payne and Pawnee counties.

PAWNEE ROCK. Notable landmark on the Kansas section of the SANTA FE TRAIL, near present Great Bend. Today Pawnee Rock Memorial Park surrounds the red sandstone outcrop near where Kit CARSON (1809-1868) camped, where Indians waited in ambush, and where Indian battles occurred. The rock is said to have been named following a major battle in which Plains Indians nearly annihiliated the PAWNEE. Settlers and the railroad removed nearly twenty feet of the rock, which once stood one hundred feet high. Among the signatures found on the stone are those of Robert E. Lee and Kit Carson.

PAWNEE, Kansas. First "capital" of Kansas from July 2 through 6, 1855, until the Free Staters gained control of the territorial legislature. the old capitol building is all that still stands. It is located on the Fort Riley Military Reservation in Geary County, east of JUNCTION CITY, and the structure is open to visitors.

PEANUTS. Crop which sometimes brings Oklahoma a third in terms of its agricultural income. In the Central West, however, Texas ranks ahead of Oklahoma in the tonnage produced. Thanks to the pioneering efforts of George Washington CARVER (1847?-1943) the lowly peanut is now used in over three hundred ways from livestock feed to wallboard.

PECANS. State tree of Texas. A member of the hickory/walnut family, it is one of the most important nut trees of the country, with a nut which produces 70% fat. Cultivated varieties usually have thinner shells, but the nuts of wild varieties still are collected. The pecan is the nut of the *Carya olivaeformis* tree, native to parts of the Southern states and Mexico. Since the CIVIL WAR, the nut has been in great demand as a food and additive to desserts. At one time it was the single most important United States nut crop, but in the 20th century it has fallen second to peanuts in annual crop harvested. Large crops are still taken from wild trees in Texas and Louisiana, and these two states are the leaders in cultivated pecan trees. In modern times hybridization has produced a variety of commercial species of pecan trees that can be cultivated in other Southern states and in states outside the South.

PECCARIES. A rooting, hoofed animal distantly related to the wild hog living in desert scrublands and forests. Resembling slender, active hogs, the animal has a coarse, grizzled blackish-gray coat. A large gland on the arched back gives off a strong musk odor when the animal is excited, leading to the nickname musk hog. Of the three living species, only the collared peccary or javelina lives as far north as the southwestern part of the United States. Traveling in bands that may range up to several hundred animals, peccaries are shy animals which will fight viciously with sharp teeth if cornered. The tough hide is used for pigskin jackets and gloves. Such items may be recognized by the pattern of evenly distributed groups of holes made by the hair roots.

PECOS HIGH BRIDGE. One of the highest railroad bridges in the world, used by the Southern Pacific to cross the PECOS RIVER at WACO, Texas.

PECOS NATIONAL MONUMENT. Midway between SANTA FE and LAS VEGAS, New Mexico, the park contains the ruins of the ancient Pueblo of Pecos and the remains of two Spanish missions, one built in the 17th and other in the 18th century. In later years, the ruins became a landmark on the SANTA FE TRAIL. The preserve is headquartered at PECOS, New Mexico.

PECOS PUEBLO. Now part of PECOS NATIONAL MONUMENT, the pueblo was one of the strongest of the later pueblos, built about 1300 A.D., in the late flowering of Pueblo culture in the upper RIO GRANDE VALLEY. Following the drouth that had caused abandonment of much of the earlier Pueblo areas, Pecos and the other pueblos of the area prospered. The two great houses of Pecos offered a total of 1,102 rooms. The village could be completely circled on its balconies, without ever touching the ground. Father Luis de Escalona was murdered at Pecos in 1544, to become one of the first two Christian martyrs in

the area. One of the great tragedies of the Southwest occurred in 1750, when Pecos sent out a huge force to fight the COMANCHE and only one man returned.

PECOS RIVER. Rising in Mora County in the SANGRE DE CRISTO MOUNTAINS in northern New Mexico, and flowing for 926 miles south-southeast across the state and into Texas to drain into the RIO GRANDE west of DEL RIO. During the frontier days of the Texas Republic, this waterway served as a boundary; law and civilization were found to its east, and the wild, lawless frontier was to the west, an area without formal government, described as "the law beyond the Pecos." The Pecos is the longest branch of the Rio Grande River and drains more than 33,000 square miles. Several lakes are located along its course including the one created by the Red Bluff Dam on the Texas-New Mexico border. The river was the center of decades-long water-use arguments between Texas and New Mexico until a federal bill written in 1949 developed a compromise on the issue.

PECOS WILDERNESS AREA. Also known as Santa Fe National Forest's Pecos Wilderness, near Cowles, New Mexico, an area famous for its large elk herd, trout fishing, and big game hunting.

PECOS, Texas. City (12,682). Seat of Ward County, southwest Texas, southwest of ODESSA. The origin of its name is uncertain, perhaps from an obscure Indian tribe. An early metropolis of the desert cow country, Pecos now is a center of irrigated agriculture, along with the production of gas and sulphur. Pecos' greatest fame comes from its reputation of inventing the rodeo. The annual West of the Pecos Rodeo commemorates the event in 1883 which featured riding, racing and roping contests. Pecos, one of the roughest towns on the frontier, gave its name to a unique method of disposing of a body described as "Pecosin'a feller," which meant filling the body with rocks and dropping it into the Pecos River. Justice came in the court of Roy Bean whose store/courtroom has been recreated for visitors. Annual rainfall of 12.68 inches is compensated for by water from a basin located under the city used to irrigate 185,000 acres. Pecos has also been the site of a nine-mile circular track used to test automobile tires.

PEDERNALES RIVER. Waterway originat-

ing west of FREDERICKSBURG, Texas. It passes through the city before it winds northeast, through central Texas, to meet the COLORADO RIVER, just east of Lake Travis.

PEGMATITE CRYSTALS. Crystals larger than three centimeters often found in very coarse-grained igneous rock. Pegmatites commonly occur in dike-like masses and often contain such minerals as topaz, fluorite, beryl, and tourmaline. South Dakota is known for the size of pegmatite found there.

PEMBINA ESCARPMENT. A high scenic ridge stretching from Canada through North Dakota into South Dakota and southwestern Minnesota. Also known as the Manitoba Escarpment, the area in North Dakota lies along the western edge of the Red River Valley and is recognized as a rise of three hundred to four hundred feet in elevation. In southern North Dakota the escarpment is known as the Coteau des Prairies.

PEMBINA MOUNTAINS. One of three groups of rolling hills in North Dakota, the Pembina Mountains rise above the floor of the Red River Valley. Known to the first white explorers and trappers as the Hair Hills, the Pembina Mountains were favorite hunting grounds of the Chippewa Indians whose control of the area was challenged by the SIOUX. The First Pembina Mountains are formed by the prehistoric delta of the Pembina River, created when the stream drained the melting glacier into Lake AGASSIZ. Having an average height of one hundred fifty feet, the eastern edge of the First Pembina Mountains show the various shore lines of Lake Agassiz as it receded. The Second Pembina Mountains lying northwest of the First Pembina Mountains are part of the Pembina Escarpment.

PEMBINA RIVER. The prehistoric Pembina River drained melting glacier water into huge prehistoric Lake AGASSIZ. It also drained prehistoric Lake SOURIS which lay in the bend of the present SOURIS RIVER. Today the Pembina is one of many tributaries of the RED RIVER OF THE NORTH.

PEMBINA, North Dakota. Town (pop. 673), Pembina County, extreme northeastern North Dakota, the first non-Indian settlement in North Dakota. The community was established in 1797 by Charles Chaboillez of the NORTH WEST COMPANY and was thought to be in British

territory until the boundary between Canada and the United States was established in 1818. The region was inhabited entirely by fur traders until 1812 when a group of Scottish settlers led by the Earl of Selkirk established a colony at the confluence of the Pembina and Red rivers. The Pembina area was also known throughout the world for the great buffalo herds. In 1840, 1,630 people took part in a Pembina buffalo hunt which yielded meat and the hides for buffalo robes, said to be the only real protection while traveling across the Dakota prairies in winter in early days. A marker north of town stands at the site of North Dakota's first church and school which opened in 1818. The first church services were led by Father Joseph Dumoulin, Father Joseph Provencher and William Edge. The Pembina mission was reopened in 1848 by Father George Belcourt.

PEMMICAN. Food of highly nutritious value, prepared by the Indians across a wide area of the country, particularly of the Central West, was the Indian version of a spicy sausage. Meat often of the deer family, but particularly buffalo, was consumed fresh, but when any quantity was left over it was boiled, shredded, mixed with chokecherries or other dried berries and herbs and put into a buffalo skin bag that had been placed in a hole in the ground. The mixture was pounded into the bag as firmly as possible, then covered with hot buffalo fat to seal it from the air. Closed by sewing, the sacks of pemmican would keep indefinitely, sometimes even for years. Later day nutritionists have praised it highly for its food value and quality. Because so much pemmican was produced along its banks the MUSSELSHELL RIVER in Montana was knicknamed the Dried Meat River.

PENALOSA BRICENO, DON DIEGO DIONISO DE. (Lima, Peru, 1624—Paris, France, 1687). Spanish governor of New Mexico. In attempting to keep church officials from exploiting the Indians in such work as spinning cotton and weaving cloth, de Penalosa fell victim to the Inquisition. Around he 1666 was made to run barefoot through the streets of Mexico City holding a green candle and made to pay a ruinous fine before being exiled from New Spain. He later sold his services to England and then France with unfulfilled plans to conquer New Spain and the Mississippi Valley.

PENNEY, James Cash. (Hamilton, MO., September 16, 1875—New York, NY, February

James Cash Penney.

12, 1971). Merchant. Penney, a department store tycoon, opened his first store in KEMMERER, Wyoming. He founded J.C. Penney Company, Inc. in 1902 which eventually operated more than two thousand domestic and foreign retail outlets including 1,700 stores in the United States. Penney was named to the Hall of Fame in Distribution, at the State of Oklahoma Hall of Fame and received the Tobe award for distinguished contributions to American retailing. Penney wrote *Fifty Years with the Golden Rule* (1950) and collaborated on *J.C. Penney: The Man with a Thousand Partners.*

PENROSE, Spencer. (Philadelphia, PA, Nov. 2, 1865—Colorado Springs, CO, Dec. 7, 1939). Mining engineer. Penrose built a fortune from his involvement in several gold mines at CRIPPLE CREEK, Colorado, and added to it with successful real estate investments. He built the luxurious BROADMOOR HOTEL near COLORADO SPRINGS and saw it become one of the world's most elegant resorts. Penrose built the auto road up CHEYENNE MOUNTAIN outside of Colorado Springs to reach the Shrine to the Sun, which he dedicated in 1937 as a memorial to his friend Will ROGERS (1879-1935). His love of animals, including his collection of bears, elephants and buffalo, led to his establishment of the famous Cheyenne Mountain Zoo in 1926.

PEORIA INDIANS. Important tribe of the Illinois Confederacy. The Peoria were originally located in northern Illinois, eastern Iowa and southern Wisconsin. By treaties signed in 1803, 1818, and 1832 they ceded their lands to the United States and were moved to the MARAIS DES CYGNES RIVER in Kansas. In 1867 the Peoria were uprooted and moved to Indian Territory where they bought land from the Seneca-Shawnee-Quapaw Indians. Their new reservation was in Ottawa County in northeastern Oklahoma. In 1873 the Peoria were joined by the Miami and were given the title of United Peoria and Miami. Their lands were allotted in severalty under the Allotment Act of 1893. In 1940 the Peoria were allowed to incorporate as the Peoria Indian Tribe of Oklahoma. By the 1970s the descendants of the Peoria were assimilated into the general population of the state.

PERALTA, New Mexico. Town (pop. 325), Valenia County, northwestern New Mexico, south of ALBUQUERQUE and northeast of Belen. The last CIVIL WAR battle between Union and Confederate forces in New Mexico was fought near there with Confederate forces withdrawing.

PERLITE. Lightweight material concentrated in the Seven Hills of Taos area of north central New Mexico. Sometimes called "mineral popcorn," perlite is used to make lightweight plasters and concretes.

PERSHING, John Joseph. (Linn County, MO, Sept. 13, 1860— Laclede, MO, July 15, 1948). Military officer. Pershing was the commander-in-chief of the American Expeditionary Force in WORLD WAR I from 1917 to 1919. This was the crowning achievement for a varied and successful military career. Pershing had served in campaigns against the APACHE in New Mexico and Arizona in 1886; in campaigns against the SIOUX in the Dakotas in 1890-1891; taught military science at the University of NEBRASKA from 1891 to 1895 and later taught at West Point; was an American military attache in the Russo-Japanese War; defeated the Philippine Moros in 1913; commanded the border patrol at EL PASO, Texas; and led troops from Texas into Mexico in pursuit of Pancho VILLA (1878-1923). The latter occurred in 1916 after the bandit had raided and burned COLUMBUS, New Mexico. After World War I, he became army chief of staff (1921-1924). He is the only officer to have held the rank of General of the Army.

PERU STATE COLLEGE. Nebraska's oldest institution of higher learning. Located in PERU, the college, established in 1867, awards the Associate and Bachelor degrees. The college occupies an eighty-two acre campus in southeast Nebraska near the MISSOURI RIVER. During the 1985-1986 academic year 1,476 students were enrolled, and the college employed 70 faculty members.

PETRIFIED WOOD. The official state rock of Texas is a true rock in the sense that it is a tree turned to rock by a process known as petrefaction. The original wood fibers have been replaced by mineral matter, molecule by molecule, while retaining the original appearance and microscopic structure of the tree. Petrified forests date from many geologic periods, and each forest displays the type of trees then growing. In the Central West petrified wood has been found in many large deposits covering the western part of South Dakota from the Nebraska border northward to the largest deposit near Lemmon. There the buildings of Petrified Wood Park are made of the substance. Giant remains of petrified sequoias, one tree having a circumference of 74 feet, now are part of a Colorado petrified forest thirty-five miles west of COLORADO SPRINGS. Petrified sequoias have also been found near Baker, Montana. Wyoming boasts a petrified forest which covers 2,560 acres near MEDICINE BOW. Judged by geologists to be 50,000 years old, the wood there shows the simplest type of petrified wood where silica has replaced the tissues of the tree.

PETROCHEMICALS. The Central West region produces more petroleum and natural gas than any other U.S. region. As a consequence the production of products other than fuel from those materials means vast added revenues and jobs. In the process known as cracking, gaseous byproducts are created which at one time were thought to have little use. Over the years, however, a very wide variety of materials have been derived from the former wastes. Among those are alcohol, ethylene, acetone, acetic acid, anhydride and ammonia, along with many others. Gases can be transformed into carbon black, synthetic rubber polyethelene and more, all widely used in such industries as explosives, plastics, synthetic fibers, automobiles and aircraft. Production figures by states on petrochemicals are not available, according to the Industries Division of the Economics Programs Division of the Bureau of the Census of the Department of Interior.

PETROLEUM. The region's oil boom began in Oklahoma when the JOHNSTONE WILDCAT WELL came in in 1897. In Texas the tremendous gush of the SPINDLETOP WELL at BEAUMONT ushered that state into the oil age. Today, despite the so-called "bust" in the petroleum industry, the states of the Central West produce almost half of the nation's petroleum. Texas continues to lead all states in crude petroleum, accounting for about 28% of the total United States production of 3.25 billion barrels. Within the region Oklahoma is second in petroleum production but a distant second.

However, the econimic decline of the petroleum producing states is shown dramatically in their diminishing production during the late 1970s and 1980s. Production of crude oil in Texas declined from a high average for 1971-1975 of 1,261 million barrels to 905 million in 1984, more than 25% reduction. Oklahoma production declined 26%; Wyoming, 23%; New Mexico, 25%; Colorado, 15%; Nebraska, 25%. However, Kansas recorded a gain of almost 15%.

In the petroleum states, the decline of the industry had a domino effect on almost every aspect of the economy, with construction being the hardest hit. Nevertheless, by 1984 employment had stabilized with an average drop in the region of nearly 3% in the unemployment rate.

Latest available figures (1984) for production of crude oil in the Central West, 1984 are: Texas (905 million barrels), Oklahoma (168 million barrels), Wyoming (124 million barrels), New Mexico (79 million barrels), Kansas (76 million barrels), North Dakota (53 million barrels), Montana (30 million barrels), Colorado (29 million barrels) and Nebraska (6 million barrels), South Dakota is the only state in the Central West that did not have any marketed production of crude petroleum in 1984.

The wealth of both Texas and Oklahoma is based as much on the processing of the petroleum as on its production. Refining, petrochemicals and other petroleum based businesses make use of the nearby raw materials. With nearly a thousand businesses operating in one or another phase of the industry or its related fields, TULSA, Oklahoma dubs itself "Oil Capital of the World." Ten percent of the members of the American Association of Petroleum Geologists live in the Tulsa area. Depending on the quantity of production, petroleum contributes to the other producing states in the region in much the same way as in Texas and Oklahoma.

PHARR, Texas. Town (pop. 21,381), in south-central Hidalgo County, in southern Texas. Established in 1909, it is named for Henry N. Pharr, a sugar plantation owner who promoted the town site. Pharr's growing season of 327 days makes it a leading area for agribusiness, and it is also a trading center. There are oil and gas wells in the area.

PHEASANTS. Popular upland game bird found in the greatest number on the Great Plains. The best known varieties, the English pheasant which the Romans supposedly introduced into England and the ring-necked pheasant of China, have both been introduced into North America since 1881. The ring-necked, the most successful breed, weighs from two pounds to over four pounds. The male, a brightly colored bird with brown, blue, golden, red and black plumage, is larger and more colorful than the female. Ring-necked pheasants introduced into South Dakota in 1898 have made the state, the "Pheasant Capital of the World," the beneficiary of a multi-million dollar annual hunting business. Huron, South Dakota, boasts the "world's largest pheasant," a forty-foot high monster of glass fiber and steel weighing twenty-two tons.

PHILBROOK ART CENTER. Extraordinary TULSA, Oklahoma, museum, located on a twenty-three acre estate of elaborate formal gardens, including among its priceless works the Kress Collection of Italian Renaissance paintings and American Indian art.

PHILLIPS UNIVERSITY. Private university opened in 1907 as the Oklahoma Christian University. Receiving its present name in 1913, Phillips still operates as an institution of Christian higher education with a Board of Trustees cooperating with the Christian Churches. Phillips receives most of its support from Kansas, Oklahoma, Wyoming, Colorado and Arkansas. Qualified students may apply for an exchange program with the People's College in Sweden or a semester in Washington, D.C. Located on seventy acres with twenty-five buildings in ENID, Oklahoma, Phillips University enrolled 1,067 students during the 1985-86 academic year and employed 70 faculty members.

PHILLIPS, Bert Geer. (Hudson, NY., July 15, 1868—Unknown). Artist. Bert Phillips and Ernest L. Blumenschein founded the TAOS, New Mexico, Art Colony. Phillips was a specialist on murals and Indian subjects whose works have been displayed in the Polk County Court House, Des Moines, Iowa; the Taos County Court House, New Mexico; and the Capitol Building, Jefferson City, Missouri.

PHILLIPS, Frank. (Greeley County, NE., November 28, 1873—Bartlesville, OK., August 23, 1950). Banker and oil magnate. Phillips, engaged in banking from 1898 to 1903, moved to BARTLESVILLE and organized the Citizens Bank and Trust Company in 1905. He entered the oil business with his Phillips Petroleum Company in 1917 and remained active in the company until his death in 1950. Phillips was the financial backer of Colonel Arthur C. Goebel who made the first flight between the Pacific coast and Hawaii, where he arrived on September 30, 1927, winning the Dole prize. His many philanthropies included the gift of Woolaroc Museum at TULSA, founded in 1925, and the Phillips Historical Collection at the University of Oklahoma.

PHILLIPS, John (Portugee). (—). Scout and trader, Phillips accomplished what has been called "one of the truly heroic rides of American history." Phillips volunteered to ride 237 miles to FORT LARAMIE, Wyoming, to request help for FORT KEARNEY which was then surrounded by an estimated 2,500 warriors under the leadership of Chief RED CLOUD (1822-1909). Using the commander's favorite thoroughbred horse, Phillips slipped through the fort's water gap at midnight and rode two days through deep snow and subzero weather to Horseshoe Station where he sent a message to Fort Laramie. Not trusting the frontier telegraph, Phillips followed his message for two more days living on a few biscuits to arrive at Fort Laramie on Christmas night during a rousing party. A rescue column of two companies of cavalry and four of infantry was dispatched from Fort Reno, and Red Cloud lost his opportunity to destroy the fort.

PICTOGRAPHS. The paintings of prehistoric peoples on walls of bluffs or caves and sometimes structures are found widely in the Central West region. One of the most unusual of these was found at Kuaua Kiva in Coronado State Monument in New Mexico. The first layer of a mural on a wall was lifted off to reveal another beneath it. Altogther twelve layers of murals were uncovered and rescued. Paint Rocks near Ballinger, Texas, offers some of the finest pictographs, painted on rock walls, some

The South Dakota state capitol at Pierre, impressive for a city of its size, rises above the storied Missouri River, which brought the capital city of Pierre into being. Today Pierre lies at the heart of a vast region, once dry and almost barren, now blessed by lakes both to the north and south which were created on the Missouri to make once dry central South Dakota a "land of great lakes," a transformation fresh in the minds of many still living there.

ancient and some dating into historical times. Some of the most skillfully made pictographs are found at Castle Gardens in Wyoming, including some of the rare red type. Some of them are placed so high on the rock walls as to seem impossible to the reach of the artists. Some of North Dakota's pictographs at Writing Rock State Park may be prehistoric, but others are believed to be more modern.

PICURIE INDIANS. Residents of New Mexico who fled northward into present-day Kansas and built an adobe village, now known as El Quartelejo, in Scott County. This village is thought to have had the first hard walls built in Kansas, but the fate of the Indians remains a mystery.

PIEGAN INDIANS. One of the major divisions of the Blackfoot tribe, also known as the Pikuni.

PIERRE, SOUTH DAKOTA

Name: From Fort Pierre which took its name from Pierre Choteau, Jr. of the American Fur Company.

Nickname: The Future Great City; Gateway to the Black Hills; The Rail Center; Home of the Giant Oahe Dam.

Area: 12.7 square miles

Elevation: 1,484 feet

Population:
1986: 12,600
Rank: Not ranked
Percent change (1980-1986): 5.2%

TV Stations: 2

Radio Stations: 4

Further Information: Pierre Chamber of Commerce, 300 S. Highland, P.O. Box 548, Pierre, SD 57501

PIERRE, South Dakota. City (pop. 11,973) capital of South Dakota and seat of Hughes County, situated in almost the exact center of the state on the east bank of the MISSOURI RIVER opposite FORT PIERRE, takes its name (pronounced Peer) from the fort, and it in turn from fur trader Pierre Choteau, Jr.

An important center of trade for an agricultural area, the city's main business is state, county and local government.

Originally the site was occupied by the fortified headquarters village of the ARIKARA INDIANS. From 1822 to it served as the distribution center for the middle Missouri River region until about 1855. In the period 1876-1885, it transshipped the commerce of BLACK HILLS gold. This was greatly assisted by the coming of the railroad in 1880. The railroad brought boom times, providing impetus for the drive to make it the capital. After a bitter battle with MITCHELL, Pierre succeeded perhaps as much in recognition of its central location as any other factor.

Construction of OAHE DAM, just north on the river, added substantially to the economy during construction years, and the vast lake above the dam has created a great lake kind of region in an arid area, offering entirely new opportunities for tourists and tourist income for the city.

The capitol is particularly impressive for a city and state of such small population. Among the historic treasures of the Robinson Museum, the state historic society, is one of the country's unique mementoes, a portion of the lead plate buried in 1743 by the Verendreyes to boost French claims to the territory. It was rediscovered in 1913 by a group of children playing.

Among its collections the State National Guard Museum has a sword that belonged to General George A. CUSTER (1839-1876).

There are guided tours of the Oahe Dam and the region is a center for outdoor recreation. The annual Oahe Days offer a parade, raft, buffalo chip fling, raft and powerboat races among other contests, in early August.

PIKA. Short-haired mammal related to rabbits. This fascinating animal, also known as the coney, earns its nickname as "the haymaker of the heights" for its custom of storing straw in tiny stacks for winter.

PIKE, Zebulon Montgomery. (Lamberton, NJ, Jan. 5, 1779—York, Canada, Apr. 27, 1813). Military officer. He entered the military as a boy and became a second lieutenant by age 20. He headed an expedition to explore the source of the Mississippi River, starting from Saint Louis, Missouri, in 1805. In 1806 he also explored the headwaters of the ARKANSAS RIVER and the RED RIVER. PIKE'S PEAK in Colorado was named for him. He was convinced it was too high and would never be climbed. His western expedition helped to consolidate U.S. control of the central and southern portions of the newly purchased Louisiana Territory. In in late July, 1806, Kansas he held a grand council with the Pawnees at which he took away the Spanish flag and instructed the Indians to fly the U.S. flag.

PIKES PEAK. Major tourist attraction in east central Colorado near COLORADO SPRINGS in El Paso County. At 14,110 feet the mountain features a mountain cog railroad and noted view from its summit. An auto road was constructed by wealthy Colorado Springs businessman Spencer PENROSE. Pikes Peak was discovered in 1806 by Zebulon M. PIKE. The view from the top of Pikes Peak inspired the song "America the Beautiful."

PINEDALE, Wyoming. Town (pop. 1,066), seat of Sublette County, west-central Wyoming, west of LANDER and southeast of JACKSON. In 1841 Pinedale was the site of the first Catholic mass in Wyoming presided over by Father Pierre J. DeSmet. The first settlers came to the area in 1878 and 1879 to winter their herds on the lush grass.

PINEY WOODS. Most important of the forest areas in east-central Texas.

PINON PINE. The pinon, or nut pine, is the state tree of New Mexico. The seed (or nut), which has a delicate nutty flavor, was an important source of food for the Indians. It is still gathered and used by them and is sold commercially as well. Four varieties of this small, scrubby pine tree are found in the semiarid southwestern regions of the United States, occasionally growing to a height of forty feet in stands mixed with scrub oaks and junipers. The wood of the pinon is used for fuel, railroad ties and fence posts.

PIONEER PRAIRIE LIFE. From the 1860s to the 1890s a great surge of people rolled into

the Central West. The lure of free government land through the HOMESTEAD ACT, the drying up of opportunities in the eastern states and the troubles in Europe all encouraged the land hungry to move west.

Most of them, perhaps a majority, had little understanding of what they would need to get started or of the problems in a kind of land which was entirely different from the regions most of them were used to. Those who had wagons, plows, horses and other necessities took them along, for they were scarce and terribly expensive in the unsettled lands. It was estimated that a homesteader needed capital of at least $1,000 to get started. A large percentage did not have that much, if any. Few had given thought to how they would buy seed, provide shelter and food while their first crops were growing. Fewer still worried about what would happen if the crops failed. Wheat was the great lure, but it was difficult to grow, and two days of hot winds might destroy it entirely.

The best farm sites were the low-lying tracts along rivers and streams, and these of course were settled first. To stake a claim the settler literally had to pound stakes into the corners of his land, then plow a furrow around the edges. Next the pioneers might have to travel as much as 100 miles to the land office to pay $14 for filing the claim.

The crush at the land offices was so great that a newspaper in Gage County, Nebraska, wrote: "The applications poured in as fast as they could be taken care of all day, the crowd inside and out never growing smaller, for as fast as one applicant, with papers properly fixed up, would worm his way through the crowd to the door and be cast out, panting and dripping with perspiration, another one would squeeze in, and become a part of the solid surging mass within."

Shelter was the next requirement. The prairies were barren of wood, so the only available materials was used, the thick sod, held firmly together by prairie grasses. With a special kind of plow, the farmer cut long strips of sod and then sliced these into a kind of brick, a foot or longer, four or five inches thick and perhaps eight inches wide. These were piled up like bricks. The roof, covered with these heavy sod bricks, had to be supported by poles, probably cut in a canyon many miles away.

In the summer the grass grew thickly on the roof. The simplest sod house was merely a lean-to cut into the hillside, with only a door and no windows, and the cow might walk onto the roof to graze. Some sod homes were more elaborate

"Pioneer Woman," a statue at Ponca City, Oklahoma, is typical of several in the region paying tribute to women's accomplishments.

with multi-paned windows and even two rooms. Those who could, brought their stove with them. This had to have a hay burner, as there was no firewood. As they grew more successful, a sewing machine and other items might be added, along with additions to the house.

Prairie fires, blizzards, windstorms, heat, drouth often brought disaster. There were spring rains, but there were long dry times in the best of seasons. Cisterns caught and held some rain water. A well was a necessity and wells sometimes had to be drilled as deep as 500 feet to find water, and these required either a handmade windmill or expensive commercial type to raise the water to the surface.

Those who hoped to get rich on a one crop farm, growing wheat or corn, often lost everything. Others went in for variety and often thrived. One pioneer wrote cheerfully in 1865 that they had a good year, with a rich harvest both from the grain that was sowed as well as from the wild fruit and grain. She reported that they had plowed and fenced in three acres of new land. On this plot they raised ninety bushels of corn, twenty-four bushels of potatoes, and a plant "called sugar cane or sorghum." They grew some fruit including

"watermelon." She reported that they grew an enormous quantity of them and that she could not compare them to anything she had ever seen in Norway. She described them as big as a child's head, some larger. Her description of watermelon continued as round, with red or yellow on the inside, sweet and juicy. They sometimes sold melons to wayfarers passing by, getting ten cents apiece for them. However, most of the melons they shared with friends and neighbors.

In later years, after the pioneer 1860s and early 1870s, many of the immigrants, particularly those from Europe, brought considerable resources with them and were able to bypass many of the hardships of the earlier penniless pioneers.

Naturally, in an area as large as the Central West, the circumstances and the experiences were extremely varied, but all the rugged individualists found loneliness in an uninspiring setting and often heartbreak in the coming of tornadoes, plagues of grasshopper and other insects, thirst and crop failure.

Some perished; some gave up, but eventually the American plains were transformed by them to become the world's breadbasket.

PIPELINES, OIL. System of pipes used to transport petroleum over long distances. Gathering lines carry the oil from the wells to trunk pipelines which may take the oil directly to refineries or may carry it to shipping points where it is taken to refineries on tankers, barges, or trucks. Refineries convert the crude oil into useable items carried to market by product pipelines. Major crude oil and petroleum products pipelines crisscross the Central West with most concentrated in and through the Texas Gulf Coastal region and Oklahoma. Fewer pipelines exist in New Mexico, Colorado, Wyoming, and Montana, with the smallest mileage in South Dakota. One of the greatest pipeline construction projects initiated in the Central West was the $360,000,000 Houston-New York pipeline, known as the Big Inch. The Big Inch, transporting crude oil, was constructed as a WORLD WAR II war effort between 1942 and 1944. The Little Big Inch, transporting refined products, was built soon after. Texas boasts its role of originating the most miles of pipeline for oil and gas in the United States.

PIRATES. The Texas coast was home ground for one of the country's best-known and most romanticized pirates. In 1817 Jean LAFITTE

(1780-1826) and his band established themselves on what is now GALVESTON ISLAND. His fortress-like home was called Maison Rouge (the Red House), and his settlement was known as Campeachy. Lafitte had a long record of Caribbean piracy when he and many of his followers helped U.S. forces in the 1814 Battle of New Orleans, and they were pardoned for this help. However, Lafitte and many of the others returned to their old ways and created the Campeachy headquarters. They helped the emerging Spanish territories in their fight against Spain by mercilessly capturing more than a hundred richly laden Spanish ships. The fortune they amassed gave them resources to create a little pirate kingdom in southeast Texas, with Lafitte being called the Lord of Galveston. However, the KARANKAWA Indians attacked them, and a severe hurricane damaged their position. So Lafitte and his remaining crew set fire to Campeachy and left Texas. No one knows what happened to Lafitte, but he may have died in Mexico in 1826.

PITTSBURG, Kansas. City (pop. 18,770), Crawford County, southeastern Kansas, south of FT. SCOTT and southeast of CHANUTE. Pittsburg was founded in the 1870s as a mining town. The region continues to yield as much as ninety percent of the coal mined in Kansas as well as gas, oil, clay, limestone and zinc. Coal-mining equipment is manufactured in Pittsburg, which is also the home of Pittsburg State University.

PLAINS INDIANS. Term used to describe Indian tribes living in the Central West including the ARAPAHO, ARIKARA, ASSINIBOIN, ATAKAPA, BLACKFOOT, CADDO, CHEYENNE, COMANCHE, CROW, GROS VENTRE, HIDATSA, IOWAY, KANSA, KARANKAWA, KIOWA, MANDAN, OMAHA, OSAGE, PAWNEE, PONCA, QUAPAW, SIOUX, and WICHITA. The largest tribes of the plains were the Blackfoot and Crow. Plains Indians lived in villages along the streams and rivers where the land was fertile. The women raised squash, beans, and corn while the men hunted buffalo, elk and deer.

Plains Indians moved onto the prairies during the summer to hunt buffalo in communal hunts which were rigidly organized and policed as the animals were often stampeded over cliffs or herded into corrals where they were easily killed by hunters who traveled on foot. Hides from the buffalo were used for shelter and clothing. The meat was preserved by drying it in the sun to make jerky or mixed with suet and berries to make PEMMICAN. Plains Indians re-

turned to their villages in the fall harvest.

The arrival of white men with horses dramatically changed the life-style of Plains Indians. After the Indians acquired horses by stealing from the Europeans or by capturing strays, they could now hunt Buffalo herds, and could follow them for long distances, and the Indians of the Central West became more dependent on these animals for their food supply. Large tepees, capable of being moved with the herds, frequently replaced earthen lodges. New tribes were forced onto the plains leading to the need for an easily understood means of communication, the Indian sign language.

Warfare, once reserved to disputes over hunting grounds or as a means of proving bravery, increased as tribes were gradually confined into smaller regions. Armed with firearms, Plains Indian warriors rushed forward into battle in an attempt to count coup. This was accomplished by such deeds as touching a live enemy, an action considered the highest form of courage.

Spiritual power was the goal of the religion of the Plains Indian. Tribes carried medicine bundles, collections of sacred objects, and individual warriors fasted to achieve personal visions. Many tribes placed their dead on tall scaffolds or in trees.

The encroachment of the whites onto the Plains led to the wholesale slaughter of the buffalo by settlers who saw the animal as a threat to their crops, by the hide hunters who valued the skin and left the flesh to rot, and finally by the military who saw the loss of the animal as a means of starving the Indians into submission. The Plains Indian tribes were gradually forced onto reservations with the hope that they would take up farming. Lands allotted to the tribes continued to be coveted by whites, and eventually the tribal lands were allocated to individual Indians, a practice which greatly reduced the amount of land in Indian hands. The last major battle between the Plains Indians and the whites occurred in 1890 on Wounded Knee Creek in South Dakota.

PLAINVIEW, Texas. City (pop. 22,187), seat of Hale County, in northwest Texas. Founded in 1887, the townsite provides a view of the surrounding plains. By 1907, when the city was incorporated, agriculture had replaced ranching as Plainview's main industry. Today, light industries include meat packing plants and clothing factories. It is home of Wayland Baptist College.

PLANKINTON, South Dakota. Town (pop. 644), Aurora County, southeastern South Dakota, west of MITCHELL and southwest of HURON. The first grain festival in South Dakota was held in Plankinton in 1891. The event is remembered because it featured a corn palace, a structure later to make Mitchell world famous.

PLANO, Texas. City (pop. 72,331), Collin County, in northeast Texas. Plano was settled in 1845-1846, and called Fillmore (for President Millard Fillmore) until 1851. It has been particularly notable for its growth as a suburb of DALLAS. In 1960 the town's population was only 3,695, after which it enjoyed phenomenal growth. Major industries today produce boats and metal castings.

PLATTE RIVER. Major United States river formed by the joining of the NORTH PLATTE and SOUTH PLATTE rivers in Lincoln County in southwest central Nebraska. The Platte River flows 310 miles eastwardly to meet the MISSOURI RIVER below Omaha. Although said to be "a mile wide and a foot deep," the Platte can produce some devastating floods.

PLATTSMOUTH, Nebraska. City (pop. 6,-295), seat of Cass County, eastern Nebraska, south of OMAHA and northeast of LINCOLN. Plattsmouth, named for its position at the mouth of the PLATTE RIVER, was incorporated on March 15, 1855, by the Plattsmouth Town Company. Early settlers depended on river commerce for their livelihood. The boisterous boatmen used the occasion of passing the mouth of the Platte to either force their less experienced companions to shave themselves with a rusty hoop or to treat the more experienced. The rich Knox silt loam of Cass County quickly attracted farmers who encouraged the development of the railroad which eventually ended river traffic. The activities of claim jumpers between 1853 and 1856 led to the formation of Claim Club courts, groups of early settlers who banded together to protect their land claims. Claim jumpers found guilty of robbing squatters of their claims were sent "over the river," meaning they were forced out of Nebraska into neighboring Iowa. The Missouri River bluffs have yielded large quantities of stone and the clay soil has been useful in pottery production. The Nebraska Masonic Home has been maintained for elderly Masons and their wives.

POLITICS AND POLITICIANS IN THE CENTRAL WEST. One of America's greatest political leaders was a native of Texas and grew up in Kansas. Until recently Dwight D. EISENHOWER (1890-1969) has not been thought of as a politician, but continuing reevaluation of his record indicates he possessed extraordinary skill in selecting his associates and quietly directing the thoughts and attention of political friends and enemies alike in way which brought them into his camp. These were skills acquired in large measure in dealing with world leaders and top brass while he was Commander in Chief of the Allied forces in World War II.

Sam HOUSTON (1793-1863), the adopted Texan was, another consummate politician who has not generally been credited with his political successes. He loved to campaign, spoke with remarkable oratory, attracted great and adoring crowds and served in more high political offices than any other American. His letters and speeches indicate that he knew how to manipulate the political will in almost every situation. He overcame a personal scandal and alcoholism to serve twice as President of the Republic of Texas and Governor of the State of Texas. However, he proved his statesmanship when, because he foretold the terrible forthcoming results for the South, he refused to support the Confederacy during the CIVIL WAR. Thrown out of office in disgrace, he never lived to see his reputation revived with a continually growing aura, as is now the case.

Another Texan noted for his political sagacity was Lyndon Baines JOHNSON (1908-1973), who masterminded the work of the U.S. Senate for many years before becoming vice president and then president. As president, his knowledge of Congress and his political skills enabled him to push through costly reform programs. His political skills failed him, however, in the Vietnam War crisis, and the pressures against his war policies forced him out of presidential politics.

Texas has had two notable political teams of husband and wife. William P. Hobby was governor of the state, and his wife, Oveta Culp HOBBY served as the first Secretary of Health, Education and Welfare. Before that she had gained fame as head of the Women's Army Corps in World War II.

Even better known as a husband and wife political team were the Fergusons of Texas. James E. FERGUSON and his wife Miriam "Ma" FERGUSON gained further fame when she became one of the first two women governors of U.S. states. She ran for office when her husband had been removed from the governorship. When it was rumored that if she were elected, he would run the state behind the scenes, she responded, "This way you get two governors for the price of one." The other woman governor, first along with Mrs. Ferguson, was Nellie Tayloe ROSS (1880?-1977) of Wyoming. After serving as governor for two terms, Mrs. Ross spent twenty years as Director of the U.S. Mint.

Charles CURTIS (1860-1936), son of a Kansas pioneer and an Indian princess, achieved the highest position of any American politican of Indian blood when he became vice president under Herbert Hoover. Alf M. LANDON (1887-1987) gained political fame as a very successful governor of Kansas, but the decline of the Republican party in the Depression of 1929, brought about his political ruin when he ran for president in 1936 and received the soundest trouncing in the history of the presidential elections up to that time. However, upon his death in 1987, he received much acclaim as the grand old man of Republican politics. His daughter, Nancy Landon Kastenbaum commenced her second term as a Kansas U.S. Senator in 1985. Kansas Senator Gary Hart, lost his bid for the Democratic nomination in 1984 and made a second try in 1987.

A Montana politican who deserves to be recalled as a stateswoman was Jeannette RANKIN (1880-1973), first woman to serve in the U.S. congress. She threw political caution to the winds when she refused to vote for WORLD WAR I and later for WORLD WAR II. However, she never lost the public support which continued to elect her to congress.

POLLOCK, JACKSON. (Cody, WY, Jan. 28, 1912—East Hampton, NY, Aug. 11, 1956). Painter. Although he grew up in the western landscape and finishing secondary school in the West, he moved to New York City and enrolled in the Art Students League (1930-1933), where his teacher was Thomas Hart Benton. Rebelling against the realistic art of his time, he turned to abstraction. His paintings became splotches and splashes and drippings and textures, said by some critics to be thoroughly controlled. His work inaugurated the art movement which became known as the "action school." He died in an auto accident in 1956. Beginning in 1973, his paintings brought the highest prices ever paid for contemporary art. On May 2, 1988, a world record for such work was set at auction, when Pollock's "The Search" was sold for $4,840,000.

POMPEY'S PILLAR. An isolated rock formation two hundred feet high on the south bank of the YELLOWSTONE RIVER near Pompey's Pillar, Montana. Long used by the Indians as a lookout and point on which to build signal fires, the rock was climbed by William CLARK, of the LEWIS AND CLARK EXPEDITION, on July 25, 1806. Clark carved his name on the rock which he named in honor of little Pompey, the son of Charbonneau and SAKAKAWEA (1787?-1812?), the guides and interpreters of the expedition.

PONCA CITY, Oklahoma. City (pop. 26,238), Kay County, northeastern Oklahoma, southwest of BARTLESVILLE and northwest of TULSA. Ponca City was one of many communities which sprang up almost overnight as a result of the Cherokee Run September 13, 1893. Certificates for lots in the business district sold for two dollars each. The industrial age arrived almost as quickly when oil was discovered here in 1910. Ponca City resident, E.W. Marland, later governor of Oklahoma, founded Marland Oil. His 55-room mansion is now a museum of petroleum exhibits and Marland possessions. Today multimillion-dollar petrochemical processing plants dot the area.

PONCA INDIANS. Siouan tribe living in northeastern Nebraska's Knox County in the 17th century. Ponca meant "sacred head" in their language. The Ponca were organized into the Chighu and Wazhazha moieties which were then subdivided into four clans. The Ponca were ruled by hereditary chiefs who led their people in political, military and religious fields. The Ponca believed that all things contained a supernatural power called xube and that there was a supreme spirit called Wakanda. Especially important to the Ponca were duplicates of a lost sacred red pipe carved of catlinite when they lived in Minnesota. Vision quests through self-torture and fasting were important. The Ponca lived in permanent villages of earth or hide-covered lodges which always faced east. Villages were located on bluffs overlooking rivers. Many were fortified. The economy was primarily agricultural. With the coming of Europeans, fur trapping also became important. Communal buffalo hunts were held twice a year. When encountered by LEWIS AND CLARK , the population of the Ponca was estimated at 200. In 1877 the Ponca were removed to Oklahoma and assigned a 101,000-acre reservation. Dissatisfied with this land the Ponca, led by Chief Standing Bear, petitioned Congress in 1881 and their original 26,000 acres in Ne-

braska were restored to them. In 1908 this land was assigned in severalty. By the 1950s the Nebraska Ponca was no longer recognized as a legal entity. In the 1970s an estimated 2,000 Ponca lived in Oklahoma, while 350 lived in Nebraska where they had little of their old culture left.

PONCA, Nebraska. Town (pop. 1,057). Dixon County; northeastern Nebraska; northwest of Sioux City, Iowa; and southeast of VERMILLION, South Dakota. Ponca, named for a tribe of Indians, is located near IONIA "VOLCANO." The site is actually a high bluff whose soil contains chemicals in the clay which react with water to form steam. Prehistoric people in the region considered the area sacred and made human sacrifices to the gods who they felt controlled the volcano. Annually a celebration has been held in August when Ponca descendants bring gifts to OMAHA INDIANS whose ancestors gave a home to the displaced Ponca.

PONCA STATE PARK. In eastern Nebraska north of Bancroft, preserves one of the finest stands of hardwoods west of the MISSOURI RIVER.

PONDEROSA PINE. The state tree of Montana is the ponderosa or western yellow pine. The ponderosa is the tallest of the true pines, identified by the leaf arrangement, one needle or clusters of from two to five, enclosed in a sheath at the base. After the Douglas fir (or Oregon pine), the ponderosa, a hard pine, is the most important timber source in the United States.

PONY EXPRESS. Postal delivery system that served the West. Starting in April, 1860, letters were dispatched from Saint Louis, Missouri, to Sacramento, California, a distance of more than 2,000 miles, via men on horseback. They traveled through great stretches of wilderness, stopping at special posts set up along the route every ten to 15 miles. The journey took eight days in each direction but this was found to be much faster than the former transit of letters by ships, stagecoaches, and wagon trains. The service was discontinued soon after the first telegram to California was transmitted from Saint Louis on October 24, 1861.

POPO AGIE RIVER. River in west central Wyoming which rises in the WIND RIVER RANGE in southwestern Fremont County where it begins to flow northeast to unite with the WIND RIVER to form the BIG HORN RIVER. The Popo Agie ranks as

one of the nation's most unusual rivers. One of its branches disappears on the side of a mountain near LANDER, Wyoming. The stream appears several hundred yards below and tumbles over a waterfall.

POPULIST PARTY IN THE CENTRAL WEST. Third party movement widely promoted in various parts of the country by farmers, small businessmen and westerners. It was formally organized at a convention in OMAHA, Nebraska, in 1892 and advocated the free and unlimited coinage of silver; abolition of national banks; public ownership of railroads, telephone and telegraph systems and steamships; direct election of United States Senators; and a graduated income tax. The movement evolved from a period of great agrarian discontent following the CIVIL WAR. James W. Weaver, the Populist candidate nominated for president at the Omaha convention in 1892, receiving over one million popular votes and twenty-two electoral votes, carried four states including Colorado and Kansas in the Central West. The Populist's greatest success came in Kansas. In 1892 the Populists and Democrats in Kansas joined together to elect Lorenzo D. Lewelling as governor and claimed control of the legislature. The Republicans also claimed control of the legislature and forced the Populists from the hall. In what was called "The Legislative War" the governor used the militia to place the Republicans under siege. The Republicans later won their fight in the Supreme Court. In the mid-term Kansas elections of 1894, the party elected six senators and seven representatives to the Kansas legislature. By 1896 much of the Populist program had been taken over by the Democratic Party. In the election of 1896 the populists chose not to run independent candidates, but backed the Democratic Party. Improving farm conditions brought about the collapse of the Populist Party before the next presidential election.

PORT ARTHUR, Texas. City (pop. 66,676), Jefferson County, in southeast Texas. This shipping and industrial center (oil processing, petrochemicals, shipbuilding, metals) is located on the west shore of Sabine Lake, at the junction of Taylor's Bayou and the Port Arthur Ship Canal, 17 miles north of the Gulf of Mexico. Founded as a rail and shipping terminal (1895), its growth began with the success of SPINDLETOP GUSHER (1901), ten miles north of Port Arthur. It is the site of Lamar College, formerly Port Arthur College, which became

part of the Texas State University system in 1975.

PORT LAVACA, Texas. City (pop. 10,911), seat of Calhoun County, in southwest Texas on Lavaca Bay. Settled in 1840, Port Lavaca's name, which is Spanish for "the cow's port," comes from its use as a shipping point for cattle and cattle by-products. Current industries in the area include fishing, shipping, and tourism.

PORTAL, North Dakota. Town (pop. 238), Burke County, northwestern North Dakota, northeast of WILLISTON and northwest of MINOT. Portal is one of the entry points between the United States and Canada. It is remembered for its unique international golf course, straddling the border. Perhaps the most remembered shot on the course was the hole-in-one fired from the eighth hole tee in Canada to the cup in the United States.

PORTALES, New Mexico. City (pop. 9,940), Roosevelt County, east-central New Mexico, southwest of CLOVIS and northeast of ROSWELL. Portales is home of Eastern New Mexico University. The 550-acre campus contains the Roosevelt County Museum which focuses on the late 19th and early 20th centuries. The university also maintains a museum at Blackwater Draw, seven miles northeast of Portales, where 12,000 year-old remains of prehistoric inhabitants have been found. The community is also a busy agricultural center for peanuts, cotton, and sorghums. Surrounded by dry lands, Portales attracted continued population growth when shallow ground-water was discovered in 1890.

PORTER, Katherine Anne. (Indian Creek, TX, May 15, 1890—Silver Spring, MD, Sept. 18, 1980). Short story writer and novelist. Educated at convent schools in Texas and Louisiana, Porter went to New York City in 1920 and supported her studies and European travels through journalism. Her first stories were published in 1924, and her first collection, *Flowering Judas* (1930), earned her a Guggenheim fellowship for further travel in Europe. Her important works include the novella *Pale Horse, Pale Rider* (1939), the novel *Ship of Fools* (1962), and *The Collected Stories of Katherine Anne Porter* (1965).

POST, Wiley. (Grand Saline, TX, Nov. 22, 1899—Point Barrow, AK, Aug. 15, 1935). Avia-

tor. He began flying in 1924 by investing $2,000 he received from insurance for the loss of an eye in an accident. He won the Chicago-Los Angeles Air Derby in 1930 flying the distance in nine hours, nine minutes, and four seconds. From his home in OKLAHOMA CITY, Oklahoma, Post served as an aerial navigation instructor and adviser for the United States Army. He made the first around-the-world flight (eight days, 15 hours, 51 minutes) between June 23 and July 1, 1931, with Harold Gatty as navigator, covering a total of 15,596 miles. This feat was made possible with the help of an automatic pilot. He and Gatty wrote about their experience in *Around the world in Eight Days* (1931). He set many records during his career. His plane went down in Alaska, while on a flight with humorist Will ROGERS (1879-1935), and both men were killed. A monument of Oklahoma stone stands at the crash site.

POTAWATOMI INDIANS. Tribe of the Algonquian language family who originally lived along the eastern shores of Lake Michigan in the early 17th century. The Potawatomi were organized into thirty or more clans with membership in a clan being inherited through the father. Villages were ruled by a chief who was responsible to a council of elders. Religion was a very personal matter with vision quests through fasting of primary importance. Burial customs varied. In early times the Hare clan practiced cremation, while other clans used scaffold burial. In later years the deceased were buried with personal items they might need in the afterlife in a land somewhere to the west. In the 1700s the Potawatomi helped the Miami in their wars against the Americans. With the Indian defeat at the battle of Fallen Timbers in 1794 the gradual process of Indian removal began. By 1830 the bands were moved as far west as Kansas and finally Oklahoma. In the late 1970s there were more than 13,000 Potawatomi descendants. The Citizen Band of Potawatomi in Oklahoma listed 11,000. The Prairie Band in Kansas counted over two thousand.

POTEAU RIVER. Ninety-mile-long, eastern Oklahoma river flowing north in Le Flore County to empty into the ARKANSAS RIVER on the Arkansas border.

POWDER RIVER. Western river formed by a confluence of forks in Johnson County in northern Wyoming. It flows north across the Montana border into the YELLOWSTONE RIVER in eastern Montana's Prairie County. The war cry

of the 91st Division from Montana was the well-known shout of the Montana rodeo, "Powder River! Let 'er Buck!"

POWWOW COUNCIL. Annual event held in August by the OMAHA INDIANS near Macy, Nebraska, at which symbolic dances are performed and traditions, myths and songs are remembered.

PRAIRIE AGATE. The state rock of Nebraska, one of the many agates of the western states. It is a variety of quartz, built up by the slow deposit of silica in softer rock.

PRAIRIE CHICKEN. A term applied to several species of grouse including the sage grouse, the greater prairie chicken, the lesser prairie chicken and the sharp-tailed grouse that inhabit prairie country.

PRAIRIE DOGS. Several species of Western ground squirrel found on the prairies. Each species is a burrowing animal once living in vast communities referred to as "prairie dog towns," many of which stretched for several miles. Burrows often cause horses to fall or break a leg when they step into one of the holes. Prairie dog towns may still be seen throughout the west including one near Devil's Tower in Wyoming. Some communities in the southwest are becoming alarmed at their increase close to urban centers, particularly because of the prevalence of rabies among them.

PRAIRIE FIRE. Dreaded natural or man-made conflagration frequently occurring on the plains of the Central West. Faced with the ever-present danger of deadly fires that could sweep in at almost any time, early settlers often plowed an area completely around their towns as firebreaks. Because of the sparse population of the prairies, these fires generally did little damage to life and property. Perhaps the most threatening of all occurred in April, 1893. The entire population of NORTH PLATTE, Nebraska was in the path of an enormous fire started by the sparks of a railroad locomotive. Quick action of every person averted total destruction and limited damage to the loss of thirty-five houses. Many travelers on the plains were caught when fast-sweeping prairie fires engulfed them almost without warning, and many prairie homes were destroyed, often before the surprised occupants were able to flee to safety.

PRAIRIE ROSE. The wild prairie rose is the

The dramatic depiction of a prairie fire by German artist Henry Lewis illustrates a common danger faced by pioneers of the region.

official state flower of North Dakota. Member of one of the largest plant families, the prairie rose is one of the many types of wild roses from which have come the thousands of cultivated varieties. The rose family includes such varied members as raspberry, almond and mountain ash, among thousands of others.

PRAIRIE STATES FORESTRY PROJECT. Effort begun in 1935 which resulted in the planting of 3,541 miles of trees to provide windbreaks, known as the shelterbelt, to hold soil moisture and prevent wind erosion and dust storms.

PREHISTORIC PEOPLES. Perhaps the most notable of all the prehistoric peoples known to have lived in the present U.S. were the dwellers of the Southwest.

The so-called SANDIA Man may have lived in Sandia Mountain caves as long ago as 25,000 years. Others, at a later date, included Folsom Man. However, the most noteworthy groups of all began to emerge in present southern New Mexico. The Mogollon people made their homes in the high Mogollon Mountains named

for them, flourishing from about 300 to 1500 A.D. These hunters and gatherers, also known as BASKETMAKERS, eventually lived in pit houses, built mostly underground, with a mud covered roof held up by young tree trunks. Their villages generally contained about thirty of these houses. Their Mimbres tribe was noted for some of the finest pottery made in the Americas. The Mogollon probably were gradually absorbed by the higher culture of the ANASAZI (ancient ones) civilization which began to flourish in the FOUR CORNERS region of New Mexico and Colorado.

Their civilization improved and expanded over almost a thousand years as they became the successful farmers generally known as the PUEBLO PEOPLES. Their sunbaked homes of adobe and stone began to come into being about 750 A.D. Gradually these were enlarged and joined together to become what we know as pueblos. Some of these grew to a size large enough to accommodate a thousand people. Some were low lying, such as PUEBLO BONITO, and others resembled skyscrapers. Some, such as CLIFF PALACE at MESA VERDE, in present Colorado, were perched in great crevices in high cliffs, shelter-

ing the subgroup now known as CLIFF DWELLERS.

The Pueblo people created wonderful pottery, wove finely crafted baskets, and created silver and turquoise jewelry, all of which are still being carried on in the area today, along with many of their traditional dances and other customs.

On the far eastern side of the Central West region, the eastern portions of Nebraska, Kansas, Oklahoma and Texas, lived the westernmost groups of the Mississippian mound builders. They had raised a great city on the site of present Kansas City and reached their peak about 1200 A.D. Mississippian cities were centers of trade on the great rivers. Ochre, other pigments, salt, game, wood for bows, fine pottery and many other articles were traded. Of course, much earlier cultures had previously occupied these states.

Beginning with the Paleo-Americans perhaps 25,000 years ago, the region we call Texas experienced a succession of prehistoric peoples, The SHUMLA CAVE DWELLERS of about 8,000 to 2,000 years ago, had a rather high degree of culture. Pueblo type ruins have been found in the Texas Panhandle. Just before European explorers reached Texas, a group known as the Neo-Americans worked with pottery, farmed and created fine bows and arrows.

Oklahoma's oldest known peoples were given the name of FOLSOM. They were followed by the Basketmakers and Ozark Bluff Dwellers, then the Slab House Culture, and finally the Mississippian Mound Builders.

Except for the Mound Builders in eastern Kansas, very little is known about the earliest peoples in that area. In addition to the Mississippian Culture, much earlier peoples were known in present Nebraska, including the Folsom, Sterns Creek, Upper Republican and Nebraskan. Among the most interesting prehistoric remains found in Nebraska were the stone burial cists, made of limestone slabs. These contained bone and shell jewelry, implements and weapons.

Relatively little is known about the prehistoric peoples of South Dakota, except that they left their mounds in several places, and petroglyphs and pictographs have been found. North Dakota's prehistoric relics are more numerous, including effigy mounds, pictographs, petroglyphs, stone age implements, boulder rings, flint quarries and other evidence from various periods.

Many Montana archaeologists divided the state's prehistoric dwellers into three main periods, Ancient Hunters, Middle Period and Late Period, closing about a thousand years ago.

Little is known about the prehistoric peoples of Wyoming, but they left one of the most interesting and mysterious remnants of their stay, the strange MEDICINE WHEEL and the arrow of rocks pointing to it from across a valley. Scattered implements and utensils have provided some insight into the ancient peoples of the state.

The Pueblo people of Colorado were preceded by groups ranging back at least 25,000 years, including the Folsom and Basketmakers, who probably were absorbed by the Pueblos.

PRESIDIO, Texas. Town (pop. 950); Presidio County; southwestern Texas; southwest of Alpine and northeast of Ojinaga, Mexico. Considered the oldest town on the continent, Presidio, with its sun-baked adobe houses, has existed for more than ten thousand years. Missions at La Junta de los Rios were formally established on June 12, 1684. After 1830 the name of the settlement was changed to Presidio del Norte or "Fort of the North," and later shortened to Presidio. American settlers arrived in 1848 and constructed Fort Leaton to protect against Indian attack. The Chihuahua Trail, one of the principal freight routes into Mexico, was constructed across the RIO GRANDE, and Presidio became a port of entry into Mexico.

PRICKLY PEAR. A species of cactus belonging to the genus Opuntia. The leaves of the prickly pear are eighty percent fluid, making them a valuable source of water for Longhorn cattle which are able to eat them with the thorns on. The plant gave its name to Prickly Pear Valley, the location of HELENA, Montana.

PRORATION. A system of production control used in the oil industry to avoid over-production. The system was organized by agreement among most of the petroleum producing states, limiting the production of each state on the basis of a complicated formula. Used by many states to avoid price reduction due to oversupply, proration was begun in Oklahoma during the administration of William H. "Alfalfa Bill" Murray in the early 1950s.

PTARMIGAN MOUNTAIN. Highest point of elevation in the ABSAROKA RANGE in northwestern Wyoming southeast of YELLOWSTONE NATIONAL PARK.

PUEBLO ARCHITECTURE. Whether a part of a large community of many apartments

or a small structure, or whether stretched across the searing plains or perched on a high mesa or in a secluded crevice of a cliff, Pueblo architecture had a number of basic characteristics.

The walls were exceptionally heavy for protection against the heat and possible enemies. Stone and adobe were the principal materials. The flat stone slabs were generally plentiful and were laid in adobe mortar. Adobe walls were poured into forms in much the same way as poured concrete today. When the lower levels hardened, the forms were raised and filled with more adobe.

Higher apartments were generally made of stone. Roofs were supported by wooden crossbeams. Generally these had to be transported long distances, as there were few wooded areas. These crossbeams protruded through the outside of the walls, giving the traditional Pueblo appearance. Layers of brush were placed across the beams to bear the weight of the roof. The roofs were sloped, with channels to carry off the infrequent but often heavy rain.

In earlier times the lower levels had no doors or windows, for protection from enemies. Entry was by wooden ladder to trapdoors in the roof. Ladders provided access from floor to floor of the higher Pueblos. The stone floored rooms averaged about twelve feet square. Walls were faced with mud for plaster.

In upper floors, where windows could be used, they consisted of simple holes cut in the walls. Cooking fires were laid in a sunken pit in the floor, with the smoke escaping from a hole in the roof above.

This architecture was developed and perfected over many generations and was one of a large number of distinctive accomplishments of the Pueblo people. With modern modifications, large numbers of the ancient buildings are in use today, still exceptionally appropriate to the climate and living requirements.

PUEBLO BONITO. One of the thirteen major Indian ruins discovered in New Mexico's CHACO CANYON NATIONAL MONUMENT and considered the largest apartments built in the United States before 1887.

PUEBLO PEOPLE. In the Central West region, at their peak the Pueblo peoples had extended their territory across central New Mexico along the RIO GRANDE and westward across the border of New Mexico into Arizona. To the north they reached present northwest Colorado where one of their most fascinating ruins is found in MESA VERDE NATIONAL PARK.

Archeologists have divided Pueblo culture into five periods. Periods one and two were spent in developing farming, religion, crafts and making various other skills and improvements in comfort and convenience, especially in architecture.

The architecture which they brought to a high peak of perfection was a distinctive contribution of the culture, well adapted to the climate and needs. Built of adobe and stone slabs, some apartment complexes could accommodate as many as a thousand people.

In some areas Pueblo culture seems to have reached its golden age in period III, from about 950 to 1200 A.D. In some areas this golden age extended into period IV. This came about when drouth and other problems in the northwest sections of the Pueblo area forced the abandonment of many Pueblos there, and others began to flower in the upper Rio Grande valley in period IV. Period V coincides with the coming of historical records and is considered to extend to the thriving Pueblo culture of the present time.

Agriculture of maize, pumpkins, beans and cotton was practiced by earlier Pueblo people. Over the centuries the Pueblo developed an amazing system of irrigation, some of which is still usable today. Hunting of jackrabbits, deer and other animals provided food and skins for clothing.

Turkeys were grown, not only for food but also for their feathers, from which beautiful feather robes were fashioned. Needles, awls and other instruments were made from animal bones. Pueblo jewelry, often of silver and turouise, set the precedent for the wonderful products of today's Southwest craftsmen. The men were the weavers and some developed that craft to a high art, widely followed today.

Some experts say that Pueblo pottery reached heights never surpassed by other prehistoric peoples. Almost as soon as she could walk a Pueblo girl began her instruction in pottery making, working with thin ropes of clay, which were coiled in layers, to form the desired bowl or pot. These were smoothed with a polished stone, an implement often handed down among the generations. Most Pueblos had their own characteristic pottery designs. The men applied the pottery designs and did the firing.

Items found in the Pueblos that were not available locally, such as tropical shells, indicate that the Pueblo people traded widely with neighbors both near and far.

Pueblo Bonito at Chaco Canyon National Monument, present day evidence of Pueblo accomplishments.

Their religion was substantially developed, with a number of divinities, beliefs and rituals. Much of the religious life centered around their belief in the Kachina. These were powerful spirits from on high, who came to earth to live in the period from the winter solstice to the summer solstice. During this time they assumed human form, being embodied in local impersonators. Whenever the impersonators wore their symbollic Kachina masks, these men (never women) considered that they actually had become Kachinas.

During their stay "on earth," the Kachina took part in many rituals, particularly the February initiation ceremonies for boys and girls. The most important parts of this ceremony were the chanting of the group history by the Kachina chief, the sprinkling with water of each child and the touching of each four times with an ear of corn. This was followed by the ritual dance in the kiva, including symbollic whipping, giving of gifts and sacred feathers, followed by a great feast.

Almost every Pueblo had one or more kivas, used for religious purposes. Many of these were large, circular in form, as wide as 60 feet in diameter, and built around a sunken area.

Paintings were made with colored sacred meal and laid on the floors of the kiva. These had traditional designs and each was a form of prayer for a different need. It is thought these were the forerunners of the Navajo sand paintings.

Each pueblo was a separate governing unit, with its own administration and social organization, and there was no all-powerful central authority. The major languages of the Pueblos were Zunian, Tanoan and Keresan. Keresan is almost completely removed from other North American Indian language groups, and Tanoan language groups were probably related to the Aztecs of Mexico.

PUEBLO PINDI. Ancient Pueblo having more than two hundred rooms, excavated near SANTA FE, New Mexico, named *pindi* or "turkey" for the large number of turkey bones found there.

PUEBLO REVOLT. During the centuries before the coming of Europeans, the PUEBLO PEOPLE of the Southwest had remained relatively isolated in their remote communities. However, as they became more and more

mistreated by the Spanish conquerors, by 1680 the pueblos had managed to form a united group in opposition to the hated white masters and made plans to drive the Spanish out. Tewa medicine man Pope of the San Juan pueblo claimed that the Indian gods had called for the destruction of the Europeans. The pueblos had chosen Tu-pa-tu, governor of the PICURIS PUEBLO to be their principal leader. They also had received the promise of help from various Apache groups. On August 10, 1680, the Indians attacked the Spanish settlers north of SANTA FE, New Mexico, killing about 400, including 21 Spanish priests. The remaining Spanish fled to Santa Fe for protection. The pueblo forces surrounded the town and sent messengers into it bearing two crosses for the governor. If he returned the white one to the besiegers, the town would be abandoned, and the pueblo forces would permit the people to leave peacefully. However, the red cross was returned, and the siege of Santa Fe began. A Spanish sortie killed 300 of the besieging group, but the Indian forces were too strong. The Spanish, numbering about 1,000, abandoned Santa Fe and retreated to EL PASO in present Texas. The Indians celebrated their victory, destroyed the churches, burned the Spanish records and even underwent ritual scrubbings to remove the traces of Christianity. They occupied the Palace of the Governors and ruled present New Mexico for twelve years. After three unsuccessful attempts to reclaim the territory, the Spanish appointed Don Diego de Vargas as governor. He marched toward Santa Fe with a well equipped army of 400 men, and the Indians surrendered Santa Fe peacefully. After one small battle with the Apache, De Vargas had reconquered New Mexico, without losing a man.

PUEBLO, Colorado. City, (pop. 101,686), seat of Pueblo County, on the ARKANSAS RIVER at the lower foothills of the Rockies. The name comes from the Spanish word for town.

The community began about 1842 as a center for trade among the Indians and Spanish of the area and outside traders. Somewhat later it was a temporary Mormon settlement. By the time the railroad reached it in 1872, Pueblo was already the leading producer of coal and steel west of the Mississippi. Today, more than half of all the products manufactured in Colorado are produced in Pueblo. The major center of mineral, timber and shipping for a vast area, the city remains a leading steel and transportation hub, with wire and lumber.

The city was laid out in 1860. One of the major problems was flooding of the Arkansas River. Levees were constructed after a severe flood in 1921, and the river has remained controlled. Begun in 1964, the Arkansas River Reclamation Project has resulted in increased irrigation, power and diversion of river waters.

The University of Southern Colorado is located at Pueblo, as are the state mental hospital and a large army ordnance depot.

Among attractions for visitors, the ordnance depot provides guided tours. The depot also offers a unique attraction for children, a playground made up of salvaged army materiel.

The university offers a Geological Museum and other attractions. Other city museums include Fred E. Weisbrod Aircraft Museum, Rosemount Victorian House Museum and Sangre de Cristo Arts and Conference Center, with a children's museum and collection of western art.

Nearby is the San Isabel National Forest, providing ski area and other winter sports and the Spanish Peaks National Natural Landmark. Mount ELBERT, highest peak in Colorado, is also within the forest.

Another natural area is the Greenway and Nature Center of Pueblo, featuring birds of prey, other nature exhibits and a typical plains Indian encampment.

PUMICE. Valuable scouring and polishing material in powdered or lump form, a natural glass formed when lava, full of volcanic gases, is turned to foam as the material quickly cools. Although no lighter than any other natural glass, pumice will float on water due to its many air holes. Principal sources of pumice in the United States include Wyoming and New Mexico.

PURGATOIRE RIVER. Colorado river beginning in Las Animas County and flowing 186 miles northeast into the ARKANSAS RIVER in Bent County.

PYLE, Ernie. (Dana, IN, 1900—Ie Shima (island in the Pacific), 1945). Pulitzer Prize winning newspaper reporter. Pyle once wrote, "If we could only have one house, then it has to be in New Mexico, and preferably in Albuquerque where it now is." One of the nation's most beloved syndicated columnists turned war reporter, Pyle never lived to return to his cherished New Mexico, but died under fire on the lonely Pacific isle while reporting on WORLD WAR II in the Far East. He had previously covered

the war in North Africa and Europe. In 1944 he won the Pulitzer Prize for his war reporting. His popularity as the most famous of all World War II reporters was due to his persistance in reporting the experiences of enlisted men, rather than the glories of battles or accomplishments of ranking officers.

PYRAMIDS (rock formations). Chalk formations rising abruptly from the HIGH PLAINS near OAKLEY, Kansas. Sometimes called Monument Rocks, the formations are said to resemble the ancient pyramids of Egypt. At the north end of the group is an eroded formation which resembles the Sphinx.

QUAKE LAKE. Montana lake formed on August 17, 1959, when an earthquake caused an entire mountainside to collapse into and dam the MADISON RIVER in Gallatin County near WEST YELLOWSTONE.

QUANAH, Texas. Town (pop. 3,890), seat of Hardeman County, north-central Texas, southeast of Childress and northwest of WICHITA FALLS. Named for the Indian chief Quanah PARKER, Quanah is remembered for what is claimed to have been the largest wolf hunts ever organized. These took place on the ranch of C.T. Watkins, which drew large numbers of hunters, eager to win the prize for the greatest number bagged. Before the turn of the century the hunt was abandoned due to the diminished number of wolves. Quanah was "washed" into its status as the county seat by declaring that any man who had done his wash in the same place for six weeks was qualified to vote thereby qualifying a large number of railroad workers.

QUANTRILL, William Clarke. (Canal Dover, OH, July 31, 1837—Louisville, KY, June 6, 1865). Outlaw. Quantrill and his raiders swept down on LAWRENCE Kansas, August 21, 1863, burning two hundred buildings and killing one hundred and fifty innocent civilians. A monument in Oak Hill Cemetery in Lawrence stands in the memory of those killed. This one event has been described as the "most devastating single incident of the CIVIL WAR in Kansas." On October 6, 1863, Quantrill attacked Federal troops and executed ninety-six prisoners at Baxter Springs. Quantrill early became known as a "bad one," betraying associates and suspected of crimes including murder. He quickly joined the Confederate forces, bringing into their service a band of guerillas already

known for robbery and other crimes. After his many crimes against civilians and uniformed Union men, he witnessed the breakup of his gang and was captured by Union forces on May 10, 1864. He died in a Louisville, Kentucky, jail, and a reputation as the "bloodiest man in American history" lives after him.

QUAPAW INDIANS. Tribe of the Siouan language family who numbered 2,500 when they lived near the mouth of the ARKANSAS RIVER in the late 17th century. The tribal name means "downstream people." They were also called the Arkansea. The Quapaw villages at the meeting place of the Arkansas and Mississippi rivers were constructed on mounds of earth and were often fortified. The men hunted buffalo, deer and fowl and fished with weirs and nets. Corn, gourds, squash and beans were raised. The Quapaw were the Indians who informed the Marquette-Jolliet expedition in 1673 that the tribes further downstream were unfriendly. By the end of the 17th century French explorers found the tribe struggling against recurrent epidemics of smallpox. By 1800 with only three small villages the Quapaw ceded their claims to southern Arkansas, southern Oklahoma and northern Louisiana to the United States. In 1833 after several failed attempts to live in the South, the Quapaw were given lands in Oklahoma and Kansas, but later had to give up the Kansas properties. In 1893 after continued hardship the Quapaw divided their town reservation, the only tribe to do so, and gave 200 acres to each of the remaining 240 tribal members. The discovery of rich zinc and lead deposits in 1905 on Quapaw land led to a flood of white miners, and several Quapaw became quite wealthy from mining leases. Most descendants are businessmen or farmers.

R

RABBIT EAR RANGE. Small range of mountains in Colorado named for a peculiar formation on the summit of Rabbit Ears Peak which is 10,719 feet high.

RAILROADS IN THE CENTRAL WEST. Many authorities consider that the railroads were the single most important element in the settlement of the Central West region. Wherever railroads went, small towns grew, and some became major urban centers. The East was eager for the surplus products of western farms and ranches, but little could reach that market until the railroads made possible a revolution in transport. The great cattle trails of Texas and New Mexico ended at the rail lines, where the animals or meat products could be shipped to the east. The grains of the region went out to market almost as soon as the rails were laid, and farmers could grow their crops with assurance of payment.

So important were the railroads to the states of the region that they granted enormous acreages of land to railroad companies to help them finance the cost of construction and operation. Within twenty years of the coming of the transcontinental railroads, beginning in 1869, Kansas and Nebraska each gained more than a million population. The two Dakotas gained nearly half a million, and other states of the region experienced similar growth. According to railroad expert Barry Combs, "...to a large extent, the railroads themselves had generated this fantastic explosion."

Almost as soon as explorers had defined the limits of the continent and railroads had been introduced in the East, the dream of many Americans was to lay tracks that would connect the country from east to west.

Abraham Lincoln had chosen Council Bluffs, Iowa, as the terminus for the first transcontinental railroad, and the road had reached that city by 1867. Only two years later the rails had snaked across Nebraska and Wyoming and were connected with California from the West. The first transcontinental railroad was an enormous success. For the first time the two coasts were connected within a relatively short time span. The nearly empty center of the continent was now easily reachable for both settlement and commerce.

In 1868 the ATCHISON, TOPEKA AND SANTA FE RAILROAD began building from TOPEKA, Kansas to the West. As the Santa Fe marched across the prairies, the various terminal towns, such as DODGE CITY, received the hundreds of thousands of cattle which were being driven up from Texas, along with all the other traffic so typical of the early railroads.

When the Santa Fe reached SANTA FE, New Mexico, it took over the duties of the famed SANTA FE TRAIL and connected the East and Midwest with the great Southwest. When the Santa Fe reached California, the southern states of the Central West could travel to and trade with both coasts.

In the north, the first railroad reached BISMARCK, North Dakota, in 1873. In 1883 the last spike of the Northern Pacific Railroad was driven near GARRISON, Montana, with great ceremony. The northern states of the Central West were now able to do business with both coasts and over the seas beyond.

Other transcontinental routes followed, all of course crossing the Central West region. The major lines built many spur lines to connect cities in the region, and other railroads, some of them local, sprang up. Wherever the railroads went, towns followed along the lines, and farms and businesses sprang up. By the early part of the new century, it was possible to travel or ship by train not only across the country but also to travel shorter distances between almost every community in the region.

RAINBOW FALLS. Once located at the site of present-day GREAT FALLS, Montana, and described by Meriwether LEWIS (1774-1809) as "from the reflection of the sun on the spray or mist...there is a beautiful rainbow produced which adds not a little to the beauty of this majestically grand scenery.

RAMPART RANGE. Ridge of Colorado

mountains stretching southwest of Denver south-southwest to an area northwest of COLORADO SPRINGS.

RANCHING. Given the wide open spaces of the Central West, the region is a natural for ranch operations. The cattle ranch was introduced to Texas from Latin America and soon spread northward across the plains and into Texas, where the open range was suitable for raising large herds, and where the legends of the COWBOYS multiplied. Ranches are mainly classified as large farms generally devoted to raising of livestock as opposed to crops, although some large fruit operations are known as ranches and many livestock ranches grow appropriate crops, as well.

Texas continues to be the kingdom of the ranch and the cowboy. Operating more than 865,000 acres, the King Ranch at Kingsville, Texas, is the nation's largest. Surprisingly, the second largest is in Hawaii. However, all of the Central West states have large and profitable ranching spreads.

At the King Ranch, Robert Kleburg, a son-in-law of the King family developed the SANTA GERTRUDIS CATTLE, the only true breed of cattle ever created in the U.S.

Two U.S. presidents were noted ranchers. Theodore ROOSEVELT tried his hand at it, with only very modest success. The LYNDON B. JOHNSON NATIONAL HISTORICAL PARK consists in part of the boyhood home and ranch of the 36th president, and his grandfather's ranch.

In some states, such as Montana, the annual calf roundup and the beef roundup are still carried on as in the past, and, of course, cowboy skills are celebrated in the dozens of rodeos held in many parts of the Central West. However, gone are the days when cattle ranchers and sheep ranchers came to blows over the use of the range and when both groups fought the closing of the open range by the newly invented barbed wire and the influx of dirt farmers.

Statistics on ranching alone are not generally available as separate from other aspects of agriculture. However, some of the figures are available from Texas, and these provide an interesting example of ranching operations. Income from livestock in Texas in 1986 reached five and a half billion dollars, 80% from cattle.

The Ranching Heritage Center at Lubbock, Texas, recreates pioneer life in the region.

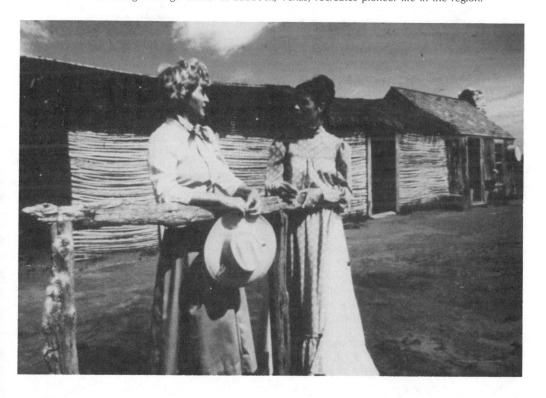

The number of ranches in Texas totalled 146,000. Large operations, over 500 head, numbered 3,650. Of the 13,500,000 head of cattle on Texas ranches, 6,400,000 were grown on the large ranches. There are 800 feedlots, and 31 of these accommodate 32,000 head.

Ranching in all its aspects is celebrated and explained in the detailed operations of Texas' Ranching Heritage Center.

RANCHOS de TAOS. One of the three villages which make up the thriving city of TAOS, New Mexico. Ranchos de Taos is the farming community which features the Mission of St. Francis of Assisi, the most splendid Spanish church in the Southwest.

RANKIN, Jeannette. (Missoula, MT, June 11, 1880—Missoula, MT, May 18, 1973). Congresswoman. Beginning in 1909, she entered social work and labored as a seamstress to gain knowledge of social conditions. After working for woman suffrage on the West Coast in 1910, she led the successful campaign for woman suffrage in her native state in 1914. In 1916 Rankin was the first woman ever elected to the United States House of Representatives. In the Congress, when votes were cast for the United States entry into WORLD WAR I, Rankin first passed. When Speaker Cannon told her she could not afford not to vote, that she represented the womanhood of the country in the Congress, Rankin replied, "I want to stand by my country, but I cannot vote for war...I vote No." She sank to her chair and began to cry. For her action, Rankin received both praise and blame. Her term ended in 1918. By the time of WORLD WAR II, Rankin was again in the House (1940-1942) and again voted against war, but by this time without the disfavor of her earlier vote. However, she declined to run for reelection in 1942 and continued a private career as an ardent feminist, lecturing on social reform. In the 1960s she founded a cooperative homestead for women in Georgia. Then at the age of eighty-seven, on January 15, 1968, she led the Jeannette Rankin Brigade of 5,000 women who marched on Capitol Hill as a Vietnam War protest.

RAPID CITY, South Dakota. City (pop. 46,492), seat of Pennington County, in southwest South Dakota on Rapid Creek, takes its name from the creek.

Called "a boom city which came to stay," Rapid City had its commercial start from the nearby gold fields, but continued to grow and prosper after gold became less important. Much of its industry today is based on timber, lumbering and mining, including a resurgence of gold after gold values skyrocketed. Bentonite, mica, uranium, feldspar and silver are other minerals processed or shipped from there. Packing houses, flour mills, manufacturers of jewelry, cement and lumber products add to the prosperity, as does nearby Ellsworth Air Force Base of the strategic air command. The city further gains from its location as the center of Black Hills tourist attractions.

Soon after gold was discovered in the BLACK HILLS in 1876 Rapid City was founded and was incorporated six years later. The city's relatively placid history was interrupted in 1972 when heavy rainfall collapsed two earth dams in the vicinity, and the flash flood took more than 200 lives, with property loss of 120 million.

As the hub of Black Hills travel, Rapid City offers easy access to MOUNT RUSHMORE NATIONAL MEMORIAL, JEWEL CAVE NATIONAL MONUMENT, DEVILS TOWER NATIONAL MONUMENT, CRAZY HORSE MEMORIAL and the attractions of historic nearby communities such as DEADWOOD, STURGIS, SPEARFISH and CUSTER. There is a fine Sioux Indian Museum and Crafts Center of the Indian Arts and Crafts Board, and the historical Minnlusa Pioneer Museum. South Dakota School of Mines and Technology is one of the most eminent of its type, and it has a fine museum of geology.

Dinosaur Park with its life-size replicas lowering on the hill, Marine Life Aquarium, Dahl Fine Arts Center, Horseless Carriage Museum and the Chapel in the Hills are other attractions.

The National High School Rodeo in mid July and the Central States Fair in early August are two of the annual attractions.

RATON PASS. Mountain pass on the Colorado-New Mexico border just north of RATON, New Mexico. The pass is 7,834 feet high and is crossed by road and railroad. It was formerly used for a branch of the Santa Fe Trail and by General Stephen Watts Kearny's army in 1846.

RATON, New Mexico. City (pop. 8,225), Colfax County, northeastern New Mexico, northwest of Clayton and northeast of Las Vegas. Raton stands where pioneers on the SANTA FE TRAIL once stopped for water. Named for the RATON PASS, the community boomed with an economy based on the railroad, cattle ranching, and the development of the area's coal reserves. A Texan, Dick Rogers, ran Jim Mas-

terson, the brother of famous Bat Masterson, out of town after squaring off in a gunflight and then humilitating him in a local dance hall by making the lawman dance to the shots of Roger's revolver.

RATTLESNAKE DERBY. Annual event begun in 1936 in McCamey, Texas, when a crowd gathered to see such racers as Drain Pipe and Slicker compete for a two hundred dollar prize.

RAWLINS RED. Paint pigment mined near RAWLINS, Wyoming. The distinctive red pigment is used for waterproofing metals in such prominent installations as the framework of the Brooklyn Bridge in New York when it was constructed.

RAWLINS, Wyoming. City (pop. 11,547). Seat of Carbon County in south central Wyoming, on Interstate 80, the community was named for John Aaron Rawlins, who made surveys on the site in 1867; previously he was an aide of General U.S. Grant. The mineral rich region provides the unique Rawlins red coloring matter, a valuable pigment used in waterproofing paint, used both in construction and in the home. Diggings near the city have yielded such finds as the skeleton of a giant mammoth. Early Rawlins was renowned for its lawlessness, until a vigilante group was formed. In 1878 one outlaw was hanged, and twenty-four others were warned to be out of town by morning. Twenty-four tickets were sold for the next train. Today those uproarious times are celebrated in the annual Renegade Roundup Days, held at the Wyoming Frontier Prison.

RAYBURN, Samuel Taliaferro. (Roane County, TN Jan. 6, 1882—Bonham, TX, Nov. 16, 1961). Politician. Raised on a farm in Texas, he attended a one-room school in Flag Springs. After graduating from East Texas Normal School in 1903, he decided to enter politics and was said to have expressed an ambition to become speaker of the house even at that early age. He became a lawyer in BONHAM after graduating with a law degree at the University of Texas and being admitted to the bar in 1908. He started his political career as a state legislator (1907-1912) and became speaker of the Texas House of Representatives in 1911. He set a record for tenure when he was elected as a Democrat to the United States House of Representatives for 24 consecutive terms (1913-1961). Appointed chairman of the Commission

on Interest and Foreign Commerce in 1931, he helped design President F.D. Roosevelt's New Deal program and co-authored six important laws to support the program, including the Federal Securities Act of 1933, the Securities Exchange Act of 1934 and the Wheeler-Rayburn Holding-Company Act of 1935. Rayburn was Speaker of the House from 1940-1947, 1949-1953 and 1955-1961. He became one of the strongest Speakers in United States history, able to dominate the chamber through informal influence. Highly regarded for his integrity and lack of pretension, he was extremely successful in exercising indirect control of the legislative process and of committee assignments through personal relationships with powerful committee chairmen. He was President Harry S Truman's chief supporter in Congress and one of his closest advisers. Except for civil rights measures, he backed much of Truman's domestic program and eventually supported his foreign policy as well. During the 1950s he worked with the Eisenhower Administration to defeat Republican isolationist measures. Although a supporter of Lyndon JOHNSON (1908-1973) for president in 1960, he worked for the Kennedy Administration on much of its initial legislation.

REAGAN, John Henninger. (Sevier County, TN, Oct. 8, 1818—Palestine, TX, Mar. 6, 1905). Politician. He was a prominent figure in Texas politics before his election as a Democrat to the U.S. House (1857-1861). At the outbreak of the CIVIL WAR he was a member of the Texas secession convention (1861) and served the Confederacy as postmaster general and acting secretary of the treasury. After the Civil War ended, he returned to the U.S. Congress (1875-1887), where he co-authored the act that established the Interstate Commerce Commission (1887). He was a U.S. senator from 1887 to 1891.

RED CANYON. Site in Johnson County near present-day Kaycee, Wyoming, where on November 25, 1876, Colonel Ranald S. Mackenzie's 4th Cavalry surprised the winter camp of Dull Knife's Cheyennes who had participated in the Custer defeat during the summer. By destroying shelter, food and clothing, the army managed to force the Indians into surrendering in the spring at Fort Robinson, Nebraska.

RED CLOUD (chief). (North Central NE, 1822—Pine Ridge Agency, SD, Dec. 10, 1909) OGALLALA SIOUX leader who directed the numerous attacks on miners and settlers often using

the BOZEMAN TRAIL which cut through the Indian's Powder River hunting grounds. Constantly resisting the white man's efforts he succeeded in bringing about the treaty which closed the Bozeman Trail and led to the abandonment of the forts which protected it. However, gold seekers violated the treaty and Red Cloud went on the warpath. On December 21, 1866, he reached the peak of his powers in the FETTERMAN MASSACRE outside FORT KEARNY. Red Cloud suffered a serious defeat on August 2, 1867, in a battle with troops from Fort Kearny in the famous Wagon Box Fight where newly issued breech-loading Springfield rifles saved the troopers' lives. In 1878 he and his people were removed to Pine Ridge reservation, Red Cloud resisted the educational program in farming, attempts to diminish the importance of tribal chiefs, and the imposition of religious and social changes which meant an end to the Indian way of life.

RED CLOUD, Nebraska. Town (pop. 1,300), seat of Webster County, south-central Nebraska, northwest of SUPERIOR and southeast of MINDEN. Red Cloud, founded in 1870, was named for the last great warrior chief of the OGALLALA SIOUX who held two war councils on the site of the present town. His daughter is buried on a bluff of the REPUBLICAN RIVER overlooking the community. Rich agricultural land surrounding the river attracted settlers quickly and the town became a county seat and center of local culture. Pulitzer Prize winning author Willa CATHER (1873-1947) lived in Red Cloud and used the community under such names as Moonstone and Frankfort in books including her *O Pioneers* (1913) which marked the beginning of a long period of interest in literature about Nebraska. The 61-acre Willa Cather Memorial Prairie preserves the native grassland as she knew it. The Willa Cather Historical Center includes a museum in the former Farmers' and Merchants' Bank and her childhood home.

RED DESERT. Part of the bowl-shaped GREAT DIVIDE BASIN in Wyoming. The Red Desert is located northeast of ROCK SPRINGS. Colors of the soil are said to change almost hourly according to the direction and brillance of the sunlight.

RED LAKE RIVER. Stream flowing west out of Lower Red Lake in Minnesota before turning southwest to empty into the RED RIVER OF THE NORTH opposite GRAND FORKS, North Dakota.

RED LODGE, Montana. Town (pop. 1,896), seat of Carbon County, south-central Montana, southwest of BILLINGS and southeast of BOZEMAN. Red Lodge is known as Montana's "melting pot" because of its many nationalities. The community recognizes its diverse ethnic base, beginning on the first Saturday of August, with its annual nine-day Festival of Nations which features exhibits and entertainment of the various European cultures of the region. Situated at the base of the rugged and majestic Beartooth Mountains, Red Lodge is a year-around resort town. In the winter, visitors ski, snowmobile and hike through nearby Custer National Forest. Summer festivities include water skiing, boating and fishing in mountain lakes and streams. The Red Lodge post office opened in December, 1884, when the town consisted of one miner's cabin. The discovery of coal and the need of the Northern Pacific Railroad's coal-hungry engines brought prosperity and hundreds of European miners. In the early days there were three Indians for every white man and four men for every woman. By 1892 the population reached 1,180, just 700 fewer than were counted in 1980. The town's first mining disaster, in 1906, hardly dimmed the prospects for a community whose population soared to 4,000. Discoveries of oil and chromite promised even greater wealth. Large herds of sheep and cattle grazed in the foothills of the Beartooth Mountains and agriculture flourished. The first of several financial disasters occurred in 1924 with the closing of the West Side Mine. The Great Depression of the 1930s caused other mines to close and resulted in large scale production of illegal bootleg liquor called "syrup" which was marketed as far away as Chicago and San Francisco. The end of the mining era came soon after the tragic death of seventy-four miners in a 1943 mine explosion, the worst coal mine disaster in Montana history. Travel and tourism are today the region's primary economic base.

RED RIVER. One of the most important rivers of the American Southwest, it is the southernmost of the major tributaries of the Mississippi River. It originates from two small streams: the North Fork in the Texas PANHANDLE and a creek in the LLANO ESTACADO. They meet north of Vernon to form the Red River, which then travels east-southeast creating the boundaries between Texas-Oklahoma and Texas-Arkansas. The river then winds south to enter Louisiana, through the Atchafalaya River, to the Mississippi River. Lake TEXOMA and its

Red wolf, one of the many once-numerous creatures of the region now on the endangered species list.

Denison Dam and Lake TEXARKANA are found on the river in Texas. In Louisiana it is navigable to above Shreveport. It measures approximately 1,300 miles long and drains 90,000 square miles. The river's name comes from the color of the heavy sediment it carries. During the CIVIL WAR, it served as one of the major export routes. The river was fully mapped after Randolph Marcy discovered its source in 1852.

RED RIVER OF THE NORTH. Major continental river formed at BRECKENRIDGE, Minnesota, from the OTTER TAIL RIVER and the BOIS DE SIOUX RIVER. The Red River flows north forming the North Dakota-Minnesota border before crossing into Canada. Important tributaries of the Red River include the RED LAKE and SHEYENNE rivers in the United States. The Red River and its tributaries drain important wheat growing lands, and its waters flow north to end eventually in Hudson Bay.

REDBUD. The official state tree of Oklahoma, the redbud is a member of the pulse family. The European version was called Judas tree because tradition said it was the tree on which Judas hanged himself.

REFUGIO, Texas. Town (pop. 3,898), seat of Refugio County, in central Texas. Located on the north bank of Mission River, Refugio was settled in the 1830s by Irish and Mexican colonists. The town's economy is based on oil and gas wells, cattle raising, and grain farms.

REGISTER CLIFF. Rock formation near GUERNSEY, Wyoming, for years a register of pioneers who recorded their names as they passed by on their way west. Some of the inscriptions date from as early as 1842. The meadow beneath the chalk cliff was the first resting point for emigrants west of FORT LARAMIE.

REGULATORS. In western slang another name for men organized into committees of vigilance when the regular law had broken down. Committees like these often had questionable motives and were frequently used to settle old scores. In 1892 the big ranchers in Wyoming organized a group called the Regulators which was comprised of gunmen hired from other states. The Regulators were responsible for at least two deaths in what became known

as the JOHNSON COUNTY WAR between the nesters and rustlers.

RELIGION IN THE CENTRAL WEST. The Indian peoples of the Central West region had a strong belief in a supreme being, who was conceived in widely different ways by the various tribal groupings. These beliefs were considered to be pagan by the Christian missionaries who were sent in to convert them. Formal religious teaching reached the Central West with the party of Francisco Vasquez de CORONADO (1510-1544). When he returned to Mexico in 1542, he left two Franciscan friars as missionaries. Louis de Escalona was killed at Pecos, New Mexico, in 1544. Juan de Padilla was killed soon afterward.

In the early 1600s the first church was established in New Mexico and named San Juan Bautista, in honor of St. John the Baptist. By 1626 there were 43 churches in New Mexico, and 43,000 Indians were said to have converted to Christianity. Missions were founded widely across the southwest, with SANTA FE, New Mexico, as headquarters.

Often, Indians who refused to convert were killed. Because of Spanish cruelty and neglect the Indians revolted in 1680. With the return of the Spanish in 1692 the Christian religion was revived, and the Catholic faith became predominant in the Southwest. However, the church leaders were wise enough to permit the Indians to incorporate many of their old customs into the Catholic practices.

In the north portion of the Central West region, Catholic missionaries also played an important part, but much more recently and in a much more benevolent manner. One of the truly remarkable religious personalities was Father Pierre Jean DE SMET, whose missionary work ranged across the entire reaches of the northern border states of the west. He was respected by the Indians for his great integrity. Although he knew about several of the locations of gold in the area, he never revealed the secret in order to keep interlopers off the Indian lands.

Father de Smet founded famed St. Mary's Mission in Montana in 1841 at a site near MISSOULA.

As new settlements sprang up across the prairies of the Central West, one of the first orders of business in almost every place was the establishment of a church or churches or place of worship, Catholic or Protestant Jewish or Mormon, depending on the beliefs of the settlers.

According to the latest census, more than a majority of the people of the Central West region, 55.23 percent, claim membership in a religious organization. North Dakota has the largest percentage of church/synagogue membership at 73.9 percent. Colorado has the smallest number of adherents, 36.6 percent.

Membership in the Catholic church in the region is only 18.08 percent of the region's total population. New Mexico, as might be expected, has the largest percentage of Catholics, with 33.5 percent. North Dakota is next with 26.7 percent. Oklahoma has the smallest Catholic membership, standing at only 3.6 percent.

Among the states of the region Texas has the largest total number of Jewish adherents, 72,-570 persons, but this is only .5 percent of Texas' population. In the region, the largest percentage of Jewish members of the total state population region is that of New Mexico with .6 percent.

REMINGTON, Frederic. (Canton, NY, Oct. 4, 1861—New Rochelle, NY, 1909). Artist. Remington, Charles RUSSELL and Ralph Camp, are considered the three premiere early artists of western subjects. Remington painted many of his best works at Fort Reno and near the Darlington Indian Agency in Oklahoma. He traveled widely throughout the West beginning in 1884, collecting material for his pictures. By 1895 Remington was successfully making sculptures of western figures in action positions and became a writer of fact and fiction in books which he illustrated, such as *The Way of an Indian* (1906). His lifetime output numbered thousands of paintings. Collections of his works are displayed in the Whitney Gallery of Western Art in Cody, Wyoming and the Remington Art Memorial at Ogdensburg, New York.

RENDEZVOUS, TRAPPERS. For more than fifteen years the traders, trappers, Indians and hangers-on of the region gathered at a different location each year for what was described as a "brawling, colorful event," mainly devoted to dealing in the furs of the region.

The first rendezvous was organized by Thomas Fitzpatrick in 1824 on behalf of his employer, William H. ASHLEY (1778-1838). At this meeting a small group of traders and Indians assembled along the banks of the GREEN RIVER in Wyoming. The next was organized by Ashley himself in 1825, near Burntfork and McKinnon, Wyoming. The meetings were held each year thereafter until the 1840s.

At the rendezvous, representatives of the many fur trading companies competed with independent traders for the furs brought by the white trappers and the Indians. The Indian traders were a picturesque group carrying on their regular life in large tepees pitched side by side with the shelters of white dealers. The Indians—men, women, children, horses and dogs—all came for both the business and the fun.

In addition to the serious business of fur trading, there were contests, any number of games, a good many fights and pitched battles among the 1,500 or more people who attended the event each year.

REPUBLICAN ARMY OF THE NORTH.
Army of outlaws commanded by Augustus MAGEE, a former United States Army officer. Magee intended to capture Texas for the U.S. Under their banner, the Green Flag, the Army captured NACOGDOCHES in July, 1812, then Goliad, and finally the Spanish capital of Texas, SAN ANTONIO. After Magee died, the Army was defeated and its remaining members captured, and the effort failed completely.

REPUBLICAN RIVER.
The Republican River meets with the Smoky Hill River at JUNCTION CITY in Geary County, Kansas, to form the KANSAS RIVER. The Republican begins its 422 mile course in eastern Colorado and flows northeast and east through southern Nebraska, then southeast through northeastern central Kansas.

RESACA DE LA PALMA.
Valley in a dried-up water bed of the RIO GRANDE RIVER, north of BROWNSVILLE, Texas. It is of historical importance as the site of the second engagement of the Mexican War on May 9, 1846. It was here that United States General Zachary Taylor and his troops charged and defeated the forces of Mexican General Mariano Aristo as they tried to return home after the battle of Palo Alto. Those Mexicans who escaped did so by crossing the Rio Grande.

RESEARCH, HIGHLIGHTS OF THE CENTRAL WEST.
One of the most notable of the many research organizations of the Central West is the ROCKY MOUNTAIN LABORATORY of the U.S. Public Health Service, near HAMILTON, Montana. The Montana State Boards of Health and Etomology conducted intensive research into the cause of ROCKY MOUNTAIN SPOTTED FEVER, one of the most dangerous health threats of the whole region. When this research indicated that the wood tick was the carrier, the Rocky Mountain Laboratory developed a vaccine against the tick bite. The laboratory continues research primarily on infectious diseases that are special problems of the region.

In an entirely unrelated health field, is the research in psychology and psychiatry done in connection with the MENNINGER organizations at TOPEKA, Kansas. As a leader in aircraft production, WICHITA, Kansas is noted for its research and development of all aspects of aircraft construction and operation.

Another Central West state is noted for its research in a specific field. Many of the more than 850 TULSA, Oklahoma, firms dealing with the oil industry in all its aspects engage in continuing research in the effort to improve their expertise. More than ten percent of the members of the American Association of Petroleum Geologists live in the Tulsa area. A unique and highly regarded division of the University of Tulsa is its College of Petroleum Sciences and Engineering. Altogether more than 35,000 Oklahomans are engaged in process and product reearch in such fields as electronics and chemicals, computers and nucleonics.

Texas also depends substantially on research and development to help fuel its business sector. In advanced science, the SCIENCE RESEARCH CENTER at DALLAS is one of the outstanding graduate research centers of the region. The Luling Farm is noted for its agricultural research. The science and engineering schools of RICE UNIVERSITY at HOUSTON are renowned, along with TEXAS TECHNOLOGICAL UNIVERSITY at LUBBOCK. Texas organizations rank among the leaders in petrochemical research.

The Nebraska Center for Continuing Education provides many seminars and other study opportunities for research in science and related fields.

Much of the nation's defense effort is researched and tested at McGregor Rocket Range of Holloman Air Force Missile Center and White Sands Missile Range, near ALAMOGORDO, New Mexico. SUNSPOT OBSERVATORY, near CLOUDCROFT, New Mexico, is one of the world's leading centers for the study of solar activity and phenomena.

Both New Mexico and South Dakota are known for their schools of mining and for the research done there in that field. These are the NEW MEXICO INSTITUTE OF MINING AND TECHNOLOGY at SOCORRO, and the SOUTH DAKOTA SCHOOL OF MINES AND TECHNOLOGY at RAPID CITY. The latter is particularly known for its Institute of Atmos-

pheric Sciences, for research on the potential of altering weather and climate. The South Dakota school's sheep Mountain Camp is known for its work in paleontology.

Because of the abundance of LIGNITE in North Dakota that state has been a leader in research for new uses for that relative of coal, along with processes for making it more usable, such as the work of the School of Mines at the University of NORTH DAKOTA in developing briquetting processes and the ongoing research of the Division of Mines and Mining Experiments cooperating with the United States Bureau of Mines. The latter collaboration developed a process for producing activated carbon from lignite. NORTH DAKOTA STATE UNIVERSITY agricultural experiment stations at FARGO and WILLISTON have been called "the most efficient system of research I have ever observed," by Senator Leo Borah.

The Rocky Mountain Herbarium of the University of WYOMING has been called unique of its type, in the study of botany. The university's Summer Science Camp in the Snowy Range Nature Area and its experimental farm also are known for their research. The later specializes in improving the state's livestock, grains, hays and vegetables.

RHODES PASS. Mountain pass named for Eugene Manlove RHODES (1869-1935), New Mexico cowboy-turned-author who vividly described the pass in his novel, *Stepsons of Light* (1921). When Rhodes died, he was buried on the pass which is now almost entirely cut off by military restrictions surrounding the White Sands region.

RHODES, Eugene Manlove. (Tecumseh, NE, Jan. 19, 1869—Pacific Beach, CA, June 27, 1935). Author. Beginning in 1906, Rhodes vividly described life on the New Mexico cattle range of the late 1800s in ten books and many articles he wrote for the *Saturday Evening Post.* He gained his insights from twenty-five years of first-hand experience working as a cowboy, and the authenticity of such writing as *Good Men and True* (1910) and *The Proud Sheriff* (1935) is said to be unsurpassed in literature of the West.

RICE. Cereal grass native to Asia and cultivated in America since the 17th century. Rice thrives naturally in low-lying, subtropical areas such as those found along the Gulf coast; however, irrigation has assisted cultivation in higher elevations with sufficient heat, such as

those found in portions of Texas, which ranks first in U.S. production.

RICE UNIVERSITY. Independent coed university located on a 300-acre campus in HOUSTON, Texas. The university was founded in 1891 by a fund set up by William March Rice who was a philanthropist and cotton merchant. Originally named William March Rice Institute, the school began as a tuition-free institution "dedicated to the advancement of literature, science and art." In 1942 a policy of admitting only 450 undergraduates annually, and unlimited numbers of graduate students, was put into practice. This plan was not modified until 1964 when total enrollment admissions were expanded. Rice is rated among the nation's top 100 producers of medical school applicants accepted. The school is also numbered among the top 100 producers of future business executives. A student body of 3,848 is instructed by a faculty of 520.

RICHARDSON, Texas. Town (pop. 72,496) in Dallas and Collin Counties, in northeast Texas. Richardson is primarily a residential area located ten miles north of DALLAS. Its industries include electronics equipment, industrial machinery, clothing, and feed mills. Richardson's population increased 189% between 1960 and 1970.

RICHEY, Anne. (Kemmerer, WY, 1890—Kemmerer, WY, May 26, 1922). Ranch operator, cattle rustler. Anne Byers was born to a moderately wealthy ranch family. At 18 or 19 she married Professor C.J. Richey. Her pleased parents deeded the ranch to their daughter and her husband. After her husband left her and she divorced him in 1920, Anne managed the ranch alone, riding herd, roping and branding with the best of the cowboys, gaining the nickname "Queen Anne." The number of cattle feeding on her OXO began to increase so rapidly that her neighbors became suspicious. Finally enough evidence had been gathered to bring Ann Richey to trial for cattle rustling. Some of the animals she had sold to a packing house were slaughtered and bought as evidence. The changed brands were distinctly revealed in the raw meat. Anne Richey became the only woman in U.S. history to be convicted of cattle rustling, December 3, 1919. However, the verdict was appealed to the state supreme court, dragging on for two years. then on October 18, 1921, the supreme court upheld the ruling. She was placed on temporary suspension so that she

might bring order to her ranch affairs, and the community was greatly excited when she was found dead on the outskirts of the ranch, having been poisoned. The mystery of her death has never been solved.

RING-TAILED CAT. Especially exotic western animal having the tail of a raccoon, the body of a squirrel, the head and bark of a fox, and the front feet of a cat. These strange animals are found on both slopes of the Rockies.

RIO DE LAS PALMAS. River on which a Texas colony was established by Alonzo Alvares de Pineda, an explorer who mapped most of the coast of the Gulf of Mexico in 1519 and discovered the mouth of the RIO GRANDE RIVER and CORPUS CHRISTI BAY.

RIO GRANDE RIVER. International river which rises in the SAN JUAN MOUNTAINS in southwestern Colorado. At 1,885 miles, it is the fifth longest river of the United States and the ninth longest in the Western hemisphere, it flows southeast and then south through San Luis Park and across central New Mexico where it forms the short western border between Texas and New Mexico, and the southwestern border of Texas with Mexico, beginning at EL PASO. The Rio Grande flows through canyons of the BIG BEND NATIONAL PARK, and Texas border towns DEL RIO, EAGLE PASS, LAREDO and BROWNSVILLE. Its flow is erratic, ranging from a very low volume of water to flood rates in excess of 600,000 cubic feet per second. Because of the flood damage potential, as well as the great need for irrigation, several water projects have been developed along its course. The river drains almost 50,000 square miles, and waters most of the Lower Valley of Texas before it empties into the Gulf of Mexico near Brownsville. By an agreement with Mexico the Rio Grande is closed to navigation.

RIO GRANDE WILD AND SCENIC RIVER. A 191.2-mile-strip on the American shore of the RIO GRANDE in the Chihuahuan Desert protects the river. It begins in BIG BEND NATIONAL PARK and continues downstream to the Terrell-Val Verde County line. Headquartered Big Bend National Park, Texas.

RIO GRANDE WILD AND SCENIC RIVER SYSTEM. Challenging whitewater enthusiasts, this rugged stretch of the upper RIO GRANDE roars through a deep canyon in northern New Mexico. Headquartered SANTA FE, New Mexico.

RITA BLANCA CREEK. Stream rising in New Mexico and flowing east into the northwest corner of Texas to join the CANADIAN RIVER at Boys Ranch, for a total distance of approximately 75 miles.

RIVERDALE, North Dakota. Town (pop. 500), McLean County, central North Dakota, northeast of DICKINSON and northwest of BISMARCK. Riverdale is an ultramodern city which was developed for the construction and maintenance of the mammoth Garrison Dam, one of the largest earth-filled dams in the world.

RIVERTON, Wyoming. City (pop. 9,588), Fremont County, central Wyoming, northeast of LANDER and northwest of CASPER. Riverton is known as the "Mining Capital of Wyoming" because of its four uranium processing mills. A rodeo and stunt pilot performances mark the annual Riverton Rendezvous in late July.

ROADRUNNER. Beloved state bird of New Mexico, the roadrunner is actually a member of the cuckoo family. This ground cuckoo (chaparrel cock) speeds along at up to fifteen miles per hour, with its tail extended horizontally, its head down and its ragged crest erect. Pioneers became attracted to it because it would race ahead of their wagons, then turn, seeming to wait for them to catch up. The roadrunner eats small snakes and lizards, but has no fear of rattlesnakes. It first pounds its prey to death with its heavy bill and then swallowing it headfirst. Roadrunners have been domesticated to kill mice. Its foot-wide nests may be found in low trees, amid prickly cactus, or in yucca. They lay their eggs in their own nests, not like the European cuckoos which lay their eggs in nests of other birds. Because they lay their eggs at intervals, a single nest may have both eggs and young birds.

ROBBERS CANYON. Site, near Pryor, Oklahoma, where searchers still dig for gold loot buried by the outlaws.

ROCK CITY. A grouping of nearly two hundred elliptical or spherical formations, created underground by water-borne calcium carbonate precipitating into spaces of loosely cemented sandstone. These were later exposed by erosion on the surface near MINNEAPOLIS, Kansas.

Rock City near Minneapolis, Kansas.

ROCK HOUND CLUBS. Local clubs of rock collectors who search among the hills of the West for such beautiful rocks and gems as onyx, pertified wood, garnet, sapphire, azurite, bloodstone, ruby, alabaster, jade, and agate. The hobby has increased at a rapid rate, and almost every known site of any collectible gem now has such an organization. The variety of gems found in Montana has made this state the premiere locale for the work of such clubs. However, most of the other states of the region rank among the finest sources for a variety of precious and semi-precious stones.

ROCK SPRINGS, Wyoming. City (pop. 19,-458). In Sweetwater County, southwestern Wyoming, the name is descriptive. Described as "a microcosm of the West," the city is noted for its multiethnic heritage, with the various nationalities being attracted by the railroads and mineral wealth. International Night has honored the diversity of the population since the 1920s. Beginning in 1862, the town benefitted as a stop for the Overland Stage route, and seven years later the railroad brought new life. Rock Springs became one of the main coaling stations on the first transcontinental route and remains a major energy supplier today. To the

west of the town are the world's largest deposits of trona, used in the making of glass, silicates, soaps, baking goods and phosphates. Less then fifteen miles to the west is FLAMING GORGE RESERVOIR, with its spectacular scenery and recreation. Two rodeos, the Rocky Mountain All-Girl Rodeo and Red Desert Round-Up, keep things humming in the summer. The latter is the largest rodeo held in the Rockies region. Late August brings the Rocky Mountain Polka Festival.

ROCKY FLATS. Site upon which the Atomic Energy Commission constructed a $43 million plant in 1951. Rocky Flats is located between DENVER and BOULDER, Colorado. The Rocky Flats plant is now one of seven operated by the AEC in the state.

ROCKY FORD, Colorado. Town (pop. 4,804), Otero County, southeastern Colorado, northwest of LA JUNTA and west of LAS ANIMAS. Rocky Ford is the self-proclaimed Melon Capital of the World. Rocky Ford watermelons became famous in 1878 when George W. Swink, who grew them, began giving them away to neighbors. The custom has continued to the present and is associated with the Arkansas Valley Fair

during the third week in August when ten thousand melons are distributed. In 1957 the Watermelon Derby, a race, was organized. The Watermelon Sweepstakes Relay started in 1962.

ROCKY MOUNTAIN BIOLOGICAL LABORATORY. Scientific center for high altitude biological experiments, located at Gothic, Colorado.

ROCKY MOUNTAIN COLUMBINE. This spectacular delicate blue flower is the official state flower of Colorado. Some of the blossoms have reached a dimension of almost two inches. Finding these blooming in the wild, visitors consider them rare treasures and are amazed by their size and beauty.

ROCKY MOUNTAIN GOAT. Sometimes referred to as the goat antelope or the antelope goat, the animal is not a true goat but a relative of the chamois. Four feet high at the shoulder and shorter toward the rear, the awkward looking animal may weigh up to three hundred pounds. Both the male and female have backward-curving horns and long shaggy white coats throughout the year. They live high above the tree-line in remote regions of the mountains.

ROCKY MOUNTAIN HERBARIUM. Unique botanical collection now with over 150,000 species of plants and animals established by Professor Avon Nelson for the University of WYOMING, a school for which he later became president.

ROCKY MOUNTAIN JAY. Also known as the Canada jay, this member of the crow family is descriptively called the camp robber. A non-migratory species these jays are continually attracted to bright objects, or anything that catches the sun. The bird will swoop down and snatch up any gleaming object that it can carry off in its beak. Nests of this burglar have been found containing such items as coins, pencils and pens, rings, keys and even gold watches.

ROCKY MOUNTAIN LABORATORY. Thoroughly modern research center near HAMILTON, Montana, where research into many infectious diseases in the West is conducted. In 1906 in one of its most notable accomplishments, scientists from the laboratory proved that the bite of a wood tick was responsible for the dreaded ROCKY MOUNTAIN SPOTTED FEVER and then developed a vaccine which effectively prevents the disease.

ROCKY MOUNTAIN NATIONAL PARK. The park's rich scenery, typifying the massive grandeur of the ROCKY MOUNTAINS, is accessible by Trail Ridge Road, which crosses the Continental Divide and is the highest major highway in the world. Peaks towering more than 14,000 feet shadow wildlife and wildflowers in these 412 square miles of the Rockies' Front Range. The village of ESTES PARK is home base for visitors to the Park, and the ascent of Mt. Evans highway provides visitors with the highest automobile road in the world.

ROCKY MOUNTAIN SHEEP. Properly called big horn sheep, the animals range from Alaska into Mexico with the southern varieties being larger than the northern. Footsure, active and hardy, the sheep display massive backward-curving horns which turn downward and then sideways. Rams, weighing three hundred pounds and measuring six feet in length, vary from white in the far north to darker shades the farther south they are found.

ROCKY MOUNTAIN SPOTTED FEVER. Dreaded, often fatal disease, first reported in 1873 in the Bitterroot Valley of Montana. Knowing neither cause not cure the Montana State Boards of Health and Entomology brought researchers to a make-shift village of tents, cabins and abandoned schoolhouses to conduct their experiments. In 1906 the scientists proved the cause to be the bite of a wood tick. The ROCKY MOUNTAIN LABORATORY of the United States Public Health Service developed a vaccine which, when administered yearly to those exposed to tick bite, prevents the disease.

ROCKY MOUNTAIN UPLIFT. Most recent geologic period when the land under much of the present GREAT PLAINS and all of the Rockies was raised up above the sea waters which covered it. The Uplift, occurring about sixty million years ago, thrust up the mountains of the region and tilted most of the rest of the region from west to east.

ROCKY MOUNTAINS. Known as the Rockies, the mighty range extends from the Arctic through much of the Central West, including Montana, Wyoming, Colorado and New Mexico before passing the U.S. border and continuing through Central and South America. The highest peak in the United States section south of

Pikes Peak or Bust Rodeo is a splendid representative of the popular sport which originated in the region.

the Canadian border is Mount ELBERT, 14,433 feet high, in Colorado, which is the highest of all U.S. states in average elevation. The Rockies are considered to be among the "youngest" of the world's mountains, being formed over a long period in the late Mesozoic and early Cenozoic eras, roughly 60,000,000 years ago. However, they are a very complex range with evidences of volcanic action, various tilts and uplifts and erosion. The usual divisions, five in number, beginning toward the north at the U.S.-Mexican border, are the Southern Rockies, Middle Rockies, Northern Rockies, Canadian Rockies and the Brooks Range in Alaska. The Rockies form the CONTINENTAL DIVIDE, separating the waters flowing to the Atlantic from those to the Pacific. The Divide separates into two sections around the Wyoming Basin. This is considered to be the major break in the system. It is sometimes said to be another separate major division. The Wyoming Basin is thought to be unique among the world divides. The divide is forced to split to go around the basin on either side. Rain falling on the inner slops of the basin flows to no ocean. In the Central West, the peaks of the northern ranges are generally not so high as those of the southern sections.

RODEOS. As the traditional home of the cowboy, the Central West lives up to expectations as the originator and perpetuator of the rodeo. Almost every sizeable community of the region, especially in the western portions, promotes some kind of rodeo.

Almost as soon as cowboys began to work with range animals they also began informally to test each other's skills and to compete with one another to see who was best in riding, roping and other cowboy tasks. The first formally organized rodeo is thought to be the one held at PECOS, Texas, on the Fourth of July, 1884. Cowboys of the area demonstrated their skills for modest prizes.

Another rodeo established at an early date is the annual Teddy Roosevelt Rough Riders' and Cowboys' Reunion at LAS VEGAS, New Mexico, begun in 1898 and said to be the oldest in the far Southwest.

Today the most famous rodeo of all probably is the huge show put on at CHEYENNE, Wyoming, as the highlight of the capital's FRONTIER DAYS. Almost equally renowned is the DAYS OF '76 rodeo at DEADWOOD, South Dakota. Wyoming's Cody Stampede is also notable.

Most of the cowboy performers of the present time are highly skilled professionals. There is a

Professional Rodeo Cowboys Association head-quartered at DENVER, Colorado, and many top performers have gained world renown. Jim SHOULDERS of HENRYETTA, Oklahoma, gained sixteen national rodeo championships. Lensapah, Oklahoma, developed five world champion rodeo performers. The professionals follow the rodeo circuit wherever suitable contests are held.

The Rodeo National Finals are held each year in OKLAHOMA CITY.

Not all rodeo performers are professional, however. The Wyoming Rodeo at SHERIDAN is said to be the world's largest featuring certified working cowboys. Not going anywhere fast are the contestants at the prison rodeos at MC ALESTER, Oklahoma, and HUNTSVILLE, Texas. Receipts are used to aid the prisoners' funds.

The sport has now gained international recognition and provides the world with a graphic demonstration of the skills and rigors of life in the Central West.

Will Rogers

ROGERS, Will (Colonel William Penn Adair Rogers). (Oolagah, Indian Territory Oklahoma, Nov. 4, 1879—near Point Barrow, AK, Aug. 15, 1935) Entertainer, philosopher. A unique American of unique accomplishments. Before Will was born his mother moved into the original log section of their home, so her child could say he or she was born in a log cabin.

However, the Rogers family was one of the wealthiest in Indian territory, with a very comfortable house an addition to the original log portion. His father was one of the region's most influential figures, rancher, banker and pioneer cattleman, for whom Rogers County, Oklahoma, is named. Later Rogers said that he was "born halfway between CLAREMORE and OOLAGAH before there was a town at either place."

His ancestry was about one-fifth Indian, of which he was very proud. He later bragged that his ancestors did not come over on the Mayflower. Actually they were on the welcoming committee. While Rogers tried to give the impression of a humble background, he grew up with every advantage the family wealth could give him in that region, including the first piano in the area.

He hated formal schooling, tried six different ones before spending four years in a military school. There he received a very good education, contrary to the impression he made of being unschooled and homespun.

He much preferred to learn trick roping, taught by a black cowboy friend. Will refused

his father's offer to take over his business affairs. When the family moved to town, Will put up a dancing platform and imported a band and made the ranch the liveliest place in the area.

His first appearance in "show business" was in a rodeo, July 4, 1899, at Claremore. He was a fine bronc rider and roper in the best tradition of rodeo. He performed in South America as the Cherokee Kid, went to New Zealand and then around the world—all preparing him for the international viewpoint which later influenced his philosophy. Rogers joined the Zack Mulhall rodeo show, the first of its kind to perform in New York City, where he roomed with future movie star Tom MIX (1880-1940). Next he took his trick roping act to vaudeville and soon joined the ranks of Florenz Ziegfeld's Follies. He quickly learned that his homespun comments made while roping were of more interest than the rope tricks, and his fame as a perceptive humorist grew.

In 1919 he began the syndicated newspaper column which grew to include over 350 papers worldwide. His observations on the U.S. and international scene were perhaps the most telling and acute in journalism history. His style was so simple and direct it was disarming, but a single column could inspire spectacular response. Much of his philosophy seems as fresh and insightful today as it did more than thirty years ago.

He went on to highly acclaimed careers in

The quality of the boyhood home of Will Rogers at Oolagah, Oklahoma, indicates that the humorist/ philosopher did not come from the humble background he often claimed.

motion pictures and radio, along with lecture tours.

Rogers was renowned for his kindliness. When he missed a train to WICHITA, Kansas, one day, he hired a special train to take him there in order to avoid cheating his fans. He never was too busy to stop and entertain a group of children, and he gave great sums to charity, along with countless benefit performances.

He received more honors worldwide than most public figures of his day. He even preceded some modern entertainers in public life by becoming Mayor of Beverly Hills. At his inauguration he joked, "They say I'll be a comedy mayor. Well, I won't be the only one. I never saw a mayor yet who wasn't comical. I'm for the common people, and as Beverly Hills has no common people I won't have to pass out any favors." He appeared to remain unaware of the world influence he had acquired. When a fan sent him a stamp to send a picture, Rogers returned the stamp and wrote, "I thank you for the use of your money. I haven't got a picture of myself. If I did have, it wouldn't be worth two-bits. If I did have one, I'd give you two-bits to keep it.

One day Rogers suddenly decided to join his friend Wiley POST (1899-1935) on a trip to northern regions. When the plane crashed near Point Barrow, Alaska, news of Rogers death shocked the world in much the same way as in the sudden death of a mighty political figure. As some one remarked, "That day the world lost both its courage and its humor." The Shrine to the Sun on CHEYENNE MOUNTAIN outside COLORADO SPRINGS, Colorado, was dedicated as a memorial to him by Spencer Penrose.

ROLVAAG, Ole Edvart. (Island of Donna, Helgeland, Norway, Apr. 11, 1876—Northfield, Minnesota, Nov. 5, 1931). Author, educator. He emigrated to the U.S. in 1896 and worked for three years on his uncle's farm in South Dakota. His determination to get an education led him to Augustana Academy at Canton, South Dakota, from 1899 to 1901. He then graduated from St. Olaf College in 1905 and returned to Oslo, where he studied at the university. Returning to St. Olaf, he remained there as professor of Norwegian language and literature for the rest of his life. His best-known work was based on his early years and experiences in South Dakota. *Giants in the Earth* (1927) is a grand epic depicting immigrant life on the South Dakota prairies in the 1870s.

ROMAN NOSE (chief). (—). Cheyenne chief who was killed leading more than one thousand Sioux and Cheyenne warriors against the fifty frontiersmen commanded by Major George A. Forsyth at the Battle of BEECHER'S ISLAND in Yuma County near the town of Beecher Island, Colorado.

ROOSEVELT, MOUNT. This modest peak

near DEADWOOD, South Dakota, provides a vantage point from which three states can be glimpsed in addition to South Dakota—Montana, Wyoming and Nebraska. The mountain's slopes contain a memorial to Theodore ROOSEVELT (1858-1919), in commemoration of his visit to the region.

ROOSEVELT, Theodore, IN THE CENTRAL WEST. (New York, NY, Oct. 17, 1858—New York, NY, Jan. 7, 1919). U.S. president, statesman. In the year 1883 an unprepossessing young man of twenty-five arrived at the community of Little Missouri (now Medora), North Dakota. He said he was unwell and it soon was known that he had recently lost both of his parents as well as his wife. He had come to North Dakota hoping to cheer his spirits and regain his health in what he came to call the Strenuous Life.

Even at that age Theodore Roosevelt was not without a background in public affairs. He had served in the New York state legislature beginning in 1881 and had done considerable writing before going to North Dakota. The different life he led in North Dakota restored his spirits and brought him renewed health. He later said that the years he spent in the west provided the background he needed in a public life which

was notable for its vigor, decisiveness and acumen.

The westerners were not immediately impressed with the dude from New York with squinty eyes magnified by thick glasses. They began to call him four eyes. However, after he knocked out a bully with bare hands and took away his gun, the term Four Eyes suddenly became respectable.

After buying two ranches near MEDORA, the wealthy New York aristocrat easily slipped into the drudgery of ranch life. Soon he had shot his first grizzly and loved the hunting and all the other outdoor activities of ranch and countryside. People were amazed at the ease with which he held his own in cow punching and other difficult ranch tasks. The Strenuous Life became like a theme song to him.

He quickly earned the liking and respect of his fellow townspeople and advanced to positions of trust in the local area. He made a number of notable addresses on such occasions as the Fourth of July, sharply honing the oratory for which he would later have wider fame.

He lived in North Dakota for two years and returned in the summer for four more years. Due to winter setbacks and a rather indifferent attitude, he had little success as a rancher, but

Theodore Roosevelt leads his Rough Riders up San Juan Hill during the Spanish American War in this contemporary cartoon.

he returned to larger public life ready for all the challenges it could offer.

ROSE ROCK. The official rock of Oklahoma is also known as barite rose, a form of the widely distributed barite.

ROSEBUD RIVER. River in southeastern Montana, rising in eastern Big Horn County and flowing northeast into the YELLOWSTONE RIVER in Rosebud County.

ROSENBERG, Texas. Town (pop. 17,995), Fort Bend County in southeast Texas on the BRAZOS RIVER. The area was first settled by colonists brought in by Stephen F. AUSTIN (1793-1836). In 1920, the discovery of oil in the county made Rosenberg a boom town. Today many residents commute to nearby HOUSTON for work.

ROSS, John. (near Lookout Mountain, TN, Oct. 3, 1790— Washington DC, Aug. 1, 1866). Cherokee Indian chief. Of Scottish-Cherokee blood, he was educated among the whites in Tennessee and fought the Creek Indians in the War of 1812. In 1828 he was made chief of the eastern Cherokee (the western division had already migrated to Oklahoma) and tried in vain to hold onto Cherokee land. He refused to acknowledge the treaty of 1835, calling for the removal of his tribe from Georgia. His resistance was futile and in 1838 he led his remaining people to the Indian Territory, many of them dying on the long journey, which is often referred to as "The Trail of Tears." Upon reaching Oklahoma and uniting with the western Cherokee, he was elected leader of the entire Cherokee nation, a position he held until his death.

ROSS, Nellie Tayloe. (St. Joseph, MO, 1876—Dec. 19, 1977). Politician. The Wyoming Democrat was one of the first two women to be elected governor of a state. She and Miriam Ferguson, governor of Oklahoma, were elected on the same day in 1924, but Mrs. Ross was sworn in two weeks earlier and so is considered to have been the first woman to govern a state. Mrs. Ross made substantial contributions to the movement for women's rights. She further enhanced the cause by serving as the first woman Director of the United States Mint (1933-1953), a post to which she was appointed by President F.D. Roosevelt.

ROSS, North Dakota. Town (pop. 104),

Mountrail County, northwestern North Dakota, west of STANLEY and northeast of WILLISTON. Named by the railroad company, Ross was the new home in 1902 of twenty Moslem families from Damascus, Syria, who homesteaded southeast of town. The Federal Government, which initially blocked their naturalization, withdrew its objections in 1909. The colony built a basement mosque in 1929 and conducted religious services each Friday. Nearby is the Verendrye Bridge, the third highway bridge built in North Dakota across the MISSOURI RIVER. The Indians from earliest times called the site of the bridge the Old Crossing because it had annually been a ford for huge herds of buffalo.

ROSWELL, New Mexico. City (pop. 39,676), Chaves County, southeastern New Mexico, northwest of ARTESIA and northeast of ALAMOGORDO. A commercially well-rounded city of shipping, oil production, and agriculture, Roswell began as a crossroads of the Goodnight-Loving Trail and the CHISHOLM Trail. Water from several large springs sustained the cattle and was exploited for irrigation. In 1891 a vast artesian basin discovered beneath the earth created an economy based on the irrigated cultivation of alfalfa, cotton and apples, making Roswell one of the fastest growing towns in New Mexico. Converting of plentiful underground supplies of saline water to fresh water through a "forced-circulation vapor-compression system" costing $1.00 per 1,000 gallons of water has lessened the pressure on scarce fresh water supplies. Until his death in 1945, Dr. Robert Goddard used the nearby prairie to test the results of his experiments in rocketry. Today Roswell boasts a branch of Eastern New Mexico University and the NEW MEXICO MILITARY INSTITUTE.

ROUGH RIDERS. At the start of the Spanish-American War in 1898, Theodore ROOSEVELT (1858-1919) began to recruit the troop later called the Rough Riders. Headquartered at SAN ANTONIO, Texas, with the help of Colonel Leonard WOOD, (1860-1927) the fighting force was assembled. The troop was trained at the fairgrounds there before going on to glory in Cuba during the war. Searching for a vigorous and colorful name for his group, Roosevelt recalled the pleasant times he had spent in the dining room of the Rough Rider Hotel, at MEDORA, North Dakota, when he lived nearby for two years. So the group gained immortality under the name of the hotel, which still operates.

ROUND MOUNTAIN, BATTLE OF. November 19, 1861, northwest of KEYSTONE, the first Civil War battle to occur in what is now Oklahoma. Throughout the war twenty-eight battles, skirmishes and other military engagements occurred there, often created by serious strife between the fullblooded and mixblooded Creek Indians who lived in poverty without supplies promised by the United States government.

ROUNDUPS. The exhausting bedlam of roundup time was an event that almost every cowboy of the Central West anticipated with excitement, no matter how dangerous, noisy and dusty it might be. Here was a chance to show his mettle, to meet old buddies and make new ones.

Before barbed wire fences separated the ranches, roundups were required because the animals grazed freely, and twice each year the cattle of each ranch had to be rounded up. The spring roundup called for selecting the calves of each owner and marking of the calves with the owners' brands. The fall brought the separating of those animals selected to be sent to market through railheads often very distant.

A roundup might cover as much as fifty square miles and was conducted with military planning and decision. For the spring roundup, cooperating ranchers picked holding areas for the stock to be gathered in each day. The men would be sent out in pairs on the most skillful horses to find the animals, sometimes well hidden in gullies, and then accomplish the difficult job of herding them back to the holding areas.

During the roundup, each man knew exactly what to do. The riders closed in on the holding areas with the stock brought together in a circle. Top hands separated the mother cows from their calves. On horses well trained for this job, the best riders then used their roping skills to capture the caves by the leg, identifying the calf by its mother's markings, then hauling each to the flankers. Each roper could keep two flankers busy. The flankers' job was to tie the hind legs of the calf so that it could be branded. The branding specialist would select the proper brand from the many brands lying red hot in the fire, after the owner was identified by the brander.

The smell of smoke and hot flesh filled the air as the calves were lightly pressed on the flank with the branding iron of their owner. The marker would then cut a small piece of ear from each calf, tossing it into a pail to be matched with its mother's mark to assure ownership. The male calves would be quickly castrated by the marker. The entire process required only a few seconds for each calf. Roundup days were eighteen hours long for the entire crew. After an exhausting day, the tired cowhands would hurry to the chuckwagons to enjoy strong coffee, lots of good food and news, wisecracks and jokes that helped them to endure the succeeding months of the often lonely and always hard life of the prairie.

ROYAL GORGE AND BRIDGE. Tourist attraction in the Grand Canyon of the Arkansas River west of CANON CITY in south central Colorado. The gorge is 4 1/2 miles long with sheer walls which rise more than one thousand feet. Railroad tracks run through the canyon. Cable cars take tourists to the bottom of the canyon for a breath-taking view of the suspension bridge which spans the gorge. Highest in the world since it was completed in 1929, the bridge hangs 1,053 feet above the canyon floor and the Arkansas River.

RUGBY, North Dakota. Town (pop. 3,335), Pierce County, north-central North Dakota, southeast of BOTTINEAU and northwest of Devils Lake. Rugby has the distinction of being at the Geographical center of North America. The Geographical Center Pioneer Village and Museum is located at the site determined to be the exact center. Exhibits include antique agricultural artifacts and over twenty restored pioneer community buildings. N.P. Lindberg, a Rugby florist, has been given credit for the expression "say it with flowers" which was selected as the slogan of the principal national florists' group and has become widely used in all its advertisements.

RUNNING ANTELOPE . (—). North Dakota Indian used as the model for the Indian image appearing on the old large-sized five dollar bill.

RUNNYMEDE, Kansas. Ghost town near present-day HARPER, Kansas. Runnymede was founded in 1887 by Ned Turnly. The community was settled by landed English people who brought their coaches, butlers and fancy clothes to the Kansas prairie. However, the settlers were not accustomed to the hard life necessary for success on the frontier, and they gradually gave up and moved away. Today only one tombstone is left at the site of the town which once sparkled with elegant life.

Royal Gorge bridge is the highest suspension span in the world.

RUSH LAKE. South Dakota site, where, according to an Indian legend, water birds who considered themselves drab and dull came to be miraculously changed into colorful waterfowl by an Indian using colored minerals and plant dyes found in the area. All the birds except the goose and loon were changed, accounting for their lack of color today, according to the legend.

RUSH RIVER. North Dakota stream whose source lies in Cass County, west of Erie, it flows south-southeast into the RED RIVER north of FARGO.

RUSH SPRINGS, Oklahoma. Town (pop. 1,451), Grady County, south-central Oklahoma, south of CHICKASHA and north of DUNCAN. Rush Springs is one of the leading watermelon marketing centers in the United States.

RUSHMORE, Mount. Famed for its gigantic presidential sculptures, the mountain was named for lawyer Charles Rushmore, who benefitted by an attempt to make him the butt of a joke. When he asked the name of a certain mountain, the jokesters told him it bore his own name. However, the name was bandied about so often in connection with the mountain that the name stuck, and lawyer Rushmore gained everlasting fame when "his" mountain became the site of the great natural memorial.

RUSK, Thomas Jefferson. (Pendleton District, SC, Dec. 5, 1803—Nacogdoches, TX, July 29, 1857). Politician. After moving to Texas in 1835, Rusk became active in Texas politics, and was the first secretary of war in the new republic's provisional government. Rusk served as chief justice of the Texas Supreme Court (1838-1840), and was president of the convention that confirmed the annexation of Texas in 1845. He was a Democratic U.S. Senator from 1846 to 1857.

RUSSELL, Charles M. (St. Louis, MO, March 19, 1865—Great Falls, MT, Oct. 24, 1926). Artist. Russell is the only artist in the United States to be honored by a place in Statuary Hall in the capitol in Washington, D.C. where his statue represents Montana. Based on an intimate knowledge of the West and its people, Russell created at least 3,000 models, sketches, watercolors, oils and bronzes

over a period of forty-six years. He is regarded as one of the two or three principal masters of "western art." Beginning in 1914, he exhibited his works in major cities throughout the western world. Major exhibits of his art may be found in the BARTLESVILLE, Oklahoma, WOOLAROC MUSEUM; the Russell Museum in GREAT FALLS, Montana; and the Montana Historical Society in Helena.

RUSSELL, MAJORS AND WADELL. Largest freighting company of the late 1850s which operated along the central route past Forts Laramie and Bridger and Salt Lake City. Adding a pony express was an idea promoted by California Senator William M. Gwin who urged William H. RUSSELL to provide California residents with faster communication. Advantages listed for the plan included the additional publicity such a venture would bring to the company and the possible mail contracts they could receive. Russell accepted the idea and when government assistance was not offered, he decided to go ahead on his own with the short-lived mail service. In October, 1861, the arrival of the telegraph brought an end to the experiment in less than a year, but not before the Pony Express had gained lasting fame as a romantic feature of the old West. When the Confederates captured a portion of the central route and property of the Butterfield Overland Stage Company, Russell expected to receive the mail contracts. When this did not come about Butterfield moved to the central route and continued his operations until 1862 by which time Russell, Major and Wadell had become bankrupt and were forced to sell out to Ben Holladay.

RUST, John Daniel. (Stephens County, TX, Sept. 6, 1892—Pine Bluff, AR, Jan. 20, 1954). Inventor. Working in his sister's garage, Rust filed his first patent on a mechanical cotton picking machine in 1928. He later collaborated with his brother on many other inventions, including a cotton cleaner.

RYE. A cereal with great potential as a food for human consumption raised in the Central West states of South Dakota, North Dakota, Nebraska and Oklahoma. Similar to barley and wheat, rye has a nutritional value nearly as high as wheat, although American farmers use it primarily as a livestock feed. Rye, frequently grown as a cover crop along new roadbeds where it flourishes in the infertile subsoil, is alternated with other crops to improve or to protect the soil. A poisonous fungus, ergot, often destroys rye grain. The fungus also supplies a valuable drug used to treat migraine headaches, aid childbirth, and control bleeding.

S

SABETHA, Kansas. Town (pop. 2,286), Nemaha County, northeastern Kansas, northwest of ATCHISON and northeast of MANHATTAN. Sabetha has been a leader in the manufacture of pre-cooked dog food machinery.

SABINE-NECHES WATERWAY. System of waterways at PORT ARTHUR, Texas, and part of the GULF INTRACOASTAL WATERWAY. The Sabine-Neches includes the ship canal at Port Arthur; the Sabine-Neches Canal which makes up the Neches river as far as BEAUMONT and the SABINE RIVER as far as Orange; and Sabine Pass, an outlet for the Sabine River stretching from Sabine Lake to the Gulf of Mexico.

SABINE PASS, BATTLE OF. Fought on September 8, 1863, between a small Confederate garrison from Fort Griffin and Union forces. The battle prevented an invasion of Texas by a Union force of four thousand troops in an attempt to cut the Confederate communication and supply lines between Texas and Louisiana. A statue of Lieutenant Dick Dowling, commander of the Confederate troops, stands near PORT ARTHUR, Texas, at the village of SABINE.

SABINE RIVER. Navigable river in eastern Texas which drains 9,733 square miles. It is formed in Hunt County in northeastern Texas northeast of DALLAS and flows southeast. The

Sabine forms the "S" section of the Louisiana-Texas border, continuing that boundary from Panola County, Texas to the Gulf. It empties into Sabine Lake and Sabine Pass on the way to the Gulf, ending its 575-mile course. Petroleum products are shipped through the SABINE-NECHES WATERWAY which is part of the GULF INTRACOASTAL WATERWAY. The river's name comes from the Spanish word *sabinas* meaning "red cedars." In the 1800s, a neutral strip of land on the Sabine between American and Spanish land claims became a haven for outlaws.

SABINE, Texas. Unincorporated village in Jefferson County, in the eastern part of the state near the Louisiana border. Founded in 1878 on the west bank of Sabine Pass, Sabine was the scene of a tragic hurricane in 1886 in which 150 people were drowned. Today the area is a fishing resort. Sabine National Forest is nearby.

SACRAMENTO MOUNTAINS. Range in southern New Mexico extending from Otero County north into Lincoln County and east into Eddy and Chaves counties. The range sometimes is said to include the Guadalupe Mountains. The Sacramento Mountains lie in the area between the RIO GRANDE and the PECOS rivers.

SACRAMENTO PEAK. Near Cloudcroft, New Mexico, site of the world's largest solar observatory.

SACRED HARP SINGING. Unusual music style developed and performed in the region around MARSHALL, Texas, where each note of the music is printed in a different shape, using a different scale from that traditionally annotated.

SACRIFICE CLIFF. A two hundred foot vertical rise near BILLINGS, Montana, from which over one hundred years ago CROW INDIANS afflicted with smallpox jumped to their death in an effort to appease their gods and stop the sickness in the tribe. Many bodies were tied to the trees on the top of the cliff, although Indian practice was usually to place only a few of the dead in any one burial ground.

SAGE. A small, thickly branched black or silver tree found over vast regions of the Southwest northward into Nebraska.

SAGE GROUSE. The largest bird of the extensive grouse family, often referred to as a "prairie chicken." It ranges in size from 25 to 30 inches and is sometimes known as cock of the plains. This bird is almost entirely dependent on the fruit, leaves and twigs of the SAGE.

SAINT JOHN'S COLLEGE. A branch of the famed St. John's College of Annapolis, Maryland, founded in 1696. Located in SANTA FE, New Mexico, St. John's offers only one curriculum: The Great Books Program. Established in 1964, the college is a four-year private liberal arts school accredited with the North Central Association of Colleges and Schools. A student body of 196 is instructed by a faculty of 35.

SAINT EDWARDS UNIVERSITY. Founded in 1885 at AUSTIN, Texas, by The Rev. Edward Sorin in the name of the Congregation of the Holy Cross. Father Sorin was also the founder of the famed Notre Dame University. The university is situated on a 180 acre campus south of the COLORADO RIVER on the slopes of what is believed to be an extinct volcano. It is noted for its year-long program of drama, which features very prominent performers. A student body of 2,500 is instructed by a faculty of 121.

SAKAKAWEA (Sacajawea or Sacagawea). (c.1784—1884?). Indian guide and interpreter. Captured by the Minnetaree Indians, Sakakawea was taken from her Shoshone home and sold to a MANDAN Indian. Later she was traded to Toussaint CHARBONNEAU and became one of his wives. Because Charbonneau was supposed to know the Rocky Mountain region through which the LEWIS AND CLARK EXPEDITION was traveling, he was hired as a guide for the party, and Sakakawea accompanied the group, the only woman making the journey. It soon became plain that Charbonneau was something of a fraud, a coward and not a very competent guide. It also soon was apparent that Sakakawea had all the character lacking in her husband. Her services as a guide proved invaluable, especially when she reached her home area in the upper Missouri River region and the high Rockies. Her service as an interpreter was perhaps even more vital. When she was not familiar with a local tribal language, she was especially skillful in the sign language which was so widely used for communication among unrelated tribes. Returning, she and Charbonneau left the party at the Mandan villages in South Dakota. Historians disagree on her later life and death. Some say that she died in 1812.

Near MOBRIDGE, South Dakota, a monument to her memory claims she is buried at Fort Manuel near the site. Another group claims that Sakakwea was buried near Fort Washakie in Wyoming among her own Shoshone people. The latter story contends that she died in 1884, which would have made her about 100 years old. In dispute also is the meaning of her name. Although generally translated as the "Bird Woman," some linguists believe this is incorrect. The form of her Indian name also has been disputed. Earlier reference works refer to her as Sacajawea or Sacagawea. However, the great North Dakota lake named in her honor bears the spelling of Sakakawea, which has led to most current references using that spelling.

SAKAKAWEA, Lake. Reservoir formed by the creation of the Garrison Dam on the MISSOURI RIVER in west central North Dakota, formerly known as Garrison Lake, for the dam which impounds it. Beginning in 1959, the impounded waters flooded most of the prime farmland and housing areas of the Indians living at the Fort Berthold Reservation. In the 1970s tourism facilities on the lake were established by the tribes.

SALINA, Kansas. City (pop. 41,843), Saline County, central Kansas, north of MC PHERSON and south of CONCORDIA. Major distribution and trade center for one of the greatest wheat producing areas in the world, Salina owes its beginnings to William Phillips, a special correspondent for the New York *Tribune*. When he left his job to move to Kansas, he opened a store on the Smoky Hill Trail. Phillips' work brought the Union Pacific to town in 1867, where it began carrying wheat to eastern markets within ten years. In later years a Salina resident, Dr. E.R. Switzer, introduced the cultivation of a second important crop, alfalfa. The closing of a nearby military base in the 1960s gave the town an opportunity to create a new municipal airport. The Brookville Hotel, west of Salina, is the oldest operating hotel in Kansas. Annual celebrations in Salina include the Smoky Hill River Festival, held in mid- June.

SALINA, Oklahoma. Town (pop. 1,115). Site in Oklahoma where prehistoric residents obtained salt by evaporating water, a process later carried on by Indians who used huge iron kettles.

SALINAS NATIONAL MONUMENT. Salinas takes its name from salt lakes that have been of great importance to this region. The park contains the ruins of three major pueblos, plus four large churches built by the Franciscan fathers. The area has been abandoned since 1670. Headquartered, Mountainair, New Mexico.

SALLISAW, Oklahoma. City (pop. 6,403), Sequoyah County, eastern Oklahoma, southeast of MUSKOGEE and north of Poteau. Sallisaw was the Oklahoma home of SEQUOYA (1770?-1843), the Cherokee genius who captured his tribe's language and established an alphabet. In Sallisaw he operated a salt spring to earn a living. Sallisaw is the home of Blue Ribbon Downs, Oklahoma's first pari-mutuel racetrack.

SALT. Salt is an important mineral in the Central West. The brine of salt springs and salt marshes, such as those in north central Kansas, has been evaporated since early prehistoric times. The salt deposits at HUTCHINSON, Kansas, are thought to be among the largest in the world. Hutchinson has become one of the major U.S. centers of salt mining and processing. The salt of the natural salt lakes of New Mexico has been exploited for centuries. In Oklahoma the salt at such places as Salina springs has also been important since prehistoric times, as have the salt fields near Auburn, Wyoming. The salt there is said to be 99.99 percent pure. Pioneer white settlers also found this salt invaluable. Texas is another state of the region possessing substantial salt resources.

SALT CREEK OIL FIELD. Considered one of the world's greatest light oil fields, discovered near Casper, Wyoming, in 1915.

SALT FORK RIVER. Stream in northwest Texas which unites with the Double Mountain Fork in Stonewall County to form the BRAZOS RIVER.

SALT RIVER RANGE. Mountains running north and south through Lincoln County east of Afton and west of Big Piney, bordering the Green River Basin in western Wyoming.

SALTER, Susan Madora. (Lamira, OH, Mar. 2, 1860—Wichita, KS, Mar. 17, 1961. Mayor. Susan Salter was the first woman to be elected to the post of mayor in the U.S. and is said to have been the first elected woman mayor anywhere in the world. When she was 12 she moved with her family to a farm near Silver

Lake, Kansas. After attending Kansas State Agricultural College at Manhattan in the late 1870s, she married Lewis Salter in 1800 and moved to ARGONIA, Kansas in 1882. In 1884 her father was mayor of Argonia and her husband city clerk. In 1886 Kansas voted to give women the vote in second and third-class cities, including Argonia. Led by Mrs. Salter, the women of the area organized a branch of the Women's Christian Temperance Union and nominated a slate of men for city office in the election of 1886. They felt the men they chose would by sympathetic to women's causes. As a joke, the men of the community responded by nominating Susanna Salter for mayor. However, the women reacted by backing Salter, who campaigned vigorously and won a two-thirds majority, although she modestly refused to vote for herself. National leaders of the women's movement congratulated her, and reporters descended on her from across the country. Articles about her appeared in such distant places as South Africa, Sweden and England. She served for a year, and her term received good reviews, but after the death of her infant son, she refused to run again for mayor. She lived to be 101 and received congratulations from President Dwight D. Eisenhower on her 100th birthday.

SAM RAYBURN RESERVOIR. Body of water lying at the center of several counties in eastern Texas. Approximately 60 miles long, it is an important water supply area formed by damming the Angelina River.

SAMAROFF, Olga. (San Antonio, TX, Aug. 8, 1882—New York, NY, May 17, 1948). Concert pianist and teacher. Samaroff (a name she "adopted" because it sounded more European than her own maiden name of Hickenlooper), made her concert debut in 1905, appearing with the New York Philharmonic at Carnegie Hall. She appeared with all the major American orchestras, and was once married to conductor Leopold Stokowski. Samaroff taught piano at the Juilliard Graduate School of Music from 1925 until her death.

SAN ANDRES MOUNTAINS. Range in New

The famed Texas mural, "Dawn at the Alamo" by H.A. McCardle, depicts an epic event at San Antonio, which has come to be considered one of the critical points not only in Texas history but also in the country as a whole.

View of San Antonio, Texas from the Tower of the Americas.

Mexico's Dona Ana and Socorro counties east of the RIO GRANDE.

SAN ANGELO, Texas. City (pop. 73,240), seat of Tom Green County, in the central part of the state. San Angelo, the "Sheep and Wool Capital of the country," is also a trading center for the livestock, oil, and farming region around it. Texas A&M Research and Extension Center and San Angelo State University are there. The town was settled in 1869 and incorporated in 1889.

SAN ANTONIO MISSIONS NATIONAL HISTORICAL PARK. Four Spanish frontier missions, part of a colonization system that stretched across the Spanish Southwest in the 17th, 18th and 19th centuries, are commemorated here. Included in the park is an irrigation system with related historic dam and aqueduct system. Headquartered SAN ANTONIO, Texas.

SAN ANTONIO RIVER. River rising east of SAN ANTONIO, Texas, and passing through the city before continuing through a rich farm and oil region. It flows southeast for 200 miles. The Medina River is a tributary of the San Antonio

in Bexar County as it flows southeast through Wilson, Goliad and Karnes counties. The San Antonio forms the boundary between Victoria and Refugio counties before it empties into San Antonio Bay. The banks of the narrow river within San Antonio have been developed with theaters, hotels, shops and restaurants to become one of the country's major tourist attractions.

SAN ANTONIO, SIEGE OF. Second significant military operation undertaken by the Texans in their revolt from Mexico. Begun soon after the Texans had repelled Mexicans who were attempting to reclaim a cannon at Gonzales, the siege dragged on because of superior Mexican strength. Colonel Ben Milam and three hundred volunteers stormed the city and under heavy artillery fire fought their way to the ALAMO where the artillery was located. Mexican General Perfecto de Cos surrendered in December, 1835, and the Texans lost only two men, one, their leader, Ben Milam.

SAN ANTONIO, TEXAS

Name: From Saint Anthony of Padua.

Nickname: The Cradle of Texas Liberty; The Alamo City; The City of Missions. The City of Contrast; When You See San Antonio You See Texas.

Area: 304.5 square miles

Elevation: 701 feet

Population:
1986: 914,350
Rank: 9th
Percent change (1980-1984): +16.3%
Density (city): 3,003 per sq. mi.
Metropolitan Population: 1,188,544 (1984)
Percent change (1980-1984): +10.9%

Race and Ethnic (1980):
White: 78.64%
Black: 7.34%
Hispanic origin: 421,808 persons (53.69%)
Indian:2,375 persons (0.23%)
Asian: 5,821 persons (0.65%)
Other: 98,368 persons

Age:
18 and under: 32.2%
65 and over: 9.5%

TV Stations: 8

Radio Stations: 26

Hospitals: 23

Sports Teams:
San Antonio Missions (baseball)
Spurs (basketball)

Further Information: San Antonio Chamber of Commerce, 602 East Commerce, P.O. Box 1628, San Antonio, TX 78296.

SAN ANTONIO, Texas. City (pop. 785,410), seat of Bexar County, in south central Texas. It is the state's third-largest city and is a military, agricultural, industrial, and educational center. A city rich in history, it was here in 1836 that the famous battle of the ALAMO took place, an event which marked the turning point in Texas' struggle for independence from Mexico.

The military has always had a prominent place in the economy of San Antonio. Today there are five air force bases and an army post nearby; 30,000 civilians are employed by the military. San Antonio is also a major cattle distribution point. It has been a cattle center since the late 1800s due to its location at the beginning of the famous CHISHOLM TRAIL. Once a city of few industries, today San Antonio's factories produce petroleum products, clothing, airplane parts, and oil field equipment.

The city was founded as a Spanish mission in 1718 and named by its Spanish settlers after their patron saint, Saint Anthony of Padua. The city grew rapidly, was incorporated in 1809, and in two decades had become the capital of the Spanish Empire's northern territories in the New World. When the Mexican revolt against Spain broke out in 1821, the city was the scene of numerous battles. Fifteen years later San Antonio was again a battlefield, this time between Mexico and Americans fighting for their independence. Mexican forces under General Antonio Lopez SANTA ANNA (1794-1876) confronted Texas troops at the Alamo, an ancient Spanish mission, and killed all the 181 Americans who were defending it. Texas forces took up the rallying cry "Remember the Alamo!" and in six short weeks soundly defeated the Mexican forces, and declared Texas a Republic. In later years San Antonio grew to become the largest city in the state, losing this status in 1930 when Houston and Dallas experienced dramatic increases in population.

With the arrival of additional military installations just before WORLD WAR II, San Antonio had a population growth of its own.

One of three large Spanish settlements prior to the Mexican Revolution of 1821, the city retains a great deal of its Mexican character and language. There is also a significant black population, as well as representation, but the Hispanic population is the largest, most rapidly growing and important of other minority groups.

Along with the Alamo, the city has many famous landmarks, including several other Franciscan missions incorporated in SAN ANTONIO MISSIONS NATIONAL HISTORICAL PARK. The most famous of these is Mission San Jose, a National Historic Landmark. La Villitia is a restored stretch of Mexican shops. Paseo del Rio, the river walk, has become one of the country's main tourist attractions, with hotels, restaurants, a river theater, and sightseeing on barges, which are converted to dining places for evening meals. San Antonio has its own symphony orchestra and opera company, and there are many museums, including the Marian Koogler McNay Art Museum and the White Museum. The city is also the home of the San Antonio Spurs, a professional basketball team.

The Alamo is open for visitors, who may see

the Alamo Cenotaph in the plaza, honoring the fallen Alamo heroes. HemisFair Plaza retains many reminders of the 1968 World's Fair, including the Tower of the Americas with its revolving restaurants, the unparalleled INSTITUTE OF TEXAN CULTURES, which makes history a fascinating adventure, and Texas Science Center. At Arneson River Theater, the stage is on one side of the river and the audience on the other.

Fiesta San Antonio annually celebrates Texas heroes with four major parades, sports, food and fun at more than 150 events throughout the city.

The city has 30 radio stations, several of which broadcast in Spanish, and there are four television stations and three newspapers.

San Antonio is the home of five institutions of higher learning: Our Lady of the Lake College, Trinity University, Saint Mary's University, Incarnate Word College, and the University of Texas at San Antonio.

SAN ELIZARIO, Texas. Unincorporated town in El Paso County, on the RIO GRANDE RIVER in southern Texas. Founded in 1772, it was the site of the Salt War in 1777, a confrontation between the town and a private citizen over ownership of nearby salt lakes. From 1850 to 1876, San Elizario was the seat of El Paso County. Once the seat was moved to Ysleta, San Elizario's importance declined.

SAN ILDEFONSO PUEBLO. Tewa-speaking village below the mouth of the Pojoaque River on the east bank of the RIO GRANDE in New Mexico. The Pueblo is known today particularly as a leader in pottery and art aided by the efforts of the Indian Arts Fund, the School of American Research, and for Kenneth Chapman, an expert in Indian design and ceramics. San Idelfonso has been home to such well known painters as Louis Gonzales, Abel Sanchez and Julian Martinez. Today San Ildefonso is perhaps best known for the work of one of the world's most distinguished potters Maria MARTINEZ, wife of Julian, well known makers of the famous black and red pottery. Ancestors of the modern residents were believed to live in the cliffs across the Rio Grande in the ruins of Tsankawi and Otowi until drought caused them to move. A mission and monastery were constructed in 1617 by Friar Cristobal de Salazar. The Indians of San Idefonso joined the Pueblo Revolt of 1680 and murdered the resident priest and his assistant. The Indians settled peacefully with the Spanish in 1692, but

The cenotaph, Alamo Battle Monument, San Antonio, Texas.

again rebelled in 1694. In that rebellion two priests were burned alive in the church when the Indians sealed all exits and set the building on fire. The beautiful chapel of 1696 was torn down, and a new chapel was erected between 1717 and 1722. This was destroyed before 1900 to make way for the present church. In 1858 the United States confirmed the San Ildefonso Pueblo Grant first made by Spain for 17,292 acres.

SAN JACINTO MEMORIAL MONUMENT AND MUSEUM. Raised at the site to commemorate the Battle of SAN JACINTO (April 21, 1836), the monument and museum are located in San Jacinto State Park. The towering shaft rises 570 feet, higher than the Washington Monument, with its top displaying a huge Lone Star of Texas, a mighty emblem weighing 220 tons. At the base of the monument stands the San Jacinto Museum of History, home of displays depicting the development of Texas from its discovery to the beginning of the Civil War.

SAN JACINTO, Battle of. War of Texas Independence engagement, which was a victory

for Texan Sam HOUSTON over Mexican General Santa Anna, on April 21, 1836, near the present site of HOUSTON, Texas.

After the fall of the ALAMO on March 6, 1836, Sam Houston (1793-1836), vastly outnumbered, commanded a controlled retreat from the Mexican force of General Antonio Lopez de SANTA ANNA (1794-1846). Houston's primary concern was gathering volunteers, and by the time he reached San Jacinto Creek his force had grown to 800 men. The original force of Mexican pursuers, however, numbered 900, and this was soon swollen by the arrival of 500 reinforcements. Nevertheless, on the morning of April 21 Houston launched a surprise attack against the superior Mexican force at San Jacinto Creek. In only twenty minutes of fighting, the Texans killed, wounded, or captured the entire Mexican army. Santa Anna, captured in the fighting, was forced to sign an armistice that eventually ended the war and granted Texas its independence.

SAN JACINTO RIVER. River rising in east central Texas, and running south into Galveston Bay. It is joined by Buffalo Bayou and it is at their confluence that the final battle of the Texas Revolution was fought in 1836. The river forms part of the Houston Ship Channel.

SAN JUAN DIVERSION PROJECT. Three large tunnels built through the CONTINENTAL DIVIDE to carry water from the San Juan River basin to the eastern side of the mountains where it is needed in the Albuquerque region.

SAN JUAN MOUNTAINS. Range running from south-central Colorado, southwest of ALAMOSA, into north-central New Mexico, near Cristobal. Peaks above 14,000 feet include Mt. Wilson, and Mt. Sneffels.

SAN JUAN RIVER. Important river in the development of the upper COLORADO. The San Juan River begins in Archuleta County in southern Colorado and flows southwest across the border of New Mexico, then bends west and northwest across southwestern Colorado into

Scene in the San Juan Mountains.

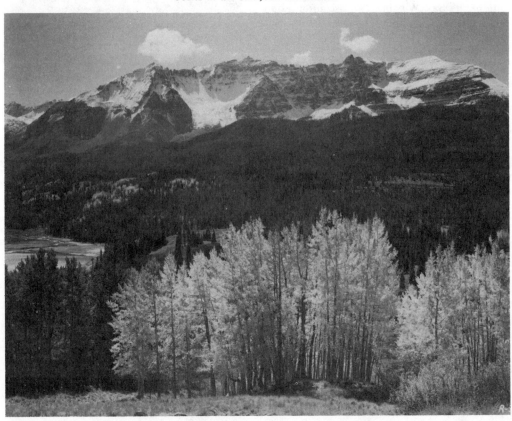

Utah. It empties into the Colorado River in San Juan County.

SAN LUIS VALLEY. Largest of the four great mountain PARKS in Colorado, the valley is separated from the rest of the state by the SAN JUAN, SANGRE DE CRISTO and SAWATCH mountains. Spanish interest in Colorado centered on the region where a few ranches operated along with gold miners, trappers and traders. It was there that Zebulon PIKE's (1779-1813) expedition was captured by the Spanish near present La Jara, Colorado. In 1852, under American control, the valley saw the construction of Fort Massachusetts which protected settlers until it was abandoned when the garrison moved to Fort Garland. Once the bed of an inland sea, San Luis Valley is level ground on which pea-fed hogs and potatoes are raised.

SAN LUIS, Colorado. Town (pop. 842), seat of Costilla County, south-central Colorado, southeast of ALAMOSA and northeast of Conejos. San Luis is the oldest continuously occupied non-Indian town in Colorado, founded in 1851 by settlers from Mexico, who sought greater opportunities in the U.S.

SAN MARCOS, Texas. City (pop. 23,420), seat of Hays County, in southeast central Texas. San Marcos' economy is primarily dependent on education and tourism, although there is some light manufacturing and cattle ranching. Southwest Texas State University, Aquarena Springs, and Wonder Cave are located there.

SAND PAINTING, NAVAJO. Religious and artistic ritual practiced by the NAVAJO who adopted the practice from the Pueblo Indians' meal paintings. Colored pigments and sands are used to create patterns of healing-harmony in private ceremonies seldom witnessed. Paintings are often destroyed in the belief this will remove the illness from the patient, who is brought to sit on the art work in the hope of cure.

SANDHILLS STATE PARK. Site covering 3,840 acres near Monahans, Texas, of sand dunes, reaching ninety feet in height, believed to date from the Trinity sandstone formation and collected by the Permian Sea.

SANDIA MOUNTAINS. Range of mountains near BERNALILLO, New Mexico, north of ALBUQUERQUE. A cave in these mountains yielded remains of an ancient band of prehistoric people now known as the SANDIA PEOPLE.

SANDIA PEOPLE. Name applied to a group of prehistoric people who once lived in the SANDIA MOUNTAINS nearly 25,000 years ago. Some anthropologists have claimed these people were the earliest humans ever discovered on the continent, but current evidence discounts this.

SANDIA PUEBLO. Village of Tigua-speaking Indians mear BERNALILLO, New Mexico. A mission and monastery established in the early seventeenth century by Father Estevan de Perea lies in ruins. The residents joined in the Pueblo Revolt of 1692, destroying the church and convent. Following the reconquest of the area by DE VARGAS, the Sandia Indians fled. In 1742 the Franciscan missionaries attempted to persuade them to return to their old home. Of the nearly three thousand who left, only 441 returned. The old grant to the Pueblo was renewed in 1748 by the Spanish and confirmed in 1858 by the Congress of the United States.

SANDOZ, Mari. (Sheridan County, NE—Sheridan County, NE, Mar. 10, 1966). Daughter of a Sandhills pioneer, Sandoz was awarded the Atlantic Monthly Prize of $5000 in 1935 for her nonfiction book *Old Jules* based on the life of her father.

SANDSTONE CREEK. Stream chosen for a pioneer conservation and flood control program, in Oklahoma, the first project in the United States to demonstrate the possibilities in relatively small upstream flood control and soil conservation projects without using mammoth dams. Beginning with the completion of the first site in February 1951, 25 major sites had been completed by November, 1952. Minor structural work continued through July, 1965. Upon its completion, the Oklahoma project protected sixty-five thousand acres.

SANGRE DE CRISTO RANGE. Range of the Rocky Mountains stretching from SANTA FE, New Mexico, to Chaffee County in central Colorado. The highest peak is Blanca Peak at 14,317 feet. The name was given by early Spanish clerics who noted the blood red color of the sunset reflected on the mountains and named them "Blood of Christ."

SANTA ANA PUEBLO. Site of the Church of Santa Ana de Alamillo, near present-day BERNALILLO, New Mexico, rebuilt by De Vargas in

1692 on the site of the mission church constructed about 1600 and destroyed in 1687.

SANTA ANNA, Antonio Lopez de. (1794—Mexico, 1876). Mexican statesman and military leader. In a period extending from 1833 to 1855, he became president and dictator of Mexico four times and was exiled three times. He is best known in the Central West region for his command of the troops that massacred Texas patriots at the ALAMO on March 6, 1836, and for his defeat one month later by General Sam Houston at the battle of SAN JACINTO, when he was captured by Houston. In the MEXICAN WAR, he was defeated again in 1847 by the United States Army under the command of Generals Winfield Scott and Zachary Taylor.

SANTA FE TRAIL. Early commercial route to the West beginning first at Franklin, Missouri, then at Independence, and later at Westport, now Kansas City. It followed the prairie divide between the tributaries of the ARKANSAS and KANSAS rivers to the great bend of the Arkansas, reaching almost to the mountains, where it turned south to Santa Fe on one of three trails: the shortest route ran from the present site of CIMARRON, Kansas, southwest across the Cimarron valley on the trail first used by William BECKNELL (1796-1865) in 1821; a middle route passed through RATON PASS; and the westernmost branch, the Taos Trail, crossed the SANGRE DE CRISTO RANGE at La Veta Pass. Before the coming of the railroads, the trail carried a vast quantity of goods between Santa Fe and the eastern U.S.

SANTA FE, NEW MEXICO

Name: From the Spanish La Villa Real de la Santa Fe de San Francisco (The Royal City of the Holy Faith of Saint Francis) in 1609 quickly shortened to Santa Fe "Holy Faith."

Nickname: The Ancient City; The Oldest and Quaintest City in the United States; The Center of Prehistoric, Historic and Scenic Interest.

Area: 36 square miles

Elevation: 6,950 feet

Population:
1986: 55,980
Rank: 400
Percent change (1980-1984): 13.9%

Density (city): 1,555 per sq. mi.
Metropolitan Population:100,482 (1984)
Percent change (1980-1984): +7.9%

Race and Ethnic (1980):
White: 82.98%
Black: 0.47%
Hispanic origin: 54.95%
Indian: 1.71%
Asian: 0.38%

Age:
17 and under: 28.9%
65 and over: 10.4%

TV Stations: 3

Radio Stations: 9

Hospitals: 2

Further Information: Convention and Visitors Bureau, P.O. Box 909, Santa Fe, NM 87504

SANTA FE, New Mexico. City, capital of New Mexico and seat of Santa Fe County. The oldest capital in the United States, it nestles in a valley in one of the country's most picturesque locations. To the east loom the SANGRE DE CRISTO Mountains, to the west the JEMEZ MOUNTAINS. The SANTA FE RIVER runs through the city. Situated in north central New Mexico, the capital lies in the heart of the Pueblo country, with historic Pueblo villages on all sides.

Renowned for its scenery, climate and as a seat of culture, the city was founded in 1610 by Don Pedro de Peralta and given the Spanish name meaning "holy faith." Its full name was La Villa Real de la Santa Fe de San Franciso. It was the first European settlement west of the Mississippi in what is now the United States. Peralta laid out the famed plaza and built the PALACE OF THE GOVERNORS.

The city's commerce is mainly based on government administration and tourism, with the addition of a concentration of shipping for Indian wares, minerals and farm products. From the beginning it was a trading center for Spanish and Indian products.

Santa Fe flourished for more than 50 years after its founding, and more than 34,000 Indians were "converted" by the Catholic missionaries, many of whom were taken into slavery and with others often treated worse than slaves. Then in 1680 the enormous cruelties of the Spanish to the Indians led To-pa-tu, governor

of the PICURIS PUEBLO to lead a revolt. He managed to unite the Indians, and in one of the few instances of its kind, one of the greatest Indian victories in the history of the hemisphere, they killed 400 Spanish and drove the invaders out. Santa Fe was held by the Pueblo peoples until 1692, when the Spanish returned in force under Diego Vargas.

Much of the subsequent history for 200 years involved the nearly constant harrasment of the Spanish and the Pueblos by the plains Indians, but the city's prosperous trade continued. It was greatly enhanced when Mexico freed itself from Spain in 1821. American goods began to flow over the famous SANTA FE TRAIL. The Spanish and Indian peoples had such longing for American goods that despite the terrible hardships of the trail many American merchants made small fortunes before the roads were improved and the railroads arrived to expand the commerce further.

Meanwhile, during the U.S war with Mexico Santa Fe was occupied by General S. W. KEARNY (1794-1848), and New Mexico became a U.S. province. During the CIVIL WAR the Battle of GLORIETTA, at the pass west of Santa Fe, Union forces saved the capital from Confederate rule.

From earliest time the city has been one of the leading U.S. centers of the Catholic faith, with several large and imposing churches, including Cristo Rey Church, largest adobe structure in the U.S.

The College of Santa Fe, St. Johns College and two Indian schools add educational significance to the community.

A number of events and circumstances have combined to make Santa Fe one of the world's leading cultural centers. Early in the 1900s artists began to discover the clear air, the peace and quiet of the area and especially the colorful nature of the landscape and the people with their costumes and ancient customs. Many of the young artists gained international recognition with their work there. Others of top reputation, such as Georgia O'Keefe, were attracted and made their homes there. Leading writers and musicians also followed their fellow artists lead and settled in the area.

The result has been an unparalleled concentration of the graphic and written arts. The art galleries of Santa Fe are sought out by collectors all over the world, and the proportion of galleries to population is unequalled anywhere.

World musicians also make their pilgrimage

The Gerald Cassidy painting depicts the "End of the Trail" at Santa Fe.

Santa Gertrudis - Sapulpa

to the city, seeking out the internationally famed SANTA FE OPERA, again unique for a community of such small size. Housed in a romantic semi-outdoor setting, the company has presented leading soloists, conductors and operas since its opening in 1955.

Everywhere in Santa Fe are the reminders of the Indian and Spanish past. The charming plaza, end of the Santa Fe trail, is dominated by the Palace of Governors, seat of government for 300 years and now an historical museum, with sidewalk vendors of Indian crafts selling their wares outside the historic structure. Many of the nearby art galleries feature works portraying the Indian culture and work of many famed Indian artists and sculptors.

The modern capitol is said to be the only one in the country to embody its area's territorial architecture. The oldest church in the country is the Church of San Miguel.

The Museum of Fine Arts features works of area artists. Other special points of interest include Loretto Chapel with its famed mysterious circular staircase, the Oldest House, the computer-controlled show called Footsteps Across New Mexico, the Museum of International Folk Art and the famed La Fonda Hotel. One of the nation's most popular annual festivals is also the oldest in continuous operation, the Fiesta of Santa Fe, celebrating the recapture of the city by the Spanish in 1692. Every historical and artistic aspect of the city is emphasized during this spectacle. Other festivals, especially featuring dancing, are held at several of the nearby Pueblos. One of the best known is the Fiesta of San Ildefonso with its Buffalo and Comanche dances.

SAN ILDEFONSO is particularly renowned for the work of one of the world's most highly regarded potters, Maria MARTINEZ.

Christmas Eve celebrations are recognized for the almost overwhelming displays of the lighted paper bags known as Farolitos.

Among the attractions within easy reach of Santa Fe is PECOS NATIONAL MONUMENT, including a Pueblo dwelling that once housed 2,000 persons, occupied for 500 years and only abandoned in 1838.

SANTA GERTRUDIS CATTLE. In the early 1900s, Robert Kleberg, Jr., of the King Ranch in south Texas succeeded in developing a breed of cattle from crossed strains of shorthorn cows and Brahman bulls. This has been one of the most successful of such developments, being widely used throughout the U.S., especially in the South. The crossing of the Brahman with European breeds of cattle has resulted in animals of greater vigor, with faster growth and reproductive rates. The breed also has been widely exported.

SANTA HELENA CANYON. In southern Texas, near MARATHON in the Mesa de Anguila, considered one of the most beautiful and hazardous gorges of the Grand Canyon of Santa Helena. The RIO GRANDE RIVER flows between limestone walls 1,500 to 1,800 feet high for a distance of approximately 15 miles. The area is rich in metals including silver and copper.

SANTEE INDIANS. Eastern division of the Dacotah. The Santee spoke the Dacotah dialect of the Dacotah language, a member of the Siouan language family. The tribal name comes from a word meaning "knife." In the 17th century the Santee lived in northern Minnesota. Descendants today can be found in Montana, Minnesota, and North and South Dakota in addition to several Canadian provinces.

SANTO DOMINGO PUEBLO. Indian village near BERNALILLO, New Mexico, whose residents have been well known for their annual Corn Dance on August 4th. Recognized as one of the notable summer ceremonies in New Mexico, the dance has hundreds of participants and thousands of observers.

SAPPHIRE. One of the two official gems of Montana is the sapphire, a blue transparent type of corundum, classified as one of the most valuable of gemstones. The North American variety, found mostly only in Montana, is known for its metallic luster. Important deposits are located in Rock Creek, Granite County, Yogo Gulch, Judith Basin County and Cottonwood Creek, Powell County. The stones are discovered in shafts of clay, called "pipes." As many as four years are required to separate the stones from the clay in which they are found. A majority of the stones recovered annually are used in better watches and meter bearings and for other mechanical purposes. The finest stones are shipped to France or Switzerland for cutting and polishing.

SAPPHIRE MOUNTAINS. Rocky Mountain range along the boundary between Ravalli and Granite counties in western Montana. The highest peak in the range is 8,995 feet high.

SAPULPA, Oklahoma. City (pop. 15,853), Creek County, northeastern Oklahoma, south-

west of TULSA and southeast of STILLWATER. Sapulpa is named for Jim Sapulpa, a Creek Indian from Alabama who farmed along Rock Creek in 1850. Oklahoma's first spectacularly productive oil field was discovered at Sapulpa in December, 1905, on land owned by a Creek Indian, Ida E. Glenn. Today the city is an industrial suburb of TULSA with glass, brick and oil-drilling companies as major employers.

SAWATCH MOUNTAINS. Range of the ROCKY MOUNTAINS in central Colorado. Mount ELBERT, at 14,433 feet, is its highest peak, and the highest in the Rockies between the Mexican and Canadian borders.

SCALAWAG. In the defeated South after the CIVIL WAR a scalawag was a collaborator with the North. The term was also used to mean a horse or man of no use for ranch work because of age or wildness.

SCALP LOCK. Narrow ridge of hair worn by PAWNEE warriors over the top of the head, while the rest of the head was shaved. This scalp lock was known as a pariki. Some form of the word pariki may have given the Pawnee their name.

SCISSOR-TAILED FLYCATCHER. This official bird of Oklahoma is a member of a very large family of birds extending over most of the world. The scissor-tailed flycatcher is distinguished by its long and deeply forked tail, from six to ten inches long. This enables the bird to do a wide variety of acrobatics as it swoops about catching insects. It is a gray bird with black wings and tail and reddish patches at the wing base.

SCOTTS BLUFF NATIONAL MONUMENT. Rising 800 feet above the valley floor, this massive promontory was a landmark on the OREGON TRAIL, associated with overland migration between 1843 and 1869 across the GREAT PLAINS, proclaimed December 12, 1919, headquartered Gering, Nebraska.

SCOTTSBLUFF, Nebraska. City (pop. 14,-156). In northwest Nebraska, on the NORTH PLATTE RIVER, near the Wyoming line. The bluffs of the site were named for fur trader Hiram Scott, who died nearby. Scott was given a kind of immortality by Washington Irving in his *Adventures of Captain Bonneville, U.S.A.* (1837). Irving tells how Scott became ill, and his companions thought he was dying. Because they had no way to take him out of the wilderness, they left him and went on. "On the ensuing summer," Irving writes, "the very individuals visiting these parts in company with others, came suddenly upon the bleached bones and grinning skill of a human skeleton, which, by certain signs they recognized for the remains of Scott. This was sixty long miles from the place where they had abandoned him, and it appeared that the wretched man had crawled that immense distance before death put an end to his miseries."

The city is a distribution point and market for a large irrigated area, crops of which are processed in canneries, beet sugar refineries, flour mills and meat packing plants. Fort Mitchell was established there in 1864, and the community grew from that point, not being incorporated, however, until 1900. To the south is SCOTTS BLUFF NATIONAL MONUMENT, a landmark on the OREGON TRAIL. Northwest lies AGATE FOSSIL BEDS NATIONAL MONUMENT. There is an annual hot air balloon rally in October.

SEAWATER CHEMICALS. An increasingly effective means of producing minerals by "mining" the sea. In the Central West commercial conversion of sea water into such minerals as magnesium and bromines has been pioneered in Freeport, Texas, by the Ethyl-Dow Chemical plant, one of Texas' largest manufacturers and now one of the major producers of chemicals from seawater.

SEMINOLE INDIANS. Combination of Oconee, Creek and Yamasee Indians from the southeastern part of the United States who fled to the Florida swamps. The name Seminole, meaning "wild" or "runaway," was used by 1775. When Florida was ceded by Spain to the United States in 1821, there were an estimated five thousand Seminole. In the 1970s there were an estimated six thousand with two-thirds living in Oklahoma. Seminoles were forced onto their first reservation as a result of the Treaty of Moultrie Creek in 1823. Whites continued to pour into the area and pressure built to remove all Indians to the West. In 1832, in a treaty signed at Payne's Landing, the Seminole were to be removed to lands in Oklahoma. Indian leaders Alligator, Arikepa, Wild Cat and the famous Osceola denounced the terms of the treaty and declared war. Osceola was captured while under a flag of truce and died in prison. The guerrilla war in the Everglades continued until 1842 when some 4,500 Seminole were forced west. A third war was conducted between 1855 and 1858. Another 123 were convinced to

leave Florida, while three hundred moved farther into the swamps where they continued to live a nomadic existence in villages not larger than that of an extended family. In the late 1970s the 4,000 Seminole living in Oklahoma held 35,443 acres of allotted land. The tribe held an additional 320 acres. Their headquarters was at Wewoka. Lost to the Oklahoma Seminole were many of the old crafts and skills maintained by the 2,000 Florida Seminole now living on four reservations.

SEMINOLE POOL. Oil discovery in 1926 at Seminole, Oklahoma, proved to be one of the richest in history.

SEQUOYAH (George Gist). (Tuskegee, TN, 1760s or 1770s—Mexico, 1843 or 1844). Cherokee scholar and teacher. Known worldwide for his invention of the Cherokee written syllabary and a system of mathematics—the only person in world history to accomplish such a feat. Sequoyah was the son of a Cherokee woman and a white or mixed blood trader. His English name was usually given as George Guess, although he was also called George Gist as he was apparently related to a white family by that name. Raised to become a silversmith or blacksmith, Sequoyah became interested in printing and writing about 1809 when he realized the power of the written word about which he then had no knowledge. Without any instruction, he spent twelve years experimenting with symbols to represent the Cherokee language. By 1821 he had developed a completed syllabary of eighty-six characters, each representing a syllable. The Eastern Cherokees endorsed the syllabary, and within months thousands had mastered the easy phonetic rendition of the language. Sequoyah traveled to Arkansas in 1822 to reach the Western Cherokees and followed them in 1828-1829 when they moved to Indian Territory, his home for the rest of his life. He died in Mexico while attempting to locate a band of Cherokee who, according to tribal legend, had migrated West in 1721. Due to his work the Cherokee nation became the only Indian group to have a constitution and body of laws written entirely in their own language. The Cherokee newspaper, printed in 1844, was the first to be published in present-day Oklahoma. Sequoyah's contributions to the Cherokees were recognized by the United States Government during his lifetime with a monetary reward. His own people granted him a pension and a medal. His name has been immortalized in the giant West Coast Sequoia

trees and on the bronze doors of the Library of Congress. His statue is displayed in Statuary Hall in the United States Capitol. Sequoyah's Cabin State Park in Oklahoma's Sequoyah County near Sallisaw preserves on its original site the cabin the famous Cherokee constructed in 1829 near a salt spring where he evaporated salt to earn a living.

SEQUOYAH, STATE OF. An attempt to make Indian Territory into a state of that name for Indians was unsuccessful. A meeting at MUSKOGEE in 1905, attended by the chiefs of many tribes, formed a constitution and completed plans for the Indian state to be named after the inventor of the Cherokee alphabet. The efforts ended when the Enabling Act of 1906 joined Indian Territory with Oklahoma Territory to create a united Oklahoma.

SEVAREID, (Arnold) Eric. (Velva, ND, Nov. 26, 1912—)Broadcast journalist. Known throughout his professional life as Eric Sevareid, he served as a correspondent with CBS News from 1939 to 1977. He gained his greatest fame as the commentator on TV's CBS Evening News (1964-1977). After leaving this post, he became a consultant for the network. He was the author of *Not So Wild a Dream* (1946) and This *Is Eric Sevareid* (1964.

SEVEN CITIES OF CIBOLA. One of the many fables of great wealth of the Americas. The greed for this wealth drove the Spanish conquistadores to mount huge expensive expeditions, endure fantastic hardships and suffer frustration and humiliation. Alvar Nunez Cabeza de Vaca had survived shipwreck in Florida in 1528 and Indian captivity and had made a tortuous way across much of Texas and New Mexico in his determined effort to return to Mexico City.

When he reached the Mexican capital in 1536, he and his three fellow survivors told about the Seven Cities of Cibola of which they heard much on their terrifying journey. These were said to be communities of culture, wealthy with gold and jewels. They also told of the similarly wealthy Gran Quivira.

Mexican Governor Antonio de Mendoza sent Fray Marcos de Niza to the north in 1538 to search for these rich cities. With him as guide was Estaban a free black survivor of the de Vaca party. De Niza reached a high point on which he could look down on Hawikuah, one of the seven cities of the ZUNI INDIANS of Cibola in present New Mexico. Charitably it might be

The tales of the wealth of the Seven Cities of Cibola inspired the spectacular expedition of Francisco de Coronado, making its burdensome way across the region and ending in equally spectacular failure. One great success was the discovery of the Grand Canyon of the Colorado River.

said that Father de Niza saw the golden sun reflecting on Hawikuah, and thought he had found great wealth.

In any event he hurried back to Mexico City with completely exaggerated tales of the seven cities. Wealthy Spaniard Francisco Vasquez de CORONADO (1510-1554) organized a huge expedition and set out across the RIO GRANDE in search of the fabulous cities (1540-1542). He crossed much of the Central West region as far as portions of Kansas. Of course, he found only the unimposing villages of the various tribes of the region he passed and returned empty handed and disgraced. He and his great expedition had passed over and around the many hidden riches of the region, leaving them for future generations to discover.

SEVENTH UNITED STATES CAVALRY. Regiment organized by Lt. Colonel George Armstrong CUSTER (1839-1876) at FORT RILEY, Kansas, in 1866 which later headquartered at FORT HAYS, Kansas. The regimental history provides perhaps the best known example of the many such units which were sent into the

region to reduce the Indians and provide protection for the travelers and settlers.

The 7th participated in General Winfield Scott Hancock's 1867 campaign, principally against the Cheyenne, and arrived at Fort Wallace, Kansas, in July to find the garrison exhausted. After relieving the Garrison, Custer and a contingent of the 7th rode to Fort Harker for supplies. He then proceeded on to Fort Riley to visit his wife, an action which led to his court-martial and suspension for a year. At Fort Wallace men of the 7th erected a stone monument in memory of ten members of the regiment who had died in in the skirmishes under Scott's command.

In 1868 Custer and the 7th were part of General Sheridan's winter campaign against the Plains Indians. On November 27, Custer and the regiment found an Indian camp along the WASHITA RIVER in Oklahoma and at dawn attacked the sleeping Cheyenne led by Chief Black Kettle. Black Kettle and one hundred Cheyenne were killed, a victory which helped to demoralize the Plains Indians who fled to the Staked Plains and other remote areas.

Between 1873 and 1876 the regiment was

stationed at FORT ABRAHAM LINCOLN near BISMARCK, North Dakota. The fort was under Custer's command during that period. In mid 1876, units of the Seventh set out from the fort under the overall command of Brigadier General Alfred H. Terry. Approaching the Bighorn Mountains from the east, Terry sent a column under Custer to swing south to flank an Indian encampment near the BIGHORN RIVER. Custer ignored Terry's order to wait for reinforcements and met a much larger force than he expected. On the morning of June 25th he launched a surprise attack. The destruction of the battalion of the Seventh and its leader was complete in what has come to be known as the Battle of LITTLE BIGHORN. The uncertain circumstances and events of that struggle and the fame of its leader have made it a U.S. military epic.

Units of the 7th participated in the disarming of the Hunkpapa Sioux at the Standing Rock Reservation in September, 1876. The 7th was headquartered at FORT MEADE, South Dakota, between 1879 to 1887. It took part in the November 20, 1890, operation at the Pine Ridge and Rosebud Reservation when participants in the Ghost Dance were confronted by the largest concentration of troops assembled anywhere in the United States between the CIVIL WAR and the Spanish-American War. The Indians at Rosebud became involved in what has been described as "indiscriminate firing," probably from both sides. This led to a massive attack by the army, in what has become known as the Massacre at WOUNDED KNEE, in which Ghost Dance leader Yellow Bird and his son were slaughtered and 146 other Indians killed. This encounter has become known as the last major conflict between U.S. troops and the INDIANS.

The Little Big Horn is quiet now.

Commanded by Colonel James W. Forsyth, the 7th participated in the Battle of WOUNDED KNEE in 1890.

SEVENTYNINE, Montana. Village in south-central Montana settled originally by immigrants from Odessa, Russia, in 1912. Seventynine, near Ryegate, was named for a ranch called the 79 started in 1879 by John T. Murphy, president of the Montana Cattle Company. The 79 Ranch was one of the largest ranches in Montana until it was broken up in 1912.

SHALAKO CEREMONY. Spectacular ceremonial close of the year and dedication of new houses for the ZUNI INDIANS of New Mexico. According to legends the Shalako, giant messengers of the rain gods, were received at sundown and guided to the new houses where they were entertained through the night with ceremonial dancing and feasting. The messengers left the following night. Today the Shalako send their messengers, the dancers, who wear impressive masks. Preparations for the dance require forty-nine days. From the departure of the Shalako until the end of the winter solstice visitors are not permitted to the series of Zuni ceremonies.

SHALE. Shale is a sedimentary rock consolidating mud or clay, with the property of splitting into thin layers. Estimates place shale as comprising 55 percent of all sedimentary rocks. It varies widely in composition from volcanic ash and alumina to coal and oil shales. The latter is expected at some time to become the world's principal source of oil. The shale beds of Colorado, alone, are thought to contain five times the oil of the present petroleum reserves of the entire world. The difficulty has been the cost of separating the oil from the shale. During the petroleum crunch of the 1970s, research and actual processing were funded to bring shale oil into practical production, and considerable progress was made. However, with the easing of the crisis, the efforts diminished. Experts expect, however, that with new demands for oil and new methods of processing the shale, the vast supplies in Colorado, and other states will provide oil resources for the U.S. far into the future.

SHAWNEE INDIANS. Algonquian tribe which led Indian resistance to white expansion into the Ohio Valley in the early 19th century. Between 1825 and 1831 the Shawnee were moved to a Kansas reservation. About 1845 the

Shawnee living in Arkansas, Texas, Kansas and Louisiana gathered in Oklahoma on the CANADIAN RIVER where they became known as the Absentee Shawnee. A group of Shawnee who had lived with the Seneca in Ohio in 1867 migrated to Ottawa County, Oklahoma, where they were called the Eastern Shawnee. The Shawnee were incorporated with the Cherokee in 1869. Today the estimated two thousand Shawnee living in Oklahoma are mostly assimilated with their neighbors, Indian and white.

SHAWNEE, Oklahoma. City (pop. 26,506), Pottawatomie County, central Oklahoma, southeast of OKLAHOMA CITY and southwest of HENRYETTA. Shawnee was the birthplace of astronaut Leroy Gordon Cooper (1927-), commander of the Mercury capsule *Faith 7* which was launched on May 15, 1963. Cooper's capsule had to be piloted back to earth manually when the automatic controls malfunctioned. For his courageous flight President John F. Kennedy awarded the astronaut the Distinguished Service Medal and referred to Cooper's accomplishment as "one of the victories of the human spirit." In its early days Shawnee was one of many Oklahoma towns settled in hours when the Indian Territory was opened for white settlement. A bustling railroad center, Shawnee aspired to become the capital of Oklahoma in 1910, a bid it lost to Oklahoma City. Oil was discovered near Shawnee in 1926 and has remained a major industry along with electronics, aircraft parts, and clothing.

SHEEP, TAILLESS. Breed of sheep developed in the 1920s by Professor James WILSON at South Dakota State College. The absence of the tail produced a more manageable animal.

SHEEPEATER INDIANS. One group of SHOSHONE who lived in Wyoming in the 1880s, named for their practice in primitive times of hunting mountain sheep with flint-pointed arrows, by first surrounding them on a crag thus preventing their escape.

SHEEP IN THE CENTRAL WEST. Animal as necessary as cattle to many local economies in the Central West. The Central West states account for about 55% of all sheep and lambs raised in the United States. About 31% of the sheep and lambs in the Central West are grazed in Texas.

	Number of sheep	Value of Product
Texas	1,810,000	$57,900,000
Colorado	690,000	$27,400,000
South Dakota	639,000	$29,700,000
Wyoming	860,000	$15,100,000
Montana	515,000	$17,200,000
New Mexico	538,000	$9,500,000
Kansas	245,000	$9,700,000

North Dakota	215,000	$ 7,600,000
Nebraska	165,000	$ 6,500,000
Oklahoma	85,000	$ 2,400,000

SHEEP WAGON. Perhaps the original of the modern house trailer, sheepwagons were the mobile homes-on-wheels for shepherds throughout the American West.

SHEEPHERDERS' MONUMENTS. Tall shafts of piled up stone, six to ten feet high, created by sheepherders to pass the long, lonely hours while tending their flocks. Many have been found around Hanna, Wyoming.

SHELBY, JOSEPH ORVILLE. (Lexington, KY, Dec. 12, 1830—Adrian, MO, Feb. 13, 1897). Military officer. At the close of the CIVIL WAR, Shelby commanded a group of unsurrendered confederate troops which crossed into Mexico on July 4, 1865. In mid-stream the troops dramatically lowered the confederate flag into the river and then crossed to the other side. The troops voted to support Emperor Maxmillian of Mexico who gave Shelby land on which a colony named Charlotta was established in 1866. Shelby returned to the U.S. about 1885 and was appointed a U.S. marshal for the western district of Missouri by President Grover Cleveland.

SHELBY, MONTANA. Town (pop. 3,142), seat of Toole County, north-central Montana, southeast of Cut Bank and northwest of GREAT FALLS. Shelby was the scene of a heavyweight title fight between Jack DEMPSEY (1895-1983) and Tommy Gibbons on July 4, 1923. For years the town has been a distribution point for the surrounding area. Although on the tracks of the Great Northern Railroad, the community has no stockyards, depending on nearby Galata for that function.

SHELDON, Charles Monroe. (Wellsville, NY, 1857—1946). Author, clergyman. After ordination in Congregational ministry in 1886, he took a pastorate in Waterbury, Vermont, from 1886 to 1888, then moved to TOPEKA, Kansas as minister of the Central Congregational Church. Preaching there for twenty-two years, he became noted for his evening sermon series about a modern man who tried to live his life as he thought Christ might have done. He developed this sermon series into a book which has been called "the best-selling novel of all time." This was *In His Steps* (1896, dramatized in 1923). During sheldon's lifetime about 30,-000,000 copies of the book were sold, and it continues to be a best-seller, with translations in over 40 languages. His subsequent books never achieved similar fame. In 1920 he became the editor of the *Christian Herald* in New York City.

SHELTER BELTS. Line of shrubs or trees planted to retain soil moisture and prevent wind erosion. The prairie states forestry project, also known as the shelter belt project, was begun by the U.S. government in 1934. Established under the forest service, the project was to develop wind barriers on farms in the central west which had suffered from dust storms and erosion. Transferred to the soil conservation service in 1942, the program planted nearly 220,000,000 trees on more than thirty thousand farms in Nebraska, North and South Dakota, Texas, Wyoming and Kansas. The plantings have been credited with great success in retaining the soil and offsetting wind erosion.

SHEPPARD, Morris. (Wheatville, TX, May 28, 1875—Washington, DC, Apr. 9, 1941). Politician. Educated at the University of TEXAS and Yale, Sheppard was a lawyer before becoming a Democratic U.S. representative from Texas (1902-1913). He was elected to the U.S. Senate in 1913 and served until his death. Sheppard introduced the law that later became the 18th amendment (liquor prohibition).

SHERIDAN, Wyoming. City (pop 15,146). Seat of Sheridan County, largest city in northern Wyoming, named for General Philip SHERIDAN (1831-1888) of CIVIL WAR fame. A favorite hunting ground of the Indians, it was not settled by whites until 1882, when the CROW, CHEYENNE and SIOUX were vanquished after a long period of warfare. the founder of Sheridan, J.D. Loucks, wrote this interesting account: "The grass was beginning to show green and over across Little Goose Creek was a herd of buffalo...a small herd of deer was browsing, and as I sat there I was fired with the idea that here was the spot for our city. I went home and cooked my supper. After I had eaten, I took a sheet of brown wrapping paper and, by the light of a candle, I marked off 40 acres and laid out a town with streets named after the few settlers. Over the top of the map I wrote 'Sheridan' in big letters." The rich prairie grasses attracted ranchers, who were troubled for years by rustlers and boundary disputes. Diversified agriculture and shipment of ranch animals predominate today, but coal mining is also impor-

tant. In 1904 nearby Wolf Creek Canyon witnessed the founding of the very first DUDE RANCH anywhere. The "dudes" have found the region fascinating ever since, as other dude ranches followed the early example. The nearby Big Horn range attracts still more visitors to enjoy the big game hunting and great fishing found there, also adding to Sheridan's tourist business. One of the outstanding museums of the area is Bradford Brinton Memorial Ranch Museum. The twenty-room mansion is replete with over 600 paintings by American artists, including REMINGTON and RUSSELL. Ranch equipment and Indian artifacts also are shown there. Annual events include Drums Along the Bighorns (a drum and bugle corps competition), the Blue Grass Festival and Sun Days Festival. Polo matches are held on sundays during the summer.

SHERMAN, William Tecumseh. (Lancaster, OH, Feb. 8, 1820—New York, NY, Feb. 14, 1891). Army officer. Renowned for his march through Georgia and other leading campaigns during the CIVIL WAR, the great general is not so well known for his campaigns in the Central West. In 1866 Sherman was placed in command of the Division of the Mississippi, with undetermined jurisdiction to the West. In that post he was responsible for restraining the Indians and developing the region. He promoted the construction of the transcontinental railroad and was on hand in 1865 with twenty other distinguished guests to ride a flatcar as the first passengers on the first tracks laid between OMAHA and Salings' Grove, Nebraska. In 1866, with Kit CARSON (1809-1868) in Colorado, Sherman gained concessions from the UTE INDIANS, which kept much of Colorado peaceful even during the Ute uprising of 1879 in western Colorado. He had Kiowa chiefs Satanta, Big Tree and Satank arrested at Fort Sill, Oklahoma, in 1871 after their warriors had wiped out a wagon train near Jacksboro, Texas, a fate Sherman narrowly missed while inspecting forts in the area. Satank attempted to escape and was killed. In 1869, Sherman was given command of the entire U.S. army. In that capacity he ordered the aggressive campaigns of the 1870s against the Kiowas and Comanches.

SHERMAN SILVER PURCHASING ACT. Law enacted in 1890 of special interest to the silver producers of the Central West, which provided that the United States Treasury would purchase 4,500,000 ounces of silver each month at the prevailing price with treasury notes redeemable in gold. Supporters of the act included debtors, farmers and silver miners who did not wish to see the price of silver decline. The act did not achieve its aim, and the government's stocks of gold continued to decline as treasury certificates were redeemed. Congress repealed the act in 1893.

SHEYENNE RIVER. North Dakota river which rises in Sheridan County before flowing east, then south, and then east again into the RED RIVER OF THE NORTH above FARGO.

SHIPROCK. Basalt core of an extinct volcano rising nearly 1,700 feet above the desert southwest of Shiprock, New Mexico. Navajo legend claims that the tribe once used the summit of the peak for protection from the Utes, with the story that the mountain developed wings that carried the Navajo to safety. Another legend claims that a slayer of monsters was rescued from the summit by a spider woman.

SHOSHONE CANYON. The only pass through the enormous sedimentary and volcanic rocks walling YELLOWSTONE NATIONAL PARK on the east.

SHOSHONE INDIANS. Various bands of Shoshone were known as "Snake," but they referred to themselves as Nomo, or "people." They lived as independent bands which came together for celebrations, hunts and councils. Their principal areas in the region were southwestern Montana and northwestern Wyoming. The bands were led by a principal chief and several minor chiefs. The economy of the Northern Shoshone depended on fishing, gathering of wild supplies and annual buffalo hunts. Summers were spent along the tributaries of the Columbia River. Some of the Shoshone used poison-tipped arrows. Obsidian was used for arrowheads and knives. Warriors carried shields of heat-toughened bull buffalo neck skin. The Shoshone and Bannock fought unsuccessfully to halt the wagon trains which destroyed the pasture land along the rivers and frightened the game. The tribes were placed on Fort Hall Reservation in southwestern Idaho. In the late 1970s about 900 Shoshone and Paiute lived on or near the 293,000 acre reservation. In the 1970s an estimated three thousand Shoshone lived on or near the Wind River Reservation in west-central Wyoming.

SHOSHONE LAKE. A source of the SNAKE RIVER lying in YELLOWSTONE NATIONAL PARK in northwest Wyoming. The lake is approximately twelve miles long and eight miles wide.

SHOSHONI, Wyoming. Town (pop. 879), Fremont County, central Wyoming, northeast of RIVERTON and southeast of THERMOPOLIS. Established in 1905 when the Shoshone Reservation was opened for settlement, Shoshoni's general store operator often piled everything from bacon to dynamite outside the cramped store inside a sixteen-foot stockade to protect food items from bears. Indian pictographs found on the C.F. Andrews ranch near Shoshoni appear to represent men in striped or slashed clothing suggesting early Spanish explorers. One picture, either a snake or the letter "s" in combination with another symbol, is believed to be a direction left by the Spanish to a treasure they buried in the area when pursued by Indians.

SHRIMP. Several species of decapod (ten-legged) marine crustaceans prized as food and an important economic resource in Texas the only Gulf state in this region. Annual catch can reach $100,000,000 in value. Shrimp live near the shore on muddy or sandy bottoms and can be netted in large numbers.

SHRINE TO THE SUN. Unique structure built of Colorado pink marble by wealthy Colorado developer Spencer PENROSE on CHEYENNE MOUNTAIN, near COLORADO SPRINGS, Colorado. Originally designed as Penrose's own monument, the shrine was dedicated by Penrose to the memory of his friend Will ROGERS (1879-1935) after the famous humorist died in an airplane crash.

SHUMAN INDIANS. Tribe of undetermined linguistic stock that lived along the RIO GRANDE RIVER near EL PASO, Texas. A western division of the Shuman are referred to as the Suma. Missionary efforts among them began in the 1620s, but because of their constant migration and their raiding of other Indian tribes, their numbers declined and they are thought to have been finally destroyed by the APACHE.

SHUMLA CAVE SHELTERS. Near LANGTRY in southwest Texas in Val Verde County, located in the steep walls of a canyon of the RIO GRANDE, once sheltered prehistoric man now known as the West Texas Cave Dwellers. In 1933 a team of archaeologists from the Witte Memorial Museum of San Antonio excavated caves revealing the culture of these people who used the rabbit stick, a wooden club manipulated like the Australian boomerang. Among the artifacts found were deep rock carvings, now

almost inaccessible, covering nearly an acre of the limestone surfaces in this area.

SIDEOATS GRAMMA. This intriguingly named grass is the official state grass of Texas. It is one of the vast family of grasses which number oats, corn, sorghum and barley among the members.

SIDNEY, Nebraska. City (pop. 6,010), seat of Cheyenne County, southwestern Nebraska panhandle, southeast of Kimball and west of NORTH PLATTE. Sidney developed around Fort Sidney and grew rapidly as the main railroad connection for the overland route to the BLACK HILLS gold fields. The community was named for Sidney Dillon, a New York attorney for the Union Pacific Railroad. Gold miners bought their supplies in Sidney and the dance halls, gambling houses and saloons never closed their doors. During the 1876-1877 gold rush, as many as 1,500 people passed through Sidney daily. Legends persist that the Union Pacific encouraged passengers not to get off the train at Sidney if they wanted to remain alive. Today Sidney is the business center for one of Nebraska's largest wheat-producing counties. Links to the rough-and-tumble past include the Fort Sidney Post Commander's Home which has been restored and furnished with period furniture. The Cheyenne County Museum exhibits pioneer, Indian and military artifacts.

SIERRA BLANCO MOUNTAINS. Range in south central New Mexico centered in southern Lincoln and northern Otero counties.

SIERRA DE ORO. New Mexico's "Mountain of Gold," the first lode of gold located and worked west of the Mississippi within the boundaries of the present-day United States.

SIERRA MADRE MOUNTAINS. Range in southern Wyoming and northern Colorado which comprises part of the Continental Divide.

SILK INDUSTRY. Of the serveral unsuccessful attempts to establish the silk industry in the U.S., only one was tried in the Central West. Silkville, a town established near present-day OTTAWA, Kansas, in the mid-1800s was the site chosen by Ernest Boissiere, who attempted to produce silk with the assistance of experts in silk brought to the U.S. from France. Problems with growing of mulberry

trees, on which the silkworms depended for food, and the cost of labor doomed this project as with so many others in the U.S.

SILVER BOW CREEK. Site where mining began in the region of BUTTE, Montana, in 1864 when William Allison and G.O. Humphrey discovered placer gold.

SILVER DOLLAR SALOON. Famous DENVER, Colorado, landmark at 1649 Lawrence Street where H.A.W. TABOR supposedly donated three thousand silver dollars to be embedded in the tile floor.

SILVER GATE, Montana. Small Alpine-like village in Park County at the northeast entrance to YELLOWSTONE NATIONAL PARK, said to be the only community in which building codes specify that all buildings be made of materials native to the area.

SILVER HEELS. Name given a dance hall girl popular in the mid 1870s in the mining camp of Alma, Colorado. She was given a pair of solid silver heels for her dancing slippers by a young miner. The young girl refused to flee the camp during a smallpox epidemic and nursed many of the miners back to health, and then she dropped out of sight. Years later a veiled, well-dressed woman visited the town's cemetery and the graves of those who had died during the epidemic. Repeated visits led to the legend that the veiled lady was Silver Heels, her beauty destroyed by the smallpox marks.

SILVER RUN PEAK. Second tallest Montana mountain peak at 12,610 feet. Silver Run Peak is located in Carbon County in southern Montana.

SILVER. Silver is found in commercial quantities in the Central West region in Texas, Montana, New Mexico and Colorado, and its production was very important in the early development of those states. However silver is not listed currently as being one of the principal minerals of any of the states of the Central West. Silver is also produced as a by-product of lead mining and some other minerals, found in most states of the region.

SILVERTON, Colorado. Town (pop. 794), seat of San Juan County, southwestern Colorado, northeast of DURANGO and southeast of Montrose. The last narrow-gauge passenger railroad in the United States operates between Silverton and Durango over a spectacular mountain route. Silverton, originally called Baker's Park, for Captain Charles Baker, the first prospector in the area, earned its name for the reputed tons of silver ore mined nearby. Silverton's rip-roaring miners caused panic among the peaceful citizens of the community who hired gunfighter and lawman Bat MASTERSON (1853-1921)to restore order.

SINCLAIR, Harry F. (Wheeling, WV, July 6, 1876—Pasadena, CA, November 10, 1956). Petroleum producer and refiner. Sinclair, educated in Independence, Kansas, entered the University of KANSAS school of pharmacy in 1897. Upon graduation he entered the drug business with his father, but by 1901 had become a principal participant in the oil business as president of the Sinclair Oil and Refining Corporation and the Sinclair Gulf Corporation. He held office in both until September 22, 1919, when they were combined as the Sinclair Consolidated Oil Corporation of which he was again president. Sinclair received a jail sentence of six and one-half months for jury tampering and perjury to Congress in the aftermath of the scandal known as TEAPOT DOME during the administration of President Warren G. Harding. He had earlier been acquitted of complicity in the scandal itself.

SIOUX FALLS, South Dakota. City (pop. 81,343), seat of Minnehaha County, situated in southeast South Dakota at the falls of the BIG SIOUX RIVER, the city's name is derived from the SIOUX INDIANS.

The city thrives today on diversified industry and as a farming and commercial center. Lately, due to new banking laws, a number of very large banks have established operations there, including the substantial investment of Citibank, the nation's largest. Center of cattle shipment from a three state area, the city has packing houses, and processes other agricultural products, There are other manufacturers, for which the falls supply some of the power, and sandstone, called Sioux Falls granite, is quarried in the area.

Another boost to the economy came with the Earth Resources Observation System (EROS), set up by the federal government, which houses the millions of satellite photos and does research on land development and management.

Joseph NICOLET (1786-1843) described the falls in 1839, and by 1858 there were about 30 residents. Indian troubles caused the settlement to be abandoned in 1862, but white

Sioux leader Sitting Bull, 1890.

TING BULL (1830?-1890). Calling themselves the Dacotah, meaning "allies," the Sioux had many subdivisions. The TETON SIOUX were buffalo hunters west of the MISSOURI RIVER. Yankton Sioux lived in the eastern parts of North and South Dakota. The SANTEE Sioux lived in present-day Minnesota. White migration into the plains led to a Santee Sioux rebellion in 1862 after which they fled westward. The Teton Sioux agreed to live on reservations in 1868, but rebelled in 1876 when they were forced to farm on poor land. Troops forced them back to the reservations, but not before the disasterous defeat of the military under General George Armstrong CUSTER (1839-1876) at the Battle of LITTLE BIG HORN (June 25, 1976). The Ghost Dance cult of the 1890s gave false hope to the Sioux. This dance was the central ritual of the religion instituted by an Indian named WOVOKA. He had prophesied that the white intruders would be pushed by miraculous means, and if they wore the ghost shirts, they would be invulnerable to gunfire. The cult spread rapidly throughout the region, but Indian attempts to carry out the promise of pushing back the white only led to further military suppression. The followers of Sitting Bull were dispersed, and the massacre of the Sioux at the Battle of WOUNDED KNEE ended the formal attempts of the Sioux to conquer the government forces. Most Sioux today live on reservations and work as cattle ranchers or farmers. A dispute over tribal leadership among OGALLALA SIOUX on the Pine Ridge Reservation in South Dakota led to the Indians seizing the village of Wounded Knee for seventy-one days in 1973. In 1980 the eight Sioux tribes received $122,500,000 from the federal government as a result of the Supreme Court decision awarding damages for lands illegally seized in 1877.

SISSETON, South Dakota. Town (pop. 2,-789), Roberts County, northeastern South Dakota, northeast of ABERDEEN and northwest of MILBANK. Sisseton is the site of some of South Dakota's better-known Indian mounds.

SITTING BULL. (Grand River, SD, 1834—Grand River, SD, Dec. 15, 1890). Sioux medicine man. Sitting Bull became the leader of a war council of the Sioux Confederacy by 1875. He took no part in the actual fighting at the Battle of the LITTLE BIG HORN in 1876, although he participated in the planning. Later he fled to Canada where he remained with his followers from 1876 to 1881. Sitting Bull took an active role in the Messiah craze of 1890 and

settlers came back after Fort Dakota was installed in 1865. It was incorporated as a village in 1877 and as a city in 1883.

The city is the site of Augustana College and Sioux Falls College, where visitors may view Indian and Oriental collections

The unified museum system, Siouxland Heritage Museums, features the collections of Pettigrew Home and Museum and old Courthouse Museum.

The Unique USS *South Dakota* Battleship Museum, occupies the same area and shape as the original warship, and its outline is delineated by actual stanchions from the ship. There are also many of the battleship's mementoes.

Buffalo Ridge is a boom town replica.

Annual events include the Sioux Empire Farm Show in late January and early February and the Sioux Empire Fair in late August. Augustana College sponsors the Nordland Fest in late June.

SIOUX INDIANS. Indian nation of many tribes of the northern plains of the Central West, famous for their bravery and fighting ability when led by such men as CRAZY HORSE (1842?-1877), RED CLOUD (1822-1909), and SIT-

was known as an enemy of white rule and Indian settlement on reservations. He was arrested by Indian police and shot when resisting arrest. When Sitting Bull's horse heard the shots he thought they signalled the beginning of a routine he had performed when Sitting Bull was a member of Buffalo Bill's Wild West Show. His strange "dance" struck terror in the hearts of almost everyone who saw it.

SITTING BULL PARK. Burial site of the famous Sioux medicine man near MOBRIDGE, South Dakota. Sitting Bull was killed there in 1890 while resisting arrest by Indian police working for the federal government. His body was buried at Fort Yates, North Dakota, before it was moved back to Mobridge in 1953. Near the Sitting Bull marker is another marker commemorating SAKAKAWEA (1787?-1812?), the Shoshone woman who served as an expert guide for the LEWIS AND CLARK EXPEDITION.

SIX FLAGS OVER TEXAS. Mammoth entertainment park with over one hundred rides, shows and attractions covering 205-acres at Arlington-Grand Prairie, Texas. Texas history is presented with a separate section of the park devoted to each of the six flags which once flew over the land.

SLAB-HOUSE CULTURE. Prehistoric group of people who lived in the Oklahoma panhandle. Unique to this group was the construction of their homes, dugouts lined with flat stones. The roofs of the dwellings were made of thatch supported with beams.

SLIM BUTTES. Renowned source of fossils in South Dakota. Located in southwestern Shannon County northwest of Pine Ridge, South Dakota, the buttes are also the site of one of the three major conflicts fought in the state between whites and Indians. The Battle of Slim Buttes was fought between Indian forces under CRAZY HORSE (1829-1890) and troops commanded by General George CROOK (1829-1890) on September 9, 1876. The result of the fighting was a statemate, but the Indians withdrew allowing Crook to burn their village.

SLOPE, THE. Land lying in North Dakota south and west of the MISSOURI RIVER in an area, marked by V-shaped valleys, buttes and hills, known properly as the Missouri Plateau.

SMALLPOX EPIDEMIC. Because American Indians had never suffered a number of diseases common among Europeans, the native peoples had no immunity to such killers as smallpox. When an infected person, or even an object, came in contact with persons of an Indian village, an epidemic was almost certain to follow. One of the country's worst epidemics occurred in 1837 when smallpox ravaged Indian settlements across the Central West, sometimes claiming more than half the people of a tribe. Sacrifice Cliff, near BILLINGS, Montana was named to recognize the heroism of a number of braves who rode their horses off the cliff in an effort to appease the gods and end the sickness. Many authorities now agree that traders sometimes deliberately brought infected blankets, which they traded to the Indians to infect them, causing this worst siege of fatal illness. However, not all white "invaders" were so ruthless and destructive. Samuel Allis once was robbed by Indians during a period when he said he was "in distress and in a state of starvation." But when the Pawnee tribe was racked with smallpox, Allis forgot his grievances and vaccinated more than two thousand of the Pawnee. His kindness was returned when the Pawnees received payment for some land. They insisted that he take a thousand dollars in payment for his assistance in their time of need.

SMITH CENTER, Kansas. Town (pop. 2,-240), Smith County, north-central Kansas, northeast of Russell and northwest of CONCORDIA. A small log cabin in Smith Center was the site where "Home on the Range," the famous song about the Kansas prairie, was written.

SMITH, Jedediah Strong. (Bainbridge, NY, June 24, 1798—Cimarron, NM, May 27, 1831). Explorer and trader. Smith, often ranked with Lewis and Clark among America's greatest explorers, was a deeply religious man in an era dominated by the profane and hard drinking. Highly respected by his peers, Smith often led his trapping companions in brief religious services. He conducted the first religious service in present-day South Dakota in 1823 while accompanying William H. ASHLEY (1778-1838) on the annual caravan of the Rocky Mountain Fur Company. Smith, a trader in the Rocky Mountains from 1826 to 1830, traveling with two companions, made one of the first crossings of the Sierra Nevadas. He was the first explorer of the GREAT BASIN region and was a participant in the Santa Fe trade. Smith was killed by Comanche Indians.

SMOKY (horse). The favorite horse of William F. "Buffalo bill" CODY (1846-1917). The horse was shipped by express to the New York studio of sculptress Mrs. Harold Payne Whitney who was making a statue of Buffalo Bill. Whitney wanted the statue to look comletely realistic, so she used Cody's horse as the model for the horse Cody is poised upon. He seemed to be nothing the worse for the ordeal of posing, when he returned to his master.

SMOKY HILL RIVER. Kansas river which begins in Cheyenne County in eastern Colorado before flowing east through central Kansas to meet with the REPUBLICAN RIVER at JUNCTION CITY to form the KANSAS RIVER.

SNAKE BUTTE. A long twisting ridge of hills in South Dakota. The area contains the Center Monument, the geographical center of North America.

SNAKE INDIANS. Name applied to various bands of the SHOSHONE tribe.

SNAKE RIVER. One of ten rivers listed by the United States Geological Survey as major rivers in the nation. The Snake source, discovered by John COLTER (1775-1813), lies in YELLOWSTONE NATIONAL PARK. The river flows 1,038 miles, through northwestern Wyoming and then south, southwest, west and then north across Idaho before turning north to form parts of the Oregon-Idaho and Washington-Idaho borders. The Snake turns west at Lewiston and flows across southeast Washington to empty into the Columbia River. The Snake has created a canyon on the Idaho-Oregon border more than forty miles long and 7,000 feet deep. The river's waters are used for irrigation in the desert regions through which it passes.

SNOWSHOES. In areas of deep snowcover, such as the Central West, the native population were very ingenious in methods of crossing snow that might lie ten to fifteen feet deep. Various tribes fashioned their own footgear of a wide variety of materials. Some were made longer and narrower for speed across long stretches of soft snow. Often the toe end was turned up to avoid catching on crusty patches of snow. When white traders and trappers came into the area, they soon adapted the native designs as most appropriate for the conditions there.

SNOWY RANGE. One of the finest, but least-known mountain resort areas in the United States. The Snowy Range, also known as the Medicine Bow Mountains, is located in southeastern Wyoming between LARAMIE and Saratoga. The University of WYOMING maintains a summer science study camp in the Snowy Range Nature Area.

SOCORRO, New Mexico. City (pop. 7,576), Socorro County, west-central New Mexico, northwest of ALAMOGORDO and southwest of ALBUQUERQUE. Socorro was a town on the northern border of an area in New Mexico and Arizona which the Confederacy proclaimed in 1861 to be part of a new Confederate territory of Arizona. Swift Union military responses at Apache Canyon and Pigeon's Ranch soon caused this dream to die. During the wild days of silver mining, Socorro was the largest city in New Mexico. A fondly remembered lawman in those days, Elfego BACA, once held off 80 Texas cowboys for 36 hours after they threatened to kill him for arresting one of their friends. Today his name is remembered in the Elfego Baca Shoot. This is a golf game on a unique par 50 one-hole tournament over two miles of cactus and shrub brush, in which the winner must finish with at least one of the ten initially allotted golf balls. With the Panic of 1893 the town saw its silver industry dwindle as more people turned to stockraising and farming. A reminder of the mining era is modern New Mexico Institute of Mining and Technology which includes an atmospheric research facility in the Magdalena Mountains.

SOD HOUSES. Shelter constructed from pieces of turf by settlers on the prairie. Due to the absence of wood the sod house, or "soddy," was made by piling the pieces of sod, like bricks, on top of each other. The sod slabs, known as "Nebraska marble," were often one foot wide and up to a yard long. The soil was held together by the tough fibrous roots of prairie grass. Dirt was packed between the sod bricks like mortar. If a hill was available it was often dug out and the structure incorporated into it. The dwelling, complete with a sod or thatch roof supported on poles, was cool in the summer and relatively warm in the winter. It also might leak like a sieve in rain storms and occasionally caved in suddenly when stray animals wandered onto the roof. Boards from the wagon which brought them west were sometimes used by the pioneers as flooring. In some homes, other pioneers had to be satisfied with dirt floors.

SOLOMON RIVER. In north central Kansas formed by the joining of the North Fork and South Fork in Mitchell County. The Solomon meets the Smoky Hill River in western Dickinson County.

SOONER. Term for to anyone who moved into an area before the legal time. The word was applied to those who started into the reserved lands in Oklahoma ahead of the starting time, to claim land. A Sooner risked forfeiting his claim if discovered. The name which originally was considered disrespectful has lost much of its stigma with the passage of time, and Oklahoma is now the "Sooner State."

SORGHUM. Grain-bearing grass, genus *Sorghum*, cultivated mainly for animal feed. Sorghum is native to Africa, where grass sorghums are still grown for hay. In the United States grain sorghums predominate, including kafir, durra, and milo. Sorghums thrive in dry areas, and the largest United States crops are harvested in the Central West plains from Texas to North Dakota.

SOURIS RIVER. The "Mouse River" in North Dakota, the stream rises in Canada where it flows in a curve through Saskatchewan, into North Dakota, and back into the Canadian province of Manitoba.

SOUTH DAKOTA. State, situated on the eastern block of the Central West region, with North Dakota to the north, Montana and Wyoming to the West, Nebraska on the south and Iowa and Minnesota on the east.

Principal rivers are the BIG SIOUX, separating South Dakota from Iowa and the mighty MISSOURI RIVER, providing the southeast South Dakota border, with Nebraska. The Missouri enters South Dakota at almost the exact center of the northern border, flows directly south, then turns southeast at Pierre.

With one small exception, the entire state falls within the Missouri River watershed. Principal eastern Missouri tributaries are the VERMILLION, JAMES and Big Sioux. The latter is an internal river of the state as well as forming part of the border. Just before reaching the border it makes an enormous double curve in the form of a letter S, with one loop enveloping the city of SIOUX FALLS. The James is said to be the longest non-navigable river in the world.

The CHEYENNE, WHITE, MOREAU, GRAND and a small portion of the LITTLE MISSOURI (flowing to the north in the northwest corner of the state) are the main rivers to the west of the Missouri.

Two other watersheds start within a few miles of each other but flow to destinations thousands of miles apart. The BOIS DE SIOUX RIVER forms the far northeast boundary of South Dakota, originating in Lake Traverse and flowing north toward Hudson Bay by way of the RED RIVER OF THE NORTH.

Separated from Lake Traverse by a short manmade border, BIG STONE LAKE is one of the sources of the mighty Minnesota River, which flows south and east to form part of the Mississippi River system. Big Stone Lake forms the rest of the northeast corner border of south Dakota.

A land of many lakes in the East, South Dakota to the west was almost barren of water except for the swath of the Missouri. Now, thanks to the damming of that great stream, the state is a land of great lakes. Just north of PIERRE the Missouri has been dammed to form Lake OAHE, stretching across the northern tier of South Dakota and on into North Dakota as well. Oahe Dam is the third largest in the world. South of Pierre, Big Bend dam forms a narrow lake which almost turns the land inside the Big Bend of the river into an island. LEWIS AND CLARK LAKE on the Nebraska border and Lake Francis complete the major Missouri River reservoirs. Only a few reservoirs are found elsewhere in the state.

South Dakota's only mountain range, the BLACK HILLS, provides the highest natural elevations between the Rockies and the Appalachians. This worn down cluster of rocks is one of the world's oldest ranges.

Aside from some picturesque widely scattered buttes in the west, the state's other principal physical feature is the twisted and colorful, desolate but fascinating region of the South Dakota BADLANDS, including BADLANDS NATIONAL PARK.

South Dakota is 17th in size among the states, 9th in the Central West. However, to those east of the Mississippi such facts can be misleading. The state would swallow up all of New England. Its largest county, Meade, would engulf the whole of Rhode Island and Delaware combined.

Throughout the Paleozoic and Mesozoic eras, present South Dakota alternated between periods of shallow seas and uplifts. Most of the north central and eastern portions of the state were covered during the glacial periods, with the Holocene epoch finding the land much as it remains today. The Black Hills were formed by the upheaval of a great granite batholith, so hard that while it has been substantially worn

South Dakota

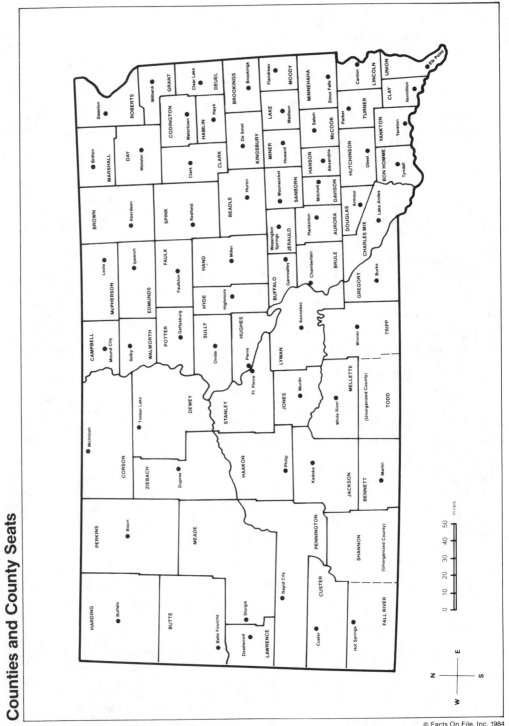

© Facts On File, Inc. 1984

South Dakota

STATE OF SOUTH DAKOTA

Capital: Pierre, settled 1880

Name: For the Dacotah Indianss which name in the Sioux language means "Friend or Ally."

Nickname: Coyote State

Motto: Under God the People Rule

Symbols and Emblems:
Animal: Coyote
Bird: Ringnecked Pheasant
Fish Walleye
Insect: Honeybee
Flower: Pasque Flower
Tree: Black Hills Spruce
Grass: Western wheat grass
Mineral stone: Rose quartz
Gemstone: Fairburn agate
Stone: Black Hills Gold
Colors: Blue and Gold
Song: "Hail, South Dakota"

Population:
1985: 706,000
Rank: 45th
Gain or Loss (1970-80): +25,000
Projection (1980-2000): -2,000
Density: 9 per sq. mi.
Percent urban: 46.4% (1980)

Racial Makeup (1980):
White: 92.6%
Black: 2,144 persons
Hispanic: 4,028 persons
Indian: 45,000 persons
Others: 4,100 persons

Largest City:
Sioux Falls (81,343-1980)

Other Cities:
Rapid City (46,492-1980)
Aberdeen (25,956-1980)
Watertown (15,649-1980)

Area: 77,116 sq. mi.
Rank: 16th

Highest Point: 7,242 ft. (Harney Peak)

Lowest Point: 962 ft. (Big Stone Lake)

H.S. Completed: 67.9%

Four Yrs. College Completed: 14%

STATE GOVERNMENT

Elected State Officials (4 year terms, expiring Jan. 1991):
GOVERNOR: $55,120 (1986)
LT. GOV.: $7,670 plus $75 a day during legislative session (1986)
SEC. OF STATE: $37,440 (1986)

General Assembly:
Meetings: January in Pierre
Salary: $3,200 in odd numbered years for 40 day session and $2,800 in even numberd years for a 35 day session and $75 per day during the legislative session.
Senate: 35 members
House: 70 members

Congressional Representatives
U.S. Senate: Terms expire 1991, 1993
U.S. House of Representatives: One member (at large)

Major Rivers and Waterways

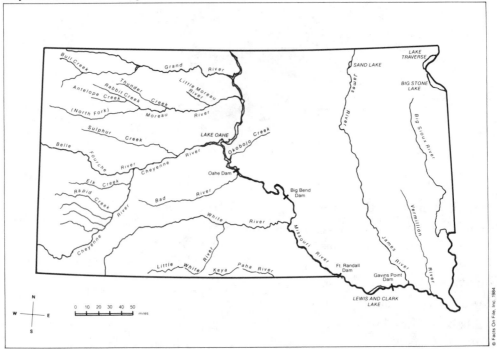

down to its present weathered shape, it remains even today as one of the oldest mountain masses on the continent. The strange, sharp pinnacles of the Needles region are the remains of the deepest of all the rocks of the uplift. Some geologists feel that the uplift may be continuing even now.

Surface outcroppings seen today are mostly Mesozoic, with Cenozoic areas in south-central and northeast. The Black Hills surface rocks represent a wide mixture of periods.

One authority estimated that "...more valuable fossils of greater variety have been recovered in the Badlands than anywhere else." They are particularly noted as the finest source of fossils from the Oligocene period, from 40 to 25 million years ago. The camel, then very tiny, probably originated there and migrated to Asia. The tiny three-toed horse also left its bones in the Badlands fossil trove, along with huge pigs, little deer, saber-toothed cats and many others, many to be seen in the School of Mines Museum at Rapid City.

Ancient shale beds of the Missouri and Cheyenne rivers yield fossil turtles, giant marine lizards called mosasaurs and plesiosaurs, fossil fish and an infinite variety of shell fish fossils. Ancestors of the devilfish, called bacu-

lites, found there are particularly fine in quality

The largest deposits of fernlike plants of the Mesozoic Era highlight the FOSSIL CYCAD NATIONAL MONUMENT. The numerous varieties of dinosaur remains are also notable, as are the many types of petrified wood found in the state.

The climate serves up hot summers and cold winters, much tempered, however, by the low humidity and the prevalant sunshine, which gives the state one of its nicknames—The Sunshine State. There is a growing season of mid-May to mid-September. Historic blizzards have swept the state, and two or three moderate to severe blizzards may be expected each winter. The East receives as much as 25 inches of rain per year, but the average for the state is 15 inches.

Annual manufacturing income of about three billion dollars is almost double that from agriculture in South Dakota. However, most of the manufactured products are based on the crops, livestock and minerals of the state. Food, machinery, petroleum and coal are the leading products. Livestock, mostly cattle, continues to lead in the state's agricultural income, with ABERDEEN a leading livestock center. Hogs and dairy products also are important. Wheat is the leading field crop, and South Dakota is second

in production of rye. Corn, oats, flax and barley also contribute.

South Dakota leads all the states today in the production of gold, also its earliest source of wealth. After the boom days, the state's gold production greatly diminished. However, the rocket rise of gold prices in recent times brought the HOMESTAKE MINE back into vigorous production. That historic operation is said to have produced more gold than any other single mine anywhere. South Dakota holds almost a monopoly on production of bentonite, important in ceramics, insulation, detergents and other products. Edgmont is a center of uranium ore production.

Surprising, perhaps to some, South Dakota has developed substantially in banking and finance, centered at Sioux Falls, where the nation's largest bank has located many phases of its operations. This influx of financial institutions was spurred by liberal state regulations. Another important Sioux Falls operation is the federal EROS Data Center, focus of worldwide space discoveries.

South Dakota has had a substantial increase in population since the census of 1980. By the year 2000 however, projections show an expected decline of about one and a half percent to a total of 688,000. The present population

divisions are, white, 92.6%, black, .031% and "others," including about 50,000 persons of American Indian descent, 7.1%.

Mounds piled up by various prehistoric people from the stone age to the age of copper are found in various areas, including Big Stone Lake, Sioux Falls, Vermillion and SISSETON. Pictographs and petroglyphs have also been found.

The ARKIKARA were the earliest Indian group known in history to occupy present South Dakota. They had travelled up the Missouri Valley to build substantial villages of lodges, constructed of sod over a framework of poles. When the SIOUX were driven in from the East, they in turn drove out most of the Arkikara. Known as the Dacotah tribe, the Sioux gave their name to the Dakotas.

When the VERENDRYE brothers, Francois and Joseph-Louis, planted a lead plate bearing the date of March 30, 1743, on the bluffs overlooking present Pierre, they were claiming the region for France. They became the first recorded Europeans in the area. Generations later that invaluable plate was recovered by children and took its place in history.

Pierre Dorion, who married a Yankton Sioux woman, was the first European settler, about 1780. Traders came and went, and the first

Topographic Areas

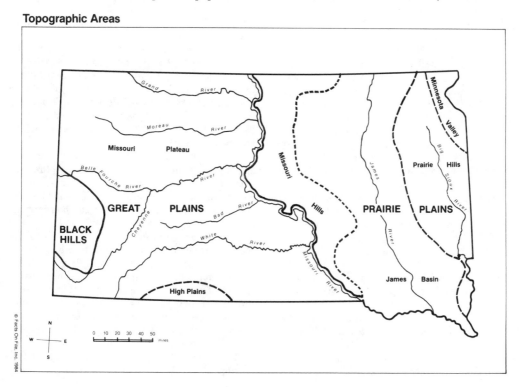

permanent trading post was established by Registre Loisel near Big Bend.

Then on August 22, 1804, the LEWIS AND CLARK party entered present south Dakota and held the first election (for a sergeant) in the Northwest. They described the barking squirrels (prairie dogs) and other flora and fauna, won a showdown with the TETON SIOUX at Pierre, smoked the pipe of peace with the great chief and ate a banquet of tender dog. On the way back they again visited with their new Indian friends, and impressed upon them the power of the government in Washington.

While the War of 1812 was going on, trader Manuel LISA (1772-1820) built many posts and prevented any British takeover of the area. The first steamboat reached FORT PIERRE in 1831, and the first permanent non-Indian settlement on the upper Missouri was made there the next year. Dakota Territory, created in 1861, included the two Dakotas and other vast areas of the region, with only about 2,000 white inhabitants of the whole area.

When Colonel George CUSTER (1839-1876) discovered gold in the Black Hills, nothing could stop the rush of gold seekers to an area that had been promised to the Indians forever. Frontier days were as wild and woolly as they had been farther west, with all the boomtowns with saloons, dancehall hostesses and blazing gun battles among sheriffs, outlaws, cattlemen and sheepmen. A rush of homesteaders added to the general confusion.

Outraged by the loss of their treaty land, the Indians went to war. Pursued by Custer who was slaughtered in Montana, the Indians finally had to give in to superior force. Stagecoach lines were established followed by railroads, which brought more settlers. By November 2, 1889, the Dakotas were ready for statehood. When President Benjamin Harrison signed the statehood act, he never revealed which of the Dakotas came first.

South Dakota experienced the nation's last Indian uprising, known as the MESSIAH WAR, in which Indian families were massacred at Wounded Knee, and famed warrior SITTING BULL (1830?-1890) was killed in an attempt to capture him.

Drouths, terrible winters and depressions had slowed but not stopped the state's growth. By WORLD WAR I the state was able to send 32,791 recruits to service. Army medics said these service men and women were the healthiest in the country. The opening of the Missouri River bridge in 1919 and the 1927 visit of President Calvin Coolidge to the Black Hills to dedicate

the unfinished Rushmore Memorial were notable events. The great drouth, the great duststorms and the great depression brought new woes, including the closing of the banks. The only one in the country that stayed open was the Nystrom bank at WALL. They had not been notified of the closing.

The creation of the Badlands National Monument in 1939 and the development of the great dams which turned South Dakota into a land of lakes were among the events of the following decades. In 1973 Rapid City experienced a devastating flood which took 200 lives. The next year a different problem brought Indian protesters to the massacre village of Wounded Knee to protest government policies in a siege which lasted 71 days. Some compensation was at last provided the Indians in 1980 when the U.S. Supreme Court ordered payments of $122,-000,000 for lands seized from the Indians in 1877.

The 1980s brought a notable plan to cultivate new business, when banks were given tax and other incentives to come to South Dakota. The first, in 1981, was the nation's largest bank, Citicorps, followed by many other financial institutions. A 1983 law was the first in the nation to permit banks to own insurance companies and other financial institutions.

Ronald Reagan won the state vote in 1984, and Republican George Mickelson won the governor's chair in 1986.

Indian leaders have a notable place in South Dakota history. Chief Crazy Horse has gained great recognition for his generalship in such battles as Powder River and Rosebud River and joining with Sitting Bull in Custer's defeat. Revered by the Sioux as their greatest leader, he surrendered in 1877 and was treacherously stabbed to death.

To honor Crazy Horse, sculptor Korczak ZIOLKOWSKI (solicited funds and made plans to carve the world's largest monument out of a South Dakota granite mountain. He died before the work was completed, but his son has carried on.

Even more famed was Gutzon BORGLUM (1867-1941) who had the vision to blast MOUNT RUSHMORE into a gigantic sculpture of four American presidents. In spite of all prospects of failure, Borglum's determination carried the project through 14 years of effort, to create one of the seven modern wonders of the world.

South Dakota artists in another field include a homesteader at Ordway, author Hamlin GARLAND (1860-1940), L. Frank BAUM (1856-1919), author of the Wizard of Oz books, and Ole

Indian Tribes before European Settlement

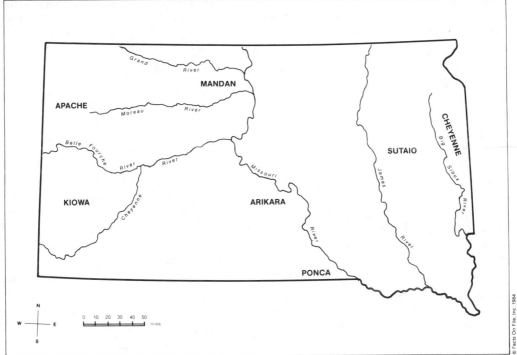

Edvart ROLVAAG (1876-1931) whose writings brought to life Norwegian life on the Dakota frontier.

Many a western character brought notoriety to South Dakota, including James Butler "Wild Bill HICKOCK (1837-1876), Martha Jane CANARY (1852?-1903) (Calamity Jane) and Poker-Alice Tubbs of STURGIS.

One of New York City's most famed and flambouyant mayors, Fiorello H. La Guardia, spent his boyhood in Fort Sully.

South Dakota can boast of the world biggest "rock stars," the faces of Washington, Lincoln, Jefferson and Theodore Roosevelt looming from Mount Rushmore above the valley. Since their completion they have proved one of the nation's most notable attractions and remain the most massive memorial ever created.

In the small area of the Black Hills are many other attractions, including the displays of the Crazy Horse Memorial, the NEEDLES, Wind and Jewel caves and the renowned Black hills Passion Play at SPEARFISH. The Homestake Gold Mine provides the final portion of the city of LEAD's claim that it is "over a mile high, a mile wide and a mile deep." Visitors may visit portions of the mine.

Pierre is dominated by the state capitol, a lofty building of Bedford limestone and local boulder granite and marble. At the Robinson Museum visitors may still see the precious historic plate buried by the first French explorers. The State national Guard Museum features Custer's sword. Nearby Oahe Dam is one of the largest anywhere. Oahe Days annually features parade, raft race, buffalo chip flip, powerboat races and other contests, early in August.

HOT SPRINGS features EVANS PLUNGE, the world's largest indoor natural warm water pool. Mammoth Site of Hot Springs marks a remarkable concentration of mammoth skeletons. DEADWOOD's annual festival, DAYS OF '76, is one of the most noteworthy in the nation, featuring a top rodeo, one of the most interesting of all annual parades and a return to the pioneer spirit.

RAPID CITY is the principal city of the Hills. Its reproductions of dinosaurs at Dinosaur Park have been a symbol of the city for decades. Dahl Fine Arts Center, Sioux Indian Museum and Crafts Center, Marine Life Aquarium, South Dakota School of Mines and Technology with its Museum of Geology and Bear Country USA are some of the attractions of the area.

Looming over the prairie near STURGIS is BEAR BUTTE, pushed up by volcanic action which never reached the eruption stage.

One of nature's most fantastic efforts is preserved in Badlands National Park, with towers and minarets and other fantastic formations "Like magnificent ruins of a fallen city." Here, too, have been found some of the world's finest collections of fossils.

VERMILLION is home to the University of SOUTH DAKOTA, boasting a museum with a unique collection of over 3,000 musical instruments, dating back to Babylonian and Egyptian days.

MITCHELL has created its unique CORN PALACE, a convention center seating 4,500, covered each year with Murals created from corn and other grains of various colors. This faux Moorish palace lures thousands of visitors to the modest city, especially during Corn Palace Festival the last week of September.

Outside Mobridge is the Sitting Bull Monument by Korczak Ziolkowski, marking the lofty burial ground of the noted medicine man.

Sioux Falls, the state's largest city features the Siouxland Heritage Museums, Augustana College with its Gilbert Science Center, Great Plains Zoo and Delbridge Museum of Natural History, along with many other attractions for visitors, including the EROS Data Center, with audio-visual displays. Annual attractions include two fairs: Sioux Empire Farm Show in late January and Sioux Empire Fair in late August.

SOUTH DAKOTA SCHOOL OF MINES AND TECHNOLOGY. Founded in RAPID CITY in 1885, the school is a full-fledged technological institution especially known for its Institute of Atmospheric Studies, where researchers study ways in which it may be possible to change weather. Noteworthy work in paleontology is carried out by the school's Sheep Mountain Camp. During the 1985-1986 academic year the school enrolled 2,260 students and employed 130 faculty members.

SOUTH DAKOTA STATE UNIVERSITY. Publicly supported university located in Brookings. Created through a legislative act in 1881 as the Agricultural College for the Territory of Dakota, the university received its current name in 1964. Work of the agriculture department, including Professor James Wilson's development of a breed of TAILLESS SHEEP, has been particularly significant. During 1985-1986 the university enrolled 6,837 students and employed 338 faculty members.

SOUTH DAKOTA, UNIVERSITY of. Publicly supported university, founded in 1862, by the state legislature. Provided no money to operate the institution, the people of VERMILLION opened and paid for the school themselves for one year through the donation of ten acres of ground from Judge Jefferson Kidder and by means of a $10,000 county bond issue. The first building was not completed when classes began in 1882. The W.H. Over Museum is recognized for its extraordinary collection of Indian relics and natural history specimens. During the 1985-1986 academic year the University of South Dakota enrolled 5,520 students and employed 461 faculty members.

SOUTH PARK CITY. Authentic restoration of an early 1850s mining town constructed in Fairplay, Colorado.

SOUTH PASS. Pass in southwestern central Wyoming at the southern end of the WIND RIVER RANGE. The pass at 7,550 feet, was discovered in 1824, but was first used for wagons in 1832 by Captain Benjamin BONNEVILLE.

SOUTH PLATTE RIVER. Joins the NORTH PLATTE in Lincoln County, Nebraska, to form the PLATTE RIVER. The South Platte rises in central Colorado in Park County. It begins a 424 mile path in a southeast and then northeast direction to cross the Nebraska border.

SOUTHERN COLORADO, University of. Publicly supported coeducational university in PUEBLO, Colorado. It was founded in 1933 as an outgrowth of Pueblo Junior College. During the 1985-1986 academic year the school enrolled 4,135 and employed 252 faculty members.

SOUTHERN METHODIST UNIVERSITY. Independent coed institution located in DALLAS. Founded by the United Methodist Church in 1911, the school is a nonsectarian institution, and no religious demands are imposed upon students. A faculty of 589 instructs a student body of 8,923 graduate and undergraduate. Degrees: Bachelor's, Master's, Doctorate.

SPACE MEDICINE. SAN ANTONIO, Texas, is the home of the Aerospace Medical Center, the first institution in the world founded for the sole purpose of studying space medicine and now the world center of the specialty. Sometimes referred to as *bioastronautics*, an outgrowth of aviation medicine and classified as a

separate medical field since the early 1960s. Every aspect of the physical and psychological conditions encountered in space flight is studied by specialists in the field. Sophisticated tests, examinations and training are provided for astronauts and are designed to meet all conditions and problems which might be encountered in space. These include human reactions to acceleration forces, cosmic rays and weightlessness. Instrument-carrying astronauts have recorded their brain waves, respiration, and blood pressure, along with other data needed to prepare for future flights into deeper space. Specialists in space medicine have developed personal life-support systems which provide astronauts with food, oxygen and water so that they may perform otherwise impossible "space walks" outside the safety of the space capsule. Among future problems confronting space medicine specialists are management of illness in space and ways of providing the necessary exercise and entertainment needed for mental health on long voyages through space.

SPANISH-AMERICAN WAR. Men of the Central West states took an active part in the short all-volunteer war with Spain in 1898. Although they could not all be accepted, the entire National Guard of North Dakota volunteered. North Dakota servicemen were particularly active in the war in the Philippines. The flag carried by the First Montana Regiment during the fighting in the Philippines was later chosen as the state flag. Colonel Frederick FUNSTON (1865-1917) gained national fame when he led the Twentieth Kansas volunteers in the Philippines, won the Medal of Honor, and then went on to capture the notorious Philippine rebel leader Aguinaldo. When Theodore ROOSEVELT (1858-1919) decided to lead a hand-picked group of cavalry recruits into the war, he remembered the hard-riding cowboys he had known when he had lived in North Dakota for two years. Thinking the cowboys of the plains had "the right stuff," Roosevelt recruited most of his regiment from the region. He and Leonard Wood brought the recruits of the 1st U.S. Volunteer Cavalry to the state fairgrounds at SAN ANTONIO, Texas, where they were strenuously trained, according to the "strenuous life" theories Roosevelt had developed in North Dakota. He also remembered the Rough Rider Hotel in Medora, North Dakota and considered its name to be appropriate for his troop, and the ROUGH RIDERS and their leaders gained eternal fame in their rugged

assault on San Juan Hill in Cuba.

SPANISH PEAKS. Landmarks for early explorers and traders. The peaks are located in Huerfano and Las Animas counties in southern Colorado. The eastern peak has an elevation of 12,683 feet, while the western peak is 13,623 feet high.

SPEAKER, Tristram (Tris) E. (Hubbard, TX, Apr. 4, 1888—Dec. 8, 1958) Baseball star. Considered one of baseball's all-around greats, especially in defense, Speaker began his professional career as an outfielder with the Boston Red Sox (1907-1915), continuing with the Cleveland Indians (1916-1926), then with Washington in 1927 and Philadelphia in 1928. His lifetime batting average was 344. He was elected to baseball's Hall of Fame in 1937.

SPEARFISH CANYON. Renowned as one of the most beautiful in the nation, portions of the valley outside of the community of SPEARFISH, South Dakota, are noted for vegetable production.

SPEARFISH, South Dakota. Town (pop. 5,251), Lawrence County, western South Dakota, southeast of BELLE FOURCHE and northwest of RAPID CITY. Josef MEIER brought his inspiring portrayal of Christ in the Passion Play of Luenen, Germany, to the United States prior to WORLD WAR II. The cast of the play chose to make Spearfish the permanent home of the play, now known as the Black Hills Passion Play. The D.C. Booth Historic Fish Hatchery, one of the West's oldest, was constructed in 1898 by the United States Government to stock trout in the BLACK HILLS. It was operated until 1983. Spearfish assumed operation of the hatchery and constructed a children's "fish feeding" area and historic displays.

SPINDLETOP. The first major oil well drilled in Texas in the 20th century. Traces of crude oil were discovered in Texas in the Corsicana area in the early 1890s by men drilling water wells. By 1899 there were some 300 oil wells in the area but they were primarily short-lived and produced only small quantities. On January 10, 1901, an exploratory well being drilled near BEAUMONT, Texas, under the direction of Anthony Lucas, gushered in, spewing oil more that 100 feet into the air. It took six days to cap the well, named Spindletop, and in that time nearly half a million barrels were discharged. A new economic base was established for the pre-

viously agricultural state, and thousands of promoters hurried to the new oil field. In the first year of its existence the Spindletop field produced four times as much petroleum as had been produced in the entire state in the previous year. Pipelines and refineries were constructed, and huge companies were organized to produce and refine the oil. Although the Spindletop oil flow slackened within a few years, almost overnight oil became the heart of the industrial economy of Texas.

SPIRO TEMPLE MOUND. Prehistoric remains of the Mound Builders in Oklahoma. Excavation of the mound, under the direction of Dr. Forrest E. Clements, yielded objects from other regions including indications that the Mound Builders may have traded with the Mayan people of Mexico.

SPORTS FIGURES OF THE CENTRAL WEST. Jim Thorpe (1888-1953), native of Prague, Oklahoma, has been praised as "the greatest all-around athlete who ever lived." He won both the Pentathlon and Decathlon at the 1912 Olympics. He starred in both professional baseball, with several major leagues, and football, was elected to the Football Hall of Fame and became first President of the National Football League.

Walter "Big Train" JOHNSON (1887-1946), native of HUMBOLDT, Kansas, is called the greatest pitcher who ever lived. Several of his records still remain unbroken. Hall of Famers Tris SPEAKER, of Hubbard, Texas, and Rogers HORNSBY (1896-1963) of Winters, Texas, were renowned in baseball in their time. Spavinaw, Oklahoma native Mickey MANTLE (1931-) is a modern record holder in baseball's Hall of Fame, known also for his marriage to Marilyn Monroe.

Many boxing greats have been associated with the Central West, including Jack Johnson of GALVESTON, Texas, first black to hold the world heavyweight title. Jack DEMPSEY (1905-1983), known as the Manassa Mauler becaue he came from MANASSA, Colorado, remains as one of the best remembered heavyweight champions. Jess WILLARD (1881-1968) of POTAWATOMIE, Kansas, was also a heavyweight champ.

Two personalities who worked with horses in entirely different ways were Jim Houston of Nebraska, world champion bronc rider, and famed jockey Earle SANDE of South Dakota.

SPRUCE BEETLE. Insect pest which threatened the spruce forests of Colorado in an epidemic beginning in 1939 and not brought under control until 1952. During the years the beetle was uncontrolled an estimated four billion board feet of spruce was destroyed.

SQUAWFISH. Largest member of the minnow family in North America.

STAGECOACHES. Popular method of overland travel in the early West. Stagecoaches were vehicles pulled by four or six horses which were changed at intervals at stations along the stage route. Stagecoaches, introduced to the Central West as early as 1785, were not widely used until the 19th century, due to the poor conditions of the roads. The increasing use of stages led to further improvements in roads. Stagecoaches averaged forty miles a day in the summer and twenty-five miles a day during the winter. A day's travel was generally fifteen hours. Stagecoaches had capacity of up to fourteen passengers plus their baggage, mail, and the driver. Ben HOLLADAY (1819-1897), the famed stage line owner, operated a daily stage across Nebraska over the Oregon Trail by 1861. Holladay claimed the record for overland travel by stage when one of his coaches raced between Salt Lake City, Utah, and ATCHISON, Kansas, at the average speed of 160 miles per day at a cost of $10.00 per mile. The Holladay line was purchased by Wells Fargo in 1866. Nebraska saw stages carrying passengers and freight as late as 1900. Stagecoaches operated from the BLACK HILLS, often carrying gold without trouble, until March, 1877, when Sam Bass held up a coach bringing currency to the DEADWOOD banks. "Treasure coaches" with "shotgun messengers" were often necessary to get a load of gold through unless the guards had reputations like Wyatt EARP (1848-1929), whose name ensured a trouble-free trip across country. When the thieves were caught, justice was often administered immediately by vigilantes with a noose and a nearby tree.

STAKED PLAINS. Extensive plateau also known by the Spanish Llano Estacado. The area covers western Texas, southeast New Mexico and northwest Oklahoma for approximately 35,000 square miles being used as a site for grazing, wheat farming, and oil and natural gas exploration. Among the legends accounting for the name of this region is the claim that a tornado roped by fictional character Pecos Bill leveled the area to the degree that travelers had to drive stakes into the ground to avoid becoming hopelessly lost.

STARR, Belle. (Washington County, AR, Feb. 5, 1848—Eufaula, Indian Territory (OK), Feb. 3, 1889). Outlaw. Christened Myra Belle Shirley, Starr served as a Confederate courier during the CIVIL WAR before becoming Oklahoma's most notorious woman outlaw known as "The Bandit Queen" or "The Petticoat Terror of the Plains."

STATE FAIRS IN THE CENTRAL WEST. An annual event in each of the states of the Central West, perhaps the largest of which is held in DALLAS, Texas. The Texas State Fair, drawing as many as three million visitors yearly, is operated by a nonprofit corporation that reinvests all earnings back into the event and its furnishings. HURON hosts the South Dakota State Fair annually in early September. The Wyoming State Fair, held in DOUGLAS in late August, features rodeos, horse shows, and arts and crafts. The Nebraska State Fair, held in LINCOLN during September, showcases exhibits of livestock, crops, and farm equipment. One of the earliest state fairs in the Central West occurs during July when the North Dakota

State Fair is held in MINOT. Rodeos, livestock contests and horseraces are all part of the festivities held the last Saturday in July through the first in August at the Montana State Fair in GREAT FALLS. Thousands are drawn to PUEBLO, Colorado, in August when the Colorado State Fair is held. The Oklahoma State Fair is held during September in OKLAHOMA CITY. The New Mexico State Fair is held in mid-September in ALBUQUERQUE.

STEAMBOAT HOUSE. The house in Huntsville, Texas, where Sam HOUSTON (1793-1863) died. In keeping with his flambouyant nature, in 1861 Houston retired to this picturesque dwelling, with its decklike galleries running its full length, with ladders and other imitations of a Mississippi steamboat. Before he died it was said of Houston that he "looked like a man who, along with his boat, was anchored safely at last in his home port." Today the house may be visited as part of the Sam Houston Memorial Museum at Huntsville.

STEAMBOAT SPRINGS, Colorado. Town

The Texas State Fair, biggest of them all.

(pop. 5,098), Routt County, northwestern Colorado, northwest of Eagle and east of Craig. Colorado community named for a mineral spring which made a chugging sound like a steamboat and no longer exists. The first settlers were attracted by the rich promise of the Yampa River Valley. Farming, raising cattle and mining coal have proven of economic benefit, but not to compare with attraction of the town as a winter sports center. Steamboat Springs was internationally known as early as 1930 when several world ski jump records were set on Howelsen Hill. Steamboat Springs, known as "Ski Town, U.S.A." hosts a Winter Carnival in early February. In the summer the Steamboat Springs Gondola carries tourists 2,200 feet to the summit of Mount Werner from which a panoramic view of the valley and surrounding mountains is available.

STEAMBOATS. Already growing rapidly in the East, the use of steamboats in the Central West began when the *Western Engineer* puffed up the Missouri River in 1819. Commanded by Major Stephen H. Long, it reached as far as FORT LISA above OMAHA.

Shallow, narrow and winding western rivers demanded structural changes in the boats. Side-wheelers common on the Mississippi and Ohio rivers were replaced with the stern-wheeler which could navigate the narrow channels easier. Keels were replaced by flatbottoms which were necessary with the shallow western streams and steamboats' heavy loads. It was said that by 1859 steamboats had been perfected to the point "where they could float on a wet sponge."

Commercial use began about 1830, when the American Fur Company launched a fleet of shallow draft steamboats for Missouri River commerce. Such boats as the *Yellowstone, Omega* and *Nimrod* joined an estimated fifty other boats by 1857 in running the Missouri. In 1859, at the height of the Missouri River traffic, 268 boats docked at Omaha with Brownville, Nebraska, being an important port farther south.

Before the coming of the railroads, steamboats were the most important transportation on the upper Missouri and every attempt was made to bring them as far up the river as possible. Eventually, FORT LEWIS, Montana, was constructed at the point where the Missouri River could no longer be navigated by steamboat.

Experiments with Steamboats were tried on the less important rivers, even the shallow JAMES, but most were impractical. The RED RIVER OF THE NORTH, however, enjoyed considerable steamboat commerce. Nature, railroads, and man all conspired to end steamboat trade on western rivers. Gradually even major rivers became more treacherous and shallow.

By farming the land near rivers, man encouraged erosion which filled the river channels. Man also built mills along streams and dammed the channels to harness water power.

Steamboat captains often risked destroying their boats by crashing through these barricades to reach their destinations. While fares on steamboats tended to decrease, the speed of the boats generally increased, often as a result of flagrant disregard for safety. Western steamboats used dangerous high-pressure boilers to achieve more power with less weight. The poor construction of these boilers caused many to burst under high pressure.

Occasionally a ship's captain ordered a black crew member to sit on the safety valve to maintain an exceptionally high degree of pressure. The pressure always went up, but unfortunately often too did the unlucky crewman and the ill-fated boat. Sparks from the wood furnaces caused many fires as the wooden craft were highly combustible. Boat captains often made a dangerous situation worse by adding pitch, tar, or lard to the fire to make it hotter, throw more sparks and produce more steam.

The height of the steamboat era came in the 1850s. Many-decked boats with gingerbread woodwork, bright paint, rich carpets, and luxurious furniture brought accomodations to travelers comparable to any in the East.

These travelers and the commerce sent by manufacturers and farmers increasingly went to the railroads after the CIVIL WAR. Today a very large volume of barge traffic continues the tradition of water transportation on the Missouri.

STEGOSAURUS. Colorado must have chosen its state fossil for its size and appearance and not for its brain power. The four-legged vegetarian dinosaur was about twenty feet long and probably weighed about ten tons. However, its brain must have weighed all of two-and-a-half ounces. Complete skeletons have been found in the Jurassic fossil beds of Colorado and Wyoming. The mighty beast had two rows of upright bony plates on the back and four long bony spikes on its massive tail.

STERLING, Colorado. City (pop. 11,385), Logan County, northeastern Colorado, north-

east of GREELEY and east of FORT COLLINS. Sterling, headquarters for much oil and gas exploration, is a trade center for farming and ranching operations in southwestern Nebraska and northeastern Colorado.

STERNS CREEK CULTURE. Group of prehistoric people whose artifacts found near PLATTSMOUTH, Nebraska, indicate that they knew how to work in bone, make pottery, apparently grew some crops, and made their houses of poles, bark and reeds.

STILLWATER, Oklahoma. City (pop. 38,-268), Payne County, northeastern Oklahoma, south of PONCA CITY and northeast of OKLAHOMA CITY. Stillwater benefits from its role as a home for missile parts defense contractors. Stillwater is also the home of the Oklahoma Agricultural and Mechanical College and OKLAHOMA STATE UNIVERSITY. A group of 200 "SOONERS" attempted to settle along Stillwater Creek in 1884, only to be forced back to Kansas by federal troops. The town was born legally on April 22, 1889, and over the years has become a recognized home of education, agribusiness and industry. The National Wrestling Hall of Fame is located at Stillwater.

STOLEY STATE PARK. Forested area near GRAND ISLAND, Nebraska, where in 1860 William Stoley planted six thousand trees and in 1864 constructed a private fortress, boasting an underground stable 88 feet long, which he called Fort Independence, to protect his family and neighbors from the Indians.

STONE CISTS. Prehistoric burial boxes used by early people living near present-day O'NEILL, Nebraska. Formed of limestone slabs, the boxes, filled with jewelry, stone hatchets, spearheads and other objects, were set in the shallow burial dugouts and covered with earth.

STRATEGIC AIR COMMAND (SAC). Long-range bomber and missile force of the United States Air Force. Headquartered at OMAHA, Nebraska, Offutt Air Force Base, SAC has been called the "headquarters of the nation's peace-keeping force" since its founding in 1946. SAC's combat ready air forces, including an estimated 1,300 jet bombers and tanker airplanes, can be mobilized within seconds of a

Gus Fohner Memorial Rotunda, Stuhr Museum, Grand Island Nebraska.

warning. Bombers can be dispatched within fifteen minutes. An airborne command plane, one of several in the air at all times, would be able to direct attacks if the ground command post was destroyed. The SAC Museum in BELLEVUE, Nebraska, contains an outdoors exhibit of aircraft and missiles dating from WORLD WAR I to the present. Indoor exhibits illustrate the development of military aviation and an introductory film dramatizing SAC's response to an attack.

STRATOSPHERE BOWL. Launching site in the BLACK HILLS of the record-setting balloon, the *Explorer II*, in 1935.

STUHR MUSEUM OF THE PRAIRIE PIONEER. Unique museum complex on an island in a manmade lake in GRAND ISLAND, Nebraska. The museum was created in 1961 through the generosity of Leo Stuhr, son of a pioneer family in Grand Island, who donated 115 acres of land and $500,000. The museum, designed by the late Edward Durell Stone, features exhibits of pioneer life in Nebraska and an art gallery. To re-create a railroad town of the 1860s, over fifty buildings were moved to the site to be restored and furnished, including the boyhood home of famed actor Henry FONDA. During the summer, craftsmen such as blacksmiths demonstrate their trades. A steam train crosses two hundred acres of prairie, and a separate building houses vintage automobiles and farm machinery. A collection of Old West memorabilia is found in the Gus Fonner Rotunda.

STURGIS, South Dakota. Town (pop. 5,184), Meade County, western South Dakota, northwest of RAPID CITY and southeast of B E L L E FOURCHE. In its early days Sturgis was known as "Scoop Town" because local poker players such as Poker-Alice Tubbs often "scooped" or cleaned out the soldiers from nearby FORT MEADE. Historic Fort Meade became a veterans' hospital. Fort Meade's most famous resident for many years was the horse, COMANCHE, the only survivor of Custer's defeat at the Little Big Horn. Near Sturgis on Dead Man's Creek is a monument to Charles Nolin, a pony express mail carrier killed on the site by Indians. The monument has been shaded by five black walnut treees, grown from slips taken from five historic battlefields, including Gettysburg, Antietam and Valley Forge. BEAR BUTTE, a volcanic rise 1,400 feet high contained in a 1,845-acre state park, is still considered a religious shrine

by Indians. The area surrounding the butte has yielded artifacts ten thousand years old. Artifacts of life in a cavalry post are found in Old Fort Meade Museum. At this fort "The Star-Spangled Banner" was first played at official functions, a practice that in 1931 encouraged its selection as the national anthem.

SUBLETTE, William Lewis. (Lincoln County, KY, c. 1799—Pittsburgh, PA, July 23, 1845). Fur trader. Sublette joined the 1820 Ashley expedition to the ROCKY MOUNTAINS and later established a company to guide people through the Rockies. His wagons were the first to cross the Rockies, in 1823. He led an expedition to SANTA FE, New Mexico, in 1831 and became a partner in 1832 with Robert Campbell in a company to collect furs on the Missouri and Platte rivers. Campbell and Sublette founded the first permanent settlement at present-day LARAMIE, Wyoming, in 1834. Sublette amassed a fortune in fur trading and later became an important figure in the state politics of Missouri.

SULPHUR, Oklahoma. City (pop. 5,516), Murray County, south-central Oklahoma, southwest of ADA and east of DUNCAN. The valuable mineral springs near Sulphur have become part of the National Park System as PLATT NATIONAL PARK. Vendome, one of the world's largest flowing mineral wells, is located there.

SUMMIT SPRINGS BATTLEGROUND. Last major battle with the Indians on the northeastern plains of Colorado. This culmination of General Sheridan's 1868-1869 campaign, occurred on July 11, 1869. Five companies of the 5th Cavalry from Fort McPherson, Nebraska, and 150 Pawnee scouts, guided by "Buffalo Bill" CODY (1846-1917), pursued Chief Tall Bull and his Cheyenne who were responsible for raiding settlements in eastern Colorado and Kansas. The troops surprised the Cheyenne, killing fifty warriors, including Tall Bull. Pawnee scout Traveling Bear received the Medal of Honor for bravery by taking four Cheyenne scalps. The battlefield, now privately owned pastureland near Atwood, is indicated by a stone marker.

SUNDANCE, Wyoming. Town (pop. 1,087); seat of Crook County; southeastern Wyoming; north of Newcastle and southwest of SPEARFISH, South Dakota. Sundance, the smallest county seat in Wyoming, lies at the foot of Sundance

Mountain where SIOUX INDIANS once held council and religious meetings. The notorious outlaw Harry Longabaugh took the name "Sundance Kid," after spending eighteen months in the Crook County jail for horse theft. Tourists stop in Sundance for trips to DEVILS TOWER and the Black Hills National Forest. Sidetrips are also made to Moskee and Welcome, two nearby ghost towns.

SUNFLOWER (HELIANTHUS). The wild native sunflower is the official flower of Kansas. The family is a native of North America. Indians found many uses for it. Seeds often were eaten raw or pounded into a meal, and the oil was used as a hair oil. Flower heads provided a yellow dye. The stalks yielded fiber. Cultivated sunflowers can produce blossoms a foot in diameter, and sunflower cultivation is increasing, for seeds and oil.

SUNSPOT OBSERVATORY. From a small beginning in 1952, it became the world's largest solar observatory, equipped with a solarscope, located atop SACRAMENTO PEAK near CLOUDCROFT, New Mexico.

SWAN MOUNTAINS. Rocky Mountain range centered in Powell and Flathead counties in western Montana.

SWEETGRASS, Montana. Town (pop. 3,-216), Toole County, north-central Montana, on the United States-Canadian border. Named for the abundance of sweet grass on the nearby prairie, Sweetgrass is today a port of entry between the United States and Canada. Gold, discovered by the BLACKFOOT in 1884, was worth

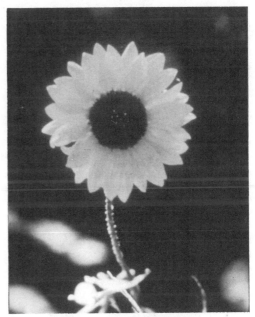

The Kansas state flower.

twenty-five cents per shovel of pay dirt, leading to the name of Two-Bit Gulch for the canyon where the mineral was discovered. Sweetgrass lagged as a trade center before 1900, and the coming of the dry-farmers, after which business improved. Sweetgrass Arch is believed to be one of the most important oil-bearing formations in the United States.

SYLVAN LAKE. Man-made lake created in 1891 behind a private dam built by Crary and Rede between two giant boulders in the BLACK HILLS of South Dakota near HARNEY PEAK.

T

TABOR OPERA HOUSES. Magnificent buildings donated to the cities of LEADVILLE and DENVER, Colorado, by H.A.W. Tabor (1830-1899). The Tabor Grand Opera House in Leadville drew distinguished performers from all over the United States. The actions of the audience were often more questionable. Vaudeville star Gladys Robeson once saw Tabor and

his friend Bill Bush compete as to who could throw the most money from their seats to her feet on the stage. When they had finished throwing nearly every coin in the house to the stage, Robeson was able to rake in over $5000, and then refused to meet either of the men. The opera house in Denver was paneled with cherry wood, imported from Japan, and imported

marble. Fine art adorned the building, and patrons walked on made-to-order plush carpets. The building and its furnishings, costing one million dollars, were displayed to the citizens of Colorado for the first time in 1881. Tabor's only complaint was aired when he found a picture of Shakespeare hung in a prominent place. Tabor had the picture removed and one of himself substituted.

TABOR, Elizabeth McCourt Doe (Baby Doe). (1862—Leadville, CO, 1935). Glamorous widow of the once fabulously wealthy Colorado mine owner and businessman H.A.W. Tabor (1830-1899). They were married in a Washington, D.C. ceremony attended by President Chester A. Arthur. Spending money nearly as fast as it came in, the Tabors were ill-prepared for the silver bust, and Baby Doe was at her husband's side when he died almost penniless at the Windsor Hotel in Denver, Colorado. His last words, "Hang on to the Matchless," referring to the mine responsible for much of his wealth, led to Baby Doe's rejection of all offers of help. She lived in a shack on their claim, never doubting that the mine would again restore her to wealth. She was found frozen to death there. Her life was portrayed in the opera *The Ballad of Baby Doe* by Douglas Moore.

Tabor Center in downtown Denver pays tribute to benefactor H.A.W. and his wife Sandy Tabor.

TABOR, Horace Austin Warner (Holland, VT, Nov. 26, 1830—Denver, CO, April 10, 1899). Senator and businessman. Tabor was Denver's greatest early benefactor. For his share of an $18 grubstake to two miners in need of supplies, Tabor eventually gained $1,500,000 when in 1878 the two miners discovered a silver lode which they named Little Pittsburg. Tabor served as lieutenant governor of Colorado and was appointed a United States Senator for thirty days to fill out an unexpired term. He amassed a fortune of nine million dollars which he spent as quickly as it came in. A large part of his fortune was spent in gifts to Denver communities, including a fire department and Tabor Grand Opera House donated to LEADVILLE, Colorado. DENVER was given a magnificent one million dollar opera house with plush carpets made to order for the building and fine art for its ornate walls. He divorced his wife Augusta and almost immediately married glamorous Elizabeth McCourt Doe on March 1, 1883, in a Washington wedding attended by President Arthur. Tabor had six more years to enjoy his wealth before the silver bust in 1889 left him almost penniless. Tabor became Denver's postmaster from 1898 to 1899. His widow heeded his last words to keep the Matchless Mine, the source of most of his great fortune, and lived in a shack on the mine property where her frozen body was discovered in 1935.

TAHLEQUAH, Oklahoma. City (pop. 9,708), Cherokee County, northeastern Oklahoma, northeast of MUSKOGEE. Tahlequah, founded in 1839, became the national capital of the CHEROKEE INDIANS. Their national prison located in the community is now a county jail. The Cherokee Supreme Court building, erected in 1844, is now the county courthouse. In 1844 the first newspaper published in Oklahoma was printed in Tahlequah. This paper, *Cherokee Advocate*, was printed partly in English and partly in Cherokee. Today Tahlequah is the home of NORTHEASTERN OKLAHOMA STATE UNIVERSITY. Life in an Indian village of 1650 may be seen in the re-created Village at Tsa-La-Gi.

TALIMENA DRIVE. Scenic fifty-five mile drive called the "Indian Highway" between Mena, Arkansas, and Talihina, Oklahoma, following the peaks of the Rich Mountains and the Wind Stair Mountains.

TAOS INDIANS. Tiwa tribe which lives in TAOS PUEBLO fifty-five miles northeast of SANTA FE, New Mexico, on both sides of Taos Creek.

Taos Pueblo

Taos Pueblo, a living reminder of past pueblo glories.

The Taos called their pueblo Ilaphai, the "red willow place." The ancestors of the Taos were probably some of the people who were driven by drought from the Chaco Canyon cliff dwellings into Taos Valley. The Taos were divided into six kiva groups. Infants were placed in a kiva of the parents' choice. The cacique was the religious leader of the Taos. With the tribal council, the cacique also had power in everyday matters. The council was composed of the heads of all the kivas plus secular officers, including a governor, who were chosen by the religious leaders. Ceremonies were associated with the kiva. There were male and female shaman who specialized in a variety of cures for the ill. Both men and women cultivated the fields. The men conducted rabbit drives which were organized by the war chiefs. Hunts were also organized for turkey, deer and buffalo. The history of the Taos and the Spanish is filled with hostility. Coronado's expedition visited the Taos in 1540. Efforts to make the Taos servants led to rebellions prior to 1680 when the Taos and other nearby tribes besieged Santa Fe forcing the Spanish to flee. When the Spanish returned in 1692 the Taos fled, only to return

within a few years to rebuild their pueblo. Despite some intermarriage between the Taos and Plains tribes, the Taos were often raided by the Ute and Comanche in the late 18th century. In 1836, New Mexico revolted from Mexico and a Taos served as the governor of the rebel government for two months. In 1847, with the encouragement of the Mexicans, the Taos rebelled against the Americans and killed the governor, Charles Bent. The rebellion was crushed with the death of 150 Taos and the execution of fifteen more. In 1906, fifty thousand acres of Taos land, including the sacred Blue Lake, were taken by the United States government and added to Carson National Forest. In 1970, after years of petitioning, the land was returned. By that time more than 1,500 Taos occupied the Taos Pueblo which maintained its five and six story dwellings. The beauty of the area and the opportunity to observe public performances of the Turtle, Sun-Down and Deer dances have annually attracted tourists to the pueblo.

TAOS PUEBLO. The name of Taos is applied to three separate but adjacent communities in

north central New Mexico. Taos Pueblo is the oldest and the most historic of the three. It is the largest and perhaps the best known of the nineteen Pueblos which have been occupied for generations and which still provide a home for the Taos people today. Author D. H. LAWRENCE (1885-1930) wrote of his love for the community: "I think the skyline of Taos the most beautiful of all I have ever seen in my travels around the world." Life goes on in Taos much as it has for centuries, with the people adapting to modern conveniences in many ways but retaining the traditional flavor of their lives and of their community. For safety reasons over most of the period of occupation there were no windows at Taos Pueblo. However, some have now been cut. For a modest fee visitors are admitted to the Pueblo and are graciously admitted to some of the homes. There is a deer dance on Christmas day. Other dances are scheduled at different times and all are performed with verve and precision.

TAOS, New Mexico. Town (pop. 3,369), seat of Taos County, north-central New Mexico, northwest of Las Vegas and northeast of Los Alamos. Taos is not one, but actually three villages. Ranchos de Taos is the farming community with the huge mission church so often included among famous buildings in the state. Pueblo de Taos, or San Geronimo de Taos, remains the home of the Taos Indians. Taos proper, Don Fernando de Taos, is the original Spanish town which has become the center of art and tourism. The community's reputation as a center for the arts owes much to Bert Phillips, Ernest Blumenschein, and Joseph Henry Sharp who co-founded the Taos Society of Artists in 1912. This gradually evolved into a thriving artist colony which still is a major force in the United States today. Taos can trace its history to 1615 when Spanish soldiers settled near the mission. The Spanish were driven from New Mexico during the Pueblo Revolt of 1680, but returned with De Vargas in 1692. During the 18th and 19th centuries Taos was an important rendezvous for traders, miners, mountain men and representatives of every ethnic group. Social unrest rose quickly with the transfer of New Mexico to American control. In Taos the trouble led to the assassination of Governor Charles BENT during the Taos Revolt of 1846. The rebellion was put down by Colonel Sterling Price and four hundred heavily armed troops. The allegiance of Taos during the CIVIL WAR was assured when Kit CARSON (1809-1868) nailed the Union flag to the pole in the plaza. Today a section of the Taos area's RIO GRANDE RIVER is popular spot for its rafting trips. Carson National Forest enchants visitors as do the mountains which author D.H. LAWRENCE (1885-1930) described as the most beautiful he had ever seen. Historians value their visits to the Ernest Blumenschein home and the Kit Carson Home and Museum. La Hacienda de Don Antonio Severino Martinez is one of the few remaining Spanish colonial homes in the state.

TASCOSA. Ghost town near AMARILLO, Texas, home of Cal Farley's Boys Ranch, patterned after BOY'S TOWN of Omaha, Nebraska. The ranch was founded in March, 1939, by a group of Amarillo businessman known as The Maverick Club of Amarillo as a second-chance for "maverick" boys who seemed to have little chance of becoming good citizens. Known today as the Queen of the Texas Ghost Towns, Tascosa developed from a sheep camp called Plaza Atascosa to become the second town in the Texas Panhandle with the title "The Cowboy Capital of the Plains." During the period of 1880 to 1925 Tascosa faded when the railroad passed to the west and south of town. The last inhabitant, "Frenchy" McCormick, refused to leave her husbands grave in Boot Hill, until illness and old age forced her to move. Cal Farley's Boys Ranch occupied some of the town's buildings, and other portions of the ghost town have been restored for visitors.

TASONKESAPA. (unknown—unknown) South Dakota Indian medicine man and prophet who envisioned nearly two hundred fifty years ago that with the coming of the whiteman, "...the buffalo and wild things will disappear."

TAWAKINI INDIANS. A separate tribe, but one often associated with the WICHITA INDIANS. In the 1970s there were an estimated eight hundred Wichita descendants including the Tawakini living in Caddo County, Oklahoma.

TAYLOR, Robert. (Filey, NE, Aug. 5, 1911—June 8, 1969) Born Spangler Arlington Brugh, he followed the lead of many other actors by changing his name, then entering films to become one of the best-known of all male romantic leads, often acclaimed as the most handsome man in Hollywood. His pictures include *Magnificent Obsession* (1935), Knights of the Round Table (1953), *Devil May Care* (1968) and *The Glass Sphinx* (1968). He

turned to a tougher character role for the lead in the TV series *The Detectives*, which ran from 1959 to 1962.

TEAPOT DOME SCANDAL. During the administration of President Warren G. Harding, Secretary of the Interior Albert Fall was indicted for leasing naval oil reserve lands in 1923 at Teapot Dome, Wyoming, to oil producers Harry Sinclair and E.L. Doheny oil interests without competitive bidding after accepting loans of hundreds of thousands of dollars. Fall resigned in 1923 and joined Sinclair Oil and in 1929 was convicted of taking a bribe and imprisoned 1931-1932. The event cast a continuing shadow on the memory of the Harding Administration.

TEAPOT ROCK. An eroded sandstone outcropping 75 feet high and 300 feet around near Midwest, Wyoming. The formation is said to resemble a disfigured human hand more than a teapot.

TEHUACANA INDIANS. Small tribe of Texas Indians who lived near the village, founded in 1844, which bears their name. Member of the Wichita Caddo group who lived in Texas near the RED RIVER. The Caddo groups are called the southwesternmost of America's mound-building Indians.

"TEJAS" Indians. An inaccurately named tribe of Indians whose name was given to the region now known as Texas. Early explorers, given the word "Tejas" by the Indians, did not know the word simply meant "friendly people" and was not the name of the tribe. However, from this happy accident the "friendly people" of Texas got their name.

TENKILLER LAKE. Described as Oklahoma's most beautiful lake, located in the southwest corner of Cherokee County and the northwest corner of Sequoyah County in eastern Oklahoma.

TENSLEEP CREEK. Site near Tensleep, Wyoming, of a raid in 1909 by cattlemen on a camp of an ex-cattleman who brought a large flock of sheep into the Big Horn Basin. The resulting investigation of the raid led eventually to the peaceful arbitration of grazing disputes.

TENSLEEP, Wyoming. Village (pop. 405), Washakie County, north-central Wyoming, east of Worland and southwest of Buffalo. Tensleep got its unique name because it was "ten sleeps" away from either FORT LARAMIE or Yellowstone. The range wars between cattlemen and sheep herders in the 1890s and early 1900s came to a peak in 1909 with the Tensleep-Spring Creek Raid led by cattlemen on the camp of a former cattleman who had brought sheep into the area. An investigation resulted in other disputes being settled through negotiation. Tensleep is only a few miles west of the Girl Scout National Center West, the largest scout encampment in the world.

TEPEE RINGS. Circles of flat stones of which some may still be seen. They were used by Indians to hold the edges of their buffalo hide tepees to the ground. Tepee rings have been found in such western states as Wyoming, Montana and North Dakota.

TEREDO PETRIFIED WOOD. The official state rock of North Dakota is the remains of a tree turned to stone by a process known as petrefaction, in which the original material is replaced by mineral matter, molecule by molecule. The original appearance and microscopic structure are retained.

TERRY PEAK. Located west of LEAD, South Dakota, the peak may be reached by a panoramic chairlift ride almost one mile long and rising 1,200 feet. At the peak, the vista stretches into Wyoming, Montana, Nebraska and North Dakota.

TESUQUE PUEBLO. New Mexico, on the west bank of the Tesuque River of the southernmost of the Tiwa-speaking branch of the Rio Grande Pueblo Indians. First discovered by CORONADO (1510-1554) in 1540, the Tesuque Pueblo is the closest Pueblo to SANTA FE and owns its land from an original Spanish grant, ratified by the Republic of Mexico in 1821 and confirmed by the United States in 1848. Annual festivals have included the one on November 12th in honor of the patron saint, San Diego. The Bow and Arrow dance, the Corn dance, and the Eagle dance are featured. Bunjabe or piki, a paper-thin wafer bread prepared by the older women, has long been used for ceremonial purposes.

TETON MOUNTAINS. Range of fault-block mountains in northwestern Wyoming considered by some observers the most beautiful in the world. The Tetons, first seen by John

The glorious Teton Mountains rise dramatically from the flat Jackson Hole valley.

COLTER, stretch north into YELLOWSTONE NATIONAL PARK. The southern portion of the range, including Grand Teton, the highest peak in the range at 13,766 feet, is in GRAND TETON NATIONAL PARK. Mt. Moran in the Tetons is named in honor of Thomas MORAN (1837-1906), an artist, noted for his paintings of the West.

TETON PASS. Long known as Hunt's Pass, for Wilson Price Hunt who crossed it in 1811, Teton Pass, at 8,429 feet, affords the traveler one of the finest scenic views in the West. Near Jackson Hole, Wyoming, Teton Pass was crossed constantly by trappers and traders before the first wagons attempted its steep grade in the late 1880s. Black troops, sent to Jackson in 1896 during the Bannock scare, found the grade so steep that their horses were unable to pull the wagons which eventually had to be hauled over the pass by hand. In 1901, $500 was appropriated to construct a wagon road over the pass which surveyors found to have grades as steep as 19 degrees. Wagoneers found that the only way to descend the pass was

to tie roughlocks, large untrimmed trees, to the wheels to prevent their turning. The road is still considered safe only for cars in excellent condition.

TETON RIVER. Northwest central Montana, rises in western Teton County and flows east into the Missouri River.

TETON SIOUX INDIANS. One of three major divisions of the mighty Sioux Indian nation. The Teton Sioux, buffalo hunters west of the Missouri River, were the largest branch of the SIOUX and included more than half of the entire tribe in its seven tribal branches.

TETON UPLIFT. Name given to the geologic action which resulted in the TETON MOUNTAINS, examples of "block-fault" mountains, rising from the earth in a great stone block, with an almost vertical eastern face.

TEXARKANA, Texas. City (pop. in Texas

31,271), Bowie County Texas, connected to seat of Miller County, Arkansas, on the Arkansas-Texas state line. Incorporated in 1880, this twin city is located 150 miles southwest of Little Rock Arkansas, and 185 miles northeast of DALLAS, Texas. It is a trade center that manufactures creosote, sand and gravel, lumber, tank cars, rockwood, and mobile homes. It is the home of a federal prison, an army depot, and an arsenal. The resort area of Lake Texarkana is nearby.

TEXARKANA, Lake. Lake in Bowie and Cass counties, in northeastern Texas, a large reservoir created by damming the Sulphur River, a water supply area for Texarkana and a resort area.

TEXAS **(battleship).** Built in 1914, the *Texas* was 573 feet long with a beam of 106 feet. Capable of reaching speeds of 21 knots and outfitted with 21-inch guns, the great ship is remembered for being in 1919 the first ship ever to launch a plane from its deck. The *Texas* served in WORLD WARS I AND II before being decommissioned on April 21, 1948, when it was presented to the State of Texas and established permanently near HOUSTON and dedicated as a State shrine. On April 21, 1958, Governor Price Daniel read his order activating the battleship as the flagship of the Texas Navy. It is now open for visitors.

TEXAS. State, southeasternmost of the Central West region. To the east are Arkansas and Louisiana, and to the southeast Texas has a 370 mile coastline on the Gulf of Mexico. To the southwest it has a long boundary with Mexico formed by the RIO GRANDE RIVER. To the west Texas faces New Mexico and projects the large Trans-Pecos panhandle between that state and Mexico. To the north it faces Oklahoma across a land boundary at the top of the northern Texas PANHANDLE, which follows the RED RIVER for most of the border, forming the longest border between any two U.S. states.

The largest of the "lower 48" United States, Texas has a special national reputation for wide-open spaces, "Urban cowboy" lifestyles, and dynasties of self-made family fortunes. The special symbols of state pride are the Texas Rangers of the past who patrolled the Texas High Plains, and the gushing oil wells that have dominated the state economy since the early 1900s. These popular images of Texas all have some basis in fact, even in the modern face of the state. The state is so large, with a land area in excess of that of France, that vast expanses of it remain so undeveloped that the principal means of transportation is the private airplane. The range lifestyle also remains intact in some areas, and Texas grazing lands support twice the number of cattle of any other state. The oil rig economy is also a fact of life in modern Texas, which continues to lead all states in oil and natural gas production despite the completion of the Alaskan oil pipeline and the problems of oil in the 1970s.

Beneath the stereotypes, however, there remains a remarkable diversity in the character of the state. Its topography is various enough to support rice paddies as well as mesquite and cattle. Its population is significantly ethnic, with the proportionately largest group of Spanish-speaking people in the United States and a new and growing sector of Vietnamese people who arrived in the 1970s. Texas also contains two of the ten-largest metropolitan areas in the country, DALLAS and HOUSTON. The economy is rich in diversified manufactures including aerospace equipment in addition to the expected petrochemical. Oil wealth has brought the state cultural riches such as the eminent research facilities at the University of TEXAS in AUSTIN, the opera company in Houston, and the posh shopping districts in Dallas. It is still possible to roam across barren unpopulated plains in Texas, but visitors to the state are more likely to encounter a very cosmopolitan state of glass and steel skyscrapers.

Topographically, Texas consists of regions of COASTAL PLAIN in the south east, plains in the center of the state, and basin and range in the far west. The belt of coastal plain along the Gulf of Mexico extends inland far enough to cover two-fifths of Texas. Averaging about 800 feet above sea level, the plain extends to the BALCONES ESCARPMENT in the west and the central lowland of the United States in the north. Along the coast itself, where elevations fall to sea level, Texas includes a network of barrier islands separated from the mainland by tidal lagoons. The largest of these, PADRE ISLAND, is the center of the National Seashore. The plains region of central Texas includes distinct regions of High Plains, Great Plains, and central Texas hills. The High Plains cover the northern panhandle, the Great Plains reach into the western panhandle, and the central Texas hills of rolling prairie reach northward toward Oklahoma. Together these plains regions represent another two-fifths of the state's area in the far west. This Trans-Pecos region includes the state's highest point, GUADALUPE PEAK (8,749

Texas

Counties

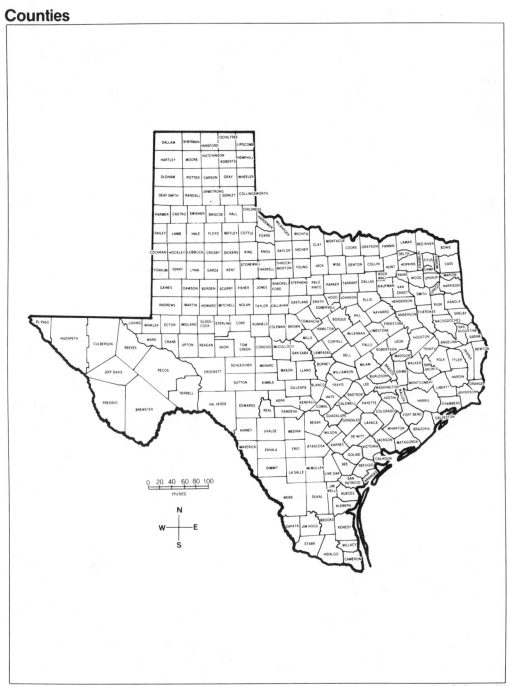

© Facts On File, Inc. 1984

Texas

STATE OF TEXAS

Name: Texias, Tejas, or Teysas from the Caddo Indian language meaning "allies or friends."

Nickname: Lone Star State

Capital: Austin, founded 1839

Motto: Friendship

Symbols and Emblems:
Bird: Mockingbird
Flower: Bluebonnet
Tree: Pecan
Song: "Texas, Our Texas"

Population:
1985: 16,370,000
Rank: 3rd
Gain or Loss (1970-80): +3,030,000
Projection (1980-2000): +6,511,000
Density: 61 per sq. mi.
Percent urban: 79.6% (1980)

Racial Makeup (1984):
White: 78.7%
Black: 12%
Hispanic: 18.23% (2,985,643 persons)
Indian: 40,100 persons
Others: 1,280,500 persons

Largest City:
Houston (1,728,910-1986)

Other Cities:
Dallas (1,003,520-1986)
San Antonio (914,350-1986)

El Paso (491,800-1986)
Austin (466,550-1986)
Fort Worth (429,550-1986)
Corpus Christi (263,900-1986)
Arlington.(249,770-1986)

Area: 266,807 sq. mi.
Rank: 2nd

Highest Point: 8,749 ft. (Guadalupe Peak)

Lowest Point: sea level (Gulf of Mexico)

H.S. Completed: 62.6%

Four Yrs. College Completed: 16.9%

STATE GOVERNMENT
Elected Officials (4 year terms, expiring Jan. 1991):
GOVERNOR: $90,700 (1986)
LT. GOV.: $7,200 plus living quarter and governor's salary when acting as governor (1986)
SEC. OF STATE: $62,400 (1986)

General Assembly:
Meetings: Odd years in Austin
Salary:$7,200, expenses while in session and travel allowance (1986)
Senate: 31 members
House: 150 members

Congressional Representatives
U.S. Senate: Terms expire 1989, 1991
U.S. House of Representatives: Twenty-seven members

Topographic Areas

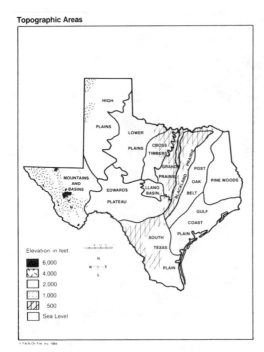

Elevation in feet
- 6,000
- 4,000
- 2,000
- 1,000
- 500
- Sea Level

© Facts On File, Inc. 1984

Indian Tribes before European Settlement

© Facts On File, Inc. 1984

feet). The special features of this region are the gorges of the Rio Grande Valley and the "lost mountains" of isolated peaks that are remote spurs of the ROCKY MOUNTAINS. Across these regions from the coastal plain inland, the rainfall in Texas becomes sparser and the climate becomes less moderate: winter temperatures in Houston average above 50 degrees, for example, while winter snows are common in the High Plains.

Prehistoric inhabitants include the Paleo-Americans of about 25,000 years ago, whose distinctive spear points are found with the remains of extinct mammoths and other animals, the West Texas Cave Dwellers, of a rather high degree of culture, and a group possibly of the Pueblo culture in more recent times. The Kitchen Middens of Central Texas reveal much of the life of the ARCHAIC CULTURE of about 4,000 BC. Medicine Mounds near lake Pauline, Burned Rock kitchen middens and the mounds of NACOGDOCHES are of archeological interest. Just prior to European infiltration, the people who lived in the area were those of what is called the Neo-American Culture. Texas is rich in prehistoric pictographs and petroglyphs.

In recorded history the earliest known inhabitants of Texas were the CADDO INDIANS in the east, the APACHE in the west, and the COMANCHE in the north. European exploration of the territory began in 1519, when Alvarez de Pineda

sailed and mapped the Gulf coast. This Spanish exploration was followed by another under Panfilo de Narvaez in 1528. The second expedition was shipwrecked on the coast, leaving survivors under Alvar Nunez Cabeza de Vaca to wander inland across present Texas in the company of Indians. After eight years, they returned to Spanish Mexico in 1536 with fabulous stories of the SEVEN CITIES OF CIBOLA. As they had in Florida, these legends of immense Indian wealth encouraged further Spanish exploration in Texas, beginning with the expedition across the state by Francisco Vasques de CORONADO (1510-1554) in 1541. The stories proved false and Spanish exploration of Texas ceased for another century.

Spain's interest in Texas was renewed by French expeditions into the region beginning with that of Sieur de LA SALLE (1643-1687) (Robert Cavelier) in 1685. He founded the French outpost of Fort Saint Louis on Matagorada Bay southwest of Houston in that year, but it was abandoned two years later. The Spanish attempted to maintain their local supremacy by extending the system of Missions that they had began at Ysleta, c. 1681, and EL PASO in 1682. Over the next fifty years they sent nearly 100 missionary expeditions into Texas and managed to establish a permanent mission at SAN ANTONIO in 1718. The San Antonio mission became the seat of local

Spanish government if 1722, but the missionary system that enabled the Spanish to conquer and control California failed in Texas due to the hostility of the Apache and Comanche tribes.

Texas was still virtually unpopulated by Europeans when the United States made the Louisiana Purchase from France in 1803. An 1819 treaty fixed the boundaries of the Louisiana Territory at the present Oklahoma and Louisiana borders of Texas. In 1820 the Missouri banker Moses Austin received rights for a Texas settlement from Spain, but in 1821 Mexico revolted from Spain and reorganized itself as an independent republic including Texas in 1824. By that time Moses Austin's son Stephen F. AUSTIN (1793-1836) had renegotiated his father's rights with the new Mexican government and established the colony of Washington-on-the-Brazos near the present site of Houston. Under Austin's guidance a wave of American settlers moved into Texas, where they were called *empresarios*.

Wary of an American-inspired revolution, Mexican authorities attempted to halt immigration from the east in 1830, but the English-speaking population continued to expand to reach about 25,000 by the early 1830s. Stephen F. Austin was the leader of the Americans, who hoped to establish a state within the Mexican republic, but the coup of Antonio Lopez de SANTA ANNA (1794-1876) in 1834 and Mexican arrest of Austin ended hope for reconciliation between the Spanish and English speakers of Mexico. On March 2, 1836, the Texans had already captured San Antonio from the Mexicans, and Santa Anna then led his troops north to recapture the city. The Texas rebels occupied an old Spanish mission in the city called the ALAMO. It fell to Santa Anna on March 6, 1836. Texan heroes such as William B. Travis, Jim Bowie, and Davy Crockett died in defense of the Alamo, and more than 300 Texans were massacred by Santa Anna at Goliad on March 27, 1836. Texas again chose Sam HOUSTON (1793-1863) as its military leader, and he surprised Santa Anna and his troops at San Jacinto on April 21, 1836, to end the war and free an independent republic of Texas.

As a separate country with the Lone Star Flag, Texas elected Houston its president and also voted to join the United States. Immediate statehood, however was frustrated by European hostility to American expansion into the Southwest and the United States federal government's reluctance to anger its European allies. Texas nevertheless eventually flourished as a republic. Austin was established as its capital in 1839, Houston was established in 1836, and Dallas was laid out in 1844. Mexican encroachments into southern Texas, however, started a border war that lasted until 1844. Texas was assisted in the war by the United States army, and this brought it into closer contact with the federal government in Washington. President James Polk was elected in 1844 on a campaign promise to annex Texas to the Union, despite Northern states' resistance to admission of another slave state. In the next year both the United States Congress and the Texas Congress voted for Annexation, and Texas became the 28th state in the Union on December 29, 1845. The Mexican War with the United States followed in 1846, but it was ended by the Treaty of Guadalupe-Hidalgo in 1848 that fixed the Texas border at the Rio Grande and ceded additional Mexican lands in the southwest to the United States.

With the coming of the CIVIL WAR, Texas was polarized between Unionist sentiment in the ranch lands of the west and Southern sentiment in the plantation areas of the Gulf coast. Sam Houston, now governor, opposed secession and lost his office on the issue. A popular vote of dubious legitimacy on February 23, 1861, supposedly ratified secession by a margin of three-to-one, a reflection of the state's population concentration in the cotton-growing areas of the Gulf coast. Texas was remote from the important Civil War theaters of action. The most notable battle within the state was at PALMITO HILL on the Rio Grande on May 13, 1865, which occurred a month after Lee's surrender and was the final battle of the war. Texas was readmitted to the Union in March, 1870.

Post-Civil War Texas remained a frontier long after the other Southern states had begun the transition to a manufacturing economy. Government interest focused on the Mexican border, and so the Texas Rangers became the sole protectors of the law in inland Texas. Railroads reached Kansas in the late 1860s, and this instituted an era of mass cattle drives across desolate stretches of Texas plains along the CHISHOLM TRAIL to sell beef in Kansas for the Chicago market. Railroad extension into Texas brought an influx of farmers and an era of range wars between them and the cattlemen. At the same time Indian wars continued to disrupt the state until the settlement with the Apaches in 1880.

The Key to the evolution of modern Texas was the discovery of oil at SPINDLETOP near

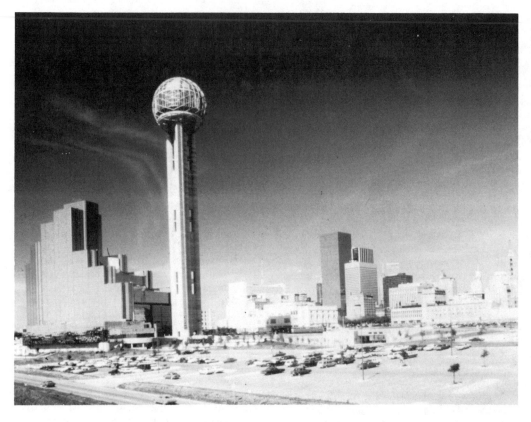

The varied towers of Dallas mark this strikingly modern Texas city.

BEAUMONT in 1901. This brought a rapid expansion of cities such as Houston and Dallas, which were built on oil wealth in the Twentieth Century. The need for oil export facilities led to the dredging of Gulf ports and expansion of cities such as CORPUS CHRISTI and GALVESTON. WORLD WAR I brought government investment to Texas in the form of military installations, a boon to the economy that continued through WORLD WAR II. By that time Texas was in the midst of a process of industrialization to refine its own mineral wealth that further encouraged urbanization. In the years after World War II this industrial expansion diversified into aerospace equipment and electronics. By the 1960s Texas had completed its expansion into national economic leadership. In that decade its importance to the country was symbolized by the Presidency of two Texans, Dwight D. EISENHOWER (1890-1969) and Lyndon B. JOHNSON (1908-1973) and the location of NASA's Manned Spacecraft Center in Houston.

The cities created by modern industrialization remain the principal population centers of Texas. Houston is the largest city in the state, although its metropolitan area population was surpassed by Dallas-Fort Worth. These areas alone represent more than 40% of the state population, and the only other metropolitan area with a population of one million is San Antonio. However, due mainly to the size of the state, Texas includes more organized villages, towns and cities than any other state. The 1970s brought a remarkable immigration to Texas from the northern industrial belt along the Great Lakes, a further gain in population from natural increase, and a rise from 4th to 3rd rank among the states in total population. In composition the population of the state is more than 20% Hispanic and 12% black.

Since the era between the World Wars, manufacturing has surpassed mining as the leading industry of Texas, second only to California in value of product. The state manufacturers remain heavily dependent on petrochemicals produced from mining yield, but transportation equipment, electronic products, and machinery are also important manufac-

tures. Texas continues to lead all states, including Alaska, in crude petroleum, and in the 1970s it surpassed its competitor Louisiana in production of natural gas. In agriculture Texas leads all states in value of farm property and number of farms. The principal farm products are beef cattle and cotton lint, and the Texas farm receipts exceed those of all states except California. There are a number of other traditional industries such as timber and commercial fishing that are important to the state. Tourism to Texas' historical sights, park lands, urban cultural centers, and other attractions accounted for $14.4 billion in 1984.

Those attractions are described in some detail in the entries on the many Texas communities, the sections on tourism and national preserves.

TEXAS AGRICULTURAL AND MECHANICAL UNIVERSITY. State-supported coed institution, part of the TEXAS A&M UNIVERSITY system, located in COLLEGE STATION, Texas, a town 90 miles northwest of HOUSTON. Chartered in 1871 and opened in 1876, A&M was once primarily a technological and agricultural college, and is the state's oldest public institution of higher education. Over the years it has grown to offer a wide variety of programs and majors. Other schools in its system are Tarleton State, Prairie View A&M, and Texas A&M at Galveston. The School of Military Sciences, located on the College Station campus, is one of the world's largest military colleges. A faculty of 2,764 instructs 33,499 students.

TEXAS ARTS AND INDUSTRY UNIVERSITY. Founded in 1925 at KINGSVILLE, the university operates on a 1,600 acre campus. The John E. Coner Museum at the university is notable for its Kleberg Hall, honoring the developers of SANTA GERTRUDIS CATTLE at the nearby KING RANCH. A student body of 5,117 is instructed by a faculty of 234.

TEXAS BRIGADE. One of the most famous units of Confederate troops during the CIVIL WAR in the Peninsula campaign and at Antietam. It was commanded by General John B. Hood.

The great Texas capitol at Austin is the largest capitol outside of Washington D.C.

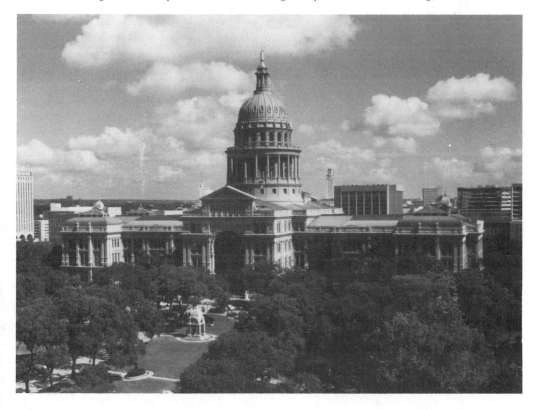

TEXAS CENTENNIAL EXPOSITION. One hundredth anniversary of Texas independence, held in DALLAS in 1936 which left the 277-acre State Fairgrounds with a number of fine buildings as a permanent legacy.

TEXAS CHRISTIAN UNIVERSITY. Independent church-related coed institution located on a 243-acre campus in the central Texas city of FORT WORTH. Founded in 1873, the university is administered by the Christian Church (Disciples of Christ). The school accepts students of all faiths, however, and the only mandatory religious requirement is one religion course. A faculty of 420 instructs a student body of 6,283.

TEXAS CITY, Texas. City (pop. 38,908), Galveston County, southeastern Texas, on the Gulf Coast of Texas southeast of HOUSTON and northwest of GALVESTON. Texas City, the major oil refining and shipping port on Galveston Bay, was the scene on April 16, 1947, of one of the greatest ship explosions in history when a French ship, the SS Grandcamp, loaded with nitrates, exploded killing 561, injuring three thousand, and causing seventy million dollars in property damage. Texas City has ranked as high as fifth among the major Texas ports in terms of volume, and fifteenth in the United States.

TEXAS DECLARATION OF INDEPENDENCE. Document hurriedly written in Washington, Texas, where delegates made a brief statement declaring Texas independence from Mexico on March 2, 1836. Two weeks later they wrote a national constitution and adopted an ad hoc interim government. The independence document, now displayed in the Lorenzo De Zavala Archives and Library Building at AUSTIN, is remembered near the site of its creation by the Texas Declaration of Independence Monument in Washington State Park, near Washington, Texas.

TEXAS RANGERS. Highly respected Texas police unit formed in 1823 as a loosely organized semi-military police force, the Rangers gave settlers some measure of protection from Indian attack. The force was reorganized by Sam HOUSTON (1793-1863) in 1844 to a strength of over 1,500. Rangers, who provided their own horses, did not wear a uniform, participate in formal drills, and were not subject to formal discipline. Serving in the Rangers was considered a high honor among such famous men as

L.H. McNelly who searched for cow-thieves in Mexico, Charles Goodnight of the Goodnight-Loving Trail fame, Sam Walker, and John Coffee Hayes-known among the Indians as Captain Jack and to Mexicans as El Diablo, the Devil. Rangers were the first to use the Colt repeating revolver on the plains. They fought Indians and raiding Mexicans and ended the careers of such outlaws as Sam Bass. Today the Rangers, the enforcement arm of the Texas Department of Public Safety, are organized into six companies with a captain, a sergeant, and one or two Rangers at each of the regional headquarters in HOUSTON, DALLAS, WACO, CORPUS CHRISTI, LUBBOCK, and MIDLAND. The remaining Rangers roam the state as trained criminal investigators. The individual Ranger is granted a right said to be unique among lawmaking bodies, being allowed to make his choice of weapons ranging from the single-action .45 to the powerful .357 Magnum.

TEXAS TECH UNIVERSITY. State-supported coed institution located in LUBBOCK, Texas. Founded in 1923, Texas Tech, with its 1,839-acre campus, is one of the largest schools in the country. This multipurpose institution offers studies through the Colleges of Arts and Sciences, Agricultural Sciences, Business Administration, Education, Engineering, and Home Economics. A faculty of 864 instructs a student body of 23,129.

TEXAS TRAIL. Route, also known as the Long Trail, over which hundreds of thousands of head of cattle were driven from Texas to the ranges of northern Wyoming and Montana in the 1870s and 1880s. The trail lay near Moorcroft and Van Tassell, Wyoming. A tribute to the many cowboys who worked on cattle drives along the trail was erected near Lingle, Wyoming.

TEXAS, University of. State-supported coed university in AUSTIN, Texas. Chartered in 1881 and opened in 1883, the University of Texas is a vast educational system with professional and liberal arts universities located in ARLINGTON, AUSTIN, DALLAS, EL PASO, ODESSA, and SAN ANTONIO . HOUSTON, TYLER, GALVESTON, SAN ANTONIO and DALLAS also have university Health Science Centers. There is an observatory at Mount Locke and a marine sciences facility at Port Aransas. The largest and oldest division of the university is the University of Texas at Austin, which opened in 1883. A faculty of 2,000 instructs a student body totalling 46,148.

TEXAS WOMAN'S UNIVERSITY. State-supported institution located on a 270-acre campus 35 miles northwest of DALLAS in the community of DENTON. The university also maintains campuses in DALLAS and HOUSTON. Founded in 1901 by the Texas legislature, Texas Woman's University remained a women's school until recently when small numbers of men were permitted to enroll in its institute of Health Sciences. It is one of the largest universities for women in the United States. The majority of undergraduate degrees are conferred in health professions. A student body totalling 4,443 is instructed by a faculty of 554.

TEXOMA, Lake. Artificial lake located on the northern Texas border with Oklahoma. It was created by the construction of the Denison Dam on the RED RIVER. Lake Texoma extends northward into Oklahoma and provides a recreational area covering 225 square miles.

THEODORE ROOSEVELT NATIONAL PARK. The park includes scenic badlands along the LITTLE MISSOURI RIVER and part of Theodore ROOSEVELT's (1858-1919) Elkhorn Ranch. Established as Theodore Roosevelt National Memorial Park April 25, 1947, redesignated November 10, 1978. Headquartered MEDORA, North Dakota.

THERMOPOLIS, Wyoming. Town (pop. 3,-852), Hot Springs county, north-central Wyoming, northwest of CASPER and southwest of BUFFALO. The hot mineral springs at Thermopolis were considered so important that a joint treaty between the United States, ARAPAHO and SHOSHONE stipulated that the springs would be available to everyone free of charge. This agreement is still honored in Hot Springs State Park, a 956-acre tract with four large springs, hot waterfalls, and terraces. The park also contains one of the largest buffalo herds in Wyoming. Bighorn Hot Springs, which releases four million gallons daily, is one of the largest hot mineral springs in the world. Big Spring is the annual site on the first Sunday in August of the Indian pageant "Gift of the Waters."

THIRTY-TWO IMMORTALS. During the war for Texas independence, the Texas insurgents had captured SAN ANTONIO, leaving a light force to hold the city. When Mexican leader

Although not raised generally in present days, the longhorns remain a striking symbol of the Texas past.

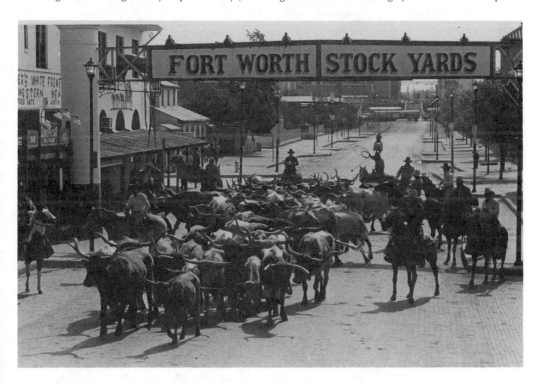

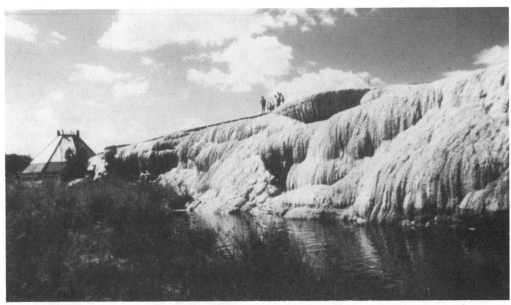

Thermopolis Hot Springs, Wyoming.

Antonio Lopez de SANTA ANA (1794-1876) approached with nearly 6,000 troops, the leaders of the American revolutionaries were divided and bickering among themselves. Sam HOUSTON (1793-1863) urged the San Antonio defenders to withdraw, but they could not because Dr. James Grant had taken most of the horses and wagons into Mexico on a foolhardy invasion attempt. The defending force moved into the Alamo, a deserted Spanish mission with heavy walls, often used as a fortress. Their commander, William Barret TRAVIS (1809-1836) sent out an urgent plea for help, but the insurgent leaders did not respond. However, thirty-two men from GONZALES, led by Captain Albert Martin, slipped through Santa Ana's lines and joined the 157 American defenders in the Alamo. They all knew it was hopeless, and all agreed that they would fight until the end, when they were indeed slaughtered by Santa Ana. Since that time those thirty-two brave volunteers to martyrdom have been known not only in Texas but around the world as "The Thirty-Two Immortals."

THOMAS GILCREASE INSTITUTE OF AMERICAN HISTORY AND ART. TULSA, Oklahoma, on handsomely landscaped grounds, which are claimed to display almost every bush and tree native to the region. A gift of Tulsa philanthropist Thomas Gilcrease in 1955, the Institute provides one of the most notable collections of art and other works related to the West. The collection includes some of the best-known works of Charles RUSSELL (1865-1926), George CATLIN (1796-1872), Frederic REMINGTON (1861-1909), Thomas MORAN (1837-1926), Alfred Miller and many others. Works of other periods and regions include those of Thomas Sully. The collection of Indian artifacts displays some dating back more than 12,000 years. The specialized library offers more than 75,000 volumes. Included in the library is the earliest known letter sent from the New World to Europe. The donor Thomas Gilcrease, was an Oklahoma oilman of Creek Indian descent.

THOMPSON FALLS, Montana. Town (pop. 1,478), seat of Sanders County, northwestern Montana, southwest of KALISPELL and northeast of MISSOULA. The first European-type house in Montana was built near present-day Thompson Falls by David THOMPSON (1770-1857), considered the greatest geographer of the early 1800s and the first person to follow the Columbia from its source to its mouth. The future community was named in his honor. Thompson Falls and nearby Belknap became rivals after the completion of the Northern Pacific in 1883. The railroad favored Belknap and refused to stop in Thompson Falls so its citizens placed huge logs on the tracks. While the trains were stopped residents of Thompson Falls boarded the trains and persuaded emigrants to settle there. Cool air seeping from crevices in the

ground near Thompson Falls range as low as 33 degrees. This frigid air has been used for refrigeration since the late 1800s.

THOMPSON, David. (London, England, Apr. 30, 1770—Feb. 10, 1857). Based on his explorations of 1789-1812, Thompson made the first definitive map of much of the northern part of the Central West region. The Indian name Kookoosint meaning "man who looks at stars," was given to the famed geographer and explorer who in 1810 built the first European-style house in Montana and for whom THOMPSON FALLS, Montana, is named. Between 1816 and 1821 Thompson served on the commission that explored the United States-Canada border. He died in obscurity until rediscovered as one of the great geographers of history.

THORPE, James Francis. (Prague, OK, May 28, 1888—March 28, 1953). Athlete. Thorpe, great-grandson of chief Black Hawk, is considered by some experts to have been the greatest athlete the world has ever known. Thorpe began his athletic career at the Carlisle (Pennsylvania) Indian Industrial School where he played on the football team from 1908-1912 and led the team to victories over such other teams as Harvard, Army, the University of Minnesota and the University of Pennsylvania. Thorpe was voted All-American in 1908, 1911, and 1912 and participated in the 1912 Olympic games in Stockholm, Sweden, winning four first place medals in the pentathlon and four first place medals in the decathlon. He returned the medals in 1913 at the request of the Amateur Athletic Union because of his participation in professional baseball in 1909-1910. Thorpe played professional baseball with the New York Giants in 1913, 1914, and from 1917 to 1919. He was the player-manager for the Canton (Ohio) Bulldogs professional football team from 1915 to 1922 and again in 1927. In 1920 Thorpe became the first president of the American Professional Football Association. In 1932 he was voted the greatest football player of the first half of the 20th century.

THREE FORKS OF THE MISSOURI RIVER. Discovered on July 25, 1804, by the LEWIS AND CLARK EXPEDITION, where the forks of three rivers joined. The rivers later were called the JEFFERSON RIVER, the MADISON RIVER and the GALLATIN RIVER, and they were declared by Meriwether LEWIS (1774-1809) to be three equal tributaries of the MISSOURI RIVER. The long

sought source of the main stream of the great Missouri had at last been located. A trading post was constructed on the site in 1810 by Pierre Menard and Andrew Henry, but twenty men were killed in Indian attacks and the post was eventually abandoned.

THREE FORKS, Montana. Town (pop. 1,-247). Southwest Montana, about 70 miles east of Butte. The community is noted mainly for its historic and geographic events and sites. Nearby is Missouri Headwaters State Park at the THREE FORKS OF THE MISSOURI RIVER. Three rivers unite there to provide the long-sought headwaters of the Missouri-Mississippi River System. The discovery of this source and its correct identification in 1805 was one of the most notable events of the LEWIS AND CLARK EXPEDITION. A tourist camp now, somewhat ironically, marks the expedition's campsite. Also near Three Forks is Madison Buffalo Jump State Monument, at the bluffs over which the Indian hunters drove the buffalo to their death. To the west of Three Forks is Lewis and Clark Caverns State Park.

TIBBLES, Susette La Flesche (Bright Eyes). (Bellevue, NE, 1854—Bancroft, NE, June 5, 1903. Indian artist, spokesperson for Indian rights. She was educated at the old Presbyterian Mission on the reservation of the Omaha Indians then went East to a private school. She first gained national attention for her work publicizing the plight of the Ponca Indians who were forced to move to an Oklahoma reservation in 1878. When Ponca Chief Standing Bear was arrested for leaving the reservation to return to Omaha that year to bury his son, Tibbles served as his interpreter in court. The ensuing case rendered the now historic ruling that an Indian is a person in the eyes of the law. While working with Standing Bear, she met and married an Omaha journalist and politician, Thomas H. Tibbles. Together the couple continued the fight for Indian rights through a lecture tour to major Eastern cities and Europe. Susette Tibbles is considered to have been the first woman to plead for Indian rights. Meeting Susette, poet Henry Wadsworth Longfellow exclaimed, "This is Minnehaha." The illustrations which she created for the book *Oo-ma-ha Ta-wa-tha* (1885) are said to be the first done by an Indian woman. A bronze bust of LaFlesche was unveiled on March 2, 1984, and placed in the Rotunda of the Nebraska state capitol at LINCOLN.

TIDELAND OIL DISPUTE. Conflict between the governments of Texas, California, Louisiana and the government of the United States dating back to the 1930s when vast quantities of oil were discovered in underwater locations lying along the coasts of the three states. The deposits remained untapped for years because of ownership controversy. Undisputed ownership was held by the states until 1947 when the Supreme Court ruled that the federal government had "paramount rights." The Court affirmed the earlier decision in 1950 when it declared that the federal government had dominion over the submerged land even though the states had always assumed ownership. These decisions applied to a three-mile-wide belt running parallel to the coast and known as the marginal seas. Resulting from the 1950 decision, the federal government impounded $8 million the states had collected in leases from various oil companies. On May 29, 1952, President Truman vetoed a bill from Congress which would have restored title in these lands to the states. Truman stated that he felt the land and its resources belonged to all the nation's people and not just that of the nearby states. A compromise worked out by Truman had earlier been rejected in the Senate. This compromise would have claimed 37 1/2 cents of the revenue from the marginal lands for the states with the rest going to aid for education in all the states.

TIMOTHY. Perennial grass, *phleum pratense*, grown widely in the Central West as hay for fodder. It is named for Timothy Hanson, a New Yorker who brought the seed to Virginia in 1720.

TIOGA, North Dakota. Town (pop. 1,597), Williams County, northwestern North Dakota, northeast of WILLISTON and north of DICKINSON. Tioga is one of North Dakota's largest processors of natural gas. As many as 65 million cubic feet are converted daily into butane, propane and gasoline.

TISHOMINGO, Oklahoma. Town (pop. 3,212), Johnston County, south-central Oklahoma, south of ADA and southwest of MC ALESTER. Tishomingo, named for a Chickasaw chief, was the capital of the CHICKASAW nation from 1856 to 1907. The Chickasaw Council House and Museum contains photographs and artifacts showing the history of the Indians since their migration westward from Mississippi and Alabama in 1838. Lake Texoma,

covering 89,000-acres, is bordered by the Lake Texoma Recreation Area in Texas and Oklahoma. Tishomingo National Wildlife Refuge on the Upper Arm of Lake Texoma is popular for observation of migratory waterfowl, fishing, and hunting in designated areas.

TITANOTHERE. Prehistoric rhinoceros-like animal found in fossil beds in Nebraska and in the White River fossil beds in North Dakota among others.

TOADSTOOL GEOLOGIC PARK. Part of the Ogallala National Grasslands along the South Dakota and Wyoming border and seventeen miles from CRAWFORD, Nebraska. Toadstool Geologic Park features a region of mushroom-like rock formations created by erosion.

TONGUE RIVER. Western river rising in Sheridan County in northern Wyoming and flowing north across the Montana border into the YELLOWSTONE RIVER in Custer County.

TONKAWA INDIANS. Nearly extinct nomadic Indian tribe which once roamed over east central Texas until moving to Oklahoma in the 19th century. The tribal name means "they all stay together." The language spoken by the Tonkawa is now classed as a separate linguistic family. The tribe consisted of many autonomous bands living primarily on buffalo, bear and deer. Religious customs prevented them from eating coyote or wolf. The Tonkawa also practiced cannibalism as did other tribes in the region. The Tonkawa lacked social cohesiveness and moved frequently. The men were noted as excellent horsemen and bowmen. In battle they wore hide vests and feathered helmets. Men wore their hair long in braids, while the women kept their hair short. The Tonkawa fought with the Spanish, but allied themselves with the United States in fighting the COMANCHE. Texas voted to deport all Indian tribes, and in the mid 1850s the Tonkawa moved to Indian Territory (Oklahoma). In 1862 more than half of the remaining 300 were killed in a combined attack by other Indian tribes in one of the many conflicts little understood by white chroniclers. In the late 1970s there were an estimated forty Tonkawa living on 481 acres in Kay County, Oklahoma.

TOPAZ. Texas has chosen the topaz as its official state gem. This gemstone is usually colorless or found in pale shades of yellow, blue or green. A hard gem, it is particularly effective in the "brilliant" cut.

Topeka, Kansas

The official drawing depicts the Kansas governor's home, Cedar Crest.

TOPEKA, KANSAS

Name: From the Siouan (Kansa) language for "good place dig potatoes (tubers)."

Nickname: The Capital City; The Center of the Nation.

Area: 52.5 square miles

Elevation: 951 feet

Population:
1986: 118,580
Rank: 142nd
Percent change (1980-1986): -0.1%
Density (city): 2,259 per sq. mi.
Metropolitan Population: 159,009 (1984)
Percent change (1980-1984): +2.6%

Race and Ethnic (1980):
White: 86.17%
Black: 9.51%
Hispanic origin: 4.64%
Indian: 1.05%
Asian: 0.53%

Age:
18 and under: 25.2%
65 and over: 13.9%

TV Stations: 4

Radio Stations: 9

Hospitals: 7

Further Information: Topeka Chamber of Commerce, 722 Kansas Avenue, Topeka, KS 66603

TOPEKA, Kansas. City (pop. 115,266), capital of Kansas and seat of Shawnee County, named for the Siouian word meaning a good place to dig potatoes or edible roots. It is situated on the KANSAS RIVER in central eastern Kansas, not in the center of the state as so many other states required of their capitals.

In addition to the substantial business of state, county and city government, Topeka draws on a rich agricultural region, distributing and processing a wide variety of produce, including meat packing and grain milling. Insurance and publishing are among the service industries, and manufactures include rubber products, processed steel and plastic sheeting; railroads shops add to the economy.

A ferry was established on the site in 1842 to afford crossing of the river on the OREGON TRAIL. When Colonel Cyrus Holliday and his associates planned their railroad, they formed a town company in 1854 to become eventually the eastern terminous of their line and named it Topeka. When Kansas became a state in 1861, the city was chosen as capital. The ATCHISON, TOPEKA AND SANTA FE RAILROAD began its westward growth in 1869, with its general offices and machine shops located at Topeka in 1878. The railroad is still important in the city's economy.

The city is known as one of the principal world centers of institutions devoted to mental health. The world-renowned MENNINGER FOUNDATION psychiatric clinic and research center has long operated there, and there are a veteran's mental hospital and a state mental center.

Washburn University operates at Topeka, and visitors are welcome to visit its Mulvane Art Center and Petro Allied Health Center, planetarium and observatory.

The capitol, situated on a twenty acre square in the city center, resembles the national capitol. Renowned murals by John Steuart Curry are a feature of the structure, and the grounds have notable statuary by Kansan Merrell Gage. The governor's mansion was

built in 1928 and given to the state in 1955.

Other stately homes are seen at Potwin Place, begun in 1869 and forming a distinctive part of the city's heritage. Other historical places and events are recalled at Kansas Museum of History and Kansas State Historical Society. The latter is said to preserve the nation's largest collection of newspapers outside the Library of Congress.

Annual events include the Huff'n Puff Balloon Rally in September, Combat Air Museum Airshow and Suberbatics also in September, and the Apple Festival in October.

TORNADOES. A whirling funnel cloud extending downwards from dark clouds. Approximately seven hundred tornadoes have annually been reported in the United States since the mid-1950s. "Tornado Alley," extending northeasterly from the PANHANDLE region of Texas through Oklahoma, Kansas, and northwest Missouri, averages more than two hundred tornadoes annually. A widespread region surrounding this area in the states of Oklahoma, Kansas, and Nebraska averages one hundred to two hundred tornadoes each year. A wide belt through southeastern North Dakota, most of eastern South Dakota, the panhandle of Nebraska and Oklahoma, eastern Colorado and New Mexico receives between ten and fifty. The westernmost extent of widespread tornado danger runs northward from the RIO GRANDE RIVER through the eastern portions of New Mexico, Colorado, Wyoming, Montana and all but the northwest corner of North Dakota. Tornado intensity is measured by the Fujita-Pearson Scale, a rating classification from 0-5 based on intensity, wind speed, and the length and width of the storm's path. F5 tornadoes are any with winds of more than 260 miles per hour. Damage from tornadoes is caused by high winds and extremely low atmospheric pressure inside the storm creating an imbalance inside buildings which causes them to explode. Notable tornadoes causing great loss of life in the Central West include that of April 27, 1942, when a tornado ripped through Rogers and Mayes counties in Oklahoma killing 52. In April 12, 1945, a tornado in Oklahoma and Arkansas killed 102, and two years later on April 9th a tornado passing through Texas, Oklahoma, and Kansas killed 169.

TOURISM. Some of the most dramatic and compelling natural attractions in the world may be found in the Central West, along with many manmade wonders and several of the outstanding fetes, festivals and notable events.

Colorado: As the state with the highest average elevation of all, Colorado contains more peaks over 14,000 feet than any other state, providing the most in the way of mountain attractions. ROCKY MOUNTAIN NATIONAL PARK typifies and emphasizes this aspect of the state. The road to the top of Mount EVANS is the country's highest. The PIKES PEAK ascent is famous, and TRAIL RIDGE ROAD is the world's highest major highway. At the other extreme is BLACK CANYON OF THE GUNNISON NATIONAL MONUMENT, noted for the shadowed depths of its sheer walls. GREAT SAND DUNES NATIONAL MONUMENT offers yet another contrast. Some of the finest prehistoric animal specimens have been found in DINOSAUR NATIONAL MONUMENT. A more recent prehistoric wonder is MESA VERDE NATIONAL PARK, the most notable of all the cliff dwellings. An even more recent manmade attraction is BENT'S OLD FORT NATIONAL HISTORIC SITE, principal outpost of civilization in the early 1800s. The metropolitan attractions of DENVER are contrasted with those of the riproaring mining communities such as CENTRAL CITY, LEADVILLE and GEORGETOWN. The COLORADO SPRINGS country with famed GARDEN OF THE GODS and AIR FORCE ACADEMY all help to make Colorado a prime tourist state.

Kansas: Kansas has no national nature preserves. FORT LARNED NATIONAL HISTORIC SITE and FORT SCOTT NATIONAL HISTORIC SITE preserve the state's past. Another national site of entirely different type is the vast EISENHOWER MEMORIAL MUSEUM AND LIBRARY at ABILENE, devoted to the general/statesman who grew to manhood there. By contrast, the memories of DODGE CITY spring from its infamous days as the wickedest town in the West. Visitors may see a reproduction of famed Front Street, and witness re-enactments of a shootout.

Montana: The precipitous peaks, GOING TO THE SUN HIGHWAY, 50 glaciers, grand hotels and enchanting animals help to make GLACIER NATIONAL PARK a major attraction of Montana. BIG HOLE NATIONAL BATTLEFIELD, site of the tragic drama of the defeat of the Nez Perce, and CUSTER BATTLEFIELD NATIONAL MONUMENT, recalling the army defeat, are striking historical contrasts. Montana, of course is the northern and northeast gateway to YELLOWSTONE NATIONAL PARK, the latter, BEARTOOTH HIGHWAY, has been called one of the world's most scenic. Historic BUTTE and HELENA recall many memories of Montana's rowdy and sometimes heroic early mining days.

Nebraska: AGATE FOSSIL BEDS NATIONAL MONU-

MENT preserves an important chapter in the evolution of mammals. Human annals are recalled in HOMESTEAD NATIONAL MONUMENT OF AMERICA, preserving probably the first land claim under the famous Homestead Act of 1862, and SCOTTS BLUFF NATIONAL MONUMENT, a major landmark on the OREGON TRAIL. OMAHA's attractions are highlighted by the annual AK-SAR-BEN Ball, considered one of the nation's ten most interesting annual events. One of the outstanding small museums is STUHR MUSEUM OF THE PRAIRIE PIONEER at GRAND ISLAND. Many visitors are attracted to the unique quality of the SANDHILLS country, with the hemisphere's largest stabilized sand dunes. The state capitol at LINCOLN is ranked fourth among the public buildings of the world.

New Mexico: A state with some of the most varied attractions of all. Three of its national preserves celebrate different aspects of nature. CARLSBAD CAVERNS NATIONAL PARK provides some of the world's best underground marvels. WHITE SANDS NATIONAL MONUMENT preserves the world's largest dunefields of gleaming gypsum, while CAPULIN MOUNTAIN NATIONAL MONUMENT presents the perfectly symmetrical cone of a recently extinct volcano. Seven national preserves offer unparalleled opportunities to study the unique Pueblo culture. INSCRIPTION ROCK of EL MORRO NATIONAL MONUMENT preserves the names and messages, petroglyphs and pictographs carved over the centuries into its soft sandstone. FORT UNION NATIONAL MONUMENT preserves a key defensive point on the SANTA FE TRAIL. TAOS PUEBLO provides visitors with a view of life still lived in some ways much as it was in Pueblo times. Both TAOS and SANTA FE are rich in such memories and in the art and artists who have added so much to the life of the area. The capital has become one of the world's noteworthy cultural centers, with one of the finest U.S. opera companies and an assemblage of art galleries incredible for its size. The ALBUQUERQUE region has many attractions, including the world's longest single span tramway to the top of Sandia Peak, and Old Town, recreating the atmosphere of an old Spanish community.

North Dakota: KNIFE RIVER INDIAN VILLAGES NATIONAL HISTORIC SITE preserves remnants of historic and prehistoric Indian villages. FORT UNION TRADING POST NATIONAL HISTORIC SITE retains the atmosphere of the principal fur trading depot in the Upper MISSOURI RIVER region. THEODORE ROOSEVELT NATIONAL PARK includes portions of the scenic BADLANDS as well as the locale associated with the man who became president after "maturing" in North

Dakota. More memories of Roosevelt are found at MEDORA, with its Rough Riders Hotel. INTERNATIONAL PEACE GARDEN marks the boundary between Canada and the U.S. For those who "collect" imaginary geography, the state provides opportunity to stand on the exact GEOGRAPHIC CENTER of the North American continent. At old FORT ABRAHAM LINCOLN near BISMARCK, visitors will recall the moment when George Armstrong CUSTER (1839-1876) galloped out of the gate with his seventh cavalry on the road to destruction.

Oklahoma: The state is unique in preserving the memories of the FIVE CIVILIZED TRIBES. Their well-built capitals, museums, recreated villages and descendants provide a glimpse of a history few Americans appreciate. Wealthy Oklahomans have been especially generous to their state in providing some of the country's finest museums, including the THOMAS GILCREASE INSTITUTE OF AMERICAN HISTORY AND ART, the PHILBROOK ART CENTER, and WOOLAROC MUSEUM, with perhaps the finest of all collections of the famed cowboy artists. Another splendid collection is found at INDIAN HALL OF FAME and Southern Plains Indian Museum and Craft Center. Memories of the country's most honored humorist, Will ROGERS ((1879-1935), abound in his home town of CLAREMORE. For some, a visit to OKLAHOMA CITY is worthwhile simply to see the nation's only oil well in the grounds of a state capitol.

South Dakota: Lovers of the colossal, which seems to include almost everyone, flock to the state for the striking view of the famed sculpture of four presidents that feature MOUNT RUSHMORE NATIONAL MEMORIAL. Others are intrigued by what some day may be an even larger memorial, the statue to Chief CRAZY HORSE (1829-1890), still under development. BADLANDS NATIONAL PARK preserves the fantastic natural wonderland of twisted shapes and brilliant colors of a "useless" area once scorned by Indian and European alike. JEWEL CAVE NATIONAL MONUMENT and WIND CAVE NATIONAL PARK provide contrast in setting. The historic mining towns of LEAD and DEADWOOD, are dedicated to preserving memories of their past. Deadwood's DAYS OF '76 provides one of the country's most noted annual celebrations. Visitor tours are available to the world's most valuable gold mine, the HOMESTAKE, at Lead.

Texas: BIG BEND NATIONAL PARK, RIO GRANDE WILD AND SCENIC RIVER and GUADALUPE MOUNTAINS NATIONAL PARK provide striking contrasts of mountain and desert. The later also preserves the world's most extensive and significant Permian

Lyndon Johnson Library at Austin, Texas, is one of the newer tourist attractions of the region.

fault. Quite different is PADRE ISLAND NATIONAL SEASHORE, noted for its wide sand beaches. BIG THICKET NATIONAL PRESERVE protects the "biological crossroads of North America." Prehistoric Americans are remembered at the ALIBATES FLINT QUARRIES NATIONAL MONUMENT. More recent events are commemorated at FORT DAVIS NATIONAL HISTORIC SITE and PALO ALTO BATTLEFIELD NATIONAL HISTORIC SITE. Very recent is the history recorded at LYNDON B. JOHNSON NATIONAL HISTORIC PARK and CHAMIZAL NATIONAL MEMORIAL. The major cities of Texas have much to offer. Most historic is SAN ANTONIO with its ALAMO and unique INSTITUTE OF TEXAN CULTURES. Among the most unusual downtown areas is the River Walk of SAN ANTONIO. HOUSTON offers the Battleship Texas memorial, the SAN JACINTO MEMORIAL and a massive downtown area. DALLAS has become one of the nation's significant centers of cultural activities and showplaces, with its new art museum among the most outstanding. EL PASO is the nation's largest border city, providing an amalgam of Mexican and U.S. customs and peoples. The capitol at AUSTIN is the nation's largest state capitol.

Wyoming: The most unusual natural preserve in the country and in the world, as well, is the principal natural attraction of the state—YELLOWSTONE NATIONAL PARK, with its variety of thermal features, grand canyon, lakes, rivers, beautiful scenery and fascinating animals. Just to the south is another nature preserve, the GRAND TETON NATIONAL PARK, where the TETON MOUNTAINS loom. They are often called the most beautiful range in the world. Nearby JACKSON HOLE area offers some of the best skiing, river rafting and other recreation in the country. Completely different is DEVILS TOWER NATIONAL MONUMENT, the nation's first in that category. This 865 foot tower of columnar rock projects itself from the flat prairie floor, made even more unusual by its corrugated appearance. FOSSIL BUTTE NATIONAL MONUMENT is noted for its abundance of rare fish fossils. FORT LARAMIE NATIONAL HISTORIC SITE honors the traditions of the original fur trading post and preserves the military establishment that guarded covered wagon trains from 1849 to 1890. Hot Springs State Park boasts the world's largest mineral hot springs. At CODY the museum complex is unique for a community of its size because it must rank among the notable

museum groups anywhere. FRONTIER DAYS at CHEYENNE is usually ranked as one of the ten best annual celebrations in the country.

TOURISM BUSINESS. In all of the states of the region the income from conventioners, business travelers and recreational visitors, is one of the five most important sources of income. Although Texas leads the Central West states in tourist income, its revenues from that source are only fourth in the production of annual income to the state. In spite of the wide variety of tourist and convention features available in such states as New Mexico, Colorado and Montana, Texas holds a commanding lead over the rest of the region. In fact, Texas income from tourism is higher than the total of all the other Central West states combined, stated in billions of dollars (1984):

Texas	13,700,000,000
Colorado	4,500,000,000
Oklahoma	3,000,000,000
New Mexico	2,100,000,000
Kansas	1,900,000,000
Nebraska	1,300,000,000
Wyoming	617,000,000
South Dakota	520,000,000
Montana	475,000,000
North Dakota	11,400,000

TOWER FALLS. At the end of the twenty-mile Grand Canyon of the Yellowstone, where Tower Creek plunges 132 feet in a nearly perfect column to meet the YELLOWSTONE RIVER in YELLOWSTONE NATIONAL PARK.

TOWER OF THE AMERICAS. Soaring steel and concrete observation structure constructed for the HemisFair exposition in SAN ANTONIO, Texas, on the 250th anniversary of the city's founding. The tower, rising 750 feet, is higher than the Seattle Space Needle or the Washington Monument. Visitors are carried to the top in glass-enclosed elevators. The first level, at 550 feet, features a restaurant which makes a complete revolution every hour. Designed by O'Neil Ford, the tower has two other levels for scenic observation of the city and surrounding countryside.

TRAIL RIDGE ROAD. Highest major highway in the nation, it follows an old Ute Indian

"TRAIL OF TEARS" by Lindneux portrays the terrible suffering of the Five Civilized tribes on their march to Oklahoma.

trail, with ESTES PARK, Colorado, one of the nation's leading resort centers, on one end and Grand Lake Village and GRAND LAKE at the other end. At its crest on the CONTINENTAL DIVIDE, it reaches its highest elevation.

TRANS-MISSISSIPPI INTERNATIONAL EXPOSITION. A World's Fair held at OMAHA, Nebraska, in 1898, which counted among its guests President William McKinley.

TRANSPECOS REGION. That part of Texas which lies in the Rocky Mountain System west of the PECOS RIVER.

TRANSPORTATION. For more than two centuries after the first Europeans visited the Central West region, foot transportation, horseback and Indian TRAVOIS prevailed throughout the region. In the northern regions where rivers permitted, early explorers and traders made their way by canoe, as did the Indians. However, some Indians only used the clumsy BULL BOATS.

Where a few crude roads were created by the Spaniards in the south, rough wagons could be used for those who could not ride horseback and for transport of freight. Don Juan de ONATE (1550?-1630), who first claimed the present American Southwest for Spain forded the RIO GRANDE RIVER into present Texas with a huge procession including his elegant ladies riding in ox carts, along with other oxcarts carrying their supplies.

Pioneer trails later were laid out with great difficulty, bringing the trade and travel of SANTA FE, over the SANTA FE TRAIL to the flourishing eastern states. The OREGON TRAIL was blazed and thousands of eager prospectors crossed over it, traversing the middle of the region, along with the even larger numbers of settlers on their way to new lands in many parts of the West. The ruts left by hundreds of thousands of wheels of conestoga wagons and carts may still be seen in a number of places in the region. The Red River oxcarts, with their squeaky wheels crossed the northern sections in thousands. The Bismarck and Cheyenne trails were well known, and the Mullen Road was an important military right-of-way between Montana and Washington.

As roads improved, passengers and light freight were carried by swift STAGECOACHES. The famous BUTTERFIELD OVERLAND DESPATCH EXPRESS and the even larger RUSSELL, MAJORS AND WADDELL were among the many companies in the field. Such travel was often dangerous. If gold or other important cargo was aboard, a famed gunslinger might be riding shotgun beside the driver, and many a stagecoach robbery and shootout has been repeated in movies and on TV.

There were regular stagecoach stops for fresh horses and overnight stops for all. Passengers might be lucky on some routes to find a log cabin with a thatched roof where each could sleep on the dirt floor for fifty cents.

River traffic was the easiest in some ways, since the routes were already in existence, but the shallower waters of many of the rivers made river travel difficult. The first steamboat reached the MISSOURI RIVER in 1819, and steamboats penetrated to the heart of the continent on the Missouri. The RED RIVER OF THE NORTH became an important river route, as well as smaller streams. Even the extremely shallow JAMES RIVER in South Dakota felt the paddlewheels of steamers. One account noted, "The craft is composed of a steam whistle, an engine the size of a teakettle, and a little boat under it." The Missouri is still very important for barge traffic motivated by towboats.

The Central West region presented monumental problems for road and railroad builders, who were forced to surmount the numberless ranges of the Rockies and to pierce the highest divides with tunnels costly in both money and lives lost.

Not until the coming of the railroads could transportation be considered "rapid." The year 1869 saw the first transcontinental railroad completed, built with extraordinary speed through the Central West region, crossing Nebraska and Wyoming. For the first time, passengers and freight could move across the country by rail.

The Northern Pacific Railroad reached the RED RIVER OF THE NORTH in 1871, arrived at FARGO, North Dakota a year later, and the first train reached BISMARCK June 5, 1873. By 1881 the first transcontinental tracks had reached Montana. The last spike in that first northern route across the country was driven on September 8, 1883, near Garrison, Montana.

To the south the ATCHISON, TOPEKA AND SANTA FE RAILROAD began building westward at TOPEKA, Kansas, in 1868. It had reached DODGE CITY by 1872. SANTA Fe, New Mexico, was connected in 1880. A year later the Santa Fe had joined with the Southern Pacific Railroad to complete the southern route across the continent.

From those first major railroads, others soon spanned the region, and before the century was over almost every town could boast at least one

railroad. Wherever the railroads went, towns sprang up, and business flourished. The great cattle trails from Texas connected with the Santa Fe as it built west from town to town, and it became possible to ship cattle and fresh meat to the markets of the east. In the wheat growing areas of Kansas, the Dakotas and elsewhere in the region, grain elevators sprang up at almost every town and railroad junction.

Railroads dominated the nation's transport until the late 1940s, when overland trucking began to take over much of the freight business, and the airlines commenced their gradual takeover of the passenger traffic.

Today, of course, every major city of the region has a substantial airport, with the airports of KANSAS CITY, DENVER, OMAHA, DALLAS and HOUSTON of world rank.

Seven Interstate highways traverse the region from east to west, and three carry traffic from north to south, along with countless lesser roads. The railroads continue to criss-cross the region, being more important today for freight than for passengers, who are still carried on the Amtrak routes.

TRAVIS, Colonel William Barrett. (near Red Banks, SC, Aug. 9, 1809—The Alamo, San Antonio, TX, Mar. 6, 1836). Military officer. His early career included teaching and the practice of law. In 1831 he moved to Texas, where he became involved in the 1836 fight for independence. Travis led troops at Anahuac and SAN ANTONIO before he was appointed commander of the Texas patriots. His forces were charged with defending the ALAMO against Santa Anna's Mexican troops in March, 1836. Although advised to leave he decided to remain and was one of many Texas soldiers who died at the Alamo.

TRAVONA MINE. At this site in Butte, Montana, the mine, which eventually reached a depth of 1,500 feet, was established on New Year's Eve in 1874 by prospector William Farlin. He named his mine the "Asteroid" with hopes that it would better his other claims. The mine produced hundreds of thousands of dollars in silver and a second fortune in manganese. The property was sold to copper king William Clark who changed the name of the mine to Travona, after a province in the Balkans. The mine operated between 1874 and 1954.

TREATY OF MADRID. Agreement in 1801 in which Spain returned all of Louisiana to France. The treaty caused great concern among Americans who used the Mississippi River. Louisiana controlled by Spain posed no threat to American farmers who transported their harvests to New Orleans for shipment. That privilege, known as the "right of deposit" was not assured under French rule. American desire to use the Mississippi eventually led to the Louisiana Purchase, one of the United States' outstanding real estate transactions.

TREE-IN-THE-ROCK. Picturesque evergreen growing on old U.S. route 30 between LARAMIE and CHEYENNE, Wyoming. It is said to be the most photographed single object in the state.

TRINIDAD, Colorado. City (pop. 9,663), Las Animas County, southeastern Colorado, southeast of Walsenburg and southwest of Rocky Ford. Trinidad has developed into a thriving coal-mining and railroad center from being a supply center on the SANTA FE TRAIL. The downtown area, known for its brick streets and architecture, is called "Corazon de Trinidad" (Heart of Trinidad). The A.R. Mitchell Memorial Museum and Gallery features the work of western artists. Exhibits in the Baca House and Pioneer Museum, a two-story territorial-style adobe dwelling dating from 1865 when it was purchased in 1870 by Felipe Baca, a wealthy sheep rancher, show the lively days of the Santa Fe Trail, the contributions of Spanish-speaking people, and the development of Trinidad.

TRINITY RIVER. Western river near WICHITA FALLS, Texas, which flows through FORT WORTH. The Trinity is formed by the meeting of the Elm Fork and West Fork northwest of DALLAS, through which it also flows, and passes through Lake Livingston on a course of 550 miles southeast into Trinity Bay, the northern arm of Galveston Bay.

TRINITY SITE. New Mexico, where the world's first atomic device was tested. Under the tremendous heat of the blast, the white gypsum sands were turned into glass.

TRINITY UNIVERSITY. Independent coed liberal arts institution located on a 107-acre campus in SAN ANTONIO. The school is related by covenant, not legal ties, to the United Presbyterian Church. Founded in 1869, Trinity has had three homes: Tehaucana (1869-1902), Waxahachie (1902-1942), and San Antonio

(1942-). Degrees are offered in a multitude of graduate and undergraduate fields and academic emphasis is on pre- professional and professional programs, natural sciences, humanities and social sciences. Undergraduate studies are offered in business and management studies, communications and the arts, education, humanities, sciences, mathematics and engineering, and social and behavioral sciences. Almost 30% of all students pursue advanced studies soon after graduating; 10% enter business school, 3% medical school, 3% dental school, 2% law school. Trinity is among the nation's top 65 producers of successful dental school applicants. Library: 499,381 volumes, 58,615 microform titles, 2,808 journal subscriptions, 4,377 records/tapes. Faculty: 300. Enrollment: 3,255 total graduate and undergraduate; 1,139 men, 1,274 women (full-time). Degrees: Bachelor's, Master's.

TRUCHAS PEAKS. Northern New Mexico, in Rio Arriba County northeast of SANTA FE. The highest of the three peaks is 13,110 feet high.

TRUTH OR CONSEQUENCES, New Mexico. Town (pop. 5,219), Sierra County, southwestern New Mexico, northwest of ALAMOGORDO and northeast of Bayard. Truth or Consequences may be the only city in the world to have chosen its name from a radio program. A live broadcast of the popular *Truth or Consequences* hosted by Ralph Edwards in 1950 caused so much attention to be focused on the small community of Hot Springs, New Mexico, that its residents chose the name of the program for their community. T or C as it is often called has become a rapidly developing retirement, resort and recreation center in the Southwest. The community benefits from the 110 degree F thermal springs once kept secret by the APACHE INDIANS. Water sports may be enjoyed at nearby Elephant Butte Reservoir.

TSA-LA-GI. Reconstructed Cherokee village, southeast of TAHLEQUAH, Oklahoma, where CHEROKEE life has been recreated with substantial realism. Tours are given from May to early September by Cherokee guides.

Tsa-La-Gi village at Tahlequah, Oklahoma, recreates the pioneer life of the Cherokee in their new home.

TSIMAJO INDIANS. Noted weavers living in and around the New Mexico town of Chimayo, where the softly colored Chimayo rugs and blankets woven by the Tsimajo are available for sale.

TSWANKAWI CLIFF DWELLINGS AND RUINS. New Mexico Indian settlement at which petroglyphs, pictures carved in the walls, are so large and horrible that it is thought they were intended to frighten away the enemies of the artists.

TUBBS, Alice (Poker Alice). (—). Poker, of course, was the favorite card game of Alice Tubbs, known around STURGIS, South Dakota, as "Poker-Alice", for skill in the game. One of the many noted women of the old West, Poker Alice generally "scooped" the suckers, particularly the soldiers from nearby FORT MEADE". They were "scooped" or cleaned out on a fairly regular basis by clever poker players, of whom Alice was the most notable. This practice gave Sturgis the nickname of "Scoop Town.

TULAROSE BASIN. Southern New Mexico location of vast amounts of ground water, extending below 6,500 square miles of the surface, which cannot yet be used for irrigation due to its high salt content.

TULSA, OKLAHOMA

Name: The name and some ashes from the ancient Creek town of Tulsa "town-old" were brought to Indian territory by the Creeks and bestowed upon a settlement there.

Nickname: "Tul see" town; Oil Capitol of the World; Home of the International Petroleum Exposition.

Area: 186.1 square miles

Elevation: 804 feet

Population:
1986: 373,750
Rank: 37th
Percent change (1980-1984): +3.6%
Density (city): 2,008 per sq. mi.
Metropolitan Population: 725,569 (1984)
Percent change (1980-1984): +10.4%

Race and Ethnic (1980):
White: 82.6%
Black: 11.8%
Hispanic origin: 6,291 persons (1.71%)
Indian: 13,816 persons (3.81%)
Asian: 2,962 persons (0.78%)
Other: 2,370 persons

Age:
18 and under: 25.8%
65 and over: 10.8%

TV Stations: 8

Radio Stations: 13

Hospitals: 9

Sports Teams:
Tulsa Drillers (baseball)

Further Information: Tulsa Chamber of Commerce, 616 South Boston, Tulsa, OK 74119.

TULSA, Oklahoma. City, Seat of Tulsa County, formed around the sharp curve of the great ARKANSAS RIVER, in northeast Oklahoma. The name of this second largest city in Oklahoma apparently comes from the two Creek Indian words old and town.

Calling itself the Oil Capital of the World, the city is headquarters for over 600 energy and energy-oriented firms, employing 30,000 persons. Gas and oil fields surround the city. However, the economy is well balanced with 1,100 manufacturing plants, with aviation and aerospace as the second largest industry. It is a major center of transportation with several of American Airlines principal operations. The city gained another star in its transportation crown with the opening of the MCCLELLAN-KERR ARKANSAS RIVER NAVIGATION SYSTEM. With its port at Catoosa three miles to the south, the city is the westernmost interior port of the U.S.

The community began to grow in earnest with the coming of the railroad in 1882, and it was incorporated in 1898. In 1901 when oil was discovered across the river, Tulsa offered to provide a safe leisurely homesite for oil workers and their home companies, where the bustle and dislocation of the wells themselves was not permitted. It has held to this course ever since, becoming in the process one of the cultural centers of the Southwest.

Adding to that base is the University of TULSA. Oral Roberts University is a unique

center of education. One of the finest collections of Western art, presented in one of the most effective settings, is the THOMAS GILCREASE INSTITUTE OF AMERICAN HISTORY AND ART. Frederick REMINGTON (1861-1909), Thomas MORAN (1837-1926), Charles RUSSELL (!865-1926), George CATLIN (1796-1872) and other outstanding artists are represented. Its collection of Indian materials dating to prehistoric times is one of the best. The grounds and gardens are planned with the goal of including every bush, shrub and tree that will grow in the area.

Another museum with a fine collection is the PHILBROOK, which includes the unsurpassed Kress Collection of Italian Renaissance paintings. Its other collections are among the most complete and diverse of their type, ranging from African to Chinese. The collection is housed in a villa of the Italian Renaissance, surrounded by 23 acres of gardens.

Among other art collections is the Gershon and Fenster Gallery of Jewish art

Theater Tulsa is the oldest continuing theater operation in Oklahoma.

The Boston Avenue Methodist Church is considered to be one of the finest modern churches in the U.S., featuring a 225 foot tower, splendid bas relief of historical figures and a sanctuary with outstanding Italian mosaic in the reredoes.

Big Splash Water Park, with its wave pool, and Bell's Amusement Park are two of the outstanding recreation areas of their type.

The remarkable Tulsa Garden Center and three nearby state parks add to the outdoor possibilities of the area.

The International Finals Rodeo in mid January brings together the top cowboys and cowgirls to determine the world championships. The Gilcrease Rendezvous in May recreates the historic fur traders renezvous, an important part in the history of the West. The annual Tulsa Indian Pow-wow is held in late July and early August.

TULSA, University of. Oklahoma institution of higher learning originally established as the Henry Kendall College in Muskogee, Indian Territory, in 1894. The present name was adopted in 1920, thirteen years after the school was moved to its permanent location. The university was widely recognized for its College of Petroleum Sciences and Engineering, one of the first of its type. During the 1985-1986 academic year the university enrolled 5,156 students and employed 420 faculty members.

TURQUOISE. New Mexico, the center of U.S. Southwest turquoise "culture," has chosen this opaque, waxy gem as its state gem. It was used in the area by the prehistoric peoples for ornamentation, and some of the finest turquoise jewelry has been crafted by the Indian peoples of the Southwest. Turquoise jewelry has become increasingly popular in the rest of the country at very rapidly increasing prices, benefitting the Indian and other turquoise artists.

TURTLE EFFIGIES. Mounds in the shape of turtles frequently found in the hills west of the MISSOURI RIVER. Turtles played an important role in the medicine ceremonies of the MANDAN INDIANS, and this suggests the mounds may have been built to win the favor of some spirits. Other theories suggest the turtle figures simply pointed weary Indians to sources of water.

TURTLE MOUNTAINS. Small range in North Dakota's Rolette and Bottineau counties.

TURTLE RIVER. North Dakota stream named for the many small terrapin found along its shores. It flows near GRAND FORKS through TURTLE RIVER STATE PARK, a site of fifteen mounds constructed by prehistoric people.

TURTLE RIVER STATE PARK. Site near GRAND FORKS, North Dakota, of fifteen mounds constructed by prehistoric man. Excavations by the University of Minnesota have found copper instruments and an ivory pipe. Unlike many other mounds in the state, these had been plowed over and the area cultivated until they were only small humps.

TUSKAHOMA, Oklahoma. CHOCTAW NATION capital in Oklahoma. The capitol building, erected in 1884, was restored in 1938 by the Choctaw who annually hold a tribal meeting there.

TWO OCEAN PASS. Location just south of YELLOWSTONE NATIONAL PARK which has been described as "the most remarkable example of such phenomena in the world." When the water in a nearby canyon is high, the flow separates exactly at the crest of the CONTINENTAL DIVIDE and flows into both Atlantic and Pacific creeks, named for the destination of their waters thousands of miles apart.

TYLER, Texas. City (pop. 70,508), seat of

Smith County, in northeast Texas. Named for President John Tyler and settled in 1846 during the early days of the Texas Republic, Tyler's present economy is based primarily on agriculture, oil, gas, and manufacturing. It is noted for its municipal rose gardens and its annual Texas Rose Festival. It is the home of

Texas College and Butler College.

TYRANNOSAURUS REX. Considered king of the dinosaurs. A nearly complete skeleton was uncovered north of Jordan, Montana, on Hell Creek and others have been found in various sections of the Central West region.

U

UDALL, Kansas. Town (pop. 891), Cowley County, south-central Kansas, northwest of WINFIELD and southeast of WICHITA. Udall was the scene, in 1955, of the worst tornado damage in Kansas history, a storm resulting in the death of sixty-five people.

UINTA MOUNTAINS. Range of mountains; including Kings Peak, Utah's highest peak at 13,528 feet; centered in northeastern Utah stretching along the boundary between Daggett and Summit counties. This is the only major range in the United States to lie east and west.

UINTAH INDIANS. One of the four main groups into which the seven tribes of Colorado UTE were divided.

UNDERGROUND RAILROAD. Highly developed escape route assisting former slaves in their flight to the North and Canada. Those who operated the route, neither underground nor a railroad, used railroad terms as a code to cover their activities. Beginning about 1840 and continuing into 1860, Abolitionists in the North established "stations" operated by "conductors," whites who would willingly help slaves hide from pursuers and move swiftly to another location at night. The underground railroad operated vigorously in Nebraska in violation of the Fugitive Slave Laws. One of the principal routes ran through the northeastern corner of Kansas into and through the southeastern corner of Nebraska into Iowa. A major station in the area was John Brown's cave near NEBRASKA CITY, Nebraska. The conductor, famed

Abolitionist John BROWN (1800-1859), also operated from a cabin near OSAWATOMIE, Kansas, owned by his brother-in-law, another conductor. The cabin now stands in Osawatomie's John Brown Memorial Park.

UNICAMERAL LEGISLATURE. A legislative body with one chamber. While municipal councils in the United States are generally unicameral, the only state with a unicameral legislature has been Nebraska, since 1936. Unicameral legislature proponents argue that it is less costly, more efficient, reduces overlapping of functions and duplication, and eliminates political bickering.

UNION COLLEGE. Private college established by the Seventh Day Adventists in 1891. Located in LINCOLN, Nebraska, the college awards Associate and Bachelor degrees. Union College enrolled 750 students and employed 84 faculty members during the 1985-1986 academic year.

UPPER REPUBLICAN CULTURE. One of several groups of people to live in the area of present-day Nebraska prior to the FOLSOM culture.

URANIUM. Uranium for the world's first atomic bomb was mined in the plateau region of Colorado. As early as 1898, a radioactive material (carnotite) was shipped from Colorado to the famed Curies of France for their work on X-rays. Colorado still produces substantial uranium. In North Dakota the recovery of uranium

from the rich lignite beds in the southwest went into production in 1963. In New Mexico uranium mining has provided a substantial source of royalties to the Navajo people since production began there in 1952. There are a number of other uranium sources in the state. Uranium has ranked as high as a third of the value of Wyoming mineral production.

UTE INDIANS. A powerful tribe in the early 19th century living in western Colorado and eastern Utah. The Ute referred to themselves as Nunt'z, or "the people." The acquisition of the horse in the 18th century ended their practice of traveling in small hunting and gathering groups. Larger bands were organized for communal buffalo hunts in the fall and for raids. Seven bands emerged as the Ute confederacy. While family groups maintained their own leadership, each band had a council and chief. Primitive brush shelters and conical pole-frame shelters covered with bark were replaced with buffalo skin tipis. After 1830, the buffalo had disappeared from the Ute territory, and other game including antelope, rabbits, ducks, and sage hen, were hunted. Coyote, wildcat, and wolf were hunted for their furs, but were not eaten. Eaglets, taken from their nests, were raised for their feathers. Ute clothing included finely-tanned buckskins, which were also traded, and rawhide eye shields for bright sun. Ear ornaments, face painting and tattooing were used for adornment. In 1863, the United States called a council of the Ute bands to convince them to move west of the CONTINENTAL DIVIDE. The Ute agreed as long as western Colorado, west of the Divide, was reserved for them. This arrangement ended with the discov-

ery of gold in the area. The land desired by the Ute was ceded by treaty in 1873. A Southern Ute Reservation was established along the New Mexico-Colorado border in 1877. Capote and Mouache bands merged to form the Southern Ute Tribe and took allotments in the eastern section of the reserve. The Weminuche, now called the Ute Mountain Tribe, took the western part of the reservation and raised cattle. The Yampa, Parianuch, Uintah and Uncompahgre bands, known as the Northern Ute, were assigned to the Uintah and Ouray Reservation in northwestern Utah. In later years the Confederated Ute Tribes won a judgement totalling thirty-one million dollars against the United States government for lands taken from them. The money was divided between the Mountain, Northern and Southern Ute. Living conditions on the reservations have benefitted from oil and gas leases, stockraising, and tourist facilities.

UVALDE, Texas. City (pop. 14,178), seat of Uvalde County, southwestern Texas, southwest of SAN ANTONIO and northwest of CORPUS CHRISTI. Uvalde, publicized as the Honey Capital of the World, was the home of John Nance GARNER (1868-1967), Speaker of the House of Representatives and Vice President of the United States during the first term of F.D. Roosevelt. Named for a Spanish commander who fought Indians in 1790, Uvalde was settled by cattlemen in 1853 and protected by nearby Fort Inge. The region along the NUECES RIVER to the southwest was infested with cattle thieves and outlaws, but most trouble came from Indians who continued their raids until the 1880s. Today the region around Uvalde is a center for the raising of angora goats.

VAIL, Colorado. Town (pop. 2,261), Eagle County, central Colorado, east of Eagle and northwest of LEADVILLE. One of Colorado's premier resort communities, Vail is internationally recognized for its winter sports facilities developed after WORLD WAR II by American paratroopers who had trained in the area. The largest single-mountain ski resort in North America, the ten square mile Vail Ski Area and Gondola features sixteen chairlifts and an enclosed gondola serving winter skiers and summer sightseers. Vail celebrations include Vailfest in September and the Vail Institute series of cultural and musical programs in early July to September. On the Mount of the Holy Cross, near Vail, the effect of a cross is caused

by snow in a deep vertical fissure 1,200 feet long cut by another fissure at right angle. The cross was the subject of a poem by Longfellow and many paintings and sketches by Thomas MORAN (1837-1926).

VALENTINE, Nebraska. Town (pop. 2,829), seat of Cherry County, north-central Nebraska, north of NORTH PLATTE and east of CHADRON. Twice annually the area's buffalo calves are tagged, branded and turned loose. The roundup occurs on the Fort Niobrara National Wildlife Refuge, home to a herd of 150 Texas longhorn cattle, a rare prairie dog town, deer and pronghorn. Valentine, on the northeast section of Nebraska's Sand Hills, the largest dune area in the Western Hemisphere, has an economy principally based on cattle ranching.

VALIER, Montana. Town (pop. 640), Pondera County, north-central Montana, south of Cutbank and northwest of Conrad. Valier, settled primarily by Belgians, is one of Montana's many communities which trace their early settlement to one major nationality.

VAN der STUCKEN, Frank. (Fredericksburg, TX, Oct. 15, 1858—Aug. 16, 1929). Music conductor. Van der Stucken was the successor to Theodore Thomas as the music director of the renowned Cincinnati May Festivals. As a student, Van der Stucken lived in Europe and studied at the Conservatory of Music in Antwerp under Peter Benoit. After conducting throughout Europe Van der Stucken returned to America where he held many positions including conductor of symphony concerts in Cincinnati from 1895 to 1907. He also was known as a composer of marches.

VAN DYKE BROWN. A coloring material in paints for artists, it is based on LIGNITE, a form of coal, in its production. Nearly fifty percent of the United States' supply of Van Dyke brown is processed in Bowman, North Dakota.

VANADIUM. Silver-white metal used to strengthen steel and other metals, found primarily in Colorado which has produced seventy-five percent of the material in the United States. Alloys of vanadium, resistant to rust, are used in springs, axles, and automobile frames, among other products.

VERDIGRIS RIVER. East central Kansas river which rises in southeast Chase County and flows south through Toronto Lake and past

Vail, Colorado, provides some of the world's best skiing, among many other attractions.

INDEPENDENCE, Kansas, across the Oklahoma border into Oologah Lake before entering the ARKANSAS RIVER in Muskogee County in eastern Oklahoma.

VERENDRYE FAMILY. Pierre Gaultier de Varennes, known as Sieur de La Verendrye, came into present-day North Dakota in 1738 on one of many expeditions to find a route to the Orient and rich areas for trading and trapping. He visited the MANDAN Indians and explored along the PEMBINA RIVER and past the TURTLE MOUNTAINS until he reached the Mandan village located near modern-day Menoken. He was accompanied by his two sons, Francois and Louis-Joseph, on a journey from Canada in 1742 to find the sea everyone believed was not far to the west. They reached the BLACK HILLS before the sons turned back, while their father continued on into Montana. Francois and Louis-Joseph have been credited with being the first Europeans to visit the present state of South Dakota. While camped along the MISSOURI RIVER, the brothers buried a lead and zinc plate with a Latin inscription claiming the area for their king, Louis XV. The other side of the plate read, "Placed by the Chevalier de La Verendrye Lo Jost Verendrye, Louis La Londette A Miotte, The 30th March 1743." The plate was found by Hattie Foster and George Reilly near PIERRE, South Dakota, on February

16, 1913. A record that the plate had been buried beneath a pile of rocks had been found in the journals of the explorers, but since the pile of stones had been removed no one ever thought the plate would be seen again. Today the site where the plate was discovered is marked by a monument erected in 1933, and the plate rests in the Historical Museum of the Memorial Building in Pierre.

VERENDREYE PLATE. On that February 16, 1913, day when Hattie Foster found a piece of dirty metal in the ground, she and her playmate George O'Reily had no idea that they were holding an important piece of history in their hands. The site was a gumbo hill near PIERRE, South Dakota. Their find dated back 170 years to March 30, 1743, when another group of people stood on the same hill. These were the French brothers VERENDREYE, Francois and Louis-Joseph. While they camped on the hill overlooking the MISSOURI RIVER, they buried a metal plate of lead and zinc. This bore the inscription "Placed by the Chevalier de La Verendrye Lo Jost Verendrye, Louis La Londette A Miotte, the 30th March 1743." Placing a pile of stones over the location, they informed the Indians that this was a memorial. Their actual intention was to claim the whole vast territory for France. Although historians had known about the incident it seemed impossible that the treasured plate would ever be found. Historians agreed that the object found by Hattie and George was indeed the long sought land claim, and it was purchased by the State Historical Society. The plate may still be seen in the Society's museum at Pierre, and a memorial was erected on the site of the discovery in 1933.

VERMILLION RIVER. South Dakota. Rises in Lake County and flows south into the MISSOURI RIVER on the boundary of Clay County. The river flows west of SIOUX FALLS and VERMILLION and east of YANKTON.

VERMILLION, South Dakota. City (pop. 9,582), Clay County, extreme southeastern South Dakota. Vermillion, on the VERMILLION RIVER's banks of red clay for which the town and river are named, is home of the main campus of the University of SOUTH DAKOTA, established by the territorial legislature of 1862 without funds to operate. At the university's Shrine to Music Museum over 2,500 musical instruments from all over the world are displayed, including a zither made in the form of a crocodile. The

W.H. Over Museum on the university campus contains an extraordinary collection of Indian relics. Spirit Mound, north of town, is one of the best known mounds of prehistoric people in the state. Indians, seeing so many birds on the hill, believed the spot to be enchanted. Lewis and Clark were among the first white men in the region. In 1835 the American Fur Company built a trading post in the area, but the site was washed away.

VICTORIA, Kansas. Town (pop. 1,328), Ellis County, central Kansas, east of HAYS and southwest of Russell. Victoria is the home of St. Fidelis Church, known as the "Cathedral of the Plains." The cathedral with its twin 140 foot towers, was built by religious German-Russian immigrants, each assessed $45.00 and six loads of stone. The stained glass windows were imported from Munich, Germany. Before these settlers, Victoria was occupied by wealthy Englishmen who brought fine cattle, sheep and horses with them from England, but they seemed more interested in saloons, dancehalls and coyote hunting on horseback than ranching. The Victoria Colony of the English folded within five years and was absorbed by the German-Russian settlement to the north called Herzog. The residents of Herzog renamed their town Victoria in memory of the area's English heritage.

VIGILANTES. Citizen organizations, formed without official recognition to eliminate conditions felt a danger to life and property in the absence of effective laws or law-enforcement officials. Also called committees of vigilance or regulators, such committees were common in the United States before they arose in the West. In the West the vigilantes opposed the activities of horse thieves and killers. The vigilantes attempted to regulate society, but sometimes the ideal soured and the organizations evolved into instruments of power and privilege. The Stranglers, a group of powerful Montana cattlemen, led by rancher Granville Stuart organized in 1884 as vigilantes. Their intent was to clear the county of smaller ranchers, sheepmen, and horse and cattle thieves. They were accused of many atrocities. "Strangler" became a general term for vigilantes given by those who disapproved of their activities. While generally started when law enforcement was absent, some vigilante groups acted out of sheer impatience with the legal process. Often the leaders of such groups were the most responsible and respected members of society. Almost every

western area saw some vigilante activity, and often the operations of the groups quickly resulted in restoring peace and bringing lawful order to a region, although in a sense actual violations of law had been practiced.

VILLA, Francisco (Pancho). (San Juan del Rio Durango, Mexico, June 5, 1878—Parral, Chihuahua, Mexico, July 20, 1923). Mexican revolutionary and bandit. In 1916 Villa led nearly one thousand followers in an attack on COLUMBUS, New Mexico, in which houses were burned and several Americans were killed. American troops commanded by General John J. PERSHING (1860-1948) hunted Villa who escaped with the help of the poor residents of Chihuahua among whom he was popular. He escaped Pershing, who had followed him into Mexico, but his operations within the U.S. were not repeated.

VINITA, Oklahoma. City (pop. 6,740), Craig County, northastern Oklahoma, southeast of BARTLESVILLE and northeast of TULSA. Vinita was named after sculptress Vinnie Ream, the first woman to be granted a federal art commission, who created the pensive statue of Abraham Lincoln at the U.S. capitol. Will ROGERS (1879-1935), who attended secondary school at Vinita, once promised to visit a rodeo in this community, but was killed before he could keep his promise. Since his death the city has held the Will Rogers Memorial Rodeo in his memory. Vinita is the gateway to the western shore of Grand Lake, created in 1941 with the completion of the Pensacola Dam on the Grand River. Artifacts from the area, and Vinnie Ream memorabilia, are contained in the Eastern Trails Museum.

VINTACOLOTHERIUM. Rare prehistoric six-horned animal whose remains were discovered in Colorado in 1926.

VIRGINIA CITY, Montana. Town (pop. 192), Madison County, southwestern Montana, northeast of DILLON and southeast of BUTTE. Virginia City, was the first town to be incorporated in Montana, known as the "cradle of Montana." Founded in 1863 near the gold strike on Alder Gulch, it was named Varina by Confederate sympathizers in honor of the wife of Jefferson Davis, President of the Confederate States of America. Union supporters blocked that name, and the community was renamed Virginia City. It was the second capital of Montana Territory and the site, in August,

1864, of the first newspaper published in Montana. Within a month after the first gold was found, 10,000 miners had descended on the region. Once one of two or three "important" towns in the United States, within ten years it had become a ghost. In 1946 a restoration program was begun, and Virginia City has regained popularity through the efforts of Charlie Bovey. The Thompson-Hickman Memorial Museum, a gift of William Boyce Thompson, displays memorabilia of the gold camps. The Bale of Hay Saloon features a working collection of hurdy-gurdies and stereopticon peep shows. St. Paul's Memorial Church is renowned for its Tiffany stained-glass windows. Bill Fairweather, discoverer of gold at Alder Gulch and eccentric who scattered gold dust in the streets for the children of Virginia City, is buried in Boothill Cemetery. Visitors have enjoyed the ride on the Alder Gulch short-line railroad old-time steam train between Virginia City and New City.

VIRGINIA DALE, Colorado. Village, Larimer County, north-central Colorado, northwest of Fort Collins and northeast of Craig. Virginia Dale was named for a stagecoach station established in 1862 when the Overland Stage was temporarily forced out of Wyoming by the intensity of Indian attacks. Steamboat Rock near Virginia Dale is a local landmark said to resemble an old-fashioned steamer with two funnels. The rocky heights were used as an Indian lookout and a place to build signal fires. A local grove of pinion trees is reputed to be the most northerly of its type on the continent, with some trees estimated to be four thousand years old.

VOLCANIC ACTIVITY. Much of New Mexico, particularly in the Northwestern section and much of Colorado, especially in the southwest, were among the most active regions of volcanic activity in prehistoric times. Volcanic action in some places there is thought to have continued until as recently as a thousand years ago.

The entire Jemez Range in New Mexico is nothing more than the dessicated rim of one of the largest calderas (craters) in the world. Another huge caldera, Valle Grande, received its name because it was so large it was considered in earlier times to be a valley. The volcanic cone of New Mexico's Mt. CAPULIN is said to be one of the most perfectly formed anywhere. The "volcanic necks" of the Mount Taylor-Rio Puerco region are called the world's finest.

Volcanic action in Montana was described picturesquely by Bob fletcher: "Hell boiled over in the west. Restless molton masses beneath the sediminteries bulged and fractured them, volcanic ash deluged the valleys, and lava sheets flowed down the mountain sides. Central Montana broke out in a rash. Skin eruptions popped out like measles; the lava cores solidified and left the isolated mountain ranges of that section."

Wyoming's most spectacular remnant of volcanic action is DEVIL'S TOWER. Rock beneath the surface became so superheated that it broke through the crust and squeezed a red hot mass into a giant cone, which then cooled to form the present national monument. Elsewhere in Wyoming prehistoric volcanoes spread lava and volcanic ash over wide areas covering nearby

basins and sometimes overflowing low mountains. The forces of wind and water have cut through the hardened lava and ash and uncovered many layers showing this activity.

The BLACK HILLS of South Dakota are a magnificent example of a batholith. These are formed when immense masses of molton rock are lifted above the surface to form mountain ranges. Generally, as is the case with the Black Hills, these ranges do not appear above the surface until the surrounding softer materials have been washed or blown away.

Oklahoma's most important volcanic region is the Black Mesa, formed by lava flows from an ancient volcano in present New Mexico. In southwestern Kansas, MEADE has the world's largest operation in the processing of volcanic ash of the region.

WACO, Texas. City (pop. 101,261), seat of McLennan County, in central Texas on the south bank of Lake Waco and the BRAZOS RIVER, 94 miles south of 12th Air Force headquarters, James Connally Air Force Base, and a veterans' hospital. It is also home to BAYLOR UNIVERSITY (1886), Paul Quinn College (1872), the first black college in Texas, and Cameron Park (680 acres), one of the largest city parks in Texas. In 1953 a devastating tornado killed 114, injured 197, and caused $40,000,000 in property damage.

WAGON TRAINS. A group of wagons organized for efficient travel and protection against Indians in the American West. The first train, mule drawn, over the OREGON TRAIL involved ten wagons and was organized in 1830 by the Rocky Mountain Fur Company from St. Louis to the WIND RIVER. Wagons, often called "prairie schooners," were covered with canvas and were pulled by horses, mules, or oxen. Beginning in St. Joseph, Missouri, the "trains" followed well-known routes into the Northwest and Southwest. More than five thousand trains were annually passing into California or Oregon

by 1849. Hazards for wagon trains included Indian attack, sickness, prairie fires, buffalo herds and storms. Traveling a slow ten to fifteen miles per day, the wagon trains were gradually replaced by the stagecoach lines and eventually the railroads. Many travelers stopped before reaching their distant destinations, either because they ran out of energy or resources or because they liked the looks of the countryside.

The travelers were varied—prosperous Easterners with fine wagons, equipment and livestock, frontiersmen hired to lead and work for the trains, penniless emigrants searching for a better life, those who simply always looked for farther horizons, and many other variations.

To be successful a wagon train had to leave the settled areas to the east after the prairie grass had come up in early May. This was essential to have feed for the livestock, and they had to cross the imposing mountains before the winter snows closed all the routes across. The blooming prairies of the Platte River valley and other eastern areas presented few problems, but the high plains offered less and less grass for the animals to eat.

Most of the wagon trains' personnel consisted of strong individualists, and there were many arguments over the best routes and the discipline of the party. The cumbersome wagons seemed always to need repair. Covers ripped off in windstorms, and wooden wheels split on a seemingly regular basis or sunk into deep mudholes. Every river was an adventure, and there were many losses of property, livestock and even human life in the treacherous river crossings.

The steep slopes of the higher regions sometimes required both winching from above and two men pushing the back wheels in order to reach the top. Poisonous alkali springs, stampedes in thunderstorms, buffalo stampedes and a host of other problems all took their toll. In the drier regions, the search for water was continuous and when unsuccessful the whole party sometimes faced death. Cholera and other deadly diseases threatened them.

"The little line of wagons was pygmy motion in immensity, the mind became a speck...always quivering with an unidentified dread," as Bernard DeVoto described a typical wagon train.

The great fear and perhaps often the greatest peril was of Indian attack, and countless novels, motion pictures and TV shows have pictured the pioneer wagons drawn up in a protective circle, surrounded by whooping, threatening, shooting tribesmen.

Despite it all, however, as mountain man Jim Clyman mused in a letter to a Wisconsin friend, "I never saw a more discontented community....The long tiresome trip from the States, has taught them what they are capable of performing and enduring. They talk of removing to the islands, California, Chili...with as much composure as you in Wisconsin talk of removing to Indiana or Michigan."

Jesse Applegate, a leader of one group of about 1,000 pioneers, described the journey from Independence, Missouri, in a fascinating journal, beginning in May 1843. His account starts with the morning discharge of rifles at four A.M. which roused the camp each morning and continues with fascinating details of the journey, the confusion of getting started each day, the arrangement and appearance of the caravan, the constant search for the best route, the herding of the cattle, setting up camp, collecting of buffalo chips for the fire, the duties of the evening watch, nighttime dances to the tune of the fiddles, the blossoming of romance, the dramatic landmarks, crossing of the rivers, the joy of reaching one of the few permanent settlements and all the other aspects of a journey which would be unthinkable to most Americans today.

WAHOO, Nebraska. Town (pop. 3,555), Sanders County, east-central Nebraska, southwest of FREMONT and northeast of LINCOLN . Wahoo was the birthplace of George W. Beadle, an outstanding educator and scientist who became the President of the University of Chicago. Wahoo is the site of John F. Kennedy College, one of Nebraska's many private schools.

WAHPEKUTE INDIANS. One of the seven divisions of the Dacotah which lived in northern Minnesota in the late 17th century. By treaties in 1837 and 1851 the lands were ceded to the United States except for a reservation along the Minnesota River. The Wahpekute occupied a portion of the Lower Agency. Numerous incidents brought about an uprising in 1862 led by a Mdewakanton chief, Little Crow. The uprising, not unanimously supported, was crushed in a few months. Leaders of the revolt were hanged and the remainder of the tribe was herded about until finally settled at Crow Creek, South Dakota. Hundreds died of illness, hardship and starvation. In 1866 the tribe was moved to the Santee Reservation in Nebraska where they faced smallpox epidemics, locusts and drought in the first years. In the 1870s many left to settle on the BIG SIOUX RIVER near Flandreau, South Dakota.

WAHPETON INDIANS. One of the seven divisions of the Dacotah. The Wahpeton were divided into seven bands, each headed by an hereditary chief and a council. A police force was provided by an elite warrior group, the akitcita, to keep order on hunts and during councils. There were female and male shaman with powers reputed to include curing the sick and forecasting the weather. The Wahpeton believed in a number of gods and spirits including Wakan Tanka, the Great Spirit and creator of the universe. The Wahpeton and Sisseton attempted to remain neutral during the Sioux Uprising of 1862, but following the defeat of the Indians their lands and property were confiscated. Many Wahpeton fled to the plains. In 1867, the Sisseton Reservation, near Lake Traverse in South Dakota, and Fort Totten Reservation near Devil's Lake between North and South Dakota were established for the Wahpeton and Sisseton. Drought and locusts made farming difficult. By 1892, the

Sisseton Reservation was divided and 300,000 acres allotted to tribal members. Nearly all of the remaining 600,000 acres was sold to non-Indians. In the 1970s an estimated two thousand descendants of the Wahpeton lived in Minnesota and North and South Dakota.

WAHPETON, North Dakota. City (pop. 9,-064), Richland County, southeastern North Dakota, southeast of JAMESTOWN and south of FARGO. Located at the headwaters of the BOIS DE SIOUX RIVER in a rich agricultural area, Wahpeton is home for the Wahpeton Indian School and the North Dakota State School of Science. Jacob Fjelde, a prominent North Dakota sculptor, is recognized for his statues of Norwegian writer Henrik Ibsen. His bust of Ibsen was given to Wahpeton by the Norwegian people of Richland County on Norwegian Independence Day in 1912.

WALL, South Dakota. Town (pop. 542), Meade County, west-central South Dakota, east of RAPID CITY and northeast of HOT SPRINGS. Wall is home for the "best advertised drug store in the world, Wall Drug." Beginning in 1936, free ice-cold water was offered to thirsty tourists. This was the beginning of a unique and very widespread advertising campaign which has drawn such attention to the establishment that today Wall Drug has mushroomed into a continuous line of speciality shops stretching several blocks in length. During each summer the city accommodates two million visitors. As many as 20,000 visitors storm the world's most famous drug store daily. During the "bank holiday" of the Great Depression Al Nystrom's bank in Wall was the only one in the country to continue operations. No one notified him of the bank closing. Wall, the northern gateway to the BADLANDS, hosts Wall Roundup Days in July with a rodeo and parade.

WALLACE, Lew. (Brookville, IN, 1827—Crawfordsville, IN, Feb. 15, 1905). Novelist, soldier and politician. Wallace served as the governor of New Mexico Territory from 1878 to 1881 and completed the famous novel *Ben Hur* (1880) while living in the Palace of Governors.

WALNUT RIVER. Kansas, rising in Butler County, flowing south into the Arkansas River at Arkansas City in Cowley County.

WAMEGO, Kansas. Town (pop. 3,159), Pottawatomie County, northeastern Kansas, northwest of TOPEKA and northeast of MANHATTAN. Wamego is the home of an old Dutch windmill. The historic Kansas structure was moved stone-by-stone from its original location twelve miles away.

WAPITI RANGE. Mountains running southwest to northeast in the northwestern corner of Wyoming, southwest of CODY and southeast of YELLOWSTONE LAKE.

WAR OF THE OUTBREAK. Name given an uprising of Santee Sioux begun in Minnesota in 1862 in which only one battle occurred in South Dakota. Sioux raided the abandoned press offices of SIOUX FALLS, South Dakota, and used type to make decorations for their pipes. Forces under General Henry Hastings SIBLEY surprised and defeated nearly 3,000 Sioux on July 24, 1863, near Big Mound, North Dakota. Several hundred warriors besieged Fort Abercrombie, North Dakota, and were beaten when reinforcements arrived from Fort Snelling. These 1863 campaigns of Generals Alfred H. Sully and Sibley in Minnesota and the Dakotas quieted the Sioux and encouraged further white settlement.

WARBONNET CANYON. In the extreme northwestern corner of Nebraska near the borders of South Dakota and Wyoming, site of one in a series of defeats for Indians after the Custer defeat in 1876. On July 17, 1876, Colonel Wesley Merritt, commanding the 5th Cavalry, intercepted nearly one thousand Cheyennes who had left the Red Cloud and Spotted Tail agencies in Nebraska to join the Sioux under CRAZY HORSE (1842?-1877) and SITTING BULL (1830?-1890). The Indians were soundly defeated and driven back to the agencies. During the battle, "Buffalo Bill" CODY (1846-1917) reputedly killed Chief Yellow Hand, an episode publicists for the frontiersman quickly turned into a legend. The battlefield is now without any monument and, under private ownership, is not open to the public.

WASHAKIE (Chief). (MT, 1804—Fort Washakie, WY, Feb. 15, 1900). Shoshone chief. Washakie became the chief of the Eastern Shoshone Indians in 1842. For the rest of his life he attempted successfully to guide his people in a path of peace with the whites who he viewed as too many and too strong to battle successfully. Washakie relinquished tribal rights to the Green River Valley in Montana in exchange for a reservation in the Wind River

region of Wyoming in 1868. He aided General Crook in battles against the Sioux Indians in the Sioux War of 1876. He was buried with full military honors at Fort Washakie, named in his honor.

WASHBURN UNIVERSITY OF TOPEKA.

Founded in 1865 as a Congregational school at Topeka, Kansas, Washburn University became a public institution in 1941. Financial support is received from tax receipts of the city, tuition, and state aid. Programs include a liberal arts college, a law school, and a program emphasizing international relations which includes the nationally recognized "Washburn Semester at Copenhagen." During the 1985-1986 academic year the school enrolled 6,830 students and employed 256 faculty members.

WASHBURN-LANGFORD-DOANE PARTY.

In 1870 the first scientific expedition to reach Yellowstone. Henry D. Washburn, the surveyor general of Montana, was the leader of the expedition. Nathaniel Pitt Langford, the noted publicist of the expedition, met with Jay Cooke, promoter and financier of the Northern Pacific Railroad, three months before the journey and was hired by Cooke to promote Yellowstone as part of a publicity campaign to obtain funding for the railroad which would pass within forty or fifty miles of the natural wonderland. The explorers were the first to climb the lofty Absaroka Range and named the geyser which erupted regularly every sixty minutes, Old Faithful. A member of the expedition, Cornelius Hedges, a young attorney from Helena, Montana, believed such wonders should be held in trust by the government for the use of all the nation's citizens. As one of the party wrote, "I think a more confirmed set of skeptics never went out into the wilderness than those who composed our party, and never was a party more completely surprised and captivated with the wonders of nature." He expressed his beliefs in the Helena *Herald*, an article now believed to have been the source of the first proposal for a national park system.

WASHITA RIVER.

Tributary of the Red River which rises in Hemphill County in northwestern Texas and flows east across the Oklahoma border, then turns southeast and south into central Oklahoma and then south to the RED RIVER. The river passes through Black Kettle National Grassland and Foss Lake before reaching the area of Clinton, Anadarko, and Pauls Valley, Oklahoma, then draining into Lake Texoma. The Washita in Oklahoma was the scene of a controversial battle on November 27, 1868, involving General George Armstrong CUSTER (1839-1876) in which a great loss of life was suffered by the Indians.

WASHITA, Battle of the.

Battle fought near the WASHITA RIVER, Oklahoma, on November 27, 1868, between military forces led by Lt. Colonel George A. CUSTER (1839-1876) and Cheyenne Indians under Chief Black Kettle. In a surprise attack at dawn on the sleeping camp, Custer's forces killed Black Kettle and one hundred men, women and children. Fifty-three captives were taken before the village was burned and the pony herd destroyed.

WATERTOWN, South Dakota.

City (pop. 15,649), seat of Codington County, situated on the BIG SIOUX RIVER, in northeast South Dakota, with two large lakes, Pelican and Kampeska, at the edge of town. The community was named for the Watertown in New York, rather than from the plentiful nearby waters. Scarcely had the town been founded in 1874 than a terrible plague of grasshoppers and a prairie fire in 1878 inhibited its growth. After that it witnessed almost steady growth and was incorporated in 1885. Today it is a center for a wide variety of recreational activities as well as for the surrounding agricultural area. Food processing is the main industrial activity. Lake Kampeska provides diverse water activities as well as a lakeside golf course and dancehall. Kampeska Heritage Museum and the Mellette House are local attractions. Arthur Mellette, the state's first governor, was renowned for his unselfish public service because he turned over most of his fortune to the state to cover the alleged dishonesty of the state treasurer, although nothing compelled him to make such a sacrifice.

WAYNE STATE COLLEGE.

Publicly supported college established in 1910 in WAYNE, Nebraska. The Master's degree is the highest degree granted. A 135-acre campus includes twenty large buildings, a beautiful outdoor amphitheater, and athletic fields. During the 1985-1986 academic year Wayne State enrolled 2,821 students and employed 126 faculty members.

WAYNOKA, Oklahoma.

Town (pop. 1,377), Woods County, north-central Oklahoma, northeast of Woodward and southwest of Alva. The Little Sahara Recreational Area nearby

has been called a "desert surrounded by an oasis.

WEATHERFORD, Texas. City (pop. 12,049), Parker County, northeastern Texas, west of FORT WORTH and southeast of WICHITA FALLS Weatherford was the home of world famed portrait painter Douglas Chandor, now remembered by Chandor Gardens, uniquely designed as a series of dramatic outdoor rooms rather than the more usual garden.

WEBB, Walter Prescott. (Panola County, TX, Apr. 3, 1888—Austin, TX, Mar. 8, 1963). Historian. A year after earning his Ph.D. at the University of TEXAS (1932), Webb became a full professor there. A distinguished scholar and speaker, Webb wrote more than 20 books about the history of America's West, including *The Great Plains* (1931) and *The Handbook of Texas* (1937).

WELK, Lawrence.. (Strasberg, N.D., March 11, 1903—). Band leader. Welk, an accordianist, led a six-man band which played on radio station WNAX from YANKTON, North Dakota, in 1925. Welk moved to Chicago during the 1930s to develop his sound, known as "Champagne Music." His band and later orchestra played at the Aragon Ballroom in Santa Monica, California, from 1951 to 1961. After 1953 his musicians were heard on radio and seen on television becoming one of the most popular programs on the air. Among the famous musicians to appear with Welk in their early careers have been trumpeter, Al Hirt and clarinetist, Pete Fountain.

WELLINGTON, Kansas. City (pop. 8,200), seat of Sumner County, south-central Kansas, southeast of MEDICINE LODGE and south of WICHITA. The Wellington area is one of the leading producers of wheat in the United States. It celebrates its position with an annual wheat festival. Wellington owed its early prosperity to the rerouting of the CHISHOLM TRAIL away from Wellington's competitor, Sumner City. Wellington men also stationed themselves at the state line to direct herdsmen toward Wellington when they inquired the way to Wichita.

WELLS, FARGO AND COMPANY. The association of Henry Wells and William Fargo began in 1844 when they formed Wells and Company, to handle shipments from Buffalo to Detroit, and a year later they extended the service to Chicago. Their most famous enterprise, Wells, Fargo and Company, was founded on March 8, 1852, to transfer goods and mail to California and the West. They had already organized the American Express Company but they felt the western operation should be separate. Taking advantage of the enormous interest in western travel and expansion, and especially of the gold of the West, the new firm rapidly expanded, taking over much of the competition or running it out of business. Eventually the firm went out of the control of the founders and now concentrates on its banking and financial interests.

WESSINGTON HILLS. Fifty-mile stretch of highlands in South Dakota which mark a glacial moraine. Prehistoric mound builders constructed a TURTLE MOUND in the area, one of many such effigy mounds similar to those found in eastern states.

WEST TEXAS CAVE DWELLERS. People who lived in the Shumla Cave Shelters between eight thousand and two thousand years ago. Considered to have had a high degree of culture, the people braided rope and twine, wove cloth and baskets, and used a throwing weapon called an atlatl and a rabbit stick, similar to the Australian boomerang. Infant burials have been discovered in which the bodies were placed in well-made cradles.

WEST YELLOWSTONE, Montana. Town (pop. 735), Beaverhead County, southwestern Montana, south of BOZEMAN and southeast of DILLON. Located as the west entrance to YELLOWSTONE NATIONAL PARK, the major industry of the community is tourism. Firefighting techniques are explained to tourists at the Interagency Aerial Fire Control Center. Artifacts of mountain men, cowboys, Indians and the United States cavalry may be seen in the Museum of the Yellowstone. Traces of the 1959 earthquake which caused nearly $3,000,000 in damage to buildings, roadways and roads in Yellowstone may still be seen in the 37,800-acre Madison River Canyon Earthquake Area.

WESTERN CATTLE TRAIL. Successor to the Chisholm cattle trail, beginning northwest of SAN ANTONIO, Texas, running near Fort Griffin, Texas, and leading north-northwest across the RED and CANADIAN rivers through the Oklahoma Panhandle into DODGE CITY, Kansas.

***WESTERN ENGINEER* (steamboat).** In 1819 the first steamboat to navigate the MIS-

SOURI RIVER. It puffed as far north as Lisa, Nebraska. Designed to intimidate the Indians, it had a bow like a serpent from which poured smoke from the engine.

WESTERN HERITAGE CENTER. Also known as the Cowboy Hall of Fame in Oklahoma City, Oklahoma. The center, founded in 1965, was based on an idea of Kansas manufacturer Chester Reynolds and was created through the combined efforts of seventeen western states. The Center gives recognition to the men and women who built the old West. Among the exhibits are guns and saddles, memorial busts, and a fifty million dollar western art collection featuring the works of Frederic REMINGTON (1861-1909) and Charles M. RUSSELL (1865-1926). The Western Performers Hall of Fame contains portraits of western movie and television stars including Roy Rogers, Tom Mix, and Gene Autry. A special gallery displays John Wayne's collection of kachinas, knives and guns. There is also a Rodeo Hall of Fame.

WESTERN MEADOWLARK (STURNELLA NEGLECTA). The western meadowlark is the official state bird of five Central West states—Kansas, Montana, Nebraska, North Dakota and Wyoming. Although it is a member of the blackbird family, the meadowlark does not have some of the undesirable characteristics of its relatives. It eats harmful insects, not grain, and it does not congregate in large flocks and create a nuisance. The western meadowlark is slightly smaller than its eastern namesakes.

WESTERN MONTANA COLLEGE. Four-year state college located in DILLON. Accredited by the Northwest Association of Schools and Colleges the college grants the Bachelor of Science in Elementary and Secondary Education, Business and Natural Heritage; the Bachelor of Arts in American Studies; and the Master of Science in Education. During the 1985-1986 academic year the college enrolled 970 students and employed 52 faculty members.

The vast wheat crops make the Central West the breadbox of the world.

WESTERN NEWSPAPER UNION. Newsgathering and disseminanting service, basis of George A. Joslyn's fortune. The Joslyn family of OMAHA, Nebraska, gave the Joslyn Museum in OMAHA to the city as a memorial to the family founder.

WESTERN WHEAT GRASS. Both South Dakota and North Dakota are among the five states of the Central West which have chosen an official state grass. Their selection, western wheat grass (agrophynon smithil), is a member of the vast family of grasses which include corn, sorghum, oats, barley and rye.

WHEAT. Cereal grass cultivated since prehistoric times and brought to North America by European settlers. For reasons of soil and climate the leading wheat states, "the breadbasket of America," are those states in the Central West on the GREAT PLAINS where close to 60% of the total United States wheat is harvested. In 1984 the Central West states harvested over 1.483 billion bushels with a farm value of just over $5 billion. Kansas harvested 431.2 million bushels of wheat with a farm value of $1.445 billion the other states in the region with a significant harvest (1984) were North Dakota (284.2 million bushels), Oklahoma (190.8 million bushels), Texas (150 million bushels), South Dakota (126 million bushels), Colorado (115.3 million bushels), Montana (104.7 million bushels) and Nebraska (81 million bushels) Wyoming and New Mexico did not have any significant wheat harvest.

WHEAT RUST. Disease which threatened crop production until NORTH DAKOTA STATE UNIVERSITY scientist Dr. Lawrence R. Waldron developed rust resistant varieties of wheat which led to multi-million dollar savings annually from crop loss.

WHITE BUTTE. Highest elevation in North Dakota, featuring solid rock cliffs towering perpendicularly from fifty to one hundred feet above the grassy side slopes.

WHITE RIVER. River which originates in northwest Nebraska and flows 325 miles northeast across South Dakota, then east into the MISSOURI RIVER. The White River passes through the Pine Ridge Indian Reservation.

WHITE SANDS NATIONAL MONUMENT. The park contains the world's largest gypsum dunefield covering nearly 230 square miles. The glistening white dunes rise sixty feet high. Small animals have adapted to this harsh environment by developing light, protective coloration. Plants also have adapted, extending root systems to remain atop the ever-shifting dunes. Headquartered ALAMOGORDO, New Mexico.

WHITE, William Allen. (Emporia, KS, Feb. 10, 1868—Emporia, KS, Jan. 29, 1944). Newspaperman. White, editor and proprietor of the Emporia *Daily and Weekly Gazette* was known as "The Sage of Emporia. White's national fame began with an early editorial "What's the Matter with Kansas? which attracted the attention of eastern politician Mark Hanna who had thousands of copies distributed throughout the country. White received the 1922 Pulitzer Prize for his editorial on freedom, arising from his arrest for opposition to a state law which he felt opposed freedom. His tribute in 1921 to his young daughter Mary just after her accidental death is considered his most remembered effort. In 1933 White received the gold medal for citizenship from the Theodore Roosevelt Memorial Association.

WHITE, William L. (Emporia, KS, June 17, 1900—Emporia, KS, July 26, 1973). Newspaperman. Son of famed newspaperman William A. WHITE (1868-1944), William L. White began his journalism career as a reporter on his father's Emporia *Gazette*. He moved on to employment with the Washington *Post* and represented the Columbia Broadcasting System as a European correspondent from 1939 to 1940. Returning to the United States, White served as a roving editor for the *Reader's Digest* and was elected to the Kansas State Legislature from 1931 to 1932.

WHITEMAN, Paul. (Denver, CO., 1891—New York, NY, Dec., 1967). Conductor. Whiteman, a highly successful leader of jazz orchestras and bands, conducted two transcontinental symphonic jazz concert tours of the United States between 1924 and 1926, the year his musicians toured the major capitals of Europe. With his work in symphonic music, he became a highly regarded link between classical and jazz forms. He was one of George Gershwin's most effective supporters.

WHITESTONE HILL BATTLEFIELD STATE PARK. Scene of the WHITESTONE HILL

BATTLE near ELLENDALE, North Dakota. Low hills covered with prairie grass have been left in their natural condition. A battlefield monument is surrounded with 22 markers each listing the name of a soldier killed in the conflict. A museum contains an interpretative center and relics of the battle.

WHITESTONE HILL, Battle of. The last major Indian battle east of the MISSOURI RIVER. Referred to as the "worst battle with the Indian in Northhe fighting took place near present-day ELLENDALE, North Dakota, on September 3, 1863, when troops commanded by General Alfred Sully were surrounded by an estimated 4,000 Sioux who had participated in the 1862 revolt in Minnesota. Sully rushed more reinforcements to his outnumbered troops while the Indians paused to apply warpaint. In the resulting battle, won decisively by the troops, the Indians suffered 300 warriors killed and 250 women and children captured. Army casualities were 22 killed and 50 wounded. The scene of battle is now preserved in the WHITESTONE HILL BATTLEFIELD STATE HISTORIC SITE.

WHITMAN, Marcus. (Rushville, NY, Sept. 4, 1802—OR, Nov. 20, 1847). Physician and missionary. Whitman, a missionary for Presbyterian and Congregational churches, demonstrated his medical skill at the 1835 fur rendezvous in Wyoming by removing a three-inch arrowhead from the shoulder of famed trapper and explorer Jim BRIDGER (1804-1881). In 1836 in South Pass, Wyoming, the Whitman party held the first Fourth of July celebration on the western slope of North America while praying for the West as "a home of American mothers and the Church of Christ." A monument at Rendezvous Park near Daniel, Wyoming, honors Narcissa Whitman, the wife of Marcus and one of the first two white women to pass through Wyoming. After journeying through the Central West, Dr. Whitman established a famous mission to the Cayuse indians near what is now Walla Walla, Washington.

WHITNEY, Nebraska. Village (pop. 72), Dawes County, northwestern Nebraska Panhandle, southwest of CHADRON and northeast of CRAWFORD. Whitney, founded along the stage route between VALENTINE and FORT ROBINSON, was first called Dawes City and then Earth Lodge before taking the name of Peter Whitney, the town site agent for the railroad. Old Fort Useless, converted to a ranch near town, was built to protect the settlers against the Indians, but was never used. Crow Butte, approximately eleven miles from town, was the legendary site where Crow Indians were trapped by Sioux.

WHOOPING CRANES. One of the rarest and the tallest birds of North America, which winters in the ARANSAS WILDLIFE REFUGE north of CORPUS CHRISTI, Texas. Also called "whoopers" for their loud buglelike call, the cranes once nested throughout the area between Louisiana and the Canadian border. Human settlement in the nesting areas caused the birds to begin dying out in the 1800s until, by 1941, only fifteen were known to exist. Today there may be as many as 120 due to the intense efforts of preservationists, protection of the law and greater care of breeding and nesting grounds. A number have been hatched and kept in zoos.

WIBAUX, Montana. Town (pop. 782), seat of Wibaux County, eastern Montana, southeast of GLENDIVE and north of BAKER. Both the county and the community, were named for Pierre Wibaux who settled in the area in 1883. Wibaux was the type of tough western towns about which movies are made. A local storekeeper was said to have made a fine sidewalk out of the empty shellcasings he found in the streets. Wibaux served as an important shipping point for cattle and sheep. In one year as many as one and one-half million head of sheep were loaded on railroad cars from the town's large loading pens.

WICHITA FALLS, Texas. City (pop. 101,-724), seat of Wichita County, on the WICHITA RIVER in northern Texas, 100 miles northwest of FORT WORTH. The city was named for a small falls in the midst of WICHITA INDIAN territory. It was founded in the 1870s and became a cattle shipping center with the introduction of rail lines, a petroleum center with the discovery of oil (1900), and an agricultural center with the introduction of irrigation. Its products include cattle, wheat, cotton, and fruit. Wichita Falls is the home of Midwestern University (1922), a city owned and administered school.

WICHITA INDIANS. Confederacy of the Caddoan language family which may have numbered 15,000 or more when visited by the Spanish explorer CORONADO (1510-1544) in 1541. The Indians lived in the area of the great bend of the ARKANSAS RIVER in south central Kansas. The confederacy included six or seven subtribes, each having an independent village.

Villages, usually unfortified, were built overlooking rivers. Some villages were reported to have as many as one thousand grass lodges. Each village was ruled by a chief and sub-chief who were elected by a council of warriors. Secret societies, existing in each village for men and women, had their own dances and ceremonies. The Wichita hunted and raised crops including corn, beans, squash and pumpkins in such abundance that the surplus was offered in trade to more nomadic tribes. By 1700, the tribe had acquired horses which were protected in battle by leather armor. Trade with Europeans began with the French about 1720. Warfare with the Spanish, Americans and Osage in addition to epidemics of smallpox reduced the Wichita's population to the point that, in 1835 and 1837, treaties with the United States and the neighboring tribes were signed. In 1859, the Wichita moved to land south of the CANADIAN RIVER in Oklahoma. In 1867, they were moved to the banks of the WASHITA RIVER. These lands were assigned to them in severalty in 1901. An estimated eight hundred Wichita descendants lived in Caddo County, Oklahoma, in the late 1970s.

WICHITA MOUNTAINS. Range in southwestern Oklahoma's Kiowa and Comanche counties. The highest peak in the range is Mount Scott at 2,464 feet.

WICHITA RIVER. The river itself forms near Hackberry, Texas, at the meeting of several intermittent streams. It flows east, forming Lake Kemp, then passes through the northern section of WITCHITA FALLS, before turning somewhat to the north and then entering the RED RIVER about twenty miles northeast of Wichita Falls.

WICHITA STATE UNIVERSITY. Founded in 1895 by the Congregational Church as Fairmount College, the school became a municipal institution in 1926 and was renamed the Municipal University of Wichita. In 1963 the University was added to the Kansas state system of higher education and was given its current name in 1964. During the 1985-1986 academic year Wichita State enrolled 16,902 students and employed 708 faculty members.

WICHITA, KANSAS

Name: From the Wichita Indians, a tribe of the Caddoan linguistic stock.

Nickname: Air Capital of the World; The Cow Capital.

Area: 112.2 square miles

Elevation: 1,305 feet

Population:
1986: 288,870
Rank: 51st
Percent change (1980-1986): +3.2%
Density (city): 2,575 per sq. mi.
Metropolitan Population: 428,609 (1984)
Percent change (1980-1984): +4.1%

Race and Ethnic (1980):
White: 84.44%
Black: 10.81%
Hispanic origin: 9,455 persons (3.55%)
Indian: 2,942 persons (0.92%)
Asian: 4,525 persons (1.39%)
Other: 4,993 persons

Age:
18 and under: 26.3%
65 and over: 10.6%

TV Stations: 4 (and cable)

Radio Stations: 13

Hospitals: 6

Sports Teams:
Wichita Wranglers (baseball)
Wichita Wings (soccer)

Further Information: Wichita Chamber of Commerce, 350 West Douglas, Wichita, KS 67202.

WICHITA, Kansas. City (pop. 279,272), seat of Sedgwick County and largest city in the state, situated in south central Kansas, where the Little Arkansas River joins the main Arkansas River. It was named for the Wichita Indian tribe, and has been described as "having a definite metropolitan flavor, with its tall buildings, wide streets and bustling tempo."

Wichita continues to be the principal commercial and industrial center of Kansas. Known as the Air Capital of the World, it boasts of the world's single greatest concentration of aircraft manufacture. The petroleum industry of the state also centers there and includes a number of independent oil companies. Some of the wheat storage elevators are among the nation's largest. There is a wide

variety of manufacturing, including meat packing, flour mills and railroad shops.

The WICHITA INDIANS had a village on the site from 1863 to 1865. This attracted a trading post in 1864, and the community was founded in 1868 in order to serve the drovers on the CHISHOLM TRAIL. In fact, Jesse CHISHOLM, founder of the trail was one of the founders of Wichita, along with James R. Mead. With the coming of the railroad to Wichita, it in turn became the final destination for cattle on the trail.

As farmers settled in the area, and after oil was discovered, the community prospered, a stability that has existed with few interruptions since.

Wichita State University, Kansas Newman College and Friends University are the city's educational institutions.

A center of culture for a vast area, Wichita supports the Wichita Art Museum, with a large display of Charles RUSSELL's (1865-1926) works, the Wichita Art Association and the Ulrich Museum of Art at Wichita State University. The Wichita Symphony Orchestra presents more than 40 concerts annually, mostly in the concert hall of Century II, the splendid new civic center.

Friends University is noted for its Singing Quakers, and it offers Fellow-Reeve Museum of History and Science. A different view of history is provided by Mid-America All-Indian Center and Indian Museum. There is an Omnisphere and Science Center, featuring a planetarium and hands-on science facilities. The forty buildings of Old Cowtown Museum depict Wichita life from 1865 to 1880. The Sedgwick County Zoo features animals in their natural habitat, including an African veldt.

The 19th century residences of historic college hill have been converted to a period-styled shopping center known as Clifton Square.

The sports center offers professional teams in hockey and baseball.

Notable annual events include the Wichita River Festival in early May, with antique bathtub races and other contests plus entertainment. The Indian Powwow gathers tribesmen from around the country to take part in traditional dances, display crafts and provide authentic food. The amateur National Championship Baseball Tournament is held from mid-August to Labor Day.

WILL ROGERS MEMORIAL. Ranch house-style museum dedicated on May 22, 1944, on the site where the famous humorist planned to build a home in CLAREMORE, Oklahoma. A well-

Wichita, Kansas, world center of airplane manufacture.

known bronze sculpture of Rogers by Jo Davidson is located in the foyer. Four galleries contain memorabilia including miniature saddles, ropes, blankets and an international saddle collection. Important events in the life of Will ROGERS (1879-1935) are depicted in dioramas. Movies made by Rogers are shown daily, and a video program of his life is shown five times each day. Both Will Rogers and his wife Betty are buried there.

WILLARD, Jess. (Pottawatomie Co., KS, 1881—1968) Boxer. On April 5, 1915 he won the world heavyweight championship from Jack Johnson and lost that title four years later, being overcome by Jack DEMPSEY on July 4, 1919.

WILLIAMS, William Sherley. (Rutherford County, NC.—Santa Fe Trail, March 1849). Preacher, trapper, and explorer. Called "Old Bill Williams," he was the guide for John Charles Fremont's fourth expedition West (1848). Against Williams' advice, Fremont led the party toward the headwaters of the RIO GRANDE RIVER where most of them died of exposure and starvation. Falsely blamed for the

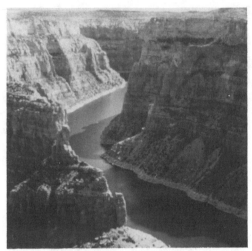

The spectacular gorge of the Wind River.

error by Fremont, Williams was killed by Ute Indians while reexploring the route.

WILLISTON, North Dakota. City (pop. 13,-336), Williams County, northwestern North Dakota, northwest of DICKINSON and west of MINOT. Long before the presence of the railroad, Williston was a trading center with the construction of Fort Union Trading post, now a national historic site. When it was still a tent-city of one square block it was reported that a tavern was located on each corner. Discovery of oil between Williston and Minot in 1951 added a new economic base to the region and prevented the city from again suffering the financial collapse of the 1930s when it was primarily a leading grain market. Economic resources include Garrison Lake which assures water for the region's cattle and grain industries. Tourist attractions in the area include Fort Buford State Historic Site. The fort, built in 1866, saw the surrender of Chief SITTING BULL (1830?-1890) in 1881.

WILSON, Harold Albert. York, England, Dec. 1, 1974— Houston, TX, Oct. 13, 1964). Physicist and educator. Educated in England, he taught in London, Montreal, and Glasgow before taking a professorship at RICE INSTITUTE in HOUSTON (1912-1947). He achieved fame for his verification of the electromagnetic equations of such predecessors as Albert Einstein. His books include *The Mysteries of the Atom: Electricity* (1934).

WIMINUCHE INDIANS. One of the three tribes which made up the Southern Ute, one of

the four main groups of UTES who were probably the only Indians to live in Colorado during a long period.

WIND CAVE NATIONAL PARK. These limestone caverns in the scenic BLACK HILLS are decorated by beautiful boxwork and calcite crystal formations. Elk, deer, pronghorn, prairie dogs and bison live in the park. Headquartered Hot Springs, South Dakota.

WIND RIVER. Joins with the Popo Agie River in Fremont County, Wyoming, to form the BIG HORN RIVER. The Wind River rises in Fremont County and flows southeast along the eastern slope of the WIND RIVER RANGE.

WIND RIVER RANGE. Rocky Mountain range in west central Wyoming in Fremont and Sublette counties. The highest peak is 13,785 foot Gannett Peak.

WINDING STAIR MOUNTAINS. Scenic range of mountains in Oklahoma through which winds the 55-mile stretch of Indian Highway, from Talihina, Oklahoma, to Mena, Arkansas.

WINDLASS HILL. Heartstopping point on a trail west near Lewellen, Nebraska. The steep route from the bluff top to the river bottom was managed only after the riders dismounted and led their horses, and wagon wheels were locked and the wagons steadied by ropes attached to windlasses.

WINDOW ROCK. Capital of the vast Navajo reservation situated on the New Mexico-Arizona border.

WINFIELD, Kansas. city (pop. 10,736). Seat of Cowley County, on the Walnut River in south central Kansas. The community, named for Winfield Scott, was founded in 1870 on land leased from Osage Chief Chetopah, who asked $6. It was incorporated three years later. The surrounding area is basically agricultural, and there is some oil and gas production. Manufactures include water coolers, ice chests, crayons, industrial boilers, steel drums, gas burners and aircraft. St. John's College and Southwestern College are found there.

WINNEBAGO INDIANS. Siouan tribe whose 3,500 descendants occupied reservations in Nebraska and Wisconsin in the late 1970s. The Winnebago referred to themselves as Hotcan-

gara, meaning "people of the real speech." The tribe was divided into the wangeregi, or air phratry, and the manegi, or earth phratry. Each division was subdivided into clans. Clan membership was inherited through the father. Important festivals included the Winter Feast, the Summer Medicine Dance and the clan feasts. The Winnebago economy was based on agriculture, fishing, hunting and gathering. Between 1825 and 1837 the lands held by the Winnebago in Wisconsin were ceded for reservations west of the Mississippi. Between 1840 and 1865 the Winnebago moved from Wisconsin, to Iowa, to locations in Minnesota and finally to South Dakota on their way to Nebraska. In the late 1970s approximately one-third of the Winnebago descendants lived on or near the Nebraska reservation in Thurston County.

WINNEBAGO, Nebraska. Town (pop. 902), Thurston County, northeastern Nebraska, northeast of Wayne and southwest of Sioux City, Iowa. Winnebago is the home of the Winnebago Indian Agency. Winnebago Indians have annually gathered in the community in August to hold their ceremonial dances, assemble councils, and remember songs and legends.

WINTER OF 1880-1881. One of the most severe winters in American history. In South Dakota heavy snows fell in October, including one of the worst blizzards on record and continued into the spring. A huge dam of ice formed on the MISSOURI RIVER near YANKTON and then stretched thirty miles. When it finally broke, a wall of water rushed downstream completely destroying the village of Green Island. Few lives were lost, but the loss of livestock throughout the area in the newly settled land was staggering.

WINTER SPORTS. Every winter sport is available in the Central West region, some reach their highest level there. Colorado claims the country's winter sports crown, including the "world's finest skiing" in such world renowned winter sports regions as ASPEN and VAIL 'long with twenty-one less advertised wonderlands such as Buttermilk, Chuchara Valley and Steamboat Springs. In Colorado the sports minded can toboggan, enjoy old fashioned sleigh rides, watch college hockey or even try a hand behind authentic dog sleds.

Wyoming offers unusual winter delights, one not found anywhere else in the world. Until the 1970s YELLOWSTONE NATIONAL PARK was closed in the winter. Then visitors were taken through the park in large heated snowmobiles. Today, in addition private snowmobiles are permitted, and the wonders of the park are enhanced by the heavy snow cover and the winter steam from the thermal activity.

The region of JACKSON HOLE, Wyoming, is another favorite of snowmobilers. Among other attractions visitors may ride horse drawn sleighs to see the great herds of elk at the NATIONAL ELK REFUGE. Jackson Hole is one of the country's most renowned ski centers, including Snow King Mountain and Jackson Hole Ski Resort. The Aerial Tramway at Jackson rises two and a half miles to the top of Rendezvous Mountain. The region offers miles of groomed trails for snowmobiling and cross-country skiing.

LARAMIE, Wyoming, is noted for its Snowy Range ski area. Altogether Wyoming offers nine top ski slopes.

Montanans love their winter sports. The first luge bobsled course in America was built near MISSOULA at LOLO HOT SPRINGS and sanctioned for Olympic competition. The state has thirteen top ski resorts, and cross country skiing and snowmobiling are popular. Montana offers a number of winter festivals. ANACONDA is known for its Snow Fest, with races, parades, snow sculpture and other events. BOZEMAN holds its Montana Winter Fare, and RED LODGE and Whitefish hold winter carnivals. The Great American Ski Chase is held at West Yellowstone in March.

New Mexico provides the warmer climate of the Southwest with high mountain areas for fine skiing. Its ten ski resorts include Ski Cloudcroft, at CLOUDCROFT, SANDIA PEAK at ALBUQUERQUE, and Santa Fe resort. Among the most interesting is Ski Apache. This is the resort built and operated by the Mescalara Apache Indians on their reservation, centered in a splendid hotel designed and built by Indian architects and contractors.

North Dakota provides three ski resorts and South Dakota has skiing at Terry Peak and Deer Mountain at Lead. The generally flat states of the region are not known for winter resorts, but the heavy snows that visit much of the Central West, provide winter enthusiasts with plenty of snowshoeing, snowmobiling and cross-country skiing.

WISTER, Owen. (Philadelphia, PA, July 14, 1860—Bryn Mawr, PA, July 21, 1938). Author. Wister spent the summer of 1885 in Wyoming for his health and became so thoroughly acquainted with western life that he decided to

make it the theme of his writing. Of his many books, *The Virginian* (1902) is considered to be the "...model and highwater mark of cowboy fiction," according to one biographer, guaranteeing the cowboy a permanent place in American fiction.

WOLSEY, South Dakota. Town (pop. 437), Beadle County, central South Dakota, northwest of Huron and south of Redfield. Richard Sears, founder of Sears and Roebuck, is said to have gotten his start in Wolsey by selling a shipment of unclaimed watches for the owners. He began a small mail order business and operated it for two years in the community before leaving when his business venture began its rise toward its status as the world's largest retail establishment.

WOLVES. Largest wild member of the dog family, now reduced to small areas of the United States, in the Central West particularly in Montana. Graywolves, also called timber wolves and lobo, measuring up to 54 inches from nose to tail-tip, weigh as much as 175 pounds. The red wolf, thought to be a variety of the gray wolf, is smaller and more slender than the gray and is found only in Texas and Louisiana. Indians regarded wolves as spiritual brothers, a source of food, and even competitors. Indians sometimes camouflaged themselves in wolf hides when hunting. Whites found wolves to be great nuisances, killing tethered animals, robbing sleeping camps and filling the night's darkness with horrible sounds. Wolves were also feared, but only one proven attack on humans has ever been recorded. Among the unusual animals of the American West are the small number of white wolves found in the Judith Basin. Legendary wolves such as "Gray Ghost" were so cunning that it took years to catch them. The Indian snare, deadfalls, and pits were replaced by dogs, traps and poison. Professional "wolfers" used strychnine to exterminate wolves from all but the most remote wilderness. Wolf skins usually brought less than $3.50 during the 1800s.

WOMEN AND WOMEN'S INTERESTS. Wyoming, Texas and Montana enjoy pioneer status in promoting the political rights and independence of women. Wyoming granted equal rights to women as soon as the territorial government was organized in 1869. This action was noted around the world, and King William of Prussia sent a cable to President U.S. Grant offering congratulations on: "...progress, en-

lightenment and civil liberty in America." In 1893 Colorado became the second state to grant the vote to women.

Montana made history in 1917 when it elected Jeannette RANKIN (1880-1973) as the first woman ever to take a seat in the U.S. House of Representatives. Almost immediately Mrs. Rankin became a controversial figure. During the vote in congress on entering WORLD WAR I Mrs. Rankin decided not to vote but Congressman Cannon admonished, "You cannot afford not to vote. You represent the womanhood of the country in the American Congress." So she stood and said, "I want to stand by my country, but I can not vote for war....I vote No." After casting the only no vote, she sat down and began to cry. However, she continued to be popular and was regularly reelected. She also cast a vote against U.S. entry into WORLD WAR II.

Women made political history again in 1924. Nellie Tayloe ROSS (1876-1977) was elected as governor of Wyoming and on the same day Miriam A. FERGUSON (1875-1961) was elected as governor of Texas. These women were the first in the history of the U.S. to be elected as governors in their own right.

Kansas, too, has a notable record of women in public life. Lydia B. Conley, of Indian descent, became the first woman to plead a case before the U.S. Supreme Court. In 1887 Susan Salter became mayor of Argonia, Kansas, which thus claims the distinction of having the world's first woman mayor. Kansas Populist leader Mary Elizabeth Lease was a fiery advocate of the masses. She toured the state calling on farmers to "...raise less corn and more hell. A modern Kansas woman of political distinction is Nancy Landon Kastenbaum, daughter of Kansas Governor Alf LANDON (1887-1987), twice elected to the U.S. Senate.

Prominent women authors of the Central West include Helen Hunt JACKSON, Willa CATHER, Marie SANDOZ, Bess STREETER ALDRICH and Rose Wilder Lane.

One of the most prominent artists of the century came to love New Mexico and call it home. Georgia O'Keefe died in 1986 at SANTA FE at the age of 98. Other talented women artists of the region include Yosette LA FLESCHE Tibbler, Maria MARTINEZ, Eugenie Lavender and Elizabet NEY.

Professionally active women of the Central West include famed flier Amelia EARHART Putnam and explorer Osa JOHNSON, both of Kansas, and business woman Josephine Roche of Colorado, one of the few women to make a great

success in mining operations. She was particularly known as a friend of union miners.

Personalities of the region include Baby Doe TABOR, Unsinkable Molly BROWN, Carry NATION, Millie Francis, entertainer Texas Guinan and singer Peggy LEE.

WOMEN'S RIGHTS. In 1869 the territory of Wyoming was the first government in the world to grant equal rights to women. One of the people credited with convincing the territory to take such a position was Esther Hobart MORRIS. Morris, the first woman jurist and Justice of the Peace at South Pass, was known as "The Mother of Woman Suffrage." William H. Bright, remembered as a champion of women's rights, sponsored the bill which gave Wyoming women full voting privileges. In 1924 Wyoming and Texas were the first two states to elect women to be their chief executives.

WOOD, Leonard. (Winchester, NH, Oct. 9, 1860—Aug. 7, 1927). Military officer. Wood led the Rough Riders with Theodore ROOSEVELT (1858-1919) as subordinate during the SPANISH-AMERICAN WAR and served as the chief of staff of the United States Army from 1910 to 1914. He directed the training of troops at Camp Funston, Kansas, during WORLD WAR I. At the time the camp was one of the largest army bases in the United States.

WOOLAROC MUSEUM. Located on 3,500 acres of timberland outside of BARTLESVILLE, Oklahoma, there is a wildlife preserve for bison and longhorn cattle, elk, deer, longhaired Scottish highland cattle and other animals. The museum features Indian artifacts and displays of such renowned western artists as Charles M. RUSSELL (1865-1926) and Frederick REMINGTON (1861-1909). The museum displays one of the finest exhibits of Colt firearms. There is a display devoted to the development of America. The 1927 lodge, once a private home, now is open to the public, and there is a display of authentic Indian crafts and art.

WOOTTON, Richens Lacy. (Mecklenburg County, VA, May 6, 1816—Trinidad, CO, Aug. 21, 1893). Trapper and pioneer. Wootton is best remembered for the toll road he built in 1865 over RATON PASS from TRINIDAD, Colorado, to the CANADIAN RIVER. The road opened in 1866. Travelers who were reluctant to pay were often encouraged by Wootton and his revolver. Indians passed through free. Wootton participated in an amazing drive of 9,000 sheep to California

in 1852, losing only 100. Among his peers Wootton was considered an expert on Indian life and lore.

WORLD WARS I AND II. Among the millions of men and women around the world who served in World War II, probably none became as well known as a native of the Central West. Dwight D. EISENHOWER (1890-1969) of Texas and Kansas rose rapidly in the war to the rank of General of the Army and Supreme commander of Allied Forces in Europe, receiving nearly every high honor given by the Allied nations.

Hundreds of thousands from the region served faithfully without such grand status. However, another president-to-be, also from Texas, was younger and not so well known but achieved distinction during the war. Lyndon B. JOHNSON (1908-1973) won a silver star as a pilot over New Guinea.

Another high ranking Texan during World War II was Oveta Culp Hobby the first commander of the Women's Army Corps (WACS).

Because of its larger population Texas had more men and women in service in both world wars than any of the other West Central States, 200,000 in World War I and 750,000 in World War II, of whom 23,022 lost their lives. Texan Audie MURPHY gained great fame for receiving more decorations for bravery than anyone else during World War II. Kansas sent 215,000 to World War II and 80,260 to World War I. The next most important Kansas wartime contribution was the flood of grain poured out to feed the hungry of both World Wars, as well as to help assure the U.S. food supply. A somewhat unusual contribution was the flood of walnut gunstocks shipped from Kansas for World War II rifles.

New Mexico was the scene of the most important wartime experiment in history when the first atomic bomb was successfully exploded at the Trinity Site. The New Mexico National Guard had the misfortune to be on Bataan in the Philippines in World War II and suffered capture by the Japanese. Countless numbers lost their lives in the hideous death march from Corregidor. New Mexico contributed the most famed and best liked correspondent of World War II in the person of Ernie PYLE (1900-1945). In that war 73,000 took part from New Mexico and 2,032 lost their lives. World War I saw 17,157 New Mexicans in service, and 500 were lost.

Oklahoma suffered one of the first casualties of World War II. In the bombing of Pearl

Wounded Knee

Two major leaders of World War II, Winston Churchill, left, and Dwight D. Eisenhower are shown conferring above. Eisenhower was a native of the central west.

Harbor at the start of the war, the renowned Battleship *Oklahoma* was sunk, with heavy losses. Oklahoma contributed 200,000 service men and women in that war, and thirteen from Oklahoma won the Medal of Honor. World War I saw about 90,000 Oklahomans in service.

World War I called 11,393 from Wyoming and 32,791 from South Dakota. South Dakota recruits had the best health record in the nation in World War II. Colorado called 43,000 to World War I service, and 1,000 lost their lives. The number of Kansans in World War II reached 138,832, with 2,700 lost.

North Dakota called 31,269 to World War I, with a loss of 1,305. In World War II 60,016 served from North Dakota, with a loss of 1,939. Nebraskans in World War II totalled 120,000 with 3,839 lost. Historic Fort Robinson, Nebraska, was the site of the World War II war dog training center.

WOUNDED KNEE, Battle of. The town of Wounded Knee in Shannon County, south-western South Dakota, northeast of Pine Ridge and south of WALL has been immortalized by Dee Brown in her book on the American Indian entitled *Bury My Heart at Wounded Knee*. On nearby Wounded Knee Creek on December 29, 1890, the last significant clash between Indians and soldiers occurred on the North American continent. Sioux Indians surrounded by superior numbers of soldiers were commanded to give up all their remaining firearms. The Indians were tragically led by some of their medicine men who urged the men to fight, claiming they would be protected from bullets by their GHOST SHIRTS. Tension mounted as a search for guns was made. Militant medicine man Yellow Bird signalled the Indians to shoot, after one weapon apparently discharged by accident, and the troops returned fire. Of the 350 Indian men, women and children, 153 were counted dead and 44 wounded, but many of the wounded escaped, and relatives probably removed many of the dead before the actual count was made. The troops suffered 25 dead and thirty-nine wounded. Except for the battle of

the LITTLE BIG HORN the total casualities were probably the highest in Plains Indian warfare. The battlefield is located on the Pine Ridge Indian Reservation.

WOVOKA (Messiah) (NV, 1858—Schurz, NV, 1932). Paiute mystic also known as "Jack Wilson." Wovoka, born of Indian parents but raised by white Nevada rancher David Wilson, founded the Ghost Dance religion after a serious illness in 1889 during which he experienced a revelation which convinced him that the Indians would reinherit their tribal lands; prosperity would return, and the buffalo would again appear on the prairies. Instead of encouraging hatred of the whites Wovoka preached brotherhood, temporary submission and love. He believed that salvation was only attained by those who practiced a code similar to the Ten Commandments and the performance of rituals which climaxed with the Ghost Dance, which was to allow expression of repressed frustration while making possible communion with the dead and hastening the coming of the millennium. Wovoka's teachings were adopted by most western and some eastern tribes. The Sioux added aggressive and anti-white elements to the practices. The nonoccurrence of the millennium and the bitter defeat of Indians at WOUNDED KNEE, South Dakota, destroyed faith in Wovoka's teachings.

WRIGHT, Allen. (Attala County MS, Nov., 1826—Boggy Depot, OK, Dec. 2, 1885). Indian leader. One of the most notable of the tribal chiefs of Oklahoma, the Reverend Wright was a Christian minister and principal chief of the CHOCTAW NATION, the most numerous of the FIVE INDIAN NATIONS. It was Wright who suggested the name Oklahoma, which after many years was adopted for the state. The name was a literal translation of the Indian words *okla* (people) and *humma* (red), home of the red people.

WRITING ROCK STATE PARK. North Dakota site, between Grenora and Crosby, site of Writing Rock, a stone covered with mysterious pictographs.

WYANDOTTE, Kansas. Now part of Kansas City, Kansas, Wyandotte was the site, in July, 1859, of a fourth convention to write a new constitution for the state. This constitution was later approved by the people of Kansas and Congress and the state entered the Union as a free state.

WYOMING. State, situated in the center of the Central West Region, one of the three U.S. states having no natural boundaries, forming a perfect rectangle, as with Colorado, its neighbor to the south. The other southern neighbor, Utah, also occupies a portion of Wyoming's western boundary, with both Idaho and Montana sharing portions of the western boundary as well. Montana occupies the entire northern border of Wyoming, and South Dakota and Nebraska are neighbors to the east.

The distribution of the waters flowing through Wyoming makes for unusual geography. Tiny Isa Lake at the very crest of the CONTINENTAL DIVIDE sends its waters in two directions, some reaching the Atlantic Ocean, others the Pacific. This is said to be a unique situation for a single body of water. Then there is a three-way division of the waters. Near Dubois some rivers flow to the Missouri-Mississippi system, some to the Pacific through the Snake-Columbia systems and others to the Pacific through the Gulf of California by way of the Colorado system.

The SNAKE originates in Wyoming near the southern border of YELLOWSTONE NATIONAL PARK. The mighty GREEN RIVER begins east of JACKSON, Wyoming, and eventually flows into the Colorado. East of the Great Divide the YELLOWSTONE, SHOSHONE, BIGHORN, TONGUE, POWDER, BELLE FOURCE and LITTLE MISSOURI rivers all begin in Wyoming and flow north or northeast to the Missouri. The long and shallow NORTH PLATTE neither begins nor ends in Wyoming but follows a winding course through the state and eventually flows to the Missouri far to the east, near OMAHA, Nebraska. Its main tributaries in Wyoming are the SWEETWATER and the LARAMIE. Altogether, and perhaps surprisingly for a dry state, Wyoming has 20,000 miles of rivers.

The Continental Divide wanders erratically across Wyoming, roughly from northwest to south central. However, it takes its most eccentric twist in Wyoming, where it splits in two on either side of a vast basin, part of which is known as the Red Desert. Any waters which happen to fall within the basin must remain there without flowing to either ocean.

Wyoming has a small part of an even larger basin with waters not flowing to any sea. The Great Basin touches the southwest corner of the state west of the Bear River Divide. The BEAR RIVER cuts across Wyoming's west border twice, before flowing crazily into Great Salt Lake, to become the longest river in the hemisphere not flowing to any ocean.

Wyoming

Counties and County Seats

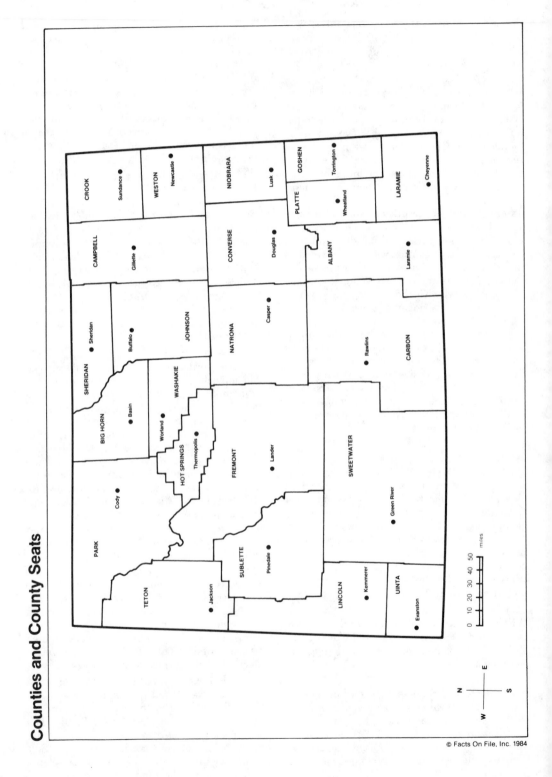

© Facts On File, Inc. 1984

Wyoming

STATE OF WYOMING

Name: From Wyoming Valley, Pennsylvania, in Algonquin means "large prairie place," or from the Delaware Indian word, meaning "mountains and valleys alternating."

Nickname: Equality State

Capital: Cheyenne

Motto: Equal Rights

Symbols and Emblems:
Bird: Meadowlark
Flower: Indian Paintbrush
Tree: Cottonwood
Stone: Jade
Song: "Wyoming"

Population:
1985: 509,000
Rank: 50th
Gain or Loss (1970-80): +138,000
Projection (1980-2000): +531,000
Density: 5 per sq. mi.
Percent urban: 62.7% (1980)

Racial Makeup (1980):
White: 94.9%
Black: 3,364 persons
Hispanic: 24,499 persons
Indian: 7,100 persons
Others: 12,700 persons

Largest City:
Cheyenne (53,960-1986)

Other Cities:
Casper (47,310-1986)
Laramie (24,930-1986)
Rock Springs (19,458-1980)
Sheridan (15,146-1980)
Gillette (12,134-1980)
Rawlins (11,547-1980)

Area: 97,809 sq. mi.
Rank: 9th

Highest Point: 13,804 ft. (Gannett Peak)

Lowest Point: 3,100 ft. (Belle Fourche River)

H.S. Completed: 77.9%

Four Yrs. College Completed: 17.2%

STATE GOVERNMENT

Elected Officials (4 year terms, expiring Jan. 1991):
GOVERNOR: $70,000 (1986)
SEC. OF STATE: $52,500 (1986)

General Assembly:
Meetings: January on even years and February on odd years, in Cheyenne.
Salary: When in session $75 per day and $60 per day expenses (1986)
Senate: 30 members
House: 64 members

Congressional Representatives
U.S. Senate: Terms expire 1989, 1991
U.S. House of Representatives: Two members (at large)

Major Rivers and Waterways

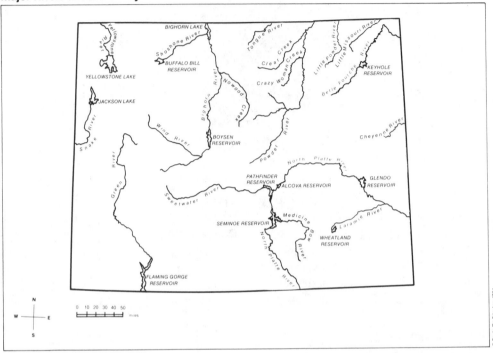

Wyoming is not a land of lakes. YELLOWSTONE LAKE, in Yellowstone National Park, is the largest, as well as being the largest body of water on the continent at a height over 7,500 feet. JACKSON LAKE in GRAND TETON NATIONAL PARK is known for its beauty. FLAMING GORGE RESERVOIR on the Green River extends most of its length into Wyoming. Pathfinder Reservoir, Seminoe Reservoir, Glendo Reservoir, Boysen Reservoir and Buffalo Bill Reservoir are other Wyoming bodies of water.

Wyoming is a state of both plains and mountains, with many dramatic ranges. The most dramatic of all and said by experts to be one of the most beautiful ranges in the world is the Teton Range, crowned by the Grand Teton at 13,766 feet. The Tetons appear even higher than they actually are, for they not only have no foothills, but they also rise abruptly from the depths of the valley called Jackson Hole. BIGHORN MOUNTAINS, with crests almost as high as the Tetons, the Snowy or Medicine Bow Range, Absaroka Range and Laramie Range are other major clusters of high peaks. Highest of all in Wyoming is Gannett Peak in the large WIND RIVER RANGE. Most of the ranges have subdivisions and divisions of divisions.

With nearly 100,000 square miles of territory, Wyoming is about the average in size in the Central West, ranking fifth in the region. In the nation it is ninth in size.

Beginning with the Cambrian period, Wyoming appears to have risen and fallen almost rhythmically as shallow seas swept in, and then the land swelled above the waters and crested in mountains. During the Mesozoic Era, most of the present state remained under water, until lifted again in the Tertiary period. The great glaciers did not reach Wyoming, but they lowered the temperature so that the higher mountains were covered with glaciers. When these melted, large lakes formed. Yellowstone Lake was much larger than it is now, formed behind a glacial dam, and it emptied into the Pacific. When the dam broke, the rush of water of the Yellowstone River cut into the yellow rocks below and formed the majestic GRAND CANYON OF THE YELLOWSTONE. This is considered to be a very "young" wonder. There still are many glaciers in the state.

The very dry climate makes the extremes of temperature (117 degrees) somewhat easier to live through. The violent blizzards are a terrible hazard to humans and their livestock. Yet in only a few hours the warm Chinook winds can bring shirtsleeve temperatures.

Wyoming is one of the few states in which manufacturing is not the leading income producer. Mining and minerals bring more than twice as much income. In spite of its small population, Wyoming holds sixth rank among all the states in mineral income. It produces the most coal of any western state. It ranks first in bentonite and soda ash and second in uranium. In oil production it holds sixth rank.

Agriculture is at the bottom of the list of major income sources in Wyoming, with cattle being the leading livestock. Wyoming ranks third in sheep production. Leading crops are wheat, sugar beets and hay. Manufacturing revolves principally around processing the mineral and agricultural products of the state.

In 1985 Wyoming had the smallest population of all the states, 509,000, a drop from 49th position in 1984. However, projections of population indicate that Wyoming population will increase 42.9 percent by the year 2000, the largest growth projected for any state. Ninety-five percent of the population is white, .71 percent black; there are 24,499 persons of Hispanic descent, and 5,254 Indian Americans.

One of the nation's most unusual prehistoric relics is known as the Medicine Wheel, on Medicine Mountain in the Bighorns. This unique construction resembles the British Stonehenge in some respects, as well as a similar wheel in the Gobi Desert. Huge rocks form a circle 245 feet in circumference. From a cairn stone in the center, 28 stone spokes radiate. Spaced around the wheel are six stone shelters, thought to have been used by ancient medicine men. The Indians were famliar with the wheel but had no idea who made it or what it meant. Perhaps even stranger is the giant arrow of rocks, 58 feet long, lying across the Bighorn basin. It seems to be pointing directly at the Medicine Wheel.

Still another mystery is the apparent stone structure near the top of the Grand Teton, also thought to have ancient origins. Yet another unknown, the mysterious "Spanish Diggings" are stone quarries which may be 5000 years old and may have been made by Europeans. An ancient stone cross found there has yet to be explained.

Many relics of stone age man have been found in Wyoming but nothing to indicate that copper age people made their homes there. Pictographs and petroglyphs are relatively common, being especially fine at Castle Gardens.

Few Indian groups occupied present Wyo-

Topographic Areas

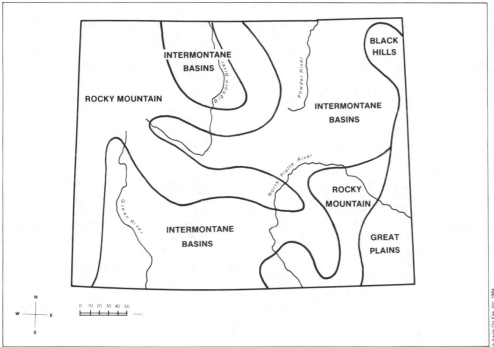

ming in early European times. The Crow were the first known; they were driven out by the others who followed: SHOSHONE, FLATHEAD, ARIKARA, SIOUX, ARAPAHO, CHEYENNE, BLACKFOOT, KIOWA, UTE, GROS VENTRE and MODOC. The primitive SHEEPEATER group lived in the Yellowstone area, a place shunned by other tribes as haunted.

Much of the area had been mapped by the 1790s, but records of exploration begin with John Colter in 1807. Scouting for fur trader Manuel Lisa, Colter discovered Yellowstone, which came to be called Colter's Hell. A white party led by Wilson price Hunt was the first known to have crossed present Wyoming, and Robert Stuart's party helped blaze the OREGON TRAIL, although returning from the west rather than starting from the east. In the 1820s William H. ASHLEY (1778-1838)installed a trading center on the YELLOWSTONE RIVER and began the series of annual fur trading meetings known as the RENDEZVOUS. The first (1825) was a roaring success at GREEN RIVER.

Captain B.L.E. Bonneville retraced the Oregon Trail in 1832, and FORT LARAMIE was established in 1834, to become Wyoming's first permanent white settlement. Beginning in 1846, thousands of Mormons passed through on their way to Utah, and soon established Deer Creek and Fort Supply in Wyoming in 1853. Peace with the Indians was ended in 1854, and intermittent Indian warfare continued for about 35 years. Indian raids were particularly worrisome to the workers on the transcontinental railroad, which, in spite of such problems, was finished from coast to coast in 1869. The next year Wyoming was organized as a territory.

Women's rights took a great step forward when Wyoming, while still a territory, became the first U.S. entity in which women were permitted to vote.

After being examined by a scientific committee, Colter's Hell, Yellowstone, became a national park in 1872, the first and still the largest, of all the great national parks to follow.

Among the major factors in Wyoming history was the herding of vast numbers of cattle up the Texas or Long trails. By 1884, 800,000 had been brought to the rich grazing lands of Wyoming, and the cattle barons had become the most influential group in the area.

Then the terrible winter of 1886 took a frightful toll of cattle. Homesteaders moved in to challenge the cattle kings, and violence took over between the two groups. The worst, known as the Johnson County Cattle War in 1892, was halted by the army. But the days of vigilante committees, hanging of outlaws and cattle

rustling were about over. In 1890 Congress approved statehood, despite the fact that the population in Wyoming was not as large as required.

New quarrels developed between cattle and sheep men. sheep were sometimes shot or poisoned, but the two eventually learned to get along with more harmony.

The Lincoln Highway, old U.S. 30, crossed the state in 1913, and seven percent of the Wyoming population served in WORLD WAR I, when Wyoming draftees were the most fit of those from any state. By 1924 Wyoming had taken another step toward women's rights with the election of Nellie Tayloe ROSS (1876-1977) as governor, one of two women governors elected that year.

GRAND TETON NATIONAL PARK was authorized in 1929, JACKSON HOLE NATIONAL MONUMENT in 1950, FORT LARAMIE NATIONAL HISTORIC SITE in 1960, and the state celebrated its 75th anniversary of statehood in 1965. Ronald Reagon won the state in 1980 and 1984, but the Democrats continued their hold on state government. In 1986 an important anthropological discovery was made when Philip Gingerich found evidence of what may be the remains of the first true primates, distant human ancestors.

Among Wyoming personalities three widely different women stand out. An outstanding advocate of women's rights was Esther Hobert Morris, the first woman ever to serve as a Justice of the Peace. Nellie Tayloe Ross was not only the first woman governor, but also was the director of the U.S. Mint. Martha Canary (1852?-1903, Calamity Jane) was an army scout and heroine of plains battles, one of the symbols of the old West.

Even earlier pioneers were Jim BRIDGER (1804-1881) and John Colter. Colter left the LEWIS AND CLARK EXPEDITION (1806) to stay in Wyoming where he discovered the marvels of Yellowstone, the Tetons, Jackson Hole and the source of the Snake River.

Notable Indian leaders were the good chief WASHAKIE (1804?-1900), who managed to keep the peace with the white intruders, and his son-in-law, the warlike master general CRAZY HORSE (1842?-1877).

Buffalo Bill CODY (1846-1917) was constantly associated with Wyoming and founded the community of Cody.

Authors Emerson HOUGH and Owen WISTER gained fame for their novels of the area, and artist Thomas MORAN (1837-1926) glorified it in his paintings. His name lives on in Mount Moran.

The capitol at Cheyenne, Wyoming.

During the early railroad period, circa 1864-1867, Cheyenne was so rough and tough it was known as "Hell-on-Wheels." Today, the city likes to recall its pioneer past as one of the symbols of the old West. One of the ten most notable annual events in the country is Cheyenne Frontier Days, in mid to late July, featuring one of the most famous of all rodeos.

However, Cheyenne is a thoroughly modern capital city with a striking capitol of Corinthian architecture.

Yellowstone National Park remains one of the most spectacular and frequently visited of all the national preserves. It is unique in its varied thermal features, geysers, hot springs, brilliantly colored pools, vast Yellowstone lake, exotic Grand Canyon of the Yellowstone, and the ever popular wildlife. In late years the park has become a favorite winter destination, available by snowmobile both individual and heated bus types.

The great beauty of Grand Teton National Park captivates all who see it, and experts have called the mountains one of the world's most beautiful ranges. Nestled in the park are such jewels as Jenny Lake and majestic Jackson Lake. Ever popular are the float trips down the Snake River.

Nearby Jackson is the hub of the vast area including the Tetons, Jackson Hole, one of the best of the nation's ski areas, and the National Elk Refuge. The community provides everything from chuck wagon dinner shows, rodeos and western musicals through art galleries, including a fall arts festival, and classical concerts.

Cody boasts Buffalo Bill Historical Center, described as one of the most complete and effective efforts of its type. The combination of its four museums has been called one of the major museum complexes of the nation. The four are the Buffalo Bill Museum, Winchester Arms Museum, Plains Indian Museum and Whitney Gallery of Western Art, including one of the best and most complete collections of its type.

Unlike any other natural feature of the country, the first national monument, DEVILS TOWER, stands out starkly, looming 865 feet above the prairie, described as looking "like a tree stump." Laramie is the site of the University of WYOMING with its Geological, Anthropol-

The rodeo during Frontier Days at Cheyenne, Wyoming, is the grandaddy of them all.

ogical and Fine Arts museums. It features the Snowy Range ski area and Jubilee Days, celebrating Wyoming statehood.

Most of the other communities of Wyoming have notable natural and manmade attractions, such as the Bradford Brinton Memorial Ranch Museum at Sheridan, the hot springs of Thermopolis, the chariot races of Torrington, the Intermittent Spring of Afton, Fort Casper Museum, Fort Bridger Museum and Old Timers Rodeo at Evanston and Fort Laramie National Historic site near Torrington.

WYOMING, UNIVERSITY OF. Founded in 1886 the university is Wyoming's only four-year institution of higher education. Located on a 753 acre campus in LARAMIE, the school had an enrollment during the 1985-1986 academic year of 10,109 students with 868 faculty members. The school is accredited with the North Central Association of Colleges and Schools. The university includes the colleges of law, health sciences, education, arts and sciences, agriculture and commerce and industry.

#

YAMPA RIVER. Colorado river rising in Routt County and flowing 250 miles north and then west into the GREEN RIVER near the Utah border.

Yankton Indians - Yanktonai Indians

YANKTON INDIANS. One of the seven main divisions of the Dacotah. The Yankton migrated from northern Minnesota to the plains by the early 18th century. The tribal name meant, "end village." They were subdivided into eight bands which were further divided into patrilineal clans. A band council composed of the hereditary chief and the clan leaders governed. As the Yankton moved onto the plains, they continued to plant crops. From the plains tribes they adopted the bullboats, dog travois and skin tipis. The Yankton worshipped Wakan Tanka, the Great Spirit and performed the Sun Dance. In the 1830s a gradual decline began in the Yankton society with repeated epidemics of smallpox, scarce game and war with many other tribes. They ceded all their lands by 1860 and moved to the Yankton Reservation on the MISSOURI RIVER in southern South Dakota. Some Yankton were moved to the Lower Brule and Crow Creek reservations in South Dakota and to Fort Totten in North Dakota.

YANKTON, South Dakota. City (pop. 12,-011), Yankton County, southeastern South Dakota, southwest of SIOUX FALLS and southeast of MITCHELL. Founded in 1858, Yankton was named the capital of Dakota Territory in 1861 when it hosted the first meeting of the territorial legislature. The upper house met in the home of William Tripp, and the lower house met in the Episcopal church. In its early days the settlement was saved from an Indian attack by the powerful Yankton Indian leader Struck-by-the-Ree, who as a child had been wrapped in an American flag and prophesied to become a friend of the Americans by Meriweather LEWIS (1774-1809) of the LEWIS AND CLARK EXPEDITION who recognized the value Indians placed in prophecies. A Yankton prospector, James Pearson, discovered gold near present-day DEADWOOD, South Dakota, in 1875 setting off a rush which brought 25,000 to the wilderness area by mid-summer of 1876. One of the worst floods in South Dakota history occurred after the terrible winter of 1880-1881 when an ice dam, formed on the MISSOURI RIVER near Yankton, suddenly broke apart sending a wall of water crashing downstream. The entire village of Green Island was destroyed including the church which was swept away intact with its bell pealing eerily, according to legend. Later the first public bridge across the Missouri River was constructed at Yankton in 1919, after the citizens raised the necessary money. Personal finances of Governor William A. Howard also built the first home for the insane in Yankton. The oldest newspaper in the state, which reported the gold rush of the 1800s and the Custer defeat, is still printed there. Yankton College was the first in the Dakotas. Prominent for its 130 foot wide streets, Yankton has restored the Territorial Council Chamber where meetings of the Dakota legislature were held. Nearby Gavins Point Dam, nicknamed "the Mighty Mite," plays an important role in flood control on the Missouri River and creates a reservoir called Lewis and Clark Lake. A visitor's center presents history of the area, the dam and the lake.

YANKTONAI INDIANS. One of seven main divisions of the Dacotah. The Yanktonai and the YANKTON were once one tribe. The ASSINIBOIN, once part of the Yanktonai, separated from them in the early 17th century. The Yanktonai and the Yankton separated in the 1680s. By the early 19th century the Yanktonai were hunting buffalo in an area bordered by the RED RIVER, west to the Missouri and north to Devil's Lake. They obtained British trade goods from the Wahpekute and Sisseton Dacotah and traded with tribes farther west. A severe smallpox

Lower Falls at Yellowstone National Park, oldest of the national preserves.

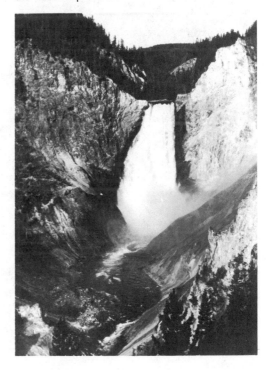

epidemic in 1856-1857 ravaged the tribe. The Yanktonai ceded their lands to the United States in an 1865 treaty. The Upper Yanktonai were sent to Standing Rock and Devil's Lake reservations in the Dakotas. Standing Rock, Crow Creek (South Dakota), and Fort Peck (Montana) received the Lower Yanktonai. By the late 1970s the Yanktonai population of five thousand was intermingled with the other Dacotah.

YELLOWSTONE LAKE. The highest large body of water in North America, at an altitude of 7,735 feet. The lake, in YELLOWSTONE NATIONAL PARK, Wyoming, is twenty miles long and has an area of 137 square miles. The Yellowstone River flows through the lake in a south to north direction.

YELLOWSTONE NATIONAL PARK. Old Faithful and some 10,000 other geysers and hot springs make this the earth's greatest geyser area. Here, too, are lakes, waterfalls, high mountain meadows and the Grand Canyon of the YELLOWSTONE RIVER—all set apart in 1872 as the world's first national park. Headquartered Yellowstone National Park, Wyoming.

YELLOWSTONE RIVER. Major river in northwest Wyoming and south and eastern Montana which is navigable for 300 miles during high water. The river starts in Park County, Wyoming, and flows north through YELLOWSTONE LAKE and YELLOWSTONE NATIONAL PARK. It continues across the Montana border, then turns east and northeast into the MISSOURI RIVER on the border between Montana and North Dakota. The entire course of the river covers 671 miles.

YELLOWTAIL DAM. Project completed in 1966 across the BIGHORN RIVER. The dam, 525 feet high, forms seventy-one-mile-long BIGHORN LAKE stretching between Montana and Wyoming.

YOGO SAPPHIRE MINES. Sapphire mining source in Yogo Gulch, near GARNEILL, Mon-

Ysleta Mission, El Paso, Texas

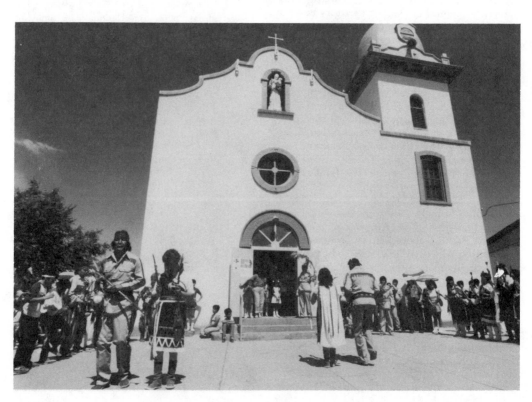

tana. Yogo Gulch is noted for its cornflower blue sapphires which are often large, with great brilliance and depth of color.

YOUNG, Hugh Hampton. (San Antonio TX, Sept. 18, 1870—Baltimore, MD, Aug. 23, 1945). Urologist. Considered an authority on urological surgery, Young, became Chief of the Department and Professor of Urology at Johns Hopkins University in 1898. His greatest contribution to the field was an operation for cancer of the prostate. His autobiography, *Hugh Young, A Surgeon's Autobiography* was published in 1940.

YSCANI INDIANS. Along with the Taovayo and Tawakinis (Tehuacana) Indians a tribe of the Wichita CADDO, one of America's southwesternmost mound builders who lived in Texas along the RED RIVER.

YSLETA, Texas. The oldest permanent European settlement in Texas, established in 1682, now a part of EL PASO. At one time the settlement was on the Mexican side of the RIO GRANDE RIVER, before the river shifted its course leaving the town on the northern (U.S.) side. The area became a center for the cultivation of Egyptian long-staple cotton.

YUCCA ELATA. This official state flower of New Mexico, is a member of the lily family, growing mostly in the western U.S. and Mexico but also found in parts of the Eastern U.S. and the West Indies. Its long spiky flower stalk sports blooms of white or purple. It is pollinated by the yucca moth. Without the help of this moth, the fruit rarely develops. Seven varieties of yucca grow in New Mexico, but the elata is the official symbol, growing sometimes to tree-like heights. It is one of the few state flowers with commercial possibilities. Quality fiber from such areas as the field of Demming, New Mexico, can be used for twine, seat pads and bagging materials, among other items. For the Indians, yucca root was a source of soap. The roots, called amole, were ground and then soaked in hot water to create a cleansing material equal to today's best. The buds and flowers were eaten raw or boiled, while the fruit was dried and eaten in the winter or used to make a fermented drink. Yuccas today also provide decorative plants in southwest gardens and as border plants along property lines.

YUCCA HOUSE NATIONAL MONUMENT. Ruins of these large prehistoric Indian

pueblos are as yet unexcavated, and the park is not now open to the public, although the site was proclaimed on December 19, 1919. Headquartered at MESA VERDE NATIONAL PARK, Colorado.

YUGEUINGGE PUEBLO. Tewa Pueblo where, on July 11, 1598, Spanish Governor Don Juan de ONATE (1550?-1630) established a settlement, the first European settlement in New Mexico and the second in the United States.

ZIA PUEBLO. Small Keresan tribe and Pueblo along the JEMEZ RIVER near BERNALILLO, New Mexico. The Pueblo, established in 1300, had its first contact with whites when the Spanish explorer Castaneda visited in 1541. The Zia participated in the Pueblo Revolt against the Spanish in 1680, and in 1687 witnessed the bloodiest battle in the revolt in which six hundred Zia were killed and seventy taken captive. The Zia were granted the right to their land in 1689, and in 1692 they joined with the Spanish to rebuild the Pueblo, an action for which they were hated by the other Pueblos. The tribe was organized into thirty-six clans which culturally resembled such other Keresan tribes as the Laguna, Cochiti, and Acoma. During the 1970s approximately six hundred Zia lived on the 112,500-acre reservation, governed by a tribal council.

ZINNIA SEEDS. According to the Colorado agricultural department, one third of all zinnia seeds produced in the United States come from Colorado's Arkansas Valley.

ZIOLKOWSKI, Korczak. (Boston, MA, Sept. 6, 1908—SD, Oct. 20, 1982). Sculptor. Ziolkowski was invited in 1947 by South Dakota Indians to come to South Dakota to produce a monument to Chief CRAZY HORSE (1842?-1877), one of the greatest of Indian war chiefs. Ziolkowski spent the rest of his life preparing for the monumental statue which was to serve as the focal point of a huge non-profit educational and cultural memorial for all North American Indians. He was a self-taught sculptor and engineer who never took a lesson in either subject. In 1939 his bust of Paderewski won first prize for sculpture by popular vote at the New York World's Fair. His works are currently displayed in the Sitting Bull Memorial near MOBRIDGE, South Dakota, and the John F. Kennedy Presidential Library in Boston, Massachusetts. With his wife, Ruth, Ziolkowski prepared three books of plans for the Crazy

Zuni Indians

Horse project so that the family, of five boys and five girls, could continue his work after his death. A Crazy Horse Memorial Foundation was established as Ziolkowski twice rejected potential federal financing in favor of private donations. The work continues under family direction.

ZUNI INDIANS. Largest Pueblo tribe with an estimated population of more than six thousand in the late 1970s. The Zuni live in the present Zuni Pueblos forty miles southwest of GALLUP, New Mexico, where the Zuni were consolidated in 1643. Men constructed the houses, and the women did the plastering inside with adobe. Zuni men grew six varieties of corn in addition to beans, cotton, and squash. Sagebrush windbreaks were constructed around the fields and diversion dams were built for irrigation. Women tended small gardens and gathered wild foods including roots and seeds. At the beginning of historic times, they occupied six pueblos in the same area in 1540 when visited by Francisco CORONADO (1510-1554). The Zuni referred to themselves as Ashiwi, or "the flesh." The tribe was organized into clans with membership in a clan determined through the mother. Each clan had one or more extended families. Clans had annual ceremonies and acted as the guardians of ceremonial paraphernalia. Cults and secret societies abounded. All adult Zuni males belonged to the kachina cult which was divided into six kivas, or ceremonial centers representing the six directions. Members of the kachina society performed masked rain dances in which the kachina, spirits associated with rain gods and Zuni ancestors, were impersonated. The Zuni joined in the Pueblo Revolt of 1680 and revolted against the Spanish again in 1705. In 1877, the reservation for the Zuni was established on the original Spanish land grant. The Zuni are recognized for their beautiful silver and turquoise jewelry, pottery and beadwork. Tourists are attracted to some of the Zuni ceremonies which are open to the public. One of the most important ceremonies, performed by the priests of the kachina society in November or December, was associated with the Winter Solstice, or Shalako.

The nation rises to its highest average altitude in the region, typified by such mountain glories as Rocky Mountain National Park, 71 miles northwest of Denver.

SELECTED BIBLIOGRAPHY

ART

Andrews, Ralph W. *Photographers of the Frontier West. Bonanza,* 1965

Catlin, George. *North American Indians* vols. 1 and 2. Ross and Haines, 1965

Ewers, John C. *Plains Indian Painting.* Palo Alto, 1939

Peterson, Karen Daniels. *Plains Indian Art from Fort Marion.* Norman: Univ. of Oklahoma Press, 1971

Ross, Marvin C. *The West of Alfred Jacob Miller.* Norman: Univ. of Oklahoma Press, 1951

Heller, Nancy and Julia William. *The Regionalists.* Cincinnati: Watson-Guptil, 1976

BIBLIOGRAPHY

Wright, Rita J. *Texas Sources: A Bibliography.* Austin: Univ. of Texas, 1976

BIOGRAPHY

Adams, Alexander B: *Sitting Bull: An Epic of the Plains* New York: G.P. Putnam's Sons, 1969

Adams, Alexander B.: *Geronimo.* New York. G.P. Putnam's Sons, 1971

Beal, Merrill D. *"I will Fight No More Forever:" Chief Joseph and the Nez Perce War.* Seattle: Univ of Wash. Press

Boyer, Richard O. *The Legend of John Brown.* New York: Knopf, 1973

Carpenter, Allan. *Dwight D. Eisenhower: The Warring Peacemaker.* Vero Beach: Rourke, 1987

Carpenter, Allan. *Sam Houston: Champion of America.* Vero Beach: Rourke, 1987

Davis, Kenneth S. *Soldier of Democracy: A Biography of Dwight Eisenhower.* New York: Doubleday, 1945, 1952

Friend, Llerena. *Sam Houston: The Great Designer.* Austin: Univ of Texas Press, 1954

Hebard, Grace R. *Washakie.* The Arthur H. Clark Company, 1930

Jackson, Clyde L and Grace. *Quanah Parker: Last Chief of the Comanches.* New York: Exposition Press, 1963

Russell, Don. *The Lives and Legends of Buffalo Bill.* Norman: Univ. of Oklahoma Press, 1960

Stewart, Edgar I. *Custer's Luck.* Norman: Univ. of Oklahoma Press, 1955

COMMUNAL LIFE

Holloway, Mark. *Heavens on Earth: Utopian Communities in America, 1680-1880.* rev. ed. New York: Dover, 1966

CULTURE

Brock, Wallace and B.K. Winer, eds. *Homespun America.* New York: Simon and Schuster, 1958

ECONOMY

Greever, William S. *The Bonanza West.* Norman: Univ. of Oklahoma Press, 1963

Groner, Alex. *The American Heritage History of American Business and Industry.* Philadelphia: American Heritage, 1972

Schlebecker, John T. *Whereby We Thrive: A History of American Farming, 1607-1972.* Ames: Iowa State University Press, 1975

Spratt, John S. *The Road to Spindletop: Economic Change in Texas, 1975-1901.* Austin: Univ. of Texas Press, 1983

ETHNIC/RACIAL

Bicha, Karel D. *The Czechs in Oklahoma* Norman: Univ. of Oklahoma Press, 1980

Blacks in the Westward movement. Washington: Smithsonian Institution Press, 1975

Brown, Kenny L. *Italians in Oklahoma.* Norman: Univ of Oklahoma Press, 1978

Dinnerstein, Leonard and Frederic C. Jaker, eds. *Aliens: A History of Ethnic Minorities in America.* New York: Appleton, 1970

Franklin, Jimmie Lewis. *Blacks in Oklahoma.* Norman: Univ. of Oklahoma Press, 1978

Reeve, Frank and Alice Cleaveland. *New Mexico: Land of Many Cultures.* Rev. ed Boulder: Pruett, 1980

Rohrs, Richard. *Germans in Oklahoma.* Norman: Univ of Oklahoma Press, 1980

Samora, Julian and Patricia Vandel Simon. *A History of the Mexican-American People.* Notre Dame: Univ. of Notre Dame Press, 1977

Smith, Michael. *Mexicans in Oklahoma.* Norman: Univ. of Oklahoma Press, 1980

Strickland, Rennard. *Indians in Oklahoma.* Norman: Univ. of Oklahoma Press, 1980

Tobias, Henry J. *Jews in Oklahoma.* Norman: Univ of Oklahoma Press, 1980

Tweton, D. Jerome and Theodore Jelliff. *North Dakota—The Heritage of a People.* Fargo: N.D. Institute for Regional Studies, 1976

EXPLORATION

Clark, William and Meriwether Lewis. *History of the Expedition of Captains Lewis and Clark to the Sources of the Missouri, Thence Across the Rocky Mountains and Down the River Columbia to the Pacific Ocean,* 2 vols. Philadelphia and New York: 1814

Cox, Isaac J. ed. *The Journals of Rene Robert Cavelier, Sieur La Salle,* 2 vols. New York: Barnes, 1905

Dobie, J. Frank. *Coronado's Children.* Boston: Little, Brown, 1941

Fuller, Harlin M. and Leroy R. Hafen, eds. *The Journal of Capt. John R. Bell, Offical Journalist for*

the Stephen H. Long Expedition to the Rocky Mountains, 1820. Glendale, 1957

Goetzmann, William H. Army Exploration in the American West, 1803-1863. New Haven: Yale Univ. Press, 1959

Lavender, David. Westward Vision: The Story of the Oregon Trail. New York: McGraw-Hill, 1963

Pike, Zebulon M. An Account of Expeditions...During the Years 1805, 1806 and 1807. Philadelphia and Baltimore: 1810

Rawling, Gerald. The Pathfinders New York: Macmillan, 1964

FOLKLORE

Dorson, Richard M. American Folklore. Chicago: Univ. of Chicago, 1959

GENERAL

Alsberg, Henry G., ed. The American Guide. New York: Hastings, 1939

Beard, Charles A. and Mary R. The Rise of American Civilization. New York: Macmillan, 1966

Dary, David. True Tales of the Old-Time Plains. New York: Crown, 1979

Lavender, David. The American Heritage History of the Old West. Philadelphia, American Heritage, 1965

Paxson, Frederic L. History of the American Frontier: 1763-1893. New York: Houghton Mifflin, 1924

Riegel, Robert E. and Robert G. Athearn. America Moves West. New York: Holt, Rinehart and Winston, 1969

GOVERNMENT

Strain, Jack M. An Outline of Oklahoma Government. Edmond: Central State University, 1978

HISTORY

Betzinez, Jason, with Wilbur Sturtevant Nye. I fought with Geronimo. New York: Stackpole, 1960

Billington, Ray A. Westward Expansion: A History of the American Frontier. New York: Macmillan

Bourke, John G. On the Border with Crook. Lincoln: University of Nebraska Press

Brown, Dee. Bury My Heart at Wounded Knee. New York: Holt, Rinehart and Winston, 1971

Frazer, Robert W. Forts of the West. Norman: Univ. of Oklahoma Press, 1964

Monaghan, James. Civil War on the Western Border, 1856-1865. Boston: Little Brown, 1955

Mooney, James. The Ghost-Dance Religion and the Sioux Outbreak of 1890. Chicago: Univ. of Chicago Press, 1965

Prucha, Francis Paul. A Guide to the Military Posts of the United States 1789-1895. Madison: The State Historical Society of Wisconsin, 1971

Utley, Robert M. Frontier Regulars, the United States Army and the Indian, 1866-1891. New York: Macmillan

INDIANS

Annual Report of the Commissioner of Indian Affairs. 1874, 1881, 1889: Washington: U.S. Government Printing Office

Andrist, Ralph K., The Long Death: The Last Days of the Plains Indians. Philadelphia, Collier Books, 1964

Cremony, J.C. Life Among the Apaches. Santa Fe: Rio Grande Press, 1970

Ewers, John C. Indian Life on the Upper Missouri. Norman: Univ of Oklahoma Press, 1968

Hodge, Frederick W., ed. Handbook of American Indians, North of Mexico, vols 1 and 2. Rowman and Littlefield, 1971

Jackson, Helen Hunt. A Century of Dishonor: A Sketch of the U.S. Government's Dealing with Some of the Indian tribes. New York: Harper, 1881

Josephy, Alvin M., Jr. The Patriot Chiefs. New York: Viking, 1961

Newcomb, W.W., Jr. The Indians of Texas: From Prehistoric to Modern Times. Austin: Univ of Texas Press, 1969

LITERATURE

Milton, John R., ed. The Literature of South Dakota. Vermillion: Dakota Press, 1976

Stein, Rita. A Literary Tour Guide to the U.S.: West and Midwest. New York: Morrow, 1979

STATES

Colorado

Abbott, Carl. Colorado: A History of the Centennial State. Boulder: Colorado Associated Univ. Press, 1976

Carpenter, Allan. Colorado: Enchantment of America. Chicago: Childrens Press, 1978

Federal Writers' Project. Colorado: A Guide to the Highest State, reprint. New York: Somerset, 1980 (orig. 1941)

Sprague, Marshall. Colorado: A Bicentennial History. New York: Norton, 1976

Ubbelohde, Carl, Maxine Benson, and Duane A. Smith. A Colorado History. 5th ed. Boulder: Pruett, 1982

Walton, Roger A. Colorado: A Practical Guide to Its Government and People. Fort Collins: Publishers Consultants, 1976

Kansas

Carpenter, Allan. Kansas: Enchantment of America. Chicago: Childrens Press, 1979

Davis, Kenneth S. Kansas: A Bicentennial History. New York: Norton, 1976

Howes, Charles C. This Place Called Kansas. Norman: Univ. of Oklahoma Press, 1984

Richmond, Robert W. Kansas: A Land of Contrasts. St. Charles: Forum Press, 1977

Socolofsky, Homer and Huber Self. Historical Atlas of Kansas Norman: Univ. of Okla. Press, 1972

Montana

Carpenter, Allan. Montana: Enchantment of America. Chicago: Childrens Press, 1979

Federal Writers' Project. Montana: A State Guide Book, reprint. New York: Somerset, n.d. (orig. 1939).

Spence, Clark C. Montana: A Bicentennial History. New York: Norton, 1978

Toole, Kenneth R. Twentieth-Century Montana:

A State of Extremes. Norman: Univ. of Oklahoma Press, 1983

Nebraska

Carpenter, Allan. *Nebraska: Enchantment of America.* Chicago: Childrens Press, 1979

Federal Writers' Project. *Nebraska: A Guide to the Cornhusker State* reprint. New York: Somerset, n.d. (orig. 1939)

Olson, James C. *History of Nebraska.* Lincoln: Univ. of Nebraska Press, 1966 (orig. 1955)

New Mexico

Beck, W.A. *New Mexico: A History of Four Centuries.* Reprint. Norman: Univ. of Oklahoma Press, 1979

Carpenter, Allan. *New Mexico: Enchantment of America.* Chicago, Childrens Press, 1979

Federal Writers' Project. *New Mexico: A Guide to the Colorful State.* Reprint. New York: Somerset, n.d. (orig. 1940)

Simmons, Marc. *New Mexico: A Bicentennial History.* Norton, 1977

North Dakota

Carpenter, Allan. *North Dakota: Enchantment of America.* Chicago: Childrens Press, 1979

Federal Writers's Project. *North Dakota: A guide to the Northern Prairie State* reprint. New York: Somerset, 1980 (orig. 1938)

Robinson, Elwyn B. *History of North Dakota.* Lincoln: Univ. of Nebraska Press, 1966

Wilkins, Robert P. and Wynona H. *North Dakota.* New York: Norton, 1977

Oklahoma

Carpenter, Allan. *Oklahoma: Enchantment of America.* Chicago: Childrens Press

Gibson, Arrell M. *The Oklahoma Story.* Norman: Univ of Oklahoma Press, 1978

Morgan, H. Wayne and Anne Hodges. *Oklahoma: A Bicentennial History.* New York: Norton, 1977

South Dakota

Carpenter, Allan. *South Dakota: Enchantment of America.* Chicago, Childrens Press, 1979

Federal Writers' Project. *South Dakota: A Guide to the State.* New York: Somerset, n.d. (orig. 1938)

History of South Dakota 3d ed. Lincoln: Univ. of Nebraska Press, 1975

Schell, Herbert. *History of South Dakota,* 3rd ed. Lincoln: Univ. of Nebraska Press, 1975

Texas

Binkley, William C. *The Texas Revolution.* Austin: Texas State Historical Association, 1979

Carpenter, Allan. *Texas: Enchantment of America.* Chicago, Childrens Press, 1978

Connor, Seymour V. *Texas: A History.* New York: Thomas Y. Crowell, 1971

Dobie, J. Frank. *The Longhorns.* Boston: Little, Brown, 1941

Federal Writers' Project. *Texas: A Guide to the Lone Star State.* Reprint. New York: Somerset, n.d. (orig. 1940)

Frantz, Joe B. *Texas: A Bicentennial History.* New York: Norton, 1976

Richardson, Rupert N., et al. *Texas: The Lone Star State.* Englewood Cliffs: Prentice-Hall, 1981

Wyoming

Carpenter, Allan. *Wyoming: Enchantment of America.* Chicago, Childrens Press, 1979

Larson, T.A. *History of Wyoming* 2nd ed, rev. Lincoln: Univ. of Nebraska Press, 1978

Mead, Jean. *Wyoming in Profile.* Boulder: Pruett, 1982

Transportation Athearn, Robert G. *Union Pacific Country.* New York; Rand McNally, 1971

Holbrook, Stewart H. *The Story of American Railroads.* New York: Crown, 1947

Latham Frank. *The Transcontinental Railroad.* New York: Watts, 1973

Index

Index

B

Index

Index

Index

E

Index

H

Index

I

Index

K

Index

M

Index

Index

N

Index

Index

Index

Index

Index

T

Index

U

Index

V

W

Index